LETTERS OF
Gustave Courbet

LETTERS OF
Gustave Courbet

Edited and Translated by

Petra ten-Doesschate Chu

The University of Chicago Press Chicago and London

PETRA TEN-DOESSCHATE CHU is professor and head of the
Department of Art and Music at Seton Hall University.

The University of Chicago Press, Chicago 60637
The University of Chicago Press, Ltd., London
© 1992 by The University of Chicago
All rights reserved. Published 1992
Printed in the United States of America

01 00 99 98 97 96 95 94 93 92 5 4 3 2 1

ISBN (cloth): 0-226-11653-0

© Bibliothèque nationale for the seventy-five unpublished letters of Courbet that are in the
collection of the Bibliothèque nationale, Paris.

This translation has been made possible in part by
The Jan Mitchell Award of the Wheatland Foundation.

Publication of this work has been aided by a grant from the John Simon Guggenheim
Memorial Foundation.

Library of Congress Cataloging-in-Publication Data

Courbet, Gustave, 1819–1877.
 [Correspondence. English. Selections]
 Letters of Gustave Courbet / edited and translated by
 Petra ten-Doesschate Chu.
 p. cm.
 Translated from the French.
 Includes bibliographical references and index.
 1. Courbet, Gustave, 1819–1877—Correspondence. 2. Painters—
France—Correspondence. I. Chu, Petra ten-Doesschate. II. Title.
ND553.C9A3 1992
759.4—dc20
[B] 91–21917
 CIP

♾ *The paper used in this publication meets the minimum requirements of the American*
National Standard for Information Sciences—Permanence of Paper for Printed Library
Materials, ANSI Z39.48-1984.

To Carlos van Hasselt,
who inspired me to start this project,
and to Yvonne and Gabriel Weisberg,
who encouraged me to complete it.

Contents

Acknowledgments ix

Editorial Principles xi

Introduction 1

 The Letters 11

Chronology 625

Correspondents and Persons Frequently Mentioned 637

Works Mentioned in the Letters and Notes 665

Chronological Inventory of Letters 683

References 701

General Index 717

Index of Courbet's Works 723

Illustrations follow page 302

Acknowledgments

Among the numerous institutions and individuals who have contributed to the realization of this edition of the letters of Gustave Courbet, my thanks go out, above all, to Wendy Wertz Alexander, who has assisted me with this project for more than three years. Without her help, her moral support, and her friendship, this book would not have seen the light of day.

Two other women have been crucial to the completion of this edition. Anne van de Jagt-Lew has done much invaluable research in Paris, and Alexandra Bonfante-Warren has polished the translation.

For their constant encouragement and help in many ways I thank the three people to whom this book is dedicated—Carlos van Hasselt, and Yvonne and Gabriel Weisberg. Above all, they have enabled me to maintain a sense of humor in the face of the numerous greater or lesser irritations that were part and parcel of this project.

Many individuals have alerted me to letters in private collections, supplied valuable information, or contributed otherwise. Among them I would like to mention the late Jean Adhémar, Janine Bailly-Herzberg, the late Robert Beare, Robert Bezucha, Albert Boime, Thierry Bodin, Roger Bonniot, Peter Bunnell, Pierre Chessex, Loïc Chotard, Mei-Mei Chu, Claude Coppens-Papeians, Roger Coupa, Paul Crapo, Carole Demas, Jean-Jacques Fernier, Madeleine Fidell-Beaufort, Marie-Thérèse de Forges, Michael Fried, Bernard Gantner, John Harrington, Klaus Herding, Werner Hofmann, the late Maria Hunink, Chantal Lombardi, Patricia Mainardi, Jean-Luc Mayaud, Terry Hughes Ryan, Hans Lüthy, Christian Klemm, Anne Korteweg, Jean-Luc Mayaud, Linda Nochlin, Theodore Reff, James Rubin, Naomi Sawelson-Gorse, Joan Scott, C. A. J. Thomassen, Hélène Toussaint, Marc Vuilleumier, and Françoise Waquet.

This project could not have been carried out without the financial support of the John Simon Guggenheim Memorial Foundation, the National Endowment of the Humanities, the Wheatland Foundation, the Princeton Institute for Advanced Study, and Seton Hall University. I am extremely grateful for their generosity and thank the individuals in those institutions who have assisted me in various ways. Among them I must single out Irving Lavin, faculty member at the Institute for Advanced Study, Bernhard Scholz, Provost of Seton Hall University, and G. Thomas Tanselle, Vice President of the Guggenheim Foundation.

For permission to publish the letters and the photographic reproductions contained in this volume, I thank their owners, who are listed in the back of this book. I am especially grateful to the individuals who were responsible for providing me with the necessary xeroxes and photographs.

In the final stages of this project I have had the great pleasure of working with the University of Chicago Press. Senior editor Karen Wilson has been a model of patience and understanding and so has Margaret Mahan, chief manuscript editor. Special thanks must go as well to Joseph Brown, who copyedited the manuscript.

It is customary to acknowledge one's family last, and perhaps that is proper for they bear the brunt of the undertaking and endure its consequences from beginning to end. Thank you all for your love and understanding.

Editorial Principles

Names that occur with some frequency in the letters are marked with an asterisk and may be looked up in the list of correspondents and persons frequently mentioned that is appended to this edition. All titles of paintings have been italicized; they are followed by a number in brackets corresponding to a list of works, likewise found at the end of the book.

Establishing the chronology of the letters has been a major problem. As Courbet did not generally date his letters until his final years, dating has been based on postmarks if available. In several instances postmarks are no longer available, but the letters are dated by another, perhaps the recipient's hand. This has been indicated by (Ad) behind the letter. In other cases the postmarks were available to authors writing on Courbet who had letters and envelopes at their disposal. Dates can be found, for example, in Bruyas 1856, Chennevières 1883–89, Léger 1948, and Riat 1906. This has been indicated by (Bd), (Cd), (Ld) and (Rd), respectively.

In the case of incomplete texts, the indication "fragment" means that the original text is known but only fragmentarily; "incomplete" signifies that the original text is not known and that an incomplete transcription or paraphrase is all that is currently available.

Introduction

WHEN I EMBARKED ON THIS EDITION OF THE LETTERS OF GUSTAVE COURBET more than ten years ago, I did so out of a conviction that, in most of the Courbet literature of the postwar years, the artist's letters (and his writings in general) had received too little serious attention. To be sure, those letters that were known through previous publications by Borel, Courthion, Riat, and others, were frequently cited, but all too often they were quoted partially, selectively (if not eclectically), and uncritically, without consideration of their context, purpose, or the identity of the addressee.[1] Now, ten years later, I am even more convinced that a contextual and critical reading of the letters in their proper chronological order is essential for any Courbet study and that it will dispel certain notions, particularly related to Courbet's social and educational background and his role in the cultural and political life of the Second Empire, that have hampered rather than helped our understanding of the artist and his work.

The correspondence of Courbet spans forty years of his life. The earliest extant letter was written in the fall of 1837, when the eighteen-year-old Gustave had left home for the first time in order to attend the Collège de Besançon. The last letter dates from the early winter of 1877, when, eight days before his death in exile in Switzerland, Courbet dictated a letter to his father and his sister reassuring them about the state of his health. Dating from all phases of his adult life, Courbet's letters thus enable the reader to follow the artist's development from a spoiled teenager complaining about the cold mutton and thin blankets in the school dormitory to an artist of international repute who had become a symbol of intellectual and political independence, if not subversiveness.

Though the content of Courbet's letters varies greatly over the years, their form does not change drastically. Perhaps the most salient characteristic of his writing is the disregard for orthography and punctuation. Courbet's spelling was a standing joke among his contemporaries, who cited it as a sign of his illiteracy and lack of education.[2] By focusing on Courbet's faulty orthography, however, it was easy to overlook the genuine literary qualities of his writing: the short pointed phrases, colorful descriptions, rich vocabulary, and creative syntax. That there was some real appreciation for these qualities of Courbet's writing style appears from the fact that such experienced authors as Francis

1. For previous publications of selected Courbet letters, see the list of references.
2. In view of the fact that Courbet had gone to school almost until the age of twenty, the possibility that his inadequacy in spelling was related to some mild form of dyslexia must be seriously considered.

Wey and Pierre-Joseph Proudhon did not hesitate to incorporate fragments of Courbet's letters into their own writing. Courbet's description of the *Stone-breakers* (letter 49-8), for example, was copied almost word for word in Francis Wey's serial novel *Biez de Serine*, and Proudhon, even though he commented disparagingly about the letters Courbet wrote him (cf. Bowness 1978, 127), did not hesitate to borrow from them in his *Du principe de l'art et de sa destination sociale* (See letter 63-17, n. 1). Several publishers also recognized the force of Courbet's writing. For example, in 1861 the publisher Furne invited him to write a series of articles on the hunt in the Franche-Comté (see letter 61-2), a project that unfortunately was not carried to completion. Finally, a relatively large number of Courbet's letters were published in the contemporary press. Some of these were letters to friends or enemies that were more or less deliberately "leaked" to the press; others were "letters to the editor" written with the specific purpose of being printed in the papers. It is noteworthy that, while Courbet initially asked his literary friends (Charles Baudelaire, Champfleury, Jules Castagnary) to write these letters for him, later in life he had enough confidence in his writing style that he composed them himself, though at times he had them edited by a friend.

While a reading of Courbet's letters with a view to his writing style (as opposed to his spelling) may begin to dispel the traditional notion of the artist as practically "illiterate" (cf. Clark 1973, 30), a look at the list of his correspondents (p.000) further necessitates a revision of the commonly accepted notion that the artist was naive and staunchly acultural (see Clark 1973, 30; and Fermigier 1971, 16). Among the recipients of Courbet's letters are many key figures on the mid-nineteenth-century cultural scene, including not only artists, dealers, patrons, and art administrators but also writers and poets. Indeed, the latter group predominates among Courbet's correspondents and is composed of such well-known authors as Max Buchon, Jules Castagnary, Champfleury, Pierre Dupont, Théophile Gautier, Victor Hugo, and Francis Wey. While it is no doubt true that Courbet cultivated these writers less out of a disinterested love of literature than in the hope of getting media publicity for his paintings, the fact remains that he formed close friendships with many of these (and other) writers, was thoroughly familiar with their literary production, and often had quite definite opinions about their works.

Though the letters set up a paradox between the accepted notion of Courbet as illiterate and acultural and his numerous contacts in the cultural and especially the literary world of his time, they help solve this same paradox as they show how the image of the artist as an illiterate peasant was part of a cleverly constructed and constantly nurtured public persona aimed at maximizing the publicity for his art.

Careful reading of the letters reveals, first of all, that Courbet was far from a country bumpkin. As the son of a provincial *propriétaire*, he was raised with a view to notability. His father, the richest landowner in his native village of Flagey, could well afford to send him first to the Petit Séminaire in Ornans (a prep school that primed students for the seminary or for the *collège* by giving them a thorough training in the classics, history, literature, and mathematics), then to the Collège de Besançon. Though Courbet did not get a *baccalauréat* from the Collège (or from the Académie, which he attended subsequently), he still spent almost two years studying with teachers who, for the most part, were respected French scholars.

Though not a peasant, he was a provincial, and, when he came to Paris in the early 1840s, Courbet, much like Balzac's Rastignac, tried hard to adjust to city norms. By the end of the same decade, however, he radically changed his attitude toward the city and decided to meet Paris on his own terms. This change in posture seems to have stemmed from a number of factors, including the liberal climate created by the Revolution of 1848, Courbet's move to a new atelier in the rue Hautefeuille in 1847, and the success of *After Dinner in Ornans* (F. 92) at the Salon of 1849. Most important, however, was the entrance into his life of several new friends who were attracted to the artist for the very traits that had embarrassed him on his arrival in Paris: his provincial manners and clothing, his Franc-comtois accent, and his deep attachment to his family and his native soil.[3] With an innate sense for public relations, Courbet appears to have understood quickly that an apparent handicap could be turned into an advantage: that the secret to public success might lie not in adaptation but rather in differentiation, in *excentricité* rather than *juste milieu*.[4] This is clearly expressed in a letter to Francis Wey of 1850, in which he wrote,

"I have just embarked on the great wandering and independent life of the bohemian . . . Don't think that this is a whim, I have thought about it for a long time. Moreover, it is a serious duty, not only to give an example of freedom and character in art, but also to publicize the art that I undertake" (letter 50-4).

Courbet's letters of the 1850s evince a careful manipulation of his new eccentric public persona, which is subtly adjusted to his perception of the expectations of his various correspondents. In his letters to writers and journalists such as Champfleury or Wey, he provides detailed descriptions of his

3. Most important among these new friends were Charles Baudelaire, Champfleury, and, somewhat later, Francis Wey.

4. Courbet's eccentric pose was certainly influenced by Champfleury's series of essays, *Les Excentriques*, which appeared in various papers from 1846 onward.

work, as well as colorful anecdotes about life in the Franche-Comté, in the hope that they will eventually make their way into print.[5] The letters to his patron Bruyas, however, evoke a more complex personality. They stress that behind the boisterous peasant facade there is a haunted soul: "Behind the laughing mask that you are familiar with, I hide, deep down, grief, bitterness, and a sorrow that clings to the heart like a vampire" (letter 54-7). Meanwhile, the letters to his friend Proudhon stress his interest in social and political questions, while in the letters to his family the emphasis is on his public and material successes. Because of their divergent tone, it is tempting to look for the "real" Courbet in these letters of the 1850s. Yet this effort is clearly futile as some of the real Courbet is present in all these various poses, or, to put it differently, the artist is the sum of his various poses.

In the course of the 1850s, as the artist grew more and more comfortable with his public persona, he increasingly identified with it. This would seem to explain the more uniform tone of his letters of the 1860s, which often lack the subtlety of those of the previous decade, but make up for that in their straightforwardness and immediacy. Courbet's yearning for material success (less for its own sake than as a mark of public appreciation), his defiance of authority in all its forms, his true capacity for friendship, and his hearty sense of humor are the main traits that characterize the correspondence of this period.

The letters from the 1870s, a period marked by the tragic results of his participation in the Commune and by rapidly declining health, are in many ways most revealing, as they show both the strength and the weakness of Courbet's character. A heroic stoicism in the face of major disasters is oddly mixed with paranoia and petty quarrelsomeness. Vicious and venomous letters alternate with others that have a feeling of warmth, candor, and generosity previously unencountered in the artist's correspondence.

While the letters are revealing about the artist's personality, the nature of his various relationships, and the evolution of his public persona, they are also important for a better understanding of his work. The letters of the 1840s provide important clues to the early years of the artist's career as they mention and at times briefly describe numerous paintings that today are unaccounted for. For the most part, these works seem to have been portraits, some made on commission, the majority as a favor to family and friends. Portraiture, of course, was a main source of income for young painters, but it was also a genre for which Courbet had a natural affinity, and the letters cause one to realize that there is an uninterrupted flow of portraits of family and friends

5. This expectation was not in vain. Courbet's description of the *Stonebreakers*, in his letter to Francis Wey, e.g., was adapted by the author to his serial novel, *Biez de Serine*, which appeared in the *National*.

beginning in the early 1840s and culminating in *After Dinner in Ornans* (1849), the *Burial at Ornans* (F. 91, 1850), and the *Painter's Atelier* (F. 165, 1855).[6] These early, frequently unknown, portraits, as it now appears, are more crucial to the development of Courbet's art than large and more belabored works like *Lot and His Daughters* (F. 13), submitted to the Salon of 1844, or the lost *Walpurgisnight* (Salon of 1848), contrived paintings that were composed with the unique purpose of being accepted at the Salon.

It is not surprising that the most circumstantial descriptions and explanations of Courbet's work are found in the letters of the 1850s. These exposés, about the *Stonebreakers* (F. 101), the *Burial*, and especially the *Atelier*, intended for his journalist friends, may, however, be less relevant for the works in question than for our understanding of Courbet's developing public pose, of which these works themselves were, of course, very much a part.

The brief but numerous and detailed references to paintings found in the letters of the 1860s are important not only because they establish a firm chronology for the works of these years but also because they reflect the increasing appreciation for various aspects of Courbet's oeuvre—portraits, nudes, landscapes, and hunting scenes. Abounding in information about patrons and collectors, the prices fetched by his paintings, the places where he exhibited, and the dealers who marketed his work, these letters tell more about the appreciation of Courbet's work in this time than any number of contemporary Salon reviews.

The references to paintings in Courbet's letters of the 1870s are important for the solution of the difficult problem of separating the true Courbets from the numerous studio productions and outright fakes that were produced during these years. The letters can help establish a solid core of works that can be attributed to the artist with certainty. These, in turn, will provoke a qualitative and stylistic norm that may be used in judging other paintings of this period.

The letters, finally, are revealing about Courbet's political outlook. They demonstrate that throughout his life the artist's ideology was dominated by a natural dislike, even hatred, of imperialism and, more generally, of centralized authority in all its forms. Though in his work Courbet took several aspects of imperial authority to task,[7] in real life his antiauthoritarian stance

6. This origin in portraiture of Courbet's large paintings of the late 1840s and early 1850s was noted by some of the artist's comtemporaries. The critic Haussard, e.g., wrote in his Salon review of 1849, with reference to *After Dinner in Ornans:* "That life-size interior, those family portraits disguised as a colossal genre painting, are a strange novelty; it has never been done, but that is precisely the unique merit of M. Courbet" (quoted in Fermigier 1971, 25).

7. Courbet's most obvious anti-authoritarian paintings, the *Return from the Conference* (F. 338) and the *Death of Jeannot* (F. 609) were directed against the church. A group of anti-militarist paintings, which was to include the *Battle of Solferino* and the *Conscript's Departure*

was demonstrated mostly blatantly in his continuous revolt against the government-controlled art establishment. His organization, in the course of the Paris international exhibitions of 1855 and 1867, of private exhibitions on or near the fairgrounds and his refusal of the Legion of Honor cross in 1870 were the most visible gestures of that subversive stance. In the light of this attitude, it is not surprising that Courbet became involved in arts administration as soon as the opportunity presented itself, first during the Liberal Empire, then under the Government of National Defense and the Commune, when he saw an opportunity to organize the entire art world along new democratic lines.

Courbet's proposal for the demolition of the Vendôme Column (letter 70-27) must be seen in the context of his anti-imperialism as well as his self-proclaimed role, after September 4, 1870, as arts administrator in charge of public art in Paris. The letters remind us that the artist's proposal was one of several aimed at the destruction of this hated imperial symbol—a destruction for which, in the end, he bore little direct responsibility as it was officially decreed by the Commune government before his election to that government and executed after his resignation. The manner in which Courbet nonetheless was made the sole scapegoat for the demolition of the Column must probably be seen as a backfire of the high public profile that he had kept throughout the Second Empire. His often ostentatious defiance of the imperial regime had not been forgotten by the Bonapartists who were responsible for the tragedy of Courbet's last years, and his numerous contacts in Republican circles were unwilling or unable to protect him from the vengeance of this political faction, which became the more vicious as its power in the political arena diminished.

Read in toto, the letters defy the traditional notion of Courbet as a naive, illiterate, and acultural provincial, upsetting Paris with his boorish behavior. Instead, they present the artist as an educated, well-informed member of the provincial bourgeoisie gone to Paris to make a career as an artist; as a provincial who chose not to adapt to Paris but rather to meet the city on his own terms; as a man with a powerful ambition for success, which he liked to measure not in traditional terms of Salon medals and Legion of Honor crosses but rather in more up-to-date terms of publicity and sales; as perhaps the first modern artist to fully realize his socio-economic position as a producer of commodities in a market-driven economy; and as the first to understand the importance of the contemporary press both as a vehicle for the promotion of

were never realized (cf. Chu 1980a). On the other hand, his portraits of known adversaries of the imperial regime, such as Pierre-Joseph Proudhon (F. 443), exhibited at the Salon of 1865, firmly placed him among the opposition.

his art and as a mirror of contemporary tendencies, trends, and tastes that could help him give shape to his own oeuvre.

Historical Background

The publication of the letters of Gustave Courbet has been attempted several times over the past hundred years, but for various, mostly logistic, reasons it has never been carried to completion. The present edition, however, is much indebted to some of the earlier attempts, which brought together and helped to preserve important collections of letters that otherwise might have been dispersed or lost altogether. A brief "prehistory" of the project therefore seems in order.[8]

For the first time in 1886, a few of Courbet's friends and admirers, led by Bernard Prost, contributing editor of the *Gazette des beaux-arts*, made an effort to gather the letters with an eye toward publication. They met with strong resistance, however, from the author Champfleury, Courbet's former friend and supporter, who wrote, in a letter of December 30, 1886, "They [the letters] contain not one penstroke that is useful for the history of the painter and his works; they can only vex decent people. What is the use?" Champfleury went on to say that the letters, with their peculiar sentence structures, their absence of punctuation, their faulty spelling, and—worst of all—their occasional rude expressions, would do the artist's reputation more harm than good. "It is nearly always a mistake to publish the correspondence of a famous man for, with few exceptions, he stands to lose by it."[9]

Champfleury had good reason for not wanting the letters published as they bore witness to the sour ending of his friendship with Courbet in the early 1860s (see letter 63-13). In order to block the project, he not only refused to cede the letters he had received himself, but he also convinced several other owners not to cooperate, thus forcing Prost to abandon his project.

While Prost's project as such was not carried out, the letters he brought together served as documentation for several biographers of Courbet. One of these was the art critic Jules Castagnary, Prost's collaborator on the aborted project, who had been a friend and staunch supporter of Courbet since 1860. Castagnary intended to make use of the material collected by Prost as well as his own extensive correspondence with the artist to write a detailed mono-

8. The history that follows is based largely on Léger (1920, 117–120) and Courthion (1948, 9).

9. Champfleury's letter to Jules Dufay, who was married to Max Buchon's widow, is quoted in a letter from Dufay to Castagnary of January 1, 1887. See Paris, Bibliothèque nationale, Cabinet des estampes, Yb3.1739 (4o), b. 2.

graph on Courbet. Because of his untimely death in 1888, this project was not completed, but Castagnary's numerous handwritten notes, as well as his exchange of letters with Courbet, were subsequently used by Georges Riat for his biography of the artist, published in 1906. Riat, in addition, had access to the correspondence between Courbet and his family, which was temporarily placed at his disposal by the artist's sister Juliette. Riat's documentation was later acquired by Etienne Moreau-Nélaton, who collected Courbet material for a monograph on the artist in his well-known ". . . *raconté par lui-même*" series (cf. Courthion 1948, 9). The monograph never came into being, but in the end the accumulated letters, notes, and documents gathered by Prost, Castagnary, Riat, and Moreau Nélaton were donated to the Bibliothèque nationale in Paris.[10]

The interest in Courbet's correspondence continued in the twentieth century. In 1913, Paul Audra published the important series of letters from Courbet to his patron Alfred Bruyas that is now in the Bibliothèque d'art et d'archéologie in Paris,[11] and Charles Léger, in his numerous books and articles on the artist, cited fragments of additional unpublished letters that he had collected over the years (see especially Léger 1920 and 1948). Léger's documentation unfortunately was auctioned off after his death and dispersed in public and private collections.

More recently, an important group of letters, mostly to the Courbet family, was obtained by Jean Adhémar, former director of the Cabinet des estampes of the Bibliothèque nationale. Adhémar, who was the first to sort and classify the Courbet dossier in the Bibliothèque Nationale, acquired his own collection, intending to prepare an edition of Courbet's letters. Owing to various circumstances, this project did not come to fruition, and the bulk of the letters collected by Adhémar were sold in America, where they ended up in the library of the University of Maryland at College Park.

An important group of letters was also brought together by the Société des amis de Gustave Courbet in Ornans, through the efforts of Robert and Jean-Jacques Fernier, past and present presidents of the society. Growing rapidly, this collection was in recent times enriched with an important groups of letters to Max Buchon (see Fernier 1987).

In addition to the major bodies of letters in the repositories mentioned above, numerous other letters by Courbet are found in libraries, museums, and public or private archives and autograph collections in France, Switzerland, Belgium, Germany, and North America. Some of them were obtained

10. Ibid., b. 1–7.

11. The letters were published again by Borel, first in a narrative contect (1922), then in a straightforward correspondence format (1951).

directly from the original recipients or their descendants; others were acquired on the autograph market, where, since the late nineteenth century, Courbet letters have appeared and continue to appear with some regularity.[12]

The present volume contains all the letters by Gustave Courbet that a ten-year search has produced. Though no claim is made for completeness,[13] as additional letters will no doubt continue to appear while many others must have been destroyed long ago, the material assembled here adequately represents the character and breadth of Courbet's correspondence and offers numerous new insights into the artist's private and public persona, his work, and his ties to the artistic, literary, and political currents of the Second Empire and the early Third Republic.

12. To gain an impression of the regularity with which Courbet letters have appeared on the market, one may consult the "Fichier Charavay" in the Département des manuscrits of the Bibliothèque nationale in Paris, which lists all the letters by Courbet that passed through the house of Charavay, one of the oldest and most important autograph dealers in Paris.

13. Indeed, as this manuscript goes to press, four letters to Jules Simon, dating from June 20, 21, 23, and 25, 1871, are about to be auctioned off in Paris (Hôtel Drouot-Richelieu, June 12, 1991). Written in Versailles on the eve of Courbet's trial, they are an attempt to win Simon's support.

The Letters

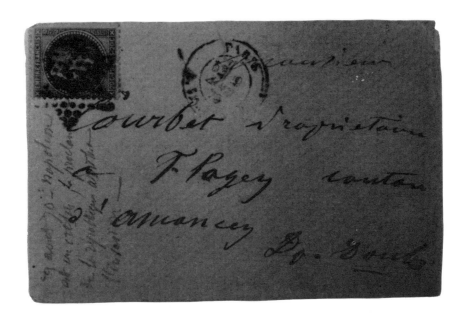

Dear family:

I am taking advantage of [the visit to Ornans of] the demoiselles Petit to send you news of my present circumstances.[1] I am glad to hear that you are all well. I will give you a few details of my way of life. We get up at 5:30 A.M., and we study till 7:30, when they bring us a basket of bread, from which we each take a piece. Breakfast lasts till eight o'clock. From there we go to philosophy class, taught by M. Bénard,[2] who did not come the other day because of the terrible incident that appalled the town of Besançon: M. Back, the philosophy teacher at the Académie and a good friend of M. Bénard, hanged himself from the beam of a closet. He was twenty-seven years old and leaves a wife of twenty-one or twenty-two and a child of five or six. He lived in the Guillaume house, in the apartment next to that of M. Paul Gaudot.

I am finally caught up in philosophy, which is rather difficult, for we must take notes as the teacher talks in order to make our notebooks.[3] Our class lasts for two hours, so we come out at ten o'clock. We have a fifteen-minute recess and then we study till eleven o'clock. From there we go to drawing class till noon. It is taught by M. Flajoulot,* who is a pretty good teacher. The drawing classroom is very ill equipped, for there is not one decent model. I think I am one of the best in the class. Then we have dinner—we are always lined up, morning till night, so that it is difficult to talk. We get fifteen minutes for dinner, which consists of a bowl of soup each, a plate of fried potatoes and cabbage or another vegetable on fastdays, then an apple or a pear each for dessert and a small glass of wine that does not have much color. It is all rather badly thrown together and it usually has a strange taste or smell. We have so little time that it is not unusual to have half of our dinner in our pocket when we leave. Next we have recess till one o'clock, and then we study till two, when it is time for the math course taught by M. Delly,* of which I understand nothing at all because they are already very advanced. So to try to catch up with them, I am also tutored by M. Lacase,* a good math teacher, who asks twelve francs a month (there is another called Boucher, who asks fifteen francs and who seems to be no better). We stay in class till four o'clock, when we have recess (at which time we get another piece of bread) until five. Then study hall till 7:30, followed by supper, consisting of a main course, salad, and an apple. At 8:30 we go to bed. The beds are very small and very hard. We have very thin mattresses and sheets for blankets. Even if you put all your clothes on top, you are still cold because, for fear of bad air, the dormitory under the eaves is aired on all sides. So I would like you to send me a blanket, my skates, etc. I am sending my red scarf back to have it lengthened by at least half an ell. The heating is very bad, for in our three classrooms (in order not to be without a fire all winter)

each student had to give about forty sous to buy firewood, lease stoves, and pay the fire attendant. Furthermore, I have had to give forty sous for the billiard table, for when it rains there is a billiard room where we go, and the rule is that all those who are in the first ward give forty sous for the maintenance of the billiard table. There is also a physics course twice a week, Mondays and Saturdays. The students are a good deal meaner than in Ornans: they are all bullies and teases and they are always out to play nasty tricks. I have not been a victim myself, for nobody has said a word to me. As for the teachers, they all look rather unfriendly. They don't say a word to the students all year. I have been well so far, yet I am already anxious to see Ornans and all of you. Since it is the first time that I have been away from home, I may be forgiven. I did not write you earlier because I was under some pressure to finish my notebooks.

Père Chauvin[4] came to take me out the other day, and with the pretext that he had company, he handed me over to Cuenot,[5] telling him to send me back on time, that is, eight o'clock at night. I have not dared visit him since he said that he had company. He did not feel like it either since he told Urbain* to take me back to school. With a parents' representative like that, I'd be living on air if I had forgotten to bring money. I dined with Cuenot* and Muselier.[6] I went to see Nini, and Mme Gaudot insisted on being my representative a week from Thursday. I am glad that père Beau* is staying in Ornans. I hope that Mother and Grandmother will come to see me soon.

I embrace you all, as well as Grandfather and Grandmother, little Marie Courbet, everybody.

Please say hello from me to whomever asks about me. Tell me what is new with you. Good-bye,

Your devoted son,

Gustave Courbet

[Address] To Monsieur Courbet, landowner
 at Ornans

1. In the fall of 1837, Courbet, at age eighteen, was enrolled as a boarding student in the Collège royal de Besançon.

2. Charles-Magloire Bénard (1807–98) was to become well-known as a philosopher. He later taught at the universities of Rodez, Besançon, Nancy, and Paris. He published numerous books, including *Hegel—philosophie de l'art* (1852).

3. Courbet's philosophy notebooks have been preserved and are currently in the Musée de l'Education Nationale at Mont Saint-Aignan/Rouen (inv. no. 3.4.08).

4. Père Chauvin, a relative or a friend of the Courbet family, was Courbet's designated *correspondant*, or parents' representative.

5. Possibly an uncle of Urbain Cuenot.*

6. The Muselier family was well known in Ornans, and Courbet appears to have had ties with several members of this family. Jean-Baptiste Muselier (1802–72) has been identified with one of the beadles in the *Burial* (F. 91), while another Muselier (perhaps one of Jean-Baptiste's brothers) was to serve as Courbet's notary in later years (see Ornans 1981, 54).

To his family [Besançon, November 1837]

Dear family:

I hate to tell you that I am homesick and long so much for Ornans that I can't stand it. This is not surprising when one is treated the way we boarders are. I was sick for four days, I had stomach cramps for a whole night, and I threw up several times. All because of the disgusting cold mutton that they give us every night. The food disgusts me so much that I can't eat anything. For the last three days I have eaten nothing but bread that one has to scrape all over to take off the dirt. I also suffer from not smoking, for every time I smoke I get caught and I risk being expelled. And when I don't smoke, I feel dizzy and light-headed, which prevents me from thinking clearly.

I cannot follow M. Delly's* math course, for it is already very advanced and I can no longer catch up. There is no history course or Greek course, and all I do in school now is study philosophy and file through the building with a lot of juniors. For there are only six of us here who are seniors, two-thirds of whom are on partial scholarships—that is to say, their fathers are employees or retirees of the government and so they have to board because it is cheap, it only costs them three hundred francs. We are more than eighty in our class: the six of us who are boarders and about eighty day students. More than one hundred follow the courses at the Académie.[1] In fact, I don't see why I should board when the others don't. While my classmates sit quietly in their little rooms,[2] I am at school, drilled like a soldier, fed like a dog, and sleeping on a bed that is harder than wood, and I don't see why I have to pay eight to nine hundred francs to be treated like that while everywhere in town boarding houses are advertised where for five hundred francs one is lodged, fed with the landlord, and kept warm. Boulet* and Bastide* have found a boarding house for thirty-five francs a month where they eat very well. If you insist on spending nine hundred francs, why don't you let me stay with M. Delly, my math teacher, where one is lodged, one's clothes are laundered, and one is fed on chicken and white wine. All his boarders are amazed, they have never seen a teacher like that, and to top things off he tutors them in math and they are sure to pass their bachelor's exam for it is he who gives it. If the price of the *baccalauréat* is to lead a maddening life boarding for a whole year and still run the risk of not passing, I would prefer to come home and forget about this diploma business. I had hoped that Mother would come last Thursday, for she would have taken me back with her. Try to come as soon as possible, for until you come I won't eat anything but bread and nuts. I am always so preoccupied that I am in no condition to work, I cannot concentrate. I hope you'll be here on Sunday or Monday.

Also, if I were to study all that I ought to study, I would have to take lessons besides those offered by the teachers at school, for I would have to

take history, Greek, and math, which I am taking already, and none would cost less than twelve to fifteen francs per month. Figure out whether, with the seven hundred francs that I am paying already, that does not add up to one thousand francs. I don't even dare stay for the little that I do here.

Père Chauvin is a worthy man [and] that is good advice he has given us. Since Father left he has not yet come to see me even once. I have not gone to see Gaudot.

Finally, we do nothing at all in the drawing course. We have a different teacher every day. I found M. Beau's* lens in my box. Tell him that it was at our house. Embrace Grandmother and Grandfather for me. I am very happy that you are all well. I embrace you all with all my heart. Your son,

G. Courbet

I will send Grandfather a few short plays by modern authors[3] (I hope he'll like them) to give him an idea what is playing on the stages in France. They are not as beautiful as those of Racine and Voltaire, but what do you want.

I don't have a single friend.

1. The Académie offered a less rigidly structured course of study than the Collège.

2. Probably a reference to his former classmates at the Petit séminaire in Ornans, such as Paul Boulet* and Urbain Cuenot.*

3. Possibly by Victor Hugo, whose *Cromwell* had been published in 1827 and whose *Hernani*, first performed in 1830, was the modern play par excellence of the 1830s. The young Courbet is known to have admired Hugo. One of his early sketchbooks in Paris (Musée du Louvre, Cabinet des dessins, inv. no. RF 9105) contains a copy of a poem by Hugo.

37-3 *To his family [Besançon, November 30, 1837]*

Dear family:

Perhaps you think that what I wrote you was a joke. Not at all, for I have already sold my school uniform for thirty-eight francs, after the tailor told me it was worth thirty-five. I absolutely want to leave my classes for I'm here perforce. I no longer ask to be in town, or even less to be in school, but only to be taken out. For that matter, the headmaster gave me two weeks to get adjusted. Write and ask him to return your money. As for me, if you insist on forcing me to stay, I will soon no longer be here.

I was touched by the letter you wrote me, but I cannot stay, no matter what. Besides, if I stayed, I would be losing a year and you would be losing one thousand francs. You might as well throw them in the water. Since I have been here, I have not yet opened a book. I cannot do a thing, no one gives a damn about me anywhere, everyone tells me I cannot keep up. By always wanting to do better than others, you make me lose my diploma. Everyone is prejudiced against me, so it's pointless to consider it now. If I'm to be an exception to every rule in every way, I'm off to pursue my destiny.

Write me as soon as possible what you have decided, for my stay here is costing me a great deal, especially as I am not doing anything.

I embrace you all with all my heart. Best regards to Grandfather and Grandmother, whom I embrace as well. I would like to be able to stay here to please you but I cannot.

<div align="right">*Gustave Courbet*</div>

[Address] Monsieur Courbet, landowner
 at Ornans
[Postmarks] Besançon, Nov. 30 [year illegible]
 Ornans, Nov. 30 [year illegible]

To his family [Besançon, December 4, 1837]

<div align="right">37-4</div>

Dear family:

I beg you, don't write me such meaningless letters all the time. Tell me clearly either to leave school or to go and live with M. Crétenet. If you don't want me to be a day student, I am leaving, for I don't do a thing in school. I don't know yet what line of action to take as I did not expect this. You tell me that it is too expensive to board with M. Crétenet. I could do it for fifty francs a month since he would like to have me. You tell me that I have to provide my own linens, but don't I do that at school, over and above the boarding fee? This would still cost me at least four hundred francs less than boarding at school.

Last Thursday I went to see Mlle Belfort,* who received me very kindly. She told me to tell Grandfather that the carriage was definitely reserved for the trip to the Geneuille papermill. She told me that she would convince Father to make me a day student. I embrace you all with all my heart. Please comfort Grandmother and Grandfather.

<div align="right">*Gustave Courbet*</div>

[Address] To Mme Courbet
 Residing at Ornans
[Postmarks] Besançon, Dec. 4, 1837
 Ornans, Dec. 4, 1837

To his family [Besançon, December 9, 1837 (Rd)]

<div align="right">37-5</div>

Dear family:

I must tell you that I have definitely made up my mind and that I don't need another two months in my present situation to do so. The fact that you have shown such an uncompromising attitude toward me has made me utterly heartsick. You insisted on forcing me, while all my life I have never been

forced into doing anything, that is not my character. You packed me off to school and now I am so turned against it that I can't do anything here.

I am sorry to quit my classes, especially as I have only one more year to go, and I know very well that I'll regret it later on, but, no matter, I could not finish them here. That means that everything I have already done so far is worth absolutely nothing, for in those classes you must do everything or nothing. And now, in whatever profession I choose, my classes will be as useless to me as if I had never taken them. For all those classes are geared towards obtaining the *baccalauréat*, which is useful. Otherwise they serve no purpose, and at this point, whatever I want to do, I have to begin again, and there will be new expenses. I would have quit a long time ago, had I anticipated those kinds of vexations. It has already gone on too long, for, at this point, there are already many jobs and many schools I am too old to enter. Anyway, I'll manage as I can, but to stay another two months at school is foolish, it is out of the question. As it is, I have not enough time left simply to go and waste yet another two months in those barracks. Please, try to come on Sunday, you and Grandfather, if you have the time, because I dare not stay here any longer. I am deserting, I have already had my time wasted long enough by being kept on a string for so long.

I embrace you all, including Grandfather and Grandmother. I'm at a loss but I cannot wait to see Ornans again.

Good-bye. I hope to see you all soon.

<div align="right">

Gustave Courbet

</div>

Tell Grandmother not to worry. I hope you are all well. As for me, I only throw up sometimes, when hunger drives me to eat their mutton.

37-6 *To his family [Besançon, ca. December 15, 1837]*

Dear family:

I am letting you know that my trunk has been packed and waiting for you for a week, but since you have not come, and since you still think that I am joking about leaving school, you will see. I am letting you know that on New Year's Day I will leave with all my things. I must tell you also that one day M. Grenier told me clearly that he did not understand quite why you persisted in sending me to school against my will and he does not commend you as much as you think. I must tell you, too, that I have been without a cent for a long time. I had ten francs when I came to school but I spent it all on collections and a thousand other required things. Only yesterday the headmaster took a collection for the poor in all the classrooms and everyone in ours gave forty sous so I could not do otherwise. Then he took another one for the common funds, though I don't know what that is. We were obliged to give another twenty sous. I was taken by surprise and borrowed five francs from

Grenier, telling him that I was expecting something. I beg you therefore to send me some money as soon as possible.

I was very pleased that my godchild wrote me such a lovely letter. She already writes awfully well and I congratulate her for it. She also told me that Juliette* was slightly ill but it probably is not serious. Mlle Marie must write me soon, too. When I leave, I will not forget New Year's gifts for my godchild and for the little ones, if I have some money. I must ask you also to send my skates before Thursday because we already went skating, on Sunday. I am stopping now because I am in a big hurry and till I leave I embrace you all. You want me to waste my time till New Year's Day, but do not think that all those meaningless replies will make me stay here.

Regards to Grandfather and Grandmother, whom I embrace as well. I had told Mlle Belfort* that I expected you around now, and she is getting ready for your visit. M. Gaudot absolutely wanted me to dine with him Monday evening because they were having a big dinner. I gratefully declined but he came anyway, and the headmaster did not allow it.

<div align="right">Gustave Courbet</div>

Say hello to anyone who asks about me, such as M. Quartin.

[Address] Monsieur Courbet, landowner
 at Ornans

To his family [Besançon, December 28, 1837] 37-7

Dear family:

I must tell you that I am no longer taking the math course. I have not been able to catch up, so I went to see the headmaster, who told me that he would notify you. You must have received a letter from him, as well as from M. Grenier, who must have informed you of what I am doing here. It seems to me that a good two months have been wasted in this place, where I went mostly to please you. The headmaster has told me, moreover, that he would advise you to come and withdraw me. You spoke in your last letter to me of Boulet's* resolutions. Indeed, and everyone who has not been forced, like me, has done the same, even Bastide.* It is not surprising that, in a year like the one I was supposed to do, one resolves to work hard, especially if one is no more advanced than we were. I assure you that I would have resolved the same thing if I had been like them. But no, you knew better—you wish! Even if you have a bias against day students, that does not keep them from being the most respected at school because they are generally first in all their classes, which is pointed out to us by our teachers at the end of the day and to them by the headmaster publicly every time the prizes for composition are given out. Because of my speech difficulties[1] I have asked my teachers not to make

me read my work out loud and I am practically a non-entity in those classes. It was determined that at all costs I would make a fool of myself at school and this was very successful, for now the feeling is general, that it is time for me to withdraw. Even the headmaster told me clearly that he would not promote me whether I boarded or not. There goes one good grade, for he is the one who is interviewed by the inspectors general for information about the students. Then there is M. Delly,* whom I have angered by not answering any questions for two months. He will be at my exam, for he is the inspector in several fields, such as mathematics, geometry, and physics. He has already forewarned me. All that means that with such grades I am sure not to pass, no matter how well I do. You must agree that you have done me a great service by boarding me at school. Please be so kind as to write the headmaster to allow me to leave, if you are not coming soon to settle your account with him.

Hoping to see you soon, I embrace you all, Grandfather and Grandmother as well. M. Beau* came to see me, and that gave me great pleasure.

Gustave Courbet

[Address] Monsieur Courbet, landowner
 at Ornans
[Postmarks] Besançon, Dec. 28, 1837
 Ornans, Dec. 28, 1837

1. Courbet, in his youth, seems to have been a stammerer (cf. Lindsay 1973, 4).

38-1 *To his family [Besançon, January 5, 1838]*

Dear family:

I must tell you that I have gone to see the headmaster and the assistant-headmaster, who both told me that the trimester was finished for everyone and that, even though I had come a month late, I had only paid for the remaining two months of the trimester; and that if I had paid for three months, I would get back the difference. They agreed with my decision. The headmaster took the trouble to explain to me what I needed to know about my new status,[1] which suits me very well. He said for you to write him quickly, before the new trimester is well under-way, otherwise you will be obliged to pay again. See whether that suits you.

As for me, I'll be home on Sunday, whether you write me or not, because I came here with the idea of completing one trimester. M. Grenier cannot imagine forcing someone to stay in boarding school, for he believes that one can work at anything anywhere. He told me that he felt like writing you, for it hurt him to see money wasted like that. I wanted to leave the other day no matter what, and when the headmaster found out, he had them tell me that

it was better to wait until you wrote. I don't go to class anymore, I have quit altogether.

I embrace you all till I see you, which will be either Saturday night or Sunday morning.

Gustave Courbet

[Address: Monsieur Courbet, landowner
 at Ornans
[Postmark] Besançon, Jan. 5, 1838

1. As a day student rather than a boarder.

To his family [Besançon, early March 1838] 38-2

Dear family:

I am delighted to have the opportunity to give you some of my news, for it is not important enough to send by mail. I saw Justin last Sunday evening. He gave me news of you as well as a letter that I received with great pleasure and in which I see much that is quite positive. I am very glad that you are all well, including Grandfather and Grandmother. M. Riduet and Mlle Belfort,* who, as usual, received me very kindly the other day, are always asking about them. I am really very fortunate to know those two kind people, who always show me the greatest consideration and I already am quite overwhelmed by the courtesy they have displayed toward me. They have urged me to send you their warm regards and to renew their invitations to Grandfather and Grand-mother, for whom Mlle Belfort is making an apron. Indeed, I am also inviting the two of them to make that little excursion come spring. Grandmother must come and visit Besançon, which she will find quite changed since she last saw it. She will see the beautiful iron suspension bridge, which has just been finished,[1] etc.

Nothing else is new in Besançon. As far as my classes are concerned, I am working, as I promised to do. I had someone buy me candles and like most seniors I stay up until ten o'clock. I am still taking M. Lacase's* class, we are now doing geometry. What worries me is Greek and history, for we don't have teachers in those two subjects. I am also vexed that I cannot con-tinue with the drawing course,[2] for the one at school isn't worth much. We are a hundred or so in a big hallway where you cannot hold your pencil because it is so cold, and also everyone yells, talks, and makes so much noise that you cannot even hear each other. I would have liked to continue with painting. In the event that I went somewhere I would have been able to copy some fragments of painting, but anyhow I'll do what I can this summer. As for my skates, I don't need them anymore now, especially since someone lent me a pair.

On my last night off I visited Cuenot,* Bastide,* and Boulet.* They rave about the courses at the Académie, which surpass their hopes, for in the beginning people had frightened them with how difficult they were to follow. Cuenot especially finds them a hundred times more within his reach than those of the Collège, particularly the philosophy course. On top of that, he has the advantage of taking three courses with the people who give the exams in history, Greek, and literature, courses that are not given at the school. If I go to M. Delly's* this summer, as we have already discussed, I almost think I might pass my certifying exam this year, because I'll have on my side, first of all, M. Delly, in math, physics, and geometry. He ordinarily does not flunk his students no matter how bad they are, because he knows how to ask questions on their level. He also carries some weight with his fellow examiners. Then, I don't know quite how père Chauvin feels about me, but he is good friends with M. Bourgon, the history examiner, and with M. Meusé, the Greek examiner. With their support, I only have to meet with M. Perron, a philosophy teacher at the Académie, and M. Perennes, a literature teacher, who will examine me in rhetoric. I'll go see them and I'll take their courses this summer. If I had done that in the first place [], today I would be certain to pass at the end of [].[3] But I won't dwell on that for it is past.

That is about all that I have to tell you at the moment. I am very well. Please send my best regards to Grandfather and Grandmother. I don't write them because I wouldn't say any more to them than I do to you, so my letter counts for two. Keep well! In about three weeks I'll see you all, I cannot wait. Only I must tell Father not to write the headmaster in his letter, "if you think it is proper." He must be positive, the more so as most students are going away. I warmly embrace you all, from Grandfather and Grandmother to Marie. My pecuniary resources are dwindling rapidly, I don't know . . . , etc.

Gustave Courbet

Kind regards to those I know, especially to the lawyers Marlet, for I believe Adolphe[4] is back, and also to Cuenot, if you see them. Don't go out of your way.

[Address] Monsieur Courbet, landowner
 Ornans

1. The Pont en fil de fer, the first iron suspension bridge in Besançon, was inaugurated in 1838 (see Fohlen 1965, 2: 316–17).

2. The course with Charles-Antoine Flajoulot.*

3. Because of a tear in the paper, the last words of several lines are missing.

4. Adolphe Marlet,* who was four years older than Courbet, was probably then studying law in Paris, and so, possibly, was his brother Alphonse.

Besançon, March 19, 1838

Dear family:

It is painful for me always to have to refuse your offers, and I would never have thought, given my inability to keep up in my classes and after all that has been said and done on the subject, that you would still have proposed this to me. I can't imagine it, but you have not grasped this yet: I have already been made to waste six months and you still don't feel that's enough, especially in the situation I'm in. And you think that I want to have the reputation of having done my senior year without having done it. At this point I don't know what I am doing at school anymore. I am no longer keeping up in anything and nobody bothers about me anymore. My philosophy teacher has not spoken a word to me since the beginning of the year. I don't know who has so well informed him about me but I can attest that he has not yet asked me for my homework or examined me. I really do not understand why I am there. I have not written any essays, though I could have, for I told him that I hoped to leave soon, to which he did not reply.

Let's talk next about physics. When I came into the class I was already very much behind. I was never able to catch up properly and I have remained one of the weakest in the class. Moreover, as they make an infernal noise in that class, which always happens when there are sixty people, he does not look for the culprits but, instead, operates like this. The twenty students who had the lowest grades on the last exam each get ten pages for the next class because he assumes it is the weakest students, the ones who don't work, who make the noise. So I have twenty pages of extra work regularly each week. If I had to stay on at school, I would begin by quitting that class at once.

Now let's talk about Lacase.* One evening I get up to go to his class. I run into Lacase, who does not want to let me in, saying that I am late and that I should have thought about it earlier. He was so drunk that he could not stand up straight. I passed him anyhow and then he flung a lot of coarse insults in my teeth, which I cannot bear to remember right now. The next day he told everything to the assistant headmaster, who called for me. After the assistant headmaster had said whatever he had to say, I started giving him an account of Lacase, telling him that he was a nasty boor, that he had treated me like a dog, and that the next time he talked to me in that tone, he would not get away with it. The assistant headmaster mollified me about the affair as best he could, telling me to forget about it. I can well believe that he has reproved Lacase. Since then, he has not spoken a word to me, nor I to him.

Let's talk about the headmaster. He caught me smoking in a certain place the other day, me and several others from my class. He proceeded to tell me in front of the whole study hall that he would say nothing about it, for he

hoped that in a few days he would be rid of my smoke, to which I answered that I hoped so too. As for Grenier, he does not speak to me only because I have not taken Greek tutorials, for when I found out how little he knows, I had had it. He is downright stupid and he is always making fun of me in front of the other students for not leaving. I cannot take courses in history and Greek at the school because there are none. Nonetheless, it is time to take some if I want to learn something. You remark that M. Delly* is very expensive, but that is not the only boarding house in Besançon, and I could still enjoy his support, even if I am not lodging with him, by taking his tutorials, as Urbain,* Boulet,* and Bastide* do. You speak to me about supplies: the school does not provide any, it gives me maybe five sous' worth of paper a month. I have all the books I need.

Last Thursday I went to see Mlle Belfort,* who received me as kindly as before. The maid who came to pick me up intimated that Mlle Belfort would very much like to go out of town for a few days at Easter, that it would give her great pleasure; that she [the maid] knew it because she had overheard her saying to one of her lady friends that she had been invited to spend a few days in the country and that she planned to go. So I indeed invited her, as well as M. Riduet, who has told me that he is going home and cannot accept. As for Mlle Belfort, she was very pleased and has promised to be ready on the 28th or the 29th at the latest, the date on which, I told her, you would come with the carriage, for I don't feel like registering for yet another trimester, which I cannot do without losing face altogether. I beg you not to force me to quit. Mlle Belfort and M. Riduet send their kind regards to all, especially Grandfather, whom he urges to come visit him there in the spring so that they can stroll together to his heart's content. Mlle Belfort wants Grandmother to come as well, she says that she has an old [?][1] cousin, who would like to see her too. For my part, I send you my best regards as well, to all of you and to Grandmother and Grandfather. I hope that everyone is well and I embrace you all, even little hunchback Marie.

Gustave Courbet

[Address] Monsieur Courbet, landowner
 at Ornans
[Postmarks] Besançon, March 20, 1838
 Ornans, March 20, 1838

1. Doubtful reading of original text.

38-4 *To his family [Besançon, November–December 1838]*

Dear family:

I hope you don't mind that I have not written sooner, but I had to find

out what the new rules of the Académie[1] are, which I did, not long ago, and I was waiting for an opportunity to get this letter to you. Adolphe Marlet* is going to Ornans today and he will give it to you.

Well, then, the Académie has just decreed that the family certificates will be verified by the minister of education and that, if they contain any false statements, the student won't pass. Furthermore, they have considerably increased the requirements in the various areas in which students are examined: open-book Greek, as well as geography, astronomy—things we have not learned in our classes—chemistry, algebra, Latin (all the known authors), as well as an essay at the outset, and if that is not done well, one need not show up. All that comes on top of the already exorbitant amount of material we had to learn before, which puts me in a terrible bind. We'll talk about it on New Year's Day.

I am very comfortable in my present set-up.[2] I went to the prefecture to pay for my registration, which cost me thirty or forty sous for my trouble. You can check the receipt. Judith told me that Mother wanted to come on Sunday if the weather was good, but as things are presently I don't think she will come. If there is some kind of errand I could do for her, just write, and I'll save her the trouble.

My clothes and my purse are in a hellishly mean state. Is it all right if I have a very inexpensive vest and coat made for myself? I'll order them from the Crétenets.

Looking forward to the pleasure of seeing you, I embrace you all, including Grandfather and Grandmother. Send them my best regards, as well as to Uncle and his family. Your beloved son,

Gustave Courbet

Be well, I am, too. Tell Grandmother that her vine sticks come in very handy for lighting my fire.

1. In the fall of 1838, instead of returning to the Collège royal de Besançon, Courbet was allowed to attend the Académie.

2. Courbet now had his own room in Besançon.

To his grandfather, Jean-Antoine Oudot [Besançon, winter 1838–39] 38-5

Dear Grandfather:

Lange told me the other day that you and Uncle were to come to Besançon on Wednesday or Thursday. I am anxious for you to come, first of all to pay off the various debts I owe and second to go back with you. If one of you is coming, try to bring at least three hundred to three hundred and fifty [francs] for it has been a long time since Father last sent money.

When you come, you'll find me at Marchand's after ten or eleven o'clock in the morning. The Crétenets will give you directions. I will stop by the

various Ornans stage coach offices Wednesday and Thursday morning in the hope of meeting you there. I am staying on the rue Neuve, next to the Sponi home, lodging with M. Sponi of the ballet. If you do not come, give whatever money you can to Lange, who will bring my things back. Answer me as soon as possible.[1]

Best regards,

Gustave Courbet

[Address] Monsieur Oudot, landowner
　　　　　Iles-Basses

1. At the bottom of the letter is the following note, written by Courbet's grandfather:

My dear Régis:

　　I leave Thursday morning for Besançon. Read Gustave's letter and tell me what to do and what you want me to tell Gustave. I'll do whatever you tell me but I need your answer by return mail. I embrace you all.

J.A. Oudot.

39-1　　*To his family [Besançon, April(?) 1839]*

Dear family:

　　I must tell you that right now I work as hard on math as on drawing. I also follow the courses at the Académie quite often. I have lately become obsessed with a kind of drawing that would definitely suit me—if my financial means allowed me to do it a little more often—namely lithography. I send you some trial sheets with which I am very pleased.[1] Please give one to Adolphe Marlet* (the one that has his name on it); the others that are not as beautiful you can give to whomever you want, but tell them that they are for now, that when I have more prints pulled I'll exchange them, for I am sending you all I have; these are only the proofs. Give some to père Beau,* to Grandfather, and to Uncle. I'll send you some more in a few days.

　　We left Marchand's boardinghouse because of their bad manners as much as because of how we were served. We have found another boardinghouse—where so far we are infinitely more comfortable—Hunce's, for the same price. It is the only one that we found at that price, they get more expensive everyday. It is in the rue de la Prison, some ten steps from the place St. Pierre. We left on the 25th, which means that I have to pay for only nine or ten days of this month. It is easy for Father to find out what the situation is with regard to them, and if you will send me the money I'll pay them. I also need money for my monthly fee for drawing lessons, which is ten francs,[2] and for my lithography, which will cost me ten francs by the time I have pulled the necessary prints. I would also appreciate it if you would send

a little more for me to go on with. Try not to delay too long for I haven't a cent at the moment and I must have lemonade made as I am constipated all the time.

I heard from Voite [?] that you are all well; I am the same. I embrace you all, including everyone at Grandmother's and Uncle's. Your loving son,

Gustave Courbet

I am in a hurry for the carriage is about to leave.

[Address] Monsieur Courbet, landowner

Ornans

1. Courbet's first lithographs may have included the *Pont Nahin at Ornans* (Fd. 10).
2. In all likelihood, Courbet was still taking lessons with Charles-Antoine Flajoulot.*

To his family [Besançon, April (?) 1839]

Dear family:

I am sending you my dirty laundry. If I have waited so long, it is because I was waiting for your samples. I am sending you my woollen socks because I don't wear them. Send me cotton socks. I am also sending you the songs, and two small prospectuses of a little book by a friend of mine for which, to oblige him, I have done some illustrations.[1] Try to show them around in Ornans, if you don't mind. Give one to Rev. Oudot,[2] and one [?][3] to the Café Pernet, if you want. They will be kind enough to collect names of subscribers, which you could send me as soon as possible.

I embrace you all, including Grandfather, Grandmother, Uncle, everybody.

They claim that I have hemorrhoids, but I don't believe it.[4] I am bleeding a lot, but I believe it is the result of my inflammation. Other than that, I am well. It does not bother me at all.

Gustave Courbet

1. The book in question was the first published work of Max Buchon,* *Essais Poétiques*, which appeared in Besançon in 1839. For this collection of poetry Courbet made four small lithographs, illustrating the following poems: "The Virgin of the Old Oak" (Fd. 9a); "The Tempest" (Fd. 9b); "My Rosebush" (Fd. 9c); and "The Girl of the Lake" (Fd. 9d). See Chu (1980b, 78–79).

2. Probably a reference to the Abbé Oudot, headmaster and teacher of rhetoric at the Petit séminaire at Ornans. Abbé Oudot was responsible for introducing drawing lessons at the school and had hired for this purpose père Beau, Courbet's first teacher (cf. Lindsay 1973, 7).

3. Doubtful reading of the original text.

4. Courbet's opinion notwithstanding, his medical advisers were probably right. He was plagued by hemorrhoids all his life and eventually, in 1872, was surgically treated for this problem.

39-3 *To his family [Besançon, May-June (?) 1839]*

Dear family:

This morning I saw Uncle,[1] who gave me your news, and who said that I don't write you often enough. I don't know what to tell you, especially since Father, who was here recently, was able to report to you on my present situation and my new boarding house, where I am very well. I very often see people from Ornans who give me your news.

I am very well and I think that one of these Sundays I'll come see you. I should have thought that Father would have written to Robe, as we agreed, for I have nothing to wear in the way of summer daytime trousers. I have only one pair, made of cloth, which is not very cool, and in the way of suits, I have only a gray English one, which weighs at least fifteen to twenty pounds. My only headgear is a straw hat that is absolutely filthy, and my daytime vest is a blue cloth double-breasted vest. If with all that I don't catch cold, it is not thanks to you.

I received the package you sent me, I am sending another one of dirty laundry back with M. Bidalot,[2] who brought the other one to me and who asked whether I had something to send you.

Father said that Grandmother was ill, but Uncle said that she is in good health, which makes me very happy. Grandfather is well, too [I hear]. I was sorry that no one let me know that Aunt[3] was so ill, though I don't regret not having been part of the whole affair as I am very poor at condolences. I have very much shared your common sorrow, however, and for several days I was unable to work, it grieved me so.

[*no signature*]

1. Probably his uncle Bastide,* the brother-in-law of Courbet's mother Sylvie Oudot.
2. Bidalot was a well-known surname in Ornans. Courbet would later include Joséphine Bidalot, née Beauquin, among the mourners in the *Burial* (F. 91). Her husband, Jean-Louis Bidalot (1817–89), may be the person here referred to (cf. Ornans 1981, 67).
3. Probably Courbet's mother's sister, whose married name was Bastide (see note 1). Her early death is confirmed by the fact that when Courbet's grandfather, Jean-Antoine Oudot, died, the inheritance was split between his daughter Sylvie and his grandchildren Bastide (cf. Ornans 1981, 43).

39-4 *To his family [Besançon, May 17, 1839]*

Dear family:

I am sending you a line with Adolphe Marlet,* first of all to discuss how much you want to spend on a frock coat, for I am really running low on that article of clothing. It would be for Sundays, a coat that is a bit dressy, for it could serve [?][1] later on. Also, please send me the names of the subscribers,[2]

if there are any, in the same letter. I cannot say more about it for they are waiting.

I embrace you all.

<div align="right">*Gustave Courbet*</div>

[Address] Monsieur Régis Courbet, landowner
　　　　　Flagey
[Postmark] Ornans, May 17, 1839

1. Owing to a spot on the paper, the word is practically illegible.
2. Probably the subscribers to Max Buchon's *Essais poétiques* (see letter 39-2).

To his family, Paris, [December] 26 [1839] 39-5

<div align="right">Paris, the 26th[1]</div>

Dear family:

I am beginning to worry and to fear that you may not have received my letter,[2] for you must know that my allowance was up on the 10th and that, consequently, I have not had a cent since the 10th. After borrowing some money from friends (which is common practice in Paris), I decided to ask my cousin for twenty francs.[3] It is almost New Year's Day, and I have to give my cousin's children a few small presents since I often eat at his house. I go there every Saturday, and sometimes I go during the week, as I do to Eliza's.[4] I also go to parties at M. Chatel's, one of their friends. I am considered rather bearish because I cannot dance and I don't like company. We have already had long discussions on the subject, my cousin and I, and I flatter myself for having scored some points with him.

But I am very rushed, for someone is waiting for this letter. It is a person from Besançon, an acquaintance of Bastide, who has to leave immediately. My cousin will be writing you that one of our female cousins has died. She is Clotilde, the daughter of Mme Vertel,* a wonderful young girl, so I am told, who was fourteen years old.

I have nothing new to tell you, my life continues to be pretty good. I am no more excited about life in Paris than before, only celebrities live here. I must tell you, for example, that I went to Versailles by the train, which goes seven leagues[5] in exactly half an hour.[6] I find that the palace, museum, and park of Versailles impressed me more than Paris did when I first arrived here.

I still work with M. Steuben,* who does not bother much with his students. All he does is appear every morning. He is satisfied with me. I am, I think, the best in his atelier. We are only three or four.

I repeat, I believe that a suit is indispensable if I am to continue to go out in society. I am also taking advantage of this opportunity to wish you all a happy New Year. I embrace you all a thousand times. I was very sorry to hear

that you were worried because I did not write the first two weeks. You remember that we had agreed on it and that I had not yet settled in. But for goodness' sake, don't worry anymore. In the future I'll write you when something happens, which is not very likely for my life here is as quiet as in Besançon. Let me have news of you as soon as possible, as well as some money, and be sure to tell Grandmother to sleep peacefully.

<div align="right">

Gustave

</div>

Best regards to all our friends and acquaintances.

1. As the letter indicates that it is almost New Year's Day, it must have been written in the month of December. From the contents of the letter, we can, moreover, deduce that it must date from the beginning of Courbet's stay in Paris, which must mean that it was written in December 1839. It is not known precisely when Courbet first left Ornans for Paris, but it must have been sometime in the fall of 1839.

2. The letter in question has not been found.

3. Julien-François Oudot,* who was Courbet's second cousin.

4. Eliza Jovinet.*

5. Approximately eighteen miles.

6. The railroad between Paris and Versailles was still a novelty in France, where the first railway was completed in 1827. By 1841, France had no more than 350 miles of railroad.

<u>40-1</u> *To his father [Paris, April 1840]*

Dear Papa:

I will try to give you an idea of my present way of life, which is not as delightful as you out there in the provinces might think. For we have not been terribly enthusiastic about the winter that has just passed, though it was pretty good and we saw the various celebrities who embellish the capital. They promise us more fun in the summer, I will let you know about that later.

In Paris, the trees have been in leaf since Maundy Thursday, the avenues are beginning to be crowded, and there are no more evening parties, which I do not regret. By the end [of the season], I was going out every night to the various homes to which my cousin went and most of the time I went in his carriage with Mme Oudot* and Mlle Clotilde,[1] so that I did not have to pay for a carriage. Nonetheless, don't think that those parties did not cost me anything, for I spent more than twenty francs on white gloves and was forced to have a suit and a pair of black trousers made. Everyone made me feel it, even my cousin's[2] children asked me why I did not have a suit like everyone else. Bastide* had one made the moment he entered my cousin's house. He has gone to many more parties than I. The proof is that he has spent some sixty to eighty francs on gloves and carriages (for you should know that white gloves can be worn only once and they cost twenty-five sous). Mme Oudot

told me one day that they spent five hundred francs a year for the three of them. Bastide who arrived in Paris three weeks after me and who does not throw his money around, as you know, has already spent twelve hundred francs. He turned to his brother, who sent him two or three hundred francs by a friend of my cousin who took a trip to Algiers. Don't tell anyone, for he does not like people to know.

We have a lot of fun at my cousin's. Recently we had a dinner party where we laughed like mad. Everyone brought a dish, which had been assigned by lots. The young people brought the hors d'oeuvres, I brought the anchovies, my aunt the gherkins, fresh butter, etc. Then those of the company were given different roles. Some were appointed to be great orators, great buffoons, great secretaries (to give a report on all that would take place during the meal). My cousin was unbelievably funny. With a three-foot paper hat on his head, he was the president, Mme Oudot was the president's wife, and cousin Eliza[3] was the great crown-giver. She, as the most sensible, was to bestow a crown on the one who behaved best all evening. The secretary, who made us nearly sick with laughter, got it. After the secretary, I had first place in the report for having most amused the company with twenty-five comic caricatures, pencil-drawings on cards, which everyone was to identify as himself. It was a surprise that my cousin and I had thought of and that I executed. My cousin's emblem was an enormous barrel that looked quite a bit like him. Out of it came wine through a hole that represented his mouth and through different smaller holes [?][4] that represented his eyes, nostrils, etc. The wine, which represented his eloquence, was caught in countless little jars, some of them with holes, which represented the students in his class.[5] My cousin overwhelmed me with compliments, as did all the people at the party, who found the cards very well done. The cards were the ones used to indicate the table seating. By the end we were making an infernal noise that almost brought the house down. My cousin was cutting capers, and we were playing the most outrageous games, for everyone was tipsy.

There were several great evenings like that this winter, including masked balls where there were two or three hundred people. At the first one I was dressed as a woman, in a dress cut lower than my shoulders, with my hair pulled back and braids at the back of my head, and I had flowers, a black velvet bodice, and wide flounces at the bottom of my muslin dress. I looked so good that I was forced to dress like that again, but that time the ladies dressed me. I had to dance with all the gentlemen of the company, for I was all the rage. My cousin must have written you about it, he tells everyone. Then we went to masked balls with seven or eight hundred people. In Paris one normally goes to bed between midnight and 2 A.M.

I often go to this year's exhibition of paintings,[6] which I don't find too marvelous. There are some paintings that are good enough, but all the rest

are insignificant, which gives us some hope of succeeding. I am doing a portrait of Clémentine, Eliza's little girl,[7] then I will paint Jules, Frédéric, and Marie.[8] Eliza is six months pregnant.

I have not had any money for a long time and I begin to be rather much in debt. We owe Panier* one hundred and forty francs that he gave me a month and a half ago. I spend as little as I can, I spend almost nothing on food, so I am not hampered by an excess of fat. I owe my tailor two hundred francs in all: one hundred and thirty francs for the suit and the black trousers and seventy francs from before. I owe my landlord for last month and in two weeks I'll owe him two months, which makes ninety francs, that is, forty-five a month (twenty-five francs for the room and twenty francs for lunch). I should tell you that I eat lunch in my room and that he provides it.

It is already steaming hot in Paris, which means that I need summer clothes. I am going to buy a jacket and two pairs of trousers, a vest, and boots. I have only five francs until I receive new funds. Tell me once and for all where I can get money with your authorization. That will not make me spend more; you'll see, when we come back to Ornans, who has spent the least. Panier has a lot of expenses in his business and cannot always give me money. My cousin has said that if Panier could not give me any, he would. See what you can do.

You said that I have drawn a conscription number, I am anxious to know the outcome. Perrier, whom I saw, was unable to tell me anything definite except that I had number 24 or 29. I am very much afraid that in Amancey the outcome will not be good.

I am glad that you bought Grandfather's house. You say that you have all the Flagey lands. I would be sorry if you had driven out the Pierrots entirely.

I am rushed with this letter for big Cuenot[9] is leaving momentarily. I illustrated the songs of a young musician, one of my friends who comes to my cousin's house.[10] They came out quite well. Give my regards to Tony Marlet,* Joseph Bocelet, and père Beau.* All three of them wanted me to tell them so much about Paris that I don't know where to start. In three or four months we'll return to Ornans. I believe that the entire Oudot family is planning to come, they are all delighted. I think that my cousin's wife and I will come first and that Julien[11] will come later. He went on a trip to Fontainebleau and with his usual agility nearly killed himself on the rocks, but he writes that only his knees are bruised.

I believe this is about all that I have to tell you, except that we want to change rooms, since the street won't be very wholesome in the summer.[12] I go to a life-model class at six o'clock every morning.[13] Ever since the weather has been fine enough to paint outside, I have left my teacher temporarily, for the exhibition and the life class take up all my time, but I will go back. I don't know whether I'll return to M. Steuben.* I think that I'll go to Picot's.[14] The

only thing that prevents me from going to the latter is that Pouchon* is there now, and I would not be very happy to be associated with that character. He is not a bad boy, on the contrary, but he always wants to be in the cafés, which does not suit me, in fact, I have been only three times since I arrived in Paris. Try to have this letter read by all who take an interest in me, particularly Grandfather, Grandmother (who I hope is well), Uncle, etc., etc. Best regards to Alphonse Marlet,* too. M. Jovinet* left for Leipzig, which makes Eliza very unhappy. He won't be back for six weeks. He is a nice guy; in fact, he is bringing some German tobacco back for me as well as for himself. These days we are trying to get my cousin to smoke. The doctors claim that it will help him. He is always confused, he has a bloodletting from time to time, and he always eats enough for four. I am very glad that you are all well. I embrace you all, Mother, sisters, cousins male and female, as well as the people mentioned above.

<div style="text-align: right">Gustave Courbet</div>

1. The eldest daughter of Julien-François Oudot.*
2. Julien-François Oudot.
3. Eliza Jovinet.*
4. Doubtful reading of the original text.
5. These caricatures by Courbet have not been preserved. The artist, as far as we know, never returned to this genre.
6. The Salon of 1840 had opened its doors on March 5.
7. This portrait has not been found.
8. The younger children of Julien-François Oudot.
9. Probably Urbain Cuenot.*
10. Perhaps these vignettes included the *Death of Cousin Moisy* (Fd. 34), which was made to illustrate a *chanson* by Ch. Adam. No longer known today, this print was exhibited in Zürich in 1935–36 (no. 152) and illustrated in Léger 1948 (fig. 11). Léger (1948, 41) and Fernier (1977–78, 2:294) both date this print around 1850, but, from a stylistic point of view, an 1840 date seems much more plausible.
11. Julien-François Oudot.
12. During his first years in Paris Courbet seems to have been living together with Adolphe Marlet* and Urbain Cuenot. His address in 1840 is not known.
13. Probably at the "academy" of père Suisse, a former model who had a studio on the Quai des Orfèvres where young artists, for a modest fee, could draw or paint from life models. Courbet was later to paint the portrait of père Suisse (F. 295).
14. François-Edouard Picot (1786–1868) was a highly esteemed history painter during the July Monarchy. A student of François-André Vincent and Jacques-Louis David, he exhibited at the Salon between 1819 and 1839.

To his father [Paris, May 29, 1840] 40-2

Dear Papa:

No doubt about it, you want to starve me out! A month ago I sent you a letter with big Cuenot.[1] You must not have received it, for at that time I had

already exhausted all the credit I could get in Paris, and since then I have had the hardest time making ends meet. I owe everyone except my cousin,[2] for he might have thought that I was asking him independently of what you were supposed to send me. It is crazy to let expenses run up so high, for at this point it will take well over five hundred francs to get me out of this hole. After all, I have received nothing for three or four months. I told you in my letter that Panier* did not want to give me money without your authorization. Don't be afraid to give it to him, for, believe me, I spend only what is strictly necessary, to the point, in fact, that I am the laughingstock of the people around me. I am always so short of money that I cannot go anywhere with them on their little fun outings, and in Paris, believe me, that is hard.

I work all the time. I follow a life course in the morning from five-thirty to eleven o'clock.[3] I also take an anatomy class in the evening and as soon as the Salon opens I will go copy one or two paintings to take with me. I have painted several portraits, including one of my cousin Jovinet's* little girl. I'll paint my cousin's three children before I leave, it would mean a lot to his wife.[4] So far she is not certain that she'll come to Ornans, but my cousin certainly will.

We saw the Versailles waterworks, they are wonderful. We also saw beautiful fireworks for the king's saint's day,[5] as well as horse races at the Champ de Mars, which are very curious. Once in a while there are quite amusing things to see in Paris, but the rest of the time it is boring as hell. I am pulling out, I think, at the end of August. Meanwhile I beg you to answer me immediately for my position is very serious. I still have my winter clothes on my back, which does not help to cool me down. I hope you are all well, even though you don't write. I assume you are in Flagey and that the shelling is finished. I am addressing this letter to Ornans, Grandmother will forward it to you. I hope Grandmother and Grandfather are still well. I cannot wait to see you all. In the meantime I give you a warm embrace.

Gustave Courbet

[Address] M. Courbet or J. A. Oudot, landowners
Ornans, Doubs dept.
[Postmarks] Paris, May 29, 1840
Ornans, May 31, 1840

1. Probably Urbain Cuenot.*
2. Julien-François Oudot.*
3. See letter 40-1, n. 13.
4. The portrait of Clémentine. See also letter 40-1, n. 7.
5. The saint's day of Louis-Philippe, May 11.

To his father [Paris, June 21, 1840]

Dear Papa:

I must tell you that I appeared before the [military] examining board on the morning of Saturday the 20th.[1] I played my role so well that these gentlemen were unable to reach a decision. If the certificates that you had sent me had been better supported, if they had been attested by the prefect, I think I would have been dismissed. Now they have decided that I should be reviewed a second time in my own region, where I am better known, and, with that object in view, they have told me to leave immediately. I really don't know how I was able to stutter like that, for I did not say a single word properly. They said I was playing dumb, but that did not stop me from continuing my role.

Well, now, I have to tell you that I had made fantastic preparations for it. First I did not go to bed, then I had a bottle of cognac sent up to my room and drank it in a punch; I also smoked more than twenty pipes and drank two or three cups of coffee to all that. Filled with those concoctions, I appeared before them as composed as I am right now.

So I will leave as soon as I receive your reply, which you should be sure to send by return mail, except that I will expect you to take a day to see what my chances are of being dismissed or accepted, for you must be aware that it would not be amusing for me to lose the two best months of the year, just when they have opened the museum, for in these two months I will do more than I have done so far. As yet I have done nothing but study and I want to turn that to account. And for you, it would not be amusing to pay for the trip from Paris twice in two months. I am very rushed, for I am afraid of missing the post. I'll send you my certificates tomorrow. They should be inserted in my folder at the prefecture as soon as they arrive. They told me at the office that they won't arrive for four or five days. You must know when the examination will take place; let me know. In the event that I have to appear, it would not be a bad idea to obtain a third certificate from one of my teachers in Besançon, either M. Delly* or M. Flajoulot.* I got one from my teacher M. Steuben* that has been attested by the mayor of the 11th arrondissement of the Seine and by the prefect of the Seine. My cousin [has put?][2] his [seal] on M. Steuben's.

I embrace you all, and I look forward to seeing you.

Gustave Courbet

[Address] Monsieur J. A. Oudot, landowner
Ornans, Doubs
Rush mail

[Postmark] Paris, June 21, 1840

1. Courbet had drawn a low conscription number, which obliged him to serve in the army. His appearance before the examining board was intended to have himself disqualified.

2. Doubtful reading of original text.

41-1 *To his family [Paris, January 25, 1841]*

Dear family:

Adolphe[1] has just received a letter that informs me that I am dead, but I solved the puzzle when I found out that my doorman did not mail a letter that I wrote you for New Year's Day. I may be careless but not yet so to the point that I would go a month without writing you, particularly not at that time of the year.

I will try as far as possible to make up for lost time by giving you an ample report on my current way of life.

Let's talk first about my departure: when we arrived at Besançon that night, we went out to dinner. Then Adolphe and I went to see M. Flajoulot.* We found no one there to talk to, so from there we went to M. Tonnet, who handles the business. We were told that he was out at a party. Not knowing where to go after that, I gave the letter to Tony[2] to put in the mail.

It was terribly cold when we got to Paris; nevertheless, we did not suffer in the carriage. We looked for rooms for two days and could find only some very expensive ones in a lodginghouse, where we are, by the way, quite comfortable. It is at rue St. Germain-des-Prés no. 4. Adolphe and Urbain* each have a room on the second floor for forty francs; mine, on the third floor, costs twenty-five francs. We could not get any closer.

I was fairly well received at my cousin's as well as at Eliza's.[3] I have already been invited to dinner once by each of them. I do not go to parties anymore, except sometimes at my cousin's, whom I live near. I could not go anywhere else anyway, for I have a drawing course from six to ten in the evening.

This is how my day is organized: in the morning at 8 A.M. I go to paint from the live model until 1 P.M. Only at 10 A.M. do I come back to eat a plate of soup the caretaker's wife makes for me, for my hotel is next door to the academy.[4] Then I go to the Luxembourg Museum to copy paintings from 1 P.M. to 5 P.M. At 5 P.M. I have dinner at Mme Laithier's [?], the little "Mourotte," where we eat very well for the price of twenty-five sous a meal. It is the kind of food we eat at home, which suits me very well, for I do not digest very well when I go to a restaurant. Then after dinner I go to my drawing course; so far, I have worked twelve hours a day and hope to go on doing so.

I saw Panier* a few days ago. He'll come to the Luxembourg to choose a painting that I will copy for him for his salon. I just finished a painting that I had started to copy when I arrived. I'll try to sell it however I can. I also did

a small painting of my own invention for a lottery that the Oudots organized for one of their parties. There were 160 lots, I myself had three or four. There were more than one hundred people. Panier and his wife came to make their first visit to my cousin's that day, more or less thanks to me. Aside from the distribution of lots by chance, there was another distribution that depended on the judgments of all the ladies together. These were, for the young men, a prize for eloquence and, for the young ladies, a prize for graciousness.

My cousin always has original ideas like that. A week earlier, for example, he gave all the young people questions, such as, "Is memory better than desire?" "Are leg-of-mutton sleeves better than narrow sleeves?" "What is the origin of the proverb, 'Lucky at cards, unlucky at love?'" And mine was, "Does tobacco smoking constitute progress in the nineteenth century?"

You had to make a speech, a talk of five to six minutes on your subject, in which you resolved the question. When everyone else had finished, and had caused the guests to laugh a lot already, it was my turn. I was last, and my question was damned awkward to deal with in front of the ladies, but notwithstanding I gave it quite a funny twist. I made a lot of puns that went over very well. I got overwhelming applause, and it all made everyone laugh so hard that no one could hear what I said. It was a complete triumph. Everyone complimented me, and my cousin and his family were delighted. M. Jovinet* rushed over to me to promise me a reward of a pound of Turkish tobacco. The furor was all the greater for my having acted so differently from my usual self.

Then it was time for the votes. The first time around I got twelve, another fifteen (the one who had given the talk about the leg-of-mutton sleeves, in which he had greatly flattered the ladies), yet another eight. As there was no majority, they eliminated the one with eight votes and voted again for the fifteen and me. At that point intrigues started among the ladies. My opponent is ordinarily very much a ladies' man and I am not one at all. He got eighteen votes, and I fifteen, and he received the prize for eloquence. This did not bother me, for a moment later one of the ladies came to say right in front of me (for she did not see me), "Sir, if you got the prize you must thank me, for I got you seven votes." The evening went on like that, and we went home at three-thirty in the morning. Mme Oudot* asked me for my lecture in order to copy it, otherwise I would have sent it to you.

M. Oudot is moving. He is going to live, I believe, at rue Monsieur-le-Prince no. 49, near the Luxembourg, for the sake of the children, who will enjoy the park. And he believes that their new apartment will be better for their health, that is why he is moving. They are well now, as are the Jovinets. I hope you are the same. As for me, I am never sick; you mustn't worry on my account, do you hear, Grandmother! You must be a little bored being all alone like that. I would love to be with you, but one cannot be everywhere. I

37

would like even better to go out to dinner with Grandfather and go to Flagey from time to time than to be here. They say it is cold in Ornans, I have not heard about Flagey but I am sure that it is not warm there either. I doubt that the little girls are still in Chantrans, for they must do poorly in winter. Here we cannot complain about the cold.

I still tell Father that he should try to organize himself a bit for the [summer] vacation as some people from here probably will come for the vacation and we should receive them somewhat properly. The farm work must be, I imagine, entirely finished for the moment, all one can do now is to keep warm.

I still have money for a while since I spend very little. Well, take care of yourselves, I embrace you all for the New Year, Uncle, cousins, as well as Father and Mother, to whom you should give this letter. I urge them to bear their ills with patience. Take care of yourselves, dear Grandfather and Grandmother.

Gustave Courbet

I arrived a little late for the Napoléon celebrations[5] but I saw all that was worth seeing there anyway.

Kind regards to all who ask about me, in particular to Alphonse and his wife and to Tony,[6] if you see them.

Moret or Larèche [?] are no longer in Paris. I don't know what to do with the letter from the priest of Chantrans.

[Address] Jean-Antoine Oudot, landowner

Ornans, Doubs Dept.

[Postmark] Paris, Jan. 25, 1841

1. Adolphe Marlet.*
2. Tony Marlet.*
3. Julien-François Oudot and Eliza Jovinet.
4. Probably a reference to the Académie Suisse on the Quai des Orfèvres (cf. letter 40-1, n. 13.
5. The celebrations on the occasion of the *Retour des cendres*, the return of the ashes of Napoléon from Saint Helena to Paris, took place in December 1840.
6. Alphonse and Tony Marlet.*

<u>41-2</u> *Letter to his family [Paris, spring/summer, 1841] (incomplete)*

. . . I am delighted with this trip,[1] which has quite developed my ideas about different things I need for my art. We finally saw the sea, the horizonless sea—how odd for a mountain dweller. We saw the beautiful boats that sail on it. It is too inviting, one feels carried away, one would leave to see the whole world.

We traveled through Normandy, a charming countryside, both for its rich

vegetation and for its picturesque sites and Gothic monuments, which can compare to the best of its kind. Rouen is the richest in these of any city in France. We stayed there for two days and only had time to see them briefly. We were away for six days. We crossed on the magnificent steamship that transported Napoleon's ashes. . . . [2]

[Elsewhere in this letter Courbet reports on his work. He copied a painting in the Luxembourg Museum for an Englishman who paid him 150 francs. He has other copies to make for M. Panier.]

1. During the spring or summer of 1841, Courbet traveled to Normandy with Urbain Cuenot.* A sketchbook containing a series of rapid *croquis* made during this trip is kept in the Cabinet des dessins of the Louvre in Paris (RF 29234; Fd. 1). It contains sketches of the boat trip along the Seine and the harbor of Le Havre, as well as the monuments of Rouen.

2. The Normandie, which had transported the ashes from Cherbourg to Paris in December 1840. Courbet made a small sketch of the Normandie on p. 3v of the Louvre sketchbook.

To his family [Paris, August 26, 1841 (Ad)] 41-3

Dear family:

I am sending you these few lines with Abbé Cuenot[1] (whom, together with Abbé Oudot,* I showed around Paris as best I could) to tell you that I will be in our part of the world the first days of September. I will leave with Abbé Oudot.[2] I would have come back a week earlier if M. Panier's* partner had been able to give me some money.

Mme Vertel,* who felt that it took a long time for her to get an answer, was very happy with her letter. M. Vertel is now in partnership with Pernet, from our part of the world, to exploit several discoveries from which they hope to reap sizable profits.

I have spent several days at M. Oudot's* country house at Sceaux, where they have been going for a month now. I cannot wait to be down there.

<div align="right">*Gustave*</div>

I embrace you all.

1. Nothing is known about this clerical member of the Cuenot family.
2. Headmaster and teacher at the Petit Séminaire of Ornans. See also letter 39-2, n. 2.

To his family [Paris, January 1842] (incomplete) 42-1

. . . I take advantage of the opportunity offered by Adolphe Marlet* to tell you something of my present way of life. First of all, to get to the room I now have you have to climb only 104 steps. I pay twenty francs a month for it. All three of us are in the same lodginghouse.[1] We eat at a boardinghouse similar to Laithier's [?], except that it costs three sous more a meal. I eat only

one, at five o'clock. In the morning I have some bread in my room. On the whole I am doing fairly well.

Soon I'll go to Panier's* to get a hundred francs. I have not had time yet to go and see him, just as I have not had time to write you. For immediately on arriving I needed to work and I started a painting that I wanted to finish.[2] In addition, I was going to my evening atelier. In short, it was another month in which I didn't have any fun. I have put off all my commissions, [which is] quite annoying. . . .

1. On his return from Ornans, Courbet appears to have rented a room at 28 rue de Buci in the sixth arrondissement, not far from his earlier room at 4, rue St.-Germain-des-Prés (cf. Paris 1977, 24).

2. Perhaps one of the paintings that he was to submit to the Salon of 1842, the *Rest of the Hunters* or *Interior*. Neither painting was accepted by the jury. Both seem to have disappeared today.

42-2 *To his family [Paris, January-February 1842] (incomplete)*[1]

. . . I received your letter, which, as usual, is full of reproaches. I don't know how you can always say things when you don't have the facts to support them. Some people are astonished by my amazingly economical way of living, others always question it. Oh well, if one were not familiar with that old habit, it would be discouraging. . . .

[He is working on M. Panier's* paintings and he is not always on the best of terms with the Oudot* family, where he is treated less than courteously. Therefore, he is happy that his cousin has commissioned another artist to do his portrait. He is living at 28 rue de Buci and is doing well.]

1. The date of this letter is derived from the fact that Courbet gives his address as 28 rue de Buci, where he lived in 1842 (cf. Paris 1977, 24).

42-3 *To his family [Paris, early May 1842]*

Dear family:

I take advantage of the opportunity offered by Uncle[1] to write you these few lines. You must have heard about the event that has shocked Paris.[2] At present, the number of dead is estimated at eighty, forty of whom, beyond recognition, were buried immediately. Fifty are mortally wounded, and everyone is injured. Uncle will provide you with more details. I could not have been involved. I did go to Versailles hoping to find Uncle there, but as I did not find him and as I did not want to see the waterworks, which I have seen already ten times, I came back very early to see the horse races at the Champ de Mars. If I had found Uncle I would have come back with them along the

right bank. It is the same train that failed us last year at the same time. No one I know was involved.

The piano you ask for is not easy to find. I have seen several for forty-five hundred francs, and I am convinced that I will find one in your price range but I would have to be lucky and that seems unlikely. Besides, I know nothing about pianos. If I go to the piano teachers, they are paid to sell me what they show me. Eliza[3] sold one to buy a finer one, but she sold hers for seven hundred francs, I believe. Well, I'll look around some more, but I think I'll have to spend more than the price you have set. M. Panier* suggested that I wait until he returns, and that he would take care of it. That would suit me fine, please talk to him.

Uncle has debarked at my cousin's, with whom he gets along very well. The day he arrived, my cousin showed him around Paris in a cabriolet. I have not been able to get much of a sense of his business. I have seen very little of him and I am not sorry about it. I am rather happy that he could do without me, first because of my money and second because of my work. I have not seen his niece because it has been some time since I have seen his nephew.

I now have a marvelous little black English dog, a purebred spaniel, which was given me by one of my friends.[4] He is much admired by everyone and is much more popular at my cousin's than I am. Urbain* will take him to you one of these days. I am going to have some summer clothes made for I have nothing to wear anymore for this weather. I'll get some money from M. Panier.

Yesterday I went to the Chamber of Deputies, to please Grandfather. I hit the jackpot: I saw M. de Lamartine and M. Teste speak.[5] I say "saw," for one cannot hear a thing. To get in, I asked M. Véjux,[6] who received me very kindly. We talked for a moment, and he assured me that we can count on the direct line of our railroad going through Besançon. He assured me that he himself placed a bet on it, at six to one, against M. Dejenoux, the representative from the Haute-Saône. In the session they spoke of absolutely nothing but the railroads.

I was pleased to learn from Uncle that everyone is well. I am well too. I think I will leave here on August 15. I embrace you all. Best regards to everyone we know.

Gustave Courbet

[Address:] Monsieur Courbet, landowner
 Ornans

1. No doubt his uncle Bastide.*

2. On May 8 a terrible train accident had taken place on the Paris-Versailles line. The total death count was close to 150 (cf. Howarth 1961, 283, n. 1).

3. Eliza Jovinet.*

4. Courbet was to include this spaniel in two self-portraits (F. 26 and F. 27), both painted in 1842.

5. The poet Alphonse de Lamartine (1790–1869) was elected to the Chamber of Deputies in 1833. He remained a deputy until Louis Napoléon's coup d'état in 1851. Jean-Baptiste Teste (1780–1852) served as minister of public works during the July Monarchy.

6. Désiré-Joseph Véjux (1795–1857) was a deputy of the Doubs Department between 1834 and 1848.

42-4 *To his family [Paris, December 24, 1842]*

Dear family:

I have finally found an atelier, at rue de la Harpe, no. 89,[1] and I have rented it. It is the former chapel of the Collège Narbonne, which was made into an atelier for M. Gatti de Gamond,[2] a well-known painter. It is currently used as a music studio by M. Habeneck,[3] the conductor at the Opera. I have rented it for 280 francs a year, or twenty-three francs a month. Now I still have to buy some furniture, including a bed, a chest of drawers, a table, and a bedside table, and some chairs. Altogether that will cost me some forty francs or fifty at the exchange. My biggest problem is a bed frame and a straw mattress, but I think that if I look around I will be able to rent, if not buy them. Now you must send me immediately, either with Adolphe,[4] if he has not left yet, or by mail, two pairs of sheets, a blanket, washcloths and towels, I believe that is all. As I moved into my present place on the fifteenth, I therefore have another two weeks here. Make sure that Liégeon* packs those things immediately and does not store them in the rain. And have them delivered to my new lodgings, 89 rue de la Harpe. Also, tell the man from Eternoz—for I don't know whether the Academy has already had his water analyzed—to send a bottle if that has not already been done, for I can't do anything without it.[5]

I got your letter from Adolphe. So it is true that in Flagey that entire wooded ridge has been razed in one shot.[6] It is a shame but it was to be expected. There is nothing else new here. I have already gone out two nights, once to Mme Jovinet's* and once to the Oudots,* both times for dinner. Tomorrow I go back to dine again at the Jovinets, with Boulet,* then the day after tomorrow to M. Oudot's with Adolphe, for a hare dinner. M. Oudot is still not well, he has had a relapse for a week. M. Jovinet asks whether you would be so kind as to ascertain from M. André Boulet the inventory of the property of his wife. Give me an answer and send me the things I need as soon as possible. I enjoyed Zoé's letter and I would be delighted to receive [letters] from Zélie and Juliette whenever they feel like writing. My best

wishes for a happy New Year to Grandmother and Grandfather, as well as Mother, Father, sisters, everybody. With a warm embrace,

Gustave

I am taking advantage of the opportunity offered by Mme Oudot, who is sending her New Year's presents to Ornans in a small box. This is undoubtedly supposed to be a surprise for Grandmother.

[Address] Monsieur Courbet, landowner
 Ornans, Doubs
[Postmarks] Paris, Dec. 24, 1842
 Ornans, Dec. 26, 1842

1. Courbet was to stay at this address until 1848, when he moved to 32 rue Hautefeuille.
2. Jean-Baptiste Gatti, the husband of the well-known feminist author Zoé Gatti de Gamond (1806–54).
3. François-Antoine Habeneck (1781–1849) was a famous violinist. Concert master at the Opera, he was also the founder of the Société des concerts du Conservatoire.
4. Adolphe Marlet.*
5. Courbet apparently was trying to act as intermediary between the Academy of Sciences and a man from the small village of Eternoz, who was interested in the chemical properties of water, perhaps from a local well or stream.
6. Perhaps cut, legally or illegally, for firewood. On the problem of firewood distribution in the Doubs Department during the July Monarchy, see Mayaud (1986, 92–96, and passim).

To his family [Paris, late December 1842]

42-5

Dear family:

If I have written to you always in blue ink, here is the reason. When I moved into my room I inherited from my predecessor a superb bottle of this ink.

Let's talk about something else. I am sorry that I asked you only for sheets and a blanket for I am forced to buy a bed frame and a straw mattress. I cannot get a decent bed frame for less than fifty or sixty francs, not to mention that they don't correspond to [the length of] my legs. Therefore, if you have not yet sent what I asked for when you receive this letter, send it all via Liégeon,* that is to say, a bed frame and an empty straw mattress (I'll get the straw here), plus a pillow, a little square one. In the meantime I will borrow them or sleep somewhere else than in my atelier. Since I must pay a month's rent anyway, I would lose fifty francs by buying those things when I went back there. That still would not make my rent very expensive, for if one spreads out those fifty francs over nine months, it comes to six francs, and consequently for twenty-nine francs a month I'd be excellently set up to work. For it is a superb large house and very quiet. The atelier, which is on the first

43

floor on the courtyard side, has a skylight and another window that looks out on the courtyard. Since the house is a roominghouse, Adolphe[1] will be able to take a room in my street and come work in my studio. Tell him to write me when I should meet his stagecoach. I am still in the rue de Buci until January 8, at which time I take up lodgings in my new atelier. Tell Urbain* that one can easily walk back and forth in it. It will be warm in winter for it is vaulted and has a parquet floor. I am also going to buy a little cast-iron stove.

M. Buquet's servant told me—which had me already quite upset—that five houses had burned down in Flagey, but he added that ours was not one of them. Try to lose no time sending me what I ask for. I embrace you.

Gustave Courbet

I have had a winter coat made like Adolphe's, an evening waistcoat, and a pair of dress pants. Now I am all set.

[Address] Monsieur Courbet, landowner
Ornans, Doubs

1. Adolphe Marlet.*

44-1 *To his family [Paris, February 21, 1844]*

Dear family:

If I have not written you sooner it is not altogether my fault. I always leave Ornans too late for my projects. I have just done a painting that is quite large and that was so much work that this last month I nearly lost my mind.[1] And still, I have not painted it the way I could have, for I was in such a hurry that I did not know where to turn and I was unable to think of anything else. If you think that I am having fun you are dead wrong. For over a month I truly have not had fifteen minutes to myself. This is why: I have very expensive models, whom I paint from the moment I can see clearly in the morning until five o'clock in the afternoon, my dinner hour. In the evening I must get whatever I need for my work, I must chase after models from one end of Paris to the other, and after that I must visit people who may be useful to me, go to the obligatory parties, so that I do not seem unsociable, etc., etc. Mme Panier's* illness has also taken up a lot of my time.

I had written you to let you know that I was sending you a dog, then again after that. It seems that you are not getting my letters. I was unable to write you a letter [to send along] with Marlet,[2] for he received your letter in the morning and left that same evening. During the course of the day I helped him with his errands but I had told him to report to you at greater length.

This winter my atelier has been a bit damp and I had a chest cold that lasted for three weeks. It went away by itself as did a bout of diarrhea that I

had almost as long. It was an effect of the dampness. I am rid of it and am very well now, but that too hindered me in my work.

It is easy for Father to talk about my carelessness. I would like to see him do as active a job as what I do in painting. It has reached the point where the people around me and who are capable of understanding what I am doing, like the teacher of Marlet, M. Hesse,* for example—whom I visit often in order to show him what I am doing and who has come to visit me, for he takes a great interest in me—and many other people are agreed in predicting that if I continue this work [schedule], I will ruin my health.

If you think that I am trying to pull the wool over your eyes, I am very annoyed. One thing is certain, I can do no more than I do. And, on top of that, Father always manages to write me letters that, far from being encouraging, are very discouraging, and always come at exactly the wrong time, for it was just when I was most pressed. I am indeed grateful to him for his admonishments, but nevertheless, one must not always say the same thing. I believe I think more about my future than anyone and I prove it. Moreover, I live so parsimoniously that it could easily appear ridiculous. Father should have had someone who spends as much as young people ordinarily spend in Paris.

I have just sent my painting to the Exhibition.[3] I had only till the 20th of this month. M. Hesse has said the nicest things about it to me and he has made me the most flattering predictions. He paid me so many compliments on what I was painting and on the works that were in my studio that I did not know how to answer him. He also wanted me to send to the exhibition a portrait that I had done two years ago. If I am not accepted, I am in trouble.[4] I'll write you in three weeks.

I am glad that he [Courbet's father?] has leased his farm but I wish Caca's horse to the devil. I hope that Mother and Zélie are well even though the weather is not too good in Flagey in winter. Zoé must be glad to be in Ornans. You paid for the dog's transport but I had already paid for it in Paris. This evening I will go claim my ten francs back from Liégeon* and when I write you I'll tell you if he has returned them to me.

Grandmother, please send this letter on to Flagey, for I don't want you to pay postage twice to tell you the same thing. I hope you are well, and Grandfather too. I am always thinking of you all. I embrace all of you,

Gustave

[Address] Monsieur Jean-Antoine Oudot, landowner
 Ornans, Doubs
[Postmark] Paris, Feb. 21, '44

1. *Lot and His Daughters* (F. 13).
2. Adolphe Marlet.*
3. The *Self-Portrait with Black Dog* (F. 27).

4. Only the *Self-Portrait with Black Dog* was accepted at the Salon of 1844. *Lot and His Daughters* and a landscape study that Courbet had also submitted were refused (cf. Paris 1977, 24).

44-2 *To his family [Paris, March 1844]*

Dear family:

I have finally been accepted to the Exhibition, which gives me the greatest pleasure. It is not the painting that I would most have wanted to have accepted, but no matter, this is all I ask, for the painting that they refused was not finished.[1] I did not have time, for I had left [Ornans] too late. I am almost glad that it was not accepted, for I'll have time to finish it for next year. They have done me the honor of giving me a very beautiful location at the Exhibition, which makes up for it. The painting that was accepted is my [*Self-*] *Portrait* with landscape background. Everyone compliments me on it. The funny thing is that it was painted two or three years ago, for my black dog is in it, by me.[2]

Yesterday I was at Mlle Clotilde Oudot's[3] wedding, which was quite beautiful. There was a magnificent meal attended by two peers of France. Then in the evening there was an enormous ball with four hundred-odd people and a splendid orchestra. It all went joyously. They were right to take advantage of it, for in that household parties don't happen every day, seeing that neither one of them has a cent. From Fresquet's family[4] there was only the grandmother, for the fathers and mothers, even though they gave their consent, are not very happy about it. She is quite lucky to have found that young man, for even though she is very nice, I think that she would have been unmarried for a long time. One thing is certain, it is done, and Mme Oudot, with her usual tact, shut me up by giving me an important role in the wedding. I was forced to witness and to sign the contract. I was invited to all the meals, I was master of ceremonies at the ball, and it was I who represented Ornans.

Let's move on to no less positive matters. I received four hundred francs from M. Panier* in two installments. My paintings cost me terribly much, yet I will be painting some for the Besançon exhibition,[5] which I'll try to sell. I will be dining tomorrow at Panier's, with Cuenot (Théodore)* and Félix Teste,[6] and I will give this letter to Cuenot.

And then there is Mourot [?] from Amathay who came here to the Agricultural Congress. I believe that if he had not been here it would have taken place anyway. I doubt very much that he understood any of it and I regret only one thing and that is not having seen Mourot appear in the Luxembourg at the congress. I am amazed they did not call on him to speak.

I went to claim my ten francs from Liégeon,* who replied that he would write to Besançon to find out who had the cheek to get paid, and if they don't

refund it to you, write me, he will refund it to me. I have no other news to write to you except that Bastide* senior passed through. He was going, so he said, to Compiègne to buy some pastures for the Pourtalès [?] [family].

I am well. I hope you are the same. I embrace you all with all my heart.

Gustave

Grandmother, as I am writing to you, send this letter on to Flagey, for I believe they are still there.[7]

1. Courbet submitted three paintings to the Salon of 1844. Only his *Self-Portrait with Black Dog* (F. 27) was accepted. His large painting, *Lot and His Daughters* (F. 13), and a landscape study were refused.

2. Courbet had first mentioned his black spaniel in a letter written in the spring of 1842 (cf. letter 42-3).

3. The eldest daughter of Jules-François Oudot.*

4. The family into which Clotilde was marrying. Her husband was probably Raymond-Ronnat-Frédéric de Fresquet,* who may have been a student of her father. Since the Fresquets belonged to the French nobility, they may have objected to their son's marriage to a commoner.

5. Courbet is not known to have exhibited his work in Besançon before 1850.

6. Perhaps Jean-François-Félix Teste, a well-to-do landowner in Ornans (cf. Ornans 1981, 49).

7. The Courbet family, which owned property in both Ornans and Flagey, seems to have shuttled back and forth between those two places.

To his grandparents [Paris, March 1844] 44-3

Dear Grandfather and Grandmother:

I am taking advantage of young Bouvret to send you my news, which does not amount to much for, when you work, all days are the same. I'll tell you only that the painting that I have at the Exhibition[1] has been hung in the Salon d'honneur, which is very much to my benefit, for it is a place reserved for the best paintings in the Exhibition. And if, instead of a portrait, I had had a more important painting, I would have received a medal, it would have been a great debut. Everyone is complimenting me.

This year I won't earn much money for I am devoted to more serious work. There is nothing as harmful as applying oneself to earning money too early. My dear grandfather, you see that I am not wasting my time. My sister wrote me that you were very pleased about that, as is the whole family. I am delighted because that is my keenest wish.

Lately, I have painted one or two portraits: one of a Belgian baron, a cavalry major,[2] and one of his father. They are relatives of Mme Blavet,[3] who is really very good to me. At this moment as I write you these few lines I am in a great hurry for I am going to another house to paint a portrait of a gentleman from Dieppe.[4]

The foreigners are flooding Paris, one cannot turn around. The Exhibi-

tion of Industry is quite beautiful.[5] There has been, it seems, great progress in mechanics. I have been there twice already but I don't understand much of it for it is not really in my line.

My sister Zoé must not get impatient, I'll answer her at the first opportunity. I carried out her errand as soon as I received her first letter. That young lady that she recommended to me had not explained herself very well. I couldn't understand what she wanted, nor what she was, nor where she came from. Nevertheless they promised me they would write her, which they must have done some time ago.

We are having here the most beautiful season I have ever seen in my life. I hope that down there it is the same and that all is well. I learned that you have been sick this winter, which worried me. I hope you are well now, and Mother, Father, and my sisters too. Tony[6] told me that lightning struck very close to our house again, it is awful. They must have it in for us. I would recommend that Father invest in a lightning rod. It appears that Father is having a very difficult time. I am sorry for his troubles but very often he could avoid them by doing everything in its own time. I won't elaborate on that for I am too far away to be able to judge.

So I embrace you all and look forward to seeing you in three months, I think. Kind regards to all the acquaintances and kiss Mother for me. Pass this letter on to Flagey, where I would very much like to be. I would help Mother plant her garden if it has not already been done. I am not very much in tune with country tasks anymore. I am very well. Everyone in the family here is well, though I see them but rarely.

Again, I embrace you.

Gustave

1. The *Self-Portrait with Black Dog* (F. 27).

2. Fernier (1977–78, 1:22) identifies the portrait of a Belgian baron with a full-length portrait in the Musée Jenisch in Vevey. This unsigned work was discovered in a bric-à-brac shop by the Swiss painter Auguste Baud-Bovy, who recognized it as a work by Courbet. This attribution apparently was confirmed by the Alsatian painter Jean-Jacques Henner, who claimed that he had seen Courbet paint it in the rue Hautefeuille. Since Henner did not come to Paris until 1846 and Courbet did not move to the rue Hautefeuille until 1848, it is impossible that the painting in question is the *Portrait of a Belgian Baron*, painted in 1844. Instead, we must assume that both the portrait of a Belgian baron and that of his father are now lost.

Perhaps the Belgian baron in question was Baron Papeians de Morchoven* from Ghent, an officer in the second regiment of the light cavalry, with whom Courbet was to stay in August 1846. Papeians's wife, Adèle Damiens, originated from Saint-Valery, a town near Dieppe, and therefore may well have been related to Courbet's acquaintance, Mme Blavet. See letters 46-9 and 46-10.

3. Perhaps the mother or wife of Paul Blavet, whose portrait Courbet painted around 1845 (F. 63).

4. Little is known about Courbet's connections with Dieppe, where, apparently, he knew several people. One of these was Paul Ansout (1820–94), the son of a cloth merchant from

Dieppe. Courbet had submitted his portrait (F. 57) to the Salon of 1843, where it was refused (cf. Paris 1977, 24, 80–81). Through Ansout, whom Courbet seems to have befriended in the early 1840s while Ansout was studying law in Paris, Courbet may have met other people from Dieppe. Among them may have been Adèle Damiens (cf. n. 2) and the unknown sitter of the portrait mentioned in this letter. Finally, his Dieppe connections may also have led to his romantic involvement with Virginie Binet,* a girl from Dieppe, who bore him an illegitimate son in 1848 (cf. Fernier 1951, 3–4.

 5. The Public Exhibition of the Products of French Industry (Exposition publique des produits de l'industrie française).

 6. Tony Marlet.*

To his family [Paris, December 13, 1844 (Ad)] <u>44-4</u>

Dear family:

 I am always behind in my writing you but, nevertheless, I think of you no less often. I am still worried about Grandfather's health although I imagine he must be getting better every day.

 I did not get my things from the carrying company until yesterday. Everything arrived in good order. Last winter I had a bad little sheet-iron stove, which I have retired. I have bought an old ceramic one that cost me ten francs and with which I am happy. I am finally settled in again and am working away.

 It is rare for Paris to get a severe winter. Mme Jovinet,* who sends many regards, has just left for the Iles d'Hyères. The doctors advised her [to go to] warm countries. She was sick when I arrived. The sea bathing had done her so much good that she was red-cheeked from happiness, like a child. She has had her hair cut off even though her illness has not gone down into her chest, and in spite of all those illnesses she has just left in the most terrible cold and snow. It is true that she was well bundled up: she wore a man's weight in woolens and furs. I was there, she sat in the coach with the children and the maid, and one couldn't see them. M. Oudot* still fears that she will be cold and as for me, I fear that she'll suffocate before she arrives, especially since nowadays the stagecoaches are heated with a kettle and a spirit lamp. God will that she come safely to port, she will be gone for five months.

 I have seen everyone I know. All the Oudots are in good health and M. Oudot has not even gone on his trip and does not say a word about it anymore. They are well aware of Grandfather's illness and of Grandmother's position. They have also inquired about Father's home. Mme Vertel,* as usual, continues to make applications. She has just obtained from the minister a relief [advance] on the pension of her husband,[1] of whom there is still no news.

 Urbain* is delighted with Paris. Marlet[2] and I have found our former friends. All three of us stay close together. Marlet, who is still skinny, was

recently a little ill, but at the moment he is completely recovered. I believe that at the moment Father and Mother and Zoé have gone down to Ornans, which would please me. I have no other news to tell you. We had a very good trip. I am very well and wish you all the same. I also would like Grandmother to calm down a bit. When I sense that she is like that, I cannot work. As for Joseph's[3] commission, I am not very inclined to get him what he needs. M. Panier* is away on a trip, I have not been able to talk to him about it yet.

Adieu, I embrace you all. Kind regards to Uncle.

Gustave

1. The husband of Natalie Vertel, who was a sea captain, died on a return voyage from America. See letter 45-2.
2. Probably Adolphe Marlet.*
3. Joseph Courbet.*

45-1 *To his father [Paris, January-February 1845]*

Dear Father:

I received your letter and hurry to reply, for Boulet* himself, who leaves tomorrow for Ornans, will bring you mine. I always like to get your letters in spite of the obligatory little sermon that I have known by heart since I reached the age of reason, for I believe you gave it even before then. You can see that I am not like "the young people of today," who do not listen to what one has to tell them. Unless you take me for a fool, I don't see what use this can prove to be. For you may be very sure indeed that I think seriously, a hundred times more than you, of all that. Furthermore, this serves more to discourage than to encourage me for it is just a goad to an animal that already is overburdened. In short, you are the opposite of those around me, who try to divert me from my work from time to time for fear that I will ruin my health.

Let us talk about something else. The weather is abominable here. Every morning when I wake up I look out the window to see what the weather is like: it is raining or snowing, or, for a change, it is snowing or raining, or, even more fun, it has snowed. In that case my window, which is horizontal, is covered with one or two inches of snow, a beautiful veil that casts my atelier in a charming chiaroscuro in which, however, one cannot work. So I climb on my roof with buckets of water and I melt all that well away.

The other day I received some money from the [][1]. Those people are not altogether honest. They came to renegotiate the price for the portrait even though we had positively settled on it. They offered me one hundred francs, to which I answered that I'd rather give it to them as a present. That ruffled their feelings a little, I think. In the end they asked me, like people who cannot pay, if I would be satisfied with 150 francs. Because I did not want to fight with them about it, I answered them rather coolly that I would be very

satisfied. They paid me the entire 150 francs in two installments. They needn't bother going to their father's funeral in a carriage or showing off as they do if they're going to act like that.

I went to find out what Joseph Courbet* was doing. He was not at home but they assured me that he had found a job. M. Oudot's* children are well now and are out of danger. It seems that in Ornans everyone is getting married. I already knew about Lapoir's marriage from Pernet. I am sorry about the death of Mlle Royet [?]. Old Royet [?] must be devastated. When Grandmother sees him, will she give him my condolences. I have always been very fond of that man, he is a truly decent man.

I embrace you all. Take care of yourselves,

Gustave

1. Illegible surname

To his family [Paris, February-March 1845] 45-2

Dear family:

I was waiting to write you that I had sent my paintings to the Exhibition. Since I left you I have not stopped working for an hour, Sundays and holidays included, and finally I completed five paintings that I have just sent off.[1] The first is a *Dream of a Young Girl* [F. 53], the second a *Guittarero* [F. 52], the third *Checkers Players* [F. 43], the fourth a *Portrait of a Man*,[2] life-size, and the fifth the portrait of Juliette, which I have called the *Baroness de M* . . . [F. 42], as a joke. The frames cost me a lot of money but one cannot avoid that. I am very tired, physically and mentally, and unable to work for the moment. Now I am waiting for the outcome. I don't expect that they will all be accepted. If they accept two, I will be very happy. I did send them a nice selection. I will know the outcome on March 15 and will write you immediately.

I recently saw Joseph Courbet,* who brought me a pair of pants. I have not had time yet to find out what he is doing. He told me that you are all well, which pleases me for here things are not so well. To begin with, all M. Oudot's* children are sick and very sick at that. For two days Jules, the eldest, was in a desperate state, it was typhoid fever, and now it is Frédéric's turn. Little Marie is also ill. They have scarlet fever, or something. Madame de Fresquet* has just been delivered quite happily of a big girl, and all those events took place at the same time, it was a regular hospital.

On to Mme Vertel.* She recently received a copy of M. Vertel's death certificate. It seems that he was returning from America and the poor devil had, I believe, done a forced march to get to the boat and without too much money, for after he boarded the ship he went to sleep and was found dead in

his bed a few hours later, without having received aid. He is already being mourned.

As for Madame Jovinet,* it seems that she likes Nice very much and that the moment she arrived she was greeted by a charming spring. M. Jovinet does not have a bad time of it either for he has left with her. Nevertheless she is still sick and it seems that that illness can last for two or three years.

Let me tell you in a few words about my current excellent system for breakfast, which I learned from the Crétenets, who are now living in Paris. This system consists of telling a milkman from the outskirts of Paris to bring you every morning 4 sous' worth of milk, which is equivalent to a little more than a *chauveau* or *chauve* in our part of the world. What surprised me a lot is that the milk is a hundred times better than La Patasse's [?] or any other milk-seller's in Ornans. Then my concierge, who is a charming little hunch-back, as is his wife (together they are an unbelievable couple), brings me at the same time three sous' worth of coffee, a portion of what they make for themselves each morning. Add to that two sous' worth of bread and a sou of sugar, and I eat breakfast at home for ten sous a day. I have bought a tin pot, and as soon as my fire is lighted I put it into the oven in my stove. The only problem is that I don't always take it out soon enough and it boils over rather often for I work while it is heating up.

Let's talk about something less important. I don't know what kind of nasty trick you are playing on me with regard to some ridiculous marriage. If it is a joke, it is a good one. I am as inclined to get married as I am to hang myself, especially with Mlle C. It cannot be Mlle Victorine [who is the cause of it] for she would not do such a thing as thus to destroy her niece's reputation. If I knew I would tell her brother and she would never hear the last of it.[3] Well, you see what it means to have nothing to do. One gets involved in foolish nonsense. Only in Ornans does one find that kind of gossip and empty-headedness.

I am very well. I am glad that you are the same. I send you all my love. I hope Grandfather is better and better, and Grandmother too. They will not be sorry to see spring arrive. One would not expect winter in Paris to be as hard as this one. I have never seen anything like it.

Embrace also Uncle for me and my Bastide nieces.

Gustave Courbet

I don't know whether you can read this, I am writing you without a fire.

1. Of these five paintings, only one, the *Guitarrero* (F. 52), was admitted.

2. According to the Salon registers, this was a portrait of "M. U.C.," no doubt Urbain Cuenot* (F. 85).

3. The identity of the figures mentioned in this paragraph is not known.

To his family [Paris, before April 22, 1845][1]

Dear family:

You are surprised, with reason, not to have received any news from me, but I must tell you that it is not my fault for I wrote you as soon as the Exhibition opened. You must not have received my letter. Adolphe Marlet* tells me that it is not surprising for he had written his brother Alphonse and he has not received any letter either. Oh, well, it is a mishap that can easily be remedied. I had written you that only one of my paintings had been accepted but that nevertheless I have no right to be discontented for a lot of famous men, who certainly deserved it more than I, have been refused. They accepted my *Guitarrero* [F. 52] and at the Salon it has attracted some potential buyers. Two people have asked to purchase it: the first is a banker and the second an art dealer. So I went to see M. Hesse* to ask him what price I should ask. He wanted me to ask five hundred francs. I found that it was a little expensive for a small picture that I had done in two weeks at most, but he gave me a letter that I was to present [to the buyer], in which he said that it was worth five hundred. Anyhow, I went to see the banker, and he, too, found it a bit expensive. So I asked him his price. He answered that he would take another look and then give me an answer. I am waiting for his answer, but in spite of everything I am afraid that I won't sell it. On the other hand, I know art dealers, and I am afraid to sell to them for they are people who don't always pay.

When you don't yet have a reputation you cannot sell easily and all those small paintings do not make a reputation. That is why this year I must do a large painting that will definitely show what I am really worth, for I want all or nothing. All those little paintings are not the only thing I can do, I feel painting should be largely conceived, I want to do large painting. What I am saying here is not merely presumptuous, for all the people around me, who are knowledgeable about art, are predicting I can.

The other day I made a study of a head,[2] and when I showed it to M. Hesse he said, in front of his entire atelier, that there were very few masters in Paris capable of doing one like it. And right after that he told me that if this year I were to do a painting like that, he assured me of a proud place among painters. I admit that there is some exaggeration in these words but one thing is certain: within five years I must have a reputation in Paris. There is no middle course and I am working toward that end. It is hard to get there, I know, and there are few [who do], for among the thousands sometimes only one breaks through. Since I have been in Paris I have seen perhaps two or three emerge who are truly powerful and original. In order to go faster I lack only one thing, and that is money, to boldly carry out my ideas. Enough of that.

Briefly, the other day I saw Mlle Perrier, who is delighted to have broken up with Lapoir, who is an idiot. He wanted to take her against her will though she did not love him. He has written a stupid letter to Mme Blavet.*

Mme Bouvret was kind enough to come see me. She did not tell me precisely what day she was leaving and she had left when I went to see her. Please apologize to her for me.

I am waiting two or three days to write you, for Promayet junior[3] is leaving on Monday and I am taking advantage of the opportunity. I am very well as is the whole family. I assume that you are all well also. I embrace you all. Kind regards to our friends.

<div style="text-align: right">Gustave Courbet</div>

[Address] Monsieur Régis Courbet, landowner
 Flagey
[Postmark] Ornans, [illegible] 22, 1845

1. The indication of the month in the postmark is unfortunately illegible, but as this is the second letter Courbet claims to have written since the opening of the Salon on March 15, I assume it was sent in April. According to the postmark, the letter arrived in Ornans on the twenty-second, which means that it must have been written around the twentieth.

2. Perhaps the study known as the *Desperate Man* (F. 20). According to Hélène Toussaint (Paris 1977, 81), the date (1841) on this study is apocryphal, and the work belongs rather to the mid-1840s. Dr. Collin,* who took care of Courbet at the end of his life, saw the work in Courbet's studio at La Tour-de-Peilz and states it was painted in 1845 (cf. Courthion 1948–50, 2:255.

3. Probably Alphonse Promayet.*

45-4 *To his family [Paris, May-June, 1845]*

Dear family:

I am not going to say very much for the friends who will bring you this letter will tell you more than I could. I did not sell my painting[1] but I was not very anxious to for I hope to sell them for a better price later on.

This year I will do a large painting that I hope will make me famous.[2] I have made considerable progress lately, and everyone around me strongly encourages me to do this painting, especially M. Hesse.* I will leave here, I think, the first of September, if my painting is finished, for I don't want to do what I did these past years. I am starting it today and I will work on it all summer. I will not earn a penny this year. One cannot work [seriously] and earn money, that is the worst mistake one can make. For the little that one can earn, one is terribly delayed in the very years that are most precious for [artistic] advancement, you must understand that.

I don't really feel like exhibiting in Besançon for it is meaningless to me. Worse, one may be vilified by people who know nothing at all. I was supposed

to have been mentioned in the *Impartial*, for the one who writes the column on art is an old friend and he asked me for information about the Salon.[3] If I were to exhibit in Besançon, it would be entirely to please you.[4]

I saw Mlle Perrier, who is also leaving. I have charged her and Promayet* to buy music for my sister, Zoé.* There is a rumor going around here about Zoé, a rumor that is absolutely ridiculous: they are talking about her marrying Lapoir. If after such a ridiculous escapade as he recently made he still presented himself, he is stupid and it is very offensive. I hope that there is nothing to it but, in any case, I will tell Zoé that when one wishes to marry one begins by choosing a person morally worthy of oneself. One never marries an ass, it is a crime. Money comes next. I hope that Zoé has not encouraged anything for otherwise she would cause me to have a low opinion of her intelligence.

Whatever my thoughts are worth, I hope that you are all well, write me. Here the whole family is well. I am very well. If I have not satisfied my Grandfather's wish right away, it is because I know the young man here who was to write for the *Impartial*. However, my reputation must start from Paris.

Gustave

[Address] M. Courbet

Ornans, Doubs Dept.

1. The *Guitarrero* (F. 58).
2. No large-size painting was exhibited at the Salon of 1846.
3. The *Impartial* was a newspaper of the Franche-Comté region. The identity of the journalist-writer to whom Courbet refers here is unknown.
4. Courbet is not known to have exhibited in Besançon until 1850.

To his family [Paris, summer 1845] 45-5

Dear family:

You do not often answer me but since the Cuenots[1] are leaving for Ornans I take the opportunity to tell you a little about my present situation. I think I am on the road to success. Everyone around me encourages me more and more. I am still slaving away and I am beginning to get very tired, it shows in my face. But nonetheless, I am working on a large painting, eight feet high and six feet wide, it is a terrible job.[2] But no matter, it must be done before I leave for Ornans. That is why I don't know yet when I'll leave.

Lately I had a visit from a Dutch dealer from Amsterdam who liked my work a lot.[3] He had been making the rounds of the Paris ateliers and he told me that he had not seen anything as much to his liking as what I made. He claims that he will make a name for me in Holland. In the meantime, he has taken two paintings of mine: a small study as big as a hand for which he paid

me twenty francs,[4] and another small painting, a pendant of the one I had at the Exhibition, for which he paid me four hundred francs.[5] He has commissioned me to do another one that I will be able to sell him for five hundred francs. That suits me perfectly for it frees me from those boring portraits that keep me from working, and from those women who want to be pale at any price. Furthermore, the Dutch pay extremely well, especially when one is French. It is like that everywhere, one is never appreciated in one's own country. That is why I won't submit anything to the Besançon exhibition. Besides I don't have time. I hope that you will show a great deal of kindness to the Cuenots, from whom I have received so much.

I must assume that everyone is well for you don't send me any news. The beautiful weather must have completely restored Grandfather and Grandmother. As for Mother, Father, and my sister, I forgive them for not writing for they must be very busy. I think it must be shelling time. As for me, I am well. Kind regards to Uncle. I embrace you all,

Adieu,

Gustave

Everyone is well here. M. Oudot* sends you his regards. Pass this letter on to Urbain.*

1. Probably not Urbain Cuenot and his family but another family by the same name, perhaps related. The Cuenot family is mentioned frequently in Courbet's letters between 1845 and 1848.

2. No painting of these dimensions was shown at the Salon of 1846. Perhaps the canvas was reused for the *Walpurgisnight*, exhibited at the Salon of 1848. That painting measured 2.5 by 2 meters, which corresponds roughly to the measurements given here.

3. H. J. van Wisselingh,* whose portrait Courbet was to paint a year later (F. 68).

4. This study cannot be identified.

5. Probably the *Sculptor* (F. 58), which, as Hélène Toussaint has pointed out (Paris 1977, 86–87), was probably a pendant to the *Guitarrero* (F. 52) exhibited at the Salon of 1845. See also letter 45-6.

45-6 *To his father [Paris, August 1845]*

Dear Father:

The two of us, Promayet* and I, are planning to leave at the end of this month, maybe next week. I am trying to get far enough ahead with my painting so that it will be dry and ready to be repainted after the vacation.[1] I wish I were already home with you for I am not doing any good work anymore, I have had it.

But let's talk about the most important issue: don't think that I will pass my vacation in Flagey, like Mother and my sisters.[2] Frankly, I cannot think of anything more boring in the world, and I swear that the prospect of such a

vacation has no appeal at all, for quite a few reasons. First of all, Grandfather and Grandmother are very old, and because they raised me and have always been very good to me, I want to live with them as much as possible, as, given my current circumstances, I can see them only during vacations. You understand that only a few more vacations and that will be finished. It is unpleasant to say those things but since you don't want to understand them I must spell them out for you.

Second, I cannot see you as I would like if I have to run from one place to the other. That bothers me for Mme Cuenot[3] said that Mother hardly saw me at all last year. And furthermore, there is no one to talk to in Flagey, it is very boring, while in Ornans I have all my friends and all kinds of entertainment that I don't have in Flagey. It is egoism on your part, you like it there, fine, but you don't care that there are five or six people who don't like it there and who are becoming stultified, for after all one must live in the world and in society. If it were very necessary for your happiness, but you manage to spend an endless amount of time there for an insignificant project. All in all, I hope that you will show enough goodwill to arrange your plans so as to spend the vacation in Ornans.

Here there is nothing new except that Mme Jovinet* and her family returned a week ago from Aix-les-Bains in Savoy, where she had been since June to take the waters, which have made her neither better nor worse. Her health is still more or less the same. Mme Oudot* left for Le Mans with her little girls to sniff out an inheritance, I am told. I hope she succeeds. M. Oudot will not go out of town this year. I am afraid it is because of lack of money for it does not seem to make him happy. Fresquet's* little girl is splendid. As for Mme Vertel,* it is the same old comedy. Her little girl is at St. Denis and she would like to remarry. The Cuenots,[4] with whom I spent a week, sold their house while I was there. They sold it for twelve thousand francs less than they had expected and should have had for it, but M. Cuenot is incapable of selling or buying something properly.

I have nothing else of interest to tell you, except that I have no more money for it is the very devil to get it from Panier.* Either he is not there or they have just made payments, etc., so that I have to go there five or six times to get any. Nevertheless I'll try to get some so that I can leave. If they had not omitted sending my painting[5] to Amsterdam, I would have received four hundred francs that now I cannot get until after Ornans.

Looking forward to seeing you, I embrace you all and I urge Mother, Zoé,* and Zélie* to insist on leaving for Ornans.

Kind regards to everyone at Grandmother's but don't show them this letter.

<p align="center">*Gustave*</p>

I have been told that Juliette* is in Ornans.

1. The large painting that Courbet hoped to exhibit at the next Salon. As indicated in letters 45-4, n. 2, and 45-5, n. 2, no large-size painting was submitted to the 1846 Salon.

2. The Courbet family had a farmhouse in Flagey and a townhouse in Ornans. Courbet's father preferred to spend most of the year in Flagey, and the rest of the family shuttled back and forth between two places.

3. Perhaps François-Angélique Cuenot, née Veille (d. 1847), the mother of Urbain Cuenot.*

4. Probably not Urbain Cuenot and his family (his mother [see n. 3] and his elder brother Théodore*) but perhaps their relatives. According to letter 46-5, the Cuenots had sold their house to move to Le Château d'Ornans, the little hamlet that had been built within the confines of the former Ornans citadel.

5. Probably the *Sculptor* (F. 58), which had been bought by the Dutch art dealer H. J. van Wisselingh.

45-7 *To his father [Ornans, autumn 1845 (?)]*

Dear Papa:

I am writing you to see whether you could lend a thousand francs to a woman from Foucherans, who is quite solvent and who furthermore has as guarantor Jeanrion, a man with a capital of sixty thousand francs. As she has been favored by her father and her uncle, her brothers are jealous and have summoned her to make her return a thousand francs she owes them. It has been postponed to a week from now, before which time she would like to have the money. Uncle told me about it this morning and told me to write you. Answer as soon as possible.

I'll come to Flagey one of these days for the weather is not very favorable. I send you greetings from everyone in the family.

Gustave Courbet

[Address] Monsieur Courbet
Flagey
Canton Amancey

46-1 *To his family [Paris, January 10, 1846]*

Dear family:

As one must follow the old customs, I wish you—albeit a little late— a happy New Year. I remind you that no one wished me the same, though I think that I am the one who needs it most for there is nothing more difficult in the world than to create art, especially when nobody understands it. The women want portraits without shading, the men want to dress in their Sunday best. There is no way around it, if you have to earn money with stuff like that you would be better off turning a wheel, at least you would not have to give

up your convictions. In spite of that, I have, since my arrival, resumed work-
ing as hard as usual. What will be, will be, double or quits.

After the [usual] errands and visits following on my arrival, I made some
New Year's visits. The devil take New Year's Day, I have never been able to get
away with less than twenty-five francs. Everyone wants, it is unbearable. Take
Barthet,* the poet, who just left. He tells me that he is in the hole for eighty
francs. Today he is making the rounds to find ten francs to buy some wood.
He came to warm himself at my place, and he maintains there is no way to
write poetry without a fire.

I saw all the Oudots* again. They are as well as can be, that is to say that
if only two of them are sick they are doing very well. Mme Vertel* is getting
crazier and crazier. For the moment she has asked for a leave claiming that
she is sick, and she roams around Paris from morning till night in search of
a husband.

I won't be doing my large painting for this exhibition,[1] for several reasons:
because I cannot see well enough to work on it seriously and I don't have
enough time; also because it requires considerable expenditures. One must
be sure to be able to sell it for what would one do with a large canvas like
that. And to sell it it must be done well. I have various things here that I will
send.[2] I hope to read about myself in the Paris newspapers this year. In the
opinion of all the painters who come to see me, that seems certain, but nev-
ertheless one cannot count on it too much for all of that depends on patronage
and cliques.

I have no other news to tell you. I was told that Pouguet and Mme Mar-
tin's little one have died. I received a letter from Urbain* the other day that
pleased me very much. If you see him tell him that I'll write back as soon as
possible. I hope you are all well. As for me, I have arrived safely and have no
intention of getting sick so Grandmother should not worry. The winter is not
severe this year, it is not cold here. Three or four days ago some snow fell for
the first time. With that I embrace you all with all my heart, and Uncle's
family as well for their New Year's Day.

Gustave Courbet

[Address] Monsieur Courbet, landowner
 Ornans, Doubs
[Postmark] Jan. 10, 1846

1. Courbet did not submit a large-scale painting to the Salon until 1848, when he sent in
the *Classical Walpurgisnight* measuring 2.5 by 2 meters. Perhaps that painting was painted over
the half-finished canvas mentioned here (cf. letter 45-5, n. 2).

2. Courbet submitted eight paintings to the Salon of 1846. Only one work, the *Portrait
of M. XXX*, was accepted (cf. Paris 1977, 25–26; see also letter 46-2, n. 1).

46-2 *To his family [Paris, February 1846]*

Dear family:

I have sent eight paintings to the exhibition.[1] Everyone who has seen them finds them very good, and they have already earned me great praise. Before I sent them, the Oudot* family finally came to see me. They seemed to be quite pleased.

The other day I received Father's letter, which gave me great pleasure, especially when he told me that he was finished with Saulnier. I was glad to hear that you are all well. I am very rushed as I write you these few lines but I am in excellent shape. The winter here in Paris has been like spring all the time. I'll write you more at greater length in about three weeks, when I'll know the outcome of the Exhibition. Meanwhile, I embrace you all with all my heart.

Gustave Courbet

1. Courbet submitted the following paintings to the Salon of 1846: *Portrait of Mme P.B.; The Waltz* (F. 46?); *A Prisoner* (F. 48); *View of the Valley of Manbouck;* another *View of the Valley of Manbouck; Landscape; Woman's Head*, [with a wreath of] *Wild Flowers* (F. 29?); and the *Portrait of M. XXX*. Only the last work, which can probably be identified with the *Man with the Leather Belt* (F. 93), was accepted (cf. Paris 1977, 26).

46-3 *To Théophile Gautier, Paris [March-April 1846][1]*

Monsieur:

When one exhibits, one risks not only being refused but also, once one has slipped by those ridiculous censors, seeing oneself slung up at prodigious heights where one is shielded from the critics, to be sure, but also in a place that admittedly does not suit my purpose very well. For, if I am making art, or, rather, if I am attempting to make it, it is first of all to make a living from it, and second to deserve the criticism of a few men like you, who will rejoice the more for my progress because they will have taken the greater care to cure me of my errors.

Now, after nearly seven years of painting my way through the labyrinth of all the schools, with only feeling as [my] teacher and guide, I am especially anxious to know where I stand and where my efforts have led me.

Deprived as I am, in the milieu in which I live, of beneficial counsel and artistic exchange, I take the liberty to turn to you, confident in the belief that you will not refuse me your opinion. But here a problem arises: of the seven paintings that I have sent to that absurd examination that they do at the Louvre, I have had only one portrait accepted, to which has been assigned, according to the law of turnabout of paintings, a place that is indisputably the

highest in the Salon.[2] But since I strongly doubt, in spite of the height, that it is a place of honor, I will try to appeal to the director of the new Tower of Babel. And if chance decrees that in the returnabout it will be more visible to the naked eye, then I would pray you to do me the favor to be so kind as to tell me what you think of it.[3] Or else, allow me to come and introduce myself and bring you something, for I dare not ask you to come to my place—it would be too presumptuous as I do not have the honor to know you.

I do not know whether the step I am taking here is indiscreet, but if so you will certainly forgive me on account of my candor.

With my respectful greetings,

Gustave Courbet

89 rue de la Harpe

1. This letter is not autograph and, like Courbet's other official correspondence at this time (cf. letter 49-2), it must have been composed by a friend, probably Baudelaire.

2. Courbet had in fact submitted eight paintings (see letter 46-2, n. 1), of which only one, the *Portrait of M. XXX* (F. 93?), was accepted. The painting was placed very high, but, on Courbet's formal request, it was rehung toward the middle of the exhibition period (cf. Paris 1977, 25).

3. Gautier did not write about this painting as far as is known.

To his family [Paris, March 1846] 46-4

[No salutation]

Though I have nothing pressing to tell you I cannot let the Cuenots[1] leave without writing you a note. I am impatiently awaiting the opening of the Exhibition, which will take place this coming Monday.[2] I would attach little importance to their judgment (which to me has no validity) if it did not affect my reputation. If it were not for that, their refusal would prove that I do not think as they do, and that would gratify me. Be that as it may, I'll write you the outcome as soon as possible.

There is someone who irritates me terribly and that is young Pierrot.[3] He is harassing me to lend him sixty francs and is telling me a lot of tales. He claims that he will write me a promissory note in duplicate; he says that he lost the money of the company mess while he was arresting a man, which cannot be true. I have asked M. Jovinet* and he tells me that that is a fairy tale, that corporals never carry any money. In short, I tend to think that he owes the baker, whom he probably has not paid, and that he has eaten the company's money. I believe that that is the true story, for he brought me a letter from the baker in which he is read the riot act. He might well have to appear before a war council where he would pretend that he has written to his father. Ask Pierrot senior about it and see what should be done. I told

him that I would go and talk it over with his captain. He has the devil's own fear of him, which confirms my theory. I have sent the letter for Joseph by regular mail.

I recently had a dress coat and a pair of black pants made at La Belle Jardinière for the price of 100 francs. That means that I am ahead 50 francs, for my tailor used to charge me 110 francs for a dress coat and 40 for a pair of pants, and these, I believe, are nicer and definitely better made.

I am very friendly with the Jovinets, where I eat quite often without being able to decline, for they get angry. I could be on the same terms with the Oudots* if I wanted to, but I dine there less often. I have become an oracle in those homes. M. Oudot professes my ideas and asks my opinion in all matters. I am still working as much as possible and I am in perfect health. So Grandmother and Mother have no cause for worry. I hope that you are all well, even Grandfather, who was ill during the vacation. I embrace you all with all my heart.

<div align="right">*Gustave*</div>

1. Compare letter 45-6, n.4.

2. The 1846 Salon opened on Monday, March 16, which provides a date *ante quem* for this letter.

3. Probably Jean-Pierre Coulet, an acquaintance from Ornans who is discussed again in letter 46-6.

46-5 *To his family [Paris, March 16, 1846 (Ad)]*

Dear family:

Luck is not with me for the moment. Of all the paintings I sent to the Exhibition only one has been accepted, namely my [*Self-*]*Portrait* [F. 93?].[1] Granted, it was artistically speaking the most important piece, but according to a lot of people and artists I know, those that were refused were no less good. There was ill will, that is clear. There are as judges a lot of old idiots who have never been able to do anything in their lives and who are trying to stifle the young people who might overshadow them. But then in Paris one no longer pays attention to those people's judgment. It becomes an honor to be refused, for that proves that one does not think as they do. What they were not able to refuse, they hung up by the ceiling so that it cannot be seen. Nonetheless I am convinced, together with all our artist-friends, that my [*Self-*]*Portrait* is among the three best [works] in the Exhibition. What a nuisance that it is placed so high. When it cannot be seen, it cannot be talked about. Yet I had hoped that this year three or four newspapers would write about me, they had promised me. Let's hope that they will hang it lower.[2] Mean-while I will be exhibiting what they refused somewhere else. I am not the

only one. Everyone is complaining and the biggest names have been refused just like me. It is a regular lottery. Imagine, they have to judge four hundred [paintings] a day, two a minute. That will tell you how conscientiously it is done.

You must have seen the Cuenot family.[3] I hope they will like it well at Le Château and that Ornans will keep them for a long time. They are charming, warmhearted people. Tell Urbain that I will give him an account of the Exhibition.

I embrace you all,

Gustave

1. For the identification of this self-portrait with *The Man with the Leather Belt* (F. 93), see Paris (1977, 25, 89–91).

2. According to the Salon registers, the painting was rehung midway through the Salon.

3. The Cuenot family (cf. letter 45-6, n. 4) had resettled in Ornans and bought a house in Le Château d'Ornans, a small hamlet located on a mountain overlooking Ornans, within the ruins of a medieval citadel.

To his family [Paris, April 18, 1846 (Ad)] <u>46-6</u>

[No salutation]

I am taking advantage of the Marlet brothers' departure to write you a few lines. I have nothing new to tell you concerning my painting except that I am going to write the director of the Louvre to be so kind as to have my painting placed a little better in the rehanging that will take place midway through the Exhibition.[1] I recently painted Fresquet's* portrait,[2] with which I am very satisfied, as are all my acquaintances, though it did not please all the ladies at M. Oudot's* as much. There, like everywhere else, no one understands anything about painting.

I come back now to that low-down Jean-Pierre Coulet.[3] His brother wrote me the other day to tell me that they had sent him sixty-five francs. They were very wrong to do that without letting me know, for he took the sixty-five and has not paid the baker, so that the baker, who is a very decent sort, came by to explain his conduct to me. He told me that a mess corporal can earn thirty to thirty-five francs a month. That was not enough for him, but on top of it he was piling up debts, or else, as I suspect, was letting himself be robbed. He is no longer assigned to the mess at this point and he deserves that. I told the baker to write him that his parents had written me not to give him anything for they had sent him sixty-five francs; that if he did not pay that he would denounce him to the colonel who is still in Paris, for his regiment has just left. If he does not pay and if the baker does that he might indeed have to appear before a war council. In short, he told me a lot of lies, in which I

have always caught him. If he continues, it seems rather unlikely that he will serve out his time without a jail term. Well, that is enough about him, he has been an absolute nuisance.

I embrace you all. Adolphe will tell you how I am.

<div align="right">*Gustave*</div>

Send a reply to his brother, who has asked me to explain things to him.[4]

1. Compare letter 46-5, n. 2.
2. Probably the portrait of Raymond de Fresquet,* the husband of Clotilde Oudot. The work has not been identified.
3. Compare letter 46-4.
4. On the same paper is a contract, signed by Pierre-François-Grégoire Coulet, the father of Jean-Pierre, in which he promises to pay back all the money advanced to his son for the repayment of debts.

46-7 *To his family [Paris, April-May 1846]*

Dear family:

I am taking advantage of Emile Besson[1] to write you a few lines. If I don't write more often it is because I don't know what to tell you. I am not like the Parisians, though I associate with them; they write letters every morning.

There is nothing more difficult than to make a name for oneself in painting and to gain the public's acceptance. The more different you are from the others, the more difficult it is. You must realize that to change the public's taste and way of seeing is no small task, for it means no more and no less than overturning what exists and replacing it. You can imagine what jealousy and bruised egos that produces!

In spite of my protests I still have a bad spot at the Exhibition. But I don't give a damn about them, that is not what is going to discourage me. Painting, when you understand it, is a state of madness, it is a continuous struggle; it can drive you crazy, I swear! Nonetheless, I will try to paint a picture, or several, for next year.

Jean-Pierre Coulet, that brute, is still writing me.[2] He will make me spend more in postage than the amount [in question]. Now he is at Le Château d'Oléron, I don't know where that is. All I know is that the letters cost me sixteen sous. I will write a promissory note to his baker, who is still on my back, and when I'll get his IOU, I'll mail it to you. There is a debt of thirty-nine francs. I have no money at this moment. Panier* is still in Holland and I have not been able to earn a thing this year. It is impossible to work seriously and to earn money as well.

I hope that the Jovinets* will be spending their vacation in Ornans this year. That is why I would like Father to prepare to receive them in a halfway

decent manner, for I almost always eat at their house and they won't let me refuse.

M. Oudot* has just published a book that has cost him much effort and money.³ I don't think that he will go out of town for the vacation. They are as well as they can be. There are always two or three who have a cold, but that is normal for them. They are always so covered up that as soon as a window is opened the entire family catches a cold. Mme Jovinet has just had pneumonia and a very bad cold, but she is prone to that, she inherited it from her mother and from Grandmother. I am very well except for an enormous boil that I had on my finger, which kept me from sleeping and painting for two weeks. I have nothing new to tell you. I hope that you are all well. With that I embrace you with all my heart.

<div align="center">

Gustave

</div>

It is extremely hot here.

Kind regards to the Cuenots.⁴ I hope they are not too bored at Le Château [d'Ornans].

1. Perhaps the husband of Joséphine Besson, née Marlet, the sister of Adolphe, Alphonse, and Antoine Marlet.*

2. Compare earlier letters, 46-4 and 46-6.

3. Oudot had just published his *Premiers Essais de philosophie du droit et d'enseignement méthodique des lois françaises, suivies de lettres adressées à M. Giraud* (Paris, 1846).

4. Compare letter 45-6, n. 4.

To his family [Paris, August 1, 1846] 46-8

Dear family:

Mme Jovinet* and her husband are leaving on Tuesday, August 4th, for the Franche-Comté. They will stay first with M. Jovinet's brother, who lives on a farm called L'Arasnée [spiderweb], which lies between Ornans and Besançon somewhere around the Saône marsh. They will come see you in the first days after their arrival, perhaps for St. Lawrence's Day.¹ I would like it very much if they were to stay with us. I think we could give them the upstairs quarters, which M. Jovinet would enjoy very much, and the two of us, Father and I, could sleep somewhere else while they are in Ornans. She has her two children with her and Madeleine, her maid, who can help you. They are not difficult, I think that could very well be arranged. It would irk me extremely if they were to stay with Uncle Bastide.* The first time they will come see you only for one or two days, then they'll spend a month at L'Arasnée, and will come back to Ornans for a month, I hope, perhaps less, but this is more or less how things are planned.

As for me, I am leaving for Holland where I absolutely must go. It is the

only country where I can earn money right away. That is why I have to go and see what they like, study their old masters, see what their contemporary painters are doing, and get to know their art dealers. I already know one who will be most useful to me.[2] For that matter, I go with a recommendation to a man named Van den Bogaerde, grand cupbearer to the King of Holland, a very influential man and one of the most important in Amsterdam.[3] Moreover, they owe me some money, which I will receive at the same time.[4] So I will not be in Ornans until September 1, I think. I cannot say for sure for I will perhaps be obliged to paint one or two portraits there, in any case, I'll write you.

At the moment I am painting the portrait of M. de Fresquet,* who has paid me the greatest compliments on the one of his son, which has made quite an impression in Bordeaux.[5] He showed me a letter in which his wife says that the Bordeaux painters maintained that it reminded them very much of Rembrandt. I am very well, as is the entire Oudot* family. I embrace you all and look forward to the pleasure of seeing you again. I urge Father again to try to get things in some kind of order to receive M. and Mme Jovinet. Zoé,* please remind him.

Gustave

I'll be leaving as soon as my portrait is finished, that is, Friday or Saturday. Kind regards to the Cuenots* and tell Grandmother to have her kitchen wallpapered for as far as I can recall it is so utterly filthy that it is embarrassing. I don't recognize her anymore, she who always had a paintbrush in hand, she has lost a very lovely habit. But she need not do it herself. All she has to do is tell Father to get her some paper in Besançon and a plasterer will do the rest, it is not a big expense.

[Address] M. Régis Courbet, landowner
 Ornans, Dp. Doubs
[Postmarks] [illegible] August 1 [illegible]
 Ornans, August 3 [illegible]

1. August 10.

2. The dealer H. J. van Wisselingh.*

3. André-Jean-Louis, baron van den Bogaerde van ter Brugge (1787–1855) was the royal chancellor under King Willem II of Holland. See also letters 46-9, n. 7 and 46-10, n. 5.

4. For the *Sculptor* (F. 58), which Courbet had sold to the Dutch art dealer H. J. van Wisselingh. See letters 45-5 and 45-6.

5. The portrait of the father of Raymond de Fresquet (cf. letter 46-6, n. 2.). Neither the portrait of Fresquet senior nor the one of Fresquet junior are known today.

To his family [Amsterdam, ca. August 15, 1846]

Dear family:

I have been in Amsterdam for two days now.[1] I have already made the acquaintance of two or three artists, whom I will visit today.[2] I am also going to see the museum, which will be open.[3] I am already delighted with everything I have seen in Holland and it is really indispensable for an artist. A trip like this teaches you more than three years of work. In The Hague, which is a charming city, I saw the finest collections.[4] It is the king's residence.[5] I do not yet know when I will leave for I might well paint a portrait here.[6] I am assured that if I were to stay for two or three months and acquire a reputation, I could make money. They like my kind of painting. I have only a small landscape with me [F. 67?], the style of which pleases them greatly. Here nobody paints that way.

In Belgium I visited M. Papeians,* with whom I stayed for three or four days. They offered me recommendations to the royal chancellor[7] and to the antiquary of the Royal Museums,[8] yet another eminent person, but I do not know how to avail myself of these people right now. I would rather keep them for later, for they can be most useful to me. You must already have seen Mme Jovinet* and her family. I doubt that she is much entertained in our part of the world. If you have not yet received my trunk, it must be in Besançon, for I put it on Liégeon* transport before leaving Paris. Adolphe Marlet* will give you the key. At the bottom there are five dresses for all of you.[9] I doubt very much that Grandmother will find any to her liking. Mother, please do with them as you wish. I think I will leave at the end of next week because life is very expensive here, almost twice as high as in France, especially for a traveler.[10]

Gustave

1. From the three letters that deal with Courbet's trip to Holland (46-8, 46-9, and 46-10), it may be inferred that Courbet left Paris ca. August 7 or 8. Traveling through Belgium, he spent three or four days with the Papeians family in Ghent and then went on to The Hague. There he probably stayed for only one day before proceeding to Amsterdam, where he arrived around the middle of the month. He stayed in Amsterdam for about ten days and then returned via Germany and Switzerland to the Franche-Comté. His arrival there must be situated around the beginning of September.

2. The identity of these artists is unknown.

3. The Rijksmuseum or National Museum, then located in the so-called Trippenhuis on the Kloveniersburgwal.

4. Probably the Royal Museum, located in the Mauritshuis.

5. The king of Holland, Willem II.

6. The portrait that Courbet painted in Amsterdam was exhibited at the 1846 Tentoonstelling van Levende Meesters (Exhibition of Living Artists) in Amsterdam as *Portrait of a Man* (no. 402). It is probably identical with the *Portrait of H. J. van Wisselingh* (F. 68).

7. The royal chancellor was Baron van den Bogaerde van ter Brugge, whom Courbet had already mentioned in a previous letter (46-8). Bogaerde had married (in 1821) a close relative of Papeians (perhaps his sister), Thérèse Barbe Ghislène Papeians de Morchoven. Though of Flemish origin, Bogaerde had become Willem II's chancellor in 1840. He was himself a renowned art collector.

8. Perhaps Christianus Johannes ("John") Nieuwenhuis (1800–1883), who published a complete catalog of the collection.

9. One is tempted to see a connection between these dresses and Courbet's painting of the *Young Ladies from the Village* (F. 127) of 1851–52, in which the artist shows his three sisters attired in what are obviously city dresses, despite the awkward way in which they are worn. For a perceptive analysis of this painting with specific reference to the clothing, see Mainardi (1979, pp. 95–103).

10. This same complaint was made by many French travelers to Holland in the nineteenth century (see Koumans 1930, passim).

46-10 *To Mme Papeians de Morchoven [Amsterdam, August 24?, 1846]*[1]

My dear Lady:

I still remember fondly the days I spent with you, your sincere kindness, your gracious reception, and your so enjoyable company.[2] Consequently, I most deeply regret that I cannot return what you give so well, and that I cannot do more to please you.

I had promised to write you immediately upon my arrival in Amsterdam, which I have not been able to do as I did not know as yet what was going to happen. But today that is becoming clearer. During my stay in Amsterdam I painted a portrait that created an enormous impression, an enthusiasm that I did not expect.[3] I had a unanimous ovation from the artists, all of whom by now I know, and many art lovers have come to see it and have paid me the greatest compliments. So, if all this continues, I am about to have quite a fine reputation in Holland, for it will be hung in the exhibition in Amsterdam that is to take place in two weeks[4] and everyone assures me that it will make an enormous impression and that the newspapers will talk a lot about it. If all those predictions come true, I hope things will go well. And so, if I were to dare to take further advantage of your kindness, I would pray you to speak to the persons about whom we spoke,[5] for all I need now is for an influential person to ask me to paint a portrait, and then there would be no reason for all this to end. That is the way things are done in Holland.[6]

I leave tomorrow, Tuesday, for Cologne, delighted about my trip, both for the charming way I have been received everywhere and for all that I have learned from it. Moreover, Holland and Belgium are charming countries, especially for an artist.

Please give my sincere and affectionate regards to M. Papeians.
I embrace you both with all my heart,

Gustave Courbet

Remember me to Fidèle.

1. Following the text of this letter, it was written the day before Courbet's departure from Amsterdam on a Tuesday. If Courbet stayed about ten days in Amsterdam, as has been surmised, he must have left the city on the twenty-fifth. That would mean that this letter was written on the twenty-fourth.

2. Courbet had spent three or four days with the Papeians* family in Ghent. See letter 46-9, n. 1.

3. Probably the *Portrait of H. J. van Wisselingh* (F. 68).

4. The Tentoonstelling van Levende Meesters (Exhibition of Living Artists). See also letter 46-9, n. 6.

5. Compare letter 46-9, nn. 7, 8.

6. Courbet's expectations were not unfounded. Several French artists were selling their works in Holland. The marine painter Théodore Gudin, for example, counted among his numerous Dutch clients King Willem II himself, who bought no less than ten of his paintings.

To his family [Paris, January 1, 1847] 47-1

Dear family:

I am taking advantage of Promayet* to write you a few lines. I returned quite happily to Paris, where I found everyone in good health, and I have settled in again. I now have one more small room, which costs me one hundred francs per year, right by my studio, across the hall.[1] It is very convenient and I am more comfortable than last year. I have been rather lucky for the winter is very cold in these parts.

I went to pay Jean-Pierre's[2] baker and played my part so well that I came out ahead eleven francs, which you must return to père Pierrot as a New Year's Day gift. I pointed out to them how poor those people are, and how expensive bread is, and told them that it would take the father a year to pay them back; that, if they were willing to share the loss with me, I would do my part for they had been our tenant farmers; and that the loss would teach them not to give such fools credit next time around. They understood quite well and told me that I was a decent chap, but that I should put up a little more. So I offered twenty-eight francs, which they accepted. They gave me a receipt for the entire amount, which is herewith enclosed.

My friends were delighted with Urbain's* portrait [F. 85]. M. Hesse* has come to see it at my place and paid me the greatest compliments. He could not get over it. Nevertheless, I doubt very much that it will be received at the Exhibition for that particular painting is entirely beyond the jurors' ideas.[3]

That will not bother me at all, on the contrary, it will prove to me that I am not like them. What makes me feel better is that there is talk among the painters of a coalition of all of the most famous painters of the new school, painters who are refused every year at the Louvre, like me. It has not yet been settled but it would please me very much. It would be a formal protest against the existing jury, I will be able to tell you more about it later. Meanwhile I went back to work as soon as I arrived.

I went to see the Oudots,* who have moved. They are farther away from me and from the center of Paris than before, nor is their place as nice, it is all, I think, for economic reasons. They won't even be having parties anymore, as far as I can tell. They are all well, as are the Jovinets,* who, contrary to what people were saying, have not bought a house in Sens. Everyone sends you many regards. I have also seen M. Panier,* who brought my suit back along with some letters that he delivered to me.

Now it only remains for me to wish you all a happy New Year with all my heart. I am in a hurry, for Promayet has let me know too late what time he is leaving. My best regards to the Cuenots.[4] I embrace you again.

<div align="right">Gustave</div>

[Address] Monsieur Courbet, Régis
 Ornans, Dp. Doubs
[Postmark] [Illegible] Jan. 1, 1847

1. Courbet was still living at 89 rue de la Harpe at this time.
2. Jean-Pierre Coulet. Compare letters 46-4 and 46-6.
3. Courbet foresaw correctly; his painting was refused. It was to be exhibited, however, at the 1848 Salon.
4. Compare letter 45-6, n. 4.

47-2 *To his family [Paris, March 21, 1847]*[1]

Dear family:

You must have known from my delay that the news I had to tell you was not good. I have been refused altogether, all three of my paintings.[2] I have as usual some very famous partners in misfortune, such as Gigoux,* who is in exactly the same position as I am. And another twenty as famous as he could be named. It is bias on the part of the gentlemen of the jury: they refuse all those who do not belong to their school, except for one or two, against whom they can no longer fight, such as MM. Delacroix, Decamps, Diaz,[3] but all those who are not as well known by the public are sent away without a word. That does not bother me in the least, from the point of view of their judgment, but to make a name for oneself one must exhibit, and, unfortunately, that is the only exhibition there is. In past years, when I had less of a style of

my own and was still painting somewhat like them, they accepted me; but now that I am myself, I can no longer expect that.

The movement to destroy that power is stronger than ever. A petition to the king has just been prepared. Others want it to be submitted to the Chamber of Deputies, still others want a counter-exhibition in a private hall.[4] Personally, I am one of the latter. I will be writing some articles in the paper *Le Corsaire* in order to carry the latter idea, which would be beyond any of the powers-that-be.[5] In fact, in the *Corsaire* of today, Sunday, there should be an article of mine.[6] We'll see whether we'll get somewhere. Everyone is exasperated, public and artists alike. Adolphe[7] had done a painting that was also refused. I would have liked them to have accepted at least Urbain's portrait [F. 85], that would have pleased him. I'll send you a few newspapers that talk of all that and if we get somewhere, I'll keep you posted.

It seems that Urbain* sings delightfully.[8] He is quite likely to gain paradise if he continues such exemplary behavior. I received his letter the other day. Tell him that I'll answer him as soon as possible. Share my defeat with the Cuenots,[9] who have always taken the greatest interest in me. Spring is off to a good start, they'll be delighted with their new home.[10] The winter has not been long. I am delighted about it for Grandmother's health. I hope she will recover completely and not torment herself too much. There is nothing else new here. I saw Boulet* yesterday and M. Panier.* Boulet is well and is working. He is in contact with M. Oudot,* to whom he shows his work. M. Panier received a letter from Amsterdam, where M. [van] Wisselingh[11] remembers himself to me in the most charming terms. If M. Cuenot's family needs to get cash from Paris, I'll be happy to get it for them. I am beginning to have debts on all sides.

The Jovinets* and the Oudots are well and have not been ill this winter. That is rather extraordinary. I continue to work as usual, and from time to time I go to the Exhibition with Adolphe, who just had the flu.

With that I embrace you all with all my heart,

Gustave Courbet

I will be picking up my paintings and visiting Thoré,* who promised in his article in the *Constitutionnel* to go and see the refused artists.[12]

Adieu.

[Address] M. Courbet, landowner
 Ornans, Doubs
[Postmark] Ornans, 23 [illegible]

1. From the postmark, we know that the letter arrived in Ornans on the 23rd (March 1847), which was a Tuesday. Courbet indicates that he is writing on Sunday, i.e., the twenty-first.

2. To the Salon of 1847, Courbet had submitted three works, *Ballad; Portrait of M. Urbain* (F. 85); and *Remembrance of Consuelo (Souvenir de Consuelo)*. The latter painting, as

Marie-Thérèse de Forges has suggested (Paris 1977, 92), is identical with the *Cellist* (F. 74). Courbet resubmitted the *Portrait of Urbain Cuenot* and the *Cellist* (under the title *Violoncelliste*) to the unjuried Salon that took place in the wake of the Revolution of 1848.

3. The Romantic painters Eugène Delacroix (1798–1863), Alexandre Decamps (1803–60), and Narcisse-Virgile Diaz de la Peña (1807–76) had made their mark in the 1830s and were well established by 1847.

4. According to Riat (1906, 45), a number of artists (including Ary Scheffer, Alexandre Decamps, Jules Dupré, Eugène Delacroix, Théodore Rousseau, Charles Jacque, Honoré Daumier, and Antoine-Louis Barye) met in the studio of Barye on April 15 and drew up an official document to establish an independent "counter-Salon." Because of the 1848 revolution, their plans were not carried out.

5. Courbet's interest in writing for the *Corsaire* seems to indicate that at this time he was already in touch with writers such as Baudelaire and Champfleury, who were regular contributors to this newspaper.

6. No article by Courbet is found in the *Corsaire* of March 21, 1847.

7. Adolphe Marlet* may have given up painting soon after. He returned to Ornans before 1849 and was married there on July 25, 1849 (cf. Ornans 1981, 61).

8. Perhaps a reference to Urbain Cuenot's involvement with the choral society of Ornans.

9. Compare letter 45-6, n. 4.

10. The Cuenots had just bought a house in Le Château d'Ornans.

11. In the original text, the name is spelled "Vislingt," which, no doubt, is Courbetian for [van] Wisselingh.* Riat (1906, 46), however, has assumed the existence of another dealer by the name of Visluiyt.

12. In his initial Salon review in the *Constitutionnel* (March 17), Thoré had been very critical of the severity and narrow-mindedness of the jury, which had accepted only established artists and seemed to have had no eye for the works of younger painters. He had even proposed to visit the studios of some of the refused artists and to devote a special article to them, (which, in fact, he was to do in a later issue of the *Constitutionnel*). Though Thoré mentioned several of the artists he planned to visit (e.g., Camille Corot, Maurice Dudevant, Jean Gigoux, and Edmond Hédouin), Courbet's name was not included (cf. Thoré 1847, 20–21).

<u>47-3</u> *To his family [Paris, August 1847]*

Dear family:

I have not written you for a long time and even now I am sending you only a few words, as Lapoir, to whom I am giving this letter, is ready to leave. But I hope before long to bring you my news myself. I don't know yet exactly when I'll arrive in Ornans. I hope to leave in a few days but I am passing through Belgium. I will be disembarking in Ghent, staying with some people who are forcing me to go,[1] as much out of friendship as for a portrait that I am to paint there.[2] It will be a splendid opportunity for me to visit Belgium and to see many paintings of the great Dutch masters, which are very useful for my education.

I am so tired that I can't stand up straight anymore. I am terribly anxious

to be in Ornans. I also had a portrait to do in Dieppe,[3] which would hardly have been on the way to Belgium, for to get there I would have had to pass through I don't know where, Calais or Dunkirk, in other words, go one hundred and fifty miles out of my way. I am so tired that I think I will give up that project.

I just came from the huge concert at the Champs-Elysées at the Palais de l'industrie. It was so magnificent that it is difficult to describe. There were a thousand musicians, between singers and instrumentalists. The enthusiasm was amazing and I think there were fifteen or twenty thousand people.

I have nothing new to tell you. I am well. Everyone in the family is well too. I won't be in Ornans until the 10th or the 15th of September, perhaps earlier. Meanwhile I embrace you all,

Gustave Courbet

I'll put a trunk on the freight carriage when I leave for Belgium. See you soon.

1. Probably Ludovicus Papeians de Morchoven and his wife, Adèle Damiens, who had received Courbet so warmly the summer before. Compare letters 46-8, 46-9, and 46-10.
2. This portrait cannot be identified.
3. The portrait commissions that Courbet received from Dieppe may have been related to his early friendship with Paul Ansout, who was the son of a Dieppe cloth merchant. See also letter 44-3, n. 4.

To his family [Ghent, September 6, 1847] 47-4

Dear family:

You should have received by Lapoir a letter in which I told you that I was going to Belgium, a very agreeable country, where I have been for a week or ten days.[1] Just imagine it as a veritable Cockaigne. I am received like a prince, which is not surprising for I move among counts, barons, princes, etc.[2] Now we eat, now we go out in an open carriage, or we go horseback riding along the avenues of Ghent. As for the dinners, I hardly dare talk about them, I don't know whether one is away from the table more than four hours a day. I think that if I stayed much longer, I would return as big as a house.

Nonetheless I have already nearly finished two portraits.[3] I have already seen part of Belgium: I have seen Brussels, Malines, Antwerp, Termonde, and Ghent, where I am now. I will be going to Bruges and to Ostend, and in two or three days I leave for Cologne via Louvain and Liège. I'll go up the Rhine as far as Mainz, from there to Strasbourg, Mulhouse, and then on to Besançon, which will bring me to Ornans around the 15th.[4] It would be too long to write you my impressions, I'll save it for my return.

My trunks, which I have sent on by Liégeon* transport, should be in Besançon. I hope you are all well. As for me, I am extremely well. I will try to return as soon as possible, for I am anxious to see you. I embrace you all,

Gustave

[Address] Monsieur Courbet, landowner

Ornans, via Besançon

Doubs Dept., France

[Postmarks] Belgium, Sept. 6

Ghent, Sept. 6

Paris, Sept. 7

1. On this, his second trip to Belgium, Courbet was probably once again the guest of Ludovicus Papeians and his wife Adèle Damiens.

2. Papeians belonged to the Belgian aristocracy.

3. These portraits cannot be identified.

4. Perhaps there is a connection between this trip and some of the drawings in a sketch-book by Courbet kept in the Cabinet des dessins of the Louvre in Paris (RF 1870–01905; Fd. 2). It contains, among others, a sketch after a *Madonna and Child* by Anthony van Dyck, then in the Hospital of St. John in Bruges (fol. 26v); a sketch of Ostend (fol. 27v); and a sketch of women aboard a boat on the Rhine (fol. 28r). A group of sketches on earlier pages of the same sketchbook (fols. 1–19), however, seem to belong to a previous trip or trips along the Rhine and in Switzerland.

47-5 *To his father [Ornans, fall 1847 (?)]*[1]

Dear Papa:

I am writing you a few lines to let you know that an acquaintance of Gaudot's will buy fifteen hogsheads of wine from you.[2] He wants to come Monday morning. Give your answer to the postman. Quote your lowest price, Grandfather would want you to [?].[3]

There is a woman who would like to buy a house in Flagey. She was told that you would sell one. I have given her some information, it would suit her rather well.

I will come see you one of these days for I am being plagued to paint some portraits of my friends. I did one of Alphonse Marlet,[4] everyone was delighted. It is a very good likeness. I hope you are well.

Gustave Courbet

1. The date of this letter is doubtful. As it mentions Courbet's grandfather, it was prob-ably written before the latter's death on August 18, 1848.

2. Courbet's father owned the so-called Valbois vineyard at Cléron, as well as the neces-sary equipment to produce wine. His production exceeded his family's need, and he often sold the surplus (cf. Mayaud 1979, 20).

3. Doubtful reading of original text.

4. While two portraits of Adolphe and Antoine Marlet* (F. 121 and 120, respectively) are known today, no portrait of Alphonse Marlet has been identified.

To his family [Paris, December 21, 1847] 47-6

Dear family:

I have been a long time without writing you but it must be said that Father and I had agreed that I would not write until he had written me. The letter arrived five or ten days ago, and the wine arrived two weeks ago. I also received the cherry liqueur by messenger from Notre-Dame-des-Victoires, which cost me seven francs, four francs of import duties and three francs after that. They liked the wine but have not yet had the time to taste it properly and they have fixed the price on arrival. Later I will give you more news. They are pleased with it even though they have been kept waiting so long.

I was careful not to give them the letter that Father wrote them for that is no way to write a business letter to people one does not know. From its four pages I made four lines, as follows, "Sir, I send you, albeit a little late, the wine that you asked for. It is of our area's best quality. I hope you will be pleased with it. Respectfully." Then I added the capacities of the barrels and their price, and the money paid out for incidental expenses. All that was condensed into six lines. They were very pleased.

I was upset by the disturbing news that Adolphe[1] wrote me yesterday. It seems that Théodore is in a bad way and that Urbain is devastated.[2] We must hope that everything will turn out for the best, for a nature such as Théodore's has immense reserves. Remember me to him, if possible. I shall write Urbain a little later for now is not the moment. Moreover, I am so busy with my painting right now that it is very difficult for me to write, for once I am doing something it is impossible for me to think of anything else at all. I started on my painting only ten days ago as I couldn't find a model before then.[3] They are all retained by painters who are as pressed for time as I am. Nevertheless, I hope to finish it in time.

My model comes at nine o'clock in the morning and I work till it gets dark at four. I go out to dinner and then see a few people in the evening.

Everyone here in the family is well. Fresquet* is in Paris in order to compete for another professorship, again in Rennes.[4] M. Oudot* is angry that no one wrote him during the vacation. Tell Adolphe that I will answer him as soon as possible and tell Urbain not to torment himself. Tell him also that I received his letter.

The winter is not severe at all. I hope Grandfather is well, and all of you also. I warmly embrace you all, Mother, Zoé,* Zélie,* Juliette,* all in order

of age, and I strongly advise Father to be more concise if he writes to M. Oudot via Adolphe. Mme Jovinet* is also waiting for a letter from Zoé.

Be well, I'll tell you about my painting later. It will cost me a lot of money. Give my kind regards to M. Cuenot at Le Château.⁵ I have given their message to Emma.

Gustave

Adolphe Promayet* wants very much to stay here without their [having] to send him any money, and he inquires wherever possible for a position, for he feels that he would have no future in the provinces. He dines at my boardinghouse. I talk to him a good deal for he is extremely steady right now.

[Address] Monsieur Courbet, landowner

Ornans, Doubs Dept.

[Postmark] [Illegible] Dec. 21, 1847

1. Adolphe Marlet.*
2. Théodore, the brother of Urbain Cuenot,* died before the year was over.
3. No doubt a reference to the *Classical Walpurgisnight*, Courbet's most important painting at the Salon of 1848. Based on Goethe's *Faust*, it measured approximately 2 by 2.5 meters. The painting no longer exists today as Courbet later reused the canvas for his *Wrestlers* (F. 144).
4. Fresquet does not seem to have obtained this position but eventually was hired in Aix-en-Provence.
5. Compare letter 45-6, n. 4.

48-1 *To his family [Paris, January 1848]*

Dear family:

I am taking advantage of Dubie to write you a few lines and to send you, albeit a bit late, my best wishes for a happy New Year. Better late than never. My painting is going great guns. I hope to finish it in time for the Exhibition.¹ If it is received, that will be most useful for me and will give me a wide reputation.² Even without that I am about to make it any time now, for I am surrounded by people who are very influential in the newspapers and the arts, and who are very excited about my painting. Indeed, we are about to form a new school, of which I will be the representative in the field of painting.

Fresquet* who competed for a professorship in common law at [the university of] Rennes has just failed but it seems that certain promises have been made him for the next competition.

I saw Joseph Courbet,* who told me to write you and ask whether you had settled accounts with his father. He would like to know for he sent money for that a long time ago.

I very much enjoyed Zoé's* letter. I received the letter for M. Jovinet.* Father's letter is also very good. I was quite distressed by the death of that

kind fellow Théodore.[3] It is an unimaginable calamity. I hope Urbain* will come stay with us in Paris.

The winter is a bit severe here, but I am well in spite of it. I hope you are all the same, Grandfather included. I embrace you all, Mother, Sisters, Father, Grandfather, all. Kind regards to my friends and to the Cuenots at Le Château.[4]

Gustave

1. The *Classical Walpurgisnight* (see letter 47-6, n. 3) was indeed exhibited at the 1848 Salon.

2. Around this time Courbet seems to have joined the Parisian bohemia, which caused him to meet with such authors as Charles Baudelaire,* Champfleury,* and Francis Wey,* who, he hoped, would write about his work.

3. Théodore Cuenot.* Cf. letter 47-6, n. 2.

4. Cf. letter 45-6, n. 4.

To his family [Paris, March 1848] 48-2

Dear family:

I am writing you a few words [that I'll send] with Adolphe, who is leaving in order to nominate a deputy or to be nominated himself.[1] Things are so interesting right now that I will excuse myself from giving you the news, you must know it all.[2] Anyhow, I am not getting very involved in politics, as usual, for I find nothing emptier than that.[3] When it was a question of destroying the old errors, I did what I could, I lent a hand. Now it no longer concerns me. Do what you think is best. If you don't do things right I will always be ready to lend a hand again to destroy what is ill established. That is all I am doing in politics.

To each his own: I am a painter and I make paintings. That is borne out by the fact that I have been painting again for two weeks despite the republic, which is not the government most favorable to artists (at least historically), we will see about this one. Everything was accepted at the Exhibition this year,[4] which did not do that much for me for I would have been accepted anyhow and I would have been noticed more. Right now it is impossible to notice anything for there are 5,500 [paintings], besides which I am very badly placed. In such a crush one cannot expect anything, there is nothing more difficult in the world than to succeed in the arts. In spite of all that I hope that I will be spoken of, for all the true connoisseurs pay me sincere compliments. I have ten paintings at the Exhibition.

M. Oudot is running for office in our region.[5] I like to think that he will have a chance even though he is not sufficiently well known. Take whatever steps are necessary in the case. Write to M. Berque [?] and to Chenoz at Pontarlier. Send them my best regards. They must put his statement of

principles in the Pontarlier newspaper. You must also try your hardest on Adolphe's behalf. Go around the villages, buy the mayors drinks.

There is no way to get silver money in Paris, it is sold at a very high price. Bills, coupons, etc., are worthless. Bills of two, three hundred, for example, are given for one hundred francs in coins. I have not been paid in full for the wine. I have so far received only four hundred francs. Those people, like all the merchants in Paris, have suspended payment. Nevertheless, I won't suspend anything. As for the wine, they found two barrels that smelled terribly musty, so much so that the wine could not be drunk. However, it is beginning to lose that taste a little. Luckily there was one that did not smell at all.

The Jovinets* are in great difficulty. They had a large part of their capital invested with the merchant who took over their business, and that merchant has just suspended payment as well. Panier* is having a difficult time paying his workers and his business expenses. Yet he has promised me some [money]. Nevertheless, it would be as well if you were to send me two hundred francs by mail. There is no telling what shortage of money we may get here.

Louis and Urbain* have been lucky to come to Paris. They, and I, too, have seen the finest thing that we will ever see in our lifetimes. The people so far have been magnificent, they are behaving admirably.

I am very well. I hope that you are likewise. I am going to take advantage of the circumstances to get a reduction in the price of my lodgings, which I find a little expensive.[6] I embrace you all. Tell me what Grandfather is up to.

Gustave

1. Adolphe Marlet* does not seem to have posed his candidature.

2. The news about the revolution of February 1848 that brought to an end the rule of Louis-Philippe.

3. Courbet, in fact, did get involved and designed a frontispiece for a revolutionary paper, *Le Salut public*, published by Charles Baudelaire,* Champfleury,* and Charles Toubin in February 1848 (cf. Chu 1980b, 79).

4. The Salon of 1848 was not juried. Courbet exhibited seven paintings (including his *Classical Walpurgisnight*) and three drawings. For a complete listing, see Paris (1977, 26).

5. Julien-François Oudot* indeed was a candidate for the Chamber of Deputies, but he was not elected.

6. According to the 1848 Salon catalog, Courbet was still at 89 rue de la Harpe, but this same year he was to move to 32 rue Hautefeuille.

48-3 *To his family [Paris, April 17, 1848 (Ad)]*

Dear family:

So far I have written at least three letters to Father without getting a reply from him. It is because of his harrow,[1] I know, but he should not complain when I don't write because I am working on a painting. I am anxious to hear

news about that contraption, I hope it works. It will become quite a necessity, the way things are going, for even painters are going to want to become farmers.

For quite some time now I have been without a sou. One cannot find so much as five francs in Paris. I will be inviting myself for dinner at friends' and acquaintances', for in situations like this the Parisians are very good sports. I laugh a lot, but nonetheless, when you have some money, even only twenty francs, please send it to me by mail.

Yesterday was Sunday and we had a great time in Paris.[2] We enjoyed the spectacle of the National Guard under arms and the [] was exposed, so as to revive their enthusiasm. Some people got it into their heads to spread the rumor that there was a schism among the members of the government; then that Louis Blanc[3] had been assassinated; that Cabet was coming to power as was Blanqui;[4] that the Communists were going to divide up all property. At last the prank worked, with the result that all day long people were shouting, "Kill the Communists," [while] others yelled, "Long live Blanqui," and "Down with" or "Long live the provisional government." All that was very ridiculous and meaningless. They did not notice all day that they had fallen for a joke and they all went home triumphantly saying that they had nipped the evil in the bud.

Though I go on guard rather often, I did not carry fervor so far as to get involved in that business. I just went to laugh with my friends, no one knew why he was there. The times are very comical. We are told that your revolutions are short-lived, then that you want the Assembly to be held in the provinces. You have some marvelous ideas! It is as if you wanted to put a man's head into his stomach, which is not surprising, coming from the provinces, which think only of their stomachs.

Oh, well, what is certain is that it is not over. If you don't send some real Republicans, there is only one thing to do with you, namely to throw your Republicans out of the windows of the Chamber, without, however, hurting them. For once, consider the maxim, "All or nothing," for half measures are always very harmful. I am very glad that Adolphe dropped out. I hope that M. Oudot* will not be nominated, because I care about them. For the Chamber will not survive more than three months and that will continue until they'll have forced you to understand something. Anyway, I am a very bad citizen.

I have already done two paintings since Urbain and Tony left.[5] There is one in particular that I did in four days, I have never painted so well. Yesterday I sent you a newspaper in which they say some wonderful things about me. I was very surprised. An Englishman named Hawke wrote the article and came to see me later on.[6] He paid me the greatest compliments. The man was very moved. He constantly clasped my hands and told me that, with Dela-

croix, I am the only one who has such a lofty understanding of art. He is a man of forty-five or fifty years, with a beard that is half white. He asked my permission to come see me and promised to talk about me a great deal, for he writes for several newspapers. He has discovered all my paintings in the Louvre.

I did not enter the competition for the sketch of the painting of the republic intended to replace Louis-Philippe's portrait,[7] but I am going to enter instead the competition for the people's song organized for musicians.[8] Besides, I hope I will be asked by the government to make a copy—one of the eight hundred copies of the painting that will be accepted.

I owe two quarters' rent. I don't know whether they will seize my furniture (it would not bother me for they will not get their money's worth), but I hope they will be more peaceable than that. I owe them 220 francs and the rent for the next quarter, which makes 330 francs. I estimate my furniture to be worth 150. Those who don't want to dress for the National Guard are dressed by the republic.[9] Let no one say that the republic is a ridiculous [form of] government. I will wear my National Guard outfit every day.[10] I will look splendid in it, and they will take me for an enraged citizen.

Give my letter to Urbain and Adolphe to read for I don't have time to write them today and I wouldn't have anything more to tell them. Tell them to write me and to make sure that they put stamps on their letters. You write me also as soon as possible. Give my best regards to M. and Mme Cuenot at Le Château.[11] Let them read the newspaper that I sent you for I have none left. They have always taken a great deal of interest in my future and this will please them. They must feel quite safe on their rock in these Republican times. I also sent a newspaper to M. Berque [?].[11]

I embrace you all. I would like very much to know what Grandfather thinks of all this. He must not worry, nobody is thinking of war, at least in Paris.

<div align="right">

G. Courbet

</div>

You should have seen M. Oudot, who left for the country four or five days ago and who apparently was so pressed for time that he did not leave me a message.

1. Régis Courbet was busy developing a new type of harrow, which was to be the subject of an article in the local press (*L'Impartial*, June 12, 1848, p. 2.)

2. Courbet's version of the events of April 16 is somewhat different from the way they are generally interpreted by historians. It appears that on April 16 the radical leaders organized a popular demonstration to force postponement of the elections. Though initially it looked as if the provisional government must fall, the National Guard arrived in time to defend the government against the workers (cf. Wolf 1963, 197–98).

3. Louis Blanc (1811–82) was one of the leading members of the provisional government.

4. Louis-Auguste Blanqui (1805–81) and Etienne Cabet (1788–1856) belonged to the radical group of 1848 revolutionaries.

5. Urbain Cuenot* and Tony Marlet.* It is not known what paintings are referred to here. Perhaps they were some of the works that were to be included in the Salon of 1849, notably the *Portrait of Marc Trapadoux* (F. 96), which must have been painted in Paris.

6. It has not been possible to find the article referred to here, but a letter to Courbet signed P. Hawke and dated May 18, 1849, is in the Cabinet des estampes of the Bibliothèque nationale in Paris (Yb3.1739 [4°], b.1). The return address indicates that Hawke was living in Dinan (Côtes-du-Nord). A three-page-long panegyric, the letter confirms Courbet's statement about Hawke's effusive admiration for his work.

7. On this contest, see Boime (1971).

8. On Courbet's activities as a songwriter, see Léger (1947).

9. Among the innovative measures of the provisional government was the elimination of the requirement that National Guardsmen provide their own uniforms, which effectively had prevented the proletariat from joining their ranks. Thenceforward, the rank and file of the Guard were equipped with rifle and uniform by the state.

10. This may be a tongue-in-cheek remark. There is no indication that Courbet ever officially joined the National Guard.

11. Compare letter 45-6, n. 4.

12. M. Berque [?] apparently was associated with a Republican newspaper in Pontarlier. Compare letter 48-2.

To his family [Paris, June 26, 1848 (Ad)] 48-4

Dear family:

We are in [the middle of] a terrible civil war,[1] and all because of misunderstanding and uncertainty. The insurgents fight like lions for they are shot when they are taken. They have already greatly harmed the National Guard. The [men from the] provinces around Paris are arriving by the hour. The outcome is not in doubt for they are outnumbered. So far the rifle fire and cannon have not stopped for a minute. It is the most distressing spectacle one can possibly imagine. I don't think something like this has ever happened in France, not even on St. Bartholomew's Night.[2] Anyone who is not fighting cannot leave home for they are taken back there. The National Guard and the [men from] the suburbs keep watch in all the streets.

I don't fight for two reasons. First, because I do not believe in wars fought with guns and cannon, and because it runs counter to my principles. For ten years now I have been waging a war of the intellect. It would be inconsistent of me to act otherwise. The second reason is that I have no weapons and cannot be tempted. So you have nothing to fear on my account. Perhaps I'll write you more at length in a few days. I embrace you all.

<div align="center">Gustave</div>

1. The bloody June uprising, which was a direct result of the closing of the national workshops on June 21.

2. Reference to a historic event that took place on August 24 (St. Bartholomew's Day), 1572, when many thousands of French Huguenots were massacred on account of their faith.

49-1 *To François Bonvin [Paris, winter 1848–49 (?)]*[1]

Bonvin, go give Hédouin[2] an answer; he left this note with me during my absence.

G. Courbet

M. Hédouin, 62 rue de l'Université

1. This short note is written on a piece of paper torn out of a tailor's measurement book. Its date can only be guessed at. It was probably written sometime in the late 1840s, when Courbet seems to have been closest to Bonvin.

2. Pierre-Edmond-Alexandre Hédouin (1820–89) was a painter and printmaker, known especially for his engravings reproducing the works of contemporary artists. Hédouin made a print after Bonvin's *Kitchenmaid*, exhibited at the 1849 Salon. He is not known to have done any engravings after Courbet's paintings.

49-2 *To the President of the Committee for the Great Lottery, Paris, May 12, 1849*[1]

Saturday, May 12, 1849

Monsieur le Président:

I have been painting for ten years. Some newspapers have already done me the honor of discussing my works. That is why, knowing of your love for the arts, I felt I was justified in calling myself to your attention and to that of the committee charged with selecting the artworks for the Great Lottery.[2] I belong to the Association des artistes and several qualified people have already appreciated and praised my paintings. I have never sold anything. Therefore I feel that I fulfill all the conditions necessary to merit your consideration. If the very short time between now and the annual Exhibition does not permit the members of the committee to honor me with a visit to my studio, I dare rely on your fairness, Monsieur le Président, to call their attention to my Salon paintings. I am sending several, including one composed of large figures, and different landscapes.[3]

Respectfully yours, Monsieur le Président.

Gustave Courbet

30 [sic] rue Hautefeuille

1. This letter, which is not in Courbet's handwriting, was doubtlessly written by the poet Charles Baudelaire* (cf. Crépet 1947–53, 1:111–12). Courbet was close to Baudelaire at least since 1848, when he contributed a drawing to *Le Salut public*, a shortlived paper founded by Baudelaire, Champfleury,* and Charles Toubin on the eve of the February revolution.

2. The Great Lottery was organized by the government to aid artists after the slump in the art market caused by the revolution.

3. Courbet sent eleven works to the Salon of 1849. Among them were the *After Dinner in Ornans* (F. 92), to which he refers in his letter; the *Portrait of Trapadoux* (F. 96); and seven landscapes. For a complete listing, see Paris (1977, 27).

To his father [Paris, ca. June 17, 1849][1] *(fragment)* 49-3

Dear Father:

The constitution has been violated from top to bottom.[2] The National Guard has taken matters in hand. The National Guardsmen may be splendid warriors, but they stood with their mouths open Tuesday and all day Wednesday, so that the troops are occupying all of Paris.[3] They took their position and instantly thirty thousand new men entered Paris through various gates. The insolence of the reactionary party is at its height. M. Changarnier[4] announced yesterday evening that we would have an emperor this morning.[5] They went to the editorial offices of *Le Peuple, La Vrai République*, and *L'Estafette*[6] and broke and trampled everything, presses, type, etc., in a barbaric fury. It's alright, their madness has reached its limits. We are in a state of siege. The people laugh a lot. It is easy for you to say, "I prefer one worker to twenty National Guardsmen." When the Chamber was dissolved (for to me it no longer exists), the Montagne was established with the Conservatoire des arts et métiers as convention chamber.[7] They appealed to the people. They were immediately invaded by the reactionary troops and escaped however they could, climbing out of windows and up the walls of the neighboring gardens. The heaviest and clumsiest were caught. M. Rattier[8] received a bayonette wound in the leg. Fortunately it seems that Ledru-Rollin and Felix Pyat were among the ones who got away.[9] It is not over yet. Yesterday barricades were raised and this morning they have begun again. If the people get mixed up in this it will not be for nothing. Except for two or three legions the entire National Guard is for the constitution. They had come out for a rally but were attacked by the cavalry and aimed at by the ranks. M. Changarnier is said to have hit one of them with the flat of his saber. Several people have already been killed, both by the cavalry and by some platoon fire from the ranks and from the first and second legions of the National Guard. M. Napoléon, who is not yet emperor, rode his horse along the boulevards, saluting with a patronizing air. M. Changarnier, who was with him, was fired at but unfortunately not hit. Everyone who fired was killed on the spot. As for M. Napoléon, he has not yet been shot at once, which is even more unfortunate.

As for me, in this business I wage my fight entirely with words. Don't worry on my account, all that nonsense does not put us painters out too much. Our exhibition opened last Friday.[10]

Since these political emotions [began] one hears no more talk of cholera,[11] it has acted as a diversion. I have had cholera but I took care of it so early that I have been completely recovered for six days. At the first symptom one must do immediately whatever is prescribed, otherwise later it all becomes ineffective; thus, only those who are going to have it can be treated but not those who have it. Today I am very well.

I have Augustin Teste here who has come to Paris at a bad time. He has spoken to me of the atelier that you are setting up for me at home.[12] It is a rather cluttered and ill-suited place. But then, if it can be done it will never be wasted. The window on the hospital side should be a hinged skylight nine or ten feet high depending on the space. . . . [13]

1. Courbet's letter was written during the June days of 1849, shortly after the opening of the Salon on June 15. A date around June 17 appears likely for this letter.

2. Courbet's words echo those of Alexandre-Auguste Ledru-Rollin (1807–74), the unofficial leader of the Republican opposition under the presidency of Louis Napoléon. Ledru-Rollin, on June 11, had declared: "The constitution has been violated, we will defend it by all means possible, even by force of arms." Ledru-Rollin's declaration was a reaction to Louis Napoléon's intervention in Italy, where he supported the pope against the Italian republic. Republicans in France generally felt that this war, against a sister republic, was unconstitutional (see Wolf 1963, 224).

3. On June 13, Ledru-Rollin led a march of National Guardsmen from the poorer districts, members of Republican societies, and proletarians toward the assembly hall. When they arrived at the rue de la Paix, government troops broke up the demonstration and quickly cleared the streets (see Wolf 1963, 225).

4. Nicolas Changarnier (1793–1877) was the commander of the army during the presidency of Louis Napoléon.

5. The empire was not proclaimed for another three-and-a-half years, not until December 2, 1852.

6. Well-known Republican and/or radical newspapers.

7. After their demonstration had been broken up, Ledru-Rollin and a small group of supporters hastened to the Conservatoire des arts et métiers to organize a direct rebellion against the government of Louis Napoléon, but their meeting was immediately broken up by government troops.

8. François-Edmond Rattier (1822–90). A well-known Republican and socialist, Rattier had been elected to the legislative assembly in the Seine Department on May 13, 1849. He played an important role in the June insurrection of 1849.

9. Ledru-Rollin and Félix Pyat (1810–89) both fled abroad.

10. The Salon had opened on June 15.

11. A major cholera epidemic had hit France in 1849.

12. After Courbet's maternal grandparents had died in 1847 and 1848, respectively, it was decided to remodel their home in the Iles-Basses quarter of Ornans (now 24 place Gustave Courbet) into a studio for Courbet.

13. The remainder of letter is missing.

To his father [Paris, summer 1849 (?)] (incomplete)[1] <u>49-4</u>

[Long letter in which he discusses the acquisition of a vineyard with two wells, and the planting of flowers in a garden. About himself he has this to say:] . . . the success of the Exhibition continues. They are talking about the large gold medal. . . .

1. The date of this letter, of which only a very incomplete quotation is currently known, is based on Courbet's remark about a gold medal. The only gold medal Courbet ever received in France was the one given to him in 1849, on the success of his *After Dinner in Ornans*.

To Francis Wey [Paris, August 28, 1849 (Ad)] <u>49-5</u>

Dear friend:
Don't expect me tomorrow at four o'clock as I had promised you. I have several things to do in Paris, family business, etc. I will be leaving soon, yet I want to see you again in your beautiful part of the world,[1] for you are [both] so good and the weather is so beautiful. I'll come in the next few days.
Regards to Mme Wey.
Affectionately,

<div align="right">

Gustave Courbet

</div>

1. Francis Wey, whom Courbet had met around 1848, lived in Louveciennes. Courbet had already visited him there in the early summer of 1849 (cf. Courthion 1948–50, 2:191).

To his family [Ornans, October 1849] <u>49-6</u>

[No salutation]
I arrived from Paris the other day and came from Besançon on foot. I had come from Paris in boots that were a little tight so that, walking from Besançon, I was flayed. Now I can wear only my slippers. Otherwise, you may be sure that I would already have come up to Flagey for I am very anxious to see you.
Aside from that reason there is another that forces me to stay in Ornans, namely that Promayet[1] is giving a concert on Sunday. I composed four ballads for the concert (words and music), which I am supposed to sing.[2] As he has not yet finished the accompaniment it follows that I must be here to make sure that it accords with my intentions, and also to rehearse. I would very much like you to come for I think that it will produce quite a surprise in

Ornans. So I await you impatiently, [come] as soon as possible. Meanwhile I embrace you with all my heart.

Gustave Courbet

[Address] Monsieur Courbet, landowner
in Flagey

1. It is not certain whether Courbet refers here to Alphonse Promayet* or to his father, Claude Louis Promayet (1785–1864), who was organist, music teacher, and conductor at Ornans (cf. Ornans 1981, 50).

2. On Courbet as a songwriter, see Léger (1947).

<u>49-7</u> *To M. and Mme Francis Wey [Ornans, October 30, 1849 (Ad)]*

Dear friends:

I am a little like a snake: I am frequently in a state of torpor. In that sort of beatitude one thinks so well! And it is so pleasant to think of the people one loves without having to tell them. Yet I will come out of it, though without the sun, do pity me.

When I returned to Ornans, my native town, I arrived on foot from Besançon. My friends had come out to meet me on the road. They all dined with us and then, during dessert, Promayet* went to get the musicians who were still rehearsing at the town hall. And then they serenaded me, followed by a large part of the townsfolk. Promayet, who conducted the orchestra, had cooked up a surprise for me: he had set my ballads to music,[1] which they played very beautifully. I'll spare you my little speech. I invited them to have a drink and at once we had a full house. I had to sing my ballads for them and then we danced until five o'clock in the morning. You can imagine how many people I had to embrace and what compliments I received from the entire town.[2] At last, it seems, I have done credit to the town of Ornans. They are already lining up to pose for me.[3] I believe I will even manage to make them pay.

The temperature in Ornans is definitely different from that of the outskirts of Paris. I enjoyed a week of magnificent sunshine and so went to Valbois to paint the castle of St. Denis [F. 110]. I have already painted two landscapes. In the place where I was I could have done ten, all imbued with a splendid and wild feeling. But one fine evening toward sundown the sky darkened and since then it has rained incessantly, and the beautiful yellow autumn leaves are blowing away.

My father had a rather respectably sized studio made for me, but the window was too small and in the wrong place.[4] I had another one made right

away that was three times as large. Now you can see as clearly as in the street. Also, I had it painted in a dark green-yellow with dark-red trim. The ceiling, which is very high, is painted sky blue down a quarter of the height of the walls. The effect is fantastic. The window embrasures are white. What a pain in the neck, what a waste of time! However, my canvas is being prepared,[5] and I'll be getting to it soon. I already wish I could come back and see you. Life is painful and the thought saddens me. I have a hard time resigning myself to my stay in Ornans.

Dear friends, you must already be back in Paris. You'll have regretfully left Louveciennes and Marly's fine avenues. Rest assured that I very much share your regrets and live in the hope of seeing you there all together again and in better health, for Mme Marie,[6] under the care of that amiable Republican friend, Clavel, will be in wonderful health next year. While I think of it, please give my affectionate regards to all our friends: Camille, Robelin, Dugasson, and others.

How little in life is disinterested! I have just received a notification from the ministry that I must come and get fifteen hundred francs[7] and so I find myself forced, in a letter in which such matters should have no place, to call on Francis to kindly take care of it. I blush when I think of how many errands of this kind I have already obliged him to do. So let him take advantage of me, if possible, he would be relieving me of a great burden. I have had a power of attorney drawn up, which I send you herewith, on which he should put his name and title. I am also sending the letter from the ministry, which he must present. After that I beg him to get a money order drawn on the Banque de France, which he should send to me.

I am anxious to hear about your health and your activities. I have told you what I am up to. Otherwise, I am very well. I spend my life dining now here, now there, it's unbearable. I embrace you both, and your aunt as well, with all my heart. Let me have news of her.

Your friend

Gustave Courbet

1. Compare letter 49-6, nn. 1, 2.

2. The reason for the serenade must have been Courbet's success at the Salon of 1849, where his *After Dinner in Ornans* (F. 92) received a medal and was acquired by the state. As Alphonse Promayet occupied an important place in that picture, the Promayet family had a direct share in Courbet's success.

3. No doubt for the *Burial at Ornans* (F. 91), Courbet's next major figure painting after the *After Dinner*.

4. See letter 49-3, n. 12.

5. For the *Burial at Ornans*.

6. Marie Wey.

7. For the *After Dinner in Ornans*, which Courbet had sold to the state. See also n. 2.

49-8 *To M. and Mme Francis Wey [Ornans, November 26, 1849 (Ad)]*

Dear friends:

If after I left you were beginning to find me lazy, my God, what would you say now? And you would be right! But I will clear myself heroically, you'll see. When I am in Ornans, I am in Paris, my thoughts wander. Here especially I enjoy that kind of vague idleness where one does so many things while doing nothing. That is not what I mean by clearing myself, but it's coming.

I had taken our carriage to go to the castle of St. Denis to paint a landscape.[1] Near Maizières I stopped to contemplate two men who were breaking stones on the road. It is not often that one encounters the most complete image of poverty, and so, right then and there, I got the idea for a painting.[2] I told them to come to my studio the next morning and between then and now I have painted my picture. It is the same size as *Evening at Ornans*.[3] Shall I describe it to you? (Lucky the man who has passed his rhetoric course! Indeed, but though I went to class, I still cannot spell.)

On one side is an old man of seventy, bent over his work, his sledgehammer raised; his skin is burned by the sun, his face is shaded by a straw hat. His pants, of a coarse material, are patched everywhere, and inside his cracked clogs his heels show through socks that were once blue. On the other side is a young man, with dusty hair and a swarthy complexion. His filthy and tattered shirt reveals his sides and arms. A leather suspender holds up what is left of his trousers, and his muddy leather shoes show gaping holes on every side. The old man is kneeling, the young man is standing behind him energetically carrying a basket of broken stones. Alas, in that [social] class that is how one begins and that is how one ends up.

Scattered here and there is their gear: a hod, a hand barrow, a hoe, a farmer's cooking pot, etc. All of this takes place in bright sunshine, in the middle of the countryside beside a ditch next to a road. The landscape fills the canvas. Yes, M. Peisse,[4] we must drag art down from its pedestal. For too long you have been making art that is pomaded and "in good taste." For too long painters, even my contemporaries, have based their art on ideas and stereotypes.

During the last two weeks I have been very busy, dear friends, as I will prove to you, so busy that in order not to waste a moment of daylight, we went skating at night near the Montgesoye Islands. The moon was splendid, the cold very intense. The ponds are three-quarters of a league from Ornans. We left at eight o'clock and came back at eleven to have a beer. Since then the weather has completely changed: we go down the streets of Ornans in boats. There is great flooding, it's still fun.

So I still have twenty feet, two inches of painting to do, that is, thirty or forty figures.[5] I must do it, not think about it. This week, definitely, I am

going to attack that canvas.[6] It, that is, the *Burial*, must be done in three months at most. I have just done eight square [feet] in two weeks. I must tell you that the people of Ornans who flock to my studio right after they have coffee, find the *Stonebreakers* more beautiful than the *Evening at Ornans*.

Every day I talk to my mother and sisters about crawfish, fish, and cherry liqueur. It will come, it will come, don't get impatient.

Mind you, if I had not got it into my head to paint this large picture, I would have done a painting of the vine grower in winter. He would have been sharpening the vine props, or *échalas*, while his wife looked after the still, but that will be for another time.[7]

How delighted I am, dear friend, that Mme Marie[8] is doing better. How delighted I would be to see you again. One wants so much what one cannot have, that sometimes it keeps me from working. I received your very gracious letter, and I am very grateful for it as well as for the errand you have done for me. I received the money order. Good-bye, take care of yourselves, I embrace you. All the best to our friends.

Gustave Courbet

I forgot to tell you that I have bought a pair of blue leather clogs.

My letter was written two days ago. By the way, I no longer want to try to clear myself, I throw myself on your leniency. I was taking this letter to the post office when the mayor,[9] who stood on the bridge, called me at the top of his voice: "You're already rather famous in Paris, let's go have an absinthe, I'll show you a letter." The first thought that came to me was, "You are going to be transported along with the political prisoners, how to save yourself?" For I have always felt that if the law took it into its head to accuse me of murder, I would definitely be guillotined, even if I were not guilty. That is as far as I had got with my thoughts when I read your letter. I began to breathe again. The joke worked, your letter is witty indeed. The mayor is delighted with it, and it has brought amusement to a lot of other people as well, for two hours later the whole town knew, it was a complete success. I tried to get it from the mayor but he does not want to part with it. "It is an autograph letter of Wey, my word, it is charming, and I want to keep it." From now on, every evening, he will talk about it at the café. It also brings a lot of pleasure to my family, who were already very fond of you but who are even fonder of you now, and who all tell me to send you their regards.

As for me, I had forgotten mine for your aunt (it is an ill wind that blows nobody any good).

Adieu again,

G.C.

1. Perhaps F. 110. See also letter 49-7.

2. The *Stonebreakers* (F. 101). Courbet's description of the scene was to inspire Francis Wey's novel *Le Biez de Serine*, in which the author describes two stonebreakers in terms

clearly borrowed from Courbet.

 3. The *After Dinner in Ornans* (F. 92). Though the two paintings are equally wide, the *Stonebreakers* is 30 centimeters shorter than the *After Dinner*.

 4. Jean-Louis-Hippolyte Peisse (1803–80), critic, curator, and translator. He collaborated on various liberal newspapers and served as curator of the collections of the Ecole des beaux-arts. Peisse was to write a scathing critique of Courbet's *Stonebreakers*, *Burial*, and other works exhibited at the 1850 Salon in an article in the *Constitutionnel* of January 8, 1851.

 5. Reference to the *Burial* (F. 91).

 6. Reference to the *Stonebreakers*.

 7. Courbet never executed this painting.

 8. Marie Wey.

 9. Claude-Hélène-Prosper Teste (1801–68) was mayor of Ornans from 1825 to 1861. He is one of the central figures in the *Burial* (cf. Ornans 1981, 60).

49-9 *To M. and Mme Francis Wey [Ornans, December 12, 1849]*

Dear friends:

 Aha! Here is some fish at last! He is one of the kings of the Loue River. Alas, kings do vanish. Louis-Philippe left without any fanfare.[1] This one, in my opinion, deserves a better lot.

 We saved it for you, dear friend. I had spoken about it with Jean-Jean de la Mal-Côté, a fisherman by trade. The aforesaid monarch found himself in a chasm by M. Ordinaire's* poplars (a site, by the way, that you can find in one of my small landscapes). "When he appears," Jean-Jean said, "he's yours."

 Last night was the fatal night (God, what a dark night it was!) when he came out of his domain. I had gone to see M. Ordinaire in the afternoon to make his acquaintance. They pressed me to stay for dinner (short of lying, I had no reason to refuse), and as I was relaxing at the home of those kind and unaffected people (where we talked a lot about you), I heard the clock strike eleven. I was taking my leave of them and thanking them when, stepping outside, we found ourselves in such complete darkness that all three of them insisted that I should spend the night there. However, I prevailed by pointing out to them that they might perhaps be depriving me of some fine emotions (as I love the night so much). M. Ordinaire walked a few steps with me, then we tried to find each other in the dark to shake hands. God, what a dark night it was! "Hey, who goes there?" "Turn left," replied a voice. And there I went, veering into the hedges on the side of the road and at times even into the plowed fields until I arrived at a plank over a brook, which I crossed on my knees. God, what a dark night it was! I felt as if I were swimming in an inkpot. And in the distance you could hear on the hillsides the hooting of owls exulting in the crevices of our old rocks. How those sinister philosophers must have laughed at my difficulty. Meanwhile, Jean-Jean de la Mal-Côté, with a swoop of his net, was catching his fish.

 I am so cunning that it is beginning to frighten me. You would never have

guessed that this whole exordium was meant to lead up subtly to a request to go and see Charles Blanc,[2] to fetch my medal, and to send it to me if you please. Do express my deepest regrets to him for not having been able to come myself, and convey my respects to him. And put the idea into his head that this year I will come to the Exhibition armed from head to toe.

At the moment I am outlining my picture on the canvas. Not only have I obtained some funeral vestments from the priest,[3] but I have even convinced him to pose for me, as will his assistant. I have had some moral and philosophical discussions with him that were truly hilarious.

I had to rest for a few days after the painting that I just completed, my head did not function anymore.

You will receive what I am sending you postage paid. I delivered it tonight to the stagecoach that stops in Ornans. It will leave tomorrow, Thursday, at six in the morning from Besançon with the Lafittes.

All this time the waters have been too high and it has been too cold, the crawfish have been uncatchable. I send you herewith my letter of invitation. Is Madame Marie[4] still ill? I would so much like to know!

I embrace you, and kind regards to our friends and to your aunt.

Gustave Courbet

Winter is a beautiful season. In winter the servants' drinks are as cold as their masters'.

1. A reference to King Louis-Philippe's quiet departure for England after the revolution of 1830.
2. Charles Blanc (1813–82), art historian, critic, and graphic artist. Brother of the social reformer Louis Blanc, who became a member of the provisional government after the 1848 revolution, Charles Blanc served as director of the Fine Arts Administration under the Second Republic. As such he held the medal that was awarded to Courbet for his *After Dinner in Ornans* (F. 92) at the Salon of 1849.
3. Benjamin Bonnet (1801–65), priest at Ornans till his death in 1865, was assisted by Vicar Arsène Querry (cf. Ornans 1981, 52).
4. Marie Wey.

To Champfleury [Ornans, February-March 1850] 50-1

[No salutation]

I am rereading your letter, my dear friend, and I am blushing with shame. But you don't need me to write you to know that I am thinking of you.

While I am at it, I'll give you a detailed account of the time that I have passed away from you. But first I feel the need to speak of Trapadoux,* that exotic friend. I say "exotic," for I have always thought that Trapadoux was the medicine man of a savage tribe. Moreover, he brings such persistence and such imperturbability to the science of life that he also reminds me, his hand on the bottle, of Mucius Scaevola, his hand on the brazier.[1]

In any case, I beg you, don't let yourself be destroyed by him, the more so as your novel in *La Voix du peuple* is on the road to success (at least in our part of the world).² I have read only a few installments (for the paper was not available to me), and liked it a great deal. As for Trapadoux, I likewise beg you not to destroy him (he is a precious monument), even though Schanne* might advise you to. Too many people would miss him. As for myself, I confess that I need him very much. I still see him, candle in hand, at the brothel or at my atelier, scurrying through the dark, his eyes and nostrils wide open. I am not surprised that he wants to become a priest. I had even said to Baudelaire* that he was a born Brahmin and that he would end up with his hands in the air, shaded by his nails, like branches of a weeping willow, combining preexistence with the infinite. Your nickname for him, the "first green giant," has thoroughly taken my fancy. I don't know much about verse, but if Baudelaire declares yours to be illogical, I think that the reverse must be true.

What a very beautiful season winter is. Aside from the fact that the servants' drinks are as cool as their masters', one hears everywhere tales of exploits that would delight Trapadoux. Here is a poacher who saw a wild boar as big as a cow, there is a farmer who, holding his rifle in one hand, grabbed a wolf by the ear with the other. As for me, I killed a wild goose that weighed twelve pounds, earning great admiration from everyone in the area. Promayet* and I were together. It was ten o'clock at night, the snow was brillant, and the moon was full. We returned immediately to make a triumphant entrance into the bar. The goose hung from the end of my rifle barrel. Even now there are those who still can't sleep from envy. The story of the goose killed by the two artists will be told in this part of the world to our children's grandchildren, and embroidered.

So much for the hunt, let's talk about paintings. I have already done more painting since I left you than you could shake a stick at. First, there is a painting of *Stonebreakers* [F. 101], which is composed of two very pitiable figures: one is an old man, an old machine grown stiff with service and age. His sunburned head is covered with a straw hat blackened by dust and rain. His arms, which look sprung, are dressed in a coarse linen shirt. In his red-striped vest you can see a tobacco box made of horn with copper edges. At the knee, resting on a straw mat, his drugget pants, which could stand by themselves, show a large patch; through his worn blue socks one sees his heels in his cracked wooden clogs. The one behind him is a young man about fifteen years old, suffering from scurvy. Some dirty linen tatters are his shirt, exposing his arms and his sides. His pants are held up by a leather suspender, and on his feet he has his father's old shoes, which have long since developed gaping holes on all sides. Here and there the tools of their work are scattered on the ground: a dosser, a stretcher [*brancard*], a hoe [*fossou*], a rustic pot in

which they carry their midday soup, and a piece of black bread in a scrip. All this takes place in full sunlight, by a ditch alongside a road. The figures are seen against the green background of a great mountain that fills the canvas and across which move the shadows of clouds. Only in the right-hand corner, where the mountain slopes, can one see a bit of blue sky.

I made up none of it, dear friend. I saw these people every day on my walk. Besides, in that station one ends up the same way as one begins. The vine growers and the farmers, who are much taken with this painting, claim that, were I to do a hundred more, none would be more true to life.

Here models are for the asking. Everyone would like to be in the *Burial* [F. 91]. I could never please them all, I would make quite a few enemies. Those who have already posed are the mayor, who weighs four hundred [pounds]; the priest; the justice of the peace; the cross bearer; the notary; Deputy-Mayor Marlet; my friends; my father; the choir boys; the gravedigger; two veterans of the revolution of '93, in the clothes of that time; a dog; the corpse and its bearers; the beadles (one of the beadles has a nose as red as a cherry but broadly proportioned and about five inches long, something for Trapadoux to fool with!); my sisters, and other women as well; etc.[3] I had hoped to get by without the two precentors of the parish, but there was no way. Someone warned me that they were offended, that they were the only church people I had not included. They complained bitterly, saying that they had never done me any harm and that they did not deserve such an affront, etc.

One must be crazy to work in the conditions in which I find myself.[4] I am working blind, with no backing space. Will I ever be settled as I feel I should be? Anyway, at the moment I am about to finish fifty life-size figures with a background of landscape and sky, on a canvas twenty feet wide and ten feet high. It is enough to kill me. You can imagine that I have not slept.

Another story: Ornans is all fired up, Ornans is standing on its head since Carnival. One would think that there was death in the family, especially among the newlyweds. I should tell you first that it is the custom in our country that, when a man gets married, he must give out treats on Carnival Sunday and Shrove Monday. This means that first, in the morning, he distributes roasted peas to the children, and in the evening he receives the masquers, who tell them a few home truths and eat and drink and bring enormous meals that they had to prepare themselves, each according to his means. That business lasts all night.

Now, my friends and I have given this a cruel and terrible twist. One must take the precaution of being completely disguised and of changing one's voice so that one is absolutely unrecognizable, otherwise one risks a thrashing. We had conceived the idea of a group of Pierrots in every color. The role I played was the Pierrot of death. I was all in black except for my white ruff

and face (they will speak even longer of the black Pierrot than of the tale of the goose). There were also white ones, and red, yellow, green, pink, and blue ones, and, like me, all played specific roles appropriate to their colors.[5] The group, thank God, was numerous. We closed the Carnival with a solemn procession through the entire town. [The figure of] Carnival was spitted on a pole twenty feet high and on top of the pole was an enormous streamer on which was written, in big letters: "Citizens, go back to your sins. For telling the truth, Carnival will be burned!" The effect was funereal and sinister. All the Carnival actors followed the banner with masks and bags on their heads. The populace followed in silence. At last we arrived at the center of town, at the small market square. There the execution began, accompanied by rounds and dances around the burning Carnival. Whatever was available in the way of cauldrons, warming pans, large chests and other kitchen instruments was included in the music.

The other day I received a letter from the director of the Lille museums, who informed me that at their request the government presented my painting to that city. He asks for information about my life and about the teachers who directed my studies.

I have already made some fruitless attempts to get the plates with rooster motifs. I will get you the peasant songs and bring you *Les Bons Sabots* from Besançon.[6]

I would be very obliged to you if you would write me immediately whatever you know about the upcoming Exhibition and for what date it is scheduled.

If you happen to see Baudelaire, say hello to him. Tell me also what my friend Bonvin* is up to, go see him on my behalf. Please send greetings to the people I know, Trapadoux, Schanne, etc. I hope that this letter counts for something. I'd rather paint a picture, it would have taken me as long.

Gustave Courbet

I am bringing Promayet and Cuenot* with me. See you soon, dear friend, I am beginning to be fed up with the countryside.

1. Legendary Roman hero, known for thrusting his hand into a fire until it was consumed. His stoic gesture motivated the Etruscan king Porsena to seek peace with the Romans.

2. Champfleury's novel, *Les Trois Oies de Noël*, was published in installments in *La Voix du peuple* between November 8, 1849, and March 31, 1850. It was later published in book form as *Les Oies de Noël* (Paris, 1853).

3. For the identity of the various figures, see Ornans (1981, 40–76).

4. Courbet was working in the atelier his father had equipped for him in the house of his deceased grandparents in the Iles-Basses quarter of Ornans. The house, which still stands today (24 place Gustave Courbet), indeed is quite small, justifying Courbet's complaint.

5. Courbet's lengthy description of the Pierrots was no doubt intended to please Champfleury, who had a great interest in pantomime. Between 1846 and 1851, he wrote at least nine pantomimes (cf. Clark 1973, 54).

6. Champfleury was known to his friends for his interest in folk art, which was to result in several major publications, including *Chansons populaires des provinces de France* (1860), to which Courbet provided two illustrations; *Histoire de l'imagerie populaire* (1869); and *Histoire de la faïence patriotique sous la révolution* (1867). On the importance of folk and popular art for Champfleury and Courbet, see esp. Schapiro (1941) and Nochlin (1967).

To M. and Mme Francis Wey [Ornans, March 10, 1850 (Ad)] 50-2

Dear friends:

Jean-Jean de la Mal-Côté,[1] who knows me, came over yesterday to offer me a trout like the first one. It is so hard to refuse a four-pound trout that I bought it from him for you since you told me that the first one did not displease you. However, don't let Robelin have any of it. That man is considerably lower in my esteem since he made me wait two weeks in the snow for the carriage.

I have no sign of life from you. I quite fear that both of you are dead. I am trusting this fish to luck. Every day I rack my brains trying to understand what could entail this obstinate silence and I don't know what to think. However, I got an idea. M. Ordinaire* put me on the track: he told me it is for not having written on the occasion of the death of M. Wey, your father. No doubt I will always lack the qualities of tact, of good manners, and of French politeness. Not so long ago I would have been unable to forgo such a formality without being quite taken to task by my female cousins and ladies of my acquaintance. And it is true, I did not speak of your father's death. I regret it now, if indeed I have offended you, but I must admit that I thought you were freer where form was concerned. I don't know whether I have told you my philosophy toward the dead. First of all, I don't mourn the dead, convinced as I am that one mourns not for them but for oneself, out of egoism. I would perhaps grieve for them if the life of one man was directly useful to the life of another, but I don't believe that is the case, for I would not appreciate a man whose existence was based on another. I would not grieve for a man for I would use the time I spent grieving to free myself of him, etc. If I were not afraid of boring you, I could write you four pages on the subject. On the other hand I am convinced that sorrow is a good thing. In person I could take part in it, but never in a letter, except, of course, if I had been able to appreciate your father during his lifetime, as you did.

In conclusion, if that is why you are angry with me, I beg you, forget it. Leave me my freedom of thought, take me for what I am, not for what I should be. Please believe that I always act consciously and not from neglect, or, at least, so rarely that it is not worth mentioning, for whatever I might neglect would be of little importance.

I am still slaving away. My painting is as good as finished.[2] I am working with a perseverance and a tenacity, and am right now experiencing a sense of fatigue that I never thought myself capable of. What tires me most is that for the last two weeks it has been summer, and after such a beautiful winter, you can imagine how lovely it is to run around outdoors, especially when you are in your own part of the world and have not seen a springtime for twelve years. In a month I will be in Paris, I hope, which I am also anxious to see again, for, except for the sunshine, Ornans is not very entertaining.

Please let me know the exact date of the Exhibition and also ask whether the painters who are exempt from the jury are obliged to send their paintings as early as the others.[3] If it is in May, I'll just make it when I arrive. I don't even know whether it is May 15th or May 1st.[4] The newspapers should be clearer.

I am worried about Mme Marie's[5] health, but I tell myself that it is up to those who are ill to write, at least that is what I would do. And you, my dear Francis, I know so little about your health and your work. I embrace you all, kindest regards to your aunt.

<div align="right">

Gustave Courbet

</div>

1. Compare letter 49-9.
2. The *Burial at Ornans* [F. 91].
3. Thanks to the fact that Courbet had received a medal at the Salon of 1849 for his *After Dinner in Ornans* (F. 92), he was exempt from submitting his works to the Salon jury.
4. The official opening of the Salon, though originally scheduled for May, was postponed several times and did not actually occur until December 30, 1850. The public was first admitted on January 3, 1851.
5. Marie Wey.

50-3 *To Max Buchon [Ornans, ca. May 1, 1850]*

My dear friend:

I waited until I returned from Besançon to answer your letters full of warmth and friendship. I congratulate you on your article and am very grateful to you for it.[1] It makes perfect sense of the nature of my talent and it is written in that style [of yours] that I love so much. For that very reason I gave a hard time to the editors of the *Démocrate*,[2] all of whom I saw. I placed much of the blame on M. Morel in particular, as he was the copy editor. I tried to make that man understand that with an art like yours no one but the author himself must alter it by so much as a word more or a word less. In fact, he almost managed to make it trivial and incomprehensible. Those good folks begin to aim for good form, for the fine manners of high society. At once they must be of good old stock. Their awe makes them stupid enough for the editorial board of the *Union*.[3]

Everyone has predicted that I will be a complete success in Besançon. The mayor[4] has placed himself at my disposal and has encouraged me a good deal. He gave me the concert hall in the marketplace, which will be mine this coming Monday. He also believes that I should be remunerated and has agreed with me on the sum of fifty centimes [for admission]. On the whole he understands me very well and has approved all my decisions. I have had posters made (which will be put up on Sunday) in the socialist printshop, I don't remember the name, in the rue des Chambrettes. They will send you two or three, to treat your eyes and those of whomever you want. We do have to celebrate the anniversary of the constitution![5]

My paintings are exhibited in the church of the Ornans seminary, where they are all the rage.[6] They are all bordered with enormous deal frames, which add considerably to their effect and make them perfectly comprehensible. There is nothing to be retouched—it is also true that I am not very good at retouching, and am proud of it.

So I will leave Ornans on Sunday and my paintings will follow Monday morning. I will be staying at the Hôtel de l'Europe. I would like very much to see you there one day during this exhibition, and Arthaud* as well. Really, I have not seen enough of you. We must hope that in the future we'll have more free time.

That poor unhappy Thomas succumbed to the jury's brutishness. Exceptionally, the bench was for him, and was less harsh than the jury. Oudet put up a very good defense and was much more straightforward than in his paper.

From Besançon I'll go to Dijon. I will try to give them the real text of your article there[7] as well as the reviews of the Besançon papers.

In Paris I'll be staying at 21 rue Hautefeuille,[8] but I will write you about the success or the failure of my expedition on my arrival in Paris.

I embrace you, dear friend, good-bye.

Gustave Courbet

I send you many good wishes from my family. Regards to your sister.

1. Max Buchon had written an article in the *Démocrate franc-comtois* of April 25 to advertise the exhibition of Courbet's *Stonebreakers* (F. 101) and his *Burial at Ornans* (F. 91) in Besançon. Courbet's exhibition in Besançon was a somewhat improvised affair motivated by a desire to exhibit these new works while awaiting the opening of the Paris Salon, which had been indefinitely postponed (cf. letter 50-2, n. 4). The Besançon exhibition, which took place in May, was preceded in April by one in Ornans and followed in June by a three-day showing of his work in Dijon.

2. *Le Démocrate franc-comtois* was a short-lived Republican paper that appeared between January 17 and August 22, 1850, in Besançon (cf. Mayaud 1986, 352–53).

3. *L'Union franc-comtoise*, which appeared between 1848 and 1852, was an anti-Republican government paper (cf. Mayaud 1986, 352).

4. Besançon's mayor during the Second Republic was César Convers (cf. Mayaud 1986, 219).

5. The constitution of the Second Republic, which had been voted in in July 1848, was the subject of much discussion in 1850. According to the constitution, no president could be in office for more than a four-year term. Louis Napoléon had been elected on December 20, 1848, and already there was a movement to change the constitution to allow him to stay on for another term. This was a hotly debated issue, however, much opposed by both Republicans and Monarchists (cf. Wolf 1963, 233).

6. In April, Courbet had exhibited his new paintings in the chapel of the seminary at Ornans. See also n. 1.

7. Buchon's article was published in unedited form in the short-lived Fourierist journal *Le Peuple, journal de la révolution sociale*, on June 7, 1850, under the heading *Annonce*. For the English translation of the *Annonce*, see Chu (1977, 60–63). For a discussion of both versions of the article, see Clark (1969).

8. As Courbet lived at 32 rue Hautefeuille, it is not clear whether this is a reference to the house of a friend or, perhaps, to his regular café, the Brasserie Andler, which was also in the rue Hautefeuille.

50-4 *To M. and Mme Francis Wey [Dijon, July 31, 1850]*

Dear friends:

In two or three days I will be in Paris and I will have the pleasure of seeing you again, *mironton, mirontaine*, my campaigns are finished. Your excellent (but timid) letter could no longer excite me and should not have, for I had to get to the bottom of the idea that tormented me and will continue to torment me.

You know that people from the Franche-Comté relate everything only to their own experience. That worked so well that, imagine, in Besançon, yes in Besançon, two hundred and fifty persons produced fifty centimes from their pockets, their own pockets, imagine that![1]

In Dijon I was not able to hold my exhibition because of the political question, which exercised everyone's mind. Also, I did not have the same advantage as in Besançon where the mayor had done me the courtesy of placing himself at my disposal and had let me have the concert hall without charge. The mayor of Dijon was not able to offer me the same deal. There were soldiers everywhere. I had to rent a hall in a building that housed a Red café. I was in a bad spot there for it seems that just passing the above-mentioned café, the Whites get sick, and it is only by providing first aid to them that the café owner does business.[2] As the room was costing me ten francs a day, I felt it was best to pack my bags, even though I was offered the foyer of a theater, where I should have gone in the first place, Mlle Araldi[3] would have been delighted. In the end the desire to see you again, to see Paris again, [and] the ignorance of the Republicans in the provincial towns are causing me to leave after exhibiting for three days and not even covering my expenses.

Yes, dear friend, even in our so civilized society, I must lead the life of a

savage. I must break free from its very governments. The people have my sympathy. I must turn to them directly, I must get my knowledge from them, and they must provide me with a living. Therefore I have just embarked on the great wandering and independent life of the bohemian.[4] Don't be mistaken, I am not what you call a flimflammer. A flimflammer is an idler, he only has the appearance of what he professes to be, like the members of the Academy, and like toothdrawers who have their own carriages and handle gold.

Some two thousand peasants came to Ornans to see my paintings. They all asked as they left how much they owed me. It was no use telling them that I owed them, that I was in my own part of the world. That did not please them and I lost a good deal of their respect. They tended to think me an imbecile, which proves clearly that generosity is foolish because you deprive yourself of your means of action without enriching others, either spiritually or financially. People want to pay in order to be free so that their judgment won't be influenced by gratitude. They are right. I am eager to learn and to that end I will be so outrageous that I'll give everyone the power to tell me the cruelest truths. You see that I am up to it. Don't think that this is a whim, I have thought about it for a long time. Moreover, it is a serious duty, not only to give an example of freedom and character in art, but also to publicize the art I undertake.

If I had to make a choice among countries, I admit that I would not choose my own. That is why I have begun with it. Besides, in life one learns above all from adversity. There is also a saying that one must try new things from time to time in order to be truthful, for you know that truth changes with the times. The saying is that one does not work miracles in one's own country, it dates from the time of Jesus Christ,[5] I find it much too antiquated.

It occurs to me that I am so talkative that it scares me and that I will be able to talk to you more leisurely in four or five days. In the meantime I embrace you,

Gustave Courbet

In Dijon I had the good luck to find Viard, who is editor-in-chief of the newspaper *Le Peuple*,[6] and who stuns all the Republicans in that town who are not fully committed to the Republican cause. They are, as in Besançon and as in the provinces in general, liberals and patriots. It will take awhile before they see eye to eye and yet the Whites will exist only as long as the Republicans don't see eye to eye.

It has been so long since I have had any news about Mme Marie's health that it has become a worry that I carry with me continuously.

Au revoir

1. While Courbet had not charged an entrance fee for the exhibition of his paintings in Ornans, in Besançon he decided to ask for fifty centimes.

2. A tongue-in-cheek reference to the antagonism that existed in Dijon between Socialists (Reds) and Monarchists (Whites).

3. Mlle Araldi, stage name of Marie-Louise Bettoni (b. 1825), enjoyed considerable fame as an actress during the July Monarchy. After 1848, she appeared rarely in Paris but mostly in provincial theatres where she drew large crowds.

4. On Courbet's bohemian pose, see esp. Clark (1973, chap. 4).

5. The saying was Christ's: "No prophet is recognized in his own country" (Luke 4: 24).

6. See letter 50-3, n. 7.

50-5 *To his family [Paris, August 1850] (incomplete)*

[He is running out of canvas and asks his mother to buy him some so he can use it for his next works.] . . . the small gray piece, though smaller, seems to me the better buy. For one thing, it is infinitely better, provided you sew the seams well. . . . You must immediately . . . cover the small stretcher with it, the one that was used for the *After Dinner in Ornans* [F. 92]. You must begin by stretching it well, for the *Stonebreakers* [F. 101], which was done on a badly stretched canvas, flaked off when it expanded. When it is well stretched you must ask Joseph to cover it with thick paint, as much as possible, and he must put less turpentine in his paint than last year. . . . [He would also like some canvas for a tent that he will use next year if he carries out his idea of painting a large scene in the countryside.][1]

[Artists] . . . of all kind . . . [and] . . . fashionable people as well . . . [have come to see his new works. Everyone agrees that they will make a great impact at the next Salon.] . . . They are fast making a reputation in Paris. Wherever I go, people talk to me of them.

[He has just finished a painting] . . . of about one square meter. It is the historical portrait of an eccentric man of our time, the apostle Jean Journet [F. 105].[2] It resembles *Malborough s'en va-t-en guerre*. Journet is so well known in Paris that it will be necessary to put a policeman beside the painting during the Exhibition. . . .

1. Probably a reference to the *Young Ladies from the Village* (F. 127).
2. On the relation between the portrait of Jean Journet (or *Jean Journet Setting Out for the Conquest of Universal Harmony*, as it was called when exhibited at the Salon of 1850–51) and popular culture, see Clark (1973, 139).

50-6 *To his mother [Paris, fall 1850 (?)]*

Dear Mother:

I am sending you some muffs. It has taken me some time, but I got them very inexpensively. Take the gray one for yourself, it is the most expensive and the most beautiful. The others are about the same price, my sisters can make

their choice. If they cannot come to a friendly agreement, it must be decided by order of age, but above all everyone must be satisfied. If you prefer another to the gray one, feel free to take the one you like.

I'll write you soon [more extensively] for the Exhibition opens the twenty-sixth. My paintings have already made a strong impression on the members of the jury, who had to see them to assign them their places. I know them all by now and they have all paid me great compliments and all want to become better acquainted with me.

I warmly embrace you all.

<div align="center">

G. Courbet

</div>

Kind regards to Urbain, Adolphe, Tony, etc.[1] Also, tell father and mother Promayet* that I'll write them soon. Alphonse[2] told me to when he left. I saw Chenoz and Saulnier.

1. Urbain Cuenot* and Adolphe and Tony Marlet.*
2. Alphonse Promayet.*

To the editor of La Presse *(Emile le Girardin), Paris, May 13 (or 15 or 18?), 1851*[1] <u>51-1</u>

Monsieur l'Editeur:

I find myself listed in this year's Salon catalog as a student of M. Auguste Hesse.* To tell the truth, I must declare that I have never had a teacher. The administration's error arises, no doubt, from a practice that in recent years has become common: painters, especially those just starting out, believe it to be necessary, in order to be admitted to the exhibitions, to present themselves under the official patronage of a well-known name in the arts. That pure formality has at times even been turned into a joke, notably by M. Français,* who registered as a student of M. Bougival, a charming village on the banks of the Seine. M. Baron[2] called himself the student of M. Titeux,[3] and M. Gigoux,[4] even better, called himself, as I myself claim to be, the student of nature.

It is true that, when I first began exhibiting about ten or twelve years ago, in order to follow the custom, I asked M. Auguste Hesse to officially back me with his name. Hence the administration's error in the preparation of the present catalog. The administration has disregarded my legitimate rectifications with inexplicable stubbornness, even though it complied with other artists who have presented similar [requests].

Therefore, Monsieur l'Editeur [to correspond to salutation], I appeal to your impartiality, while apologizing to you in advance for filling your columns with details of so little importance to the public. But I wish nevertheless to

affirm that I have had only myself as a teacher and that my life's most constant effort has been devoted to the preservation of my independence.

Most respectfully yours,

G. Courbet

Paris, May 13 [?], 1851

1. Though the draft letter is dated May 13 (or 15 or 18?), it did not appear in *La Presse* until May 20, 1851. This translation is based on Courbet's autograph draft for the published letter and incorporates the corrections made in it by a friend (Champfleury?).

2. Henri-Charles-Antoine Baron (1816–85) was a student of his fellow Franc-comtois Jean Gigoux (see n. 4). He became a specialist in Italian genre scenes.

3. A. Titeux was known to every educated Frenchman in the mid-nineteenth century as an illustrator of secondary school texts. Among the books he illustrated was the two-volume school edition of Homer's *Iliad* and *Odyssey* by Eugène Bareste (Paris, 1842–43).

4. Jean Gigoux (1806–94) was a late-Romantic history, genre, and portrait painter who is sometimes grouped with the proto-Realists for the simplicity in style and subject matter of his early genre scenes. Like Baron and Français, he was part of Courbet's circle in the Andler Keller (cf. Riat 1906, 55).

51-2 *To his family [Brussels, September 9, 1851]*

Dear family:

We left Paris on the second of this month. We have been in Brussels for three to four days. Till now we are very pleased with our trip. On route, we went to Lille to see my painting *After Dinner in Ornans*.[1] At the Brussels exhibition[2] my *Stonebreakers* [F. 101] and my *Cellist* [F. 74] are far greater successes than I expected in Belgium. There is even talk of giving me the gold medal.[3] We will be leaving for Munich in a few days[4] and will arrive in Ornans in two or three weeks. I'll write you more later.

I had told Urbain* to come—it would have been a good thing for him. He has not answered me at all, but Buchon* has answered me.

I don't know whether you have had the front room wallpapered so that one can live in it. It would be handy for vacations, for some friends might come see me during the vacation, including Français,* and most likely Champfleury.*

I embrace you all in anticipation of the pleasure of seeing you. I charge Mother with the business of the room. I am very rushed as you can tell.

G. Courbet

[Address] Monsieur Courbet, landowner
 Ornans, Doubs Dept.
 France
[Postmarks] Brussels, Sept. 9, 1851
 Belgium, Sept. 10, 1851

1. The *After Dinner in Ornans* (F. 92) had received a medal at the Salon of 1849 and was bought by the state. After the Salon, it was sent to the Musée des beaux-arts in Lille.

2. The Exposition générale des beaux-arts (the Belgian equivalent of the Paris Salon), where Courbet's two paintings were exhibited under nos. 238 and 239 (as *Le Joueur de basse*), respectively.

3. Courbet did not receive a medal at this time.

4. According to letter 51-3, Courbet exhibited in Munich as well. His reputation in Germany was first established in 1851 by a long article in the *Deutsches Kunstblatt* dealing with Courbet's exhibit at the 1850 Salon (partly quoted in Hamburg 1978, 360).

To the editor of Le Messager de l'assemblée, *Ornans, November 19, 1851* 51-3

Monsieur l'Editeur:

In its November 15 issue, the *Journal des faits* quotes an article excerpted from the *Messager*, in which I am accused by a certain Garcin of having been present at a meeting held by the Friends of the Constitution in the Salle Saint-Spire on Monday, November 10.[1]

I thank M. Garcin very much for the honor he does me, first by disassociating me from his [own] party and second by associating me with the men he cites in his article. Nevertheless he does not have to make me act, I am strong enough to act on my own. I dare not believe that M. Garcin himself saw me at that meeting for, according to his article, it included only Republicans and police spies. In any case, he was very badly informed. Having left Paris on September 1 for the Brussels and Munich exhibitions, where I had sent my paintings, I traveled from there through Switzerland to go to my native town, where I have been for a month. Unless I have the gift of ubiquity, it seems unlikely that I was present at the meeting in the Salle Saint-Spire.

M. Garcin calls me "the socialist painter." I accept that title with pleasure. I am not only a socialist but a democrat and a Republican as well—in a word, a partisan of all the revolution and above all a Realist. But this no longer concerns M. Garcin, as I wish to establish here, for "Realist" means a sincere lover of the honest truth.

And now M. Garcin can freely pursue the course of his delightful articles, and, if he will allow me, I will continue a painting that I have started, the *Young Ladies from the Village* [F. 127], which I find infinitely more interesting than his insinuations.

With fraternal greetings,

Gustave Courbet

Ornans, November 19, 1851

Monsieur l'Editeur, I would like very much for this letter to be reproduced exactly in your forthcoming issue.[2] I expect that from you.[3]

1. On November 15, an article signed "Garcin" (probably Eugène-André Garcin, b. 1831) appeared simultaneously in the *Messager de l'assemblée* and the *Journal des faits*. The article

reported on a meeting of the Friends of the Constitution in the Salle Saint-Spire on Monday, November 10. Many of those who attended the meeting are mentioned by name, including "David d'Angers, the famous sculptor; Courbet, the socialist painter, author of the *Stonebreakers*, a painting received at the latest Paris Salon; Pierre Dupont, the democratic songwriter; Faure and Vasbenter, former editors of *Le Peuple* and friends of Proudhon."

2. Courbet's letter was not printed either in the *Journal des faits* or in the *Messager de l'assemblée* but the following correction appeared in the *Messager* of November 19: "The name of the painter Gustave Courbet has been associated erroneously with the democratic delegates who met on November 10 in the Salle Saint-Spire. Absent from Paris for more than five months, M. Courbet, after having traveled in Belgium and Germany, is at this moment with his family in the Franche-Comté, where he is working on one of those village scenes that have earned him—quite inappropriately, in our opinion—the qualification of socialist painter. Art is a neutral terrain and painting has no political opinion." The text of this correction departs from Courbet's letter, particularly in that it denies that Courbet is a "socialist" painter. As it appeared on the very day that Courbet wrote his letter, it was probably unrelated to it, but based instead on a letter to the *Messager* by Francis Wey. Courbet makes reference to Wey's letter in letter 52-1.

3. There are two nearly identical autograph versions of this letter. Only the signature and the postscript of the second version are different, reading as follows:

Gustave Courbet, painter

M. l'Editeur, please insert this letter in your forthcoming issue.

52-1 *To Francis Wey [Ornans, January 1, 1852 (Ad)]*

My dear friend:

The reasoning in your letter[1] was so poor that it suggested four pages of comments to me, which is why I did not write you. The generation to which you belong has neither faith nor convictions, whereas I have worked all my life to have a raison d'être that should, as much as possible, be unique; and every act of my life is directed to that end. You, you follow the ebbs and flows, I stick to my principles, that is the difference between us. Whatever form of government, whatever eventuality may happen, in no way intrigues me. The most dreadful bourgeois of France would not have told me that I should change the nature of my inspirations. Dear friend, this rankles. This puts you among those who think that I am practicing politics in painting. I paint stonebreakers, Murillo paints a "lousebreaker."[2] I am a socialist and Murillo is an honest man, it is unbelievable! And another fine thing is that Français* is making it his business. You were wrong not to tell me about Demesmay.* I would give something to know what he can have said on this subject.

Unusually for you, you had a little oversight (which you skillfully turn against me). You should have sent me the answer that you gave *Le Messager*.[3] I would have been very happy to have had an excuse for not responding. But in the end the harm was little. M. Garcin quite deserves more.

The revolution made me lose three weeks. I was so distressed that I puked a hatful. I am in a better disposition now, but as all my friends are in it, I am

monitored very actively as far as both my words and my actions are concerned. Thanks to my bearing I have not yet been arrested. I have the honor of being trailed by a police sergeant from Ornans (whom I don't know from either Eve or Adam), who, as early as a year ago, felt the need to inform against me at the police station. The man pursues his task without rhyme or reason, telling himself, "In these fine times, I will be the only one in France not to have the Legion of Honor or a commission." I don't know whether it is wise for me to return immediately to Paris for the wireless will precede me when I leave. If you could make some inquiries about that, you would do me a great favor, for I don't feel like going to Guyana at the moment—later, who knows.[4] The officer of my *Firehouse* is on the run, or dead, I have been told.[5] The painting is quite daring; however, I would have liked to have finished the portrait of Mme Cuoq [F. 223] for the exhibition.[6] If the exhibition were postponed by a month, it would suit me perfectly, even though the two paintings I have at Ornans are finished.[7]

I am very happy about your successes at the Théâtre français.[8] I would have liked to have been there for them. I am a simple man. I would have applauded you, you may be sure, as I'll never applaud M. Napoléon, whatever he may do.

I don't need to wish you a happy New Year for you already have it. But because of it and in spite of it and in spite of your letter, I embrace you only once, but Mme Wey twice, for I don't dare think that she applauded your letter. I embrace Français as well for he is also a beautiful boy, moreover I want to butter him up for I feel like doing some more landscapes at Fontaine-bleau. With that, kind regards to those of your friends who will ask after me, men and women.

<div align="center">

Gustave Courbet

</div>

They open my letters, watch out, and don't always give them to me.

1. Wey's letter has not been preserved, but it dealt, no doubt, with the coup d'état of December 2, 1851.

2. Reference to Courbet's painting of the *Stonebreakers* (F. 101) and to a well-known painting by the Spanish artist Bartolomé Esteban Murillo (1617–82) in the Louvre, the so-called *Young Beggar*, which shows a street urchin cracking a flea between his nails.

3. Apparently, Francis Wey had sent a letter to the *Messager* as well, to respond to the article of M. Garcin accusing Courbet of taking part in a meeting of the Friends of the Constitution on November 10. Compare letter 51-3, n. 2.

4. Guyana was notorious for its penal colonies.

5. Victor Frond,* the main figure in Courbet's painting of the *Firemen Going to a Fire* (F. 118), was a militant Republican who had tried hard to prevent the coup d'état of December 2, 1851 (cf. Adhémar 1977, 200–201). He was exiled to Lambessa in Algeria (cf. letter 52-3), but he seems to have escaped and made his way to London in 1853.

6. The portrait of Mme Cuoq was not exhibited until 1867, when in the catalog it was dated 1857. For the history of this painting, see Paris (1977, 147–48).

7. To the Salon of 1852, which opened, without delay, on April 1, Courbet sent the *Young Ladies from the Village* (F. 127), a portrait of Urbain Cuénot,* and a Franche-Comté landscape. The last two works cannot be identified with any certainty.

8. Francis Wey's *Stella*, a comedy in four acts, was just then performed at the Théâtre français.

<u>52-2</u> *To Champfleury [Ornans, January (?) 1852] (incomplete)*

[Champfleury has informed him that his mistress, Virginie Binet, has left Paris, taking their infant son with her.]

. . . may life be good to her, if this is what she thinks she ought to do. I'll miss my little boy very much but I have enough to do with my art without worrying about a household. Moreover, to me a married man is a reactionary. . . .

It is hard for me to tell you what I have done this year for the Exhibition. I am afraid of expressing myself badly. You will be a better judge than I when you see my painting. For one thing, I have misled my judges, I have put them on to new terrain: I have made something graceful. All they have been able to say until now will be useless. . . .

<u>52-3</u> *To his family [Paris, June 15, 1852 (Ad)]*

Dear family:

I have just convinced Alphonse[1] to write his family. Justin Cretin, who lodges in our house, is with us and is taking advantage of the opportunity to write his wife also.

If I have not written you sooner it is because at the moment I am doing a painting of the wrestlers[2] who were in Paris last winter.[3] It is a painting the size of the *Young Ladies of the Village* [F. 127] but vertical. I do it to paint nudes and to appease them on that account.[4] It is hard to please everyone. It is impossible to tell you all the insults my painting of this year has won me, but I don't care, for when I am no longer controversial I will no longer be important. The painting that I am doing now will cost me quite a bit of money, which I would have liked to avoid. But it is going well, and that makes up for it. I am halfway done with it.

I called on M. de Morny,* who received me very graciously.[5] We talked about painting. He knows nothing about it, but that does not matter, he thinks he knows a lot. I told him that too many things were demanded of me; that I did not have the means to meet all those demands; that I had done my duty for I could paint better than anyone in our society; that it was up to him now, and to all those who understood what I was doing, to commission paintings from me. He replied that he would speak of it to the government. He prom-

ised that I would receive some commissions. On the other hand, M. Romieu,[6] who is the director of the Fine Arts Administration, has declared that he would give me none at all; that the government could not support a man like me; that, were I to do other kinds of paintings, he would see what he could do; that, moreover, I was perceived as a political force and that they would show me that they were not afraid of me. Others say that I'll get the first medal of fifteen hundred francs: a commission goes with that. All in all, I really don't know at the moment what the outcome of all this will be. I am still not afraid of them, my business goes well, my reputation is growing, and one day I'll be right [and] they will all be wild for Realism.

This year's painting[7] won me a whole category of people who were not on my side last year. The painters are all furious, they hadn't taken the business seriously. They don't come to see me anymore like last year. They feel that they have been taken in and that I have got the better of them. Even Delacroix* went to the ministry to knock my painting (this comes from Romieu).[8] The man is amazed that he is no longer as talked about.

I wrote Lunteschütz.* My *Burial* [F. 91] and *Self-Portrait* [F. 39?] created a sensation in Frankfurt,[9] to the point that they were writing [signs] in the cafés and casinos, "No talking about M. Courbet and his paintings here," for it led to arguments. They were exhibited for two weeks. The gate money amounted to six hundred francs. We had to quit because of the fair. Now I am thinking of sending some more, and it will start over again. Lunteschütz would like to take them all over Germany. It is a way to make money, I know, but on the other hand they will be damaged. It seems that the German papers talked a great deal about me. In the Berlin ones they said that no colorist since Titian had been as powerful as I. I'll send you the few papers I have in which they talk about me. I have had no time to look for them so that I don't even have a fourth of them. You waste all your time—if only there was nothing else to do. You can pass them on to Adolphe Marlet,* who asked me for them.

I have put out some feelers among people I know to see if I could extricate Buchon* from his present whereabouts,[10] but it is impossible to do here. Only a petition from his own region, complete with signatures and sent to the government by the prefect or the archbishop, will get him out, and even with that he will have to make an awful retraction, worse than Urbain's.[11] Justin informed us of his troubles, it is a bit annoying not to be able to leave Ornans. As for me, I was lucky and narrowly escaped. If I had been in Ornans two weeks later, I would be in his position, or two weeks earlier in Paris, and I would have been transported because of my association with that idiot Frond,* officer of the fire brigade, who has just been sent off to Lambessa[12] for having roused his firehouse to insurrection.[13] I could have undergone the same fate, quite likely, for I had put him in my painting.[14] I am forbidden to

continue until further order and everyone is quite amazed that I am allowed that much.[15]

Champfleury* has written to Buchon and has sent him reviews and has received no response. I don't know whether one can write Urbain without fear. I have seen Flarot with his wife, they are gadding about Paris. They'll come back to see me one of these days. I am unable to send what Juliette asked me at the moment. My kind regards to all my friends, Urbain, Adolphe, Tony, Teste, Bertin, Guyot, Ordinaire,[16] and those who ask news of me. I embrace you all with all my heart. Father has done well to sell all those horses, it is a deliverance.

<div align="right">

G. Courbet

</div>

1. Probably Alphonse Promayet.*

2. Courbet's *Wrestlers* (F. 144) was to be shown at the Salon of 1853.

3. In the winter of 1852, an important wrestling tournament was held in Paris. Among the fighters were such well-known names as Arpin ("the invincible Savoyard"), Blas ("the ferocious Spaniard"), Robanon, and L'Océan. Though the fights appear to have taken place indoors, in the Salle Montesquieu and the Salle Valentino, Courbet painted his figures in the Hippodrome, i.e. in an outside setting. On the *Wrestlers* and its place in nineteenth-century art history, see Herding (1977).

4. Courbet was to exhibit a painting of female nudes as well at the 1853 Salon, namely, the *Bathers* (F. 140).

5. The comte de Morny had bought the *Young Ladies from the Village* (F. 127) from Courbet sometime before it was exhibited at the 1852 Salon, which had opened on April 1. Courbet's visit no doubt was still related to this sale.

6. Auguste Romieu (1800–55) was director of the Fine Arts Administration from 1852 until his death in 1855.

7. Courbet is probably referring to *Young Ladies from the Village*, his most important work at the 1852 Salon.

8. Delacroix's opinion of Courbet, in fact, appears to have been ambiguous. Judging by his diary, he admired the artist's vigor but loathed the vulgarity of his subject matter (cf. Delacroix 1972, 292–93, 479–80).

9. Beginning in 1852, Courbet appears to have exhibited regularly in Frankfurt. His initial contact in Frankfurt probably was the painter Jules Lunteschütz, who had grown up in Besançon.

10. After the coup d'état of December 2, 1851, Max Buchon had gone into exile in Bern.

11. Urbain Cuenot* had been detained in Marseille (cf. letter 69-14), but apparently he had made a full retraction of all his writings and pronouncements that were offensive to the new government.

12. Penal colony in Algeria.

13. See letter 52-1, n. 5.

14. *Firemen Going to a Fire* (F. 118). On the political significance of this painting, see Adhémar (1977, 200–201).

15. Adhémar (1977, 201) suggests that Courbet was perhaps protected by the comte de Morny, who had recently acquired his *Young Ladies from the Village* (F. 127).

16. Urbain Cuenot; Adolphe and Tony Marlet;* Prosper Teste (1801–68), the mayor of Ornans; Bertin and Guyot, unidentified friends in Ornans; Edouard Ordinaire.*

To his family [Paris, October 15, 1852]

[No salutation]

I was supposed to leave a month and a half ago, when an unexpected adventure happened to me. Some fellow came to write my biography,[1] which was almost three weeks' work. I had to review and explain all the paintings that I had done in my life and all the phases I went through to get where I am now, which was a terrible job and not very amusing, but very important as you will see and as I will explain to you more at length.

I have also decided to do nothing but nudes for the next Exhibition. I have done [a] lifesize [painting of] *Wrestlers* [F. 144], and have just started another painting, which is half done,[2] so that I will have very little to do in Ornans this year. If I have stayed in Paris so long, it has not been entirely by choice. I still have to work today and tomorrow, Saturday. On Sunday it will dry a little. I think I'll leave on Monday, unless something extraordinary happens. I am very anxious to be in Ornans. I am exhausted, especially in spirit. I sent some new paintings to Frankfurt.[3] Had I been able to leave earlier I would have gone to see Buchon* in Switzerland. Now it is too late. I see that Français,* whom I sent to you, has made quite an impression in Ornans. He is a charming boy. Alphonse Promayet* sends you his best regards. I embrace you all and look forward to seeing you.

<div align="right">

Gustave Courbet

</div>

Best regards to Urbain and Adolphe from both Alphonse and me.[4] If I have not written them it is so that I'll have more to tell them.

[Address] Monsieur Courbet, landowner
 Ornans, Doubs Dept.
[Postmark] Paris, Oct. 15, 1852

1. This must have been Théophile Silvestre,* whose biography of Courbet was to appear in the author's projected *Histoire des artistes vivants, français et étrangers, peintres, sculpteurs, architectes, graveurs, photographes: Etudes d'après natures.* Silvestre's original plan was to publish, in installments, a series of about one hundred illustrated artists' biographies. Two formats were anticipated—in-folio with photographs and in-quarto with wood engravings made after the photographs. The price per fascicle was twenty francs for the large version, one franc for the small one. In the end only about ten fascicles were issued, including one devoted to Courbet (copy in Paris, Bibliothèque nationale, G 1479). It includes a portrait photograph of Courbet by Victor Lainé and E. Defonds in addition to photographs of the *Young Ladies from the Village* (F. 127) by Edouard-Denis Baldus and the *Bathers* (F. 140) by Victor Lainé and E. Defonds. See Daniel (1991, 295–96, n. 168; additional information was obtained from Dr. Daniel in a telephone conversation on June 14, 1991). Silvestre's text may be found in Silvestre (1856) and Courthion (1948–50, 1:25–62).
2. Probably the *Bathers* (F. 140).
3. Courbet had earlier sent his *Burial* (F. 91) and *Self-Portrait* (F. 39?). Compare letter 52-3. It is not known which paintings he sent this time.
4. Urbain Cuenot;* Adolphe Marlet;* and Alphonse Promayet.

53-1　　*To Adolphe Marlet [Paris, January 1853 (?)]*

My dear friend Adolphe:

I was getting worried about my paintings in Frankfurt. Dr. Goldschmidt* has just set my mind at ease with a very kind letter. He tells me that my paintings arrived in good order and that in the artistic and intellectual world they have caused the same sensation as the first ones. The second exhibition, however, has not produced much money. The expenses were enormous, the transportation alone amounted to eighty florins. It also has to do, according to him, with the nature of the subjects.[1]

I cannot resist the pleasure of telling you some details from this letter. It seems that in Frankfurt, as in Paris, I have formidable detractors and supporters. The arguments were so violent that they felt compelled to place a sign with the following words in the Casino: "In this club it is forbidden to talk about the paintings of M. Courbet." At the house of a very rich banker, who had invited a large company for dinner, each guest found in the fold of his napkin a small note on which was written, "Tonight we will not talk about M. Courbet." When he sends me the reviews of the newspapers that talk about me, I'll pass them on to you.

Prince Gorchakov (what a name, for Pete's sake), the Russian ambassador, has been asking to buy my [self-]portrait for some time already.[2] They are asking me what price I want for it.

In the spring the exhibitions will continue in Vienna and Berlin, where these paintings are in demand. When I have more news, dear friend, I'll let you know. Kind regards on my behalf to Arthaud* and to Fidancet [?], as well as to Chopard.* My best to your lady. With an embrace,

<div align="right">

Gustave Courbet

</div>

1. Courbet apparently organized two successive exhibitions of his work in Frankfurt, in late spring 1852 and winter 1852–53. In the first, he showed the *Burial* (F. 91) and a self-portrait, probably the *Self-Portrait with Pipe* (F. 39). It is not known which works were shown in the second exhibition.

2. Aleksandr Mikhailovich Gorchakov (1798–1883) was a Russian diplomat who at that time served as the ambassador in Stuttgart. Courbet probably did not deal directly with Gorchakov but with the latter's friend and artistic adviser, the Belgian dealer Arthur Stevens.* Gorchakov did not buy the *Self-Portrait with Pipe*, which later was acquired by Bruyas.

53-2　　*To the comte de Morny [Paris, May 13, 1853]*

Monsieur le Comte:

Allow me to ask you a favor that I hope you will not refuse.

M. Théophile Silvestre will be publishing a book, *Les artistes vivants* [living artists], in which I am to be included.[1] The book will be illustrated with photographs after the original paintings of painters, sculptors, etc., all

contemporary. [In it] M. Silvestre would like to reproduce the *Young Ladies from the Village* [F. 127] twice, by photography and wood engraving. I am certain in advance of your courtesy in authorizing this.[2] As the book is to appear during the Exhibition, I would be obliged if you would be so kind as to have an answer for me as soon as you can. This is the formula that was given to me by him:

"I authorize Monsieur Théophile Silvestre to reproduce by means of photography and wood engraving the *Young Ladies from the Village*, of which M. G. Courbet is the author and I am the proprietor. Paris, the . . . , etc."

With heartfelt compliments, I am,

Sincerely yours,

<div align="right">G. Courbet</div>

M. Martinet told me that in order to receive the balance of what is owed me for the painting,[3] I was to speak to your secretary, to whom he had given my bill. Please be so kind as to let him know that I will stop by his office one of these days.

[Address] Monsieur le Comte de Morny
 Rond-point des Champs-Elysées
 Paris

[Postmark] May 13, 1853

1. 52-4, n. 1.
2. The comte de Morny had bought the *Young Ladies from the Village* in 1852.
3. Probably Louis Martinet,* who may have served as an intermediary in the sale of the painting to the comte de Morny.

To his family [Paris, May 13, 1853][1]

<div align="right">53-3</div>

Dear family:

It has taken me forever to write you, because my life here is a continuous tribulation—comings, goings, visits, in short, I am in a fluster. My paintings were accepted a few days ago by the jury without any objection at all.[2] I was considered to have been accepted by the public and above being judged. They have finally left the responsibility for my works to me. I am gaining ground every day.

All of Paris is getting ready to see them and to hear the noise that they'll make. I have just heard from Français* that they have been very well placed. The *Spinner* [F. 133] has the most followers. As for the *Bathers* [F. 140], it appalls a little, even though, after you saw it, I added a bit of drapery to the buttocks. The landscape of that painting is generally admired. As for the *Wrestlers* [F. 144], so far it is neither well nor ill spoken of. M. de Morny* lent me the frame of the *Young Ladies of the Village* [F. 127], which saved me two hundred francs.[3] I have been offered two thousand francs for the *Spin-*

ner.[4] I have not given it up for I hope to get at least three thousand for it, depending on how things look. I am taking a chance. I have lately sold a small *Landscape of the Essart-Cendrin* [F. 80], of one foot square, for two hundred francs to M. Demandre,[5] an ironmaster from our part of the world.

It seems that Urbain* is preparing to come to Paris soon. We will be very pleased to see him. Alphonse[6] told me that he would come in the course of this month. The Exhibition opens on Sunday the fifteenth (the day after tomorrow). As I have received no letters from you for a long time, I assume that you are all well. I learned with sorrow of the death of mère Promayet,* and Alphonse was devastated. Please send my condolences to père Promayet. Tell him that I felt for him, in the calamity that grieves him.

I'll write you again when I have some news. For the moment I know nothing more than that the biographical sketch that Silvestre did on me will be appearing soon.[7] We have been very busy these days having photographs done of the *Wrestlers*, the *Spinner*, the *Bathers*, as well as my portrait. There is nothing as difficult as those processes. We had three or four photographers give it a try and they could do nothing.[8] My portrait is splendid.[9] When I get prints of it, I'll send you some, along with those of my paintings.

Kind regards to the people who take an interest in me. As for you, I embrace you all. I no longer see Joseph Boulet,* I don't know whether he is in Ornans. Embrace Urbain, until we see him here.

G. Courbet

1. The date of this letter has been derived from Courbet's remark that the Salon is to open "the fifteenth (the day after tomorrow)." As the Salon of 1853 opened on May 15, Courbet's letter must have been written on the thirteenth of that month.

2. Courbet had submitted three works: the *Wrestlers* (F. 144), the *Bathers* (F. 140), and the *Spinner* (F. 133).

3. Since the *Wrestlers* had the same dimensions as the *Young Ladies of the Village*, bought the year before by the comte de Morny, Courbet had asked the count whether he could temporarily borrow his frame.

4. Probably by Alfred Bruyas,* who eventually bought the painting.

5. The ironmaster Charles Demandre or de Mandre, according to Fernier (1977–78, 1:48), lived in the château de la Chaudeau in the Haute-Saône Department. The painting is still in the collection of the Demandre family.

6. Probably Alphonse Marlet.*

7. Compare letter 52-4, n. 1.

8. These photographs were intended as illustrations for Silvestre's essay on Courbet that was to appear as one of the first installments in the author's *Histoire des artistes vivants*. Due to various problems, including probably the technical difficulty of photographing large paintings, only the *Demoiselles du village* and the *Bathers* were reproduced in the Courbet issue (cf. letter 52–4, n. 1). Besides Baldus and Lainé and Defonds, who photographed those two paintings, it is not known who were the other photographers engaged in making the photographs of Courbet's paintings.

9. The portrait photograph by Lainé and Defonds.

To Champfleury [Paris, June-July 1853]

My dear friend:

I am afraid my letter will come too late. I have just arrived from Louveciennes and Bougival, where I stayed for two days.[1] I wanted to go bathing again and I was sick again, just like the first time. I must definitely give up cold water. The doctors call that "a phenomenon," which explains nothing.

There is absolutely nothing new in Paris, the main topic of conversation is the Turkish war.[2] My friend Buchon's* poems are very successful in Paris.[3] I heard that the bookstore sells a lot of them.

Baudelaire,* whom I saw the other day, told me that he would oppose in your name the publication of one of your *chansons* in the *Almanach de Jean Raisin*, published by Bry.[4] He has just retrieved his own from Mathieu.* Mathieu had wheedled *La Mère Evrard* out of me,[5] which I retrieved as well, telling him that I felt it was inappropriate to show myself in a literary light when I have the reputation of a painter to uphold.

Bornibus has just screwed a woman of the world, apparently using my name.[6] Now things are turning sour and he does not know how to get out of it. The woman has just written him a perfumed but stinking letter, extremely insulting. Apparently the fake Courbet behaved badly. That man gives me a nice reputation! Silvestre* is still arguing in all the cafés, and when midnight comes around he is exhausted. Th. Gautier* has not deigned to talk of me in his Salon of this year,[7] [but] Nadar,* that so talented man whose ignorance is his strength, has squarely told me the truth.[8] I am saved and I have now firmly decided what I have to do. All is well.

I don't have to give you letters of recommendation for Frankfurt. Go see M. Lunteschütz* on my behalf (his address: painter, Frankfurt). Tell him to introduce you to Dr. Goldschmidt,* who is a very intelligent person, as is his wife. They are down to earth. He will also introduce you to five or six painters who came to see me the other day, painters in revolt. I would be very happy if you could get a clear answer to the question of the portrait, by presenting yourself to the Russian ambassador,[9] or, if you don't dare do that, ask M. Goldschmidt, for I have no news from Stevens.*

I think that you will like Frankfurt and Homburg, too, you'll get an idea of Germany. You'll have seen Switzerland and Buchon;[10] you'll have made a very productive and very pleasant trip.

Tell Buchon that I believe he should do whatever he can to get out of his position as an exile, which now becomes more ridiculous and meaningless every day. I think that I will be put in contact with M. Pietri, the police commissioner. I don't know what I will be able to do on that account. With a cordial embrace, for Buchon, too. I'll write him later.

G. Courbet

1. In Louveciennes, Courbet must have stayed with Francis Wey.

2. Courbet is no doubt referring to the unrest in Eastern Europe that was to lead to the Crimean War of 1854–56.

3. Probably the *Poésies complètes de J.-P. Hebel, suivies de scènes champêtres* (Paris, 1853).

4. The *Almanach de Jean Raisin, revue joyeuse et vinicole*, was founded by Gustave Mathieu c0014/565and published by Bry, 27, rue Guénégaud. The first almanach appeared in 1854. Two more volumes came out in 1855 and 1860.

5. Courbet had made a reputation among his friends for the folk songs that he composed, of which *La Mère Evrard* was perhaps the most famous. On Courbet as songwriter, see Léger (1947).

6. This is probably a reference to a story told by Champfleury and paraphrased by Lindsay (1973, 147), in which the publisher of Silvestre's book pretended to be Courbet to a lady admirer of the artist. After the publisher seduced her, the affair went sour.

7. Gautier's Salon review appeared in *La Presse* in two installments. His scathing critique of Courbet's paintings at the 1853 Salon, the *Bathers* (F. 140), the *Wrestlers* (F. 144), and the *Spinner* (F. 133), was not to appear until July 21.

8. Nadar produced numerous caricatures with reference to Courbet's 1853 Salon paintings in the *Journal pour rire* (cf. Léger 1920, passim).

9. The Russian ambassador in Stuttgart, Aleksandr Gorchakov, had offered to buy Courbet's *Self-Portrait with Pipe* (F. 39). See also letter 53-1, n. 2.

10. Max Buchon was still in exile in Bern. He was not to return to France until 1856.

53-5 *To Alfred Bruyas, Paris, June 18, 1853*

[No salutation]

With great regret I must ask you to please postpone the sitting until Tuesday morning.[1] I fear I am taking advantage of your great kindness.

With my warmest and most affectionate regards, I am,

Cordially yours,

Gustave Courbet

Paris, June 18, 1853

If the weather is bad tomorrow you could still come because we wouldn't be able to go to the country.

1. Alfred Bruyas,* who had bought Courbet's *Bathers* (F. 140) and the *Spinner* (F. 133) at the 1853 Salon, also commissioned Courbet to do his portrait (F. 141).

53-6 *To Alfred Bruyas, Ornans [October (?) 1853]*[1]

[No salutation]

I am horribly rude to you, dear friend, but you will forgive me when you know that I am slaving away. I left Paris a few days after I enclosed a note for you in the letter Silvestre* wrote you. When I arrived in Ornans I was forced to go on business to Switzerland, to Bern and Fribourg.[2] That was annoying

and it has delayed the paintings on which I wanted to start working. I was the more annoyed [as it occurred to me] that, had I come to see you, I would have spent the same amount of time and it would have been more useful and more pleasant.

My good friend, I received with the greatest happiness your letter full of affection and courage. Courage is necessary. I have burned my bridges, I have broken openly with society, I have insulted all those who have put a spoke in my wheel. And now, here I am, alone, facing that society. It is win or die. If I am defeated, it will cost them dearly, I swear to you. But more and more I sense that I will triumph, for we are two and the times being what they are, to my knowledge, perhaps only six or eight, all young people, all hard workers, who have all arrived at the same conclusions by different means. My friend, it is the truth, I am as sure of it as I am of my own existence. In a year there will be a million of us.

I want to tell you something that happened: before I left Paris, M. de Nieuwerkerke,* director of the Fine Arts Administration, had me invited to lunch, on behalf of the government.[3] And for fear that I might refuse his invitation, he had picked as his ambassadors M. Chenavard* and M. Français,* two self-satisfied medal-recipients.[4] I must say to their shame that they were acting for the government with regard to me. They tried to mollify me and supported the views of the Director. Obviously they would have been pleased if I had sold myself as they had. After they had implored me to be what they referred to as "a good boy," we went to lunch at Douix, at the Palais-Royal, where M. Nieuwerkerke awaited us. As soon as he saw me, he rushed towards me and shook my hands, exclaiming that he was delighted that I had accepted, that he wanted to be frank with me, and that he was not concealing the fact that he had come to convert me. (The other two exchanged glances that said, what a blunder, he just has spoiled everything.) I replied that I was already converted but that, if he were able to change my way of seeing, I asked nothing better than to learn. He went on to tell me that the government grieved to see me go my lonely way; that I should change my ideas, water my wine; that everyone was entirely on my side; that I mustn't be contrary, etc.—all kinds of nonsense like that. Then he ended his introductory address by telling me that the government wanted me to do a painting worthy of my talent for the Exhibition of 1855; that I could take his word for it; and that he would stipulate that I present a sketch and that when the painting was finished, it be submitted to a committee of artists that I would choose, and to a committee that he would choose on his end.

You can imagine into what rage I flew after such an overture. I answered immediately that I understood absolutely nothing of what he had just said, first, because he was stating to me that he was a government and because I did not feel that I was in any way a part of that government; that I too was a

government and that I defied his to do anything for mine that I could accept. I went on to tell him that I considered his government to be nothing but a private person; that, whenever my paintings might please him, he was free to buy them; and that I asked him but one thing, that is, to leave art its freedom in his exhibition and not to support, with a budget of three hundred thousand francs, three thousand artists against me. I went on to tell him that I was the sole judge of my painting; that I was not only a painter but also a human being; that I had practiced painting not in order to make art for art's sake, but rather to win my intellectual freedom, and that by studying tradition I had managed to free myself of it; that I alone, of all the French artists of my time, had the power to represent and translate in an original way both my personality and my society. At that he replied, "M. Courbet, you are quite proud." "I am amazed," I told him, "that you are only noticing that now. Sir, I am the proudest and most arrogant man in France." That man, perhaps the most inept I ever met in my life, was looking at me with a bewildered expression in his eyes. He was all the more dumbfounded as he must have promised his masters and the ladies at court that he would show them how one buys a man for twenty or thirty thousand!

He asked me again if I would not send something to the Exhibition. I answered that I never entered competitions because I did not acknowledge any judges; but that it might happen that I would send them, as an act of cynicism, my *Burial* [F. 91], which constituted my debut and my statement of principles; that they should deal with that painting as best they could; but that I hoped to have the honor of organizing on my own (perhaps) an exhibition rivaling theirs, which would earn me forty thousand francs, an amount that I would certainly not earn with them. I reminded him also that he owed me fifteen thousand francs for the admissions that they had collected with my paintings in previous exhibitions, as the employees had assured me that each of them had shown the way to my *Bathers* [F. 140] to two hundred persons daily. To that he replied the following nonsense, that "those people did not come to admire them." It was easy for me to reply by challenging his personal opinion, and by telling him that that was not the issue. Whether out of criticism or out of admiration, the truth was that they had paid the admissions and that half the reviews in the newspapers referred to my paintings.

He went on to tell me that he was quite unhappy that "there are people like you in the world"; that they were born to destroy the finest organizations; and that I would be a striking example of that. I started to laugh till the tears came to my eyes and assured him that only he and the academies would be the victims of that.

I dare not tell you more about that man, I am afraid of boring you too much. To conclude, he finally left the place, leaving us just standing there in the dining room. He was on his way out the door, when I grasped his hand

and said, "Sir, please rest assured that we are friends as before." Then I turned to Chenavard and Français and asked them also to please rest assured that they were two idiots. After that we went out to have a beer.

Here is another remark from M. de Nieuwerkerke that comes to mind: "I hope, Monsieur Courbet," he told me, "that you will have no grounds for complaint: the government is certainly flirting with you. Nobody will be able to boast of that as much as you. Please note that it is the government and not I who invites you to lunch today. So that I am accountable to the government for a lunch." I wanted to pay him back but that made Français and Chenavard very angry.

You see, my dear friend, that the way is open to us and that we can give ourselves up to our independence with full knowledge of the facts.

I am working furiously here. I have five or six paintings going, which will be finished in the spring. So you see that even when I do not write, I think of you. I am delighted that you are relying on me, I won't fail you, be sure! Allow me that honor, for I offer you as a guarantee a hatred of men and of our society that will die only when I do. And as that is only a matter of time, you are more important than I. You have in your hands the means that I have always lacked and will always lack. With your background, your intelligence, your courage, and your financial means you can save us in our lifetime and allow us to enter a new era.

Sacrifice everything to restore your health. Rest and don't make any effort, even verbally. From now on you must cultivate an attitude of confidence. I will finish what I have undertaken as soon as I can and on my return to Paris I'll come to see you in Montpellier, if you are still there. If you are in Paris, we'll go together to look for your gallery, if we decide to set up an exhibition. I cannot send you my *Bathers*, for they are in Paris in my studio.

If you have time, write me. I apologize to you for all this babbling, which could tire you, and I am your very devoted friend.

With repeated greetings,

Gustave Courbet

Ornans (Doubs)

I received a letter from Champfleury,* who tells me that Silvestre is suing his partners about the wood engravings.[5] I am afraid that he has bitten off more than he can chew. That doesn't matter, we'll do it some other way.

1. This letter has been variously dated in 1853 (Grimmer 1951, 4–6; Paris 1977, 30) and 1854 (Borel 1951; Mainardi 1987, 58), but it was doubtlessly written in the early fall of 1853, when the luncheon with the comte de Nieuwerkerke, described in the letter, must have taken place. An imperial decree of June 22, 1853, had set forth the plans for the International Exhibition of 1855. Under the decree, the Salon of 1854 would be postponed to coincide with the International Exhibition, which was to have a large section devoted to the fine arts. Between June 22 and December 29, when the first meeting of the Imperial Commission for the fine arts

section was to take place, Nieuwerkerke apparently wished to assure himself of the participation of certain key artists, such as Courbet. Hence, his luncheon with Courbet must have taken place sometime between June and December. Bruyas, in his notes, has dated Courbet's letter ca. October 1853 (cf. Montpellier 1985, 120–21).

2. Perhaps to visit Max Buchon.*

3. On the significance of this luncheon in view of the cultural politics of the Second Empire, see the essay by Albert Boime in Weisberg (1982, 107–110). See also Mainardi (1987, 57–59). It must be noted that the comte de Nieuwerkerke was not director (cf. letter 52-3, n. 5) but "superintendant" of the Fine Arts Administration, a title that had been newly created for him.

4. Both Chenavard and Français had been named knights in the Legion of Honor in July of 1853.

5. Probably the wood engravings that were to illustrate the *Histoire des artistes vivants*. Compare letters 53-2 and 52-4, n. 1.

53-7 *To Francis Wey [Ornans, December 22? 1853]*[1]

My dear Wey:

You have just been appointed chief archivist of the French Empire and you don't tell me about it![2] To think that some people complain that painters do not write! I write you nonetheless for I have something to ask you— something to which I attach great importance—if it is within your power and ability. In a word, is it within the jurisdiction of the inspector of departmental archives to have those of the departments, cantons, and municipalities put in order? If the Doubs Department is under your authority and if it is necessary to increase the number of people employed in those archives, I would rec- ommend to you Adolphe Marlet,* who would be very interested in working there. As for his ability, in addition to literary and general studies, which go back some time, he has devoted himself for the last three or four years to a complete and careful study of the title deeds of the town of Ornans and is planning to publish his findings this very year in a book of historical research on the city and Le Château d'Ornans. If you had an important task for him, he would devote himself to it exclusively and would be entirely loyal to you. My friend Marlet, who is my oldest friend, is a very lovable chap, even though he is married to a very pretty wife,[3] of M. Grand's [?] family. Besides that, he is a man on whom you can count, otherwise I would not recommend him to you. He is a very well-educated man who can carry out in a superior fashion whatever task he might be charged with of this kind. Now you see what it means, my dear friend, to be in power and to control human destinies!

I will try to earn forgiveness for the first part of my letter by giving you a little of my news, though it is not necessarily very interesting. First, I went to Switzerland, to Bern and Fribourg. I went there to see a refugee and some blue-stockings with very progressive ways.[4] My trip lasted three weeks. Back in Ornans I have painted some landscapes[5] [that are] not bad, and have

started two paintings that are intended to continue my "highway" series and the *Young Ladies from the Village*.[6] Later I will give you descriptions of the latter paintings, which at this point are still in the sketching stage. I also took up my *Return from the Fair* [F. 107] again, which I have made three feet wider in order to correct the error in perspective there was in it.[7] I had also begun a life-size statue representing a *Fisher of Bull-Heads* [Fs. 1] for the public fountain that is across from our house.[8] I couldn't go on with that project because my atelier does not allow me to have anyone pose in the nude in winter, something I had not thought about. After having begun all those fine things, I turned to fine things of a different kind: I went hunting and beat our mountains for game, up hill and down dale, in waist-deep snow. We killed quite a few hare and also three wolves. I would have sent you a hare but it isn't worth the trouble, and you wouldn't know what to do with a wolf. We had quite a few hunters' dinners, which are quite pleasant, and I was arrested by the police, which provided me with an opportunity to spend three days in Besançon. My fine cost me one hundred francs [and] lost time but I sold a painting for four hundred francs to M. de St. Jean.[9] I am definitely a believer in M. Azaïs's system![10] In the spring I will be obliged to go to Montpellier to M. Bruyas, who commissioned me to do some painting, so I won't be in Paris until the beginning of summer.

I am very thirsty for news. Tell me about everything except the war. Give me news of Mme Wey, her health, your work, your prosperity, the position you have obtained, which you deserved more than anyone else and which has given me the greatest pleasure. My sincere congratulations.

I always have the most pleasant memories of you, dear friends. I embrace you. Please give my best to all your friends who are mine as well.

Gustave Courbet

I keep forgetting to tell you that I was master of ceremonies at a ball opposing the priest, a ball that was most successful. We were more than one hundred people. Can you see me as a master of ceremonies? Small-town affairs are always very amusing.

1. This letter is known through a copy only. This copy is dated December 22, 1854, but that date does not fit the content of the letter, which must have been written in the fall of 1853. The indication of month and day may be correct.

2. Wey had been appointed chief inspector of departmental archives in France in 1852.

3. Adolphe Marlet had been married in 1849 to Jeanne-Marie-Irma Coignet (cf. Ornans 1981, 61).

4. In Bern, Courbet had visited Max Buchon,* still in exile there.

5. Probably the *Château d'Ornans* (F. 173), the *Stream of the Puits noir* (F. 174), and the *Roche de dix heures* (F. 156?). All three paintings were exhibited at the 1855 Universal Exhibition. About the problematic identification of F. 156 with the painting that was exhibited as the *Roche de dix heures* in 1855, see Paris (1977, 139–40).

6. Up to this point, Courbet's "highway" series consisted of the *Stonebreakers* (F. 101) and

the *Return from the Fair* (F. 107). The next painting he was planning in this series was a *Gypsy Woman with her Children* (cf. letter 54-1), but the work was never executed. Years later, however, the motif of the gypsy woman was incorporated in the *Alms from a Beggar at Ornans* (F. 660). Compare Chu (1980a, passim).

The *Young Ladies from the Village* was conceived as part of a series of paintings depicting local customs in the Franche-Comté. The painting Courbet was working on, the *Grainsifters* (F. 166), was intended as its sequel.

7. As is clearly visible today, Courbet attached a strip of approximately thirty centimeters to the right side of the painting, reworking the entire side (cf. Paris 1977, 130–31).

8. The house in the Iles-Basses quarter of Ornans, where Courbet had his studio.

9. Both the collector and the painting he bought are unknown.

10. Pierre-Hyacinthe Azaïs (1766–1845) made his reputation with a three-volume philosophical work, *Des compensations dans les destinées humaines*, in which he argued that misery and happiness alternate and that, in the total of human experience, there is a balance between them.

54-1 *To Alfred Bruyas [Ornans, January 1854]*

Dear friend:

If it has taken me a while to answer you, it is the fault of the police. I had gone out hunting—my head was spinning, and I needed to get some exercise. The snow was splendid, but happened to be off limits [for hunters].[1] On my return to town they gave me a summons, which caused me to lose three days, for I had to go to Besançon to hear myself sentenced and to avoid jail. Hurrah for liberty!

You have been most kind to send us candy. Ever since then, my sisters, who have rather a sweet tooth, never weary of looking at your portrait.[2] As for me, I am delighted with your photographs,[3] I am having them matted. I am even more delighted with the prospect of visiting you and of working in Montpellier.[4] I accept all your offers with pleasure and will see about finding out what happened to my portrait and whether it still belongs to me.[5] I am anxious for you to have it.

So we will lay our plans and proceed to this great burial.[6] You have to admit that the role of gravedigger is a fine role, and that sweeping the earth clean of all that rubbishy jumble is not without its charms. Forty thousand francs, it is a dream!

At this point we have to rent a site from the city of Paris, opposite their big exhibition.[7] I can see it here already: an enormous tent with a single column in the middle, walls made of wooden frames covered with painted canvas, all mounted on a platform. Then, hired municipal guards, a man in a black suit in the ticket office, opposite him the walking-sticks and the umbrellas, and two other attendants in the exhibition space.

I believe that we will earn those forty thousand francs, even though we are speculating in nothing but hatred and envy.

Subject to change, this is the title:

"Exhibition of paintings by master Courbet from the Bruyas collection."[8]

This is really something that will make Paris stand on its head. We will undoubtedly be responsible for the most powerful piece of theater to be performed in our time. It will make some people's stomachs turn, I am sure.

I have taken up once more my *Return from the Fair* [F. 107], which was missing many things and had a faulty perspective. I have also made it larger by a fourth.[9] I just finished a small replica of it for a collector in our area.[10] In addition, I have sketched in two other paintings that I will finish forthwith. The first will be the *Grainsifters* [F. 166], the second—I believe I have already mentioned it to you—is a painting that will form part of the "highway series," a sequel to the *Stonebreakers* [F. 101]: it is a *Gypsy Woman and Her Children*.[11] I also have three landscapes in the works.[12] I will give you a more complete description of all that in the next issue. I am sending you a piece written about me by a fellow from our region.[13] Tell me what you think of it and whether you find it appropriate. If it is worth the trouble, you could lend it to Silvestre.[14]

With a cordial embrace,

Sincerely yours,

Gustave Courbet

You had written "postage paid" on the address label of your package. I believe the parcels office made a mistake. In order not to pay double, I asked the supervisor for a receipt, for I had to pay 46.75 francs and I was told to file a complaint in the Montpellier office.

If you know the address of Stevens,* the art dealer, please write it to me.

1. Compare Riat (1906, 113).

2. Perhaps a photograph of Courbet's portrait of Alfred Bruyas (F. 141), painted in 1853.

3. Probably the photographs of two other works by Courbet acquired by Bruyas at the 1853 Salon: the *Bathers* (F. 140) and the *Spinner* (F. 141)

4. Courbet was to visit Bruyas in Montpellier from the end of May to the end of September 1854. During these four months, he painted several portraits and landscapes in addition to his famous painting, *The Meeting*, or *Bonjour, Monsieur Courbet* (F. 149.)

5. The *Self-Portrait with Pipe* (F. 39) had been exhibited in Frankfurt, where the Russian prince Gorchakov had expressed interest in buying it (cf. letter 53-1). This sale apparently did not materialize, and the painting was later acquired by Bruyas.

6. Reference to Courbet's plans for a private showing of his work, which would "bury" outmoded Romanticism and stale academism, an idea that Courbet subsequently was to express visually in his *Atelier* (F. 165), which in the foreground contains the castoffs of Romanticism—guitar, plumed hat, and dagger—and behind the easel the contorted body of a mannequin, emblem of academic painting.

7. The 1855 Universal Exhibition in Paris. The site that Courbet eventually hired was on the avenue Montaigne, not far from the fair building that was devoted to the fine arts.

8. In its final form the exhibition was called "Exhibition and Sale of 40 Paintings and 4 Drawings from the Oeuvre of Gustave Courbet." Bruyas did not financially support the exhibition but did lend a painting.

9. Compare letter 53-7, n. 7.

10. The whereabouts of this replica are unknown.

11. Compare letter 53-7, n. 6.

12. Compare letter 53-7, n. 5.

13. Perhaps a reference to the essay by Max Buchon* that was later to appear in his *Receuil de dissertations sur le réalisme* (Neuchâtel, 1856).

14. Théophile Silvestre* was a good friend of Bruyas and may, in fact, have been responsible for introducing Bruyas to Courbet.

54-2 *To Alfred Bruyas [Ornans, May 3, 1854 (Bd)]*

My dear friend:

Yesterday my portrait arrived from Frankfurt:[1] I am delighted with it. It is not only my portrait but yours as well. I was struck when I saw it: it is an awesome element in our solution.[2] It is the portrait of a fanatic, an ascetic.[3] It is the portrait of a man who, disillusioned by the nonsense that made up his education, seeks to live by his own principles. I have done a good many self-portraits in my life, as my attitude gradually changed. One could say that I have written my autobiography.

The third to last was the portrait of a man in his death throes,[4] the next to last was the portrait of a man of ideals and absolute love[5] in the manner of Goethe, George Sand, etc.[6] Finally this one arrived. I have only one more to do, of a man confident in his principles, a free man.[7] I was forgetting the portrait photograph in the biography by Silvestre,[8] which, like the painting of the *Bathers* [F. 140], represents a curious phase of my life, namely irony. It is a man who succeeds in spite of wind and tide.

Yes, my dear friend, in my lifetime I hope to realize a unique miracle. I hope to live by my art all my life without having ever departed an inch from my principles, without having betrayed my conscience for a single moment, without having made a painting even the size of a hand to please anyone or to be sold.

I have always told my friends (who were frightened by my valor and feared for me), "Do not fear! If I had to travel the world over, I would be sure to find people who understood me. Were I to find only five or six, they would keep me alive, they would save me."

And I am right, I am right! I have met you. It was inevitable because it is not we who have encountered each other but our solutions.

I am delighted that you have my portrait. It has finally escaped the barbarians. It is a miracle, for in a period of utter poverty, I had the courage to refuse it to Napoléon, who offered the sum of two thousand francs, and later to Gorchakov in spite of pressure from the dealers.[9]

Dear friend, how difficult life is when one is true to one's beliefs. In this charming country of France, when a man reaches his goal, he does so like

that Greek soldier: dead. But as there is always something new under the sun, the words of the wise notwithstanding, we shall give them the example of two fellows who do not want to die.

I pray you, dear friend, do not be irritated any longer by those people. Now, in order to be true to our convictions, we must study them objectively and use them as they are, for the purpose of our task.

As for me, I confess that I look at human beings with curiosity, just as I look at a horse, a tree, or any natural object, that is all. Thus, I have not been angry for quite some time now. In that respect, I assure you, I have regained my tranquillity. I'll go even further, they have succeeded in making my happiness, for when I study them attentively, [I find that] the more I see of them, the more I encounter different phenomena, which fills me with joy and indicates to me their superiority to horses.

I am most grateful to you for everything you sent me: it is a token of your esteem and, more, of your sympathy, of which I am very proud. Yes, I have understood you and you have living proof of it in your hands: your portrait.[10]

I am ready, I am off to Montpellier. I will leave Ornans this coming Monday, stay one or two days in Besançon, and then I do not know how many days it will take to get to your place. There I will do whatever you want and whatever is necessary. I am impatient to leave, for I am delighted with this trip, with seeing you, and with the work that we shall do together. If anything changes, write me immediately on receiving this letter. You will still have time before my departure from Ornans. In any case, I will leave even if I do not receive an answer.

I shall bring you the portrait; I would have sent it to you before my departure but I am afraid of accidents. I embrace you warmly. See you soon, in ten or twelve days, I hope.

Gustave Courbet

Wednesday morning

1. Courbet's *Self-Portrait with Pipe* (F. 41) had been exhibited in Frankfurt in the late spring of 1852 and perhaps again in the winter of 1852–53.

2. The term "solution" (*solution*) apparently was very significant to Courbet and Bruyas. It is a vague term that has been alternately explained as a catchword in the relationship between the two men without a mutually agreed-on, precise meaning (Paris 1977, 120), as an equivalent of Cézanne's *réalisation* (Gläser 1928, 88), or as a word that simply referred to the fact that each one held the solution to the goal of the other (Rubin 1980, 13). Bruyas himself, in a brief printed essay entitled "Solution: Confession of Faith" (*Solution: Confession de foi*), advanced the following: "Pretension on pretension—let us be above all in the world, the expression of truth. Duty and goodness must be morally [identical with] that truth, which in turn will be God to us. But seek God, alas! He is, unfortunately, unattainable . . ." (Paris, Bibliothèque d'art et d'archéologie, autographs, folder 42, *amateurs*). Following the tenor of this statement, the term "solution" may perhaps be explained in an alchemistic sense as the solution of elements that leads to the "stone," the truth, or God. This would explain Courbet's use of the term "element" in the first paragraph of this letter.

3. The word in the original text is *assête*. Hélène Toussaint (Paris 1977, 97) has interpreted this as *estète* (aesthetic), but Courbet doubtlessly intended *ascète* (ascetic). Compare also Haedeke (1980, 267, n. 22).

4. The *Wounded Man* (F. 51), probably painted in 1844. On the problems related to the date of this picture, see Paris (1973, 9–10).

5. The *Man with the Leather Belt* (F. 93), probably identical to the *Portrait de M. XXX*, submitted to the Salon of 1846, and to the self-portrait that was exhibited at Courbet's private exhibition of 1855 as *Portrait d'auteur: Etude des Vénitiens* (cf. Paris 1973, 3–4; Paris 1977, 89–90).

6. The references to Goethe and George Sand point to a possible identification of the *Wounded Man* and the *Man with the Leather Belt* with characters in these authors' books. Perhaps the *Wounded Man* conveys the spirit of Goethe's *Werther*, while the *Man with the Leather Belt* may have been inspired by a character in one of Sand's early Romantic novels on Italian subjects.

7. Presumably, this idea was realized in the *Self-Portrait with Striped Collar* (F. 161), painted during Courbet's stay with Bruyas in the summer of 1854 and acquired by the latter for his collection. It was this portrait that served as the prototype for Courbet's self-portrait in the *Atelier* (F. 165).

8. This photograph of the artist by Victor Lainé and E. Defonds (Paris, Bibliothèque nationale, Cabinet des estampes) had been commissioned by Théophile Silvestre* for his *Histoire des artistes vivants* (see letter 52-4, n. 1).

9. Napoléon III saw the painting at the International Exhibition of 1851 and placed it on his list of works to be acquired. In the end, he did not buy it, however, presumably because of financial restrictions (cf. Paris 1977, 96; and Fernier 1977–78, 1:24. Aleksandr Gorchakov, who at the time served as Russian ambassador in Stuttgart, had wanted to buy the painting when it was exhibited in Frankfurt (see letter 53-1).

10. Courbet's *Portrait of Bruyas* (F. 141) had been painted in Paris in the spring of 1853. It shows Bruyas standing by a table and leaning his hand on a book inscribed "Etude/ sur/ l'art moderne/ Solution/ A. Bruyas."

54-3 *To Zoé Courbet [Montpellier, mid-September 1854]*

My dear Zoé:

Try to marshal your thoughts, your head is spinning. There is no question that, if you believe that strongly in cholera, you are sure to get it.[1] Cholera attacks only those who want it. If you take care of yourself you don't get it. You should not eat fruit, or very little; do not get a chill; and when you feel the first symptoms, take care of it immediately. Usually it manifests itself in cramps and diarrhea. Take at once twelve drops of laudanum in a linseed enema. That will almost immediately stop the diarrhea. In Montpellier twelve to fifteen hundred people have died and everyone has had cholera to a greater or lesser degree. I myself have just recovered from a bout. I stayed in bed for four or five days, I had some rubdowns, I took what they gave me, and I am completely cured. I have been working for a week and I go out to play mall every evening from four to seven o'clock in the evening. So that by the time

you get to Montpellier to take care of me, I'll be in Marseille, in Switzerland, or elsewhere. I won't be leaving for a few more days, for Bruyas* has commissioned another portrait from me.[2] It seems that those fraudulent priests of yours are filling you with panic terror and that their plan is to cause the deaths of you all. If you take part in all their mummeries, you'll likely establish the cholera in Ornans for good, for there is nothing as conducive to cholera as fear and stupidity.

Tell M. Proudhon[3] that I have been appointed knight of the rolling wood, a title that I won at the game of mall. I will bring it to Ornans, and tell him that I am very much counting on him to establish it in our part of the world, in fact, I am doing it for him. It is a game of skill and of strength too, that is played outside in the byways.

I won't be able to pass through Ornans on my way to Switzerland. From Lyon I'll go to Geneva, from Geneva to Bern, where I am impatiently awaited.[4] Urbain* wants to go hunting in Ornans, then to come back to fetch me in Bern. Please write him to stay put, especially as Champfleury* will be there as well. He has time to hunt.

You gave me the greatest pleasure by writing to me, you, Juliette,* and Father. I had Bruyas read your letters; they gave him the greatest pleasure. He wants to come see me when I am in Ornans. As for presents, my trunk is chock-full and, anyway, the South is more expensive than our part of the world, it is an uncivilized place.

When I am in Ornans I'll take you to Besançon in Father's splendid carriage (if it can make the trip) and there you can buy whatever you please. I urge you not to fear the cholera. Only poor people die, for they do not have the means to take care of themselves or to eat properly. I seem to witness from here your conversations about the cholera with Mme Bourdieu. Please send my regards to that dear lady since she wishes me to think of her.

So long, I'll write you from Switzerland. Bruyas sends his regards. Tell Father that he wants to pay me not only for the painting that I did for him but also for the time that I spent with him. The painting that I did for him[5] has made the greatest impression here, and his compatriots are dying with envy. I did him the kindness of refusing all commissions that I received, so that he might be the only one to have my paintings. I embrace you all. So long, I will leave for Switzerland as soon as I can. Stay well, take care of yourself. Kind regards to all my friends and acquaintances,

G. Courbet

1. A major cholera epidemic had hit France in 1854. Cholera was still a rather "new" disease in the 1850s, as the first pandemic did not reach Europe until the early 1830s. This would seem to explain Zoé's fear and Courbet's lengthy prescription for dealing with the disease.

2. Courbet painted two profile portraits of Bruyas during his stay in Montpellier in 1854 (F. 142 and F. 143). The order in which he painted them is not known.

3. Probably Léon Proudhon, a family friend, who is also mentioned in later letters (notably 55-6 and 55-8).

4. By Max Buchon, who lived in exile in Bern. See also letter 54-4.

5. Compare note 2.

<u>54-4</u> *To Max Buchon [Montpellier, September 13, 1854]*[1]

My dear Max:

Write Champfleury* to come. I will be in Bern,[1] I hope, on the tenth, the eighteenth, or the twentieth at the latest. But please, do not wait for me, don't hold me to a time. Don't worry, I will come see you. Sleep on your feet, on your butt, on your head, on your two ears, but, please, do not wait for me. When I arrive I will go to Mme Poiterlin,* who will tell me where you roost. If I arrive late, I will sleep at the Hôtel de la Poste.

Urbain* has no business in Ornans with this cholera going on.[2] As for hunting, he will spend forty or fifty francs to kill a lark or a partridge. Really, it is not worth the trip; he does not have the sense to stay where he is comfortable.

I would already be with you if Bruyas* had not commissioned yet another portrait.[3] You must be aware that, when opportunity presents itself, one must take advantage of it. As for your portrait, it is a good idea. You could write my sister to have it crated and sent to you. That would give me the greatest pleasure. I'll finish it for you.[4] Urbain, who cares about appearance, claims that you are about to train your hair from the nape of your neck onto your forehead.

Here there are setbacks in my love affairs.[5] Jealousy on the part of Camélia, a young girl from Nancy; denunciation of our outings; Rose in prison; Blanche will replace her; police inspector pissed off at Blanche; Blanche exiled to Cette; tears; visit to the prison; promise of love; a trip to Cette on my part; Camélia in prison; mère Cadet at her wits' end; mère Cadet in love with me; Nino, in anguish, takes a new lover; I am left with Rose. Rose wants to come with me to Switzerland, telling me that I can leave her where I wish. My love does not go so far as a trip with a woman. Knowing that there are women everywhere in the world, I see no point in dragging one with me. Besides, there is one who has been waiting for me in Lyon for fifteen months.[6] When I finish the portrait I'll go to Marseille to visit mère Blavet* and to buy some real mocha coffee for Urbain. From there to Lyon, to Geneva, and to Bern. Please write Champfleury on my behalf and tell him to come to Bern.

We'll take him to Ornans and then we'll have a lot to talk about together. I will bring you a photograph of my [*Self-*]*Portrait with Pipe* [F. 39]. Adieu, I look forward to seeing you again! My respects to Mme Poiterlin. Urbain has no business in Ornans.

<div style="text-align: right;">

G. Courbet

</div>

I forgot to tell you that I have just had a bout of cholera. I was in bed for four or five days; I took all the St. John's wort I could; and I have recovered. Actually the only people who die are those who do not take care of themselves and the poor; this illness has lost many of its characteristics and much of its intensity. In Montpellier about sixteen hundred people have died. Now it is over and I am all the better for it for I have lost some weight—I had become disgusting. Ever since they have purged me, I digest better. When the cramps begin one takes twelve drops of laudanum in a linseed enema. That stops the diarrhea almost immediately. See you.

I have received a letter from the *Revue*.[7] Cuenot* is leaving today, the thirteenth, in spite of this letter, which I send you for your edification. I am still waiting for your news. Lots of greetings to everyone.

1. Max Buchon* was still in exile in Bern, when Courbet wrote him this letter in September, at the end of his stay in Montpellier. The letter's exact date is mentioned in the last paragraph, where Courbet refers to "today, the thirteenth."
2. Compare letter 54-3, n. 1.
3. See letter 54-3, n. 2.
4. Before Buchon's exile to Switzerland, Courbet apparently had begun his portrait (F. 164), which he now promised to finish in Bern. The work, in fact, is dated 1855.
5. Apparently a reference to his adventures in a local brothel.
6. See also letter 54-7, in which Courbet refers to this woman as "a Spanish lady." She may be the woman Courbet portrayed in a painting dated 1855 and exhibited at the International Exhibition of that year as *A Spanish Lady* (F. 170).
7. Probably the *Revue des deux mondes*, which in June and October 1854 published two of Buchon's stories. Compare letter 54-7, n. 2.

To Mme Balloy [or Villoy], Montpellier, September 18, 1854 <u>54-5</u>

<div style="text-align: right;">

September 18, 1854—Montpellier

</div>

Madame Balloy [Villoy?]

I am grateful to you for wanting something from me. You are right and within your rights, for you deserve it. My painting addresses itself only to people of feeling.

<div style="text-align: right;">

G. Courbet

</div>

I regret I can offer you only a photograph of my portrait.[1]

1. The *Self-Portrait with Pipe* (F. 39).

54-6 To the comte de Nieuwerkerke [Ornans, November 1854][1]

Monsieur le Directeur:

I would like to send to the 1855 Exhibition,[2] if possible:

Paintings[3]

	Number	Length	Height
1.	1 canvas	7 meter	4 meter
2.	1 ———	6 m	4 m
3.	1 ———	2.50 m	1.80 m
		Standard Measurements	
4.	1 canvas of	60	
5.	1 ———	40	
6.	1 ———	40	
7.	1 ———	25	
8.	1 ———	12	
9.	1 ———	8	
10.	1 ———	8	

Gustave Courbet

Paris, 32 rue Hautefeuille[4]

1. The date of this letter is based on an announcement in *L'Artiste* of April 15, 1854, p. 94, informing artists that they must send to the Imperial Commission a list of the paintings they wish to exhibit. The deadline for the submission of such lists is November 30, 1854 (cf. Mainardi 1987, 206, n. 27).

2. The Universal Exhibition of 1855.

3. The works may be identified as follows: (1) *The Atelier* (F. 165); (2) *A Burial at Ornans* (F. 91); (3) *The Stonebreakers* (F. 101); (4) *The Young Ladies from the Village* (F. 127); (5) *The Grainsifters* (F. 166); (6) *The Meeting* (F. 149); (7) *The Stream of the Puits Noir, Valley of the Loue* (F. 174); (8) *Le Château d'Ornans* (F. 173); (9) *Self-Portrait with Pipe* (F. 39); (10) *Portrait of Champfleury* (F. 172).

4. This last line, which is not in Courbet's handwriting, replaces another one that has been crossed out, which reads, "Ornans, Doubs."

54-7 To Alfred Bruyas [Ornans, November–December 1854]

My dear friend:

I received your letter with much pleasure. You can count on me every time. When I have made up my mind to love someone, it is for life! You are my friend, you cannot doubt that, and I have done justice to your intelligence every time. The people who feel and love on this earth are so unique that you could not escape me.

I have been in a great deal of turmoil since I left you. My life is so difficult that I am beginning to believe that my moral faculties are wearing out. Behind the laughing mask that you are familiar with, I hide, deep down, grief, bitter-

ness, and a sorrow that clings to the heart like a vampire. In the society in which we live, one does not need to make much of an effort to find emptiness. There really are so many fools that it is discouraging, to the point that one is afraid to cultivate one's intelligence for fear of finding oneself in absolute solitude.

When I left you I still had a trace of cholera. In Lyon I fortunately met a Spanish lady whom I knew.[1] She recommended a remedy to me that has radically cured me. From there I went to see my friend Buchon, who is a refugee in Bern for having wanted to do good in his country. I found him in the darkest of moods, in spite of the fact that he is a big literary success in Paris.[2] I stayed with him in Switzerland for ten days. Switzerland is an exclusively agricultural country. That is relaxing, for one is not at all preoccupied with intellectual matters. That said, one enjoys nature fully. Back in Ornans I went hunting for a few days. It is an excuse for some violent exercise that I am rather fond of. Then, all of a sudden, I was hit by a terrible jaundice, so bad that they called me the prince of Orange. You can imagine how that suited me. As it was, I already did not have time to do what I had planned to do for the Exhibition. For a month and six days I have not left my room. For a fortnight I did not eat at all, that frightened me. As a matter of fact, I lost that stoutness with which you are familiar.

In spite of all that I have managed to sketch my painting,[3] and at the moment it is entirely transferred to the canvas, which is twenty feet wide and twelve feet high. This will be the most surprising painting imaginable: there are thirty life-size figures. It is the moral and physical history of my atelier, including all the people who serve me and who participate in my action. In the background of the painting will be the *Bathers* [F. 140] and the *Return from the Fair* [F. 107]. On my easel I'll paint a landscape with an ass-driver and donkeys carrying sacks to the mill.[4] I'll title it the "first series,"[5] for I hope to have society pass through my studio, in order thus to have my propensities and my aversions known.

I have two and a half months to carry it out, and I still have to go to Paris to do the nudes, so that all told I have two days for each figure. You understand that this is no fun. I have mailed off the list of paintings that I will have at the exhibition, I will be sending fourteen.[6] Of yours I have included my [*Self-*]*Portrait with Pipe* [F. 39] and the *Meeting* [F. 149]. What a pity that we have not been able to do this exhibition on our own, it would have had a great new spirit, beyond all the old ideas of the past. The painters, so it seems, will be sending everything they have. As for me, I won't send anything old except my *Burial* [F. 91] and my [*Self-*]*Portrait*. At this point you must send me my portrait in profile as well as your own,[7] the two that I did in Montpellier; as well as that photograph of a nude woman about which I have spoken to you.[8] She will be behind my chair in the middle of the painting. Then comes your

portrait and those of the artists who hold Realist ideas. Those things are very necessary to me. You will perhaps not like to part with them but I will keep them as briefly as I can and send them back to you as soon as possible.

I asked in Paris for the *Spinner* [F. 133] a long time ago already. I am told that M. Selve has gone to the country and that he will not be back for a fortnight. I thought you already had it for I wrote to M. Selve three weeks ago and had someone give a message to M. Cotel.* Perhaps you should write the latter also.[9]

My sister received your photographs.[10] She is delighted with them. I am a little less so: I find the *Meeting* burned and dark. That painting is very well liked in Ornans.

Tell the family of F. Sabatier* how much I love them if you have a chance to see them. Best regards also to all my acquaintances as well as those who inquire about me: Fajon,* Delmas, Bermond, Martin, Borel, etc., etc. Tell them that I remember them and your part of the world fondly, and that I hope to return there one day to beat them at mall. We have not yet had time to play.

My parents pay you a thousand compliments. Please pay mine to M. and Mme Bruyas, to your sister, and to M. Tissié.*

Champfleury* writes from Paris that he has no word or sign from Silvestre.* I do not know where to write him. You could write him two letters, one to Paris, the other to his home in the country. I don't have his address. He has spoiled a beautiful undertaking. If he had had your tenacity or mine, he would have achieved something monumental. What he had begun was something splendid.[11]

Good-bye, dear friend, I embrace you, and I always remember you and your most enjoyable hospitality with the greatest pleasure.

Gustave Courbet

I am about to buy a plot to build an atelier.[12] The asking price is four thousand francs. I have trouble resigning myself to that as I find it expensive. But I will have to pay up, as that location suits me very well.

Send me as soon as possible the two profiles and the photograph of the nude woman.

1. See letter 54-4, n. 6.
2. Probably as the result of the appearance of Buchon's two stories, "Le Matachin" and "Le Gouffre-gourmand," which had appeared in the *Revue des deux mondes* in June and October 1854, respectively.
3. The *Atelier* (F. 165).
4. See letter 54-8, n. 3.
5. On Courbet's preoccupation with painting in series, see Chu (1980a, 134), and Rubin (1980, 61–63).
6. The list Courbet sent to the comte de Nieuwerkerke includes only ten paintings (cf. letter 54-6). Perhaps Courbet sent an addendum later on?

7. While in Montpellier, Courbet had painted the *Self-Portrait with Striped Collar* (F. 161) and two profile portraits of Bruyas (F. 142 and F. 143).

8. Though the exact photograph used by Courbet for the model in the *Atelier* is not known, it probably was one of the many nudes photographed by Julien Vallou de Villeneuve (1795–1866) in the 1840s and 1850s (cf. Scharf 1974, 131–33).

9. This entire paragraph relates to the shipping to Montpellier of the *Spinner*, which had been bought by Bruyas at the Salon of 1854 for twenty-five hundred francs. Later letters indicate that the *Spinner* never reached Bruyas, and, when Courbet wanted to exhibit it at the Universal Exhibition in Paris, the painting had gone astray (cf. letter 55-4).

10. Bruyas had had photographs made in Montpellier of the paintings by Courbet that he had acquired.

11. No doubt a reference to Silvestre's project of the *Histoire des artistes vivants*, which was planned as an ambitious serial publication richly illustrated with photographs and wood engravings but which was eventually scaled down to a modest little book, not published until 1856 (cf. letter 52-4, n. 1).

12. It is not sure whether Courbet acquired the plot referred to here. As it was, he would not build a studio until 1860.

To Champfleury [Ornans, November-December 1854] 54-8

Dear friend:

Even though I am turning into a melancholic, here I am, taking on an immense painting, twenty feet long and twelve feet high [F. 165], perhaps larger than the *Burial* [F. 91], which will show that I am not dead yet, nor is Realism, for there is Realism in it. It is the moral and physical tale of my atelier. First part: these are the people who serve me, support me in my ideas, and take part in my actions. These are the people who live off of life and off of death; it is society at its highest, its lowest, and its average; in a word, it is how I see society with its concerns and its passions; it is the world that comes to me to be painted.

You see, the painting has no title.[1] I shall try to give you a more precise idea of it by describing it to you plainly. The scene takes place in my atelier in Paris.[2] The painting is divided into two parts. I am in the middle, painting. On the right are the shareholders, that is, friends, workers, devotees of the art world. On the left, the other world of trivial life, the people, misery, poverty, wealth, the exploited and the exploiters, the people who live off of death. In the back, suspended from the wall, are the paintings of the *Return from the Fair* [F. 107] and the *Bathers* [F. 140], and the canvas that I am working on is a painting of an ass driver who is pinching the butt of a girl he meets, and donkeys loaded with sacks in a landscape with a mill.[3]

I will detail for you the figures, starting from the extreme left. On the edge of the canvas is a Jew whom I saw in England,[4] making his way through the feverish activity of the London streets, religiously carrying a casket in his right arm and covering it with his left hand. He seemed to say, It is I who

have the best of it. He had an ivory complexion, a long beard, a turban, and a long black robe that trailed on the ground. Behind him is a priest with a triumphant expression and a red bloated face. In front of them is a poor old man, very skinny, an old Republican of '93 (that minister of the interior, for example, who was part of the assembly when Louis XVI was condemned to death! the one who as late as last year was taking courses at the Sorbonne), a ninety-year-old man, with a beggar's wallet in his hand, dressed in old patched white linen and a double-peaked [*brancard*] hat.⁵ He looks at the romantic castoffs at his feet (the Jew pities him). Then a hunter, a reaper, a muscle man, a clown, a fancy-clothes merchant, a worker's wife, a worker, an undertaker's mute, a skull in a newspaper, an Irishwoman nursing a child, a mannequin. The Irishwoman is another product from England. I encountered that woman in a London street. Her only clothing were a black straw hat, a green veil with holes, and a frayed black shawl beneath which she carried a naked child under her arm. The clothes merchant presides over it all. He displays his tawdry fineries to all these people, who pay the greatest possible attention, each in his own way. Behind him is a guitar and in front of it a plumed hat.

Second part: then comes the canvas on my easel and myself painting, showing the Assyrian profile of my head.⁶ Behind my chair is a nude female model. She is leaning on the back of the chair, watching me paint for a while. Her clothes are on the floor in front of the painting. Then there is the white cat close to the chair. Behind the woman is Promayet* with his violin under his arm, just as he is in the portrait that he sent me [F. 128]. Behind him are Bruyas,* Cuenot,* Buchon,* and Proudhon* (I would very much like to include the philosopher Proudhon, who shares our views, I would be happy if he were willing to pose. If you see him ask him whether I can count on him).⁷ Then comes your turn in the foreground of the painting; you are seated on a stool with your legs crossed and a hat on your knees. Next to you, even more in the foreground, is a fashionable lady, very elegantly dressed, with her husband. Then at the far right, seated on a table with only one leg [showing], is Baudelaire,* who is reading a big book; next to him is a Negress who is very coquettishly looking at herself in the mirror.⁸ In the background of the painting one notices in the window embrasure two lovers whispering sweet nothings to each other. One is seated on a hammock. Above the window are great draperies of green serge. Also on the wall are some plaster casts, a shelf with a half-size wine bottle, a lamp, pots.⁹ There are, as well, canvases turned against the wall and a screen. For the rest, nothing but a great blank wall. I have explained it all to you quite badly. I started at the wrong side, I should have begun with Baudelaire, but it is too long to start over. You'll have to understand it as best you can. The people who want to judge will have their work cut out for them, they will manage as best they can.¹⁰ For there are those

who wake up with a start in the middle of the night, shouting, "I want to judge, I must judge."

Just imagine, my friend, that when I had this painting in mind I was suddenly hit by a terrible jaundice, which lasted for more than a month. I, who am always in a rush when I resign myself to doing a painting! I leave it to you to imagine how distressed I was at losing a month, I who didn't have a day to lose. However, I think that I will finish in time; I still have two days for each figure, not counting the accessories. No matter, it must be done. I'll be sending fourteen paintings to the Exhibition,[11] almost all new works except the *Burial*, the *Stonebreakers* [F. 101], and my [*Self-*]*Portrait with Pipe* [F. 39], which Bruyas just bought from me for two thousand francs. He also bought the *Spinner* [F. 133] for twenty-five hundred, I was lucky. I'll pay my debts and face up to [the expenses of] the Exhibition. I don't know what I would have done without that—one must never despair. I have a painting of country life, all finished, the *Grainsifters* [F. 166]. It belongs to the series of the *Young Ladies from the Village* [F. 127], also a strange painting. I am in a sad state of mind, my soul drained, my heart and spirit filled with bitterness. In Ornans I frequent a café of poachers and outlaws. I screw a waitress. None of that cheers me up. You know that my wife is married.[12] I have neither wife nor child anymore.[13] It seems that poverty has forced her to that extremity. This society swallows up its people. We had been together for fourteen years. Promayet also appears to be very unhappy. Try to find him something [to do]. Pride and integrity will kill us all. At this moment I can do nothing. I must absolutely be prepared for the Exhibition. Tell Promayet that I have not received the canvases. I embrace you with all my heart.

Gustave Courbet

Cuenot sends you his regards, as do my parents. We talk a lot about you around your portrait. Please send my best regards to Promayet, and to père and mère Andler.*

Tell Promayet that I have written to Bruyas for the *Spinner* and that it will be sent to him without fail. Tell him that Cuenot will answer him. This is all I'll tell you for now. Write me, I'll tell you more. Keep me informed.

1. When first exhibited in 1855, at Courbet's private exhibition on the avenue Montaigne, the painting was entitled *The Painter's Atelier: Real Allegory Determining a Phase of Seven Years of My Artistic Life.*

2. Courbet's atelier on 32 rue Hautefeuille, where he had moved in 1848.

3. Courbet apparently abandoned the idea for the naughty subject of the painting within the painting and decided on a Franche-Comté landscape instead. On the function of this landscape, see Levine (1980).

4. There has been much speculation about Courbet's trip to England. As no documentation has been found to prove that he crossed the Channel, authors have accepted or denied it, depending largely on their overall faith in the truth of Courbet's writings. For opposing views, see Lindsay (1973, 129–30) and Nicolson (1973, 31–32).

5. Hélène Toussaint (Paris 1977, 253) has identified the old Republican as Lazare Carnot (1753–1823), claiming that he was the only regicide who became minister of the interior. In fact, Dominique-Joseph Garat, another regicide, was minister of the interior in 1793. Be that as it may, the old Republican is more likely to be identified with count Antoine-Claire Thibeaudeau (1765–1854). The longest surviving regicide, Thibeaudeau, who died at the age of eighty nine, occupied a host of political functions during the First Republic as well as the Empire. Exiled during the Restoration, he returned in 1830 to devote himself to writing several historical and autobiographical volumes. After the coup d'état of 1851, Louis Napoléon invited him to become a senator and made him grand officer of the Legion of Honor.

6. On Courbet's affectation of his Assyrian profile, see Alexander (1965).

7. As there was no way to have Proudhon pose, either in Ornans or in Paris, Courbet was obliged to use a lithograph by Charles Bazin (1802–59), supplied no doubt by Champfleury (cf. Nicolson 1973, 54–55; and letter 55-2).

8. The Negress must be a reference to Baudelaire's mistress Jeanne Duval. The figure was later effaced, probably at the poet's request. Her outlines are still vaguely visible.

9. This detail does not appear in the final version. Courbet uses the term *fillette*, often used in the western part of France for a half-size wine bottle. In earlier English translations this word has generally been translated as "a statue of a little girl."

10. As Courbet predicted, the *Atelier* has indeed presented a major challenge to art critics and historians. The literature on the painting is extensive and includes Huyghe et al. (1944), Winner (1962), Bowness (1972), Nicolson (1973), Paris (1977, 241–71), Herding (1978, 223–47), and Rubin (1980, 38–47).

11. The Universal Exhibition of 1855.

12. Courbet's mistress, Virginie Binet,* seems to have entered his life in the early 1840s. After having borne him a son on September 17, 1847, she left him to move to Dieppe in the winter of 1851–52. Though she may well have announced her marriage to Courbet in 1854, her death certificate indicates that she was unmarried (cf. Fernier 1951, 4).

13. Courbet's son, Désiré-Alfred-Emile Binet (1847–72) appears to have become an ivory carver in Dieppe, where he married in 1868. His early death at the age of twenty-five appears to have genuinely upset Courbet, who expressed his grief to Lydie Joliclerc in 1872 (cf. Fernier 1951, 1–7; Lindsay 1973, 89).

55-1 *To Louis Français [Ornans, February (?) 1855]*

My dear friend:

Be so kind as to render me a service that is of great importance to me. I had cholerine in the South, which lasted a month. I have just had jaundice, which has kept me out for forty days, and I am behind in the painting that I have started. It is a painting the size of the *Burial* [F. 91], if not bigger, with thirty life-size figures.[1] All in all I have lost three months because of sickness. I would like to know whether it would be possible to obtain, by special permission from M. de Nieuwerkerke,* some kind of extension, ten days, fifteen days. Try to take care of it since you are familiar with all that, you would be doing me a great favor. I have been working on that painting for only a month and I have only another one to go. I will never be able to finish it. M. de Nieuwerkerke offered me his help in your presence. I would be happy if I could hold him to his word at this time. I also would like to know if my

paintings that are in Frankfurt[2] can come to the Exhibition at the government's expense. I would like to know further if I can send my paintings to the Exhibition without frames for I don't have time to take care of that. Between now and then I won't be in Paris until the first days of March and I could never have them made by the fifteenth. Please take care of all that, please. I will embrace you when I come down, I throw myself at your knees, old man, but answer me as soon as you can, for I must write to Frankfurt.[3]

Our Courbet-Bruyas* exhibition fell through.[4] Bruyas père, who is the backer, is afraid he'll be sent to Cayenne. I have consequently a lot of stuff to send to the large exhibition, which I would like to send to the devil for it bothers me a lot. My word, I confess that my heart is not in my work, and I say openly that I would rather follow the hounds (I have already killed three hare) than do what I do, but since fate decrees otherwise, I must submit. Yet I cannot wait to have nothing more to do. I have become a fanatic poacher.

Please answer me, I repeat it again, at the risk of annoying you, even though I did not answer a very kind letter you wrote to me. But I was sick when I got it, and once the inspiration passes (you know how it goes), that's the end of it. You should have written me another one. Two to one I would have answered you, which proves that one should never lose faith.

Perhaps you would like to know the subject of my painting. It will take so long to explain that I want to let you guess when you see it. It is the story of my atelier, what goes on there morally and physically. It is fairly mysterious, it will keep people guessing. I also have a painting of *Grainsifters* [F. 166], which is a sequel to the *Young Ladies of the Village* [F. 127], as well as landscapes, that is, brooks and rocks.[5]

Now, let us talk about you. You will write me what you are doing, how successful you are, what père Achard[6] is doing, what phenomenal news there may be. Keep me somewhat posted.

Looking forward to the pleasure of seeing you, I embrace you. Kind regards from me to all those who take an interest in me. Kind regards to Chenavard,* Comairas,[7] Achard, Promayet.* Ask the latter how Champfleury* is doing. Kind regards to the Andlers,* if you still go there.

Good-bye, see you soon. Please answer me.

Gustave Courbet

Good heavens, I forgot M. de Nieuwerkerke. Tell him that I adore him. Urbain Cuenot* and my parents ask me to send you their best regards for you have made quite an impression in our part of the world, where I clamor for you.[8]

1. The *Atelier* (F. 165).
2. Courbet had twice shipped paintings to Frankfurt, to be exhibited there in the summer of 1852 and the spring of 1853. Among the works that must still have been there were the *Burial* (F. 91) and the *Stonebreakers* (F. 101).

3. Courbet's contact in Frankfurt was probably the painter Jules Lunteschütz.*

4. Courbet had first conceived of a private showing of his works under the sponsorship of Bruyas in the winter of 1853–54 (cf. letter 54-1). Bruyas never seems to have been very enthusiastic about this project, and, during Courbet's visit to Montpellier in the summer of 1854, he must have made it clear that he would not participate.

5. These included *Le Château d'Ornans* (F. 173), the *Roche de dix heures* (F. 156?), and the *Stream of the Puits noir* (F. 174), which he had painted in the winter of 1853–54 (cf. letter 53-7, n. 5).

6. Jean-Alexis Achard (1807–84) was a landscape painter and engraver. He exhibited at the Salon between 1831 and 1866.

7. Philippe Comairas (1803–75) was a painter of portraits and historical scenes. He collaborated with Paul Chenavard on cartoons for murals for the Pantheon, which were never executed.

8. Français had visited Ornans in the fall of 1852 (see letter 52-4).

55-2 *To Champfleury [Ornans, March 8, 1855]*

My dear friend:

We have done what we could to find you some grapes, Urbain* and I. The postmaster gave us some trouble about the postage for the box, saying that it very often causes problems. I am vexed that I have not been able to do you this little courtesy, for I fear that what I am sending you is not worth the freight. My sisters have packed the grapes in moss like the infant Jesus—I hope they will last as well as he has—and if they don't last it is not their fault. They send them with their concern and kindest regards, as does Alphonse Promayet.* Promayet senior has asked me to inform you of the death of his brother-in-law (which I already did) because he is unable to write at this time, he said.[1]

I am still in the greatest difficulty, I am writing everywhere. The Besançon committee made a request on my behalf, but so far without a response.[2] Yet, I have some faith in what Français* says, who dares not come out with it but who nonetheless gives me the greatest confidence, as he seems to have it from a good source. I understand that that business cannot be agreed on officially.

So now I'll be arriving in the first days of April, please talk to him about it, I'll ask Promayet. My painting is still progressing[3] little by little but it goes less quickly than in the beginning. That is understandable, I am beat, but such is life. You'll be the principal figure after me, you are finished. All that makes for an inextricable jumble, it will be curious. The frame is almost finished, the Besançon committee will send it to arrive on the fifteenth together with other things. That will save some transportation expenses.

I am going to write Bruyas* to send the *Meeting* [F. 149], another unusual painting, and the *[Self-]Portrait with Pipe* [F. 39], which in Montpellier they call the *Christ with Pipe*. It goes with the *Burial* [F. 91] in the same way that

a new *Self-Portrait* [F. 161] that I did in Montpellier, commissioned by Bruyas, goes with the painting that I am working on, which is conceived differently and in another state of mind.[4]

I would very much like you to send me any portrait of Proudhon,* a lithograph, whatever, as long as it resembles him a little.[5] I no longer have any other way to do it, as I will be finishing my painting in Ornans. Send it to me as soon as possible, please. With that I embrace you both, keep getting better.

Gustave Courbet

Answer me.

[Address] Monsieur Champfleury, writer
 Rue Pierre Sarrazin, n° 2
 Paris

[Postmark] Ornans, March 8, 1855

1. Alphonse Promayet's father, Claude Louis (1785–1864), was married to Jeanne Marguerite Victoire Sevré (1785–1853). Cf. Ornans 1981, 50. The name of her brother, whose death is referred to here, is not known.

2. Apparently in Besançon (and probably other French cities as well) a committee had been formed to coordinate the transport of paintings to Paris for the International Exhibition.

3. The *Atelier* (F. 165).

4. While the pairing of the Montpellier *Self-Portrait* with the *Atelier* is obvious, as the former served as a prototype for the latter, the pairing of the *Self-Portrait with Pipe* and the *Burial* is less readily understood. Perhaps to Courbet these two paintings typified the rural side of his life, while the *Atelier* and the Montpellier *Self-Portrait* represented the urban side.

5. Courbet was to paint Proudhon's portrait after a lithograph by Charles Bazin (cf. letter 54-8, n. 7).

To Alfred Bruyas [Ornans, March 14, 1855 (Bd)] 55-3

My dear friend:

I write you a few words in haste because I have been waiting every day for news from Paris. I finally obtained an extension of two weeks, on the grounds that I was ill for three months. Français* managed to get it for me.[1] He tells me that he saw a photograph of the *Meeting* [F. 149] and that the painting is already a sensation in Paris.

The works that I will exhibit are impatiently awaited. I have announced fourteen paintings.[2] First there will be my *Burial* [F. 91], together with my [*Self-*]*Portrait with Pipe* [F. 39] and the *Stonebreakers* [F. 101]. That is the only old stuff that I'll be sending. As for the new, I'll have the painting on which I am working now,[3] together with my [*Self-*]*Portrait in Profile* [F. 161] and the *Meeting*, which will determine two very distinct phases of my life. Then there will be three landscapes,[4] two of which were recently sold to

an ironmaster in my part of the world for the sum of two thousand francs.[5] Then there will be my *Grainsifters* [F. 166], a painting of peasant life, and one or two other portraits, one of a woman,[6] the other of Champfleury* [F. 172].

I had frames made in Ornans, which I have just had sent to the Besançon committee so as to take advantage of the transportation that the government offers to exhibitors. I'll have to be back in Paris with my paintings on the twenty-ninth or the thirtieth at the latest. Consequently, if you want to lend me your paintings, you have to send them immediately, either to a dealer or a framer or to my place in Paris, 32 rue Hautefeuille. My *Burial* and the *Stonebreakers* must already have arrived there.

I have only four or five more figures to do to finish my *Atelier* [F. 165]. There are thirty-three life-size figures. I swore that I would do it and it is done. You are in a magnificent position. You are in the pose of the *Meeting*, but the sentiment is different. You are triumphant and commanding. The painters from Besançon came to see it. They are floored. Our two profiles fascinated them. I won't put your profile portrait in the exhibition because it would be tactless of me and would offend the public.[7] I'll send it back to you tomorrow. When you receive it, send mine only to Paris, with the frame, as well as the *Meeting* and the [*Self-*]*Portrait with Pipe*. You would be doing me a great favor, if it would not bother you. I am afraid of taking advantage of your kindness.

My dear friend, I am half-dead from work and worry. Forgive me for not having written more often and convey my excuses to M. Sabatier,* who wrote me a charming letter that I have not yet answered, and also to Mlle Louise, who embroidered me an equally charming tobacco pouch for which I have not yet thanked her.

Please send my regards to your father and your mother, as well as to your sister.

Your devoted and sincere friend,

G. *Courbet*

Answer me. Please spare me some worry. Best regards also to the friends I have made in Montpellier.

1. Compare letter 55-1.
2. That is four more than he had announced in his letter to the comte de Nieuwerkerke (cf. letter 54-6, n. 3).
3. The *Atelier* (F. 165).
4. F. 156 (?), F. 173, and F. 174 (cf. letter 53-7, n. 5).
5. *Le Château d'Ornans* (F. 173) and the *Stream of the Puits noir* (F. 174) had been sold to the ironmaster Vauthrin. About Courbet's numerous links to the industrial world, see, among others, Léger (1948, 53), and Lindsay (1973, 135–37).
6. *A Spanish Lady* (F. 170).

7. This appears to be an awkward excuse on the part of Courbet for not wanting the painting in the exhibition.

To Alfred Bruyas [Paris, April 5, 1855 (Bd)] 55-4

My dear and loving friend:

I am at my wits' end! Terrible things are happening to me. They have just refused my *Burial* [F. 91] and my latest painting, the *Atelier* [F. 165], together with the *Portrait of Champfleury* [F. 172].[1] They have made it clear that at any cost my tendencies in art must be stopped as they are disastrous for French art.[2] Eleven of my paintings have been accepted. The *Meeting* [F. 149] barely got by. They found it too personal and too pretentious. Everyone is urging me to have a private show and I have given in. I will organize another exhibition of twenty-seven of my new and old paintings,[3] saying that I am taking advantage of the boost the government has given me by receiving eleven paintings in its exhibition.

To have a show of the paintings of my atelier will cost me ten or twenty thousand [francs]. I have the site already, at a rent of two thousand for six months. The construction will cost me six to eight thousand. What is odd is that the site is enclosed within the very building of their exhibition.[4] I am taking steps with the police commissioner to take care of the necessary formalities.[5] I already have the six thousand you gave me.[6] If you wish to give me a pledge for what you still owe me, send me the *Bathers* [F. 140], and I will be saved. I'll earn a hundred thousand francs in one shot.

A young man came to see me, sent by you. He wants a painting in the style of the *Bathers*. If you know him, send me his address, he forgot to leave it with me.

I received everything you sent me.[7] Thank you very much. The profile portrait [F. 161] arouses everyone's admiration. The *Spinner* [F. 133] has finally been found.[8] The justice of the peace had to get involved. She [the *Spinner*] is at the Exhibition and your name is in the catalog. That does not commit you to anything. As I was not able to deliver it to you when you asked me, you are still free to take it any time.[9]

Good-bye, dear friend, we are on the right track, the cause needs you. I embrace you with all my heart. Answer me as soon as possible. I cannot tell you more for the moment. I'll write you in a few days to keep you informed. Paris is exasperated that I have been refused. I am on the run from morning till night. Take care of yourself at this time when much courage and good health are needed. Good-bye again and best regards to your friends, my best regards to your good family.

<div style="text-align:right">*Gustave Courbet*</div>

32 rue Hautefeuille

1. The judging of the Universal Exhibition took place between March 19 and April 11. Courbet may have been informed about the jury's decision in the beginning of April. On the complicated and difficult judging process, see Mainardi (1987, 62–63).

2. There is no record that such a statement was ever made, either in public or in private. Most likely the *Burial* and the *Atelier* were not accepted because of their large size. Lack of wall space was the major problem at the 1855 Universal Exhibition and it forced the jury to refuse nearly three-quarters of the approximately eighty-one hundred works that were submitted. In light of these statistics, Courbet fared relatively well, as eleven out of the fourteen paintings that he had submitted were accepted (cf. Mainardi 1987, 63–64, 92–96).

3. Courbet was to expand this number to a total of thirty-nine paintings and four drawings.

4. Courbet's pavilion was located at 7 avenue Montaigne, opposite the Palais des beaux-arts, a location that was indeed within the confines of the Universal Exhibition.

5. On Courbet's efforts to obtain permission for his 1855 pavilion, see Mainardi (1987, 60–61). The chief commissioner of police at the time was M. Premorin (cf. letter 55-6).

6. Bruyas must have owed Courbet a considerable sum of money as since 1853 he had committed himself to buying nine paintings from Courbet (F. 39, F. 133, F. 140, F. 141, F. 142, F. 143, F. 149, F. 150, and F. 161). With the exception of the *Self-Portrait with Pipe* (F. 39) and the *Spinner* (F. 133), which Bruyas had agreed to buy for two thousand and twenty-five hundred francs, respectively, it is not known how much Bruyas owed Courbet for these paintings. However, if we take two thousand francs as an average price, his debt may have amounted to approximately eighteen thousand francs.

7. Bruyas had sent Courbet the *Meeting* (F. 149) and the *Self-Portrait with Striped Collar* (F. 161) for the Universal Exhibition of 1855 (see also letter 55-3).

8. Apparently, the *Spinner*, which had been exhibited at the 1853 Salon, had gone astray and had to be recovered before it could be shown at the 1855 Universal Exhibition.

9. Courbet had originally agreed to sell this painting to Bruyas for twenty-five hundred francs (see letter 54-8), but he had never been able to arrange for its transportation from Paris to Montpellier.

55-5 *To Alfred Bruyas [Paris, May 11, 1855 (Bd)]*

My very dear friend:

I have very little time to write you today. After a month of running from one ministry to the next, and after two audiences with the minister, M. Fould,* I have just obtained the final permission to organize an exhibition with an admission charge.[1] It will be held in an atmosphere of extraordinary independence. The site that I have just rented is within the site of the government exhibition. People will think I am a monster, but I'll earn a hundred thousand francs by all estimates.

At the moment I am busy building. I'll have thirty paintings in this private exhibition.[2] I have eleven paintings in their exhibition. By that very fact I am covered against any protest and any blame.

My dear friend, an incredible attack was mounted against me. Fortunately I noticed it in time. The paintings that I have in the Exhibition are horribly placed and I cannot even get them to put them together, as the rules dictate.[3]

In a word, they wanted to finish me off, they wanted to kill me. For a month I have been desperate. They have systematically refused my large paintings announcing that it was not the painting they refused but the man. My enemies will make my fortune. That has given me the courage of my ideas, ideas that I had already communicated to you a long time ago.

I am winning my liberty, I am saving the independence of art. They have felt the blow that I dealt them, but my plans were so well laid that they were unable to retreat.

Your painting the *Meeting* [F. 149] is making an extraordinary impression. In Paris they call it *Bonjour, Monsieur Courbet,* and the exhibition guards are already busy taking foreigners to my paintings. *Bonjour, Monsieur Courbet* is a universal success. It is curious: I am approached from all sides, people write me letters to encourage me in my enterprise. The public expects that from me.

I will appeal to all the people who have paintings of mine, to be so kind as to lend them to me. I have just written the director of the museum in Lille to let me have my *After Dinner in Ornans* [F. 92]. I'll get my *Burial* [F. 91], my new *Painter's Atelier* [F. 165], my *Wrestlers* [F. 144], my *Return from the Fair* [F. 107], and my *Bathers* [F. 140], on which I am counting very much. In addition, I'll have some filler, portraits, landscapes, small paintings. Champfleury* will write me an annotated catalog, which will be on sale.[4] People are haggling with me over the stand for the walkingsticks and umbrellas, and I will sell photographs of my paintings, which M. Lainé is making for me at this moment.[5] He uses collodion and I am very dissatisfied. I am about to dismiss him.

I would like you to do me a favor, namely to have M. Miguel Moliner [?] make a photograph of the *Bathers* on paper at my expense, as he very much wants to. That would be useful to me, especially if you kept an eye on it, for I know you are rightly demanding. And then, I do not doubt that your kindness and very distinguished intelligence will permit the *Bathers* to be sent to me. I am obliged to you, dear friend, too obliged, but then, should I ever be able to do you a good turn, you know I am at your service in whatever way you like. You would be contributing to my independence and my dignity.

Answer me as soon as you can. And rest assured that in this you are serving a holy and sacred cause, the cause of liberty and independence, a cause to which I, like you, have consecrated my entire life.

With a cordial embrace,

Your devoted friend,

Gustave Courbet

You may add to my request, if it pleases you, your profile portrait, if you think that is appropriate. It is already at the Salon, it will be in my large painting.[6] See [if you want to do that]. I would also like you to send me

the negative of the *Meeting* in order to have some prints made of it. That is sure to sell, if you'd like. I am ashamed of taking advantage of your kindness this way.

Please answer me as soon as possible. Kind regards to your parents.

1. The question of admission fees to museums and exhibitions was hotly debated at the time (cf. Mainardi 1987, 44-46). For Courbet's own opinion on this subject, see letter 50-4.

2. Compare letter 55-4, n. 3.

3. On the installation of the artworks in the Palais des beaux-arts, see Mainardi (1987, 65).

4. Courbet's "catalog" was to be no more than a pamphlet with an introduction (possibly written by Champfleury in consultation with Courbet) and a list of titles.

5. Victor Lainé or Laisné was a painter of landscapes and animals who also practiced photography. He was associated with E. Defonds. Lainé's photographs of Courbet's paintings are no longer known. He had earlier made a portrait of Courbet and a photograph of the *Bathers* (F. 140) for Théophile Silvestre's *Histoire des artistes vivants* (see letter 52-4, n. 1).

6. Courbet had painted two profile portraits of Bruyas, one turned to the left (F. 142), the other to the right (F. 143). While the latter portrait served as the prototype for the *Meeting* (F. 149), which was exhibited at the Universal Exhibition (and not at the Salon, as Courbet writes here), the former was the model for Bruyas's portrait in the *Atelier* (F. 165), which was to be shown in Courbet's private exhibition.

55-6 *To his family [Paris, mid-May 1855]*

Dear family:

I have been having the most terrible time since I came back to Paris. Right now it is worse than ever. I have just begun to organize my exhibition.[1] I saw to details that took three weeks. I met with the minister[2] twice and obtained the authorization. The minister wants to commission a painting from me. M. de Nieuwerkerke* wanted me to paint a portrait of the empress.[3] I refused the latter. That is not the problem, those are trifles. It seems that my exhibition, by all estimates, will bring in a great deal of money. I have rented a piece of land that adjoins the building.[4] I made a deal for two thousand for seven months.[5] I also made deals with a contractor and an architect (who comes from Besançon, M. Isabey*) for a building for four thousand, keys in hand. My exhibition will open the eighth of next month. It is something that delights everyone, even the government. M. Fould* is delighted with it, and so is Nieuwerkerke, etc. It will have every chance of success with the police. M. Premorin, the chief of police, has been very kind to me. He has even gone out of his way and maintains that I will earn eighty thousand francs. In short, all goes well. The place that I have chosen is a little daring, that is the only thing that worries me. To help me in this undertaking I have had M. Picard, an ironmaster, who has been wonderful.[6] M. Bruyas* from Montpellier, who is not dead at all, is sending me the *Bathers* [F. 140]. I wrote

to Lille for my *After Dinner in Ornans*.[7] The city does not want to give it to me but I will reply and if necessary ask authorization from the government.

Here in Paris they were preparing to kill me this year; we'll see how it goes. My building is situated in the middle of a garden planted with lilacs, it will be charming. You'll come see it later on. Promayet* will be the cashier. The police commissioner has assigned a military policeman and M. Cretin* will take care of checking the walkingsticks and umbrellas. His son will collect the tickets. The building has started, I am up to my neck in construction.

I had my studio whitewashed and had a room built.[8] I have just sold two sketches to a painter for the sum of one thousand francs.[9] I saw M. Proudhon, Léon,[10] and Bertin, who gave me news of you. He is leaving for the South to become an employee in a business firm, I cannot tell you more about it today.

You must send me immediately my *Return from the Fair* [F. 107] so I can finish and complete my exhibition with it. Tell Chabot* at once and take it to the wagon office. Send me also that painting with a horse and a woman.[11] I believe there is a small packing crate for it in the attic.

Give Urbain* my letter to read and tell him to write me when he wants a room. Tell him also to write Buchon.* I have no time, I am on the run from morning till night. I am also having photographs made of my paintings, which will be sold in my palace of industry.[12] There are still very few people in Paris and the industrial exhibition promises little. I'll have thirty paintings at that exhibition.[13] I'll have to spend quite a bit of money. I still have a thousand francs' worth of frames to be made. But in spite of everything I believe that I'll get through this. Kind regards to everyone. Say hello to Mme and M. Boudier [and] Mlle Marie. I embrace you all with all my heart.

Gustave Courbet

Calm down, please, it will be all right.

1. Courbet's private exhibition on the avenue Montaigne.

2. There are no documents referring to Courbet's audiences with Achille Fould,* who, as minister of state (1852–60), was ultimately responsible for the Universal Exhibition of 1855. Fould is known, however, to have been involved in the decision to grant Courbet the land for his pavilion on the avenue Montaigne (cf. Mainardi 1987, 61).

3. There is no record to confirm these assertions.

4. Courbet probably refers to the Palais des beaux-arts, which was right opposite the terrain he had rented.

5. Courbet obviously intended his exhibition to last as long as the Universal Exhibition, which was to close on November 15.

6. The ironmaster P. Picard had married the daughter of the director of the Audincourt Ironworks. According to Saint-Simonien custom, he had added his wife's last name to his own and thus became Picard-Boulard. An important figure in the iron industry, Picard-Boulard had a depot at 64 rue Amelot. He was one of Courbet's many contacts in the industrial milieu of the Franche-Comté (cf. Lindsay 1973, 135).

7. The *After Dinner in Ornans* (F. 92) had been bought by the state in 1849 to be deposited in the Musée des beaux-arts at Lille.

8. Reference to the studio in the rue Hautefeuille.

9. *Nude Woman Near a Brook* (F. 59) and the sketch for the *Young Ladies from the Village* (F. 126), which had been bought by Alexandre-Abel-Félix Lauwich, a painter born in Lille in 1823 who exhibited at the Paris Salon between 1850 and 1869. A note written by Lauwich, dated April 20, 1854, in which the artist agrees to pay five hundred francs for the sketch of the *Young Ladies from the Village*, is in Paris, Bibliothèque nationale, Cabinet des estampes, Yb3. 1739 (4°), b. 1.

10. See letter 54-3, n. 3.

11. No such painting has thus far been identified.

12. No doubt a joking reference to his exhibition pavilion, which competed directly with the giant International Exhibition in the Palais de l'industrie. Courbet's nickname for his pavilion may also have applied to the industrial look of the building or to Courbet's own industriousness of which it was a product.

13. Compare letter 55-4, n. 3.

55-7 *To Alfred Bruyas, Paris, June 4, 1855*

Paris, June 4, 1855

My dear friend:

The temple is finished and now awaits only the paintings.[1] Everyone in Paris is asking me when the opening is. Everything is going perfectly, I am encountering no opposition at all. In fact, it is going so well that it frightens me. The building is charming, it is built of hollow bricks. It is large and beautifully situated in a garden amid lilac bushes. One can see it from the road—it is adjacent to the painting exhibition. All I am waiting for is the *Bathers* [F. 140], which you have courteously promised me. I must open on the fifteenth of this month,[2] please make haste to send them [the *Bathers*] to me. I am going shortly to have the posters put up.[3] I believe that in the end I will win the independence necessary for art. I have so far received great support from the government. M. Fould* and M. de Nieuwerkerke* are even delighted with my idea and want to come and see. All in all, it will be a magnificent and hitherto unprecedented event. Everyone is delighted. As for me, I become ecstatic when I contemplate the building. I'll have thirty paintings.[4] At the moment I am extremely busy finishing them.

Your friend, M. Gozzonis [?], called on me the other day, but I was not there. I was sorry about that but I hope he'll come back. I had my studio repainted (32 rue Hautefeuille) and I was not staying at my place when that gentleman came.

Please hurry and let me know where you are with what you will be sending me. If I had the negative of the *Self-Portrait with Pipe* [F. 39] as well,[5] I could sell many photographs. The painting of the *Meeting* [F. 149] is an enormous success: everyone in Paris calls it *Bonjour, Monsieur Courbet*.[6]

I embrace you, dear friend, and I look forward to seeing you, for, what-

ever you say, you cannot avoid coming to Paris in this period. Kind regards to all those who still think of me and to your dear family in particular.

G. Courbet

1. The pavilion of Courbet's 1855 private exhibition.
2. In fact, the exhibition did not open until June 28.
3. No posters appear to have been preserved.
4. In the end, Courbet was to exhibit thirty-nine paintings and oil sketches and four drawings.
5. Bruyas had had photographic reproductions made in Montpellier of this and other paintings by Courbet.
6. Another popular nickname for the painting was *Fortune Greeting Genius*. Courbet wisely omits to mention it in his letter.

To his mother [Paris, June 5, 1855 (Ad)] (incomplete) 55-8

. . . If I don't write more often, keep in mind that I don't know which way to turn at this moment. All the errands required by this exhibition are endless and I have to retouch almost all the paintings that I will have in it. So far everything is going beautifully. All of Paris talks about it and impatiently awaits the opening.[1] Things are shaping up extremely well and everything bodes well for my earning some money. . . .

I received my *Return from the Fair* [F. 107], which I am finishing now and I am waiting for the *Bathers* [F. 140] from M. Bruyas.* I have not been able to get my *After Dinner in Ornans* [F. 92] from the city of Lille. I brought the municipal council together twice and in spite of that they rudely refused though I have every moral reason on my side.[2] My building is practically finished. It is in a charming location surrounded by lilacs and within an enclosed garden. It adjoins the exhibition of paintings. . . . There is no hurry to come to Paris right now. The Industrial Exhibition is not finished and is badly organized. I believe that all that will fall through. In part it lacks enthusiasm and spirit. . . .[3]

[In this same letter, Courbet inquires about the health of his mother, who is suffering from an upper respiratory infection. He gives her a recipe for an infusion of herbs and marsh-mallow root. He wishes that his father be relieved of the troubles related to the haymaking season and talks about several friends: Champfleury,* Max Buchon,* Urbain Cuenot,* Adolphe Marlet* (who has just lost a child), and Léon Proudhon.[4]]

1. Courbet's show opened on June 28 (cf. Paris 1977, 31).
2. There is no record of these meetings in the Lille municipal archives.
3. In spite of Courbet's pessimistic forecast, the Universal Exhibition was relatively successful, drawing 5,162,330 visitors. However, this number did not surpass, as had been ex-

pected, the number of visitors to the Crystal Palace Exhibition of 1851, which had attracted 850,000 more visitors.

 4. Compare letter 54-3, n. 3.

55-9 *To Alfred Tattet [Paris, fall 1855 (?)]*[1]

My dear friend:

 I know how well disposed you are toward me, and since you advise me to let the person[2] interested in the *Franchard Valley*[3] have that painting for the sum of 150 francs, I'll let him have it, even though it is very inexpensive, for the ones I have already sold, and which are less important, have been sold for 300, 350, and 400 francs.

 As for the portrait for which you ask me as well, M. Grangier[4] is paying me 800 [francs], he will give me 400 silver francs, plus a magnificent rifle that he has ordered for me from St. Etienne.

 I have just painted the *Portrait of M. Laurier*[5], a lawyer from Bourges. He paid me 1,000 francs for it. I'll paint the portrait you request for 500 or 600 at your discretion. I leave this evening for L'Isle-Adam[6] to go hunting. I'll come by your house this evening at half past five. With cordial greetings and my respects to Mme Tattet [?].

<div align="right">

G. Courbet

</div>

 1. According to Léger (1948, 21), this letter was addressed to Alfred Tattet. As Courbet mentions his landscape of the *Franchard Valley*, I have tentatively dated it in 1855 as in that year the *Franchard Valley* was exhibited, probably for the first time, in Courbet's private show (cat. no. 29: "Fontainebleau Landscape, Franchard," 1841).

 2. Nothing is known about Courbet's contacts with Alfred Tattet and his circle, which included numerous late Romantic artists and writers, most importantly the poet Alfred de Musset (1810–57). Tattet lived in Fontainebleau, and the person mentioned here may well have been one of his neighbors, interested in acquiring a painting of one of the most spectacular sites in the Fontainebleau Forest.

 3. The painting is no longer known today.

 4. Courbet had painted Grangier's portrait (F. 164) early in 1855.

 5. Courbet's portrait of Clément Laurier (F. 171) is dated 1855.

 6. Courbet probably had several contacts with the L'Isle-Adam group of landscape painters, which included Jules Dupré,* Charles Daubigny,* and Camille Corot.*

55-10 *To Jean Gigoux [Paris, October 14, 1855]*

My dear M. Gigoux:

 By order of the committee I have had to return the tickets that I was responsible for.[1] M. Laemelin, my neighbor, is [now] responsible for everything. If the ladies are going you will receive the two tickets you requested tomorrow morning. The tickets are now only twenty francs instead of twenty-

five. You are entitled to ask for a refund of the five extra francs that you have paid, but nobody is asking for them, for what is left over from the feast is for the poor.

Sincerely yours, my dear Gigoux,

G. Courbet

[Address] Monsieur J. Gigoux, painter
 17 rue Beaujon
 Paris
[Postmark] October 14, 1855

1. It is not clear to what event these tickets gave admission. It is unlikely that it was Courbet's private exhibition, as mention is made of a committee.

To Alfred Bruyas, Paris, December 9 [1855] 55-11

My dear friend:

Today I only have time to write you a few words. I am in the midst of taking down my exhibition. The time is up, I must vacate the place. I am at sixes and sevens.

I am troubled by problems other than those relating directly to painting. Yesterday I had M. Houdemont, my agent, send you a crate containing the *Bathers* [F. 140], the *Spinner* [F. 133], the [*Self-*]*Portrait with Pipe* [F. 39], and the [*Self-*]*Portrait in Profile* [F. 161].[1] I hope that you will receive it in good order. Please deduct the transportation cost from what you owe me.

I am still very obliged, confused, and grateful to you for your great kindness in entrusting me with them, especially for so long. But you desire the good, dear friend. And I believe I have done it. Therefore I feel less bad for having troubled you, for I believe that you have participated in my action.

I am forced to end my letter, for the post office is about to close and this letter must reach you before the paintings do. My dear Alfred, I embrace you, and I love you, as I always have loved you.

If you could manage to send me some money, I would be very grateful to you. I am leaving for Ornans for three weeks, where I am sorry I am obliged to go, for I have work to do in Paris.

You can write me in Ornans during that time.

G. Courbet

Paris, December 9

My exhibition has gone perfectly and it has given me an enormous importance: things are going well.

1. The *Bathers* had been exhibited in Courbet's private exhibition, and the two self-portraits and the *Spinner* had been shown in the Universal Exhibition. It is not clear why Courbet's shipment does not include the *Meeting*, which was likewise at the Universal Exhibition.

<u>56-1</u> *To a friend [Ornans (?) 1856 (?)] (incomplete)*

. . . I took a cowherdess and made her into a spinner[1] . . . the critics growled. This year I'll paint them a real swineherdess,[2] the critics will howl. . . .

 1. Reference to the *Spinner* (F. 133). The painting had been exhibited at the Salon of 1853 and the Universal Exhibition of 1855.

 2. The painting can probably be identified with the *Little Swineherdess* (NIF. 2) in the Bührle Collection in Zürich, which matches the description of a painting by that title in Léger (1948, 61). Though in the catalog of the Bührle Collection Zemisch (1973, 84) has assigned to this painting an approximate date of 1849, I tend to agree with Léger who dates the painting (and consequently the letter) sometime in 1856.

<u>56-2</u> *To Ernest L'Epine, Paris [January or February (?) 1856]*

[No salutation]

 Nearly four years ago I sold a painting entitled the *Young Ladies from the Village* [F. 127]. The comte de Morny* still owes me five hundred francs of the price agreed on for that painting.[1] That money is very important to me at this moment.

 I decided to turn to you, Monsieur, as I do not wish to bother the comte for something of so little importance.

 With respectful greetings,

<div align="right">

G. Courbet
</div>

32 rue Hautefeuille

I would be very obliged to you if you would grant me an answer.

[Address] Monsieur Lépine

 1. The price that was agreed on is not known.

<u>56-3</u> *To Max Buchon, Paris [March 1856]*

My dear Max:

 I have just come from seeing M. Tourangin,* the senator, to ask for amnesty for you.[1] He replied that he would be delighted to help you. I have explained everything to him in order to safeguard your self-esteem. He understood all that perfectly but in spite of all they can say and do, they still need an official document, that is to say, a formal statement of compliance. He assured me that even the emperor himself, after having been duped several times in the cases of Barbès, Charras, etc., no longer grants anything without some official statement from the individual [in question].[2]

 M. Tourangin told me that he found this hesitation on your part childish

and that you were out of touch with the governmental mechanisms. Then he said, "When I arrived in the Doubs department, I immediately declared that everyone was permitted to think whatever he wished, even to express it, but that in the latter case one was subject to the law and its punishments. Once arrested one has no appeal. One is in the situation of a man who wants to jump over a brook and falls into it." The upshot of all this is that, whether you are right or wrong is not the point. The point may be condensed into these few words, *you are exiled*, and when one is exiled for political reasons, and wishes to return to one's country, one declares that one will no longer engage [in politics], using certain stock phrases to that effect. Whether one does a little or a lot, that matters not at all, it is never a question of the individual. France is a system, governments are successions of systems in which the individual matters little. You can explain your business to the government, they can find you pure as the driven snow; they'll still tell you, "Fill out the form and we will be delighted to bring you out of exile." Because an existing government, by the very fact that it exists, cannot be wrong.

Now, as a personal point, once you have made a statement of compliance, you have made two. The thing is done, you are now obliged to do it over and over again until you do it right. You are [], you feel as if you had done it, but you don't reap the benefit, you have made your position worse, increased your guilt, in a word, you are the horse's ass.

M. Tourangin is waiting impatiently for a correct statement of your compliance. You must have someone do it for you (because you don't understand anything of all this), then send it to me, I will take it to him, and he will take care of it. The moment could not be more favorable. The empress is about to make an emperor.[3] Here everyone is praying, and the stock market is going up. I must tell you that I play the stock market, I have bought twenty-five Austrians.[4] The new emperor's arrival better bring me some gain too. All goes well, as you can see. It will bring you your release.

So long, dear friend. Best wishes to Mme Poiterlin* (whom I remember fondly) and to the people I know.

Gustave Courbet

32 rue Hautefeuille

1. Max Buchon was still living in exile in Bern. Though Courbet used the word "amnesty," he probably meant "pardon." Amnesty was a political act that the emperor was empowered to exercise by a decision of December 25, 1852, and it generally applied to large groups of people at once. Thus, Napoléon had given amnesty to 4,312 political prisoners on February 1, 1853, at the occasion of his marriage. For individuals, generally a pardon was granted.

2. The emperor had lost face when Armand Barbès (1809–70) had openly refused the unconditional pardon granted to him on October 5, 1854, and had departed instead into self-imposed exile. A similar incident had happened in the case of Jean-Baptiste Adolphe Charras (1810–65). Henceforth, no pardons were granted without a statement of compliance.

3. When the empress bore a son on March 16, the emperor proclaimed general amnesty for all those who would give their word of honor "to submit logically to the government which the nation had chosen." Buchon eventually seems to have taken advantage of that opportunity.

4. Austrian imperial bonds.

56-4 *To Max Buchon [Paris, April 1856]*

My dear friend:

I swear to you that you are exaggerating ridiculously at this moment. As for me, I have acted exactly as I ought to have. If you have not received any letter for a few days, it is Champfleury's* fault. He is fine, and he assured me that he would answer you immediately, thus making it unnecessary for me to do so.

We found your pamphlet very good,[1] so much so that we are asking about having it reprinted. You were wrong to have only one hundred printed, even though it is badly printed. I'd like to add to it a letter of appreciation, with some general observations on Realism and the critics. We took the one you sent me to Proudhon* in the hope that he will reply with a letter to you. If that works out, the fortune of the pamphlet will be made as far as publicity is concerned.

I saw Darimon,* who would like to get in touch with you. He lives at no. 18 rue des Vieux-Augustins. He pressed me very hard to send him your second petition and claimed that he would obtain your release in a week. I promised, but I have thought about it and I feel that it might offend Tourangin* and hamper the efforts that are currently under way.[2] I saw him again yesterday at the Music Conservatory, where there was a great, solemn ceremony for the distribution of the poetry prizes of the Société des gens de lettres. I made my hesitation known to him. He said that I was right but that he would always be there, and if things did not work out the way we had started out, he repeated, he would get it done in a week.

At the moment you are extremely impatient, which makes you unreasonable. Of course you can reply that it is because you have said nothing for four years. Everyone assures me that it ordinarily takes three months. I'll go to police headquarters immediately to see whether I can speed things up through M. Vilmorin. As soon as I know something, be sure that I will write you. I have never felt this bad in all my life. Actually it is not the situation itself that affects me, it is the extraordinary slowness of officialdom.

As for Baudelaire,* I have as yet read neither the translations nor his preface.[3] There were in fact some analogies between our personalities, in the way we looked at certain things, metaphysics, for example. Right now I do not know how much of that still holds true, as I have not seen him for a long time.[4]

I have nothing new to tell you. Kind regards to Mme Poiterlin* and to the people I know in Bern.

I embrace you with all my heart. Try to believe that I will overlook nothing in all this. Meanwhile, enjoy the springtime. I would like to be in your place for a month, I am going crazy.

G. Courbet

1. The *Recueil de dissertations sur le Réalisme* was published in Neuchâtel in the spring of 1856.

2. Apparently, Buchon's original request for a pardon, submitted through the office of Senator Victor Tourangin, was complicated by the proclamation of general conditional amnesty on March 16, and there was some uncertainty as to what course to follow.

3. Baudelaire had just published a translation of Edgar Allen Poe's *Tales* (1845) under the title *Histoires extraordinaires*, with a lengthy introduction.

4. Courbet probably met Baudelaire in 1848 (cf. letter 49-2, n. 1). For a while he was quite close to the poet, whom he portrayed in a painting that, in the catalog of his 1855 private exhibition, is dated 1850 but that probably was done in 1848. Later, their friendship cooled and Baudelaire, in all likelihood, did not even pose for the *Atelier* (F. 165). On the relationship between Baudelaire and Courbet, see Bowness (1972).

To Max Buchon [Paris, August 1856] 56-5

Dear friend:

Keep in mind, my dear friend, that I am not a stranger to your situation for, though in France, we are as much in exile as you are. These days everything that touches art, thought, the mind, is in exile.[1] You will be surprised.

Well, I have not neglected your case. I join M. Tourangin's* to my letter. After he wrote me this letter he came to see me and told me to wait a little longer before writing you. He believed, as I did, that the answer would come faster. I hoped to send you your release. If I knew what M. Tourangin has done with your request, I would go to police headquarters to speed things up. If you could find the *Moniteur*, you would perhaps do well to write one in accordance with it.[2] M. Tourangin pointed out that your request preceded the article and that therefore it [the request] does not exactly meet the conditions. M. Tourangin has assured me that your fears of being harassed after your return are unnecessary; that he himself would write to the subprefect of Poligny,[3] if need be. Meanwhile, you must begin by requesting a passport for Paris, and in Paris you can be sure of always having passports for wherever you would like.

As to the other objections you raise to me, if you do not want to live in Salins, you could always live in Besançon, or in Ornans or Vuillafans, if you do not want to live in Paris. As for Maubert,[4] one makes him happy when one harasses him, that is what he seeks. He gets excited and will wind up believing that he has a faith. The road of art is quite idle, but the one he has chosen is

even more so. But then, everyone does what he can to feel that he is important. If only he were a follower of a new religion, American or Chinese, for example, one could understand it better.

Champfleury* is not enjoying very good health. He really has a feverish and sickly constitution that worries me. He has gone to Le Havre during an absurd time of the year, which has caused him to be ill, and he stays there on purpose, not knowing whether it will get worse or better.

Silvestre* has just published my essay, which I'll send you.[5] I don't find it to the point. It seems to me that it is more his than mine, or in any case it is what he, Silvestre, thinks of me and of himself, but it is not me. He has been very awkward in quoting me, or, if he wanted to quote me, he should have let me correct the proofs. All this has been done exactly opposite to what I expected. Here is another man who has the silly sickness: he wants to judge, he has to judge even what he doesn't understand at all. Silvestre, though a Realist, sacrifices me for the sake of Romanticism. He took from my notes what was important, then put it all in a semicomical mode, in order to twist the issues and dodge the responsibility for something he could not do. I am not even talking of all the nonsense he makes me say, that is typical of his part of the world: all southerners are like that.[6] Oh well, you will see.

In conclusion, if you want to send me another profession of allegiance, I will take it to Tourangin. If he needs it, he will use it. One must be able to get the *Moniteur* somewhere in Bern.

Meanwhile I embrace you. Best wishes to Mme Poiterlin.* Don't be angry with me.

<div align="right">*G. Courbet*</div>

1. Reference to the censorship laws under Napoléon III.

2. The *Moniteur universel*, the official newspaper of the Second Empire, in its anouncement of the general amnesty of March 16, had presented the exact wording to be used in all requests for amnesty. Since Buchon's request for a pardon had predated the amnesty, and since therefore his statement of compliance was not in accordance with the official formula, Courbet advised him to rewrite it.

3. Poligny was the seat of the subprefect of the arrondissement of Lons-le-Saulnier, in which Salins, Buchon's birthplace, was located.

4. The identity of Maubert has remained elusive. According to other letters (e.g., letter 59-9), he was a physician in Salins.

5. Silvestre's *Histoire des artistes vivants* finally appeared as a book in 1856. The author had begun to publish the individual artists' biographies in installments illustrated with portrait photographs and reproductions of individual artworks. Owing to various problems this project failed, and Silvestre ended up publishing the biographies he had collected in the form of a book, illustrated with the artists' portraits only. The biography of Courbet was reprinted in Courthion (1948–50, 1:25–62). A partial translation in English is found in Chu (1977, 23–26). See also letter 52-4, n. 1.

6. Silvestre was born in Fossat, a small town in the Pyrenees.

To his family [Lyon, October 15, 1856 (Ad)]

Dear family:

I have been in Lyon for a week. As my painting was very successful last year, I had to see quite a few people who will be useful [contacts] and who want to buy my paintings.[1] I did not waste my time. I have just left père Robelin's house, where the painters of this part of the world came to see me. I stayed there for three days.

I spent five weeks in Le Blanc.[2] I painted a portrait[3] and four landscapes,[4] in spite of Laurier's* wedding. I hope to be in Ornans in two or three days, I cannot wait. It is later than I thought, but things never work out the way one wants, and one must handle the present with an eye to the future. I am leaving Lyon tonight for Chalon. I must visit a commander there who has commissioned his portrait.[5] I embrace you all and look forward to seeing you.

Gustave Courbet

1. Little is known about Courbet's contacts in Lyon, other than that he had a mistress there—a Spanish lady whom he had visited in September 1854 (cf. letter 54-4)—and that he was well acquainted with Paul Chenavard,* who was born in Lyon.

2. Courbet's friend Clément Laurier* owned the château de l'Epineau near Le Blanc in the Indre Department. Courbet went there to attend Laurier's wedding to Mlle Maquet.

3. No doubt the *Portrait of Mme Charles Maquet* (F. 200), the mother-in-law of Clément Laurier.

4. One of these landscapes (F. 191) was presented by Courbet to Clément Laurier, possibly as a wedding present. The other three landscapes cannot be identified with any certainty.

5. This portrait cannot be identified.

To his father [Paris January-February 1857 (?)]

Dear Father:

M. Jovinet,* who is trying to marry Zoé* off, asked me to write you immediately to ask you what you plan to actually give your daughters when they marry.[1] In these matters speeches and parables don't mean a thing, it is numbers they want from you, and nothing can be done until you answer. He tells me that he has a young merchant in mind. You must tell him whether it is cash, income, or property. Answer in a few words for M. Jovinet is very impatient and does not want to start any discussions that are beside the point.

I send you this letter via Paul Boulet,* as I don't know whether Urbain* is in Ornans. Maréchal* wrote me the other day and told me that Urbain had pitched his tents in Levier.

At the moment I am painting Gueymard's* portrait [F. 213]. I am well, Zoé too. She is staying with the Jovinets until we can settle her one way or another.

Good-bye, dear Father, I embrace you.

G. Courbet

[Address] Monsieur Courbet, senior
Ornans

1. Zoé Courbet had probably come to Paris with her brother in order to find a husband. Jovinet's activities as a marriage broker were to be unsuccessful.

57-2 *To Amand Gautier [Montpellier, June 23, 1857]*

Dear friend:

I authorize the painter Amand Gautier* to reproduce the painting *Hind at Bay in the Snow* [F. 215], which he would like [to use as an illustration] for the paper *L'Artiste*.[1] In return I expect to receive forty or fifty copies.

Gustave Courbet

32 rue Hautefeuille

Dear friend:

I will be in Montpellier for a few more days. I hope to take advantage of my trip by doing a few seascapes. I passed up the discount offered by the Botanical Congress.[2] I have been to the beach already and did three sketches. I am going back tomorrow, and I will do two serious paintings, one and a half meters long.[3]

It seems that I have been a great success this year at the Exhibition.[4] I am happy to be in Montpellier during this time. Someone asked to buy my painting the *Quarry* [F. 188], but there is no rush. Ask my friend Promayet,* for me, to reply that I am in the South and that I will be able to talk it over with them when I come home, but have him take the address.

So long, dear friend, I'll be in Paris one week from now.

Gustave Courbet

Montpellier, no. 3 passage Bruyas
I have seen your friend, M. Gachet,[5] who has been so kind as to give me your letter. As I was surrounded by people, I was not able to answer you earlier.

[Postscript by Paul Gachet]
My dear Gautier:

I am writing you from the Café du Commerce, where I was able to catch Courbet in passing, which I am very pleased about in connection with our business, which is thus arranged without delay. I pray you, as I am sending you this letter, don't go out of your way.

P.S.[6] I am unsealing this letter to tell you that Courbet (who from exces-

sive shyness dares not tell you this himself) found, behind the citadel, in front of the grotto, a colossal flea, as big as two hands, that came, they say, from some gypsies. I have seen it, Champfleury* has seen it, and will be able to tell you about it. It has been subjected to the scrutiny of Professor Martin of Montpellier. If there were only two that size in the South of France, one couldn't stand it. It is always those from whom one expects the least who find the most. Because of this they wanted to make him a member of the Entomological Society. At the moment Courbet is about to discover a new species of bug. He already has one in a bottle (which he feeds with the greatest care), which is the size of an apple.

Montpellier, June 23, 1857

Gachet

P.S. to the P.S. Courbet has been complimented in a public meeting by count Jobert, president of the Entomological Society. He also found the mason spider, but don't tell anyone—I'll tell you about it later and I hope to bring you one.

[Address] Monsieur Amand Gautier

12 rue de Seine

St. Germain

[Postmark] Montpellier, 23 VI 57

1. Courbet's authorization came in response to an oral request of Paul Gachet, then a medical student in Montpellier, who was a close friend of Gautier. Gautier had written to Gachet on June 22, "Try to find Courbet and tell him to send me at once a letter that I can show to the director of the journal *L'Artiste*, so that I can make for that journal a lithograph after his *Exhausted Doe* (snowy effect). If he consents, have him send me a note immediately." (cf. Gautier 1940, 6).

2. Probably in order to get a reduced train fare to Montpellier, Courbet (together with Champfleury and Alexandre Schanne) had joined an excursion of botanical students under the direction of Adolphe Chatin. Apparently, he chose not to return with them and thus passed up the reduced return fare.

3. One of these was probably the *View of Les Cabanes* (F. 151), which Courbet sold to Bruyas's friend Emile Mey.

4. At the Salon of 1857, Courbet exhibited six paintings, including the *Young Ladies on the Banks of the Seine* (F. 203), the *Portrait of Gueymard* (F. 213), and two large hunting scenes (F. 188, F. 215). The success of the latter outdid the scandal of the *Young Ladies on the Banks of the Seine*, and Courbet was even awarded with a *rappel de médaille*.

5. Dr. Paul-Ferdinand Gachet (1828–1909), well-known through his association with Vincent van Gogh, had since his youth been a close friend of Amand Gautier. For Gautier's numerous letters to Gachet, see Gautier 1940.

6. The meaning of this postscriptum is not clear. Should it be taken at face value or as a tongue-in-cheek reference to some amorous adventures in which Courbet had become involved during his stay in Montpellier (cf. letter 54-4)?

57-3 *To Alfred Bruyas [Montpellier, June 29 (?) 1857]*[1]

Dear Alfred:

I am very annoyed not to be able to see you before I leave.[2] I will await you in Paris. You told me that you would try to get there. I get letters from everywhere telling me that I am the great success of the Exhibition and in the newspapers they say that Realism is vindicated.[3]

I need not tell you again how delighted we were, my friends and I, by the charming way in which you received us in Montpellier. Given our [intimate] terms, I would offend you, dear friend, if I were to flatter you.

Good old Calas[4] has faithfully returned to me what I had entrusted to you. I would have liked you to have seen what I did at the seashore.[5] But I'll await you in Paris. I have asked Calas to take the small seascape,[6] which will be at Fajon's* until your return. I could not give it back to you because there was no one home at your house. We will lunch tomorrow at Mejon's[7] and I hope to leave on Wednesday.[8] They tell me that you are going fishing. Have a good catch! Please, do not forget to mail me the negatives of the [*Self-*]*Portrait with Pipe* [F. 39] and of the *Meeting* [F. 149]. I'll give them back to you when you come. In Paris they make better prints than in Montpellier and less expensively. Likewise, do not forget the *Portrait in a Dignified Restful Pose* [F. 142?] that I painted for you and the drawing of the little Aubin. In that way I'll try to make myself useful to him. Don't lose sight of that young fellow, I recommend him to you, my dear Alfred. Kind regards to your charming friend Louis Tissié.* I embrace you, my dear fellow.

Gustave Courbet

If you get any letters addressed to me, please forward them.

[Address] Alfred Bruyas
 c/o M. Louis Tissié
 Brionne [?], Hérault.

1. In his letter to Gautier of June 23, 1857 (57-2), Courbet had announced that he would be back in Paris in a week. To Bruyas, he wrote that he would leave on Wednesday, which, following the 1857 calendar, was July 1. The letter was probably written on June 29, which would have given Courbet time to lunch at Mey's on Tuesday before his departure on Wednesday.

2. Several days before Courbet left Montpellier, Bruyas had gone away to visit his friend Louis Tissié.

3. On the various reviews of Courbet's Salon submission in 1857, see Riat (1906, 154–59). Jules Castagnary's first Salon review, which appeared this year, featured the term "Realism," in preference to "Naturalism," which had been used earlier by Théophile Silvestre.*

4. Bruyas's servant, whom Courbet had portrayed in the *Meeting* (F. 149).

5. According to letter 57-2, Courbet had done three sketches and two finished paintings at the seashore. One of these was the *View of Les Cabanes* (F. 151).

6. Probably the *Ponds at Palavas* (F. 220).

7. Perhaps a nickname for Emile Mey, an acquaintance of Bruyas in Montpellier. Mey must have been friendly with Courbet as well. He bought one of the artist's paintings (F. 151).

8. Probably July 1.

To Pierre-Auguste Fajon [Paris, August 1857] <u>57-4</u>

My dear Fajon:

Before answering you I would have liked to have had the opportunity to read the *Revue des deux mondes*, in order to be familiar with the matter.[1] Anyway—without knowing what is going on—if M. Champfleury* has been the least bit offensive to my friend Bruyas,* I blame him strongly for it and I am very hurt that anyone could have thought that I had anything to do with it.

My dear friend Alfred Bruyas is the most well-bred, the most honest, the most charming man I have ever met in my life. He is, moreover, one of the most intelligent men in Montpellier. I don't think that, even for a moment, he could have had the shadow of a doubt about my friendship and the sincerity of my feelings in this case. Besides, his own experience of all our previous contacts could prove the contrary. And you yourself, my dear Fajon, you could confirm what I say here. You know my sincere friendship and unflagging devotion for our great mutual friend. I am the most independent man you could ever meet in your life and consequently I never feel obliged to assert feelings that I don't have.

And if ever my dear friend Alfred should feel harassed by his family or by anyone, he has only to come live with me. I will answer for it that he shall not be disturbed for I swear to you that I am not afraid of either life or men. One has to have the kind of imagination they have in Montpellier to invent such nonsense.

M. Champfleury does absolutely anything he wants, without any intervention on my part, obviously. Nevertheless I have chided him for his action according to what you told me. He replied that the piece was written before he went to Montpellier and that it had been at the *Revue* already.[2]

In short, please remember that I am personally responsible only for what I do and that what others think in no way concerns me.

Please convey all that I tell you here to that dear friend as well as to those people whom it may still interest: MM. Tissié* and Martin and so many others that you and I both know—our friends Maquat and Roustan, etc., etc.—because it is a point of honor to me to have had nothing to do with that business, not even providing any information. Besides, you know to what extent I think the opposite.

We are still privileged to have Mme Iphigénie Fajon[3] at my boarding-house. She has been mistaken for a man, but never for a singer. I advised her

to go back home, that she was grieving her brother by being in Paris, and that all her pretentions, based on ignorance, could not succeed in Paris. That hurt her, and fortunately she left the house. She is trying to come back but I leave for Brussels in ten days. Villa fears her like fire, for that woman sticks like glue.

My paintings were very successful and attracted quite a crowd.[4] They are now in Belgium, where they are doing equally well.[5]

Good-bye, my dear Fajon.

Your friend

G. Courbet

1. On his return from Montpellier, where he had stayed with Alphonse Bruyas (together with Courbet and Alexandre Schanne), Champfleury published, in the *Revue des deux mondes* of August 15, 1857, a short story entitled "Histoire de M. T. ***." The eccentric hero of this story was an ill-disguised caricature of Bruyas, easily recognizable for all who knew him.

2. This may well have been true, but Champfleury could have based his story on Courbet's reports from his first visit to Bruyas in 1854.

3. Fajon's sister.

4. Compare letter 57-2, n. 4.

5. Courbet exhibited four paintings at the Exposition générale des beaux-arts in Brussels, including the *Grainsifters* (F. 166) and the *Quarry* (F. 188). See Paris (1977, 33).

58-1 *To his father [Brussels, June–July (?), 1858]*

Dear Father:

Champfleury* left so quickly yesterday that I was unable to give him a letter for you. I received the painting, though a bit late. You almost made me lose the sale because of your tardiness.

I am in Belgium to try to develop a new line of action.[1] I am working here and carving out a niche for myself for the future when I may want or need it. The way things are going in France, this is useful, especially for me. I have two more portraits to do here,[2] and then I go to Frankfurt, where my paintings are exhibited.[3] I don't know what nonsense you are talking about, saying that the government did not want them in France. I don't know what idiots told you that. In France, Belgium, and Germany they have met with the greatest success that paintings could have and everywhere they are saying that nobody has ever painted like that, not even the ancients. On the contrary, it is a triumph, which is a far cry from the fables you are relating.

I will be leaving for Frankfurt as soon as possible to sell them for whatever price I can get. I have already lost a sale because my prices were too high. Urbain* is supposed to come get me and we'll go together. They tell me he is in Paris. I have been ill, it's true. I lost a month and a half but I am entirely recovered now.

I must owe my concierge two quarters' rent. I have in my mirror ward-robe on the bottom shelf two hundred francs in sight-bills and two hundred francs in 100-franc banknotes. The key of the wardrobe is hanging behind the mirror. Get it and use the sight-bills, which are under a green cardboard box or inside it, to pay the two quarters. Leave the two other bills, because my sister will send them to me. If you wish, Urbain can bring them for me. They are IOUs from M. Thiroudt. Put the key back where you found it.

You reproach me for being in Belgium. I would like to know what the devil you are doing in Lyon and St. Etienne. Urbain tells me that, while you babble about agriculture in Ornans and take pleasure trips, Mother takes care of the farm in Flagey. It is incredible that you insist on driving everyone to despair and on destroying an entire family so that you can boast about your agricultural expertise. I don't understand how, at your age, you have not yet been able to attain greater tranquillity and a more rational and positive state of mind. You are carried away by your vanity. Try to rent the farm and have done with it. You will kill everyone with your chaotic mind. Our house is hell and Mother is too old to keep up that pace. We don't want her to die before her time, she has suffered enough as it is. As for me, I cannot work at home. My eldest sister is in Paris, another escapes to Besançon, the others weep, and it all disgusts the whole neighborhood. It seems to me that you should reflect a bit more soberly on all that. Rent the farm for whatever price you can, and live quietly like a man with common sense, taking care of the things that you cannot rent. Sell your products like other people do, and amen.[4]

Promayet* has settled in Russia.[5] He must have written Urbain. If you have news of him, let me know. I still have a painting that has been held by the government since the Exhibition. I was not able to pick it up before I left. Someone should ask M. Lambert whether he can keep it at his place until I return and if he could pick it up, I'll send him the receipt with which he can get it.

If Urbain is coming, ask him to bring my letters. You can first open them all and mail me the most urgent ones for there is a man who wants his portrait done as a hunter for the amount of fifteen hundred francs.[6] I must find out who it is and come to an agreement with him. I'll write Champfleury and Gautier to see whether they can take care of my business in Paris for a while. I'll be returning to Ornans with Urbain via Switzerland. Kind regards to everyone, M. Andler,* etc. I embrace you as well as my sister and Urbain. My address: c/o M. Radoux,* rue Montagne de la Cour 73.

G. Courbet

1. Little is known about Courbet's whereabouts between September 1857, when he seems to have traveled to Brussels (see letter 57-4), and the late spring and/or early summer of 1858, when apparently he was in Brussels again. It is known that in the intervening period works by

Courbet were present in exhibitions in Besançon (Exposition des beaux-arts) and Dijon (Exposition de Dijon), and it is possible that the artist followed his works around. Courbet must have arrived in Brussels for the second time before July 11, 1858, as on that day Amand Gautier wrote a letter to Paul Gachet in which he provided him with Courbet's address (c/o M. Radoux, photographer, rue Montagne de la Cour, Brussels). See Gautier (1940, 30).

 2. Perhaps the *Portrait of Mlle Jacquet* (F. 224) and the *Portrait of Mme de Brayer* (F. 232).

 3. Courbet had been invited to exhibit his works in the spring exhibition of the Frankfurter Kunstverein.

 4. By all accounts, Régis Courbet was an impractical man, always full of ideas on how to improve agriculture but less inclined to tend to his own farm holdings properly. Cf. Riat 1906, 2.

 5. Alphonse Promayet had taken a job as a private music teacher with the Romanov family in St. Petersburg.

 6. Perhaps F. 71? Fernier dates that painting very early (mid-1840s), probably on the grounds of the stiff profile pose of the model. However, this pose, resembling Flemish fifteenth-century portraiture, may have been dictated by Courbet's Belgian patron.

58-2 *To Amand Gautier [Brussels, July (?) 1858]*

My dear Gautier:

 It is very bad of me not to have written until now but I am in a melancholy state of mind. I am sending you the authorizations that you asked for. I would like you to have someone pack up the small painting on my console, the sketch of a hippodrome with a bullfight [F. 157]. There is a man from Brazil here who bought it from me and would like to have it right away.[1]

 If my concierge has any letters, please make a packet of them and send it care of M. Radoux,* photographer, 73 Montagne de la Cour, Brussels. If you have to spend money, ask M. Andler* for it on my behalf. I think there is a small crate on my landing that could hold the painting. Also, tell my concierge to write me if there is anything new.

 I left a painting at the Exhibition, I would like to know what has become of it. Should it be necessary to pick it up, please tell Lambert, the paint-shop owner, to pick it up and keep it at his place. You could also ask him to pack up for me the small painting I asked you for.

 Those are quite a few errands, my dear friend, I am taking advantage of your friendship. The life I lead here bores me. It is all portraits and lawsuits. I am going to send it all to the devil and leave for Frankfurt,[2] where my paintings are a sensation. I saw Champfleury,* who is in Amsterdam.

 Write me, that is all I am saying for now, write me. Cordially yours, and kind regards to our friends,

Gustave Courbet

 1. The identity of this collector is not known.

 2. Courbet exhibited several paintings at the exhibition of the Frankfurter Kunstverein in the spring of 1858. He probably left Brussels at the end of July or the beginning of August. A

letter by Urbain Cuenot,* dated August 10, confirms his presence in Frankfurt at that time (cf. Paris 1977, 33).

To his family, Frankfurt [December 21, 1858 (Ad)] 58-3
c/o M. Schmitz restaurant, Church Street, no. 6a, Frankfurt-am-Main[1]

Dear family:

Urbain,* on his way to Rome, writes me from Chalon[2] that he has just bought, as we had agreed, Michel's and Cretin's plots.[3] He maintains in his letter that Mme Joséphine Besson[4] promised on her honor to sell her plot to me rather than to Bidalot (who is slow to protest). I absolutely must buy that plot, even for fifteen hundred francs, because without it I would be obliged to resell the ones that I have just bought, and that transaction would hardly make me rich. Don't worry about a thing, I have the money I need for the deal. Pursue the matter actively: go see Mme Joséphine—it is appropriate for Mother to go, she will get along with her better. They have promised it to me for quite a while [and] I hope that for the sake of our long friendship she will not break her word.

A rather curious and interesting thing is happening to me at the moment. Two Russians are asking to buy the contents of my Paris atelier. Even if they only took half, it would still be a good piece of business.[5] Recently, Zoé,* as well as M. Nicolle,* a friend of mine (who has taken Alphonse Promayet's* place and is equally devoted to me), pressed me for the specific price of each painting. I answered immediately, finding that the paintings that I remember and that still are mine amount to seventy-six thousand francs. The business is in motion and my sister writes that they like the paintings they have already seen. When they have seen everything they will quote a price. If this deal goes through I'll decidedly have made it big, for that will have me selling everything and unable to keep up with the demand. And in that case I should also buy Lapair's plot, which bounds the land with a ditch, so that later no one will be able to obstruct my view.

Since I have been in Frankfurt, I have been slaving away; I have never done so much in all my life. I will send four or five paintings to you in Ornans one of these days.[6] There are two large ones, one the size of the *Burial* [F. 91], the other of the *Atelier* [F. 165], which I must finish for the Exhibition in March. All I have left to do are the [background] landscapes. One is a stag at bay with dogs and a huntsman, the other a battle of stags in a large forest. I will have to go to Levier to do the landscape for the latter.[7] At the moment I am doing the portrait of Mme Erlanger,* née Lafitte, for the sum of fifteen hundred francs.[8] I will be finished in ten days. If I have time to finish those two paintings for the Exhibition,[9] I think they will be worth a lot of money, and if I sell my atelier and add that to the eleven thousand francs for which I

161

sold the two hunting pictures last year,[10] I stand to bring in 120,000 if I am lucky, in these odd times. If all this could materialize—at this moment there is every chance that it will—or even if I should sell only half of my atelier, I think that henceforth we could proceed without worry. In the meantime we should not count chickens. Urbain tells me that Mother still thinks that Father gives me money. That hurts me, as I have not received a nickel from Father in ten years, on the contrary. Ask him whether it is true, or ask Urbain, who knows my business better than he does.

If I have not written you, what do you expect? I could only write insignificant things, full of unhappiness, nothing very interesting. I ramble through foreign countries to find the independence of mind that I need and to let pass this government that does not hold me in honor, as you know. My absence has been very good. My stock is rising in Paris. On all sides they are writing me and my friends that my supporters have more than doubled and that in the end I will be the only one left on the battlefield. I believe, from what I can foresee, that this year will be a crucial one. It is not that I am so keen on success: the people who succeed right away are the people who break down open doors.

Here in Frankfurt I have a great following among young painters.[11] Urbain must have read you the letters that I wrote him. He would like me to go to Rome, but I have no time. I take part in phenomenal hunts here. The day before yesterday we killed 270 hares. During the day it is useful for me to see all that.

I embrace you all for the New Year, in anticipation of the pleasure of seeing you, I hope, soon.

Best wishes to Mme Bourdier and Marie from me, and be sure not to dally with the Besson plot. Not having that piece of land would cause problems.

Gustave Courbet

If you need money, write me.

As soon as I get news from Paris, I'll write. That deal would be worthwhile!

[Address] Madame Sylvie Courbet
Ornans, Doubs Dept.
France

1. In the original text, the entire address is written in French rather than German. Courbet stayed in Frankfurt from August 1858 until February 1859.

2. Courbet writes "Châlons," but he is probably referring to Chalon. Traveling from Besançon, Chalon would be on the route to Lyon, a major stop on the way to Rome.

3. These lots were among the thirty-seven that Courbet acquired between 1849 and 1870. They formed the land on which he was to build a studio the following year. On Courbet's numerous land acquisitions, see Mayaud (1979, 16–17).

4. Josephine Besson, née Marlet, was the sister of Courbet's childhood friends Adolphe and Antoine ("Tony") Marlet.*

5. Little is known about this "beautiful deal," other than that it fell through (cf. letter 59-2). The two Russian clients may have been referred to Courbet by his long-time friend Alphonse Promayet,* who had gone to Russia to become the private music teacher for a branch of the Romanov family.

6. Aside from the two large paintings of which Courbet speaks in the following lines (see n. 7), these "four or five paintings" probably included the *German Hunter* (F. 244), the *Hunting Picnic* (F. 231), and the *Lady from Frankfurt* (F. 235). A sixth painting, *View of Frankfurt-am-Main* (F. 236), was sold immediately to the Frankfurt dealer Christian Steinmann.

7. The second painting can doubtlessly be identified with the *Battle of Stags* (F. 279), which has about the same dimensions as Courbet's *Atelier* (F. 165). The first painting is presumably identical to the *Stag at Bay* (F. 277; cf. Riat 1906, p. 164). Yet the dimensions of that painting (220 by 275 centimeters) are considerably smaller than those of the *Burial* (F. 91), which measures 313 by 664 centimeters. Moreover, the painting does not include the dogs and the huntsman of which Courbet speaks (unless he is referring to the minuscule figures in the distance). As no other known painting by Courbet corresponds to his description, however, we may consider the possibility that Courbet subsequently cut down the painting, eliminating the huntsman and the dogs. When exhibited at the Salon of 1861, the *Stag at Bay* was in fact accompanied by a painting of a huntsman on a galloping horse (F. 83). Together with the *Battle of Stags*, the two paintings were to form "a hunters' sequel." See letter 61-6; see also Hamburg (1978, 247–249).

8. The portrait cannot be identified with certainty. Both Riat (1906, 167–68) and Léger (1948, 70) state that it showed a youthful Mme Erlanger in gypsy costume. Perhaps the portrait is identical with the *Peasant Girl with Kerchief* (F. 210), which, despite its title, looks less like a portrayal of a peasant girl than that of a young lady dressed up as a gypsy.

9. Courbet did not participate in the Salon of 1859. The *Stag at Bay* was first exhibited at the Exposition universelle de Besançon in 1860, and again at the Salon of 1861, when it was shown together with the *Battle of Stags* (see n. 7).

10. In the summer of 1858, a certain Van Isachers had bought for eleven hundred francs the *Hind at Bay in the Snow* (F. 215) and the *Quarry* (F. 188).

11. On Courbet's influence in Germany, see Hamburg (1978, passim). During his stay in Frankfurt, Courbet was particularly close to Angilbert Göbel (1821–82), Jules Lunteschütz (1822–93), Victor Müller (1830–71), and Otto Scholderer (1834–1902). See Hamburg (1978, 409–24).

To G. Radoux [Frankfurt, January-February, 1859] 59-1

My dear Radoux:

I had Mme Erlanger's* portrait[1] to finish before I could leave, but they have been forced to leave for Paris for six days, so willy-nilly I am still here. I hope to leave definitely on Monday or Tuesday of next week. You still have time to send me what you have to send me and M. Hetzel* too. He got that drawing too cheaply.[2] I would like him not to disclose the price for which he bought it because I don't feel like painting all my life for nothing and I hope

that, if he sells it, he will share the profit with me as we agreed. If you send it to me through M. Opesseur it will not cost me anything.

All of a sudden I have to pay for yet another field. Urbain* asked for it in my name before he left for the Italian Campagna. I am very short of cash at the moment. I must spend money for the Paris Exhibition a month and a half from now.[3] Instead of the two large paintings I will send only one—I no longer have the time I need—but it will be accompanied by two or three other, little ones.

You have not told me about your Spa campaign, apparently you did not make your fortune.[4] I want to become a hunter. I just killed another roe-deer during a hunt to which I was invited by M. Gouvernant [?], a man from the Franche-Comté who has settled in Frankfurt, where he has made a fortune. My extraordinary luck has aroused universal jealousy in this country. So far it is I who am in the van. I don't know whether one of them will surpass me this year, it is not likely. On top of that, the French are not much liked at the moment thanks to that sham war in Italy,[5] which lost the Frankfurt bankers an enormous amount of money. I am delighted about it for I have never seen a country that is so pro-Napoléon. There are definitely more Napoléon supporters in Frankfurt than in all of France put together. One of them came to me the other day and said, "You must admit that this Napoléon is greater than the first one." I said to him, "I don't like this one because of the first one and I don't like the first one because of this one."

I always remember our cheese soups. Here the food is at least a little better than in Belgium, but they cannot cook, it is curious. They eat like pigs, at all hours of the day, on tables without tablecloths drenched with beer. There is no doubt about it, only in France do they really know how to eat. Other peoples are like savages, and these days they are to me really less civilized than in France, whatever they may say out of vanity.

The devil take me! I seem to remember that you reproach me for becoming a landowner.[6] So you don't want me to build according to the plans that you conceived for my atelier and that I am sticking to: the greenhouse and the poultry yard in trellis work in the shape of distaffs, the atelier in the shape of rods, to correct the Academy?

With that I embrace you and all our friends. Write me and send it to me. Even if I am no longer here they will send it on to me. I am happy that Mme S. [?] is in Brussels. That will prove perhaps that she is not in Frankfurt.

G. Courbet

You did not put enough stamps on.

1. See letter 58-3, n. 8.
2. It is not known what drawing is referred to here.
3. Reference to the 1859 Salon, in which Courbet did not participate after all.
4. Probably in the casino in Spa.

5. On New Year's Day 1859, Napoléon III had begun a campaign of words against the Austrian emperor that escalated into mutual threats of war before the end of the month. In April Napoléon would lead the French army into Italy to free it from Austrian domination.

6. Compare letter 58-3, n. 3.

To Juliette Courbet [Frankfurt, February 8, 1859] 59-2

Dear Juliette:

I was very glad to receive your letter and I thank you very much. I am happy to know that you are all well, even though you are in Flagey (a rather sad place to be stationed). Let's hope that the end of that delightful stay will arrive as soon as Father is willing to sell his products, instead of letting them go to waste.

Let's talk of more serious matters. I nearly made a fortune this year, but I was not lucky enough to succeed. If, as I already told you, I had sold my atelier to those Russians who wanted to buy it for only fifty thousand francs[1] (I had estimated that there was eighty thousands francs' worth), I would have left Frankfurt that very moment, scorning the earnings I had made there, and I would have gone to Ornans to execute three or four paintings for the upcoming Exhibition, which I would certainly have sold for forty or fifty thousand francs. Now all that is no more. With a capital of one hundred thousand one can earn anything one wishes. You see what fortune depends on, a *yes* or a *no*. I must say one thing, those Russians were dealing with two nitwits, my sister and M. Nicolle.[2] It is not at all surprising that it did not go through. I should have gone there [myself] but what kept me were the paintings that I wanted to do for the Exhibition. So in the end everything has slipped through my hands this year, save for some fifteen thousand francs, which will allow me to pay for the land.

I am not yet sure of the construction[3] because if I miss out on the Exhibition I'll have to go to England[4] and will need money. This lousy government we have at present has prevented me from making a fortune, for I do not want to act as they do. If I were to make a fortune now, I'd insist on doing it honestly and sticking to my rights and my principles. I'll never make a fortune anyway for I do not want to enough.

Mme Erlanger's* portrait is finished,[5] that will bring me seventeen hundred francs. I have a commissioned painting,[6] finished, for the Frankfurt exhibition, which will bring me two thousand francs. I have also sold six hundred francs' worth. I have been here for four or five months. I have not wasted my time. The other paintings that I started here, which I planned for the Exhibition, will be worth a great deal of money. I have never worked so hard.

On a different note, on St. Sylvester's Day[7] a splendid adventure hap-

pened to me. In a hunt in the German hills I killed an enormous stag, a twelve-pointer, that is to say a thirteen-year-old stag—the largest killed in Germany in the last twenty-five years. Gutted he weighed 274 pounds in the summer. Alive he would have weighed more than four hundred. This adventure aroused the envy of all Germany. The grand-duke of Darmstadt[8] said he would give one thousand florins for it not to have happened.[9] A rich industrialist from Frankfurt tried to steal it from me but I must give credit to the inhabitants of the city of Frankfurt: everyone was on my side. A protocol was drafted by the Hunters' Society and at the end of the protocol were forty signatures of the most important hunters of the country (that means the richest) demanding that the stag be returned to me. A splendid story! The whole city was excited for a month, the newpapers became involved. They were unable to give me back the entire stag, it had been eaten and sold unbeknownst to the society, but they returned the teeth and the antlers, and the society gave me a skin that is very fine but smaller, to make up for its carelessness. They also gave me a photograph showing the stag dead, with my gunshots. In the right barrel I had one bullet and five buck pellets and some double-zero pellets. That shot entered the flanks below the shoulderblade and my bullet came out on the other side. As he did not fall down, I doubled the five buck pellets and shot a dozen double-zero pellets into his rump above the left thigh. These are no doubt the two best gunshots that I will ever fire in my life. Afterwards a hunter offered a dinner at which seven hundred glasses of Bavarian beer were drunk. We stayed there till morning. I have been hunting some ten times or so. I killed that magnificent stag, four or five roe-deer, and some thirty hare. This last is not surprising. The first time I went hunting for hare we killed eighty, the last time we killed three hundred minus five, and all that takes place in five hours' time by forty or fifty hunters. Six stags were killed, including a doe that I could have killed as well, had I been assigned it. Once you have hunted in Germany you no longer care to hunt in Flagey. I regret one thing and that is that I was not able to kill a buck. A dozen of them were killed. As for killing wild boar, I have not had the time. I hope to receive my money at the end of this week so that I can be in Ornans at the beginning of next week.

I'll try to do a painting for the Exhibition. I'll be more rushed than ever. I don't want to ask the government for anything. For my part, it behaved too badly last year.[10] I'll paint a picture and if, when it comes time for the opening, they want it they will take it, if I can finish it in time. I must absolutely go to England every year instead of going to Paris. I embrace you with all my heart and look forward to seeing you.

I cannot bring you a German clock for they [the Germans] work like pigs and eat the same way. I'll buy one in Besançon with Arthaud.*

I am delighted with the purchase of the Besson land,[11] it was very impor-

tant. I must get to the river, that is easy to understand, and, besides, it is a very pleasant piece of land well planted with trees. I want to have the land enclosed with a quick-set hedge and with long lattices tied together with wire and I want to plant clumps of trees of all species for my painting. See you soon, try to be in Ornans to help me.

Kind regards to everyone. I cannot wait to be back, I am very tired of all these travels.

Gustave Courbet

[Address] Mademoiselle Juliette Courbet
 Ornans or Flagey, Doubs Dept.
 France
[Postmark] Frankfurt, Feb. 8, 1859

1. Compare letter 58-3.
2. Compare letter 58-3.
3. Of his new studio.
4. It is not known whether Courbet went to England at this or any other time of his life. As early as 1854 (cf. letter 54-8) he claimed to have visited London, but the truth of that statement has been debated. Surely, Courbet felt sympathetic toward England, both for its political structure as a constitutional monarchy and for its foreign policy, which, particularly during the early years of Palmerston, was favorable toward liberalism. As an Anglophile, Courbet was preceded by numerous other French artists, including Théodore Géricault and Eugène Delacroix.
5. Compare letter 58-3, n. 8.
6. Perhaps the *View of Frankfurt-am-Main* (F. 236), which Courbet sold to the dealer Christian Steinmann. Cf. Hamburg 1978, 259.
7. December 31, 1858.
8. Louis III, grand-duke of Hesse-Darmstadt (r. 1848–70).
9. Courbet's story may well be true as the grand-dukes of Hesse-Darmstadt were known for their passionate love of the hunt.
10. Perhaps a reference to the strong measures of repression that followed the attack on Napoléon III by Felice Orsini (1819–58) on January 14, 1858. The most unpopular of these was the law of "Common Security," which allowed for the arrest, imprisonmentù or exile of every citizen suspected of subversive activities.
11. Compare letter 58-3.

To Auguste Poulet-Malassis, Paris [August 10, 1859 (Ad)] 59-3

Monsieur:

I have just received the note that Champfleury* just brought me. I hope that I will see you on your arrival in Paris, or, should you want the painting immediately, let me know where I should send it.

With kind regards,
Sincerely yours,

Gustave Courbet

32 rue Hautefeuille

I have received from M. Poulet-Malassis the sum of five hundred francs for the *Portrait of Baudelaire* [F. 115].[1]

1. In 1857, Poulet-Malassis had moved his publishing house from Alençon to Paris, where he hired an office at 4 rue de Buci. In 1858, he moved to 9 rue des Beaux-Arts, where he stayed until 1861. Courbet's *Portrait of Baudelaire* may well have been intended as a decoration for his *librairie*, which featured Baudelaire as one of its major writers.

59-4 *To his family [Paris, September 16, 1859 (Ad)]*

Dear family:

I have never been able to rake in my money as I expected to. The war,[1] deals not going through, the little goodwill people have toward artists, etc. have prevented it. So far, I have been put off both by them and by people who wanted to buy or commission paintings from me. I have earned something in the time that I have spent in Paris, and my way of seeing takes on more and more importance every day. I am assured by everyone that next year I will be completely master of the field.

If I did not return to Ornans as I planned, it is most certainly against my will, but I have lost nothing. If I have not been able to rake in my money, I have at least found the way to have my studio built right away. The other day I was dining at M. Luquet's* house, and M. Bleaudeau [?], a contractor from Besançon, was dining there too. He happened to say that he had done a million's worth of construction jobs this year. So I said to him, "You really should build me a studio in Ornans." He replied that I must be quite dumb not to have already said so before, and the people around me as well; that if I wanted he would build me ten and that I could pay for it whenever I wanted to. If I want, he'll give me ten or fifteen years to pay. Isabey* will do the plan and I will have the keys in my pocket on the first of December if I let him start working today. He asks for two months. I told him that he was saving my life; that, had I known him earlier, I would not have lost so much time chasing after my money.

Now that I no longer need money for that, I am beginning to think that the lot is too narrow, for they will be building something good; and I was thinking that before they begin it would be a good thing to buy that strip of land from Pommey immediately, before anyone finds out. Father must go there one of these days and should not make a fuss for a hundred francs. We could do the same for Besson, but it is less pressing.[2] Nevertheless, it costs nothing to discuss a price with him. If I had Pommey's lot I could maneuver around the house. At the moment it is really a bit narrow. So, if it can be done, I'll send five hundred francs by mail, if it is done right away and if you need it before I arrive.

What is still keeping me here is the *Portrait of Jules Favre*, the famous

lawyer, which I am going to do for the sum of four thousand francs.[3] He won't be back in Paris until the first of October. I am definitely going to get a lawyer to handle my affairs. My *Stonebreakers* [F. 101] has just been lithographed.[4]

I don't know whether the grape harvest has started in Ornans. I would like to be able to be there for that time. I hope that you are all well. I am wonderfully well. Looking forward to the pleasure of seeing you, I embrace you all. Best regards to Urbain,*

<div align="right">G. Courbet</div>

1. Probably a reference to the French intervention in Italy.
2. Courbet, in previous years, had bought several adjoining lots on the route de Besançon in view of having a studio built for himself. On this topic, see also letters 58-3 and 59-2.
3. In the original text, the words "Jules Favre" and "4,000 francs" have been scratched out, perhaps at a later date when Courbet's association with the Republican lawyer Jules Favre* might have been compromising for him. If he did, in effect, paint Favre's portrait, its whereabouts are unknown today.
4. By Emile Vernier (1829–87), who made a folio-size lithograph after the painting, which was exhibited at the Salon of 1861 (cf. Brune 1912, 276; Beraldi 1885–92, 12:225).

To Louis Gueymard, Paris [October 1, 1859][1] 59-5

My dear Gueymard:
 Tonight, Saturday, we are having a reading of a pantomime comedy by M. Fernand Desnoyers.[2] There will be many people and the evening will be quite lively. We'll dine at six o'clock at Andler's,* then go up to my atelier. We—and myself in particular—would be very pleased if you could come.
 Please convey my kindest regards to your wife. With a cordial handshake,

<div align="right">Gustave Courbet</div>

32 rue Hautefeuille

1. This letter must have been written on the day of the Grand Realist Celebration (Grande fête du Réalisme), which took place in Courbet's studio on Saturday, October 1, 1859.
2. Fernand Desnoyers* was to read his pantomime *Monsieur et Madame Durand*. The program also included a symphony by Haydn, played on the double bass by Champfleury;* the reading of an epic poem by the socialist writer Adèle Esquiros (née Battanchon; 1819–86); and brief numbers by François Bonvin,* Amand Gautier,* Charles Monselet,* Alexandre Schanne,* and others (cf. Léger 1929, 79–80 and BAGC 54 [1975]: 9–12).

To Auguste Poulet-Malassis, Ornans [ca. December 14, 1859][1] 59-6

My dear Malassis:
 I am lost amid mountains and snow. I have gone into retreat at the house of a friend of mine,[2] far from any means of communication. My plan is to work like a slave and that is what I am doing. If I have not answered you sooner it is not entirely my fault. I had left your promissory note in Paris and

had to write my agents, who are not the most efficient of persons, to send it to me. The note is for next August tenth, which seems all the farther away as I need it now.[3]

I am very gratified by the letter you wrote me. It has always been my ambition to paint only for men like you. Thus I am delighted that you are the owner of a certain number of my works.[4] As for the *Reclining Woman*,[5] I should have finished it some time ago for the architect of the Solférino bridge, for twelve hundred francs.

If you find that too expensive, I will finish it for you for one thousand francs but, for heaven's sake, don't write me notes with such long cashing dates, I regret having advised you to do so.

I wish you the very best of health,

Affectionate greetings,

Gustave Courbet

Ornans, Doubs

Champfleury* has just written me on rose-colored paper that he wants me to paint a wild dance of the Auvergne in the Coeur Saignant cabaret.[6]

1. Courbet has written "Ornans" at the bottom of the letter, but it was probably sent from Vuillafans (see n. 2). On a copy of the letter in the Bibliothèque nationale in Paris is an annotation indicating that the letter was received on December 16, 1859. Hence, it must have been written around December 14.

2. Félix Gaudy,* who had a house in Vuillafans, some eight miles from Ornans.

3. Poulet-Malassis had bought Courbet's *Portrait of Baudelaire* in August 1859. See letter 59-3. The promissory note here referred to no doubt was in payment of that portrait.

4. It is not known what other works by Courbet were owned by Poulet-Malassis.

5. The work cannot be identified, though several paintings of reclining nudes from the late 1850s and early 1860s do come to mind, including the *Woman with White Stockings* (F. 285) and the *Reading Woman in the Forest* (F. 287). Courbet did not finish the work until December 1860 (cf. letter 60-10).

6. Compare letter 59-7, n. 11.

<u>59-7</u> *To Champfleury [Vuillafans, December 1859]*

My dear Champfleury:

Right now I am in the mountains, up to my neck in snow. I have gone into retreat and I have succeeded! For a month now I have been at my friend Gaudy's* in Vuillafans, where I am set up like a prince. I have the entire house and his servants and his horses at my disposal. At last I am for once in my life in the most perfect circumstances one can imagine. There is only one thing that bothers me: the cooking is too good. As for the cook, she is splendid, fresh, round, immensely broad and naive. Her husband is her peer in a different way. In Paris it was impossible for me to work. In Ornans it had

become difficult. Here, in one month, I have sketched in eight canvases, I have another two in Ornans and two in Maizières. You see that since I last saw you I have made up for lost time.

I have just paid two thousand francs that I owed for those fields that I bought.[1] I am absolutely penniless. That plagues me a great deal and strangely troubles my view of the future. If at this moment I had to sue that Belgian pig who owes me six thousand francs I could not.[2] And yet, I feel like sending you his entire dossier, to acquaint you with the precise facts to see whether together with a lawyer you could get it for me. That reminds me, if you want a letter for Jules Favre,* I could send you one.[3] He would advise you and you would meet him. Poulet-Malassis* asked me for another painting, the *Nude Woman*.[4] He wrote me a charming letter. I quoted him one thousand francs and made a point of telling him not to make out his note for such a far-off cashing date. The last[5] one he made out was for August.

Vernier* the lithographer has written me that Nadar* wants to buy the [*View of the*] *Mediterranean*, which has some horses in it.[6] I don't know on what terms you are with that idiot, otherwise I would ask you please to go see him and show it to him. You would make him feel obliged to buy either that painting or another one.

I have no news of Isabey.* I don't know what is happening with the construction of the atelier,[7] unless he gives me a plan. If you see him, tell him that I have already done enough paintings to pay the contractor. I don't know whether Hetzel* is in Paris. If you see him tell him either to pay me or to send me back my drawing,[8] which I would like even better. He owes me two hundred [?] francs.

I received the songs that you sent me for my sisters.[9] They thank you very much. I also received an installment of your works[10] and the story about the Maine gate. One of these days I will do the drawing you asked for. I have not gotten to it yet for I have been preoccupied with other things. We're agreed, then, that it is to be the Coeur Saignant wineshop near the Montparnasse gate: folks from the Auvergne dancing with us present in the place.[11]

I have just done a painting that I think you will like. It is a peasants' gathering in the evening with all its goings-on, all its nuances—a real novel. There are twenty-odd figures but it is on too small a scale. I find it too important to abandon, so I am going to redo it half life-size on a large canvas.[12] My sister is convalescing now, she wrote my father.[13] Thank you for having gone to visit her. My host is in Paris for another month, so much the better. When he left he was quite put out by a terrible accident that had happened to him. His servant had killed a man with his carriage. The servant is in prison and he will be fined heavily. Before he left he told me to commission Buchon* to write, for the Vermot bookstore on the quai de la Vallée, a

small book that should not be anti-Catholic, for a fee of seven hundred to one thousand francs.[14] I shall write him. Continue to write me at Ornans. Kind regards to all our friends, Duranty,* Gautier,* etc., etc. Though it is good to appear rich, Bastien is not very well off.

Affectionately yours,

Gustave Courbet

1. Compare letter 58-3.

2. The "Belgian pig" may have been the dealer Van Isachers, who had bought Courbet's *Quarry* (F. 188) and the *Hind at Bay in the Snow* (F. 215) and had not paid him the full sale price. Courbet later hired a lawyer to make him pay. Compare letter 60-3.

3. Courbet was acquainted with Jules Favre, whose portrait he had painted in September of the same year. See letter 59-4.

4. See letter 59-6, n. 5.

5. Probably for the *Portrait of Baudelaire* (F. 115), which Poulet-Malassis had bought in August 1859.

6. It is not known to what painting Courbet is referring here.

7. Courbet's new studio on the route de Besançon outside Ornans.

8. An earlier reference to this unidentified drawing is made in letter 59-1.

9. Perhaps an advance copy of Champfleury's *Les Chansons populaires de France* (Paris, 1860), for which Courbet had done two illustrations.

10. Perhaps an installment of *La Mascarade de la vie parisienne*, which had been published in *L'Opinion nationale* since September 5 (cf. letter 59-9).

11. Champfleury had sent Courbet his story, "L'Homme aux figures de cire" (The man with the wax figures), which had first appeared in *Les Excentriques*, a collection of literary portraits published in 1852 by Michel Lévy, and again as part of *Les Grands Hommes du ruisseau*, published in 1855, likewise by Lévy (see Clouard 1891, 7–11). Champfleury's story deals with a maker of wax figures by the name of Diart, who falls in love with his own creations. The storyteller, Champfleury himself, and his friend Courbet witness a dramatic scene in a wineshop near the Maine and Montparnasse gates, as Diart's wife surprises her husband dancing with his wax mistress. She attacks the couple, but Diart manages to escape.

Around the time of this letter, Champfleury, together with his new publisher, Auguste Poulet-Malassis,* had conceived the idea of reissuing a number of his works in illustrated editions, and he contacted his friends in the art world to commission several drawings. Appropriately, Courbet was asked to do a drawing for the story in which he himself played a role. The first volume of Champfleury's *Oeuvres illustrées* appeared in 1861, and three more volumes followed, the last in 1862. "L'Homme aux figures de cire" was not reissued in these volumes or in any subsequent editions of Champfleury's works. It is doubtful that Courbet executed the drawing promised here.

12. Neither the sketch nor the finished painting are known today. The only work that can be vaguely connected with this description is *Dressing up the Bride* (or *Dressing up the Dead Woman*; F. 251), which shows fourteen figures.

13. Probably Zoé Courbet,* the only one of Courbet's sisters who was living in Paris.

14. Buchon does not appear to have accepted the commission, for no work published by Vermot is known.

To Félix Gaudy, Ornans, December 29, 1859 <u>59-8</u>

Ornans, December 29, 1859[1]

My dear friend:

I have been in Ornans for a few days. We went hunting for woodcock. I have taken Christmas week off. I am sending you Buchon's* letter. You can answer me whatever you like on the subject.

Champfleury* absolutely wants to see you. He lives at 27 rue Neuve-Gigot (Montmartre). Do drop him a note to let him know when you'll be in Paris, where you are staying, and when he can see you. Everything is going well. In a few days I will return again to Vuillafans to take advantage of your hospitality. I have done masses of paintings since you left.

Your devoted. A handshake,

Gustave Courbet

1. This letter is known to me only through a transcription in the *Bulletin des amis de Gustave Courbet* (6 [1949]: 13). Though the transcriber has recorded the date as 1864, I am convinced that it was written in 1859, when Courbet was staying in Vuillafans in the house of Gaudy, who had absented himself for a prolonged period of time.

To Max Buchon [Vuillafans, late December 1859] <u>59-9</u>

Dear Max:

I am still at Vuillafans. For once in my life I am working peaceably, as I understand it. Gaudy* left for Paris and placed his house at my disposal. I have done a great many paintings since I have been alone.

When he left, Gaudy told me to ask you if you would sell him one of your works, preferably a short story that is not too antireligious, or, even better, does not mention the subject, for he is a silent partner in a Catholic bookstore that apparently does quite some business. It is the Vermot bookstore on the quai de la Vallée. He said that if you agreed to do business, your fee would be eight hundred to one thousand francs. The evening that you came to his house, he had had you invited for that, but it slipped his mind.[1]

Champfleury* just wrote me to ask for a drawing of the fantastic dance in "L'Homme aux figures de cire" (The Man with the Wax Figures).[2] He also told me that Realism is very much under attack at the moment, that we must marshal new forces and do everything we can. The situation apparently is dangerous. He himself has just been attacked on account of his novel *La Mascarade [de la vie] parisienne* (The masquerade of Parisian life),[3] in the newspaper *L'Opinion nationale*, and if he publishes he will be subject to action by the correctional police. The high court accuses him of socialist tendencies and consequently of an outrage on the public morality. That suspension is causing him to lose five thousand francs. He is strongly urging me

to organize another private exhibition next year, especially as the government is not holding one. I will try to get ready for it. If you accept the proposal, please write me or, rather, write Gaudy in Paris, no. 11 rue de Verneuil. With that I wish you a happy New Year without a runny nose and the same to our friends the Richardets, to your uncle, and to Dr. Maubert.[4]

Ever yours,

Gustave Courbet

1. See letter 59-7, n. 14.
2. See letter 59-7, n. 11.
3. *La Mascarade de la vie parisienne* had been published in installments in *L'Opinion nationale* since September 5, 1859, but in December further publication was suspended by the censor.
4. The Richardets may refer to the family of Victor Richardet (b. 1810), a journalist in Salins of strong Republican convictions. Buchon's uncle must be Pierre-François Pasteur, a brother of Buchon's mother. Nothing is known about Dr. Maubert, a friend of Buchon, who is mentioned in other letters to Buchon as well (see, e.g., letter 56-5).

60-1 *To Max Buchon [Vuillafans, February (?) 1860]*[1]

Dear Max:

You did not come to Vuillafans. The week you wanted to come you could not make it. Gaudy* himself was here for three days, it would have been a chance to talk to him. He came for the trial about the man who was killed by his servant. He was fined four thousand francs by the tribunal. He has gone back to Nice, where he'll stay three months, but you can write him anyway, or, if not to him, to Vermot.

Champfleury,* who as my business representative is not succeeding in collecting what is owed me, has just written me. He would like to see your book reprinted for the occasion of the Hebel celebration.[2] That might be your chance. We could, if you agreed, send him on a mission to Vermot,[3] whose bookstore is on the quai de la Vallée, near the corner of the rue Gît-le-Coeur. I know Vermot. You tell me that you might perhaps come to Vuillafans this week. We'll talk. Look me up on your way through Ornans, perhaps I'll go with you.

I told Champfleury that our generation is being sacrificed to the times, and that the education that we received in our youth cannot help us cope with what goes on today; but that even so there could be no advantage in changing our principles because in order to do so we would have to change our natures. The only possible chance [we have] is to wait patiently, continuing to do what we have to.

I was very pleased that you sent me your poetry piece.[4] You have got an idea, but I feel that you have explored it in a very restrained way. There was

an opportunity for an enormous satire. If you wanted, you could get a book out of it.

Isabey* is asking me to agree to pay the Bleaudeaus thirty thousand francs. As he knows my position, I think he is mad. How can he expect me to forgo the prudence that has guided me all my life for a house in Ornans? I would be risking my future and on top of that would wind up paying fifteen hundred francs in rent here and five hundred in Paris, which would add up to two thousand francs, just what I would like to have as income.[5]

Your poetry is always very well done but don't wear yourself out writing it.

Adieu, see you soon. I embrace you,

Gustave Courbet

The post stage is waiting for me, I won't read this over. Say hello to everyone.

Sunday evening.

1. According to Fernier (1987, letter 7), this letter is dated February 24, 1860. However, the letter lacks a date and cannot have been written on February 24, as that was a Friday, not a Sunday, as Courbet indicates in his letter.

2. For the centenary of the birth of Johann-Peter Hebel (1760–1826), a German clergyman who wrote moralizing poems with a rustic flavor, Buchon had translated his work in 1846 and again in 1853.

3. Compare letter 59-9.

4. Perhaps one of the poems that Buchon would subsequently publish in the collection, *Poésies franc-comtoises, tableaux domestiques et champêtres* (Salins, 1862).

5. Compare letter 59-4.

To Amand Gautier [Ornans, late May 1860] 60-2

My dear Gautier:

I am obliged to you for your efforts. I am ashamed to ask you [to do] so much, yet, in order to have the painting of the *Bathers*[1] accepted at the Belgian exhibition, it would perhaps be well to send them something else with it. M. Vernier,* the lithographer who did my Stonebreakers [F. 101], also wanted to do the head of the *Woman with Mirror* [F. 269]. He picked it up at M. Luquet's,* rue Bergère, Bergère building. If it is not at the former's house, it must be with the latter. If Cotel* can still send something to Brussels, it would be [a] good [idea] if he could send that too, and a landscape. He could take one of the landscapes that are in my atelier, perhaps the landscape that was at Gueymard's* and has come back, entitled *Woods in Winter* (F. 266?] with that frame that needs touching up, or else the other winter landscape with red trees that is in front of my wardrobe. If it is too late for the exhibition, I can still have them accepted by writing myself.

My dear friend, all that will help us. If we don't want to die from hunger in our old age, we must stock up and cash in on the talent we are credited with. If you were to send something too, it would give me great pleasure—and to Besançon as well, where I am also showing.[2] You would still have time, if you go through me. Leboeuf* wants to send my footlength portrait (or rather my statuette) to Besançon, I'll take care of it.[3] All he has to do is to send it by regular mail and notify the exhibition [committee]. Yesterday I went to Besançon, it is all arranged. If you want to exhibit you still have three weeks. If you could send something to Brussels, I would take care of your submission as well. We have lots of followers there. When I was in Brussels eighty male students presented themselves.

We also must, if it is still possible (I think it is) send something to London now (ask Cotel). He should tell me whether I have time and send me my *Stag Taking to the Water* (F. 277), I'll finish it and send it in.[4]

As for the boxes for Belgium, he must make new ones for my concierge has thrown those things out without my permission. It seems to me that he could have taken them apart and put the boards, which cost money, in a corner or in my studio.

My dear friend, we must proceed. The articles about us are taking on an entirely different cast. M. Castagnary* has just written a splendid one about me in the *Opinion nationale*.[5] Another step and we will be there!

In a nutshell: I am sending to Brussels, send something too. Send something to Besançon, I'll take care of it. Tell Cotel to send me my *Stag*. If I could exhibit in London. I'd make a frame [for it] this very moment. As for you, choose the landscape that should go with the *Seine Bathers* and send the *Head with the Mirror* with it. Pick it up at Vernier's or at Luquet's.

Here my atelier is coming along.[6] I'll be working here in two weeks.
Cordially yours

Gustave Courbet

Ornans

1. The title *Bathers* almost certainly refers here to the *Young Ladies on the Banks of the Seine* (F. 140), which indeed was exhibited at the Brussels Salon (Exposition des beaux-arts) of 1860. Note that later in the same letter Courbet refers to it as the *Seine Bathers*.

2. On Courbet's participation in the Universal Exhibition at Besançon, see Delestre (1960).

3. Leboeuf's statuette of Courbet was to be exhibited again at the Paris Salon of 1861.

4. In the end the *Stag Taking to the Water* was exhibited at the Besançon Universal Exhibition.

5. Jules Castagnary's first article on Courbet, based on a visit to the artist's studio in Paris, appeared in the *Opinion nationale* of May 19, 1860.

6. Courbet's new atelier on the route de Besançon.

To Jules Lunteschütz [Besançon, May 29, 1860]

My dear friend:

Though I don't write, I do think of the people I love from time to time. I am in Besançon, where I am in your brother's company.[1] I take this opportunity to send you my regards and to ask you another small favor. Some two or three months ago I wrote M. Erlanger,* but I have not received a reply since. I asked him for the five hundred francs that he still owes me[2] and that I would very much like to have for I ended up building a studio in Ornans cheaply and badly, but which nevertheless costs a lot of money, especially for a painter in whatever circumstances he finds himself, as you well know.

With the help of a lawyer I finally got the better of M. van Isachers.[3] Speaking of M. v.I., please send my regards to my friends M. and Mme Reinach.[4] Be as eloquent as you can, for I am still very touched by their kind and sympathetic reception. I was all the more touched as they were the only people in Germany to receive me that way.

To come back to the point, I was telling you that having written M. Erlanger once I was embarrassed to write him again, especially with such a request. So if you could perform the small service of speaking to him on my behalf, you would be doing me a great favor, for at the moment I am short of money. You have too much tact for me to tell you how to go about it, do as you think best.

Please send my regards to M. Becker[5] and his wife, to M. Kohlbacher,[6] and to my painter friends and others. If you do not see M. Emile [Erlanger], another one of his brothers or his father will do, I think. I don't understand their delay, especially in view of their position. Please be assured, my dear friend, of my liveliest feelings of friendship for you.

Affectionately yours,

Gustave Courbet

[P.S. from Joseph Lunteschütz]
My dear brother:

I take the same opportunity as M. Courbet to say hello. Hoping to hear from you soon.

Your devoted br.,

Joseph Lunteschütz

[Address] Lunteschütz, painter
 Frankfurt-am-Main
 Germany
[Postmark] Besançon, May 29, 1860

1. Joseph Lunteschütz. The Lunteschütz family, except for Jules, lived in Besançon.
2. For the portrait of Mme Erlanger. Compare letter 58-3, n. 8.

3. The Belgian dealer Van Isachers had bought Courbet's *Quarry* (F. 188) and the *Hind at Bay in the Snow* (F. 215), but he apparently had not paid the full sale price.

4. Though his name is mentioned in several of Courbet's letters, notably in those to Pasteur in the 1870s, the identity of Reinach remains elusive. He seems to have collected Courbet's work and is known to have owned at least two paintings (Cf. Fernier 1977–78, 2:375). Perhaps he was the father of Joseph Reinach (b. 1856), a noted writer of historical works, and of Salomon Reinach (b. 1858), who for many years was associated with the Louvre.

5. Jacob Becker (1810–72) was a professor at the Städelsches Kunstinstitut in Frankfurt.

6. Ludwig Kohlbacher (1828–94), a former student of the Städelsches Kunstinstitut in Frankfurt, was an art dealer and printmaker. From 1855 to 1889 he was *Inspektor* of the Frankfurter Kunstverein.

60-4 *To Auguste Poulet-Malassis [Ornans, August 1860]*

My dear friend:

So far I have not yet been able to finish the painting that you would like to have (the *Nude Woman*),[1] but since our last exchange I have had a series of quite annoying tasks to perform. I have finally bought a shack in my part of the world and had an atelier built onto it so that, should you ever come to Ornans, I can receive you there, which would please me very much. Then I had an exhibition of twelve paintings in Besançon, the capital of my region.[2] I also exhibited five paintings in Brussels.[3] You can tell, my dear friend, that I have not had much fun since our last exchange.

Your note is payable in the rue des Beaux-Arts on August 10. I gave it to M. Andler* for him to settle my boarding terms. I don't know for sure whether I will be in Paris in September. I would like to if you will be going there.

Please write me, I enjoy it. I like sympathy. Tell me if you still feel the same about that painting.[4]

With an affectionate handshake, I am,

Sincerely,

Gustave Courbet

1. See letter 59-6, n. 5.

2. Courbet speaks here of twelve paintings, but in later letters he mentions the figure fourteen. This discrepancy may be explained by the fact that Courbet had twelve paintings officially listed in the catalog (nos. 305–16), while an additional two, perhaps added as an afterthought, were exhibited but not listed (cf. Delestre 1960, 5–6).

3. Only three paintings are known to have been shown in Brussels. See also letter 60-6, n. 5.

4. The painting of the reclining nude woman, mentioned in several earlier letters. Compare letter 59-6, n. 5.

To Amand Gautier [Ornans, September-October 1860]

My dear Gautier:

I just met a man in Luquet's* company at the Besançon exhibition¹ who made me the following proposition. He said spontaneously, "I'll give you a thousand francs out of my own pocket if you will donate your *Burial* [F. 91] to the museum in Lons-le-Saulnier." Faced with such uncommon devotion, I asked him whether I could think about it—for I wanted to consult you on the subject as well as Champfleury*—and I told him that the painting did not concern me alone.

As for M. Détrimont,* I am quite delighted with his devotion and also with the role you are playing in it, my dear Gautier.²

Please consider this letter as an authorization to give M. Détrimont the *Stonebreakers* [F. 101] and other [paintings], of which you will notify me.

Affectionately yours. I still have a small errand to be run that I would like to entrust to you. I'll write you tomorrow.

<div align="center">

Gustave Courbet

</div>

I have written to Belgium to take a painting out.³ Tell M. Cotel.*

1. The man in question was Jean-Pierre Mazaroz* (see letter 60-6). Courbet met him at the Universal Exhibition held in Besançon in the late summer and fall of 1860. Courbet was represented by fourteen paintings in this exhibition.

2. Détrimont, in his gallery at 12 rue Lafitte, organized an exhibition of works by Courbet and Gautier in the spring of 1861.

3. One of the five works he had planned to send to the Brussels Salon. See letters 60-4, n. 3 and 60-6, n. 5.

To Champfleury [Ornans, October (?) 1860]

My dear friend:

I am writing you on an off-chance at Baden-Baden, poste restante. I just received a letter from our friend Buchon,* who is quite angry. This is why. The other day in Besançon at the exhibition, I met Luquet* and a certain Mazaroz* from Lons-le-Saulnier, a woodcarver in Paris. The latter said to me spontaneously, "I'll give you one thousand francs out of my own pocket if you will donate your *Burial* [F. 91] to the museum in Lons-le-Saulnier." We were all surprised by this disinterested gesture, and everyone pressed me to agree, especially Luquet. Yet I refused, saying that I could do nothing without you and the people whom this painting concerns. I was going to ask your advice (as I had not made up my mind to do it) when Buchon arrived, furious, and wanted to make up the one thousand francs if necessary.¹

If you are in Baden, I would like you to inquire whether it would not be opportune for me to exhibit my *Stag Taking to the Water* [F. 277] in the conversation room or another respectable place. I have been thinking about this for a year already and for numerous reasons: it is an area known for large hunting parties; it is Germany; [and] it is a place of great lords and lordlings, who are there to spend money. I think that Benazé, who is very kind to writers and artists, will be very happy with the proposal.[2] Explain to him the importance of this painting. If this worked out, I would finish it right away. It is 2.5 meters wide.

While I have been writing you, I received a letter from the Besançon exhibition in which I am asked to sell the landscape that I just painted for one thousand francs, [all this] very secretly, as they don't want the price to be known so that they can say they paid more. I will let them have it even though they are stupid people. They will be representing me in the Besançon museum by a landscape, but it is a way to get in, we will make them swallow other things later on.[3]

Gautier* just wrote that M. Détrimont,* a dealer in the rue Lafitte, is crazy about my painting as well as his, and that he wants to exhibit my *Stonebreakers* [F. 101] in his window. I wrote Gautier that he could do it. He has already exhibited his *Sisters*[4] etc. at that dealer's and says that it created a sensation. Gautier is doing well, he has just had success and a medal at the Troyes exhibition.

I have fourteen paintings at the Besançon exhibition, I have four in Brussels, and Bruyas has exhibited his [paintings] at the Montpellier exhibition.[5] I also have two [works] at the Amsterdam exhibition,[6] everything is going extremely well.

I saw M. Février, whom you sent me. I have not seen him again even though he had promised to come back. He gave me your articles on the *Burial* and on Wagner.[7] I am most grateful to you, I found them charming and very serious. They delighted everyone in Ornans. We obtained the newspapers and they are making the rounds from house to house. They did not want (to my great regret) to reproduce them in the *Franche-Comté* because they offended the Proudhons.[8]

Max Buchon just did a very amusing [literary] portrait of me,[9] in exchange for the one I did of him for the Besançon exhibition [F. 163]. He will be doing yours forthwith, if it is not already done. The newspapers in my part of the world have no idea what to make of my exhibition, they behave like idiots in my regard.

I believe that what you ask me about excursion trains is already done. In any case, I'll go see the mayor the next time I go to Besançon.

Affectionately yours,

Gustave Courbet

1. No doubt influenced by Buchon and, perhaps, other friends as well, Courbet did not accept the offer of Mazaroz, but he did sell him numerous other works in later years.

2. The identity of (de) Benazé is difficult to recover. He is mentioned in several letters by Courbet, including letter 60-10, where it is implied that he is a lawyer.

3. Apparently, the deal fell through. No painting by Courbet is known to have entered the Besançon museum at this time.

4. One of Gautier's numerous paintings of sisters of charity.

5. On Courbet's participation in the Universal Exhibition of Besançon, see Delestre (1960). On the Besançon exhibition in general, see Tainturier (1860). To the Brussels Salon Courbet sent the *Young Ladies on the Banks of the Seine* (F. 203), the *Woman with Mirror* (F. 269), *Rocks at Honfleur* (F. 253), and an unidentified snow landscape (perhaps F. 266). At the Montpellier exhibition, which was finished (it had opened on May 1), the six paintings in the collection of Alfred Bruyas and the *View of Les Cabanes* (F. 151) in the collection of E. Mey were shown.

6. The Tentoonstelling van Levende Meesters (Exhibition of living artists), a regularly held exhibition of contemporary art in Holland, in which Courbet frequently participated.

7. In the *Courrier de Paris* of June 21, Champfleury had published an article entitled "Wagner et Courbet" and in a subsequent issue (July 2) an article on Courbet alone. Both articles appeared in somewhat altered form in *Grandes figures d'hier et d'aujourd'hui* published by Poulet-Malassis et de Broise in 1861 (cf. Clouard 1891, 17–18).

8. Probably the family of Hippolyte Proudhon (1807–86), the brother-in-law of Urbain Cuenot* and future mayor of Ornans (1871–82).

9. Buchon's literary portrait of Courbet must have appeared in a local paper. I have been unable to trace it.

To Amand Gautier [Ornans, October-November 1860] 60-7

My dear Gautier:

I have just come back from the festival of the choral societies and brass bands in Besançon.[1] I did not get your letter until yesterday [and] I am sorry that I was not able to answer it earlier. I am absolutely delighted with what you are doing for me and with M. Détrimont's* participation in the matter. Whatever you have done has been well done. Just be careful that you don't make me spend too much money. At the moment I am overwhelmed by expenses. Among his friends and collectors, M. Détrimont will always be able to sell one of those paintings, or, if not, another small one that will cover the expense of the frames. Choose one in my atelier if necessary. The *Stonebreakers* [F. 101], together with the frame that you are having made for it, is worth, I think, 3,000 or 4,000 francs. Stay within that price range. I can give you only approximate prices but you have a great deal of latitude that I leave to your judgment. As for the other two, the framed seascapes, I believe that they are worth 800 or 1,000 francs each, with frame. Now you can write me what is happening and how they are assessed. Until now I have always asked 5,000 francs for the [*Stone*] *Breakers* and I have always priced the seascapes at 1,000 francs. Nadar* wanted one, you could try him again.[2]

My dear Gautier, come see me whenever you want. Write me beforehand so I'll be here. If you see Champfleury,* tell him that the Thiroudts, who owe me two thousand francs and who had requested seventy days to pay, have exceeded the term requested.[3] As a matter of fact, I will write Champfleury myself.

I wanted to entrust you with a small errand, namely to recover a sum of five hundred francs from M. Erlanger,* married to Mlle Lafitte, but that will be for another day, I don't have his address with me.[4]

Good-bye, my dear friend. In two or three days I will be working in my new atelier. Kind regards to all our friends and my compliments to M. Détrimont in particular.

Gustave Courbet

I am rushing for the mail.

1. Probably one of the festivities organized on the occasion of the Universal Exhibition at Besançon.
2. See letter 59-7.
3. The Thiroudt family apparently had bought but not paid for one or more paintings by Courbet. The artist later sued them. See letters 58-1 and 60-10.
4. Courbet was still trying to recover part of the payment for the *Portrait of Mme Erlanger* (cf. letter 58-3).

60-8 *To Amand Gautier [Ornans, early November 1860]*

My dear friend:

I am infinitely grateful to you for everything you are doing for me. I will try to produce a remarkable exhibition,[1] I will write you on that subject later. As I have quite a few animal and landscape paintings, I had asked you for *Amor and Psyche* so I could finish it.[2] It will be a biting mockery of the gentlemen of the grand art of painting[3] and thereby have a serious side.

You tell me that the exhibition at M. Détrimont's is taking on serious dimensions.[4] Well, then, I am all the more grateful. I have at your disposal at the moment twelve paintings that I will send to Paris (following your instructions), either to M. Détrimont or to my atelier. Answer me on this point for I am obliged to remove them from the Besançon exhibition, which is over.[5] As the exhibition must transport them for me at its expense to the place that I will indicate, let me know where I should send them. These paintings could make up an entire exhibition [by themselves], it's like a museum. Every genre is included.

Speaking of the Besançon exhibition, I just received, in a public ceremony, the grand medal of the exhibition, a unique and special medal. That is to say, there were four special medals, for agriculture, industry, commerce, and the arts, and I received the one for the arts, so that I swept all the painters

in this exhibition before me.[6] It is rather extraordinary, especially when one is exhibiting in one's own country.

I cannot tell you more about it today. The mail is about to go.

Affectionately yours,

G. Courbet

Answer me as soon as you can. Daubigny* came to see me in Ornans, he left again yesterday. He received a second medal.

[Address] Monsieur Amand Gautier

 8, rue d'Issy

 Paris

[Postmarks] Ornans, Nov. 1860

 Paris, Nov. 1860

1. Reference to the Salon of 1861, to which Courbet was to send five paintings.

2. No painting of *Amor and Psyche* is known today. Courbet is supposed to have made a copy of a painting of *Amor and Psyche* by the Montpellier artist Magnol in 1857, during his second stay with Bruyas (cf. Troubat 1878, 254). The painting mentioned here may be identical with that copy or inspired by it.

3. No doubt a reference to the Academicians. See also letter 60-10.

4. See previous letters to Gautier.

5. The Universal Exhibition of Besançon, which was officially opened on June 24 (though not complete until the end of July), seems to have closed in early November.

6. The medals were distributed on November 4. According to Léger (1948, 74), Courbet's medal was accompanied by the following citation: "For his paintings, which successfully represent sites and scenes in the Doubs Department."

To Amand Gautier [Ornans, December 1860] **60-9**

My dear Gautier:

I have not yet written M. Détrimont* for I don't know whether my paintings in Besançon have been sent off.[1] I will write my concierge to accept them and to collect five hundred francs from M. Emile Erlanger,* banker, son-in-law of M. Charles Lafitte. He will pay my rent for my landlord will throw me out if I don't pay it by the first of January (he is an amiable fellow, that M. Pancoucke!).[2]

When you write, I would like you to tell me exactly how much time we have left for the Government Exhibition and what is the official grace period.[3] I just received your letter and am very surprised to learn that my paintings have not yet arrived in Paris. They were to have been sent more than three weeks ago. True, they were sent by slow transport, but all the same they should have arrived. I'll write the Besançon administration immediately to understand this delay or negligence, for you must know that the provinces are impossible and the Franche-Comté in particular.

Do assure M. Détrimont that I am most grateful to him for what he is *183*

doing for my painting and that my pictures and myself are entirely at his disposal. I will do whatever I can to oblige him. I was terribly unsettled by the construction of my atelier at Ornans but by the same token I am now able to do whatever painting calls for.

At the moment I am entirely occupied by my [submission to the] Exhibition. I have just painted two female heads in the same style as the *Woman* [F. 269] that I sold in Belgium; [they] were commissioned from me because of it and for the same price.[4]

I will also finish the *Sleeping Woman* for M. Poulet-Malassis,[5] who bought it from me for a thousand francs. I only have an arm left to do. Then after that I'll take up my *Battle of the Stags* [F. 279], in which there is still an enormous landscape to be painted, and I will see about three others for I believe that one can send only four paintings to this exhibition. I would like to know that as well.

My dear Gautier, in these times, how much trouble and torment one has in life to achieve a mere trifle in the realm of the spirit. Be that as it may, we must let the water flow by and hold out in spite of everything.

Affectionately yours, my dear friend. Please assure M. Détrimont of my most sincere regards.

Gustave Courbet

I will write Besançon, for those people are capable of not having sent off anything yet.

1. On the exhibition in Détrimont's gallery, see previous letters to Gautier. Courbet planned to show at Détrimont's the same works that he had shown at the Besançon Universal Exhibition, in addition to selected works taken from his studio in Paris.

2. Ernest Panckoucke (1806–86), the director of the *Moniteur Universel*, was Courbet's landlord in the rue Hautefeuille.

3. As usual, Courbet was working up to the last minute and beyond to complete his paintings for the Salon.

4. These duplicates of the *Woman with Mirror* (F. 269) are not known today.

5. See letter 59-6, n. 5.

60-10 *To Champfleury [Ornans, end of December 1860]*

My dear friend:

I am working a great deal these days. I had a very hard time getting back to it because age creeps up without your noticing it and work starts to become slower and more difficult. It is also true that the times in which we live do not lend themselves to it. Aside from all that, the construction of this atelier had mentally drained me. In the provinces they can't do anything, I had to do those laborers' work practically to the point of hammering in the nails. It

is something that I would not do again for twenty thousand francs. But at last it is finished and I have been working here for a month and a half. I decided to finish, for the upcoming exhibition,[1] first my large *Battle of the Stags* [F. 279], then the dramatic *Stag Taking to the Water* [F. 277]. With those we are on neutral ground where everyone agrees and where we'll benefit from the current vogue for landscape and animals.

Now for something quite risqué: I just finished *Amor and Psyche*, which you are familiar with, with some minor additions.[2] I also feel like doing a painting for them about the war, with either the cemetery at Solferino or another carnage in the middle ground, and in the foreground two of their soldiers who excel in that kind of exercise, a Turco and a Zouave. The two wild beasts will charge like two vampires, carrying away Austrian heads on the points of their bayonets, together with their spoils—all this at dusk, the Negro's teeth will light up the countryside.[3] This will make two figure paintings, the first will be for the Academy, the second for the warriors. I confess, my dear friend, that I have such hatred for French institutions that, in spite of my poverty, I cannot give up the struggle and take governments seriously.

The Besançon exhibition is over, as you know.[4] I got nothing from the painting jury, chaired by M. Lancrenon,[5] though the committee chaired by the prefect and [including] forty other members awarded me the medal of honor given by the marquis de Conegliano.[6] The medals were four in number, for painting, industry, commerce, and agriculture.[7] Our friend Arthaud* received the one for industry for having introduced the manufacture of enamels and having distinguished himself in that field. Of the fourteen paintings I had in that exhibition, not a single one was sold, so I have spent nine hundred francs out of my own pocket for nothing, which does not suit me very well at the moment. I had expected as much but I gave in to the urgings of my parents and friends. Once and for all, one should never try to be a prophet in one's own country.

I sold the *Head of a Woman with Mirror* [F. 269] for thirteen hundred francs at the Brussels exhibition. As several collectors were arguing over it, I have commissions for two similar ones that are almost finished.[8] I also finished the *Reclining Woman* for Poulet-Malassis.[9] I must absolutely make some money these days, I am three thousand francs in debt. Before I forget, I would very much like to know what happened with the Thiroudt suit.[10] They asked for three months, now it has been more than six, I don't know what M. de Benazé[11] is doing. It seems to me that it is time to end that business, I think that they have been accommodated enough.

As for M. Hetzel,* if I knew him to be in Paris, I would write him to send me the hundred francs that he owes me.[12] I would be very obliged to you if you would go see M. de Benazé to see what the status is of those affairs.

I saw Buchon,* who was furious after Besançon. Barthet,* the "Sparrow from Lesbos,"[13] wrote a very nasty article about the jury, he has shown his true colors.

There is one thing I would like to see in Paris: Bonvin* married to a seventeen-year-old girl.[14] There will be tragedies and comedies, and it will earn Bonvin many students.

M. Détrimont* will give me a show in the rue Lafitte, Gautier* is organizing all that. It has been so long since I have heard from you that I no longer know what is happening with you or your school. Speaking of literature, I cannot resist quoting you a line spoken to me the other day by a peasant named André Darbon. "So there you are, André, how are you?" "Monsieur Auguste, this cannot go on, I have too many ailments." A moment later, as the conversation flagged, he said, in the local dialect, "Oh, Monsieur Auguste, death is a whore, she does not want me because I am poor." I found the idea quaint.

Nothing is new here. When I left Buchon he was sick, he had had more big dinners than was good for his stomach. I have not seen him since. Cuenot* was seasick [*sic*] in a carriage and threw up all over the carriage. Buchon was supposed to be back [by now], and we were going to see the Manuel woman, an old woman from Clairon who knows more than two hundred folk songs, a real "manual."[15] With that I wish you a happy new year.

Affectionately yours,

Gustave Courbet

1. The Salon of 1860, which was to open its doors on May 1.
2. See letter 60-8, n. 2.
3. The painting in question was never carried out. On this and other unexecuted projects by Courbet, see (Chu 1980a).
4. The Besançon Universal Exhibition. See previous letters.
5. Joseph-Ferdinand Lancrenon (1794–1874) was a painter from Lods (Doubs) who had studied with Girodet-Trioson. He exhibited at the Salon from 1819 to 1845 and later became director of the Besançon Museum.
6. Charles-Adrien-Gustave Duchesne de Gillevoisin, marquis de Conegliano (1825–1901), had been elected in 1857 to a six-year term as deputy from the Doubs Department to the legislature. He would be reelected for another term in 1863, but would lose to Edouard Ordinaire* in 1869.
7. Compare letter 60-8, n. 6.
8. Only one version is known today.
9. See letter 59-6.
10. See letter 60-7.
11. See letter 60-6, n. 2.
12. Probably for the painting of the *Stag by the Stream* (F. 108). See letter 60-11.
13. A reference to Barthet's play by the same title.
14. After the death of his first wife, Elisabeth Dios, in 1859, Bonvin remarried the young musician Céline Prunaire in 1860.

15. This remark was no doubt geared to Champfleury's special interest in folk art.

To Pierre-Jules Hetzel [Vuillafans, December 1860 (?)] 60-11

Hetzel, my dear friend:

I am extremely short of money. If you could pay me for the *Stag*,[1] which you bought from me for two hundred francs, you would be doing me the greatest favor, for I have just built an atelier in the country to be able to work quietly, which is indispensable to me.

Then there is our friend Radoux,* who owes me nearly double that.[2] I would very much like to hear from him. If he could pay me too, that would come in equally handy.

With kindest greetings, to your wife also, and a cordial handshake,

Gustave Courbet

I am asking our friend Champfleury* to bring you this letter.

1. In two earlier letters (59-1 and 59-7), Courbet mentioned that Hetzel had bought a drawing from him. In this letter, however, he seems to refer to a painting. The *Stag by a Stream* (F. 108), a small oil, is known to have been in the Hetzel family until 1974 (cf. Fernier 1977–78, 1:68).

2. Perhaps this was also a debt related to the acquisition of one or more works by Courbet. Courbet had earlier written to Radoux to request his money (cf. letter 59-1).

To Amand Gautier [Ornans, January (?) 1861] 61-1

My dear Gautier:

I don't know where you stand with regard to the exhibition in the rue Lafitte.[1] Imagine, those idiots at the Besançon exhibition sent my paintings to Paris only ten days ago. I thought that they had left five weeks ago, they promised me that on their word of honor two weeks ago. I go to Besançon. What do I find there? Only my paintings, all the others have been sent off. It is a mischief of M. Lancrenon's, that old trickster.[2] You can guess what a scene I made. They had lost my crates. New ones had to be made, that took two days. They must have arrived in Paris two or three days ago. I am very annoyed by this delay because of M. Détrimont. But if after all there are some that suit him, write me, and I will quote him a price.

I have at last gone seriously back to work. It is going very well at the moment. Soon I'll have two [works] finished, the large *Battle of the Stags* [F. 279], which is twelve feet high and seventeen feet wide, and the *Stag at Bay* [F. 277], which you know. I will also finish *Amor and Psyche*,[3] and another one if I have time. Do tell me what you are doing for the Exhibition and tell me also what is the latest deadline to send paintings. I believe that we should copper the large black frame that is in my studio for the *Battle of the Stags*. It will be two or three feet too long but it will be easy to cut it down.

Champfleury* just sent me a book in which he talks a great deal about

me and very positively.[4] I am very happy with it. Furne junior just commissioned an article from me on hunting, accompanied by vignettes.[5] I'll try to do it if I can.

Good-bye, my dear Gautier, keep me up to date with what is happening there. I am like a hermit here. Is there talk of the paintings that will be at the Exhibition? But the main thing is to let me know, if you can, about the deadline. If my paintings are not at the station, they are in my atelier, for this time I am sure that they have all left.

Affectionately yours,

G. Courbet

I do not know whether I told you that I twisted my left shoulder falling on a stone staircase; that I suffered quite a bit; and that it prevented me from working for quite a long time. Even now I can hardly hold my palette. I did not need that!

1. In the gallery of Détrimont.*
2. Compare letter 60-10, n. 5.
3. Compare letter 60-8, n. 2.
4. Champfleury's *Grandes Figures d'hier et d'aujourd'hui*, published in 1861 by Poulet-Malassis et de Broise.
5. See letter 61-2, n. 1.

61-2 *To Max Buchon [Ornans, January (?) 1861]*

My dear friend:

I just received from M. Furne[1] a letter and the woodblocks for the illustrations of the article on hunting that he asked me for.[2] I have already begun to work up the outline for the article. I have not much time to work on it, for when I am busy painting, I have no head for it anymore. You know that I can do only one thing at a time; with me, everything proceeds systematically.

This is what he says: "I completely accept your program of the deerhunt with greyhounds, with all the realism you wish to put into it—your figures in action. And M. Buchon's song is my business. If in the future you can give me some more time I'll ask you for more articles on the hunt in your department and even a realist history of the old-time and present-day hunters of the Jura. For the moment, do the deerhunt for me in a few pages, as I have only thirty-two pages in each issue. If the article is too long we'll have it appear in several issues. Without inconvenience to us you can treat your subject in six, eight, twelve, or twenty pages, just as you like."

Then he talks about the drawings. He comes up with the following conditions: "I pay twenty centimes for a line of sixty letters (Alexandre Dumas[3] taught me to count that way), except, however, for those of the chap whose name I just mentioned. As for the drawings, it is impossible for me to set the

price. What I can promise you at the moment is that you are making the business possible for me, and that the price you will ask for it will be mine." All in all, it seems to me that he is conducting himself properly.

Now, as for us. I will be able, I think, to give you my papers next Monday, if you want to come and see me in Ornans.

There is something else that is more pressing than all this: bring me four or five hundred thousand francs (depending on how much Varéchon[4] can come up with), if at all possible, because I could settle my affairs and owe only one person. If he is afraid to lend to me, he can hold the mortgage on a piece of land and a house. I would do it in Ornans through Muselier or Henriot,[5] but I prefer it to be done outside Ornans. I will perhaps be able to pay him back in six months but nonetheless he would have to lend it to me for two years.

With this I embrace you with all my heart.

G. Courbet

Kind regards to Varéchon.

Answer me, for my workmen are asking for money.

1. Probably the son of the better-known publisher Charles Furne (1794–1859), who continued his father's business after the latter's death.

2. Nothing seems to have come of this project.

3. Alexandre Dumas (1802–70), French novelist, famous for *The Count of Monte Cristo* and *The Three Musketeers*.

4. Varéchon probably was a notary in Salins.

5. Muselier and Henriot appear to have been notaries in Ornans. See letter 66-17.

To Auguste Poulet-Malassis, Ornans, March 8 [1861] 61-3

My dear P.-Malassis:

I feel a great need to ask you whether you could help me by going on a diplomatic mission to your friend M. de Chennevières,* director of the Exhibition. But first I must tell you my misfortunes. This past winter, as I was leaving a house in the village after dinner, I slipped on an awful stone staircase and fell on the macadam at the bottom, with all my weight on my left hand. Naturally I broke my thumb and cut the brow ridge over my left eye. For two months I was unable to work. It was all the more unfortunate as I had plenty of work. I had a commission for Belgium,[1] I had sent for the painting you asked for so that I could finish it,[2] etc. I had four or five large-sized paintings for the Exhibition that I had started. I set to work on those that were most pressing, and my two large hunts are finished, the *Battle of the Stags* [F. 279] and the *Stag in the Water* [F. 277]. As I did not want to send only animals and landscapes to the Universal Exhibition, I began a figure painting that I hope to finish.[3] However, as the newspapers declare that no painter can

pass the April 1 deadline for submitting his paintings, I would like you to approach M. de Chennevières in spite of that ruling, and see whether there is any way, in view of my misfortunes, to obtain a special postponement. In that case, I would address a petition to the appropriate person (who that is you have to tell me); find out whether it is M. de Chennevières or M. de Nieuwerkerke.* In any case I will be in Paris with all my baggage towards the middle of next month.

Sincerely yours, my dear fellow, I am in such a rush that I cannot tell you more.

G. Courbet

March 8, Ornans

Try to reply immediately, I am terribly concerned.

1. Probably for a copy of the *Woman with Mirror* (F. 269). Compare letter 60-9.
2. It is not certain to what painting Courbet refers here.
3. Probably the painting of *Amor and Psyche*, mentioned in several previous letters.

61-4 *To Auguste Poulet-Malassis [Ornans, ca. March 23, 1861]*

My dear Malassis:

The less I hear from you the more worried I get. If I am to draft a request to the authorities, you must realize that there is only a week left,[1] and therefore I would like to know M. de Chennevières's* opinion, for when I am forced to make a request, I do so reluctantly. If I can come to an agreement with those gentlemen I can send twenty-four square meters of inoffensive painting to this year's Salon. The artists of this part of the world promise me twice the success of the *Burial* [F. 91], but for that I need some goodwill on the part of the administration and a place [on the wall where my works will be hung] together and in full daylight. But don't think that I expect to get all the above. I am not in favor in high places. If I cannot come to an understanding with the administration, I will be obliged to take whatever line of action I can. I'll start asking about the hall where I exhibited last winter, as a precaution.

I write you even though the mail has not arrived yet. We have had some extraordinary snowfalls. I am writing you anyway for I have not a day to lose. Your letter, my dear friend, is very kind. As for a bite to eat,[2] I am your man, I am always game. Answer me as soon as possible, even if you have nothing to tell me.

Affectionately yours,

G. Courbet

One of my friends, M. Gaudy,* tells me that your store is now at the corner of the passage Mirès, all decorated with paintings.[3]

1. The deadline for submission of Salon paintings was April 1. Courbet's letter consequently must have been written ca. March 23.

2. Poulet-Malassis was known as a true gourmet (cf. Dufay 1931, passim).

3. In January 1861, Poulet-Malassis had moved his publishing house and bookstore to 97 passage Mirès. The store was elegantly decorated with built-in oak bookcases surmounted by medallions that held paintings of the authors represented by Poulet-Malassis, such as Charles Baudelaire,* Champfleury,* Théophile Gautier,* and Victor Hugo* (cf. Dufay 1931, 75–79).

To Alexandre Pothey, Ornans [March 30, 1861][1] 61-5

My dear friend:

Even though I wanted to, and even though it was to my advantage to answer you immediately, I have not been able to answer you until today as I did not know what paintings I would have at the Exhibition. I just sent them the day before yesterday, on the twenty-eighth. They ought to have arrived at the exhibition palace.[2] I am sending, first, a large *Battle of the Stags* [F. 279], 5.30 meters long, then a *Stag in the Water (at Bay)* [F. 277], and to complement the latter a *Sounding Huntsman* [F. 283]. Those three paintings are exactly to the taste of the English.

Now you can see for yourself what suits you best for your reproduction,[3] which pleases me very much. So you must go find M. Détrimont,* the art dealer, at 33 rue Lafitte. He is seeing to the framing and unpacking of the paintings. He will assist you in having a photograph made in the exhibition rooms of the canvas that will suit you best. Or, if those won't do, there is at his shop an exhibition of my paintings from which you can choose as well.

I forgot to put my name on the crate that I sent to the Exhibition but it is easy to recognize. On the lid of the crate, which is 5.40 meters long, is written, in red chalk: "Crate with paintings for the Universal Exhibition in the Palais de l'industrie (Express)." Please let M. Détrimont know.

My dear friend, I would have liked to send other paintings to the Exhibition, figure paintings, to appear on this occasion with paintings other than landscapes and animals, but I was prevented for two reasons. First, because I broke my left thumb and have not been able to work for a month and a half, and then because I learned that I would not be able to succeed because of the government. Nonetheless I will finish one of the figure paintings before returning to Paris. I'll be there in two weeks or eighteen days. My dear friend, please give my best to our friend Castagnary,* whom I find charming. As for you, my dear Pothey, I have never doubted your kind friendship for me.

Affectionately yours,

Gustave Courbet

Best regards also to all my friends in the neighborhood.
Ornans, Sunday

1. The date is derived from the information given in the first paragraph.

2. From 1857 onward, the Salon was no longer held in the Louvre but in the Palais de l'industrie, built for the 1855 Universal Exhibition.

3. According to letter 61-6, Pothey was planning to make a wood engraving after one of Courbet's paintings for a publication by the English publisher-engraver Leighton (?), who was preparing an album of reproductions of important French (?) paintings.

61-6 *To Francis Wey, Ornans, April 20 [1861]*

My dear friend:

I was very touched by the kind letter you wrote me. It gave me the opportunity, once again, to appreciate your good heart and the steadfast concern you have always shown for me. My parents are delighted (you were even the occasion of some reproaches) and my father declared that it sounds like Solon.[1] Its success does not end there. I took it [the letter] to the Ordinaires* and shared it with U. Cuenot.* Everyone agrees with you, dear friend.

You are predicting good fortune for me, dear friends, and it is about time that it come. Yesterday I was unable to reply. I had to go to Flagey. Someone had set fire to a stand of magnificent young oaks. Twenty-four acres belonging to us burned down. My family, who were in Flagey, were very grieved for it was something we cherished and that we had held on to for fifty years.

But let us talk about things that may be more serious from another point of view. My dealer at the moment is M. Détrimont,* 33 rue Laffitte. He has seven or eight paintings of mine, mostly those that were at the Besançon exhibition. He is a man whom I don't know and whom I have never seen, but from his letters he seems very kindly disposed toward me. It is he who made the frames and stretched the canvases that I have at the Exhibition. I just wrote him six days ago that those paintings must be cleaned and very carefully varnished. I value them a great deal, for not only in my opinion but in the opinion of [other] painters and collectors as well, the *Battle of the Stags* [F. 279] ought to have the same impact as the *Burial* [F. 91], though in a different way. The painting's elements, besides its artistic value, are almost impossible to find. As it is, it has cost me already three or four thousand francs. Without dwelling on the value of those paintings, allow me to explain the meaning that they have for me.

The *Spring Rut* or *Battle of the Stags* is something I went to observe in Germany. I saw those battles in the reserves of Homburg and Wiesbaden. I participated in the German hunts in Frankfurt for six months—an entire winter—till I had killed a stag that served [as a model] for this painting, as did those that my friends had killed.[2] I am absolutely sure of the action. With those animals none of the muscles show. The battle is cold, the rage deep, the thrusts are terrible and they seem not to touch each other. That is easy to

understand when one sees their formidable defense. With that, their blood is as black as ink and their muscular strength makes them able to cover thirty feet in one leap, effortlessly, something I saw with my own eyes. The one I killed had twelve tines (a thirteen-year old, as the Germans have it, or five-pointer in France). He took my no. 14 bullet below the shoulder (it passed through his lungs and heart), and six buckshot pellets, in the second shot, in the crural bone, which did not keep him from going one hundred and fifty meters before he collapsed. That gives you an idea of his power.

Those three paintings form a series for hunters and depict a theme that I am familiar with.[3] They are unlike anything either traditional or modern. There isn't an ounce of idealism in them. Their values are mathematically precise. Those three stags are in the wild and in those rutting battles the does flee and sometimes even leave the forests.

The second painting, *Stag at Bay* [F. 277], shows a stag that is about to drown himself (a drive hunt). I took part in such a hunt in Rambouillet, on horseback. I escorted Mme de Violenne, Mme Lafarge's sister. I took part for five weeks, it was the imperial hunt.[4] The *Huntsman Sounding the Horn to Go for the Water* [F. 283] is the exact pendant of the *Stag*, likewise true to life. I painted the horse and the man after two models: the former was Gaudy's* horse, a cross between a barb and an Arab thoroughbred that produces the English pony, a hunting horse. Be careful when you use the words movement or energy. This is no Horace Vernet horse,[5] with its rippling muscles and fiery eyes and nostrils. This is a trained horse that does a kilometer in two minutes without seeming to touch the ground and whose galloping gait easily matches that of the third period at the Champ de Mars. This is the one that enjoys the calm and serenity of power that seems appropriate to the animal it pursues. As for the huntsman, I saw M. Leroy[6] (chief huntsman), who was already a kennelman under Louis XVIII, sound the horn, his horse going flat out. He sounded [the horn in the way it is done in] the classic hunt, the old Norman hunt, regular and without flourishes, the hunt of the Prince de Condé. He rode French style. I have seen him ride at that speed down the slope of a pit dug in two years of stonecutting, it reminded me of the Arabs. The huntsman in the painting is riding closely along the edge of a forest, which justifies the light in which the horse is painted. The landscape is in the beginning of fall.

The landscape of the *Three Stags* [F. 279] is a landscape in the beginning of spring. It is the moment when everything that is close to the ground is already green (as it is at this moment), when the sap rises up into the great trees, and only the oaks, the most behindhand, still have their winter leaves. The action of the painting demanded that moment of the year, but in order not to put in the bare trees of the season, I preferred to take our landscape of the Jura, which is exactly the same, with its mixture of evergreens and deciduous trees. I introduced, as in Reugney, a forest that is half deciduous,

half evergreen. As for the landscape of the *Stag at Bay*, it is at the same time of year as that of the *Huntsman*, except it is evening, for it is only after hunting for six hours that one can bring a stag to bay. It is dusk, the last rays of sunlight glide across the countryside, and the smallest objects cast very long shadows. The way in which the deer is illuminated enhances the [impression of] his speed and the [overall] effect of the painting. His body is entirely in shadow and yet modeled. The ray of light that hits him is enough to outline his form. He seems to pass by like an arrow, like a dream. The English ought to like the expression on his face, it recalls the feeling of Landseer's animals.[7]

The landscape of the *Oraguay Rock*[8] was done at Ordinaire's house, in Maizières, in a wild spot on the banks of the Loue River. It is June. There is a dish of spinach, as M. T. Gautier* used to say when Cabat[9] was reacting against Romanticism, which produced only landscapes with fireworks. I was in too much of a hurry when I did that landscape. It was done at the request of people in Besançon to match Vauthrin's* landscape, the *Puits noir* [F. 174]; it was done for a birthday.[10] Nevertheless the only part that is weak is the composition of the right side. The rest is especially powerful because of its impression of freshness.

I am speaking very freely to you, my dear friends, because I have known for a long time how I stand with you. You know better than anyone that I act without calculation, without shame, and that I let the public itself see my shortcomings. That is, perhaps, arrogance, but if so, it is an arrogance that is praiseworthy, for my very integrity deprives me of what my painting could bring me. In my poverty, I have always had the courage to be only what I am, without balancing acts, without lashing out at anyone, and yet, being as skilled in my art as I am, it would have been easy for me to act otherwise. But there are certain laws of birth that are difficult to break. My grandfather,[11] who was a 1793 Republican, adopted a maxim that he always repeated to me: "Shout loud and walk straight." My father has always followed it and I have done the same.

M. Détrimont is a man who knows painting. He found good qualities of light in that red winter landscape and put it in the Exhibition on his own without reflecting that the public admires only what is finished. If the tiniest detail is missing, the work no longer exists for them. That landscape was not finished, the leaves were not picked out, they existed only as a mass. It would have been successful only among artists. Consequently, I rely on your judgment. If you feel that it may hinder my success, withdraw it. Ask M. de Nieuwerkerke* or Chennevières.* Besides, my dear fellow, I'll tell you something, For a month now I have had it in mind to send only the canvas of the *Large Stags* [F. 279]. Later Arthaud* came by, the only man in Besançon who has both a feeling for art and talent. He said, "My dear fellow, that

painting is a masterpiece; I would send it by itself." I replied that I was of the same opinion, but the other paintings were done, and moreover they were more within the range of private collectors than that one. It even annoys me to appear at the Salon only in the categories of landscape and animals. I would have liked to have sent a figure painting had I been able to obtain an extension but the government did not allow it and my thumb is the cause of it all.

As it is absolutely necessary that I sell this year if I want to continue painting, I have had to send those paintings, and I would have sent even more if I had not broken my left thumb this winter, which prevented me from working for a month and a half. The government, which is a slave to its own institutions, cannot support me. Consequently I must rely on private collectors if I want to go on being as free as I am. As for the finished aspect of my paintings, that reminds me of a letter from Wagner in the papers: "Without finish in painting and ballets in operas, there is no salvation."

By the first of the month, dear friend, I'll be in Paris and I will have the pleasure of seeing you again. You came to Besançon but you did not come to see me. Your visit had been announced to me. Many of my friends have already come and soon you will be the only one who has not. The last one here was Daubigny,* who is a very charming fellow whom I recommend to you, though he does not need it.

See what is going on with Détrimont and urge him to clean my paintings scrupulously and varnish them as you think best. M. Pothey,* the engraver, is reproducing one of my paintings for Leighton's [?] publication. He is the English engraver who is making a large album of wood engravings of the most important Salon paintings for England.[12]

And now, dear friends, I embrace you both with all my heart.

Ever yours,

Gustave Courbet

Ornans, April 20.

1. Athenian statesman and lawmaker active at the beginning of the sixth century. He was known for his wisdom and strong sense of social justice.

2. Compare letter 59-2.

3. The three hunting scenes he sent to the Salon, F. 277, F. 279, and F. 283. On Courbet's interest in serial painting, see Chu (1980a, 134) and Rubin (1980, 61–63).

4. Nothing is known about Courbet's participation in the imperial hunts in the Rambouillet forest, which took place rather regularly from 1859 to 1870. In view of the artist's contacts with members of the imperial circle, notably the duc de Morny, it is not impossible that he took part in one or more of these brilliant affairs, which commonly included a large number of hunters. (cf. Lenotre 1984, 184, 203ff).

5. Horace Vernet (1789–1863), late Romantic painter, especially known for his depictions of battle scenes and horses.

6. Though in the manuscript copy of this letter (which is not known in the original) the name is written as "M. Leroy," Courbet may have referred to "M. (de) La Rue," the general overseer of imperial hunts (cf. Lenotre 1984, 203).

7. Edwin Landseer (1802–73), English painter of animals and hunting scenes, whose work had proved very popular at the 1866 International Exhibition. On the possibility that Courbet was inspired by a specific work by Landseer, see Nochlin (1967, 213) and Brooklyn (1988, 138).

8. Fernier (1977–78, 1:158) has identified this work with a landscape painting in the Folkwang Museum in Essen (F. 262). The latest catalogs of the Folkwang Museum do not support this identification. Indeed, the Essen painting does not correspond with the description of Riat (1906, 184), who apparently saw the painting. No other large finished landscape painting is known, however, that fits this description.

9. Nicolas-Louis Cabat (1812–93), a landscape painter whose early work anticipated the paintings of the Barbizon school.

10. According to letter 61-10, Courbet sold the painting to his friend Baron Dejean.

11. Jean-Antoine Oudot.*

12. Perhaps a publication planned by George Cargill Leighton who, together with his brother, the short-lived painter Charles-Blair Leighton (1823–55), had founded a fine printing business called Leighton Bros.

61-7 *To Alfred Bruyas, Paris, May 16, 1861*

[No salutation]
　　I arrived from Ornans the day before yesterday.

Gustave Courbet

　　Paris, May 16, 1861
　　[Address] M. Bruyas, Alfred

61-8 *To the comte de Nieuwerkerke, Paris, June 6, 1861*

Monsieur le Comte:
　　A few days ago I returned from my part of the world. You have been kind to me and I have always remembered you with affection.
　　Knowing that you had returned from Rome, I called at your home yesterday as I wished to pay you a brief visit. I should be very obliged if you would give me a day and a time when I would not be intruding.
　　Please accept my most sincere greetings,

Gustave Courbet

　　32 rue Hautefeuille
　　1861, June 6

61-9 *To the comte de Nieuwerkerke [?] [Paris, June 14, 1861 (?)][1]*

Monsieur le Directeur:
　　I regret very much that I was unable to come to the appointment that you fixed for me. Your letter reached me only yesterday evening at Louveciennes,

where I had gone to spend a few days with my friend Francis Wey.*

I hasten, Monsieur Director, to make my apologies to you in person and to inform you that I will be at the ministry today at two o'clock.

If your engagements prevent you from seeing me today, Monsieur, please suggest another interview in a note that the office boy will bring me.

Respectfully,

Gustave Courbet

Friday morning

1. I have assumed that this letter was a sequel to letter 61-8, which was written on Thursday, June 6. If Nieuwerkerke answered Courbet immediately (i.e. on June 7 or 8), Courbet may have received his answer with some delay on Thursday evening, June 13. His own letter, then, would be dated Friday, June 14.

To his family [Paris, late June 1861][1] 61-10

Dear family:

I put off writing until now because I kept waiting for positive news to tell you. On my arrival in Paris I sold the painting of the *Hanging Roedeer* [F. 159] (from the Besançon exhibition) at the exhibition of the Boulevards[2] for 2,500 francs, and I have just sold Baron Dejean, a friend of mine, the *Oraguay Rock* [F. 262] landscape for 3,500 francs at the government exhibition.[3] At the same exhibition the *Fox* [F. 263] was bought from me for 1,800 francs. Had I been in Paris I would have sold the *Fox* for 5,000 francs. I learned that later from M. de Chennevières,* who told me that the [committee of the] lottery had thought of offering me that price.[4] Francis Wey,* who talked so well, was not able to do it; he should have asked the price that was being offered. I lost 3,000 francs on that last painting. I always have that kind of luck!

The government is at a loss about how to deal with me. The public has forced its hand. All of Paris is waiting to see me decorated and my painting bought for the Luxembourg.[5] Twice already I have been asked the price of the *Large Stags* [F. 279]. I was clever with them. I replied both times, first to M. de Chennevières,* then to M. de Nieuwerkerke,* that, as I had set the price for the *Fox*, I would not set a price for my [large] painting; that I was leaving it entirely up to them; but that they could be sure that I would not quote them any price, that I relied on their goodwill so that they could make no public objections, claiming neither that the price was high nor anything else. Consequently, (so far) the painting is going to the Luxembourg, and everything suggests that I will be decorated. We shall know it all in four days, next Tuesday, the third of the month. I'll write you the day after to tell you how it went. So far I have received nothing official, they are waiting until the last moment. They are in an awkward position with regard to me at the moment.

I sold two small seascapes and have received commissions for two small land-scapes. Financially things could work out well if this continues.

I have seen Zoé[6] a few times. She and her lady are going either to Baden-Baden or to Spain. She is delighted, she is well now. She had been ill again for she had insisted on taking too strong a purge. For three days I have had a stereoscope and sixty photographs to send you. I'll send them to Ornans tomorrow by coach, they'll arrive in a few days. Father should put a coat of grey plaster of Paris everywhere but not on the ceiling for I want to cover it with paper that I'll bring from Paris. Also, have the facade roughcast while the weather is good. Armand Barthet* gave me a small Louis XV watch with enamelwork, which I will bring you. I embrace you all with all my heart. I hope you are all well.

<div style="text-align:center;">

G. Courbet

</div>

1. As the official prize distribution for the 1861 Salon took place on July 3, this letter, written shortly before the event, must date from the end of June.

2. Probably a reference to a group show in the gallery of Louis Martinet* at 26 boulevard des Italiens.

3. See letter 61-6, n. 10.

4. The *Fox in the Snow* was in effect bought by the committee in charge of the state-run annual benefit lottery (cf. Fernier 1977–78, 1:160).

5. There was indeed a movement within the arts administration to buy the painting, but in the end it failed. Similarly, Courbet's name was struck from the list of nominees of the Legion of Honor (see Paris 1977, 35).

6. Zoé Courbet* was the hired companion of the marquise de Saint-Denys (cf. Grimmer 1956, 9).

61-11 *To his family [Paris, July 1861] (incomplete)*

. . . Now, here is something that is more important than that scoundrel Levier: I was decorated ten days before the distribution of the awards, and then, two days before, the emperor, on I don't know whose advice, or his own, I don't know, crossed my name off the list with his own hand,[1] and I am very glad of it for I was in a false position. It bothered me to wear that cross, which out of dignity I would not have worn, for my opinions don't allow it; yet not wearing it would have done me a hundred times more harm than good.

Now the people who don't know my opinions are scandalized because the government has not decorated me and at the moment that is creating a hell of a stir in Paris. The result is that things are working out wonderfully well for me.

They blundered in giving me a revocation of the second-class medal that I received ten or eleven years ago, which is utterly ludicrous, I, who was proclaimed king of the Salon of this year by everyone without exception. The

public is exasperated, this flies in everyone's face, and the indignant artists are trying to organize their own exhibition in the future.

In spite of all that my painting will yet be bought for the Luxembourg[2] and that is all I want for increasingly I have the entire artistic youth looking to me and at the moment I am their commander-in-chief as they have no idea anymore what to hold on to besides me.

Later I will tell you more about it. I have already sold nearly ten thousand francs' worth.

<div align="center">

G. Courbet

</div>

I embrace you all.

I will send you the stereoscope.

1. This allegation is confirmed by other sources, including a letter of Jules Laurens to Alfred Bruyas, dated April 16, 1861 (cf. Paris 1977, 35).

2. Though both the marquis de Chennevières and the comte de Nieuwerkerke appear to have favored the acquisition of one of Courbet's Salon paintings by the Luxembourg Museum, the transaction failed to materialize.

To Baron Isidore Taylor (?), Paris [August, 1861] 61-12

Monsieur le Baron:[1]

My friends told me that you could see to it that I obtain a reduced fare on the trains that will carry the artists to the Antwerp celebrations.[2]

As I have an important painting in that exhibition,[3] I would like to go, having been invited by the city of Antwerp.

As I am obliged to stop and see M. Renard, the director of the Lille Museum, I would like the reduced fare to allow for the stop in Lille.[4]

With respectful regards,

<div align="center">

Gustave Courbet

</div>

Rue Hautefeuille

1. The recipient of this letter may have been Baron Isidore-Justin-Severin Taylor (1789–1879), who fulfilled various functions in the official art administration during the July Monarchy and the Second Empire.

2. The Antwerp exhibition and congress. See letter 61-14, n. 2.

3. The *Battle of the Stags* (F. 279), after having been exhibited at the Salon, was subsequently sent to Antwerp.

4. The museum in Lille had acquired Courbet's *After Dinner in Ornans* (F. 92).

To an unknown correspondent, Paris, August 28, 1861 61-13

<div align="right">

Paris, August 28, 1861

</div>

Monsieur:

I am infinitely grateful to you for your consideration and I thank you.

I would like to sell that painting, which has been requested of me numerous times, for five thousand Swiss francs.[1] If you have the opportunity to be of assistance in selling it for me, please do whatever you can to reach the above figure. In any case, at the moment I don't wish to go below four thousand Swiss francs. If the prices cannot be reached, please submit to me the offers that are made.

With respectful greetings, Monsieur,

Gustave Courbet

32 rue Hautefeuille

1. This letter, kept in the archives of the Musée des Beaux-Arts at Nantes, refers to the *Grainsifters* (F. 166) of 1855. Shown at the ninth exhibition of the Société des amis des arts of Nantes in 1861 (cat. no. 312), the painting was bought by that society for the Nantes Museum. It is not known who was the middleman to whom Courbet addressed this letter.

61-14 *To his father [Paris, early September 1861]*

Dear Father:

I was unable to answer you immediately, I was in Fontainebleau. My sister[1] left for Baden-Baden three weeks ago. As for Tigre, you can claim a dog back after eighteen months or not, but [if you do] you have to pay for food, lodging, and his taxes, that is to say 150 francs. I cannot find the letter that he wrote me. I believe that he asked me for a painting of the dog should I do one.

You tell me that the cherry trees have recovered, but you don't tell me whether the other trees have recovered. I sent my sisters a stereoscope. You don't tell me whether they received it.

After the Exhibition I sent my large painting to Antwerp where there is a universal exhibition.[2] It was as big a success as in Paris. I had to leave two weeks ago for that city, by its own invitation.[3] They paid half our train fare and on our arrival in Antwerp we were housed at the expense of the city and of the inhabitants who had requested [to host] us. For example, I stayed with M. Gossi, a ship owner. Proudhon* and Victor Hugo* were supposed to stay there [too], but neither one was able to come, Hugo because he was ill and Proudhon because he had pressing work. We were very sorry. It would be impossible to be with people more delightful than those I stayed with. The city of Antwerp conducted itself marvelously towards us, no one could have done better. The festivities were splendid. If we had had to stay two more days, we'd all be dead, no one could take any more. It lasted a week. We were fifteen hundred artists and writers. The purpose of the gathering was an artistic congress[4] to treat concerns of art and its philosophy and the connec-

tion between the world of the spirit and the needs of our time. It was divided into three preliminary sections. In one of the three sections,[5] I immediately came in for a shower of speeches, in which my way of seeing in art (Realism) was debated by professors, philosophers, priests, painters. Everyone was trying to get the better of everyone else. On all sides one heard M. Courbet here, M. Courbet, Realism there, etc. I enter the hall of philosophy of art. Several painters rush over to tell me, "They have just given two lectures against you and the one who is speaking now is also against you. Listen and ask to speak so as to answer him." I ask to speak, even though I am not prepared. That was when I said what I am sending you in [an article in] the *Courrier du dimanche*.[6] Then there was no end to the bravos. I was such a success that I had to give more than three hundred autographs to all the people in the hall as well as in the city. The session closed with my way of seeing. From there we were invited by the city of Ghent to a luncheon. There were still four hundred of us. At the luncheon they made me propose another toast to the city of Ghent. Then we went to Ostend and Bruges. After that I returned to Brussels, where I spent two days. Then, stopping in Lille, I spent a day with M. Renard, director of the museum.[7] He had been waiting for me for five years.

I have been in Paris for two days. I cannot say exactly yet when I'll leave for Ornans. It will be in the course of this month. Belgium and its artists have brilliantly avenged the stupidities of the French government in my regard. The edition of the *Courrier du dimanche* sold out that very evening. The speech is as successful as in Antwerp. I hope that you are all well. I am staying here to finish some paintings that I have sold.

I embrace you all.

Gustave Courbet

1. Zoé Courbet,* who was the hired companion of the Marquise de St. Denys, often accompanied her on her various trips.

2. The exhibition, featuring works of Belgian and foreign artists, was part of a series of events and festivities intended to celebrate the city of Antwerp and its glorious history. The festivities included an official banquet for two thousand people, concerts, fireworks, a torchlight parade, and a congress about art to which artists, critics, and philosophers were invited.

3. Courbet apparently was one of the invited participants in the congress.

4. On the congress, which took place from August 19 to August 21, see Crapo (1991).

5. The section that was devoted to the impact of "l'esprit moderne" on contemporary art. It took place on August 20, the second day of the congress.

6. Courbet's statements at the Antwerp congress first appeared in the *Précurseur d'Anvers* of August 22, 1861, and they were reprinted in the *Courrier du Dimanche* of September 1. For a modern reprint, see Crapo (1991).

7. Courbet's first major painting, *After Dinner in Ornans* (F. 92), had been sold to the Lille Museum.

61-15 *To Max Buchon [Paris, September (?) 1861]*

Dear Max:

I sent you five hundred francs two or three weeks ago with Alphonse Promayet,* who has been in Ornans since then. I am amazed that you have not received them yet. Please write a note to my father, who will ask him for them and send them to you.

I must tell you about some of my tribulations. I don't know whether you heard that the jury of the Academy and the minister of state awarded me a decoration this year, to my great regret. But fortunately the emperor took it on himself to personally take it back from me. I am grateful to him for that, and he is doing what he must. I finally learned that it was for making him reply in 1854 "that his government was not free enough to allow for a man like me."[1]

The minister of state[2] had acquired two paintings of mine, the *Battle of the Stags* [F. 279] and the *Stag at Bay* [F. 277], for the Luxembourg and Compiègne [respectively,] for the sum of twenty-five thousand francs. The entire public knew it and still believes it. I go to the ministry of state to call them to account. They reply that they cannot contradict the emperor and that what was arranged between us was as if it had never been. I replied that it was a dubious way to behave. All that aside, I hope to sell thirty thousand francs' worth this year before returning to Ornans, and even with that I think I'll be back in two or three weeks.

I went to Antwerp, where I was a huge success and where my way of seeing was considered the last word in the philosophy of art.[3]

I have just been nominated by the artists on the jury for the exhibition of French paintings that will travel to London.[4] There are five of us who are temporary associates at the Academy for this purpose. It is a protest, I don't know whether it will last. No matter, I'll go to London and make other arrangements myself. I feel like establishing residency in London so as to have the right to exhibit with the English. I will also see whether I could have a private venture with my paintings.

Champfleury* has retired. No one talks about him anymore, I rarely see him.

Here, I am up to my ears in love. Youth must have its fling. There is still time if I wish to take advantage of it. I am sorry to miss the beautiful days in the country that I could be enjoying in Ornans right now.

Affectionately yours and please shower your lady with my compliments,
 Gustave Courbet
I sold the *Stag at Bay* for twelve thousand francs.[5]

1. It is not known at what occasion the emperor said this.
2. At the end of 1860, Napoléon III had reconfigured his cabinet and replaced Achille

Fould (1800–1867) with Alexandre Walewski (1810–68) as minister of state. The minister of state was ultimately responsible for the administration of the fine arts.

3. See letter 61-14.

4. On the formation of the admission jury for the 1862 British International Exhibition, see Mainardi (1987, 124). In the end, Courbet was not part of the jury, which included four (rather than five) artists elected by all those submitting works.

5. This deal must have fallen through subsequently. In fact, Courbet did not sell the painting until 1865, when it was bought for three thousand francs by the city of Marseille.

To the young artists of Paris, Paris, December 25, 1861[1] 61-16

Paris, December 25, 1861

Messieurs, dear colleagues:

You wished to open a painting atelier[2] where you could freely continue your education as artists and you have been so kind as to offer to place it under my direction.[3]

Before I answer anything, we must come to terms about that word "direction." I cannot be accused of allowing a teacher-student relationship between us. I must remind you of what I recently had the opportunity to say at the Antwerp congress:[4] I do not have, I cannot have students. I, who believe that every artist must be his own master, I could not imagine setting myself up as a teacher.

I cannot teach my art, or the art of any school whatsoever, because I deny that art can be taught, or, in other words, because I maintain that art is entirely individual and is, for each artist, simply the ability that issues from his own inspiration and his own studies of tradition. I would add that, as I see it, art, or talent, should be to an artist no more than the means of applying his personal faculties to the ideas and the events of the times in which he lives. To be specific, art in painting should consist only of the representation of things that are visible and tangible to the artist.

Every age should be represented only by its own artists, that is to say, by the artists who have lived in it. I hold that the artists of one century are totally incapable of representing the things of a preceding or subsequent century, in other words, of painting the past or the future. It is in this sense that I deny the possibility of historical art applied to the past. Historical art is by nature contemporary. Every age must have its artists, who give expression to it and reproduce it for the future. An age that has not managed to find expression in the work of its own artists has no right to be expressed by later artists. That would be falsifying history.

The history of an age finishes with the age itself and with those of its representatives who expressed it. It is not the task of later times to add something to the expression of previous times—to aggrandize or embellish the past. What has been has been. The human mind has the duty always to begin

working afresh, always in the present, building on results already obtained. One must never begin something anew but always proceed from synthesis to synthesis, from conclusion to conclusion.

The true artists are those who pick up their age exactly at the point to which it has been carried by previous times. To go backward is to do nothing, to waste effort, to have neither understood nor profited from the lessons of the past. That explains why antiquated schools of all kinds always end up producing the most useless compilations.

I also maintain that painting is an essentially concrete art form and can consist only of the representation of real and existing things. It is an entirely physical language that is composed, by way of words, of all visible objects. An abstract object, not visible, nonexistent, is not within the domain of painting. Imagination in art consists of knowing how to find the most complete expression of an existing thing, but never of inventing or creating the thing itself.

Beauty is in nature and occurs in reality under the most varied aspects. As soon as one finds it, it belongs to art, or rather to the artist who can see it. As soon as beauty is real and visible, it carries its artistic expression within itself. But the artist has no right to amplify that expression. He cannot touch it without running the risk of altering its nature and, consequently, of weakening it. Beauty provided by nature is superior to all artistic conventions. Beauty like truth is relative to the times in which one lives and to the individual capable of understanding it. The expression of beauty is in direct relation to the power of perception acquired by the artist.

This is the basis of my ideas on art. With such ideas, to conceive of the project of opening a school to teach conventional principles would be to return to the ill-thought-out and trite ideas that until now have everywhere guided modern art. There can be no schools, there are only painters. Schools serve only to explore the analytical processes of art. No school could alone lead to synthesis. Painting cannot, without falling into abstraction, allow one incomplete aspect of art to dominate, whether it be drawing, color, composition, or any other of the so multiple means that only in combination make up this art.

I cannot, therefore, presume to open a school, to educate students, to teach this or that part of the artistic tradition. I can only explain to artists (who would be my associates and not my students) the method whereby, in my view, one becomes a painter—the one that I myself used from the beginning in order to become one—while leaving it to everyone [to choose] his entirely individual direction, the complete freedom of his own expression in the application of that method. To that purpose, the development of a group atelier, recalling the fruitful collaborations of the Renaissance ateliers, can

certainly be useful and contribute to opening up the phase of modern paint-

ing, and I would lend myself willingly to anything that you wished me to do to achieve it.

Sincerely yours,

Gustave Courbet

1. This letter, one of the most complete statements of Courbet's ideas about art and art education, was published in the *Courrier du dimanche* of December 29, 1861. It is generally believed that the letter was composed by Jules Castagnary rather than by Courbet himself. Indeed, the only manuscript version of the letter that is known is in Castagnary's handwriting, with nothing but a signature by Courbet.

2. On December 6, 1861, Jules Castagnary* had signed a lease (to become effective on December 9) for an atelier at 83 rue Notre-Dame-des-Champs (street level), where Courbet was to teach painting. Student applications began on December 9, and that same day thirty-one students registered (cf. Bonniot 1973, 190). For a list of students, see Castagnary 1864 (190–91). The atelier would last until March 1862.

3. The plan for the atelier was not conceived by Courbet but rather by Castagnary, who, on September 28, 1861, had organized a meeting of art students in the brasserie Andler, where it was decided to request Courbet to open a teaching studio.

4. Compare letter 61-14.

To his father [Paris, March 10, 1862 (Rd)] 62-1

Dear Father:

I apologize for not answering you sooner but you must take into account that in Paris I am not really my own man. I have important things that I must do here, that I cannot manage to do. I have too much of a following, especially recently, with all of modern painting converging around me. At last I have triumphed across the board.

I have just done, as the first piece at my students' atelier,[1] the statue that I wanted to make for the fountain in front of our house in Ornans.[2] It is a figure fishing for bullheads, about 4 1/2 [feet] high, a twelve-year-old child.[3] It is practically finished, only the hands are still to be done. My bold approach and its happy result have surprised everyone. I'll have it cast in iron[4] but I would like the Ornans municipal council to redo the column that is in the middle of the fountain to adapt it to the statue—if they want me to donate it to them;[5] also, for Mother to have new shutters made for the distillery and the laundry room for it is too embarrassing to admit that the house belongs to us when one sees it in such a state of disrepair. We are known for our negligence, but this offends the local people, especially when everyone does whatever he can to be clean and decent.

There will be a large crowd of strangers for the statue's inauguration and I hope that Urbain* and his choral society will organize a meeting of the local choral societies. For my part, many artists will follow me on this expedition.

Isabey* the architect just got married in Rambouillet. I was a witness. I caught a cold that has been killing me for a week, but I think I am doing a little better this morning.

I just came across some very cheap unsized paper, with which I want to paper the entire inside of the atelier,[6] rooms, foyer, kitchen, and small rooms. So I would like you to tell me how many meters I need for the whole house, including the ceilings. I have also found some moldings and drapes, which will form panels and frame the paper four inches from the edges, both on the ceiling and at the windows. You have to tell me for each room how many meters of paper and of molding, as soon as you can. Try not to dawdle too much and tell Marquinet to prepare the walls and the ceilings to be hung with coarse paper. [Tell him] not to be too meticulous. He is asking me eight hundred francs for it, I'll send him the money, and Chabot as well.[7] Tell me how much I should send for the moment, I'll send it by mail. Give each one a partial payment till we settle finally. Kind regards to Chabot. Tell him to make the doors and the slatted shutters for our house in Ornans. Don't mangle my trees and my hedge too much, let a few things grow.

I embrace you and Mother and my sisters as well. Take care. Affectionately yours,

Gustave Courbet

My statue will be at the Besançon exhibition,[8] I hasten to finish it.

Our sister Zoé* is well. M. Andler* sends his regards, as does M. Usquin.*

1. An allusion to Courbet's teaching atelier on the rue Notre-Dame-des-Champs (see letter 61-16, n. 1).

2. The house in the Iles-Basses section of Ornans, currently on the place Gustave Courbet, no. 24.

3. Fs. 1. The original plaster is in the Musée Gustave Courbet at Ornans.

4. Originally, two casts were made. One was donated to the town of Ornans and surmounted the Iles-Basses fountain until 1871, when it was removed and returned to the Courbet family. In 1872, Courbet donated it to Alexis Chopard* in Morteau. The cast is still in the collection of his descendants. The second cast was inherited by Juliette Courbet, who donated it to the town of Ornans around 1885 to replace the first. It continues to surmount the fountain today. On the history of the statue, see Fernier (1969, 88).

5. A letter from Régis Courbet to his son (May 24, 1862) indicates that Courbet's conditions were agreed to. The town of Ornans repaired the basin and private funds were raised for the renewal of the column (cf. Bonniot 1973, 351–52).

6. Courbet's studio on the route de Besançon.

7. Marquinet and Chabot appear to have been workmen who were permanently or frequently employed by Courbet's father.

8. The *Boy Catching Bullheads* was indeed exhibited in Besançon, where Courbet's father saw it in May (cf. Bonniot 1973, 351). It was also shown at the Salon of 1863, at Courbet's private exhibition in 1867, and at the International Exhibition in London in 1862. In each case, it is difficult to ascertain whether the original plaster or one of the casts was exhibited. The

problem is further complicated by the fact that the 1863 Salon catalog refers to a *marble* sculpture. No marble version of the work is known today.

To his father [Paris, April 1862] 62-2

Dear Father:

I am sending with M. Usquin* the 1,500 francs you ask me for to settle my business in Ornans. I am adding 500 francs so you can buy père Bon's field (I have thought it over carefully).[1] As I recall, he was offering it for 1,800 francs. Accept and give him 500 francs.

I am supposed to spend two weeks with a friend of mine[2] in the Saintonge, in Saintes.[3] I'll write you if I go. I sent my statue to London.[4] It is creating an extraordinary sensation in Paris. I'll have another copy of it tomorrow or later, which I will be sending to Besançon.

I went to buy paper with Isabey.* I think you can glue it up without me. It takes a little patience but you can hire a day laborer if Marquinet does not want to do it. It will be extraordinarily cheap.

I'll write you more another time. I go to London around the end of May.[5] On my way back I'll go to Ornans and there will be quite a few people with me. I embrace you all, Mother, my sisters, and you.

Gustave Courbet

Kind regards to everyone, Urbain,* mère and père Bon,* etc.

1. Courbet was still expanding the terrain around his studio on the route de Besançon. Jean-François ("père") Bon lived next door to Courbet's home in the Iles-Basses section of Ornans.
2. Etienne Baudry.*
3. On Courbet's stay in Saintes, see Bonniot 1973.
4. The *Boy Catching Bullheads* (Fs. 1). Compare letter 62-1, n. 8.
5. It is unlikely that this visit materialized as Courbet arrived in Saintes on May 31, 1862 (cf. Bonniot 1973, 5).

To Léontine R[enaude?] [Saintes, June 1862] (incomplete draft) 62-3

. . . My friend[1] and I were flabbergasted and sick throughout our trip, as we reflected on the unspeakable rudeness of your behavior Saturday night.[2] We have never in our lives seen anything like it.

. . . First of all, when you thought I was at the ticket counter, I saw you in the middle of the yard, looking at the cars; then later, the photographer,[3] forgetting the plan, became interesting when he left his box to come over to our table to shake hands and, pretending to be friends, to cleverly tell us that he had just walked from the Champs Elysées, then later that he had missed the five o'clock train. He is a man with a resourceful mind. But you who

[feigned that you] did not recognize him, though we knew the opposite was true, Madame, you still have quite a bit of work to do to achieve the great art of your profession.[4] You looked at him with a devious and furtive glance just like a scared ostrich, with that dead calf's head and that blank and cold glance with the cowardly and cruel expression of a chained wild beast. It was on account of him, however, that you had put on your walking shoes and that you could not kiss me when we parted. You know the rest. Your deceit was too transparent: you saw as well as I how the coachman followed him while he hid in the café not daring to see us off. You saw yourself getting in and out of the carriage because the photogapher feared the light; then you saw yourself do a little act at the ticket check where you kissed me like Judas, who is of your same race. At last the train's departure put an end to your trials and crowned your success. That was a pretty farewell and for a person with any dignity a well-chosen moment to be unfaithful to someone who for a whole year did you the honor of treating you as if you were an honest woman. I could never have imagined all that playacting in a railroad station, the more so as we had agreed that we would leave each other before we would be unfaithful to each other.

Madame, I am happy to be able to return to you the only thing that I have left of yours, that is, the knife that I will pass along to M. Tournachon for his services to you as well as to me. If you were trying to make me jealous, I swear you made a mistake. I knew very well that with you I was in a brothel and in those circumstances one never knows whom one is following. Thus one night, when I returned to your house, the eiderdown was on the floor in the middle of the room. Someone had walked on it, the bed was rumpled and uncovered; there had been an assignation during the day. Another evening my head was cold. You gave me the nightcap, but it didn't fit anymore, the person who had slept there the night before had a smaller head than mine and had tightened it by five or six holes. With you I was only ever jealous of my personal dignity and I saved it in every way that I could because I was foolish enough to love you as an honest man does any woman with whom he keeps company. That is why it took me a year to convince myself willy-nilly that you were of that despicable class.

I would say much more without even delving into the past if the subject were worth it, but it annoys me, even though I have the time. Let's talk a little of something that interests me even though you don't care about the interests of others. I don't know what I should do to retrieve various things of mine that are at your house and that could signify to the people you receive that I had intimate relations with you. That seems trying to me: I propose to buy them from you. Have them appraised or appraise them yourself. I particularly want the two portraits, the one of you and the one of your dog.[5]

My concierge will accept them for payment. It is not as souvenirs [that I

want them], you may be sure, but to destroy them; or else destroy them yourself before a witness and then I will pay, as all your gentlemen do, according to my means and my consumption, either M. T. or you, for the use that I had of your body for a year.

Yours truly, . . .

My first idea was not even to write to you, but as I am enjoying some leisure time in a splendid countryside and as I must inform you of the intentions with regard to you of people who don't even know you, I have decided to [write after all]. With this, I will truly be done with you. Madame, your room awaited you (something I did not know), with blue walls and magnificent cabinets; carriages all day long and champagne instead of beer. You rushed things by a day, but one cannot control one's impulses, which means that one sometimes makes mistakes. I live alone in this castle ten minutes from town, the home of a charming friend and his mistress. I am entirely happy, especially coming from the brutalizing sentence that I have served with you, and every evening there is a tableful of charming friends, artists, lawyers, doctors, etc. There you could have paraded your airs. Instead I tell the tales of my woes, and we laugh like mad. . . .

1. Probably Jules Castagnary.*
2. Léontine's behavior is described at length in letter 62-4.
3. Adrien Tournachon* (cf. letter 62-4, n. 1).
4. Like many nineteenth-century *grisettes*, Léontine was probably a part-time actress.
5. Compare letter 62-4, n. 9.

To Jules Troubat [Saintes, June 1862] 62-4

My dear Troubat:

I would like to entrust you with a diplomatic mission. I was grossly insulted by Mlle Léontine,* the evening I left Paris for Saintes. Mlle L. got it into her cynical whore's head to make a date with M. Tournachon[1] at the railroad station, where she was accompanying me. Tournachon, like a vaudeville stooge, arrived dressed in a flowered cravat and ditto vest as if for a country wedding. His behavior being as despicable and as beastly as Mlle Léontine's, he was unable to say a word. He played the role of traitor in a stupid fashion, about which I'll tell you. In the end they left for the country, together, half an hour after our departure. The impudence of the prostitute I was with surprises me less than Tournachon's false, sugary, debauched impudence (Castagnary* nicknames him "Tourne-à-cochon").[2] Neither Castagnary nor I has ever seen such behavior in all our lives.

To come back to your mission, I wrote the woman an exemplary letter,[3] and I would like to know what effect it has had, as she has not answered (and could not answer). I would like you to call on Mlle Marguerite, Mme Dufour's

friend, who is close friends with a seamstress who goes three or four times a week to Léontine's. Mlle Marguerite's friend is the sister of a woman named Henriette. They have talked very often about me and my love affairs. Tell Mlle Marguerite to play dumb and adroitly ascertain from the latter what the status is of my affair with Mlle L. since Mlle L. has been seen with Tourna-chon the photographer. She can then go on to say that I have been ill in Saintes since I left Paris because of an insult that I received before I left. I wrote to Champfleury* to tell my attorney to retrieve the paintings and the statuette that I have at the lady's house. Tell her also that the sadness that that wild animal caused me has practically wasted my trip as it prevents me from working.

All that is only to rouse her curiosity and put a bee in her bonnet. We'll get a good laugh out of it later. You must handle this matter with care. I must make her furious. Tell her also that I wrote a circular letter to all my friends apologizing to them for having introduced such a woman to them. Last but not least, Marguerite must be diplomatic. She can add that the whole story will be related in Carjat's* newspaper[4] in a series of letters that already have been written so that the woman will become a byword, and that after that I have something else up my sleeve for her.

Please, my dear Troubat, have fun with this. There will be plenty to laugh about and Mme Dufour will be very pleased. Send my best regards to the latter and to M. Sainte-Beuve.[5] Best regards [also] to Champfleury. I am here slaving away and delighted to be rid of the woman who shamed me. I am painting nude women and landscapes in the prettiest countryside you have ever seen, and in a magnificent castle where I live alone except for a man and his mistress.[6] Give me news of my statue[7] and the Martinet exhibition.[8]

Sincerely yours, my dear Troubat, reply quickly to Saintes, c/o M. Baudry (Charente-Inférieure).

Gustave Courbet

Make it clear to Mlle Marguerite that I have sold the painting of the dog and the portrait of Mlle Léontine[9] to someone and that my attorney, M. B.,[10] must deliver them by legal authority. Tell her that I have [enough of a sense of] honor not to leave a souvenir like that with such a woman. Say all that in front of Mme Dufour. Go find Mlle Marguerite and tell her that you have read Champfleury's letter. Make it clear to her that M. Lireux [?] and all my friends who have seen her with me have received this serious letter and that a newspaper will be reproducing it.[11]

1. Courbet probably refers here to Adrien Tournachon,* the younger brother of Félix Tournachon, better known as Nadar* (cf. Bonniot 1973, 80–81).

2. The literal translation of "Tourne-à-cochon" is "turn-to-pig."

3. Compare letter 62-3.

4. *Le Boulevard*, published by Carjat between 1862 and 1864.

5. Charles-Augustin Sainte-Beuve (1804–69), well-known author and literary critic, employed Troubat as his secretary.

6. Courbet was staying with Etienne Baudry* at the Château de Rochemont in Saintes. Baudry's mistress may have been his future wife Isabelle Bardin, whom he married in 1864.

7. The *Boy Catching Bullheads* (Fs. 1).

8. Louis Martinet,* in 1859, had opened a permanent gallery at 26 boulevard des Italiens. In 1862, to lend greater credibility to his gallery, he founded the Société nationale des beaux-arts, composed of contemporary artists and critics. The society held its first exhibition in June 1862. Courbet was represented by three paintings and the *Boy Catching Bullheads* (cf. Bonniot 1973, 285–86).

9. Hélène Toussaint (1980, 91–93) assumed that Courbet was referring to the *Nude Woman with Dog* (F. 631). However, both in this letter and in the letter to Léontine (62-3), mention is made of two separate paintings. Perhaps the painting of the dog may be identified with F. 1019, an undated study of a lapdog; the portrait of Léontine cannot be identified.

10. M. de Benazé. See also letter 60-6, n. 2.

11. It is not clear to what letter by Champfleury Courbet refers here. In any case, no such letter seems to have been published in the papers in 1862.

To Léontine R[enaude?] [Saintes, June 1862] (incomplete draft) 62-5

. . . Oh well, ill winds blow much good. Since one is obliged to run into photographers everywhere and will end up finding them in the butter and [floating] on the soup, I must accept the facts. But he will have served a purpose. You know how much and for how long I have been eagerly seeking an opportunity to let you go. Tournachon* must be quite proud of the trick he played on me but he can't know the favor he is doing me. He is finally relieving me of the shame of going out with a woman of your sort; he is relieving me of the task of reprimanding you in public establishments; he becomes responsible for the rolling of eyes seasoned with sighs; he will be patronizing women who in town wear diamonds in their ears, gold combs in their hair, [and] red hairnets, but [who make] lousy impressions at the table d'hôte. He can do even more: he can take you to London, do his business during the exhibition, and you can take him into your houses in Paris and Asnières and go about your business. When one reflects calmly on all that, the blood rushes to one's face. Tournachon is definitely behaving well, therefore will get the knife. . . .

To Jules Castagnary [Port-Berteau, August 23, 1862] 62-6

My dear Castagnary:

Since you left, success has been piling on success.[1] I am sorry you were not here. I was carried in triumph by the ladies of Port-Berteau, in front of two thousand people.[2] As Baudry* told you, the festivities will continue tomorrow, Sunday, in Port-Berteau.[3]

The steamboat will bring people from Saintes. [There will be a] concert, fireworks, and a ball on the place Courbet. In Rochemont, a week later, the same again. Before I leave, [there will be] a public exhibition of what I have done in this part of the world.[4] In addition I am in love with a splendid lady,[5] the driving force behind my triumph.

You told me about Malassis's bankruptcy,[6] to my great disappointment because he is my friend and also because I had a financial interest tied up there.[7] I would like to know what I should do under the circumstances. At the moment I would like to know if I can send Mlle Duchesne, if I can still send her the painting that she asked me for. I am afraid of only one thing, that she bought the *Stags* from Malassis.[8]

Affectionately yours,

G. Courbet

Please have Baudry's articles published, either in Carjat's* journal or somewhere else.[9]

1. A reference, no doubt, to the festivities organized in Courbet's honor in August 1862: a concert followed by a ball in Rochemont on August 12 and an outdoor fair in Port-Berteau on August 17 (cf. Bonniot 1973, 112–20).

2. Courbet's claim is confirmed by a report of the festivities in *L'Indépendant de la Charente-Inférieure* of August 23, 1862, 3 (cf. Bonniot 1973, 114).

3. The second celebration at Port-Berteau was held on Sunday evening, August 24.

4. An exhibition of paintings done by Courbet during his stay in the Saintonge was to be held in the town hall of Saintes from January 15 to February 17, 1863. In addition to works by Courbet, the exhibition also included paintings by Camille Corot, Henri Fantin-Latour, and several local painters (cf. Bonniot 1973, 232–40).

5. Probably Laure Borreau.*

6. The publisher Auguste Poulet-Malassis* was declared insolvent in August 1862.

7. When the bankruptcy proceedings for Poulet-Malassis were completed on September 2, 1862, his debt to Courbet was estimated at three hundred francs (cf. Bonniot 1973, 123, n. 10).

8. It is unclear what painting is meant here.

9. Though several of Baudry's publications are known, it is not clear what articles are referred to here.

62-7 *To Léon Isabey [Port-Berteau, September? 1862] (incomplete)*

. . . I have done the sketches for my pictures for the Paris Exhibition.[1] I will be organizing an exhibition of the pictures I did in Saintes.[2] I will be in Paris in three weeks at the latest. If you write me, address your letter to Port-Berteau, place Courbet.

I have enjoyed incomparable triumphs. I was carried in triumph by the ladies of Saintes and a square was dedicated to me by those same ladies.[3] I am staying with some painters,[4] where I am working prodigiously.

I hope you and your lady are well. I embrace you with all my heart, your lady and you, and am wholeheartedly,

Your sincere friend,

Gustave Courbet

Kind regards to all our friends.

1. Only Courbet's *Return from the Conference* (F. 338) seems to have been painted especially for the Salon, but it is possible that Courbet originally planned other Salon paintings as well.

2. On the Saintes exhibition, see letter 62-6, n. 4.

3. Compare letter 62-6.

4. In Port-Berteau Courbet stayed at the inn of père Faure, to be in close proximity to his colleagues Louis-Augustin Auguin* and Hippolyte Pradelles* (cf. Bonniot 1973, 163–67).

To Jules Castagnary [Paris, September 10 (?) 1862] [1] 62-8

My dear Castagnary:

Malassis* had me invited to present myself at the commercial court for his bankruptcy proceedings.[2] Please present yourself tomorrow at 9 A.M., that is, Thursday morning. I received his notice four days too late because it was misaddressed.

I am claiming eight hundred francs from him for various paintings, not including the one that I have at home.[3]

Affectionately yours,

Gustave Courbet

I wrote the assignee. Ask to see my letter if you can attend the hearing. I am too rushed to get this into the mail right now. I won't tell you anymore. The Chevé revolution continues.[4]

1. This letter is dated by another hand September 9, 1862. Yet, as Courbet implies that he is writing on a Wednesday, the date must be September 10.

2. Poulet-Malassis had been declared bankrupt on September 2.

3. It is not quite sure what paintings Courbet had sold to Poulet-Malassis other than the *Portrait of Baudelaire* (F. 115). In his letters to Poulet-Malassis, Courbet repeatedly refers to a painting of a reclining nude woman, but it is not known whether such a work was ever delivered. In a letter written to Castagnary on August 23, 1862 (62-6), mention is made of a painting of stags, belonging to Poulet-Malassis.

4. In defiance of the mayor of Saintes, who had fired the town's musical director, Brossard, Baudry* had helped the latter form a rival musical society that used the revolutionary teaching and notation methods propagated by Emile-Joseph-Maurice Chevé (1804–64) as the Galin-Paris-Chevé method (cf. Bonniot 1973, 108–111).

To Léon Isabey [Port-Berteau, autumn 1862] (incomplete) 62-9

. . . You tell me that Champfleury* wanted to marry Mlle G. Mathieu.[1] That seems to me quite unreasonable on Champfleury's part. I don't believe

that at his age one can maintain the cult of poverty in that way. One can still observe it, of course, but one keeps it to oneself.

As for Leboeuf,* that is different. Sculptors are sedentary and theirs is, in a way, the life of a workman. They need someone to make the soup. If I had come back to Paris soon enough, I would have liked to have been best man. I doubt moreover that the person he is marrying is endowed with a great fortune. When one is not rich, it is for life, for it is well known that on this earth a girl prefers a grocer with money over a genius in straitened circumstances. . . .

1. Probably the sister of Gustave Mathieu.* Champfleury did not marry the woman in question, and it was not until seven years later that he made a late marriage to Marie Pierret, the goddaughter of Eugène Delacroix.

62-10 *To Etienne Baudry [Port-Berteau, October 1862]*[1]

My dear Baudry;

Would you please be so kind as to remit two hundred francs to M. Fortin, the concierge at 32 rue Hautefeuille, on behalf of M. Courbet?

We waited for you tonight at Auguin's.* The model I was waiting for in order to work could not come today.[2] I am staying here tonight in case she comes tomorrow. I took advantage of the situation to finish my large landscape.[3]

If you can come tomorrow, try to come.

G.C.

1. This letter is written on the verso of a note addressed to Courbet by M. Fortin, dated October 11, in which his concierge, in the most friendly terms, reminds Courbet that his rent is overdue. For the full text of this note, see Bonniot (1973, 153).
2. Perhaps the model for the *Sleeping Nude* (F. 335).
3. It is unclear which landscape is referred to here.

62-11 *To Léon Isabey [Port-Berteau, October-November 1862] (incomplete)*

. . . I have been worse than my word with regard to taking you to my part of the world, but that is no loss. I am being detained here obstinately, and in spite of all the distractions of different kinds I have done some fifty paintings,[1] more or less finished, more or less sketched in. It was not fun. Nonetheless they are saying in Paris that I have died of a stroke.[2] I have lost fifteen pounds, I am svelte and charming, I am driven by love.[3]

Please pay M. Richebourg,* for he is driving me mad. I don't know whether you settled the Détrimont* account, I hope so. . . .

1. This figure does not appear too exaggerated. At the Saintes exhibition in January-

February 1863, Courbet was to exhibit forty-three works, all painted in the Saintonge region. Not included in the exhibition were several portraits that Courbet had painted during his stay in Saintes and Port-Berteau.

2. On the false rumors of Courbet's stroke, see Bonniot 1973, 127–36.

3. On Courbet's love affair with Laure Borreau,* see Bonniot 1973, 124–26, 329–339.

To Etienne Baudry [Port-Berteau, December 1862] 62-12

My dear Baudry:

I would like M. Belet to bring back from Saintes a few handfuls, that is, a small package, of plaster of Paris so that I can finish the sculpted figures for the exhibition.[1] Ask him to go nudge Arnold to finish the backing.[2]

Sincerely yours,

G.C.

1. At the exhibition in Saintes (January-February 1863), Courbet was to exhibit two women's heads in plaster (cat. nos. 156, 157). Both works seem to have disappeared.

2. Camille Arnold was a decorative sculptor who must have done some framing for Courbet (cf. Bonniot 1973, 55).

To Léon Isabey [Port-Berteau, December (?) 1862] (incomplete) 62-13

. . . Perhaps it is love that brings me to this part of the world.[1] In any case, I have done a great deal of painting. At the moment I am doing a major painting for the upcoming Exhibition.[2] The painting makes everyone here laugh and especially me. It is the most grotesque picture ever to be seen in [the history] of painting. I dare not describe it to you, but it is a picture of priests. I'll be here for [another] two weeks in order to have it well advanced if not finished by the time I arrive in Paris.

I have also done two sculptures during my stay in Saintes.[3] I hope to have two at the forthcoming Exhibition. I am anxious to get to Ornans, where my family is awaiting me impatiently, then to come back to Paris and see you all. . . .

1. On Courbet's love affair with Laure Borreau,* see Bonniot (1973, 124–26 and 329–39).

2. The *Return from the Conference* (F. 338).

3. Compare letter 62-12, n. 1.

To Etienne Baudry [Port-Berteau, winter 1862–63] 62-14

My dear Baudry:

If we are still planning to leave tomorrow, as you said, I will be at the carriage tomorrow, Thursday, at six o'clock in the morning. Please give the

bearer your reply and bring me two shirts, two pairs of socks, and my hat. If not, tell me when we leave. I will be at your disposal.

Sincerely yours,

G. Courbet

Don't wait for me tonight, I will stay overnight in Saintes. I'll be rather tired.

In any case, give the bearer a shirt and a pair of socks.

63-1 *To Etienne Baudry [Port-Berteau, early January 1863]*

My dear Baudry:

I wish you a happy New Year, of course, but as I have had various small expenses required by New Year's Day, I would be much obliged if you could send me three hundred francs, if possible, by the bearer of this letter.

I will also write my parents and send some money to my sisters for their New Year's gifts.

G. Courbet

63-2 *To his family [Saintes, early January 1863]*

Dear family:

I am, here, in a part of the world that is difficult to leave. Everyone in his own way is trying to keep me here. The city officials have just gotten into the act. They absolutely want me to have an exhibition of the works that I have done in the Saintonge during my stay.[1] I finally agreed on account of the artists of this part of the world, who are now my students, so that the exhibition will consist of about forty of my paintings and of works by M. Auguin,* with whom I have been staying for some time, and by Pradelles,* another talented painter. Other artists who want to join are welcome to do so.

I took advantage of all the delays to paint a picture for the upcoming Exhibition.[2] It is a large canvas, like those that are ready in my Ornans studio, nine or ten feet [long] by seven or eight high. This painting is critical and comical in the highest degree. Everyone here is delighted with it. I won't tell you what it is, I'll show it to you in Ornans. It is almost finished. I hesitate whether to do others for the Exhibition because it is an opposition painting and because it is wasted effort to exhibit with the government, which is in opposition to me. If I paint other pictures they will refuse this one and accept the others, whereas if they refuse this one I could make a fortune with it if I have no other paintings at the Exhibition. Nonetheless I will still paint the other paintings that I have wanted to do and exhibit one or two sculptures.[3]

I am writing you this letter to wish you all a happy New Year, Mother,

Father, sisters, and I send with these wishes two hundred francs as New Year's gifts for my sisters Zélie and Juliette.

I cannot tell you exactly when I'll be in Ornans, but it should be in the course of this month. When I am there we will discuss all our business. Meanwhile I embrace you all. How I love you!

Gustave Courbet

Best regards to my friends, Urbain,* Ordinaire,* Proudhon,[4] etc.

Father, who is such an organized person, never acknowledges receipt of the money that I send him.

1. On the exhibition in Saintes, which was to take place between January 15 and February 17, 1863, see Bonniot (1973, 225–64).

2. The *Return from the Conference* (F. 338).

3. On the two sculptures Courbet did in Saintes, see letter 62-12, n. 1. Courbet was not to exhibit them at the 1863 Salon. Instead, he showed the *Boy Catching Bullheads* (Fs. 1).

4. Not Pierre-Joseph Proudhon but probably Hippolyte Proudhon (1807–86), the brother-in-law of Urbain Cuenot* (cf. Ornans 1981, 57).

To Jules Luquet [Saintes, February-March, 1863] (incomplete) 63-3

My dear Luquet:

I am sending you a crate of paintings with which you'll be pleased.[1] There are thirty-three of them, quite a selection. I hope you'll act wisely and use your judgment. Either hide the paintings, or else organize a mysterious exhibition of them at your place only, for I want to sell them fast, as I am in great need of money.

Speaking of money, please give Isabey* a hundred francs to pay Richebourg,[2] for he wrote me that he resembles the crucifix Mary Magdalene used to beat herself: all the silver is gone. He has just had a son (and not a daughter, as you said), and he needs money.

I would like to have the painting of the *Magnolias* [F. 361], as well as the *Portrait of a Young Girl* [F. 334?], at the Martinet exhibition,[3] to offset the paintings that I'll be sending to the government [exhibition]. The frames must be made at Dugrit's [?], ask Isabey. I need money! Sell! I cannot repeat it too often.

I still have a load of canvases here that I'll bring with me. I have a wonderful place to work here in Saintes. I have at my disposal the stud-farm stable, an enormous place with eighty horses, and the directors with whom I am on very good terms.[4]

I had asked you to be diplomatic with regard to the painting of the *Large Stags* [F. 279], in finding out whether it is possible to bring an action against the government,[5] for I am becoming litigious. I also want Isabey to bring an action against Détrimont,* who stole five hundred francs from me. . . .

1. These paintings were probably sent to Luquet directly after the Saintes exhibition. A marked-up catalog of the exhibition in the Bibliothèque nationale in Paris (reproduced in Bonniot 1973, figs. 55–57) shows which paintings were shipped. Courbet may have sent additional paintings not shown in the exhibition.

2. Perhaps Jules-Emile Richebourg (b. 1833), author of *Contes enfantines* (1857), *Lucienne* (1858), *L'Homme aux lunettes noires* (1864), *L'Histoire des chiens célèbres* (1867), and other popular books.

3. The second exhibition of the Société nationale des beaux-arts organized by Louis Martinet* in the gallery on the boulevard des Italiens.

4. Courbet needed a large place to work in view of the *Return from the Conference* (F. 338). The stable was placed at his disposal by its director, a certain Mailhard de Couture (cf. Bonniot 1973, 143–50).

5. Courbet was apparently still angry that his *Battle of the Stags* had not been acquired by the government for the Luxembourg Museum, but since he had never received any official promise, it is not clear on what grounds he could have sued.

63-4 *To Léon Isabey [Saintes, February 1863] (incomplete)*

. . . I am painting an extraordinary picture for the new Exhibition.[1] As perhaps it won't be received, I am sending it alone instead of three [paintings], to force them to refuse or accept me at the Exhibition. If I am refused, we will be able to show the painting [ourselves] and earn a great deal of money.

My picture is finished, it turned out well . . . I would like to know if the [winners of] second medals bypass the jury.[2] Please write me that immediately. I would send two others if I were sure to be received. They would be a hunting scene and a portrait of a lady . . .[3]

If I may not submit without being juried, I will send only the picture of the *Priests* [F. 338]. . . .

1. The *Return from the Conference* (F. 338).

2. At the Salon of 1861, Courbet had received a second "repeat" medal (*Second rappel de médaille*), which, he hoped, might entitle him to bypass the jury (as indeed it did).

3. Probably the *Fox Hunt* (F. 341) and the *Portrait of Laure Borreau* (F. 358), the two paintings Courbet actually showed at the 1863 Salon.

63-5 *To Etienne Carjat, Saintes [February 1863]*

Saintes

My dear Carjat:

I love you, as you know. You are the confidant of my love affairs, you are my photographer, you are my biographer, you are my friend.[1] The ladies of Saintes[2] insist on having my portrait, done by you. They have seen some and find that only the one you did looks like me.

Please send me a few small ones with the cane,[3] there are two of them. Affectionately yours,

Gustave Courbet

Saintes, rue Porte-Aiguières

I am painting pictures that will surprise you, that is all I will tell you.

1. Etienne Carjat made several portrait photographs of Courbet, notably during the 1860s (cf. Hamburg 1978, 529–31).

2. When he wrote this letter Courbet was staying with the Borreau family in Saintes at 13 rue Porte-Aiguières. The "ladies of Saintes" must refer to Laure Borreau* and perhaps her daughter, Gabrielle.

3. Carjat made at least two photographs of Courbet with a cane around this time. One of these shows the artist seated on a chair and holding a cane in his right hand. The other (a knee-length portrait) shows him standing with his left hand in his pocket and his right hand leaning on a cane (reproduced in Hamburg 1978, 529; and Bonniot, 1973, cover, respectively.

To Nadar [Félix Tournachon], Saintes, February 23, 1863 63-6

Saintes, February 23, 1863

My dear Nadar:

Send me the finest portraits you have been able to do of me,[1] for the ladies of Saintes won't let me leave this part of the world before your delivery. You have always behaved very badly towards me, you have never had the courtesy to give me one of your photographs. I hope you will make me forget your poor behavior towards me by sending me promptly what I ask you.

Gustave Courbet

Saintes, 13, rue Porte-Aiguières

1. Like Carjat,* Nadar had often photographed Courbet in his studio at 35 boulevard des Capucines (cf. Prinet 1966, 128–29).

To Léon Isabey [Saintes, March 1863] (incomplete) 63-7

. . . I asked you to tell me if the [winners of] second medals bypass the jury.[1] I have just met a painter who claims to have read this in the [*Journal des*] *Débats*. Consequently, I am sending another two paintings, a *Fox Hunt* [F. 341] and a *Portrait of a Woman* [F. 358].

. . . It is also important that Luquet* tell Martinet* to send my statue to the Exhibition.[2] I have done another bust here but I don't know whether I will send it too.[3] In any case, the statue must be there. . . .

1. Compare letter 63-4, n. 2.

2. The *Boy Catching Bullheads* (Fs. 1), which had been shown in Martinet's gallery on the boulevard des Italiens.

3. One of the two portrait heads Courbet had done in Saintes (cf. letter 62-12, n. 1).

63-8 *To Léon Isabey [Saintes, April 1863] (incomplete)*

. . . I am delighted with the letter you wrote me the other day. My purpose has been achieved. If the painting of the *Priests* [F. 338] has aroused as much embarrassment as you have indicated to me, this is the time to move.[1] Go see Champfleury,* Malassis,* Chennevières,* Castagnary,* etc. Keep up the revolution. If it is refused, have it withdrawn immediately and put it back in my atelier. Any Barnum can have me earn fifty thousand francs whether in France, England, Belgium, Germany, or Italy.[2] Everything is going well. . . .

Since sending the paintings to the Exhibition, I have done four flower paintings.[3] Flowers are making me a mint. . . .

Write me immediately about the *Priests*. Write me about the emperor's speech.[4] I do hope that the painting has been a slap in the face of that "socialist."[5] You see that I have aimed right. I'll write you at leisure about the wit in that painting.

Make a lot of noise. If the painting of the *Priests* is not accepted, the picture of the *Magnolias* [F. 361] must be put in its place. They'll take it. . . .

1. Though Courbet was entitled to bypass the jury, because of the medal he had received in 1861, his painting could be refused access to the Salon on the ground of immorality. At the time this letter was written, the jury was apparently still deliberating, and Courbet felt that this was the time par excellence to give it some publicity.

2. Reference to Phineas Taylor Barnum (1810–91), then director of Barnum's American Museum, who toured Europe with Charles Stratton ("General Tom Thumb"), exciting crowds with freaks and curiosa from his museum or with dioramas and "moral" plays. Courbet, at this time, may have considered touring the *Return from the Conference*, much in the way Théodore Géricault had previously toured the *Raft of the Medusa* in England.

3. During his stay in Saintes, Courbet became seriously interested in flower painting, a genre that he thus far had rarely practiced. More than fifteen flower paintings from this period are known today.

4. Probably a reference to the emperor's traditional speech at the occasion of the opening of the Salon. Courbet apparently did not yet know about the emperor's surprising decision, announced in *Le Moniteur* of April 24, 1863, to organize a "Salon des refusés," a special exhibition of the works refused by the 1863 jury.

5. An ironic reference to Napoléon III who, ever since his early essay on *L'Extinction du paupérisme* (1844), had expressed a concern with the fate of the working classes and the poor and who, two years later, would welcome the establishment of the Paris bureau of the International. His strong alignment with the Catholic church, however, was often seen as a contradiction of his claims to socialism.

63-9 *To Albert de la Fizelière [Saintes, April 23, 1863] (incomplete)*

. . . I had wanted to know the degree of liberty that our times allow us. I had submitted a painting of priests, very true to life, the *Return from a Con-*

ference [F. 338]. It corresponded rather well to the emperor's insult of last year,[1] and also to what is happening with the clergy.[2]

The painting hit home, it went straight to its author. It has been taken down and rehung three or four times. If one were to talk to Walewski,[3] it could perhaps be hung a fifth time. I painted the picture so it would be refused. I have succeeded. That way it will bring me some money. Yet, considering the dread it causes it would be comical to force the administration's hand. . . .

1. A reference to the rumor that the emperor had personally eliminated Courbet's name from the list of artists to be decorated at the occasion of the 1861 Salon.

2. A reference to the flirtatious attitude of the empire towards the church.

3. Napoléon's bastard son Alexandre Walewski (1810–68), minister of state since the end of 1860, was ultimately responsible for the administration of the fine arts in France.

To Léon Isabey [Saintes, late April 1863] (incomplete) 63-10

. . . I still fear that what you tell me is not true. We read in the papers that my painting[1] had been refused by the administration and that, by order of the emperor, the other paintings, refused for artistic insufficiency in the opinion of those gentlemen, would be exhibited in a separate salon.[2] Well, write me in any case. If thus far it has been accepted it must be by the jury and consequently it has to be placed in the juried Exhibition.

Tell Champfleury* to talk up the painting as much as possible in the papers so that it will be difficult for the administration to get rid of it, if it is not accepted at least with the refused works, which would be the same to me. If it is accepted, [the opportunity for] speculation in Paris is lost. The only thing left is the sale of the photograph,[3] but there are still the foreign powers. . . .

If the *Priests* [F. 338] are accepted, there will be an uproar! I expect that so audacious a painting has never been seen. They can no longer say that I am dozing . . .

1. The *Return from the Conference* (F. 338).

2. In a decision made public on April 24, the emperor had decided that all the paintings refused by the jury would be exhibited in a special section of the Palais de l'industrie. This unprecedented exhibit was soon to be called the "Salon des refusés." *The Return from the Conference* was not admitted to either the official Salon or the Salon des refusés. Courbet's other two submissions, the *Fox Hunt* (F. 341?) and the *Portrait of Laure Borreau* (F. 358), were admitted to the official Salon, as was the *Boy Catching Bullheads* (Fs. 1).

3. Courbet at this time customarily had photographs made of his major works, the sale of which brought him a small profit. The photograph of the *Return from the Conference* had been made by the photographer Robert J. Bingham.*

63-11 *To Pierre-Joseph Proudhon, Paris, May 25, 1863*

Paris, May 25, '63

My dear Proudhon:

Please, do be so kind as to go as soon as possible to the address herewith enclosed to have your picture taken.[1] I would be very happy to have it. At the same time, by granting me my wish you will be obliging my friend Victor Frond,* an associate of the photography firm whose address I send you.[2] I believe I can recommend M. Frond to your goodwill in a few words, by telling you that he has long fought and suffered for the democratic cause, and that the exile that was his reward for his honorable efforts obliged him to learn a new trade. From a soldier our friend became a photographer and a good photographer at that.

With a cordial handshake,
Your devoted

Gustave Courbet

I went to see Chaudey.* I will expect you within forty-eight hours to see my painting of the *Priests* [F. 338].

[Address] Monsieur Proudhon
Grande rue, no. 10
Passy

1. Judging by letter 63-16, Reutlinger's* photograph of Proudhon was originally intended for the title page of the treatise Proudhon was writing at this time about Courbet's art. The photograph and a subsequent one (cf. letter 63-14) were later to serve Courbet as an aid for his portrait of Proudhon and his children.
2. The firm of Charles Reutlinger, with which Frond was associated.

63-12 *To the editor of the* Figaro, *Paris, May 26, 1863*[1]

Paris, May 26, 1863

My dear friend:[2]

In the Saintonge I did seventy or eighty sketches or lay-ins for paintings, including the two that are at the Salon.[3] But the painting of the *Priests* [F. 338] is the one that is most significant in all respects and the only one that I wanted to exhibit.

I have been accused of immorality. Yet lithographs are permitted of fat priests on horseback, with girls riding pillion, whose dresses are pulled up above their garters.

However, I have been assured that the painting will be exhibited after May 31.[4] I also intend to exhibit it in the great cities of Europe.[5] Besides, the

exhibition has already begun at my place, where there is a crowd every day and where sincere critics are welcome.

Affectionately yours,

Gustave Courbet

1. The letter was published in the *Figaro* of May 27, 1863. It provoked several printed answers. Philippe Burty* commented on it in the *Chronique des arts et de la curiosité* of June 7, and a certain Togno responded to it in *L'Indépendant* of August 3 (cf. Bonniot 1973, 301–2).

2. Courbet seems to have been well acquainted with Jean-Hippolyte-Auguste de Ville-messant (b. 1812), founder and editor of the *Figaro*, hence his familiar salutation.

3. The *Fox Hunt* (F. 341) and the *Portrait of Laure Borreau* (F. 358).

4. The *Return from the Conference* had been barred from the Salon as well as from the Salon des refusés. It is not clear where Courbet expected it to be exhibited after May 31.

5. Courbet had plans to have the painting tour the major cities of Europe. See also letter 63-8.

To Champfleury [Paris, mid-June 1863][1] 63-13

I write you a few lines in haste, for your letter weighs on me. Excuse the wordiness.

My dear friend:

I am annoyed at having to justify myself to you for the simple reason that it is too easy for me. Your letter, which brings the friendship and concern of a good heart, is unwittingly repressed, professorial, and lacking in frankness. It makes only one serious point and that is the gratuitous accusation that you level toward me when you say, "You have sold out to the government."[2]

Whoever it is, the person who could have given you such a report should be careful and is in no way responsible for his words. He must have told you that tale about his own situation. It reminds me of Silvestre,* who said that I had spread a rumor that he was an informer. It is like the professor who came to my home yesterday morning and informed me that a so-called ripping remark that I am supposed to have made about M. de Nieuwerkerke* is circulating throughout Paris.

You know that I live at odds with society. Whichever way the wind blows, I sheer off, and yet I never change my mind. I never had a coterie so that I could do what is right and do my work. I move reluctantly and the fierceness of my independence and of my individuality prevents me from being any more [easily] influenced today than I was at the outset. This year I have only one tactical mistake for which to reproach myself, and that is sending in three paintings, two of which were sketches[3] (sent against my better judgment). In

so doing I partly paralyzed the effect I wanted to achieve with the *Priests* [F. 338].

As for production, I have worked as much this year as I have worked in the last five years.[4] I covered seventy or eighty canvases, between finished and unfinished. First error on your part.

Second, I cannot earn the reputation of a Dupont,* or his way of life,[5] when I cover a canvas every three days, either in a room or from nature during a year of absence. I have been in Paris for two weeks. I came by your house to see you, I visited those persons that you know; and for four or five days I cleaned and put my atelier in order and hung one hundred paintings. So far you see that I am not very dogmatic and that I am talking to you as a friend.

Another error: as for what you say about the government, you are entirely mistaken about the way I judge it and hate it. It is for the reason I stated above and for the sake of freedom of choice that I want France to govern itself. Otherwise, if I think only of myself, this government serves my purpose admirably and allows me the pride of being a personality.

Another error: I do not love art for art's sake, or the distinguished circles of shameless great wits, were it the minister of state himself. I find my business everywhere and I draw whatever conclusions I want.

Nor do I admit that a man may retire from public action. The greatest minds to be admired in the past were constantly involved in everything that took place in their time.

As for me, I take my convictions from nature, and for me the totality of men and things is nature.

I don't like schoolteachers, which is perhaps what makes you say, "You think you are a great speaker, a writer, a philosopher, a thinker." My dear fellow, I don't want to use the schoolmasterly, professorial tone that you use in your letter, and yet it seems to me that I could have a field day if I wanted to.

In a word then, your letter is completely unacceptable and reveals deep down a man who is infinitely more bombastic than I am, whatever you may say. It is sententious and tries to wound with every word, but as it essentially lacks truth, it is merely pretentious, and I cannot take exception to it.

In vain I rack my memory to understand how I deserve all the gratuitious insults that you write me with sweetness and perfidity. I cannot think of anything except the conversation we had with Bonvin* at Louise Kohler's.[6] There I explained to you that I prefer being a man to being a professional in literature or painting. I respect the painter and the writer but not the profession.

I saw our friend Troubat* two days after I arrived. I don't remember having talked to him about your privilege in a manner that was unfavorable to you.

To conclude these annoying explanations, I don't give anyone advice. Let everyone manage as he thinks best, as long as his way of life does not infringe

on my freedom. The government does not buy as many people as it is said to. I won't elaborate on that idea, which makes me too emotional.

Aside from that remark, which I don't understand (or don't want to understand), I cannot imagine how Bonvin,* who works three days a week at a very tough job,[7] often in bad weather, and who is paid eighteen hundred francs a year, could be sold to the government. And the terrible Silvestre from the South, who does a giant's job extracting Carrara marble from the quarries of Italy for the modest sum of six thousand francs,[8] is then sold! And our friend Duranty,* who entertains all the children in the Tuileries Gardens[9] for the patronage of the imperial prince, is then sold. You yourself, who in two or three years will be the happy director of the Théâtre des funambules,[10] which may ruin you completely in spite of all the trouble you give yourself, you would then have sold yourself. When I consider all the jobs, I confess that, in spite of the little money I have, I am happy not to be sold.

I could go on forever, but let us finish with the last remark you make to me, a remark that must have very much pleased the writers who surround you: "I must retemper my hand in the mountains." That idea seems to have been ill considered on your part. You yourself said in the *Figaro* that you did not have a hand (it is funny, but, for that matter, I don't know whether the public has ever acknowledged that you have a head). As a result I don't know what you are talking about in this instance.

My dear friend, I hope you will regret so thoughtless a letter. I talk to you without bitterness, not only as a friend, but also as a relative. I will always love you in spite of everything for I know your character.[11]

Affectionately yours,

Gustave Courbet

Remember that we have been together for eighteen years.

1. This letter seems to have been a direct answer to Champfleury's letter to Courbet of June 9, 1863 (Paris, Cabinet des dessins du Louvre, b. 8, folder 98), in which the critic had released all his bottled-up irritation about Courbet's behavior, his latest works, as well as his new-found friends.

2. Courbet and Champfleury at this time mutually accused each other of having sold out to the government.

3. It is interesting to see that Courbet refers to the *Fox Hunt* (F. 341) and the *Portrait of Laure Borreau* (F. 358) as sketches.

4. Champfleury had written, "You talk too much, you no longer paint enough."

5. Champfleury had threatened Courbet with the example of Pierre Dupont, whose popularity had sunk dramatically at this time.

6. Probably the mother of Bonvin's future companion, Louison Kohler.

7. In 1862, Bonvin had taken a part-time job in the Police Department, where previously, between 1839 and 1850, he had worked full time.

8. Nothing is known about this aspect of Silvestre's life.

9. Duranty directed a marionette theatre in the Tuileries Gardens.

10. On April 16, 1863, Champfleury had obtained permission to build a theater on the

boulevard des Amandiers. The project never materialized, and Champfleury, instead, assumed the directorship of the Théâtre des fantaisies-parisiennes on the boulevard des Italiens, founded by Louis Martinet* in 1865 (cf. Troubat 1900, 170–71).

11. In spite of these last conciliatory lines, the friendship between Champfleury and Courbet was ended definitively at this time.

63-14 *To Pierre-Joseph Proudhon [Paris], June 3, 1863*

My dear Proudhon:

Please be so kind as to go to M. Reutlinger,* 21 boulevard Montmartre, to have your picture retaken.[1]

I received a print of the one that was done. It is beautiful but this portrait is not at all adequate to the purpose. It takes too long to print and our friends are unable to satisfy the numerous requests they have received. Besides, I need a different pose, and I am counting on you for Monday. Tell me what time and I'll meet you at the Reutlinger studio.

Many friendly regards,

Gustave Courbet

June 3, '63

1. As the first photograph of Proudhon made in Reutlinger's studio did not please Courbet, the philosopher was requested to return for a second sitting. Neither photograph is known today, but one of them, probably the second, was utilized by Courbet for his portrait of Proudhon (F. 443). See letters 65-4 and 65-5.

63-15 *To Victor Frond [Paris, June or July 1863 (?)][1]*

[No salutation]

The entrepreneurs who will take charge of my painting just came to see me to discuss my painting's peregrinations[2] and to ask what itinerary they should follow now. I am rather interested in that for, as I told you, it is from one of them that I am trying to get the money of which I spoke to you.

Come lunch with me tomorrow, I am going out for dinner tomorrow night.

G. Courbet

[Address] Monsieur Frond
 Chaussée du Maine 32 or 36
 A large house

1. Written on stationery of the printshop of the Corps Législatif, rue du Bac.
2. This letter is no doubt related to Courbet's efforts to organize a traveling exhibition of the *Return from the Conference* (F. 338), and it must consequently date from June or July 1863. On July 6 of that year, Courbet signed a contract with Félix Ratier and Charles Bataille, landowner and quarryman, respectively, who engaged themselves to exhibit the *Return from*

the Conference in England, Switzerland, Belgium, and Germany. They promised to advance all the expenses in return for a share in the profits. The contract also contained a section about reproduction rights, both of the *Return from the Conference* and of the *Burial at Ornans* (F. 91). See Bonniot 1973, 305–6. The letter to Frond probably predates the contract.

To his father [Paris, July 28, 1863] 63-16

Dear Father:

You must have received or will receive a double-barreled rifle from St. Etienne such as you have never seen. It is damascened in solid gold, it is one of a kind, and it has a very long range. It comes with a splendid case with all the tools for maintaining it. You will have to pay fourteen francs for repairs I had done on it, in addition to the freight. I'll reimburse you for all that.

As you may have seen in the papers, I sold my painting of the *Priests* [F. 338] (which has raised a dust as you have never seen) to an American building contractor.[1] I will perhaps be forced to follow the painting to England, to the Newcastle congress,[2] where it will begin its peregrinations.[3] The people who booked it for two years hope to earn two or three hundred thousand francs. As I have a share of the profits, I am not sorry to hear that.

The painting has been in London for a week but it cannot be exhibited. The English have left town but will come in three months. Meanwhile we are going to tour the other provinces.

Every day I try to find a way to come and see you but I know that I won't be able to go to Ornans until next month. I believe the celebration is set for August 14, perhaps I will be there. It is all right to commission Lapoir, Charles to make the basin for the fountain:[4] he is from Ornans and he is my friend. It would be an insult to him to withhold such a curious job from him. Tell him to send me his plan, I'll tell him what I think of it. As for me, I will be ready before you make the fountain, don't worry about me. I would like the fountain's post to be a block of rough rocks with the water cascading or dripping down from the platform on which the little guy is standing. As for the basin, if it were octagonal or pentagonal, I believe that would be more in keeping with the subject.

In short, do what you want. The cast of the statue will be done at the end of September. If I were sure that you would execute the basin, I would announce it in all the papers. I would like to inaugurate it on October 5. The choral groups of the Franche-Comté are coming and people from Paris and newspaper editors. We would give an enormous meal in the Iles-Basses.

These days I am in correspondence with Proudhon.* Together we are writing an important work that makes the connection between my art and his philosophy and between his work and mine. It is a brochure that will be sold at my exhibition in England, with his portrait and mine: two men who have

synthesized society, one in philosophy, the other in art, and both from the same country.[5] I still have seven pages [of a rough draft] to copy for him before six o'clock. I leave you.

Kind regards to Mother, whom I embrace, and to my sisters. I hope you are all well and I hope to be able to come see you before I go to England and Scotland.[6]

I send you herewith a small photograph of the *Priests* (while waiting for a more sizable one) to show you that there is nothing in it especially against those gentlemen, as it has been made to appear.

I embrace you all with all my heart. Kind regards to Ordinaire* and Urbain,* Proudhon,[7] etc., all our friends.

Gustave Courbet

1. According to an announcement in *L'Indépendant* of July 18, 1863, the painting had been sold to a Mr. Ratheman from Washington, D.C., but, apparently (according to this letter), the tour planned by Bataille and Ratier (see letter 63-15, n. 1) was still to continue (cf. Bonniot 1973, 306). Whether the sale to Ratheman actually materialized is doubtful. In March 1866, the *Return from the Conference* was shown in an exhibition in New York, organized by Jules Luquet* and his partner Alphonse Cadart,* who apparently either had borrowed it from Courbet or held it in commission. In 1881, it was auctioned off at the first sale of the contents of Courbet's studio.

2. One of the projected venues of the *Return from the Conference* exhibition was the town of Newcastle. There seems to have been some local opposition, however, to showing the painting in Newcastle, as an anonymous letter to a M. Guette (perhaps Ratheman's agent), dated July 28, 1863, indicates. Written on stationery from the Aluminum Works Washington, County of Durham, the letter states, in so many words, that painting exhibitions generally are not successful in Newcastle and that the exhibition of Courbet's painting is expected to be a failure (cf. Bonniot 1973, 307).

3. The painting does not seem to have been exhibited in Newcastle, or in any other city in England, except perhaps London.

4. The fountain in the Iles-Basses quarter of Ornans that was to be surmounted by Courbet's *Boy Catching Bullheads* (Fs. 1).

5. Proudhon's *Du principe de l'art et de sa destination sociale*, which was the outcome of these efforts, was not to appear until after his death in 1865. It would appear from this letter that Courbet initially thought it would be a pamphlet-sized publication, coauthored by himself and Proudhon. For Proudhon's views on the matter, see Bowness (1978, 127–28).

6. Nothing is known about this or any other trip to England.

7. See letter 63-2, n. 4.

63-17 *To Pierre-Joseph Proudhon [Paris, July-August 1863]*

My dear friend:

I will recite you a few of my own kind of litanies, jotted down in no particular order.[1]

— The past is useful only as education.

— One must use only the present in one's works.

— Banish the mysterious, the miraculous, don't believe in the incomprehensible.

— Set sentiment, imagination, intelligence, and the ideal to serve reason.

— One must ceaselessly balance one's thinking faculties; reaffirm oneself constantly; draw conclusions continually, without shame and without departing from one's principle; always be one's own man.

— Come forward in public (the only judge) in one's works without restrictions and in complete self-assurance.

— Don't adopt a course of humility, suffering, or resignation.

— A virtuous man is he who has the courage of his convictions and who follows unswervingly the road he has mapped out for himself.

— The man who spends his life amassing a fortune has no business in the intellectual world.

— In the current social organization, wealth falls to the lot of men in inverse proportion to what they are able to produce.

— In order for a man to spend money usefully and without doing any harm, he must have earned it himself.

— Had Napoléon a billion a year to spend, he would still be unable to take a serious and intelligent action on his own.

— The sons of [rich] families have no idea how to use their money. Those who ruin themselves do it to no avail and often to the detriment of society. Those who are intimidated by their powerlessness "economize" and then sanctify this new word among the bourgeoisie of the Empire.

— One must become a millionnaire.

— An intelligent man who wishes to serve society must be able to live without precaution and use completely all the resources he has at his disposal to benefit what he has undertaken.

— Society must be organized in such a way that a man is not humiliated by charity and does not die from hunger.

— The concern that decentralization should have for the individual could easily abolish the literary and artistic Bohemia including that of the inventors.

— It is not necessary for an individual fortune to exceed a million, yet an individual can attain that figure by his abilities.

— Decentralization must be extended to finances. M. de Rothschild[2] has no particular genius, consequently a certain number of men who size him up can do his operations if necessary.

— M. de R.'s gigantic fortune is a power within a power, which cannot exist.

— In France there is, I believe, no more religion or legitimacy; no more *juste milieu;* no more (more or less historic) republic. Democracy is drawing to an end and the empire is worn out. All those old forms have disappeared or are disappearing—what is left today is man and national representation.

— With decentralization, towns could inherit proportionally, according to the size of the [local] fortunes, which would be entirely equitable, for man, besides the taxes that he pays during his lifetime, owes further payment when he dies to the social order that protected him and enabled him to develop and make his fortune in safety. By that arrangement, children would have (depending on their parents' work) the minimum or maximum means necessary to complete their education and to serve their undertakings. Thus, every man would be obliged to work, and, in that way, none of society's strengths would be lost.

— Today, aside from the sons of [rich] families who inherit money, the man of little merit has stopped working.

— Taking that as a point of departure, it seems to me that towns, by their very structure, by making work obligatory, could also provide free and compulsory education, and those two laws would already conserve the dignity of man.

— A man who does not work turns inward. He cannot make progress for lack of terms of comparison.

— One is not born with genius, one is born with propensities and particular faculties. It is by willpower and work that one comes to be a man.

— Work disappears proportionately as one's faculties increase. This is true to the mathematical second power.

— Pride is inseparable from man but it is justified only by work; pride is self-awareness; pride is a reward.

— In art, to work without respite is to become stultified. It is pursuing a single idea for too long, which leads to sterility. Plodders don't think much and those who did well in school do nothing later on.

— Works of art are conceived all at once, and the composition, once it is well established and firmly outlined in the mind in all its details, casts it into its frame on paper or on canvas in such a way that there is no need to modify it in the course of the execution. The beauty of the execution results from the clarity of the conception.

— Fertility is in the variety of conception. Fertility has nothing to do with the multiplicity of one's works.

— Never work on commission unless you are given full and entire freedom of expression.

— It is useful to live indiscriminately with all classes of society without taking sides with any one. It is the way to find truth, to expand one's judgment and to cast off one's prejudices.

— The superiority of one class over the other does not exist. The only superior man is the man who is superior by virtue of his work or his actions.

— A man who works in the arts must concede nothing to public opinion

that is at odds with his own ideas. If he does, his originality does not exist. He chooses the beaten path.

— One of the best-argued and most spirited aspects of men is the tenacity they employ to assure themselves of the firmly held tenets of the individual. A single concession is enough to kill him. Men among themselves recall a circle of wolves: the first who falls is eaten.

— A made man can diagnose and size up his equal in one day by reasoning.

— The great men who have illuminated humanity are all equally great. They have responded to different times and to different needs, hence one great man is equivalent to another.

— He who is his own man can, with impunity and without danger, enjoy and participate in everything that life contains in the way of allurement. Indeed, he is best served by those things that are believed to be dangerous.

— The extreme love one may feel for a woman is a sickness. It absorbs the thinking faculties, makes man jealous and worse than an animal. Jealousy is misplaced pride.

— Work requires the domination of the senses and the preservation of one's authority over the woman. That is why marriage must be free.

— A man who is aware of himself can, to a certain point, I believe, reproduce himself morally in his children.

— Woman, who has neither aesthetic nor dialectic faculties, must be subject and faithful to man.

— The most gifted men are those who are born with independent characters; independence leads to everything.

— Then when one has come to be a man, one returns to the earth for the great sleep.

— One survives only through one's works, and men who have not succeeded (either because of their natures or because of a lack of ancestry) survive only in their progeny: thus does history end.

Write me when I ought to quit.

Yours,

Gustave Courbet

1. This long letter, filled with aphorisms on art, morality and politics, appears to have been one of many extensive memoranda sent by Courbet to Proudhon for the benefit of the latter's treatise on art. For Proudhon's reactions to these letters, see Bowness (1978, 127). Though Proudhon derided Courbet's letters, he seems to have read them carefully, as is evident from the notations he made in the margins of this letter. Some of Courbet's aphorisms directly found their way into his book. For example, Courbet's line, "The past is useful only as education," is cited word for word by Proudhon, while others, such as Courbet's exhortation to never work on commission, are closely paraphrased (Cf. Proudhon 1865, 283).

2. Probably a specific reference to Jacob Rothschild (1792–1868), head of the Parisian branch of the famed Rothschild bank, founded by Mayer Alselm Rothschild (1743–1812).

<u>63-18</u> *To Max Buchon [Paris, August 1863]*

My dear Max:

Two weeks ago, Proudhon* charged me to write you on his behalf (it is not the same thing but I must submit anyhow for he really does not have the time). He has undertaken a summary of the art of this time, a summary that I suggested to him. He had thought, ignorant (or nearly so) as he is of the subject, that he could get away with a few pages. This is what he wrote me: "You write me that I frightened you when I wrote you that I thought I could finish this pamphlet in two or three days. You were perfectly right. In two or three days, I could have written ten or twelve pages without significance and without consequence. Instead, I have been at this job for nearly three weeks already and am still quite far from having finished it. My work will make up a small treatise of at least one hundred and sixty pages, with which I hope the public will be satisfied. Even if it is not very brilliant, as is pretty much the rule in these kinds of works on art, it will at least contain some strong arguments, and I don't think that there will be serious attempts at rebuttal."[1]

We will have a solid treatise on modern art at last, and the direction that I suggested corresponds to the Proudhonian philosophy. Never in my life have I written so much. If you could see me you would split your sides laughing, I am swamped with paper. Every day I write Proudhon my eight or ten pages of aesthetics, on the art that is being done, the art that I have done and wish to establish.[2] Proudhon tells me that I missed my calling as a writer; that Champfleury* understands nothing about it, that he cannot write, that he does not have the intelligence to do a critical piece, and that he does not know how to reason. He is not telling me anything new. If I dared, I would say a good deal more than he. As I had not completed my mission, I did not care that Champfleury was writing whatever he wanted about the Realist movement (of which he never was a part). What I did care about was that in so doing he was misleading the public about me because they believed me to be associated with him.

You are really the one who is guiltiest, as I wrote to Proudhon[3] (who loves you very much). I said, "If that lone wolf friend of ours, Max Buchon, had wanted to live in Paris and to learn about [city] ways, in short, to do what we have done, he would have been perfect. It is all the more regrettable as he has in him qualities that he has not exploited. He has a critic's mind, and a Franc-comtois's rationality, he has style, the necessary education, the ability to generalize, the money we don't have, and he has everything that Champfleury lacks. Our friend Max is guilty. He has clung to sentimentality, which is

nothing at all, or worse, a sickness that distances one from reality. My dear Proudhon, reality is the keynote. With the reality that of course demands balance between the mental faculties and the various elements that make up an art, one is out of hell, one belongs to oneself, one serves a purpose during one's lifetime, one can enjoy life, and one serves a purpose for the future. If Max B. had joined us, the three Franc-comtois mountain dwellers would have successfully replaced the three mountain dwellers from Switzerland."[4]

You have only to sit tight: we have plotted, Proudhon and I, to come badger you in Salins in early September and shake you up, as you deserve. The painting of the *Priests* [F. 338] aroused a degree of excitement that I cannot describe, I must tell you in person.

I was so sick recently that I went seabathing in Fouras, near Rochefort. I had friends there who convinced me to come [and] I took advantage of it for I was exhausted and constipated and my hemorrhoids were killing me. I am a little better now. Proudhon gave me ten days' vacation.[5] Please do not tell my parents. They would be furious, they think I am in Paris. I will probably stay only ten or twelve days in Ornans, but I'll come back in October. I will probably be forced to go promote the painting [of the *Priests*] in Belgium. They hope to make ten thousand francs. At last the priests will have served some purpose in their lives.

In anticipation of the pleasure of seeing you and your lady, I embrace you.

Gustave Courbet

In the meantime I send you a large photograph and a small card size of the *Priests*.

1. Proudhon expressed his displeasure about the unintended growth of his treatise on art in a letter to Gustave Chaudey* of September 11, 1863 (cf. Bowness 1978, 127).

2. Proudhon complained about Courbet's memoranda in a letter to Buchon, likewise written in August: " . . . he kills me with his letters of eight pages; you know how he writes, how he argues!" (cf. Bowness 1978, 127). One of Courbet's letters to Proudhon may be found in this volume (63–17). Most others appear to have been lost. Some notes written in pencil, currently in Paris, Bibliothèque nationale, Cabinet des estampes, Yb3.1739 (4°), b. 1, and published in Courthion (1948–50, 2:64–65), may also have been intended for Proudhon.

3. The original letter to Proudhon has not been found. A one-sentence quotation, somewhat different from the quotation in Courbet's letter to Buchon, may be found in Paris, Bibliothèque nationale, Cabinet des estampes, Yb3.1739 (4°), b. 1.

4. On Courbet's trip to Fouras, see Bonniot (1973, 313–16). It is not known who the friends were who had invited Courbet.

5. From sending him notes for the planned treatise on art.

To his father [Paris, September 12, 1863] 63-19

Dear Father:

Every day I put off writing you because I never know the exact day when

I will be able to come back to Ornans. I am finishing a portrait at the moment[1] and I am going about having a cast made of the small statue[2] and even finding a base to put it on. Isabey* maintains that the entire basin could be done in Grenoble cement, as one does a molding; he maintains that it is very hard, like stone. In spite of all that I think that it would be safer to have M. Condrad make the molding in stone.

I have not done badly by not leaving Paris right away. I have just sold fourteen or fifteen thousand francs' worth of paintings to three private collectors.[3]

I would like you to send me the measurements of the paneling in the alcove, the height and the width, in order to put some drapes there.[4] The drapes are to go on the inside and reach to the floor. Write me also the lengths of the wall panels between the doors and the windows, to see what furniture could be put there; the height of the mantelpiece windows, from the marble to the bottom of the embrasure; the width of the embrasure; also the wall space between the two drawing room windows, in order to put a mirror and a console there.

Tell me also whether you received the rifle. I saw the person who sent it to you and he maintained that you should have received it, for he sent it to you himself. If you have not received it, write me, and I'll write him at once, as I hope to leave here in four or five days. Answer me right away so that I can see to my business before I leave.

I embrace you all, Mother, my sisters, and you.

<div align="right">

G. Courbet

</div>

By courier, if you can.

[Address] Monsieur Courbet, landowner

Ornans, Doubs Dept.

1. Perhaps the portrait of the sculptor Louis-Joseph Leboeuf (F. 355), which is signed and dated 1863. Courbet was in close touch with Leboeuf in the early 1860s. Leboeuf had exhibited a plaster statuette of Courbet at the Salon of 1861, and he may have helped Courbet with his sculpture of the *Boy Catching Bullheads* (Fs. 1), exhibited at the 1863 Salon.

2. *The Boy Catching Bullheads.*

3. These collectors may have included Jean-Paul Mazaroz,* who seems to have bought a number of paintings at this time.

4. No doubt a reference to his studio on the route de Besançon at Ornans.

63-20 *To Léon Isabey [Ornans, December 17, 1863 (Ad)] (incomplete)*

. . . Judging by its location I think that an oval fountain of five by four meters would be right for that spot and would make it easy to use rather powerful rockwork on which the statue would be placed.[1] The water would

drip and stream over the rocks. The animals could still drink from the basin. . . . Rockwork of rustic blocks is the idea: it suits everyone here including us. . . .

1. Isabey, who was an architect, was charged with the revamping of the fountain in the Iles-Basses section of Ornans. The fountain was to be surmounted by Courbet's *Boy Catching Bullheads* (Fs. 1).

To Armand Barthet [Besançon, January 5, 1864] 64-1

My dear Barthet:

Demesmay,* who came from Paris especially to see you, declares that you are just an asshole. Like Demesmay, I also came to see you, on the occasion of the New Year. Having left Ornans yesterday afternoon at 4 o'clock, I was a block of white marble, or, if you prefer, Lot's wife on arriving in Besançon. We are here, only you are missing. You fall entirely short in all your obligations. We await you tomorrow at noon without fail. You are staying in a region that is not on the map of France.[1] With the best will in the world we could not come see you.

A handshake, also from Demesmay.

Gustave Courbet

[Address] Monsieur Barthet, Armand
 Landowner at Cendrey
 Doubs (near Marchaux)
[Postmark] Besançon, January 5, 1864

1. On his recent return from Paris to the Franche-Comté, Barthet had settled in the village of Cendrey.

To Jules Castagnary [Ornans, January 16 (Rd); January 18, 1864 (Ad)] 64-2

My dear Castagnary:

My life is a web of accidents. I had begun an "epic" painting, a serious critical piece, but comical. I was two-thirds finished with the painting, which I intended to send to the next Exhibition, when, yesterday—Sunday—I go to dine at the home of a friend of mine, some distance from Ornans. During that time a person enters my studio. One leg of the easel was touching a door behind it. As soon as the door opened, the leg was pushed forward, the weight of the canvas and the easel shifted, and the chair on which I always sit went through the painting.

Farewell, painting! I don't have time to start over. The painting was an allusion to modern poets. I had them drinking at the Hippocrene fountain[1] in the sacred vale that receives its water from the Castalian spring and from

the Parnassus. Farewell, Apollo, farewell, muses, farewell, splendid vale that I had already finished painting, farewell, Lamartine, with his beggar's scrip and his lyre,[2] farewell, Baudelaire,* with notes in hand, Dupont,* who was drinking, Mathieu* with his guitar and sailor's hat; Monselet* accompanied him and remained skeptical.[3] The source, invisible to the modern army of Apollo, was in the foreground, visible to the public. It was a very attractive woman, entirely nude (like M. Ingres's* sources),[4] a beautiful Paris model. Reclining on her moss-covered rock, she was spitting in the water that was poisoning them all.[5] Some were already hanging, others had drowned.[6] Gautier himself was smoking a chibouk, attended by an almeh.[7] I cannot tell you everything, for if one could explain paintings, translate them into words, there would be no need to paint them.

Farewell, nasty reviews, farewell, recriminations, farewell to poetry's hatred of Realism. The next Exhibition will once more lack gaiety. If, by chance, I am wronging my critics, it is not my fault! My intentions were good.

Inasmuch as I am not giving up on the Exhibition, I would like you to write me what is the latest date allowed the artists to send in their paintings. I am going to start something new. Answer me, please. Best wishes to all our friends. I am enjoying a charming country winter here.[8]

Affectionately yours. Ask about Proudhon's* book.[9] Find out how far along it is.

Gustave Courbet

1. Mythological fountain whose waters were thought to impart poetic inspiration.

2. Alphonse Lamartine (1790–1869), by far the oldest of the poets in Courbet's painting, was totally impoverished in his old age. A national subscription was organized for him in 1858, but it had little success, forcing Lamartine to work without respite until in 1867 the imperial government finally granted him a pension.

3. At first glance, Courbet seems to have assembled a rather incongruous group of poets. Many of them, however, figured in Jules Vallès's book *Les Réfractaires* (1865), which was based on a series of articles published in the *Figaro* between 1857 and 1865. The *Réfractaires* or "insubordinates" were the bohemians of the 1850s and 1860s, who eked out a precarious living while existing on the fringes of society. Courbet was quite familiar with the *Réfractaires*, who frequented the Andler Keller and the Brasserie des Martyrs, Courbet's two favorite hangouts.

4. Ingres's famous painting, *The Source* (Paris, Musée du Louvre), though owned by a private collector in the 1860s, was well known through numerous copies, hence Courbet's reference to the "sources" of M. Ingres.

5. The painting's true intention, apparently, was to show poetic inspiration as a fatal force.

6. Reference to the multiple suicides (Gérard de Nerval, Alexandre Leclerc) and premature deaths (Gustave Planche) among the *Réfractaires*.

7. Théophile Gautier* wrote numerous travelogues and often spiced his novels and short stories with evocations of faraway places. The chibouk and the almeh are no doubt references to Gautier's exoticism.

8. Riat (1906, 215–16), who first published this letter, has added several lines to this and the previous paragraphs. Apparently, he did not have recourse to the original letter but perhaps

took his transcription from an "improved" copy by Castagnary intended for publication in some newspaper or magazine.

9. Proudhon's health was declining throughout 1864, and he was to die on January 19, 1865. He never finished his treatise on art, but, on the basis of his notes, his friends published *Du principe de l'art et de sa destination sociale* some months after his death.

To Jules Luquet [Ornans, February-March 1864] (incomplete) 64-3

My dear Luquet:

Please write that collector that the painting belongs to you,[1] I have already written him two letters to that effect. Now you can write him on my behalf, I gave you his address.

I received a letter from M. van Wisselingh* of Amsterdam.[2] He does not want to send them back, he claims he is creating a school in Holland with those paintings (it is an illusion, but so what).

I have a snow landscape, a size 30 canvas, *Two Poachers with Dogs Following the Trail of a Hare* [F. 381]. If it suited your collector, I would finish it. You could exhibit the *German Hunter* [F. 244] that I sold to Mazaroz.* He would perhaps resell it to the collector.[3]

I had a world of bad luck with my Exhibition paintings of this year. Two in a row were ruined.[4] I had the courage to undertake a third one. It is of two nude women, life size and painted in a manner that you have never seen me do.[5] Tell me if it is possible to send it as late as March 30.

Tell the collector from St. Etienne that I can do something else for him. If you cannot work something out with him, ask him to write me. . . .

1. It is not known to which collector or to which painting Courbet is referring here.

2. In the copy of this letter, the name is written *"Van Wiking,"* but this almost certainly is a misreading of *"Van Wisselingh."*

3. Mazaroz instead donated the painting to the museum of Lons-le-Saunier.

4. The *Hippocrene Fountain*, referred to in letter 64-2, and perhaps the *Conscript's Departure*, another work that was laid in but never completed (cf. Chu 1980a, 140).

5. *Venus and Psyche* (F. 370).

To Etienne-François Haro, Ornans, March 3, 1864 64-4

Monsieur Haro:

Encouraged by the agreeable dealings I have had with you, I would like to ask you a small favor, in the hope that what I will ask you may be acceptable to you. After having two paintings in a row punctured[1]—paintings that I was doing for the Exhibition—I had the courage to begin a third, even though I had only six weeks until March 10. That painting is as good as finished; a friend of mine had a frame made that will be ready on March 12. The painting

represents two life-size nude women. The subject is unimportant, if one wanted to give the painting a high-flown title one could call it *Venus in Jealous Pursuit of Psyche* [F. 370]. What I am telling you here is only to give you an idea of the composition of the painting for, until now, I had resolved to call it *Study of Women* in the catalog of the Exhibition.[2]

To return to what I wanted to ask you: I would like to send this painting to you, so that you can see it first and then present it yourself to the Exhibition, so that it won't be dragged around or lashed up the way the hangers usually do with my paintings in order to please the administration. If you present it, that will inspire some respect in them for this painting, which is very important to me.[3] Even though this painting was done on the spur of the moment, it is in my own style. I am anxious to know what you will think of it. I still have the entire background and the accessories to complete and I have only a week left before I must send it off. Tell me, please, if you personally have been granted an extension.[4] If I did not have to send it off until March 30, I would be delighted indeed. In that case I would finish the *Woman's Head with Cat* [F. 431], which I sold to Mazaroz.* At this point I would also like to have Bingham* do the photograph,[5] it is up to you to send it. Before taking it to him, you could ask him what day would suit him and send it to him at the time he specified. Excuse me, Sir, for bothering you with all this. If you cannot do me this favor, please let me know as soon as possible, for I'll tell Mazaroz to take care of it, seeing as I cannot come back to Paris for a month and a half.

With kindest regards,
Sincerely

Gustave Courbet

Ornans, March 3, 1864

1. Compare letter 64-3, n. 4.
2. The painting never appeared in the Salon as it was refused on moral grounds.
3. Etienne-François Haro was a much-respected figure in the Parisian art world. Artist, dealer, collector, and restorer, he was the official restorer of the Tuileries and the Ministry of Public Works.
4. Haro himself regularly exhibited his work, mostly portraits, at the Salon.
5. Of *Venus and Psyche*.

64-5 *To Etienne-François Haro, Ornans, March 15, 1864*

My dear Monsieur:

I am sending you my painting, as finished as was possible in the little time that was available to me.[1] The frame must be ready and delivered to my studio at 32 rue Hautefeuille. If it has not arrived, please have it picked up

(or notify them to send it to you) at [the shop of] M. Laurent, Eugène, no. 98 rue Ménilmontant. He had to deliver it on March 12. The painting is leaving tomorrow, Wednesday, March 16, by express mail; it will be in Paris on Thursday at noon. As you asked me to, I am sending it to you two or three days before the final deadline, for I would like M. Bingham* to take a photograph, but a better one than the one he did of the *Priests* [F. 338]—he must make up for that.

I pray you, M. Haro, you who know something about art, tell me what you think of this painting after you have seen it, and if you have any contacts in the place, don't let it be dragged around by those insolent hangers. If the frame is not finished, write me.

With kindest regards,
Sincerely

Gustave Courbet

Ornans, March 15, 1864
I enclose the [text for the catalog] entry, with a meaningless title.[2]

1. To the Salon of 1864 Courbet submitted *Venus and Psyche* (F. 370), a work that he had not begun until late January or early February of the same year. The painting was refused on moral grounds.

2. Courbet submitted the work under the title *Etude de femmes* (cf. Paris 1977, 39).

To Jules Luquet [Ornans, March 17, 1864 (Ad)]

64-6

My dear Luquet:
I am dead from too much work. For six weeks now I have not stopped for an hour. For two days only, the painting[1] is either with M. Haro,* the museum's painting restorer, rue du Marais, St. Germain, or at M. Bingham's,* the photographer. I am anxious for you to see it.

I also have the kind of study of a roedeer that your collector would like. It is 1 meter long and 70 centimeters high.[2] There is a grand duke who is crazy about it. It is a forest. You will like the painting, and so will he, I hope, if he still wants it.

Gustave Courbet

Answer me on behalf of the collector. Answer me if you have seen my painting. Tell La Fizelière* to come too.

[Address] M. Luquet, associate of M. Cadart,*
 Art dealer
 Rue Richelieu

1. *Venus and Psyche* (F. 370).
2. The painting cannot be identified with any certainty.

64-7 *To Pierre-Auguste Fajon [Ornans, April 26 (?) 1864] (incomplete)*

[Courbet announces that his painting *Venus and Psyche* (F. 370) has been refused by the jury] . . . for being immoral. It's prejudice on the part of the administration, for if this painting is immoral, one must close all the museums in Italy, France, and Spain. I had painted *Venus in Jealous Pursuit of Psyche Finds her Asleep* . . .

64-8 *To Etienne-François Haro, Ornans, May 11, 1864*

Dear M. Haro:

I am very concerned about the fate of my painting.[1] People write me that it stands neglected in a room of the Exhibition. If that's true, please have it taken to my atelier. I received no notice that the painting was refused, which surprises me. They write me claiming that the painting was refused at the instigation of the priests and the empress, and that the jury and M. Nieuwerkerke* did what they could to have it accepted. I haven't the faintest idea of what this is all about. I would be very obliged to you if you would be so kind as to let me know what is going on or at least what you know about it. That would be of great service to me because I must think about all this. I was refused regardless of the rules of the Exhibition and I am being portrayed to the public as an immoral man.[2] You more than anyone must understand that I cannot permit such slander.

As it is, I thank you in advance for your goodwill in sending the painting on the designated day, only you did not tell me whether M. Bingham* took a photograph of it. What would prove to me that M. de Nieuwerkerke did not agree with the refusal is that he did not inform me of the refusal and that he left that to those who followed orders and refused me.

I would be delighted indeed, Monsieur, if you would reply in a few lines. I have the honor to be,

Sincerely yours

Gustave Courbet

Please have someone pass by my concierge's lodge to see whether they received a notice, or tell me if you received it yourself.

Ornans, Wednesday

May 11, 1864

[Address] M. Haro

 Restorer of paintings

 20, rue Bonaparte

 Paris

1. Courbet's submission to the 1864 Salon, *Venus and Psyche* (F. 370) or *Study of Women*, had not been accepted because of impropriety. Apparently, the artist had not been officially notified of this decision, and he was left in the dark as to the fate of his picture.

2. *Venus and Psyche* was the second painting by Courbet to be refused on moral grounds. In 1863, his *Return from the Conference* (F. 338) had met with the same fate.

To Jean-Pierre Mazaroz [Ornans, end of May (?) 1864] 64-9

My dear Mazaroz:

I beg you to find out what has happened to my Salon painting.[1] I have already written two letters to M. Haro, which have remained unanswered.[2] I asked him as a favor to tell me merely if he had received from the administration a refusal notice. He carries discretion or prudence to the point where he refuses me a simple piece of information. Please ask him what has happened to my painting, it worries me, besides I need to know. My dear Mazaroz, also ask M. Bain, my concierge, what he knows about it. I cannot endure that unfair charge of immorality that has been publicly leveled against me.[3]

My dear friend, you cannot imagine a man more unhappy than I at this moment. That whole series of incidents that has happened to me has done me in; moreover, the losses of money I was counting on; that refusal to take a stand, and all the consequences it entails.

Besides the two paintings in England,[4] I have just lost twelve thousand for a painting in Marseille,[5] in approximately the same circumstances as in England. Not only do I lose it, but on top of that I must buy it back for two thousand so as not to lose everything.

Oh, my dear friend, if you could help me a little at this moment, it would help me out a great deal. We should be able to sell that refused painting to a free-thinking man.[6]

Answer me as soon as possible if you can, for I want to respond in a defiant letter in the newspapers and ask for justice from the public.[7]

It is impossible for me to continue to exhibit. It is a tricky business. Those people want revenge at all cost. I am going to try to retire with fighting honors, I am entitled to that.

Try to find out as much as you can so that I won't make a blunder.

Cordially yours

Gustave Courbet

With all these troubles, I have internal hemorrhoids that are killing me. I am literally unable to work. I am into leeches, into baths, armed with a syringe, and I am up all night.

1. *Venus and Psyche* (F. 370).
2. See letters 64-5 and 64-8.

3. It would seem that Courbet was never clearly and explicitly informed that his *Venus and Psyche* was refused on the grounds of immorality. The painting was simply not exhibited (cf. Paris 1977, 39).

4. It is unclear to which two paintings Courbet refers here.

5. Perhaps a reference to the *Stag at Bay* (F. 277), which was exhibited in Marseille in 1864 and subsequently acquired by the museum (1865). Before that transaction took place, there seem to have been a number of problems that, eventually, were solved by Castagnary.* See letter 65-3.

6. The painting found a buyer in 1866 in the person of Lepel-Cointet,* who offered to pay sixteen thousand francs for it if a bit more drapery was added to Venus. Courbet complied, but Lepel-Cointet tried to withdraw from the agreement. This led to a lawsuit, which was won by Courbet on July 26, 1867.

7. Courbet subsequently seems to have abandoned that idea.

64-10 *To M. Bosset [Ornans, July 1, 1864 (Ad)]*

My dear M. Bosset:

I am excited about those bedroom wall hangings, as I am about to build one upstairs in my house.[1] I would very much like to know what size they are, for I could have it built accordingly. If I deserve to have them, I will have them cleaned and perhaps I'll use them as they are. If you wish to do me a favor, please bring them with you as well.

Try to sell some paintings for me. Tell Piquet to give me 200 or 300 francs for the portrait.[2] I sold the one with the pipe for 2,000 and a profile for 800 francs.[3] I'll write you at Arbois, I expect it will reach you.

If you go to Besançon, please stop in at M. Guillaume Brandt's, rue du Clos, no. 18. From what he tells me, he has a piece of furniture for sale that is more beautiful than the one I have in my atelier—he says it is Henri II or III.

I await you impatiently, my dear Bosset—Thursday, as you told me— with your family. We'll go out together wherever you like.

Cordially yours,

Gustave Courbet

The glass has made an impression, bring me some pots.

Best regards to M. Maire and to the friends [][4] M. Maire.

[Address] Monsieur Bosset, antique dealer in Arbois or surroundings.

1. Probably the studio on the route de Besançon.

2. Judging from the following line, this is a reference to one of the self-portraits by Courbet. In view of the low price, it must have been one of the smaller portraits, perhaps the *Self-Portrait with Black Dog in an Interior* (F. 26).

3. Both the *Self-Portrait with Pipe* (F. 39) and the *Self-Portrait in Profile* (F. 161) had been sold to Alfred Bruyas.*

4. Illegible word.

To Jules Luquet [Ornans, July or August (?) 1864] (incomplete) **64-11**

. . . Please tell me where you are in your new venture. I was delighted with the success of the *Roedeer Hunt*.[1]

I went to the source of the Loue recently and did four landscapes 1.40 meters long, more or less like those you have,[2] and one of Mouthier, the *Siratu Cascade*.[3] While passing through Mouthier I ran into that poor Pouchon, the vintner-painter.[4] That unlucky fellow has a curious talent, resembling Holbein in its naiveté. I bought two small still lifes of fruit from him, though I hardly need paintings, but you cannot let a fellow-painter starve, especially of your own part of the world. I'll send them to you so you can sell them. I recommend them to you especially because I want to put the rich people in the valley to shame. I paid him two hundred francs. Try to sell them for him for three hundred francs and I will let you have them because I will give him the full price for which you can sell them for him. You'll be making a very fine gesture. You may be sure that M. Ingres* could not paint that and that M. Flandrin could not paint the portraits he does.[5] Yet, that man lives on charity, on bread and garlic, and on the nuts he gathers for his dinner. . . .

[In the same letter Courbet writes that he has sold two paintings (not specified) to M. Ferré (?), an English dealer or collector, who does not pay. He asks Luquet to write to that gentleman telling him to settle with him other than through renewed bills of exchange that could not be cashed when due. Ferré had written Courbet that he wished to buy the *Wrestlers* [F. 144] and the *Return from the Fair* [F. 107] from him. Courbet wants some guarantees or else that Ferré come to Paris himself to see those paintings.[6]]

1. The *Roedeer Hunt* or the *Quarry* (F. 188) had been acquired by Luquet and his partner Alphonse Cadart around 1862. It was exhibited in their gallery in 1863, and perhaps on subsequent occasions, before it was sold to the Allston Club in Boston.

2. These four views of the source of the Loue River may have included F. 387, F. 393, and F. 394.

3. Probably F. 420. The whereabouts of that work are not known today, but a reproduction may be found in an album of photographs taken by Eugène Chéron at the time of the 1882 Courbet exhibition in the Ecole des beaux-arts (cf. Hamburg 1978, 553).

4. On Charles Pouchon (1814–82), amateur painter and friend of Courbet, see Fernier (1970, 8–11).

5. The only paintings by Pouchon that are known today are two portraits (cf. Fernier 1970, 9–10). Courbet preferred them over the work of Hippolyte Flandrin (1809–64), whose large historical portrait of Napoléon III (Versailles, Musée national du château), commissioned from the artist for twenty thousand francs, had been a popular success at the Salon of 1863.

6. The deal with the Englishman does not appear to have materialized.

64-12 *To Alfred Verwee, Ornans [August 1864]*

My dear Verwee:

Despite all my efforts I am still unable to take the French government seriously, especially those who govern. Consequently, if you wish to create a serious art exhibition, I am entirely at your disposal. You ask me for a serious painting. I believe I have never done anything to compare with the painting of the *Women* [F. 370] that I did this year. As they had proclaimed that I was unable to work in a graceful vein, they were shocked by this painting.

For my part, I assure you that there is not the slightest indecency. Besides, if your virtue blushes at it, you are free to put it in a separate room, as long as it is done discreetly, so as not to encourage the incomprehensible censure that has been inflicted on this painting. The subject is Venus in jealous pursuit of Psyche.

You must absolutely see this painting (which I prefer to any I have done) in your own country,[1] where people still love painting. It is of two nude women, life-size, one of whom is sleeping, the other having come, in her jealousy, to look at her. The one sleeping is blond and the one who watches her sleep is brown-haired. They wear draperies that hide all nudity. There is not a single old-master painting that is so little indecent as this one. I am counting on you, my dear Verwee, and on your compatriots of whom I am so fond, for whom I feel so much sympathy, and with whom I have already drunk so much. I'll come see you, but I miss our poor friend Siouff [?],[2] whom I will never see again.

If this proposition appeals to you and to the society that is directing this exhibition,[3] write me. I will place this painting at your disposal. It is now exhibited at my place, where there were as many as a hundred visitors a day, most of whom wrote me that the painting is magnificent.

I hope that you'll also write me what you think of it for the entire town of Ornans has seen it without raising any objections and I promise you that there is more morality in Ornans than there is among the judges in Paris.

Affectionately yours, my dear friend. My kind regards to your parents, whom I remember with pleasure. Kind regards to all our friends.

Gustave Courbet

Ornans, Doubs Department

I will send you some landscapes, if you want, a little later. For the moment this painting is the only one I can send you. It is very well framed and ready to go. Have your agent in Paris pick it up at 32 rue Hautefeuille.

Write me and, above all, don't make me pay the freight, I have already laid out a thousand to twelve hundred francs for that this year.

I write you in haste for I am very hurried. I have just done thirty landscapes from nature.[4]

1. That is, Belgium. Courbet may have felt that, in the land of Rubens and Jordaens, his nudes would be quite acceptable.

2. The original text of this letter is not known. In the copy the name reads "Siouff," which may well be what Courbet actually wrote. As such a name would have been highly unusual in Belgium, "Siouff" is probably Courbetian for a Flemish name such as Schoef(f), or Schoof(f). Perhaps this is a reference to the little-known painter Henry Schoofs who had died in 1862.

3. The painting was indeed shown in Brussels in 1864 at the Exposition générale des beaux-arts.

4. Courbet spent most of if not the entire year 1864 in the Franche-Comté and painted numerous landscapes, including a series of paintings of the source of the Loue River.

To Alfred Verwee, Ornans, August 15, 1864 (incomplete) 64-13

Ornans, August 15, 1864

My dear Verwee:

It appears that the priests, remembering the *Conference*,[1] are retaliating and that, by the influence of the empress, they have obtained the refusal of my painting of this year, the *Women* [F. 370], which I am sending you.

I remember the action I took in Ghent, in Brussels, and in Antwerp during the revolution of the Liberals and the Catholics.

I know from the papers that you are not losing ground, I congratulate you. I am justified in assuming that this painting will not receive the same censure in Brussels as it did from the Fine Arts Administration in Paris.

As for the painting of the *Burial* [F. 91], it is impossible for me to comply with your wish, though I would like to and am honored that you want it. The frame is ruined, the stretcher is in poor condition, the canvas is rolled up and in bad condition because of the weather.

I directed my concierge to deliver the painting of *Venus and Psyche* [F. 370] to a M. Carpentier-Desforges[2] and to let him know that it was at his disposal if he did not come get it within the time specified by you.

Please let me know what is happening with regard to this painting, which interests me very much. . . .

Gustave Courbet

1. The *Return from the Conference* (F. 338).
2. The proprietor of an art supplies store and a part-time art dealer, Desforges was the Belgian liaison in Paris for the Exposition générale des beaux-arts in Brussels. See also letter 64-19.

To Alfred Verwee [Ornans, August 30, 1864] 64-14

My dear Verwee:

I am sending you the letter that my concierge wrote me about the paint-

ing.[1] Let me know what is happening with the Malines and Amsterdam congresses.[2] Tell me also whether I could submit after the tenth of next month. I am asking you that because at the moment I am painting a landscape that I like[3] and if I knew the day your exhibition opens, I could, I believe, still send you the canvas, which measures about 2 meters on each side. I would send it to Paris and your agent could just pick it up at my atelier.

Farewell, my dear Verwee, I am counting on you. Try to have the painting accepted at your exhibition. You cannot imagine the pleasure that would give me.

Sincerely yours,

G. Courbet

[Address] Monsieur A. Verwee, painter
 7 rue Rogier
 Brussels
 Belgium
[Postmarks] Ornans, August 30, 1864
 Brussels, August 31, 1864

1. *Venus and Psyche* (F. 370), which was to be exhibited in Brussels at the Exposition générale des beaux-arts of 1864.

2. Artists' congresses like the one that was held in Antwerp in 1861 apparently were popular around this time. Generally little information is available about them.

3. Perhaps *Solitude* (F. 406), which measures 1.89 meters by 1.93 meters.

64-15 *To M. Bosset [Salins, November 4, 1864 (Ld)] (paraphrase)*

[The rain is keeping him in Salins. He will make an appointment with that collector when he is back in Ornans.]

64-16 *To Victor Hugo, Salins, November 11, 1864*

Salins, November 11, 1864[1]

Dear M. Hugo:

All decent people share in the exile you have chosen for the sake of human dignity and your convictions.[2] Allow me to offer you the tribute of my admiration.

Freedom is in limbo, and the people who have not been weaned [from it] are awaiting messiahs. All men of reason were humiliated on December 2, of sad memory,[3] and France continues not to rise up. Though you are far away from your country, you are fortunate to have your freedom.

M. Ch. Bataille,* an acquaintance of yours, assured me that you would be pleased to have a portrait of yourself painted by me. If that is the case, I owe it to you. This spring I will be at your disposal.[4]

Your most devoted compatriot[5] and admirer,
the painter from Ornans,

Gustave Courbet

1. The letter was written at the house of Max Buchon,* who was in regular contact with Victor Hugo. Though Buchon was responsible for mailing the letter, his role as its instigator may have been only limited. On the correspondence between Courbet and Victor Hugo, see Léger (1921, 353–63), and Bonniot (1972, 241–48).

2. Victor Hugo, who had fled France shortly after Louis Napoléon's coup d'état of 1851, had remained in exile on the British island of Guernsey, even after Napoléon III had decreed a general amnesty for political offenders in 1859.

3. December 2, 1851, date of the coup d'état of Louis Napoléon.

4. Though Hugo wrote back in flattering terms, welcoming Courbet to Hauteville House at any time, and placing his "head" and his "thought" at the artist's disposal, Courbet never traveled to Guernsey or painted Hugo's portrait, not even after the poet's return to Paris in 1870. Hugo's letter to Courbet, however, was published in *La Presse* of December 9, 1864, and it was suggested that the idea for the portrait had come from Hugo rather than Courbet. This greatly disturbed Hugo, as is clear from a long letter he wrote to Auguste Vacquerie on December 11, 1864, in which he asked him to try to set the record straight (quoted in Bonniot 1972, 243–44).

5. Victor Hugo was a Franc-comtois like Courbet. By a strange coincidence, Courbet, as a student in Besançon, seems to have lived in the house where Hugo was born (cf. Riat 1906, 8).

To his family [Salins, November 27, 1864] 64-17

Dear family:

After Father's visit to Salins,[1] I had a bout of constipation and hemorrhoids as bad as those I had in the spring. This time I did not wear underwear for twelve days. I take three-hour baths every day in infusions that Mme Buchon* is kind enough to prepare for me, and for food nothing but soup. My behind was so sore that I was getting up some twelve times a night. Anyway, I think I am at the end of this illness, I have been better since yesterday.

In spite of all that, I have worked hard since you left. I painted the *Doubs Falls* [F. 422] at Morteau, the *Portrait of Lydie* [*Joliclerc*]* [F. 429] at Pontarlier, and four landscapes. I sold one to M. Bosset* for two hundred and fifty francs and a gilded Louis XVI console that will go between the windows of the living room in my atelier. In addition I did a landscape of the *Source of the Lison River* [F. 402] and a smaller version [F. 403] for M. Meyer* that I had promised him in exchange for the donkey.[2]

I also did the *Portrait of Mlle Bouvet* [F. 425], the most difficult thing one could ever see: a three-year old child, tow-blonde and white as milk. She is very pretty indeed! I think I will be paid one thousand francs for that. I sold M. Bouvet* a landscape of the *Gour de Conche* [F. 416]. I also took advantage

of my illness to do a sculpted medallion that turned out very well and is a good likeness.[3] It is the first one I have ever done in my life.

I still have a few days of work here to finish the little girl's portrait. If Father is in Ornans, have someone tell him to open the spigots of the water tank that is in the kitchen of my atelier and that is full of water. They will all crack with the freezing weather. Open the one that is in the bathtub and the one that is in the drain in the kitchen sink.

We went to visit M. Bosset in Arbois, who received us wonderfully well. I met M. Jars, who would like a landscape of mine.[4]

Buchon and his wife are extremely kind to me and say hello to you. I embrace you all and look forward to seeing you.

<div style="text-align:right">*Gustave Courbet*</div>

I received a magnificent letter from Victor Hugo.* He would like me to paint his portrait. He closes by telling me that his house is wide open to me and that his head and his thought are at my disposal.[5]

[Address] Mesdames Courbet
 Landowner at Ornans
 Forward to Flagey in case of absence
 Doubs
[Postmark] Salins, Nov. 27, '64

1. Courbet was still staying with Max Buchon* in Salins, where apparently his father had visited him.
2. Courbet's donkey, Gérôme, pulled a little wagon on which Courbet transported his painting paraphernalia when he went out to paint landscapes from nature. On this subject and, in particular, on the genesis of the *Source of the Lison River*, see Claudet (1878, 8–12).
3. Probably the *Portrait of Alfred Bouvet* (Fs. 4). Courbet may have executed this plaster medallion in the studio of his friend Max Claudet.*
4. M. Bosset, an antique dealer, appears to have served as a middleman in the sale of several of Courbet's paintings.
5. Compare letter 64-16, n. 4.

64-18 *To Victor Hugo, Salins, November 28, 1864*

Dear and great poet:

You have said it: I have the fierce independence of the mountain dweller.[1] They will, I hope, be able to write boldly on my grave, as our friend Buchon says: "Courbet who would not be curbed."[2]

You, poet, know better than anyone else that our part of the world is fortunately in France, the reservoir of those men who at times are as disruptive as the land to which they belong but who are also often hewn from granite.

Do not exaggerate my importance. The little that I have done was difficult to do. When I arrived, together with my friends, you had already consumed the entire world like a humane and well-polished Caesar.

When Delacroix* and you were in your prime, you did not have, as I do, an empire to say to you, "Outside of us there is no salvation." There was no warrant for your arrest; your mothers, unlike mine, did not make underground passages in the house to hide you from the police;[3] Delacroix never saw soldiers violating his home, erasing his paintings with a bucket of turpentine, by a minister's order;[4] his works were not arbitrarily excluded from the Exhibition; ridiculous chapels were not fashioned with his paintings outside the Exhibition rooms;[5] the official speeches did not single him out for public censure every year; unlike me, he did not have that pack of mongrels howling at his heels, in the service of their mongrel masters. The battles were about art,[6] about questions of principle; you were not threatened with banishment.

The pigs tried to eat democratic art in its cradle, but in spite of everything, democratic art is growing up and will eat them.

In spite of the oppression that weighs on our generation, in spite of the fact that my friends are in exile, hunted down, even with dogs, in the Morvan forests, there are still four or five of us left. We are strong enough, despite the renegades, despite the France of today with its demented sheep. We will save art, the life of the mind, and integrity in our country.

Yes, I'll come see you. I owe it to my conscience to make that pilgrimage. With your *Châtiments*[7] you have halfway avenged me.

In your sympathetic retreat[8] I will contemplate the spectacle of your sea. The viewpoints of our mountains also offer us the limitless spectacle of immensity. The unfillable void has a calming effect. I confess, poet, I love terra firma and the orchestration of the countless herds that inhabit our mountains.

The sea! The sea with its charms saddens me. In its joyful moods, it makes me think of a laughing tiger; in its sad moods it recalls the crocodile's tears and, in its roaring fury, the caged monster that cannot swallow me up.

Yes, yes, I will come, though I don't know how much I will prove myself worthy of the honor you will do me by posing for me.

Cordially yours,

Gustave Courbet

Salins, November 28, 1864

1. Hugo's letter to Courbet is not known in the original but only as it appeared in *La Presse* of December 9, 1864. The printed version does not contain the line quoted here by Courbet. However, Hugo, in a letter to Auguste Vacquerie (quoted in Bonniot 1973, 243), claimed that his letter had been cut, so it is possible that the quote was included in the original version of the letter.

2. In French: "Courbet sans courbettes."

3. The only time in his life when Courbet had cause to fear the police was after Louis Napoléon's coup d'état of 1851. His association with Victor Frond,* whom he had portrayed in his ambitious painting of the *Firemen Going to a Fire* (F. 118), made him suspect. Yet, judging from letters 52-1 and 52-3, which deal with this period, Courbet exaggerates the degree of his persecution.

4. There is no record of a forcible entry into Courbet's studio.

5. Probably a reference to Courbet's private exhibition, which, of course, the artist had organized himself.

6. No doubt a reference to the famous literary battle about Hugo's play *Hernani*.

7. Hugo's *Les Châtiments*, a collection of politically motivated satirical poems, had been published in 1853.

8. Hugo lived in exile on the island of Guernsey.

64-19 *To Pierre-Joseph Proudhon, Salins, December 8, 1864*

Salins, December 8, 1864

My dear Proudhon,

I had sent Dr. Blondon* to you to remind you of your promise to visit me in Ornans. For my part, I was preparing to accompany you to Salins to see our friend Buchon,* as we had agreed.

Blondon told me that you were impatiently awaiting the opportunity to see the painting of the *Women* [F. 370], who are the talk of the town in Paris at this moment. I was not able to comply with your wish immediately for it was then at the Brussels exhibition, by invitation.[1] Now it is back. I have already written four letters to no effect, both to my concierge and to M. Desforges, who was the liaison for the Brussels exhibition, but I have not been able to get it back to my atelier. When you go to the boulevard Montmartre, please be so kind—which you are anyhow—as to go into that gentleman's shop (Desforges, paint-shop proprietor, at the corner of passage Jouffroy). Ask him to show it to you there (for I suspect that he shows it to collectors) or else, if he tells you that you can see it at my atelier, at 32 rue Hautefeuille.

My dear friend, at the moment I am about to do the counterpart of that painting.[2] It is a stout plebeian woman who is busy kneading. Her children are around the trough, the youngest is in his high chair smearing himself with cornmeal porridge[3] from a tin dish; on the table are gingerbread cakes, pastry boards, and flour.[4] The children are waiting for the cakes. The splendid woman, blonde, fresh and powerful, has tousled hair—but not like the fashionable "lionesses"—tousled by her work. With effort she lifts an enormous amount of dough, which falls down again heavily and puffs out. The big pot of hot water is on the cast-iron stove.

All that is in the foreground. The place is strewn with dog, cat, shovel, poker, in short, all the necessary apparatus. In the background of the painting is the open mouth of the oven with the glowing coals and the red smoke coming out of it. This charming woman looks after everything, for the men are in the field.

Since the painting of the *Women*, I have done some forty landscapes. I have already sold several. At the moment I am with the Buchons in Salins,

where I have done masses of portraits and landscapes, as well as a sculpted medallion of Buchon and his wife.[5]

Ever yours, I pass the pen to Buchon,

Courbet

[Courbet's letter is followed by a postscript by Buchon, of which the most relevant passages follow below:]

Dear M. Proudhon:

I take advantage of the occasion to send you my regards and to ask you for news about your book on art, which we have been awaiting for some time with keen anticipation. Courbet has talked to me again about the numerous manuscripts on the subject that he has manufactured for you, and he wonders whether it would not be advisable for him to retrieve them from you at some point, for he is afraid that those long letters, if ever they were to fall into the wrong hands, could be used as war machines against him.[6]

You'll see him again in Paris in the spring. That would probably be the time to take care of it, unless you prefer to send them by mail. . . .

Courbet will be here for a few more days. You can send your letter to him at my address if you write as quickly as we would like you to. . . .

1. *Venus and Psyche* (F. 370) had been shown at the Brussels Salon (the Exposition générale des beaux-arts) in the fall of 1864.

2. This pendant of *Venus and Psyche*, of which a lengthy description follows, was never executed. Opposing a "decent woman" to the "lionesses" depicted in *Venus and Psyche*, the projected painting was no doubt intended to please Proudhon inasmuch as it reflected the philosopher's ideas about the role of women in society, set forth in such works as *De la justice dans la révolution et l'église* (1858) and *La Pornocratie* (1867). See Chu (1980a, 134–35).

3. Cornmeal porridge or *gaudes* was a standard dish in the Franche-Comté, habitually eaten in the morning and the evening. The inhabitants of the Franche-Comté were even referred to as *mangeurs de gaudes*, "cornmeal porridge eaters."

4. The translation of *tonnoires* as pastry boards is based on the explanation of this term in Léger (1948, 99).

5. Only the medallion of Mme Buchon is known today. At least two casts have been preserved (Fs. 3 and 3 bis).

6. It is not known what actually happened to Courbet's letters to Proudhon. Only one of them is known today (see letter 63-17). That letter, now in the Musée Gustave Courbet in Ornans, was donated to the museum by Proudhon's granddaughters, which indicates that Proudhon did not return it to Courbet.

To Jules Castagnary, Salins, December 10, 1864 **64-20**

Salins, December 10, 1864

My dear Castagnary:

I was in Salins with my friend Buchon* when your letter reached me. I am delighted with your impulse! I will be starting Monday on a lady's portrait,

which will take me a few days.[1] Consequently, as I will be unable to spend time with you then, come to Salins in four or five days. Buchon will be very glad to make your acquaintance. We'll leave together for Ornans, after you see Salins and its environs. Time is pressing.

Affectionately yours,

Gustave Courbet

My painting of the *Women* [F. 370] is back from Brussels. It is again on view in my atelier. Write me at Max Buchon's what day you arrive in Salins.

1. Probably the portrait of Mme Bouvet (F. 427).

64-21 *To Jules Castagnary [Salins, December 14, 1864 (Ad)]*

My dear Castagnary:

You have not answered the letter I wrote you. In two or three days I will be free. The shortest way for you is to come to Salins: the train will take you there directly. From there, as I told you, we will set out for Ornans. On the way I will show you many of the picturesque sites in our part of the world.

I have the donkey with me and the scenery cart that will transport us.[1] You'll see Salins, you'll see Poupet and Alaise—or Alesia, according to the Druids[2]—Nans, and the source of the Lison River. From there we'll go and see my mother in Flagey, on the road to Ornans. We'll stay overnight there and then go down to Ornans to my atelier. Your visit will please everyone.

Would you find out about the painting of the *Priests* [F. 338] and the sale of the photograph,[3] which is sold everywhere? Those fellows tell me nothing at all about that business and Bataille* still owes me four hundred francs.[4] I would be very happy if he would pay me back. Go to the Legislature printshop and see Poupard, he must know what is going on.

I mailed you a Salins newspaper. The *Figaro* is overly optimistic about the terms reached between Realism and Romanticism, for there is abolutely no question of any of that.[5]

Sincerely yours and kind regards to our friends,

Gustave Courbet

1. Compare letter 64-17, n. 2.
2. On the controversy about the location of the ancient Alesia of Vercingetorix, see Brooklyn (1988, 57–58).
3. The photograph of the *Return from the Conference*, made by the photographer Bingham.*
4. The exact nature of this debt is unknown.
5. A reference to a notice by a certain Jean Rousseau in the *Figaro* of December 11 ("Propos du jour"), in which the author refers to the project of Courbet's portrait of Victor Hugo* (cf. letter 64-16) as the reconciliation of Romanticism and Realism. The full article is quoted in Bonniot 1972, 245.

To Victor Hugo, Salins, December 19, 1864

Dear poet:

I read in the *Figaro* of December 18 an article that I feel the need to share with you. It is signed "Jean Rousseau," one of M. Villemessant's* henchmen.

> Latest news on the serious Hugo-Courbet affair. *La Presse* is ill in- formed. I can positively state that Victor Hugo has not asked the painter from Ornans to do his portrait. I further state that he has never seen the traveler from Jersey who signed the item.
>
> > *J. Rousseau*

At the moment I don't know the address of M. Bataille* (who perhaps invented the wish that he had you express),[1] and yet feeling obliged to be prepared against the literary mob, I turn to you.

As for your portrait, neither one of us asked for it, which lends it addi- tional charm for both of us, something the *Figaro* could not understand.

All the painting I have done in my life was done only from the point of view of my own satisfaction. Obviously, by giving myself the pleasure of oblig- ing you, if I can, I did not intend to magnify the glory of M. Victor Hugo. Neither did I have it in mind to publicize myself. What I offered was spon- taneous. I have done it for all my friends,[2] and if I have not yet come to see you, as I have gone to see all the exiles,[3] it is because till now I have not dared.

Please believe that my notion was very much misread by certain people who speculate in scandal and in false or subtle provocations.

As for the visit I increasingly want to pay you, needless to say, nothing can prevent me.[4]

If I sent your kind letter to *La Presse* of the ninth inst., it was in order to correct a news item of the 6th, submitted by I don't know whom.[5]

Cordially yours,

> *Gustave Courbet*

Salins, December 19, 1864

1. Compare letter 64-16.

2. Courbet, indeed, had painted a considerable number of literary friends. On this sub- ject, see Haddad (1988).

3. Courbet had visited several French exiles, including Max Buchon,* who had gone to Bern, and the group of French exiles, including Pierre-Jules Hetzel and Théophile Thoré, who were living in Brussels.

4. Courbet was not to meet Victor Hugo until 1871 (cf. Bonniot 1972, 246.

5. A first news item related to the portrait of Victor Hugo by Courbet had appeared in *La Presse* of December 6. In response to that notice, Courbet (or Max Buchon) had sent Hugo's letter to *La Presse*, which reproduced it on December 9 (cf. Bonniot 1972, 243).

65-1 *To Max Buchon [Ornans, early January 1865]*

Dear Max:

After we left you we arrived safely in Nans, although the carriage listed. The next day I showed M. Castagnary* the source of the Lison River and the Devil's Bridge. The day after, Meyer arrived. We went hunting in Villeneuve, we killed a roe-deer and two foxes, and after that I bought his horse and his harness from him for about three hundred silver francs and a small landscape to be a pendant to his own.[1] The horse is flawless and is not too high-spirited. It is in every respect suitable to being painted in my *Stag Hunt*.[2]

Castagnary left Ornans Tuesday evening. I showed him your letter, which gave him great pleasure. He wants to write M. Boulangier, he told me, as it was with him that we talked at the hunt dinner we had in Villeneuve. We explained to him that M. Toubin* had behaved in an off-handed, inconsiderate, and dishonest way towards you and me, who were introducing M. Castagnary; that, moreover, M. Toubin had the kind of memory characteristic of men to be feared. In order to convince you, I am sending you a far-fetched letter that I received from him. We explained to M. Boulangier that Toubin's mistakes occurred too often and that you had already been the victim of them on another occasion. I cannot reply without your opinion. I'll reply whatever you like.[3]

I will try two paintings for the Exhibition,[4] and after I send them off I will be able to come to Salins to do the portraits the ladies want,[5] if they are still so inclined. Ask whatever advance you consider appropriate. As for M. Marcou,* he shall pay whenever he is willing or able.[6] In Ornans we were received with general enthusiasm. All our friends were gathered in the café when we entered. We left at three o'clock in the morning.

My mother, my father, and my sisters have all charged me to send you their compliments and best wishes for the New Year, as do I.

I took Castagnary to Pierre François's one night after dinner. We gave him news of you. We told him that you were keeping his portrait[7] and that in return he should have that of the mother of Realism.[8] He said that he preferred that. You could send me the one that served as the casting model. I will send it to the Exhibition. If M. Bouvet* has had a good mold made, tell him to send me one for my gallery. I embrace you both and expect Constance to be a good girl. Best wishes to my friends M. Bouvet, the Claudets,* father and son, Germain, your son-in-law, Madame Germain, etc., etc. Write me.

<div align="right">

[no signature]

</div>

1. M. Meyer had earlier exchanged a small painting of the *Source of the Lison River* (F. 403) for Courbet's donkey, Jérôme. It is not known what painting he acquired in return for the horse.

2. Probably *Mort of the Stag* (F. 612). Though painted in 1866 and not exhibited until 1867, Courbet must have conceived the painting at this time.

3. Nothing is known about the incident involving Charles Toubin that is mentioned here.

4. One of these may have been the *Puits noir* (F. 462).

5. The identity of the ladies mentioned here is not known.

6. The well-known French geologist Jules Marcou had commissioned Courbet to do a painting of the *Roche-Pourrie* (F. 409), a rock formation near Salins that had been a special object of study for Marcou (see Brooklyn 1988, 58–59).

7. The work cannot be identified.

8. One of the plaster relief portraits of Mme Buchon (Fs. 3).

To Jules Castagnary [Ornans, January 13, 1865 (Ad)] 65-2

My dear Castagnary:

You must see Proudhon* immediately on my behalf. Ask him, by way of pretext, for the letter I wrote him on the freedom of the Exhibition and the hell required to do free painting.[1] And, with that pretext, see whether there is still a way to do his portrait. Try to arrange it [illegible word] with him, or at least with his wife. If so, I will give up painting the *Woman Kneading*.[2] I'll go to Paris immediately and paint Proudhon's portrait, the way I told you before that I would, with him working in the rue d'Enfer at the foot of his stairs, surrounded by his children playing in the sand. This is extremely important. If he dies without his portrait [done], we will never have it, on account of his indifference so far.[3] And it is up to us to have it and to do it, as he deserves, for posterity.

Answer me by return mail. I have not a moment to lose for the Exhibition.

Sincerely yours,

 G. Courbet

1. This letter to Proudhon does not seem to have been preserved.

2. Compare letter 64-19.

3. Proudhon died six days after Courbet wrote this letter, on January 19. Courbet nevertheless painted his portrait, using photographs and a death mask to achieve a likeness of Proudhon. See letters 65-3 and 65-4.

To Jules Castagnary [Ornans, January 20, 1865 (Ad)] 65-3

My dear Castagnary:

Crushed by the irreparable calamity that has hit us,[1] I want nonetheless to paint a historical portrait of my very intimate friend, of the man of the nineteenth century. I will put everything I have into it. For ten years I promised it to him. Please send me, for your own sake and mine, the death mask

reported in the *Moniteur*. A sculptor made it. Send me also what my friend Carjat* did,[2] ask him for me. Go to Reutlinger* and ask him on my account or on Frond's* for the large portrait he did of the philosopher in the pose I arranged.[3]

Send it to me as quickly as possible, as we agreed. I want to paint him at 146 rue Notre-Dame-des-Champs,[4] with his children and his wife, as befits the sage of this time and the man of genius. I told you the theme of this painting at Buchon's.* I am putting everything by for the moment, I await the documentation. If there is a painted portrait, however bad it may be, tell Chaudey* or his wife to send it to me. She knows how close her husband and I were, she knows the limitless devotion that I had for him.

Buchon writes me, "It is with a heart heavy with the grievous news of Proudhon's* death that I answer your letter. The news reached me in one of Castagnary's letters and in the newspapers. What an immense, incommensurable void this death will leave in the intellectual world. As for myself personally, I am in a state of mind, of personal distress that could compare only to losing you and a few other people. I hope that the thought of his death will bring out all your great gifts and raise out of your exalted struggle your success at the upcoming Exhibition. It is the greatest homage that you could pay to the memory of our beloved philosopher, and you can do it, which gives you an advantage that I particularly envy you at this time. If, at this moment, I had a piece worthy of a similar destination, I would not spare myself. Fortunately for such men, the hour of death is, to the public, the moment when justice begins.

That whole life of work, integrity, and luminous reasoning will finally shine in all its brilliance in the darkness that surrounds us. The end of the nineteenth century has there its beacon, which will rise above the masses, ever brighter. Let us think continually of that life and of that death. We will find there the soundest lessons and the highest incentives."

I am writing you, in great haste for the post.

Gustave Courbet

You did not say whether you saw him before he died. I miss him very much. Get busy, please. As we are able to do so little, let us extoll the man of genius!

I am infinitely grateful to you for the Marseille business. I'll write my friend Jeanron.[5]

I don't know which Tournachon that is.[6] I found Léoni's [?] letter again.[7] I wrote M. Hesse.[8] That will help Jeanron.*

1. The death of Pierre-Joseph Proudhon on January 19, 1865.

2. Etienne Carjat had made a photograph of Proudhon on his deathbed. Courbet was to

use it as the prototype for a drawing made in 1868 for a cover of Jules Vallès's magazine, *La*

Rue. The issue in question did not appear as it was blocked by the censor (cf. Chu 1980b, 81–82).

3. Compare letters 63-11 and 63-14.

4. Courbet planned to paint a "historical" portrait of Proudhon, representing the artist in 1853. At that time, however, Proudhon lived at 83 rue d'Enfer, not at 146 rue Notre-Dame-des-Champs. The two addresses are physically very close, and Courbet may have been momentarily confused with the address of another friend. Indeed, in an earlier letter to Castagnary (65–2) he had indicated that we would paint Proudhon at the rue d'Enfer.

5. This must be a reference to the acquisition of the *Stag at Bay* (F. 277) by the Musée des beaux-arts in Marseille. The museum's director, Philippe-Auguste Jeanron (1808–77), himself a Realist painter of note, must have been instrumental in the transaction.

6. Courbet probably means Félix Tournachon, usually called Nadar,* or his brother Adrien.

7. Léoni may be an abbreviation of Léontine. On the Léontine affair, which involved Adrien Tournachon, see letters 62-3, 62-4, and 62-5. It is not clear why the affair is surfacing again at this time.

8. Compare letter 65-5, n. 3.

To Gustave Chaudey, Ornans, January 24, 1865 65-4

Ornans, January 24, 1865

Dear Chaudey:

The nineteenth century has just lost its guiding force and the man who embodied it. We are left without a compass, and mankind and the revolution, adrift without his authority, will once again fall into the hands of soldiers and barbarism. Everyone, even the most ignorant, felt the blow that was striking him when he heard about the death of our poor friend Proudhon.*[1]

The poet Max Buchon,* his friend and follower—one of the most fervent and devoted—used to read us his great work aloud in his home. He never finished a reading without saying, "If we have the misfortune to lose Proudhon, we are lost." That dear friend Buchon just wrote me a desperate letter full of tears.[2]

As for me, I am in a state of mental exhaustion and discouragement that I have experienced only once in my life—on December 2.[3] On December 2, I went to bed and threw up for three days on end.

Like Proudhon, I will not have the revolution derailed by throwing a bone to the people. The revolution must return to the right people, the revolution must come from everyone and from no one. When we achieve liberty, we will establish the revolution.

My dear Chaudey, we must admit one thing: all the men who for twenty years have actively, honestly, and disinterestedly striven for the public good are broken spirits today, even if they do not realize it. Of those oak trees, only the bark remains.

My dear friend, I fear that this discouragement will last as long as the first one, for man is like a single-purpose machine, if by mischance sorrow seizes him, with all his reason he will not be able to move.

They are lucky, those whose hearts are independent. Three cheers for Nefftzer and Darimon and associates.[4] Their only baggage is the little they have been able to retain of the lessons of P.-J., their teacher. Thus, in order to believe in their own worth, they give him as little credit as possible.

Each one of them has gone off with his bone. One went off to gnaw it in a tiny corner of the room, making himself as small as possible so as not to be embarrassed. The other, puffed up like a [typical] Alsatian Jew, salvages his newspaper's cashbox. Half an hour after his teacher's death, he says to his subscribers, "Please note, rate payers, that I never shared my teacher's principles. I do not know what keeps me from disrupting his funeral and refuting those who speak over his grave. But I have an elementary education. They won't lose anything by waiting. Let the body get cold, so that I am no longer afraid of it, and you will see what is left after I put him through the mill."[5] That enormous impertinence hurt the people in Ornans.

Dear friends, I would not want to be in your shoes, you who have to answer for our friend and his family. When we read that ludicrous article laced with stuff that he had to admit to (*Le Temps*, January 20), Dr. Ordinaire* was present (Ordinaire, the phalansterian), and he said, "I do not know where that Alsatian brewer came up with Proudhon's having no elementary school education. I myself had the honor to be Proudhon's schoolmate at the Collège de Besançon, and with his extraordinary intelligence he did two years while we did one and in spite of that got all the prizes."[6]

My dear Chaudey, as I had the misfortune not to see him again, nor to accompany that dear friend to his grave, I beg you to convey my very sincere regards to his wife, his daughters, to yourself, M. Langlois, M. Massol, Carjat,* Dupont,* Castagnary,* in short to all our friends, who are his disciples, saving the grace of M. Nefftzer and anyone who does not consider Proudhon a meteor.[7]

I do not understand how you could entrust his head to the ground, when I need it so badly. Have a mask made as soon as possible and send it to me in a tin box.[8] Not only do I want to do his portrait, but also a sculpture of him. I want to do him sitting on a bench in the Bois de Boulogne, just as he was, everyday, talking to people,[9] and I want to put an epitaph of my own below:

Wiser than man, his learning and his courage were without equal.

Please send me also the large Reutlinger* portrait.[10] You have it, or else Mme P.

Affectionately yours,

Gustave Courbet

Greetings to your lady.

I am sending you this letter via my friend Castagnary, in case you are not at the address you gave me.

I shall do also and first the historical portrait of P.-J. The head especially, the painted portrait if there is one, hurry, hurry.

1. The death of Pierre-Joseph Proudhon on January 19, 1865, was a shock to leftist Paris. A crowd of six thousand, largely made up of anonymous working-class people, accompanied the philosopher to the cemetery of Passy (cf. Woodcock 1956, 268).

2. Part of that letter is quoted in letter 65-3.

3. December 2, 1851: the coup d'état of Louis Napoléon.

4. Auguste Nefftzer (1820–76) was the founder and editor-in-chief of *Le Temps*. Alfred Darimon (1819–1902) was a follower of Proudhon who in 1875 was one of the five members (Les Cinq) of the opposition party, elected to the Corps législatif.

5. As Courbet indicates later on in the letter, Nefftzer's necrology of Proudhon appeared in *Le Temps* on January 20.

6. Though Proudhon did attend the Collège de Besançon and did get academic prizes, he was not able to complete the *baccalauréat* because of financial difficulties (cf. Woodcock 1956, 6–8).

7. Amédée Langlois (b. 1819) was a close friend of Proudhon and one of the executors of his will. As an editor of *Le Peuple*, he was deported in 1849. Back in France, he published *L'Homme et la révolution* (1867) and subsequently became affiliated with *L'Internationale*. Marie-Alexandre Massol (b. 1805) was a Saint-Simonien thinker who collaborated with Proudhon on *La Voix du peuple* and was one of the executors of his will. Master of a masonic lodge in Paris, he regularly contributed to *Le Monde maçonnique*. He also founded his own paper, *La Morale indépendente* (1865).

8. Courbet must be referring to the mask that had been made on Proudhon's deathbed. He had read about it in *Le Moniteur* (cf. letter 65-3).

9. On this sculpture, which was never executed, see Chu (1980a, 137, 141).

10. The Reutlinger photograph of Proudhon was taken in the early summer of 1863 by the photographer Victor Frond,* who worked in Reutlinger's studio (cf. letters 63-11 and 63-14).

11. The portrait of Proudhon that Courbet refers to was a work by Amédée Bourson (1833–1905). Painted in 1860, it was exhibited at the Salon of 1861 (no. 392). An anonymous copy of this portrait is now in the Musée Granvelle in Besançon (cf. Paris 1977, 174).

To Jules Luquet [Ornans, late January, 1865] (incomplete) 65-5

. . . I am overwhelmed in every way. The death of my friend Proudhon* has made me ill and just when I had the most work to do.[1] I will paint a historical portrait of Proudhon for the Exhibition as I promised him.[2]

I am engaged in a lawsuit to try to retrieve my painting of the *Stag at the Stream* [F. 277], which was left with M. Hesse,[3] a banker, as security for the sum of two thousand francs. It is a painting that I had delivered to a fellow to do him a favor and for which he did not pay me, so that I am obliged to buy it back in order not to lose everything. M. Hesse does not want to return

it, though I am within my rights and am offering him the two thousand francs plus interest. It seems to me that this could be an opportunity for you. The painting is worth five or six thousand francs. If you act in my stead you will definitely be able to get it. As for me, I am ready to give up the fight. . . .

I told Castagnary* to go [to Reutlinger] and ask for a large-size portrait [photograph] of Proudhon.⁴ He is charging me thirty francs, even though it was I who went to fetch Proudhon at home and brought him over by force, which was not easy, as you know. Go to Reutlinger,* ask for my friend Frond,* and tell him the story. I think Frond will send me one. If Frond cannot do it, take one and count out the money for him, for that Austrian is impossible. I'll pay you back in Paris or send it to me payment on delivery. But hurry, hurry, for I am very pressed, as you can imagine.

I would send you some landscapes if I knew what it was exactly that you need. Give me the size. I have some rugged landscapes that I could send you . . .

I have been ill, and I am still suffering from a very annoying ailment, hemorrhoids, which make any activity impossible. I am greatly to be pitied.

I'll leave for Paris in two months or later, for I am on Proudhon's family's advisory board and I have to be there to correct a piece he wrote about me, which I was supposed to do with him but which I'll do with his delegates. . . .⁵

1. Pierre-Joseph Proudhon had died on January 19, 1865.

2. Courbet, indeed, seems to have contemplated the portrait of Proudhon for a long time already, but Proudhon apparently was unwilling to sit for him (cf. Bowness 1978, 126–27). He now intended to do a "historical" portrait, which could mean simply that it was a portrait of Proudhon some years earlier or that it represented Proudhon at a historical moment. When exhibited at the Salon of 1865, the painting was called the *Portrait of Pierre-Joseph Proudhon in 1853* (F. 443). Perhaps Courbet wanted to represent the philosopher at the time when, just released from prison, he was ready to write his most important works, including *De la justice dans la révolution et dans l'église*, which was to appear in 1858.

3. Little is known about this lawsuit, but the painting was subsequently sold to the Musée des beaux-arts in Marseille, thanks to the intervention of its director, Philippe-Auguste Jeanron.*

4. Two photographs had earlier been made in Reutlinger's studio. See letters 63-11 and 63-14.

5. *Du principe de l'art et de sa destination sociale* was published later in 1865. Proudhon had designated a group of six friends to take care of his literary heritage and to publish posthumously some of his unfinished manuscripts (cf. Proudhon 1865, i-vii).

65-6 *To Jules Luquet [Ornans, February-March 1865] (incomplete)*

My dear Luquet:

. . . The painting that I am working on at the moment is a *Historical Portrait of P.-J. Proudhon** [F. 443]. He is in his little yard at the rue d'Enfer,

working beside his wife and children,[1] as was his habit. The painting is in keeping with his taste and habits. I submitted the idea to him. He approved of it completely. Except that, humble as he was, he thought he was worth neither the effort nor the importance of a painting. But for me it is an extremely important duty, which I am fulfilling with pleasure and awe, for he is the only man who stood both for my country and for what I think. The painting is 1.90 long and 1.48 wide. . . .

1. Courbet later eliminated Proudhon's wife. On the history of the portrait, see esp. Bowness (1978).

To Etienne Carjat [Ornans, February-March 1865] (incomplete) 65-7

. . . When it did not rain, he [Proudhon] was in the habit of carrying all his paraphernalia—his books, his papers, his briefcase, his writing desk—out to the three stair steps, and when the sun shone, his wife and children came to work with him. . . . Thus, my painting [F. 443] represents that yard. Proudhon,* in his shirtsleeves, is sitting on the steps; one child is playing in the sand; the other is spelling out her letters under the eye of her mother, who is in the middleground.[1] You see one wall of the house and a glimpse of foliage from the neigboring dwellings. The place is surrounded by a little picket fence like the kind the railroads use. . . . I like my painting and it moves everyone here. It was done in thirty-six days. I am half dead. You'll see, it is very original. . . .

1. Compare letter 65-6, n. 1.

To Alfred Verwee, Ornans, February 2, 1865 65-8

Ornans, February 2, 1865

My dear Verwee:

As I don't know the address of M. Bourson, who, I am told, has a portrait of the philosopher Proudhon,*[1] please forward the letter herewith enclosed to him. I would be very obliged if you would forward it to him immediately for I have very little time left before the Exhibition.[2]

You promised to send me a detailed account of the painting that I sent to the Brussels exhibition[3] and you have not written me anything. That painting has returned to my atelier. Drop me a line and help me get M. Bourson to send me his portrait as is.

Affectionately yours. Kind regards to your family and to our friends,

Gustave Courbet

1. Compare letter 65-4, n. 11.
2. The 1865 Salon was to open on May 1. The deadline for submission of paintings was March 20.
3. *Venus and Psyche* (F. 370).

65-9 *To Jules Castagnary, Ornans, March 18, 1865*

Ornans, March 18, 1865

My dear Castagnary:

I think the painting is perfect.[1] It is a hell of a tour de force. It left Ornans on the 18th [or, 15th?] and will be at the station in Paris tomorrow morning, Sunday, at 6 A.M. I wrote Luquet.* Go see it at his place tomorrow or Monday. Pick up Carjat* on your way. A lot of publicity can be done around this painting, I believe. Mobilize the army of supporters.

Affectionately yours,

Gustave Courbet

I'll be in Paris before long, in early May.

1. The *Portrait of Proudhon* (F. 443).

65-10 *To Lydie Joliclerc, Ornans, April 15, 1865*

Ornans, Saturday, April 15, 1865

[No salutation]

And now, my dear Lady Lydie,* I admit that the sky looks completely blue to me. You who are my go-between, the dispenser of my happiness, you who hold my future in your hands, you who, with a word or a gesture, can change the course of my existence—fly, beautiful migratory bird, fly swiftly toward Lons-le-Saunier and bring me back a bird of paradise like you. The season lends itself to it, everyone is making a nest.[1]

At the Besançon exhibition[2] I saw the flowers sown by the bird who charms my days and charms my nights. I am planting as many groves as I can in Ornans so that she will want to make her nest here. Oh, dear lady, you who can do what you wish, fly, fly!

We will, let us hope, produce a generation of painters and artists of every kind; we will, let us believe, found a world that is more intelligent than the one that exists in our country [now]. The activity required by the kind of life I have created for myself is wearing me out. I would like someone to help and support me. My freedom is great, but birds love freedom. That is what makes them attractive and graces them. It is their proper plumage, and as a result they owe nothing to anyone. Speaking of which, I will tell you privately what the prefect of Besançon proposed to me since I had the pleasure of seeing

you. But go, go, beautiful lady, in my impatience it seems to me that you do not move.

Forgive me that I have not been able to come to Pontarlier sooner. "If I had wings," as someone once said, I would already have made more than a hundred trips you know where. But life's torments! Oh, how futile and injurious is misfortune!

I had to go to Besançon, they wanted me to paint a picture for their lottery.[3] I finished two or three, now I am free for the time being. Next Tuesday I will come to Pontarlier, unless it pours. You will see me and Mohammed,[4] too, I say no more. As for the rest, you'll be stronger than I. Juliette* sends her best regards to you and to M. Joliclerc* as well. In anticipation of the pleasure of seeing you, I embrace you both.

Gustave Courbet

1. In the spring of 1865, Courbet's friend Lydie Joliclerc unsuccessfully served as a matchmaker between Courbet and an unknown painter of flowers, Céline N.,* from Lons-le-Saunier.
2. The third exhibition of the Société des beaux-arts de Besançon, held in 1865.
3. Probably a lottery organized by the Société des beaux-arts.
4. Courbet's horse.

To Jules Luquet [Ornans, May or April (?) 1865] 65-11

My dear Luquet:

Our friend Carjat* has just written me a magnificent letter about my paintings. He is delighted with the painting of *Proudhon** [F. 443]. Only the woman leaves something to be desired as far as resemblance, the children enchant him. I cannot tell you all the compliments he pays me and has been asked to pay me by friends who have seen it. As for the woman, it was understood from the start: the woman that is there is a provisional figure that has, however, some of the quality of Mme Proudhon.

I felt strongly about not asking anything of an administration that has always and on every occasion behaved so badly toward me. However, if, as you assure me, I could work for a day or half a day at the Exhibition before the opening without too much bootlicking, I would, on my arrival in Paris, paint a portrait of Mme Proudhon from life on a bit of canvas and transfer it to my painting. It is a matter of three hours.[1]

What strikes me profoundly and what strikes even more all the people from the Ornans area and the people from Besançon who have come to see my paintings is the [low] esteem in which the landscape[2] is held in Paris. In these parts, it was considered the most beautiful one I had ever done in my life. If that one is not beautiful and does not make a profound impression, then it is not worth doing them. It all has to do, I believe, with different ways of seeing. For myself, I will never show more skill.

Regarding the small canvases you ask me for, my dear Luquet, I would like to sell the little *Seascape* you have for 290 [francs]. A similar one was sold to M. Fanton for 300; another similar one to the landscape painter who lives in the rue des Saints-Pères, at the corner of the quai Voltaire, for 400; another one to M. Gaudin* of Saintes, for 300. I will sell it to you for 250 francs with no discount;[3] second, the *Undergrowth* [F. 345], same terms; third, the *Stag Taking to the Water*,[4] 300 francs, same terms. As for the portrait, I believe it is a dark head on a canvas split by a seam and backed.[5] I want 1,000 francs for it. If not, I would be obliged if you would send it in my name to the current director of the Uffizi Gallery, Aurelio Gotti, in Florence. It is a unique gallery, which contains portraits of all the painters since Masaccio, painted by themselves. He has already asked me twice and I believe that that one will do.[6]

I am obliged to stay here another ten days or so on business and in order to send off two landscapes that I sold to M. Félix Teste at the Besançon exhibition,[7] together with a sculpted medallion of Mme Max Buchon [Fs. 3].

As for the painting of Proudhon, I want 6,000 francs for it, and if by any chance the resale were to exceed 12,000 francs, I would want half of the amount over 12,000 francs; were it to be shown for paid admission, I would also want half.[8] This painting would be very successful in Switzerland, Belgium, and Germany.

Sincerely yours, my dear Luquet,

Gustave Courbet

1. Though Courbet probably did paint a portrait sketch of Mme Proudhon, he did not receive the authorization to alter the *Portrait of Proudhon*. When the Salon was finished, he decided to eliminate the figure of Mme Proudhon altogether. The sketch may have been used later to paint the *Portrait of Mme Proudhon* (F. 444).

2. Courbet exhibited the *Portrait of Proudhon* together with a landscape entitled *Entrance to the Valley of the Puits noir: Evening* (F. 462?).

3. The four seascapes that are discussed here were probably painted in Saintes. The one belonging to M. Fanton (F. 351) was exhibited in Saintes in 1863 (no. 95); the remaining three are more difficult to identify. These paintings and the others discussed further down in the paragraph were probably part of the crate of paintings Courbet had sent to Luquet in 1863, after the exhibition at Saintes. See letter 63-3.

4. Judging by the price, this cannot be the large painting of the *Stag Taking to the Water* (F. 277), which was sold to the Musée des beaux-arts in Marseille. Perhaps the painting is identical with *Forest Pool with Roedeer* (F. 637), though that shows a roedeer rather than a stag.

5. Probably the *Self-Portrait* in the Musée des beaux-arts at Besançon (F. 73).

6. Courbet's *Self-Portrait* did not enter the collection of artists' portraits of the Uffizi Museum and no correspondence between Aurelio Gotti and Courbet has been found.

7. The *Plaisir-Fontaine Brook in the Valley of the Puits noir* (F. 379) and the *Landscape with the Chauveroche* (F. 410).

8. Courbet may have thought of a special touring exhibition for the painting, much like the one he had planned for the *Return from the Conference* (F. 338).

To Lydie Joliclerc [Paris, June 1865] 65-12

Dear Lydie:

You will see how unlucky I am! First, I was unable to see you in Paris, then, having just finished answering Stéphanie's letter, I forgot once again, in my haste, to ask for Céline's* portrait.¹ I forgot to send her mine and to give them my address in Paris. I must already be in love. Céline is proceeding faster than I, which is as it should be. It must be she who wants it if she is to be happy. I am too fat! I am too old! Those are terrible points. Yet, as I told Stéphanie, I am one of the youngest of the well-known or famous men of my generation. It is impossible to be something without having worked at it, unless you are a notary. All that must matter little to her, as she once wanted to marry M. de Lamartine.² As for my weight, alas, marriage will take care of all that. The duties of husbands and the little freedom they have to drink beer will suffice.

I sent those ladies two paintings,³ one for St[éphanie] and the other for C[éline], but I want the one from her exhibition,⁴ and I said that if everything were to fall through, I would at least have that keepsake, and I also said, "If it ends in disillusionment, I will kill that little devil, Lydie," for you know, you are the scapegoat and you shall take the heat. Every situation must have a victim.

With that I embrace you and Joliclerc,* too. Affectionately yours.

Write me if there is any progress. I have been received extremely well by everyone and my students have all come to invite me to dine. Write Juliette.*

Gustave Courbet

1. Probably a portrait photograph of the woman with whom he was romantically involved, Céline N. Stéphanie may have been a mutual friend of Céline and Lydie.
2. Probably Alphonse Lamartine (1790–1869).
3. The two paintings cannot be identified.
4. The flower still life by Céline N. that was at the 1865 exhibition of the Société des beaux-arts de Besançon (cf. Riat 1906, 221).

To his family [Paris, June 19, 1865] 65-13

Dear family:

When I came back from Fontainebleau this morning, I found Father's letter. It is true that I am at fault, but what could I have told you until now? I reached Paris, fortunately.

Yesterday I sold four thousand francs' worth of paintings: a landscape scene at Bois-Mort, done one winter long ago above L'Essart-Cendrin; a small one of Doney's [?] paper mill; a larger one of the Paper Mill Brook, seen from

the direction of le Pontet; a copy of the *Wounded Man*, all for four thousand francs to a friend of mine.[1]

I asked Paul Boulet* to give me back M. de Chevigné's book, because M. de Chevigné came to bring it to me in a barouche drawn by four horses and wanted me to come visit him in his château, fifteen leagues from Paris.[2]

I sent you the book that P.-J. Proudhon* wrote about me.[3] It is the most marvelous thing one could ever hope to see and it is the greatest kindness and the highest honor a man could wish for in his lifetime. Nothing like this ever happened to anyone. Such a book by such a man on one individual's account? It is staggering! All Paris is jealous and dismayed. This will increase my enemies and make me a man without equal. What a calamity that he is dead and that he was unable to carry on the principles that he advances. Buchon* and Urbain* will be beside themselves. I sent the book to Flagey, canton d'Amancey. You should have received it, though Father does not mention it.

M. de Nieuwerkerke* is still asking to settle with me.[4] If he reconsiders, it will cost him dearly: thirty or forty thousand. M. de Nieuwerkerke is ashamed, he has nothing [illegible], yet he governs.

I was unable to go see Mme Lapaire, I did not know her address. M. and Mme Joliclerc* left the day I arrived in Paris. Juliette* must write them. I received a charming letter from Lons-le-Saunier,[5] I don't know yet what will come of all that. I went to see M. Mouline in Bayonne. They are nice people but mercenary, as provincials are. M. Mouline knows nothing about horses and irritated me a good deal. I finally sold him the horse for four hundred francs including the harness, but I reserve the right to take it back. His haggling got on my nerves. What a pity to sell a horse like that for that price, while we keep sick and utterly useless nags. A friend of mine, M. Furne,* has a twelve-year-old black Arab horse that is not as beautiful as Mohammed.[6] He wants fifteen hundred francs for it and will throw in only the saddle.

I found everyone in good health. M. and Mme Andler* have retired. Everyone here asks for you. Yesterday I drove Furne's tilbury to the Fontainebleau races. It was charming. The horselovers themselves rode their horses in the steeplechase. They jumped ditches, water jumps, walls, and hedges. Only two took a fall. I send you all my love. Do write me the latest about Mother, as you promised. I wasn't worried because I know that when pneumonia gets better, one always survives. In any case, you promised to write.

Sincerely yours, with an embrace,

G. *Courbet*

[Address:] Monsieur Courbet
Landowner in Ornans
If not [present], forward to Flagey
Doubs Dpt.

[Postmark:] Paris, rue de la Harpe, June 19, '65

1. None of these paintings can be identified with certainty. The painting of the paper mill may be F. 451; the one of the Paper Mill Brook, F. 454; and the copy of the *Wounded Man*, F. 546. It is not known who was the collector who bought these four works. See also letter 66-26.

2. Perhaps Louis-Marie-Joseph le Riche de Chevigné (1793–1876), author of *La Chasse et la pêche* (1832) and *Contes rémois* (1833; new edition 1858). Nothing is known about Courbet's contacts with de Chevigné.

3. Proudhon's *Du principe de l'art et de sa destination sociale* was published posthumously in the late spring of 1865.

4. Probably about the acquisition of the painting of the *Puits noir* (F. 462).

5. From Céline N.*

6. Courbet's horse.

To Alfred Sensier [?] [Trouville, September 8, 1865] (incomplete) 65-14

. . . I had a chance to paint the portrait of a Hungarian princess.[1] It is so successful that I cannot work any longer because I have too many visitors. All the other ladies are asking me [to do] theirs. I'll paint another two or three to satisfy those who are most anxious. . . .

1. Princess (or Countess?) Karoly. See also letter 65-15.

To Urbain Cuenot [Trouville, September 16, 1865 (Ad)] 65-15

Dear Urbain:

I am here in Trouville in delightful circumstances. The Casino has given me a splendid apartment overlooking the sea and there I paint the portraits of the prettiest women in Trouville. I have already painted the portrait of the comtesse Karoly [F. 439] of Hungary. That portrait has had an unparalleled success. More than four hundred ladies came to see it and some ten of the most beautiful of them would like their own [painted]. At the moment I am doing Mlle Aubé de la Holde's [F. 442], a young lady from Paris, who, in a different way, is as beautiful as Mlle Karoly. They pay me fifteen hundred francs apiece for these portraits. I have already done M. Nodler, Junior's portrait [F. 541]. I still have to do those of his brother and his father.[1] Luckily I work fast. I also have a seascape to do for the comte de Choiseul.*[2] I'll be doing the sea in a painting that I started, the *Podoscaph* [F. 449] or the *Modern Amphitrite*, and [with all that] I won't be able to leave Trouville before the end of the season.

I am gaining a reputation as a matchless portrait painter. The ladies I won't be able to do here will have themselves done this winter in Paris. That will give me an enormous clientele. You'll agree that is better than to go over to the empire, like Frond.[3]

I will write Fajon.* I don't know what he wants from me. I don't know

when I will be able to return to Ornans, I'll have to go on my way back from Trouville in October. Kind regards to my family. Give them my letter, I really have no time to write. There are so many people all around me that I don't know whom to listen to. You made a great mistake not coming to Trouville. The weather is splendid, the bathing, too. I go bathing sometimes twice a day, it is as warm as in summer. Kind regards to everyone in your family and mine, and to our friends.

<div align="right">G. Courbet</div>

The people from Besançon are free to say what they wish, they are idiots.[4]

1. Courbet did paint the portrait of M. Nodler's brother (F. 541) but does not seem to have painted that of his father.

2. The seascape in question may be the *Dunes at Deauville* (F. 598).

3. Victor Frond* remains a shadowy figure among Courbet's acquaintances, and the precise meaning of the artist's remark is unclear. It appears that at some point before the date of this letter Frond had quit his job as a photographer in the studio of Charles Reutlinger* to start directing the publication of the *Panthéon des illustrations françaises au XIXe siècle*, produced by the printer Lemercier (cf. letter 66-1, n. 2). In 1866, Frond's name crops up in connection with the notorious Nieuwerkerke affair.

4. The cause of this outburst is not known.

65-16 *To his family, Trouville [November 17, 1865 (Ad)]*

<div align="right">Trouville, Friday evening</div>

Dear family:

As usual, I went to Trouville for three days and stayed for three months. This time I did not play my cards wrong. I have doubled my reputation and have made the acquaintance of everyone who can be useful. I have received over two thousand ladies in my studio, all wishing to have their portraits painted after they saw the portrait of princess Karoly [F. 439] and the portrait of Mlle Aubé [F. 442]. So I shall be forced to stay in Paris this winter, also because I have begun two paintings for the upcoming Exhibition that I can do only in Paris: the one that belongs to M. de Nieuwerkerke *[1] and another that I started in Trouville of a lady going about on the sea in a boat called a "podoscaph" [F. 449], which consists of two boxes the size of narrow coffins and joined together. Another reason: I think I will sell many paintings if I stay in Paris this winter. Nonetheless, I'll come see you if I can after a while.

In addition to these portraits of women, I painted two of men,[2] as well as other figure paintings and seascapes. Altogether I have painted thirty-five canvases, which has astonished everyone.

I received Juliette's* letter, which gave me great pleasure. She tells me that you, Mother, and Zélie* went to Vichy. I hope that it has done you some

good. As there was cholera in Paris, I was not sorry to be in Trouville. I am in wonderful health and I have gotten over my constipation. I have taken eighty sea baths. Six days ago I was still taking them with the painter Whistler,* who is here with me. He is an Englishman who is my student.[3]

I am happy also that Juliette has gone to Lons-le-Saunier. I sent everything to the devil and haven't replied to all that twaddle.[4] In the last letter that young lady wrote me she asked me for five hundred francs for Mlle Th., whom she dares not support by herself, with all her money, still because of her brother. I believe she is quite delighted with that guardianship, which exempts her from all good deeds. Stéphanie[5] and Lydie* are furious with her, and she and Stéphanie are furious with Lydie. Let them get all tangled up!

I am leaving Trouville Sunday or Monday. Love to you all. Kind regards to our friends. I'll write you from Paris what I will be doing. I cannot say right now.

<div align="right">*Gustave Courbet*</div>

I'll write Buchon* tomorrow.

1. Probably the *Woman with a Parrot* (F. 526).
2. Probably the portraits of M. Nodler, Senior (F. 540) and M. Nodler, Junior (F. 541).
3. Whistler, who was fifteen years younger than Courbet, certainly respected the older artist. However, in 1865, he was thirty-one years old and hardly a "student" any longer.
4. The affair with Céline N.* See letters 65-10 and 65-12.
5. Compare letter 65-12, n. 1.

To Victor Frond [Trouville, November 19, 1865]　　　　　　　　　　65-17

<div align="right">Sunday night</div>

My dear Frond:

I am very sorry about what is happening to Georges and, at the same time, delighted about what you have done for him in my absence. I thank you. I had seen it coming in Trouville, when he came, but I did not think there would be such consequences. It is not dangerous but it is extremely annoying for me.[1]

As long as a week ago I thought I had finished what I had started here, but the weather is not always favorable, and yet I wanted to make the most of what I had started. There was motive enough in that regard.

I will be in Paris, if nothing to the contrary happens, on Tuesday evening or Wednesday morning.

All the best to you, my dear fellow, as well as to Georges and your family.

<div align="right">*G. Courbet*</div>

If I had known that I would stay here so long I would have had my letters

forwarded. The one from Bordeaux is important.[2] I have thirty-five finished canvases.

[Address] Monsieur Frond, Victor
 57 rue de Seine
 Impr. Lemercier
 Paris
[Postmark] Trouville, November 19, 1865

1. Neither the identity of Georges or the incident Courbet refers to is known.
2. Perhaps a letter of invitation from that city's Société des beaux-arts. Courbet had participated in the 1865 exhibition of the society but would not participate in 1866.

66-1 *To Jules Luquet [Paris, winter 1865–66] (incomplete)*

My dear Luquet,

Please remit to the bearer the small painting *Stag at the Stream*.[1] There is great interest in my doing a line drawing of it for the *Panthéon des illustrations françaises*.[2] Rosa Bonheur has done some dogs, etc., etc.[3]

I would also like you to give him the Mazaroz landscape.[4] That will relieve you of having to send it to me. . . .

1. It has not been possible to identify this painting with any certainty. See also n. 2.
2. In the mid-1860s Victor Frond* had become the director of the *Panthéon des illustrations françaises*, a serial publication devoted to the biography of famous living people in France, which was eventually reissued in the form of a multivolume book (1869). Each installment contained a portrait, a biography, and a facsimile autograph of the person in question. Sometime during the winter of 1865–66, Frond had asked Courbet for a drawing and an accompanying biographical sketch. When the section on Courbet appeared, however, it did not contain a sketch of the *Stag at the Stream* but rather the autograph text of Courbet's brief statement on Realism, printed in the catalog of his 1855 private exhibition (*Panthéon*, 1869, vol. 4). Moreover, Courbet never seems to have sent Frond his biography, and in the end Frond seems to have written it himself. In a letter to Courbet, dated January 14, 1866 (Paris, Bibliothèque nationale, Cabinet des estampes, Yb3.1739 [4°], b. 2), Frond asked Courbet to read over and, if necessary correct, his draft biography of the artist. The text of that biography may be found in Courthion (1948–50, 2:25–33).
3. An earlier installment of the *Panthéon* had been devoted to the animal painter Rosa Bonheur. It had contained a signed sketch of two dog heads (*Panthéon*, 1869, vol. 3).
4. Probably one of the numerous works Courbet sold to Jean-Pierre Mazaroz.*

66-2 *To his family, Paris, January 3, 1866*

1866, January 3, Paris

[No salutation]

I am writing to wish you a happy New Year and to keep you posted as to my situation. I returned from Trouville—where I did thirty-eight paint-

ings—on November 20th. Though I don't want to, I am obliged to stay here this winter, both to finish paintings that I sold and that are difficult to do in Ornans, and to sell a few of those that I did. I may end up selling thirty or forty thousand's worth this year. Urbain* must have told you something of that. First I have the two paintings sold to M. de Nieuwerkerke,* Luquet,* etc. My painting of the *Priests* [F. 338] is leaving for America as is the *Wrestlers* [F. 144]. I will share in the profits, I hope. I made an enormous name for myself in Trouville with ladies' portraits and seascapes.

You will receive for your New Year's gifts the armchair that you wanted for Mother. It is of black wood and upholstered with oak-leaf-brown Utrecht velvet. M. Roux, who came to see us with Mazaroz,* and his associate, M. Robin, are making it.[1] It is their fault if you did not receive it on the first of the year. There will also be in that mailing two baby tiger skins for my sisters and a pair of sailor's binoculars, of the very finest quality. I am not sending it to you express in order to save twenty-five [francs].

I received a very curious letter the other day from Mlle Antoinette Chapuis, our childhood friend from M. Hébert's at La Froidière. Nowadays that dear Antoinette is Sister Ste. Cathérine in the convent of St. Dominique on the avenue de Neuilly in Paris, which is the third convent of its kind that she has founded under the direction of M. Lacordaire.[2] She is the prioress of the convent. I went to see her today before writing you. She is as tall and as big as I am. She seems happy with her situation. She was delighted to see me and remembers you with great pleasure, saying that we are the most distinguished family she has ever seen in her life. I could not embrace her for she cannot embrace men. I felt her situation was unnatural. She told me of the marriages they had wanted her to make and how little she was inclined to that kind of thing, and about the ranks her father had attained in the administration. She teaches her students about my painting. She thinks that I am the worthiest person of the present day, etc., etc. and urges me to send you her best regards and to remember her to everyone. She still remembers Clarisse[3] affectionately. And with that my mission is accomplished. From there I went to see . . . [4]

Something is coming to mind. I believe my two-wheeled cart, which that idiot Mouline, who has poor Mohammed, is still in Besançon at the Hôtel de Paris.[5] Have L'Ange pick it up.

I also need Father to send me immediately the two mannequins, the woman and the man, in the square crate that is in the attic (without the pine base, just the mannequins). [Send them] slow goods service, addressed in care of M. Galiber et Cie, 43 rue Lepic, Montmartre. They have to be retouched and then I will need them here.[6] Those gentlemen will take care of the repairs.

The success I am having in Paris at the moment is unbelievable. In the end I am the one and only. If one has the will, one can achieve anything.

The comte de Choiseul* and his sister, the marquise de Montalembert, just left here. They bought some seascapes.[7]

I chose that chair out of sixty [models] as the most comfortable one for your indispositions. I embrace you all with all my heart. Kind regards to our friends. I received Urbain's letter.

Gustave Courbet

I have not answered Céline's* last letter, as you know. I just received from her a picture of flowers that she painted. I also received a letter from Lydie* who says that I did well to let everything be. It is all mystifying.

Put a cotton undershirt and the warmest pair of underpants in the box with the mannequins (wrapped in paper with my address). There is no winter in Paris. So far I have lit a fire twice.

As for the priest in Ornans, I certainly don't miss him. He was a miserable and lowly thief.[8]

Father Hyacinthe[9] spoke about me in his lectures at Notre Dame.

I am still working on the large landscape painting of the *Puits noir*, where Juliette's* poets used to be.[10] I put in some roedeer that I rented from a game butcher. Now it is a delightful corner of nature.

1. Courbet's patron Jean-Pierre Mazaroz was in the furniture business. Through him he must have met the two furniture makers mentioned here.

2. Henri Lacordaire (1802–61) was a French Dominican preacher who was instrumental in bringing about a Catholic revival during the July Monarchy.

3. Courbet's sister who had passed away in 1834, at the age of thirteen.

4. Courbet's sentence ends here.

5. Courbet has forgotten the end of clause, *which that idiot . . .* etc.

6. It is not clear for what painting Courbet needed the mannequins.

7. Mme de Montalembert bought the *Beach at Trouville during Low Tide* (F. 512). The comte de Choiseul may have bought the *Dunes at Deauville* (F. 598). See also letter 65-15.

8. Probably a reference to Benjamin Bonnet (1801–1865), who had died some six weeks earlier. Courbet had portrayed Bonnet in his *Burial at Ornans* (F. 91).

9. Charles Loyson (1827–1912), known as Father Hyacinthe, was a Carmelite friar who was interested in wedding Catholic dogma and modern science. His sermons and lectures drew large audiences.

10. The *Covert of the Roedeer* (F. 552) was painted over Courbet's earlier painting of the *Fountain of Hippocrene*, which was accidentally destroyed when Juliette opened the door to Courbet's studio in Ornans and knocked over his easel (cf. letter 64-2). Courbet's remark, "where Juliette's poets used to be," is a tongue-in-cheek reference to this accident.

66-3 *To Alfred Bruyas, Paris, [early] January 1866*

Paris, January 1866

Dear Alfred:

I just saw M. Causse,[1] whom I sent to see you. He is one of my students.

He gave me news of you. I ask everyone. I also saw the elder M. Bimar,[2] who was kind enough to come see me. We talked about you the whole time that he was here.

I wrote you once or twice. I sent you my poor friend Proudhon's* book[3] [and] the photograph of the *Priests* [F. 338], [and] still no answer.[4] I would be justified in believing you dead. Fortunately there are travelers: everyone says that you are in an Eldorado that you have had yourself built. Some say that you are in love—that takes you off the hook. And yet, when one is as happy as all that, one has no right to forget poor unhappy toilers like me who move heaven and earth to achieve their goal. There was a time when you took part, and quite effectively, in my political work in the world. I am still most grateful to you for that.

If you knew how much painting I have done since I last saw you, you would be appalled! I believe I have already done a thousand paintings, and in spite of that, because of ill will, because of ignorance, and because of the ridiculous powers that be, I am still in the position I was when you met me.

I would like to see you again. I would like to have the time and the means to come back to Montpellier and see my friends, the countryside, and the mall. Thanks to you, I had a wonderful time.

Last summer I went to Trouville for three months. I took eighty sea baths. They were more efficacious for me than the Fountain of Youth! I am still feeling amazingly well, fortunately. I did thirty-eight paintings in that place, including twenty-five seascapes similar to yours and to those I did in Sables d'Olonne;[5] and twenty-five autumn skies, one more extraordinary and free than the next. It's fun. I also painted ladies' portraits, etc., etc. I wish you could have seen them all.

M. Causse told me that M. Alicot has died. That must have grieved you after all, because of your sister. Please send her my respects, as well as to your mother. M. Causse also told me that you wanted a landscape of mine. You know that I am always happy to oblige you. At one point you offered me the Troyons in exchange for paintings of mine. If you are still of the same mind, send me a Troyon, and I will send you a landscape of my part of the world.[6]

Kind regards, dear friend, to our friends from me. I close with wishes for a happy New Year and good health, to use the common phrase. I would also like news of Sabatier.*

Affectionately yours, I embrace you,

Gustave Courbet

If you have photographs of my portraits [F. 39 and F. 161], of the *Meeting* [F. 149], and of the *Bathers* [F. 140], send them to me. I would also like you to send me some money for Proudhon's widow. Excuse my bluntness but one can ask only people with heart. As he named me to his board of relations, I am obliged to ask everyone in order to take care of them.

1. Perhaps Jules Causse, a painter who exhibited at the Salon between 1864 and 1866. Causse's name is found on the list, prepared by Castagnary, of students in Courbet's short-lived atelier in the rue Notre-Dame-des-Champs (1860). Compare Castagnary (1864, 190).

2. Perhaps the painter Pierre-Charles-Henri Bimar, a native of Montpellier, whose *Landscape*, dated 1863, is in the Montpellier Museum.

3. *Du principe de l'art et de sa destination sociale* (1865).

4. Annotation by Bruyas in the margin: "Did not receive either letters or book from that dear friend at that time."

5. Nothing is known about Courbet's visit to Sables d'Olonne.

6. Courbet was to send his painting *Solitude* (F. 583) to Bruyas. It is not known which painting by Troyon he received in return.

66-4 *To Jules Vallès [Paris], January 17, 1866*

January 17, '66

My dear Vallès:

You ask me if I would like to do, for the January 19 anniversary [issue], a drawing of *Proudhon on His Deathbed*.[1] I accept wholeheartedly and eagerly seize this opportunity to offer a token of sympathy and admiration for that man of matchless integrity who, born in the same part of the world as I, was, during his lifetime, my comrade and my friend.

Thank you for having thought of me in this matter.

Sincerely yours,

Gustave Courbet

1. Editor of the radical magazine *La Rue*, Jules Vallès had asked Courbet to make a drawing of the philosopher Pierre-Joseph Proudhon* on his deathbed for an issue commemorating the first anniversary of Proudhon's death. Courbet's drawing, which was based on a photograph by Etienne Carjat,* has not been preserved, but an engraving after the drawing published by Lemercier et Cie can give a fair idea of what it looked like. The issue of *La Rue* in which Courbet's drawing was to appear was blocked by the censor before it could be distributed, and apparently the entire edition was destroyed (cf. Chu 1980b, 82).

66-5 *To Alfred Bruyas [Paris, January-February 1866]*

Dear Alfred:

If you have an aversion to weaklings, it is because you like people of merit and genius and because you show it to them. You cannot complain.

I thank you very much for the money you sent me for the Proudhon* family. They need it all the more as we shall be obliged to cancel the contract we had made with the publisher Lacroix* for P.-J.P.'s complete works. M. Lacroix has just been sentenced by the tribunal, at the government's instiga-

tion, to a fine of fifteen hundred francs and a year in prison; his partner,[1] too; the printer M. Poupard got three months in prison and a fine of five hundred francs. All that for having published Proudhon's annotations to the Gospels,[2] a book that appeared for a month and against which there was not a word to say, even the priests said so! The government urged M. Lacroix to cancel the contract and insists he return to Belgium. All this is disgraceful and can only benefit the revolution. As for us, we cannot complain except that it is up to us to support the family until better times. (As I already told you, I believe, Proudhon named me to his board of relations.)

My dear friend, the people in our country who blow so much hot air would never do what you have done. It is easy to silence them, one only has to ask for their contribution. P.'s reputation and the mourning he left behind increase every day. M. de Sainte-Beuve's* articles have done him outstanding justice.[3]

I will send you a splendid landscape of profound solitude, done deep in the valleys of my part of the world. It is the most beautiful one I have, and perhaps even that I have done in all my life. It must be on a par with the paintings of mine you already have. This landscape is 1 meter 37 wide and 95 centimeters high.[4]

I don't know how to draw on your account. Would you be so kind as to post the money yourself when you receive the landscape? It will be unframed because I do not have any at the moment and because it is better that you have one made to match your other frames and suit your taste.

I am finishing it now, I'll send it to you in a few days. The upcoming Exhibition keeps me very busy. I have only one and a half months left. I'll have a landscape similar to yours with roedeer in it, and a nude woman.[5]

Again, I thank you very much, dear friend, and acknowledge receipt of the five hundred francs for the contribution, which I took to M. Garnier;[6] and of the two thousand francs for the commission that you have kindly given me.

Affectionately yours,

Gustave Courbet

1. In 1861, Lacroix had formed a partnership with the Belgian publisher Verboeckhoven.

2. Proudhon's *La Bible annotée*, a two-volume work, had been published by Lacroix, Verboeckhoven et Cie in the winter of 1865–66.

3. The critic Sainte-Beuve had devoted several articles to Proudhon in his *Nouveaux lundis*.

4. *Solitude* (F. 583).

5. *Covert of the Roedeer* (F. 552) and *Woman with a Parrot* (F. 526).

6. One of the two Garnier brothers, who published most of Proudhon's books. The Garniers apparently were in charge of the Proudhon family fund that was raised by Proudhon's friends, including Courbet, to support the philosopher's widow and children.

<u>66-6</u> *To Arthur Stevens, Paris, March 22, 1866 (incomplete)*

... This painting [the *Burial at Ornans* (F. 91)] is too important for me and for the time to come to let it go for less than half its worth. I consider Belgium my country. I have been going there for twenty-six years and have received all kinds of ovations and tokens of friendship. I would like to see my *Burial* there and yet I cannot let it go for a price less than fifteen thousand. ... [1] [He tells his correspondent that both the city of Lyon and two collectors have made an offer for the painting but that he would prefer it to go to Belgium.] ... it is the country of painting and literature [or *struggles?*].[2] This twenty-foot-long painting with fifty-two life-size figures is the statement of the principles of Realism, which will book its ultimate success this year at the Exhibition, opening on the first of May, with the two paintings that I have just sent there. ... [3]

[He informs Stevens that the seascapes that he has painted at Trouville are ready and at his disposal.] ...

Try to settle that business, for I would never be able to paint that painting again. It is a closed chapter of my life. ...

Kind regards to Baudelaire. ... [4]

1. Arthur Stevens, the brother of the painter Alfred Stevens, was a critic and dealer in Brussels. Apparently, he had a local client interested in buying the *Burial*.
2. Courbet's letter to Stevens is known through two partial transcriptions (see the list of letters). One of these has the word *lettres* (literature), the other *luttes* (struggles).
3. To the Salon of 1866 Courbet had sent the *Covert of the Roedeer* (F. 552) and *Woman with a Parrot* (F. 526).
4. Baudelaire* had sojourned in Belgium since 1864. Around the time that Courbet wrote this letter he became very ill and was transported back to Paris, where he was to die in the summer of 1867.

<u>66-7</u> *To Urbain Cuenot [Paris, April 6, 1866 (Ad)]*

Dear Urbain:

They have finally been killed! All painters, all painting, it is all topsy-turvy. Comte de Nieuwerkerke* sent a message to tell me that I had done two masterpieces and that he was delighted.[1] The entire jury said the same thing, without objection. I am the uncontested great success of the Exhibition. There is talk of the medal of honor, the cross of honor, and what have you.[2] The landscape artists are dead in the water. Cabanel complimented me on the *Woman*,[3] as have Pils and Baudry.[4] I told you a long time ago that I would find a way to give them a fist right in the face. That bunch of scoundrels, they caught it! Imagine, in Paris they are saying that the administration is charming and that all the harm that derives from it is the fault of the painters. Do you remember the drawerful of letters that Nieuwerkerke showed me one day? In

it were more than three hundred letters written against me that left nothing unsaid.

Luquet's* exhibition was very beneficial. I had twenty-five paintings, old and new, including my Trouville seascapes, which were most successful. Those seascapes done in two hours sold for twelve or fifteen hundred francs apiece. In certain painters' circles they call me a charlatan, a hoaxer, a humbug, and ask me why I played dead for three years. The notorious Courmont,[5] director of the Exhibition, said what a pity it was that it was a man like that, such an impossible man, who made things like that.

It is the landscape painted over the canvas that Juliette* ruined, the *Hippocrene Fountain*[6] (the one we carried to the Puits noir, my father and I) that is causing all this ruckus. You must remember it. It shows the embankment of the stream, with rocks and large trees. Everything is golden. Last winter I rented some roedeer and turned it into a covert. In the middle sits a small female roedeer who receives, it is like a salon. Next to her, outlined against the rocks, is her mate, who nibbles at the ivy on a tree on the left. Another roedeer is crossing the stream and is followed by a little yearling that drinks from the bank. It is enchanting, and they are as polished as diamonds.[7]

Our friend Bruyas* asked me for a landscape. I sent him a copy of the one I sold Nieuwerkerke—he wrote me to send him a two-thousand[-franc] landscape.[8] Altogether that hole of the Puits noir will have earned me twenty or twenty-two thousand francs,[9] thanks to Gérôme.[10] Three cheers for Gérôme! I am sure my father does not give him any oats. Nieuwerkerke was figuring on giving me ten thousand for the *Woman*.[11] I don't know whether he will stick to that price.

Like every year when I finish my [paintings for the] Exhibition, my hemorrhoids started acting up. Since March 20 I have been half dead. I don't get any sleep, day or night. I am writing you in the tub, they are beginning to get better. I wanted to go to Ornans from March 20 to May first, but I cannot. See whether you can do me a favor and have the trees planted that I will write Lavigne to send you. I will ask for thirty grafted cherry trees that you should have someone plant like those that are there already and take them into père Bon's field, the same distance, that is, from your brother-in-law's field to the hedge and then, starting from the hedge, the entire length of the hedge up to the house. Lavigne will send you eighty-two apple trees for open terrain, grafted if possible, because I want to make cider. That worked very well for me in Trouville, it softens the stools and can be a beneficial substitute for beer. Here is the plan so you won't make a mistake [sketch; see fig. 2]. I believe there are twenty-seven cherry trees to be planted. My father, if he is in Ornans, or my mother should go ask the Jaquins. They are the most skillful and best farmhands. My father should also graft the cherry trees that I grafted last year and that did not take. The reason I write you is that no one in our

family is at home. If my father cannot do it, tell père Vieux to do me this small favor.

I am very rushed at the moment in spite of my illness. I want to send something to London for the exhibition, some ten days from now.[12] I am still working on the portrait of Proudhon* [F. 443]. I removed the little wall that was in the back and it is larger by half. I will be painting Mme Proudhon [of] whom I have [a sketch] ready at my atelier.[13] I sent your money to the Garniers in your name an infinitely long time ago.[14] Soon, I will not be able to keep up with the sales.

Cordially yours, I embrace you. Take this letter to my parents right away, if they are in Ornans, or have someone give it to them in Flagey.

Gustave Courbet

Kind regards to all our friends.

I saw Mathieu,* I saw Ordinaire,* who [both] gave me news of you. Kind regards to your family and to Briot.

The American exhibition is making a lot of noise.[15] In short, everything is fine so far. We must wait and see what will come of it, one is never sure of anything.

Champfleury* told me that Buchon* was going to come to Paris for the Exhibition.

1. The two paintings that Courbet submitted to the 1866 Salon, *Woman with a Parrot* (F. 526) and *Covert of the Roedeer* (F. 552), were not only accepted but given a place of honor. The comte de Nieuwerkerke may have played an important role in that decision (cf. Paris 1977, 42).

2. Courbet was to receive neither medal nor cross at the award distribution on August 14.

3. Alexandre Cabanel (1823–89) had exhibited his famous *Birth of Venus* at the Salon of 1863. The immense success of that painting may well have inspired Courbet to do some Salon nudes, including *Venus and Psyche* (F. 370) and the *Woman with a Parrot*.

4. Isidore Pils (1813–75) and Paul Baudry (1828–86) were among the best-known artists of the Second Empire. Pils received a medal in 1861 and was made a professor at the Ecole des beaux-arts in 1864. Baudry was made chevalier of the Legion of Honor in 1861.

5. Henri Courmont (1813–91) had first entered the fine arts administration in 1837. He became its director in 1864 but resigned two years later, in 1866.

6. See letter 64-2.

7. The entire paragraph is a reference to the *Covert of the Roedeer*.

8. The painting sold to Bruyas represents the Puits noir but is generally called *Solitude* (F. 583). It was based on an earlier painting of the Puits noir (F. 462) that was bought by the comte de Nieuwerkerke in 1866 for two thousand francs.

9. Courbet had done well over a dozen paintings of the Puits noir.

10. Courbet's donkey. Courbet writes "Gérome" rather than using the more obvious spelling "Jérôme." Though the likelihood of an orthographic error must be considered, it is also possible that the donkey was named after Jean-Léon Gérôme (1824–1904), one of the Second Empire's most successful Salon painters.

11. The *Woman with a Parrot*.

12. As far as is known, Courbet did not exhibit in London in 1866.

13. When Courbet first exhibited the work, he did not have a portrait of Mme Proudhon available to him, and he had therefore painted a woman with generalized features. Now he planned to finish the figure. In the end, however, he was to eliminate Mme Proudhon altogether and to replace her by her mending basket.

14. The Garnier brothers were the publishers of most of Proudhon's books. Courbet apparently had asked Cuenot to contribute to the Proudhon family fund. See also letter 66-5, n. 6.

15. The exhibition of Courbet's *Quarry* (F. 188) in Boston (see Brooklyn 1988, 68–69).

To the marquis de Chennevières [Paris, April 18, 1866 (Cd)] 66-8

Monsieur:

When I received your letter yesterday evening, I was just going out to dine with a group of artists. I put to them the proposition that you made me,[1] substituting for your name that of a collector, introduced to me by Abbé Lenoir, who also wishes to buy that painting.[2] We went over all the prices of paintings that are sold these days, from 4,000 up to 80,000 francs. We ended up comparing mine with those of Rosa Bonheur and Troyon,[3] paintings in the same genre. Thus it was determined that I was not to sell the painting for less than 15,000 (the price, by the way, that I had in mind) because, they said, this painting was going to have an unparalleled success at the opening of the Salon.[4] Since these paintings are everywhere considered masterpieces, I don't think that this is the moment to lower their prices—I am not rich enough to do so—and it seems to me that, rather, it is the administration's duty to raise them if it can. The best-invested money is that invested in art because one cannot make art without money, I know something about it. I have sold for 8,000 at one time, for 12,000 at another. M. Luquet* wants 20,000 for my *Quarry*.[5] Consequently the price of 15,000 seems extremely reasonable to me. It is the price that I would charge a private collector and it is much lower than the usual prices set by my fellow artists at previous exhibitions. If things could be worked out on these terms, M. le Marquis, I would be very obliged to you. I have not yet made any other commitment.

With my most respectful greetings, I am,

Sincerely yours,

Gustave Courbet

M. le comte de Nieuwerkerke* has authorized me to finish a piece of drapery in my painting of the *Woman with a Parrot* [F. 526] before the opening of the Salon. So far I have not been able to get there because of an illness caused by constipation that has not yet permitted me to go out. I will have the honor to come and ask you for the authorization tomorrow or the day after.

1. The marquis de Chennevières had made an offer for Courbet's *Covert of the Roedeer* (F. 552) before the opening of the Salon on May 1. Courbet assumed that Chennevières acted on

behalf of the state, but he was later told that the marquis represented a private party. See also letter 66-9.

2. The collector in question may have been the stockbroker Lepel-Cointet,* who, after the opening of the Salon, bought the painting for 15,000 francs, the price Courbet wanted for it.

3. Rosa Bonheur (1822–99) and Constant Troyon (1810–65) were two painters who specialized in animal painting.

4. The painting was indeed unanimously praised by the critics.

5. In 1858, Courbet's painting of the *Quarry* (F. 188) had been bought from the artist by the dealer Van Isachers for 8,000 francs. Luquet acquired the painting in 1862 through an exchange. He sold it in 1866 to the Allston Club in Boston for 25,000 francs (cf. Fernier 1977–78: 116; Brooklyn 1988, 68–69).

66-9 *To the marquis de Chennevières [Paris, April 21 or 28, 1866 (Cd)]*

Saturday

Monsieur de Chennevières:

From the terseness of your letter I thought that you were requesting the painting[1] on behalf of the administration. Indeed, if, as you say, it is a private person who wishes it,[2] I could have set other terms. And if that person still wishes it, let [that person] tell you what price he or she was thinking of paying. I'll see whether I can let it go.

I thank you very much for having acted in my interests in this matter.

With kindest regards,

Gustave Courbet

1. The *Covert of the Roedeer* (F. 552).
2. The private person in question appears to have been the empress (cf. Paris 1977, 188). It is not sure from this letter whether Courbet was aware of this.

66-10 *To the marquis de Chennevières, Paris, May 12 [1866]*

Paris, May 12

Monsieur le Marquis:

I am vexed by what is happening. You did not answer my last letter,[1] in which I asked you to quote me a price.[2] When I left M. de Nieuwerkerke's* last Thursday, I went to M. Lepel-Cointet,* to whom I had promised [the painting] if the administration did not buy it. M. Lepel gave me fifteen hundred francs and commissioned a nude woman from me in the same genre as the one in the Salon,[3] as I wrote to M. de Nieuwerkerke this morning.

If this creates a problem for the person whom you represent, there is only one solution, and that is to tell M. de Nieuwerkerke to please ask M. Lepel-Cointet, at 59 boulevard de Strasbourg, whether he would be so kind as to

allow an exact copy to be made of that painting, something he will not refuse, I think. Otherwise, if you trust me, I can paint similar pictures that are as attractive as that one.

Monsieur le Marquis, I thank you again for your kindness. With my compliments and warmest regards,

Gustave Courbet

32 rue Hautefeuille

1. See letter 66-9.
2. For the *Covert of the Roedeer* (F. 552).
3. The *Woman with a Parrot* (F. 526). Courbet did not want to sell the painting itself to Lepel-Cointet, as he was convinced that the comte de Nieuwerkerke was going to buy it (cf. letter 66-14).

To Maxime David [Paris], May 20, 1866 66-11

Dear David:

This is a sample of my drawing. Had I had more time, I would have done what I could.[1]

Affectionately yours,
May 20, 1866

G.C.

1. This is not strictly speaking a letter, but rather a note, accompanying a landscape sketch that Courbet made for the autograph album of the miniaturist Maxime David (see fig. 3). David started the album as a present for his daughter Marie Maxime, and he dedicated it to her on her birthday, December 25, 1854. On the facing page of the album is a landscape drawing by Auguste Allongé (1833–98), with the following accompanying text: "Thanks to my dear fellow artist Maxime David for having provided me with the opportunity to put down a few lines next to Courbet's. February 4, 1867. Allongé."

To Jules Luquet [Paris, late May or June 1866] (incomplete) 66-12

. . . The painters are furious with me because of the articles that have been written about me.[1] At the moment, they are seeing to it that the medal of honor is taken away from me. . . .[2]

It is advisable to defer the statue until after the outcome of all this. . . .[3]

I had Fonvielle place the Boston article in the *Figaro*. . . . [4]

1. Courbet's two paintings at the 1866 Salon had caused a flood of laudatory articles.
2. In effect, Courbet did not receive a medal on August 14, the official distribution day.
3. Perhaps a reference to the lawsuit regarding the casting of the *Boy Catching Bullheads* (Fs. 1). Compare letter 66-13.
4. On May 22, 1866, an article on Courbet's *Quarry* (F. 188), entitled "Notes on *La Curée* at the Allston Club's Exhibition" and signed E. S., had appeared in the *Boston Daily*

Evening Transcript. Courbet may have known about the article through Ulric de Fonvielle (1833–1911), who had spent several years in America, fighting in the Civil War. Fonvielle had returned to Paris in 1864 to become a journalist. I have not been able to find his article in the *Figaro*.

66-13 *To Gustave Chaudey [Paris, June 16, 1866 (Ad)]*

My dear Chaudey:

I finally have a case. I owe M. Desachy, a caster, 259 francs, according to his bill, which was for 459 francs, of which I have already paid 200.[1] The gentleman made me a waste mold and then a permanent mold, but the latter was not delivered to me. I am not refusing to pay his bill, on the condition that he delivers his work.

It seems insane to me to haul me before that court. Get an attorney. I am summoned before them in six days, I send you the notice.

Yours. Come for lunch on Monday.

G. Courbet

I have already had some troubles with justices of the peace, when I did not appear.

1. As early as March 7, 1866, Courbet had received a letter from Desachy's lawyer, L. Lefort, urging him to pay his debt of 259 francs for the casting of the *Boy Catching Bullheads* (Fs. 1) to Desachy as soon as possible. Lefort's letter may be found in Paris, Bibliothèque nationale, Cabinet des estampes, Yb3.1739 (4°), b. 2.

66-14 *To the comte de Nieuwerkerke, Paris, June 16, 1866*

Paris, June 16, 1866

Monsieur le Surintendant:[1]

I am in receipt of a request from the Fine Arts Administration that has caused me some surprise. I refused to sell the *Woman with a Parrot* [F. 526] to a collector who offered me fifteen thousand francs for it. I am compelled to exercise the same refusal to the administration, which is offering me six thousand francs for it. It is not that one or the other price is not agreeable to me, but that for quite some time now I have been unable to dispose freely of the painting you ask me for. The *Woman with a Parrot* belongs to the comte de Nieuwerkerke, who commissioned it from me and who himself freely set the price of ten thousand francs to the person who brought him the *Landscape*.[2]

It is in accordance with the wish of the comte and repeated suggestions on his part that I (aware of the price he was offering me for it) resolved to finish the painting for the Exhibition.

Consequently, Monsieur, I send you herewith enclosed the receipt for that painting, which is at present in the Exhibition.

With respectful regards,

Sincerely yours,

Gustave Courbet

1. In a handwritten pencil notation in the margin of this letter, the comte de Nieuwerkerke has indicated to his secretary how to answer it: "Tell him that we never agreed on any price. I did urge him to paint this picture so that I might buy it at the Exhibition, but I don't pretend to be able to pay six thousand francs for it as a rich collector could. Therefore I suggest to him to take advantage of the offer of fifteen thousand that has been made to him." In another notation, the secretary has indicated that an official reply was sent to Courbet on June 19. For the text of this letter, see Mazauric (1968, 28).

2. Earlier in the year the comte de Nieuwerkerke had acquired a painting of the *Puits noir* (F. 462) for two thousand francs. When this work was delivered (probably by Courbet's friend Victor Frond*), Nieuwerkerke, according to Courbet, had quoted a price for his painting of the *Woman with a Parrot*, which he wished to buy for his private collection. Nieuwerkerke subsequently (again following Courbet's version of the events) had offered to buy the painting for the state against a much lower price. In this letter, Courbet, in tongue-in-cheek fashion, writes to Nieuwerkerke the arts administrator about Nieuwerkerke the private collector.

To the comte de Nieuwerkerke, Paris, June 27, 1866 66-15

Paris, Wednesday June 27, 1866

Monsieur le Surintendant des Beaux-Arts:[1]

I can see that you are not acquainted with the comte de Nieuwerkerke's affairs.[2] The comte de Nieuwerkerke presented himself at my atelier ten months ago. It was the first time (I have been painting for twenty-seven years) that my atelier had seen that high official, who is charged especially with the patronage of the fine arts.

The comte de Nieuwerkerke chose two paintings: a landscape, which was sent to him a few days later [F. 462], and the *Woman with a Parrot* [F. 526], which was still in the sketching stage. Referring to the latter canvas, the comte said, "If that canvas does not belong to anyone, it belongs to me, it is mine. Finish it exactly as it is, without adding anything."

I left it to the comte de Nieuwerkerke himself to set the price for his purchases. He had two thousand francs delivered to me for the landscape. As for the *Woman with a Parrot*, "Do you think M. Courbet will be satisfied with ten thousand francs?" he asked the person who brought him the landscape. The answer was yes.

I acknowledged that oral agreement. As December 2 brought no modifications to our civil law with regard to obligations, I considered the question and the reply as constituting a genuine contract. Every notary in the empire

would have abided by it, as they could not have made it more binding by so much as a letter. There was offer and acceptance, which made it legal. As everyone knows, it was governed by that contract that I worked for the ten months it took me to finish my painting. The entire press trumpeted in every key the unusual, doubtless singular news that the comte de Nieuwerkerke had bought a canvas from me for ten thousand francs. If I had had any doubts about the existence of a contract between us, the comte de Nieuwerkerke's silence would have sufficed to dispel them: silence implies consent.

Today you inform me that the comte de Nieuwerkerke did not commission the *Woman with a Parrot* from me, that he did not buy it, and that he did not himself set the price at ten thousand francs; that he merely "urged me to do the painting so that he might buy it from me at the Exhibition." Fine! But you must admit that the fact of a superintendent of the Fine Arts Administration descending on my atelier merely to "urge" me to finish one of my paintings is rather original, it is exactly as if he were to advise the emperor of Austria to defend himself against the encroachment of the king of Prussia.

But let us leave aside the comte de Nieuwerkerke. I have already had a dispute with him on the subject of the *Battle of the Stags* [F. 279], which I thought I had more or less sold him one day at the Fontainebleau station and which nonetheless is still at my atelier. If you please, Monsieur le Surintendant, let's keep it between the two of us.

You offer me fifteen thousand francs for a landscape (the *Covert of the Roedeer* [F. 552]) that you know has definitely been sold. You offer me a mere six thousand francs for a figure painting that I refused to sell for fifteen thousand francs at a propitious moment. I find this belated and paltry offer unseemly in regard to me and unfair in regard to a work that has been judged, and in fact is, superior to the landscape.

I refuse it, I am in no hurry to get into the Luxembourg.

Monsieur le Surintendant, I am,

Most respectfully yours,

Gustave Courbet

1. The letter bears the following notation from the comte de Nieuwerkerke: "Ask M. Frondt [*sic*] to come and talk to me at the Senate tomorrow at 2:30 P.M." No doubt he was referring to Victor Frond.*

2. This letter was written in answer to Nieuwerkerke's letter of June 19, 1866, in which the comte denied he had ever quoted a price to Courbet. As in his previous letter to Nieuwerkerke, Courbet refers to the comte in the third person, thus making a distinction between the official function of Nieuwerkerke, as superintendent of the Fine Arts Administration, and his private existence as comte de Nieuwerkerke. For the text of Nieuwerkerke's letter, see Mazauric (1968, 28).

3. Victor Frond (cf. letter 66-14, n. 2).

To the marquis de Chennevières, Paris, June 29, 1866 66-16

<div align="right">Paris, June 29, 1866</div>

Monsieur le Marquis de Chennevières:

When I presented myself at the Palais de l'industrie to finish the painting of the *Woman with a Parrot* [F. 526], I gave you a letter from the comte de Nieuwerkerke,* the text of which, as best I can recall, was as follows:

"I authorize M. Courbet to finish, in the Palais de l'industrie, in a room to be designated to him, the painting of the *Woman with a Parrot,* 'which belongs to me'."

I don't know whether that is the exact order of the words in the text but I am absolutely sure of the line "the painting of the *Woman with a Parrot,* 'which belongs to me.'" "Which belongs to me" is in the text.

Because I need this letter, I went yesterday to the Palais de l'industrie to ask for it. I did not have the honor to see you there, Monsieur le Marquis, but M. Buon,[1] to whom I explained the purpose of my visit, told me that the letter of authorization could indeed be found at the relevant date in your archives and that nothing prevented me from taking note of its contents.

Consequently, I respectfully request, Monsieur le Marquis, that you be so kind as to return this letter to me, or at least, if you need it for the proper maintenance of your archives, to have a certified true copy of it delivered to me.

With respectful greetings,
Sincerely yours,

<div align="right">*Gustave Courbet*</div>

1. Frédéric Buon (d. 1880) was the assistant to Philippe de Chennevières. His official title was Inspector of the Fine Arts Administration (cf. Chennevières 1979, 83). In Chennevières's absence it was Buon who opened Courbet's letter, which he forwarded to Chennevières together with a short note, in which he wrote, "M. Courbet puts too many words into my mouth. I told him that I did not have the letter he was talking about and that, if the letter had been written, you might have it. From the way he insists on getting it, it seems to me that he has been encouraged by someone to retrieve that document to use it as a weapon if the occasion presents itself" (unpublished letter in Paris, Bibliothèque d'art et d'archéologie, Fondation Jacques Doucet, carton X, *peintres*).

To the marquis de Chennevières, Paris, July 10, 1866 66-17

<div align="right">Paris, July 10, 1866</div>

Monsieur le Marquis:[1]

On June 29 I wrote you a letter that remains unanswered. The letter relates to an administrative matter, and, consequently, your absence from Paris is not sufficient to explain the silence it has met with.

I am compelled to renew my request. When I presented myself at the Palais de l'industrie about two weeks before the opening of the Exhibition, in order to finish my painting of the *Woman with a Parrot* [F. 526], I was asked whether I had an authorization from the comte de Nieuwerkerke,* and I submitted a letter in which that high-ranking personage accorded me the right to go work, in a room to be designated to me, on the painting of the *Woman with a Parrot*, a painting "that belongs to me," he added in his own words. "That belongs to me" is in there.

I wanted to keep the letter but I was asked to give it up and later I learned from M. Buon[2] that it had been entered into the archives. I know too well the respect that archives inspire in France to think for one moment that yours are no longer intact today. Nothing therefore could be simpler than to give me a copy of the letter. That is how it is done by notaries, attorneys, and even in the offices of court clerks. At least, that is how it is done in Ornans, and neither maître Muselier nor maître Henriot[3] would think of refusing me the duplicate of a document that involved me personally.

Thus, I am respectfully requesting a copy of that letter from you a second time, Monsieur le Marquis. I must warn you that if I have not received it within three days, I will consider your silence or that of your administration (for it is impossible that no one would replace you during your absence, when the administration is deprived of your services) as an acknowledgment of the terms that I have cited above and I will use that acknowledgment as I see fit.

Respectfully,

Gustave Courbet

32 rue Hautefeuille

1. The letter bears the following annotation, probably from the hand of Buon: "The document requested was mailed on July 11, 1866."
2. See letter 66-16, n. 1
3. Two notaries in Ornans.

66-18 *To the comte de Nieuwerkerke, Paris, July 27, 1866*

Paris, July 27, 1866

[No salutation]

At last, Monsieur, you emerge from the administrative cloud that serves you as a mantle. It is no longer the "Senator and Superintendent of the Fine Arts Administration" who has a reply sent to me, in the common hand of an office copyist, it is Monsieur de Nieuwerkerke in person who takes up the pen to contradict me and deny the truth of my statements.[1] Excellent! I prefer that. An administration has no flesh, no blood, no soul. Its stereotyped formulas are even more irritating than its calligraphed handwriting. By writing me yourself, you were able to be indignant, violent, aggressive! Right away

you see the advantage of being a human being! Merely by speaking freely to you, I have allowed you to be outspoken. And so both of us set a good example, you to the superintendents of the future, I to the artists of the present. Those poor artists must not always maintain, when they deal with the powers that be, the attitude of the Siamese ambassadors in the painting by my colleague Gérôme.[2]

But let's get back to business.

I have tarried a little in answering you. There are several reasons for that. First of all, I have been in the country. After all, from time to time one must ask nature for a few of those motifs that you buy with such grace and pay for so generously.

Then I had to retrieve an important letter that the marquis de Chennevières* kept in his archives. That was difficult and time consuming. I had to ask for it twice and cite the example of maîtres Muselier and Henriot, notaries in Ornans, who have never dreamed of refusing to pass on to me a document that involved me personally. It seems that that argument settled the matter, for the very next day they sent me the document.

Finally, I had to empty all my drawers one by one, to put together, classify, and read through our correspondence, in a word, do a hellish job, or a clerk's job, which is, I am told, the same thing. I did not find everything I was looking for. But do not fear, there is enough left here in my hands to enable me—if I wanted—to have a superintendent sentenced, not in Vienna, for Austria annoys you, but in Berlin, where they have judges. But do not worry, all my life I have wanted no other judge than the public. And this time again, it will be the public to whose attention I will call our dispute.

So let's talk.

Your position is as follows: "I did not buy the *Woman with a Parrot* [F. 526], I only urged M. Courbet to finish the painting along the lines I saw it had been begun, so that I might buy it after the Exhibition." That is your statement, isn't it? That is the story by which you stand and which you maintain on your dual word as individual and official? Having advanced it a first time in your letter of June 19, signed "Senator and Superintendent of the Fine Arts Administration," you confirmed it in your letter of July 3, signed "Comte de Nieuwerkerke." And you add, "I allow no one to cast doubts on my honesty." And what about my honesty? I don't want to go into that, but what would you say if, to send your story up in smoke, I had only to compare it with your own testimony, if I destroyed your present allegations with your past statements?

You cite against me the memory of an intermediary for whom you can do anything and I nothing. But it is written records, *your own written records*, that I will submit to you. Let's take them one by one.

Two days after your visit to my atelier I sent you the landscape that you

had bought from me. That consignment was accompanied by a letter that began as follows: "Monsieur le Comte, I am working at present on *your large painting*. I have a model who is posing for me and I don't plan on leaving my atelier, etc. . . . " Now, if at the time you had not already bought the *Woman with a Parrot*, would not those words, "your large painting," have attracted your attention? Would you not have remarked on it? Would you not have said to the person who brought you the painting, "Monsieur Courbet has mistaken the meaning of my words? I have not yet bought the *Woman with a Parrot* from him. I will buy it only at the Salon, if I am satisfied with it." If you did not show any emotion, if you said nothing to the messenger, wrote me nothing, it is because you really had bought it, because you knew you were the buyer.

Let's continue:

In the course of March, when I had almost finished the *Woman with a Parrot*, I invited you to stop in at my atelier to see it. I had had to change models several times and, mentioning that I would undoubtedly need an extension to finish it, I said, "If you could sacrifice an hour of your time, I would be very glad of it, for I don't know if the painting that you commissioned from me is to your liking." Now I ask you, if you had not already bought the *Woman with a Parrot*, would you not have realized it at this time? I spoke to you about "your painting," commissioned "by you," which had to be accepted "by you." I urged you to come see it in my atelier and offer me your comments. Then or never was the time to protest against utterances that were tending to make you its owner against your will, just as Sganarelle of merry memory was made a doctor against his will.[3]

Did you do it? No.

Yet nothing would have been easier for you, for you did answer me. But in your reply, dated March 20, you confine yourself to telling me that it is impossible for you to come to my atelier and that I have to manage, for I won't be allowed any extension. Nothing more. Do you believe that your silence in regard to the purchase does not imply once more that you had bought it and that you acknowledged that you really were the buyer?

All that is a matter of induction, reasoning, logical conclusions. Here is more direct proof.

On April 2, that is, two days after I sent the *Woman with a Parrot* to the Palais de l'industrie, as I realized how important it was for me to render this piece beyond reproach, I addressed a formal request to you to have the painting back in my atelier again, even if only for a few hours. "Since the painting belongs to you," I wrote you, "and since the rules don't pertain to you, will you not send it to me for a single day so that I can finish a few feathers on the parrot, the tapestry in the background, the ends of the hair, etc." What did

you answer to that request? Ah! Now I have you, now the truth comes out, not like a confession that a guilty person lets slip, but as the quite simple and quite spontaneous statement of a true fact that nobody would dream of challenging and that would brook no challenge. I believe I remember your sending me, so that I might read it again, a copy of the letter that I wrote you on June 27. One courtesy deserves the other: I transcribe here, and offer you to meditate on, the letter you addressed to me at that time. It is dated April 7 and signed with your last name, first names, and titles. I hope you won't make any difficulty about acknowledging it. Besides, I have the original in my hands, it is the one that was kept by the marquis de Chennevières. I had trouble getting it back and I won't let it go again.

<div style="text-align:center">The Emperor's House Ministry of Fine Arts</div>

<div style="text-align:center">Louvre Palace, April 7, '66</div>

Monsieur:

The painting in question, though it belongs to the administration, may not be removed from the Exhibition to be returned later on. A permission of that nature would be an exception that the rule cannot allow.

If you wish to retouch it, I will be happy to have it placed in a private room in the Palais de l'industrie. This is a favor that I have granted others and that consequently I can grant you as well.

<div style="text-align:right">Respectfully,
Senator and Superintendent of the Fine Arts Administration
Comte de Nieuwerkerke</div>

To Monsieur Courbet

So what do you say to that? "The painting in question, though it belongs to the administration. . . ." Is that clear? And do we still have to rely on the neighbors' memory? Do you think there is any testimony in the world that could prevail over such a statement, covered by your signature? Are you not aware that, when you appeal to a third party to challenge the purchase of the *Woman with a Parrot*, that third party is testifying not only against me but chiefly against you?

Come, now! I ask you, what remains of the brusqueness and bullying of your letter? Have I alleged facts that are untrue? Have I distorted the truth? Was I not completely in command of my faculties when I took up my pen? For, don't forget, those are the expressions that you did not hesitate to use about me, without thinking that I am evincing character, and to a certain point even courage, when I speak to you with firmness, I who am only a painter, to you who are the superintendent of the Fine Arts Administration, but that the same cannot be true when you use offensive remarks in my re-

gard. Once more, what do you think? Don't you find that I have the moderation of an angel in appearing so calm when I have such a stack of grievances and such irrefutable evidence in my hands?

Ah! You claim that you don't have time to read the newspapers and that it would be wrong to infer consent from the silence you kept when the entire press—and not only the little papers as you say—announced that you had just bought the *Woman with a Parrot*. I know very well that, even if you don't read them, you have people who read them for you. And three kilometers of offices in the Louvre are a sufficient guarantee to us that everything that is published about the Fine Arts Administration in France reaches you, just as long ago the conversations of Syracuse used to reach the ears of Dionysius the Tyrant.[4] But let us assume that you did not. At least you read the letters that you sign and it is not rash to infer the reality of a sale from the presence of your signature at the bottom of a letter that states that my painting of the *Woman with a Parrot* belongs to the administration?

So let us conclude:

On April 7, 1866, that is, three weeks before the opening of the Salon and two and a half months before anyone had even begun to think of the state acquisitions, my painting "belonged to the administration." It is you who state that, in a letter signed, "Senator, Superintendent of the Fine Arts Administration, Comte de Nieuwerkerke."

On June 19, 1866, my painting "no longer belongs to the administration." Again, that is your statement, in a letter signed the same way, "Senator, Superintendent of the Fine Arts Administration, Comte de Nieuwerkerke."

What! On April 7 the *Woman with a Parrot* belonged to the administration and on June 19 it no longer belonged to it! How did this miracle come about? If, however, on April 7, I had forgone the Salon and shipped my painting directly to you—for, don't forget, it is to you that I sold it, to you personally and not to the administration, as I stated to you during your visit to my atelier—if, I say, on April 7, I had sent you my painting you would have received it, you were obliged to receive it. I don't know to whom it would have belonged, to you or the administration, but assuredly it belonged to one of the two. On June 19, however, I was obliged to take it myself from the Palais de l'industrie, as if you had never come to my atelier, as if I had never seen you, as if you had never said anything to me, never written anything. "The painting does not belong to the administration." That is really extraordinary, and if it is a manifestation of the goodwill you claim to entertain toward me, I would be obliged if you would bestow it on others. The public, however, is less conciliatory and more curious. It wonders how that sale could have been in effect for ten months and then suddenly not be in effect any more.

It has been whispered in my ear that between the date of April 7 and that

of June 19, two phenomena occurred that might very well be related to this event. The first is that my pictures were successful in the press and with the public and that certain journalists used my painting—the painting that the government must in no way encourage, as you say—to attack the painting that the government does encourage. The second is that, at the time of the voting for the great medal of honor, because my name was excluded right from the first day, certain other journalists used that incident as a pretext to give their views of that ridiculously abortive voting process. I don't know what to believe about these things. But you, Monsieur, whose position is so high that you can do what no one else in France can do: renege on obligations, rescind contracts, render what was true on April 7 no longer true on June 19; you, announcing those metamorphoses of the law to me with such adminis-trative severity; do you perhaps owe me the key to that mystery?

You will have noticed that I have not said a word about the price. That is a secondary detail. All artists, and myself in particular, loathe these discus-sions of numbers. You deny having set a price. I solemnly declare that I was told that you had set one: 10,000 francs for the *Woman with a Parrot* and 2,000 francs for the landscape.[5] That is what was reported to me, and I believed it all the more readily as, not having been present when the price was set for either one, you had 2,000 francs remitted to me for the landscape, which gives a singular authority to the figure of 10,000 francs for the *Woman*. But that is not the problem. I would perhaps have let you have my painting for 6,000 francs had you not had the tortious idea to deny its purchase. By the same token, you on your part would not have shocked anyone by paying 10,000 for it. It would not have been the first time that the administration had agreed with the artist about the price of a work. In any case, we would have come to an understanding, and, in the worst case, since the sale was already in effect and it would have been a matter only of determining the price, arbitrators would have brought us to an agreement.

We must be done with this. You oblige me to do a lawyer's work, for which I am not trained, and you don't want me to do that of a painter, which is mine. That is not encouraging. But the demonstration that I have just done concerning the *Woman with a Parrot* dispenses me from doing another one for the *Battle of the Stags* [F. 279]. So let us end with a general truth derived from our respective positions.

You must admit one thing, that you did not come to me out of personal goodwill or to be of service to me in a critical situation. Those who told you that I needed to sell one of my paintings to survive took advantage of your sensitivity and you could easily have convinced yourself of that when you came to my atelier. Until now, thank God, I have been able to place my art above the necessities of daily life. No obstacle has made me deviate from the path that I have traced for myself. After twenty-five years of struggle, I am still

fighting; and today I am still doing exactly the same kind of painting that in the beginning unleashed the entire official world against me. I have fought against you, I will fight without you. But if it was not from a desire to help me, then what was your purpose in coming to me? I suspect that you would not have minded granting me your patronage, and, accustomed as you are to success, you would have considered that conquest as your finest triumph. But there are times when the oldest and best-established maxims tremble on their foundations: "Never was a superintendent found to be cruel" said Boileau.[6] To be sure, he had not counted on either you or me when he wrote that alexandrine. And it is marvelous to be able, after two hundred years, to belie the man who was flatterer to the Great King.

So now you know, from personal experience, that I am not one of those who accept patronage, and you are only doing me justice by declaring that "the nature of my compositions is not the kind the government should encourage." That is exactly the position I aspire to. My paintings are for whoever wants to buy them. Once they are made, they go where they may, I don't worry about them anymore. But my art is mine and I won't give that up. Place me all alone on a scale, "the man the government must not encourage." You stand on another scale, you and all the art that the government encourages. The future will say to which side the scales will have tipped.

With respectful greetings,
Sincerely yours,

Gustave Courbet

1. The comte de Nieuwerkerke had written to Courbet on July 3, 1866. For the text of this letter, see Mazauric (1968, 30–31).

2. The *Reception of the Siamese Ambassadors by Napoléon III and the Empress Eugénie at Fontainebleau, June 27, 1861* by Jean-Louis Gérôme (1824–1904), now in the Musée national du château at Versailles, was first exhibited at the Salon of 1865. The painting shows the ambassadors kneeling slavishly in front of the emperor and the empress.

3. A reference to Molière's comedy *Le Médecin malgré lui* (first performed in 1666), in which Sganarelle is forced into acting as a physician.

4. Dionysius the Tyrant ruled Syracuse in the first half of the fourth century B.C.

5. The *Puits noir* (F. 462).

6. Nicolas Boileau (1657–1711), poet, critic, and, after 1677, royal historiographer of Louis XIV.

66-19 *To his family [Paris, August 6, 1866 (Rd)] (fragment)*

. . . I am on the ministry's list for the cross of honor. The fifteenth of August[1] will be amusing. If they don't give it, they will be savaged by the newspapers; if they give it, I'll be justified in refusing it, throwing everything onto M. de Nieuwerkerke.*[2] In any case, I wanted to refuse it as I have already done in Besançon.[3] But this time I would have to refuse it publicly,

so that three quarters and a half of France would be on my back. So that, at the moment, whichever way things go, I am easy in my mind and sheltered by the rascality of those people. . . .

[. . . there is] nothing as tiresome as earning money. . . .

[He must go to Trouville, to the abbey of Jumièges, to M. Lepel-Cointet;* return to Paris to finish the painting for Khalil Bey; *4 leave again for Vendôme to paint the hunting dogs of a collector;5 pick up his Frankfurt paintings on their return from Holland, where they have won a gold medal;6 send his *Woman with a Parrot* (F. 526) to the Brussels Exhibition, which has been delayed for five days so that it could be shown there.7]

1. The day of the award ceremonies.

2. Courbet did not have the pleasure of refusing the cross of honor until 1869. In 1866, no cross or medal was awarded him.

3. Nothing is known about Courbet's refusal of an award in Besançon.

4. The *Sleeping Women* (F. 532), which had been commissioned from Courbet by Khalil Bey.

5. Perhaps the *Greyhounds of the comte de Choiseul* (F. 545).

6. Courbet had won a gold medal for the *Seeress* (F. 438) at the Tentoonstelling van Levende Meesters (Exhibition of living artists) in The Hague in 1866.

7. The *Woman with a Parrot* was shown at the 1866 Exposition des beaux-arts in Brussels, together with the *Portrait of Jo* (F. 537?).

To the comte de Nieuwerkerke, Paris, August 10, 1866 66-20

Paris, August 10, 1866

Monsieur:

I am sorry that you have not acknowledged receiving my letter of July 27. It was difficult, I worked on it for a long time, and, I confess, I was proud of it. To write twenty pages like that in one breath, you can imagine how hard that is for a man who is not a professional [writer] and who would rather dash off ten roedeer than organize a sentence. That is why I would have hoped that you had liked my small opus as much as I did and I was almost counting on compliments from you. You know the common weakness: we prefer to be praised for the arts we are less familiar with, and Leonardo da Vinci was more sensitive to the praises bestowed on his music than to those earned by his painting. But you say nothing: I have no luck with you.

Why don't you give me a sign of life? Could it be that you are unable to refute it? Refute! I am well aware that there is nothing you'd rather do, but how?

You stated that you did not buy the *Woman with a Parrot* [F. 526]. I proved as clearly as $A \times B$ and by adducing your correspondence that you did buy it. The letter of April 7 must have been an especially bitter pill for you: "The painting in question, though it belongs to the administration . . . ,"

there is nothing you can say to that, and that is probably why you say nothing.

But there was one point in our dispute on which I did not think I would have to insist: the price. My friends have shown me that my argument leaves something to be desired on that score. So I must return to it at the risk of increasing your vexation.

What do you say we resume:

You say in your letter of June 19: "No price was ever agreed on." You add in your letter of July 2, after having adduced your version (that famous version according to which you would have simply urged me to finish the *Woman with a Parrot* so that you could buy it after the Exhibition), you add, "After receiving your unspeakable letter, I saw M. Frond.* I conveyed to him the indignation it caused me. I appealed to his memory. He remembers the facts exactly: namely that no price was ever stated with regard to the painting representing the *Woman with a Parrot*." That is it, isn't it, just as you denied the fact of the sale, you deny that a price was set. And you retreat behind the recollections of M. Frond, who served as our intermediary and whose memory, you say, is more accurate than mine.

Alright, fine. I accept M. Frond's testimony. But you will grant me that a testimony in his hand is worth even more than his memory, however accurate it may be. I have proved to you with a letter signed by you—the letter of April 7—that there is no question at all with regard to the purchase. I will show you now with a letter from M. Frond, written in his hand on August 15, 1865—that is, one or two days after your visit, consequently, at a moment when his "accurate memory" was at its freshest—that, neither is there any question about the setting of the price. In effect, M. Frond wrote on August 15, 1865 (the fifteenh of August: may that date cast a preventive balm on the injury you are about to receive¹), to one of my friends in the country, who sends me his letter:

Paris, August 15, 1865

My dear Georges:²

M. de Nieuwerkerke finally came to visit Gustave's atelier (it is I, in all modesty, who is designated by that informal first name). He bought a painting that Courbet is currently working on and a landscape. It is a "small" commission for twelve thousand francs. Your friend (it is still I) is delighted and I am happy to have contributed to bringing about this result.

I am not going to Cahors. If you can move up your arrival in Paris, do come. You'll find me always ready to receive you.

Sincerely yours,

Signed: Victor Frond

Did you read that? . . . twelve thousand for two paintings. I wanted to know how much the *Woman with a Parrot* represented of that sum. I had little Paul, the concierge's son, come upstairs. He is six years old and goes to

the neighborhood school. I had the following conversation with him:

"Paul, M. de Nieuwerkerke bought two paintings from me, a landscape and the *Woman with a Parrot*, for 12,000 francs. He has had 2,000 francs remitted to me for the landscape. How much does he still owe me for the *Woman with a Parrot?*"

"Gee, that's a piece of cake," said Paul. "You've got 12, take away 2, leaves 10. M. de Nieuwerkerke still owes you 10,000."

You see, Monsieur, that is what the little children in my neighborhood say, and their ingenuousness hardly changes the simple truth. Enough. Every point has been clarified. Thanks to you the *Woman with a Parrot* will have its legend, and a merry legend at that, one that some truth-loving writer (they say that some remain) will not hesitate to put on paper in order to contribute to the history of the Fine Arts Administration under the superintendence of the comte de Nieuwerkerke.

In the meantime, for the sake of artists who would rather see than read, I plan to hang, in my atelier, a photographic picture that will consist of three parts, arranged in a triangle. The first will be the letter in which M. de Nieuwerkerke denies purchasing the *Woman with a Parrot*. The other two will be the two letters—M. Frond's, on the one hand, and the Superintendent of the Fine Arts Administration's, on the other—refuting that assertion.

I will have the honor, Monsieur le Comte, of sending you the first proof to come out of the photographer's hands. That will crown the whole affair.

With respectful regards, I am,

Your servant

Gustave Courbet

1. August 15 was to be the day for the distribution of the Salon awards.
2. The identity of "Georges," the recipient of Frond's letter, is not known.

To the editor of the Monde illustré *(Charles Yriarte), Paris, August 14, 1866* 66-21

Paris, August 14, 1866

Monsieur:

Someone brought me the latest issue of the *Monde illustré*,[1] and in it I read, below your signature, a score of enigmatic lines that seem to refer to a debate taking place between the comte de Nieuwerkerke* and myself.

There are two possibilities: either you were unaware of the nature of the quarrel and [in that case] it was your duty to remain silent about it; or, which is more likely, you had seen the documentation, in which case it was your duty to speak as an impartial judge. In any case, the vagueness and the insinuating tone of your account is neither in keeping with my sense of my own

dignity nor capable of satisfying the legitimate demands of public curiousity.

The comte de Nieuwerkerke bought from me, a year ago, the painting of the *Woman with a Parrot* [F. 526] for ten thousand francs. Today the comte de Nieuwerkerke denies having made that purchase. But since I have in my hands the proof of the sale, announced by the administration and sanctioned by the signature of the comte de Nieuwerkerke himself, his present disclaimer is worthless, as it has no clearly stated reason.

On that occasion, Monsieur, a correspondence was initiated between the comte de Nieuwerkerke and myself, and it is to that correspondence that you allude when you insinuate that I lack "good breeding." Unquestionably, Monsieur, if frequenting salons and anterooms, lobbying in offices, toadying to high officials, and begging for favors from the powers that be, are, in your eyes, signs of good breeding, you are right to taunt me with having been ill or poorly bred, and I greatly fear that I shall deserve your taunts until the end of my life.

But however independent one's character and opinions, one is nonetheless aware of the social (and not *sociable*, as you say in some language unknown to me) conventions.

Do you wish to be convinced? I will show you an easy way. The correspondence that I have had with M. de Nieuwerkerke consists of three letters that I wrote and one that I received. Print all four. They are long, it is true, but they are instructive, I assure you, and entirely likely to entertain the reader. Once you have published those, you will be forced to admit that my three letters show a courtesy that I do not hesitate to call praiseworthy, in view of the situation and my humble origins; while, with regard to M. de Nieuwerkerke's, one has to remember the title and qualifications of its author to find it entirely irreproachable in that respect.

When you read that edifying correspondence, you will moreover be convinced, Monsieur, that between the comte de Nieuwerkerke and myself there has never been any talk of the cross of honor, but merely of the purchase of the *Woman with a Parrot*, which he denies and I maintain.

With regard to the cross of honor, which my art had won for me, and from which, according to you, my poor breeding disqualifies me, I don't have to explain to you here what I think of it, but, without making a virtue of the independence that is the law of my life and the true source of the talent attributed to me, allow me to remind you how easy it would have been for me not to "ruffle the administration's feathers" on the very eve of the bounty of August 15, to which so many people attach so much importance. I in no way mean to criticize ways of seeing that I don't share; and, believe me, whatever aversion I may have always shown for that sort of award, I would never have dreamed, as you have, Monsieur (on the very day that they were distributed), to describe them as mere prizes for politeness.

I rely, Monsieur, on your sense of fairness to publish this letter.[2] It will dispense me from any other efforts.

Most sincerely yours,

Gustave Courbet

32 rue Hautefeuille

1. In the *Monde illustré* of August 11, 1866 (pp. 82–83), an article had appeared by Charles Yriarte, which read in part: "If we wished to engage in some dangerous gossip, we could relate what has happened between Courbet and the superintendent of the Fine Arts Administration. . . . M. Courbet is supposed to have ruffled the administration's feathers, which will probably cost him his cross on August 15. People will tell me that, if M. Courbet has talent, a social matter (or perhaps we should say 'sociable,' which would be closer to the truth), should not prevent him from getting his reward. . . . But I cannot help repeating what I say each time something like this happens, namely that 'good breeding definitely has its value. . . . '"

2. Courbet's letter does not seem to have appeared in the *Monde illustré*.

To Jules Castagnary [Paris, late summer (?) 1866] 66-22

Friday night

[No salutation]

Dr. Brambeau insists on taking us to his friend Menard in Nogent-sur-Marne. There is a floating platform for bathers and a good dinner in the bargain. To do this, you must be at my house tomorrow, Saturday, at 4:30.

This note is brought to you by the sensitive Caroline, who wishes to look after you if you are sick, as I was told yesterday in the Rat Mort. Schanne* was waiting for us yesterday at the Maison d'Or. When I learned that you were not coming, I made the most of it by going to bed. No news at all from M. de Nieuwerkerke.*[1]

I received my paintings from the exhibition in The Hague.[2] They didn't buy anything.

Sincerely yours,

Gustave Courbet

[Address] Castagnary
 19, rue Capron
 Batignolles

1. About the acquisition of the *Woman with a Parrot* (F. 526).

2. In 1866, Courbet had exhibited the *Seeress* (F. 438) and *Two Dogs Fighting about a Hare* (F. 620?) at the Tentoonstelling van Levende Meesters (Exhibition of living artists) in The Hague (cf. Paris 1977, 139). Though the *Seeress* received a gold medal, it was not sold, nor was the other painting.

66-23 *To his family [Paris], September 2 [1866]*

Sunday, September 2

Dear family:

I am writing you a few lines so you won't believe an absurd and vicious rumor to the effect that I have had a stroke.[1] It is an act of revenge on the part of the official press for the disagreement I am having with the comte de Nieuwerkerke.* I am suing the latter to the last penny, for he must pay for all he has done to me. I have written letters to the papers and I will even be publishing a pamphlet against him.[2] He has reneged on the purchase of the *Woman with the Parrot* [F. 526], which he bought from me for ten thousand francs. I'll send you the papers that talk about it tomorrow.

I am so busy finishing the paintings commissioned from me[3] that I am not really in the mood to write a letter. I cannot very well return to Ornans until the end of the month. An official statement was issued to me in the papers, it is how the government proves it is right. But I will not let go, I must be proved right. I am extremely well and will respond to the newspapers that announce my illness.[4] I embrace you all.

G. Courbet

1. It has been impossible to ascertain in which paper this rumor appeared. On this matter, see Bonniot (1973, 134).
2. As far as can be ascertained, this brochure was never published.
3. The commissions probably included the *Sleeping Women* (F. 532), commissioned by Khalil Bey.*
4. Courbet's letter, refuting his illness, has not been found.

66-24 *To his sister Juliette, Deauville, September 27 [1866]*[1]

Deauville, September 27

Dear Juliette:

I have not stopped painting since August of last year, particularly in Trouville, where I did some forty pictures.[2] I have worked on my paintings for the Exhibition and on commissions that came my way. I have worked throughout the time of the Exhibition and throughout the summer, and I have wound up exhausted. I wanted to finish those paintings, it was a matter of thirty thousand [francs]. I did them after the Exhibition.

After the very difficult battle I had with M. de Nieuwerkerke* (whom I have silenced), I came to Deauville, where M. de Choiseul* had been inviting me for some time.[3] I yielded to his request because I absolutely needed it. My brain churned so that I could no longer see straight.

Here, I am in an earthly paradise, alone with this young man who is really charming. He has the truly great, distinguished manners of France's best-bred ages.

I need it because I must battle Nieuwerkerke, who is a scoundrel like everyone else in his circle. He has let me know that, as long as he is where he is, I will not make a single sale [to the government] and that he will do whatever he can against me. M. de Choiseul, who knows Princess Mathilde,[4] tells me that they are terribly afraid of me at the palace and that he would give anything in the world to win me over to them. I have escaped them once more this year.[5] I want no part, large or small, of that gang, despite the enormous fortune that it could bring me. Besides, they have only one or two years left.

Life here is very simple in its routine but there is great luxury. There are six domestics to serve us. The men dress in white ties, black suits, and pumps, like prefects at an evening party. The table is set with solid silver plate and chased silverware, a basket of flowers in the middle of the table, the most splendid fruits in the four corners of the basket, and every wine imaginable. The drawing room, indeed, the whole house is hung with peau de soie worked in a reed pattern, and the color is pearl gray. The beds have canopies and are placed in the middle of a panel in the room. [There are] washstands in white marble, with two pairs of ewers of English porcelain, with an enormous capacity; basins for hydrotherapy; dressing mirrors and mirrors above the fireplaces; double portières, etc., etc. The anterooms have the same wall-coverings as the drawing room. The drawing room is decorated in every corner with enormous English ceramic pots with exotic plants the size of a man. It is divided in two by portières and two stucco columns of the same color. Between the two columns is a double fireplace, [and] on the mantel is an enormous vase of flowers reaching to the ceiling. [There is also] a grand piano and low divans everywhere. A maidservant burns incense throughout the house several times a day. Despite all that, M. de Choiseul's ways are exactly the same as mine.

This chalet-style house, which has a very tasteful exterior, is furnished outside, on all floors, with continuous rows of geraniums and other hanging plants, which form four bands around the house. It is charming. Around the house, all the way to the ocean, there are round flowerbeds, tastefully laid out.

Every morning I bathe in the sea. I get out of bed, they bring me a dressing gown and bathing trunks, and I walk into the sea, which is below my window.

We have a carriage that stands with the horses in harness all day. Tomorrow or the day after we'll go to the abbey at Jumièges, the finest ruins in France. He has rented a steamboat to take us to Yvetot and back in a day. I'll stay here for another week or ten days. I must go back to Paris. I expect to go to Ornans in a month.

I embrace you all.

G. Courbet

1. Letterhead: "Chalet Choiseul à Deauville, Calvados."

2. In 1865, Courbet had spent more than three months in Trouville, where he painted his first major series of seascapes as well as several portraits of society women.

3. The comte de Choiseul was one of Courbet's patrons during the latter half of the 1860s. In January 1866, he had bought some seascapes from Courbet (probably F. 598 and 599; see letter 66-2).

4. Princess Mathilde (1802–1904), the first cousin of Napoléon III, was well known in Paris as a patroness of arts and letters. Her liaison with the comte de Nieuwerkerke was a public secret.

5. By not getting a medal after the 1866 Salon.

66-25 *To Eugène Boudin [Deauville, September-October 1866]*

My dear Boudin:

At M. de Choiseul's* request, I am inviting you and your lady to dine tomorrow, Wednesday, at 6 P.M. I have already invited Monet[1] and his lady, who last night in the Casino promised to come. I don't doubt that you will give us the pleasure of accepting.

Sincerely yours,

Gustave Courbet

Pick up Monet on your way and do come, all four of you. I'll expect you without fail.

1. The Impressionist Claude Monet (1840–1926) appears to have been rather closely befriended with Courbet during the mid-1860s. Though only one letter from Courbet to Monet is currently known (see letter ND-4), a number of letters by Monet to Courbet are extant (Paris, Fondation Custodia and private collections). Most of them are requests for loans, to which Courbet seems to have responded generously.

66-26 *To Jules Luquet, Deauville, October 10 [1866]*[1]

Deauville, Oct. 10

My dear Luquet:

I will return to Paris in a few days—Monday, I think. As for the *Wounded Man* [F. 51], it mustn't be touched nor have the varnish removed. A light coat of varnish should be applied after a sponge is passed over it. For the frame, I don't want to spend anything on it, it is fine as it is. All you have to do is throw cold water over it to remove the dust, without rubbing or wiping, just let it dry.

I don't want to sell it at any price. If I had wanted to sell it, I could have sold it a long time ago for three or four thousand francs.

 The copy that is at my atelier was commissioned for the sum of two

thousand francs.² If the person were to withdraw the commission, we could send it to America later so that there will be a figure painting.³ Besides, the American newspapers have already talked about it at the instigation of the friends that I have there. While I am in Paris we must settle our accounts together for I will be leaving again for Ornans to do my paintings for the Exhibition.

Cordially yours,

Gustave Courbet

1. Letterhead: "Chalet Choiseul à Deauville, Calvados."
2. Probably F. 546. It is not known who commissioned the painting.
3. The painting, now in the Kunsthistorisches Museum in Vienna, does not appear to have traveled to America.

*To M. Weyer, Ornans [November 1866?]*¹ 66-27

My dear Weyer:

Since I had the pleasure of seeing you, I have not heard a word about the paintings and photographs that I left in Strasbourg. If you have sold everything, don't keep it from me, please, and if you have not sold anything, please send them back to me in Ornans, for I need them for my upcoming exhibition.

I would have liked to have returned to Strasbourg this summer, but I was not able to—another time.

You told me that you could send me a small quantity of beer. If that were possible, you would be doing us a great favor, for here we are literally being poisoned by the beverage. So tell the magnificent brewer at La Cloche to send us a half hogshead of his best if he wishes to give us a great pleasure. We'll send him back his barrel. And he (or you) should let us know how to treat it once it has arrived; whether one has to bottle it; in other words, how to tap it, for people who don't want to drink it all in one day.

As I may not be there to receive it, please send it to M. Urbain Cuénot* in Ornans, Dept. Doubs.

With that, please send my regards to all those gentlemen. As for you, my dear Weyer, I await your response. With a warm handshake and my compliments to your wife,

Gustave Courbet

Ornans

1. As nothing is known about Courbet's dealings with the Strasbourg dealer Weyer, it is difficult to date this letter. Since Courbet refers to his upcoming exhibition, it may have been written at a time when he first contemplated his private show of 1867. Urbain Cuénot, who is mentioned in this letter, died on January 11, 1867. This provides a definite date *ante quem*.

66-28 *To Gustave Chaudey [Paris], November 15 [1866]*

Thursday evening, 11/15

My dear Chaudey:

I learned from the lawyers at my bar that my case was called in an empty court last Friday at noon.[1] A law officer asked that it be postponed to the following Friday, that is, tomorrow morning. If I lose it will be your fault.

Last night M. Lepel-Cointet's* attorney brought me some real offers, again for a full settlement. I refused, as we had agreed, which he wrote on his carbon notebook. I took the sheet that he left me to M. Vivet,[2] who was not at home.

Yours,

G. Courbet

M. Lepel states that it is he who had me change the arm. You or M. Vivet could obtain from M. Lepel-Cointet in conversation that it was he who had me change the arm of one of the women, that will be important.

1. Courbet's lawyer-friend Gustave Chaudey represented him in a lawsuit filed against the stockbroker Lepel-Cointet. The latter had bought the *Covert of the Roedeer* (F. 552) at the Salon of 1866 and had also offered to buy *Venus and Psyche* (F. 370) for sixteen hundred francs provided Courbet make a few changes. When the painting was completed following his wishes, Lepel-Cointet withdrew his offer, whereupon Courbet brought an action before the Tribunal de la Seine (cf. Lindsay 1973, 219).

2. Vivet was Courbet's attorney in the mid-1860s. He seems to have replaced Benazé, who had earlier represented the artist.

67-1 *To Gustave Chaudey [January 9 (?), 1867]*[1]

Wednesday evening

My dear Chaudey:

To my great regret it is impossible for me to be at your meeting of tomorrow, January 10.[2] I have just received a letter from Ornans that obliges me to leave on Thursday at 11 o'clock in the morning. My very best friend is dying and wants to see me. He followed me everywhere in my life. The least I owe him is to go and see him in the hour of his death.

Sincerely yours, my dear Chaudey, I'll be [back] here in four or five days.

G. Courbet

1. The date of this letter is derived from its content, notably from the reference to a dying friend. The friend in question must have been Urbain Cuenot,* who died on January 11, 1867 (cf. Ornans 1981, 59). January 11 was a Friday. The letter was probably written two days earlier, on Wednesday evening, January 9.

2. The text of this letter is known only through a handwritten copy. The word *pluvier* (plover) in this copy is probably a misreading of *10 janvier*.

FIG. 1. Letter to Alfred Bruyas, Ornans, January 1854 (54–1); Bibliothèque d'art et d'archéologie, Fondation Jacques Doucet, Paris.

FIG. 2. Letter to Urbain Cuenot, Paris, April 6, 1866 (66–7); University of Maryland, College Park.

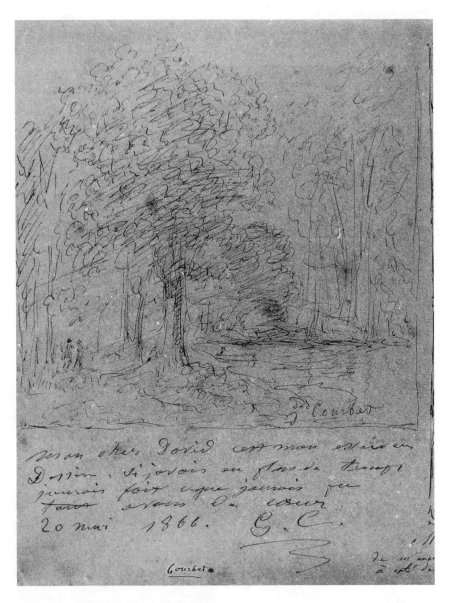

FIG. 3. Letter to Maxime David, Paris? May 20, 1866 (66–11); Bibliothèque municipale, Laon.

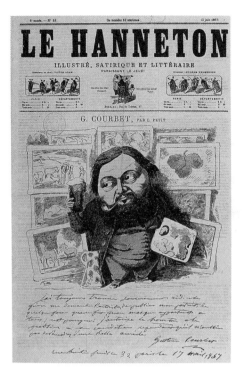

Fig. 4. *Le Hanneton*, June 13, 1867, with facsimile reproduction of Courbet's letter to the editor, Eugène Vermersch (67–8). Bibliothèque nationale, Paris.

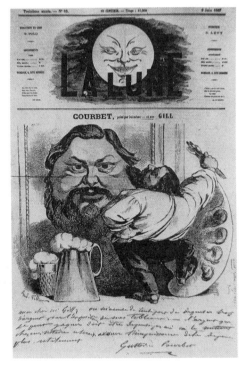

Fig. 5. *La Lune*, June 9, 1867, with facsimile reproduction of Courbet's letter to Gill (67–20). Bibliothèque nationale, Paris.

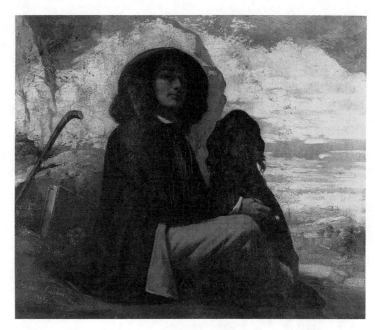

FIG. 6. *Self-Portrait* or *Courbet with Black Dog*, 1842 (Salon of 1844); Musée du petit palais, Paris.

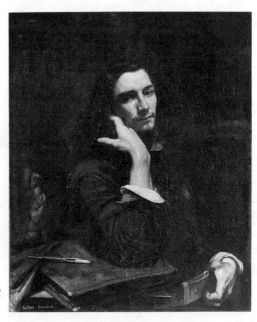

FIG. 7. *The Man with the Leather Belt*, 1842 (Salon 1846?); Musée d'Orsay, Paris.

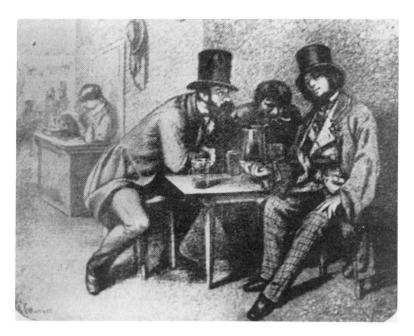

FIG. 8. *The Andler Keller*, drawing, ca. 1848; current whereabouts unknown. Courbet, seated on the right, is seen in the company of Marc Tradadoux (left) and Jean Wallon (center). In the background, Madame Andler is seated at the cash register.

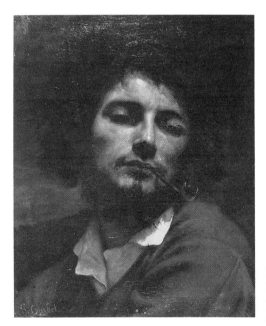

FIG. 9. *Self-Portrait* or *Man with a Pipe*, 1849? (Salon of 1850); Musée Fabre, Montpellier, France. Photo Mairie de Montpellier, Direction de la Communication.

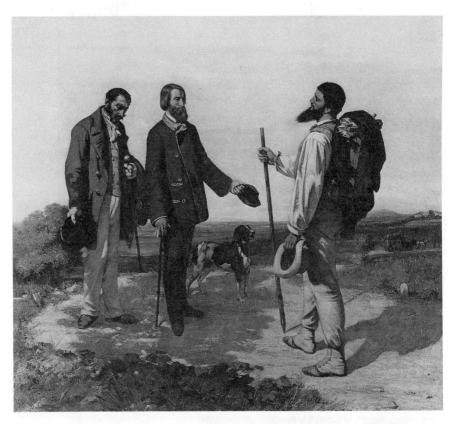

FIG. 10. *The Meeting* or *Bonjour, Monsieur Courbet*, 1854 (Universal Exhibition of 1855); Musée Fabre, Montpellier. Courbet is greeted by Alfred Bruyas and his male servant, Calas.

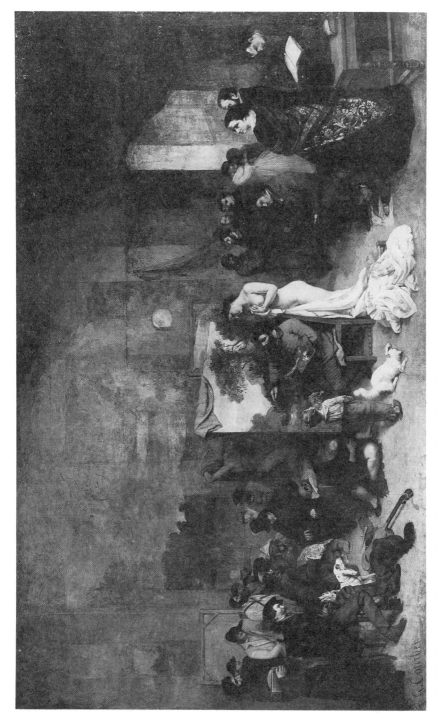

FIG. 11. *The Painter's Atelier: Real Allegory Determining a Phase of Seven Years of My Artistic Life*, 1855 (Private Exhibition of 1855); Musée d'Orsay, Paris. Courbet in the company of several of his friends and patrons, including Alphonse Promayet, Alfred Bruyas, Pierre-Joseph Proudhon, Max Buchon, Champfleury, and Charles Baudelaire.

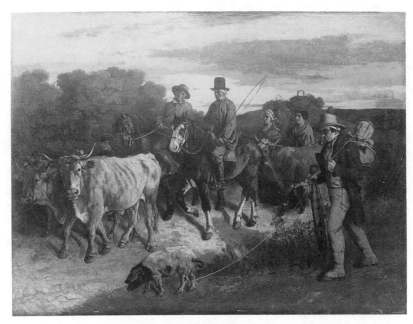

FIG. 12. *The Peasants of Flagey Returning from the Fair* (Salon of 1850–51); Musée des beaux-arts et d'archéologie, Besançon. The man wearing the tall hat and mounted on a horse is Courbet's father, Régis.

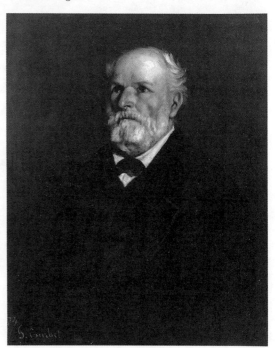

FIG. 13. *Portrait of Courbet's Father, Régis,* 1874; Musée du petit palais, Paris.

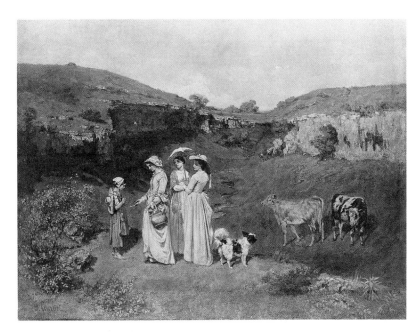

FIG. 14. *Young Ladies from the Village* (Salon of 1852); Metropolitan Museum of Art, New York. The three young ladies are, from left to right, Zélie, Juliette, and Zoé Courbet.

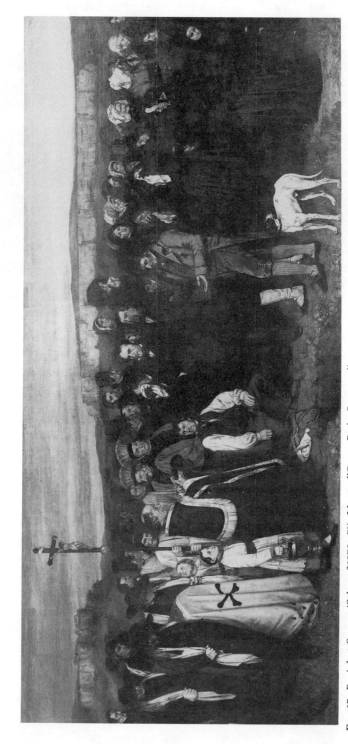

Fig. 15. *Burial at Ornans* (Salon of 1850–51); Musée d'Orsay, Paris. Surrounding the grave are friends and relatives of Courbet as well as several notables of the village of Ornans.

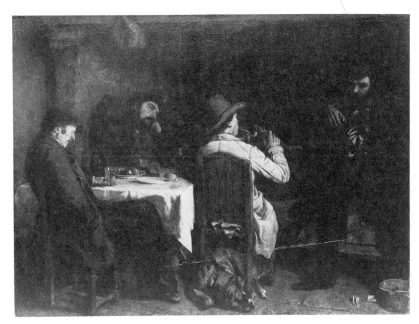

FIG. 16. *After Dinner in Ornans* or *Evening at Ornans* (Salon of 1849); Musée des beaux-arts, Lille. The four figures represented in this painting are, from left to right, Courbet's father, Urbain Cuenot, Adolphe Marlet, and Alphonse Promayet.

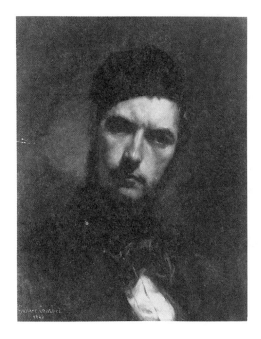

FIG. 17. *Portrait of H. J. van Wisselingh*, 1846; Kimbell Art Museum, Fort Worth, Texas.

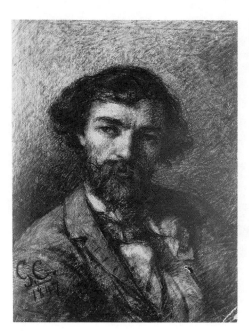

FIG. 18. *Portrait of Alphonse Promayet*, drawing, 1847; Musée du Louvre, Département des arts graphiques (fonds du Musée d'Orsay), Paris.

FIG. 19. *Portrait of Charles Baudelaire*, Ca. 1848; Musée Fabre, Montpellier, France. Photo Bulloz.

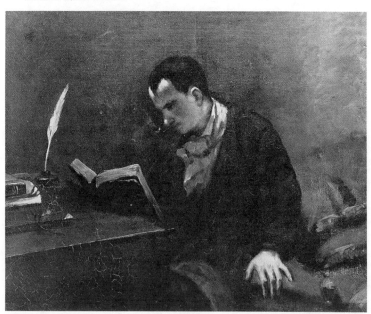

FIG. 20. *Portrait of Urbain Cuenot* (Salon of 1848); Pennsylvania Academy of the Fine Arts, Philadelphia. Gift of Mary Cassalt.

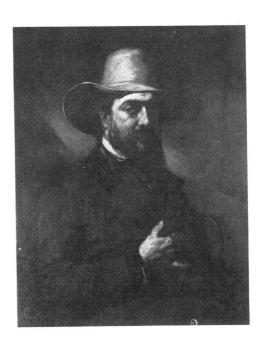

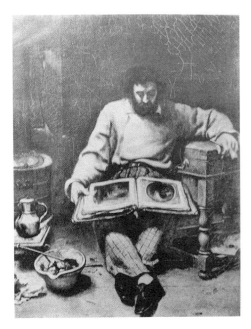

FIG. 21. *Portrait of Marc Trapadoux Looking at an Album of Prints* (Salon of 1849); current whereabouts unknown (after Léger 1929, plate 8).

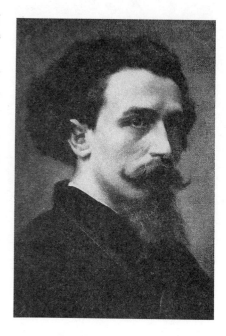

FIG. 22. *Portrait of Francis Wey* (Salon of 1850–51); current whereabouts unknown (after Léger 1929, 154).

FIG. 23. *Portrait of Jean Journet* or *Jean Journet Setting Out for the Conquest of Universal Harmony*, lithograph, 1850; New York Public Library, S. P. Avery Collection, Miriam and Ira D. Wallach Division of Art, Prints, and Photographs. Lithograph, with *complainte*, after lost painting, exhibited at the Salon of 1850–51.

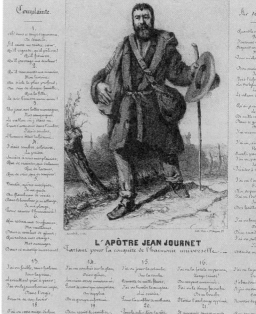

Fig. 24. *Firemen Going to a Fire*, ca. 1851; Musée du petit palais, Paris. The captain of the fire brigade is Courbet's friend Victor Frond.

FIG. 25. *Portrait of Alfred Bruyas*, 1853; Musée Fabre, Montpellier.

FIG. 26. *Portrait of François Sabatier*, drawing, ca. 1854; Musée Fabre, Montpellier. Photo Bulloz.

FIG. 27. *Portrait of Max Buchon*, ca. 1854; Musée national des beaux-arts, Algiers.

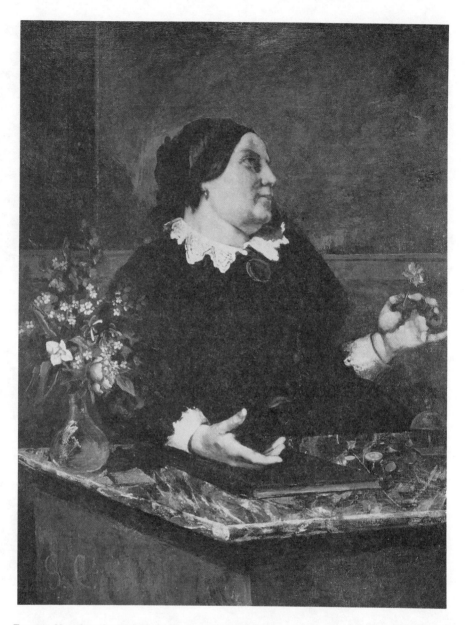

FIG. 28. *Mère Grégoire*, 1855 or earlier; Art Institute of Chicago. Following the tradition, this is a portrait of Madame Andler, proprietress of the Andler Keller.

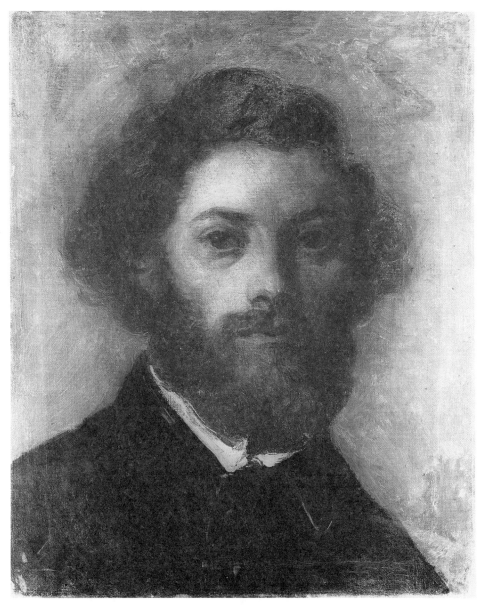

FIG. 29. *Portrait of Jules Lünteschutz*, 1858? Städelsches Kunstinstitut, Frankfurt-am-Main.

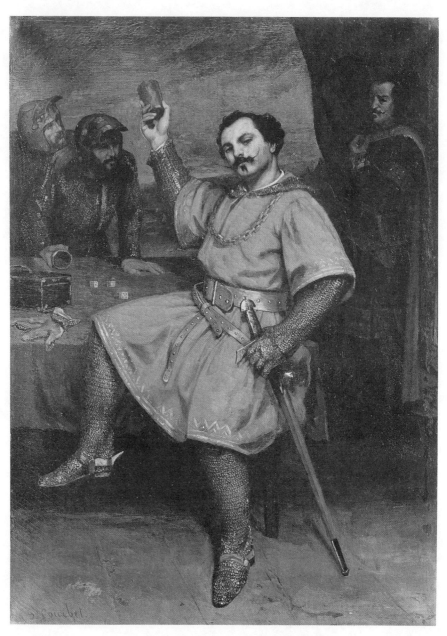

FIG. 30. *Portrait of M. Gueymard, Opera Singer, in His Role of Robert-le-Diable* (Salon of 1857); Metropolitan Museum of Art, New York.

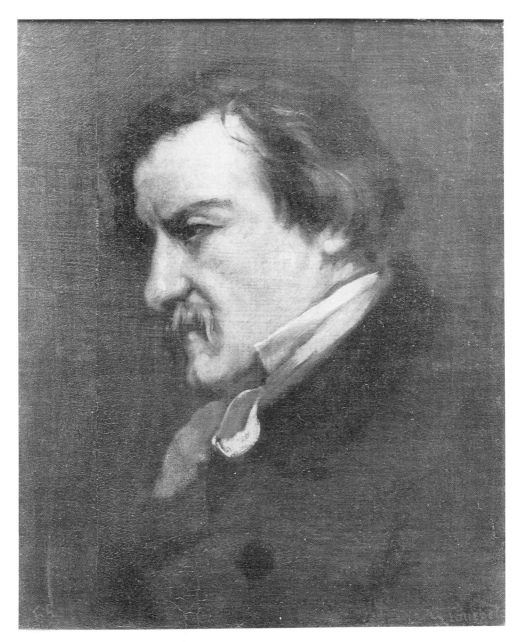

FIG. 31. *Portrait of Champfleury*, 1855; Paris, Musée d'Orsay.

FIG. 32. *Portrait of M. Usquin*, 1861; The Carnegie Museum of Art, Pittsburgh, gift of G. David Thompson, 1960. (F. 292).

FIG. 33. *Portrait of Jules Vallès*, ca. 1861? Musée Carnavalet, Paris. Photothèque des Musées de la Ville de Paris.

FIG. 34. *Portrait of Pierre-Auguste Fajon*, 1862; Musée Fabre, Montpellier.

FIG. 35. *Portrait of Laure Borreau*, or *Portrait of Mme. L . . .*, or *Woman with Black Hat*, 1863 (Salon of 1863); Cleveland Museum of Art.

FIG. 36. *Portrait of Mme. Lydie Joliclerc*, 1864? Rijksmuseum Kröller-Müller, Otterlo, Netherlands.

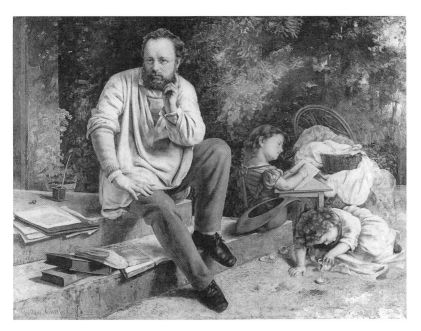

FIG. 37. *Portrait of Pierre-Joseph Proudhon in 1853*, 1865 (Salon of 1865); Musée du petit palais, Paris.

FIG. 38. *Portrait of Pierre-Joseph Proudhon on His Deathbed*, drawing, 1868; current whereabouts unknown. Drawing made for unpublished cover of *La Rue*, after a photograph by Etienne Carjat.

FIG. 39. *Portrait of Jo* or the *Beautiful Irishwoman*, 1866; The Metropolitan Museum of Art, New York; Bequest of Mrs. H. O. Havemeyer, 1929; The H. O. Havemeyer Collection.

FIG. 40. *Mort of the Stag*, 1867 (Salon of 1869); Musée des beaux-arts et d'archéologie, Besançon. Tradition has it that the man on the horse is Félix Gaudy and the man with the whip Jules Cusenier.

FIG. 41. *Portrait of Amand Gautier*, 1867;
Musée des beaux-arts, Lille.

FIG. 42. *Portrait of Pierre Dupont*, 1868;
Staatliche Kunsthalle, Karlsruhe, Germany.

FIG. 43. *Portrait of Gustave Chaudey*, 1868; Musée d'art moderne, Troyes.

FIG. 44. *Portrait of Marcello (Adèle Castiglione, née d'Affry)*; Musée Saint-Denys, Reims.

FIG. 45. *Portrait of Jules Castagnary*, 1870; Musée d'Orsay, Paris.

FIG. 46. *Portrait of Marcel Ordinaire*, 1872? current whereabouts unknown.

FIG. 47. *Portrait of Louis Ruchonnet* (attributed to Courbet), 1876? Musée cantonal des beaux-arts, Lausanne, Switzerland.

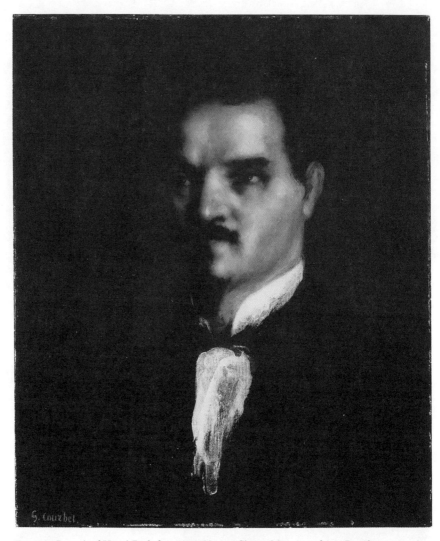

FIG. 48. *Portrait of Henri Rochefort*, 1876; Norton Simon Museum of Art, Pasadena, California.

To M. Bardenet [Ornans, January 31, 1867 (Ad)]

My dear Bardenet:

The death of a friend,[1] which brought me to Ornans earlier than I had planned, has convinced me to stay until I have done what I planned to do here.[2] I am painting pictures that are as important as those that you will sell, if all goes well, to M. de Jolival.[3] There is no need at all for me to be in Paris for the sales you refer to. You will do better on your own than if I were there. Just write me as things develop, and that's that.

Go and see the elder M. Ledot[4] tomorrow and tell him that my *Woman with a Parrot* [F. 526] must be returned to my atelier so that you can show it to those collectors. Put it in a frame so as to show it at its best. If M. de Jolival can help me sell the paintings you refer to, I'll give him the paintings he wants at the price he offers. If not, he can still have them, on the condition that he give me a written commission for an important painting. I would like to sell *Venus and Psyche* [F. 370] immediately because from one day to the next the court can force M. Lepel-Cointet* to take the painting.

I wrote to M. Delaroche for a reflector so that I can work at night. I have a series of snow landscapes that will be similar to the seascapes.

With friendly greetings,

Sincerely yours,

G. Courbet

Write me often, tell those gentlemen that M. Bruyas* was offered one hundred thousand francs for the pictures I painted for him long ago. So the price you are quoting them is very reasonable.

I'll stay in Ornans for a month.

1. The death of Urbain Cuenot* (cf. letter 67-1, n. 1).

2. As he had returned to Ornans in the middle of winter, when the mountains were covered with snow, Courbet had conceived the idea to paint a number of snow scenes, including *Mort of the Stag* (F. 612) and *Poachers in the Snow* (F. 613).

3. M. de Jolival played an important role in the Lepel-Cointet affair. His identity, however, remains somewhat vague. It is unclear whether he was Lepel-Cointet's attorney or a dealer. In any case, he seems to have acted as a mediator between Courbet and Lepel-Cointet, representing the latter's interests.

4. In June 1866, Courbet had signed a contract with the well-known publisher Ledot granting him the right to reproduce the *Covert of the Roedeer* (F. 552), the *Woman with a Parrot* (F. 526), and *Venus and Psyche* (F. 370). The contract has been preserved and may be found in Paris, Bibliothèque nationale, Cabinet des estampes, Yb3.1739 (4°), b. 1.

To a dealer [?] [Ornans (?), February 1867 (?)][1]

Cher Monsieur:

Preoccupied these days by every kind of anxiety, I had misplaced your letter and was distressed to be unable to answer your kind letter. I should tell

you that I never painted the picture that you are so kind as to request from me. As I will be having a private exhibition and as the painting the *Burial* [F. 91] will be in it, I could perhaps make a reduced copy of it,[2] if that suits your friend, in any size he would like. I would be very glad to justify your admiration and the interest you take in me.

With kindest regards,

Greetings,

<div align="right">

Gustave Courbet

</div>

We'll talk about the price if he agrees. I fear my answer comes too late. Please excuse me.

1. I have tentatively dated this undated letter in February 1867, but it may as well have been written in 1855, as in both years Courbet organized private exhibitions that included the *Burial*.
2. No reduced copy of the *Burial* is known today.

<u>67-4</u> *To Alfred Bruyas, Ornans, February 18, 1867*

<div align="right">

Ornans, Monday, February 18, 1867

</div>

My dear Bruyas:

In your last letter you offered me, for the Universal Exhibition, the paintings of mine that you own. I am thinking of sending to the Champ de Mars exhibition only four paintings: a hunting scene, a portrait of a woman, the *Seeress*, and—I would like it as a pendant to the latter—my *Self-Portrait in Profile*, which has never been seen in Paris and which is, as far as I can remember, one of the best things that I have done.[1] Please send it to me, in a small crate, to 32 rue Hautefeuille, Paris. It should be sent immediately, for the final deadline is the 27th of this month, that is to say in nine days.

You know how pressed for time I always am. Now I am more so than ever. I am doing a large hunting scene,[2] fifteen or eighteen feet wide, for March 15.

If you cannot send me the portrait, write me by return mail so that I will have time to write to Paris before sending the paintings.

Besides these two exhibitions, I hope to have another one, privately, to receive the foreigners who will come to Paris. In it I will exhibit all the works that I have and that people will be willing to lend me. I will send you another request later on.

I am about to start building in about the same spot where I built in '55.[3] This time I will have a permanent atelier for the rest of my life,[4] and I will send almost nothing to the exhibitions of the government, which has so far behaved so badly toward me. I cannot tell you more about it today.

Affectionately yours, dear friend,

<div align="right">

G. Courbet

</div>

Please answer me right away to Ornans (Doubs)

The [*Self-*]*Portrait in Profile* [F. 163] could turn out to be as successful as the [*Self-*]*Portrait with Pipe* [F. 39].

1. To the Universal Exhibition, Courbet sent the *Hunting Dogs with Dead Hare* (F. 620), the *Seeress* (F. 438), the *Self-Portrait with Striped Collar* (F. 163), and the *Puits noir* (F. 462). He did not participate in the Salon of 1867.

2. *Mort of the Stag* (F. 612).

3. Courbet's 1867 exhibition was on the rond-point near the Alma Bridge.

4. The building was indeed more permanent than Courbet's 1855 exhibition pavilion, though it did not outlast the Franco-Prussian War and the Commune.

To Gustave Chaudey [Ornans, February 1867] 67-5

My dear Chaudey:

I am doing a very special painting that I am bent on finishing, for it is the picture that I will do this year for my reputation's sake.[1] I promise you that it is more important than losing a lawsuit.[2] One can always lose lawsuits, but one cannot always paint pictures like the one I am doing now. I am working like a fanatic, night and day. It is three times as much work as I had anticipated but I must manage it.

Isabey* the architect is putting together an exhibition for me on the Champs Élysées. I'll open on May first with three hundred paintings.[3] If you see Castagnary,* do tell him that I think of him every day but can't write him. I have so many letters to write that it takes time away from my work; I have more than fifty here waiting to be answered.

I cannot come to Paris for three weeks. Tell him to write me.

Sincerely yours, my dear friend. Try to do this without me, I cannot tell you anything more about the suit. Kind regards to your lady, to our friends. Work is killing me.

<div align="center">

G. Courbet

</div>

1. *Mort of the Stag* (F. 612).

2. The lawsuit against the stockbroker Lepel-Cointet* concerned the latter's purchase of *Venus and Psyche* (F. 370).

3. The exhibition, in fact, opened on May 30 and included 115 works listed in the catalog and some twenty paintings that were added later.

To Gustave Chaudey, Ornans, March 2, 1867 67-6

<div align="right">

Ornans, March 2, '67

</div>

My dear Chaudey:

Drop the suit![1] At the moment I am tied up in Ornans with matters of greater importance. As in life one must cut one's losses, I cannot sacrifice what I am doing at the moment to the possibility of a lawsuit.

At the moment I am working on a painting that is eighteen feet long, and very important artistically.[2] It is a snow scene. I tried to have it ready for the Champs Elysées exhibition but I cannot finish it by March 10. I took advantage of the meter of snow that fell in the countryside to execute this painting, which I had planned for a long time. Perhaps I should have decided to ask M. de Nieuwerkerke* for an extension, but I won't do it after what happened between him and me last year. Nonetheless I am finishing this picture, which is very important to me, and I will exhibit it at an exhibition that I'll organize myself or with the Belgians, asking them for a contribution.

You have a friend who knows Khalil Bey* and who spoke to him of this matter. Please give him a sample of the letter that he is to write as he promised in front of your friend and me.[3] Send me a copy too, which I'll transcribe and send to the president of the court, M. Benoît Charpuy [?] (I believe).

My dear friend, please take care of that lawsuit without involving me in it. I am exhausted and no longer have the heart for anything. I work with a reflector until 1:30 in the morning. As for erotic subjects, there is no lack of them, but that should not determine the discussion.

Please write me, for I cannot come to Paris at the moment, especially since my mother is very ill. I would be of very little use to you in Paris. If it becomes necessary to take the painting to court,[4] have it picked up at my atelier at my expense. Tell the concierge whatever is necessary.

Sincerely yours, dear friend. I'll come to Paris as soon as I can. Kind regards to your lady and our friends.

Gustave Courbet

1. The lawsuit against Lepel-Cointet,* regarding the sale of *Venus and Psyche* (F. 370).
2. The *Mort of the Stag* (F. 612).
3. One of Chaudey's major arguments in the Lepel-Cointet case was the allegation that the stockbroker had attempted to sell *Venus and Psyche* to the Turkish ambassador, Khalil Bey. The latter in effect was to write a letter in which he stated that Lepel-Cointet had offered him the painting for twenty-five thousand francs but that he had preferred "to order from M. Courbet a new picture, which he has painted for me" (cf. Lindsay 1973, 219). The painting that Courbet had done for Khalil Bey was the *Sleeping Women* (F. 532).
4. *Venus and Psyche*.

67-7 *To Gustave Chaudey [Paris], March 29, 1867*

March 29, Friday '67

My dear Chaudey:

I have made several mistakes in this affair. The first is to have taken M. Lepel-Cointet's* word for it when he said that he was an honest man with whom there was no need to have a written contract. I believed him the more readily as usually the people with whom we deal are well educated and intelligent, and—this is a great thing—they don't need to lie, owing to their social

position. Second mistake, I should have delivered the painting[1] to him before the stockbroker disaster.[2] Third mistake, not to have let my paintings go out of my atelier before being paid.[3] Fourth mistake, to have retouched the painting according to his suggestions. Fifth mistake, not to have delivered the painting to M. Khalil Bey* since I did not have a written contract with a man like M. Lepel. Sixth mistake, to have sold my *Roedeer* (the *Covert*) [F. 552] to M. Lepel on his assurance that he would buy other paintings and give me commissions.

In order not to be robbed any more, I have already withdrawn in writing from a commission that he had given me. I have not yet started the paintings that he wanted for his billiard room. And now that he is not taking *Venus and Psyche* [F. 370], which he was buying as compensation, I am robbed of the painting of the *Roedeer*, which I was so stupid as to deliver to him and which he was so dishonest as to keep, sending me back *Venus and Psyche*, which had been bought under the same conditions as the *Roedeer*.

My dear Chaudey, if you believe that, because he is able neither to pay nor to keep his promises, M. Lepel will invoke the question of indecency, please make the point that that indecency is in the painting only by his orders. The photograph made before the retouching done on M. Lepel's order will show that all nudity was covered. Besides, the jury called to serve as censor morum admitted this painting as being beyond reproach in that respect.

Finally, I cannot understand why, if M. Lepel finds the painting unsuitable, he has the unscrupulousness to offer it to M. Khalil Bey for 25,000 francs, twenty hours after having bought it. I had sold it to him for 16,000, but we agreed that I would say 18,000, the price that I had first quoted him. M. Khalil offered him 19,000, that is, 3,000 more than he paid for it. M. Lepel wants 25,000, that is, 9,000 francs profit in twenty hours, a bit much! In short, it was M. Lepel himself who took me in his carriage to M. Khalil Bey to have me sell the painting in his name, to which M. Khalil Bey, a perfect gentleman, answered, "I will never allow such a man to make money on me. If the profit were to go to you, M. Courbet, I would accept."

To sum up, M. Dupont[4] of the Tuilerie offered me 12,000, her majesty the empress, 15,000, another collector 15,000. So that, as a result, M. Lepel has now, by not fulfilling his terms, cheated me out of 3,000 on *Venus and Psyche* and 5,000 francs on the *Roedeer*, a total of 8,000 francs, not counting the opportunity I had to sell his commission to another collector with the authorization that he had foolishly but luckily given me. I remember that M. Lepel told me that he had been involved in a suit with a painter, M. Bénédict Masson,* if I remember correctly, so it is not the first time he has done this. It is something we should find out for the suit.

M. Lepel has already prevented me twice from selling *Venus and Psyche* to other collectors, he is doing me real harm. In any case, if he does not want

to take this painting, the transaction of the *Roedeer* cannot take place because there is breach of trust. I am prepared to give him back the 5,000 francs that I received from him, though I gave him a bill for 10,000 francs, something he insisted on in order to raise the purchase price of his painting up to 15,000, another dealer's trick.

Yours truly,

G. Courbet

1. *Venus and Psyche* (F. 370).

2. In 1867, France went through a major economic crisis that culminated in the collapse of the Crédit mobilier in October. Cf. Echard 1985, 205–7.

3. Courbet seems to get lost here in the structure of his argument and incorrectly uses the negative "not." His mistake was, of course, to have let his painting go out of his atelier before being paid, rather than the other way around.

4. Not Pierre Dupont,* the songwriter, but perhaps a dealer.

67-8 *To the editor of* Le Hanneton *[Eugène Vermersch], Paris, April 17, 1867*[1]

[No salutation]

I have always found it supremely ridiculous to be asked to authorize publication of my portrait in whatever way it may be. My mask belongs to everyone. That is why I authorize *Le Hanneton* to publish it, but on the condition that they do not neglect to frame it with a fine halo.

Gustave Courbet

32 rue Hautefeuille
Paris
April 17, 1867

1. This letter was printed in facsimile in *Le Hanneton* of June 13, underneath a portrait caricature of Courbet by Léonce Petit (see fig. 4). Though trained as a painter by Henri Harpignies and François Feyen-Perrin, Léonce-Justin-Alexandre Petit (1839–1884) was known especially as a caricaturist.

67-9 *To Jules Castagnary, Maizières, [April] 21 [1867]*

Maizières, Sunday, the 21st

Dear friend:

I am currently staying with M. Ordinaire* in order to finish a painting that I started. It is a haymaking scene with oxen,[1] it will be as good as the *Roedeer* [F. 552]. Since I left you I have painted, at Ornans and Maizières, the *Death of the Hunted Stag* [F. 612], a canvas similar to the *Battle of the Stags* [F. 279], with twenty-five dogs, a whipper-in, a mounted hunter, all life-size in the snow; plus six other winter scenes, including four studies and the *Poachers* [F. 613] and the *Poor Woman Leading Her Goat, Begging from Door to Door* [F. 550].

I have never worked so hard in my life. I have great hopes for these works. With these pieces alone one could set up an exhibition. Putting together my winter and snow scenes, I have about twenty [paintings]. Putting together the seascapes, I have about thirty; then the flower series, and the portrait series, and the landscape paintings, and the animals, and the subject pictures, and the hunting scenes, and the genre paintings, and finally the *Burial* [F. 91] and the studies: [altogether] I have easily three hundred paintings, [between] paintings that I have and those I can easily secure.[2] When I am in Paris, I will request the *Sifters* [F. 166] from Nantes, the *Stag in the Water* [F. 277] from Jeanron* in Marseilles (they do not want to give me the one in Lille),[3] and the *Young Ladies from the Village* [F. 127] from Mme de Morny.* I am so out of my wits from the hard work that I have been doing that I have not had the heart to write you or even answer you till now.

Oh, dear friend! Do you think I have done well to send nothing to the government exhibitions? I sent only three paintings to the one in the Champ de Mars. All three [are] badly placed, invisible, and they were not big: the *Dogs with Hare* [F. 620], my portrait in profile [F. 161] that belongs to Bruyas, and the *Seeress* [F. 438]. I reclaimed, according to the rules, the famous landscape sold to Nieuwerkerke* for two thousand,[4] which now belongs to the empress and was taken from her gallery at St. Cloud—the same that M. Lajolais is requesting from you, Lajolais here, Lajolais there, the budding commissioner of the Fine Arts Administration (I think that's a joke).[5] I do not know whether those three paintings could be withdrawn from the exhibition. Now that I am sure that I will organize one myself, I regret having sent those three paintings to those people.

The Isabey* show will close, according to him, on the fifth of next month.[6] Consequently, we will not be able to open until the fifteenth.[7] It is true that it will be up for a year. I think it is time to announce it in all the papers as of now and to list it in the general catalog of the exhibition. M. Vermorel[8] and his colleagues, who publish it, have offered to insert it without charge.

Chaudey* doesn't understand a thing about my lawsuit.[9] He creates difficulties where there are none in that affair. He is trying to make it a political case. M. de Jolival[10] is offering him the discontinuance of the suit and fifteen thousand francs for the *Roedeer* [F. 552], [but] he prefers to litigate. I will lose this case for sure. The [painting of the] *Priests* [F. 338] is a millstone around my neck. Already they have prevented it from being shown at the Exhibition, and Lepel* is using that, double-dealer that he is!

In any case, I will leave Ornans on the first of the month, as I cannot deposit my pictures in the Isabey building before then. So we will have a complete exhibition, with either paid or free entry—let us see how the wind blows. If Napoléon is absolutely determined to inaugurate it, he must give a

speech about the Luxembourg [Museum],[11] for these inaugurations without speeches are not to the liking of the people of Maizières and Ornans. To advertise the show, go all out in the American way. A thousand regards to all friends and acquaintances.

Cordially yours,

Gustave Courbet

Write me at Ornans. The police have just arbitrarily destroyed the photographs of the *Priests* at Bingham's,* by what right I don't know.

1. *Siesta at Haymaking Time* (F. 643).
2. The grouping of his works in different categories, as is done in this letter, was repeated in the catalog of Courbet's 1867 exhibition.
3. *After Dinner in Ornans* (F. 92).
4. The *Puits noir* (F. 462).
5. Little is known about Lajolais, who does not seem to have made much of a career in the Fine Arts Administration. He is not mentioned in Chennevières's *Souvenirs* (1979).
6. The exhibition pavilion where Courbet held his second private one-man show in Paris was built by his architect-friend Léon Isabey, who had also designed the "Realist Pavilion" for Courbet's 1855 exhibition. From the wording of this letter, it may be deduced that Isabey first used the building for an exhibition of his own.
7. Courbet's show, in fact, opened on May 30.
8. Auguste-Jean-Marie Vermorel (1841–71) was a journalist who wrote for various papers. In 1867 he was charged with the publication of the catalog of the Universal Exhibition.
9. The lawsuit against Lepel-Cointet.
10. Compare letter 67-2, n. 3.
11. In the course of the Second Empire, the acquisition policy of the Luxembourg Museum was becoming increasingly complicated, leading to much error and confusion. As the organization of the museum was largely controlled by the Emperor's House Ministry of Fine Arts, Courbet makes the ironic suggestion that Napoléon III give a speech on the subject at the occasion of the opening of his exhibition (cf. Paris 1974, 8).

67-10 *To M. Lemoine [Ornans], April 23 [1867]*

Tuesday, April 23

M. Lemoine:

On the 21st (Easter Sunday) I sent you two frames to be gilded in the same way as the one I already sent you. Accordingly, you should have them ready in one or two days, for you are so obliging as to attend exclusively to my exhibition. I am counting on you and your punctuality. Take on whatever workmen you need if you cannot do it yourself, as long as everything is ready by May 10. You understand the importance of this business as well as I. I won't need any more exhibitions after the foreigners leave, and I'll have missed my mark.[1] In my atelier there is another large frame on the beam above the door. It is the one of the *Burial at Ornans* [F. 91]. It is more than twenty feet long. That one, too, has to be regilded and repaired. Also on the beam, opposite the bedroom, are several gilt frames that need repair. If they

can be used for canvases already painted, take them down and either cut them down or enlarge them. They'll do when they are regilded. Gild them with copper for they can be used only for this one occasion. I sent M. Isabey* some measurements for the paintings that I did here in Ornans. He was to give them to you. There are two more to be done, besides the two I am sending you: a frame 1.03 meters high and 1.22 meters wide; ditto, 1.18 meters high, 95 centimeters wide. Also, make a beautiful and permanent frame for the *Mère Grégoire* [F. 167], which is a [size] 60 or 80 canvas. The portrait of the shepherdess, which I mentioned to you, is that landscape with a moon in the sky, two cows, and a little standing shepherdess.[2] Make a frame for that too. That is all I can think of for the moment. I repeat, I am counting on you. Bring the stretcher that you will receive by train to my atelier so it won't be in your way. Against the wall under the beam there is a large coppered frame that you can cut to size for the *Wrestlers* [F. 144]. It is good for that painting. I am sending you the frame for the *Shepherdess with Sheep* [F. 547?] on my easel. Write me by return mail if the *Return from the Fair* [F. 107] is framed.[3]

 With friendly greetings,

<div align="center">

G. Courbet

</div>

 1. Courbet's 1867 exhibition was organized to coincide with the Universal Exhibition organized in Paris that year. The exhibition had opened on April 1 and was to close in July. Courbet depended on the visitors to the Exhibition to come and see his show.

 2. It is not clear to which painting Courbet is referring here.

 3. The letter has the following annotations by Lemoine:

 1 smooth frame for landscape, 201—167

 The *Mère Grégoire*, 130—98

 1 smooth frame

 Cut to size the frame for the:

 Wrestlers, measurements

 Return from the Fair, measurements

To Alfred Bruyas, Ornans, April 27 [1867] **67-11**

<div align="right">

Ornans, April 27

</div>

Dear Alfred:

 I am writing you a few lines in haste to ask you whether you are still inclined to send me a few paintings from your gallery for my exhibition. The building will be ready for occupancy on May 5 and will open on the 15th of the same month.[1] Collectors and museums have promised their cooperation. If you can send me for my exhibition (at my expense, of course) the principal paintings that I have had the pleasure of selling you and painting for you, I would be delighted.

 I will have, I think, three hundred paintings at the exhibition.[2] It is lo-

cated at the rond-point by the Alma Bridge, between the Champs-Elysées exhibition and the [long] side of the Champ de Mars. If you decide to do me this favor, it will be the last time that I'll bother you, for several reasons: first of all, because this is the last exhibition of my paintings; the second reason is that I am getting old, quite old. We get old, despite the resilience of our spirits. My dear Alfred, your action is my own and increasingly I believe that the paintings I sold you will do you honor.

Last year, either I or those who held my paintings sold twenty-five thousand francs' worth of my paintings. Consequently yours are already worth more than a hundred thousand [francs]. Those figures mean nothing to me, but for collectors and the public they are the touchstone.

To sum up, if once again you will be so kind as to send me, at your convenience, the paintings that you deem suitable, such as the *Bathers* [F. 140], the *Spinner* [F. 133], the portraits of yourself [F. 141, 142, 143], that of me [F. 161], etc.—anything but the last landscape that I sent you[3] because the empress has a somewhat similar one that is in the Champ de Mars exhibition—I would be delighted. As my exhibition opens on the 15th of May you can still send them by slow goods service, for I have expenses that to me are enormous. If I do not succeed I will once again ruin myself. That is no joke at my age! How much work it is to do what is right.

I have not asked you for them until now because I wanted to be certain of this exhibition, which has met with obstacles everywhere. The city of Paris kept me dangling for a month and a half about the site. Finally we found out, but too late, that they wanted a hundred thousand francs under the table. They wanted to get the better of me as well as of the buyers I had found. How troublesome is life, dear friend, but you know something about that.

I await your reply. If you can, mail it to my address, 32 rue Hautefeuille. Or else let me know when and where they will arrive. It is very important to me. I want to prove you right.

Affectionately yours,

Gustave Courbet

I hope I will see you at the exhibition. I am beside myself with work and worries.

1. In fact, Courbet's exhibition did not open until May 30.

2. The catalog of Courbet's exhibition includes only 115 numbers. Some twenty paintings appear to have been added later.

3. Bruyas's painting *Solitude* (F. 583) much resembled the *Puits noir* (F. 462), which Nieuwerkerke* had bought for the empress in 1868.

To Alfred Bruyas [?] [Ornans or Paris, early May (?) 1867] (incomplete?) <u>67-12</u>

. . . I now have two hundred paintings to exhibit, ready for that gallery that opened with 140. Send them to me and I can still find a way to put yours in as well.

When we were doing an inventory of the paintings that I have done in my lifetime, Castagnary* and I found another 270 that are in provincial museums and privately owned. That means that I have done a thousand paintings in the course of my existence.[1] If you could continue what you have already done for me, it would be tremendous.

Think about it.

<div align="center">

G.C.

</div>

1. It is not clear how 200 paintings added to 270 makes 1,000. The figure seems exaggerated. Fernier (1977–78) lists only 626 paintings done by 1867.

To Zélie or Juliette Courbet [Paris, May 26, 1867] <u>67-13</u>

<div align="right">

Sunday

</div>

Dear sister:

I am opening on Tuesday, I am exhausted. Instead of writing me [to ask] when you should come, you should have answered my letter [by telling me] what day you were arriving. Your accommodations are ready. It is really a shame that Mother cannot come. It vexes me that she won't see this. Come whenever you like. Write me. I am opening on Tuesday the 28th. I embrace you all.

<div align="center">

G. Courbet

</div>

Write me. I haven't been able to answer you for three days now.

[Address] Mesdames Courbet, landowner
 Flagey
 Canton Amancey, Doubs
[Postmark] Paris-Montrouge, May 27, 1867

To Noriac [Claude-Antoine-Jules Cairon] [Paris], May 27, 1867 <u>67-14</u>

<div align="right">

Monday, May 27, 1867

</div>

Monsieur Noriac:

Because of circumstances beyond my control the invitations that I had printed for the opening of my painting gallery of the 28th inst. have been delayed by two days. On Thursday, May 30, Ascension Day, special guests and the public can attend the inauguration of my exhibition at the Alma rond-point.

If you have not yet received my letter of invitation, this note will serve as such, and I hope that you and your friends will do me the honor of coming.
Respectfully yours,

Gustave Courbet

67-15 *To a newspaper editor [Paris, May 28, 1867] (incomplete)*

[He requests the editor of a newspaper to publish a notice relating to his upcoming exhibition.] . . . The private opening of M. Gustave Courbet's exhibition, which had been announced for today, Tuesday, will not take place until Thursday, May 30. All the invitations that have been sent are valid for that day. The public opening will take place the next day, Friday, at ten o'clock. . . .

67-16 *To Théophile Thoré [Paris, May 28 (?), 1867]*[1]

Tuesday evening

My dear Thoré:

I heard that you wanted to help me with my catalog. I don't see anything forthcoming even though I have already written you two letters of invitation. I am definitely opening on the day of the exhibition, Thursday the 30th.

I hope you will honor me with your presence. You will see some old paintings again.
Yours,

Gustave Courbet

Alma rond-point, Champs-Elysées

1. The letter must have been written a short time before the opening of the exhibition, probably on Tuesday, May 28. Thoré also received a letter from the art dealer Bardenet,* who likewise asked him to help in the preparation of Courbet's catalog. For the text of that letter, see the *Bulletin des amis de Gustave Courbet* 52 (1974): 13. In the *Bulletin*, Bardenet's letter is dated Tuesday evening, May 25, which must be erroneous as the twenty-fifth was on a Saturday. Its signature is transcribed as "Bardonnet (?)," which is probably a misreading of "Bardenet."

67-17 *To Alfred Bruyas [Paris], May 28 (or 30?) [1867]*[1]

Thursday, May 28

[No salutation]

Bravo, my dear fellow, you have the courage of your convictions. We must not hide it from each other, our destinies are closely linked. You are a man of feeling like me, you are my corollary in life.

At the moment there is a splendid thing to be done. I appeal to your

enthusiasm to have you understand it properly. For us, money does not count, it is action that is our goal. In 1855, thanks to you, I had twelve thousand francs to spend in the service of my idea. I have spent them all, with no fear for the future. Last year, I increased my sales figure. I have just spent fifty thousand francs, again toward the same goal. Except that this time is a triumph for me. I have had a cathedral built in the most beautiful spot that exists in Europe, by the Alma Bridge, with limitless horizons, on the banks of the Seine and in the heart of Paris. And I have astounded the whole world.

You see that money can have other returns than when placed egoistically with a notary. We have two-thirds of our existence behind us, alas! What do we want with money, the money of men? Let us do some good. What I am saying to you is so true that I have insured your three paintings, the *Bathers* [F. 140], the *Spinner* [F. 133], and my [*Self-*]*Portrait* [F. 161] for one hundred thousand [francs].

Another thing, all the painting in Europe is exhibited in Paris at this moment. I triumph not only over the moderns but over the old masters as well. An equilibrium has been reached. I have two hundred paintings exhibited, I could exhibit twice as many if I wanted to take the trouble.

As a collector, your action is the counterpart to mine. Bring your gallery, I will complete it for you, and we'll build a second salon attached to the one of mine that is already built. We will earn a million by being right. What is fifty thousand francs to you? If you were to lose them, it would not prevent you, with your wealth, from living as you like. With an effective space the same size as mine, we'll have 240 meters in length, 10 meters in width, and 30 meters in height. It is the Louvre gallery. There will be no more Champs-Elysées, no more Luxembourg, no more Champ de Mars: it will be all the easier for us to settle the matter as it is already done. I have staggered the art world.

Think about it. Your life will become very respectable and you deserve it. You'll belie the slanderers.

<div align="center">

G. Courbet

</div>

I am insuring for six hundred thousand francs, I wanted a million. If you want to build, it will be done in a month.[2] I will stay open for a year,[3] and, if I buy the plot with you, perhaps forever. And painting will only exist in France.

Sincerely yours,

1. There is some problem here as to the date of the letter. Courbet writes "Thursday, May 28," but the twenty-eighth fell on Tuesday. Perhaps the artist erroneously put "28" instead of "30."

2. Bruyas did not fall in with Courbet's suggestion.

3. Courbet's exhibition was to stay open for only half a year (cf. letter 67-27).

67-18 *To Jules Castagnary [Paris, May 31, 1867 (Ad)]*

My dear Castagnary:
 Everyone who comes to the exhibition asks for a catalog. I say no more.
I'll be home till 11 A.M., then at the Alma Bridge. [].[1]

 G. Courbet

 1. The last line of this letter is illegible.

67-19 *To his father [Paris, May-June 1867]*

Dear Father:
 I just got your letter and I am answering it right away. I have found two
rooms in my street with beds: the travelers can arrive.[1] There is one for the
Boulet ladies[2] if they wish [to come as well]. I will see Paul[3] to let him know.
As for Zoé,* she has found a very good post, by chance, for all her schemes
don't always turn out well. She can be said to have beginners' luck. She is
with Mme Castelli, a rich Italian lady who has actually taken a liking to her.[4]
I am quite happy to see her there for . . .[5]
 As for my exhibition, I am in a very bad location. I blundered in follow-
ing the government's example and from a financial point of view I failed;
however, from a conceptual point of view it is entirely successful, I could not
have done better. Had I been located on the boulevards I would have earned
a hundred thousand francs, everyone thinks so, while over there I will at best
cover my expenses. It does not matter, I have made a great step forward, I
have gained enormously in importance and independence. If I can only re-
cover my expenses, all the windbags are dead for I can act without the gov-
ernment and I'll be the only one in France. They understand that very well
and that is what makes them rage in the newspapers. I have up to one hun-
dred people a day, at an entrance fee of fifty centimes. If I had it to do over
again I would spend less, for people no longer believe in the Exhibition. At
the time everything was prohibitive—land, workmen, materials, etc. For ex-
ample, to get a place on the boulevards, all things considered, I would have
needed twenty-five to thirty thousand.
 Anyway, tell them to come whenever they want.
 I embrace you,

 G. Courbet

 1. Courbet's sisters, Juliette and Zélie.
 2. Though the transcription of the letter has "Boutet," this must be a reference to the
sisters of Paul Boulet.*
 3. Paul Boulet.
 4. Zoé Courbet had come to Paris around 1856 to find a position as a governess. Between

then and 1867, she seems to have had several jobs as governess and lady's companion (cf. Grimmer 1956, 5).

5. The remainder of the sentence is missing from the transcription.

To André Gill [Paris, early June 1867][1] <u>67-20</u>

My dear Gill:

Everyone accuses me of spending too much money on exhibiting my paintings. The money that I am able to earn must be spent by me. Placing it with a notary would be to admit my inability to spend it more usefully.

Gustave Courbet

1. This short note was reproduced in facsimile underneath Gill's caricature of Courbet, which appeared in *La Lune* of June 9, 1867 (see fig. 5).

To Bénédict Masson, Paris, June 6 [1867] <u>67-21</u>

Paris, June 6

My dear Masson:

I am very flattered by your visit to my exhibition. I am sorry that I was not there.

To turn to another matter, in my quarrel with M. Lepel-Cointet[1] I seem to have heard him say that he had had a quarrel with you.[2] That is what I would like to know from you (that is, if he was referring to you). Let me know, for it would indicate that he habitually behaves this way toward artists.

Sincerely yours, my dear fellow,

G. Courbet

1. The lawsuit over the painting of *Venus and Psyche* (F. 370).
2. Compare letter 67-7.

To Gustave Chaudey [Paris, June 11, 1867 (Ad)] <u>67-22</u>

My dear Chaudey:

I am sending you a wonderful letter[1] to add to the dossier of the Lepel* lawsuit.[2] If you need the pieces that M. Masson* claims to have, I think I can get them. Or else you can go see him yourself.

Sincerely yours,

I cannot do too much business, I am traipsing around Paris with my sisters.

G. Courbet

Best regards to your charming ladies.

1. Probably a letter from Bénédict Masson. See letter 67-21.
2. The lawsuit concerning *Venus and Psyche* (F. 370).

67-23 *To Jules Castagnary [Paris, July 14, 1867]*

Sunday

My dear Castagnary:

Tomorrow, Monday, at 1:30 P.M., the students as a group will come to my exhibition at the Alma Bridge. It seems to me indispensable that you be there.

I fear that their demonstrations will make me lose my lawsuit, which I am winning at the moment but which will not be adjudicated until next Friday. It is good that you will be there, they want the *Priests* [F. 338]. I have already put in *Proudhon and His Family* [F. 443] as we are held in high honor in court. I removed the woman,[1] I finished the children, I redid the background, I retouched Proudhon.* It now looks splendid to me. What a pity that you could not come to court. I am told that *Le Nain jaune* has been suspended.[2] Be sure to be there tomorrow, there is work to do.

I will be waiting for you,

G. Courbet

[Address] Monsieur Castagnary, man of letters
 17 rue Capron
 Batignolles—Paris
[Postmark] Paris, July 14, 1867

1. Courbet painted out the figure of Mme Proudhon and replaced it by a mending basket placed on top of some garments draped over Mme Proudhon's chair.
2. Founded in 1814 as a satirical journal, *Le Nain jaune* experienced several eclipses and revivals in the course of the nineteenth century. It was revived a fourth time in 1867 by Grégory Ganesco, who turned it into a political opposition paper. That same year one of its more radical writers, Arthur Ranc,* was condemned to four months in prison. Though the paper was not suspended, it was forced to soften its political tone (cf. Dumesnil 1945, 230).

67-24 *To Jules Castagnary [Paris, August] 16, [1867 (Ad)]*

Friday, the 16th

My dear Castagnary:

We live in a time of tailors. If M. Dusautoy [?] puts himself forward, M. Laurent Richard[1] puts himself forward as well. Here is the contract that I have just signed with the latter (written in his own hand):

"I declare that I am purchasing from M. Courbet his painting of the *Stonebreakers* [F. 101] as well as another painting of his, *Poverty in the Snow* [F. 550]. These two paintings are presently in his exhibition at the Alma rond-

point. I am buying these two paintings for the sum of 20,000 francs (16,000 for the [*Stone*]*breakers*, and 4,000 for the *Woman in the Snow*).² I am giving him 4,000 francs on account. I still owe him the sum of 16,000 francs, payable on delivery of the aforesaid paintings at the end of October of this year. [Signed:] G. Courbet [and] Laurent Richard, 18 boulevard des Italiens."

You see that I make written contracts now. This is the most advantageous deal that I could make under the circumstances. Imagine, if you please, what effect it will have all down the line. It is imperative that the newspapers announce this event, which is of the utmost importance at this moment.

Sincerely yours,

G. Courbet

I say no more.

1. Laurent Richard was an important collector of Courbet's works. Besides the two paintings mentioned here, he owned, at one time or another, *Le Château d'Ornans* (F. 173); the *Stream of the Puits noir* (F. 174), and the *Covert of the Roedeer* (F. 552). See Fernier (1977–78).

2. Another designation of *Poverty in the Snow*, mentioned earlier in the same paragraph.

To Zoé and Juliette Courbet [St. Aubin, August 25, 1867 (Ad)] 67-25

My dear sisters:

Yesterday I arrived safely at M. Fourquet's,¹ but it was a bit far. It took us five and a half hours to reach Caen and one and a half hours to reach St. Aubin.

M. Fourquet and the lady in whose home he lives² are charming people. They went out of their way for my arrival. There are also two amusing secondary school students. The countryside is not very beautiful. As for the beach, it is nothing special, and the house is very ordinary. It reminds me of the outbuilding behind our house at Ornans. It is comfortable in the sense that it is very simple. There are no trees as in Trouville and Deauville. I have already gone bathing, I'll go again this evening. I would love for you to see the sea but here it is a bit far and bare. M. Fourquet, who is charming, absolutely means to cure Zélie* of her tapeworm before she leaves, there is nothing to it. He assures me that if he cannot do it no one in the world can. Zélie, with all her troubles, is lucky, she always finds doctors like that. If he could cure Juliette of her religion as well, we would be saved!

Have the workmen finish my room. Write M. Isabey,* 174 faubourg St. Honoré, or M. Chapontot [?] at the Mint if the workmen don't come. All that remains [to be done] are the window and the staircase. Go to my exhibition every other day at least and do the books.

I embrace you both. Sincerely yours,

G. Courbet

Send me a letter if something serious comes up: people who want paintings, or a lawsuit.

1. M. Fourquet, a pharmacist in the rue des Lombards in Paris, owned a summer house in St. Aubin-sur-Mer on the Norman shore, where he had invited Courbet in the most cordial terms. (For Fourquet's invitation, see Paris, Bibliothèque nationale, Yb3.1739 [4°], b. 1.) Courbet, together with his sister Zélie, stayed with Fourquet for about ten days, from August 24 onward. Apparently Zoé and Juliette were watching his exhibition in his absence.

2. Probably a certain Mme Richard, whose name is mentioned frequently in Fourquet's letter.

67-26 *To Zoé and Juliette Courbet [St. Aubin, August 31, 1867 (Ad)]*

My dear sisters:

Michel's[1] stupidity is remarkable: he never thinks to ask the addresses of those who come asking for me. I am terribly sorry that Chabot arrived just when I was sea bathing for a week.[2] If he had written I would have stayed home. I'll be in Paris Monday evening,[3] though it would be very pleasant to stay at the seashore, where we sometimes go bathing twice a day.

You must give some money to the Public Assistance Board. Tell Michel to ask people for their addresses. I cannot sell the *Poachers* [F. 613] for less than four thousand francs since M. Richard[4] (the one who bought the *Stonebreakers* [F. 102]) paid four thousand for *Poverty* [F. 550]. As for the Americans,[5] ask for their address so that I may go see them on my return. I had told Borreau junior[6] to go and help Michel, who was ill. Don't pick on him even if he drinks beer, for he is useful: he keeps Michel from drinking hard liquor. Moreover, I will have him stay there one or two days while Michel comes to set up the atelier, if the carpenters and the painter have finished. Try to push them, for I have to paint when I return.

Much love, my dear sisters, I embrace you. Juliette [] a line in order that my heart can prevent me from seeing the truth. I did not understand.

<div align="right">G. Courbet</div>

I received the pants.

1. Courbet's manservant.
2. Toward the latter part of August, Courbet had gone to St. Aubin-sur-Mer to vacation at the house of his friend M. Fourquet.
3. September 2.
4. In 1867, Laurent Richard had bought both Courbet's *Stonebreakers* (for twenty thousand francs) and *Poverty in the Village*. See letter 67-24.
5. The Americans in question may have been connected with the Allston Club in Boston, which in 1866 had bought Courbet's *Quarry* (F. 188).
6. Perhaps Jules-Lucien Borreau (1852–1907), the son of Laure and Jules Borreau* of Saintes.

To his family [Paris], October 15 [1867]

October 15

Dear family:

I don't understand any of this, I don't know when Father plans to see the exhibition. So far it closes at the end of this month. I don't know whether it will be extended. In any case, you should hurry because they are beginning to move everything out. I have a spare room, I am sleeping in my new one, which is very nice. I paid Mme Roménaire [?][1] five hundred francs. Neither my sisters nor I owe her anything.

You have written me nothing about Zélie's* health. We are worried. Marie Pacaud [?] is furious. She maintains that if she had any say in the matter, you would not get off so easily.

If Mother could come with Father, she would make me very happy. I will perhaps have some Hungarian musicians this winter who will give concerts in the evening and we could see . . .[2]

One of these days I'll give a concert for Pierre Dupont.*

I am in a hurry, write me. I embrace you all. My exhibition continues to go well.

G. Courbet

1. Probably the lady from whom Courbet had rented a room for his sisters.
2. The rest of the sentence is illegible.

To Jules Luquet [Paris, November-December 1867 (?)][1]

Tuesday

My dear Luquet:

I'll be happy to come over for lunch at your place tomorrow and I'll be happy as well to see my old friend Thoré.* The exhibition attendants have returned the paintings that were at the Exhibition. They want you to send my receipts to the administration. Please do so.

I'll be at your place at noon.

Sincerely yours and kind regards to your lady,

Gustave Courbet

1. The date of this letter is not certain. I suggest it may have been written at the conclusion of the 1867 Universal Exhibition in Paris, when Courbet had renewed his contacts with Théophile Thoré (see letter 67-16).

68-1 *To his family [Paris, January 9, 1868]*

Dear family:

You must excuse me for not having written you yet for New Year's Day. It is because we are not a family that writes every day. Yet there is great news in our family at the moment. You announce that my sister Zoé* is marrying M. Eugène Reverdy* and that Father and Mother are about to divide their property among their children.[1] Those are indeed welcome changes for everyone's peace of mind. It was irksome to see you burdened with all that farming and with the other burdens that it requires. Now Juliette* must marry. Zélie* and I will remain bachelors. She is not healthy enough to marry, and I have my art, which hardly allows marriage.

Father claims that he wants to celebrate his anniversary.[2] Aren't three marriages at once enough? Father has strange ideas, he would want four marriages at once for economy's sake. He also claims that, since I am the eldest in the family, I must be favored. That is too much! He has not left the Middle Ages. He would like to reestablish entails and nobility as if '93 had not overthrown those fine ideas.[3] Not only do I not want to be favored, I want in fact to be disfavored. And that is not because I owe my family anything because, though I spent more than the other children for my education, on the other hand, I have not shared in any of that same family's wealth for over twenty years, which more or less evens things out. Of course it is also true that parents are free, with respect to their children, to give them an education that is in keeping with their nature and ability and the potential they manifest to raise their family in society and thereby distinguish it. In short, these arguments that I present here are not raised by anything on your side. I know very well that you are not reproaching me for anything and that you three have always conducted yourselves quite decently toward me and that, in the event, I will always be able to acknowledge the spirit of that conduct if I can. Contrary to what Father thinks about this division, make my share up of everything you don't want and keep for yourselves the things that bring in immediate returns.

M. Reverdy did not show me Zoé's letters, I don't know what to write her. He said only that she was ill with a fever. I will write her. As for M. Reverdy, I do not know him. He tells me that he is a painter—I have never seen any of his painting—but he fortunately has another job; I don't know what it is, though he told me.[4] He is a tall, good-looking man who seems very quiet and suitable. He appears to be the same age as my sister.[5] I'll ask Mme Godin about him, she knows him.

Here I am deeply involved with the Ordinaire* family, which has been hit with a lawsuit filed against them by the Bidalot and Tripard families.[6] The pamphlet is extremely witty and well written. It is hilariously funny and so

clever that it destroys the people it depicts. They will never rise again, they have been killed by ridicule. That pamphlet will remain a thorn in those families' sides. It is an honorable act on the part of M. Ordinaire, who is a man who would like to save humanity in our part of the world—it is courageous. He was the only one who could do it. I'll place myself at his service in keeping with my earlier actions against the Bidalots, with respect to police commissioner Maréchal and Annette Bouvot's license.[7] Twice I have got the better of them at the prefecture. That will help Ordinaire, it is the same action. M. Proudhon[8] has returned Urbain's* letters to me. They must be in my atelier. In one of these letters is a copy of the one that I wrote to M. de Chevigné,[9] try to find it. If the lawsuit takes place, they will spread the scandal. The sharpest lawyer in Paris, M. Léon Duval,[10] will plead against M. Oudet,[11] who has been very dishonest with Ordinaire. We'll have a lot to laugh about. It is a pity that the newspapers will not be able to reproduce it.

I am sending Father a receipted bill from Annette Bouvot[12] because I think there is a mistake in it. If I owe another two hundred francs over and above what he has paid, he must compare the dates. I will send the money in the next few days. Now, I have only to wish you all a happy New Year, with heartfelt embraces. I hope Mother is well since you don't mention her. Let's hope that the pains will subside.

<div style="text-align: center;">*G. Courbet*</div>

Marie wants someone to write her. My manservant, Michel, is at Mazas awaiting judgment. He was stealing twenty-five to thirty francs a day. The cap has turned up again.

[Address] Monsieur Courbet, landowner
 Flagey
 Canton Amancey
[Postmark] Paris, January 9, 1868

1. Zoé Courbet and Eugène Reverdy had known each other since approximately 1856. On March 1, 1858, and on May 30, 1860, respectively, Zoé had given birth to two sons (Eugène-Jean-Charles and Edmond-Jean-Eugène), who apparently were fathered by Reverdy. It was not until August 11, 1868, that the couple finally got married. They officially recognized their two sons on January 9, 1869 (cf. Grimmer 1956, 3–10).

2. Régis Courbet and Sylvie Oudot were wedded on August 22, 1816, and consequently they had been married for more than 51 years at the time of this letter.

3. The radical Jacobin constitution of 1793 had abolished all feudal rights.

4. Reverdy had indeed been trained as a painter and he had exhibited at the Salons of 1847 and 1848. By the age of twenty-five, however, he had given up painting to become the curator of the art collections of the marquis de St. Denys (cf. Grimmer 1956, 7–8).

5. In fact he was two years older than Zoé.

6. Toward the end of 1867, Marcel Ordinaire had anonymously published a sixty-two-page pamphlet entitled *Une Election dans le grand-duché de Gérolstein* (An election in the grand-duchy of Gerolstein), which satirized conservative local politics in the Doubs Department. The pamphlet, supposedly translated from German by a fictitious M. Reynold, deals with the "hap-

piest country in the world," the grand-duchy of Gerolstein, situated between Austria and Prussia. Ruled by Duke Yéri-Dumm XXV, whose male descendants will succeed him "until the end of the world," the duchy has a constitution that guarantees the people all liberties that are compatible with public order. As Courbet reveals, in this and other letters, the pamphlet was especially directed against the Bidalot and Tripard families. A Bidalot was mayor of Ornans during the 1860s, succeeding the popular Prosper Teste, who had been mayor from 1825 to 1861. Tripard's identity remains vague. The precise cause of Ordinaire's attack is not known.

7. Courbet had himself been embroiled with Bidalot, when the latter served as mayor of Ornans (cf. letter 68-8, n. 1).

8. Probably Hippolyte Proudhon (1807–86), justice of the peace at Ornans and the brother-in-law of Urbain Cuénot,* who had died on January 11, 1867. It is not clear what letters Courbet refers to here, but it would seem, from the context, that Proudhon returned the letters Courbet himself had written to Cuénot.

9. See letter 65-13, n. 2.

10. Léon Duval (1804–78), a well-known lawyer in Paris who was especially sought after by actors and society people (not to confuse with Charles Duval,* Courbet's attorney in the 1870s).

11. Gustave Oudet (b. 1816) was a left-wing lawyer in Besançon.

12. Perhaps for the dinner referred to in Courbet's pamphlet *Opinions et propos d'un citoyen d'Ornans*. See letter 68-8, n. 1.

68-2 *To Pierre Dupont [February 1868 (?)] (incomplete draft)* [1]

. . . Make no mistake, life is cruel. Like me, you have seen Homer, Rembrandt, and associates, all tamers of wild beasts, dogged, some by editors, Maecenases, directors of the Fine Arts Administration, others by Englishmen—dogged, I say, so as to be present at their deaths. The man who cannot do anything seeks to enjoy the work of others.

Oh, my dear Dupont! How far away that time is from us. We were young, we believed in everything. We were [living] in a republic, we thought that freedom was upon us. To our imaginations, everything was a fairy tale. We believed in love, we cried over unfaithfulness, we were slim and easily pleased with a good meal. Our needs were modest: good shoes and a white linen coat; a wide straw hat; a woman in short petticoats, with a fichu and bareheaded; a three-franc umbrella in hand more than fulfilled our hearts' desires. And all week our thoughts were full of the picnic we would have on Sunday in the Meudon and Fleury woods, at the Bazin farm, at Plessis-Piquet; and of the dinner we would have at the tavern "Au coup du milieu." Our gang was then at its most complete with Monselet,* Champfleury,* Murger,* Baudelaire,* Bonvin,* Gautier,* etc., etc.

But tossed about and worn by the hard life that we have had to endure, all those dreams have slipped away with age, and soon we will be condemned to build our future on memories. . . .

1. The letter has been dated 1869–70 by Lindsay (1973, 285), but it was probably written in the early months of 1868, around the time that Courbet painted Dupont's portrait (F. 654). Perhaps the letter is identical with the "short story . . . for Dupont, who is so unhappy," mentioned in letter 68-3.

To Max Buchon [Paris, February-March (?) 1868] 68-3

My dear friend:

Ordinaire's* pamphlet[1] is very powerful, it opens up a new course. With this mode there is no more need for novels. Realist stories, laced with philosophy and socialist politics, will be a positive substitute for the worthless hackneyed novel. I could do ten books like this, if someone helped me.

But Ordinaire has one fault: he does not want to deal with the Proudhonian question, which he has stubbornly refused to examine, out of loyalty to Fourier.[2] Nevertheless, he is wavering at the moment, Paris has done him good. He sees new horizons. The social problem should be dealt with squarely, even the mayors should be abolished and replaced with presidents of municipal councils. It is easy to understand today—as I already said some time ago—that the reason that one can no longer find mayors is that they have become outdated: no longer can one man, even Napoléon, fulfill people's wishes.

Ordinaire's pamphlet has made an enormous impression, even in Paris. It is very well written and very courageous. By way of combat weapon, I had nominated him in the [] for the Chamber for the first elections. Whether he succeeded or not did not matter, it was meant as an antithesis. But it was declined by the family. They claimed that it could be interpreted as a scheme underlying the idea for Ordinaire's pamphlet. I can't see that, but I'll postpone the idea till later, especially as he is well positioned, having sworn a mayor's oath to Napoléon.[3] The step has been taken, it does not commit him to anything. I believe that if he is clearly nominated, he will succeed.[4] He stands for the positive and organizing principles of life. That is what he does, and we'll have a deputy who thinks like us, instead of a Montalembert or a Conegliano.[5] Think about all this, but write, shake that provincial torpor. Thank you, I received your book of poetry.[6] I have just written a short story too, for Dupont,* who is so unhappy.[7]

 [*no signature*]

1. *Une Election au grand-duché de Gérolstein.* See letter 68-1, n. 6.

2. Courbet found Ordinaire old-fashioned for following the precepts of the social reformist thinker Charles Fourier (1772–1837) rather than the ideas of the younger and more progressive Pierre-Joseph Proudhon.*

3. Ordinaire was mayor of Maizières during most of the Second Empire period.

4. Ordinaire, in effect, became a deputy of the Doubs Department in 1869 (cf. Mayaud 1986, 218).

5. Comte Charles de Montalembert (1810–70) and Marquis Charles-Adrien-Gustave de Conegliano (1825–1901) were deputies of the Doubs between 1848 and 1857 and between 1857 and 1869, respectively.

6. Perhaps the new, expanded edition of *Poésies franc-comtoises, tableaux domestiques et champêtres*, which came out in 1868.

7. Probably a reference to letter 68-2.

68-4 *To his family [Paris, spring-summer 1868]*

Dear family:

It seems that it is not easy to get married, even under the most normal of circumstances.[1] Will all the formalities never end? M. Reverdy has received only one consent, and Muselier, the notary, has not sent us a proxy, as Father said he would in his letter, and without that document we cannot prepare the contract from the draft that Father was to finalize with the notary.

Yet the contract is very simple. It consists of saying, "I promise to divide my property among my children and to guarantee her part to my daughter Zoé." He can decide whether that suits him and when he will effect the division, the notary will help him. That is all. As for the other things, he can do them on unstamped paper between himself and M. Reverdy. It is not necessary to make those trifles public. Write up the proxy as soon as possible for there is no end to this.

They say that a large aerolite has fallen in Flagey. M. Marcou* came to ask me if he could have a fist-sized piece of it to analyze and deposit with the Academy of Sciences.[2] Father should find out from Roussel [?] and send it to me by the stage coach.

I embrace you all and look forward to the pleasure of seeing you and the newlyweds.

<div align="right">G. Courbet</div>

1. Reference to the marriage of Courbet's sister Zoé to the painter Eugène Reverdy.* The wedding took place on August 11, which provides a date *ante quem* for this letter.
2. On Courbet's contacts with the well-known geologist Jules Marcou, see Brooklyn (1988, 58–59).

68-5 *To Alfred Bruyas, Paris, February 7, 1868*

<div align="right">Paris, February 7, 1868</div>

Dear Alfred:

We are bound by our feeling for art. When such bonds happen to occur, they are unbreakable. It is the will of nature herself. Besides, even if we had met under different circumstances, our bond would have existed just the same. Your chivalrous and loyal nature, inclined toward the good, would have

been sympathetic to me. How I regret not being able to spend more time with you. You know, I loved having you nearby, we talked so well together. I supported you in your actions. You know that I am not a spoiled child because society has taken it on itself to educate me harshly. Oh, what torments and disappointments I have already known. What a nature one must have been given to resist such unrest! Oh well, one gets used to everything. These torments finally become a necessity, a need. When one has renounced happiness and the enjoyment of tranquillity, one makes it up in duty.

I cannot cease telling you, at the risk of boring you, how important you were to me when you came to the rescue of the freedom that I stood for. I was starting out without means. I will never forget the lift you gave me.[1] My situation as regards society is still the same, except that I broaden my manifestation every day. This year I had an immense exhibition in the most beautiful part of Paris. I would have liked it to be permanent, but alas, we must tear it down.[2] How sorry I am. Again I won't have achieved my exhibition, my permanent museum yet. Nevertheless, I hope to attain that during my lifetime.

At the moment I am involved in a ridiculous business: I am after some thieves. I am trying to retrieve the paintings that have been stolen from me everywhere. Yesterday two that were stolen from me in London were sold at the auction hall. They were sold for forty-five hundred francs. It is hard to see that money go by without being able to touch it. The man who ran my show has been sentenced to two years in prison.[3] They estimated that he took four or five thousand francs from me.

Please accept my warmest regards and believe me to be your most loyal friend, as always,

<div align="center">

Gustave Courbet

</div>

1. By acquiring the *Bathers* (F. 140) and the *Sleeping Spinner* (F. 133) at the Salon of 1853, Bruyas gave Courbet a major break at the beginning of his career.

2. In fact, Courbet's pavilion was not torn down, and Courbet reopened his exhibition in May 1868 (cf. letter 68-12).

3. Nothing is known about this incident.

To Edouard Ordinaire [Ornans, March 1868 (?)] (draft, fragment)[1] 68-6

My dear Ordinaire:

You know our Franc-comtois meals. The simplest ones last six hours, and the conversations are random, crossing and interlacing wantonly. One person speaks to his neighbor, another to the person across, a third appeals to a dinner guest at the other end of the table. Everyone shouts at the top of his lungs, it is a jumble of words. Some say, "His honor, the mayor this," others, "His honor, the mayor that," or else, "The reverend fathers this," "The rev-

erend fathers that." And everyone bases his argument on a heartfelt story, like the one about the priest of Bonnevaux or the one of Guyans-Durnes.[2] I was within earshot of an imaginative chorister who told, very humorously, the story of the priests of Scey, which you know. You were even mixed up in it (the story as it was told), in the train of all those Christians of primitive and fabulous churches. He went on very picturesquely, asking everyone to vote on the building of Our Lady of the [] in order to expand the country in that direction.[3] "But," he said, "on one condition, and that is that the town have nothing to do with it and that only individuals will contribute," giving as his reason that it would be a more efficient way to poll the people with whom one lived than universal suffrage. So he started the contributions, and in his hat he found ten francs, which we gave to the waitress. He thanked the company and ended by saying, "After all, if one day I am to go to Paradise, I would not like to meet all those church builders and hobbling pilgrims there. If I met them in hell I wouldn't care to be with them either." We drank the speaker's health and asked for a local country song. A chorister from Ornans got up and sang an improvised song in the local dialect:

> The Lovers in the Village.
>
> On Sunday after vespers,
> In the evening after supper, (Bis)
> When I went there for a walk,
> I saw a shining light.
> It came from my sweetheart,
> Who was going to rest (Bis)
>
> Good evening, my love, good evening,
> Are you already in bed? (Bis)
> A month ago, six weeks ago
> Already I talked to you of this.
> Open your door for me
> Sweetheart, if you love me. (Bis)
>
> I won't open my door
> In the midnight hour. (Bis)
> My father and my mother
> Are sleeping in their beds.
> Come see me tomorrow
> Boy, if you love me. (Bis)
>
> I am wet from the rain
> In water to my knees. (Bis)
> Can't I have, sweetheart,
> A few words from you?
> Open your door for me
> So I won't get wet. (Bis)

My father's coat
Is in our rooms upstairs, (Bis)
I will get it for you.
Go stand on a high spot
So that you won't get wet,
So you won't get wet

Your father's dogs
do nothing but yelp at me.
They tell me in their language,
Boy, you're wasting your pains,
Boy, you're wasting your time,
Boy, you're wasting your time. . . .

1. This incomplete letter and the following (68-7) appear to be drafts for a printed letter in support of Edouard Ordinaire's pamphlet *Une Election dans le grand-duché de Gérolstein* (cf. letter 68-1, n. 6). Courbet eventually was to mail these drafts and/or other similar ones to Max Buchon, who reworked them into a ten-page manuscript, now in the Musée Gustave Courbet in Ornans. See also letter 68-8.

2. Bonnevaux, Guyans, and Durnes are three small villages in the Franche-Comté not far from Ornans.

3. The village of Scey was located near Ordinaire's home in Maizières. In 1803, a young peasant girl had miraculously discovered a terra-cotta statue of the Virgin inside the bark of an oak tree near Scey. Later a chapel was built nearby, called the Notre-Dame-du-Chêne, or Our Lady of the Oak Tree, which became an important pilgrimage place. The real or fictitious chorister in Courbet's letter mocked the priests who promoted the pilgrimage traffic by suggesting the building of another pilgrimage church, the name of which can unfortunately not be read conclusively, but which must have been a pun: Notre-Dame-des-meules ("of the haystacks"), des-môles ("of the moles"), or des-mules ("of the mules").

To Edouard Ordinaire [March 1868 (?)] (draft, fragment) [1] 68-7

My dear O.:

So it was you who wrote that charming pamphlet *Une Election dans le grand-duché de Gérolstein*.[2] You rascal, I caught you! You too want to preserve honesty and morality in the happy valley of Seligenthal. You revolutionary, you too respected the unclouded serenity that once reigned in that fertile valley and among its so united inhabitants.

It is just like you, unbelieving Sacripant, fanatic socialist! Could it be that the proximity of the Amancey highlands and the memory of Vercingetorix has launched you along that dangerous road? Or might it be a return of your youth, Virgil's *Eclogues*, with its happiness in mediocrity? Or then again, could it be the hatred you feel toward private interests, toward parvenus with neither convictions nor principles?

Who could have caused you to deny the shameless new ways of getting rich or of choosing that need for phony importance, impudence, lies, and

ignorance. Who is trying to get ahead of you? Who could have exasperated you like that?

You are getting old, my friend, the times are passing you by. Since you have the audacity to go against the majority, well, I get the impression that you are a rebel, someone who disturbs the existing order. I think one would do well to convict you.

And yet, I have here this pamphlet; I have had rebels and reactionaries, even partisans of the current regime, read it, and I don't know how it is possible, but everyone finds it good. There are some who go even further and find it splendid, well-written, subtle, intelligent, clever, full of decorum and reason, and what have you. That shakes my hasty condemnation so much that I take it back, for I have never seen so many diverse opinions converge without opposition. I take it back, first of all, because, even if you had not always enjoyed my complete esteem and respect, I would eagerly seize this opportunity to grant you them. Second, because if I think carefully and go back into the past, I happen to find myself in exactly the same position as you with regard to those very same people, if indeed it is Messrs. Bidalot,[3] senior and junior, whom you intend. . . .

1. See letter 68-6, n. 1.
2. See letter 68-1, n. 6.
3. See letter 68-1, n. 6.

68-8 *To Max Buchon, Paris, April 2, 1868*

Paris, April 2, 1868

Dear Max, my dear friend:

I am sending you a pamphlet,[1] written in my abracadabra fashion. It was impossible for me to do it the way I wanted to: all the Ordinaires were against it,[2] not to speak of those who sided with them. The Ordinaires now have a nymph Egeria in Mme Ordinaire. The rally is complete, and Ordinaire is a martyr. It has been impossible for us to put in a single word about the priests, or even about Montalembert.[3] This is all the more regrettable as women should concern themselves only with cabbage soup and housekeeping. In the end I had to give in to them since, despite my attitude, I was writing it to be agreeable to them and to support Ordinaire's heroism.

I have submitted this pamphlet to two publishers in Paris. There is such a panic here that they refused to publish it. I turn to you, my dear [friend], to have it published for me in Switzerland. We'll have the packages sent to someplace in Morteau or Pontarlier, to Chopard* or Joliclerc,* and once they are there I have a publisher in Paris who'll go to Switzerland and who has taken it on himself to sell them in Paris to all the booksellers and publishers of France. They tell me here that what I have written is very amusing and

bound to be a success—I hope so. I must say that in Paris there is absolutely nothing new, consternation prevails. Send this manuscript either to Thomas[4] in La Chaux-de-Fonds or to Neuchâtel, but as soon as you can. Go through it, revise it to your liking according to the custom of the country and of literature. In a word, turn it into something, as you know how to do, you who write so clearly. I wrote it in twelve hours by dictating to Olivier Ordinaire,[5] who was my secretary, and it has taken us one and a half months to transcribe it owing to the terror of the Ordinaire family. We must predate it, it is useful for the trial. A lot of things are missing that I could not put in because I have too much work and I wrote it under difficult conditions. I would like you to insert a phrase to decry the Proudhon family of Ornans.[6] In it you should use above all the word "faint-hearted," making it clear that all evil comes from those people. They are arrogant people who have to be put in their place. You could put that in the speech that I make to Ordinaire. String together any little shafts that you may find here and there. Imagine they made me cut out half of my arguments: I had talked about Notre-Dame-du-Chêne[7] and others, about the peasants and the new law, and about the lawyer Grandjacquet[8] farting on the priest who was taking his confession. It's a pity, that last witty remark of his was charming since he could no longer speak through his mouth. I hope, my dear Max, my dear cousin, that you will follow suit and write one yourself on the authorities, and that you, too, will come to the rescue. What has been done to Ordinaire is infamous, we must act cleverly and say more about it than he. What they have made me take out could fill a volume of the same size. As soon as you have read it, write me. I embrace you, and your wife as well.

<div style="text-align:center">*G. Courbet*</div>

I'll send you the necessary money as soon as you or he ask me for it. I think that this pamphlet will delight the whole country. They are in a state of excitement that is difficult to describe. Our friend Oudet is a scoundrel, and Justice Proudhon declines to give an opinion.[9]

1. Courbet's draft for the pamphlet in question, *Opinions et propos d'un citoyen d'Ornans*, is not known, but Buchon's corrected version, a ten-page manuscript, is currently in the Musée Gustave Courbet in Ornans. A transcription of its text may be found in the *Bulletin des amis de Gustave Courbet* 51 (1974): 11–23. The pamphlet, entirely in Buchon's handwriting, describes an incident, which must have occurred in 1863 or 1864, in which the mayor of Ornans, Bidalot, had tried to prevent the customary dinner after the annual concert of the Ornans chorale under the direction of Urbain Cuenot.* Just before dinner was to be served, Bidalot sent police officer Maréchal, who threatened Mme Paillot, the owner of the hotel where the dinner was to take place, that he would withdraw her operating license if she served the members of the chorale any food. Thus, in the last moment the chorale had to find another location. On the outskirts of Ornans was the restaurant of Annette Bouvot, who agreed to prepare an improvised meal.

After describing this incident, which no doubt had a powerful political dimension (a Bonapartist mayor vs. a politically liberal chorale), the pamphlet goes on to praise the accom-

plishments of the Ornans notary Grandjaquet, who had personally initiated a number of civic projects beneficial to the town of Ornans. In the end, the pamphlet expresses the wish for less government and more personal initiative, after the example of Grandjaquet, for whom Courbet proposes to erect a bust in his garden on the rue de Besançon, next to the bust of Pierre-Joseph Proudhon.*

2. Courbet's brochure was written as a follow-up to Ordinaire's pamphlet *Une Election dans le grand-duché de Gérolstein* (cf. letter 68-3). Since Ordinaire's name was mentioned in it, Ordinaire had reason to be concerned with Courbet's text.

3. Count Charles de Montalembert, deputy of the Doubs Department between 1848 and 1857.

4. See letter 68-9.

5. One of the sons of Edouard Ordinaire.

6. Perhaps the family of Hippolyte Proudhon (1807–86)?

7. Indeed, the material on Notre-Dame-du-Chêne, which is found in draft form in letter 68-6, is not present in Buchon's corrected version of the pamphlet. No doubt Mme Ordinaire, who had strong connections with the priesthood, had forced Courbet to eliminate all references that could be construed as anticlerical. On Notre-Dame-du-Chêne, see letter 68-6, n. 3.

8. Grandjaquet, who had been notary of Ornans during the July monarchy, was held up by Courbet as an exemplar of private initiative in civic affairs. Courbet hailed such private initiative, which he opposed to the forced apathy of citizens under a monarchic, centralized government. Though a whole section of Buchon's corrected brochure deals with Grandjaquet's accomplishments, the story about the notary's fart in a confession box has been eliminated, again probably on the request of Mme Ordinaire.

9. The role of the lawyer Gustave Oudet (see also letter 68-1, nn. 8, 11) and the justice Hippolyte Proudhon in this affair is not entirely clear.

68-9 *To Max Buchon, Paris, April 9, 1868*

Paris, April 9, '68

My dear Buchon:

We are all very touched by your concern for us. As you are the authority in these matters, we are obliged, despite our valor, to give you full and complete control, for we feel that, were some misfortune to occur, you would be the first casualty.

According to you three alternatives present themselves. One is to cut anything that might be open to attack—that is, a third of the pamphlet[1]—and simply publish it in France. The second is to publish it in Switzerland, written in the third person, and maintain anonymity. The third combination would be to publish it in a small-print edition, as you usually do—with the result that my mother has never been able to read a word of your works, even with her glasses, and that many people have, like her, shrunk from the difficulty.

I lay no claim whatever to the title of man of letters, for one excellent reason: I am so little versed in these matters that, when I write something, I do not rightly know whether it is good or bad. Nonetheless, this kind of new novel seemed to me to be important. Getting away from art for art's sake, it

made the writer a more complete human being. I believe you have always felt that way. Your writings have always included a political element, as well as moral, literary, pictorial, historical, and other elements. It is a general tendency that is becoming useful these days.

To get back to the pamphlet. If you think that the third person is an effective safe conduct, put me in the third person but have it printed like Ordinaire's pamphlet. The format is pocket-size and legible as well. If I understand what you want to say, it would be just an ordinary citizen of Ornans who is supposed to be telling the story (that seems implausible to me). If there are only a very few things to be cut, as you say, for it to be witty, I can still accept the role of a witty man. If then, with minor limitations, we can print it in France without danger, that would perhaps be the best.

As for Thomas, he is the former printer from Pontarlier who was exiled to Switzerland at the same time as you and who settled in La Chaux-de-Fonds or Verrières. I don't absolutely insist on him. I like Fribourg just as much. What I would do would be to make sure that Morteau[2] could pass me as many pamphlets into France as I would want. Perhaps a day will come when we will be able to publish the unabridged text in a revised edition. I embrace you as well as your wife.

Say hello to our friends. My paintings will make a great sensation at the Salon. I believe I told you the subject, the *Alms of a Beggar* [F. 660].

<div align="right">Gustave Courbet</div>

1. Courbet's pamphlet, *Opinions et propos d'un citoyen d'Ornans*. Cf. letter 68-8, n. 1.
2. A town in the Doubs department, located near the Swiss border. Courbet had many friends in Morteau, including the brewer Alexis Chopard, who was the director of the local musical societies.

To Max Buchon [Paris, mid-April (?), 1868] 68-10

My dear Buchon:

My writer friends are familiar with the pamphlet[1] that Castagnary,* Pothey,* etc. read in public. Even several people from Besançon attended the reading. I believe the best thing to do is to confront the situation and sign the pamphlet. It is not so much that I want to be known as a writer, as I have already told you, but that the pamphlet will be more apt to be prosecuted if it is attributed to others than myself. Take yourself, for example, you would certainly be accused, and you would be nabbed in my place. You nearly were for Ordinaire's* already.

Don't say that I have not been able to find a publisher in Paris, that sounds bad. Say instead that it is because I have printer friends in Switzerland and that out of friendship I turned to them rather than elsewhere. It seems that there are cantons in Switzerland where there are libel laws and others

where there are not. Chaudey* claims that that of Neuchâtel is in the latter category.

I believe, therefore, that it is definitely better that I sign it and that you take out, as you did in the first part, the things that are unconfirmed. For Grandjaquet's[2] sake, for example, you could say that his power was so extensive that he had forbidden the people to greet a certain man from Ornans and that that rule has been observed even though the man has since served in an official capacity, without specifying Bidalot.[3]

This whole business must be extremely annoying for you, and wearing as well. I am very touched by the trouble you are giving yourself and by the interest you are taking in all this.

I am still for a format like that of Ordinaire's little pamphlet. Later, if I am inspired to illustrate it, it will be more convenient, whereas with your idea, we would have to print a new edition. We should not worry about a hundred francs or so.

As for the Justin Chaillet[4] business, the style must be grotesque: a way of talking full of "we arrived," full of "we were," "we went," "we saw"[5]—I imitated his way of talking on purpose. Change it back to the first person. I embrace you,

<div align="right">*G. Courbet*</div>

We will do another volume later. I have notes all ready on various subjects.

Don't apologize!

1. *Opinions et propos d'un citoyen d'Ornans.* See letter 68-8, n. 1.
2. On Grandjaquet, the notary praised by Courbet in his pamphlet, see letter 68-8, nn. 1, 8.
3. The mayor of Ornans (1861–70) and the person against whom the pamphlets of Courbet and Ordinaire were directed.
4. Courbet's pamphlet relates, as an example of the wisdom of former Ornans mayor Prosper Teste, the story of Justin Chaillet, a local physician. Chaillet had caught a vintner who was cutting some willow branches on his land. He took him before the mayor, who invited thief and victim for dinner. After they had had a good time together, the mayor condemned the victim (!) to have supper with the thief as well.
5. The verb forms are in the *passé indéfini*, a past tense that is used in literature but that sounds stilted in spoken French.

68-11 *To Max Buchon, Paris [late April, 1868]*

<div align="right">Paris, Monday</div>

Dear Max:

I am in despair about everything that is happening and about the terrible problems caused by this pamphlet.[1] I am extremely vexed about all the trouble you have gone through, especially going about it heart and soul as you did.

You must have worked at it day and night, and I assure you that I am very hurt by all this. Excuse me for my part, but I am not in this alone. The Ordinaires* rule the roost, and rightly so, up to a point, as it was written for them, only in the hope of doing something to please them and so as not to let the people currently in power eviscerate a courageous man. If you believe the Ordinaires' tittle-tattle you are going about things backward. There are two sides to the Ordinaires: the revolutionary and the clerical. It is the latter that governs and that has caused so much trouble and limitations of all kinds— pride, fear—that Ordinaire has gone mad in the end and has resorted, as I can see you have been told, to a violence that made him lose all dignity. Without me, there would have been a disaster, the other man was beginning to show the whites of his eyes. I have my own way of supporting my friends. But I have already found myself once in a precarious situation like this between him and Briot, so I don't know what to think. On his own he is charming, but the moment his wife or his children are involved, he loses his reason. That is understandable.

What is not understandable is that you could believe for an instant that anyone here could doubt your talent. Pierre Denis[2] read your poems aloud and declares himself your admirer. As for the Proudhon affair, this is how it went. It was eight-thirty at night and we had to go to dinner. Pierre Denis was writing the Grandjaquet story from my dictation. At the end I said, "It is too late to finish it for I must relate G.-Jaquet's action to his Proudhonian leanings." At that point I dictated four paragraph topic sentences to him so as not to forget them, and he said, "I'll take them with me if you want, I can even write out the full text for you, as I do that all day long for the papers. It is my specialty and I can do it faster than you. You can see whether it was what you wanted to say." I agreed with what he had done.

My dear Max, like you, Denis has taken infinite pains. He transcribed the entire pamphlet from an illegible manuscript written by M. Olivier Ordinaire[3] who prides himself on that indecipherable handwriting. It was annotated by Castagnary,* which made it an even bigger mess. The Ordinaires just played an incomprehensible trick on me. They invited me to dinner to patch things up again and at the end of dinner, at which there was a priest—always priests—they announced that the manuscript annotated by Castagnary had been burned. I was appalled. They are frightened to the point of insanity, it is worse than Mme Paillot.[4] I do not know whether it is true, but one way or another, it is amazing. He is lost to me. Here you have something that started with a laugh and that is ending in tragedy. I'll tell you more about it another time. Someone is waiting for me. Before you believe anything, write me. I embrace you with all my heart, as well as the mother of Realism.[5]

G. Courbet

Chaudey* has just come in and wants me to send you his warmest greetings. He is upset, as I am. I received your pamphlet in the mail. Thank you.

1. *Opinions et propos d'un citoyen d'Ornans*. See letter 68-8, n. 1.
2. Pierre Denis (d. 1907), journalist with strong Proudhonian leanings, who contributed to such papers as *Le Nain jaune*, *Le Courrier français*, *Le Cri du peuple*, and *Le Combat*.
3. One of the sons of Edouard Ordinaire.
4. Owner of the Paillot hotel in Ornans. Compare letter 68-8, n. 1.
5. Mme Buchon.

68-12 *To Jules Castagnary [Paris, April 28, 1868]*[1]

Tuesday evening

My dear Castagnary:

Please try to come tomorrow during the day, or the day after tomorrow in the morning, to see what I have just finished painting—female nudes.[2] I will reopen on Friday, May 1,[3] and I need something published. I am going to order posters, I am already too late.

Sincerely yours,

G. Courbet

1. The letter is dated April 29, 1868, in Castagnary's handwriting, but as the twenty-ninth fell on a Wednesday and Courbet's letter was written Tuesday evening, its actual date must be April 28.
2. These may have included F. 627, F. 628, F. 629, F. 631.
3. In May 1868, Courbet reopened his private exhibition at the Alma rond-point (cf. Mainardi 1987, 188 and 224, n. 7).

68-13 *To Jules Castagnary [Paris, May 12, 1868]*

Monday night

My dear friend:

At last Th. Gautier* has come unhinged![1] This definitely announces the end of Romanticism, as he himself explains. It would be too cruel to stop a cat from miauling when one steps on its tail.

His official command column is illogical from beginning to end (so it was worthwhile abandoning Romanticism in favor of Realism, that is splendid!). In drawing, the Romantics are no experts. In aesthetics, only the Romantics ignore it by nature and on principle, and that is the weapon with which I killed them.

When M. Gautier says that my name no longer causes any reaction, he is deluding himself, for at the height of the furor, no one ever wrote as violent an article on me as the one he has written now. The Romanticism and the Classicism of the administration are dying. The rage will reach a paroxysm. It is wonderful.

I have just sold M. Boucicaut[2] (the firm "Bon Marché" in the rue du Bac) the *Roedeer on the Alert* [F. 623] for four thousand [francs]. That comes just in the nick of time.

The splendid Mme Cassin, collector of paintings, has just written to compliment me on the *Poor Woman* [F. 550]. She maintains that the painting shows a perfect delicacy. I have answered her.

Take heart, all goes well.

<div align="center">

G. Courbet

</div>

Gautier announcing the death of Romanticism, it is amazing! It is Jehovah's cry, "To me, Father."

1. Théophile Gautier had reviewed the 1868 Salon in the *Journal officiel* of May 11, 1868. He was especially critical of Courbet's *Alms of a Beggar* (F. 660), which he referred to as a "muffled gunshot" (cf. Riat 1906, 260–61).

2. Aristide Boucicaut (1810–77), a progressive businessman, was the co-owner, later sole owner, of Au Bon Marché, which he expanded from a boutique into one of the first department stores in France.

To Etienne Baudry, Paris, May 18, 1868 68-14

My dear Baudry:

As your book has just come out,[1] I would like you to send me a few copies so I can give them to the press of the Latin quarter and also to the newspapers in my part of the world, and to my family too.

Please return the drawings to me[2] as I want to look at them again. I find them incomplete and I don't want to see them appear anymore with my signature in this sorry state and so badly reproduced. Above all, I don't want M. Dentu[3] to have them, especially in this condition. I have to tell you all this in order to do myself justice and escape criticism as much as possible.

Sincerely yours, my dear Baudry,

<div align="center">

Gustave Courbet

</div>

Return the drawings to me as soon as possible.

Paris, May 18, 1868

1. Etienne Baudry's *Le Camp des bourgeois* (1868), for which Courbet had drawn the illustrations.

2. Only five of the twelve drawings for *Le Camp des bourgeois* have been preserved (cf. Chu 1980b, 82–83).

3. Edouard Dentu (1830–84), the publisher of *Le Camp des bourgeois*.

To M. Vivet [Paris, July (?) 1868] 68-15

M. Vivet:

I would like you to have someone represent me tomorrow, Thursday, at the town hall before the justice of the peace. I have not had time to attend to

this matter, and M. Andler* wants me to trust his claim and pay him in full, without giving me a detailed bill.[1] Moreover, in the note that he sends me, the figure seems excessive. I'll fill you in when the time comes. I am not at all refusing to settle this long overdue bill with M. Andler, but so far he has not been able to give it to me because it lacked a breakdown of the items.

<div align="right">G. Courbet</div>

Please do whatever is necessary in the case and ask for [a delay of] two weeks for I must have my papers sent from the country.

> [Address] M. Vivet, attorney
> 5 rue du Pont-de-Lodi
> Paris

1. On the lawsuit between Courbet and Andler about unpaid debts, see letter 68-16. See also Lindsay (1973, 230–31, 236).

68-16 *To Gustave Chaudey, Paris, July 8, 1868*

<div align="right">Paris, July 8, '68</div>

My dear Chaudey:

You must have received the dossier of my Andler* suit from my attorney, M. Vivet.* M. Vivet has notified me that the case is coming up the day after tomorrow, July 10, in the third chamber of the court.

You will find in the dossier a copy of the bill produced by Andler. I have quite a few observations to make about this bill, which is a statement of my account at Andler's from 1855 to October 1863.[1] It lists my expenses month by month without details or specifics that could help me verify whether it is correct.

The total of my expenses amounts to 7,153.35 francs, from which Andler has subtracted a lump sum partial payment of 3,500 francs, which leaves me owing him 3,553.35 francs.[2] I knew that I had an outstanding account to settle with Andler, but I was far from believing that it was such a large sum. I really have grounds to cast some doubt on Andler's bookkeeping and I would very much like to see him hand over his current books.

I took my meals at Andler's place for a long time, it was in a way my boardinghouse.[3] I can safely say that I even contributed somewhat to bringing this establishment into vogue.[4] I thought that I was dealing with them entirely in good faith, I let them keep a record of everything, write down everything, without ever verifying anything, and when I gave them money I never thought of getting a receipt for it.

I am unable at this moment to contest the figure of the outstanding account indicated on the bill, and I am not even thinking of doing so, in view of the fact that I have paid only thirty-five hundred francs, but am I not justified in asking that I be informed about my total expenses?

Several of my usual table companions have told me that every time that I sat down at a table in that establishment, they called it "M. Courbet's table" at the cashier's desk, and whatever the various people who came to sit with me consumed was put on my bill, if they did not know whom else to charge it to.

You will agree that, even though that is a generous and convenient way to simplify the bookkeeping, I could certainly have something to say about it.

I realize that it often happened that I had friends to lunch or dinner with me, but though it is right that I pay for my guests, whom I was always very careful to identify as such, I do not accept that I was therefore allowed to keep an open board for everyone and that today I have to foot the bill for all the clients in my immediate surroundings whom no one knew.

I am quite convinced that in that respect M. Andler has overextended my responsibility. I remember one time in particular that I was in the billiard room unbeknownst to Mme Andler when I heard her ask one of the waitresses in the adjoining room, "Whose are the eight large glasses of beer left on that table?" The waitress answered, "I have no idea but they were gentlemen who were with M. Courbet." "And where are those gentlemen now?" "They're gone." "Oh well," replied Mme Andler, "M. Courbet is already down for five large beers, I'll add those eight as well, for I cannot take a loss." I then stepped out of the billiard room and made an observation, which was no doubt heeded, but you understand that with that way of doing things, my account could get very much expanded when I was not there.

I have another reason to doubt M. Andler's bookkeeping a bit. If I can believe the reports that have reached me from various sides, several of M. Andler's bills have given rise to disputes following which he has had to consent to sizable reductions. That does not tend to give me complete confidence in the bill that he is presenting to me, and I insist on asking that he produce his current books so that I can examine the details of my account a bit. I would be very surprised if after such an examination I did not come to the conclusion that I owe Andler no more than fifteen or fourteen hundred francs.[5]

There, my dear counsel, is some information that I have to give to you about the Andler business, and I leave it to you to use it in my interest.

Cordially yours,

G. Courbet

[Address] M. Chaudey, lawyer
 50 rue Neuve des Petits-Champs

1. Courbet had avoided paying his outstanding debt to the Andlers since that time (cf. Lindsay 1973, 231).

2. Courbet's arithmetic is faulty. In reality, he owed Andler 3653.35 francs.

3. Courbet had frequented the Andler Keller between 1848, the year he moved to the rue

Hautefeuille, and 1863, when he began to visit the Brasserie des Martyrs and the Pension Laveur instead.

4. This is no exaggeration. The Andler Keller owed its popularity largely to Courbet (cf. Delvau 1862, 3ff; and Schanne 1886, 295–302.

5. Though the court considered the possibility that Courbet had been charged for the consumptions of others, his debt was reduced only slightly, to 3,000 francs, in view of the long period it had been outstanding (verdict of April 16, 1869). See Lindsay (1973, 236).

68-17 *To Jules Castagnary [Paris, August (?) 1868 (?)]*[1]

My dear Castagnary:

M. Parvilet had invited me to his home with you. I forgot to take his address when I left home, so that I am obliged to go back, as his address is not in the *Bottin*. However, I would like very much to see you, I have a letter that I want you to read. I'll expect you tomorrow, Saturday, at Laveur's* at 7 P.M.

<div style="text-align:right">G. Courbet</div>

1. The date of this letter is difficult to ascertain. It must have been written in the late 1860s, when Courbet frequented the Pension Laveur. Courbet states that he wants to consult Castagnary on a letter. This may be his letter to Lacroix of Friday, August 21 (68-18), concerning matters of copyright. As Castagnary was a lawyer, Courbet may have wanted him to read the letter before he sent it off. If that were indeed the case, the present letter must likewise date from August 21, as it was written on a Friday.

68-18 *To Jean-Baptiste-Marie-Albert Lacroix, Paris, August 21, 1868*

<div style="text-align:right">Paris, August 21, 1868</div>

Monsieur Lacroix, publisher
15 boulevard Montmartre

I will abide by the conditions expressed in your letter of August 19[1] relative to the printing of two pamphlets, *Les Frais du culte* and *La Conférence*.[2] This agreement will have a term of five years.

It is understood that my paintings and drawings can be reproduced only for the pamphlets, which leaves me the right to exploit the reproduction of my own paintings and drawings in formats unlike the one that I have granted to you.[3]

Respectfully,

<div style="text-align:right">G. Courbet</div>

32 rue Hautefeuille

1. The text of Lacroix's letter was first published by Robert Fernier (1968, 7) and reads in part:

We commit ourselves to print in Brussels and to publish the text of two small brochures, relating to the paintings you are planning to exhibit in Ghent:

Les Frais du culte [The cost of worship]

La Conférence [The conference]

You will provide us, for the first brochure, with two of your drawings, one of which is the engraving of your painting, and for the second brochure, with four drawings, one of which is the engraving of your painting.

We will determine the size of the editions, judging by the demand, as well as the sale price. Once the expenses have been covered, we will share equally with you the potential profits of this undertaking. . . . You will not grant the rights to these reproductions to anyone without our participation. . . .

2. In 1868, Courbet sent an important group of paintings to the Ghent Salon, which was held in the casino between September 3 and November 15. Among the twelve paintings that he submitted were two strongly anticlerical works, the *Return from the Conference* (F. 338) and the *Death of Jeannot*, also called the *Cost of Worship* (F. 609). To accompany these paintings, Courbet had prepared two anticlerical pamphlets, *Les Curés en goguette* and *La Mort de Jeannot: Les Frais du culte*. Both pamphlets included several illustrations by Courbet. On Courbet's participation in the 1868 Ghent Salon, see Hoozee (1986, 82–86). On the two pamphlets, see Chu (1980b, 83–84).

3. This gives a slightly different twist to Lacroix's requirement that Courbet cannot grant the reproduction rights to anyone without his firm's participation.

To Alfred Bruyas [Paris], September 10, 1868 68-19

September 10, 1868

Dear Alfred:

I want to thank you for the extreme kindness you have shown me in sending your paintings for my exhibition.[1] I was obliged to be away for a few days and it was during that time that the [frame] gilder sent them back to you. I'm sorry that the freight was not prepaid. I still have my two portraits to return to you, the [*Self-*]*Portrait with Pipe* [F. 39] and the [*Self-*]*Portrait in Profile* [F. 161]. They did not leave with the other paintings because the frames were damaged; he is repairing them at this moment and will send them to you in two or three days.

My dear friend, these paintings are making a growing impression in Paris. The portraits have been compared with the best portraits in the Louvre, etc., etc. As I wrote you already, I have lost a great deal [of money] with this exhibition, but that is not the point: the real point is a triumph all down the line. It is a shame that this exhibition could not go on forever. I have had the bad luck to have had to deal with the Pomereuxes,[2] who are the most idiotic and ridiculous people in France. They have so managed it that it is they who have done me the most harm.

Yesterday I saw M. Berge, a businessman from Montpellier, with whom I talked about you for a long time. He told me about your new building

projects and that you are quite comfortable in the house near the theater where you live now. I am glad to hear that you are happy and in your element.

I leave tomorrow for Le Havre, where I have eight paintings in the exhibition,[3] including the *Alms of a Beggar* [F. 660], which I would have liked you to have seen. But you didn't come to the Exhibition. When I come back from Le Havre in a few days, I will leave for Ornans to do a few more paintings true to life and socialism.

I embrace you with all my heart,

<div align="center">

G. Courbet
</div>

I am up to my neck in problems, my hair has turned white. I also have twelve paintings in the Ghent exhibition, including ten paintings and drawings about the good fathers.[4] I quite [] them, as indeed they deserve. There is an illustrated volume to accompany these paintings.[5] When it comes out, I will send it to you, if it can enter France.

1. Bruyas had lent five works to Courbet's private exhibition in 1867.
2. Courbet had rented the terrain for his 1867 private exhibition from the marquis de Pomereux. In a letter of March 25, 1868 (Paris, Bibliothèque nationale, Cabinet des estampes, Yb3.1739 [4°], b. 2), the latter notified Courbet that he needed the terrain for his own use by July 1868. Courbet, who wished to retain his pavilion as a permanent exhibition building, fought Pomereux in court, but eventually he was forced to vacate the terrain.
3. The exhibition of the Société des beaux-arts du Havre.
4. Compare letter 68-18.
5. Courbet (1868a, 1868b).

68-20 *To Ferdinand van der Haeghen, Le Havre, September 11, 1868*

<div align="right">

Le Havre, September 11, 1868
</div>

My dear Van der Haeghen:

Since I last saw you quite a few things have happened. I thought I had understood that we had to do something to fight the reverend fathers. I felt that it was accordingly more useful to continue our crucifixion in Antwerp. You have my paintings, the *Robbery* on the one hand, and the *Drunkenness* on the other.[1] To support the two paintings I had someone write two leaflets, or accounts of the true occurrences[2] (that I know of) that gave rise to the paintings. I hope that they will cause a great war, for I have a great mind to push them to the limit.

What you have seen already leaves little to be desired. You will receive the rest in the form of large framed photographs. There are ten of them, four for the *Death of Jeannot* and six for the *Conference*.[3] M. Lacroix is publishing the illustrated book, and the ten photographs, which I hope you will exhibit (for they were done for your exhibition), will serve as advertisement.

After those compositions I will also send you the photographic [reproduction of the] painting of *Proudhon and His Family* [F. 443], framed for the

purpose.⁴ You should place a register close by in which people who would like either the series or the individual photographs could write their names. I am being rushed, I cannot write you any more tonight. I count on you and the inhabitants of Ghent.

Let's hope we will be excommunicated, for we have not been decorated. Sincerely yours,

G. Courbet

It will be good for a laugh. The text is not written to my liking but that doesn't matter. The drawings will be enough. I can already see the archbishop of Mechlin!

Write me. I don't know what is happening with my paintings or what you can do.

Help Lacroix with the sale. We'll slam those priests in the pay of those who use them. It will make them respectable first and us second, for this must end.

The Le Havre exhibition is a rotten affair and its director is an animal.⁵

1. The *Robbery* is probably identical with the *Death of Jeannot* (F. 609) and the *Drunkenness* with the *Return from the Conference* (F. 338).

2. Compare Courbet (1868a, 1868b).

3. These must have been photographs of Courbet's drawings for the illustrations of his two brochures, *La Mort de Jeannot* and *Les Curés en goguette* (cf. Chu 1980b, 83). Courbet was probably unable to exhibit the drawings themselves as they were used by the wood engraver(s) who cut the blocks for the illustrations of his two pamphlets.

4. Proudhon's portrait was also exhibited at the Ghent Salon.

5. The exhibition of the Société des beaux-arts du Havre, to which Courbet had sent eight paintings.

To Jules Castagnary, Ornans, October 6, 1868 68-21

Ornans, Tuesday, October 6, 1868

My dear Castagnary:

You can use this letter to pick up the portraits of Caroline¹ from my atelier. In the confusion of my departure I forgot to varnish them.

Mme Faiquart in St. Voust-par-la-Louvière, Belgium, has asked to buy the *Lady with a Jewelry Box* [F. 626] at the exhibition in Ghent. Answer nicely for she is also asking for the *Roedeer by the River* [F. 644], for which I quoted her [a price of] seven thousand francs. As for your woman,² sell her if you want. I'll do something else for you. That's your business. She belongs to you. I will expect you in Ornans this winter. You will be writing me.

Sincerely yours. (The lady will write you.)

G. Courbet

Kind regards from everyone here. I will start working soon. Best wishes to our friends.

1. Perhaps a reference to the *Lady with a Jewelry Box* (F. 626) and another painting of the same model, auctioned in Paris in 1963 (*Portrait de Mme M.*, Paris, Galliera, March 21, no. 60). Both paintings may have represented Castagnary's mistress (cf. Riat 1909, 246), who in turn may have been identical with the Caroline mentioned here. The *Lady with a Jewelry Box* was given to Castagnary by Courbet at the time of its execution, and it remained in his widow's collection until 1901 (cf. Paris 1977, 197).

2. Probably one of the paintings mentioned in n. 1.

68-22 *To Ferdinand van der Haeghen, Ornans, October 7, 1868*

Ornans, Oct. 7, 1868

Monsieur van der Haeghen:

I am very much obliged to you, dear friend, for having taken care of the sale of my paintings. What you wrote me this morning has given me the greatest pleasure. I will try to return the favor to the person who does me the honor of asking to buy from me the *Return from the Conference* [F. 338] as well as the painting of the *Death of Jeannot* [F. 609].[1]

Let's take them in order. The first of these paintings, the *Return from the Conference*, had been appraised by shippers in England and America at an insured sum of thirty thousand francs, assuming the usual fifty-fifty profit sharing. In short, as I would like to comply with the wish of the person who is asking you for the painting, I will sell it to him, according to your valuation, for the sum of twelve or even ten thousand francs.

As for the painting of *Jeannot*, I cannot quote you a price lower than the one that I have just quoted to a Belgian lady who asked me for my *Roedeer by the River* [F. 644] and to whom I replied that I would sell it to her for seven thousand francs.[2]

I cannot make a deal with you about the *Roedeer* until I receive an answer from that lady, who has also asked me for the *Lady with a Jewelry Box* [F. 626]. But as soon as I receive her answer, I will write you whether you can sell the *Roedeer* to the one who is asking you.

I knew very well, my dear friend, that you were expecting too much of the independence of thought in Belgium from a philosophical point of view. Those gentlemen of the jury, as you wrote me, rejected the paintings in spite of the horrible business that had just occurred in Antwerp and that spread terror in every country.[3]

I would like to know what happened to the ten photographs under glass that I sent you.[4] I would also like to know if the book published by M. Lacroix of Brussels, with the engraved illustrations after the photographs, has come out and whether it is within your power to send me one or two copies in a small box with sealed string care of M. Courbet at Ornans, Doubs Department. You would be doing me a great favor.

Please answer me, my dear Van der Haeghen, if your busy schedule allows it, and keep me abreast of the situation.

With respectful regards, I am, as you have been able to ascertain, Cordially yours,

G. Courbet

1. The sale did not materialize. In a letter of October 14, 1868 (Paris, Bibliothèque nationale, Cabinet des estampes, Yb3.1739 [4°], b. 1), Van der Haeghen informed Courbet that the gentleman in question, a certain M. Soenen, who apparently acted for some association, renounced the sale. The two paintings eventually were auctioned off at the two estate sales held after Courbet's death in 1881 and 1882.

2. Compare letter 68-21.

3. This must be a reference to a contemporary scandal involving the priesthood. It has been impossible to identify the incident to which Courbet refers here.

4. Neither the catalog of the Salon nor the newspaper reviews mention the ten photographs and the two pamphlets (cf. Hoozee 1986, 86).

To Jules Castagnary, Ornans, October 17 [1868] 68-23

Ornans, October 17

My dear Castagnary:

I am suffering so badly from my hemorrhoids that I cannot concentrate on anything. I put off writing you for an entire week and now I no longer know what I wanted to say. I had an idea for an article of protest; it was full-blown and now it has escaped me. It will come back to me, I hope. You have surely seen M. Arène's[1] article in the *Figaro*,[2] which attacks you. It is too easy to defend oneself and to explain to M. Arène that he was born yesterday and has no formed character. I had the independence I have now at the age of fifteen. I scorned prizes and any kind of title that might take the place of talent in the eyes of the public.

"You made me miss the August 15 prizes." That is wonderful! "You made me paint political paintings." That is even more wonderful! In other words, it means that M. Arène would be very happy to be decorated. In fact, he must be decorated, especially as he is from the South.

Let us turn to the Academy, that is even more hilarious. This farce is truly comical, you must admit. It is I who ought to replace M. Picot![3] M. Picot, who for seven years—either on his own or by means of his influence—caused me to be refused at the Exhibitions, from 1840 to 1848, and for the best things I ever did in my life! My dear friend, do you understand the illogicality of that idea? How do you expect me to retaliate against the poor martyrs who enter the art world because M. Picot behaved foolishly? Am I to make others suffer the despair that I did during my youth? The idea is insane.

No, established institutions, academies of all kinds, authoritarian "gov-

ernmentation," all indicate a false state of affairs and hinder progress. Had it not been for the February revolution, my paintings might perhaps never have been seen. I established the rebellion, now we are seeing the new freshmen.

An academician is put in a false position by the social organization. How do you expect this man to raise up budding talents to the detriment of his own worth and voluntarily cause his [own artistic] death during his lifetime? It is asking more from a man than he can do. Look at Napoléon:[4] he is progress,[5] and it is through him that France is to have genius, not to mention that he must get the glory for it.

No, it is high time that someone have the courage to be an honest man and that he say that the Academy is a harmful, all-consuming institution, incapable of fulfilling the goal of its so-called mission. Until now there has never been a national art. There were only personal endeavors and artistic exercises that imitated the past. As everything is centralized, there were those who thought that Raphael was art personified and that to be a good artist it was enough to imitate him. France at the moment seems to wish to revive the spirit of lost art. Why? Because she has an idea she wants to exalt and a freedom she wants to establish. It is this belief that is opposed to the old religions, which produced the works of art in our museums. In order to help a movement one must give free rein to the genius of the people, do away with administrators, patrons, the academies, and above all the academicians. You can allow free academies where young people who have no money can go work. Open the museums, that is all you can do for art. With that, I very humbly refuse to acknowledge any authority on my part in academic matters.

In addition to all the reasons stated above, there is another, which alone would suffice to prevent me from accepting anything from the government; I need not tell you, of all people, what it is.

[*no signature*]

1. Paul Arène (1843–96), poet, novelist, and journalist, who contributed articles and short stories to the *Figaro*.

2. In the *Figaro* of October 12, 1868, Arène, in his *Bagatelles parisiennes* (Parisian trifles), had accused Castagnary of having created a false public image of Courbet. While Courbet, according to Arène, was simply a good painter faithfully imitating nature, Castagnary had constructed the image of a painter-philosopher with radical political opinions.

3. François Picot (1786–1868), a well-known academic painter who had died in March 1868. Early in October, the Parisian newspapers, including *La Presse* of October 9, had reported that Courbet had put himself forward as a candidate for Picot's chair in the Académie française.

4. No doubt Napoléon III.

5. Courbet uses the words *le progrès c'est lui*, no doubt a pun on the famous quote of Louis XIV, *l'état c'est moi*.

To Jules Castagnary [Maizières, November 4, 1868 (Ad)]　　　68-24

My dear Castagnary:

I am at M. Ordinaire's* in Maizières and I am taking advantage of his letter to send you my greetings.[1] I wrote you a letter in which there was the material necessary to dismiss my candidacy for the Academy,[2] and I have not received an answer from you. Yet, I believe that the time has come to tell all and intimidate them in their nomination [efforts].

I read in the *Gaulois* an article in which there was concern about my silence and in which it is maintained that the candidates are being prepared for November 6.[3] It is impossible that you did not receive my letter. Drop me a line right away. M. Ordinaire's article directed at the mayors[4] created furor [?],[5] he is creating partisans on all sides.

Sincerely yours,

G. Courbet

1. Courbet's note is written in the margins of a letter to Castagnary by Edouard Ordinaire.
2. Probably a reference to letter 68-23.
3. The following brief item had appeared in the *Gaulois* of October 31, 1868:

> The master of Ornans must no doubt have decided not to upset the election by the members of the Academy for the chair of M. Picot. Indeed, on the list of candidates whose merits will have to be discussed this coming Saturday, we see the names of MM. Barrias, Bouguereau, Fromentin, Isabey, Jalabert, Lenepveu, junior, Pils, Roger, and Yvon, but as for M. Courbet, no presence. The Academy is anyway too classical and too religious for the painter of the *Woman with the Parrot* to have much chance to find grace in their eyes.

> Right, but what about the *Covert of the Roedeer*! . . .

4. Ordinaire's pamphlet, *Une Election dans le Grand-duché de Gérolstein*.
5. Doubtful reading of original text.

To Eugène Vermersch, Ornans, November 13 [1868]　　　68-25

　　　　　　　　　　　　　　　　　　　　Ornans, November 13

My dear Vermersch:

I was in the country when your first letter arrived, I found it with the second. At the time I had already given M. Petit the authorization to do my caricature,[1] that was enough. Please consider this letter a new authorization.

I am out landscaping in spite of the snow. That is all I have to say but I do feel the need to tell you also that you are very kind.

Sincerely yours,

G. Courbet

I have not seen my friend André Lemoyne's[2] book, to my regret. Send him my best regards.

[Address] M. Eugène Vermersch, Author
 27 rue de Seine
 Paris (express mail)
[Postmark] Ornans, 13 [Nov.] 68

1. Probably a reference to the permission Courbet had given earlier, on April 17, 1867. See letter 67-8. Vermersch was the editor of *Le Hanneton*.
2. Camille-André Lemoyne (b. 1822) studied law but later became a poet. He wrote several books of poetry as well as novels and travel books. The book here referred to may be *Les Charmeuses*, which had appeared in 1867 and again in 1868, with a preface by Jules Vallès.*

<u>69-1</u> *To Jules Castagnary [Paris, March-April 1869 (?)]*

My dear Castagnary:
 I am sending you M. Jules Borreau[1] from Saintes, who would like to take advantage of your kindness by asking you for theater tickets for himself and his sister. He is here [on leave] from a *collège* in the provinces and would like to use his Easter vacation to explore the capital.
 Sincerely yours, dear friend,

 G. Courbet

[Address] 31, boulevard de Clichy

1. Jules-Lucien Borreau (1852–1907) was the son of Jules Borreau and Laure Herbault. Courbet had stayed with the Borreau family in Saintes from January to April 1863, and may have had an amorous relationship with Laure Borreau. As at the time of this letter Jules-Lucien was a student in some provincial *collège*, it must date from the spring of 1869 or 1870 (cf. Bonniot 1973, 330).

<u>69-2</u> *To his family [Ornans, March 13, 1869]*

My dear family:
 I would have liked to go to Flagey, but with the carriage [like a millstone] around my neck it is impossible, for it is not yet finished and it must go to Paris now for the Longchamp exhibition.[1] Monday of Holy Week it leaves in the morning for André the cartwright, who will paint it. I hope to bring it back finished to Ornans. I am going to Besançon on Monday.[2] I'll come see you on my way back.
 I embrace you,

 G. Courbet

[Address] Monsieur Courbet, landowner
Flagey

Canton of Amancey
Doubs
[Postmarks] Ornans, March 13, 1869
Amancey, March 14

1. Courbet had designed a carriage that rode on only one wheel and he planned to show a prototype at the 1869 Longchamp exhibition. Courbet's interest in design and machinery was no doubt inspired by his father, who had designed a new type of harrow and a five-wheel carriage (cf. Lindsay 1973, 2–3, 234–235).

2. March 15.

To M. Vivet, Ornans, May 7, 1869[1] 69-3

Ornans, May 7, '69

M. Vivet:

I have already written once to my architect, M. Isabey,* 174 rue du Faubourg St. Honoré, to kindly send you the receipts and various documents related to M. Delaroche,[2] 45 rue Bonaparte (I think), near the [Ecole des] Beaux-Arts, a dealer in paintings and objets d'art, who owes me five thousand silver francs that he borrowed from me, in addition to twelve thousand francs for paintings that he sold, with interest, and on top of that various paintings that I consigned to him. I would like you actively to pursue M. Delaroche so that I can come up with the sum that you request. I lodged this claim two years ago. I hope that this time he will see that it is urgent and that he will be willing to give me back what he owes me.

Please come to an understanding with M. Isabey and write him to send you those documents, for which you will give him a receipt in exchange.

Looking forward to the time when I will see you, I send you my respectful greetings. I am detained in Ornans for a few more days.

G. Courbet

1. In the corner of the letter is the following annotation by Vivet: "On May 8 I wrote M. Courbet and M. Isabey."

1. The art dealer Delaroche was to be declared bankrupt in July 1869. Compare letter 69-4.

To Jules Castagnary, Paris, July 5, 1869 69-4

Paris, July 5, 69

My dear Castagnary:

I am delighted that you liked the frame. Moreover, it was newer than the other and less heavy. But the other one is still at your disposal.

Since I last saw you I have had a terrible disaster. M. Delaroche[1] has just

gone bankrupt and once again I am back to zero. He owed me twenty-five thousand francs for my twenty-five Trouville seascapes and an additional five thousand francs that I had lent him in cash. I am summoned to the Chamber of Commerce on the seventh at one P.M. I will get one or two percent, besides which my creditors from my exhibition are coming looking for me. I really have no luck.

I sent four paintings to Brussels.[2] M. Gauchez* took charge of it, I think he will sell some. I am sending four others to Munich.[3] They are leaving today.

I don't know what to do about M. Delaroche under the circumstances.[4] I will go to Pantin tomorrow at two o'clock for a commissioned painting, if you come tomorrow morning. If not, I'll go to Madrid[5] at six o'clock.

Sincerely yours,

G. Courbet

1. See letter 69-3, n. 1.
2. To the Exposition générale des beaux-arts, the Brussels equivalent of the Paris Salon, Courbet had sent two paintings of nudes and two landscapes (cat. nos. 252–55).
3. To the Internationale Kunstausstellung in the Glaspalast in Munich, Courbet sent the *Stonebreakers* (F. 101), the *Mort of the Stag* (F. 612), the *Woman with a Parrot* (F. 526), and the *Oraguay Rock* (F. 262?).
4. Compare letter 69-3, n. 1.
5. Probably the Café de Madrid, on the north side of the boulevard Montmartre, where anti-imperialist journalists and the leaders of the approaching Third Republic used to congregate.

69-5 *To Charles-Paul Desavary, Paris, July 27, 1869*

Tuesday, July 27, '69

Monsieur Desavary:

I am very happy that the painting has been received favorably by your society. It is an impression of the seashore at Trouville—the daughter of a beachcomber.[1] The painting is quite inexpensive compared to the paintings that are being sold today. Besides, it was priced more than twice as high at my exhibition. But a society has some privileges as it promotes the common interests of art in a spirit of publicity that should be encouraged.[2]

I accept with great pleasure the honor you do me in wishing to count me as one of the honorary members of your artistic society. I am also very pleased that M. Vernier,* my friend and a talented man, is doing a lithograph of this picture. It lends itself very well.[3]

As for the paintings you are asking for, at the moment I have nothing that is suitable. I have only some studies that I made when I was young and to which I am much attached.

You tell me also that your brother might be able to sell a few of my

paintings. I would be very glad of it. He should write me in what price range he sells. When I have something that would suit his clientele, I could send it to him.

As for the payment you expect to make in December, write me in advance, for I will be either in Paris or in Ornans, Doubs Department.

And now, Monsieur, it remains for me to thank you very sincerely for the goodwill you and all those of your society have shown me. Please accept my compliments and warmest greetings to all of you and consider me,

Your devoted servant,

Gustave Courbet, painter

32 rue Hautefeuille
Paris

1. Courbet's painting *Girl with Seagulls* [F. 435], painted in Trouville in 1865, was bought by the Société artésienne des amis des arts in 1869 for their annual benefit lottery. Charles Desavary was the president of the society. Two letters by Desavary to Courbet, on the subject of the acquisition of the painting, are in Paris, Bibliothèque nationale, Cabinet des estampes, Yb3.1739 (4°), b. 2.
2. The painting was sold to the society for one thousand francs.
3. Emile Vernier indeed did a lithograph of the painting (cf. Brune 1912, 277).

To Léon Gauchez [Etretat, August-September, 1869] 69-6

Monsieur:

I have the pleasure of informing you (in exchange for your kind letter informing me that the Belgian artists have just awarded me the medal of their exhibition)[1] that, like the artists of Belgium, the artists of Munich, gathered for the International Exhibition of Bavaria, had the king of Bavaria[2] grant me at their request the first class medal of the Order of St. Michael, which I just received at Etretat, where I am for the moment. I am very delighted with this custom of medals given by artists. It proves that it is not necessary to be Napoléonist, as in France, to do painting.

I have not yet received anything from Brussels, but other people as well as you have assured me that I had been given the award unanimously. I am all the more flattered by what is happening as I was very dissatisfied with Belgium, for I had been exhibiting in that country, in Brussels, Antwerp, and Ghent, for twenty years, without the least success. That seemed unfair to me, as I have spent more money in Belgium than in France because of the distance.

The Bavarian government in one shot has compensated for all the contempt that I have had to suffer from this terrible government that degrades France. It gives the lie direct to this idiotic administration that arrogates to itself the right to control art and artists.

It is thanks to you, M. Gauchez, that I have had this success in Brussels.[3]
I am very grateful to you as well as to the people who saw to it.

With kindest regards and greetings,

Gustave Courbet

1. Courbet received a gold medal at the Exposition générale des beaux-arts in Brussels.
2. Ludwig II.
3. Gauchez seems to have served as Courbet's agent in Belgium in the late 1860s.

<u>69-7</u> *To his family [Etretat, September (?) 1869]*

Dear family:

You'll find the reason odd, but since I left Ornans I have not had time to write anyone. I have had terrible troubles in Paris. I lost twenty-five thousand francs that were owed me.[1] It has been one headache after another. At the same time I have had to paint constantly. I have sold four or five thousand francs' worth in Paris. I came to Etretat for some commissioned paintings.[2] In the month that I have been here I have already done ten seascapes. I sold five of them for a total of forty-five hundred francs.

Other news. I have just been named knight, first class, of the Order of Merit of St. Michael by the king of Bavaria, at the request of the jury of the Munich exhibition. That is a real honor because it comes from artists, my confreres. At the Brussels exhibition, under the same conditions, I received the first medal of the exhibition. I had four paintings in Brussels and six in Munich. That all gives the lie direct to the French administration. In those places you don't have to be a Napoléonist to be honored. You see that, since I left you, the going has been rough.

Here I am doing a seascape for the Exhibition[3] and in ten days or two weeks I'll go to Munich. I must go thank those people, as well as the King!

After Munich I'll go to Ornans to do a painting for the next Exhibition.[4] That will be, I think, in October.

In Paris I did not see M. and Mme Reverdy* again. They are very afraid of me. They came to see the concierge while I was not there.

We are very comfortable in Etretat. It is a charming little resort place. There are rocks here that are bigger than in Ornans, quite curious.

I'll write you from Paris before I leave for Munich. I hope that you are all well. If you write me, write me in Paris. Give me news of your health. In Flagey there is not much news. Tell me about the chickens, the doe, etc.

I embrace you all,
The Knight of St. Michael

Gustave Courbet

1. Through the bankruptcy of the dealer Delaroche (cf. letters 69-3 and 69-4).

2. Possibly seascapes commissioned from him by dealers such as Paul Durand-Ruel and Etienne-François Haro.

3. Courbet was to exhibit two Etretat scenes at the 1870 Salon, *Stormy Sea* (F. 747) and *Cliff at Etretat* (F. 745).

4. Courbet was not to exhibit any Franche-Comté scenes at the Salon but only the two Etretat landscapes mentioned above (n. 3).

To Jules Castagnary [Etretat, September 6, 1869][1] 69-8

My dear Castagnary:

The decision has been made. At the request of the artists of Munich and of the awards committee, I have just been named knight, first class, of the Order of Merit of St. Michael by his majesty, the king of Bavaria.

At the Brussels exhibition—which is organized along the same lines, that is, the artists appoint their jury and the jury acts without any government intervention—they have just unanimously awarded me the medal of the Brussels exhibition.

This gives the lie direct to the "governmentation" of the arts, to the control of art and artists by the French administration.

Finally, here are two decorations that I can accept because they are awarded by our rivals and with great reluctance. Besides, this decoration (if one accepts decorations) is more rational than the Cross of Honor: it is called Cross of Merit.

The way is clear. Henceforth one need no longer be Napoléonist to be a painter, etc., etc. Once out of reach of the empire's powerful arm and of its fanatical partisans, I become the success of both the Belgian and the Bavarian exhibitions at once.

What is happening there is very important, for the Germans and the Belgians are inordinately inclined to continue my painting, and the Munich exhibition, among others, was organized for that purpose. They are inclined to abandon all their old baggage, and the paintings [of mine] that are in their exhibitions were specifically requested, which is very significant. M. Petit,[2] at my request, sent the *Stonebreakers* [F. 101] and the *Oraguay Rock* [F. 262?], and the Munich consul told me that, according to the German critics in all the papers, the *Stonebreakers* would be the great success of the exhibition. That is significant.

In the twenty years that I have exhibited in Belgium, I have, thanks to the French government, exhibited at my own expense and at a net loss (the Belgian government kept a close watch). Only the free artists overcame that ill will and that influence, but they were not up to the Germans of Munich.

I have been in Etretat for twenty-five days. If I had been able to see you before I left, I would have tried to bring you along. The countryside is charm-

ing, you still have time to come and stay for a week. It is very hot. The bathing is delightful. I have already done nine seascapes that I am pleased with. To-morrow I will start a 1 meter 60 seascape for the Exhibition.[2] I have never exhibited that genre. If you cannot come to Etretat, set some time aside for Munich. I will be leaving on the twentieth or the twenty-fifth for the festivities that begin on the first of October. Try to come. We will be received in triumph, the consul told me so a month ago, and it will be more true now. I promise you that they will see to everything, it is an opportunity not to be missed.

If you could announce this news with some amplification, all those who have received official decorations will die.

Sincerely yours,

Gustave Courbet

Answer me at Etretat. They say that Napoléon is dead. Don't keep it from me.

1. Letterhead "Bains de Mer—Casino d'Etretat."
2. Probably Georges Petit, a well-known art dealer in Paris.
3. Courbet exhibited two Etretat scenes at the Salon of 1870. Both were approximately 1.60 meters wide (cf. letter 69-7, n. 3).

<u>69-9</u> *To Jules Castagnary, [Paris, September] 29 [1869]*

Wednesday night, the 29th (Laveur)

My dear Castagnary:

In Etretat I met the architect with whom you made the Loire trip. He told me that you were in Saintonge. I did not think you were back yet but this evening's letter addressed to Charton[1] tells us otherwise.

Did I ever earn my bread and butter in Etretat! I painted twenty seascapes, two of which are for the Exhibition.[2] You must absolutely come and have lunch with us tomorrow. Charton will come from his office. We'll meet at my place tomorrow at 11 A.M., or else come for dinner, but in that case wire, for I leave for Munich the day after tomorrow. I was going to leave tomorrow, until you arrived.

Sincerely yours,

G. Courbet

1. Probably Edouard Charton (1807–90), journalist and politician. Charton was the founder of the *Magasin pittoresque* (1833), the cofounder of *L'Illustration* (1843). During the 1860s, he was the editor-in-chief of the *Tour du monde* and the *Bibliothèque des merveilles*.

2. Compare letter 69-7, n. 3.

Interlaken, November 20
Switzerland

My dear Castagnary:

I left Munich two weeks ago. You said to write you because you might come. I did not feel it was worth the trouble of such a long trip. You will find the German newspapers that refer to the exhibition at the Munich embassy on the rue de Berry, Champs Elysées. They are very nice and will give you whatever you want. Only two of us were named officers of the Order of St. Michael by the artists: M. Corot* and I. The other two, M. Cabanel[1] and M. Doré,[2] were nominated, the first for the painting of *Adam and Eve,* commissioned by King Maximilian, the father of the one who is reigning at present (the king nominated Cabanel by his own authority); Doré was nominated by the "officiality," which means, I think, by the ministry, for services rendered in sending over French paintings.

There is almost no good painting in Germany. They are all concerned with the negative qualities of art. One of the principal qualities [they look for] is perspective. They talk about it all day long. Another important quality is the accuracy of historical costumes. They are very much into anecdotal painting, and all the walls in Munich are covered with frescoes as if they were wallpaper: red, blue, green, yellow, pink, or other cloaks; silk stockings; riding boots; pourpoints. Here, a king is taking his oath; there, a king is abdicating; yet another shows a king signing a treaty; etc., etc., marrying, dying, etc. As for sculpture, it is unbelievable, one could easily count three thousand statues in the city. They are all the same. I proposed something quite simple to them. If the heads screwed on, they could be changed every two weeks, and they would need only about ten statues. A wit told them that foreigners had only one thing to fear in their town, and that is to be made into statues.

When you come down to it, the Corneliuses, Kaulbachs, Schwinds,[3] etc. have had their day, and Chenavard* in particular. His painting inspired a good guffaw from everyone. As the Germans are very knowledgeable about that kind of painting, they found that all his figures and groupings were borrowed from Italian paintings. One of them was looking for figures stolen from the old masters in the painting. He said, "You can recognize nearly all of them." His neighbor answered, "Unfortunately, treated like this, they are unrecognizable."

Chenavard, Charles Blanc,[4] and Couder[5] created a big scandal in the Glyptothek, among the young people. The amazing trio was sitting on the steps of the monument in question bewailing the state of contemporary art. The three sages said, "Kaulbach would put the entire exhibition into his mortar."

The young people in Munich are doing well.[6] I stayed a little longer for that reason. They have all decided to abandon all the old relics. I saw some young painters spit on the floor when they spoke of all the princes of German art.

I have done five paintings in Munich, three copies—one of Frans Hals [F. 670],[7] a portrait by Velazquez [F. 666],[8] and Rembrandt's [*Self-*]*Portrait* [F. 668],[9] all in their museum. I painted a female nude [F. 667] and a Tyrol landscape (Starnberg Lake) [F. 673]. I have painted six autumn landscapes with mountains since I have been in Switzerland.[10] I leave tomorrow for Ornans.

<div align="right">*G. Courbet*</div>

1. Alexandre Cabanel (1823–89), a successful Academic painter.

2. Gustave Doré (1832–83), though known primarily as an illustrator, from 1851 onward regularly submitted paintings to the Salon.

3. While in the previous paragraph Courbet seems to refer to his artistic contemporaries in Munich—artists such as Karl Theodor von Piloty (1824–86), whose famous painting *Seni, the Astrologist, Contemplating the Dead Body of Wallenstein* (Munich, New Pinakothek) was contemporary with his own *Atelier* (F. 165)—here he refers to an older generation of artists: Peter von Cornelius (1783–1867), Wilhelm Kaulbach (1804–74), and Moritz von Schwind (1804–71).

4. Charles Blanc (1803–1882), well-known French art historian and theorist.

5. Probably Alexandre Couder (1808–79), a successful painter of still lifes of flowers and fruits.

6. Courbet does not mention by name any of the younger artists he met in Munich. They may have included Franz Lenbach (1836–1904), who was actively involved in the organization of the 1869 exhibition; Johann Sperl (1840–1914); Wilhelm Leibl (1844–1900); Theodor Alt (1846–1937); Rudolf Hirth du Frênes (1846–1916); and Wilhelm Trübner (1851–1917). See Hamburg (1978, 396, 426–459).

7. Frans Hals's *Malle Babbe*, now in the Staatliche Museen in Berlin-Dahlem, was then in the Suermondt collection in Aachen. It was exhibited in Munich at the occasion of the International Exhibition.

8. No copy is known of the *Portrait of a Young Man*, the only work by or attributed to Velazquez in the collection of the Alte Pinakothek.

9. This *Self-Portrait* in the Alte Pinakothek in Munich is no longer attributed to Rembrandt.

10. Only one of them can be identified today, the *Landscape at Interlaken* (F. 671).

69-11 *To his family, Interlaken, November 20 [1869]*

<div align="right">Interlaken, November 20
Switzerland</div>

Dear family:

I left Munich two weeks ago and as I was passing through Switzerland on my way back I stopped over in Interlaken at my friend Ebersold's to do some landscapes of the Swiss mountains in autumn. I am leaving for home tomor-

row. I'll spend a day with Joliclerc* in Pontarlier and another day with Buchon* in Salins and from Salins I'll go straight to Flagey.

I was very well received in Munich by all the artists, and my paintings were the success of the Munich exhibition, and the young people are all going to paint like me. We were the only two Frenchmen to get the decoration of officer of the Order of St. Michael, namely Corot* and I. It is the highest award those people can bestow.

In Etretat I did a lot of seascapes, about twenty, and between Munich and Switzerland I did eleven paintings, which I am bringing back with me. I already sold eight thousand francs' worth of seascapes in Etretat. I sent you two crates of very precious crystal ware, I don't know how they have arrived. It is the finest they make at the glassworks in Pantin. A friend of mine, M. Stumpf, to whom I have sold some paintings, gave it to me as a present.[1] Now there is a bowl that you can put on the table!

I embrace you all and look forward to the pleasure of seeing you again.

G. Courbet

[Address] Monsieur Courbet, landowner
 Flagey, Canton of Amancey
 Doubs Department
 France
[Postmark] Interlaken, November 21, 1869

1. Like Ferdinand Barbedienne* and Jean-Pierre Mazaroz,* both patrons of Courbet, Stumpf appears to have been a manufacturer of luxury articles, notably of fine crystals. Together with his associate, Monod, he owned a glassworks in Pantin. Stumpf, at one time or another, owned several of Courbet's works. In 1869, he bought one of the landscapes Courbet had painted in Interlaken (F. 671) and perhaps also one of the landscapes painted earlier the same year in Etretat.

To Félix Gaudy, Salins, December 8 [1869] 69-12

Salins, Wednesday, December 8

My dear Gaudy:

I have just had an immeasurable success in Etretat with my seascapes. In Brussels I received the gold medal of the International Exhibition. In Munich I was named, the first time out, officer of the Order of St. Michael at the Munich International Exhibition.

I spent two weeks in Switzerland at Interlaken. I did six landscapes of glaciers. I came to Pontarlier, [where] I found Joliclerc* with erysipelas. I painted mère Loiseau's portrait [F. 662].[1]

I arrive in Salins and I find Buchon* with a carbuncle on his behind. He is in bed, very ill. He tells me to ask you whether you will be in Vuillafans until January 1 because he would very much like you to send him the story-

books that he was hoping to find in Vuillafans. If you have some copies of them, please send them to M. Desbois in Ornans, who is the courier from Ornans to Salins. He will leave again on Tuesday.

In a week or so I hope to be in Ornans. I'll come see you.

Till then, please accept my warmest greetings to you and your lady, from Mme and M. Buchon as well.

<div align="right">G. Courbet</div>

1. Sophie Loiseau was the wife of Alfred Loiseau, the president of the Pontarlier tribunal.

69-13 *To his family [Salins, December] 14 [1869]*

<div align="right">Tuesday, the 14th</div>

Dear family:

A great calamity has befallen us. Cousin Buchon* died this morning at 6 A.M. We will bury him tomorrow at 10 A.M. I would have been in Flagey a week ago had this not happened. He had carbuncles, then bad blood and a typhoid fever. It is incomprehensible that he should have died in so little time. I had called in M. Blondon* and M. Monot from Besançon, Dr. Maubert and Dr. Germain were there, four doctors in all. There was nothing to be done. His wife has conducted herself admirably and very courageously. She looked after him by herself for twelve days. It is an affliction and a great loss for the department and for Salins in particular. I'll try to leave for Flagey in a day or two with people from the funeral. Father need not trouble himself. I embrace you all and look forward to the pleasure of seeing you.

<div align="right">G. Courbet</div>

[Address] Monsieur Courbet, landowner
 Flagey, Canton of Amancey
 Doubs
[Postmark] Salins, December 14, 1869

69-14 *To Jules Castagnary [Salins] December 16, 1869*

<div align="right">Friday, December 16, '69</div>

My dear Castagnary:

My old friend Buchon,* my poor cousin,¹ died in my arms on Tuesday at six o'clock in the morning. He died of a typhoid fever that poisoned his blood. And not without cause! He had swallowed so much rot in the past fifteen years that he would have to have had the stomach of the Boulogne eagle² to withstand it. That tamer of eagles will end up swallowing our entire generation.

After the June revolution, Buchon was led with a chain around his neck

from Besançon to Lons-le-Saunier to be tried.³ After a year of preventive detention, he walked twenty leagues, between two mounted policemen, in those conditions by order of Napoléon II, that is, Cavaignac.⁴

On December 2, Napoléon III grabbed him again. There was a warrant out for his arrest. He was tracked like a wild animal. All that time he was hidden below a false floor, where he stayed a long time. Then he slipped out disguised as a plasterer. He stayed hidden in the house of a poor old neighborhood bachelor. Finally, one fine night he appeared unexpectedly at my house and spent the night with me. He stayed hidden with us for two days. My mother had had trapdoors and oubliettes made where we could hide. By escaping he had fallen into the lion's mouth, for there was an outstanding warrant for my arrest as well.

The situation was no longer tenable. Urbain Cuénot* was interned in Marseille. We decided to leave, he for Switzerland, I for Paris under a false name. While this was going on, his father died.⁵ There was a weird episode. Buchon's father had been a captain in the infantry. They had placed his saber and sword crosswise on his coffin. When the body was carried through the street, the police grabbed the saber and the sword.

Buchon was exiled for eight or nine years in Bern, in Switzerland.⁶ After his father's death the little money he had shrank day by day. His friends brought him back to France, where he remained under police surveillance till his death.

As he could no longer engage in regular politics, Buchon became involved in paper politics in a very remarkable way. As a pamphleteer he had the force of a Paul-Louis Courier.⁷ Moreover, he was a student of P.-J. Proudhon* and P.-J. P. held him in the highest esteem. He was, without a doubt, the one socialist of our day who most clearly understood the social questions that concern us today.

Buchon was a noble soul, of matchless unselfishness, and of extreme humility and sensitivity, always thinking of others and never of himself, unable to bear receiving credit or compliments. His courage was invincible. In spite of how badly he was treated, he had the courage of his convictions and spoke with awe-inspiring eloquence. Nobody dared oppose him for, with his Franc-comtois nature, he acted only when he was right twice over. Thus, his authority in the area was very great. With his great mind he saw to the nomination of opposition candidates both in the Jura and the Doubs [departments]. He was continuously and tenaciously concerned with the problems of the people.

What brought on his last illness was the reversal of a democratic newspaper toward the Orleanist party. The least violation of principle and integrity wounded him to the quick.

Even his poetry was honest and simple. He sought to take up as little

room as possible on earth. He would have crawled into a mouse hole. You got the impression that he felt himself to be superfluous. He died with the candor of a righteous man, without anyone's moral support. He considered death an arrival, a harbor.

I won't speak of his works, which are among the most remarkable Realist works of the day for their truth, their philosophical logic. He left some post-humous works.[8] Recently, he planned to undertake [the writing of] a French democratic constitution modeled after those of Switzerland and America, so that he might be ready should the occasion arise. It is I who suggested the idea to him, when I came back from Switzerland, where I had discussed it with certain politicians.

My dear Castagnary, I must stop here for today. We will make my Buchon a bronze monument, with Claudet* the sculptor, who has already made his bust.[9]

I leave for Ornans tomorrow. Write me poste restante. Other people will give you his exploits and his chronology better than I.

I embrace you,

G. Courbet

I have just discovered a curious thing, a secret that could be useful to us. It is Badinguet's correspondence in America, deposited in the vaults of the Bank of New Orleans.[10] It consists of a dictionary-size pack of letters written in Murat's[11] handwriting, in English, French, and German. The trick is to get hold of them. I know the people who have them. They go from 1815 to Boulogne. The whole fine family is compromised by their schemes for insurrection, etc. I will work on it, I don't know whether I will succeed. What a pity that Buchon is dead.

1. In 1867, Max Buchon, after studying the will of one of his ancestors, found that the Buchon and Courbet families were related. He immediately wrote a letter to Courbet's father to inform him of this happy fact (letter of July 27, 1867). See Fernier (1987).

2. The eagle of Boulogne was the unlucky bird (actually a vulture) that was taken along on Louis Napoléon's ill-fated expedition to Boulogne in 1840. On the sea voyage from London to Boulogne, the bird had been trained to eat out of Louis-Napoléon's hat in the hope that, once in France, it would alight on the future emperor's head: a "miraculous" sign to the crowd that he was their chosen leader.

3. Max Buchon, who had founded an opposition paper, the *Démocrate salinois*, in the wake of the February revolution, was arrested after the June days.

4. During the June days, General Louis-Eugène Cavaignac (1802–57) had dismissed the provisional government in order to assume dictatorial powers for himself—much in the same way as Napoléon III was to do in 1851.

5. Jean-Baptiste Buchon had died in 1850.

6. Courbet exaggerates: Buchon lived in exile in Bern from December 1851 to 1856, i.e., less than five years.

7. Paul-Louis Courier (1772–1825), famous French pamphleteer.

8. Several short pamphlets by Buchon appeared with the date of 1869: *L'Avocat Oudet et*

Max Buchon; Les Fromageries franc-comtoises comparées à celles de La Gruyère et de l'Emmenthal; Lettre d'Aimé Jeannin aux actionnaires et lecteurs du journal "Le Jura"; and *Saint-Vernier, statue en pierre, érigée à Vuillafans, par mon oncle Pierre-François Pasteur, et inaugurée le 10 mai, 1869.* Some or all of these may have come out after his death.

9. Claudet's bust of Buchon is currently in the Musée Gustave Courbet at Ornans. The Buchon grave monument is at the cemetery of Salins.

10. Napoléon III, nicknamed "Badinguet" after the workman's name he supposedly had assumed when escaping from the fortress of Ham, had been exiled to America in 1836, after his failed coup d'état at Strasbourg. He had spent some six months in America, and it is therefore possible that some of his letters had remained there, though it is not known to what correspondence Courbet refers here.

11. No doubt Lucien Murat (1803–78), son of the former king of Naples and cousin of Louis Napoléon, who lived in America at the time of the latter's exile.

To M. Ilmoëton [?], Ornans, January 17, 1870 **70-1**

Ornans, January 17, 1870

My dear Ilmoëton [?]:

I have just come back from a long trip to Germany. On my return I knew the despair of losing my oldest friend, Max Buchon* the poet, and also a relation of mine.[1] I am in such a state of depression that I did not answer you. Nevertheless, your letter is very kind and very courteous.

I give you complete permission, as you may well imagine, and as for payment, that is as you will. There is one thing that concerns me. I had sold the rights to photographic reproduction to the elder M. Ledot of the Rivoli Arcades for three years. That was when the picture was exhibited, but I think that was more than three years ago. Take a look in the catalog.[2]

You will find photographs in two sizes at Michelez's,[3] 50 rue Jacob. If that is not enough, go to my atelier and show this letter to my concierge to get in and work.

Yours ever, dear friend. Best regards to all my friends.

 G. Courbet

Let's play a game of billiards soon. I'm not quite strong enough for it yet.

1. Max Buchon had died on December 14, 1869 (cf. letter 69-13).

2. This entire paragraph deals with the photographic reproduction rights to one of Courbet's paintings, probably the *Woman with a Parrot* (F. 526). In June 1866, Courbet had signed an agreement with the publisher Ledot, Sr., in which he had ceded to Ledot the reproduction rights for three paintings, the *Woman with a Parrot, Venus and Psyche* (F. 370), and the *Covert of the Roedeer* (F. 552). See documents in Paris, Bibliothèque nationale, Cabinet des estampes, Yb3.1739 (4°), b. 1. The painting referred to here must be one of these three works. It cannot be *Venus and Psyche* since that was never exhibited, and it is unlikely that it was the *Covert of the Roedeer* as that painting was in the Lepel-Cointet collection until 1881. Courbet refers to a painting in his atelier, which must be the *Woman with a Parrot*, sold later that year to Jules Bordet.*

3. The photographer Charles Michelez, whose atelier was at 45 (not 50!) rue Jacob, had made several photographs of Courbet's work. A receipt and a letter by Michelez to Courbet are found in Paris, Bibliothèque nationale, Cabinet des estampes, Yb3.1739 (4°), b. 1.

70-2 *To Léon Gauchez, Ornans, February 8, 1870*

Ornans, February 8, 1870

Dear M. Gauchez:

I acknowledge receipt of forty-five hundred francs, the balance due on my entire account to date.[1] I will be in Paris in a few days [and] will have the pleasure of seeing you.

Sincerely yours, my dear M. Gauchez,

Gustave Courbet

1. No doubt for the sale of paintings.

70-3 *To Max Claudet [Ornans], February 10, 1870*

February 10, 1870

My dear Claudet:

Since I saw you I have been ill continuously. I have been so exhausted and constipated that I have been unable to work.

Immediately on arriving in Ornans, I went to Vuillafans, as promised, to see Uncle Pasteur.[1] I was more disillusioned than I could say or than you could imagine. Mme Flick[2] had passed by there. You cannot conceive the profound heinousness, the meanness, and the slander of that evil woman.

So extreme was it that the uncle to whom his nephew had been everything now called him in front of us "that scamp Buchon" and "his good-for-nothing wife." "They did without me during his sickness, they'll do without me after his death, etc., etc."

That was the first conversation. I went back the next day, same speech. Then it was my turn to get angry. I appealed to every emotion, especially to family pride, which is a ruling emotion. Nothing! Then I lost my temper. I terrified the household banging the table with my fist, and I ended by saying that, as a man like Buchon could not have a bit of ground among his family after his death, I would take care of things; that I would petition the prefecture for the right to exhume his body and have it transported to Ornans to my land, where he would not cost his family anything. In short, there is a lack of reason in all this that I understand.

Mme B. was wrong in her dealings with Pierre F. She should have taken the uncle as he was and, as I told her, invited him to see his nephew when he

was ill, without relying on M. Flick, who cannot write and who anyhow did not especially want him to come.

Lastly, I wrote the Pasteur family a letter that was a hundred times more terrible than Champfleury's* in the Montbéliard paper,[3] which remains unanswered. And I told the uncle that he has to order Flick to pay for the plot or they would regret it. In any case, the people should not pay for the plot. If the plot is included in the twelve hundred francs that you are asking for, subtract it. In fifteen years we'll see about providing all that, if the family pride stays out of it.

M. and Mme Flick have come to explain, in tears, that they would be ruined if the conditions of the will were met; that if they had thought about it they would have renounced the inheritance. Third conversation: Uncle P. wants to give one hundred francs and the other uncle also, but they want to see how the contributions go.

Latest news: Pasteur junior will take himself to Salins to see his sister and find out what to do and I think they will definitely do what remains to be done.

My dear Claudet, show this letter to Mme Buchon. Please offer her my apologies. Say hello to all our friends.

I'll be sending you fifty francs from me, five francs from M. Verreur, and five francs from Alexis Bourgon from Chantrans.[4] I was supposed to send Gaudy's,* but this is it. I will try again to do something. I am not very good at these collections.

If you send the contributions to the newspaper *Le Doubs*, we could involve those from the Casino and various people.

Sincerely yours. Kind regards to your father.

G. Courbet

1. An uncle of Max Buchon,* whose mother's family was called Pasteur and originated from Vuillafans.
2. Buchon's younger sister, who had married a Salins merchant by the name of Pierre Flick.
3. I have been unable to trace this letter. It is not listed in Clouard (1891).
4. Contributions to the Buchon monument, to be sculpted by Claudet.

To Léon Gauchez, Ornans, February 13, 1870 <u>70-4</u>

Ornans, February 13, 1870

My dear M. Gauchez:

I did not answer you right away because I was traveling and I did not find your letter until my return from Munich, a country where my painting is very successful and has determined the young people to adopt this way of

seeing. Also, the death of my friend Buchon* had temporarily disheartened me, and the third reason is that I had always meant to return to Paris and meet with you. But I fell ill and have been purging for a month. As I must stay here another month, I am writing you to comply with your collector, if there is still time. As for the two seascapes, one with cliffs, the other with village and trees,¹ I was offered a thousand francs each for them in Etretat. I did not sell them on the advice of Diaz,² who maintained that I could get more money for them in Paris. Moreover, the *Seascape with White Cliffs* [F. 593?] was sold for that price to M. Collinet³ and the others as well to other collectors. If your client decided [to buy] at that price, I would sell to him at that price. I believe that they were offered to him for three thousand francs for both. As for the *Landscape with Roedeer* [F. 644?], it had been commissioned from me by a Parisian collector for the sum of six thousand francs. Then, when I had finished the painting, I lost his address. That means that it is for sale, as I have not seen the gentleman again, perhaps because of my travels. I would like to sell the latter for four thousand francs. The roedeer and the landscape are as pleasing as those in the *Covert* [F. 552], which I sold for fifteen thousand francs. You still have not sold anything in Brussels. You told me that you had been made some offers. If you would refer them to me, we could perhaps let them go.

I would like to sell some paintings this winter. When I come to Paris before the Exhibition I will consult with you about that. With this new ministry, the attacks of the Fine Arts Administration, Nieuwerkerke* and associates, will perhaps let up on me a bit.

Sincerely yours, Monsieur, I have the pleasure of offering you my congratulations.

Gustave Courbet

I did some curious paintings in Munich: some copies—the [*Self-*]*Portrait* of Rembrandt [F. 668] and a Frans Hals [F. 670], a *Portrait of Murillo* by Velazquez⁴—a female nude of my own⁵ and some Swiss landscapes.⁶

1. It is unclear to what paintings Courbet refers here.

2. Narcisse Virgile Diaz de la Peña (1807–76), a well-known member of the Barbizon school.

3. A letter by E. Collinet, dated January 12, 1870, informing Courbet that he has taken possession of the painting, is in Paris, Bibliothèque nationale, Cabinet des estampes, Yb3.1739 (4°), b. 2.

4. Compare letter 69-10, n. 8.

5. The *Lady of Munich* (F. 667).

6. Including the *Landscape at Interlaken* (F. 671).

To Jules Castagnary, Ornans, February 15, 1870

Ornans, February 15, '70

My dear Castagnary:

Monsieur de La Rochenoire,* the painter (25 boulevard Rochechouart), has just written me, on behalf of the election committee for the jury of the 1870 Exhibition, that I have been named unanimously by the committee to be one of their candidates.[1] It is the most annoying thing imaginable, but I must resign myself to it.

I replied that it was time for artists to regain their independence and leave the service of the Emperor's House Ministry and the protection of M. de Nieuwerkerke.[2]

I referred them to you (I don't know whether they will go) so that you could draft a petition for them to the Chamber, invoking the logic of the new ministry, in order that they may henceforth be allowed to ally themselves freely to a ministry rather than to a house [ministry].[3]

To that end I cited the examples of Belgium and Munich. In the event, the Chamber could allocate the Palais de l'industrie to them. The organizers would be paid out of the admission fees, the commissions decided by an appointed committee, which would decide the acquisitions for the lottery as well. The same committee would also distribute the awards, for only thus are they acceptable.

That would not prevent the famous Emperor's House Ministry from giving out its own commissions with its own money instead of with our admission fees. If things were done that way, it would already be one olive branch thrown into the art world, and one could practice painting with less disgust.

It is also necessary that all the annual receipts from the admission fees be spent, entirely, with no reserve fund. The administrative structures will last only for the duration of the Exhibition because they all eventually turn into little governments. It is also necessary that all the current personnel of the exhibitions organized hitherto, such as the attendant, the hanger, the sweeper, the director, the deputy director, the usher, the doorman, etc., etc., be replaced, because deep down among all those [illegible word] there is deep-rooted corruption and swindling too.

All this will not happen because artists don't like independence and the others like government too much. In the casserole of France stew is simmering into which, by accident, a turd has been dropped. No matter how much you fix it, season it with a pinch of pepper, a clove, cinquefoil, a bay leaf, or even an olive leaf, none of that will do any good.[4] The only thing to do is to toss the stew down the privy, for even if you remove the aforesaid incongruous object, it would always leave a trace. We need a revolution of '89 on new foundations, a constitution made by free people.

Ordinaire* is going to the devil.[5] The presentation of Rochefort's* letter cost him dearly with the voters;[6] they are flabbergasted. Only the most liberal would have been glad to see it, such as Jules Favre.*

My dear friend, since Buchon's* death I have been unable to work. For two months I have been in a torpor that I am unable to shake. I have purged myself two or three times yet I feel I still have liver trouble. I think it is the result of an earlier fatigue. Buchon's tomb is coming along slowly.[7] The family has behaved shamefully.[8] I will be in Paris in a week to send my paintings to the Exhibition.

Yours sincerely, dear friend, and kind regards from my family,

G. Courbet

1. In 1868, the rules for the formation of the Salon jury had been changed to make them more liberal and democratic. Henceforth, all artists who had been admitted to the Salon at least once (excepting the unjuried Salon of 1848) were allowed to participate in the election of two-thirds of the jury. The remaining one-third continued to be appointed by the government. To prepare a slate of candidates for the jury election, artists' organizations and ad hoc groups formed committees to select candidates of their choice. One of the most powerful committees was the one headed by the painter Jules de La Rochenoire.* This committee nominated Courbet as a candidate for the jury, but the artist failed to be elected. He was, however, the fifth runner-up, and as such his name was listed in the introduction to the 1870 Salon catalog (cf. Mainardi 1987, 187; Salon catalog 1870, introduction; and Jules Castagnary's first article on the 1870 Salon in *Le Siècle*, May 9, 1870.

2. From the mid-1860s onwards, the comte de Nieuwerkerke's* power had steadily increased, and by 1867 he presided over both the admissions and the international awards juries. His title had become Superintendent of the Fine Arts Administration, and he was directly responsible to the Emperor's House Ministry. All this could hardly increase his popularity among artists, and, in 1868, when the press censorship laws were relaxed, Nieuwerkerke became the target of severe criticism (cf. Mainardi 1987, 194–95).

3. On January 2, 1870, a new cabinet had been formed by Emile Ollivier. It included several men of great integrity, including the new minister of fine arts, Maurice Richard.* Courbet clearly felt that the changes in the organization of the Salon made since 1868 had not gone far enough and hoped to interest La Rochenoire's committee in petitioning the new minister to make more radical modifications in the installation and hanging, the acquisitions for the state lottery, the distribution of awards, and the spending of the admission fees.

4. According to Crapo (1990, n.p. [n. 1]), the laurel and olive leaves are references to Clément Laurier* and the new prime minister, Emile Ollivier.

5. Edouard Ordinaire was elected deputy of the Doubs Department in 1869, replacing the marquis de Conegliano.

6. After having been arrested and imprisoned for his role in the Victor Noir affair, Rochefort, on February 12, sent a letter to the Chamber via Edouard Ordinaire. Though Ordinaire was not given the opportunity to read the letter, it did establish his close alignment with the radical left.

7. The tomb by Max Claudet,* for which Courbet was one of the major fund-raisers.

8. See letter 70-3.

To Léon Gauchez, Ornans, February 19, 1870

Ornans, February 19. '70

My dear M. Gauchez:

I am very grateful to you for your excellent intentions in my regard and for the readiness with which you serve my interests. Collectors always want what they believe is being kept from them and what one appears not to want to sell them.

This is the story of the little *Woman*[1] that is in the upstairs room. I painted it in Frankfurt, a long time ago, and I sold it on the spot to an art dealer, who resold it to another art dealer in Paris, and the latter sold it to M. de Jolival* for five thousand francs. M. de Jolival has just bought from me a painting of a woman of the same size, for which he has not paid me.[2] As he had lent me the [first-mentioned] painting for my exhibition,[3] I kept it as a collateral. As he could not pay me for the other one, he agreed in the end to an exchange.

Consequently, this painting belongs to me now and was bought for five thousand francs from M. Martin[4] (I believe), art dealer in the rue Laffitte. If your collector decides to take both the *Roedeer* [F. 644?] and the *Woman*, let him have the lot for a floor of six thousand francs. If on top of that you can get ten percent, so much the better.

Now the *Woman* has been relined and put in a humid place. It should be glued together again by a reliner because the canvas is cockling in the right corner.

I am upset to hear that you are ill because it is unpleasant. I am still in a state of depression that prevents me from working. With kindest regards,

G. *Courbet*

1. Probably the *Sleeping Nude* (F. 228), which is dated 1858. See also n. 3.

2. Perhaps the *Reclining Woman in Boat* (F. 629), which has approximately the same dimensions as the *Sleeping Nude* (F. 228).

3. Perhaps the Brussels Salon of 1869, to which Courbet had sent four works, including a *Sleeping Nude*. See letter 70-8.

4. Pierre Firmin-Martin, or "père Martin," became an art dealer around 1848. His gallery, first located in the rue Mogador, became a gathering place for Realist artists, including Jean-François Millet, Camille Corot, Théodore Rousseau, Eugène Boudin, and Adolphe-Félix Cals. Martin later moved his gallery to the more fashionable rue Laffitte, where he championed several Impressionist painters, such as Alfred Sisley and Stanislas Lépine (cf. Weisberg 1981, 167–68).

70-7 *To Léon Gauchez, Ornans, February 22, 1870*

Ornans, February 22, '70

My dear M. Gauchez:

My compliments and I am delighted with this sale,[1] which is the begin-
ning of our business relations together. My reliner is M. Mortemard, next
door to me in the rue du Jardinet. He might be willing to do it for you
immediately, for it is not much of a job, just to lift the corner of the canvas
and dampen it. But those people make a great mystery of it because there are
none in their profession.

I received from Belgium, from the Société des arts libres, an extremely
flattering letter. We will send them something, as well as to the exhibition in
Antwerp.[2] When I come to Paris I'll come see you or you'll come [to me],
we'll work it out.

The Paris painters have nominated me to their jury.[3] It is a terribly an-
noying thing because they have no independence in regard to the government.
Nonetheless I will abide by whatever they ask of me.

Sincerely yours and regards,

G. Courbet

I authorize M. Gauchez to take from my atelier a *Landscape with Roedeer*
[F. 644?] and the little *Nude Woman* [F. 228], which is in the little room
upstairs on top of the chest of drawers. G.C.

1. Compare letter 70-6.
2. Courbet did not participate in the Brussels Salon of 1870, but he did submit a painting
to the 1870 Antwerp exhibition, entitled the *Courtisan* (*La Courtisane*; cat. no. 217). According
to Fernier (1977–78, 2:4), the *Courtisan* is identical with the *Woman with a Parrot* (F. 526),
but that painting was sold in the spring of 1870, to Jules Bordet.* Perhaps the painting exhib-
ited in Antwerp was the *Lady of Munich* (F. 667).
3. Compare letter 70-5, n. 1.

70-8 *To Léon Gauchez [Ornans, February 26, 1870]*

My dear M. Gauchez:

I received your letter this morning. There is no reason to despair yet in
this deal. We can always sell the *Landscape with Roedeer* [F. 644?] for more
than he is offering for it. As for the paintings that were in Brussels,[1] I don't
remember very well how we had them priced. I believe it was as follows: the
Woman at the Spring [F. 627], seven thousand francs—let it go for five thou-
sand francs; the little *Woman* [F. 228?], three thousand francs—let it go for
two thousand or eighteen hundred francs; the *Landscape with Lock* [F. 282?],

one thousand francs; the *Seascape* [F. 597?], one thousand francs. Hoping for good news, I send you my warmest greetings,

G. Courbet

1. At the 1869 Exposition générale des beaux-arts in Brussels, Courbet had exhibited four works (cat. nos. 252–55), listed in the catalogue as, respectively, *La Source* (The spring); *Dormeuse* (Sleeping woman); *Les Roches Noires de Trouville* (Black rocks at Trouville); and *Moulin de Scey, Vallée d'Ornans* (Mill at Scey, Ornans valley). As the question marks in the text indicate, the works cannot be identified with certainty, with the exception of F. 627.

To Jules de La Rochenoire, Ornans, March 4, 1870¹ (incomplete) 70-9

[Courbet recommends to La Rochenoire to make the committee over which he presides more independent.²]

. . . If I have proved nothing else, I have at least demonstrated that, without privileges, without protection, and without being a Napoléonist, one can have an artistic career, if one has the right temperament. I have just come back from two countries where I have had complete success: Belgium and Bavaria.³ Those artists are independent. . . .

1. This letter is known only through a partial citation by Léger (1929, 151), who gives the date of the letter as March 4. Crapo (1990, n.p. [n. 18]), believes Léger may have copied the date wrong and suggests an earlier date of February 4. However that may be, this letter and letter 70-10 seem to have been part of a rather intensive correspondence between Courbet and La Rochenoire between the beginning of February and the end of March.

2. Léger refers to La Rochenoire as the president of L'Association des artistes peintres. This is most certainly a mistake, as that society was presided over by its founder Baron Taylor.* Léger's error must have arisen from his unfamiliarity with the ad hoc committees that were formed in 1870 (cf. Crapo 1990, n.p. [n. 18]).

3. Reference to the two medals he had received in Brussels and Munich in 1869.

To Jules de La Rochenoire, via Jules Castagnary, Ornans, March 9, 1870 70-10

Ornans, March 9, 1870

My dear fellow-artist:

I read your proposed constitution but I see no revolution in it except in articles 4, 5, 8, 9, 15, 17, 18, 20, 24, and 26.¹ You must understand one thing: all those articles pertain only to form and will not change in any visible way what has happened until now.

You have other articles that are terrible, that are against freedom, and that will become justified and sanctified by the votes of men who do not possess the spirit of freedom. In Europe you'll pass for people who are not fussy about their independence. Beware of voting for something that sanctions any kind of power, such as:

— Article 7: useless power.

— Article 19: Freedom consists of doing without the state under all circumstances (the revolution seeks only to obtain this goal). Men should only and continually be answerable to themselves. In that passage you regress and you are outside the current movement.

— Article 21: This has no justification whatsoever. One submits [works] to an exhibition by one's guts; shopkeepers, farmers, industrialists, in short, all of France does it that way. As you propose to do it, the Champs-Elysées and the Bois de Boulogne over two years would not be adequate exhibition rooms. Your ideas are far behind those of the Germans. In Germany the admission receipts are used to pay the contractors appointed by the artists to hang the paintings and to organize [the exhibition], and the surplus is spent entirely on acquiring works of art, chosen by their committee. That money is combined with that of the lottery and it is constantly converted into acquisitions until the moment of the drawing.

When a man exhibits his works, he does so to find out what people think; it is like the man who shouts to the mountain to know whether his tone is true. Nobody has the right to repay those shouts. That is the business of the one who has the idea of shouting. If his shouts are true, he is rewarded by that very fact, and he lives by the people's support. The idea of sharing his admission fees is unbelievable.

— Article 22: The state is subordinate to the French people and should do only what they desire. When a city in France wants a painting, it turns to the state, which is its business agent, and this business agent turns to the painters' committee, which determines which is the appropriate painting and what its price is. The state must not take the initiative.

— Article 23: A monstrosity. The Ministry of Fine Arts is a fetish that could be respected by Africans only. The Ministry of Fine Arts will bestow the rewards and the honorable mentions that the committee, appointed by the painters, tells it to bestow, as in Munich.

— Article 25: Do not commit to hanging the paintings only on the line. For the smallest ones that is fine, as long as it can be done. With that commitment you would have an exhibition three kilometers long and a never-ending stream of complaints.

— Article 26: Is the best of your articles, for no one has the right to rank anyone. All my life I have asked the government for one thing only, to leave me alone, and I have never been able to get it.

There is an article missing from your constitution. Intelligence is found in all classes of society but independence is found a hundred times more often among the poor than among the rich. A man may be so poor that he cannot be on your jury, either because he has job obligations or because of his clothes. On the other hand, as no one should accept something for nothing (not even the Sisters of Mercy), I would like the vouchers for attendance to

be paid ten francs. That is not a great sum relative to the entrance fees. Besides, no one has to accept it.

Miscellaneous considerations:

The article, "No Division," is unintelligible. Remember, dear colleague, that we are human beings and that among us there is good and evil, that is to say, the good that we understand each in our own way and the evil that we don't understand. Consequently, and whether we like it or not, we must, to be honest, vote as we believe and for the good according to our degree of judgment. The struggle between good and evil has existed since the world began. If Jesus Christ had heard you, he would have said, "Man of little faith, I don't like lukewarm people." With this system you'll still have the official list prevailing.

I repeat what I told Castagnary:[2] beware of the Exhibition's current organization, the directors, the deputy directors, the managers, the assistant managers, the secretaries, employees of all kinds—ushers, equipment managers and assistant managers, hangers, guardians. That whole group is corrupt to the core, they are all extortionists. Those insolent fellows come and talk familiarly with you, right in front of the public, and poison everyone with their smell of brandy. All that rot harms you more than you think. They know all the collectors and buyers of paintings and they dissuade them from purchases that they don't like. In your new organization, throw them all out, for half of them extort paintings and sketches from artists, the other half tips.

Sincerely yours, my dear fellow-artist. I leave tomorrow.

G. Courbet

My dear Castagnary:[3]

Please be so kind as to show this letter to M. de La Rochenoire, I have not had time to copy it over for you. Yours sincerely.

1. The painter Jules de La Rochenoire had formed an ad hoc committee composed of himself as president, Camille Corot,* Charles Daubigny,* Charles Chaplin (1825–91), Ignacio Mérino (1818–76), and Félix Ziem (1822–1911), to prepare a slate for the jury of the 1870 Salon. This committee had decided to draft a proposal for a new "constitution" for the Salon, aimed at making it more democratic (more control by artists, less by the Ministry of Fine Arts). La Rochenoire's committee was not the only one to develop a project for Salon reform. A handful of other committees were similarly engaged. The proposal of La Rochenoire's committee went further than all others, however, in the autonomy it gave to artists to organize their own Salon. For a thorough discussion of the proposed Salon reforms in 1870, see Crapo (1990). Crapo points out that, owing to the variety of the proposals and the inability of artists to agree on a compromise, relatively few changes were made in the organization of the 1870 Salon.

It is likely that La Rochenoire sent Courbet a manuscript copy of the proposal in a letter, but it has not been preserved. The text of the "constitution" found below is a translation of the published proposal as it appeared in the *Revue artistique et littéraire* of January 1870 (cited in Crapo 1990, n.p.). It probably differs slightly from the text Courbet is commenting on in this letter:

CONSTITUTION OF ART EXHIBITIONS

First article: The artists, painters, sculptors, etc. having been admitted to the Salon, are *de jure* electors.

2. All electors are eligible.

3. The members of the admission jury are chosen among the eligible artists and elected by the majority.

4. Excluded from the jury is any artist who is not an elector.

5. No portion elected by the Administration will be admitted to the jury.

6. The jury will be chosen among the exhibitors of the preceding Salon.

7. Outgoing members can be reeligible only every two years.

8. Excluded from the vote are the students from the Ecole des beaux-arts, as well as any artist not meeting the eligibility requirements.

9. Admitted *de jure* to the Exhibition are all artists who have already exhibited.

10. To be admitted, artists who have not exhibited must submit their works to the jury appointed by the artists' electors.

11. After their reception they'll enjoy the same rights as their colleagues.

12. French artists alone will be part of the jury.

13. Foreign artists can in no case be eligible.

14. If they are found to fulfill the conditions of art. 9, foreign artists will be permitted to vote.

15. To be admitted to the Exhibition, it is sufficient to receive one-third of the votes of those voting.

16. The number of the jurors [who must be] present for the admission will be determined.

17. The Fine Arts Exhibition is completely independent from the Ministry of Fine Arts.

18. The Palace of Industry, being a national property, is conceded to us for the amount of time deemed necessary for the exhibition of our works.

19. The administrative expenses will be borne by the state.

20. The jury will appoint, by majority vote, the administrative director of the Fine Arts Exhibition.

21. The total income from the entry fees shall be divided and shared among the exhibitors.

22. The state will make its acquisitions freely and it will maintain the prerogative to utilize the funds allotted by the Chambers to enrich our museums with the most remarkable works of the Salon.

23. The Minister of Fine Arts will retain all his rights to [give] encouragement and honors.

24. A special office will be created adjacent to the Exhibition for the sale of the artworks exhibited.

25. The jury will be able to make decisions on the placement of paintings; it may be necessary, however, to make a definitive decision and to place all paintings, large and small above the line.

26. Medals and rewards are eliminated, for any bias of taste, clique, friendship, or other is pernicious, as it creates an enormous prejudice against artists for the distinctions it establishes and the unfavorable light in which it causes the public to see the majority of them.

The undersigned accept the proposed constitution outlined above in its entirety but are ready to entertain partial modifications that will be submitted to them."

2. Compare letter 70-5.

3. Castagnary seems to have been greatly interested in the matter of Salon reform and no doubt had read La Rochenoire's proposed constitution as well. He would comment positively on it in his first article on the 1870 Salon in *Le Siècle* of May 9.

To Juliette Courbet [Paris], April 29, 1870 (incomplete) **70-11**

Friday, April 29, 1870

Dear Juliette:

. . . I have not yet had time to write you since I arrived. . . . In the month that I have been here I have sold 31,600 [?] francs' worth of paintings and it will continue. I am a huge success at the Salon with my two seascapes.[1] I have already sold one for eight [?] thousand francs[2] and the other will undoubtedly be sold [as well]. My paintings are in demand on every side.

I sold the *Woman with a Parrot* [F. 526] to M. Bordet* from Dijon, Mme de Villebichot's brother, for fifteen thousand [francs], two seascapes to her sister for one thousand, and two others to a brother for one thousand. But I am not getting married.[3] Imagine a Lélia Dard,[4] but even less pretty, dark, a little faded, little bosom, big hands, ugly feet, but in spite of all that a woman of distinction, in the sense that she is very decent and good, kind, very devoted, and very unaffected and natural. Her brother has come to Paris and we have never been able to keep him from coming and joining us here. She came last Sunday, we lunched together, and she left again on Monday morning. Passing through Dijon I had dinner with her and now I am obliged to visit them regularly when I pass through Dijon. We are going to organize a benefit exhibition for the wives of the Creusot workers during the Dijon regional exhibition.[5]

I sold the small *Female Nude* [F. 228?] for four thousand francs and half the profits from the resale. I sold the *Swiss Landscape* [F. 671] to M. Stumpf* for six hundred francs.

There is a [][6] woman, a dealer, in Paris, who wants to make my fortune, but I don't know where she is anymore. She found a collection of older paintings that can be bought for five thousand francs and I went to see it. There might indeed be, among those paintings, some of great value. But she has disappeared and I don't know whether she bought them. . . . I have been waiting for a week already.[7]

On Thursday I moderated a conference at the Sorbonne.[8] I embrace you all,

G. Courbet

Tomorrow I am going to Ste. Pélagie to see Rochefort,* who wants a landscape of mine.[9]

Try to get people to vote "no."[10] It is the going catchword.

1. To the Salon of 1870 Courbet had submitted two recent seascapes, *Stormy Sea* (F. 747) and *Cliff at Etretat* (F. 745).

2. According to letter 70-17, the *Cliff at Etretat* was sold to the dealer Hector Brame,* who may have sold it to a M. Carlin, as the work was auctioned off, with the rest of the Carlin collection, on April 29, 1872.

3. Apparently, Courbet had entered into a relationship with the sister of Jules Bordet, Mme de Villebichot, and there had been talk of marriage.

4. A female acquaintance, perhaps related to the painter Pétrequin-Dard* (b. 1838).

5. The exhibition, Exposition au profit des femmes des condamnés du Creusot, was organized in Dijon in 1870 for the benefit of the wives of the striking workers in the armament factory at Le Creusot.

6. Illegible word.

7. Courbet was to buy the collection, which belonged to a Mme de Planhol, for thirty-five hundred francs. See letter 70-13 and Riat 1906, 277.

8. On April 27, Courbet had presided over a special Soirée littéraire et artistique to benefit the printmaker Rodolphe Bresdin (1825–85), who was in dire financial straits. A program for this soirée, which was held in the Salle du gymnase of the Sorbonne and which included lectures, poetry readings, and music, has been preserved in Paris, Bibliothèque nationale, Cabinet des estampes, Yb3.1739 (4°), b. 2. Courbet seems to have been confused about the day of the week. The twenty-seventh fell on a Wednesday, not a Thursday.

9. The radical journalist Henri Rochefort, though elected to the Corps législatif in 1869, was arrested on February 7, 1870, and detained in Ste. Pélagie Prison until September 4. It is not known what, if any, landscape Rochefort bought at the time.

10. Reference to the plebiscite of May 8, 1870, whereby the people were asked to vote for (yes) or against (no) the new Liberal Empire of Napoléon III.

70-12 *To Jules Castagnary [Paris, early May 1870]*

My dear Castagnary:

Make whatever changes you like in what M. Bordet,* Jules, has written above.[1] Puissant is just leaving here and will write about it his way in the *Marseillaise*.[2]

Sincerely yours,

G. Courbet

1. Courbet's note is written at the bottom of a draft for a press release by Jules Bordet, which reads as follows:

We are glad to learn that the painting known the world over by the name of the *Woman with a Parrot* [F. 526] (Salon of 1867) has just been bought by M. Jules Bordet of Dijon for the sum of twenty thousand francs.

We are sure that this inimitable work by our great painter Gustave Courbet will stay in our country. It will therefore not undergo the fate of two other paintings by the same artist, one of which is in Constantinople, the other in Boston. We are referring to the *Mort [of the Stag]* and *Venus and Psyche*.

M. Jules Bordet was also the purchaser of five other paintings by the same painter and is preparing to exhibit them for a charity in the course of the regional event that will soon be taking place in Dijon.

We therefore cannot urge the inhabitants of the town of Dijon too strongly to

respond to the appeal that will be made to them. In that way they will be contributing to a good cause, while taking advantage of the opportunity offered them to form their own opinion of this fine painting.

The references in the second paragraph are to the painting usually known as the *Quarry* (F. 188), which was bought by the Allston Club in New York, and to the *Sleeping Women* (F. 532), which had been bought by Khalil Bey* and was presumed to have been taken to Constantinople when the Turkish ambassador returned home. In fact, the painting never left Paris but was sold to the well-known baritone and art-collector Jean-Baptiste Faure (1830–1914). It is not clear whether Bordet erroneously refers to the painting *Venus and Psyche* or whether that name was on occasion used for the *Sleeping Women*.

According to Riat (1906, 276), Bordet bought five seascapes, in addition to the *Woman with a Parrot*. It is not possible to identify these works today.

The Dijon exhibition referred to in the last two paragraphs of the release is the Exposition au profit des femmes des condamnés du Creusot (Benefit exhibition for the wives of the men convicted at Le Creusot).

2. *La Marseillaise*, a paper founded by Rochefort.*

To Juliette Courbet, Paris, May 11, 1870 70-13

Paris, May 11, 1870

Dear Juliette:

Yesterday I sent you a basketful of flowers. You can pick and choose and vary the colors.

I am about to leave for Dijon for an exhibition that M. Bordet* is organizing to benefit the women of Le Creusot.[1]

The plebiscite is arousing a great deal of laughter.[2] The empire is terrified. The army voted better than the bourgeois, and it [the empire] is left with only the inert mass of the peasants. The empire continues to raise barricades but nobody stops for them.

I had mentioned to you the lady from our part of the world who wanted to buy a museum with me. I have not seen her again or the flowers that she wanted to buy either, so I went out to buy them myself. I took everything I could find in order not to [].[3] As the lady did not come back I bought the museum myself.[4] I have struck a fantastic bargain. I paid thirty-five hundred francs for it and I rented accommodations for thirteen hundred francs to leave it where it is.[5] It is something that could be worth perhaps three hundred thousand francs. I don't even dare think of it, let alone look at it. I paid on the spot so that they would have no grounds for complaint. It belonged to a lady from Normandy who had it from a minister of Charles X.[6] It contains among other things some ten Rubenses that are worth a fortune, etc. I believe that my deal is even better than Father's. I am also about to sell my second seascape.[7] They continue to be the rage. The salon where they are is jammed with people.

If I have time to go to Dijon I may come see you. Your flowers are in Ornans. Tell Father not to get overtired and to live quietly. I hope Mother is well. I embrace you all.

G. Courbet

1. Compare letter 70-12, n. 4.
2. The result of the May 8 plebiscite in which Frenchmen were asked to vote for or against the Liberal Empire. The result was a notable triumph for the emperor, who received 67.5 percent of the vote.
3. Word(s) missing due to a tear in the paper.
4. On Courbet's acquisition of this collection, see Riat (1906, 277).
5. At 24 rue du Vieux-Colombier.
6. According to Riat (1906, 277), the collection belonged to a certain Mme de Planhol, who had inherited it from her uncle, M. de Naglis, ambassador under Charles X.
7. Courbet had already sold one of the two seascapes at the Salon of 1870 (see letter 70-11) and now hoped to sell the second one as well. See also letter 70-17.

70-14 *To Jules Castagnary [Paris], May 13 [1870]*

May, Friday 13th

My dear Castagnary:

We really don't see you anymore. It is sad for everyone in our group. Chartan[1] received some fish that we plan to eat tomorrow, Saturday. Why don't you come? That will show us that you are not angry and that you are still one of us. I compliment you in the highest terms on your article in the *Siècle* about me.[2] It has been impossible for us to get hold of a copy. Please be so kind as to bring us one or two copies. I'll send one to my family. Till tomorrow. I have received an invitation from M. Maurice Richard,[3] which I plan to refuse. I'll expect you at five or six o'clock at my place.

G. Gourbet

1. Compare letter 69-9, n. 1.
2. Castagnary wrote a series of articles on the 1870 Salon in the *Siècle* between May 9 and June 17. Courbet's two paintings were discussed in the first article on May 9.
3. Maurice Richard,* the new minister of fine arts, was courting Courbet in order to win him over to his side. Courbet, however, kept his distance. See also letter 70-15.

70-15 *To Maurice Richard [Paris], May 16, 1870*

Monday, May 16, '70

Monsieur le Ministre:

Please excuse me. I am expected in Dijon for important business, namely an exhibition of paintings[1] that I am organizing in that city, to coincide with

the regional fair. I would be delighted to accept an invitation from you to a less official occasion.²

Please excuse me and convey my regrets and my compliments to Mme Maurice Richard.

With respectful greetings to both you and your lady,

Gustave Courbet

1. The benefit exhibition for the women of Le Creusot. Compare letter 70-11, n. 5.
2. Compare letter 70-14, n. 3.

To Jules Castagnary [?] [Paris, May 27, 1870] 70-16

[No salutation]

I was invited to Minister Maurice Richard's* home for tomorrow, Wednesday. I refused, but I am not sure that he will not make any other attempts to have me there, his servant has already come by.¹

Furthermore, I will be leaving for Dijon, Friday at eleven o'clock in the morning. I am organizing an exhibition of paintings to benefit the women of Le Creusot.² I will be back next week.

Sincerely yours,

Gustave Courbet

1. See letters 70-14 and 70-15.
2. Compare letter 70-11, n. 5.

To Gustave Poret, Paris, June 3, 1870 70-17

Paris, June 3, '70

Dear M. Poret:

According to your conversation with M. Briet, it would appear that I could oblige you by selling you the painting of the *Stormy Sea* [F. 747], which is a pendant of the *Cliff at Etretat* [F. 745]. The *Cliff* was sold for ten thousand francs to M. Brame,* an art dealer.

If you seriously want the other painting, I'll let you have it for the same price, in spite of other bidders and higher offers.¹

Sincerely yours,

Gustave Courbet

32 rue Hautefeuille

1. Apparently, the sale to Poret did not take place. *Stormy Sea*, like its pendant, *Cliff at Etretat*, became part of the Carlin collection and appeared in the sale of that collection on April 29, 1872.

70-18 *To Jules Castagnary [Méry-sur-Oise, June 22, 1870]*

My dear Castagnary:

I have dashed off this letter that I am sending you in hopes that it will appear right away in full.[1] If the *Siècle* cannot [print it], take out of it whatever you can use, and in that case, send the complete text to the *Réveil* in my name.[2] I will stay here another day so as not to be bothered further, for they are already writing me from Laveur's[3] that I must accept. It appears that your message has borne fruit. Ordinaire* has not disturbed anything, I was shaking. I will be leaving tomorrow evening for Paris. I'll come to see you in the cave.[4] Try to be as prompt as possible so as to avoid the papers' insults.

Sincerely yours. If anything turns up between now and then, write me care of M. Usquin* in Méry-sur-Oise.

<div align="right">G. Courbet</div>

I met Dupré,* who is quite a fellow!

1. The letter to Maurice Richard.* See letter 70-19.
2. The letter was to appear in the *Siècle* of June 23, 1870.
3. The Pension Laveur, Courbet's boarding house in the late 1860s and early 1870s.
4. This may be a reference to one of the cafés where Castagnary and Courbet often met, possibly the Brasserie des Martyrs.

70-19 *To Maurice Richard, Paris, June 23 [1870]*[1]

Monsieur le Ministre:

It was at my friend Jules Dupré's* home at L'Isle-Adam that I learned of the publication in the *Journal officiel* of a decree naming me knight of the Legion of Honor.[2] This decree, which my well-known opinions on artistic awards and nobiliary titles ought to have spared me, was conferred without my consent, and it was you, Monsieur le Ministre, who felt it your duty to put it forward.

Do not fear that I might misjudge the feelings that guided you. When you came to the Ministry of Fine Arts,[3] after a deadly administration that seemed to have set itself the task of killing art in our country (and would have succeeded by corruption or violence, had it not encountered here and there a few great-hearted men to thwart its attempts), you sought to mark your advent with a measure that contrasted with your predecessor's[4] style.

That line of action does you credit, Monsieur le Ministre, but permit me to tell you that it can in no way change either my attitude or my resolutions.

My opinions as a citizen do not allow me to accept a title that derives essentially from the monarchic order.[5] My principles spurn the decoration of the Legion of Honor that you stipulated for me in my absence. At no time, in no case, and for no reason would I have accepted it. How much less would I

do so today, when betrayals are multiplying everywhere and the human conscience is grieved by so many self-serving recantations. Honor is neither in a title nor in a ribbon, it is in actions and the motivation for those actions. Respect for oneself and for one's ideas constitutes the greater part of it. I do myself honor by staying true to my lifelong principles. Were I to abandon them, I would be giving up honor to wear its symbol.

My artist's feeling also goes against my accepting an award that is granted to me at the hand of the state. The state is incompetent in matters of art. When it takes on itself to give out awards, it is usurping the public's taste. Its intervention is entirely demoralizing, fatal to the artist, whom it misleads as to his worth; fatal to art, which it confines within its official conventions and which it condemns to the most sterile mediocrity. The wise course would be for it to stay out of it. The day it lets us be free, it will have fulfilled its duty toward us.

Allow me therefore, Monsieur le Ministre, to decline the honor that you believed you were bestowing on me. I am fifty years old and I have always lived in freedom. Let me end my life as a free man. When I am dead, they must be able to say of me, "That one never belonged to any school, to any church, to any institution, to any academy, and, above all, to any regime except the regime of freedom."

Please accept, Sir, that along with the above sentiments, I am,

Sincerely yours,

Gustave Courbet

Paris, June 23

1. This text is a translation of Courbet's letter as it appeared in the *Siècle* of June 23, 1870. The actual letter was probably written the day before in Méry-sur-Oise at the house of M. Usquin,* not at the house of Jules Dupré, as Courbet claims (cf. letter 70-18, and n. 2 of this letter). The letter must have been of great personal importance to Courbet, as is borne out by the fact that two alternative drafts for it are known. The first of these, written in another hand but approved and signed by Courbet, is in Paris, Bibliothèque nationale, Cabinet des estampes, Yb3.1739 (4°), b. 2. The second is an incomplete autograph draft that has recently turned up in the autograph market. The two drafts read as follows:

[First draft]

L'Isle-Adam, S. & Oise, Tuesday, June 22

To the editor,

Monsieur:

During my stay in the country at the home of my friend Jules Dupré, the empire has been so indiscreet as to decorate me, without my approval of the rewards given after the painting exhibition of 1870.

I infinitely regret not having been in Paris under those circumstances. I could have answered to the visiting card of the minister, M. Maurice Richard, which he had kindly delivered to my home and which was forwarded to me. Present in Paris, I would have avoided the feeling of profound vexation that I experience at this

moment when I feel obliged to react against this action that I always have, and always hoped to be able to avoid.

Everyone in France knows the innate and instinctive repulsion that I have had from old for that institution. The public will agree with me that, having been able to avoid it, the moment has not come to betray the class of people in France to which I have belonged since my youth, especially when chance, in the form of the plebiscite, has provided us with an unexpected success: a total of two million five hundred thousand men in our country (unparalleled in Europe) instead of the fifty thousand we were in the beginning.

I am very sorry, for courtesy's sake, to have publicly to refuse this decoration, which admittedly was given to me wholeheartedly (I have no doubt about it) by my colleagues on the jury and by the minister of fine arts, but in no way, at no time, and for no reason can I accept it if I am to remain true to my convictions. Let the people who have wished this honor for me have no fear: I will be able to do my duty on my own accord, and in the future, as in the past, I will need no rewards, neither during my life time nor after my death.

If I have quite gratefully accepted the exceptional decoration that was given to me by the joined artists of the International Exhibition of Bavaria in Munich, it is because I am not a German citizen and because I don't need to give my opinion in that country. I have accepted [that expression of] their convictions on their terms and I was quite flattered by it. I will always be flattered by similar gestures abroad. In France it is different: I have a right to act and as a citizen I always have the right to express my opinion.

At this point I wish that, instead of that honor and without ill feelings, I will be allowed and respected for that independence and that liberty that I request, for it is essential to the practice of my art. It is the only reward that I appreciate beyond the public approval of my work, at the annual exhibitions, if I deserve it.

I also wish that my resolution be not attributed to the persecution I have had to endure from the side of the empire in the course of the last twenty years, for the dogged efforts of those gentlemen and the rigor of their institutions, though they killed all my friends, paralyzed my efforts, and damaged my interests, have only caused the public esteem for me to grow.

No, I would not know how to distinguish myself from anyone among my fellow citizens except by my talent, and I could never visit them carrying a distinctive insignia on my person. I also wish to end my life by being my own man entirely, without belonging to any church, any institution, any academy, and above all to any regime, except for the regime of liberty.

M. le Rédacteur, at the end of this small profession of faith, allow me this reflection: If by chance you were to visit the fair at Ornans, you would notice that all the most beautiful sheep in the fair are marked with a slash of red chalk on their backs. Innocent and well-intentioned people who don't know the laws of agriculture and the arts might think, in their naïveté and pastoral candor, that it signifies an homage rendered to their beauty. But alas! They don't know that the butcher has marked them to be slaughtered!"

Regarding the second paragraph of this letter, Courbet seems, judging by letters 70-14 and 70-15, to have deliberately avoided all contacts with Richard, so as not to be accused subsequently of having made common cause with the government.

In the third paragraph Courbet refers to the plebiscite on May 8, whereby Frenchmen were asked to vote for or against the new Liberal Empire. Courbet's figure of 2,500,000 must apply to the Republican vote, which as a rule had been

abstentionist or negative. In fact, the result of the plebiscite was 7,350,000 yes, 1,500,000 no, and 1,900,000 abstentionist votes.

Regarding the fourth paragraph, Courbet, in fact, was befriended with many of the artists on the jury of the 1870 Salon, for which he himself had been a runner-up.

The Bavarian knighthood cross of the Order of Merit of St. Michael, mentioned in the fifth paragraph, was awarded to Courbet in the summer of 1869.

[Second draft]

If one has decorated me without embarrassment, it is because I belong to the artists' race. But there are artists and artists, they are not all alike. I know that, by force of authority, one has lowered the moral voice of that class. This lack of embarrassment would not have existed in the case of anyone else. Today one can catch people like frogs, with a bit of scarlet, that is, of course, those who want to let themselves be had. I don't understand all these rewards. It establishes superiorities that three-quarters of the time are false. A rewarded person is an individual who has sold out his duty. Society no longer owes him anything: they're quits.

At this point the very number of decorated individuals would suffice already to obliterate their value. A decorated man is suspicious. When spotting him, everyone is on guard, withdrawing like a snail within his shell.

The need for gratitude and submission has pushed the empire to distribute these insignia ad infinitum. In the pool of village mayors, for example, I know quite a few who would be more suitably jailed rather than decorated, which [in effect] means public notoriety. People who respect themselves, however, cannot be confused and join ranks with such a crowd. That aristocracy does not seem enviable to me.

It is best, in my opinion, for that false distinction not to exist. Look at England, America, Switzerland. A Swiss was once asked why there were no decorations in his country. He answered, 'Sir, if one decorated one Swiss, one should decorate all the others for all Swiss do their duty.'"

[Here follows a postscript, which is largely identical to the last part of the first letter starting with the sentence, "The dogged efforts of those gentlemen and the rigor of their institutions . . .]

2. Courbet's knighthood had been anounced in the *Journal officiel* of June 22. According to letter 70-18, Courbet at the time was not in L'Isle-Adam but in Méry-sur-Oise, where he stayed at the house of his friend, M. Usquin. He did meet Dupré, however, and may have decided to include his name in the letter to lend it greater weight.

3. Richard had become minister of fine arts on January 2, when the government of Emile Ollivier assumed power.

4. Richard's predecessor, Marshall Vaillant, had been firmly attached to the Emperor's House Ministry.

5. The Legion of Honor had been instituted by Napoléon in 1802.

To his family [Paris, June 24, 1870] (incomplete) 70-20

[He tells his parents that Maurice Richard,* the minister of fine arts, had asked Edouard Ordinaire* to feel him out about the Legion of Honor. That made him decide to leave for Méry-sur-Oise, to wait for the event at the house of his friend, M. Usquin.]

[The letter in the *Siècle*[1] is making] . . . an unbelievable commotion in *381*

Paris and it is not over yet. The papers all speak as one man. It is frightening. We will see what comes of it, for it hurts all those who have been decorated and all the institutions of the empire. . . . [The congratulations and the flowers come in droves.]

. . . Nobody has ever had a success like the one I had this year with my seascapes.[2] My year is splendid in every way. . . .

1. See letter 70-19.
2. The two seascapes (F. 745 and F. 747) that Courbet had exhibited at the 1870 Salon. See letter 70-11, n. 1.

70-21 *To his family, Paris, July 15, 1870 (incomplete)*

Paris, July 15, 1870

My dear family:

War has been declared.[1] The peasants who voted "yes" will be paying dearly for it.[2] Just to begin with, they will kill five hundred thousand men and that is not the end of it. They say that the Prussians are already at Belfort and are marching straight for Besançon. We are in a situation in which we'll see the allied forces once more join forces with the Napoléons, naturally. Everyone is leaving Paris. As for me, I will be leaving here in five or six days to go sea bathing, perhaps in Guernsey, at Victor Hugo's,* and will return to Etretat.

There is a general feeling of desolation. The police and the government are forcing people to shout, "Hurrah for the war," in Paris. It is a disgrace. All the decent people are withdrawing into their homes or fleeing Paris. Do write me, for if the Germans come to Besançon, I'll go to Besançon immediately. . . .

Paul Boulet,* on my instigation, has had a statement prepared on behalf of the people of Ornans. It was published in the *Siècle.*

I am overwhelmed with compliments.[3] I received three hundred letters with such compliments as nobody in the world ever received.[4] Everyone agrees that I am the foremost man in France. M. Thiers* summoned me to his home to compliment me.[5] I even receive princesses to the same end, and a dinner for eighty or one hundred people was given to congratulate me.[6] The entire press and all the scholars of Paris were there. When I go down the street I have to keep my hat in my hand, like a priest.

I was absolutely delighted with your support and with the bouquet you sent me. Everyone was as delighted as I was with your support. The support of the people of Ornans was diplomatic and weakish, don't say anything about it! The exception was Jeannier,[7] who wrote me a splendid letter. The Ordi-

naires* played a sad part in the affair. They did not come to the dinner. I rarely see them, I let them go their own way. The gesture that I have just made is a marvelous stroke, it is like a dream, everyone envies me. I have no opponents. I have so many commissions at the moment that I cannot see the end of it. And so I am leaving. Paris is odious and one risks getting nabbed every day. Keep writing me in Paris. In any case, I will be in Ornans in September . . . provided the Prussians are not at our doorstep in a week.

<div style="text-align: right">*G. Courbet*</div>

My coup lasted three weeks in Paris, in the provinces, and abroad. It is over now. The war is taking my place.

1. On July 15, 1870, the Senate and the Corps législatif voted to start a war with Prussia. War was officially declared on July 19.

2. In the plebiscite of May 8, 1870, the French countryside had voted overwhelmingly in favor of the Liberal Empire.

3. On account of his refusal of the Legion of Honor cross.

4. Several of these letters are found in Paris, Bibliothèque nationale, Cabinet des estampes, Yb3.1739 (4°), b. 2.

5. Courbet's account of his visit to Thiers, perhaps intended for publication in a newspaper, may be found in Paris, Bibliothèque nationale, Cabinet des estampes, Yb3.1739 (4°), b. 2. A partial translation is found in Lindsay (1973, 246).

6. On July 5, a banquet in Courbet's honor was held at Bonvalet's on the boulevard du Temple (cf. Riat 1906, 279). Gustave Chaudey presided over the dinner, which was also attended by Honoré Daumier. The latter had refused the cross as well, though with less noise than Courbet.

7. Jeannier's letter from ca. June 30 is found in Paris, Bibliothèque nationale, Cabinet des estampes, Yb3.1739 (4°), b. 2. It is cosigned by some forty friends of Courbet from Ornans.

To a justice of the peace [Paris], July 22, 1870 **70-22**

<div style="text-align: right">1870 Friday, July 22</div>

Monsieur:

I know nothing about what you are writing me. If M. Rossi,[1] the painter, and M. and Mme Eilerignard [][2] would like to make an appointment to see me at 11 A.M., please indicate a day to them, 32 rue Hautefeuille.

Respectfully,

<div style="text-align: right">*Gustave Courbet*</div>

Notify me after you have previously notified the gentlemen.

1. Probably the Italian painter and illustrator Lucio Rossi (1846–1913), who had settled in France in 1867. It is not known why Rossi wanted to visit Courbet. Perhaps he was the artistic adviser of the couple that accompanied him.

2. Illegible word.

70-23 *To his family [Paris], August 9 [1870]*

Tuesday, August 9

Dear family:

We are in an indescribable time. I do not know how we'll get out of it. Monsieur Napoléon is waging a dynastic war, for himself. He has proclaimed himself commander-in-chief of the armed services,[1] and he is a cretin who in his ridiculous and culpable pride marches forward with no campaign plan.[2] We are defeated all down the line; our generals are resigning and the enemies are expected in Paris. Or else, they say, they are marching on the Franche-Comté. They crossed the Rhine at Colmar. They already hold Lorraine and Alsace.[3] Today we are marching sixty or eighty thousand strong on the Chamber in order to declare the fall of the empire.[4] This is, in the end, what those stupid animals, the peasants, have brought us to by voting "yes."[5] This is Napoléon's France. The empire means invasion. If this invasion rids us of it, we'll still gain because one year of Napoléon's reign costs us more than an invasion. I believe that we will become French again.

Right now I cannot come back to see you. My presence here is useful, and moreover I have considerable interests to protect in Paris. As for you, you have nothing to fear from the Germans. Use my Munich cross of honor.[6] In fact, they are the ones who will be going into the Franche-Comté, if we do not stop them by declaring the republic. I sent you an illustrated magazine and some other [papers] to keep you up to date on the situation. I'll send you more. Yours truly, I embrace you fondly. Don't worry about me. I have nothing to fear from anybody.

G. Courbet

The Prussians have demonstrated a hitherto unknown talent for war. They fight methodically and according to the campaign plan. They have excellent spies, they beat us to all the positions that we want to take. It is an abominable massacre and all for a groundless war.[7] Watch what you say!

[Address] Monsieur Courbet, landowner
 Flagey
 Canton of Amancey, Doubs. Dept.
[Postmark] Paris, August 9, 1870

1. The Franco-Prussian War had started on July 19. Initially, Napoléon III took supreme command of the troops himself, probably to prevent bickering among his generals. On August 12, three days after Courbet's letter, the command was taken over by Marshal François-Achille Bazaine (1811–88).

2. Indeed, it soon appeared that, despite Marshal Edmond Leboeuf's (1809–88) contention that the army was ready "down to the last gaiter button," the French defense was hopelessly disorganized at the outbreak of the war.

3. After a victorious surprise attack on the French near Wissembourg on August 4, the

Germans again defeated the French on August 6 in the Battle of Woerth. This meant that Alsace-Lorraine was open to them.

4. With Napoléon III absent from Paris, both Republicans and conservative Bonapartists tried to defeat the Liberal Empire, instituted in May 1870. The Liberals indeed lost control on August 9, but the credit for that was due not to the Republicans but to the conservative Bonapartists, notably to the opportunist Clément Duvernois, who brought a want-of-confidence vote in the lower house on that day.

5. In the plebiscite of May 8, 1870, the peasantry had overwhelmingly voted for the Liberal Empire.

6. In 1869, Courbet had received the knight's cross of the Order of Merit of St. Michael (Ritterkreuz des Sankt Michaels-Ordens, 1. Klasse) from Ludwig II of Bavaria (cf. letters 69-7 and 69-8). As he returned from Munich to Ornans, he must have left the cross with his family.

7. In the three weeks since war had been declared, a large number of casualties had already been suffered. In the Battle of Woerth (August 6), seven thousand Frenchmen were killed and wounded and four thousand taken prisoner. The German casualty figure was as high as ten thousand.

To his family [Paris, ca. September 7, 1870][1] 70-24

My dear family:

I have read with great sympathy the excellent letter that Father wrote me,[2] but I cannot comply with your wish at the moment. The artists of Paris as well as M. Jules Simon,* the minister, have just done me the honor of electing me president of the arts in the capital.[3] I am happy about that for I did not know how to serve my country on this occasion as I have no inclination to bear arms. Besides, you cannot possibly believe that the German invasion will reach as far as Ornans. In any case, you have in your hands a trusty talisman, namely my Bavarian cross of honor, which represents a high order.[4] You'll find it and the certificate in the chest of drawers in my room. The Germans are very respectful of their institutions. Show it to their commanders and you'll have absolutely nothing to fear. You agree with me that the performance of civic duties comes first.

I'll write you as soon as I can. Take care. I embrace you all with all my heart.

G. Courbet

1. The tentative date of this letter is based on Courbet's statement that he has just been designated president of the arts in Paris, an occurrence that took place on September 6.

2. Courbet's father had written him the following note:

> My dear Courbet,
> You know that your mother and I are old and that your sisters are in delicate health. Join us as soon as possible, we expect you without fail. For in these times of emergency, with the threat of an invasion hanging over our heads, it is best to have the family together. Your mother as well as your sisters join me in embracing you with all our hearts.
>
> Courbet

A copy of this letter may be found in Paris, Bibliothèque Nationale, Cabinet des Estampes, Yb3.1739 (4o), b. 7.

3. See n. 1.

4. Courbet had been granted the first-class medal of the Order of St. Michael by Ludwig II of Bavaria in the summer of 1869.

70-25 *To his family [Paris, September 9 (?), 1870]*

Dear family:

I cannot come back to Ornans at the moment, as Father would like me to. I have been elected president of the General Superintendence of the National Museums.[1] I have nothing to fear, I think. I'll be in the Louvre, and, besides, I have less to fear in Paris than in the provinces, where I would be obliged to act. I think you have nothing to fear. Show them my cross.[2] I think the Prussians are close to Paris. I don't know yet whether the siege will happen. I think communications will be interrupted. Tell my sisters to take the money that, in case of death, I have with M. Henriot* in Lyon railroad bonds.

I'll also leave a note with my concierge or with Chaudey,* my attorney. I embrace you with all my heart.

Gustave Courbet

Only my sisters Zélie and Juliette.[3]

G. Courbet

[Address] Monsieur Courbet, landowner
 Flagey
 Canton of Amancey
 Doubs Dept.

1. On September 6, two days after the proclamation of the Third Republic, the artists of Paris had appointed a committee to safeguard works of art in national museums in and around Paris. Courbet was elected president of that committee, which was composed of the painters Honoré Daumier (1808–79), François Nicholas Feyen-Perrin (1829–88), Emmanuel Lansyer (1835–93), and Jules-Jacques Veyrassat (1828–93); the sculptors Adolphe-Victor Geoffroy Dechaume (1816–92); Hippolyte-Alexandre-Julien Moulin (1832–84); Auguste-Louis-Marie Ottin (1811–90) and Armand-Jules Le Véel (1821–1905); the printmaker Félix Bracquemond (1833–1914); and the designer Emile-Auguste Reiber (1826–93). See Riat (1906, 286).

2. The cross of the Order of Merit of St. Michael, awarded by Ludwig II of Bavaria.

3. Even at this early date Courbet appears to have been less friendly disposed toward his sister Zoé.

70-26 *To Jules Simon, Paris, September 11, 1870*[1]

[Louvre Palace] September 11, 1870

Monsieur le Ministre:

Called yesterday to Sèvres by the urgent requests of the Ceramic Syndical Committee, which had sent a representative to us, we hastened to the factory

to accomplish our mission of safeguarding the riches housed in the Ceramic Museum, a collection of the greatest interest and value, founded sixty years ago[2] and since expanded, through acquisitions and numerous generous donations, by its estimable and venerable curator, M. Riocreux.[3] We found, amid communication problems that will only worsen, that the museum is still located in the old factory, which currently finds itself in the crossfire from three redoubts, one of which is under construction one hundred meters away. The original building is now only a vast hovel, full of cracks and propped up on all sides. It will not stand up to the atmospheric vibrations produced by the detonation of large-caliber cannon. It is our opinion, therefore, that the artistic collections are in great danger there and that it is necessary to proceed as quickly as possible to an immediate rescue. After inspecting the premises we decided to remove a door opening onto old abandoned quarries that form part of the factory area but that are occupied in part by the mushroom industry. These sorts of catacombs form a complex of about six leagues of tunnels. It is obvious that the factory's administration could not find a more suitable and more accessible storage place—wherein these precious art collections could be placed immediately, with the assistance of the rather numerous personnel of the factory.

As the director, M. Regnault, was absent and busy at the ministry, we were received by Messrs. Riocreux, the curator; Milet, head of pâtes; Salvetat, a chemist; and Peyre, head of molds.[4] We found these gentlemen dismayed and upset about remaining inactive. They had been able to send four wagons, provided by the Furniture Depository, to Paris in order to be received in the administration's warehouses. But it seems clear that this system is too time-consuming and dangerous. The factory officials therefore assured us that they would convey our observations to M. Regnault on his return. For our part we advised them to begin packing that very night in order to stave off an imminent peril.

Therefore, M. le Ministre, mindful of the urgency of the case, we beg you to come to an understanding with Minister Magnin,[5] in order to:

1. allow these gentlemen the credit they request to immediately have crates made and hampers and baskets provided (this expense is not very large);

2. apply to the commune of Sèvres to obtain the use of the sites occupied by the mushroom industries.

In case of peril to the population of Sèvres and Chaville, they themselves could even find a secure refuge in those catacombs.

On behalf of the members of the Artists' Committee to Safeguard the National Museums, I am,

Most sincerely yours,

G. Courbet

President

1. The letter was signed by Courbet but written by Emile-Auguste Reiber, secretary of the Artists' Committee, on stationery with the crossed-out letterhead of the "Ministère de la Maison de l'Empereur—Surintendance des Musées Impériaux." Courbet and Reiber seem to have personally delivered the letter to Simon, whose response was largely positive. See Crapo (1992).

2. The ceramic museum at Sèvres had been founded in 1823 by Alexandre Brongniart (1770–1847).

3. Denis-Désiré Riocreux (1791–1872) had been curator of the Sèvres Museum since 1840.

4. The curator here referred to was probably Alfred Riocreux, the son of Denis-Désiré (see note 3), who succeeded his father. Louis-Alphonse Salvetat, first employed at Sèvres in 1841, had become director of chemical operations in 1846. Jules-Constant Peyre, a student of Antoine Barye, had exhibited at the Salon in the 1840s and 1850s. Nothing is known about Milet. See Crapo (1992).

5. Joseph Magnin (1824–1910) was minister of agriculture and commerce under the Government of National Defense. As the safeguarding of the collections of the ceramic museum involved the use of the cellars used for mushroom culture, the cooperation of Magnin was necessary for carrying out the committee's plans.

70-27 *To the Government of National Defense, Paris, September 14, 1870 (draft)*[1]

Paris, September 14, 1870

Proposition to the members of the Government of National Defense:

Citizen Courbet, president of the artists' committee charged with the preservation of the national museums of works of art, appointed by a general assembly of artists:

Whereas the Vendôme Column[2] is a monument devoid of any artistic value, tending by its character to perpetuate the ideas of wars and conquests that were part of the imperial dynasty but that are frowned on by a republican nation;

Whereas, for that very reason it is antipathetic to the spirit of modern civilization and to the harmony of universal brotherhood that henceforth must prevail among nations;

Whereas, furthermore, it offends their legitimate susceptibilities and makes France ridiculous and odious in the eyes of European democracy;[3]

Expresses the wish that: the Government of National Defense will be so kind as to authorize him to unbolt[4] that column, or to take itself the initiative thereto by charging with that task the administration of the Artillery Museum and by having the materials transported to the Hôtel de la Monnaie.[5]

He also wishes that that measure be applied to the statue,[6] which has been removed and now stands in Courbevoie on the avenue de la Grande Armée.

Finally he desires that those street names that recall victories to some, defeats to others,[7] be stricken from our capital to be replaced by the names of

benefactors of humanity or by such as may be derived from their topographical location.

Gustave Courbet

1. Courbet's petition is known only in this draft form, which, though not autograph, is signed by the artist. No definitive document has been found.

2. The Vendôme Column, one of the most hated imperial monuments in Paris, was built by order of Napoléon to commemorate his successful military campaigns. Begun in 1803, the column was crowned in 1806 by a statue of Napoléon in Roman imperial garb by Antoine-Denis Chaudet. With the Bourbon restoration in 1814, Chaudet's statue was removed, melted down, and replaced by the white royalist flag. During the subsequent July Monarchy, the column was surmounted by a statue of Napoléon in military uniform by Gabriel-Bernard Seurre, which in turn was taken down during the Second Empire to be replaced, in 1863, by a new statue of Napoléon as Roman emperor by Augustin-Alexandre Dumont. The destruction of the Vendôme Column was a common Republican concern after the Battle of Sedan, and Courbet's petition, therefore, is in no way unique or even radical. In fact, his presidency of the artists' committee to preserve works of art in Paris made it necessary to take a stance on the issue.

3. The following line has been stricken at this point:

[whereas] moreover, it must be feared that the enemy, should misfortune allow him to enter our city, will recommence the violent destruction of that provocative monument.

4. Courbet used the French term *déboulonner*, to unbolt, which later became the cause of much legal squabbling. Courbet always maintained that he had not wanted to destroy the column, but merely to take it apart, preserving the bronze reliefs as artifacts.

5. Courbet at some later time may have changed his mind and seems to have recommended that the reliefs be transported to the Hôtel des Invalides.

6. The statue of Napoléon by Augustin-Alexandre Dumont.

7. The question of street names was much debated after September 4 and there was a movement, supported by Courbet, to eliminate all names commemorating imperial victories.

To Jules Simon, Paris, September 14, 1870[1]

70-28

Paris, Sept. 14, '70

Monsieur le Ministre:

A deputation from Versailles headed by M. Bataille,[2] assistant curator of the Museum,[3] has come to ask the ministry to please establish a field hospital in the Versailles Palace and to send the wounded there rather than anywhere else. He feels it is the only way to save our museum from the enemy's devastations.

The imminence of the danger calls for the government's immediate attention.

For the committee

G. Courbet

P.S. This request has already been addressed to General Trochu,[4] but has so far remained unanswered.

1. In the margin: "Wire."

2. Eugène Bataille was the son of the resident physician of the Versailles Palace, which may explain his interest in the field hospital. See Crapo (1992).

3. The Palace of Versailles, built under Louis XIV, had been turned into a museum by Louis-Philippe in 1837.

4. Military governor of Paris after the outbreak of the Franco-Prussian war, General Louis Trochu (1815–96), had been named president of the Government of National Defense on September 4.

70-29 *To Louis Ulbach, Paris, September 15 [1870]*

Paris, Sept. 15

My dear M. Ulbach:

Please insert this notice[1] in your newspaper.[2] I would be very obliged to you.

Regards, Citizen.

Citizen Courbet
President of the Free Artists' Committee of Superintendence

1. The notice in question, partly written in another hand, is added to the letter:

The painters, sculptors, architects, etc. are summoned for Sunday, the eighteenth of this month, to the Salle Gerson (Sorbonne), in order to hear their delegates' report on the mission that was entrusted to them at the general meeting of Tuesday, September 6.
Note for the newspaper *La Cloche*.

2. Louis Ulbach was the founder and editor of *La Cloche*, a fiercely anti-Bonapartist newspaper.

70-30 *To Jules Simon, Paris, September 16, 1870*

Paris, Sept. 16, '70

Monsieur le Ministre:

The battalion of artists asked by M. de Chennevières,* curator of the Luxembourg Museum, to help him remove the sculptures, paintings, etc. in order to take them to safety, has just announced to us today, through their spokesmen, the sculptors Messrs. Gauthier and Valette,[1] that, when M. de Chennevières found that one of the rooms on the ground floor of the Luxembourg Palace was needed because it offered all the conditions desirable for security, General de Beaufort,[2] military commander of the Luxembourg, expressly opposed it, claiming that the room was used by him personally. The

artists' delegation appeals to the Committee and requests that this be brought to the attention of the Minister of Public Education.³

For the committee

The President

Gustave Courbet

1. Charles Gauthier (b. 1831) and Jean Valette (1825–1878).
2. Pierre-Philippe-Léonce de Beaufort (1825–1890) was one of the generals in charge of the defense of Paris.
3. In the margin of this letter is the following annotation, initialled by the secretary general of fine arts under Jules Simon, St. René de Tallandier:

> Absolutely untrue. M. de Montfort immediately granted what I had requested of him, namely the rooms that are mentioned here.
> September 19
> S. R. T.

*To Jules Simon, Paris, September 19, 1870*¹ 70-31

[Louvre Palace,] Sept. 19, 1870

Monsieur le Ministre:

The committee, after its recent inspection of the sculpture rooms of the Louvre, hastens to inform you that the packing already begun three days ago, against which it protested strongly in a letter to the minister, continues.

Nothing of what, after long and mature consideration, it [the committee] advised doing is being done. The measures being taken by the curator are declared by himself to be "excellent" and will be carried out, barring orders to the contrary issuing from the ministry.

The committee protests once again the uselessness of these measures and the costs they entail, and has finally heard from M. Ravaisson² that those "excellent" measures will cease and that as a result of consultation with the architect of the Louvre, M. Lefuel,³ the statues will simply be placed in niches revetted with gabions, while the casement windows will also be revetted with gabions on the inside, with sacks of earth that are being prepared at this moment—all measures that had been recommended by the committee in its report of September 9,⁴ with the following exception, that the committee had recommended interior gabions of sacks of plaster or hydraulic cement, which the Canal []⁵ had offered the Committee of Defense. That way time and money could be saved.

The committee is astonished at M. Ravaisson and is disturbed by that inertia, that apparent indifference. The time for tact is past. The enemy could shell Paris tomorrow. If an irreparable disaster were to strike the Louvre's sculpture galleries, responsibility for it would fall entirely onto the present

curator. The minister has a great deal else to do at this moment. He has, he had to be aided by an intelligent and dedicated plan.

If the committee has permitted itself to express its opinion rather vividly, Monsieur le Ministre will be kind enough to forgive us. Time is pressing, the danger is here, personal considerations no longer exist.

For the committee

The President

G. Courbet

1. Letterhead: "Ministère de la Maison de l'Empereur—Surintendance des Musées Impériaux" (crossed out).

2. Jean-Gaspard-Félix Ravaisson (b. 1813) was chief curator of the Louvre. Courbet and his committee were locked in a on-going power struggle with Ravaisson, an imperial appointee retained by the Government of National Defense, over the ultimate control of the museum. See Crapo (1992).

3. Hector-Martin Lefuel (1810–1880) had been architect of the Louvre and the Tuileries since 1854.

4. See the minutes of this day's meeting of the Artists' Committee in Paris, Bibliothèque d'art et d'archéologie, Fondation Jacques Doucet, carton 46 (dossier XIII).

5. Illegible word.

70-32 *To the Government of National Defense, Paris [October 5, 1870]*[1]

To the Government of National Defense:

That is exactly what I was afraid of: a bronze statue! It will recall, you say, the glory of Strasbourg unalterably?[2] Is history so forgetful, then, and have we lost forever the memory of the heart?

Some fools pretend not to have understood my letter. I did not request that the Vendôme Column be broken. I wanted to have that mass of melted cannon that perpetuates the tradition of conquest, of looting, and of murder removed from your street—called the "rue de la Paix."[3] Amid the boutiques stuffed with silk dresses, laces, ribbons, baubles, and diamonds, next door to the dressmaker Worth,[4] ennobled by the tarts of the empire, it looks as out of place as a howitzer in a lady's drawing room. Would you keep the bloodstains from an assassination in your bedroom at home?

I see no harm in transporting the reliefs to a historical museum or in arranging them in panels on the walls of the courtyard of the Invalides. Those brave souls have earned those cannon[5] at the price of their limbs. The sight will remind them of their victories—if you want to call them victories!—and especially of their suffering.

It will be a long time before we agree on the true sense of the word "democracy"!

A statue! Continuous misunderstandings and returnings to the monstrous

mistakes of the past! Seriously, is this monument, that will perpetuate hatred and conservatism in us, a strenuous effort and a step forward toward universal socialism?

The stone statue already exists, respected and reverenced by all. Leave her where she is, with her flags, her crowns, and her dismal veil. Strasbourg, after all, has merely done her duty. She remembered that she was an integral part of France,[6] she died like a true Frenchwoman.

If you want to raise a statue to her, so be it! But then, be fair and logical: cast effigies as well for Metz, for Toul, for Laon, for Bitche, for Phalsbourg, for every city that will fall as the Prussian crushes it. A thought! Will you not also vote a little half column for Sedan?[7]

So you would turn the place de la Concorde into a branch of Barbedienne?[8] For I fervently hope that all the cities of France will do their duty as valiantly as Strasbourg.

Believe me. Be satisfied with a marble plaque with a short inscription on the pedestal of the current *Strasbourg*. The rest of us will take care of spreading her immortality—and let's keep the bronze to make ourselves new cannon. We need them.

Courbet

32 rue Hautefeuille

1. This letter appeared in *Le Réveil* on October 5, 1870.

2. On September 14, Courbet had proposed to the Government of National Defense that the Vendôme Column be dismantled (Courbet used the verb *déboulonner*, lit. "unrivet," "unbolt") and that the materials be removed to the Hôtel de la Monnaie. Courbet's proposal had been followed by several others, including one submitted on October 2 by the armament committee of the sixth arrondissement, which asked that the column be melted down and recast into cannons. Around the same time, Jules Simon* had suggested that the statue of Napoléon be melted down and reused to make a bronze statue of the City of Strasbourg, replacing the stone one by James Pradier (1790–1852) on the place de la Concorde (see Riat 1906, 287–88). During the heroic resistance of the city of Strasbourg, Pradier's statue had become a place of pilgrimage for patriotic Frenchmen, and, even after the capitulation of the city on September 27, it continued to be a symbol of defiance (cf. Kranzberg 1950, 33).

3. The rue de la Paix (street of peace) runs from the place Vendôme to the place de l'Opéra.

4. The English couturier Charles-Frederick Worth had established his fashion boutique, the House of Worth, on the rue de la Paix in 1857. In addition to the empress, Worth dressed many of the famous courtisans of the day (cf. Briais 1981, 136–37).

5. The Vendôme Column was made from the melted-down Austrian cannons conquered in the Battle of Austerlitz.

6. A reference to Strasbourg's location in the Alsace-Lorraine region, the cause of a long-standing dispute between France and Germany.

7. The first French city to fall in the Franco-Prussian War (September 2, 1870). Its fall had marked the end of the Second Empire and the beginning of the Government of National Defense.

8. Ferdinand Barbedienne* had a well-known gallery in Paris where he sold bronze reproductions of the works of famous French sculptors.

70-33 *To Jules Simon, Paris, October 13, 1870*[1]

[Louvre Palace] Oct. 13, 1870

To the Minister of Public Education:

Monsieur le Ministre:

There has appeared, in the *Journal officiel*, an article about the measures taken by the minister of public education to protect the museums against the effects of shelling.[2] In this article mention is made of the various committees appointed by the minister of public education and by the Institute, and reference is made to a forthcoming report by M. "Guillaumin" (M. Guillaume, no doubt) that will prove, with supporting evidence, that every precaution has been taken.

Not a word is said about the committee appointed by the artists in a general assembly authorized by the minister of public education. However, Monsieur le Ministre, you surely know better than anyone else where the proposal for all those measures came from.

Appointed on September 6, the committee began its work on the seventh, at the Louvre, Luxembourg, and Cluny museums, the Gobelins, the Furniture Depository, Sèvres, and Versailles. Our minutes and the notes that we have sent you daily since then bear witness to that. The minutes were also read to the artists at a general assembly on Sunday, September 18, before the appointment of the Archives Committee and that of the Institute.[3]

As to the "erroneous allegations" to which reference is made in the article, we want to say and repeat that in the Louvre one did not put forth the effort that was rightfully expected from the administration and that, had the shelling taken place as early as you yourself expected it, Monsieur le Ministre, all the measures proposed by you from the beginning and not put into effect until two weeks later would have been absolutely useless.

We need not speak here of the Archives Committee, whose mission is foreign to ours. Neither do we mean to say that no credit should go to the Institute Committee, which, in a letter dated September 26, asked to join forces with us and whose task has consequently been limited to assessing the measures that were proposed or already taken. We do not wish to make of this silence in our regard an empty question of pride, but, conscious of the mandate with which we were charged and of the duty that we have to report on our mission to our constituents, we are justified in being astonished, Monsieur le Ministre, that the official article makes no mention of our efforts.

Convinced that the matter is an oversight, we turn directly to you, Mon-

sieur le Ministre, and bring to the attention of the public the letter that we have the honor to address to you.

On behalf of the members of the committee, I am, Monsieur,

Most sincerely yours

G. Courbet

President

1. Letterhead: "Ministère de la Maison de l'Empereur—Surintendance des Musées Impériaux" (crossed out).

2. The article Courbet refers to here did not appear in the *Journal officiel* but rather in *Le Rappel* of October 13, 1870, under the heading *Avertissements et questions*. The article was a response to "erroneous allegations" that the minister of public education, worship, and fine arts (Jules Simon) had not taken sufficient measures to protect the Parisian museums against shelling. The article enumerates all the measures taken by the Archives Committee (Commission des archives) and the Institute Committee (Commission de l'institut) but does not mention the Artists' Committee formed on September 6 and presided over by Courbet (cf. Crapo 1992).

3. The Archives Committee and the Institute Committee were both appointed by the minister to study various aspects of museum administration. On the Archives Committee, of which Courbet himself was a member, see letter 70-36, n. 2.

To the German army and the German artists, Paris [October 29, 1870][1] 70-34

Prologue

In this time of siege everyone goes mad: it is the Germans' fault. As for me, instead of the painter I used to be, I am now a writer. Writers are polytechnicians, musicians are gunners, all businessmen are generals, generals are legislators, judges as well as medical doctors are soldiers, and the nobles, who used to be sick, have become doctors in turn. By the same token one sees amazon women holding rifles and priests turned Republican. In a word, everyone treats himself to a share of what he cannot do: we are free people.

If I have got myself into a hornet's nest, those gathered here will be so kind as to forgive me. I am so anxious to fire some cannon shots at the Prussians that I would like to buy one (with your money, of course), and since these days one can be everything, I will become a gunner, if you want me to. You can see already that I am not as guilty as I look, and if I succeed only in annoying you, please blame my friend Considérant,* on whose instigation I stand before you.[2]

While waiting for the cannon, let's machine-gun the Prussians a little!

To the German army:

Winter is almost here, poor fellows, and you knock at our door with large hammers. Oh, we hear you well: you think that in our country it is always party time and that we are still in 1867.[3] You have learned to like our hospitality, but it should not always be our treat. Like the besiegers of Troy, you can keep knocking for ten years, and we won't open up. At this moment we cannot do anything for you. Be on your way.

Be on your way! The times are hard and we are just setting up house.[4] To provide for our family we must be economical for our fiancée has no money. This year we are not rich, we have no hay in our boots or even for our horses.

Be on your way! Your prayers don't move me. You tell me that you have spent much money on your voyage and on getting ready for it; that your master is godly; that he promises us civilization and even heaven at the end of our days. We don't believe it.

Be on your way. We have been told that you were jealous of us, of our country, of our reputation. Too bad, for we have never been jealous of you in any way. We have been told that, for forty years, you have prepared yourselves to destroy us and that, at this moment, if we did not give you our money, you would destroy, with fire and carnage, our farms and our houses. Follow your nature, for it is difficult to prevent evil. You won't destroy us and it is you who will be chastised for your acts in the face of humanity.

Poor fellows! be on your way and watch out. It is true that in 1848, on an impulse as yet foreign to you—an impulse toward democracy and humanity—we have unknowingly encouraged ignorance and brutality. The immediate results of that were the savage war habits that we have spurned for eighteen years[5] and it is these same habits that are the cause of your appetite today.

Believe me, you are on the wrong course. France, which has retreated from that course, will make you see that he who believes in courage and progress cannot fail.

Believe me, go away, you'll become a laughingstock.

What! For forty years, like trappers, like wild animals, you have had the patience to stalk your prey and when you see that a scoundrel, in order to protect his booty, ventures out with two hundred fifty thousand men, you descend on us with one million three hundred thousand men! Admit that you have always been afraid of France and that your courage, at this moment, is based on numbers. You are right for, so far, if we had predicted victory on the basis of the smallest number of dead, I believe that we would have won.

Believe me, go away. May Wilhelm[6] bless you!

Oh well, famous strategists, the republic has not sterilely passed forty years of its life to bear you a grudge. In forty days it reduces you to impotence; in forty days, this nation that you rightly envy has improvised, by its activity, its genius, its resources, what you have achieved in forty years.

Go away, you should be ashamed! You come like clockwork. Don't you see that your course of action is not within the modern spirit! You spend too much time on your conclusions, you cannot distinguish the mind-set of this time; your own mind is as heavy as your matter.

You won't vanquish us, for we are fighting on the terrain of propaganda

of ideas and on the side of civilization, and all that brutal giant action that you display at the moment, in the face of patience, talent, and suffering, serves only to prove the state of barbarism into which you have sunk, and it will consolidate, without your knowledge, the very things you want to destroy.

Far from me the thought of sustaining France in this imperial war of occupation, nor do I want to greatly diminish your triumph, but note that our soldiers were fighting against their will for such a cause. You had the irrefutable proof of that in your hand, namely our three hundred thousand war prisoners, something never seen before by mankind.

Go away, believe me, we cannot do anything for you in this humanitarian moment.

Oh, Teutonics! Do whatever you want, the Gauls will always keep you at a distance. Despite all their misfortunes, you will never prevent them from advancing toward civilization. We are subtler and faster than you in our conclusions, and our method of concretion, though at times too rash, will always be ahead of you.

Dear friends from across the Rhine, I admit that you were sympathetic to me and that I have seldom laughed as much as in Germany. In true patriarchal fashion, your wives are kept in servitude, and one drinks a lot of beer in your country. You are beautiful at home and I would miss you individually as sorely as I would miss the fellows of Marseille. But I am told that at this moment you are furious and that in that state you are dangerous.

(Tacitus was the first to say so and in 1814 we experienced it. We called you blockheads. If that is the case [again], it would not be prudent to receive you here. Come back next year, please.)

You'll admit that this is no life. Here we are eating [the meat of] rabid cows, horses unfit for service, donkeys, and what not. We'll end up eating our rats, cats, and mice. But we'll hold out, even if we have to become cannibals. Go away, please, you who love boots so much. I am sure that at this moment you don't have any shoes. Go away! God bless you!

You talk about civilization! I have seen you in action; I have seen you unable to invite someone for dinner; I have seen how at home you don't eat, but (on a table without a cloth) stuff yourselves with food four times a day; I have seen your peasants with a spoon-and-fork case in their pocket, a knife on a chain, a porcelain pipe resembling a cruet stand on a chain; florins by way of coat buttons, boots with mule-shoe reinforcements on the heels slung across their shoulder, and a green hat; and everyone reading the Bible by way of instruction. I am not trying to upset you but I think that you'll be a flop on the boulevard [des] Italien[s].

Believe me, go back home for a little while. I'll come to see you. Go back to your country: your wives and your children are calling you back, they are dying of hunger. Our peasants, who have come to combat your criminal en-

croachment, are in the same boat as you. As you return, cry out: Long live the republic! Down with the borders. You'll only gain by that: you'll have a share in our country as brothers.

To the German aritists:

I have lived with you in thought for twenty-two years, and you have gained my sympathy and my respect. I found you tenacious in your work, full of prudence and will power, hostile to centralization and the constraint of thought. When we met in Frankfurt and Munich,[7] I declared that we had common tendencies. Like me, in asking liberty for art, you asked as well for the liberty of the people. In your midst I felt at home, among brothers. We drank then to France and to the coming of the European republic. Even in Munich, last year, you swore the most terrible oaths not to be enfeoffed to Prussia. Today you are all enlisted in Bismarck's troops;[8] you wear a rank number on your forehead, and you know how to give the military salute.

You, whose honesty and loyalty were exalted; you, who despised small-mindedness; you, the elect of the intellect; today one would take you for nocturnal marauders who have come to rob Paris, shameless in front of the entire world.

Yes! draw humanitarian symbols on your canvases, give birth daily to hymns to fraternity; dissolve in water and rhymes! Bismarck and Wilhelm are laboring to patch up the musty bonnet of Charlemagne with the rags of human flesh.

Yesterday you defended and saved Germany. Today you remain enrolled in a war more infamous than the filthiest wars of feudal times and you are forging irons for Germany. Ah, you are not even any longer the bastards of the old serfs of Franconia. They, your fathers, made their emperors tremble at times. They heard the voices of Luther, of John Hus, and they got up, and they shook the thrones that broke their backs till they fell to the ground. [As for] you, your Wilhelm only lifts a finger, and you are biting the dust at the feet of your Prussian Caesar, the cousin of our French sham Caesar.

Until September 4, men with progressive views did not have to worry about the repugnant quarrels of sovereign against sovereign. Their praetorians were happy to cut each others' throats, to the great satisfaction of Europe. Until Sedan you even did us a favor,[9] for all the harm you did to us and will be able to do to us will never totally equal the harm that the maintenance of the empire would do to us or the good turn you did us by overthrowing it.

But now that you have settled the score with Bonaparte, what business do you have with the Republic? You want to put the revolution in chains? Poor fools! You put the cord around your own neck.

Well, it is a Franc-comtois, it is an American from France, who tells you this very clearly. It is more than just a felony on your part to pursue this conquest, it is foolish and awkward. Pack together soldiers with soldiers, pile

cannons on top of Howitzers, machine guns on top of mortars, the revolution is not afraid of you.

The republic, which cannot dream of such battles, which has as its resources only the will power of its people, the republic will not be vanquished, I'll give you my word. Steal, burn, kill! you'll only succeed in making France a martyr nation. You'll substitute one fetishism for another fetishism: the myth of a deified nation to the fable of a man-God, that is all.

To sum up:

Germans of all names, you who are sacrificed, soldiers of the Prussian who takes care of himself: Bavarians, Wurtembergians, Badeners, you, our conquerors as far back as September 4, I'll tell you what is your task at this moment.

They say that you are needy, so much the better. In France, poverty is the badge of honesty. Only the rich have the means to steal, so we do understand you. You have trailed behind you your relics, your antiques, all the chariots of your ancestors, the Cimbri and the Teutons, and the famous war cart of Arminius.[10] Of course, you don't want to bring them back home empty, when you cross the Rhine again.

You need an indemnity, all right, take it. Pile on your wagons the stones of the walls of Toul and Strasbourg,[11] we'll let you have them. You'll be able to sell them for a profit in your country, as heroic souvenirs. You can do even better. As you pass, throw down your citadels; if your heart tells you so, we'll give you a hand, and together we'll throw down the bleeding boundary stones that marked the borders and severed groups of people of the same stock.

When the borders have disappeared, there will no longer be a need for fortresses to protect them. No more fortresses, no more armies. No more armies! Only the assassins will kill—at least, we hope so.

Do you value your nationality? Once liberated, you say the word, and we'll help you. Only in that case you can make Alsace and Lorraine into neutral and free countries, testimonies to our alliance, where all those who detest national chauvinism and who wish life to be without political fetters can take refuge; and in those mutilated, crucified provinces, forgetful of the wounds bleeding in our sides, we'll shake your hand at last, and we'll drink together to the united states of Europe.[12]

With fraternal regards.

An idea:

Listen: leave us your Krupp cannons, we'll melt them together with ours; the last cannon, its upturned muzzle covered with a phrygian bonnet, planted on a pedestal resting on three cannon balls: that colossal momument that we'll erect together on the place Vendôme will be your column, for you and for us, the column of the peoples, the column of Germany and France forever federated.[13]

The goddess of our liberty, as formerly Venus crowned the god Mars, will hang from the trunnions that are attached to each side like arms, garlands of grapes, ears of corn, and hops blossoms.

G. Courbet

32 rue Hautefeuille

1. This "letter" was published in a small brochure with the following brief introduction:

These letters have been read by Courbet at the Athénée on October 29, 1870, on the initiative of Victor Considérant, who gave the painter the opportunity to expose his ideas in public. They have been published in the form of a brochure by the author, 32, rue Hautefeuille, Paris, 1870.

2. See note 1.
3. Probably a reference to the International Exhibition of 1867, when France was visited by an unprecedented number of foreigners.
4. Metaphor for the Third Republic.
5. Since the beginning of the Second Empire in 1852, Courbet had always equated the empire with militarism.
6. The German emperor.
7. Courbet had visited Frankfurt in 1858–59 and Munich in 1869.
8. Otto von Bismarck (1815–98), the Prussian chancellor, was the architect of the Franco-Prussian War.
9. The battle of Sedan on September 2, 1870, had spelled defeat for the French army under Napoléon III, who was taken prisoner by the Germans. Two days later the republic was proclaimed in Paris, Lyon, and Marseille.
10. Arminius (18 B.C.?–A.D. 19), German leader who crossed the Rhine to inflict a major defeat on the Romans in the Teutoburg Forest.
11. Two French cities that had been besieged and finally conquered by the Prussians.
12. Lindsay (1973, 252) has pointed to a possible connection between Courbet and Charles Lemonnier, who together with Victor Hugo* and Giuseppe Garibaldi had founded a journal called *Les Etats-Unis de l'Europe*.
13. Courbet expressed the same idea in a seven-page manuscript article on the column (partly cited in the 1988 summer catalog of the Librairie de l'échiquier in Paris] in which he proposed to replace the Vendôme Column by "the last cannon, planted on a pedestal on three cannon balls, its upturned muzzle covered with a phrygian bonnet, signed by the peoples' alliance; and the goddess of liberty, wreathing that cannon with garlands of flowers."

70-35 *To Philippe Burty, Paris [before December 1, 1870]*

My dear Burty:

As I promised you, I sent in my resignation to M. Jules Simon* and to M. Vacherot.[1] I have been looking for you for a week to see whether you are willing to publish yours as well as mine.[2] I believe it is useful. I will keep it at your disposal.

Sincerely yours,

G. Courbet

32 rue Hautefeuille

Answer me.

1. For Courbet's letter of resignation from the Archives Committee, see letter 70-36. The letter was sent to Jules Simon, the minister of public education, worship, and fine arts, and to the philosopher Etienne Vacherot, the president of the committee. It also appeared in *Le Rappel* of December 1, 1870.

2. Burty resigned from the Archives Committee as well. His letter of resignation appeared together with Courbet's in *Le Rappel*. See also letter 70-36, nn. 1, 2.

To Jules Simon [Paris, December 1, 1870][1] 70-36

Monsieur le Ministre:

On no account can I approve passage of the emperor's acts, nor can I lend my support to the men who have served him so well, in spite of the apparent order they have been able to bring to the regularization of the acts of that abominable regime.[2]

Our committee's work will, nevertheless, be useful, as it records, however superficially, the existence of what art objects remain to us. One can keep it for reference, though it makes no mention of the already long-standing deterioration of our paintings, such as the restoration of the Rubenses.[3]

In the hope that I can continue to be useful, I am happy to stay with the committee with which I have been entrusted by the artists in assembly and in which I have been confirmed by all.[4] I wish to remain able to report to them, in a timely fashion and with full knowledge of the facts, on the matters that concern them, something that our Archives Committee attempted to do in vain.

Gustave Courbet

1. This letter, Courbet's official resignation from the Archives Committee to which he had been appointed at the end of September, appeared in *Le Rappel* of December 1, 1870, in an article entitled "Les Archives du Louvre." The same article also contains a letter of resignation by Philippe Burty. Compare letter 70-35.

2. On September 24, Jules Simon,* then minister of public education, worship and fine arts, had set up the so-called Archives Committee to "inspect the Louvre archives and trace to their sources any frauds that may have been committed by functionaries of the fallen government" (cf. Lindsay 1973, 250). Initially, the committee was composed of five members, including the philosopher Etienne Vacherot (b. 1809), who served as its chairman; the architect Emile Boeswillwald (1815–96); the lawyer Charles Ballot (1818–85); and the archeologist Baron Roch-François-Marie Guilhermy de Nolasque (1808–78). A few days later, the critic Philippe Burty* and Courbet were added to the membership. The majority in the committee found no signs of fraud among museum officials, and thus most curators and museum administrators appointed by the imperial regime were allowed to remain in office. Courbet and Burty strongly objected to this decision and hence resigned from the committee.

3. Many artists had long doubted the leadership of the Louvre curators with regard to the restoration and preservation of masterpieces. Courbet's reference to the Rubenses, no doubt the Maria de Medici cycle by Peter Paul Rubens, must be seen in that context.

4. The Artists' Committee of which Courbet had been elected president on September 6. See letters 70-24 and 70-25.

71-1 *To Pierre Dorian, [Paris,] January 5, 1871*

January 5, 1871

My dear M. Dorian:

You are utterly charming, you and your ladies.[1] I have not been able to come see you yet for I was ill.

Considérant* tells me that we are to dine at your house tomorrow, Friday. Count us in.

When I have my chassepot,[2] watch out. I have already had a red band sewn on my trousers.[3]

Sincerely yours, dear friend. Kind regards to your ladies and happy New Year,

Gustave Courbet

1. Judging by the tone of this letter, Courbet seems to have been quite familiar with Dorian. Their acquaintance may well have been long-standing as Dorian originated from the Franche-Comté (he was born in Montbéliard) and made a career in the metal industry, a milieu in which Courbet had several friends and patrons. Dorian's "ladies" must have been his wife (née Holtzer) and daughter(s).

2. Courbet and Pierre Dorian had a common interest in rifles and guns. Dorian, who was minister of public works under the Government of National Defense, was responsible for providing Paris with arms.

3. During the siege of Paris, the wearing of military dress was popular. Even those ineligible to wear an army or National Guard uniform liked to lend a military look to their civilian clothes by sewing epaulettes on their suit jackets or red stripes down their pants (cf. Kranzberg 1950, 27).

71-2 *To Etienne Carjat, [Paris,] January 18, 1871*

January 18, 1871

My dear Carjat:

Here is the schedule and route of the cannon "The Courbet," which was presented to the National Defense by the Grenelle forty-fifth battalion.[1] The cannon is the result of a painting that I donated[2] and that was raffled at the presentation of that object at the Grenelle opera house. The cannon, following M. Iresca's [?] requirements, will leave from the Arts et métiers [building] at 1 P.M. to go to Dorian* at the Ministry of Public Works, and from there it will return to the Hôtel de ville with all its apparatus, horses, and caissons.

I would appreciate it if you were to go to one of the locations indicated, in order to cover it for one of the newspapers at your disposal. Commander Joute,* a friend of mine whom you know well, will unfortunately not be present at the ceremony. He leaves tomorrow for Moulin-Saquet.[3] His staff is made up of Cerfontaine, captain; Lemaire, reporting lieutenant; E. Pieron,

quartermaster-sergeant; Duchatel, lieutenant adjutant. Naturally, Mayor Corbin[4] will take part in the festivities.

I count on you. With a handshake,

Gustave Courbet

Come for dinner sometime.

1. In the course of the siege of Paris, the various battalions of the National Guard raised money to acquire some two hundred cannons. Courbet's friend and fellow Franc-comtois Emile Joute, the commander of the forty-fifth battalion, headquartered in the Grenelle arrondissement, had asked the artist to donate a painting for a raffle. The proceeds were used to buy a cannon, which, in recognition of the artist's generosity, was called "The Courbet." The National Guard cannons would later become a major item in the struggle between the government and the National Guard for control of Paris. On the cannon affair, see Serman (1986, 197ff).

2. The painting in question has not been identified. According to Lindsay (1973, 252), it was a seascape.

3. Joute's departure to Moulin-Saquet, one of the major fortresses on the outskirts of Paris, was probably related to the last major sortie from Paris that was attempted on January 19.

4. The mayor of the Grenelle arrondissement.

To the citizens of Paris [Paris, late January-early February 1871][1] <u>71-3</u>

Citizens:

Having been informed that several arrondissements have nominated me for the formidable assembly that will take place in Bordeaux,[2] I readily accept, if you believe that I can serve my country. There I will display the logic and complete independence that mark my character, in defending the freedom and democracy that I have never ceased to practice before you for the last thirty-two years.

Long live the republic. Any other profession of faith would be humiliating to me in this moment.

Sincerely yours,

G.C.

1. This letter was no doubt intended to be published in various newspapers in order to support Courbet's candidacy in the elections for the National Assembly in February 1871. As Courbet subsequently decided against putting his name on the ballot (see letter 71-4), it did not appear at that time. After the Commune, however, during the course of Courbet's trial in August 1871, it was published in facsimile in the *Autographe* and reprinted in the *Liberté* of August 20. The editor of the *Liberté*, who was careful to transcribe all Courbet's spelling errors, wrote the following introduction to the letter: "The *Autographe* reproduces in its latest issue a letter of the painter Courbet, candidate to the National Assembly. The style and the spelling of the master of Ornans deserve to hold the attention of those whose votes he tried to obtain. So much ignorance and so much pretension marked, ever since January 1870, the position of the Realist painter amid the outcasts of the Commune. 'The people rejected him,' as our colleague M. A. d'Aunay rightly remarked, 'so the populace picked him up.'"

2. The National Assembly, to be elected on February 8, ten days after the armistice with Prussia, was scheduled to have its first meeting in Bordeaux on February 12 (cf. Serman 1986, 173–75).

<u>71-4</u> *To his father, [Paris,] February 23, 1871*

February 23, 1871

Dear Father:

You relate the disasters in Ornans that I was expecting. I was very worried about you, for this could have turned into massacres and wholesale burning as in Alsace.[1]

Please, don't feel sorry for us here in Paris for the siege was a joke. Though that was certainly not the fault of the people, who wanted a war to the death. The reason lies with the government of Paris, which was not republican and did not want the republic to save France. You must have guessed that when, in the beginning, you saw M. Thiers* leave to come to terms with the foreign monarchical powers.[2] That whole bunch of traitors, scoundrels, and idiots that ruled us have done nothing the whole time but instigate sham fights, causing a lot of people to be killed for nothing.[3] Those murderers brought not only Paris to its knees but France as well, by causing as much paralysis and discouragement as was in their power.

Simply stated, the peace treaty was as signed five months ago as it is now. We have all been duped and betrayed. They used torture to convince the people to surrender. From the outset, they wanted it to come from them [the people], for their own glory. They had more than two hundred thousand National Guardsmen at the fortifications, where only twenty-five thousand men were needed.[4] At the municipal butcher shops, they made two thousand people stand in line starting at six o'clock in the evening, to get a piece of horsemeat half the size of a fist at ten o'clock in the morning. You had to be there in person, so that women, old people, and children were spending winter nights outdoors and everyone was dying of rheumatism, etc. Paris did not want to surrender, and they surrendered it themselves, three days before anyone knew anything about it.[5] On the last day there was no more bread, another hoax.[6] There were food warehouses with four hundred thousand kilos rotting away, and they had us eating bread made of sawdust and chaff. All that time M. Trochu,* a cretin, was unwilling to make a serious sortie, and when the National Guardsmen took any positions, they made them beat a retreat[7] the next day. The army had orders not to fight, thus all the time the provinces were fighting, we were five hundred thousand prisoners of war in Paris.

Everyone now knows for certain that, without that enormous pack of traitors, the republic would have acted as it wanted to act and as it could have

done, and there would not be a single Prussian in France at the present time. The true enemies were not the Prussians but rather our friends the French reactionaries, supported by the clergy. M. Trochu had novenas said and wanted a miracle from St. Geneviève.[8] He wanted a general procession. We laughed, to be sure. All the Germans who are surrounding Paris would like to see the French guillotine Trochu for they knew two days ahead when they were going to be attacked.

It is all too much to tell you in a nutshell. I don't know how we could still have a republic at this point. As for me, quite a lot of things have happened. First, I was appointed, by the artists, president [of a committee] in charge of saving art objects and museums. I was appointed to [the committee in charge of] examining the archives by the minister, but I resigned on the grounds, as I told him, that the government was not republican.[9] I have given the republic a cannon, which is named "The Courbet," and which we will get back.[10] It belonged to the infantry of the Grenelle National Guard and I was made Commander Joute's* de facto sergeant-major. The government has never wanted to admit that I donated that cannon. I wanted to have the Vendôme Column demolished. I could not get the government to grant it, though the people were for it. I wrote a letter to the Prussians, which I read aloud in a theater, etc., etc.[11]

Some shells fell against our house and across the street. I had to leave my atelier[12] and I am staying in the passage du Saumon. Lately, the people of Paris nominated me to the [Chamber of] Deputies and I received 50,666 votes without doing a thing. If I had put my name on the ballot, and if it had been known that I would accept, I would have had a hundred thousand at least. As it stands now, it is a great honor for me, but if they nominate more deputies, it is possible that I'll be nominated in the second round, though that would mean a useless and highly difficult and annoying trip to Bordeaux.[13] But that is exactly why one cannot refuse.

I have not suffered at all from the siege. I was just in need of a purge and I was not hungry. I am thin now, which is good. I am happy that you were rescued like that. I believe that you will soon be rid. I wrote you but apparently my letters have not arrived. I hope this one will arrive. I embrace you all with all my heart. Kind regards to our friends and acquaintances. I'll come to Ornans as soon as I can.

<div align="center">

G.C.

</div>

I cannot wait to see Mother and my sisters. I knew that my cross of honor would work. I have not seen the Reverdys* again, fortunately. I'll bring you some guns from the siege. I am annoyed that my atelier[14] was burgled, we'll have it fixed as well as we can.

1. When the armistice with Prussia had been signed, on January 28, three eastern departments, Doubs, Jura, and Côte d'Or, had been excluded, leaving them open to German

attacks and potentially condemning them to the fate of Alsace, which had been overrun by the Prussians in August 1870.

2. At the beginning of the war, Jules Favre, minister of foreign affairs in the Government of National Defense, had asked Adolphe Thiers to go to London to try to gain foreign support for France. Thiers consented not only to go to London but to try to gain assistance in Vienna and St. Petersburg as well (cf. Williams 1969, 92).

3. The suspicion of treason on the part of the Government of National Defense was widespread (cf. Kranzberg 1950, 150).

4. On the massive overrecruitment of National Guardsmen, see Williams (1969, 86–87).

5. The news of the armistice, which was signed by Jules Favre in Versailles on January 28 at 11:15 P.M., was slow to reach Paris and even slower to reach the provinces.

6. On January 18, the bread ration was set at 300 grams per adult and 150 grams per child (cf. Serman 1986, 144).

7. This same complaint is also found in the journal of Edmond de Goncourt (see Goncourt 1969, 200–201).

8. Trochu was generally discredited at this time for his presumed religious fanaticism (see also Goncourt 1969, 207, 213).

9. See letter 70-36.

10. See letter 71-2.

11. See letter 70-34.

12. At 32 rue Hautefeuille.

13. As Paris was still officially under siege, the National Assembly was to be convened in Bordeaux on February 12.

14. The atelier in Ornans, on the route de Besançon.

71-5 *To his colleagues [Paris, March 18, 1871]*

My dear fellow artists:

You have done me the honor, at your meeting, of appointing me your president.[1] I am calling you together here, on behalf of the committee that was assigned to assist me, to report to you on our inspection and our actions. We will also take advantage of this meeting to submit to you various insights that arose during the exercise of our duties, in a proposal to you for a new reorganization of the Fine Arts Administration, intended to promote the Exhibition and the interests of art and artists.

The preceding regimes that governed France nearly destroyed art by protecting it and taking away its spontaneity. That feudal approach, sustained by a despotic and discretionary government, produced nothing but aristocratic and theocratic art, just the opposite of the modern tendencies, of our needs, our philosophy, and the revelation of man manifesting his individuality and his moral and physical independence. Today, when democracy must direct everything, it would be illogical for art, which leads the world, to lag behind in the revolution that is taking place in France at this moment.[2]

In order to achieve this goal, we will discuss in an assembly of artists the

plans, projects, and ideas that will be submitted to us, in order to achieve the new reorganization of art and of its material interests.

It is beyond a doubt that the government must not take the lead in public affairs, for it cannot bear within it the spirit of a nation; consequently, any protection will in itself be harmful. The academies and the Institute, which want to sustain only conventional and trite art so that they may be judged by those who belong to them, are necessarily [and] systematically opposed to any new creations of the human mind and inflict martyrs' deaths on all inventive and talented men, to the detriment of a nation and to the glory of a sterile tradition and doctrine.

Look, for example, at the deplorable example of the Ecole des beaux-arts, patronized and subsidized by the government. That school not only leads our youths astray but deprives us of French art, with its fine antecedents, favoring above all the turgid and religious Italian tradition, which goes against the spirit of our nation.

These conditions can only perpetuate the school of art for art's sake and the production of sterile works with neither character nor conviction while depriving us without compensation of our very history and spirit.

So, in order to make rulings on bases that are more rational and more suited to our common interests, in order to abolish privileges, the false distinctions that establish pernicious and illusory hierarchies among us, it is desirable for artists themselves (as in the provinces and all the neighboring nations) to set their own course. Let them determine how they shall exhibit; let them appoint the committees; let them obtain a building for the next Exhibition. It could be fixed for this May 15, for it is urgent that every Frenchman immediately start to help save the country from this immense cataclysm.[3]

It is impossible that any artist not have one or two works in his studio that have not yet been shown publicly. For the rest we will call on foreign artists. We will exclude, of course, the German artists, even though that goes against our principles of decentralization and brotherhood. But the Germans, after having benefited from France's purchases and commissions for so long and without reciprocating, force us by their treachery and their spying to take this action for now.

The meeting place will be announced as soon as possible,[4] as will the proposals to be submitted to the artists.

Fraternal regards,

<div align="center">*G. Courbet*</div>

1. This letter appeared in several papers, such as *Le Rappel* and *L'Ami du peuple*, on March 18, the very day when the Thiers government fled Paris for Versailles and the Central Committee of the National Guard took its place.

Taking advantage of his position as president of the Artists' Committee, Courbet apparently felt that this was the time to carry the task of his committee beyond the safeguarding of

artworks in and around Paris to a radical reform of the Salon. He had been interested in this already the previous year, as appears from his letters to Jules de La Rochenoire (see letters 70-9 and 70-10).

2. Reference to the Commune.

3. Subsequent events, of course, would make a Salon impossible.

4. See letter 71-7.

71-6 *To Citizen Bernard [Paris, March 19? 1871]*

Chief of Communications
Citizen Bernard:

Eugène Grandperrin, a merchant from Besançon here to make his purchases, wishes to return to his region.

With fraternal greetings. Please let him have a passport.[1]

G. Courbet

President of the Arts

1. Since after March 19 all requests for travel documents were made to Raoul Rigault, it is possible that this request was made on March 18 or the morning of March 19 on behalf of a Besançon merchant anxious to get out of Paris.

71-7 *To Citizen Constant [Paris, March 19? 1871] (incomplete)*

[Citizen Constant is requested to announce in his newspaper that] there will be an artists' meeting tomorrow, Monday, at two o'clock in the afternoon [and also, that Courbet will be a candidate in the sixth arrondissement][1]. . . .

1. This letter to an unknown newspaper editor probably dates from Sunday, March 19. It may be related to letter 71-5, in which Courbet writes that he will announce a meeting as soon as possible. Courbet's remark about his candidature also is appropriate for March 19 as this was the day when the Central Committee of the National Guard announced general elections, to be held on March 26.

71-8 *To the artists of Paris [Paris, April 6, 1871]*[1]

[No salutation]

We are avenged! Paris has saved France from dishonor and humiliation. Oh, Paris! Paris, in its genius, understood that one cannot combat a regressive enemy with his own weapons. Paris took to its familiar ground, and the enemy will be vanquished in the way he has not been able to vanquish us. Today Paris is free and is its own master while the provinces are in bondage. When a federate France can include Paris, Europe will be saved.[2]

Today I am appealing to all artists, I am appealing to their intelligence, to their emotions, to their gratitude. Paris has nurtured them like a mother

and has given them their genius. Artists, in this time, must with all their effort (it is a debt of honor) join in restoring her morale and reestablishing the arts that are its wealth. Consequently, it is of the utmost urgency that the museums be reopened and that we give serious thought to having an exhibition soon. Let each of us, starting now, get to work, and the artists of friendly nations will respond to our appeal!

We are avenged! Genius will soar! For the real Prussians were not those who attacked us first. They helped us, by starving us physically, to take our lives back and to raise every individual to human dignity.

Oh Paris! Paris, the great city has just shaken off the dust of all feudality. The cruelest Prussians, those who exploited the poor, were at Versailles.[3] This revolution is all the more just as it originates with the people. Its apostles are workers, its Christ was Proudhon.* For eighteen years great-hearted men have died longingly, but the heroic people of Paris will overcome the mystagogues and torturers of Versailles. Man will govern himself, the federation will be complete, and Paris will enjoy the greatest share of glory that history has ever recorded.

Today, I repeat, let each go to work unselfishly. It is the duty we all owe our soldier-brothers, those heroes who are dying for us.[4] Justice is on their side. The criminals have saved their courage for the holy cause.

Yes, when everyone surrenders to his genius without hindrance, Paris will redouble its importance, and this international European city will be able to offer to the arts, to industry, commerce, and business of all kinds, to visitors from other lands, an undying order, an order by citizens, which can never be disturbed by the monstrous ambitions of monstrous pretenders.

Our era is about to begin, and, what a curious coincidence, next Sunday is Easter. Is that the day our resurrection will take place?

Farewell old world and its diplomacy.

Gustave Courbet

1. This letter first appeared in the *Journal officiel de la Commune* on Thursday, April 6, 1871, under the heading "Call to Artists." It accompanied a call to all artists for a meeting in the Ecole de médecine the next day. The letter was reprinted, with some minor changes, in Jules Vallès's *Cri du peuple* on April 7, 1871 (now under the heading "The Artists"). According to Darcel (1871–72, part 2, 44) the letter also appeared in *Le Soir* of April 6, 1871, but I have not been able to locate it. The version here given is the one in the *Cri du peuple*.

It is not certain that the meeting called for Friday, April 7 actually took place. Perhaps it was postponed to Monday, April 10, when Courbet presided over an ill-attended meeting at which a commitee charged with the study of reforms was nominated by acclamation. That committee submitted its proposals at a much more succesful meeting on Thursday, April 13. See Darcel (1871–72, part 2, 46–51). See also letter 71-9.

2. Written nine days after the official proclamation of the Commune on March 28, Courbet's letter is permeated with the sense of euphoria that characterized the early days of the Commune.

3. A reference to the Versailles government.

4. Courbet's letter appeared in the wake of an ill-planned sortie of the Communards that had cost the lives of two generals and innumerable National Guardsmen.

<u>71-9</u> *To the artists of Paris, [Paris, April 7, 1871]*[1]

[No salutation]

As standing president of artists, I have been asked by several of them to offer some general suggestions about the future organization of the arts, so that in the general meeting[2] we can proceed immediately to the study of the bylaws and avoid too much confusion. In response to that request I have prepared the following outline,[3] which corresponds to the spirit of the Commune.

As Paris has finally won itself freedom of action and independence, I call upon artists to assume control of the museums and art collections which, though the property of the nation, are primarily theirs, from the intellectual as well as the material point of view.

As I see it, in order to attain that goal, the artists from the twenty-two arrondissements of the Seine shall appoint two delegates per arrondissement, who are to assemble in the Louvre, in a special room, with the purpose of forming a new committee and determining its ad-hoc jurisdiction.

That assembly alone shall be able to appoint museum directors and curators of art collections, as well as the necessary personnel.

It shall also have the right to advise on annual exhibitions, their opening date, duration, and the appointment of an administrative board, while leaving to the exhibitors, following hallowed usage, the responsibility for choosing the admission jury—in sum, adoption of the measures that are in everyone's greatest interest.

In accordance with the principles established above, the fine arts section of the Institute shall be abolished and shall no longer have a raison d'être except as a private association.

The Ecole de Rome shall also be abolished and so shall the Ecole des beaux-arts; but the Parisian building shall be left at the disposal of students so as to cultivate the development of their studies by allowing them totally free choice among their professors. This shall not prevent the city of Paris from allocating a certain sum every year for a contest which shall provide the winners with the means of studying the arts of other nations.

The authority of the city of Paris over the provinces shall be abolished as well.

The drawing teachers of the parochial schools of Paris shall be appointed by representative delegates on the basis of a competitive examination.

For any commission for art works with a recognized purpose a contest

shall be organized by the same delegates. Through their effort a newspaper shall be published which might be called the Arts Monitor.

Artists who feel the need to separate themselves from the majority shall be allowed to exhibit together in one of the rooms of the common exhibition area.

The general assembly, together with the jury, shall preside over the distribution of the prizes, which shall be awarded by way of an official report listing every exhibitor.

Honor crosses and medals of all classes shall be entirely abolished.

The adaptation of the space shall be assigned to the lowest-bidding private company, and if the funds advanced exceed the expenses, the remainder shall be converted in its entirety into raffle tickets, which shall be sold in lieu of entrance tickets. The drawing of the raffle shall be fixed for the end of the exhibition.

Each artist, when submitting his paintings, shall indicate the sale price, which shall be printed, for those who give their consent, in a special booklet so that a winner in the raffle can freely choose a painting corresponding to his winning ticket, even a painting in a higher price range if he pays the difference in price.

The various government bodies of Paris shall address themselves for their acquisitions or commissions to the exhibition committee which shall refer them to the assembly. The procedure shall be the same for the provincial cities unless they prefer to address themselves directly to the artists.

Ten days after the exhibition the space may be used for different purposes the rest of the year.

Exhibitors who so desire shall be allowed to leave their paintings there by paying the administration a fee per surface area of the canvases stored.

It [the space] may also be used for exhibitions of private galleries, old or modern paintings and art objects of all kinds, which may result in a permanent exhibition.

Gustave Courbet

1. According to Darcel (1871–72, part 2, 45), this letter first appeared in *Le Rappel* on April 7, 1871. It was reprinted in Jules Vallès's *Cri du peuple* on Monday, April 10. Though Darcel claims the letter is not authentic, there seems to be no reason to doubt its authorship, especially in view of Courbet's ongoing interest in art reform (cf. letter 70-10)

2. Probably a reference to the meeting of April 10 to be held in the Ecole de médecine (cf. letter 71-8, n. 1).

3. As may be seen in the proposal that follows, Courbet hoped finally to realize his dream of an art world controlled by artists rather than by the government. To that end, he had scheduled a meeting for April 10, where all artists were invited to discuss a new organizational structure for the arts. The meeting was ill attended, but a following one, on April 13, was a huge success. According to an account in the *Journal officiel* of April 15, more than four

hundred artists attended. Presided over by Courbet, the meeting resulted in the formation of the Federation of the Artists of Paris, whose manifesto was published in the *Journal officiel*. It called for artistic independence, freedom of expression, and equality among the federation members. The federation was to be administered by a committee of forty-seven members elected from its ranks by universal suffrage. The committee's mission was (1) to conserve of past art, (2) to promote present art in all its forms, and (3) to cultivate future art through the enhancement of art education. A list of the committee's membership was printed in the *Journal officiel* of April 22. On the activities of the committee, see Boudry (1951) and Serman (1986, 380–87).

71-10 *To Raoul Rigault, Paris, April 8, 1871*

Paris, April 8, 1871

Urgent!

My dear Rigault:[1]

I, [or rather] my female companion[2] and I, need a laissez-passer for Charenton for tomorrow, Sunday.

I count on our old friendship [hoping] that you will be so kind as to send it to me immediately with the bearer of this note.

Friendly regards,

G. Courbet

1. As head of the Committee of General Safety, Rigault was in charge of regulating all travel into and out of Paris.
2. Possibly Mlle Girard, Courbet's landlady in the passage du Saumon.

71-11 *To Raoul Rigault, Paris, April 14, 1871*

Paris, April 14, 1871

My dear Rigault:

Please authorize a female relative of mine[1] to go see her father, who lives in Charenton, for two weeks.

Farewell, Citizen,

Citizen Gustave Courbet

President of the Arts
Addressed to Citizen Riel, Secretary
[Address] M. Rigault
 Police headquarters

1. Possibly Mlle Girard (cf. letter 71-10), who sometimes posed as Courbet's cousin.

Paris, April 15, 1871

Dear citizen:

I have been asked for a profession of faith.[1] That must mean that, after thirty years of a publicly revolutionary and socialist life, I have not been able to get my ideas across. No matter, I will comply with this request as not everyone is familiar with the language of painting.

I have been unswervingly occupied with the social question and the philosophies connected with it, choosing my own path, parallel to that of my comrade Proudhon.*

Renouncing the ideal as false and conventional, in 1848 I hoisted the flag of Realism, which alone places art at the service of man. That is why, logically, I have struggled against all forms of government that are authoritarian and by divine right, for I want man to govern himself—according to his needs, for his direct benefit, and in accordance with his own ideas.

In '48 I started a socialist club,[2] as opposed to the clubs of Jacobins, Montagnards, and others, whom I called "republicans without natures of their own," [or] "historical" republicans.

The republic—one, indivisible, and authoritarian—was frightening. Socialism, because it had not been sufficiently elaborated, was rejected, and the reaction of '49 prevailed in favor of the "later on" of a monstrous regime.

Taking refuge in my individualism, I struggled ceaselessly against the government of the time, and not only did I not fear it, but I actually provoked it.

To summarize in a few words: while recalling the American and Swiss republics and their organizations, let us consider ours as born yesterday. Today, we have a clear field. Therefore, let us set aside revenge, reprisals, and violence. Let us establish afresh an order of things that is ours and that springs from us alone.

I am happy to tell you that the painters, on my instigation, have just taken the initiative in this connection. Let all governing bodies in society follow their example and in the future no government will be able to prevail over ours. All associations that are self-regulated and constituted according to their own interests will be our "cantons," and the more they govern themselves, the more they will ease the task of the Commune. That way the Commune's only concern will be matters of general interest and its relations with the rest of France. By so doing, the present Commune will become the federal council of those associations.[3]

I take this opportunity to thank the voters for the fellow-feeling they have shown me in the last two elections.[4]

G. Courbet

1. This letter to the editor of *Le Rappel*, Auguste Vacquerie, was written in view of the supplementary Commune elections to be held the next day, on April 16. The purpose of the supplementary elections was to fill thirty-one seats left vacant because of resignations and deaths. Courbet had been a candidate in the first Commune elections (see letter 71-7) on March 26, but was not elected. In the supplementary elections, however, he was selected as a delegate from the sixth arrondissement with 2,418 out of 3,469 votes. While the text in *Le Rappel* corresponds to a handwritten but not autograph draft in Paris, Bibliothèque nationale, Cabinet des estampes, Yb3.1739 (4°), b. 2, it departs significantly from an autograph draft that appeared on the art market in 1987 (Maison Charavay, *Bulletin d'autographes* 134, 790 [October 1987], 18–19) and that reads in part:

> I have been asked for a profession of faith: it is simple. This effort would be humiliating if after thirty years of a publicly revolutionary, socialist, and pacifist life, I had not managed to get my ideas across. If I agree to make the effort, it is because I admit that the language of painting is not very familiar to the public.
>
> I have been unswervingly occupied with the social question and the philosophies connected with it, choosing my own convictions parallel to those of my comrade Proudhon.*
>
> In '48, repudiating the false and conventional ideal, I hoisted the flag of Realism in all the arts, in order to place them in the service of man alone. For that reason, I have logically fought against all forms of authoritarian government and divine right, to arrive at a stage where man would govern himself, meeting his own needs, benefiting himself directly, and following his own ideas. . . . In '48 . . . the republic, one, indivisible, and ruling, caused fear; socialism, not sufficiently elaborated, was rejected, and the reaction of '49 prevailed, subsequently contributing to a monstrous regime. . . . "

2. The truth of this statement is doubtful. Courbet seems to have been little involved in the 1848 revolution, judging from his letters of that year and from other contemporary sources (see also Clark 1973, 47).

3. Courbet was a strong advocate of decentralization and the adoption of a federal system following the American and Swiss examples. In this he was obviously influenced by Proudhon, who, in 1863, had published his *Du principe fédératif*, which advocated the ideas of decentralization and federalization.

4. The election for the National Assembly in Bordeaux on February 5 and the first Commune election of March 26.

<u>71-13</u> *To Auguste Rogeard, Paris, April 22, 1871*

My dear Rogeard:

I answered you but you did not publish my letter contradicting your own.[1] I have no rough draft of what I wrote you, please send it back to me. Under the present circumstances, even if I had been nominated with three votes, I would have accepted the position because it is dangerous. I would have accepted if they had authorized me to nominate myself. You see how different we are.

I carried you in the sixth [arrondissement], believing you to be a revolutionary, and I had posters and flyers made at my expense as I was certain that

was so.[2] I am only for what is right and for the revolution, and that excludes law and order, which cannot exist for the moment. That is all I have to say to you. I deplore your ideas, especially because you know that the election could not have been held any other way, because there were numerous defections, and because the departures from Paris justified the situation. I am still hoping that you will reconsider your decision.

Send me back my letter. I'll have it published in a newspaper other than *Le Vengeur*.

With fraternal regards,

G. Courbet

32 rue Hautefeuille
April 22, '71
The newly nominated federation of artists shows several similar results.[3]

1. In the supplementary elections held on April 16, Courbet and Rogeard were elected as deputies to the Commune from the sixth arrondissement. The vote was so scanty, however, that a number of candidates, including Courbet and Rogeard, received less than the required one-eighth of the votes. Rogeard refused to sit under those conditions and resigned, by means of a letter in the newspaper *Le Vengeur* (for the text of this letter, see Bourgin and Henriot [1924, 340]). Courbet did not agree with him and apparently sent him a letter, to be published in *Le Vengeur* as well. The letter was not published, however, and its text is unknown. On the April 16 election, see Mason (1967, 236–37).

2. For a reproduction of one of these posters, see Fernier (1969, 103).

3. As president of the Federation of Artists, Courbet had likewise experienced a great deal of apathy among his constituency (cf. Lindsay 1973, 256–57).

To the citizens of Paris [Paris, April 29, 1871][1]　　　　71-14

[No salutation]

In a communication from the Versailles government, addressed to the prefects on the tenth or twelfth of this month, M. Thiers* announces that the battle against Paris will be carried on with as much energy and as undaunted by sacrifice as the one North America has just fought against the South.[2]

Aside from the inaccuracy of the comparison (for here it is Paris that is fighting for freedom and human rights), I note that M. Thiers, in comparing us with the confederates of the South, has not thought about our rights as belligerents. It is obvious that he has not thought about it, for it is only after receiving his orders that Vinoy shot Duval.[3]

According to the right of all peoples, according to international law, according to precedents in the civil war, one is only a rebel the first few days, and it has always been recognized as legitimate to fight, bearing arms, when a faction has organized itself militarily and fights in good faith, in the state's stead, for a principle of public interest. The faction that is strong enough

to organize itself militarily and that pledges to keep order is de facto a belligerent.

And, please note, citizens, that we have not been fighting for only three months. We have been fighting since September 4. It is time, therefore, for Europe to recognize our rights, and citizen P. Grousset, before anything else, ought to have begun by calling for official recognition by all nations of our rights as belligerents. It is an important matter, which I especially call to the attention of the Committee of Exterior Relations.[4]

G. Courbet

P.S. In other words, we have been fighting against the government of Versailles for more than 101 days, both morally and bearing arms.

1. This letter to the citizens of Paris, which appeared in the *Cri du peuple* of April 29, was actually the text of a speech Courbet had delivered at the April 27 meeting of the Commune.

2. Thiers's communication had been intended to ward off criticism in the provinces of his organized offensive against Paris launched on April 11.

3. On April 3, the Commune had made a failed sortie toward Versailles. Among the Commune's many casualties was General Emile-Victor Duval (1840–71), who was captured by the Versaillese and shot the next day by order of General Joseph Vinoy (1800–1880).

4. Paschal Grousset (1844–1909), journalist and editor of the radical papers *La Marseillaise*, *La Bouche de fer* and *L'Affranchi*, became a delegate to the Committee of Exterior Relations under the Commune. His task was to popularize the Commune in the provinces and abroad. He was generally criticized for his lack of effort. Rochefort is supposed to have said of him that he had more "exterior" than "relations" (cf. Mason 1967, 256).

71-15 *To his family, Charenton, April 30, 1871*

Charenton, April 30, 1871

Dear family:

Here I am, thanks to the people of Paris, up to my neck in politics: president of the Federation of Artists, member of the Commune, delegate to the Office of the Mayor, delegate to [the Ministry of] Public Education, four of the most important offices in Paris.[1] I get up, I eat breakfast, and I sit and I preside twelve hours a day. My head is beginning to feel like a baked apple. But in spite of all this agitation in my head and in my understanding of social questions that I was not familiar with, I am in seventh heaven. Paris is a true paradise! No police, no nonsense, no exaction of any kind, no arguments! Everything in Paris rolls along like clockwork. If only it could stay like this forever. In short, it is a beautiful dream. All the government bodies are organized federally and run themselves. And it is I who presented the model for it with artists of all kinds.[2] The priests too have their tasks like the others.[3] Just as the workers, etc., etc., the notaries and the bailiffs answer to the Commune and are paid by it, as are the collectors of registry fees and stamp duties.

As for the priests, if they want to practice in Paris (though no one is very interested), they can rent churches.

In our free time we fight the swine at Versailles. We take turns going there. They could fight as they are doing for ten years without being able to enter our territory and when we let them enter, it will be their tomb.[4]

We are within our walls, we lose very few people, and they are losing enormous numbers. That is not a bad thing, for the only ones at Versailles, as if we had chosen them, are the people we must get rid of in order to have peace. They are all the irritating sneaks, the soldiers of the pope, the cowards who surrendered at Sedan, and, as for the politicians, they are the men who sold France: the Thierses,* the Jules Favres,* the Picards,[5] and others, scoundrels, the old servants of the tyrants, the old dregs of feudal, monarchical times, in a word, the plague of the world.

Paris has given up being the capital of France. France no longer wanted Paris to send its prefects. France must be pleased, its prayers have been heard. But in return Paris no longer wants to be led by France nor by the votes of the peasants who vote for "père Blicite."[6] It makes sense: if the province sends those who are felt to be most qualified among them to Paris to be educated, they must not pretend to direct them with their ignorance once they have been educated. One must be logical. Today Paris is its own master. It will contribute to the needs of France up to a point, while remaining united with the country as a whole, and it would like all the provinces of France to follow its example, so that this federation might become a powerful unity that will forever paralyze governors of all sorts, as it has the old monarchical, imperialistic, and other systems. It wants freedom (and there is no turning back) to be consecrated on earth. I certainly hope that the Franche-Comté, which wanted to become a Swiss canton (in order to be done with the possibilities of wars and the fluctuations of governments and their pretenders), will not be one of the last to understand this movement.

Dear family, I don't know at this point when I'll have the pleasure of seeing you again. I am obliged to carry out energetically all this work that has been entrusted to me and toward which I have so inclined all my life—I, who was decentralized in the sense that I had retrenched into my individuality all my life. I don't need to think in order to enter into the spirit of the Paris Commune, I have only to act naturally.

The Paris Commune is more successful than any form of government has ever been. We have just received the freemasons' delegation at the Hôtel de ville.[7] There were ten thousand of them. They guarantee us two hundred fifty thousand supporters and soldiers. We will no longer be called a handful of troublemakers. In Versailles they are intentionally and clumsily establishing true disorder, establishing it with those marvelous deputies that the provinces sent them, and with the d'Orléans and Napoleonists.

I embrace you and urge you not to worry about my future. Be well and sleep tight.

I have been unlucky. I have lost everything that I had built up with so much trouble, notably my two ateliers, the one in Ornans, to the Prussians, and my exhibition building by the pont de l'Alma,[8] which I had had transported to La Villette, and which has been used for the barricades against the Prussians.

G. Courbet
Member of the Commune of Paris

1. Courbet had been elected a member of the Commune on April 16 and president of the executive committee of the Federation of Artists on April 17. The Commune appointed him the special delegate for the fine arts at the time of his election and a member of the Committee of Public Education on April 21.

2. Reference to the Federation of Artists, which had been founded on Courbet's initiative.

3. On April 2, the Commune had issued a special decree pertaining to the church and the clergy. In it, church and state were separated, religious cult budgets were eliminated, and church property was nationalized. The practical execution of this decree took place in an atmosphere of anarchy. While schools were generally completely laicized, hospitals were often secularized in name only; the nuns were retained as nurses and henceforth referred to as "citizenesses" rather than "sisters." Priests were sometimes given special tasks, as Courbet states here in his letter, but more often than not they were arrested and jailed. On the Commune and the church, see Serman (1986, 393–97).

4. Courbet may feign optimism here to reassure his family. In fact, since the organized offensive of the Versaillese had started on April 11, the Commune had suffered substantial losses and Courbet could not seriously have expected Paris to hold out for another ten years. On the very morning of April 30, the Issy fortress had capitulated after, overnight, several dozens of Communard soldiers had been killed or wounded and some hundred had been taken prisoner by the Versaillese (cf. Serman 1986, 466).

5. Ernest Picard (1821–77), a major supporter of Thiers.

6. An ironic reference to the ignorance of peasant voters, who called the plebiscite "père Blicite."

7. On April 29, ten thousand freemasons assembled in the courtyard of the Louvre, then marched to the Hôtel de ville, where they were received by the Commune. Accompanied by several members of the Commune, they proceeded to the Arc de triomphe and placed their white banners on the ramparts, in defiance of the Versaillese army (cf. Jeanneret 1872, 77).

8. The pavilion of the 1867 private exhibition.

71-16 *To the editor of* The Times *(Paris), May 20, 1871*[1]

May 20, 1871

[No salutation]

Not only have I not destroyed any works of art in the Louvre, but, on the contrary, it was under my care that all those which had been dispersed by various ministers in different buildings throughout the capital were collected and returned to their proper places in the museum.[2] In like manner, the

Luxembourg was benefited. It was I who preserved and arranged all the works of art removed from the house of M. Thiers.[3] I am accused of having destroyed the Vendôme Column, when the fact is on record that the decree for its destruction was voted on the fourteenth of April, and I was elected to the Commune on the twentieth, six days afterwards.[4] I warmly urged the preservation of the bas-reliefs, and proposed to form a museum of them in the courtyard of the Invalides. Knowing the purity of the motives by which I have been actuated, I also know the difficulties one inherits in coming after a regime such as the Empire.

<div align="center">

G. Courbet

</div>

1. The text reproduced here is the exact one that appeared in *The Times* of June 27, 1871. The English translation of Courbet's original letter, which is not known today, was probably done by Robert Reid, no doubt an English journalist who had made Courbet's acquaintance in Paris. It was Reid who mailed the letter to *The Times* with the following introduction:

Sir:

M. Courbet, the late Minister of the Fine Arts for the Commune, and at present on the eve of his trial at Versailles, gave me the following letter for publication in answer to a charge made by the English Press that he personally had destroyed several works of art in the Louvre. I received the letter from his own hands in the Hôtel de Ville, the morning before the entry of the Versailles troops into Paris. . . . "

After quoting the text of the letter, Reid concludes as follows:

The many false accusations that have been brought against him by the Press, and the critical position in which he is placed, claim our sympathy as a duty in giving publicity to the truth.

Yours respectfully,

<div align="center">

Robert Reid

</div>

Coles's Hotel, 69 Euston-road, N.W., June 26."

Courbet's letter came in response to a flood of articles in *The Times*, published in the course of the month of May, in which the artist's name was mentioned in connection with the supposed vandalism of artworks in the Louvre, the destruction of the house of Adolphe Thiers,* as well as the fall of the Vendôme Column.

2. As president of the Federation of Artists, Courbet, indeed, seems to have made an attempt to return to the proper museums the many objects that were removed from them during the Franco-Prussian War.

3. On May 10, the Committee of Public Safety had ordered the destruction of the house of Adolphe Thiers on the Place St. Georges. Courbet, at the Commune session of May 12, had expressed concern about the fate of Thiers's outstanding art collection. A committee of five, including Courbet, was appointed to take charge of the removal of the contents of the house and their distribution among museums, libraries, and public institutions (see Bourgin and Henriot 1924, 2: 359–61).

4. Though the demolition of the Vendôme Column had been a matter of discussion since September 4, 1870, it did not become a serious issue until after the proclamation of the Commune. On April 4, Jules Vallès* published an article in the *Cri du peuple* in which he asked for its immediate destruction. Eight days later, on April 12, the Commune, acting on a proposal by Félix Pyat, officially decreed its demolition. On May 1, the Committee of Public Safety concluded a contract with Citizen Iribe, a civil engineer, to have the column demolished on May 5, the anniversary of the death of Napoléon. Iribe was unable to complete the preparations

in time, and the demolition was postponed until May 16. Though Courbet was no doubt present when the column tumbled on May 16, his responsibility for its destruction remains a matter of debate. As Courbet notes in this letter, he was not yet a member of the Commune when the demolition was decreed. Indeed, he had been elected on April 16 (not on April 20, as the letter states), four days after the decree was issued.

71-17 *To Jules Castagnary [Paris, June 8, 1871]*

My dear Castagnary:

I was arrested last night at 11 P.M.[1] They took me to the Ministry of Foreign Affairs, and then, at midnight, they brought me to the police station. I have slept in a corridor packed with prisoners, and now I am in a cell, no. 24.[2] I think that I shall be taken to Versailles soon.

If you could come see me, I would be very happy to talk to you for a while.

Sincerely yours, my dear fellow,

G. Courbet

My situation is not bright. This is where the heart leads.

[Address] Deliver this letter to M. Castagnary, to him personally

 31 boulevard de Clichy

 Paris

 Or to the office of *Le Siècle*

 (See whether he is there)

 Rue des Poitevins, no. 6, at Père Laveur's

1. Courbet was arrested on June 7 in the house of a certain A. Lecomte, a maker of musical instruments, who lived at 12 rue St. Gilles. He had stayed with Lecomte since May 23 (cf. Riat 1906, 309–10).
2. At the Conciergerie.

71-18 *To his family, Paris, June 11 [1871]*

Paris, June 11—Sunday

My dear family:

I cannot yet come home right away because the horrors that have just taken place[1] make my presence in Paris necessary. I was president of the arts and I owe it to my reputation to account in the most rigorous fashion to France for my conduct under the September 4 government as well as under that of March 18. At this moment I am requesting an investigation into my affairs as well as a court verdict so that there remains not a single doubt about me in Europe.

As for the members of the Municipal Council of the town of Ornans, who do not scruple to insult my family and myself, I'll deal with them later.[2] I'll

teach that little pack of ignorant cowards what they are worth. I'll teach that little pack of wretches that they have no right to judge anything without first knowing the facts, in spite of their impotence, their envy, and their debased politics.

At this moment I am a prisoner,[3] until a calmer time, which will not be long in coming, will be able to hear me.

I hope to show France what it means to be a man who has enough sense of honor to do his duty under all circumstances.

I embrace you with all my heart. Do not worry at all on my account.

Your son

Gustave Courbet

At the Conciergerie, Paris, Palais de Justice

1. No doubt a reference to the so-called Bloody Week, the period from May 21 to May 28, 1871, when the Versaillese broke the final resistance of the Communards, killing some twenty thousand people and imprisoning nearly thirty-six thousand.

2. On May 28, the Municipal Council of Ornans had ordered the removal of the *Boy Catching Bullheads* (Fs. 1) from the fountain in the Iles-Basses quarter of Ornans. Two days later the statue was forcefully knocked off its stand and, with one arm broken off, handed over to Régis Courbet.

3. See letter 71-16, n. 1.

To Pierre Dorian [Paris, Conciergerie, mid-June 1871] **71-19**

My dear Dorian:

Our friend Considérant* must have spoken to you at length about me and the deplorable events that I had to witness, without being able to prevent them. You were lucky not to find yourself in Paris in those days for we wanted you badly to take part in the Commune.[1] Today you would be in a cell next to mine in solitary confinement.

I just wrote a letter to M. Victor Lefranc,[2] our minister of commerce. It occurs to me that he must have been very surprised for, when I wrote him, I forgot that he knows nothing at all about what is happening to me. Please speak to him. He is one of my old comrades from the Latin Quarter. I was telling him that, after they went through my letters and papers, they must have convinced him, easily and effortlessly, that my intentions and methods of action were diametrically opposed to the ones that had been used. When one has been a phalansterian in one's youth, one remains a pacifist. Look at Considérant![3] Besides, you know me well enough that I have nothing to teach you in that regard.

In spite of all my efforts, there is still one shadow hanging over me, the fall of that miserable column. What a service you would have rendered me if you had had it taken away [during the days of the] September 4 [govern-

ment], for my only liability, with regard to that object of fetishism, was the petition that I addressed to you at that time.[4]

This is what I wrote M. Victor Lefranc yesterday: "If they insist on believing that it was my power that knocked down the Vendôme Column (which would give me an opinion of myself that I do not and cannot have), there is a very easy way to come to an understanding. The loss of money is not fatal. As there is no question of artistry in that monument, as it is merely a[n object of] fetishism that must be respected, I offer the government to have it put back up at my expense" (as I already asked you to tell them a long time ago). But this is what I forgot to tell him, that I have no money, as he knows, but I have two hundred paintings, my own and Old Master[5] paintings, and that by auctioning off those paintings, there would be more than enough funds for raising it up again, the materials being still on site. I lived with those paintings, but the sacrifice won't be great. They will do me more honor in private collections and foreign countries than at my home. In that way I hope to be entirely rehabilitated in the public's opinion and to ease in the process the lot of my fellow devotees of the minority.

Please be so kind as to propose this offer (if you have not already done so) to your government, so that all that will be left for you to do is to thank me for having done your duty while you were away from Paris. For I am the only man since the September 4 era (witness M. J. Simon*) to have saved anything in the capital throughout all the disasters of nearly a year now. This task will be much more genuine and infinitely more pleasant for you and for me.

Sincerely yours. I embrace you, my dear compatriot. With fraternal salutations and my compliments to your ladies,

Gustave Courbet

If you could obtain the privilege to come see me, I would be delighted. Conciergerie, cell 24, Paris, Palais de Justice.

1. Pierre Dorian, who had been elected to the National Assembly on February 8, 1871, had played an important role in the efforts toward reconciliation between the Commune and the Versaillese government in March 1871. It is because of his conciliatory attitude toward the Commune and because of their old friendship that Courbet turned to him after his arrest.

2. The letter to Victor Lefranc (b. 1809) has not been preserved, but its text must be analogous to the letter Courbet sent some days later to Jules Grévy (see letter 71-19).

3. It is difficult to ascertain to what extent Courbet was interested in Fourierism in his youth. He was no doubt familiar with the ideas of Charles Fourier (1772–1837), who, after all, was a Franc-Comtois by birth. At least one of his boyhood friends, the poet Armand Barthet,* had strong Fourierist leanings. The connection between Fourierism and pacifism made here by Courbet is one that was especially emphasized by Fourier's follower Victor Considérant, who, during the July Monarchy, had turned Fourierism into a movement for "peaceful democracy" (cf. Beecher and Bienvenu 1972, 65).

4. See letter 70-27. Though the petition (at least in the draft form that is known to us today) was addressed to the Government of National Defense, Courbet may have sent it to

Dorian, as he was then minister of public works and, as such, in charge of public monuments like the Vendôme Column.

 5. On Courbet's collection of Old Master paintings, see letter 70-13.

To Jules Grévy, Versailles, June 19, 1871 (incomplete draft) 71-20

<div align="right">Versailles, June 19, '71</div>

My dear M. Grévy:

 I don't think there is anyone better for me to turn to than you[1] in this troublesome situation, which, though a mistake on my account, has all the trappings of reality because of the contempt I have to suffer from the minister of public education, Jules Simon.* You know better than anyone my devotion to art, to which I have dedicated my life, and my intentions in that regard, as you have seen me at work under the September 4 government, disinterestedly applying all my energy to the preservation of our museums and works of art, not only in Paris, but also in the Seine Department, with the help of my committee; you have seen me unwilling to take on so great a responsibility as that of examining the archives (to which committee I was nominated by you[2]); you have seen my painstaking search for our works of art lost in Paris during the empire; you have seen my proposals to shell-proof the Arc de triomphe and the Marly horses, to casemate the objects in the Louvre, to crate the statues and paintings we had left, to organize [] projects [] by artists in order to economize.[3] Indeed, when all those who were responsible for the task had left Paris, I and I alone reorganized the elements necessary to continue this preservation effort in order to save civilization in France. I called for a general assembly of artists a second time, at which I was appointed provisional president a second time until that assembly, according to the agenda that had been adopted and the decentralization of power, was prepared to run itself. They [the assembly] split up into committees and sections by art form, and everything runs in accordance with regulations. The president was appointed every day.

 But the people who spontaneously gave me five and some thousand votes for the Bordeaux Chamber[4] (to which I could have been elected had I wanted to be and had I thought of myself as a politician) called me back to my arrondissement to take part in the Commune. The first time I obtained the eighth place in the popular vote but the list of delegates stopped with me.[5] Then I was renominated by a majority, which is what I wanted.[6] I wrote a friend of mine asking him to accept on his part.[7] I would have accepted had I been nominated with ten votes. If they had allowed me to nominate myself, I would have nominated myself, because the people of Paris wanted reasonable and peace-loving people, and also because I was to be the intermediary between that assembly and mine. I have within me a moral courage that has

<div align="right">*423*</div>

never abandoned me and I was braving all the possible outcomes of the situation by risking my neck and my reputation. Yet, it would have been so easy for me to do like everyone else; to abandon Paris, where I had suffered so much during the Prussian siege; to go either to England, where my interests called me, or to my family, in my part of the world, where my parents, who are old, pled with me to come, and where the Prussians had ransacked my atelier, my paintings, my collections, my mementoes—the story of my life—all that burned, stolen, destroyed. Today I would be honored, and I would not be languishing in dungeons, in infested places, or in Black Marias, as a reward for my devotion, and people would not be sacrificing my honor, reputation, and money to their ambition and their pride.

I felt that my duty was in Paris, I stayed there. I have done my duty for twenty years, in spite of the empire. I did it under the September 4 government, I did it under the March 18 government, and I hope to do it for the rest of my life and without any need for rewards, for I don't care to have my self-esteem taken away by any compensation whatever.

Yet one must admit that in all things there is good and bad, and though the good is difficult to grant, it is impossible to believe that there was not a single honest man left in Paris. Without going too far afield I will cite three who have stood by me: Messrs. Beslay, Theisz, and Barbet de Jouy, the curator of the museum.[8] I can affirm that those people were moved by the same spirit as I. I don't see why they do not share [?] my fate, the triumph would be complete.

As for me, I am now free from all cares for the future. I no longer have any right (depending on the needs of the cash box) either to the man or to the reputation. My entire working life has been erased. My artistic talent is no longer exhibitable. I no longer have an atelier in Ornans. The September 4 government has taken from me a building worth twenty thousand francs,[9] which I used for my exhibitions, and has dumped it at the Porte de la Chapelle to make barricades out of it. One shouldn't stop when one is ahead.

I have never had wealth, I don't care to have it, or to possess anything at all. I have two hundred paintings left, my own and Old Master paintings that I bought with what I earned, both in France and in the countries I passed through. I stand by the offer that I made to the Chamber some two weeks ago and that I repeated to M. Dorian* and M. Victor Lefranc[10] when I saw that my letter had not been delivered and hence did not receive a response. I still stand by that offer. They insist on holding me responsible for the fall of the Vendôme Column though I have nothing to reproach myself for except the proposition that I addressed to the Chamber of September 4, [in which I stated] that the column has nothing to fear for its artwork and that it is a fetish to be respected for the sake of everyone's freedom. I will hold, if I am permitted to, an auction of those paintings to raise it up again at my expense. . . .

1. President of the National Assembly since February 16, 1871, Jules Grévy represented the Jura Department, one of the three departments of the Franche-Comté.

2. The truth of this statement is doubtful. The Committee of the Archives was appointed by Jules Simon. Grévy, who kept a distance from the September 4 government because he considered it illegal, had probably nothing to do with the formation of the committee.

3. This sentence contains at least two illegible words.

4. In the February 8 elections.

5. First elections of the Commune held on March 26.

6. In the supplementary elections of April 16.

7. No doubt a reference to Auguste Rogeard (cf. letter 71-13).

8. Courbet cites these three names as apparently he saw them as men who, like himself, had done their duty scrupulously during the Commune. Charles Beslay (1795–1878), elected to the Commune on March 26 and appointed to the Committee of Finance on March 29, had, as delegate to the Banque de France, defended the integrity of the bank against the radical elements in the Commune. Albert Theisz (1839–81), elected to the Commune on March 26 and appointed director of postal services, had managed to partly reestablish services after the former director had carried off to Versailles the most important materials necessary for the functioning of the postal system, as well as the cash box. Though not a member of the Commune, Henri Barbet de Jouy (1812–96), the chief curator of the Louvre, had stayed in Paris throughout the Commune to protect the art treasures in the museum. While officially replaced by another curator after May 22, he had stayed on his post throughout the tumultuous last days of the Commune. Both Beslay and Theisz had managed to escape into exile immediately after the Commune (to Switzerland and England, respectively). Barbet de Jouy would eventually be honored for his heroic stance.

9. The pavilion built for Courbet's 1867 private exhibition.

10. See letter 71-19.

To Emile Joute [Paris, July 3, 1871] 71-21

My dear Joute:

That M. Ajasson[1] is getting on my nerves. Taking advantage of my absence, he is bombarding me with letters about my paintings. They are the only asset I have left. I don't wish to allow myself to be robbed. I just wrote Adèle[2] to ask her to have those paintings (which are, moreover, getting ruined) transported to my atelier in rue Hautefeuille and the pieces that are too heavy and unmanageable to my warehouse in Grenelle.

I beg you, dear friend, to please lend a hand with all that. I would be very grateful to you, for there are some very important paintings that are at the mercy of chance and whose value one cannot imagine. It frightens me to see them like that. I count on you and your friendship.

I am hiding out here in painful circumstances, not knowing when I will be tried. I wrote my friend Dorian* and Victor Lefranc,[3] the minister, to try and put an end to this misunderstanding on my account, for, as you know better than anyone, my role in the Commune was that of a peacemaker. I have asked them to try and put an end to this misunderstanding on my account as soon as possible.

Do write my parents to reassure them, to Flagey, canton Amancey, Doubs. They'll be delighted. I am extremely grieved by all the disasters that have happened, and by the death of my friend Chaudey,* whom I tried to save up until the last moment, as I am not an advocate of capital punishment under any circumstances.[4]

Kind regards to our friends as well as to your ladies.

Sincerely yours,

Gustave Courbet

You can help me in this business.

A long time ago I proposed having the Vendôme Column put back up at my expense by holding an open auction of my paintings.

[Address] Monsieur Emile Joute
Representative of the
Ironworks of the Franche-Comté, Inc.
Rue des Fabriques
Grenelle

[Postmark] Paris, July 3, 1871

1. Stéphane Ajasson de Grandsagne. See letter 72-4, n. 3.
2. Adèle Girard,* Courbet's landlady in the passage du Saumon.
3. See letter 71-19.
4. In spite of Courbet's alleged attempts to save his friend, Gustave Chaudey had been executed by the Commune on May 23, after the Versaillese had already entered Paris.

71-22 *To Alexandre Daguet, Paris, Mazas Prison, July 14, 1871*

Mazas, July 14, '71

My dear Daguet:

Our dear friend Buchon,* our poet-philosopher, who died in my arms, he too believed in disinterestedness, in duty, in doing good for its own sake. With a chain around his neck he did twenty miles on foot, between two mounted policemen.[1] He did the same, under the same conditions, to return to Besançon. He went to be tried in Arbois,[2] where he was acquitted. He was acquitted in Besançon as well, after nine months of preventive detention. For forty days now, dear friend, I have been languishing in the same conditions. I hope the outcome will be the same.

As you put it very well, you know my humaneness and the horror I have of violence and of armed combat, of destruction and of the death penalty, to whomever it is meted out. We'll see each other soon, dear friend, else integrity is the crime of modern society.

I stayed in Paris, it is true. I could not get away, for several reasons. The situation would have occurred in any event, whether or not I stayed. Similarly, without changing the line of conduct I followed by one iota, as my artistic

position was worth more than any government job, foreseeing a cataclysm, I accepted, on September 4, the presidency of the arts, both to save the arts in Paris and to save my own paintings, which are my whole life and all my wealth. I achieved my purpose and now I await the people's understanding of my intentions.

I hope, dear Daguet, that one day we'll take up our peaceable philosophy again.[3]

Many thanks to the people who are concerned about me. Tell them that another year like this one will turn me into an old man.

<div align="center">G.C.</div>

1. Reference to the events of 1851.

2. Small town in the Jura Department, not far from Salins-les-Bains, Buchon's home town.

3. Daguet was a professor of Swiss history at the Academy of Neuchâtel. Courbet, who was greatly interested in the political structure of Switzerland, must have had many discussions with him about political thought.

To Eugène Reverdy, Paris [July 8 or 15, 1871] (incomplete) 71-23

<div align="right">Sunday, Mazas</div>

. . . I fear violence, sudden anger, recriminations, arguments, and the evil that usually results from them. I would rather agree to everything and have peace. . . .

[He asks him to pass by Durand-Ruel* and Brame* to see what they still owe him. He asks him for the address of his cousin, Charles Courbet, a secretary at the Hôtel de ville, who has been trying to have the city of Paris reimburse him for his 1867 exhibition building.

[He authorizes Reverdy, together with M. Gonet, the police commmissioner, to have his paintings moved from his lodgings in the rue du Vieux-Colombier to his home at 32 rue Hautefeuille.]

. . . Be careful not to lose anything. There are some small things that don't look like much but that are useful. . . .

I have been interrogated by M. de Vienne.[1] I hope that the public and the journalists will change their minds. I am still very affected by [the death of] my mother.[2] I have a kind of illness that is common in this prison: stomach-aches and constant diarrhea. . . .

<div align="center">G. Courbet</div>

[Address] M. E. Reverdy
 Rue d'Assas 4
 Paris

1. After his initial interrogation by police commissioner Bérillon on the day of his arrest (cf. Riat 1906, 310), Courbet seems to have been interrogated several more times before his actual trial in the latter half of August.

2. Courbet's mother had died on June 3, 1871.

71-24 *To Auguste Bachelin [Paris, Mazas Prison, mid-July 1871]*

My dear Bachelin:

You talk to me about painting, about poetry.[1] Alas, all that is far from my thoughts. I don't remember having been a painter. Farewell sea and large skies, and forest [].[2] Besides, I have lost everything. The Prussians burgled my atelier in Ornans, the September 4 government turned my exhibition building into barricades that are targets for shells. My paintings are completely damaged from having been moved so often, and of late they have been rotting in cellars. I am in prison, my mother is dead, my family and my friends are heartbroken, and my future has to be rebuilt.

Woe to the greathearted!

Cordially yours, my friend, and my apologies.

Switzerland is very lucky![3]

Gustave Courbet

1. Courbet's letter was written in response to a letter by Bachelin of June 28, 1871, now in Paris, Bibliothèque nationale, Cabinet des estampes, Yb3.1739 (4°), b. 2.

2. Illegible word.

3. Courbet's letters to Auguste and Rose Bachelin, as well as to Alexandre Daguet, all living in Neuchâtel, Switzerland, may have been motivated by his plans, already at this early date, to take refuge in Switzerland. See also letters 71-29 and 72-3.

71-25 *To Rose Bachelin [Paris, Mazas Prison, mid-July 1871]*

Chère Mademoiselle Bachelin:

It is impossible, dear friends, to give greater pleasure to a man than you have done by writing to me. Your reminiscences came just as I was spending part of my day thinking of you and of the unclouded happiness that you enjoy (what else can you do in a den but dream!).[1] Your situation at the moment is so entirely antithetical to mine that it seems to me to be ideal.

Alas, dear friends, you do well to think of me, for at this time I am steeped in the most enormous afflictions a man can bear. For, aside from the efforts they are making to discredit me publicly as a reward for my services, I have been hit in addition by an even greater calamity, an irrevocable calamity: my poor mother has just died,[2] without my having been able to see her again.

My poor father, who will not survive this—a white-haired old man pros-

trate with grief—has come all the way from Ornans to tell me the terrible news himself, leaving my sisters alone with their despair. And it was in prison, where his afflictions were multiplied by seeing his son, that he broke down in earnest.

Oh, I am asking you to take part in all these dreadful things in return for your charming reminiscences. I cannot tell you when I will be able to come see you. While awaiting happier days, please accept all my compliments and best wishes.

<div align="center">

G.C.

</div>

1. The origins of Courbet's friendship with Auguste and his sister Rose Bachelin are not known. It is possible that he had met them in Switzerland during one of his numerous trips to that country. This letter suggests that Courbet perhaps at one point stayed with the Bachelin family in Neuchâtel.
2. On June 3, 1871.

To Juliette and Zélie Courbet, Versailles, July 27, 1871[1] 71-26

<div align="right">

Thursday, July 27, '71
Versailles

</div>

My dear sisters:

My poor father has informed me of the irrevocable calamity that has struck us.[2] This terrible news, coming on top of the state of mind in which I already found myself, has plunged me into the deepest despair. I immediately thought of you and how alone you were, while I was unable to come and join you.

We must hope that I won't have to suffer much longer. Next week the trial will begin,[3] and, as my sister[4] must have written you, I have M. Lachaud* to defend me. Everybody here is trying hard to quell the contempt that exists in my regard.[5] Deputies, men in the government, everyone is protesting except the people from Ornans, that is to say, the Municipal Council of Ornans, which I hope to set straight before long, as it deserves.[6] That is why I am writing you these few lines.

When I learned about Mother's death—the only thing I dreaded, for I already had a presentiment of it when I left you—I lost my head and I forgot to get from Father the Ornans council's resolution,[7] which I absolutely must have. I don't need it in two weeks, I need it tomorrow. As soon as you receive this letter, get it from Father and post it without envelope by return mail. It must appear in the papers before my case comes up, that is all I need to tell you. It is very important, I am counting on you. Address it to M. Coussol, director of the holding prison in Versailles, to be forwarded to M. G. Courbet. I cannot respond without knowing the terms of their resolutions and the gentlemen's names. They will have some publicity. Anyway, I just have to be

patient. All the same, when one has tried hard to do the right thing and one is rewarded this way, it is hard.

I am suffering from my hemorrhoids, and I have lost a lot of weight, which is not a bad thing. My sister is turning Paris upside down. She makes me shudder because when she is done thoroughly explaining the situation, nobody will understand a thing.

As you know, it was impossible for me to leave Paris. My entire life was there—six hundred paintings threatened with shelling every day. I moved them three times. My dear sisters, I am less to be pitied than you. I can already imagine all the difficulties you are in. Anyway, I embrace you with all my heart. How I love you, and Father too.

<div style="text-align:center">*G. Courbet*</div>

Make a copy before you send it to me.

1. The letter bears the stamp of Fumey, attorney in Besançon.

2. According to the archival records studied by Jean-Luc Mayaud, Courbet's mother died on June 3, 1871 (cf. Mayaud 1979, 18), but apparently Courbet learned about it much later, though possibly before his father's visit here referred to.

3. The trial of Courbet and fifteen other Communards (plus two members of the Central Committee) was scheduled to begin on July 31, but it did not actually start until August 7. Courbet was called to the stand on August 14. For the purpose of the trial, Courbet had been transferred from Mazas Prison in Paris to Versailles on July 21 (cf. Riat 1906, 309–13; and Serman 1986, 528).

4. Zoé Reverdy.*

5. Though Lachaud was one of the most brilliant lawyers of the Second Empire, Courbet never seems to have trusted him completely. Later, he would accuse Lachaud of being a Bonapartist sympathizer.

6. The Municipal Council of Ornans had ordered the removal of Courbet's statue of the *Boy Catching Bullheads* (Fs. 1) from the fountain in the Iles-Basses quarter of the town. See letter 71-17, n. 2.

7. No doubt the resolution related to the *Boy Catching Bullheads*.

<u>71-27</u> *To Emile Joute, [Versailles,] August 1 [1871]*

<div style="text-align:right">August 1</div>

My dear Joute:

If, on the day when I so unfortunately took up lodgings with Mlle Girard,* I had broken a leg on the way, it would have been all to the good. This is the worst thing that has ever happened to me. Not only did she inform on me and make me do seventy-eight days in prison,[1] but she also made such fantastic and false accusations on my account that the Versailles court considers her a chronic liar. I have seen all her depositions, it makes one shudder. I have already obtained for her a waiver of preventive detention before the trial. At the moment I am trying to have her disqualified as a witness.[2]

Aside from all that I believe that her maneuvering will backfire because

she is putting an inexplicable stubbornness into refusing to return anything that belongs to me, any of the things I unfortunately left with her.

In all this, my dear friend, you were seeking to help me, and it was unquestionably an unintentional mistake. You are a very honest man. On your recommendation I went there trustingly. I cannot tell you what she has made me suffer, it hurts to think of it. Indeed, without her, absolutely nothing would have happened to me. I believe she has made it her business to cause my death. Due to her I have traveled from Paris to Versailles in Black Marias, in which I was literally suffocating, in order to depose in Paris about stories that she had invented and that remained unresolved.[3]

On the other hand, she is advised by the passage du Saumon[4] (you know whom I mean), which is just a trap, a thieves' alley, and at the moment, as in fact for a long time now, it is impossible for me to get what belongs to me from her house: my papers, my account-books, my contracts, my securities, my railroad shares, and the money that you yourself put in a sealed envelope with the amount written on it. (My shares are numbered at the bank and at a notary's office. There is nothing worse than stupidity.)

I am scared to death that she'll sell some of my letters as autographs, people have already mentioned it. She had one of my letters published, I am told, I don't know which one.[5] It is a hopelessly entangled tissue of lies. In court she says she is my cousin. She came to see me in Mazas[6] to try to make me believe that my sister and brother-in-law had informed on me, when I myself had seen her depositions. She told me that they had taken your money from her house as well as mine. That is not true. She mixed things up so much that it was not possible for me to get a word of truth out of her.

Yet all this cannot go on like that if I use, as she would like, the Versailles War Council to get my belongings back. The last captain who interrogated me told me that, with the charges pending against her and with her dossier, she will get at least six months in prison. I am not like her. I would not want to be the cause of such misfortune. I know what it is like.

It is for that reason, my dear friend, that I appeal to you to prevent all that so that you may act decisively toward her. Before showing her this letter, find out from her what she still has of mine, for she is very dangerous and cunning. Go about it as if you didn't know anything. Once she is caught she is as stupid as thirty-six geese. She handed over my guns from Dorian* and Laveur junior,[7] how clever! I send my sister and my brother-in-law every day with authorizations from me to deal with her. My sister knows nothing from me about the tales you have been told, not even that you know them, you believe that in all this your name has never been mentioned.

The chief of police will get an attorney. Now we are talking about costs, about prison. I could easily be done with Versailles in a single swoop. But six months in prison? I don't want to do that to her. And yet, if I am exiled to

Switzerland or England, I have to live somehow in those countries. I have to pay for my trial, my lawyer, my expenses; I have to buy clothes.

I beg you, please settle my account with her. I owe her for some lunches and laundry; I bought shoes that I paid for; a pair of trousers that I paid for; she went for medicines that she paid for, as she did the doctor. But all that was with my money and hers. She took some banknotes, she told me. Aside from the money that we put in the envelope, I don't remember how many one-hundred-franc notes I kept. I received 315 francs from the Commune, which I deposited with her. She received 1,000 francs from M. Durand-Ruel,* of which I took 600 francs to leave with.[8] She paid a lawyer 200 francs for me, and insurance for one hundred and something. My contribution was, I believe, about 1,350 francs, plus what I still had in banknotes when you closed the envelope. I don't remember, but she knows all that, and I left with 600.[9]

I pray you, go see my sister at 4 rue d'Assas (Monsieur Reverdy) and talk it over together. They have given her an authorization. Write up the statement any way you like, it will be fine, for she has made me suffer too much. I never want to see her again. She is threatening my sister to tell even more.

My dear Joute, you will perhaps be called as a witness to state that I did not fight.

Sincerely yours,

G. Courbet

1. Courbet exaggerates. Arrested on June 7, he had spent only fifty-four days in prison.

2. In spite of Courbet's efforts, Mlle Girard was called as a prosecution witness in Courbet's trial. However, her testimony was not very damaging to his case (cf. Riat 1906, 318).

3. At the end of June, Courbet had been taken from Paris to Versailles to be interrogated. In July, he was back in Paris in Mazas Prison, only to be taken back to Versailles for his trial on July 21 (cf. Riat 1906, 309;;3–13).

4. Mlle Girard lived in the passage du Saumon, no. 14. Courbet had moved to her home on January 6, 1871, because several bombs had fallen dangerously close to his studio in the rue Hautefeuille. Courbet stayed in the passage du Saumon until May 23, 1871, when Mlle Girard asked him to move for fear that he be arrested in her house (cf. Riat 1906, 318).

5. I have not been able to verify this charge.

6. Courbet stayed at Mazas Prison from July 4 to July 21.

7. No doubt the son of père Laveur, keeper of the Pension Laveur in the rue des Poitevins, where Courbet generally took his meals in the late 1860s and early 1870s.

8. The money that Mlle Girard had received from Durand-Ruel consisted no doubt of the proceeds of the sale of one or more paintings by Courbet.

9. These mixed-up finances suggest a closer relationship with Mlle Girard than that of landlady and boarder.

To Léon Bigot, Versailles, [mid-August] 1871 **71-28**

My dear Bigot:

I thank you. You have spoken like a great-hearted man,[1] and as the people say, I shed a tear.

 Gustave Courbet

Communard at the Versailles trial, 1871.

1. The lawyer Léon Bigot defended several Communards and also appears to have spoken out in favor of Courbet. Since Courbet's hearing started on August 14 and Bigot died from a stroke on August 20, this note must date from the week between the fourteenth and the twentieth. The note is written on a drawing by Courbet, signed, dated 1871, and inscribed "Les Fédérés à la Conciergerie" (New York, Coll. Wildenstein & Co.). The drawing was lithographically reproduced in *L'Autographe* of September 9, 1871 (p. 19), with the following comment (p. 13):

"The drawing by Courbet to some extent reflects the terror felt by the big artist two days before his mild verdict. It has some qualities but its defects are much more numerous. One cannot understand the subject. The figures' poses do not express anything and cannot be explained from a design point of view either.

"As for the legend, it is absolutely crazy. Can you see Courbet, member of the Commune, writing these words, 'as the people say.' Isn't it clear that he by no means wants to be reelected."

To Juliette Courbet, [Versailles,] August 27, 1871 **71-29**

 Sunday, August 27, '71

Dear Juliette:

I heard from the sister superior at the Versailles military hospital that you had inquired about my health. I am very grateful to you. I was very happy to be transferred to this hospital, where I am very happy.[1] I have entirely recovered from what I suffered in solitary confinement. Solitude weakens the brain. This is a three-week respite from misery. I am as thin as [I was] the day of my First Communion, you'd be amazed. Sister Clotilde looks after me. She is extremely nice to me and gives me as much food as she can. In spite of the rule we are on the best of terms. I am being treated for my hemorrhoids.

All goes well. The facts and the charges are being ironed out, especially in my case. In the end all this will be to my advantage, I can tell already.

Our cases have been in court for a few days now. The lawyers are doing everything they can. As for me, I have the number-one lawyer in Paris, who moreover is in the privileged position of having the ear of all parties.[2] M. Grévy* assigned him to me. I believe that my case will be heard next Wednesday or Thursday. After that there will be a replication from the government, then another one from our lawyers, and that will be the end of it. If in the end I am only sentenced to exile, I'm not going to appeal. I will do my time without asking them for a pardon because I don't want those who had the

 433

impudence to prosecute me, after the outstanding service I have rendered, to be rid of me so cheaply. I want to reserve the freedom to accuse them at any time.

Here, the opinion of the majority is that I will be acquitted. If I get a jail sentence I'll ask that it be converted to exile. I think that if I were to be acquitted, I would first go for a week or two of sea bathing, before coming to see you, for two reasons: because I need it very much (I did not go sea bathing this year and I am all wrinkled); and, secondly, because I would like to sue the people on the Ornans Council before going back and immediately after the trial. I cannot sue them while I am there. Those people, those idiots are nothing but murderers. By their decision[3] they were decreeing my sentence, and had I not been in hiding, I would certainly have been shot.

The question of the column has disappeared entirely from my record and not too soon. All that remains is that I was part of the Commune in order to be able to carry out my mission. With that authority I had five battalions at my disposal, and I said to them, "Is something missing from all the museums in Paris? No. Well, then, the means I used to reach my goal is my business, not yours." Besides, I am proud to have belonged to the Commune, despite the accusations that are leveled against it, for that government, which in principle resembles Switzerland, is the ideal government. It drowns ignorance and renders wars and privileges impossible.

I hope you are all doing well. I am very worried about you. I hope that in this season the work is progressing somewhat. Zélie* must be doing better. If I go to Switzerland I will send for you all. I'd go to Neuchâtel. I also hope that Father is doing well and has no time to be sick. Don't reply in any way for at least a week. Whatever you write, especially Father, can endanger me. I'll write you again the day of the summation for the defense. I took a subscription to the *Siècle* in your name to keep you informed. The *Siècle* is trembling like a leaf and so is Castagnary.[4] I embrace you all,

<div align="center">G. Courbet</div>

I received a letter from Mlle J. Thiebaud [?] and from Lydie.[5] My letters get to me about a week after one writes me. My sister and brother-in-law are still bustling about. I'll be owing rents all over Paris.[6]

1. During his trial, Courbet developed serious hemorrhoidal problems and had to be transferred from the Orangerie to the military hospital in Versailles.

2. Charles Lachaud.*

3. To remove the *Boy Catching Bullheads* (Fs. 1) from the Iles-Basses fountain in Ornans.

4. Jules Castagnary* was an editor of the *Siècle*. It was felt by many that the *Siècle* had been responsible for the January 22 massacre at the Hôtel de ville, which spelled the beginning of the Commune. The *Siècle*'s editor-in-chief, Gustave Chaudey,* had been executed on May 24, immediately after the entrance of the Versaillese troops into Paris. See also note 6.

5. Lydie Joliclerc.*

6. Castagnary, who later had access to this letter, wrote the following comment on it:

"Error: The *Siècle* has been the first paper and Castagnary the first journalist to ask amnesty in 1871, while everyone else trembled. Castagnary."

To Louis Gatineau, Versailles, August 28, 1871 [1] 71-30

To Maître Gatineau:

When Paris organized itself into a federation, it was, in a sense, an apologue it was addressing to the provinces. That sudden idea, born of inspiration, was the consequence of the action that it has taken five times for human independence,[2] and that has always gone astray and miscarried, owing to the regressive efforts of provincial France.

Paris must be its own master, that is undeniable. It has passed the tests, it has graduated. Europe recognizes it. Why would a student at school who can do two grades in one year wait until the most ignorant ones reach his level? Life is short and one must proceed without respite.

The provinces are not only ungrateful to Paris, but they are also illogical in their own regard. Complying with the centralizing current they send the most gifted of their children to Paris so that they may improve there and become teachers in their turn. And they [the provinces] constantly rebel against that authority, which arose from themselves and by their own will.

The reason for this is that they are torn in different directions, on the one hand, by the very men they have set on the road to progress, on the other, by clerical obscurantism struggling desperately in the foreknowledge of its ultimate defeat.

But what started as a mere apologue, a lesson, an example, soon became more substantial. By decentralizing, by trying to put an end to that antinomy, Paris was performing an act of abnegation unique in history: it renounced on its own the authority that it had been tacitly and de facto granted for over two centuries (it was a great vision). It raised the provinces to its own level, and acknowledged them as its equal, and spread light by abolishing privilege. From that moment on, the Frenchman was governing himself, shaking off all false authority based on divine right and the right of might.

I cannot understand that, for so just and so inoffensive a cause, so many men had to be massacred and the freedom of so many others threatened for, in principle, Paris lived in expectancy. It awaited France's decision calmly (because it was in the right) and secluded in its individuality.

France did not understand. She stood inflexible, and the Chamber that represented her was gripped by an incomprehensible fear. Therefore it is back to her [France], to her violence, to her rage, like that of a wild boar disturbed in its den, that one must trace the responsibility for and the shame of the final cataclysm.

Some people in the world reach an agreement by dotting the i's, and some, by punching each other's eyes.

Sincerely yours, citizen,

Gustave Courbet

Communard, defendant at Versailles, August 28, 1871

1. Judging by the language of this letter, it may have been destined for publication in a newspaper, but, if it was, the paper in question has not been found. Gatineau was a well-known lawyer who defended numerous Communards and who, in 1876, was to introduce the so-called Gatineau Bill, asking for a ban on further prosecutions of Communards. Courbet's letter to Gatineau may be compared with his note to Léon Bigot, another lawyer who defended numerous Communards (cf. letter 71-28). Both letters were written in the course of Courbet's trial, which began on August 14 and ended with his conviction on September 2.

2. A reference to the revolutions of 1789, 1830, 1848, September 4, 1870, and to the Commune itself.

71-31 *To Charles-Alexandre Lachaud, Versailles, September 1, 1871*

Monsieur Lachaud:

You have rendered irrefutable to everyone the words with which I answered the first officer to interrogate me: "I have nothing to blame myself for."[1]

Since my life began I have belonged to art. I have dedicated myself to its preservation, to its development, to its greatness in my country. I have wanted to give art back what it had given me, and, under every government, that has been the motivating force of my actions, for which I have sought no other reward than the satisfaction of having accomplished my duty. It is because I have continued to accomplish my duty through the countless perils of a terrible revolution that I find myself torn from my painting, dragged into prisons and afterward into the docks of the War Council. In the proceedings of which I am the object, there really is a strange interpretation of human activity. Your eloquent speech has demonstrated that extremely well, Monsieur, and the injustice done me will, I hope, receive a brilliant redress.

Indeed, will I ever be able to thank you, Monsieur, for the support that you have lent me? I don't believe so, for it is not only in my name but in the name of my family that I declare myself to be very gratefully and all devotedly in your debt.

Gustave Courbet

Versailles, September 1, 1871

[Address] Monsieur Lachaud, senior
 Attorney
 Versailles

1. Lachaud had presented his final defense arguments in Courbet's trial the day before, on August 31 (cf. Riat 1906, 321).

To his family, [Versailles,] September 3 [1871] 71-32

Sunday, September 3

Dear family:

I have been sentenced to six months in prison,[1] I still don't know why.[2] Those people are trying to make amends to the public. After it had been proved that I had had nothing to do with destroying the Column, they maintained nonetheless that I had participated in it, in spite of assertions by the defendants themselves and in spite of the decree that had been issued before I joined the Commune.[3] I believe they want to look as if they are sentencing everyone[4] so that they can pardon me afterward, which is not the same thing to me, for had it not been for this sentence, I could have attacked the Municipal Council of Ornans.[5]

I don't know yet whether it will be a pure and simple acquittal or a commutation to exile. In the second case I would go to Switzerland. I don't want to appeal, so as not to thwart their plans. They have also sentenced me to a fine of five hundred francs, I don't know why. They imagined me to be rich, it is a very widespread notion. I must look rich, perhaps because I am fat. Anyway, we'll see what will come of all this, but I won't serve the prison term, that is almost certain. My comrades have received very stiff sentences, some to convict-prison, others to deportation, and two of them to death, which will not be carried out.[6] Everyone thought that I would be acquitted but I didn't think so because I know them and I know how offended they are by the contempt that we showed them with our action in Paris. I say no more about it. Now my sister[7] has come to see me to ask whether I want a review of my sentence. I don't know what would come of it.

I embrace you all with all my heart. Do not worry. All that business has had no effect on me. I have resigned myself all along to all the nonsense done to me. I'll write you two or three days from now.

G. Courbet

1. The verdict in Courbet's trial had been pronounced the previous day, September 2, 1871. He was sentenced to six months in prison and a fine of five hundred francs.

2. The official charge was "to have provoked, as a member of the Commune, the destruction of the Column" (cf. Paris 1977, 47.

3. The demolition of the Vendôme Column, demanded by the *Cri du peuple* of Jules Vallès* on April 4, had been officially decreed on April 12 after a vote by the Commune. Courbet was not elected to the Commune until the supplementary elections of April 16 (cf. Mason 1967, 237;;3–38).

4. Indeed, the National Assembly, which ruled France between 1871 and 1876, was determined to rid France of all radical tendencies. To that purpose, it intended to prosecute everyone who had been even remotely associated with the Commune.

5. For the removal of his statue of the *Boy Catching Bullheads* (Fs. 1) from the fountain in the Iles-Basses section of Ornans.

6. On the legal prosecution of Communards and sympathizers with the Commune, see Serman (1986, 527;;3–37). Among Courbet's friends, Gustave-Paul Cluseret* fled to Belgium and was later sentenced to death in absentia; Paschal Grousset and Henri Rochefort* were deported to New Caledonia, but escaped; Arthur Ranc* was sentenced to death but granted amnesty in 1879; and Jules Vallès* fled to London.

7. Zoé Reverdy.*

71-33 *To Colonel Louis-Dieudonné Gaillard [?] [Versailles,] September 6, 1871*

September 6, 1871

Monsieur le Colonel:

According to my sentence, I answer to the minister of the interior, and I should be at this moment either in the holding prison or in Ste Pélagie, which is my destination. I believe that it is by mistake that I have been transported from the military hospital to the Orangerie of Versailles,[1] which is under the jurisdiction of the War [Ministry]. As I am ill, I am in a very bad situation. I would be very obliged to you if you would have me transferred to my final destination.

With respectful greetings,

Gustave Courbet

1. The Orangerie at Versailles was one of the most notorious improvised jails created after the Commune to hold the excess of prisoners (cf. Serman 1986, 525–27).

71-34 *To Colonel Louis-Dieudonné Gaillard [?] [Versailles, mid-September 1871] (incomplete)*

Monsieur le Colonel:

. . . The director of the holding prison[1] has notified me that I have no money left to pay for my food. I would be obliged to you if you would send him fifty francs from the money of mine that you have.

By law, as soon as my trial is over, I am under the jurisdiction of the minister of the interior and the civil court of the Seine Department, which is my place of residence. Again, I would be very obliged to you if you would be so kind as to have me transported as soon as possible to Ste Pélagie, where it appears I will be serving my prison term.

I am very sick and I need air; moreover, to save the little that I have left

after my complete ruin, brought about by the political affairs of France and my loss of work. . . .

1. Apparently, Courbet had been transferred from the Orangerie, where he had been taken immediately after his conviction (cf. letter 71-33), to the holding prison in Versailles.

To Jules Castagnary, [Paris, Ste Pélagie prison,] September 23 [1871] <u>71-35</u>

September 23

My dear friend:

I have been at Ste Pélagie since yesterday.[1] They insisted on considering us under common law rather than as political prisoners. We are surrounded by thieves. They have used every means to discredit us. As a result, when you come to see me, I will only be able to receive you in the visiting room.

I have been anxious to see you for some time, as you know. Please ask the commissioner of police for the authorization to see me and for my sister and brother-in-law[2] as well. I have to untangle some business concerning an apartment that I rented in the rue du Vieux Colombier in order to start a club.[3] I would be very pleased if you could advise my brother-in-law in this matter. We'll talk about it. If you can get permission[4] to see me somewhere other than in the visiting room, please do so. If one of my friends wants to come with you, ask permission for him as well.

Parent[5] must have told you how much we have suffered. It is a peculiar reward for the services that I have rendered for the public weal, and the government has found a peculiar way to express their gratitude toward me. One must have one's share of injustice in life. However, in this case they could have chosen a person other than mine to give satisfaction to the public.

In spite of my efforts, and those of my codefendants, and those of my lawyer, the court has decreed that I was responsible for the fall of the Column. This fate was allotted to me, in spite of the factual evidence. I am carrying [the blame for] the Column, and one gives credit to that error in public, while I am unable to defend myself. I am going to write to the commissioner of police for authorizations at once.

Cordially yours,

G. Courbet

[Address] Monsieur Castagnary
 Writer
 31 boulevard de Clichy
 Paris

1. In spite of his protests (see previous letters), Courbet stayed in Versailles until September 22, when he was finally transported to Ste Pélagie prison in Paris.
2. Zoé and Eugène Reverdy.*

3. According to Riat (1906, 277), Courbet had rented the apartment at 24 rue du Vieux-Colombier, to house his collection of Old Master paintings. He later sublet part of the space to a political club, probably Les Défenseurs de la république, founded by Dr. Jean Robinet.* Courbet would later sue Robinet for unpaid rent (cf. Lindsay 1973, 291).

4. The words found in the margin of the second page of this letter, "through the director of Ste Pélagie, who has talked to me about you," probably belong here.

5. Though originally a member of the Commune, representing the ninth arrondissement, Ulysse Parent (1828–80) had resigned on April 5, in protest against the sally of the previous day. He was tried in August, together with Courbet, but acquitted on September 2.

71-36 *To the police prefect, Paris, Ste Pélagie prison, September 23, 1871*

September 23, 1871

Monsieur le Préfet:[1]

I would be very obliged to you if you would authorize M. Castagnary,* writer, 31 boulevard de Clichy, to come see me at Ste Pélagie, as well as my sister and my brother-in-law,[2] rue d'Assas, for I have family business and personal matters to discuss with these persons.

With respectful greetings,

Gustave Courbet

Ste Pélagie

1. Annotations of the prefect: "With regard to M. Castagnary, authorize for one time only. The sister and brother-in-law are to receive a permanent permission."
2. Zoé and Eugène Reverdy.*

71-37 *To the director of Ste Pélagie prison [Paris, Ste Pélagie prison, ca. September 23, 1871][1]*

Monsieur le Directeur:

I would be very obliged to you if you would be so kind as to see to my being given a sitz bath for permanent use in my room so that I may continue the treatment prescribed for me by doctors in Paris and Versailles for a hemorrhoidal condition.

I would also like you to authorize me to have a bottle of beer purchased every day, for I cannot really drink wine because of my ailment.

Also, please have someone bring me the catalog of your library and a cotton nightcap and a large bathtub.

With respectful greetings,

G. Courbet

[Address] The Director of Ste Pélagie

1. This letter must have been written soon after Courbet's arrival in Ste Pélagie prison on September 22, 1871.

To Juliette Courbet, [Paris, Ste Pélagie prison,] September 29 [1871]

Friday, September 29

Dear Juliette:

I am writing you in a hurry, not because I am pressed for time, but because I never have the opportunity to write, as I am in a monitored area. I can neither write nor receive letters without their passing through the hands of the honorable prefect, who is very mean. That is why I told you not to write anything, for the things that seem the best, that are most natural, are interpreted here in peculiar ways.

I have at last got out of Versailles and out of jail cells. Today I am already better and I am feeling healthier, for jail cells weaken the brain. Now I have fresh air, I am free to walk around and talk with people.[1] Even so, they were so low as to put us with thieves and murderers.[2] I don't care about all that, you know. I defy them to discredit me. They can write against me, cry out in the streets to drum rolls, and preach from the pulpit anything they like on my account. I won't even answer them, so sure am I of myself and my reputation. I receive congratulatory letters from everywhere, from Germany, from England, from Switzerland. They are all opening their arms to me, except the reactionaries and the men in the pay of the government and of Napoléon, for at the moment they are working for the latter. What a humiliation for France if he were to return! We'd go live in Switzerland.

My sister[3] frets so much that she is making herself ill. Her pride has been wounded. As for me, I have done nothing but laugh about it the whole time. So do not worry about me. I lack for nothing here. Stay very quiet and do not move. I have already done one month, I only have five more to go. I'll come see you the first of March. It will soon be over. I will try to work. We talk so much here that there is no time to do anything. I'll try to get my paints and work a little. I don't know whether my sister will obtain permission to have me transferred to a nursing home at Dubois's.[4] There I could receive friends and models. Everyone envies my lot, they feel that my sentence was too light. That Column makes them furious. They absolutely want it to have been I who had it demolished, I must put up with that. It is true that all my comrades have been transported to forts and convict-prisons and sentenced to death. I got off easy, especially as those criminals on the municipal council of Ornans singled me out to be shot in their resolution. And to think that, because of this verdict, I can no longer do anything against them. My lawyer was very talented.

Please, they tell me that you want to come. I beg you, don't come. It would distress me to know that you were alone on the roads and in Paris, which is very dangerous. You could be put in prison, almost certainly. My sister has not been because she is married, but all the sisters and brothers and *441*

fathers of my friends are in prison. The greatest pleasure you and Zélie could give me would be to stay very quiet and, above all, not to grieve. I hope Father is well and you two as well. I have received charming letters from Lydie[5] and Stéphanie.[6] I embrace you. My sister is coming to see me for the first time at Ste Pélagie. I'll try to give her this letter and the one for Lydie. I'll write you when I can. I embrace you all with all my heart.

<div style="text-align: center;">G. Courbet</div>

You can write my sister and she will forward your letter. Kind regards to everyone, including the Ordinaires.*

M. Reverdy* was able to retrieve some rifle barrels that I had made for Father. I'll send them to him on one condition, that he won't kill himself with them.

Once again I won't be there for the grape harvest. I constantly think of everything that you do.

1. On the organization of Ste Pélagie prison, see Larousse XIX, s.v. "Pélagie, Sainte." Thanks to the fact that he had some money, Courbet had a private room and had his meals brought in from the outside (cf. Riat 1906, 324).

2. Contrary to usual practice, the convicted Communards were not housed in the "Pavillon des princes," which was reserved for political prisoners, but together with common criminals.

3. Zoé Reverdy.*

4. Courbet was eventually transferred to a nursing home; however, it was not Dr. Dubois's but Dr. Duval's at Neuilly.

5. Lydie Joliclerc.*

6. Compare letter 65-12, n. 1.

71-39 *To Lydie Joliclerc, Paris, Ste Pélagie prison [early October? 1871]*

<div style="text-align: right;">Sainte Pélagie, I don't know what day</div>

Dear Lydie:

My dear, worthy friend, tell Joliclerc* that I love you both and that I think of you often. How happy one is to receive kind letters like yours, letters that spring from the heart and come to you from your own part of the world.

One is so happy, when one is in chains—"in chains" is the word, for every night we are locked up in irons as thick as my arm after being with thieves and murderers all day—one is so happy, I say, to be able to know that, despite persecutions (which seek to discredit us and lower us in the public esteem), one still has friends who don't let themselves be influenced by the criminal plots of those phony rulers who are forever trying to suppress freedom.

442 In those terrible moments of solitude [when one is suspended] between

life and death (for you could never imagine what we have suffered), thoughts arise of one's youth, one's family, one's friends. I have traveled through all the places where I went as a child with my poor mother (whom I will never see again, a deep and singular sorrow amid all the misfortunes that have befallen me since I last saw you). In thought's looking glass I beheld once more the fields of Flagey, where I used to go nutting with her; the fir woods of Reugney where I used to pick raspberries and what have you. I remembered the pies she used to bake for me. It's peculiar, in these extreme moments you think of the most childish things. You also think of all your friends and of the pleasure their company has given you. You are moved by the smallest trifles. In my misfortune I have been extraordinarily lucky. Dear friends, in the course of this general and cruel confusion, I have escaped certain death several times, but I felt my hour had not yet come.

It is difficult to do good, and one may be rewarded in peculiar ways when one pits honesty, dedication, and disinterestedness against society's egoistic advance. I have been robbed, ruined, defamed, dragged in chains through the streets of Paris, of Versailles. I have been reviled, heaped with abuse. I have rotted in solitary confinements that drain you of your mental and physical faculties. I have slept amid the rabble on the vermin-infested ground, been transported and retransported from prison to prison, in hospitals with people dying all around me, in Black Marias, in cells too small for a body, [always] with a rifle or a revolver at my throat, for four months. But, alas, I am not the only one. There are two hundred thousand of us, more dead than alive. Ladies, working-class women, children of all ages, even infants at the breast, not counting the abandoned children that wander around Paris with neither father nor mother, [and are] imprisoned by the thousands every day.[1]

Since the world began, the earth has never seen such a thing. Among no other people, in no other period of history or other era has one seen such a massacre, such vengefulness.[2] To make things worse, we are passing presently from the grip of the September 4 Republicans to the reprisals of the Bonapartists, who are secretly seizing power. In short, it is impossible to describe what is going on.

I don't know if France will once again suffer the shame of another Napoleonist government. That would make one leave the country and become a Swiss citizen. Anyone with talent and self-respect is leaving Paris now.

I have yet to tell you about the people of Ornans and the unspeakable conduct of the municipal council of my native city.[3] You must admit that it is a pleasure to belong to a country of idiotic and envious people of that stripe. They have behaved criminally toward me. They have caused my mother's death and could have caused me to be shot, had I not already been in prison.

I have lost fifty pounds, I am in better health now. I am in the open air and I have only five more months to do before I can come see you. Please

write Stéphanie[4] for me and thank her very much for her kind letter. I am in a monitored area and cannot write. I venture sending you this letter through someone who is getting out. They bear a special grudge against me, for they think that because of my merit I lent weight to that insurrection, and neither I nor my lawyer have been able to persuade them that it was not I who caused the fall of the Column.

<div align="right">

Gustave Courbet

</div>

Cantagrel[5] is getting out with the help of the municipal council of Paris. It's lucky for him and unlucky for me, it makes my solitude worse.

1. Courbet's figures are exaggerated. According to an official statistic, 43,522 suspected Commune sympathizers were taken prisoner in the months immediately following the entrance of the Versaillese into Paris, though further arrests were made later on. When the Commune trials ended in 1875, 46,835 cases had been heard. There were about 13,450 convictions, ranging from death to banishment, jail, forced labor, and/or deportation (cf. Serman 1986, 524–31).

2. On the Commune massacre. see Serman (1986, 517–24.

3. Of all the measures taken against him, Courbet was most offended by the removal of his statue of the *Boy Catching Bullheads* (Fs. 1) from the fountain in the Iles-Basses quarter of Ornans.

4. See letter 65-12, n. 1.

5. François-Jean-Félix Cantagrel (1810–87), a left-wing journalist, had been imprisoned for sympathizing with the Commune but he was released after being elected to the municipal council of Paris in the La Chapelle quarter.

71-40 *To Jules Castagnary, [Paris, Ste Pélagie prison,] [October ?] 1871*

<div align="right">

Thursday, August,[1] '71

</div>

My dear friend:

It is not possible for me to have you come here.[2] My requests mean nothing. There is also another difficulty: you are a journalist. However, ask on your own, that is the rule.

Something incomprehensible has come up: they are preventing me from working, on purpose, notwithstanding my requests and my sister's. M. Valentin[3] doesn't want me to. There are people who are put in prison because they do not want to work, whereas I am in prison to be deprived of my work. This is all the more frustrating as I have had an idea, which is to paint bird's-eye views of Paris, with [emphasis on the] skies, as I would do for seascapes. The opportunity is unique, as on top of the building there is a gallery that goes all around. It was built by M. Ouvrard and it is splendid. They would be as interesting as my Etretat seascapes. But—and it is an unprecedented and unparalleled outrage—I am not allowed to have what I need to work with, and I am the only one treated this way at Ste Pélagie, where everyone is forced to work. I am supposed to make list slippers but because I don't know

how, I pay five sous a day out of my twenty francs a week, in addition to [the fee for] my privileges, [the payment to] the jail tout,[4] etc., etc.

You who see Gambetta,[5] explain all this to him and tell him to send me an order or a commission forcing me to work. Put this in the *Siècle* if you want.

Sincerely yours,

G. *Courbet*

Hurry, for the weather is magnificent. I must take advantage of this opportunity.[6]

1. Though Courbet has dated this letter "August," it must have been written in late September or early October, after he had been transferred to Ste Pélagie. Perhaps the artist absent-mindedly wrote the wrong date.

2. According to an annotation on letter 71-36, Castagnary was allowed to visit Courbet only once.

3. The prefect of police in Paris.

4. The jail tout (*aboyeur*) called up the prisoners when there were visitors for them.

5. Gambetta* had been elected to the National Assembly in February 1871 and had become the leader of the Republican forces in the Assembly.

6. Courbet never was able to carry out this project (cf. Chu 1980a, 137).

To an unknown correspondent, [Paris, Ste Pélagie prison] <u>71-41</u>
October 6 [1871]

Friday, October 6

Cher Monsieur:

You are mistaken when you think that I can authorize you to come see me. I cannot request a thing in that respect. Only you can do that yourself or through someone you know. Go to the prison desk at the police station where permissions are given in person.

In the hope that you will be authorized, I am,

With cordial greetings,

G. *Courbet*

I don't put on any stamps for reasons that you can easily guess.

To Charles-Alexandre Lachaud, [Paris, Ste Pélagie prison,] <u>71-42</u>
October 25, 1871

Wednesday, October 25, 1871

Cher Monsieur:

I am less suited than many others to discuss the fees that talent deserves. Yours have stood me in such good stead in my misfortune that whatever price you might put on it, I would still feel obligated to you. But circumstances

nonetheless oblige me to beg you to allow a little more room for my gratitude from a pecuniary point of view.

You treat me a bit too much as if I were entirely prosperous. The news reports, I believe, must have made it sufficiently clear to you that I have always practiced art to serve art and that I do not, by nature, care much to amass money. What I wish to say is that, however many works I may have delivered to the public, it has not made me rich.

You ask five thousand francs for the service that you rendered me. That sum is more than what events have left me. To insist on it would be to add the last straw to the disasters that have beset me in the last year and a half. I beg you therefore to treat me as you would the humblest of mortals and not to take at all into account my individuality from that point of view. The rules of your profession dictate that remuneration for assistance rendered must be in accordance with the client's position. I request to be treated on that basis in the present instance.

It is now or never, for I confess that no matter how much goodwill I might bring to it, it would be completely impossible for me at this time to pay back such a debt. On the one hand, all the art dealers with whom I used to deal have canceled their contracts. On the other hand, I have not done anything for a very long time, and you will agree with me that I have to postpone the resumption of my work indefinitely, as I will be obliged to change country momentarily.

I must confess that the hesitation you showed in setting the amount of your fees had made me fear that the price would be too high for my current situation. Moved by that uneasiness, I questioned my friends and acquaintances. Many expressed the idea that the matter could be settled with an exchange of talent. I never gave much thought to that suggestion, given that my kind of painting does not please everyone. Others set the figure at one thousand francs and the greatest number at two thousand francs. As it is de rigueur to yield to majorities, I got used to the latter figure.

Consequently, I offer you the latter amount, with the statement that I do not consider that it relieves me of all gratitude toward you.

With kind regards,

Sincerely yours,

Gustave Courbet

I am in every kind of pain: all the guards are preventing me from working at Ste Pélagie and from carrying out here what I had planned.

They just authorized me to paint in my cell without leaving it, without any kind of light or model. Their authorization is useless for in that case I have no other motifs than God Almighty and the Holy Virgin.[1]

1. Probably a reference to the religious imagery found in Courbet's cell.

To Madame Dupin [Paris, November 12, 1871][1] 71-43

Chère Madame Dupin:

I sincerely apologize: the director told me that he had sent you away as I cannot be visited without permission.

Be so kind, therefore, as to go and ask M. Cadon, chief of the prison office at police headquarters, for permission to come visit me on a day other than Sundays or Thursdays, if you can work it out. I'll be very happy to see you.

I am very touched by your kind and devoted efforts. Looking forward to the pleasure of seeing you, I send you my warmest regards and greetings.

Gustave Courbet

1. The letter is dated by another hand, as follows: November 12, 1871. Ste Pélagie.

To Madame Dupin [Paris, Ste Pélagie prison, December 28, 1871] 71-44
(incomplete)

[He has given her a painting of *Oranges and Pomegranates* (F. 792?). His hemorrhoids are getting worse and he will have to have Nélaton* operate on him. He hopes the operation will be successful.] . . . It would be too much bad luck if after dodging the stubborn attacks on my life, I were to fall victim to surgery. . . .

To Eugène Boudin, Neuilly, January 6, 1872 72-1

Neuilly, Jan. 6, '72

My dear Boudin:

I am especially pleased to have received your charming letter[1] because there are many deserters these days. Amand Gautier* was brave, but I have been afraid of jeopardizing him by engaging him to come see me. I have not written anyone because they compile your profile at police headquarters, and that leads to dossiers, which is something one must watch out for nowadays.

But now you no longer have anything to fear. You can make a pilgrimage to see a man who has just spent seven months in a prison cell, which is no small thing.[2] That is my reward for services rendered and for the good I meant to do. I have learned that Gautier tasted the same bitter fruits.[3] There are no longer any formalities necessary to come see me. One has only to show up.

After escaping the fierce fusillades directed at me, I am about to have myself operated on by Dr. Nélaton,* who may accomplish what the fusillades could not do. Let's hope, however, that I'll escape once more. I will have my

hemorrhoids operated on. I cannot go on living like this, I am in constant pain and cannot concentrate.

Come see me one of these days. You will give me the greatest pleasure, it is good to see one's friends again. I am at Neuilly at Dr. Duval's, 34 avenue du Roule. I have finally escaped those unspeakable prisons. I am painting fruit these days.[4]

Come with Gautier, Monet,* and even the ladies, if they feel like it.[5]

Best regards to everyone, especially your lady.

<div align="center">

G. Courbet

</div>

I am a prisoner on parole. My time is up on March 1.

1. For the the the text of Boudin's letter, see Jean-Aubry (1968, 84).

2. After having spent a total of seven months in the Conciergerie, Mazas prison, the Orangerie in Versailles, the military hospital in Versailles, and Ste Pélagie, Courbet had been transferred on December 30, as prisoner on parole, to the nursing home of Dr. Duval in Neuilly, to be treated for an intestinal stricture and severe hemorrhoids.

3. Courbet's friend Amand Gautier had also been arrested in June 1871 and was held prisoner in Versailles and Mazas, respectively. Unlike Courbet, he was acquitted (cf. Gautier 1940, preface).

4. Courbet had started to paint fruit still lifes in Ste Pélagie prison in 1871 and continued to do so at Dr. Duval's and, after his release, in Ornans. As the public had a sensational interest in his prison works, Courbet freely inscribed the notation "Ste Pélagie" and the date 1871 on his still lifes, even when they were painted in 1872 (cf. Léger 1948, 146).

5. According to Léger (1948, 145), Boudin came to Neuilly with Amand Gautier and Claude Monet. Courbet invited his friends to choose one of his still lifes. Boudin chose a painting of *Red Apples* (perhaps F. 772), Gautier one of *Peach Blossoms* (perhaps F. 782). See also Riat (1906, 330).

<u>72-2</u> *To his father and sisters, Neuilly, January 6, 1872*

<div align="right">

Neuilly, Saturday, January 6, 1872

</div>

Dear Father, dear Sisters:

At last, after the storm, the good weather returns! The good news for your New Year's Day and mine is that I am finished with those unspeakable prisons. I resorted to a foolproof measure, which was awaited impatiently, I think, by those scoundrels in the government, for they were as fed up as I with the knowledge that I was in prison. Make no mistake, I did their work for them when they were so cowardly—or so smart—as to leave Paris. So I caught the blows for them, and to sidetrack everyone, they let me take the charges that they deserved. And the whole time that I was being prosecuted, they were not being prosecuted, which, by the way, I said in court. In all fairness, I deserved a national medal, for only the arts and the things I was responsible for were not harmed and were not [even] touched, thanks to me, for the people of Paris love me. The measures I adopted will cost me a bit dearly, but that does

not matter. When you have spent seven months in a prison cell, please believe me, you have had enough! It takes only three months to drive an ordinary person crazy. I'll tell you, I did not suffer enormously. I kept my mind active and I did not lose my cheerfulness for a moment. I suffered more for you and for my fellow captives than for myself. The only thing that hurt me was Mother's death. Finally, I suffered enormously from my hemorrhoids, and they are what helped me to get out of this dreadful situation.[1] I figured that if I went to the greatest surgeon in Paris, M. Nélaton,* no one would dare refuse him anything, and that is exactly what happened. He has had me transferred to a nursing home, where I am in heaven. I have never been so comfortable in my life. I have a large park to walk in and a beautiful room. I eat wonderfully well at their table, at which there are guests almost daily, all old friends. I had been friends with their son, who died during the Commune.[2] I had even dined with them before. The only thing is, it costs ten francs a day. But I don't care. A hundred francs per month more than at Laveur's,[3] in such surroundings, matter little. As of now, I have only seven more weeks of captivity to go. It will pass like a shot, for I am painting and at the same time Nélaton is going to cure me for the rest of my life of this unbearable ailment, which is extremely important, for I could no longer work because of it, or even go out, for I was constantly having to go to the bathroom. I'll have had the two most famous men in Paris on my side, Messrs. Lachaud and Nélaton.[4] The reactionary journalists are furious.

My sister Zoé* has taken unbelievable trouble for me, as has her husband. They have, in fact, done three times as much as was necessary, but that is in keeping with my sister's fanatic nature. I should be very grateful to them. They came to see me regularly in prison, two times a week, and obtained for me everything I needed. The entire Laveur* family also proved to be very kind. Quite a few people would have helped me, but it was unnecessary, and, besides, I would have jeopardized them.

Juliette* really did very well not to come. It would have caused me a great deal of worry. I am as grateful to her as I am to all of you, who have suffered so much. I am anxious to see you again.

As for the disaster of my Ornans atelier,[5] Father's reports are meaningless. To begin with, to get 3,000 francs it would have been necessary to report at least 12,000. As it is, you'll get 150 francs. Furthermore, they are not correct. That odd collection of serpents alone is worth his estimate and more. And then, if I am missing any painted canvases, it is even more. I also had a collection of books in a small carved sideboard, books that were given to me to hide (by a friend from Besançon) and that were very important and worth well over 3,000 francs. The furniture of Mazaroz* and others was worth 6,000 francs. These are the paintings that I remember: the *Portrait of Zélie* [F. 138?], my [*Self-*]*Portrait with Pipe* [F. 41?], another one on panel [F. 40?],

449

a *Head Study of a Spanish Woman* [F. 170], a *Head Study of a Sleeping Woman* [F. 139], a *Woman Seated in a Landscape with Flowers* [F. 211], a *Woman Combing her Hair*,[6] a large canvas, *Lovers at the Water's Edge* [F. 46?], an *Evening in the Village* [F. ?], two paintings, my plaster medallion,[7] a Louis XIII clock, some Spanish figurines, a collection of Indian weapons,[8] a pipe made of precious stone, a Spanish pistol, a hunting horn, a lamp with reflector,[9] an aloes-wood hammock,[10] a soldiers' tent, some boxes of photographs of nude women (in my desk),[11] a mirror in a black Spanish frame, ceiling paintings, carpenter's and gardening tools, iron firedogs, a copper foot bath, a large red leather portfolio with a clasp (my [*Self-*]*Portrait in Profile* [F. 160?] is at Chabot's*), a cheval glass, a folding screen with painted panels, a large piece of red silk, some china, vases and plates with a rooster motif, bird cages, a spring mattress, a cast-iron stove and a faience one, deer and roe antlers, a tortoise-shell shaving basin, a mannequin, some harnesses, two garden benches, two stepladders, a bathtub, antique Pompadour watered-fabric room hangings, a collection of exotic birds in a glass-fronted cupboard, and some silks, a butterfly collection,[12] two rifles, a riflebox with accessories, Old Master paintings: a *Diana*, a *Faun*, an academy figure, some Flemish paintings, some studies of female heads. All those items are worth a great deal of money. The [*Self-*]*Portrait with Pipe* alone is already worth four thousand francs. I would like to know what I am missing of all that. I could send you the amount I think they're worth, [including] meerschaum pipes, letters of mine in the wall closets, etc., etc. If you get around to making a revision one day, write me. There are 15,000 or 20,000 francs' worth of painting at least. Here, too, I have been robbed left and right.

Lydie J.[13] has written me many charming letters. I am behindhand in her regard. She sent me some boxed cheese. Mme Buchon* also wrote me. I am presently staying at the Duval home, 34 avenue du Roule, near Antoinette Chapuis's.[14] If the Folletestes were willing to sell their little place, this would perhaps be the time to buy it. We could place the statue of the *Fisherboy* [Fs. 1] in a little garden, to keep the thing intact. I have started to paint again but I can't concentrate on anything much at the moment. I don't feel like writing anyone and yet I have quite a few letters to write. I embrace you all with all my heart. As you can imagine, I am glad that you are all well. I am still planning to send Father an American rifle. He will be able to hit the Syley church tower from our window. He'll be armed to the teeth.

<div align="right">G. Courbet</div>

I am a prisoner on parole. My time is up on March 1. I will return the one hundred francs that you sent me through my brother-in-law for I still have money left. I thank you anyway for your consideration and am very grateful to you. I cannot send you anything right now.

1. By being transferred to the nursing home of Dr. Duval in Neuilly.

2. Nothing is known about Courbet's friendship with the son of Dr. Duval.

3. In Ste Pélagie, Courbet had ordered his meals from the Pension Laveur in the rue des Poitevins.

4. Courbet is not exaggerating: Lachaud was one of the best-known lawyers in Paris at the time, just as Moreau Nélaton was a highly respected surgeon.

5. Probably a reference to the ransacking of his studio by the Prussians.

6. Probably Courbet's early painting on that subject, now in a private collection in London (NIF-E).

7. Perhaps the plaster medallion that is found in the background of the *Atelier* (F. 165). See Paris (1977, 260).

8. Probably the collection of American Indian weapons presented to Courbet by the well-known geologist Jules Marcou* (cf. Riat 1906, 217).

9. Used by Courbet to paint in the evenings. Compare letter 67-2.

10. Maybe the one used in the painting the *Hammock* (F. 53).

11. Courbet is known to have used such photographs for several of his paintings, including the *Atelier* (F. 165) (cf. Scharf 1979, 131;;3–34).

12. Perhaps the butterflies Courbet had collected in his childhood (cf. Riat 1906, 4).

13. Lydie Joliclerc.*

14. A childhood friend of Courbet and his sisters, Antoinette Chapuis was the prioress of the convent of St. Dominique on the avenue de Neuilly. See letter 66-2.

To Marcello (Adèle Colonna), [Neuilly,] January 24, 1872 72-3

January 24, 1872

Chère Madame:

I was so indiscreet as to write you and ask for your intervention at a very critical moment.[1] My excuse is that I didn't believe myself as guilty as some odious contrivances made the public imagine. The government's method of action toward me reminded me of a peasants' saying that goes as follows: "Call him a thief before he calls you one." In my soul and conscience, I had saved the arts during the Prussian siege, I saved them during the Commune, and, had there been a third siege, I would not have left my post, for I was not paid to carry out that mission. In a word, I wanted to render to the arts the service they had rendered me. It is difficult to fulfill a duty that is dictated primarily by disinterestedness. When you do, far from reaching your goal, you arouse men's suspicions, for they believe only in the main chance.

When I was arrested, I declared to the police commissioner that, if I believed in rewards, I would deserve a national reward, for the arts that were in my charge during the two sieges were intact, and I dare say that thanks to me they were the only things that did not suffer in the general disorder. He was astonished, which did not prevent him from sending me to sleep on the ground amid the vermin of the Conciergerie's cells. Eight months of similar treatment were the national reward I received from that self-styled govern-

ment and in spite of it they won't be right. Let us leave those pleasant things aside and, horrified, try to turn our thoughts away.

For a brief moment you were for me one of the Parnassian Sisters.[2] You inspired some of my paintings[3] and even some sculpture.[4] Switzerland was the meeting place, did I ever not go without a second thought? You should be able to paint by now and I should be able to sculpt.

If I was guilty, I have served my sentence. Nothing prevents you any longer now from practicing the charity that was once a prisoner's due. For five more weeks I will be a captive in Dr. Duval's nursing home, 34 avenue du Roule, Neuilly, and from there I expect to go to Switzerland, where I will become a citizen. Better late than never.

Madame la Duchesse, in the hope of seeing you, I send you my kindest regards.

Yesterday I saw the comte de Choiseul,* who spoke of you to me.

Gustave Courbet

1. It is not quite clear from the letter what Courbet expects his correspondent to do. Like the letters to the Bachelins* and to Alexandre Daguet,* this one may have been intended to pave Courbet's way in the event he decided to move to Switzerland.

2. It is not known how and when Courbet met Marcello. Perhaps they were introduced to each other by the comte de Choiseul.*

3. Perhaps a reference to the *Portrait of Marcello* (F. 659) and to the landscape, now in the museum of Fribourg (NIF-3) that Marcello bought from Courbet (cf. Fribourg 1980, 54).

4. Perhaps a reference to the sculpted head of the marquise de Tallenay (Fs. 5), who was a friend of Marcello.

72-4 *To Juliette Courbet, Paris, March 3, 1872*

Paris, March 3, '72

Dear Juliette:

I am slightly clairvoyant: for some time I have felt an uneasiness about you that I could not understand. It must have been the illness that you have just endured. It is a very terrible illness, not only because it makes you suffer, but also because of the nervous disorders it can very often cause. In any event, I am glad you are over it. As for me, I have just survived an ailment that is equally terrible in another way. One risks death if it does not succeed but it went absolutely perfectly.[1] Of course, it must be said that I had the foremost surgeon in France,[2] so that now I am rid of it and free as I have never been in my life. Not only do I no longer suffer, but I can even drink brandy, which I had not been able to do for more than fifteen years. And since yesterday I am also free from imprisonment, I can assure you of that now, but nevertheless I cannot come and embrace you yet. At the moment some other very trying problems are cropping up. Some of the paintings that I had hidden in

the cellars at the passage du Saumon were stolen from me during my imprisonment. Two enormous crates with some of the finest ones have gone off to America. The thief is M. Ajasson de Gransagne,[3] the manager of the passage, who has also taken with him 350,000 francs from Nubar Pacha, who was the owner.[4] For me this means a loss of at least 150,000 francs. I am counting only my own paintings, for there were also in those crates a painting by Van Dyck and one by Murillo, the values of which I don't know.[5] I have been robbed left and right, in my apartment in rue Hautefeuille and also in rue du Vieux Colombier, in my exhibition building, [and] my Ornans atelier.[6] In two years this venture has cost me, conservatively, 300,000 francs, without counting the suffering, and Mother's death, and the family's sorrows.

It doesn't take many years like this to age a man. It is that unspeakable Napoléon who is the cause of everything. Of course it was easy to foresee that nothing else could be expected from a man like that. He is a punishment that I do not deserve: for the past twenty years I have not ceased to do whatever was in my power to destroy him. But those who installed him should not complain. I am the one who is most unhappy, not only because of my losses, but because I had always predicted it, and because I am the one who has to pay the price instead of those who deserve it.

I have been convicted jointly and severally, which means that I have just had to pay seven thousand francs in legal fees. If I add to that [the fees for] M. Lachaud* and Nélaton* and incidental expenses, I am out quite a bundle. Fortunately I have just sold sixty thousand francs' worth of paintings to Durand-Ruel,* who is having an exhibition of my works these days. Since I have been at the Duval house I have done thirteen paintings.[7] I am wonderfully well here. I have a park at my disposal and the trees are beginning to leaf.

In order to let the fuss that the Napoléonists are making at my heels die down I must take some precautions. It would still be imprudent for me to go out and about in Paris. That could provoke demonstrations and verbal attacks that are to be avoided. I receive visits and congratulations from everyone. I received an emissary from Napoléon, who came to offer his condolences. He assures me that he has never resented me, that he does not understand why I resent him, and asks me if I would still be against him in the future. I told the emissary to go to hell and told him that he could tell his boss for me that were I to live another hundred years, I would still feel the same way about him.[8]

I am therefore obliged to stay voluntarily where I am for another two weeks, first of all on account of my interests and two lawsuits in which I am involved,[9] and to try to retrieve my paintings that have left for America; second, in order to be prudent and to let the fuss die down; third, my paintings are selling marvelously, [and] I am obliged to take advantage of it in order to make up for my disasters. Furthermore, the season is not yet far enough along

to go to the country, neither Flagey, Pontarlier, nor Switzerland. I could not yet paint from nature. Here, I had the idea of doing some curious paintings of fruits, which are quite successful. My sister bought me some apples, pears, grapes, which served me well in Ste Pélagie. I could not see well, I did very few things, but here it has gone well.

M. Daguet* from Neuchâtel is the philosophy professor I met in Fribourg with Buchon* (who has done well to die). He had had a room prepared in his home against my arrival in Switzerland. It is still at my disposal. The other day he sent over a painter, M. Bachelin,* a friend of his whom I know too, to urge me to go to Switzerland for a while. He assured me that the people of Neuchâtel, Bern, Fribourg, are expecting me and send me their regards.

My sister[10] still bustles about too much but there is no way to stop her. She is a fanatic and she is mad with fear. I have just found a way to keep them in Paris. I'll give them my apartment in [rue] Vieux Colombier, which costs me thirteen hundred francs a year, for one and a half years. They'll leave their apartment and will go live there and take care of my affairs. At last my sister has got what she wants! But she makes me tremble. She is extremely tactless, she annoys everybody, she will make a pretty sad businesswoman. Just like a dog, she abhors poor people, and the self-styled rich and noble people she knows are not only useless but harmful to a man like me. But she does not have the brains to understand that. She is too full of herself. She resents everyone, gives everyone advice, yet does not know how to behave herself.

I count on you to write Lydie* immediately what I am telling you here. I cannot come see her yet, even though I am free, explain the whole business to her.

I bought M. Michaud's[11] book, it is good for putting one to sleep. It is illogical: he calls the pope a "Luther" without noticing that he is just as schismatic.

I embrace you all with all my heart. You tell me that Zélie* is better and that Father is well. Try to get better without fretting. I estimate my losses in Ornans to be ninety-six thousand francs. I embrace you.

G. Courbet

Kind regards to the Ordinaires,* who want me to go live at their house.

1. Courbet had had surgery for his hemorrhoids.
2. Dr. Auguste Nélaton.*
3. Probably Stéphane Ajasson de Grandsagne, who was director of the *Moniteur général des cours de matériaux de construction de la ville de Paris*.
4. Nubar Pacha (1825–99), Egyptian diplomat who later became minister of commerce in Egypt.
5. These were part of the collection of Old Master paintings that Courbet had bought in 1870 (cf. letter 70-13). It is highly questionable whether the collection contained real works by Anthony van Dyck and Bartolomé Esteban Murillo.

6. During the Franco-Prussian war, Courbet had vacated his atelier on the rue Haute-feuille and had moved to the passage du Saumon, where he lived with Mlle Girard.* He had also rented storage space on the rue du Vieux Colombier. Meanwhile, his 1867 exhibition pavilion was torn down and his atelier in Ornans was ransacked by the Prussians.

7. Most of these appear to have been still lifes. It is possible that several of the still lifes inscribed "Ste Pélagie" were actually done in Neuilly at the Maison Duval. The inscription appears to have been added (by Courbet or unscrupulous dealers) as it appeared that collectors were fascinated with Courbet's "prison art."

8. I have been unable to substantiate this anecdote. If it is true, it is not known who the emissary in question was.

9. On these lawsuits (all about money) against Léon Isabey, Mlle Girard, and Dr. Robinet, see Lindsay (1973, 290–91).

10. Zoé Reverdy.*

11. Perhaps Eugène Michaud, *Comment l'église romaine n'est plus l'église catholique* (Paris, 1872). Courbet may have read the book at the request of Juliette, who was much interested in religious issues.

To Emile Joute [Neuilly, March 1872]

My dear Joute:

Mme [*sic*!] G. strikes me as being completely mad at this point.[1] I saw my friends at M. B.'s. She told them that I had spent piles of money at her place, that I had drunk the cellars dry of Bercy (I, who could not drink because of my illness). Then she told them that she respected herself for not having had me shot.[2]

Then she went and told Isabey* that I had told her that he had stolen ten thousand francs from me,[3] just as she told the examining magistrates that I had sold the paintings from the Musée de Cluny to England. I don't know how to explain all this and what I can explain even less are the lies she took the trouble to come and tell me in Mazas (where she had been sent by the police, I think). There she explained to me that the police had taken all the money that I kept at her place (whereas she herself had taken it to Durand-Ruel*), saying also that they had taken hers and yours from her.

It took no less than Colonel Gaillard* to recognize all these falsehoods. She added, furthermore, that I owe her nine hundred francs. All that seems very fishy to me. I cannot imagine what I could have done to her. In any case, she is giving me a fine reputation. I also cannot understand why she does not want to give me back my things, as well as the various objects that she took from my house in my absence. It is true that I had told her to go and get them, for at the moment I trusted her (a well-placed trust), but I don't know now why she does not want to give them back. In the small leather trunk there was among other things a very large ring in yellow gold in which was mounted an antique precious stone engraved with a nymph and a satyr—worth between two and three hundred francs. There were, furthermore, sixty Italian

erotic photographs that a friend of mine from Besançon had given me. I had told her to hide them, but now I would like her to give you back all those objects, as well as a vase of gilt glass decorated with a Greek woman, which Stumpf* gave me as a present and which I had promised to the lady who hid me, not to mention whatever she might have taken from my house that I don't know about. She also has various pieces of clothing of mine, which would be useful to me at the moment, such as my coat and my wool gloves; two short cotton capes, one with red stripes and trim, the other knitted, and a pair of drawers; also, my black cashmere trousers and my vest of the same fabric, which I was never able to get to wear at the trial. The trousers she wanted to take in, I'll dispense her from that, they are fine as they are. [She also has] an umbrella of rubberized fabric with a cane handle. Also, I don't know whether she has returned a pair of heavy shoes that would serve me well at the moment for it is cold. When I first moved into her place (to my great misfortune, as I already told you), we put 8,300 francs into an envelope together. In addition I kept back, in your presence, four or five hundred francs in one-hundred franc bills for spending money (I don't remember the exact figure, perhaps you know it), which I put in my wallet along with the envelope containing the 8,300 [francs]. Apart from that I also received 400 [francs] from M. Stumpf one day when he came to pick me up at her place. On top of that I received 315 francs from the Commune. Then she received 1,000 francs from Durand-Ruel, of which 1,000 francs I took 600 francs when I went out, which means that I left 400 francs.

Thus, I brought into her house 8,300 francs, which she returned to me along with my railroad bonds. But apart from that, I had the following cash amounts at her place:

> 500 francs, when I moved in, or 400 (I don't remember)
> 400 francs, Stumpf
> 315 francs, Commune
> 1,000 francs, Durand-Ruel
>
> 2,215 francs

out of which she paid the doctor for me, baths in the passage du Saumon, insurance to the Aigle company, and 200 francs to an attorney. I don't know what else, if there is anything else. And I took 600 francs when I left, which must be deducted from those 2,215 francs, as well as my pocket money, which I cannot say exactly. Everything that I am saying here is not meant to be an exact accounting or to claim all that money from her. It is only to help me account for the 900 francs she is claiming. I owe her only for her room and the lunches I ate fairly often at her place, for we spent absolutely nothing else, as you know yourself. As for all that wine she told M. B. that we had drunk, we used to drink one liter between three, sometimes four, at lunch.

I would be very obliged to you, my dear friend, if you could reason with her from all these angles, in a tactful manner, and if you could make her stop her systematic slandering and bragging, for I am humiliated enough by her present conduct toward me (though she has nothing concrete to blame me for) and at having lived with her and spent time in her company.

I would also be very obliged to you if you could keep an eye on my interests with regard to Cazalot and Robinet[4]—one is worse than the other— who also would like to drag me through the mud.

I bid you an affectionate farewell. Kind regards to your sister and to all your company. My brother-in-law will explain the rest to you.

G. Courbet

Everyone is on my back.

1. While still at Duval's in Neuilly, Courbet became engaged in an argument, later to develop into a lawsuit, with Mlle Girard,* over an unpaid bill for room and board in the passage du Saumon (cf. Lindsay 1973, 291).

2. Mlle Girard had been called as a prosecution witness at Courbet's trial, but her testimony had not been very damaging to Courbet's case (cf. Riat 1906, 318).

3. Courbet subsequently was to sue the architect Isabey (his former friend) over the loss of the stored materials of his 1867 exhibition pavilion (cf. Lindsay 1973, 291).

4. Dr. Jean Robinet* had sublet some space in Courbet's apartment in the rue du Vieux-Colombier for his political club, Les Défenseurs de la république. Courbet would later sue him for unpaid rent (cf. letter 71-35, n. 3). The identity of Cazalot is not known.

To Colonel Louis-Dieudonné Gaillard, Neuilly, March 5, 1872 (incomplete) 72-6

[He asks his correspondent to] . . . be so kind as to give orders to the effect that I may take back from the hands of the military authorities the objects, papers, and letters that were seized in the course of the searches made in my various apartments, now that I have served my sentence and paid the court costs. I would be very obliged to you if you would let me know when M. Reverdy,* my brother-in-law, can present himself in Versailles to that end. . . .

To Jules Castagnary, [Neuilly,] March [14, 1872] (Ad) 72-7

Wednesday, March

My dear Castagnary:

Duval senior* warmly desires you to bring G. Tessier with you tomorrow, Thursday. I would like it as much as Duval senior, for I have not seen him for a very long time. But I don't know if now he is afraid of the Communalists?

Until tomorrow. Let him know if you can, but don't let it prevent your coming by yourself.

Sincerely yours,

G. Courbet

72-8 *To Claude-François Marchand, Neuilly, April 16, 1872*

Neuilly, April 16, '72

My dear M. Marchand:[1]

I am delighted to be able to send you a friend from Ornans, my part of the world, with whom I am very close.[2] As you told me that you wanted to give up your pharmacy, I don't think you could ever encounter such an opportunity again. He is sympathetic to our ideas, he is a first-class pharmacist who got his degree in Paris, I recommend him, and so does Duval senior.* If you do business with him, I will vouch for him. His education is matched by his honorable character. I would like to talk to you about him. Come and see us before I leave, that is, as soon as possible. If you would be so kind as to accommodate him in the terms you will arrange, you may count on my gratitude.

Sincerely yours,

G. Courbet

He has been offered a pharmacy in Montrouge. I don't think it is right for him.

1. The French pharmacist Claude-François Marchand had taken refuge in Switzerland after the 1851 coup d'état and had become a Swiss citizen in 1859. Courbet must have met him in Switzerland during one of his numerous trips to that country. Their relations were apparently cordial. A letter from Marchand to Courbet is found in Paris, Bibliothèque nationale, Cabinet des estampes, Yb3.1739 (4°), b. 2.

2. The identity of Courbet's friend is not known.

72-9 *To Juliette and Zélie Courbet, [Paris,] May 1, 1872*

Thursday, May 1, '72

My dear sisters:

We are trying to deal here with so many problems that it is driving us crazy. All my things have been stolen and ransacked, it is a question of more than two hundred thousand francs. If I abandon this business now by drawing back from the search, I lose everything. But we are on their trail, so, please, be patient. Everything is going wonderfully well for me at the moment, contrary to what the common people might have expected. That is, my sister,[1] who doesn't understand anything about it, with her feverish brain has

done me a hundred times more harm than good by trying to exonerate me. Her fool of a husband is in her service. They are on my back from morning till night. They help me in a way, but I can tell that I will pay dearly for it. They are building their existence on mine. How exasperating idle people are to people who work!

No matter what, they will not succeed in keeping me here, even if I have to move to another country. My sister's pretention is to decide what company I should keep. I have become fashionable!

Yesterday they went to Versailles with our friend Demitry,[2] who has arrived, in order to try to get my papers back, without which I can do nothing. Demitry is leaving in the next few days for Montpellier to see Alphonse Promayet,* who is there but who is very ill and about to die from a disease of the spinal cord.

I am so impatient to come see you that it is making me ill, but it is impossible for me to do otherwise. Every week things are postponed by another week. I have been at Duval senior's* for four months already. In order to get on my feet again, I have painted fifty pictures—all sold. The day before yesterday three of my paintings were auctioned off, one for 17,000, another for 16,000, and a little one for 3,500. The attention I get is tremendous.

I am sending you a carriage, Zélie and Juliette, which is called a "brig." One gets into it in back, and one gets into it in front, it seats seven or eight, and it is both light and well-enclosed. Now you can travel comfortably. And with it, some very fine harnesses. It cost me 1,300 francs and 135 for transportation. As of right now, it has been at the Besançon station for a week. I would like to send you the railroad bill and the 135 francs to claim it. L'Ange can bring it back to Ornans, unless Father goes to pick it up at the station with the cart. He could ride in the brig to go back and attach the cart to the rear. It is very beautiful and I am informing you that it is yours so that no one can object when you want to use it.

I saw J. Bordet* from Dijon, who wants me to come and spend one or two days with him on my way. I'll also stay one or two days in Besançon to have fun with my crowd, and then I'll go to Maizières,[3] where I must stop to find out what is what with the people in Ornans and how I should deal with them.

Don't worry about me, please. Rest assured that I will come to Flagey as soon as I can.

Write Lydie* that I am not keeping up our correspondence so that the time will go faster, and that I'll come see her as soon as I can. I'll see you soon. Meanwhile, I embrace you all, Father and you.

<div align="center">

G. Courbet

</div>

All is going well and marvelously. I will end up being right, right down the line. Hide this letter from those who will come to make inquiries.

In Paris they say that Mme [illegible name] has just given birth to a Prussian baby girl. She wants the country to be seized.[4]

Mme Duval has given me seeds from the Villemoines's. They are for plants to hang from the ceiling and at the windows. You can sow them, I put some in the envelope.

1. Zoé Reverdy.*

2. Probably Demitry Romanov, a member of the Russian family in St. Petersburg that had hired Alphonse Promayet as a tutor (cf. Sterling and Salinger 1966, 110–11).

3. To visit the Ordinaire* family.

4. As the name of the lady in question has been scratched out, it is not clear to what incident Courbet is referring here.

72-10 *To his family, Paris, May 19, 1872 (incomplete)*

Paris, May 19, '72

Dear family:

. . . Having given up on what has been stolen from me and on the search that I could do, I have decided to come back to be with you, where I have been so anxious to be. I will leave tomorrow. I'll write you in the next few days. Don't trouble yourselves, I'll go to Maizières.[1] I embrace you . . .

G. Courbet

1. To stay with the Ordinaire* family.

72-11 *To Charles Beauquier, Ornans, June 5, 1872*[1]

Ornans, June 5, 1872

My dear Beauquier:

You ask me, courteously and in a way that is most flattering to me, to write a few words for your special issue.

But have you thought it over carefully? In the peculiar position in which, owing to the circumstances, I find myself—sacrificed to the people who are in the habit of saving society—whatever I could say to you in this instance would be interpreted as meaning the opposite of my ideas. Didn't the Versailles papers report in the provinces that I personally smashed the statues in the Museum of Classical Art with a sledgehammer? Was it not said that I sold our finest paintings and the Cluny Museum to the English, whereas, on the contrary (I dare say it without fear of being contradicted because the fact was advanced by the Versailles court), the arts of Paris and those of the Seine Department suffered nothing at all, thanks to my intervention. At present, nothing is missing.

Yet, while far away from my country I was trying to preserve national treasures, my atelier in Ornans was devastated, and the works contained

within it were destroyed. Moreover, without ever stopping to consider their own ignorance and the unpopularity of their outburst against me, some of the local notables have bravely declared war on my statue of the *Fisherboy* [Fs. 1], so alien to any politics. That was to punish me in the grave in which they thought I was lying at that time. But let us leave all that aside.

You, dear editor, to whom so many complaints are addressed, must admit that the misfortune that weighs on man is great, that it is powerful and difficult to overcome; that the dark clouds that obscure his intelligence are slow to break. What ineffectual efforts he must make, what fruitless labor, what useless sweat, what sighs, what desires, what genuflected prayers, what sorrows of the soul, what tears, what deaths, in a word, what human waste it takes for man's uncertain march toward the conquest of his emancipation! In the society in which we live, whichever way we turn, like fish in a net, we encounter a mesh.

Alas, like those superstitious and fanatical pilgrims who carry their desires to holy places in faraway countries, mankind too marches two steps forward and one backward. Braving hunger and thirst, as well as the bandits who await him around the bend of the road to tear him to shreds, he advances toward progress, slowly but surely. Or he wants to reach his goal, to accomplish his destiny, and to save his kind and future generations.

Let us hope that this last hecatomb will at last establish the Republic.

My dear Beauquier, in a less dangerous time I will answer your call more explicitly. Today I thank you from the bottom of my heart for the courage you show in not doubting me. I expected no less from the sound judgment of a Franc-comtois.

Yours,

Gustave Courbet

1. Addressed to Charles Beauquier, the editor-in-chief of the *Républicain de l'est*, this letter was published in the June 9 issue of that paper. Two similar autograph drafts for the printed letter exist. One is in Paris, Bibliothèque nationale, Cabinet des estampes, Yb3.1739 (4°), b. 2, the other in Paris, Bibliothèque historique de la ville de Paris. The latter draft is closest to the printed version given here. In addition to the two autograph drafts, there is a third one written in another hand, likewise in Paris, Bibliothèque nationale, Cabinet des estampes, Yb3. 1739 (4°), b. 2.

To Juliette and Zélie Courbet, [Ornans, June] 21 [1872] (Ad) 72-12

Friday, 21

Dear sisters:

I had promised Father to come to Flagey in order to go with him to Salins tomorrow, Saturday. It is not possible for me to come. It has rained so much here that I have not been able to do what I had to do. We have measured M. Ordinaire's* lot that belongs to me and is surrounded on two sides by [the land of] M. de Pirey—that great Catholic. By removing the meres he had

taken more than an are and a half.[1] I must settle this business for Bati Pissot is waiting with his workmen.

I also have trouble getting around much at the moment. I need rest. For the moment I lack energy.

I must fetch my trunk, which is at Lange's, and moreover I could not be away for long at this time when I already have to go to Pontarlier and Morteau. I'll go to Salins as well on my way back. They have decorated the fountain again with branches and flowers, for its anniversary.[2]

I'll come to Flagey as soon as I can, but even though I cannot make the trip with him, Father must have his load transported without me.

I must also rent some haystacks. See you soon. I embrace you all with all my heart.

G. Courbet

1. Approximately fifteen square meters.

2. It was one year ago that, in the wake of the Versaillese takeover of Paris and the subsequent imprisonment of Courbet, the Municipal Council of Ornans had ordered the removal of the *Boy Catching Bullheads* [Fs. 1] from the fountain in the Iles-Basses quarter of the town.

72-13 *To Juliette and Zélie Courbet, Maizières, July [26, 1872]*

Maizières, Friday—July

Dear sisters:

I am back and forth between Maizières and Ornans, but I am incapable of going to Flagey in this heat. You must realize that after the Maizières fire I got a liver ailment, the first traces of which had already been present. I got overheated from working. Dr. Rith* made me follow a regimen and now I am cured. I go bathing in the Loue River. Altogether I have done four landscapes at the Puits noir and at Maizières.[1] I have not wasted my time. I have already profited by the time spent at Maizières.

Furthermore, the other day I sold, for ten thousand francs, my *Return from the Fair* [F. 167], which I painted a long time ago in Flagey.[2] Everything is going marvelously. If the Commune caused me some difficulties, it also increased my sales and my prices by one-half. That means that in the last six months I and those who own my works have together sold 180,000 francs' worth of my paintings. When that is the case, one can let people yell.

I have painted some pictures of fish that the sons of Ordinaire* caught.[3] They weighed nine pounds, they were magnificent. You'll see them. And [I have also painted some] mushrooms [F. 869].

You spoke of Burgundy wine. I bought a 180-bottle cask for 150 francs from a traveling salesman. It had been intended for a priest two years ago and had been in storage at Lange's. It is in our cellar, it is a Beaune wine, you can come and fill some bottles whenever you like.

When it is less hot I'll come see you. This weather is dangerous for me. I need a great deal of peace at the moment, because I suffered too much for two years. My liver would act up. So you must excuse me for not having come to see you more often for I am always thinking of you. I'll come see you when the weather changes. I'll write Lydie* the same thing.

I embrace you with all my heart, and Father too.

Gustave Courbet

[Address] Mesdemoiselles Courbet, landowner
Flagey
Canton of Amancey, Doubs
[Postmark] Ornans, July 26, 1872

1. These works cannot be identified with any certainty.
2. The buyer of the painting is unknown.
3. These must include the *Trout* (F. 786) in the Kunsthaus in Zürich, though it is dated 1871 and inscribed "in vinculis faciebat." Courbet and his dealers are known to have intimated that certain pictures, painted in Neuilly at the Maison Duval or later in Ornans, were made in prison, in order to make them more marketable. Other trout pictures are in the Kunstmuseum in Bern (F. 885) and in a private collection in Paris (F. 883).

To Eugène Reverdy, Ornans, August 1, 1872 (incomplete) 72-14

Ornans, August 1, 1872

My dear brother-in-law,

My father came down from Flagey today. He has asked me to reply to a letter that you addressed to him regarding me and concerning a painting commission. It would be impossible for me to carry out this painting commission at this time for two reasons. First of all, I have been unwell: I have had a liver ailment for a month, arising from anxieties of all kinds and the excessive heat. Secondly, I have none of the elements to execute those paintings in this season. Wolf hunts take place in winter. I am very willing to paint him whatever he likes but for that one he would have to wait a while, unless he drops the idea and considers [ordering] landscapes or ordinary animals, and then he must let me know the prices he wants to pay. I have at the moment seven commissions which I must do before his, unless he takes some paintings that are already done. . . .

G. Courbet

To Jules Castagnary, [Ornans,] August 14 [1872] 72-15

Wednesday, August 14

My dear Castagnary:

I am impatiently awaiting news of you. I saw the Ordinaires,* who told me that you wanted to write me. Since I left Paris, I have been in Ornans and *463*

in Maizières, where I had begun to set up a studio. I have been ill with a swollen liver for a month. The cause of the illness was a fire in Maizières that obliged me to carry hundreds of liters of water for four hours in order to put out a fire in the house of a legitimist. And to think that they call me a *pétroleur*![1] It makes it all the more disgusting.

I have already done five paintings: two landscapes and some gigantic fish from the Loue River.[2]

We still live in anticipation here, waiting for the little Republic to grow. If it follows the development of children, we are anxious for it to walk. It would be phenomenal if it reached that stage under such a small president.[3]

The painters are arriving in our part of the world. We already have here Rapin,* Jean-Jean Cornu,* some Swiss, and Pata.* The latter told me that one of my paintings was just sold in London for 76,000 francs, which would prove that the Commune is appreciating. I think it must be my painting of the *Hunt in the Snow* [F. 612]. I also sold my *Return from the Fair* [F. 167] for ten thousand francs to Durand-Ruel.*

I am going to charge you with a very important mission, namely to take yourself off to those gentlemen and ask them, on my behalf, for an accounting of these two sales, and also for a second payment, of 25,000 francs that they owe me for the paintings I sold them when I was in Paris. They play absolutely fast and loose with me. They never bother to drop me a line, even about such important things.

I have had the greatest success since my return to my part of the world, first in Dijon and then in Dôle. In Besançon there was an incident at the Boaters' Club, which numbers one hundred and twenty people. I had gone in to drink some beer. When I stepped out onto the sidewalk, a Napoléonist grocer who had stayed in the club after us broke the mug I had drunk from. I had the greatest trouble preventing him from getting a thrashing, but a week later he was ousted from the club by eighty-four votes to six. And the *Figaro* mentions only the broken mug!

Gaudy* came back to Vuillafans with some horses. I am going to get a fast one, one of these days, I'll be able to get around. Come and see us if you can, we'll go everywhere. I have to go to Geneva for a painting commission.

We are all well, I embrace you with all my heart. Hello to our friends.

G. Courbet

1. In the defense of Paris, the Communards burned hundreds of houses, setting fire to them with petrol. The term *pétroleur* came to be associated with radicalism.
2. See letter 72-13, nn. 1 and 3.
3. A reference to Adolphe Thiers, who was small in stature and, to many, small in his ability to lead the country.

To Juliette and Zélie Courbet, Ornans, September 10 [1872] 72-16

Ornans, September 10

Dear sisters:

The ladies who went to visit you were delighted with your welcome and with having seen Father as well as you. I had to take them to Maizières yesterday. Mme Ordinaire* came to invite them to Ornans. I am leaving Thursday morning for Pontarlier, I am writing Lydie* at this very moment.

The inquiry that I made to recover the things that were stolen from me (which amount to 51,000 francs) is causing quite a stir in Ornans. I was led astray, I was told that my gun "the Reaper," which I found in Flagey, had been taken by a certain Robichon, a worker at the mill. I descended on his house with the police. Fortunately he was away. Yet I could have found other objects, for Father found the works of my clock. At the moment I am in the position of having falsely charged him in the matter of my gun "the Reaper." Try to make Father understand that and hide it until further notice, without saying anything to anyone and without bringing it out later on. I'll find a way to make it reappear, especially as the initials on it are Etienne Baudry's.* Hide it and say no more about it. Because I don't want to let M. Robichon off, when he emptied my entire atelier.

I'll come home in a few days for I don't want to go to Switzerland this time. They just wrote me from Bern that they were counting on me for the October exhibition.

I embrace you and Father too. See you soon.

G. Courbet

[Address] Mesdemoiselles Courbet, landowner
 Flagey
 Canton of Amancey, Doubs
[Postmark] Ornans, September 10, 1872

To Juliette and Zélie Courbet, Morteau, September 16, 1872 72-17

Morteau, Sept. 16, '72

Dear sisters:

I have been very well received in Pontarlier and all my friends at Pontarlier . . . [1]

But at Morteau, where I am staying with Joliclerc,* it is a real success. They offered me in no time at all dinner for thirty or forty.[2] It is unbelievable, nowadays, to see a place as advanced as Morteau. I think it is due to [its proximity to] Switzerland.

I have just written the Ornans postmistress to send my letters to Flagey, where I'll be in two or three days. I embrace you,

G. Courbet

Before I left I sent you an excellent setter, sired by a famous gundog from the Fontaine forest. It points wonderfully and then doesn't budge, even for an hour. I don't know whether he has arrived safely. The Piquet children went to get him and were supposed to give him to the Flagey courier on Saturday.

1. The sentence has not been completed.
2. The dinner in question was probably organized by Alexis Chopard,* a local brewer and the director of the musical societies of Morteau, who gave the artist a magnificent welcome speech. Courbet, in recognition, presented Chopard and the town of Morteau with the *Boy Catching Bullheads* (Fs. 1), which had been removed from the Ornans fountain (see Riat 1906, 340).

72-18 *To M. Cornuel, Ornans, October 6, 1872*

Ornans, Oct. 6, '72

My dear M. Cornuel:

You can see that with my artist's eye and my great experience of life, I divined in five minutes all your feelings about Mlle Léontine.[1] I saw in her an upright, honest, sympathetic, and natural nature. It was what I had been seeking for twenty years, for, to the people who know me, I have, I believe, exactly the same nature. I saw her first in a grove, simply dressed, engaged in activities that please me. My whole family is of like mind. We are not at all bothered by the social differences.[2]

This chance, this meeting (which I had always anticipated) was expressed by the friends who were with me when we came out of the Glacière.[3] Spontaneously, they said, "There is a person that would suit you, an artist must be surrounded by pleasant and natural people." I was already of their same mind even before they spoke.

On my arrival in Ornans I consulted my sisters, who shared my opinion. I went to Pontarlier. I confided my impression to some ladies from Pontarlier[4] who are very intelligent and clear-sighted and who agreed to come with me to persuade Mlle Léontine to come live with me. For I must be frank. I have suffered so much in my life, I have rendered so many services to so many people, that I would be entirely ready to render service to an honest person. It is impossible that Mlle Léontine, despite the stupid advice she may receive from the peasants, may not accept the brilliant position that I am offering her. She will be indisputedly the most envied woman in France and she could be reborn another three times without ever coming across a position like this one. Because I could choose a wife from all of French society without ever being refused.

With me, Mlle Léontine will be absolutely free. She can leave me in spite of me whenever she wants. Money means nothing to me. She will never regret her association with me. My dear Cornuel, just think that with two days' work

I can give her a dowry that no woman in the village has. In a word, if she joins me, I solemnly declare that she will be the happiest woman alive in Europe. Let her ask advice on this subject, not from the villagers, but from educated people.

It is up to you, my dear Cornuel, to make this clear to her family, who can have no idea at all of who I am. I am counting on you. Write me what I must do, whether I should go seek her out one more time, either at the Glacière or at the Gros-Bois Hospital. Arrange a meeting anywhere, anytime, and spend whatever money you have to to make it as soon as possible, for I have to work and go to Switzerland. If it can be arranged, I would take her with me. There are some commissions for paintings waiting for me, and so are the friends of democracy and the Bern exhibition. Kind regards, my dear fellow, and to Mlle Léontine.

G. Courbet

What difference could it make in the public's opinion whether we live at my home or yours? That is no argument at all.

1. The Léontine here mentioned, a young girl from the Franche-Comté, is not to be confused with Léontine R., with whom Courbet had been involved in the early 1860s. Compare letters 62-3 and 62-5.

2. Léontine apparently was not of the same landowning (*propriétaire*) class as Courbet but instead was a peasant girl (*paysanne*).

3. An area in the pine forest of Joux, south of Ornans.

4. Probably Lydie Joliclerc* and some of her friends.

To M. Cornuel [Ornans] October 9, 1872　　　72-19

Oct. 9, '72

My dear Cornuel:

As you know, I wrote Mlle Léontine[1] a very serious letter, in which I made her a proposal that many young ladies of a far higher social position than hers would have been delighted to accept. It seems that I was wrong on that young lady's account, for, instead of simply replying to a proposal made in good faith, she felt it necessary to consult (as I had predicted to you) her sweetheart, who seems to me to have a corner on all the wit of Nancray[2] and who answered me with the most sentimental of village ballads, which may get a laugh from the village wags but which we have never been able to understand. From that I conclude that Mlle Léontine prefers, to a serious position, which could pledge both her future and mine, a cottage and the heart of an idiot who reminds me of a soldier on leave or in retirement.

In any case, my dear Cornuel, I will always be grateful to you for the friendly offer you were kind enough to make to serve me in this matter. If this is to be the end of it, please find out first whether this answer was given with

her consent or without her knowledge. But assure her in the strongest terms that in any case, as far as I am concerned, all the sweethearts, all the sweetie pies of the village have an intellectual worth about equal to that of their cows, without being worth the money.

I am still counting on you, my dear Cornuel, and I hope to get news from you soon about the things that I have asked you.

Farewell and fraternity,

G. Courbet

1. See letter 72-18, n. 1.
2. Small village east of Besançon.

72-20 *To an unknown lady, Ornans, October 19, 1872*

Ornans, October 19, '72

Madame:

I am charmed by the flattering wish[1] that the gentleman of your acquaintance expressed in my regard. It makes one happy when such nice people have such feelings, for it compensates for the suffering that one endures in trying to do what is right.

My regards, and I thank you, Madame, as well as the gentleman.

Yours very truly,

Gustave Courbet

1. Possibly a request for the artist's autograph.

72-21 *To Edouard Pasteur, [Ornans,] November 23, 1872*

November 23, '72

My dear M. Pasteur:

You are a very charming man. I am very grateful to you for your kindness toward me.

In this period I have done several paintings from nature and will try to make myself worthy of the esteem you have for my painting, by painting a landscape for your friend for one thousand francs.

Please do count on my goodwill, and convey my compliments to your lady, to your friend, and to M. Reinach.*

With friendliest regards,

G. Courbet

[Address] Monsieur E. Pasteur
 1 rue Malesherbes
 Paris

[Postmark] November 23, 1872

To Edouard Pasteur [Ornans, December 1872] (incomplete) 72-22

[M. Edouard Pasteur wants to commission several paintings. Courbet proposes to paint him several landscapes, still lifes, and women's heads] . . . I have to find some women's heads. Here I don't have much to choose from, and moreover I have to convince them and overcome the misplaced pride of these people who don't understand art. I'll paint you your ten paintings for eight thousand francs because you ask me to. . . . [As M. Pasteur works at the Franco-Italian bank, Courbet asks him to transfer some securities in his name as payment for the paintings.]

To Edouard Pasteur, Ornans, December 15, 1872 72-23

Ornans, Dec. 15, '72

My dear M. Pasteur:

I have heard from M. Burat, through M. Hoheberger, that he has bought me 3,973.85 francs' worth (with fees, 3,979.50) of obligations at 84.45. I have not received the coupons.[1]

Dear M. Pasteur, every time I have had the pleasure of selling you a painting, you have been indecisive. That is why I recently wrote you, Is this really what you want, is this quite set? You have only to say yes, and I'll begin what I am supposed to pull off for you.

I send for a woman from Paris, today that is no longer it, it is landscapes that you must have right away. I have already worked on them but I don't run on steam. I'll cancel the woman if there is still time, and I'll work exclusively on your landscapes in order to be done by December 31, since that is your whim.

I have lost almost two months' work because of a liver ailment, followed by pleurodynia. If you add to that three months of rain and a complete lack of daylight, you will see that I have not been very lucky all this while.

With kind regards to you and your wife,

Sincerely yours

Gustave Courbet

Ornans
Doubs Dept.
[Address] M. Ed. Pasteur
 1 rue Malesherbes
 Paris
[Postmark] Ornans, December 15, 1872

1. It appears that Courbet at this time was apprehensive about making any direct cash transactions, and therefore he asked his clients to buy stocks or bonds in his name. Burat and Hoheberger appear to have been Pasteur's stockbroker and banker, respectively.

72-24 *To Edouard Pasteur, Ornans, December 25, 1872*

> Wednesday, December 25, '72
> Ornans, Doubs Dept.

My dear M. Pasteur:

Despite all my good intentions, it has been impossible for me to finish your landscapes along with the still life. You who are an artist, you should have understood that art cannot always be achieved within a given time.

It is impossible for me to deliver those five paintings to you by December 31. Keep in mind, first of all, that I could not see clearly for more than one or two hours a day. Consequently, with the paint half dry, I had to start over again the next day, it was a Sisyphean labor. Second, I have a liver complaint and I also have, I don't know, a pleurodynia, a rheumatism in my left ribs that goes into the kidneys. I have a sister[1] who is ill at my father's house in a village two leagues from here.[2] I am having repairs done on my studio, which was burgled and set afire by the Prussians. I have a great many letters to write. I go to bed at two or three o'clock in the morning. I cannot finish anything.

I also have more serious reasons. I very much want, my friend, to make you some good paintings. I am an artist, not a tradesman. It is as much for you as it is for me, it is for my reputation. And for that one must wait to be drawn to one's work, or in other words, for inspiration.

I had done all your landscapes on size 25 canvases—81 centimeters by 65 centimeters—because I assumed that that was the most pleasing size for apartments.[3] The still life (an error of measurement) is 1 meter [wide] and 65 centimeters high, it is a huge trout from the Loue River.[4]

I acknowledge receipt of 3,979.50 plus charges, for a total of 4,000.70, from M. Hoheberger. I thought that you would not send me the stock coupons until delivery of the paintings, but M. Hoheberger sent them to me this morning.[5]

If you insist on having the paintings delivered by December 31, it is impossible for me to deliver them to you. In that case I will send the coupons to your address as soon as possible so that you can sign them back over to your name. I will continue them anyway for I have received some twenty commissions in this genre, both from Parisian collectors and from dealers.

This morning I received a remittance of fifteen hundred francs from M. Barbedienne, a gilder, at 76 rue Taitbout,[6] for a landscape similar to yours that he had sold for me. He also has a *Gypsy Woman's Head* [F. 210?] of mine that is for sale. He asks me for more landscapes.

I am sorry not to have been able to oblige you as I hoped but circumstances have unfortunately prevented me. The things that I did from nature could not be delivered, they had to be finished, and they were in every size,

too small, too large, etc. Please write me. I am keeping those stocks at your disposal if that is what you want.

As for the women's heads, I am going to set myself up in Besançon to do them. I have already hired a woman from Paris, as I told you.

Kind regards to M. Reinach* from me, and to you and to your lady, my warmest regards.

If M. de la Tault [?] wants something of mine, tell him, please, that I am entirely at his disposal.

Gustave Courbet

1. Probably Zélie Courbet,* who was to die on May 22, 1875.
2. Flagey.
3. The landscapes for Pasteur cannot be identified.
4. The *Trout* (F. 786). See also letter 72-13, n. 3.
5. Compare letter 72-23, n. 1.
6. The gilder Barbedienne apparently operated as a dealer as well. At one time or another he seems to have owned several of Courbet's paintings (cf. Fernier 1977–78, 2:370). It is not known what, if any, was his relationship to Ferdinand Barbedienne (1810–92), internationally known for his foundry in the rue de Lancry, where fine reproductions of old and modern sculptures were produced and sold.

To Jules Castagnary, Ornans, January 16, 1873 73-1

Ornans, January 16, 1873

My dear Castagnary:

I read in the *Siècle* a proposal, supported by twenty-three deputies in the Chamber, that is unparalleled in its insanity.

They "merely" ask that I put the Vendôme Column back up at my expense since I already paid the expenses of the War Council for joint and separate liability.[1] In that War Council, I was sentenced to a fine of six hundred francs and six months in prison for my part in the destruction of that monument, which is already an exaggeration as the law does not sentence an individual in my position to more than a fine of five hundred francs and one month in prison. In short, in spite of that, the matter is a good deal more serious than it appears at first. If the Chamber's vote results in my condemnation, they will seize my share of my mother's estate, of my father's later, and, worst of all, my paintings. What to do? The entire majority will vote for it and a part of the moderate left as well.[2]

I wish you would do me the kindness of inquiring at the Chamber about all this and even of consulting a lawyer of your choice—M. Allou[3] if need be, whom you suggested to me some time ago, for the registration necessary for fictitious sales costs a lot of money.[4] Try to find out what is happening and to warn me so that I can arrange for them before the vote of the Chamber.

I will not be exhibiting in Vienna.[5] I wrote their administration to see if

I could exhibit on my own or under the aegis of a foreign nation.[6] They replied that I could only exhibit through the French committee, presided by M. Dusommerard,* which is impossible since I attacked the latter's administration when he, in association with M. de Nieuwerkerke,* organized an exhibition in London with the Prussians in France.[7] Neither will I exhibit in Paris this year. I am sick of that whole crowd. That whole pack of scheming and abject busybodies, toadies without any genius of their own, disgusts me.

I have been ill all winter with a pleurodynia and with an enlarged liver—I was afraid it was dropsy. I have many commissions that so far I have not been able to carry out, and just as I am about able to start working again, another annoyance crops up worse than all the others.

I was quite delighted to find père Ordinaire,* who was a great help in my difficulties and showed a great deal of courage. We have been together nearly all the time since I left you. I have also engaged a maid who nursed me and who cooks for me. I do not know which way to turn right now, when everyone is trying to grab from me.

I will write you some jokes about the Column. I took them to Dr. Rith, who has the same illness as I, as I did not have time to transcribe them.

The Commune has given me a woman[8] in Paris who is noble, who idolizes me, and with whom I don't know what to do, as she has illusions about me and about my physical ability. I am engaged in a passionate correspondence with her. She is charming. Don't tell anyone. Answer me if you can.

Sincerely yours,

Gustave Courbet

Besides everything else, I am involved in three lawsuits in Paris.[9] Durand-Ruel* might organize an exhibition in Vienna, please find out.[10]

1. In early January 1873, the Chamber had begun to discuss a bill to reerect the Vendôme Column. A motion was made and supported by twenty-three deputies, to the effect that the reconstruction cost be borne by Courbet. As Courbet's case had been heard by a military tribunal, it was still possible to treat his participation in the Vendôme Column affair as a civic offense, hence prosecute him. Courbet may himself have inspired the Chamber's action through his earlier offer, immediately after his arrest in June 1871, to reerect the column at his own expense. Compare letters 71-18 and 71-19.

2. This meant, in essence, all the Legitimists and Orleanists (cf. Williams 1969, 159).

3. Edouard Allou (1820–88), a lawyer and politician. Allou, in spite of his liberal convictions, had earlier refused to defend Courbet and other Communards, including Paschal Grousset and Henri Rochefort. By 1873, however, he seems to have changed his mind as in May of that year he put up a powerful defense for Gambetta.

4. Courbet considered holding fictitious sales to make his paintings "disappear."

5. The Vienna International Exhibition of 1873 was to include an art section in which each country was invited to exhibit a representative group of works. Courbet decided not to submit any works because he feared that the organizing committee of the French exhibit, headed by Edmond Dusommerard,* might refuse his participation or worse, seize his works.

6. The text of this letter, also mentioned in letter 73-8, is not known.

7. Dusommerard had organized the French art exhibit at the 1871 London International Exhibition.

8. Countess Mathilde Montaigne Carly de Svazzena.*

9. Compare letter 72-4, n. 9.

10. Courbet apparently hoped to organize an exhibition of his work simultaneously with the official Vienna exhibition, just as he had done in Paris in 1855 and 1867.

To Zoé Reverdy [Ornans, January 16, 1873 (Rd)] (incomplete) 73-2

[He informs her about his health] . . . I have been ill, off and on, all winter, with rheumatism of the chest and an enlarged liver. I have engaged a maid to take care of me, and I have stayed in Ornans all the time, visiting the family in Flagey when I could. I had many commissions for paintings, which I have not been able to carry out. Besides, I felt so sick of all that is happening, that I stayed in bed till noon. . . .

To Lydie Joliclerc, Ornans, January 17, 1873 73-3

Ornans, January 17, 1873

My dear L[ydie]:[1]

I received your charming letter but what amazes me is that you are about to give birth again. You really want to populate the world with Republicans all by yourself! Good for you!

I have sold that *Blue Spring* [F. 823] for one thousand francs to a Parisian collector, who had commissioned two [ten?] paintings for ten thousand francs.[2] As I did not have any others, I gave him what I had. Except that I have not sent it yet. I can still make a copy of the *Spring* and there would be nothing to lose because it was painted very rapidly. See whether that would suit that lady, whom I embrace, even though I do not know her.[3] I love the ladies.

If you knew, dear friend, in what a critical position I find myself, you would pity me. Twenty-three majority deputies have decided that I must put the Vendôme Column back up all by myself.[4] I will have my sisters organize a sale of my possessions. I am in a state of inexpressible anxiety. I have to go to Paris, Switzerland, etc. I have to paint pictures. I have three lawsuits in Paris, I don't know which one to pay attention to. I would give my life for a *sou*. I could use a wife. Fortunately, a Parisian countess has just declared her love.[5] The only thing is, I do not know whether she is a good businesswoman. It doesn't matter, it is a good thing. Her love will sustain me.

I embrace both you and J[oliclerc].

Sincerely yours,

Gustave Courbet 473

1. This letter and 73-21 are known not in the original but only through their publication in La Nouvelle Revue of May/June 1901. The published transcriptions of the letters do not give the full name of the addressee but only the first initial, L. Roger Bonniot (1973, 331–33), who was one of the first authors to reprint the letters in full, was of the opinion that they were addressed to Laure Borreau.* This, however, seems unlikely, for the following reasons. In 1873, Laure Borreau (b. 1826) was forty-seven years old, i.e., beyond normal childbearing age, while Lydie Joliclerc (b. 1840) was thirty-three. Furthermore, the lengthy discussion of the painting the *Blue Spring*, which Courbet had painted during his stay with the Joliclercs in November 1872, also points to Lydie as the recipient (see also n. 2). Where in Bonniot's reading J. is said to refer to Jules, the husband of Laure Borreau, it could as well refer to Joliclerc. In other letters to Lydie, Courbet likewise refers to her husband as Joliclerc rather than Charles (cf. Lindsay 1973, 302.

2. The painting of the *Blue Spring* depicts a spring some ten miles south of Pontarlier, which feeds into the Saint-Point Lake. Courbet had painted the spring with its sapphire-blue water while staying with the Joliclerc family (see n. 1). The collector to whom he claims to have sold the painting was most likely Edouard Pasteur,* who, according to Léger (1948, 146), had commissioned ten paintings from Courbet at the end of 1872 or the beginning of 1873 (in the transcript of this letter *deux*, "two," probably is a misreading of *dix*, "ten"). Courbet originally asked for ten thousand francs, i.e. one thousand per painting. According to Léger (1948, 146) the final deal was made for eight thousand francs.

3. Lydie Joliclerc, who must have taken a strong liking to the *Blue Spring*, probably wanted to buy the painting. Familiar with Courbet's generosity when it came to his paintings, she may have written to him that one of her friends wished to acquire it. Courbet appears to have seen through the ruse. Today only one version of the *Blue Spring* is known, which was in the possession of Lydie Joliclerc, who later sold it to Durand-Ruel.* As we know from Courbet's next letter to Lydie, the painting that she eventually received was the original (see letter 73-21), and it seems that no copy of it was ever made.

4. See letter 73-1, n. 1.

5. Mathilde Montaigne Carly de Svazzena.*

73-4 *To G. Poret, Ornans, January 20, 1873*

Monsieur G. Poret:

I have the honor of acknowledging receipt of the 1,060 francs you sent me this morning, in Franco-Italian Bank shares, in payment for the *Portrait of Mlle Aubé* [F. 442] on account for M. Pasteur.* Regards,

Gustave Courbet

Ornans, January 20, 1873

73-5 *To Jules Castagnary, [Ornans?] January 24 [1873]*

Friday, January 24

My dear Castagnary:

In a universal exhibition the section allocated to a nation falls under its jurisdiction. Consequently, if the Chamber decides on a general seizure of my possessions, they can attach the paintings that are at the exhibition. That happened at the Paris exhibition on behalf of some tradespeople.

If Durand-Ruel* exhibits my work through Dusommerard* the paintings have to belong to him or be thought to belong to him by means of a deed in duplicate, if they take any of my paintings from my atelier. The Dusommerard committee will be very hostile toward me and I will be badly placed in Vienna unless Durand-Ruel directs its delivery.[1] See whether that can be done. In any case I will send you an authorization for Durand-Ruel in the name of my brother-in-law,[2] who has the keys to my atelier, instructing him to hand over to you the paintings that you, Castagnary, and Durand-Ruel choose for the exhibition.

Meanwhile I will notify my attorney, M. Duval,* 189 rue St. Honoré, who is at the moment engaged in legal proceedings against those who stole my paintings from the passage du Saumon.[3] You should perhaps have the precinct captain present when you assess the value of and identify the paintings you take away. There is also a [painting of a] woman, the *Spring* [F. 627], at M. Francis Petit's,* which has to be sent to Vienna. She was the great success of an exhibition in Brussels.

Here, in order to protect myself against the Chamber, I am going to have a notary witness a deed of gift of my property—my atelier and other things and also the part of my mother's estate that falls to me. However, I will specify in the deed that I retain the use of my atelier until my death.

As for removing my paintings from rue Hautefeuille and rue du Vieux Colombier, I think that the easiest solution would be to send them to M. Joliclerc's* in Pontarlier, for I'll have them transported from there to Switzerland as soon as I have rented a place there.

I am going to see père Ordinaire,* who cannot believe all this. The only thing left will be my father's estate on his death, but he can disinherit me, depending on whether the law allows it.

In their crazy state of mind those people are actually capable of getting a majority, for not only will the majority [party] vote but a part of the moderate left as well. The Code sentences me, as the law applies to a person in my position, to one month in prison and a fine of five hundred francs. That was already determined once by the Versailles court, where for good measure I got six months in prison and a fine of six hundred francs and court costs of nine thousand francs. What do they want? It is an ineffable insanity. Furthermore, they will be discrediting the very column that they are trying to put back up. None of this is aimed at me, but rather at the September 4 government. If they were being logical, I should also have to put M. Thiers's house back up.[4]

Sincerely yours,

Gustave Courbet

Write me.

1. In a letter of January 23, 1873, Castagnary had strongly encouraged Courbet to participate in the Vienna exhibition, telling him that he should show his work not in Paris or even

France, but abroad (cf. Riat 1906, 341). Courbet, worried that the government might seize his paintings, considered the possibility of submitting them under the aegis of Durand-Ruel, who would be listed as the official owner of the works. See also letters 73-1 and 73-8.

2. Eugène Reverdy.*

3. In the chaotic period after the Commune, while Courbet was imprisoned, a large number of his paintings (some already sold to such collectors as Etienne Baudry) were stolen from his studio in the passage du Saumon.

4. The house of Adolphe Thiers* had been destroyed during the last days of the Commune by a decree of May 10. Courbet was no longer a member of the Commune at the time, having opposed the formation of the Committee of Public Safety. Still preoccupied with the preservation of artworks, however, he expressed concern about the fate of Thiers's art collection at the May 12 session of the Commune. On his instigation, a committee was created to oversee the removal of the collection to museums in Paris. Cf. Bourgin and Henriot 1924–45, 2: 359–61.

73-6 *To Jules Castagnary, Besançon, January 28, 1873*

Besançon, January 28, 1873

My dear Castagnary:

You know the parliamentary swindle that is threatening me.[1] They have just met. I beg you to see to it that the paintings of mine that are in my atelier are packed up immediately. Send them to me at the following address: M. Tramut, restorer in Montbéliard, care of the station, Lyons line.

The first shipment should be made up of canvases painted by me. Immediately after you must send me the Old Master paintings, which are not by me. Notify me and M. Viette, in Blamont (Doubs), when each shipment leaves. Get the key to my atelier from my brother-in-law, Monsieur Reverdy,* 4 rue d'Assas.

Write M. Viette, to inform him of the sending, a trivial letter that does not mention the shipment.

Gustave Courbet

Keep the contents of this letter a secret from my brother-in-law.[2]

G.C.

Spend as much as you have to, you and Durand-Ruel.* Or else you could take the paintings away earlier, under the pretext of the Vienna exhibition. Let Durand-Ruel in on the secret and ship them off to me. I have consulted Oudet.*

G.C.

1. The Chamber was still discussing the matter of the reerection of the Vendôme Column (cf. letter 73-1, n. 1).

2. As is apparent from other letters of this period, Courbet had begun seriously to mistrust his brother-in-law.

To Jules Castagnary [Ornans, late January 1873] <u>73-7</u>

My dear Castagnary:

Try to fix this up for the *Eclipse* or the *Charivari*,[1] for I have learned from behind the scenes that someone asked at the Ornans town hall, piece by piece, what was the value of my estate. I am going back to Besançon yet again tomorrow. I almost feel like dropping the whole thing, for the fees are very high, and those deeds will be broken. Write me in Ornans. What I am sending you are some incoherent notes, which, however, are true, with a tongue-in-cheek twist.

I received your letter this morning. I won't go to Besançon, I am dropping everything, that is my sisters' opinion. The *Charivari* could, with these notes, paralyze that insane decree: I cannot be convicted twice of the same thing, and the conviction of the War Council has remained unchallenged.

As for my brother-in-law,[2] I have spoken to him very harshly. I told him to hand over the keys of my apartments to you if he could not be responsible for them. He is an insolent fellow, keep him at a distance. As for my interests, he went at them hammer and tongs.

I have my two self-portraits, the *Christ with Pipe* [F. 40 or F. 41] and the one in profile [F. 160]. They are copies, but are as good as the originals. I think we have to send them. That makes three portraits of me, but it does not matter, the dates are not the same. It is characteristic, along with the *Portrait of Cuenot* [F. 85] and the *Spanish Woman* [F. 170]. They will replace the *Burial* [F. 41].[3] Do as you think best and take the keys of my studios if the opportunity presents itself.

Sincerely yours,

You must have seen the advance reports that I have provoked with regard to the Vienna exposition. I sent them to M. Legrand* for him to pass on to you, ask him for them. I can also have a small retrospective exhibition at the Art Union, that will be a small version of the large exhibition.[4] I wrote M. Legrand.

 G. Courbet

This will be fun. I believe, for example, that France can attach my paintings in Vienna. Forestall that, have M. Legrand make a dummy purchase, and put them all under his name. Twenty different painters' names can be put on the old paintings.

Kind regards to you and our friends. Tell them to be apolitical, that is the new thing. Say hello to Ranc,* Spuller, Durieux, Carjat,* etc., etc.[5] I am letting it all go. The honor that will fall to me from the Column is worth more than my possessions.

1. The autograph text of this letter is written at the bottom and in the margins of a ten-page manuscript article, written in a hand other than Courbet's, entitled *La Colonne*. For a

transcription of this article, which does not appear to have been published at the time, see Léger (1920, 127–130).

2. Eugène Reverdy.*

3. Courbet apparently was still planning his shipment to the Vienna International Exhibition, where he hoped to exhibit his paintings under the aegis of Durand-Ruel.

4. With all the difficulties related to showing his work in the context of the Vienna International Exhibition, Courbet seems to have begun to consider alternative possibilities, such as joining the exhibition of the Oesterreichischer Kunst-Verein in Wien (the Austrian Art Union in Vienna) or, as he called it, the "Cercle de Vienne."

5. Eugène Spuller (1835–96) was editor-in-chief of *La République française*. He was to be elected to the Chamber of Deputies in 1876. The identity of Durieux (or Durieu?) is unclear.

73-8 *To Alphonse Legrand, Ornans, February 6, 1873*

Ornans, February 6, '73

My dear M. Legrand:

I am sending you what you request as soon as I can,[1] on my arrival from Besançon, in order to anticipate anything that may happen to me. I had foreseen that M. Dusommerard* and associates would refuse me.[2] This is what I wrote the Vienna Exhibition a long time ago.[3] Please convey it to M. Castagnary.* It will all serve as documentation. I'll write you at once about the other things that concern us. I am most grateful to you (and to M. Durand-Ruel* as well, of course) for all you are doing for me.

Sincerely yours,

G. Courbet

1. No doubt the authorization for Durand-Ruel of the same date, that reads as follows:

Ornans, February 6, 1873

I authorize M. Durand-Ruel to exhibit at the Vienna Exhibition three paintings by me that belong to him:

1. The *Trout Fisher*
2. The *Source of the Loue*
3. The *Peasant Girl Strewing Flowers*

Gustave Courbet

Born in Ornans, June 10, 1819."

2. Castagnary had informed Courbet in a letter dated January 31, 1873, that Dusommerard and such "associates" as the painter Ernest Meissonnier (1815–91) had refused his participation in the official French exhibit at the Vienna International Exhibition (cf. Riat 1906, 341).

3. The text of this letter, also mentioned in letter 73-1, is not known.

To the director of the Austrian Art Union in Vienna (Oesterreichischer <u>73-9</u>
Kunstverein in Wien) [Ornans, early February? 1873] (incomplete draft)

Monsieur le Directeur:

Owing to the exceptional position in which the revolution in France has placed me, I have not been able to inform you (in accordance with [paragraph] no. 13 of your regulation) that I wished to do some paintings that could be submitted to you, according to paragraph no. 10, until April 15. Nevertheless, I would have wished to appear at the Vienna exhibition since Austria has always been especially congenial to me.[1]

As I consider that the manifestation of art must be free and of all nations, I turn to you and to your committee [to see] whether you can authorize me to send you the works that I will have completed specifically for you by the above-named deadline.

Beside these considerations, as you may know, this request on my part is all the more natural since I am used to addressing myself directly to the public, having never belonged to any art school or jury.[2]

Should you agree to this request, I will send you two paintings of three square meters, done especially for the Vienna exhibition, two smaller ones, and four Old Master paintings. . . .[3]

1. In a letter of January 31, Castagnary had informed Courbet that he would not be allowed to participate in the International Exhibition, and he advised him to submit some works to the Austrian Art Union (the Oesterreichischer Kunstverein). Through this letter, Courbet informs the director of the union of his intention to participate in the union's exhibition.

2. Beginning with the words "this request," this sentence has been crossed out in the original.

3. Courbet later changed his mind and sent fourteen of his own paintings (cf. Hamburg 1978, 586–87).

To his family, Besançon, February 8, 1873 <u>73-10</u>

Besançon, February 8, '73

My dear family:

I have been in Besançon for three days, again to put my business in order and try to save my property and yours. I have already done one substantive thing: I unconditionally renounced Mother's estate,[1] but without being able to specify the persons, because otherwise it would have been a deed of gift, with enormous costs. I paid nine francs, and naturally my three sisters will

inherit, that follows the normal course. Anyway, my name is registered with the clerk of the county court.

If I can I will mortgage my atelier and my fields. As for my paintings, that is a problem too. They can be seized abroad as well as in France. Most of them are in Vienna, in Austria, I will scatter the rest.

I am going back to Ornans tomorrow, for Pata* the painter is coming to see me to do some paintings that have been commissioned from me. I was planning to go back to Ornans today but it was raining too hard.

I found M. Gelet, the one who sold my horse to M. Charmant. He is a horse breaker and gives riding lessons. He wants to take care of my horse for nothing for as long as I like and they will not be able to take him away.

Gaudy* wrote Briot that I only just have time to save my things, if I can. I embrace you all and am looking forward to seeing you.

<div align="right">

G. Courbet

</div>

1. When Sylvie Oudot died on June 3, 1871, she left to her four children a total of 6,700 francs in real estate (cf. Mayaud 1979, 18) and a small amount of liquid assets.

73-11 *To Jules Castagnary, [Ornans,] February 9, 1873*

<div align="right">

Monday, February 9, '73

</div>

Dear friend:

At the end of the day I am writing some authorizations for you [and] for Durand-Ruel,* to take paintings of mine from my atelier under cover of the Vienna exhibition. I wrote M. Alphonse Legrand* with authorizations for my brother-in-law,[1] listing the documents they must hand over to you. I don't know what else to do. I would like to go to Paris to do it myself but I am afraid of arousing attention.

My letters must not be reaching you. Please, therefore, stop by M. Alphonse Legrand's, please [*sic*]. He has things to communicate to you. I have sent you and him an authorization without context.

I am going to tell you something in confidence that you must keep to yourself: I am afraid that my brother-in-law is a member of the secret police and that he has been particularly instructed to watch me. He is an insolent fellow, a good-for-nothing, a man without a trade, who lives I don't know how and who is seeking to exploit me. He and my sister, with their stupidity, have done me all the harm one can do to a man, and there is only one thing I regret about the Commune: that I was forced, under cover of family ties, to accept their services. But I don't need them anymore.

You and M. Alphonse Legrand, with the authorizations that I have given you, can forcibly take my paintings to M. Durand-Ruel's, using that firm's packers, and choose whatever is right for the Art Union in Vienna.[2] The

Burial [F. 91] is no good,[3] take the *Battle of the Stags* [F. 279] or the *Mort in the Snow* [F. 612], for the large painting, and, to take the place of the *Burial*, the *Portrait of Cuénot* [F. 85], the *Spanish Lady* [F. 170], the *Portrait of Promayet* [F. 128], my own with the hand, leaning on a book—it has never been exhibited.[4] M. Durand-Ruel has landscapes of mine and female nudes, *Woman by the Sea* [F. 628], etc. Send the *Spring* [F. 627], which was a tremendous success in Brussels.[5]

As you can see, my sister and brother-in-law are extremely dangerous people, as you were able to see for yourself—I have absolutely been of your mind for a long time now. This is the procedure: demand that my brother-in-law give up my paintings and hand them over to M. Durand-Ruel; choose from among the paintings [the works] to be exhibited at the Art Union in Vienna; crate the rest, which will be sent to M. Viette later; wire me if my brother-in-law does not want to give up [the paintings].

In his correspondence to the newspaper *Républicain de l'est*, Asseline[6] declares that the committee has given up on having me put the Column back up. I don't know if that is true.

All I want to save is my paintings. In M. Oudet's* opinion I should abandon everything. That is my opinion too. I'll give up my mother's estate and my atelier and my land, that is not too dear for the fall of the Column. Let's let it take its course, the situation is grand. We must confront the situation, there will always be time for me to get the hell out. I don't want to go to court.

Sincerely yours, it's a laughing matter.

<div align="right">

Gustave Courbet

</div>

It's not finished.

I can have a complete exhibition of my paintings at the Art Union in Vienna and a retrospective exhibition of my Old Master paintings. I have just written my brother-in-law that he has to hand over to you anything you want.

1. Eugène Reverdy.*
2. Compare letter 73-9, n. 1.
3. In his letter to Courbet of January 31 (cf. letter 73-9), Castagnary had told Courbet not to exhibit the *Burial* at the Austrian Art Union for, as he wrote, the painting was "made for a certain milieu. It has its time and its history in France. It must stay here . . . , in order not to give renewed impetus to old arguments" (cf. Riat 1906, 341). In a subsequent letter (February 12), Castagnary expressed his satisfaction with Courbet's decision not to exhibit the painting.
4. Perhaps the copy (F. 94) made by Courbet after the so-called *Man with the Leather Belt* (F. 93). While the original had been exhibited in 1849 and 1855, the copy had never been shown.
5. At the 1869 Brussels Salon.
6. Louis Asseline (1829–78), lawyer, writer, and journalist, was the Parisian correspondent to the *Républicain de l'est*, a paper published in Besançon.

73-12 *To Alphonse Legrand? [Ornans, ca. February 10, 1873?]*

Cher Monsieur:

It seems that the Chamber has rejected the proposal to have me put the Column back up.[1] There is nothing left to fear now but the Napléonist courts. It doesn't matter. It is good to be prepared anyway. I await what you have to write me.

With kindest regards to you and M. Durand-Ruel,*

Sincerely yours,

G. Courbet

1. Compare letter 73-11.

73-13 *To Moncure Conway, Ornans, February 11, 1873*

Ornans, Doubs Dept., February 11, 1873

Mon cher Monsieur:

It is with the greatest satisfaction that I received your letter and the commission that you give me for your friend in Cincinnati.[1] But just think in what an exceptional situation I find myself: I am ill and I have been so all winter. You can easily understand it if you think of prison and the sorrows I have had to suffer.

Furthermore, in an unprecedented move, the French Chamber has undertaken to have me put the Vendôme Column back up. They are going to seize all my property, my atelier, and perhaps even myself. I ask you, how can I be expected to paint under these circumstances?

We must hope that all this will pass. It is an ineffable insanity, the more so as I have already received my sentence once and served it. Whether this ends or whether I seek my freedom, I will hasten to execute the kind order you have given me for your friend as soon as I can.[2] Rest assured that I will not forget you and that I hope to oblige your friend, so well intentioned toward me, as well as yourself, who have been so kind to serve as an intermediary.

I beg you to be patient and take into consideration the exceptional situation in which I find myself at the moment.

Please allow me to express my most respectful sentiments. My compliments to your friend,

Gustave Courbet

1. The collector in question was Judge George Hoadly (1826–1902), who was to serve as governor of Ohio in 1883–85.
2. Hoadly eventually received his painting when Moncure Conway traveled to Switzerland in midwinter 1874 and personally selected a work for him in Courbet's studio (see Conway

1904, 1: 251). *Sunset in Vevey* [NIF. 4] was later presented by Hoadly to the Cincinnati Art Museum (1887). In a letter of January 1887 to the museum's director, A. T. Goshorn, Hoadly stated that he had ordered the picture because he sympathized strongly with two acts of Courbet's political life, "first, his destruction of the Column Vendôme . . . an emblem of subjugation of France to imperialism; and secondly, his attempted protection during the Commune of [the] valuable residence and objects it contained belonging to M. Thiers" (cf. Sutton 1971, 240). Conway's record of his trip to Vevey provides an interesting insight into Courbet's attitudes toward landscape. Commenting that he found Courbet's recent paintings of mountain and lake scenes "powerful, but with a somber tone," Conway expressed preference for a painting with a figure. Courbet answered, "I cannot insert a figure in the presence of these grand mountains. It would belittle them. And, indeed, since I left Ornans I have had no heart to paint human figures" (see Conway 1904, 1: 251).

To Alphonse Legrand, Ornans, February 11, 1873 73-14

Ornans, February 11, '73

My dear M. Legrand:

Please act exactly as you think best, when you seek information from M. Castagnary,* editor of the *Siècle.* As you know, M. Castagnary has rendered me the greatest service and he will do the same for you at the Vienna exhibition.

Send to the Vienna Art Union an assortment of my paintings of your choice: women's heads, female nudes—take Ottoz's or Petit's.[1] The one at Petit's[2] belongs to me and had an enormous success in Brussels[3] and, I believe, the prize of that exhibition. Send a snow landscape, the *Portrait of Urbain Cuenot* [F. 85], the *Spanish Woman* [F. 170], my [*Self-*]*Portrait as a Young Man Leaning on a Book* [F. 94?], green and autumn landscapes, some animals, the *English Horse* [F. 881] or the *Horse in the Stable* [F. 882], one or two seascapes. Don't send the *Burial* [F. 91], send the *Battle of the Stags* [F. 279] or the *Mort in the Snow* [F. 612], and demand that my brother-in-law deliver those paintings to you immediately since he has the keys to my atelier. As for the rest of my paintings, I would like them to be transported to your place to be stored there. Do me that favor.

My dear Monsieur, you have nothing to lose with me for my artistic career is not over and I swear to you that later on we'll have more considerable business than this to do together. Let my current problems pass, show understanding in this difficult time, and you'll see unprecedented things from me.

Do not neglect M. Castagnary, who can be useful to you as he is to me by his high intelligence.

If you want the [*Self-*]*Portrait with Pipe*, as well as the one in profile, I'll send them to you. They are copies that I made for myself after the two originals that belong to M. Bruyas.*[4]

Do also exhibit the two portraits that I did in Munich at the museum, [the copy of] the [*Self-*]*Portrait of Rembrandt* [F. 668], which is as good as the original, and that of the woman by Frans Hals, the *Woman with Owl* [F. 670]. Those two pieces, which I especially recommend to you, will be received with the greatest pleasure. You can also exhibit the head of the *Somnambulist* [F. 438] and my dark [*Self-*]*Portrait* [F. 542?]. All those are curious anomalies in a retrospective exhibition. My brother-in-law can give you the *Entombment* by Rubens, [painted] on copper; his sketch for the painting of *Catharina de' Medici Drawn by Lions;* the *Portrait of Rabelais*, a period portrait (the name of the painter escapes me); a *Head of Christ* by Le Sueur; a *Visitation* by Rubens; a Bonington; a *Virgin* by Murillo; a Van Dyck, the *Bound Christ*, the *Magdalen in the Desert*, etc. We could hold a retrospective exhibition at the Union with my paintings, propose it to them. It will be very complete, [including] a Claude Lorrain, etc., etc.[5]

Sincerely yours,

G. *Courbet*

With all my compliments.

There will always be time for that retrospective exhibition. As soon as I can go to Paris, let me know. I'll come before going to Vienna.

I can have a small, comprehensive exhibition at the Vienna Art Union like the large official one.

I just wrote my brother-in-law about all this.

1. Ottoz and the Petits* were dealers who sold Courbet's work.
2. No doubt the *Spring* (F. 627). Compare letters 73-5 and 73-11.
3. At the 1869 Brussels Salon.
4. Probably a reference to F. 40 (copy of F. 39) and F. 160 (copy of F. 161), respectively.
5. These paintings all formed part of the collection of Old Master paintings that Courbet had bought in 1870. Compare letter 70-13.

73-15 *To Alphonse Legrand, Ornans, February 16, 1873*

Ornans, February 16, 1873

Monsieur Legrand:

I am most grateful for the efforts you are making on my behalf. I hope that this time my brother-in-law[1] will not raise any more objections and that he will have sufficient guarantees to safeguard his responsibility. Why don't the two of you, you and Castagnary,* try, as I have already suggested, to arrange a small exhibition at the Vienna Art Union that would be complete in every genre and that would compete with the large one.

Ask my brother-in-law to let you see my Old Master paintings, which are in the little room upstairs. There are Rubenses, etc., everything in small sizes. They are curious and very valuable things. This is the time to show them in Vienna. It is really a pity that I am not there to organize it all. You did not

answer me with regard to my two self-portraits, which I have here in Ornans, the [*Self-*]*Portrait with Pipe* and the profile, which are already in the Montpellier Museum. They are exact copies but more accomplished than the originals.[2] You also need [my copies of] the *Woman with Owl* [F. 670] by Frans Hals and the [*Self-*]*Portrait* by Rembrandt [F. 668] from the museum in Munich. As for the *Portrait of Cluseret*, it belongs to him,[3] we cannot sell it. As for the *Spring* [F. 285?], I believe it is the one that Brame* bought for four thousand francs. It is almost square and done as a sketch. We have to send it to Vienna, this is the one that will appeal most to the artists in a club. It is perfect, it shows my work methods.

In any event, I trust you and Castagnary to make a curious and eccentric choice of paintings for that Union, and to compete by means of their exhibition, which I like infinitely more than their official exhibition.

With warmest regards, my dear M. Legrand,

Sincerely yours,

G. Courbet

Some inquiries have been made by the Chamber concerning the things I own in Ornans, you'd better hurry.

Let's hope that my brother-in-law will listen to reason. As for M. Castagnary, he is indispensable.

1. Eugène Reverdy.*
2. See letter 73-14, n. 4.
3. I am in agreement with Robert Fernier (1977–78, 2:224) that the painting exhibited in the Petit Palais in 1929 (Paris 1929, no. 24) as the *Portrait of General Cluseret* is, in fact, the portrait of an unknown old man, the authenticity of which, moreover, seems doubtful. Courbet's portrait of Cluseret, which is also mentioned in letter 73-32, cannot be identified.

To Edouard Pasteur, Ornans, February 20, 1873 73-16

Ornans, February 20, '73

[No salutation]

My word! You are in such a hurry that you almost made me spoil the copy of the fish still life.[1] I am sending you the original [F. 786]. It is a huge trout for this river. In any case, it is uncopyable, as you may see for yourself. It is 89 centimeters long by 55 ½ high. [I am also sending you] a landscape painting of the *Hammer Mill at Scey-en-Varais, Vallée de Valbois* [F. 828], 85 centimeters long by 67 high. The other three are 81 ½ long by 24 high. They are all three the same size.

I am going to order a crate for you this instant, and send you the first two now, to appease you, and I will immediately finish the other three, which will be sent by the first of March, unless everything falls apart.

I am beginning to feel less worried. The Chamber has rejected the idea

of making me set the Column up again at my expense. That idea might be very funny to everyone, but it isn't to me.

I will send you the two paintings by fast goods service and I will write the following epitaph on the *Trout* [F. 786]: "One sees that it's good to be in prison."[2]

Sincerely yours, my dear M. Pasteur. Regards to your lady and to M. Reinach.*

<div align="right">

G. Courbet

</div>

I will send them to you at 1 rue Malesherbes.[3]

1. The copy of the *Trout* (F. 786) mentioned here may be identical with F. 883, though that shows the fish in reverse.
2. In fact, the painting was inscribed, *In vinculis faciebat*, i.e., "he made it while in shackles."
3. Pasteur's address.

73-17 *To Juliette and Zélie Courbet [Ornans, February 20, 1873 (Ad)]*

My dear sisters:

I have come back from Besançon. As I wrote you, I renounced Mother's estate unconditionally.[1] Any other way was too expensive and unfair. Now, for the money that I have placed in registered, nonnegotiable, securities there remains one thing to do and that is to transfer it as quickly as possible and to have it made out to bearer. To do that, we must sell.

The painter Pata* came to Ornans four days ago to make me work. I have already done ten paintings for America, which will bring in quite a bit of money.[2] After he leaves, I'll come see you and I'll bring back Juliette* so that she can give me the shares so I can go to Besançon to deal with all that. Mme Ordinaire* wants to help me.

I have sent you, through Victor, some figs, grapes, and almonds for dessert. I hope you are all well and that Father can work his saw to his satisfaction.[3] It is raining enough—if he does not take advantage of this year, he'll never see the like again. This is the year of the water mills.

Looking forward to seeing you, I embrace you all.

<div align="right">

G. Courbet

</div>

I sent one thousand francs back to Mme de Villebichot,[4] along with her brother's portrait.[5] I have just received a supplicating and quite humble letter from the latter, who is nothing but a scamp.

[Address] Mesdemoiselles Courbet, Landowners
　　　　　　at Flagey
　　　　　　Canton of Amancey
　　　　　　Doubs

1. Compare letter 73-10.

2. Though several of Courbet's works had been shown in America in the 1860s, the *Quarry* (F. 188) is the only work by the artist known to have entered an American collection during that decade. After the Commune, his sales in America seem to have increased, partly as a result of the publicity he had received over his involvement in the Commune (cf. letter 73-13), partly as a result of Courbet's own efforts in establishing contacts in America. On Courbet's reception in America, see Brooklyn (1988, 67–75) and Edelson (1988).

3. Courbet's father apparently had bought a water-powered sawmill on the Bonneille River a short time before. See also letter 73-27.

4. Courbet had had a brief affair with Mme de Villebichot, the sister of Jules Bordet, in 1870 (cf. Lindsay 1973, 242).

5. The *Portrait of Jules Bordet* (F. 759).

To Jules Castagnary, Ornans, February 22, 1873 73-18

February 22, 1873, Ornans

My dear friend:

After all the countless authorizations I have already given, I am going to give you yet another one. Tell M. Legrand* to send to London[1] also the *Woman with Blond Hair* [F. 625?], the *Three English Girls, Misses Potter* [F. 437] (without naming the misses P.), the *Pony in the Stable* [F. 882], the *English Horse and Scottish Servant*,[2] The *Glaciers and Chalet*,[3] the *Starnberg Lake in the Tyrolean Mountains* [F. 673], the *Seascape with Waterspout* [F.604], the *Dutch Woman*,[4] and, if he wishes, my *[Self]-Portrait with Pipe* [F. 40], which I have, as well as the *[Self-Portrait in] Profile* [F. 160], unless he wants to send them to Vienna, otherwise the *[Self-]Portrait Leaning on a Book* [F. 94]. The *Head of the Woman with Parrot* [F. 526] can go either to London or to Vienna. He has so many things of his own and mine that it is easy to choose for London: the *Alms of a Beggar* [F. 660] or the *Landscape with Shepherdess by Moonlight* [F. 547?] or else my *[Self-]Portrait* [F. 542] on panel with the light and one hand [visible], the *Girl with Goat* [F. 268], whatever! I don't remember all those paintings anymore. For London, it's fine, the theme is more important than the technique. A snow landscape, etc.

As for Vienna, send some austere paintings such as the *Portrait of Cuenot* (*Urbain*) [F. 85], the *Spanish Woman* [F. 170], the *Spring* [F. 627], (a nude woman). Don't send the *Conference* [F. 338], or the *Atelier* [F. 165], or the *Burial* [F. 91]. With all this business on my mind, I can't think straight. To London [send] the *Seeress* [F. 438], if he wants, the *Source of the Loue* [F. 393]. Please go and make a selection with him. You two know as well as I what will suit these two countries: highly colored, serious paintings for Vienna, pleasant subjects for London, not [illegible]. To Vienna, the *Death of Jeannot* [F. 609].

Sincerely yours,

G. Courbet

News about the Column, which is a pain in the ass.[5]

1. To the International Exhibition of 1873.

2. The study generally referred to as the *English Horse* (F. 881) does not include a human figure.

3. During his stay in the Franche-Comté in 1872–73, Courbet often worked in the eastern part of the Franche-Comté near the Swiss border. Some of the Alpine scenes he did there have generally been attributed to the artist's Swiss period. This makes it very difficult to identify the painting mentioned here.

4. The *Dutch Woman* cannot be identified. The title "Dutch woman" or "Beautiful Dutch woman" has sometimes erroneously been applied to the *Portrait of Jo* (F. 537), probably owing to the confusion of "Irlandaise" and "Hollandaise."

5. On February 19, Castagnary had informed Courbet that the bill related to the reconstruction of the Vendôme Column had been placed on the agenda of the Chamber (cf. Riat 1906, 342).

73-19 *To Alphonse Legrand, Ornans, February 26, 1873*

Ornans, February 26, 1873

Dear M. Alphonse:

As I told you, I was very sorry to see you leave so quickly. I did not have present in my mind the questions that concerned us. You would have done better to have stayed for the evening, we would have taken care of everything.

Let's move on to business:

1. I exchange M. Durand-Ruel's* *Breton Spinner* [F. 547] for the *Woman with Cat* [F. 431] and the *Woman with Bird* [F. 286?].

2. I sell the *Woman in the Wave* [F. 628] to M. Durand-Ruel for the sum of 50,000 francs, or 45,000 francs in bonds.

3. I hope we don't need the intervention of a lawyer for the payments. Send me forty-five thousand francs' worth of obligations in coupons or securities through your banker, so as not to burden my spirit or my mind. I am wasting all my time with money matters.

4. I will send you the *[Self-]Portrait with Pipe* or the *Christ with Pipe*, as well as the *[Self-]Portrait in Profile* for the Vienna Exhibition.[1] I cannot lay my hands on them at the moment. I have to consult M. Bruyas* of Montpellier, who has the originals. I will send you in the same crate the landscape of the *Puits noir* [F. 466?].

5. Send me the copy of our contract, or else the two contracts, which I will sign, sending yours back with the titles of the paintings sold.

6. Try to send sixty of my paintings to the Art Union of Vienna. The number sixty is important in this instance. Include all genres, it is important for the critics. Ask my brother-in-law[2] for one of my drawings. I have two in my atelier, *Two Women's Heads* [Fd. 40] and *Woman with Guitar* [Fd. 25], [both] curious pieces.

7. I am glad that you did not find M. Bordet* in Dijon, as I am on bad

terms with him. I am seizing the opportunity, since I have not been paid, to reclaim that painting from him.[3] I'll write you about that. He has just refused sixty thousand francs for it from a Dutchman who had made the trip on purpose. Now he is in an awkward position in my regard, as he has not paid me the principal of fifteen thousand francs. Wait, we might be able to get it. Find out about the Dutchman. Write to Dijon, if you have contacts there. As for me, I can do no more. I have asked him to send the painting to me at Ornans at his convenience.

Sincerely yours, my dear friend, and my sincere compliments to M. Durand-Ruel, as he knows them to be.

When you come see me again, arrange to stay longer.

Gustave Courbet

1. The copies of F. 39 and F. 161, respectively. The originals were in the collection of Alfred Bruyas. Courbet made at least two copies of F. 39 (F. 40 and F. 41) and one of F. 161 (F. 160).

2. Eugène Reverdy.*

3. No doubt the *Woman with a Parrot* (F. 526), which Bordet had bought in the spring of 1870 for fifteen thousand francs, a sum that apparently was never paid in full.

To Chérubino Pata, Ornans, February 26, 1873　　　　　　　73-20

Ornans, February 26, '73

My dear Pata:

I am in an incomprehensible situation: I run from Besançon to Ornans, from Montbéliard to Pontarlier, in order to be ready to make off with my paintings and myself. I cannot even think of painting for the moment. They want me to have the Vendôme Column put back up. Everything I own is going to be seized.[1] What vexes me is my atelier.

I'll do whatever you want, my dear Pata, to oblige you, but you must give me time. I have at the moment forty thousand francs' worth of commissions and I cannot carry them out. Send me the small canvases you speak of, and in my spare time I'll paint a few if I can. Give them a black undercoating and write on them what I should do. I am extremely grateful, dear friend, for your profound devotion to me, and I'll try to oblige you.[2] I'll go to the Vienna exhibition, where I will be having a complete show of my work at the Art Union of the young [artists]. Kind regards to your lady, to the children, and to our friends who want to commission paintings from me. Assure them that if I am unable to do it for them, it is not my fault.

Sincerely yours, dear friend,

Gustave Courbet

1. Since January, when Courbet had found out that a proposal was made in the Chamber to make him financially responsible for the reerection of the Vendôme Column, the artist was

trying to arrange his affairs in such a way that the state would seize only a minimum of his movable and immovable property. The matter became particularly urgent at the end of February, when a bill related to the reerection of the Column was placed on the agenda of the Chamber (cf. letter 73-18, n. 5).

2. Chérubino Pata and his wife Emilie were actively engaged in the marketing of Courbet's work, both by organizing exhibitions abroad and by securing commissions for paintings. On Pata's role, see esp. Ornans (1988, 36–44).

73-21 *To Lydie Joliclerc, Ornans, [late] February 1873*

Ornans, February '73

Dear Lady L[ydie][1]:

I am deeply ashamed when I think that I have not punctually answered the charming and very interesting letters that you write me. I am very touched when I think of all the devoted friends who still love me in spite of my foolish democratic leanings. You are wrong, dear friend, to accuse me of neglecting you, that is, you and your friends, for the sake of an Omphale—a maid who has been in Paris for three weeks now to learn to cook, or for that other Omphale, who has not yet arrived in our part of the world.[2]

These days, I am taken up, first of all, with keeping my paintings out of the hands of the majority [party], and with leaving them my landed property as booty, to assuage them and to assess their foolishness, which will earn me a hundred times more than they could ever take from me. My stock is going up thanks to the Commune. I just sold fifty thousand francs' worth of paintings to a Paris dealer who made the trip specially.[3] I have forty thousand francs' worth of commissions at this very moment, besides the other, and I will be having an exhibition of sixty of my paintings in Vienna, at the Art Union of the young [artists], which will be the equal of the French government's,[4] of the large exhibition that allows only sixty paintings. I will also be exhibiting in London,[5] where France does not exhibit. You see that everything is going well. What bothers me is that I alone am getting the benefit of the Commune.

I will do whatever I can to enjoy the pleasure of spending a few days with you to try to please you with my painting. I love the ladies more and more, but mostly in my mind's eye and imagination, as I always have, but now, I think, it is more from necessity. Nonetheless I still love to kiss them, to say things that please them, which does no great harm. I think that nowadays I could be trusted with a Sister of Mercy.

All that said, I will be glad to paint, if I can, Mme M.'s portrait, even her husband's, and if necessary the doctor's, plus all the landscapes it takes, provided I can come see you. I'll come as fast as I can.

I hope to send you the *Blue Spring* [F. 823] before long. I have already done, as I told you, a copy of it that was sold for one thousand francs.[6] The

one I will send you, which is the original, had a narrow escape. The Paris dealer offered me two thousand for it.[7] Sometimes one must be virtuous. I kept my word. I hope you will still see me with my sentimental horse, which does not fear the whipcords[8] when he pulls the carriage for the ladies.

Kind regards to all my male and female friends. As for you, I embrace you with all my heart.

Gustave Courbet

But be patient, for I am involved in some terrible business and trials. I love the ladies even more. But alas, I am no longer a boy at his first communion.

1. Compare letter 73-3, n. 1.
2. Probably a reference to the two women he had recently become enamored with, Mlle Léontine (cf. letter 72-18, n. 1) and Mathilde Carly de Svazzena.* The latter had announced her arrival in Ornans.
3. Probably a reference to Alphonse Legrand* (cf. letter 73-19).
4. The official French art exhibit at the Vienna International Exhibition.
5. The London International Exhibition of 1873.
6. The copy is not known today.
7. According to Léger (1929, 171), Lydie Joliclerc later sold the painting to Durand-Ruel* for eighteen hundred francs.
8. This letter is not known in the original but only in transcription. The word *fer* (iron) in the transcription may be a misreading of *fouet* (whip).

To Alfred Bruyas, Ornans, March 1, 1873

73-22

Ornans, March 1, 1873

My dear friend Alfred:

In life there are those unfortunate natures who are born, no one knows why, with a sense of what is right and just, with no motive other than the love of justice. The dedication I have always had for the man who suffers has stood in the way of the comfort that I could have achieved for myself in life. I regret nothing. I fear only one thing: to end up like Don Quixote, for lies and egoism are invincible.

Society's disinherited have once again tried to free themselves violently from the exploitation and the oppression of their fellows, but this time—I stand witness to it—the men of September 4 pushed them willy-nilly to it in order to serve their schemes and their detestable politics.

The revolution was peaceful, [it was one] of propaganda, which explains my participation. But the massacre happened[1] in spite of us. That suited the plans of that odious government,[2] for those liberal bourgeois of 1830 wanted [a repetition of the] June days,[3] which they sought in order to cover their shame after October 1870.[4]

Since I saw you, my dear Alfred, I have gone through the most terrible

times a man can experience in a lifetime. I have survived, let us say no more about it. What is certain is that I saved the arts of the nation.

I recommend to you my good friend Raoul Marlet,[5] the son and nephew of neighbors and close friends with whom I spent my youth. Please help him with his exams, for you know how difficult it is for some natures to pass them. In that moment of agitation sometimes one forgets everything. Please recommend him to M. Dupré and to M. Martin and remember me to the latter.

I thank you very much for the excellent attentions you have lavished on my worthy friend Promayet.[6]

It is a pleasure to see that you are well, as is the solution.[7] I believe we have succeeded! Raoul will tell you about me. I am having an unexampled success these days. The action that I took during this revolution has caused the prices of my paintings to triple. I embrace you with all my heart, as you know. Best regards to our friend Fajon,* who is always full of kindness toward me. I will come see you one of these days.

Gustave Courbet

1. The bloody overthrow of the Commune between May 21 and May 28, 1871.
2. The government of Adolphe Thiers,* who had been a leading liberal during the July Monarchy.
3. The bloody uprisings of June 1848.
4. In October 1870, after the fall of Metz, the September 4 government had realized the hopelessness of France's situation in the war against Prussia, and on the thirty-first it had sent Adolphe Thiers to make a deal with Bismarck. While this appears to be the specific "shameful" event to which Courbet refers in his letter, the failure of the "bourgeois of 1830" (of whom Thiers was one) to share with the proletariat their victories of 1848 and 1870 was generally seen as the ultimate cause of the Commune (cf. Williams 1969, 114).
5. Raoul Marlet was probably the son of Alphonse Marlet* and the nephew of Courbet's friends Adolphe and Antoine (Tony) Marlet.* He must have been enrolled at the University of Montpellier.
6. Alphonse Promayet,* Courbet's boyhood friend, had died in Montpellier on May 24, 1872.
7. On the meaning of the term "solution," see letter 54-2, n. 2.

73-23 *To Jules Castagnary [Ornans, March 19, 1873]*

Monday night

My dear friend:

If one is to crush the beast, one must be unafraid. The whole filthy press does not bother me a bit, especially abroad. On my side I have all of democracy, all women of all nations, all foreign painters—the Swiss, the Germans—and I will be passing through Munich on my way to Vienna.[1] In Vienna I am in contact with all the foreign powers and the entire world outside of France, where I never want to exhibit again for the rest of my life.

In Ornans I already have no end of commissions. I absolutely have to take on apprentices to carry them out.[2] It is awkward to say this, but it is I who am reaping all the benefits of the Commune, not my coreligionists. At the moment I have commissions for more than fifty paintings and everyone is [illegible] my paintings. Had I become a member of the Commune for the express purpose, I would never have been so successful, I am in seventh heaven!

As for my brother-in-law,[3] I am going to have my attorney notify him that he simply must return the keys of my apartments to the concierges, that in the future he need not concern himself with my business, and that I am weary of the importance he gives himself on my account.

But believe me when I tell you, my dear friend, that the exhibition in Vienna is the happiest occasion of my life and the one that is most congenial to me. I am friends with all those people there and I have the same ways they do. As for France, frankly I have never felt the same way, I dislike those characters.

It is difficult to leave one's country but we will be decentralizing and it won't matter much if I do not live in France.

If you come to Vienna, as I hope, that is where we will laugh wholeheartedly, and we will have more fun than you have ever had before. Trust me, that is my country. I will have Paticarius the gypsy come around, and others.

You will frequent very charming men and women, I will see to that. There will be people from [illegible word] Steiermark, I will take them Buchon's* poems. If you come to Vienna, it will be the best time of your life. Tell M. Legrand* not to mention Mme Cuoq by name in the catalog.[4] I have signed away my mother's estate but I have not been able to sell my lands and my atelier. I am surrendering them to the political rage of the majority, which wishes to win the army over.

Sincerely yours, my dear friend. Give my kind regards to the people who have remained my friends. Pata* the painter is here, and he is making me paint to excess.

G. Courbet

1. Courbet was not to travel to Vienna to attend the opening of the Art Union exhibition.

2. Courbet already seems to have had a number of younger painters help him, including Jean-Jean Cornu,* Marcel Ordinaire,* Chérubino Pata,* and Alexandre Rapin* (Compare letter 72-15. See also Ornans (1988, 88).

3. Eugène Reverdy.*

4. Apparently, Courbet planned to send the portrait of Mathilde Cuoq (F. 223) to Vienna, but did not want her name mentioned in the catalog.

73-24 *To the prefect of the Doubs Department [Baron de Cardon de Sandrans],*
Ornans, March 27, 1873[1]

Ornans, March 27, 1873

Monsieur le Préfet:

An intolerable mutilation of the trees in the Iles-Basses [quarter] of Or-
nans[2] is currently taking place. This mutilation was ordered (we must as-
sume) by an administration that is incompetent in such matters and [carried
out] by inept workmen who are only interested in making firewood.

In the name of the people who live in my quarter, I request that you be
so kind as to have such vandalism cease (if you can). Cut in that way, those
trees will surely die.

Please have that work cease immediately. All that needs to be done is to
have some people of the trade cut the few unhealthy branches that could fall
on passers-by.

Please excuse me, Monsieur le Préfet, it is my urgency that makes me
write you in such an improper manner and because of my fear of seeing so
congenial a spot in the town of Ornans destroyed.

Please accept, Monsieur le Préfet, my most respectful regards,

Gustave Courbet
Painter

The branches to be cut should be so designated by the administration
and by that of the Department of Bridges and Highways.

1. This letter was published in the *Figaro* of April 14, 1873, with the following
introduction:

> One would have thought that, after his misfortunes, and especially after the lenient
> way in which the War Council has treated him, Courbet would have kept quiet a
> little.
> Not a chance! Courbet raises his voice louder than ever before. This is the letter
> that he has addressed to the prefect of the Doubs. The letter is not in need of any
> comment.

2. Courbet's first studio (the house he had inherited from his grandparents Oudot) was
in the Iles-Basses quarter (now Place Gustave Courbet) of Ornans, which explains his concern.

73-25 *To Jules Castagnary, Ornans, March 31, 1873*

Ornans, March 31, 1873

My dear Castagnary:

I authorize you and M. Legrand* to move all my paintings out of my two
apartments, in rue Hautefeuille and rue du Vieux Colombier.

I have just explicitly authorized M. Duval,* an attorney, 189 rue St. Ho-
noré, to request from my brother-in-law, M. Reverdy,* 4 rue d'Assas, the keys
of those apartments and to keep them in his office for your use, so that you

can move all my paintings, both mine and the Old Masters, under cover of the Viennese exhibition.

I would like you to render me this service as it would be imprudent for me to go to Paris. Let M. Legrand transport them to a safe place in a delivery van, until [we have] a destination that we deem suitable.

I hope that you will no longer have anything to do with M. Reverdy, M. Duval being positively charged with obtaining those keys by any means necessary. Please number the paintings and keep a list.

Sincerely yours, my dear friend. I see in the paper that we have not a moment to lose.[1] Cordially yours,

Gustave Courbet

1. The reconstruction of the Vendôme Column was being discussed in the Chamber of Deputies.

To M. Hollander, Ornans, April 26, 1873 73-26

Ornans, April 26, '73

My dear Hollander:

You amaze me with your surprises. I am unacquainted with this way of doing business. One day you send me a wire offering me half price for my paintings, another day you say, "Send me paintings," without specifying anything.

I cannot do business like that. Tell me, "I want one or two canvases of such-and-such sizes and I am offering you such-and-such a sum. Have the paintings delivered COD to such-and-such a place in Paris." I don't want any more bother.

At the moment I have more than a hundred commissions. I owe it to the Commune. I don't know which one to do first, and my paintings have doubled in price.

If you had not been so niggling with me you would have been earning a lot of money with my paintings for some time.[1]

Sincerely yours,

G. Courbet

1. Angered by the tone of this letter, Hollander got back at Courbet by publishing it in *Der Salon*, a Leipzig periodical, commenting on the artist's spelling errors (cf. Riat 1906, 340 and Lindsay 1973, 5–6).

To Juliette and Zélie Courbet [Ornans, April 26, 1873 (Ad)] 73-27

My dear sisters:

I just missed Victor. I would have sent you a cake and then I also would have let you know that you could send me the fences for my atelier that were

taken to Flagey. At the moment they are still rotting away in front of our house. Since Father is coming down on Monday, I think that it would be a good thing if he could put them on his wagon [so] I won't need to order one. They would be very useful to me just as they are. They will exactly replace those that were destroyed. I am counting on them.

I gave Father a thousand francs not to cut down the poplar in the orchard, for it is filled with memories and the wood is useless because of the sap that is inside. The worms will get at it and it won't last more than a year. Furthermore, he is to use the thousand francs exclusively for his Bonoeille mill,[1] without spending it on anything else.

We have no end of commissions, there are about a hundred paintings to be done. The Commune would have me be a millionaire. We have already delivered a score, we have as many again still to deliver. Pata* and Cornu* are working out well. Marcel[2] has come back. I hope he will be working too for I pay them a percentage on the paintings they prepare for me. Pata and Cornu have already received eighteen hundred francs, but Father must not come and exasperate them and meddle in things that are none of his business and that he cannot understand. Let him take care of Bonoeille, it is what he can comprehend.

Yours sincerely, I embrace you with all my heart,

G. Courbet

Let Father mind his own business. We are earning twenty thousand francs a month.

Berthe's marriage plans are shattered. The wife of Jean, the gardener, died in the garden. Sister Ménard spoke to M. de Vauchier, who came to see his Jhankovick niece and dined at the hospital. He has not replied but that proposal is worthless now.

The Viennese painters themselves are holding my exhibition at their own expense and without the government.[3] They are exhibiting eighty thousand francs' worth of my paintings. I'll be going to Vienna in a month.[4] I'll come see you as soon as I can.

Our vines were not dressed, fortunately. They won't have frozen.

1. Courbet's father apparently had acquired a sawmill on the Bonoeille or, as it is called today, Bonneille River, a small tributary of the Loue.

2. Marcel Ordinaire.*

3. From April 23 to the end of June 1873, six paintings by Courbet were shown in an exhibition of the Oesterreichischer Kunstverein (Austrian Art Union) which was held in the Schönbrunnerhaus, Tuchlauben, no. 8, in Vienna. This exhibition was one of several artistic events that were organized in conjunction with the 1873 International Exhibition in Vienna. Though Courbet had sent fourteen paintings to the Kunstverein exhibition, owing to space problems only six were shown: the *Atelier* (F. 165), the *Wrestlers* (F. 144), *Alms of a Beggar* (F. 660), the *Portrait of General Cluseret* (whereabouts unknown; see letter 73-15, n. 3), a *Self-*

Portrait, and a *Bather* (cf. Hamburg 1978, 586).

 4. Owing to worsening political circumstances, Courbet was not to travel to Vienna.

To Etienne Baudry, Ornans, April 28 [1873?] 73-28

Ornans, April 28, 1863[1]

My dear Baudry:

 Though I have done whatever I could, I have not yet been able to find a trace of your paintings, and I am as unhappy about it as you are, for I had sold you *Madame Grégoire* [F. 167] only in the hope that you would not get rid of it. I will never be able to redo that bit of painting. It would be difficult for me to resume the *Wounded Man*.[2] You would have done better to take it along unfinished. I would have finished and signed it at your place, as well as the other paintings.

 As for the *German Landscape*,[3] the *Bathers*,[4] and the studies, without committing myself to redo the same subjects for you, I can promise you some paintings of the same quality. Besides, my health is improving every day, and I can assure you that you will be happy.

 Offer my excuses to your lady.

 My dear Baudry, please accept my apologies,

 Devotedly yours

Gustave Courbet

 1. Though the letter is dated April 28, 1863, it is unlikely that it was written then for at the time Courbet was not in Ornans but in Saintes. Moreover, the content of the letter as well as the reference to Baudry's wife (Baudry did not marry until 1864) all speak against the 1863 date. It is possible that, reminiscing about the time he had spent with Baudry in 1863, Courbet erroneously misdated the letter, which was probably written ten years later, on April 28, 1873.

 The letter addresses the matter of several stolen paintings. Though the exact sequence of events is not clear, it seems that Baudry had agreed to buy (though he had probably not yet paid for) four paintings and several studies by Courbet sometime before the Franco-Prussian War. He left the works in Courbet's studio for some finishing touches, but, owing to the war and the subsequent Commune, the paintings remained unfinished and were stolen from his atelier in the passage du Saumon sometime after the Commune. A year later, in March 1874, Baudry and Castagnary were to rediscover the paintings mentioned in this letter in a shop in the rue Neuve-St-Augustin. In a letter to Courbet, quoted by Riat (who erroneously dates it 1875, though it must have been written in March 1874), Castagnary mentions four paintings that seem to match up with the ones mentioned in this letter (cf. Riat 1906, 366; see also notes 2, 3, and 4).

 2. Probably the copy of that painting, done in 1866 (F. 546). See also letters 65-13 and 66-26.

 3. Probably the *Woman of Frankfurt* (F. 235), which has an elaborate landscape background. Castagnary, in his letter to Courbet (see n. 1), refers to it as a *Lady Drinking Tea on a Terrace*, a description that fits the *Woman of Frankfurt* perfectly.

 4. Perhaps the *Three Bathers* (F. 630), which matches the description in Castagnary's letter (see n. 1).

73-29 *To Chérubino Pata [Ornans, early May 1873]*

My dear Pata:

I am sending you the latest letter from that filthy woman.[1] She bears you quite a grudge, it is comical! We could play a trick on her. Tell her that I was recently in Paris but that I had to go to England for my painting and that in the meantime you are responsible for opening my letters in my absence.

Tell her that you have received three of them but that you are answering only the last one because it concerns you: "As for the unspeakable letters that you write M. C., he has never paid any attention to them, and he never will pay them any attention. Of course you horrify him with your blackmail, and never in his life has he imagined there could be a creature as despicable and debased as you, especially when he sees you use intimate and amicable letters in public to try to extract money from him. You can write him all the letters you want in order to disgust him, and I will send them to him, but you may be sure that he won't answer you. He makes a gift to you of whatever you have stolen from my house, because he cannot do otherwise."

My dear Pata, beware of that monster. In my present situation she could harm me in Paris by publishing those unfortunate letters. M. Allard is only to threaten her for he cannot be paid. Write me about the Exhibition—whether you have been accepted. I think the *Hares* did not make it.[2]

Kind regards to you and our friends. Please send my best wishes to your wife, to your children, and to our friends the Ordinaires,* Robert, Boudiette, etc., etc.

Sincerely yours,

G. Courbet

1. Mathilde Montaigne Carly de Svazzena,* who, in the course of the previous winter, had elicited a number of sexually implicit love notes from Courbet, was now blackmailing the artist with the threat of publishing his letters. About this affair, see Gros-Kost (1880, 51–60) and Ornans (1988, 38–39).

2. None of Pata's works were accepted by the jury of the 1873 Salon. Pata's *Hares* is not mentioned in the oeuvre catalog appended to Ornans (1988).

73-30 *To Chérubino Pata, Besançon, May 18 [1873]*

Besançon, May 18

My dear M. Pata:

I am working on the commissions that I have received. When I have finished, I will be obliged, before I go to Vienna, to go first to Geneva and Neuchâtel to paint some landscapes that have been commissioned from me. I don't know whether Mme Montaigne is still in Ornans.[1] I would very much appreciate it if, before she leaves, she were to give you the money for the

painting that she sold for twenty-five hundred francs and the two hundred francs for the frames that you advanced her.[2]

I had replied to that lady, who wanted to come to Ornans, that I could not receive her just then. She came anyway. She took a hotel room. All that has nothing to do with me. I did not sanction either her or the hotel. You can readily imagine that, had I been able to receive her, I would have put her up at the hotel where we eat. If any difficulties arise, please warn the people at the Hôtel de France so there won't be any misunderstanding.

Sincerely yours, my dear Pata,

G. Courbet

Kind regards to Cornu.*

1. Sometime in May, Mathilde Montaigne Carly de Svazzena* had come to Ornans to step up her blackmailing campaign against Courbet. See letter 73-29, n. 1. Courbet immediately left town and apparently went to Besançon to await her departure.
2. Apparently, Mathilde, on occasion, had acted as a dealer of Courbet's paintings.

To Jules Castagnary, [Ornans?] June 1, 1873 73-31

June 1, '73

My dear Castagnary:

I just received a letter from M. Gialdini, a friend, who warns me in very urgent terms that I must immediately guard against the Versailles assembly by creating a distance between it and myself.

They are once more taking a serious look at my involvement in the matter of the Column.[1] Please find out from Ranc* and others if the new government is planning a sweep of people already tried, as in '52,[2] and if it really is I and the city of Paris who will have to put the Column back up.

E. Baudry* wrote me that he wanted to come see me and that he would try to bring you with him. I have not heard from him since. I would also like to know what is happening with Durand-Ruel's* business, which is quite shaky, I hear. I would not like to lose as well the latest deal I just made with him.[3]

Try to find out all that at the commercial court. It is all worrying me terribly. I work to excess, I have already done some forty paintings in the last month and a half. I cannot see to the end of the commissions that I have. I have over a hundred paintings commissioned from all sides.

Best to you and to my friends in general.

G. Courbet

Best wishes from the Ordinaires.*

1. In the course of April, the political situation had worsened for Courbet. Adolphe Thiers* had been forced to resign as president and was replaced by Marshal MacMahon. On May 30, the Chamber had adopted a bill to reconstruct the Vendôme Column, to be crowned

as before by a statue of Napoléon. A motion to amend the bill had been made by the Bona-partist faction of the Chamber, which directed the government to begin the construction only after a complete legal investigation of the responsibility of Courbet and his accomplices in the Column's destruction. Though the amendment was not accepted in its original form, its general drift was incorporated in the bill (cf. Riat 1906, 348).

2. After the coup d'état of Napoléon III.

3. Probably a reference to the deal made with Alphonse Legrand* in February (cf. letter 73-19).

73-32 *To Zoé Reverdy, Ornans, June 15, 1873*

Ornans, June 15, 1873

My dear sister:

In the end it took nothing less than a distraint to make you decide to give me back my paintings![1] Who has ever heard of a man being unable to dispose of what belongs to him. I have already given forty authorizations in this mat-ter. I will give ten more and that's all. Since you insist on sacrificing my interests to yours—contrary to the notion prevailing in France—you have succeeded in making even M. Duval* believe that it would be disloyal to watch over my interests. Now that all the verbiage; all the accusations against me, against my friends; all that evil politicking of yours that is contrary to my dignity and my individuality, my nature, in short, my whole way of being is finally done and the tittle-tattle too, I send you herewith enclosed some au-thorizations. It is side-splitting! Four more. I have sent them to M. Legrand,* to Castagnary* (the paintings of mine that he has do not belong to him), to M. Duval, and to Cusenier.* I don't know to whom else to send one to stop this fairy tale that the police made you responsible for me and my paintings, which made M. Duval very angry.

Lastly, I still have to get all my paintings and my furniture out of my atelier. Send the furniture to M. Cusenier because I will be leaving France and I will let them know a subsequent destination; the Old Masters at the station in Besançon to Dr. Blondon;* and the paintings that are in France to Morteau. This concerns E. Cusenier especially. I authorize him to do this, for that way you absolutely have to take this letter as a final authorization. Oth-erwise M. Duval has been urgently requested to have the court order you to comply.

If they tear down my atelier in rue Hautefeuille I am left with five years on my lease. I had nine years, it is on record. They owe me an indemnity.

I don't know how much I had at M. Petit's* and M. Gauchez's.* They will tell you. There was a small *Seascape at Sunset*, a small *Sleeping Woman*, and the *Spring*, 60 or 80 in size.[2]

I authorize M. Durand-Ruel* to return to General Cluseret* his portrait, which he wants back.[3] In a few days I'll let M. Durand-Ruel know that he is

to send my paintings that are in Belgium, London, and Vienna to Switzerland, without their passing through France.

I embrace you,

G. Courbet

[Address] Mme Reverdy
4 rue d'Assas

1. Zoé and Eugène Reverdy had meddled in Courbet's affairs since his imprisonment. While initially Courbet had welcomed their help, gradually he came to resent it, especially as he felt that he lost control over his own works still stored in Paris.

2. As these three paintings all belong to categories that are amply represented in Courbet's oeuvre, it is difficult to identify them with any certainty.

3. See letter 73-15, n. 3.

To Alexis Chopard [Ornans, mid- to late June? 1873] (incomplete) 73-33

My dear Alexis:

I would like you to send me forthwith the name of a commission agent in La Chaux-de-Fonds, where you will deposit my things, for those that are in London, in Brussels, and in Vienna, will go there directly. I have sent the necessary authorizations directly. I would also like to know whether bonds that are currently registered in my name could be made payable to bearer more safely in Switzerland than in France. The persecutions have begun. . . .[1]

1. After, on May 30, the Chamber had adopted the bill to reconstruct the Vendôme Column (see letter 73-31, n. 1), on June 19 the minister of finance, Pierre Magne, had ordered the sequestration of all Courbet's property in France. Courbet's remark about the persecutions having begun probably refers to the latter event.

To Zélie Courbet, [Ornans, mid to late June 1873] 73-34

Dear Zélie:

Juliette left without joining the pilgrimage to Paray-le-Monial the day before, telling me that she would be back the day after. I left Besançon after asking for her at Gratel's, who explained to me that she did not think that she would be back before Sunday. I guess she is doing a novena or a retreat, I am not well informed about all that nonsense. All the pilgrims were booed by the people.[1] It's lucky she was not part of the group. She will come back tomorrow or the day after via Amancey.

And now Blondon* is in Ornans. Tomorrow I will send him to Gratel's. I have decided not to go to Switzerland for, if I did not get out during the Commune, I don't see why I would leave now.[2] I have only my belongings to worry about, not my person, according to a notice I just received from the government. I'll come see you perhaps tomorrow or the day after. I have a lot

of things to do that are wearing me out and that never end. They are extremely serious and I cannot say exactly when I will be free. What makes it even more difficult is that I sold my little dog, which made me very sad.[3] I have sent you an easy chair and an orange tree and a myrtle bush.

Don't fret. She [must have] stayed one or two more days longer than she said because she was afraid of getting too tired. But she should have written you. Don't worry about anything, either about me or about Juliette. I embrace you,

<div align="center">

G. Courbet

</div>

Dr. Rith* is dying. I am obliged to stay here. There is nothing to eat in this house.

1. Perhaps a reflection of the anticlerical sentiment in Besançon.
2. It is interesting to see how Courbet vacillated with regard to taking refuge in Switzerland.
3. Courbet writes *biche*, meaning "doe," but perhaps he is referring to his "*bichon*," i.e., a small lapdog of the spaniel family.

73-35 *To Jules Castagnary, [Ornans,] June 28, 1873*

<div align="right">

June 28, 1873

</div>

My dear Castagnary:

Our poor Dr. Rith* has just died. We were not able to arrange for a secular funeral, this place does not permit it. But it was close, there was only one priest. He had been so poor that we had to pay the funeral expenses. Yet another loss for democracy! The funeral was splendid and congenial.

Please go to Durand-Ruel's* and find out what is to be done. They don't write, I am terribly anxious. I think that they were so clumsy as to let the paintings from their most recent purchase from me be seized.[1] I don't know on what grounds, for it was not paid for. They must have known that in that instance they were to pay the government, it is wearisome to have to tell everyone what they have to do. M. Alphonse,[2] to whom I made the sale, wrote me, "I'll bring you the money." A month and a half later I have not received a thing. My attorney has requested them ten times to arrange payments, but they have not complied, under the pretext that everything had not been delivered. As it happens that the sale took place four months ago, that account should have been settled well before today. I don't understand what is going on. I sent word to M. Alphonse either to give me back the paintings or to pay me. There is no need in either case for everything to be delivered to him. There are still five or six [paintings] that I have not been able to deliver to him, so as not to increase the disaster, but let him pay for the others, we have been asking him to long enough. Waiting for those combined payments is wearisome.

Please let me know whether I have anything to fear personally, for I

am thinking of going to Switzerland. I don't want to go to prison again, it upsets me.

I have mortgaged my properties to the people to whom I owed money. I wanted to transfer some securities to the bondholder of the Lyons Railway but the minister has illegally opposed it. They have just attached my atelier in rue Hautefeuille, it is unbelievable. It is true that it is my sister[3] who is the source of all my troubles. Hated as she is, she sets all Paris against me. It is a plague that I cannot rid myself of.

Please, then, go to Durand-Ruel's to see what can be done, for they don't write me.

Here they are issuing seizures for security, they send seven or eight notices to every house to increase the costs, and the prefect of the Doubs demands five hundred thousand [francs] in damages. What scoundrels those people are! If people acted this way in a revolution, what a fuss they would make, those villains! Write me immediately. Ranc* is hurting my case.[4]

Tell Baudry* to send me the money from the *Gypsy* [F. 663] to Ornans in a double envelope. Write me likewise, care of M. Girardet, Hôtel du Nord in Ornans. I am so confused that I can't think.

I have to hire Lachaud* again, there is no other way, he has my documentation.

[*no signature*]

1. The sequestration of Courbet's property had started, on June 19, with the seizure of property in his own hands; it continued on June 23 with the seizure of property in the hands of others: banks, companies in which he held stock, dealers, etc. (see Riat 1906, 348). A major seizure was made in the gallery of Durand-Ruel, who had just acquired a large group of Courbet's works (cf. letter 73-19).

2. Alphonse Legrand.*

3. Zoé Reverdy.*

4. Arthur Ranc, like Courbet, had been a member of the Commune for only a short time. Elected on March 26, 1871, Ranc had resigned in less than a month as he realized that the Commune's aims were becoming increasingly revolutionary. After the Commune, no formal charge was brought against him until June 12, 1873, when the Chamber received a letter from General de Ladmirault, the governor of Paris, requesting the prosecution of Ranc, "the only one of the members of the Commune seriously compromised who has not yet faced charges." The Chamber voted overwhelmingly to authorize Ranc's prosecution, but Ranc promptly disappeared and had to be sentenced in absentia (cf. Joughin 1955, 1: 75–76). Courbet felt that the government's zealous pursuit of his property was motivated by the suspicion that he too was about to leave the country.

To the prefect of the Doubs Department [Baron de Cardon de Sandrans], Ornans, mid-July 1873 (draft)[1] 73-36

Ornans, July—, 1873

Monsieur le Préfet:

In spite of the ideal that sweeps you away where I am concerned and that

I have no right to control, it would be well if you were to return to a relative sense of reality, in my regard. In the official notices served by your orders against various inhabitants of the Loue Valley, you do me the honor of establishing against me a provisional charge of 500,000 francs, which gives me, in the eyes of the public, a financial importance that I do not deserve and that could call me to great destinies.[2]

But as, in fact, I decline any honor of the kind, I ask you again to please return for a moment to the reality in which I find myself at this moment and that has been my reason for living. I would have you know, Monsieur le Préfet, that I have never inherited from anyone in all my life, and that it is by dint of forty years' stubborn work that, in spite of my inborn independence and outside the routine channels, I have succeeded in earning a living and, at the same time, in rendering a recogized service to art, both in France and abroad.

There was a time when, with only a small part of that provisional charge that you place on my head, I could have contributed in the name of the French nation to the reerection of that column that you miss and that was not toppled by me but by public sentiment and the action of a social revolution.

Two years of war and revolutions, during which I dedicated my disinterested devotion to the preservation of artworks, which taught me so much, caused me to lose the little I had earned with my life's work, as well as some very valuable paintings that were stolen from me in the confusion.

Amid this wreckage, I had nothing left but debris, such as industrial securities, which the government seized, and my atelier in Ornans, which I have had to mortgage in order to meet my obligations.

The rigorous seizures you have ordered of all things belonging to me or supposed to belong to me, at present or in the future, place me in an exceptional position of such abstruseness that I cannot but turn to you, who are, I believe, a competent authority in this matter, to clarify it for me.

I think I have the right to live, at least until the end of the trial that has been brought against me and that could last a long time. However, I cannot do so without practicing my art. Therefore, please tell me if I am still allowed to paint pictures and to sell them freely, for my own profit, in France or abroad, or if I am a slave, henceforth condemned to work for the benefit of a master, which is the French state, in the name of which you will serve writs against me.

Please be so kind, Monsieur le Préfet, as to give me this important information.[3]

Most sincerely yours,

[*no signature*]

1. This is a draft, written by another hand, of a letter that perhaps was intended for publication in a newspaper. It is not known whether Courbet dictated the letter or whether it was written for him by one of his friends.

2. The prefect, by virtue of an ordinance from the Besançon tribunal, had served notices against all persons who had in their possession property belonging to Courbet, ordering them to yield it up to the extent of 500,000 francs, the estimated charge the artist would have to pay for the reconstruction of the Vendôme Column.

3. In a reply dated June 17, the prefect justified his actions but did not answer Courbet's question whether the works he would henceforth produce would automatically become the property of the state (cf. Léger 1929, 184).

To Juliette and Zélie Courbet [Ornans, mid July, 1873][1] 73-37

My dear sisters:

I am sending you the carriage. I wrote you from Paris, you recall, that I was making you a gift of this carriage and that I was sending it to you for your own use.[2] It does not run the risk of being seized.

My sister's[3] lifelong stubborn attempts to exploit me have finally resulted in my complete downfall. My fiercest enemies could not have done me as much harm as those people [have] in the last two years. They have offended all my friends and have prevented them from acting for me; they have vitiated public opinion toward me by depicting me as a renegade and by getting every party to despise me.

M. Castagnary* was absolutely right. If I had listened to him I would have lost absolutely nothing, whereas with their self-interested guidance I have so far already lost a hundred thousand francs seized from the bank and from Durand-Ruel's.* Even the Bordet* debt can be seized now.[4] I will be going to Switzerland via Pontarlier. I'll try to pass through Flagey. If I don't have the time I'll go directly to Dr. Gindre's,* and the Pillods* will take me to Switzerland. It is not far from Salins or Pontarlier, some one or two hours by train.

I embrace you all and am sending you an easy chair and some pots of flowers. I am very sorry not to have seen Zélie,* whom I have not seen for a long time, but she will come to Switzerland.

[no signature]

1. This letter bears the stamps of Simon, attorney in Besançon, D. Monnet, attorney at the Besançon court, and Fumey, attorney in Besançon.

2. Compare letter 72-9.

3. Zoé Reverdy.*

4. Jules Bordet still owed Courbet 15,000 francs for the *Woman with a Parrot* (F. 526). Compare letter 73-19.

73-38 *To Charles Lachaud, via Charles Duval, Ornans, July 20, 1873*

Ornans, July 20, 1873

Monsieur:

I read in the newspapers that my case came up recently and that it has been postponed until Wednesday, the twenty-third of this month.[1] As M. Castagnary* of the *Siècle* and I are very close friends, I would like to ask you, if it is possible, to be so kind as to discuss with him the strategy you intend to follow in my trial. You must understand how important it is for me to have a friend in Paris who is very well informed at every stage of the judicial persecution of which I am the object. I am risking five years' imprisonment for debt if I cannot pay the enormous damages to which I will certainly be sentenced. Certain newspapers have made a point of informing me of the possibility.

You understand that, if I am to be lodged at government expense for such a long time, I do have to take some precautions before letting myself be locked up. If M. Castagnary could discuss things with you, he could inform me of the precise moment at which I must take care of those small affairs of mine into which the French state, since there is the French state, cannot stick its nose.

There is likewise another question on which I must also consult you. When an attachment for security is levied on an ordinary debtor, it is not, I believe, customary to convert the seized personalty into realty so as to cut off the livelihood of the distrainee completely. That situation would be extraordinarily harsh, it seems to me, especially if one thinks of my particular case, which concerns especially assets that could subsequently be created with my brush.

Since a sequestrator has been appointed to administer the seized property,[2] would it not be advisable to present to the court a request intended to fix a sum to the amount of which the sequestrator would be allowed to furnish me with the funds necessary for my material existence?

I wrote a letter to this effect to the prefect of the Doubs,[3] who replied that on that score he had no advice to give me, and that I had to discuss it with my advisers. This question exercises me keenly, as you can readily understand, and I hope that you find it neither inappropriate nor legally impossible to submit it to the appropriate person.

Finally, Monsieur, I think it is absolutely essential that this trial does not go beyond the bounds of a purely civil trial. Indeed, it would be disagreeable to me that in this instance the men of the Commune be the objects of any kind of attacks. They have been unfortunate enough to have at least the right to silence in a proceeding in which politics should have no place, at least as far as the purely legal inquiry is concerned.

You will oblige me, Monsieur, by taking all these remarks into account in the direction that you will take with my case. It means a great deal to my family and me to have a friend as devoted as M. Castagnary called in to confer with you.

Respectfully yours,

Monsieur Duval, please keep in mind the instructions that are given to you in this letter.

<div align="right">

G. Courbet

</div>

M. Castagnary, editor of the *Siècle*, 33 Avenue Trudaine, has information to give to you that is important for the success of the case.

[Address] M. Duval, attorney
 Paris, 189 rue St. Honoré
 Forward to M. Lachaud in Paris
[Postmark] Besançon, July 21, 1873

1. In the beginning of July, the government, through the intermediary of the Domain Administration, had ordered the civil tribunal of the Seine Department to decide whether the seizures of Courbet's property had been legal and whether he could, by common law, be made financially responsible for the reerection of the Vendôme Column. The hearing, first scheduled for July 12, was deferred to July 23, 1873 (see Riat 1906, 348).

2. On July 12, pending the outcome of the hearing on July 23, a certain M. Quest, at 90 boulevard Beaumarchais, had been appointed as the official sequestrator of Courbet's property (cf. Riat 1906, 348).

3. Compare letter 73-36.

To Charles Blondon, [Maizières,] July 20, 1873 <u>73-39</u>

<div align="right">

Sunday, July 20, '73

</div>

My dear Blondon:

I received your letter here at Maizières, today, Sunday, at noon.[1] I am answering you immediately. I can no longer budge from here because of my attorney's letters. My case will be tried on Thursday[2] in Paris, and I am ready to leave, as you know.[3] I will leave on Wednesday. Consequently, if you could come here, it would give me the greatest pleasure. If you can come, get off on the road to Maizières, where we will wait for you on Monday and Tuesday only.

Sincerely yours,

<div align="right">

G. Courbet

</div>

1. Courbet apparently had just arrived in Maizières. His letter to Lachaud, also dated July 20, 1873, was still written in Ornans.

2. In letter 73-38, he had indicated that the hearing was to begin on Wednesday, July 23.

3. Courbet had decided not to wait for his case to be heard by the Tribunal civil de la Seine but to leave for Switzerland instead.

73-40 *To Lydie Joliclerc, [Maizières,] July 20, 1873*

Sunday, July 20, 1873

My dear Lydie:

The time has come to depart. My troubles are looming ever larger and will end with my exile. If, as everything indicates, the court[1] will fine me 250,000 francs, it is a way to have done with me.

The question is now to get out of France adroitly, for, depending on the sentence, I'll get five years in prison or thirty years in exile if I don't pay. In that case, M. O[rdinaire] and I will leave for La Vrine,[2] where we'll arrive on Wednesday at five o'clock in the afternoon. We are counting on you—that is, either Joliclerc,* or the doctor,[3] or M. Pillod*—to pick us up in a closed carriage and to drive us straight to Les Verrières,[4] where we'll have dinner.

All this must remain absolutely secret. Consequently, we will count on one of you, and you needn't answer. There is no time to lose, my case will be tried on Thursday.[5] I am addressing my letter to Mme Pillod in case you are in Morandval.

To all of you collectively, my dear friends, I am,

Sincerely yours,

G.C.

1. The Tribunal civil de la Seine.
2. A village on the road from Ornans to Pontarlier.
3. Dr. Gindre.*
4. Village on the border between France and Switzerland.
5. Compare letter 73-39, n. 2.

73-41 *To Juliette and Zélie Courbet, [Maizières,] July 20, 1873*

Sunday, July 20, '73

My dear sisters:

At last the time has come to leave for Switzerland. I was not able to come see you, no matter how much I wanted to, as you can well imagine. I was running from Besançon to Ornans making deeds of gift in your names in order to safeguard the little that I own.

This Thursday[1] my trial takes place, and I am certain to be convicted. I will be sentenced to a fine of perhaps 200,000 francs, obliged to go into exile, as I have already told you, which does not displease me. You'll come to see me whenever you like, it will be very pleasant. Moreover, it will not be for long.

My atelier and my land have been mortgaged. Only my shares in the southern railways have been taken. I don't care. The most important part has been saved, and Mother's estate as well. I'll come see you on my way to

Switzerland Wednesday morning, with M. Ordinaire,* who will be accompanying me to Switzerland. I wrote Lydie* and Dr. Gindre* and the Messrs. Pillod.* We'll go straight to Switzerland. Once there, I'll be in an Eldorado, as Max Buchon* used to say.[2] It will not be very far to come see me and it will be a diversion. Father is pushing me, he says that he would like it, that he has never seen Switzerland. I embrace you, and am sincerely yours.

We'll dine Wednesday at noon, and we'll go to La Vrine, where M. Joliclerc* will come and fetch us to take us to Switzerland at 5 o'clock in the afternoon.

I embrace you all and look forward to seeing you again before leaving.

<div align="right">

G. Courbet

</div>

Expect us.

1. Compare letter 73-39, n. 2.
2. Max Buchon had lived in exile in Switzerland from the end of 1851 until 1856.

To Jules Castagnary, Maizières, [July] 21 [1873] 73-42

<div align="right">

Maizières, Monday 21

</div>

My dear Castagnary:

The members of the Commune, speaking through Grousset,* have declared before the War Council that I had absolutely no part in the fall of the Column,[1] and it was likewise established that, to the best of my ability, I had opposed it by going to the Chamber—though I was no longer a member—in my capacity as president of the arts of all kinds, which title had been granted me twice by the artists in assembly and by two different governments: that of September 4 and that of the Commune.

As a last resort, and unwilling to give up my ideas for those of the Commune, I asked that at least that part of the Column that belonged to the original republic be preserved. My motion failed and they stuck to their decree in spite of me. All that remained for me to do during the course of events was to prevent the kind of accidents that such a violent fall might cause.

Consequently, at this moment I have nothing to my name except the petition that I proposed to the artists' assembly and that I addressed to the September 4 government.[2] That petition asked only that the Column be transferred to the Invalides in order to appease all parties in the matter.[3] That petition was presented at the same time as one by Messrs. Jules Ferry,* Robinet,* Jozon, etc., who, for their part, asked that the monument be melted down for cannons.[4] Those two petitions were both pigeonholed by the September 4 government, and were never spoken of again. That was my role in the demolition of the Column.

The members of the Commune, having declared themselves responsible for it—all those who were present on April 11,[5] when I was not yet one of

them[6]—are, by reason of the decree that they promulgated, the only ones guilty of the destruction. I, on the other hand, in spite of a vile press and a mistaken public opinion, I am the only man to have opposed the very act that I am accused of. I call the War Council and all my codefendants to witness.

You advise me to place the blame on Rastoul;[7] why him rather than the others? You say, because he is in California, which would give me a six months' respite. I would be willing, if I could be sure that I would not be arrested as a preventive measure. But as they are capable of anything, I don't know what to tell you on this point, for that six months' delay could also backfire and get me six more months of prison or exile. Nonetheless, I leave it to you to make the decision.

My family and I very much wish you to take part in my trial, as counsel, as you are the only man in Paris who sees me in a positive light. Yesterday I wrote M. Duval* to that effect. Consequently, on receipt of this letter, and without losing any time, please go to him, for the trial is on Wednesday. I don't know why my attorney took the liberty of signing a useless sequestration without my authorization. He is increasing the fees and preventing Durand-Ruel* from acting on my behalf [].[8] My attorney is thereby acting in the interest of my adversaries, which is what Dr. B[london],* in a conversation he had with him, was able to ascertain.[9]

As M. Lachaud* complains that I don't pay him enough, I would be only too pleased if he were replaced by M. Allou,[10] for several reasons, as you know. All my friends were quite offended and I myself was hurt by the rude way in which he treated me before the War Council. If he succeeded, it was because of his Napoléonist opinions. But what makes it difficult to leave Lachaud is the fact that he has kept all the documents from my first trial.

So, please, go see M. Duval. Lachaud has already briefed him, I believe. Tell him that the statement I wrote about the Column is in my sister's hands and that he is to ask her for all the documents she has.

I am truly suffering with a liver ailment and the beginning of a case of dropsy and I am leaving for the waters at Vichy,[11] from where I'll write you right away. Act as you see fit, for you know my incapability in these kinds of concerns. Act as if it were your own concern.

Sincerely yours,

G. Courbet

Give them this information.

G.C.

1. In the course of Courbet's 1871 trial, Paschal Grousset, himself a Communard, had testified (on August 17) that Courbet was not to blame for the fall of the Vendôme Column, that he, Grousset, bore the full and entire responsibility for its destruction. This claim was later reiterated in an open letter to *The Times* on June 23, 1874 (see Riat 1906, 320–21).

2. Compare 70-27.

3. In his original proposition, Courbet had asked that the reliefs of the column be taken

to the Hôtel de la monnaie. Criticized for wanting to turn the Column into money, he later always claimed that he had called for their transportation to the Hôtel des invalides (cf. Riat 1906, 287).

4. Courbet's proposition to take down the Vendôme Column had been one of many similar proposals drafted after the fall of the Second Empire. One of these had been submitted to the government by the armament committee of the sixth arrondissement, which included among its members Dr. Robinet* and a certain Jozon. It had asked, on October 2, 1870, that the Column be melted down and recast into cannons. This proposal had received strong support from Jules Ferry (cf. Riat 1906, 288).

5. Courbet seems to be mistaken as to the date, for the demolition of the Vendôme Column had been decreed by the Commune on April 12 (see Mason 1967, 238).

6. Courbet did not become a delegate to the Commune until the supplementary elections of April 16.

7. Paul Rastoul (1835–75), a delegate to the Commune from the tenth arrondissement, had served on the Committee of Public Services. Arrested and tried together with Courbet in Versailles during the summer of 1871, he had been exiled to New Caledonia (not California!), where he remained until his death, caused by an unsuccessful attempt to escape.

8. Several illegible words

9. Doubtful reading of the original text.

10. Compare letter 73-1, n. 3.

11. Courbet had probably informed Castagnary of his planned clandestine departure for Switzerland, but in his letter, which Castagnary was supposed to share with his lawyer Lachaud,* he pretended to leave for Vichy.

To Charles Blondon, [Fleurier,] July 23, 1873 73-43

Wednesday, July 23, 1873

My dear Doctor:

We have arrived safely,[1] we are delighted. I count on your extreme kindness and concern to take care of those very dangerous matters in Besançon. M. Pata* will come see you. He is determined to sue the damozel[2] for the frames for which he advanced the money[3] and he will also be asking the Paris hotels as well as the jeweler and the police superintendent to lodge similar complaints. I would willingly do the same if I were not afraid of losing the letters, for her debt to me antedates the one she imagines to be groundless. That would give her six summonses at once, enough to kill an ox.

Something strange has happened to me: I can find only seven thousand francs' worth of share certificates. That bothers me. Could the rest have been taken at the hotel in Besançon with a duplicate key to the desk? That is the only thing I can see to fear. Tell me how much there was. Write me in Fleurier, canton Neuchâtel, poste restante at the hotel, care of M. Ordinaire.*

Kind regards to our friends and especially to our friend Madame [][4] and to Dujardin. I don't know what they will have done in Paris. I wrote what you advised me to, to the attorney and to Castagnary.*

[*no signature*]

1. In Fleurier, Switzerland.
2. Mathilde Montaigne Carly de Svazzena.*
3. Apparently, Mathilde had not only blackmailed Courbet but also rifled Pata.
4. Illegible name.

73-44 *To his father and his sisters Juliette and Zélie Courbet, [Fleurier,]*
 July 23, 1873

Wednesday, July 23, '73

My dear Father, my dear sisters:

I have arrived safely,[1] and my friends too. Lydie* and Mme Marlet[2] came along, over all objections. We are as happy as if we were in a paradise. We'll take the train to pay some calls on people in the interior of the country. In a few days, when we have decided where we'll be staying, I'll write you again. For the moment it is enough that you know that we are perfectly safe. A little later on I will let you know to come see me.

In Ornans all my papers and clothes must be put in order, as I told Juliette, and given to she knows who, who will take care of them and send them to me if the occasion presents itself, or will take them to Flagey. Also, the carpenter I told her of must move several things. There are several things that have to be placed properly, including the clocks. There is one that works very well. The weights are there, the pendulum and the key are in my room. I forgot my glasses.

Well, I'll see you soon. Set your mind at rest. I embrace you all with all my heart.

I went to see Dard.[3] They had offered 160 and not 170. I told them to cut. I don't know whether they did. Write them.

Monsieur O. has written his wife to answer him in Fleurier, canton de Neufchâtel, poste restante at the hotel. Address it to M. O. M. J., Charles, is with us.[4]

[no signature]

[Address] Mesdemoiselles Courbet, Landowners
 Flagey
 Canton Amancey—near Besançon
 Doubs, France
[Postmarks] Besançon, July 24, 1873
 Amancey, July 25, 1873
 Other illegible postmarks

1. At Fleurier, Courbet's first stop in Switzerland, where he was to stay for approximately one month (cf. La Tour-de-Peilz 1982, 19).
2. Perhaps Jeanne-Marie Coignet, the wife of Adolphe Marlet.*

3. Probably the Lausanne-based painter Gustave Pétrequin-Dard (b. 1838), who earned money on the side as an art dealer. The passage no doubt refers to the sale of a painting.

4. Courbet has deliberately abbreviated the names of Edouard Ordinaire* and Charles Joliclerc,* in case his letter were to be opened.

To Charles Blondon, Fleurier, July 23, 1873 73-45

Fleurier, July 23, '73

Dear Doctor:

I have just urged Pata* to sue that lady[1] for the sum of 230 francs for breach of faith. He had authorized the gilder to make him some gilt frames. The gilder will also be filing his complaints and will give the names and addresses of five or six people whom she has robbed, as she did me. They will be sent to you, and Jules A.[2] will give them to the police superintendent, who is willing to make inquiries in Paris. In the meantime the suit must be postponed until the documents are available.

That scoundrel has reversed the roles. She has stolen paintings, she was supposed to pay for them on the first of July (this month). She owes me 3,000 francs for one painting, 1,500 for another one; I lent her 50 francs once, 100 another time, 20 another time; in all, 4,670, and I am responsible for the 220, or 230. If her claims were justified, we would owe her 60 or 80 francs. You will read in her letters that she came to the Franche-Comté in spite of me and my objections. She says, "I'll follow my impulse and I'll come surprise you. Besides, I would just as soon live in Besançon as in Paris." Consequently, I owe her neither damages nor interest.

We must retain Forien [?] as our lawyer and he must treat her harshly. Forget about Lerch [?], who has received an advance of 100 francs, or Lachaud,* who asks 3,000 francs paid in advance.

You must absolutely send captain Guichard the certificate of illness that I promised him at my attorney's request.[3] If you don't, I will be in for another five hundred francs in fines and some prison time. It is quite a trap that they have set for me. Send it to the Third War Council, Small Stables, Versailles. I am glad that you found those pieces of paper, I was quite worried.

Sincerely yours,

[*no signature*]

Still poste restante, Fleurier

1. Mathilde Montaigne Carly de Svazzena.*
2. Probably Jules Arthaud.*
3. As Courbet had been released on parole from Ste Pélagie prison to spend the remainder of his half-year sentence in the nursing home of Dr. Duval, he must have needed a medical certificate to prove that he, in fact, had served his full prison term.

73-46 *To Charles Blondon, [Fleurier,] August 1, 1873*

August 1, '73

Dear Doctor:

Finally they have achieved their goal. I am expelled from France for good. We found out unofficially from police headquarters.[1] The trial of the Third War Council of Versailles was nothing but a trap!

Keep writing me care of M. O.,[2] poste restante in Fleurier. I am sending you the summons for the Ornans justice of the peace. Please remit it to the attorney that you'll have chosen.[3]

Cordially yours,

[*no signature*]

1. On July 31, a fourth seizure of Courbet's property had been ordered by the prefect of the Seine Department (see Riat 1906, 363). Apparently, the hearing aimed at determining the legality of those seizures, which had been scheduled for July 23 or 24 (cf. letters 73-38, 73-39, and 73-40), had been postponed or had been inconclusive. In any case, Courbet felt that, in view of the government's arbitrary measures against him, his decision to leave for Switzerland had been correct.

2. Edouard Ordinaire.*

3. These last two lines seem to refer to Courbet's legal quarrel with Mathilde Montaigne.*

73-47 *To Zélie Courbet, [Vevey? October? 1873]*

Dear Zélie:

Juliette tells me that the Reverdys* came to see you in Ornans. Give them my regards and urge them especially to send me immediately and especially with no shilly-shallying—for there is barely enough time—all the documents relevant to the Vendôme Column for the upcoming trial. I must absolutely think long and hard about the way I should handle this matter, which is of the greatest importance, as much for my moral and material interests as for history. It is incomprehensible that they refuse to understand that. They are absolutely incapable of putting themselves in my place. Besides, it concerns me alone, it is nobody's business but mine. Be sure to tell them that there must be no question of needing fifty authorizations, as in the case of saving my paintings, which ended up being seized in my atelier, owing to shilly-shallying. I have to think things over and write my lawyer[1] every day. I expect those documents without delay and the statement that I wrote about it all in prison.[2] If I lose this lawsuit I at least want to have the benefit of an honorable defense and one without a Napoléonist profession of faith on the part of my lawyer.[3] I expect those things immediately. I embrace you warmly.

Gustave Courbet

1. Charles Alexandre Lachaud.*

2. Courbet wrote several statements about the Column. One of these is attached to letter 73-8 (text in Léger 1920, 127–30); the other appeared on the autograph market in 1988 (partial text in stock catalog of Librairie de l'Echiquier [Frédéric Castaing], Paris, June 1988, p. 13). The latter statement, which is autograph and seven pages long, may be the one he is referring to here.

3. Though Lachaud had followed an apolitical course during the Second Empire (except for a brief flirtation with politics in 1869), Courbet tended to think of him as a Bonapartist.

To his father, Vevey, October 15, 1873 73-48

Vevey, October 15, 1873

Dear Father:

I hear that M. and Mme Reverdy* are in Ornans with the intention of settling in that part of the world and living in our house there. That cannot be done as easily as they think, for a number of reasons. First, that house was jointly owned and now is still jointly owned by my three sisters since I transferred Mother's estate and you, on your end, gave up the enjoyment of your rights to that property. Consequently, it is impossible for the Reverdys to encroach on the rights of my other two sisters. When I made my transfer that was not my intention. If, therefore, M. Reverdy insists on starting trouble in our family by moving in against our will—he and his children—it becomes necessary to divide Mother's estate and sell the house, which cannot be divided. There is only one serious drawback to that, namely that it will unsettle you in your ways and deprive you of Mother's estate, which stands you in good stead, and of the wine that you need in Flagey as well as in Ornans, and that in the future you will have to buy, for the vineyard I own in Charmont is insufficient for your needs.

As the house cannot be purchased by any of the co-heirs, it will have to pass into the hands of strangers, which will most certainly be very painful for you and for us. On the other hand, if M. Reverdy were to take an apartment in Ornans, I don't see what respectable pursuits he could find in this part of the world for himself and his children.

Second, it is evident that neither I nor my sisters can live with Mme and M. Reverdy. Our characters, our natures, and our principles are diametrically opposed. My sister alone married M. Reverdy, she cannot foist him on us, for everyone is free to live with whomever he wants. Consequently, if their indiscretion and their presumption press them so far as to live in Flagey, my sisters—it is already settled—will leave the family home, with all the scandal that that will raise in the area, in order to yield their place to strangers. In doing so they will have received a nice reward for having sacrificed their lives to their parents and for having kept their fortune intact by helping them.

There is no employment in Flagey for M. Reverdy, nor for his wife, nor for his children. The only thing they're good for is to cause distress. The Flagey revenues are barely adequate for your current needs, and later, when they will have use of the quarter that falls to them, they will not be able to live on it any better.

As for the children I am always hearing them talk about, we have to find out for certain whether they exist, whether they belong to our family, and how old they are.[1] A family has the right, it seems to me, to know the members of which it consists and to accept or not those that are foisted on it. In June 1870, Mme Reverdy announced to her acquaintances that she had just given birth to two twins in rue d'Assas. You and Mother were made godfather and godmother, along with Baron d'Hervé. It turns out that that childbirth was illusory.[2] During the Commune I had occasion to speak to Baron d'Hervé and congratulated him on having done my sister the honor of being godfather to one of her children. I made a complete fool of myself. The man looked at me in utter amazement and said, "Sir, I can assure you that your sister has never had any children, to my knowledge, and that, in any case, I am not their godfather." I did not know how to reply. Alerted by that notion, I was later in a position to do some research that was within my power at the St. Sulpice city hall in the records of the city clerk. I checked four years along with the clerk and I found no trace of the birth of those mysterious children, and no children were acknowledged at M. Reverdy's marriage. In Italy, where she spent some time, my sister had no children with her. In short, I can't understand it. On the one hand, Mme Reverdy wrote a letter (which you sent me), in which a child that can only have been three years old had a great talent for drawing; on the other hand, people in Paris and Ornans to whom she has spoken about them say that they are fourteen years old.

The upshot of all this is that a family cannot be so foolish as not to demand the birth certificates of the children, if they exist. The first time that, following your advice, I asked Mr. Reverdy that question, he replied that the children were well, thank God, an answer that justified any suspicions.

Now there remains for me to speak of M. Reverdy's conduct in my regard. This is even more serious. The first time that M. Reverdy came to Flagey, he told us that it was none of our business what he did for a living. Those words are no less obscure than the children.

What is clearer is that when it is all over they claim that the authorities made them responsible for my management and my property, whereas the authorities no longer have any jurisdiction over me, as I have paid my court costs and served my prison term and consequently am as free as you, unconditionally.

I would like to know by what right M. Reverdy is answering for me in the business of the court costs for the Column. Does he want to pay the

25,000 francs for me or serve the five years of prison or exile that nonpayment entails? I would like nothing better. I doubt it and yet I read it in the papers. No, M. Reverdy must leave me alone, me and my friends; my sister must stop her letter writing and her perfidious insinuations, which are incapable of creating confusion and hatred among my sisters, my friends and myself. She has nothing to gain from that game. I'll prove it to her sooner or later. Even if she were to win you over in some unwholesome way, which I doubt, for I trust your judgment, she wouldn't advance her interests at all, she must be made to understand that. We have more character than she has audacity.

My sister feels that she has been harmed in money matters. She is wrong. She has received more money than my other sisters have spent at home while working. If she wants more, we should pay my sisters wages for their services.

As for my paintings, about which they fret so much, they don't have to bother. They are in safe-keeping in America,[3] secure from any legal action, and had it not been for their ill will, my atelier in Paris would not have been attached.

They have my entire dossier on the Column and the statement that I wrote on the subject.[4] I cannot redo it. They reply to that that they have handed it over to the authorities. I would like to know by what right and to what authorities. I'll be obliged to take them to court to get those documents. My case cannot be heard without them. It is causing tremendous prejudice against me and prevents me and my lawyer from arguing my case. It is sad to have people like them in one's family. I would like you to tell them, and very firmly, that they are not to bother with the family's honor or with mine. They should just see to their own. I embrace you and Zélie as well.

<div align="right">*G. Courbet*</div>

You can read this letter to the Reverdys if you can't manage any other way, I don't care. What I say is only reasonable.

1. On March 1, 1858, Zoé Courbet had given birth out of wedlock to a son by the name of Eugène-Jean-Charles; a second son was born on May 30, 1860, under the same circumstances. The father of both sons must have been Eugène Reverdy,* but his name is not mentioned in the birth registers. It was not until August 11, 1868, that Zoé and Eugène Reverdy were married. More than a year later, on January 9, 1869, the couple officially recognized their two sons. On the subject of Zoé Courbet, her children, and her marriage to Eugène Reverdy, see Grimmer (1956).

2. Courbet appears to be correct here. There is no evidence that Zoé had any children other than the two sons mentioned in note 1.

3. Nothing is known about the shipment of Courbet's paintings to America. It may be an untrue statement, intended for the eyes of the police who might open his mail. If he did send paintings to America, it must have been a small number and not, as this letter suggests, the bulk of the paintings that were left in his Paris ateliers.

4. See letter 73-47, n. 2.

73-49 *To his father, [La Tour-de-Peilz, winter 1873–74]*

Dear Father:

Your weakness could cause us a lot of trouble. It is out of the question for M. Reverdy,* in spite of his affectionate behavior (which [in fact] is distasteful to us), to impose his family of four persons on our home.¹ He absolutely must respect everyone's freedom and assume responsibility for his family. Moreover, neither you nor I can sanction a profession like his,² which can bring disasters to the country and to various people.

As for me, he must leave me alone. Let him practice on others, I have had my fill. I don't need a guardian or a manager. As for what belongs to me, I'll do with it what I please, they have nothing to do with it. I also hope that you will come to see that in a house where one can barely make ends meet, one does not assume responsibility for four people and one does not sell all one's assets during one's lifetime in order to live as M. Reverdy wishes, while leaving nothing after one's death. I say nothing more about it. I embrace you again.

G.C.

1. Zoé and Eugène Reverdy and their two sons. Compare letter 73-48, n. 1.
2. It is not known what profession Reverdy assumed after his move to Ornans.

73-50 *To the editor-in-chief of the* Gazette de Lausanne, *Vevey, October 26, 1873*¹

Vevey, October 26, 1873

Monsieur le Rédacteur:

My attention has been drawn to your issue of the 15th of this month in which, in an account of M. Ranc's trial,² there is a statement that is slanderous toward both him and myself. Though I am not in the habit of responding to these kinds of attacks, I cannot let this one pass by in silence, in a country that is giving me asylum.

Permit me, therefore, to present in your paper the historical account of the very serious matter of which I am accused, when it is said that "M. Ranc was present at the looting of M. Thiers's* house, in the company of Courbet."³ This way, the public will be enlightened about one of the charges that have been unjustly leveled against the Paris Commune.

The destruction of the Vendôme Column was decreed by the Commune eleven days before I entered the Chamber and it was the Committee of Public Safety, of which I was never a member, that ordered the demolition of the Thiers house, at a time when the members of the minority, to which I belonged, had already resigned.

But as I was "president of the arts of every kind," appointed by the September 4 government and by that of the Commune, I had to intervene any time there were questions concerning them, and furthermore, M. Barthélemy-Saint-Hilaire[4] had written me a letter in which he asked me to save the works of art contained in the house of the president of the republic, who himself had once asked me to appraise those objects in his gallery.

I read M. Barthélemy's letter to the Commune, and, appraising those objects ideally, in the light of an intimidation I wanted to bring to bear against a brutal measure, I estimated them at the fictitious amount of 1,500,000 francs.[5] M. Barthélemy-Saint-Hilaire told me in his letter that M. Thiers proposed to bequeath them to the Louvre after his death. In acting as I did, I was doing my duty as president and consequently as guardian of the arts.

I managed to carry the day and was delegated, along with two members of the Commune, to see to the protection of those objects, and of the furniture, the library, etc. M. Fontaine, curator of the Furniture Depository, was naturally responsible for their transportation.

We did not spare any necessary precautionary measures and we established the absence of only a few small statuettes that were missing from their pedestals. I found two of them among the rubble, which I restored later to the collection. That made me think that the others might have been lost the same way. All the rest of the furniture was carefully packed by the employees of the Furniture Depository and transported by that institution's conveyances. So, during the alleged looting (where I did not see M. Ranc), I established the disappearance of these five or six statuettes only. The ones that I found, and which were terra cottas, could have come from Pompeï. They were not worth much. Next, we went to the Furniture Depository, to make sure that the objects were receiving the greatest care and to ascertain that they were placed in a safe location.

I am all the more validated in the statements that I am making here freely and dispassionately, as they were made before the War Council for twenty-nine days, at the same time as the business of the Column, which is no more true, as far as I am concerned, than the looting of M. Thiers's house. In both cases my protective intervention was the same, which I will prove later on. But I was unable to achieve the same results.

Monsieur le Rédacteur, please be so kind as to publish this letter in one of your upcoming issues.

Sincerely yours,

Gustave Courbet

1. This letter, which appeared in the *Gazette de Lausanne* of October 27, differs significantly from a signed draft, dated October 16, of which the text follows below:

Vevey, October 16, 1873

To the Editor of the *Gazette de Lausanne*

Monsieur:

In your October 15 issue you present some particulars about M. Ranc's trial; and as my name is mentioned therein in an unseemly manner, I believe I should send you some observations, strictly on that point.

As M. Ranc has deemed it inappropriate to defend himself, it is not up to me to enter into his case by defending him myself before a public that in general accepts all too easily the accusations brought against the men who are devoted to the Republican cause.

The correspondence that you reproduce claims that M. Ranc 'was present at the looting of M. Thiers's house, in the company of Courbet.'

Here, M. le Rédacteur, I leave it to the War Council to form an opinion and make assertions on his political conduct, as I don't believe the moment has yet arrived to exonerate the Commune as well as its actions and deeds. But I appeal to your judgment and that of your readers to evaluate this particular issue: the decree for the destruction of the Vendôme Column predates by eleven days my entrance into the Chamber of the Commune and the one mandating the destruction of the house of Thiers was issued by the Committee of Public Safety, the formation of which was contrary to our opinions and motivated my resignation as well as that of the minority group of the Chamber on May 15, 1871. But, appointed "president of the arts of every kind" by the artists' vote, ratified by the September 4 government and later by that of the Commune, I had to intervene in that affair as conservator, the more so as M. Barthélemy-Saint-Hilaire begged me in a letter to save the art objects belonging to M. Thiers. The latter had himself invited me to admire them, at his home, at a time preceding those events. I read that letter in a meeting of the Commune and subsequently I appraised the value of those objects ideally at the amount of 1,500,000 francs. I tried, by exaggeration, to oppose their destruction as I knew, on the one hand, through the letter of M. B.-Saint-Hilaire, that M. Thiers intended to bequeath them to the Musée du Louvre after his death and, on the other hand, that the Commune had to safeguard material interests like all others. Finally I did my duty as guardian of the arts.

My tactics succeeded, and I was immediately delegated, along with Messrs. Vallès and Félix Pyat, to preside over the execution of the preservation measure, which was to extend over the library and the furniture in general.

Vallès and I went to the spot, where we found Messrs. Fontaine and Andrieux, delegates from the Domain Administration and Public Services, who were already occupied with the transport in the conveyances of the National Furniture Depository, where everything was being transported in the greatest order. We posted national guards at all the entrances to the house to prevent theft, and we could establish the removal only of some statuettes, 10 to 12 centimeters high, as the pedestals were empty. They had been removed the day before, according to M. Fontaine, by some maniac collectors who had taken them along as souvenirs.

Subsequently Vallès and I went to the Furniture Depository, where we recommended that they take the greatest possible care with the obects of M. Thiers and to place them in a safe location, which was done under our very eyes.

What follows from these facts is that, when the house of M. Thiers was demolished, there was no looting, and if I have had to intervene in this troublesome affair, it was to fulfill my duty as guardian of the arts and, consequently, with intentions

that were diametrically opposed to those attributed to me by the War Council following your correspondent. What followed also is that later M. Thiers received from the National Assembly an indemnity of one million based on the inflated estimate of 1,500,000 francs that I had made of his property on the place Saint-Georges.

I am the more validated in these statements as they were made and discussed by the War Council for twenty-nine days. That gratuitous slander has as little foundation as the other reproaching me to have demolished the Column for which I have made the same efforts without having the same results.

As for M. Ranc, I can affirm that I did not see him in the course of those operations.

Sincerely yours

Gustave Courbet

2. Arthur Ranc* was prosecuted in 1873, after he had been elected to the Chamber of Deputies. He fled to Belgium, was court-martialed in absentia, and sentenced to death.

3. About Courbet's role in the demolition of the house of Adolphe Thiers, see letter 73-5.

4. Barthélemy-Saint-Hilaire* was, at the time, a member of Thiers's government.

5. At the meeting of the Comité du salut public of May 12, 1871, Courbet had indeed estimated the value of Thiers's collection of bronzes at that figure (cf. Bourgin and Henriot 1924–45, 2:360).

To Jules Castagnary [La Tour-de-Peilz, December 1873]　　　　　　　　73-51

My dear Castagnary:

My brain is so muddled that neither M. Ordinaire* nor I have the heart to do this insane job over again. We got to the end of it by hook and by crook.[1]

All that is left [to be done] are some general remarks, which you can do better than we. Nonetheless, we will write you a few more ideas.

My dear friend, when one has started off badly, one can't make it up anymore. To make matters worse, it had to be M. Lachaud* who will plead my case. He is quite likely to say that the empress, M. Bismarck, and Prince Charles[2] have great esteem for me, so that I will have a fine standing among my crowd and the Communards in particular! Oh well, it has to be gone through. Lachaud has already received an advance of three thousand francs. Read the December 16 *Rappel* on the Column. I hope that Lachaud will once more postpone the trial, which was scheduled for the end of this month. The longer it is delayed the better. Nonetheless, please find out from the attorney[3] so that we can print this statement before the trial. I was never able to get from my sister, who is mad, I think, the [original] statement, which is more complete than this one.

We are very well here. We will be having an exhibition of paintings in

Geneva in a shop.[4] We have done many landscapes, one cannot do anything else in Switzerland.

With a heartfelt embrace and kind regards to our friends,

G. Courbet

M. Ordinaire, who sends his greetings, will write you.

1. Sometime during the early fall of 1873, Castagnary had asked Courbet to draft a memorandum on the Vendôme Column affair, which he intended to have printed in the form of a pamphlet for distribution to the justices of the tribunal that was to hear Courbet's case. Courbet, together with Edouard Ordinaire, prepared some notes, which they sent to Castagnary to be edited. In a letter of December 21, Castagnary informed Courbet that he had received his notes, which must have been sent to him a few days earlier. Though in subsequent letters to Castagnary mention is made of the pamphlet repeatedly (see letters 74-7, 74-8, and 74-9), it appears that it was never printed, largely because Courbet's lawyer Lachaud was against it (see letter 74-9). In 1875, before Courbet's appeal hearing, the idea for the pamphlet was revived, but, again, it did not materialize. It is possible, however, that Courbet's printed letter to the Republican deputies and senators elected in February 1876 (cf. letter 76–8) was the final outcome of the pamphlet idea.

2. Prince Frederick Charles of Prussia.

3. Charles Duval.*

4. Perhaps in the art supply store of Paul Pia.*

74-1 *To Jules Castagnary, La Tour-de-Peilz, January 2, 1874*

La Tour-de-Peilz, January 2, 1874

My dear Castagnary:

I received your three letters. From what you say, the first two did not require urgent replies. You can keep writing me c/o M. Dulon,* pension Bellevue. Of course, I am always at your disposal, to provide you with any useful information.

It is a fact that around September 15, 1870 (get the exact date[1] from Amand Gautier,* the painter; from the Ottins, sculptors;[2] from Moulin,[3] the sculptor; from père Laveur's,* who can inform you better than I as they were my delegates), I became president of the arts, that is to say, a man who must give orders and not carry them out himself. In that capacity I fulfilled the duties that were called for by my office. In order to achieve that end I organized my committee[4] in such a way that I think no one could fault me for how responsibilities were allocated. I thus divided up my colleagues on the committee in order to proceed with the rescue of all art objects, notably those of St.-Cloud, Meudon, Sèvres, Malmaison, St.-Germain, Fontainebleau, and Versailles. I was never aware that M. de Kératry,[5] as police commissioner, was working toward the same end through M. Commissaire,[6] who had been appointed by him for the purpose, though I don't deny that he, for his part, did his duty in that instance.

When the regular troops entered Paris, all my letters were stolen from Mme Girard's,* where I was living, in the passage du Saumon. She alone, who was a police spy, was the person who gave away my hiding place. It was she, too, who stole the capital assets that you know from my atelier, which could be assessed at one hundred fifty thousand francs. Thus, I cannot produce Barthélemy-Saint-Hilaire's[7] letter or other, even more important documents, such as, for example, the letter from M. de Gilly, M. Gustave Mathieu's* friend. On the advice of the latter I had lent him [M. de Gilly] two paintings in order to help him make a success of a small tearoom on the boulevard behind the new opera house. That crook, who already went bankrupt once before when he exported hats to London, is feeling the need, at this moment, to steal those two paintings, which I lent him out of the goodness of my heart. You know the canvases: one represents a woman playing with a dog by the side of stream [F. 631] and the other a Puits noir landscape.[8] Gilly claims to have already sold one of them and also asks me eighteen hundred for the locale. Thank M. G. Mathieu for having involved me in that scheme! I did not think he could involve me in a business of that kind, as he has always been extremely careful. Mathieu could be useful in regard to Gilly, getting back my possessions, especially as I have an IOU from Gilly that I will find sooner or later.[9]

I am very glad that you found a luminous and demonstrable explanation of my business. It will be a great pleasure to paint you a landscape of the Lake of Geneva, as soon as I am able.[10] You know, my dear friend, that I have always been at your disposal in matters like that.

I tell you again that M. Saint-Hilaire told me in his letter that he turned to me for help, on behalf of M. Thiers,* in saving the latter's art objects, which you know as well as I, because M. Thiers intends to bequeath them to the Louvre after his death.

Write us. With cordial regards and best wishes for the New Year,

G. Courbet

1. The exact date was August 6, 1870.

2. Auguste-Louis-Marie Ottin (1811–90), and possibly his son, Léon Auguste, though he seems to have been primarily a painter and stained-glass artist.

3. Hippolyte-Alexandre-Julien Moulin (1832–84).

4. For the composition of that committee, see letter 70-25, n. 1.

5. Comte Emile de Kératry (1832–1905) was police commissioner of Paris from September 4 to October 14, 1870. He escaped the besieged city of Paris by balloon.

6. Sébastien Commissaire (1822–1900) had been appointed, after September 4, 1870, curator of the castles at St. Cloud and Meudon.

7. The letter from Jules Barthélemy-Saint-Hilaire, in which Courbet had been asked to use his influence to save the art collection of Adolphe Thiers.

8. The work cannot be identified with certainty.

9. Nothing is known about the Gilly affair other than the information provided by Courbet in this letter.

10. Courbet was to paint for Castagnary one of his numerous versions of the *Château de Chillon* (F. 990).

74-2 *To Paul Pia, La Tour-de-Peilz, March 20 [1874]*

Tour-de-Peilz, March 20

My dear Pia:

Tomorrow or the day after, don't fail to send either the *Calf* [F. 880] or the *Fish* [F. 885] (preferably the *Calf*) to the London exhibition,[1] with or without frames, to M. H. S. Murcott, gilder, 16 Hanover Street, Longacre (London), postage paid by Belgium. Write on the back of the stretcher of the canvas: *Swiss Calf.* Send it by mail, postpaid, by all means with the frame, if it is finished. If not, write M. Murcott a wire to get him the measurements of the canvas immediately, so that he can make one. The last day it can be received is March 30. In London they make frames in six days.

I sold fourteen thousand francs' worth of paintings to M. Conway* at the Lausanne station—it was impossible for me to take him to Geneva—it is fantastic.[2]

I will do the snow landscape next Monday. I will be working for the London exhibition until Saturday night.

Sincerely yours,

I received the two paintings. The *Circe*[3] has already risen to 200,000 francs in my head, I think it will reach 300,000.

G. Courbet

1. The paintings were probably intended for one of Durand-Ruel's* exhibitions in his London gallery in New Bond St. See also letter 77-9.

2. According to his autobiography, Conway visited Courbet in "midwinter" (perhaps January or February, 1874) to select a picture for Judge Hoadly (see Conway 1904, 1:251; and letter 73-13). Conway writes that he actually visited Courbet's studio (and not merely the Lausanne station) and does not indicate that he bought any work other than the one he commissioned for Judge Hoadly. In a letter to Courbet of September 1 [1874] (Paris, Bibliothèque nationale, Cabinet des estampes, Yb3.1739 [4°], b. 1), Conway likewise mentions only one work, the painting for Hoadly, which he promised to buy from him for five thousand francs. Though it is possible that Conway bought some additional paintings from Courbet on his own, it is more likely that Courbet misinterpreted Conway's enthusiasm after a visit to his studio as a prospect for some major commissions.

3. See letter 74-3, n. 4.

To Jules Castagnary, La Tour-de-Peilz, March 26, 1874

Tour-de-Peilz, March 26, '74

My dear friend:

Here is how I found out that Mlle Girard* sold my paintings. M. Bernheim,* another thief, who fills Paris with forgeries of my paintings, says to me, "I want to tell you something without being compromised." He gives me the address of a man in the rue Montmartre (I believe, for I cannot find it anymore) who had told him, "There is a self-styled mistress of Courbet (or at least one who claims to be)[1] who sells me his paintings dirt cheap. She brings them here rolled up." In my great haste to get the hell out, I left half my notes and papers hidden at your house. It would be worth a great deal to me now to have that address. Besides, Mlle Girard has a father and a brother, who is a thief who has returned from America, where he turned himself in. The above-named lady, who works for the police, set up her father, who is poor, in a room, and some cabinetmakers in the rue St. Antoine told me that he had some paintings there. She is the mistress of Joute,* the agent for the Franche-Comté ironworks in Grenelle, rue des Usines, next to Caille. She is the one who denounced me.

I remember now that I wrote M. Duval* with the name and address of the man who used to buy the rolled-up paintings from her, I am almost sure. Tell him to look among my letters. Perhaps it is Paupier. If it is Paupier he must still have the *Hare Brought to Bay* [F. 620] with the two dogs under the oak trees, and the *Man with the Hump* [F. 71?] of 1847, some self-portraits, female nudes, the *Bathing Sarah* [F. 433?], another small *Psyché* [F. 373?], a *Woman* with big tits with her feet in the water [F. 432 or F. 436?], a vertical *Nude Woman* with birds in the foliage [F. ?], etc., etc. As for the three nude women of '45 [F. 55? F. 56, F. 59], I cannot remember them well enough. It was at the time that I did that famous *Walpurgis Woman*, pursued by the young philosopher and guided by a djinn, an imp, [a painting] that I still miss.[2] I painted the *Wrestlers* [F. 144] over it later because I didn't have the money to buy a canvas, etc., etc.

If we knew Mlle Girard's address, we could find, at her place and at her father's, paintings of mine that she made out to be hers, just as she pretended that she was my mistress. Joute has shown an enormous weakness in this business. It seems that she even took some of these rolled-up paintings to the Ecole militaire to one of her friends. It was I who glued the head of *La Mère Grégoire* [F. 167] on that large canvas, again, to save money. It must have come off when the canvas was rolled up.[3]

I have just made an enormous find, it's worth at least three or four hundred thousand francs. It is a *Circe*,[4] I believe, summoning the demons and

setting fire to the temples. She has a magic wand in her hand and a book of spells in the other. She dances bewitchingly inside an enchanted cabalistic circle. The painting is composed of four figures, [including] three splendid demons. It is more beautiful than the *Antiope*,[5] and than Murillo's *Virgin*,[6] which was bought for 740,000 francs. The painting is 2.20 meters high and 1.80 meters wide. It is perfectly preserved and on panel.

Do some research at the Bibliothèque nationale, go take a look at the engravings, and have a photograph made, they allow it.

I cannot tell you more about it at the moment. The mail is going out. Kind regards to Baudry,* to Pata.* Get on with it! Sincerely yours,

Gustave Courbet

Write me and tell Duval to seize the paintings with a court order, only the well-known ones.

1. Courbet's letter is part of an exchange of letters with Castagnary about paintings stolen from his atelier in the passage du Saumon. Riat cites a series of letters by Castagnary in which the critic informs Courbet that, together with Baudry, he has found some of his paintings in the shops of various dealers. Though Riat implies that Castagnary wrote these letters in 1875, they were probably written in the spring of 1874 (see Riat 1906, 366; see also letters 74-6 and 74-5).

2. The *Woman of Walpurgis* or *Classical Walpurgis Night*, a large painting of 2.5 by 2 meters, was exhibited at the Salon of 1849. Courbet later reused the canvas for the *Wrestlers* (F. 144).

3. Castagnary had discovered the portrait *La Mère Grégoire* in a shop in the rue Neuve-Saint-Augustin. Informing Courbet about this in a letter, he told him that the head, painted on a separate piece of canvas, had come loose from the background (see Riat 1906, 366).

4. We learn from a later letter (74-8) that the *Circe* here referred to was a painting attributed to Pierre-Paul Prud'hon (1758–1823). The work is not known today.

5. No doubt the *Sleep of Antiope* by Antonio Allegri or Correggio (ca. 1489–1534) in the Louvre in Paris. Prud'hon, in the nineteenth century, was often compared with the Italian Renaissance artist.

6. The *Immaculate Conception of the Virgin* by Bartolomé Esteban Murillo (1617–82) had recently been acquired for the Louvre.

74-4 *To Paul Pia, La Tour-de-Peilz, March 26, 1874*

Tour-de-Peilz, March 26, '74

My dear Pia:

It pains me to see the new course you are trying to follow with regard to me. If you continue to do so, I would like you to note that you would be taking unfair advantage of my situation, which I cannot allow.[1]

You use a word in reference to me that I want to have framed, namely that I am "suspicious." That is cute! If I am afraid you are going too fast, I must rein you in.

I open your letters, and I read in one of December 9, '73, this paragraph:

"I consulted M. Richard, who will make up a dummy bill of sale in order to shield you from the rapacity of the French treasury. I will give you full security and all guarantees in another letter." I have seen no contract, no bill of sale, no signatures in front of witnesses.

Open your notebooks and you will see: such and such a painting, two thousand francs for you, one thousand for me in the event of a sale. That does not make it your property. In short, I want to remain the owner of my paintings as it has been understood from the beginning, even if it means that the French government can seize them. And my paintings, I affirm to you, are deposited with you only in trust, as I can prove by twenty people's testimony.

I am writing the Ordinaire* family, who introduced me to you and who are partly responsible for this matter, so that they may remind you of the accuracy of what I am telling you and of the intentions that guided us.

Let's go back to the beginning. You said to me, "Courbet, if you were to give me some paintings to sell, you would be doing me a favor, for I would also have some from other painters, and I could set my wife up in a little shop that I would rent in order to keep her busy on her end, while I would be busy on mine." I replied, "I am afraid that the French government would seize them from me." You replied, "We'll have a 'dummy' sale." It was at that point that we went to M. Anderny [?].

If you will believe me, you will no longer follow the course you are taking. I warn you that it will only serve to rouse the public's annoyance and to paralyze your undertaking from the start.

Sincerely yours,

G. Courbet

On Sunday I am going to Geneva with the Vevey choral society.[2] Come to your senses, my dear friend, for since last year I have been forced to sell paintings for cash only.

It seems to me that by depositing paintings in trust with you and by agreeing to provide them to you as you sell them (if I have some that are ready and suitable for you), I am not taking you lightly. When I place some with Durand-Ruel,* he has two millions' worth at his place. I am letting my paintings be spoiled and depreciated by exhibiting them like pheasants in a shop window. That is your problem, not mine. You think only of yourself, allow others to think of themselves too.

1. Courbet's differences with Pia are largely explained in the text of the letter. Apparently, Pia had requested that Courbet give him some paintings on commission. To avoid possible seizure, "dummy" sales were arranged with the aid of a certain M. Anderny [?] and a M. Richard, who were probably notary friends of Pia. Pia subsequently tried to take advantage of the situation by exhibiting and selling Courbet's works on his own terms, without consulting with Courbet.

2. Courbet had been involved in choral societies since his youth in Ornans. In Switzerland, he seems to have been in contact with several choral groups, including those of Vevey and Bulle (cf. La Tour-de-Peilz 1982, 88).

74-5 *To Etienne Baudry, [La Tour-de-Peilz,] April 3, 1874*

Friday, April 4, '74

Monsieur Baudry
Paris

The pictures you mention to me are definitely among the eleven pictures that you bought from me and that have been stolen from my atelier after the Commune.[1] Please be sure, dear friend, that I am still at your disposal to complete them as was agreed in principle.

With a cordial handshake and my compliments to your wife.

Yours

G. Courbet

1. The paintings that Baudry and Castagnary had discovered in a shop in the rue Neuve-St.-Augustin (see Riat 1906, 366; cf. also letter 73-28, n. 1).

74-6 *Authorization for M. Duval, Vevey, April 7, 1874*

I authorize my attorney, Monsieur Duval,* residing in Paris, rue St. Honoré no. 189, to prosecute, if need be, the detainers of those paintings of mine that were stolen from me at the passage du Saumon,[1] at the time of the Versailles government's entry into Paris, according to instructions that will be given him by my friends Messrs. Panis,* Baudry,* and Castagnary.*

Gustave Courbet

No. 267. The justice of the peace of the Vevey district attests to the authenticity of the signature appended herein above to confer power of attorney, by M. Gustave Courbet, whose identity has been attested to by M. Dulon,* retired minister.

Vevey, April 7, 1874

Justice of the Peace,
Maillard.

1. From the boarding house of Mlle Girard.*

74-7 *To Jules Castagnary, La Tour-de-Peilz [April 9, 1874 (Ad)]*

Tour-de-Peilz

My dear Castagnary:

I am delighted with the statement that you were kind enough to write out

from our notes.[1] There are some things that are dangerous: when you deal with the Commune and other forgotten things, such as, for example, the decree of Jules Simon, who wanted to take the *Napoléon* down from the Column to use it for a bronze casting of the stone figure of the *City of Strasbourg* that is on the place de la Concorde.[2] I was against it, on the grounds that the Column had to be moved and that the operation of taking down the bronze would have cost as much as taking the entire Column apart, for it would have required a scaffolding. I wrote an article to that effect that was placed in the *Rappel* by the writer Puissant, in September, between the 10th and the 20th, as far as I can remember.[3] It will be easy to find that article, which is very important. Later, as I did not want to change my idea for the Commune's, I went to the Chamber, though I was no longer a member, to make my observations as president of the arts, in order to oppose the Column's destruction.

As you have said it so well, the *Officiel's*[4] shorthand reporters and editors very often had us speak according to their own ideas and in the way that they themselves understood the revolution.

I was so sure of my nonparticipation in the destruction that I stated at the time, in a letter to M. Jules Simon from my cell in Versailles, "If they can prove to me that it was I who destroyed the Column, I will take it on myself to have it put back up at my expense," words that had a great deal of repercussions and that prove sufficiently that I am not the man behind the act.[5]

On another subject, I am sending you M. Duval's* letter so that you can use it to your advantage, for I perceive in it M. ___'s[6] conceit as well as some future expenses resulting from a new trial. When you bring Duval the enclosed authorization that he asked me for, try to come to an agreement with him about the advisability of printing or not printing the statement. Tell Duval that I am not as expert as you in juridical matters and that I make you my counsel in this matter, in view of the fact that I am so far away.

I don't see any dangers to which I am exposing myself by producing the statement. Please also ask M. Duval for the address of the first fence of my paintings, which I sent him in one of my letters. I don't have that address here and I would like to have it.

I am quite delighted with the concern that you, M. Baudry,* and M. Panis* have shown me. The latter was charming to take the trouble to come see me, and if the occasion presents itself whereby I can do anything to please him, I am entirely at his disposal.

As for the paintings, you can involve the four paintings[7] in the proceedings since they are being sold as mine, and I hope that, thanks to your cooperation, you'll be successful both in this business and in the one concerning Gilly,[8] a swindler to whom I was only of service and to whom I owe nothing. I have a paper signed by him that establishes that the paintings were only deposited with him to oblige him.

Affectionately, dear friend. Kind regards to our friends. See about that engraving of *Circe* [9] at the library.

<div align="right">

G. Courbet

</div>

1. Compare letter 73-51, n. 1.
2. See Riat (1906, 288).
3. Courbet seems to be mistaken. The article he refers to here is probably identical to the letter published in *Le Réveil* of October 5, 1870 (cf. letter 70-32).
4. The *Journal officiel*, the official government paper.
5. See introduction, n. 13. Courbet made a very similar offer to Jules Grévy. See letter 71-20.
6. Though the name is left out, Courbet no doubt means Lachaud.
7. Probably a reference to four paintings by Courbet, stolen from his lodgings in the passage du Saumon, discovered by Baudry and Castagnary in a frame shop in the rue Neuve-St.-Augustin (see Riat 1906, 365–66).
8. Compare letter 74-1.
9. Compare letter 74-3, n. 4.

74-8 *To Jules Castagnary, La Tour-de-Peilz [April 13, 1874 (Ad)]*

<div align="right">

La Tour, Monday

</div>

My dear friend:

I read in the *Journal illustré* of Sunday, March 15, an article announcing an upcoming exhibition at the Ecole des b.- arts of all Prud'hon's works. Among the paintings announced I find none that can compare with the one I own.[1] As I already told you, it is 2.20 meters high by 1.84 meters wide and combines Italian composition with French realism and sentimentality. I have never seen such flesh in a painting: imagine the *Woman with a Parrot* [F. 526], more delicately modeled but nevertheless in the grand historical style. It is impossible to organize a comprehensive exhibition of the painter without having first seen this painting, which is in La Tour. They can send a representative of the Fine Arts Administration to find out for themselves. I was informed by a collector that the engraving after this painting is to be found in Leipzig. I do not know whether you found it in the Bibliothèque nationale. In any case, the discovery of this painting could be the subject of an interesting article for you.[2]

I have, in addition, a life-size Watteau, a Girardon, a Steen, two female heads by Guido [Reni], [and] a Tintoretto[3]—a large composition on a small canvas. It is a pity that you cannot find the time to come see me, as you promised. Don't you have Easter vacation?

I'll attempt the experiment of [having] a photograph [made] in Vevey. If it comes out well, I'll send it to you. Whatever the quality, it will give you an idea.

 I have heard nothing from you, Panis,* or Etienne Baudry,* or about my

paintings that they found. Tell them to act forcefully, not to let themselves be intimidated. Go and see my idiot attorney and start printing the statement no matter what he says.⁴ Add to it the most recent thoughts that I sent you⁵ and tell me whether my trial is coming up next Friday.⁶ It worries me so much that I am unable to work. In the last year they have made me lose more paintings with that iniquitous trial than it would take to put the Column back up twice.

See also about M. de Gilly.⁷ Threaten him with the paper I have of his.

Sincerely yours, dear friend. I await news of you. Best regards to our friends.

<div align="center">

G. Courbet

</div>

1. The painting of *Circe*, attributed by Courbet to Prud'hon, was mentioned in several earlier letters, including 74-3 and 74-7.
2. Castagnary indeed became interested in the work and corresponded about it with Camille-Constantin Marcille (1816–75), curator of the Musée de peinture in Chartres. The exchange of letters between Castagnary and Marcille may be found in the Cabinet des estampes of the Bibliothèque nationale in Paris (Yb3.1739 [4°], b. 2).
3. The attribution of these paintings, which formed part of the collection of Old Master paintings that Courbet had bought in 1870 (cf. letter 70-13), is doubtful.
4. Compare letter 73-51, n. 1.
5. Perhaps a reference to the remarks made in 74-7.
6. Courbet's trial was not to come up until June 19.
7. Compare letter 74-1.

To Jules Castagnary, La Tour-de-Peilz, April 28, 1874 74-9

<div align="right">

La Tour, April 28, 1874

</div>

My dear Castagnary:

M. Lachaud* is a very ambitious man, an imperious and unsociable man. Granted those attributes, I understand him up to a point. He is telling himself, "If M. Courbet acts in his own defense, he does not need me." Your idea to have the statement printed without distributing it is very good. I am all for it because it will be remembered, alas, and we will still have time to distribute it.¹

When I prevented Jules Simon from taking the statue of Napoleon as Roman emperor down from the Vendôme Column in order to cast the *City of Strasbourg* in bronze for the place de la Concorde, the article that Puissant wrote at my dictation stated: "that as all the cities of France were going to do their duty, as a result, by the end of the war the place de la Concorde would have been turned into a Barbedienne warehouse."² For you understand that those bits of stone do not deserve bronze. One might as well have bronzed the Office of Naval Administration, seeing that all the sailors were the heroes of the siege. Moreover, the scaffolding would have cost the same amount as

the dismantling of the entire Column. The bronze would have been too expensive.

The article was placed during the first two weeks of September, either in the *Rappel* (ask little Pelletan), or in the *Avenir national*, or in Rochefort's *Lanterne* (ask the editor-in-chief), or in the *Journal du père Délécluze* (likewise ask the editor-in-chief),[3] but in any case you can cite the above underlined phrase,[4] which still proves that in keeping with my role as conservator, I did not want to destroy anything. In addition, something that has been forgotten, as I was no longer a member of the Commune, I was asked by the [Committee of] Public Safety for the plaster casts of the Column, which I knew to be in the cellars of the Louvre. I never replied to that and I refused at risk to myself.

I will send the statement to M. Ordinaire* as you asked me to. Beware his weakness, for he sometimes displays a dangerous candor.

Herewith enclosed, a photograph of the painting[5] that I will title more simply the *Sibyl* or the *Sorceress*. I maintain that the painting is by Prud'hon, but the photograph came out very badly, without any modeling. Our photographers cannot reproduce paintings, they are not equipped for it. This will give you enough of an idea for the research that is to be done, either in the Biblioth. nation., or in the Bibl. des beaux-arts, or the Leipzig library. Besides, the director of the Napolis, who sold the painting as well as other objects from the Château Castellan in Marseilles, states in his catalog that it is by Prud'hon.[6]

Baudry* is quite right to let himself be sued:[7] that way he does not have to spend anything. I promise to uphold his right on this occasion, and you know that one recovers one's property when one finds it: that is the law. I have no news of M. Baudry so far.

The first trial will determine guilt, if there is cause. The second trial, in case of a guilty verdict, will determine the part that I have to pay for the reerection.

Sincerely yours, my dear friend, and regards to our friends,

G. Courbet

I also know of a signed portrait by Prud'hon. It is in Geneva. It is a man's portrait. Tell me whether I should buy it in the event that it is inexpensive. My painting is superior to Murillo's *Virgin* as painting, even though it cost 740,000 francs.[8]

1. On the statement, see letter 73-51, n. 1.
2. Compare letter 70-32.
3. Actually, the letter appeared in *Le Réveil* of October 5, 1870. See also letter 74-7, n. 3).
4. Here in quotation marks ("that as all . . . warehouse").
5. The so-called *Circe* attributed to Prud'hon (cf. letter 74-3, n. 4).
6. No information about this sale is available.

7. Perhaps about the stolen Courbets belonging to him that he had repossessed (see Riat 1906, 366).

8. Compare letter 74-3, n. 6.

To Etienne Baudry, La Tour-de-Peilz, June 2, 1874 **74-10**

La Tour, June 2, 1874

My dear Baudry:

I am extremely grateful to you for the trouble you are taking with respect to my affairs; as for M. Dubourg,[1] it is unfortunate to be in the situation in which I find myself vis-à-vis the government, for in ordinary times I would not have to pay anything to M. Dubourg, and it would be up to him to appeal to his vendor, whom he knows quite well, in spite of what he says. These paintings have been sold dirt cheap by Mlle Girard,* who was the thief. At this point, let us try to make the best of things as my attorney[2] has not wanted to give me the address of the person who had bought them from her. Do as you think best, at the very least as you put it so well. I give you complete authority, as I don't know any better than you what price to ask. The amount can be discussed on the spot. Begin with two hundred francs per painting: M. Dubourg should lose as much as I on this deal.

As for M. Durand-Ruel* versus the French State, that cannot be anything but a sham.[3] He must say that they were paintings that could not be sold because of their subject and that he had been forced to part with them for a hundred francs apiece as he had no room in his place to keep them any longer. See what Durand thinks of the proposition and if there is a way to come to an understanding on that basis.

As far as M. Panis* is concerned, I am at your disposal, as I have already written you, to repay the cost of his trip to Switzerland[4] and to give him a present for his extreme kindness. I will send you that money or else I will let you have some landscapes that you will be able to sell to some dealer. Since you plan to come to Switzerland,[5] you could perhaps advance that money, and we'll settle here during your visit.

I have nothing special to add. My answer to your letter is a few days late because of an outing that I made: I have just come back from a trip to the Oberland.

I repeat my thanks for your concern on my behalf, and, my dear Baudry, I send you my warm greetings as well as to Madame, to Castagnary,* and to the usual friends.

Gustave Courbet

1. M. Dubourg was probably the owner of the paintings Baudry and Castagnary had discovered in the rue Neuve-St.-Augustin (see Riat 1906, 366). It appears that Baudry's efforts to buy the paintings back at a reasonable price were successful.

2. Charles Duval.*

3. In a letter of May 21, 1874 (Paris, Bibliothèque nationale, Cabinet des estampes, Yb3.1739 [4°], b. 2), Baudry had written to Courbet that Durand-Ruel had told him that the government would oppose the payment due to him for the recent sale of two paintings, including the *Portrait of Proudhon* (F. 443). Baudry advised Courbet to buy them back himself.

4. Panis had visited Courbet in April 1874. See letter 74-7.

5. Baudry's long-announced trip to Switzerland was not to take place until the very end of April 1875.

74-11 *To Paul Pia, [La Tour-de-Peilz,] June 2, 1874 (incomplete)*

. . . Begin immediately by taking whatever you have of mine to Seren [?] and erase the consignment entries from your books. You will say that you gave them back to me. We will be looking into the matter of dummy sales. . . .

M. Blanc had some of the administration's employees fired.[1] . . . M. Margerat delivered a suit of clothes for one hundred francs. . . .

1. Charles Blanc (1813–82), who had succeeded the comte de Nieuwerkerke as director of the Fine Arts Administration, had resigned in 1873. Courbet must refer here to an event that took place in the past.

74-12 *To the editor of the* République française, *Geneva, June 16, 1874*[1]

Geneva, June 16, 1874

To the Editor-in-Chief of the *République française* in Paris
Monsieur le Rédacteur:

I[2] read in your issue of June 16 "that a fake-Courbet factory has been established in Geneva (Switzerland)."

As I have recently opened a painting shop in Geneva in which several paintings by Gustave Courbet are exhibited, I would appreciate it if you would be so kind as to state in your estimable paper that my shop, located at 28 place de l'Entrepôt (rue de Mont Blanc), has nothing to do with the den of fake Courbets to which you refer.

Respectfully yours,

Paul Pia

P.S. They make more than just fake Courbets in Geneva, they also make fake Corots, fake Daubignys, and fake Rousseaus, even fake Regnaults and fake Calames—for those who care.

[Signed]
Approved, G. Courbet

1. Letterhead: "Paul Pia, 28 Place de l'Entrepôt (Rue du Mont Blanc), à Genève. Peintures et objets d'Art."

2. This is a letter jointly written by Paul Pia, who wrote the body of the letter, and Courbet, who wrote the postscript.

To Charles Monselet, La Tour-de-Peilz [June 22, 1874?][1] <u>74-13</u>

La Tour, Monday

My dear Monselet, old friend:

I am very happy to see in *L'Evénement* that you are coming to the rescue by trying to decry that iniquitous trial that has no other purpose than to distance me from you and from France.[2] You have been very intelligent as usual. In the beginning you let me think as I would without making useless efforts to help me, respecting my way of thinking even though it was the opposite of your own. Now that the whole thing is over, you come to my aid and reach out a brotherly hand to me. This brings me joy in my sorrow and already reconciles me a little with mankind.

Urge Carjat* and other friends who have a say in the matter to lend a helping hand, for at the moment my fate is in the balance. With a single word it can be tipped to one side or the other, like the wedges that pushed the Vendôme Column.

I give you a warm handshake. Needless to say, I would like to see you again, were it for only an hour.

Give kind regards to all the friends who take an interest in me and much love to you,

Gustave Courbet

[Address] La Tour-de-Peilz, near Vevey
c/o M. Dulon
Hôtel Bellevue

If you want to answer me write care of Monsieur Dulon.*

1. It appears that this letter was written in the course of the hearing of Courbet's case by the civic tribunal of the Seine Department, June 19–26 (see Riat 1906, 363). As the letter is dated "Monday," it was probably written on June 22.

2. Charles Monselet had written an article in Courbet's defense in *L'Evénement* of June 20.

To Etienne Baudry, La Tour-de-Peilz [June 29? 1874][1] <u>74-14</u>

La Tour, Monday

My dear Baudry:

I am delighted with all you are doing for me. You are a very kind friend. Without you and Castagnary* I don't know what would have become of me.

We are now very much at ease: all the seizures of the state are irregular.[2] You can freely take at this moment the two paintings at Durand-Ruel's* as well as others of mine he may still have (look at his books), and have them transported to your place without fear and without pay.

As for M. Dubourg,[3] a court order was sent last year to M. Durand-Ruel

as well as to the auctioneers not to accept any of my paintings that were stolen when the Versaillese entered Paris. In view of that bill of indictment and in view of the tribunal's reexamination that has just taken place, it is impossible that M. Dubourg has any rightful claim at this moment. Besides, M. Legrand* must have told you that (14 rue des Martyrs). He sent you a telegram to that effect from La Tour-de-Peilz. M. Legrand knows now where all my other stolen paintings are, including the large [*Self-*]*Portrait* of 1842 with my hand under my chin and the leather belt [F. 93], to which I am very attached. With prudence you will still be able to regain possession of all those paintings. We must take advantage of the tribunal's decision without delay.

As for the paintings that are left in the rue Hautefeuille in my atelier, and as for the furniture, you'll be able to have everything transported in a moving van at your convenience either to a factory outside Charenton or anywhere else. On that score, come to an arrangement in my best interest with Castagnary and with my attorney.

With kind regards, my dear Baudry, and greetings to your lady as well as Castagnary.

Gustave Courbet

1. Courbet's letter was obviously composed in the wake of the decision of the civil tribunal of the Seine Department on June 26. As it is dated "Monday," it was probably written on June 29.

2. After a week of hearings, Courbet, on June 26, was declared an accomplice in the demolition of the Vendôme Column "by abusing his authority." A complex ruling was made with regard to the sequestration of his property whereby some attachments were declared valid, others invalid. For the details of the ruling, see Riat (1906, 363).

3. Compare letter 74-10, n. 1.

<u>74-15</u> *To Jules Castagnary, La Tour-de-Peilz [July 10, 1874]*

La Tour, Saturday

Dear friend:

I was in Lausanne[1] for a week and as your letter[2] arrived during that time I did not reply. There is no loss. It is not necessary for me to go to Geneva to pick you up at M. Baud's:* I will await you here at La Tour. If M. Baud wants to come with you, I'd be pleased. I am vexed that you did not come to Switzerland a day earlier because I have just now come back from taking my father back to the station. He was visiting me[3] and would have been delighted to see you and to talk with you about the insane slanders that my reactionary eldest sister[4] is spreading everywhere.

Send me a letter or a telegram letting me know what day and time you will be leaving for La Tour.

We'll talk about our friends and our business matters, about Baudry* and

Lachaud,* and about what course to follow, whether we appeal the existing suit or move for a new suit against the government,[5] for the question of the Column as regards myself can be considered only in the context of the September 4 government.

Sincerely yours, dear friend, I await you impatiently.

G. Courbet

[Address] M. Castagnary
c/o M. Baud-Bovy
170 Montbrillant
Geneva

1. Courbet appears to have had several contacts in Lausanne, including the painter Gustave Pétrequin-Dard,* who, like Paul Pia in Geneva, aided Courbet in selling his paintings (cf. letter 73-44).

2. Castagnary had announced his visit to Switzerland in a letter to Courbet dated July 3, 1874, in which he informed his friend that he planned to leave Paris on Thursday (July 9). See Riat 1906, 364.

3. Régis Courbet appears to have visited his son in Switzerland several times (cf. La Tour-de-Peilz 1982, 41).

4. Zoé Reverdy.*

5. Compare letter 74-14, n. 2.

To F. Dulon, Fribourg [August-September, 1874] 74-16

Fribourg, Wednesday

Dear Monsieur Dulon:

Castagnary* left for Basel.[1] I was unable to follow him, the hot weather had given me liver trouble. I stayed in Fribourg to accept various invitations.[2]

Yesterday I was invited by a few magistrates of the city, among them Professor Majeur, to attend the general distribution of prizes in the city schools. I distributed to the young girls and boys more than a hundred books with gilt everywhere, to the great joy of the inhabitants of this city. It was wonderful!

The Gymnastics Society has just made me a member of their delegation to the Zürich games.[3] There are sixty of us, [complete] with sashes and banners. We'll go from there to Lucerne, to Rigi, to Interlaken or to Schaffhausen, to Basel, etc. Our permits are for seven days. We'll be leaving Saturday morning at 8 o'clock.

If anyone from La Tour is going there, I would like him to bring my umbrella. I don't need anything else. One more thing, I have had some shirts made in Fribourg. If I have letters or anything else, send them to me at the "Ostrich," care of M. Jacques Despont, in Fribourg.

With all these activities, and all the sentimentalities of every kind happen-

ing here,[4] including the trip, I cannot be back before the end of next week.

I have not written Pata* as I don't know if he is there. Regards to everyone in the house, especially your lovely family. Best wishes,

G. Courbet

1. Apparently, Courbet and Castagnary had set out on a trip through Switzerland together, but Courbet had stayed behind in Fribourg.

2 Courbet appears to have had several contacts in Fribourg, notably in democratic circles. In 1875 he was even made an honorary member of Fribourg's democratic club.

3. Competitions (in gymnastics, target shooting, choral singing, etc.) were popular in nineteenth-century Switzerland. Usually organized by one of the Swiss cantons, they served an important role in shaping a national consciousness (see La Tour-de-Peilz 1982, 99).

4. While in Fribourg, Courbet may have visited "Marcello" (Adèle Colonna*), and, at her home, he could have met Olga de Tallenay,* with whom he seems to have been briefly infatuated (cf. letter 74-19).

74-17 *To Chérubino Pata [La Tour-de-Peilz, fall 1874?] (incomplete)*

. . . We will expect you whenever it will be convenient for you to come back and see us. Kind regards to you and to your lovely and devoted wife, to your young lady whom I thank for her nice present, and to the good father. Tell him that I am smoking his pipe and that it burns very well now. Sincerely yours, my dear Pata. Don't let them put you in prison with the cretins on my account. . . . [1]

1. Pata had been interrogated during Courbet's original trial in 1871, and, as a known friend of Courbet, he may still have been a suspect.

74-18 *To J. Granger, La Tour-de-Peilz, November 22, 1874*

La Tour, near Vevey
Nov. 22, 1874

Monsieur:[1]

I am delighted to hear, these days, a man who talks like you.[2] Within the terms of the aesthetics of art, you have understood it in a way that is very gratifying to me. In fact, it is my way of seeing that, in the wake of Romanticism and following on Delacroix* and his school, has caused people to talk about art in France and in Europe for thirty-four years, with all the animation that the subject, which you call Realism, required. I can state this claim because today it is clear, as you found out for yourself, that no other artist except Corot contributed to this animation.

At the moment I have nearly eighty paintings saved from my wreckage. They will serve admirably to shed light on your ideas about me and I believe they can stand up to classical art and the schools of the past. I don't know

your current circumstances, or else I would invite you to come see me. If you can, do so. It will not be unedifying for you. As for the commission for some small pictures that you wish to give me, it is not for me to refuse you[3] because painting belongs to those who have the ideas for it.

I await your brochure[4] impatiently, yet I would be opposed to your presenting it to the public until you have seen what I spoke of above. What you will see will corroborate your very accurate feeling.

I read your review of the Lyon exhibition.[5] It gave me a great deal of pleasure. I thank you for the good feelings you express. If I have not answered you until now, it is not from indifference. I was traveling in Switzerland, very annoyed by matters foreign to art, of which you are aware.

Respectfully yours,

Gustave Courbet

[Address] M. J. Granger
 38 rue St. Marcel
 Lyon
[Postmark] La Tour-de-Peilz, 23 XI 74

1. It is possible that Courbet's correspondent was the Lyon painter J. Granger, about whom very little is known. He exhibited at the local Salon between 1868 and 1878 and published the *Album de la Drôme et l'Ardèche.*

2. It appears that Granger had written a long letter to Courbet to inform him that he was writing a pamphlet on his art and to commission some small paintings from him. Judging by Courbet's reaction, Granger's letter must have been quite flattering.

3. It is not known whether Courbet ever did paint any pictures for Granger.

4. The brochure has not been found.

5. Probably a review of the 1874 Lyon Salon.

To Olga de Tallenay, La Tour-de-Peilz, November 28, 1874 74-19

Tour-de-Peilz, November 28, 1874

Madame la Marquise:

It is the ladies' task to correct, with their feelings, the speculative rationality of men among themselves. I will always be grateful to Mme Colonna,* persuaded as I am that she looked after me in prison.[1]

You came to see me, to see my painting, to see an exile, a victim who misses his family, his own part of the world. You came to see a worker who has spent his life in the service of the art of France. You came without ulterior motives: I will long remember you for that.[2]

Madame, you have enchanted my home; you have enchanted my thought, my imagination, with the astonishing beauty of your person, of your kindness, of your likeable disposition. I do not presume to return the pleasure that you have given me. But allow me to offer you a small memento.

It seemed to me that a small *Impression of Falling Snow*[3] had pleased you. I am sending it to you, simply accept it.

With respectful compliments,

Gustave Courbet

1. Compare letter 72-3.
2. Apparently, Olga de Tallenay, together with Marcello, had come to see Courbet in La Tour-de-Peilz shortly before.
3. The painting cannot be identified with certainty. In a note dated "Sunday" (probably November 29), Olga de Tallenay thanked Courbet for the "charming souvenir" (see Lindsay 1973, 311).

75-1 *To Juliette Courbet, La Tour-de-Peilz, January 5, 1875 (incomplete)*

Tour-de-Peilz, January 5, '75

Dear Juliette:

You must be very brave to have removed the money that I had hidden in the piano under the Alguazils'[1] very nose. Therefore I am going to reward you forthwith. I am giving the 480 francs in interest that it earned to you, Zélie,* and Father. Give Father a hundred francs. Since you must buy Burgundy for Zélie, I have a cask of Burgundy in the cellar in Ornans. I authorize you to take it. There is some plaster in it against the dregs. You can transport it to Flagey without moving it too much. You'll need two strong men, have them pick it up as it is and set it on the wagon without turning it. Let it rest in Flagey. Now, if our policemen—my watchers—have already drunk it with our enemies in Ornans, forget about it.

As for all those stories about hay and the atelier, I have leased everything to Simon to be done with those worries. Father does not want to read the commodity exchange reports. That is a source of misery and fruitless labor, and everybody's loss.

Simon is paying me very dearly. Besides, it is only for three years. Write me your news, please, news of Father, you, my friends. I embrace you all with all my heart. . . .

1. Courbet probably uses the term "Alguazils" (Spanish officers of justice) here in reference to Zoé and Eugène Reverdy,* who had moved into the house at Flagey. Courbet looked on them as accomplices of the police.

75-2 *To Jules Castagnary, [La Tour-de-Peilz,] February 15, 1875*

February 15, '75

My dear Castagnary:

I have just completed a *Helvetian Republic* [Fs. 6] with the federal cross. It is a colossal bust to be placed on the fountain in La Tour-de-Peilz.[1] She is

540

splendid, everyone is delighted with her. I'll have a mold made and I would like to know from you whether I should send a casting to the Exhibition.[2] She is rough in style, and her overall effect is splendid. She is positive, direct, large, generous, good. Smiling, she raises her head and gazes at the mountains. With the base she might be 1 meter 20 centimeters high. In order to get it accepted you should go to M. Barbedienne[3] to ask him whether he would take the responsibility of sending it to the Exhibition with his shipment, as a work that belongs to him. In any case, he could exhibit it in his window, which would be a great success. Go and see him immediately, for time is pressing. The deadline for submissions is the evening of March 18. I have had a photograph taken of it, which I'll send you as soon as I have the prints. I'll have one cast in a kind of bronze for La Tour. Answer me right away, the days are numbered.

As for the Baudry* business,[4] I do not know how to answer. I am very embarrassed, as you are. It would be better if he made an offer. There is still the *Cellist* [F. 74], which is at Durand-Ruel's* and which must be claimed. It belongs to me.

I'll write you tomorrow about something else, more important. I have read the depositions of M. Renaud, the police prefect, and this is the moment to get rid of M. Reverdy,* who is a Napoléonist agent, terribly dangerous to my family and me, and to you, Ordinaire,* and all our friends. My sister,[5] who is a monster, is trying to ruin me [and] is using the police to chase my money, even in Switzerland. They are calling everyone a thief, etc., etc. Till tomorrow.

Answer me about the statue. Send me Ordinaire's address—96 rue d'Enfer, I believe, let me know. Ordinaire should approach Renaud and so should you. Gaudy* is not smart [enough].

<div align="center">

Courbet

</div>

As for the *Portrait of Rochefort* [F. 1022], there is no scandal,[6] which is not to say that he found the portrait worthy of his destiny.

The police prefect must recall Reverdy to Paris, to other duties than that of ruining his family, robbing them, and exiling them. Now or never. Best regards to everyone, to Baudry, etc. Tell me what I should write him. Don't sell Pia* any more paintings at auction. He earns twice as much as I do at this trade.

1. On the *Helvetian Republic* and its donation to the town of La Tour-de-Peilz, see La Tour-de-Peilz (1982, 81–87).

2. The *Helvetian Republic* was not shown at the 1875 Salon.

3. This is probably a reference to the foundry owner Ferdinand Barbedienne and not to the gilder Barbedienne mentioned in letter 72-24. Ferdinand Barbedienne (1810–92) had founded, together with Achille Colas, a famous foundry in Paris, where he cast sculptures as well as objets d'art. He helped make the reputation of modern sculptors by producing reduced copies of their works, which he marketed, giving the artists a commission.

4. In a letter of February 10, 1875 (Paris, Bibliothèque nationale, Cabinet des estampes, Yb3.1739 [4°], b. 2), Baudry had asked Courbet to sell him a "German landscape" (probably the *Woman of Frankfurt* [F. 235]); the *Wounded Man* (probably the copy of that painting [F. 546]); and, if possible, also the *Mère Grégoire* (F. 167), paintings he had intended to buy earlier (see letter 73-28) but that were subsequently stolen from Courbet's atelier. Baudry and Castagnary had rediscovered these paintings and bought them back for Courbet (cf. letters 74-5 and 74-10). Baudry now proposed to buy them from him, but left it up to Courbet (or Castagnary) to set a price. This placed Courbet in an embarrassing position as he owed Baudry many favors.

5. Zoé Reverdy.

6. After his escape from New Caledonia, Henri Rochefort had settled in Geneva. During a visit to La Tour-de-Peilz in September 1874, Courbet painted his portrait. Rochefort did not take to the work and gave it to Paul Pia* in 1876 (see La Tour-de-Peilz 1982, 71).

75-3 *To Etienne Baudry, [La Tour-de-Peilz,] March 15, 1875*

Monday morning, March 15, '75

My dear Baudry:

Yesterday I was in the country and I was not able to answer you. You misunderstood the word "business." That was not what I had in mind, it was a word used offhand in a phrase.[1]

I am very grateful to you for all the efforts and troubles I cause you, and I am quite delighted, my dear friend, with [the prospect of] your visit. You cannot believe the pleasure you cause me. I have been awaiting you for more than a year.[2]

You go via Pontarlier to Le Vernier, Lausanne. Or, if you want to see Neuchâtel, you don't stop in Le Vernier, but you go directly to Neuchâtel, and from Neuchâtel you come down to Lausanne, Vevey, and La Tour-de-Peilz. If you are in a direct train that does not stop in La Tour, you stop in Vevey. We have the most beautiful weather in the world. You'll see the most beautiful country you have ever seen.

As for the paintings about which we have been informed, I don't understand why we should be obliged to act and seize them if the person handed them over for twenty-five hundred.[3] I would understand, but, as you know, we cannot carry out a seizure without the government getting hold of things, and you'd still have the same troubles as before. That understood, I believe it is Dubourg[4] who is the informer or M. Alphonse.[5] They [the paintings] must be at Durand-Ruel's* or at Mlle Adèle Girard's,* the one who stole them, or in the apartment of her father. In that case it should be either Mlle Girard or her brother, an ex-offender, who provides that information.

M. Pata,* who has left me two days ago, is perfectly acquainted with all these matters and with the sordid actions of my sister and M. Reverdy,* my brother-in-law. If you could go and see him, he would perhaps give you some instructions. He lives at 20 rue de Seine.

I enclose a note for you to give him, he'll give you a complete explanation. If you can, go and see him. If you stop at Pontarlier, go to my friends Pillod,* Hôtel de la Poste; in Vevey to the Grand Hôtel du Lac; in Neuchâtel to Le Faucon.

I am looking forward to seeing you. With a handshake and kind regards to your lady,

G. Courbet

If you could bring along the *Bathers*[6] remove the canvas from the stretcher and roll it around a stick or a piece of cardboard.

1. Baudry had read Courbet's letter to Castagnary of February 15, 1875, and had become disturbed about Courbet's phrase, "the Baudry business" (see letter 75-2). On March 12, he had written a letter to Courbet (Paris, Bibliothèque nationale, Cabinet des estampes, Yb3.1739 [4°], b. 2), in which he told Courbet that he did not consider his offer to buy some paintings from Courbet (see letter 75-2, n. 4) a matter of business. Instead, he had intended to do Courbet a favor by offering him to buy these and other paintings (he had earlier also expressed interest in buying the Three Bathers [F. 630]).

2. In his letter of March 12 (see n. 1), Baudry had announced his visit to La Tour-de-Peilz and had asked Courbet to mail him some travel instructions. As it turned out, Baudry was not to visit Courbet until the very end of April.

3. On February 24 and March 5, 1875, a certain "H.K. 113" had written two notes to Castagnary (now in Paris, Bibliothèque nationale, Cabinet des estampes, Yb3.1739 [4°], b. 2) to inform him that he knew the exact whereabouts of several of Courbet's paintings. For a fee of twenty-five hundred francs he would see to it that they were returned to Courbet. After speculating about the possible identity of H.K. 113, and after thinking up several strategies to avoid paying the ransom, Courbet eventually appears to have paid it in order to retrieve his paintings (cf. Lindsay 1973, 312).

4. See letter 74-10, n. 1.
5. Alphonse Legrand.*
6. Probably F. 630. See n. 1.

To Jules Castagnary, La Tour-de-Peilz, April 1, 1875 <u>75-4</u>

Tour-de-Peilz, April 1, '75

My dear Castagnary:

The most important thing right now is to rid ourselves of M. and Mme Reverdy.* They have wrought enormous havoc in Ornans and terrorize the town, by using the government to bully people. They are Napoléonist police agents[1] who write anonymous letters that seemingly come from the Besançon city police. They have behaved toward our family in a way you cannot imagine. They are trying to cause my father's death in my absence and to terrify my sisters with threats and coarse insults, in order to get our fortune. He is an informer, a troublemaking pimp, as they say in Paris.

I was sentenced to prison, to fines, I served and paid it all, but I have not been sentenced to have an informer in my family who bullies the region in

order to dishonor it. If it is the police prefect[2] who is foisting this on me, he is mistaken. I am not afraid of police agents, I have had them around me all my life. But the government should not pick a fellow who happens to be married to my sister and without our knowledge. The police prefect should have the decency to send us someone else and to call this one to other duties. He is a sinister ruffian who has already turned the entire region against himself.

First he occupied our house by force and took possession of the master keys, then of the cellar, so that, when my poor old father came from Flagey with his pass key, he had to sleep on the stairs for two nights, at his age, to avoid a scandal. He used to write me, "I am wasting away from unhappiness, confronted with such creatures. I must have an iron constitution to withstand such trials." The latest is that he was choked with the most violent insults and was thrown out of our home. Now he stays at the Hôtel de France with Volinde, when he comes to Ornans. My sisters, when they go there, stay with their friends. The other day my father came with a wagon to fetch some wine from his cellar and found nothing left. He had to buy wine.

They search me in Switzerland, they inquire whether I have money and paintings. It is impossible to imagine all the dirty tricks they use. They aren't waiting for the redistribution of property. If the government believes all the slanders and accusations of those villains, we will never get out from under them, nor will any of the honest people they accuse. They are a real plague. I would like you to bring the contents of this letter to the attention of the police prefect any way you can as soon as possible, and to tell Ordinaire,* who is at least as slandered as we are by those scoundrels. I have a letter, allegedly from the Besançon police, which is addressed to my sisters. M. Reverdy should be with his family, not ours. He has emptied our house, I don't know by what right, and the reactionaries put up with it all. If a federate had done one twentieth of that, he would already have been shot ten times.

Yesterday I received a letter from Etienne Baudry,* I am anxious to see him. Show this letter to Gaudy,* too, for he has not been spared. Write me.

Sincerely yours,

Courbet

You have seen Pata.*

1. The charge that the Reverdys were informers is found repeatedly in Courbet's letters, but it has not been substantiated.
2. M. Renaud, referred to in letter 75-2.

75-5 *To Jules Castagnary, [La Tour-de-Peilz, April 22, 1875 (Ad)]*

My dear friend:

Write that ape,[1] that informer, that my means do not permit me in my

present situation to pay so much money. Offer him fifteen hundred or two thousand as a reward. But go about it as follows: don't agree to make out the receipt he'll want you to, you will be considered a fence by the government, and so will I, and liable. Tell him that you are grateful to him, as I am, since he means well by me.

At this point there is only one way left to handle this matter, that is, by sending the paintings COD by train to M. Dulon,* minister at La Tour-de-Peilz—he cannot mistrust the railroads. However, in order to prevent their being seized at the border, he must first remove the signatures on the paintings. It is easy to understand that I cannot pay until I have received the paintings. Write him right away that he should have the paintings packed up for Switzerland at the appointed address at the lowest price that you can get, taking the packing into account.

As for Baudry,* for the last two months I have felt like Mme Marlborough, I stand at the window and see no one come.[2]

As for that pimp, watch out, a regular receipt is a dangerous thing in his hands.

It appears that Marcel Ordinaire* has been accepted and Pata* refused,[3] please write me.

I was speaking to the police prefect, not about our family affairs, but about assigning M. Reverdy* to another venue as secret agent. That would help us a lot. My father can no longer get into his house.

Be sure to inquire about the paintings that were just sold at the auction hall.[4] Look at the notice: one landscape, seventy-five hundred francs, etc., [altogether] seven paintings. There must be some of the stolen ones. If I knew for sure that I would not be sentenced to much, as M. Victor Lefranc* tells me, we could ask the police prefect to look into the sixteen paintings. He could give the order to the post office to seize the anonymous individual and we would make twenty-five hundred francs. But, of course, the prefect would seize them in turn. Think about it.

Sincerely yours,

G. Courbet

H.K. 113[5] is one of that policewoman Girard's* lovers.

1. See letter 75-3, n. 2.

2. Reference to the famous French folk song, "Marlborough s'en va t'en guerre," in which Lady Marlborough waits for her husband to return from war. Baudry had announced his visit to La Tour-de-Peilz at least since the spring of 1874, but he was not to visit Courbet until the late spring of 1875 (cf. Bonniot 1973, 325).

3. To the 1875 Salon.

4. Reference to the sale of modern paintings that had taken place in the Hôtel Drouot on April 16 and 17 (cf. Fernier 1977–78, 2:351).

5. See letter 75-3, n. 2.

75-6 *To the town council of La Tour-de-Peilz, April 24, 1875*

Monsieur le Syndic et Messieurs:

The municipal council of La Tour-de-Peilz, in order to adapt the fountain and fit it with the bust that I have offered your town,[1] had appointed four experts capable of determining the best and most economical way to carry out the project. The four appointees were M. Dulon,* town councillor; M. Doret,[2] marble cutter; M. Burnat,[3] architect; and myself.

Yesterday, Saturday, I was unexpectedly summoned by M. Burnat, the architect, who had finished his plan, to go to M. Doret's at two o'clock in the afternoon. Because we were all sympathetic but unbiased toward this project, we examined as scrupulously as possible the cost price of the monument on the basis of M. Burnat's plans.

After checking the materials and the color combinations of marble in the lower price range, M. Doret, though he could not give us an exact price, still concluded that it could not be done for less than five hundred francs—if we left the existing spouts in place, for changing them would require an additional expense of one hundred fifty francs or more. M. Doret requested me to submit [these figures] to the town council before undertaking the work.

It is up to you, Messieurs, to make a decision on the proposed price. Now, as for me, I assure you that for my part I have done everything possible to create a favorable climate for this plan. I have had ten copies executed in plaster, intended to be donated to your surrounding cantons and to the Arlaud Museum.[4] I have also had a large number of photographs made for this purpose, at great cost. At the same time, the mold for the casting that has been promised you is finished, and it will be cast on Wednesday at 3 o'clock at the Roy factory, according to what they promised me. M. Doret has asked me for twenty days to complete his work.

Messieurs, please reply to the question that is submitted to you by M. Doret and M. Burnat, who wish to know if you agree to these conditions. In anticipation of an answer at the earliest opportunity, I thank you for the honor that you have done me by accepting my work.

Sincerely yours,

Gustave Courbet

P.S. As you requested,[5] I replaced the federal cross with a star and the word "Helvetia" with the word "Liberty," but I have left the words "Homage to hospitality" on one side of the base and on the other side "Tour-de-Peilz, May 1875."

La Tour-de-Peilz, April 24, 1875

1. The *Helvetian Republic* (Fs. 6).
2. The Dorets were a family of marble cutters and sculptors in Vevey. The family member here referred to may be David Duret (b. 1821).

3. Ernest Burnat (b. 1833) was an architect in Vevey, also known for his paintings and watercolors.

4. Several of these casts have been preserved. Two are in the communal archives of La Tour-de-Peilz, two others in private collections in Lausanne and Pontarlier. Additional casts are in the Musée de Besançon and the Musée Jenisch in Vevey. *Helvetia* is also known in three metal casts, placed in public places in Martigny (Switzerland), Meudon (France), and La Tour-de-Peilz (see Fernier 1977–78, 2:318). It is noteworthy that the casts are not completely identical. While some wear the Helvetian cross, others wear a medallion with a star, and are generally referred to as allegories of Liberty. One plaster cast bears a medallion with the letters "JRS" on a rising sun (see La Tour-de-Peilz 1982, 78–94).

5. Acting on a letter by a certain Frs. Papon, the municipality of La Tour-de-Peilz had requested Courbet not to name his work *Helvetia* but *Liberty* (cf. La Tour-de-Peilz 1982, 83; see also n. 4 above).

To Edmond Levrand, La Tour-de-Peilz, May 12, 1875 (incomplete) <u>75-7</u>

La Tour-de-Peilz, May 12, 1875

My dear Levrand:

Please keep my paintings at your place until further notice. After a while it will be possible for me to give you the name of a person in London who will take on their sale, but at the moment I cannot tell you anything else. . . .

To Zélie and Juliette Courbet, La Tour-de-Peilz, May 22, 1875 <u>75-8</u>

'75, May 22, Tour-de-Peilz [1]

This is what I just wrote to the Reverdy* family: [2]

Madame Reverdy:

The Bern supreme court has received through diplomatic channels denunciations signed by you and transmitted by the French government, inviting them to gather information about myself and my property. [3] The Swiss government, having seen in these denunciations a maneuver that is absolutely contrary to individual liberty, has become alarmed and has communicated with me about it through the Swiss court. But the judicial power of this country immediately saw that criminal scheme against me for what it was, and so it was in that much better a position to undo the slander, as the magistrates on whom it is incumbent to obtain the information are people who have me over for dinner every week.

Was it not enough then to have scandalized the entire Franche-Comté by your base behavior? Did you also have to bring scandal into a country where I am obliged to live?

Faced with such an unspeakable act, added to so many others, I must order you to leave the house immediately until the division has been completed, [4] to leave our household and to join your own. You should be able to leave without regret the house that you have emptied to the point that Father

is obliged to buy his wine in town and to live at the inn. It is time for Father and my sisters, whom you have driven from their home, to come back to a place that you occupied by sheer force, after shamelessly letting your father, that unhappy old man, sleep on the staircase of the house (as he sorrowfully wrote me), after causing your sisters the humiliation of having to ask for their friends' hospitality.

That unspeakable behavior must come to an end, just as there must be an end to those anonymous letters that you write to Father, to my sisters, and to me. Those letters are so disgusting that they become unreadable. Only people without a sense of honor, like you, would use means of that sort.

It is time to bury the endless slanders that you spread about my friends, whom you call thieves and who have refrained from suing you only out of consideration for the family.

That is enough, and be careful, you parricide, that you don't come to a bad end.

These two years of drama and shameful stratagems used to achieve your unspeakable goal constitute genuine attempts on the lives of Father and my sisters. If you perpetrate them, I'll show you that I am not sick (as you say I am). Now, I warn you that I will take the precautions necessary to stop those shameful machinations that make nature blush and that may never have been seen [before]. Be well.

<div align="right">*G. Courbet*</div>

My dear sisters,

I think that for the moment she has had enough. If she renews the attack I have more to say to her. Write me and beware of them. I'll end by notifying M. Rousillion, the justice of the peace. She is a real monster. She is rabid. It is laziness that drives those two idlers. I embrace you all,

<div align="right">*G. Courbet*</div>

[Address] Mesdemoiselles Courbet, Landowners
 at Flagey
 Canton Amancey
 Doubs department
 FRANCE

[Postmark] Tour-de-Peilz, May 22, 1875

1. The letter bears the seals of Fumey, attorney in Besançon; Simon, attorney in Besançon; and D. Monnet, attorney at the Besançon court.

2. While the actual letter to Zoé has not been preserved, a draft, written in a different hand, is in the same collection as the letter to Zélie and Juliette. The differences between the two texts are minor.

3. These documents have not been located.

4. The Reverdys were living in the house in Ornans, which was part of the estate of Courbet's mother, Sylvie Oudot Courbet. Though Courbet himself had renounced his share

on February 8, 1873, the estate had not yet been divided among his sisters (see Grimmer 1956, 23).

To Juliette Courbet, La Tour-de-Peilz, May 29, 1875[1] 75-9

La Tour-de-Peilz, May 29, '75

My dear Juliette:

Your letter and the shocking disaster[2] that has happened to us have driven me to despair. My poor darling, it is up to you alone, now, to try to sustain us all, that is, Father and me. I beg you, don't torment yourself.

I have cried out every tear I have. My poor Zélie,* who never had any other pleasure in life than to please others and to serve them. What a sad existence our poor sister had, and without complaining. Always sick, always courageous, always amiable! Our charming sister will remain forever engraved in our memory, like Mother, exactly as if they were still alive. But it is you, my dear that I am thinking of. What difficulties you will have until I return.

I would have liked to have lived all my life knowing that you were together, I would have been happy. Indeed, it would have been the greatest happiness that you could have wished for, and I, too. I would not have needed to worry about you, my only care would have been to support you in those circumstances and to live with you. Now you must try to find some disinherited, unfortunate, but well-bred woman, who will help you with the work ahead. As for me, my dear friend, you know that we are forever inseparable, if you wish it, and that I am prepared to support you in every way.

What also grieves me deeply is Father, who loved our poor darling so much. He has already been tried enough by those monsters that are seeking to destroy our family.[3] When it comes down to it, it is their persecution of you that killed my poor sister.[4] It is grief, which swells the liver, that exacerbated the illness that she had in that organ. My Ornans sister, that monster, who is as healthy as a horse, could kill everyone. If you don't pay more attention, and if you are not firm and serious with those good-for-nothing inheritance hunters, it will happen to you. Please, don't let those wretches get away with anything. Accuse them fearlessly, as [I did] in my last letter, of being murderers and thieves, it is the truth. As I have warned them already, I tell you again, more forcefully than ever: don't see those people, they are swindlers.

Father does not want to come. Come and see me as, to my delight, you have said you will. I am expecting you. Write me what day you are coming, I'll meet you.

I embrace you with all my heart, you and Father. Be firm!

Gustave Courbet 549

What a pity that Zélie did not give you her share of Mother's inheritance, but I'll give you mine.

Don't you think I was lucky to write those people in Ornans the terrible letter that I wrote them? It has hit the spot. They are to get the hell out, as I told them. I don't want to see them again.

[Address] Monsieur Courbet, Landowner
 at Flagey
 Canton Amancey
 Doubs Department
 France

[Postmark] Tour-de-Peilz, May 29, 1875

1. The letter bears the seal of Fumey, attorney in Besançon.
2. Courbet's sister Zélie had died from a liver ailment on May 22, 1875.
3. Reference to Zoé and Eugène Reverdy.*
4. Zoé, in a letter to Alfred Bruyas* of January 14, 1876, would reciprocally accuse Courbet of having caused Zélie's death (cf. Borel 1922, 1443–45).

75-10 *To Paul Pia [La Tour-de-Peilz, June 1, 1875 (Ad)]*

My dear Pia:

Please take these negatives to M. Denisot at Vérésoff[1] so that he can get them to his photographer to copy. Order as many as you like. I am sending you Baudry's* watch, the hands don't move. Ask our friend Cambrion to exchange it and tell him to send it to him in Paris, 16 rue de Lancry.

A great tragedy has happened to me, namely the death of my sister Zélie,* who was the heart of our home. My father and my sister Juliette* are inconsolable, as am I, as you can imagine. Both my mother and my sister have died without my being able to see them, and that aggravates the bitterness of my exile for my father and my sister, poor things!

There you have the triumph of the "social order." They will end up being the death of my entire, decent family, but not before ruining us, whose only offense was to want to save the national property.

Sincerely yours. Regards to Rochefort[2] and your ladies,
 G. Courbet

1. The printing and stereotyping firm of Antoine Vérésoff & Co. in Geneva was a favorite among political refugees in Switzerland. Courbet would later ask them to print two pamphlets in his defense (cf. La Tour-de-Peilz 1982, 733–74).
2. After his escape from New Caledonia, Henri Rochefort* had taken refuge in Geneva, where he lived until 1880 when amnesty allowed him to return to France.

La Tour-de-Peilz, June 2, '75

My dear Baudry:

I would have written you earlier but we have searched my correspondence without obtaining any result. The larger part of my letters and of the contracts signed with Durand-Ruel* have remained in Ornans as I was not able to get them before my departure. You know that I cannot obtain anything from my brother-in-law, who is withholding those things. It is simpler to ask Durand-Ruel to see his books and to ask him for a list of everything that may be stored at his place.[1] That way I will be able to more or less reconstruct from memory what is missing.

As far as I can remember at this point, there are:

1. The *Cows at Haymaking Time* [F. 643]
2. *Proudhon and His Family* [F. 443]
3. *Hunters (Poachers) in the Snow* [F. 613], which, I am told, has been seen in Ostende (Belgium) this winter.
4. *Basket of Flowers* [F. 366]
5. *Portrait of the Musician Promayet* [F. 128]
6. The *Man with the Contra-Bass* [F. 74]
7. The *Hare Brought to Bay with Two Dogs, Undergrowth* [F. 620]
8. The *Woman with the Bird* [F. 286?]
9. The *Forest of La Laurencey (Port-Berteau)* [F. ?]

If you find the *Cows*, send them to me after having erased my name. Try to sell the two large paintings of deer,[2] the one of the *Battle* [F. 279] and the *Mort* [F. 612].

10. The *Breton Shepherdess* at Durand-Ruel's [F. 547]
11. A *Source of the Loue* (with waterfall) [F. 387]
12. A *Snow Landscape* with icicles hanging from the rocks [F. ?]

Take care of the sale of the Ingres.[3] Have a frame made and whatever is missing.

Try to go to my atelier to see what paintings are left there. The concierge will give you the address of M. Quest[4] if she cannot let you see them by her own authority. You will be able to obtain from the latter the transfer of what is still left there to a shed on your estate, making an inventory and taking charge of the sequestration of those objects, which will save a fee of two francs a day to my concierge and also the price of the rent which does not do me any good and which the government will make me pay for sure.

13. There is a portrait of the *Guerrero* [F. 125], a Spanish dancer, at a dealer's on the rue Lafayette. It must have been stolen in Ornans by the

Prussians. Since we must sacrifice a painting to track down Mlle Girard* who has taken them in the passage du Saumon, have the one of Luquet* seized[5] (the *Woman in the Water* [F. 59]), and in that case, by going to the source, it becomes the business of the police prefect, and, one thing leading to another, that will bring him to the source, which will be Mlle Girard.

I don't know what Castagnary* is doing with the informer of those seventeen paintings for twenty-five hundred francs.[6]

Try to find out if Poulet-Malassis* still has paintings of mine, among them *Deer's Love* [F. 243]. We could write to Bruyas* to buy it and could seize the money when it is in his hands. As for M. de Gilly, if necessary let him have the landscape. If you can get your hands on the small *Nude Woman with Dog* [F. 631], they both belong to me.[7] I will send you a notarized receipt for all the money at Durand-Ruel's. Go to Pata,* find out about Girard, who owes me twenty-two hundred francs.

We are very sorry that you left and we hope to see you again soon. Yours, and greetings to your lady.

<div align="right">*G. Courbet*</div>

A handshake from Morel.*

Morel the secretary apologizes for his terrible scribbling.[8]

The rental of Bon-Port is a fact.[9]

1. There seems to have been an enormous confusion about the numerous works that were sold to, given in commission to, or stored in Durand-Ruel's gallery. In part this confusion arose from the fact that Durand-Ruel had shipped several of Courbet's paintings to Vienna, in part from his continued sale of Courbets throughout the early 1870s. To compound the problem, Courbet had dealt mostly with Durand-Ruel's employee Alphonse Legrand, who often seems to have acted rather independently from his boss. Courbet's list does not seem to have corresponded to what was still physically present in Durand-Ruel's gallery.

2. In the original text one finds the word *soeurs*, (sisters) rather than *cerfs* (deer). Since both words sound approximately the same, it would seem to be an error caused by dictation.

3. A painting (or paintings) by Ingres is mentioned a few times in the correspondence between Courbet and Baudry in 1875. Perhaps included in Courbet's collection of Old Master paintings, the so-called Ingres may have seemed an apt object to sell in order to acquire some necessary cash.

4. Courbet's sequestrator.

5. Courbet much resented the fact that Luquet, unlike Durand-Ruel, had admitted to the government that he had several paintings by Courbet in commission—which made them subject to seizure. Therefore he targeted a painting that Luquet had bought back from the thieves of Courbet's paintings as one "to be sacrificed" for the sake of tracking down the thieves.

6. On the mysterious informer H.K. 113, who had offered to return seventeen stolen paintings to Courbet for a ransom of twenty-five hundred francs, see letter 75-3.

7. On the Gilly affair, see letter 74-1.

8. Like many of Courbet's later letters, this one is not written by the artist himself but dictated to a friend, in this case Auguste Morel.

9. Around this time, Courbet moved from the Dulon pension to a house, called Bon-Port, which overlooked the harbor of La Tour-de-Peilz.

To the president of the town council of La Tour-de-Peilz, June 5, 1875 75-12

Tour-de-Peilz, June 5, '75

Monsieur le Syndic:

My sister,[1] who took care of my father and the poor, has just died. It is customary in my country to pay respect to people's ideas after their death. For that reason I am sending you one hundred francs, which you may give to whomever needs it, in honor of my sister.

Respectfully,

Gustave Courbet

1. Zélie Courbet* had died on May 22, 1875.

To Etienne Baudry [La Tour-de-Peilz, June 18, 1875] (incomplete?)[1] 75-13

My dear Baudry:

When the war broke out we could not bring ourselves to leave France. They turned to me to save the arts. The people appointed me, as did the artists and even the September 4 government. Under those circumstances the puppets of favoritism are dropped in favor of the men who are the real backbone of the nation.

I wrote my father at the time, "You are strong enough to protect our interests in our home and in mine against the Prussians, the more so as you can use my officer's cross of St. Michael of Bavaria, the first prize of the Universal Exhibition in Munich, or München. Those people respect their institutions."[2] I was right. My father, the mayor of a small village, Flagey,[3] on receiving 150 Prussians, men and horses, showed them my cross. They left the next morning, offering gifts of Arab horses, which my family did not accept. In Ornans, where my father was unable to go every day, they broke into my mother's house and into my atelier, whence they carried away, with 150 men and as many horses, all the valuables and the collections that were there. That was a loss of fifty thousand francs for me, which I registered as damages with the Besançon court, with the sergeant of the Ornans police, specifying the objects.

Meanwhile, in Paris, M. Rochefort* and M. Cournet,[4] in charge, by order of the September 4 [government], of the Paris barricades against the Prussians, ruined me in the amount of twenty-five thousand francs' worth of materials from my exhibition hall by the Alma Bridge[5] (which had cost me eighty-three thousand francs), which were stored with a contractor located by the Porte de la Chapelle in St. Denis.

All this for having wanted to serve France by saving the arts of all kinds: Louvre, Tuileries, libraries, the Dusommerard Museum, St. Cloud,

Versailles, Meudon, Malmaison, Sèvres, St. Germain, Fontainebleau, etc., etc. Moreover, I donated a cannon from the Caille foundry—donated to the National Defense;[6] and to the Grenelle arrondissement thirty Old Master paintings from my apartment in the Vieux-Colombier, including a Rembrandt, *St. Peter in Chains;* an *Entombment* by Caracci; [and works by] Simon Vouet, Velazquez, Rubens, Wouwermans, Poussin, Delacroix, etc., etc.[7]

With the shells falling into my atelier in rue Hautefeuille, I take the paintings from my atelier to the Ecole de médecine. They tell me that if the Prussians enter, the monuments of Paris belong to them. I take my paintings away again, to the cellars of the [passage du] Saumon. When the Versaillese entered Paris, thirty-three crates were stolen, which I estimate at a hundred thousand francs at least and the Old Master paintings of the Vieux-Colombier at least as much.

The government has stolen my capital, which was in registered securities at the Banque de France; it has confiscated my property and my securities illegally, depriving me of my means of employment in Paris and in Ornans. It has discredited me in its world for no reason. It has made me pay for the War Council's crosses in addition to a fine. I did ten months of solitary confinement, twenty-nine days in court before Villemessant, Dumas,[8] and some police officers; I was put up against the wall to be shot by the Corsican Police; dragged through the streets of Paris, my hands in chains; flat on my stomach in three centimeters of vermin in the Orangerie, under the loaded guns of the Corsican M. Serret de Lanoze, where I had no business being after having been sentenced.[9]

To continue with the national rewards, they sent me to prison with thieves;[10] they made me ill; Nélaton performed a terrible operation on me;[11] they caused my mother to die with grief; my younger sister[12] has just died the same way. Then some deputies from Besançon, suffering from the particular jealousies and hatred typical of cretins and dishonest people, take me to court again, in a civil action for debt, to exile me from France, without rhyme or reason, trumping up a story that I destroyed the Vendôme Column, the most colossal joke I ever heard, which is making all Europe laugh.

To proceed with the list of my rewards, after serving France in the most effective manner, and in a position that none of those who are accusing me could have held (because I was loved by the people of Paris), I can say that I have never received any pay, as my predecessors did, not even as those of September 4 did, in whose ranks I was. Over four years of different tasks and importunities, I lost, by acceding to the duties imposed on me, sixty to eighty thousand francs per year, I don't know to what purpose, especially when I consider that I was unable to practice my art, which has served France for thirty-four years, from the Romantic period to the present.

In the horrible situation he had created in France, M. Thiers,* my reluc-

tance notwithstanding, nevertheless turned to me, through the intermediary of M. Barthélemy-Saint-Hilaire, who asked me (during the Commune, when I had stayed so as not to be a coward) to do my duty as an honest man in the absence of those gentlemen. He asked me to save his friend M. Thiers's house and art objects. I acted on that request promptly, and I diplomatically appraised all those objects at 1,500,000 francs, so that on the basis of that fictitious estimate the Chamber later awarded him one million, of which, were he to be perfectly fair, he owes me at least 500,000 francs.[13]

I saved the Column even in its downfall (which I was unable to oppose—one does not oppose two million individuals) and it was I who took measures to prevent damage and fractures. And I was so sure of my action that I wrote M. Jules Simon, "If it can be proved that I destroyed the Column, I take it on myself to put it back up at my expense."[14]

Had I had the management of them, those expenses would not have been great. Had I been guilty, having some acquaintances in the building trade, I would have undertaken to put it back up as it had been, not for 510,000 francs, but for a mere 140,000 francs, and without all the fuss.

Truth be told, I am the only man to have saved something for France, and of her most precious good. And I told M. Merlin,[15] president of my War Council, "Monsieur, if my life were not unmotivated by rewards, I would feel entitled to ask for the nation's reward, instead of being in its dock."

To continue with the acknowledgment due me, after people were done momentarily trying to cheat history, out of passion and hatred: they have already made me serve two years of exile, which was undeserved, assuming, in advance, an arrest, which by French law is the prerogative of the government alone. So that, had I not been forewarned, I would by now have served two years of preventive detention, without knowing whether I was wrong or right.

I always come back to my pet subject: I cannot see what France has to gain by preventing me from practicing my art for so long. Life slips by, and the cretins remain.

To add to my misfortune, I have a miserable brother-in-law[16] who, in my absence, takes advantage of the situation by murdering our family in order to inherit from it, as we have no children. They are trying to cause my poor father's death. I believe that in history it will be hard to find a man in my position who, having worked all his life to try to establish the good and the arts in his country, has been so shockingly persecuted by that same country. . . .

1. This long letter was probably intended to provide Baudry with ammunition for an appeal to his compatriot Jules Dufaure,* recently reappointed minister of justice in the cabinet of Louis Buffet (1818–98), which governed from March 10, 1875 to February 23, 1876. This thesis is confirmed by letter 75-14, in which Courbet speaks of an appeal, to be launched by

Baudry and Frédéric Mestreau, two friends from Saintes, through the intermediary of Dufaure's son, Gabriel, with whom they were befriended. In addition to Dufaure, Baudry and Mestreau also attempted to influence Léon Say,* recently reappointed as minister of finance, and Victor Lefranc,* as may be seen in Baudry's numerous letters to Courbet in Paris, Bibliothèque nationale, Cabinet des estampes, Yb3.1739 (4°), b. 2.

2. Compare letter 70-23.

3. Though Régis Courbet was the richest landowner in Flagey, he is not known to have been the official mayor of the hamlet.

4. Frédéric Cournet (1838/9–85), member of the Commune, who briefly served as police prefect.

5. The building that had been used for Courbet's 1867 private exhibition.

6. Compare letter 71-2.

7. Part of the collection of doubtful Old Master paintings that he had bought in 1870 (cf. letter 70-13).

8. Hippolyte de Villemessant (1812–79), editor of the *Figaro*, and Alexandre Dumas fils (1824–95), who reported on Courbet's trial.

9. After being sentenced to prison on September 2, 1871, Courbet was transferred to a temporary jail in the Orangerie at Versailles. Here he was accused by Captain Serret de Lanoze of holding conspiratory meetings and threatened with execution (cf. Riat 1906, 324).

10. Though political prisoners were customarily held in a special section of Ste Pélagie prison, the so-called Pavillon des princes, condemned Communards were locked up together with common criminals (cf. Riat 1906, 324).

11. A reference to the operation performed by Dr. Nélaton, about which Courbet had previously been very satisfied. Compare letter 72-4.

12. Zélie Courbet.*

13. Compare letter 73-50.

14. See introduction, n. 13. Courbet had written in very similar terms to Jules Grévy. See letter 71-19.

15. Colonel Merlin was president of the tribunal that had condemned Courbet in 1872 (see Riat 1906, 317).

16. Eugène Reverdy.*

<u>75-14</u> *To Jules Castagnary, La Tour-de-Peilz, July 26, 1875*

La Tour, July 26, 1875

My dear Castagnary:

Now my attorney[1] tells me that my lawyer is about to treat the tribunal, at the appeal next Monday, to some Napoléonist effusions.[2] I would like to know if this new speech for the defense will cost me another three thousand francs, to hear myself being convicted. In that case I would prefer to drop M. Lachaud,* who has always believed that he was compromising himself by entering into relations with me and who is one of my secret enemies. That man gives me the worst reputation; he gets me coming and going, and gratuitously causes me to lose the esteem of my political coreligionists.

We are left with two courses: perhaps you could [][3] Dufaure* senior, by going through his son, who is a friend of Baudry* and Mestreau;[4] or we

could forget about this new lawsuit, and instead begin again immediately in the *Constitutionnel*, with documents substantiating the losses that I have taken and suffered in the service of France during those three years of war and revolution.

In the third case, if M. Lachaud demands his fee for having already prepared his preliminary arguments—as the attorney tells me in the letter that I am herewith sending you—I am obliged to suffer another loss of three thousand francs, but, if he were to waive that, I could take a young lawyer who would cost us two hundred francs and who would be delighted to have this case to argue.

In any case, we must obtain a delay so that we can publish the pamphlet that we wrote together for that purpose,[5] and add to it the latest documents and the list of the losses that you asked me for, for I have no faith whatsoever in M. Lachaud's juridical improvisations.

Please, there is no time to lose: go and see my attorney Duval immediately to reach an agreement on these matters and to make him, in so far as you are able, give you an account of the state of my affairs.

Also, take back as many paintings as you can find from Durand-Ruel* since he cannot pay. He has the prices in his account book. I'll send them to you from my end. I'll write Baudry in the same vein as I am writing you here.

Cordially yours. Kind regards to our friends,

<div align="center">G. Courbet</div>

I am starting to be completely broke, one cannot sell paintings in Switzerland.

1. Charles Duval.*
2. After the verdict pronounced in Courbet's trial on July 19, 1874, his lawyer, Lachaud, had immediately lodged an appeal. Courbet's case was to be heard again on August 2, 1875, but, apparently, at the last moment the artist doubted whether he should go through with it, especially because it would mean another fee for Lachaud. Courbet's case was heard in appeal, however, and, on August 6, the July 19 verdict was confirmed. This still left the amount Courbet had to pay to be decided by the state. Compare letter 74-15, n. 5 and Riat 1906, 367.
3. Illegible word.
4. On Courbet's idea to approach Jules Dufaure through the intermediary of Etienne Baudry and Frédéric Mestreau,* see letter 75-13, n. 1.
5. On the planned pamphlet, see letter 73-51, n. 1.

To the president of the typographers' federation of Geneva, 75-15
La Tour-de-Peilz, August 2, 1875

<div align="right">La Tour-de-Peilz, August 2, '75</div>

Monsieur:

As I have already told M. Lacalle,[1] I need an engraving or a lithograph of Gutenberg along the lines of the portrait you wish, for I have no documen-

tation at hand. Moreover, I would ask you to indicate to me the exact size that the portrait is to be. I am entirely at your disposal.

With best regards,

G. Courbet

1. Antonio de la Calle, a Spanish refugee in Geneva, had requested Courbet, on behalf of the typographers' federation of Geneva, to make a portrait of Johann Gutenberg, the inventor of printing in Europe, for the federation's banner (cf. La Tour-de-Peilz 1982, 73, and 77; and especially Vuilleumier 1978, 19). The portrait has not been found and may never have been executed.

75-16 *To Georges Favon, La Tour-de-Peilz, October 19, 1875 (draft?)*

Tour-de-Peilz, October 19, 1875

Monsieur:

As I was away in the Valais for a few days, I was unable to reply immediately to the serious article published in your October 9 issue, titled "A Major Painter and a Minor Rhymster."[1] Your sonnet, Monsieur G.F., is quite simply delightful, and while I pity the one to whom you did the honor of addressing it, I congratulate you and thank you for the sentiment that inspired it. That sentiment is one of those that do human nature honor, it is solidarity—the solidarity that the great-hearted men of all civilized countries understand and know how to put into practice.

Monsieur, please allow me to tell you that you are one of those men and permit the undersigned refugee, notwithstanding the reservations expressed in your article, to thank you and shake your hand.

Cordially,

G. Courbet

1. In the radical Genevese newspaper, *Le Petit Genevois* (October 9, 1875), Georges Favon had published an article entitled "Un Grand Peintre et un petit rimailleur," in which he chided the anonymous author of a poem that attacked Courbet through his bust of *Helvetia*. The said poem had appeared in the *Feuille d'avis de Vevey* on September 8, 1875, signed only with the letters "L.D." Favon was not the only one to take up the pen in Courbet's defense. A certain M.T. wrote a counterpoem that was published in the *Feuille d'avis de Vevey* of October 1, 1875. On this affair, see La Tour-de-Peilz (1982, 75), where the texts of both poems as well as Favon's article may be found.

75-17 *To Etienne Baudry, La Tour-de-Peilz, November 26, 1875*

La Tour, November 26, 1875

My dear Baudry:

This is what my lawyer, Duval,* writes me: the government has just opposed my inheriting from my mother and my sister Zélie,* who have passed away as you know.[1]

He furthermore informs me that M. Durand-Ruel* is in liquidation[2] and that he is afraid that he will not be able to settle with him. He believes that he will not pay and that he will use the state's opposition as a convenient excuse. If this proves to be the case, he urges me to have Durand-Ruel declared bankrupt.[3] Once he is adjudged bankrupt, he will pay. If he pays he will deposit the money he owes with the consignment office. That sum will then at least be out of Durand-Ruel's cashbox and will not be lost. It could be returned to me one day, if the state withdraws its claims against me. Or, if it does not withdraw, it will go toward paying a debt to the state. M. Duval asks my opinion about this.

At Durand-Ruel's request, I had, as you know, written an authorization for Castagnary* to take back from Durand-Ruel's, at the original price, all the paintings he would let me have, so that he might amortize his debt. I don't know what Castagnary has done with that authorization. In any case I'll reauthorize him. If Castagnary does not want to take on working out the exchange that he proposed to me, I would very much like it if you yourself would see to it as soon as possible, that is, immediately. Otherwise, as you can see, all will be lost. I have already taken back from M. Durand-Ruel the paintings stolen from me by the Prussians in Ornans for ten thousand francs though the original contract price was forty-three thousand francs. Right now, Durand-Ruel still owes me thirty-three thousand francs. Ask to see his books to verify the sale of the paintings that add up to that sum. Take them all back, if possible, or else retrieve whatever you can. I had sold him the *Breton Shepherdess* [F. 547], which was exchanged later for another painting.[4] Consequently, she must remain off the market, at my disposal. She cannot be seized by the government. On the other hand, I very much doubt, until I get proof to the contrary, that the government has seized the paintings that were stored at Durand-Ruel's. M. Legrand,* Alphonse, has asserted that he had paid seven thousand francs of the thirty-three thousand, which has not been confirmed by my attorney. Insist that Durand-Ruel show you the paintings he has that belong to me, both in his showroom and in his private rooms, and see for yourself in his books which are the paintings in storage. I have in my trunk, if you did not take it with you, the list of the paintings sold.

I have nothing more to tell you on the subject right now. Castagnary has not answered my last letter.

If we decide to let the state seize everything that was stolen and bought from me by Durand-Ruel, this seizure will comprise the Lugnés, the De Laroches (Henri N.'s fosterbrother), the Gillys, and associates.[5]

I would be much reassured if you could go to rue Hautefeuille. My lease there has expired. I cannot imagine what they will want to do with everything that is still in the atelier. The concierge is not the same. If you can only get back some of the paintings from Durand-Ruel's, withdraw, preferably, the

figure paintings, such as the *Woman in the Wave* [F. 628], the head of the *Woman with a Parrot* [F. 526], etc., etc.

We are still leading the same life, Morel* and I, and we very much regret not having the pleasure of your visit, as you had let us hope.

My attorney writes me that I shall be sentenced to pay four or five hundred thousand francs in damages and interest to the state: I am massacred on all sides.

My dear M. Baudry, I join our friend in sending you my warmest regards. Cordially yours, my friend,

<div align="right">A. Morel G. Courbet</div>

We should try to make some money with my paintings as soon as possible. My attorney affirms that they can even be seized in Switzerland as soon as the verdict is in. Send me news of the paintings by Ingres.[6]

1. Since the amount of the damages to be paid by Courbet still remained to be decided by the state, he was not allowed to touch the inheritance from his mother and his sister Zélie.

2. An economic slump in the mid-1870s forced Paul Durand-Ruel to suspend all purchases and to liquidate his stock (cf. White and White 1965, 135).

3. This does not appear to have happened, as a settlement with Durand-Ruel was eventually reached (cf. letter 76-2).

4. Compare letter 73-19.

5. Reference to various other dealers and patrons who had not paid Courbet for paintings delivered.

6. Compare letter 75-11, n. 2.

76-1 *To Etienne Baudry, La Tour-de-Peilz, January 22, 1876*

<div align="right">La Tour, January 22, 1876</div>

My dear B[audry]:

Herewith, the copy of the letter I received from the attorney,[1] which, I think, oversteps our plans, all the more so as he is the one who holds the notes already signed by Durand-Ruel.* As you rightly thought, it would be dangerous to set the man against us, as he will be called to confirm subsequent juries.

I saw M. Guersin, formerly an attorney in Paris, who is presently working with M. Elisée Reclus.[2] He said that, if M. Duval is my attorney, he warned me that he is a Napoléonist, but that, on the other hand, he held him for the most honest attorney in Paris. That should reassure us. We must advise Castagnary,* to whom I'll write, to agree to have the notes made payable to him. As for Poupart's[3] portrait, get what you can for it.

I received the latest shipment of brandy that you sent me.[4] I thank you with all my heart. It is a magnificent present to which we will do honor. We read in the papers that you are the Saintes delegate for the Senate nominations. We send our congratulations!

Bernheim,* that thieving Jew, has just announced in the papers that he will hold a sale of my paintings in Lille and that he guarantees the authenticity of the signatures. Unfortunately I have no one in Lille to whom I can write to have those paintings, which must come from Mlle Girard,* seized. I received a visit from an elderly spinster from Besançon, Mlle Piguet, who brought me a landscape of the *Puits noir*,⁵ from Mlle Girard and the cellars of the [passage du] Saumon. It will be easy, I think, to get in touch with that Mlle Piguet. I must have her address. For my part, I rather blundered in not seizing the painting on the spot.

Sincerely yours,

[no signature]

1. The letter by Charles Duval,* cited in full in letter 76-2. Apparently, Courbet had involved Baudry as well as Duval in trying to retrieve from the financially strapped Durand-Ruel both money owed him and paintings still belonging to him. This was a delicate task as it had to be done in such a way that government seizures were avoided. It seems that Baudry and Duval worked independently from each other, which led to the kind of complications alluded to in this paragraph.

2. Elysée Reclus (1830–1905), a well-known geographer and anarchist humanitarian, had been marginally involved in the Commune. Condemned to a prison term in 1871, he went into exile, first in Switzerland (Geneva), then in Belgium. Courbet appears to have had some contact with him (cf. La Tour-de-Peilz 1982, 69).

3. This work, also mentioned in several letters from Baudry to Courbet (Paris, Bibliothèque nationale, Cabinet des estampes, Yb3.1739 [4°], b. 2), has not been identified. Baudry, in one letter, further identifies it as a portrait of Poupart-Davyl. Louis Poupart-Davyl was a writer who in the 1870s and 1880s wrote a number of theatrical works. Nothing is known about his relationship to Courbet.

4. Baudry, on several occasions, sent Courbet a cask of brandy. The latest one, announced in his letter to Courbet of December 12, 1875 (Paris, Bibliothèque nationale, Cabinet des estampes, Yb3.1739 [4°], b. 2), contained fifty-two liters.

5. It is not possible to identify the specific painting among Courbet's many versions of this motif.

To Jules Castagnary, La Tour-de-Peilz, January 22, 1876　　　　76-2

La Tour, January 22, 1876

My dear Castagnary:

I am sending you the copy of my attorney M. Duval's* letter, as I have just sent it to Etienne Baudry.* This is what it says:

Sir:

You have learned from my letter and other sources that M. Durand-Ruel* has been obliged to liquidate.¹ I greatly feared that the money owed you would be lost, and, if it were not, all or in part, I greatly feared that Durand-Ruel would refuse to pay, using the government's opposition as an excuse. I was successful enough to give you a somewhat serious hope of

getting paid and, in particular, [to be able to tell you] that M. Durand-Ruel will make up his mind to pay without taking the government opposition into account.

This is what I have obtained:

M. Durand-Ruel still owes you 27,500 francs.[2]

He'll pay 3,000 francs in cash, 12,000 francs this year, at the rate of 1,000 francs a month, and the balance in six months, in equal monthly installments. In addition, he will pay interest.

In order to liquidate his debt, M. Durand-Ruel will make out notes of hand to a third party, and you will receipt the bill herewith enclosed. That way you will have discharged him and he will have liquidated his debt to you.

I shall keep the notes in my safe and I will collect on them as they fall due.

Please give me the name of a man you trust in whose name the notes can be made payable. What do you think of M. Castagnary? Would he take care of it?

I urge you to accept this arrangement, I don't see a better one. If you accept, please write me so and give me a power of attorney in proper form to negotiate on these bases.

Sincerely, etc."

I would be very obliged to you, my dear friend, if you did not let this matter drag on now that the iron is hot. Please go see my attorney, M. Duval, and work things out with him. I am sending him the full and complete authorizations that he asks for, to handle things in the way he suggests.

I know very well that I am taking up your time, which is very precious, especially at this moment, when you are about to be nominated deputy from Paris.[3] For my part, I am counting on your long-standing friendship for your help in my troubles, and I know that you will be glad to do it.

In Fribourg and in the entire canton, I was acclaimed an honorary and lifetime member of the democratic societies that are very numerous in that region.[4] The celebrations lasted for three weeks, with banquets for three hundred people. My statue[5] was a very great success: the people from the Valais have asked me for a cast, as have those of La Chaux-de-Fonds, and others, too.[6] In Switzerland the Communards have won everyone's esteem. I wrote Baudry about Mlle Girard's* thefts of paintings. He will talk to you about it.

Sincerely yours,

Gustave Courbet

Pata* has to go to Paris soon, he'll come by and say hello.

1. Compare letter 75-17.

2. Durand-Ruel had bought a large number of works by Courbet in the period between his release from Ste Pélagie prison and his exile to Switzerland, as may be gathered from the letters to Alphonse Legrand* in this collection.

3. Castagnary was a candidate for the Chamber of Deputies in the 1876 elections, but he was not elected.

4. Compare La Tour-de-Peilz (1982, 8).

5. The bust of *Helvetia* or *Liberty* (Fs. 6).

6. The Valais indeed received its *Liberty*, which was erected in one of the public squares of the town of Martigny. No other Swiss towns, except La Tour-de-Peilz, seem to have received (or accepted) a cast of the statue (cf. La Tour-de-Peilz 1982, 81–94).

To Jules Castagnary, La Tour-de-Peilz, January 27, 1876 76-3

La Tour-de-Peilz, Jan. 27, '76

My dear friend:

I am very aware that if you agree to having Durand-Ruel* make out the notes to you, you also have to receive the money and send it to me.

I confess that, were I in your place, I would want it to be that way. That is how I understood M. Duval's* letter. Please be so kind as to see him and to come to an understanding with him on the matter. I believe that M. Duval will understand it the way we do. That means that it is quite clear that the notes will be made payable to you, that you will receive the money, and that you will send it to me. So please get things started by accepting the three thousand francs that Durand-Ruel is offering at the moment and send it to me, for I need money.

I sent M. Duval a power of attorney and the receipted bill, as he requested in his letter, a copy of which I have sent you.[1]

I saw to it that Baudry* got the list of the paintings indicated on the bill that M. Duval has. He will be so kind as to inform you of whatever I may have forgotten to tell you.

Good luck in the first elections,[2] this success will change the very foundations of your life, which is something to think about.

Many thanks, dear friend, and kind regards. With a warm embrace,

G. Courbet

All our friends send you their regards. Pata* and Morel,* who appreciated your kind greetings, send you their best.

I approve what is written above.

G. Courbet

1. See letter 76-2.
2. Compare letter 76-2, n. 3.

To Gustave-Paul Cluseret, La Tour-de-Peilz, February 7, 1876 76-4
(incomplete)

[Courbet explains that he would like to receive some information, but that he would prefer if it were mailed to Cluseret because, sent in his own

name] . . . it could be seized. . . . [All this might be done through the intermediary of the Swiss committee].

. . . Our friends [here] send their regards to you and regards as well to the friends in Geneva. . . .

Sincerely yours, my dear Cluseret

G. Courbet

<u>76-5</u> *To Juliette Courbet, [La Tour-de-Peilz,] February 9, 1876 (incomplete)*

February 9, 1876

Dear Juliette:

Mme Reverdy* has just written a foolish and wicked letter to my friend Bruyas,* in Montpellier.[1] That makes three letters that indignant men have written me from that part of the world. She wrote an unspeakable letter. She accuses me of every crime. Bruyas is flabbergasted and does not want to answer her. That monster is a devil.

I cannot understand your letting those scoundrels leave your house without making an inventory of what was there. Now my whole life is gone: my manuscripts, my catalogs, my paintings, all kinds of things, everything is lost. . . .

The man Reverdy and his wife have robbed me of a hundred thousand francs' worth of paintings. They accuse J[oliclerc?] of it in a letter but they have plenty of others. One could do a domiciliary visit of their house and get back what they have of mine and of yours. . . .

1. On January 14, 1876, Zoé Reverdy had written a letter to Alfred Bruyas in which she accused Courbet of allowing forgeries to be marketed under his name. For the text of this letter, see Borel 1922 (144–45).

<u>76-6</u> *To Juliette Courbet [La Tour-de-Peilz, early March, 1876]*

Dear Juliette:

There is so much to say that I really don't know what to write you.

For my defense[1] I have two men who are cowards, M. Lachaud* and Duval,* the attorney. Those inveterate Napoleonists—as you were able to see during the last elections—are furious and would rather see me lose than win. I am in the lion's mouth. Nevertheless, I believe that I will pull through. The French state is demanding 286,500 francs and 48 centimes from me. It is ridiculous.[2] I am going to write a letter to the deputies[3] in which I will explain to them that, having already been sentenced for my participation in the Column [affair], and having served my time, I cannot be sued a second time. The *Figaro*, Mme Reverdy's* newspaper, maintains that my properties in

Ornans and Paris will be auctioned off. Yet the sentence has not been passed and will not be for another month. They are assessing my atelier in Ornans at 18,000 francs. The Proudhons[4] are behind it, they want that property, but they are not going to get it. I mortgaged it for 24,000 francs to Blondon,* Arthaud,* and Sancey;[5] it was registered before the attachment, by M. de Chambrette. One could always oppose the auction and raise thirty or forty thousand francs, if necessary. Find out about that, you and Father, and go see, or write Blondon, who administers my liquid assets. But [preserve] the greatest secrecy because of the Reverdys.

I don't dare write you often so as not to put you in the same frame of mind all the time, which causes you grief. I don't know what you are doing down there with Simon and Reverdy. I saw Cusenier* junior, who gave me the news from Ornans (he came from Lausanne to see me), about the girls, the pregnant women, etc. In the end we have been proved right, the republic has been proclaimed, thanks to us. I have been told that M. Ordinaire* was sued for sixty thousand francs by M. Estignard,[6] because of the elections. It is heartbreaking for old Ordinaire.

I think that Father is still doing well, as are you and that his mill[7] is running. This is a year like no other. Five months of rain, he doesn't need to listen whether it is raining.[8]

I am delighted with our horse. Tell Father that I have discovered a device to keep the donkey, Gérôme, from running. All one has to do is to tie the tip of his tail with some sturdy twine, pass it between his hindlegs, under his belly, bring it up to the bit, and hold it along with the reins. If his tail is under his belly, he can't run, it is a foolproof discovery. Have him write me the result, he can use it any way he likes. It's what they do with the oxen in Mexico.

My dear Juliette, I am perfectly well. Never in my life have I felt so good, even if the reactionary papers are saying that I am under the care of five doctors, that I have dropsy, that I am returning to the church, that I am making my will, etc., etc. All that is the last vestige of Bonapartism, it is the *Figaro* and the clerical papers.

I was happy to see Gaudy* nominated again, in spite of his lack of courage.[9] M. Viette of the *Démocratie*, Ordinaire's paper, gave me a great deal of pleasure.[10] I hope that we will be together soon, for the amnesty will come soon, and I will be included in it, in any case.

In any case, if the auction takes place, I count on you and Father to have the auction entailed with a mortgage, and I authorize Blondon to bid up that property as high as is necessary and at any price, as you [must do] for the Ornans house. If you wish, write Blondon immediately. I don't think it will happen but we must be prepared. Write Fumey,* too. The furniture and the paintings from my atelier, which Mme Reverdy wanted to have the govern-

ment and the police seize, will also be sold. She is truly a phenomenal family monster. As for the paintings she stole from me, saying that it was Mlle Girard,* she has not heard the last of that.

Father and you must not give anything a thought, you must live as quietly as mice. If anything happens, if the amnesty does not come through,[11] Father will have to take out a mortgage on his property for some thirty thousand francs with anybody at all. The money borrowed by him will be invested and will cover the interest on the loan. It is as simple as that.

I recently received a wonderful welcome in the canton of Fribourg. I am an honorary member of all the clubs in the Fribourg canton, where I have had an enormous success, as well as in the Gruyère, in Bulle, etc.[12]

I thank you very much for the splendid socks that you sent me with Arthaud and Blondon. I embrace both you and Father again. I hope that all these annoyances will soon be over. Take care of yourself, and don't give a thought to all that, which would sadden you. Kind regards to everyone,

Gustave Courbet

Keep me posted.

1. Though Courbet had been sentenced to pay for the reconstruction of the Vendôme Column on June 26, 1874 and again, following an appeal, on August 7, 1875, the amount of the indemnity still needed to be specified. The hearings to that effect were not to begin until January 1877, and it would take until May 24, 1877, for the exact amount of damages and the terms of payment to be legally determined.

2. On March 9, Charles Duval sent Courbet a letter notifying him that he had received an official summons for payment of a provisional indemnity of 286,549.78 francs (cf. letter 76-8). The amount Courbet quotes in this letter to Juliette is slightly different, which may indicate that Courbet had not yet received the letter from Duval but knew about the summons from hearsay.

3. See letter 76-8.

4. The family of Hippolyte Proudhon, who had become mayor of Ornans in 1871.

5. Louis Sancey was an accountant in Besançon.

6. Alexandre Estignard (1833–1918), who was later to write a biography of Courbet (1896), was elected deputy of the Doubs Department in the second ballot elections of March 5, 1876.

7. Courbet's father owned a mill on the Bonneille River. Cf. letter 73-27, n. 1.

8. Courbet generally refers to his father's watermill with the old-fashioned term *écoute-s'il-pleut*, lit. "listen whether it's raining." His line here is intended as a pun.

9. Félix Gaudy had been reelected deputy of the Doubs Department in the February-March elections.

10. François Viette (b. 1843), a left-wing republican, had been elected deputy of the Doubs department as well.

11. In the 1876 elections, the question of amnesty for all participants in the Commune had been an important issue. Since the Republicans had gained a majority in the Chamber of Deputies, Courbet was optimistic that general amnesty might be on the horizon. As it turned out, however, amnesty was not to take effect until after Courbet's death, in 1880. On the amnesty decision, see Joughin (1955).

12. On the enthusiastic reception of Courbet in Swiss democratic and radical political clubs, see La Tour-de-Peilz (1982, 81).

To Jules Castagnary, La Tour-de-Peilz, March 10, 1876

La Tour-de-Peilz, March 10, 1876

My dear Castagnary:

Following an arrangement made between M. Durand-Ruel* and myself, it was agreed that Durand-Ruel would write me notes of hand to pay off his debt to me.

In order to protect the notes from government actions, it was agreed that I would ask one of my friends to lend me his signature.

Would you be that friend? You will, won't you? If so, please be so kind as to pass by my attorney's, where you'll find the notes payable to you. Please sign them over to M. Duval,* who will undertake to keep them in his safe and to apply the proceeds to my account as they fall due.

This, dear friend, is yet another service I am hoping you will do me.

Many, many thanks.

Your devoted

Gustave Courbet

I will send you without delay a final, printed letter addressed to the Senate and the Chamber.[1] Let it fall where it may. I dashed it off as best I could.

1. Compare letter 76-8. The letter was printed by the firm of Antoine Vérésoff & Co. in Geneva.

To the Republican deputies and senators elected to the national assemblies in February 1876, La Tour-de-Peilz, [mid-] March 1876[1]

Monsieur:

On the ninth of the current month of March, my attorney wrote me the following, "The state is waking up: it has sent you, yesterday, at my home address, a summons for provisional damages of 286,549.78 that you'll have to pay. I will give you the details later. In two weeks you'll be assigned payment of those 286,549.78 francs. You'll be bound to pay them. I don't see any way to extricate you from that fate."

The experience of an already long career has robbed me, one by one, of quite a few illusions, but there is one that I'll retain, namely a belief in the justice and generosity of the French people. If my attorney is right in not doubting the outcome of the suit that will be filed against me, I, for one, don't doubt one single instant that that suit will not take place. Consequently, I

appeal here and now, to a tribunal, higher than all others, than the legislator who makes the attachment laws, than the judge who applies them. I appeal to those elected on February 20 the decision of those elected on February 8, 1871.

Is it necessary, Monsieur le Député, that I try to refute the arguments used by those who have made me materially responsible for the destruction of the Column? I don't think so. Isn't there one fact that overshadows all others in this case, namely my non-presence at the Hôtel de ville when that destruction was decreed?[2] I have asked myself since then and I will ask every intelligent man if it was fair and rational to place the burden of responsibility on me alone. My colleagues in the Commune have paid for their participation in the events of 1871 with their lives or their liberty. Like me they have been judged and sentenced for that participation to more or less serious punishments. The state therefore is right in no longer claiming anything from them. Why then does it claim something from me? Have I not served my sentence, and does the juridical axiom, *Non bis in idem,*[3] no longer exist when it concerns the painter Courbet?

Was it to punish me for having refused the decoration under the empire,[4] that I must carry a cross of a different kind?

Perhaps! For during the last five years the persecutions that I have had to suffer are evidence of a ferocity of sentiment that is hardly a credit to human nature. I won't elaborate on that sad subject. Suffice it that I protest against the way all the standard rules in the area of seizures have been violated when it came to me. In all persecutions one lets the hapless victim keep at least his working tools. Mine have been taken. It is felt, no doubt, that the artisan deserves more consideration than the artist. It is probably thought that I had done enough paintings and that it would be to France's credit and advantage if there would no longer be any new work signed "Gustave Courbet," either in the exhibitions of Paris or in those of Vienna or Philadelphia. If this was the goal to be attained, I can assure you that it has been attained.

Yet, I would get over seeing my palette broken, my paintings confiscated, if, on the other side of the Jura, my mother and sister had not died from grief with my name on their lips. As long as the border of France will remain closed to me, I won't even be there to say a last farewell to my old father. That last duty will therefore fall on the shoulders of my youngest sister, the only child he has left.[5]

I believe that I have demonstrated that physically I was not responsible for the destruction of the Column. Am I morally responsible? Yes, but on the same grounds and to the same extent as thousands of citizens who cannot be blamed for their lack of patriotism or intelligence. It is not up to me here to judge the Commune. Posterity will take care of that. I'll limit myself to speak

of the Column and to tell why I accepted my share of the moral responsibility of its fall, just as so many others accepted their role in the responsibility for rebuilding it.

Yes, that role I accept, I accept it completely. The motivation by which we have been guided is not one for which we need blush. That motivation was none other than the hatred of the hideous spectacle of glory, paraded before a bleeding and humiliated France by the Prussians. The sight of our "William,"[6] far from consoling us for our present defeats, made us regret our victories of the past, which, after all, had ended up in invasion and shame.

The Column has been rebuilt. It is right. But who should pay the reconstruction cost if not the instigators of the damned war? Has one sent a subscription card to the man in Metz who has sold to the Prussians enough cannons to make ten columns?[7] And that other lighthearted man, is he not walking around freely in the France from which are banned thousands of citizens whose homes he has destroyed and whose lives he has broken?[8] And that third one who pretended that not a gaiter button was missing?[9] Has he been made to pay all those who were missing at the roll call?

No, no one has thought twice before protesting as long as that Assembly, nominated "one unlucky day," was seated in Versailles. Those men, misguided by their emotions, blinded by their success wrought with panic and fear, which could cause them to imagine that they were the masters of France—those men would have been immune to any fair and generous sentiment. The country has understood that the defenders of moral order[10] worked, no doubt unconsciously but no less certainly, at its demoralization. That is why for the most part it has retired them, and it has done the right thing.

"These days," as the venerable senior president of the Chamber of Deputies, Raspail,[11] has said, "a new era begins for France, an era of appeasement and conciliation." It is comforting and beautiful to see a martyr like Raspail, and another great victim of the opposition, Victor Hugo*—those who have suffered so much—speak of forgetting and forgiving, at the very moment when their cause has triumphed. Homage to those noble minds who don't think of persecuting yesterday's adversaries and who have no other preoccupation than to send to the banished a word of encouragement and comfort.

I believe that the moment has arrived for me to ask the new National Assemblies to repair an injustice committed against me by the defunct Assembly. It is unworthy of the majesty of the French people to have made in its name a law especially to vex one individual.[12] I address myself to all deputies and senators to beg them to make a written proposal in their respective chambers for a project of law aimed at lifting the sequestration that has been imposed on my property, to repeal with one word a hateful law whose makers

were inspired by the most detestable of all reasons, the reason of state. You are a Republican, Monsieur, and I would feel that I did you an injustice if I doubted for a moment that you would not receive my request favorably.

One more word and I'll be done. The country where I have come to seek refuge, to escape the persecutions that should have stopped after my imprisonment, has, it too, had its bad days. In 1847 an insurrection started there known under the nickname, "Sonderbund."[13] On the one hand there were the faithful citizens, united under the federal banner, on the other, the revolutionaries, incited by fanatical priests who then as now took their orders from Rome instead of taking them from their conscience as men and citizens. Well! The first concern of general Dufour,[14] the commander of the federal army, was to save the lives of the rebels. He found that civil war was sad enough as it was, and that one should avoid, on both sides, to lend to the war a sense of hatred or vengeance. Consequently there were very few victims, and when the insurrection had been put down, not only were there no reprisals, not only were there no deportations, no exiles, but the expenses of the rebellious cantons were borne by the entire confederation.

That is, Monsieur, how Switzerland has been able to recover immediately from its disaster; that is how it has been possible to erase in very little time all traces of civil discord.

The United States, after the Civil War, did not act differently, and that is why the United States has remained a great country, free and respected.

France is Republican, we are told these days. I wish from the bottom of my heart that it be true, but I won't believe it until there will no longer be any deportees, any exiles, until it will have replaced a policy of anger and rancor by a policy of justice and magnanimousness.

Gustave Courbet

Tour-de-Peilz,
Canton Vaud (Switzerland)
March 1876

1. Courbet had this letter printed by Antoine Vérésoff in Geneva. He planned to send it to all Republican deputies and senators newly elected in the 1876 elections, in the hope that they would either repeal the bill of May 30, 1873, which condemned him to pay for the reconstruction expenses of the Vendôme Column, or else introduce a general amnesty bill for all those who had been involved in the Commune. It appears that only four letters were actually sent, to Castagnary,* Jules Grévy,* Victor Hugo,* and François Raspail (cf. n. 11). Negative feedback from Paris may have convinced Courbet not to distribute it any further (cf. La Tour-de-Peilz 1982, 74; and letter 76-11).

2. Courbet was no longer a member of the Commune when the demolition of the Vendôme Column was decreed.

3. "Not twice for the same crime."

4. Courbet had refused the Legion of Honor cross in June 1870.

5. Since Courbet's mother and his sister Zélie had died, and since the family had broken off relations with Zoé and Eugène Reverdy, it was Juliette who was now responsible for the care of Courbet's father. As it turned out, Régis Courbet was to survive his son.

6. No doubt a reference to the imperial counterpart of Kaiser Wilhelm, Napoléon I, whose effigy had surmounted the Vendôme Column.

7. Probably a reference to Marshal François-Achille Bazaine (1811–88), who had been accused of treachery after his incompetent command of the army divisions at Metz, which led to the capitulation of that city on October 29, 1870.

8. Perhaps a reference to General Uhrich, who had conducted the unsuccessful defense of the city of Strasbourg.

9. On July 14, 1870, when asked whether the French army was ready to fight the Prussians, Minister of War Edmond Leboeuf (1809–88) had gallantly answered that the army was ready "down to the last gaiter button" (cf. Adriance 1987, 3).

10. The term "moral order" (*ordre moral*) was identified with religious conservatism.

11. Elected deputy in 1876, the aged Republican maverick François-Vincent Raspail (1794–1878) presided over the first meeting of the new Chamber on March 8. In his opening speech he had indeed said, "A new era begins today for France," and he had advocated that in this new era past disasters and differences be forgotten. Raspail was a strong protagonist of general amnesty, and, on March 21, he and Victor Hugo introduced identical amnesty bills in the Chamber and the Senate, respectively (cf. Joughin 1955, 103).

12. See n. 1.

13. The Swiss Sonderbund was a separatist alliance of several Roman-Catholic Swiss cantons, formed in the early 1840s. In 1847, the Swiss Diet decided to dissolve the Sonderbund by force. The federal army under the command of General Guillaume-Henri Dufour (1787–1875) defeated the Sonderbund forces in twenty-five days. The casualties on both sides were minimal. The expenses of the war were borne by the Sonderbund cantons that had actually engaged in the war. Those that had not participated in the war paid a fine that was used as a pension fund for veterans.

14. See n. 13.

To Jules Castagnary, [La Tour-de-Peilz,] March 22, 1876 76-9

Wednesday, March 22, '76

Dear friend:

M. Duval* is sending me all the notes of hand signed by Legrand* and Durand-Ruel.* I really don't understand this ploy for having things done sooner. I am sending you M. Duval's letter with the note that fell due March 10. If that is alright, I will send you the other notes, if you want to cash them all or have Baudry* cash them; or, if you prefer, I will send them directly to Duval, who will have you cash them one after the other. Do whatever is best, for I confess to you that I don't understand it at all anymore. As I have already told you, "I acknowledge receipt of the first three thousand francs from you."[1]

I still would like to find out whether my paintings can be seized in Switzerland. Let me know.

I wrote our friend Etienne Baudry. He should have passed my letter on to you a long time ago.

Sincerely yours, dear friend,

Gustave Courbet

Have you seen Pata?*

1. This entire passage refers to the complex transaction needed to return to Courbet part of the debt owed him by Paul Durand-Ruel.

<u>76-10</u> *To Jules Castagnary, La Tour-de-Peilz [March 26, 1876]*

Tour-de-Peilz

My dear friend:

Yesterday I received your letter, today I received M. Duval's* letter. He is becoming more and more inflexible, ever since the Napoléonists were routed,[1] I think he blames me for it. I thank you for agreeing to sign those notes. M. Duval is demanding them back from me very sharply. I imagine he considers them a guarantee. I am sending you two copies of the letter that I am addressing to the Chamber.[2] In my opinion, it has only one defect: it is too soft. But in France right now there is so much intimidation that people no longer dare speak out. There is so much mutual intimidation that people fear their own shadows.

Only M. P. de Cassagnac[3] has the floor. The Republicans, with their moderation, have outdone the reactionaries. These beggars are also misguided, as too-well-behaved people are by priests, so that already, as of now, the true republic is lost, lost for at least fifteen years, for everything depends on a good start.

Tell me immediately what I must do to have that[4] arrive before the discussion of the amnesty.[5] I have one thousand copies arriving from Geneva. Give me the name of an advertising agency that can distribute these letters.[6] If you think you cannot write me soon enough, send a telegram. I'll pay you back in stamps.

Sincerely yours,

G. Courbet

1. In the elections for the Chamber of Deputies held in late February and early March, the Republicans had gained 340 out of 493 seats, while the Bonapartists had won only forty-five seats (cf. Wolf 1963, 367).

2. See letter 76-8.

3. Paul de Cassagnac (1842–1904), a Bonapartist Catholic journalist elected deputy in 1876, relentlessly attacked the Republicans.

4. The printed letter to senators and deputies (letter 76-8).

5. On March 21, Victor Hugo* and François-Vincent Raspail had introduced identical amnesty bills in the Senate and the Chamber, respectively. Compare letter 76-8, n. 11. Referred to committee, the bill was discussed in April and May and eventually rejected by the Chamber of Deputies on May 18 and by the Senate on May 22 (cf. Joughin 1955, 103–113).

6. The letter does not appear to have been distributed. Compare letters 76-8, n. 1, and 76-11.

To Jules Castagnary, La Tour-de-Peilz, April 3, 1876 <u>76-11</u>

<div align="right">La Tour-de-Peilz, April 3, 1876</div>

My dear Castagnary:

I have just written Duval* that I am sending you the seven notes that I have left. You'll find them in this letter. Please let me know that you have received them and work something out with M. Duval about it.

As you say so well in your letter, go see M. Grévy[1] on my behalf. I must tell you that I have addressed only three of these printed letters:[2] one to Hugo,* the other to Raspail,[3] and finally, the last one to Grévy, in my eagerness about this amnesty question.

I am very well aware, as you say, that my case is unrelated to that question and that I don't have to follow that course—a minister of justice or of state can set this trial aside. We could interest the deputies from the Franche-Comté—Grévy, Viette,[4] Gaudy* and associates—in this question that must be brought to an end. It is a disgrace for France.

I regret one thing and that is that my timorous friends from Besançon did not testify to the mortgage that they took out on my Ornans atelier and that was registered before any kind of order of seizure[5] and legally. If there is an auction, we must absolutely buy back the atelier and interest Viette and Ordinaire* in the matter. It is a question of some twenty thousand francs.

Pata* wrote us that Etienne Baudry* was going to exhibit.[6] I am very glad to hear it. Kind regards to the Ordinaire family and to Pata.

Sincerely yours,

<div align="center">*G. Courbet*</div>

1. Jules Grévy,* who had served as president of the National Assembly between 1871 and 1873 but had resigned because of the increasing hostility of the right and his discontent with Adolphe Thiers, had been elected to the Chamber of Deputies in March 1876.

2. The printed letter to deputies and senators. See letter 76-8.

3. Compare letter 76-8, n. 11.

4. On Viette, see letter 76-6, n. 10.

5. Compare letter 76-6.

6. Etienne Baudry, an enthusiastic amateur painter, had apparently decided to submit one or more works to the Salon of 1876. Since no work by Baudry is mentioned in the catalog, however, he was apparently rejected by the jury.

76-12 *To Jules Castagnary, La Tour-de-Peilz [April 9, 1876 (Ad)]*

Tour-de-Peilz

My dear Castagnary:

It appears that Étienne Baudry* has taken the plunge and submitted his work to the Exhibition.[1] It would be good if he were accepted, it would commit him. Marcel Ordinaire* has also submitted work and so has Pata.* I hope they will all succeed, we'll soon find out. I thank you all for having thought of me at dinner at Pata's. I send my regards to everyone and to you in particular.

I authorized my attorney to deliver to Mme de Morny the *Young Ladies from the Village* [F. 127], [which is] in my atelier in rue Hautefeuille.[2] The painting is completely ruined.

She should have it relined and she should send it to me to have it put back into shape. I would take advantage of that to make a copy of the detail of my poor sister Zélie,* who died without seeing me again. The Reverdys* in Ornans are selling the paintings that they stole from me in the rue du [Vieux-] Colombier and from my atelier in the passage du Saumon. One of them passed through my hands,[3] but I blundered and didn't keep it because I wasn't thinking.

Sincerely yours,

Just address the money to M. Bavon, postmaster at La Tour. He is expecting it.

I have had a cold for four months, I am half dead, I have neither bronchia nor lungs left.

[no signature]

1. Compare letter 76-11, n. 6.
2. Mme de Morny, widow of the Duc de Morny,* had inherited the *Young Ladies from the Village*, which her husband had bought from Courbet in 1852. Courbet had borrowed it from her for his private exhibition of 1867 but had never returned it. After the Commune, the painting was sequestered together with other works in Courbet's atelier in the rue Hautefeuille. According to Riat, Mme de Morny was not to retrieve her painting until a provisional judgment in November 1876. It was subsequently sold at auction on March 29, 1878 (cf. Riat 1906, 368).
3. Compare letter 76-1.

76-13 *To Gabriel Eynard, La Tour-de-Peilz, May 3, 1876*

Tour-de-Peilz, May 3, '76

My dear Eynard:

You rented that little shed to put things in and for us to use when you might come to La Tour. I thought I could dispose of it for four days for a

neighbor who was thrown out of his home before he was able to find another. The man has four children, a wife, he is a dyer.

The Building Society is harassing me in every way they can because of this act of charity, for on this occasion I was counting on you as I would on myself. I would be very obliged to you if you could place that thing at my disposal (although, as you know, I do not need it), so that I might be out of reach of that matchless society's protests. If necessary, I will offer to pay you for the balance of your lease.

I would be very obliged to you if you could answer me right away, for tomorrow they are going to send me a summons. Please write them and me.

<div align="right">G. Courbet</div>

Give us your news and come see us.

[Address] Monsieur Gabriel Eynard
 Canton Vaud
 Switzerland

[Postmark] La Tour-de-Peilz, May 3, 1876

To M. Montet, La Tour-de-Peilz, May 3, 1876 <u>**76-14**</u>

<div align="right">May 3, La Tour, '76</div>

M. Montet:

M. Chalet has just told me on behalf of M. Glos that I was supposed to write M. Eynard,* which I have just done, though it was not necessary, as there was an understanding between myself and M. Eynard, so don't worry.[1]

But you should worry about something else, namely the roof. The roofer stopped a leak, it's true, but they started three or four others by walking on the roof, so that yesterday one could have gone boating in the attic. The water has seeped through the ceilings[2] of the upstairs apartment and drips onto the paintings.

M. Glos told M. Chalet that pretty soon I would be cutting their trees for firewood. I have more to fear from M. Glos than M. Glos has to fear from me. I spent eight francs to have the trees trimmed in order to care for them as they have been until now. If M. Glos wants to repay me the eight francs, I'll give him back four bundles of twigs. I am counting on you,

Sincerely yours,

<div align="right">*Gustave Courbet*</div>

1. It would seem that M. Montet was an employee of the Building Society. Possibly M. Glos was the landlord of Courbet's neighbor, Gabriel Eynard. M. Chalet may have sublet Eynard's house during his absence.

2. A small bit of paper has been pinned to the letter with the following footnote: "Ceilings that I had made, at my expense, and that cost me some one hundred francs."

76-15 *To Louis Ruchonnet [Lausanne, May 17, 1876 (Ad)]*

Dear M. Ruchonnet:

I came to Lausanne to see you, as I did not know whether you had received the bust of *Helvetia* [Fs. 6], which is at your disposal to be used as you will see fit.¹ Congratulations on the latest [illegible word] elections.²

Sincerely yours,

G. Courbet

Send me the crate back to La Tour-de-Peilz.

1. Louis Ruchonnet, who until May 1874 had served as head of the Department of Education, Religion, and Cultural Affairs in the canton of Vaud, and who subsequently sat on the Federal Council, was a strong supporter of Courbet. To show his appreciation, Courbet had given a plaster cast of his *Helvetia* to Ruchonnet, who donated it to the Musée Arlaud in Lausanne (cf. La Tour-de-Peilz 1982, 90–92).

2. Reference to Ruchonnet's election to the Federal Council.

76-16 *To Jules Castagnary, La Tour-de-Peilz, May 20, 1876*

La Tour-de-Peilz, May 20, 1876

My dear Castagnary:

You announce that you have something to send to me from M. Legrand:* this April's installment. Please address it to M. Bavon, postmaster in La Tour (Vaud, Switzerland), as you did the last time and as you will be so kind as to continue to do in the future.

We would very much like to have news of Paris—about the amnesty,¹ the Salon, and our friends, Pata and Ordinaire.² If you could send us the articles that you must be writing for the *Siècle*, you would do us a favor, for here we get no news at all.

Kind regards to Baudry.* I have heard nothing from him for quite a long time. Pata is complaining a lot about his meager sales, which keep him from coming to see us.

Our friends here send you cordial greetings, and I, my dear fellow, send you my best wishes.

G. Courbet

P.S. The director of the Toulouse artistic committee, M. Journet,³ is currently in Paris. I have been told that this committee, thanks to M. Journet, has sent me five hundred francs. So far I have not received anything, which could be explained by the mail's being addressed directly to my name. Please inquire, and if that is the case, please tell M. Journet to make a claim at the post office, saying that the money does not belong to me.

Give M. Journet the above address or that of M. Duchesne, general storekeeper, rue du Simplon, Vevey.

At the request of the director of the Philadelphia Exhibition I have sent four paintings to the exhibition, although three weeks late. We'll see what comes of it.[4]

1. Compare letter 76-6, n. 11.

2. Cherubino Pata* was represented at the 1876 Salon with a *View of the Town of Sion, Switzerland* (no. 1597). Marcel Ordinaire* did not exhibit.

3. Little is known about this donation, which no doubt was intended as a gesture of solidarity on the part of the Toulouse artistic committee. The director of the committee, M. Journet, may have been related to Jean Journet (b. 1799), whose portrait Courbet had exhibited at the Salon of 1850.

4. Courbet indeed was represented by four works at the Philadelphia Centennial Exhibition of 1876. Two of these paintings were views of the Castle of Chillon, the third was a *Huntsman*, and the fourth a *Bather*. Following the catalog, the first three works were owned by a certain Reitlinger, but it is possible that Reitlinger was merely Courbet's representative in America (cf. Brooklyn 1988, 69 and letter 77-9). None of the four works can be identified with any certainty.

To his father, La Tour-de-Peilz, May 29, 1876 76-17

La Tour, May 29, '76

Dear Father:

I am very sorry that I cannot help you with all those problems, and with those disgusting individuals, those thieves![1] Lately I was asked to finish two paintings that they took from me in Paris and I was so foolish as not to keep them. Mlle Piguet,[2] the sister of the marble cutter who died, brought them to me. But you must say nothing about it because I want to try to recover them, especially as they were so foolish as to send me one of M. Reverdy's* landscapes, thinking that I would no longer remember. But enough about those scoundrels.

As for purchasing, you should buy, at any price, the house; the little garden along the water; and Les Burettes, the vineyard at Charmont. Bid as high as you have to for those three things, I'll be good for it. There is another reason: if they don't have the house they won't have any way to buy another one and that might be a way to get rid of them.

It is impossible for me, as you know, to come to Ornans unless I spend five years in prison for my debt to the state. I think that things are winding down. They have rejected the amnesty but that has nothing to do with my case. I think that my lawyer will ask for the charges to be dismissed and take advantage of the situation.

Make M. Reverdy pay rent for three years for he is a stranger to us and he does not belong to our community nor does my sister. He has no right to our house. Do an inventory of what belongs to us, to Father as well as to me. The furniture is nothing to do with them. They won't have a right to their share of the furniture until your death, if they don't die before you, which is

likely in their case. Consequently, buy at any price the house, the little garden, and Les Burettes.³ That won't cost us much since there are three of us and they waived my deed of gift of Mother's estate. It is not worth doing without, and we can remain in our ways, and our dear parents' house, which they built with their own hands, will not be inhabited by a man who lives off women and whom society repudiates. Don't let them steal any of my papers, and, another thing, you should already have put the seals on. Don't even think of coming to get me. Keep up the good work. Regretting that I am not there to help you, I embrace you wholeheartedly, you and Juliette.

G. Courbet

See you soon, I hope. Hold on. Write me immediately.

1. Zoé and Eugène Reverdy.
2. Compare letter 76-1.
3. All this property had been seized from Courbet, who now wanted his father to try to buy it back.

76-18 *To Paul Pia, La Tour-de-Peilz, June 1, 1876*

June 1, '76, Tour-de-Peilz

My dear Pia:

I am going to send you two paintings, which M. Morel* and I will pack up together. As soon as you receive this letter, send me the measurements of the frame of the *Fisherman of Clarens* [F. ?], and I will send you another [painting] for that frame.

I acknowledge receipt of 850 francs for the painting of the *Fisherman*. You still owe me for the previous paintings, as your last letter but one states.

I have just made a medallion [Fs. 8] for a house that is being built on the quai de Navez.¹ It is larger than life-size—but only by a little—and represents a gull in two guises: a woman's head and a seagull, which forms the headdress for the woman. It is something that I think turned out very well. When I have some casts of it, I'll send you one.

Leloup,* the editor of La Chaux-de-Fonds's *National*, who came to see me,² did an article on the sculpture, which will appear well before the casting.

The paintings that I'll send you are small-sized. Please pay ninety something to Leret for his shipment to London³ and eighteen francs to Vérésoff for printing the letter.⁴

The newspapers are saying about Rochefort* what the clergy of Fribourg used to say about me: that he is dropsical, bloated with an enlarged heart.

Kind regards to him and to everyone, particularly your family. I hope your mother has recovered.

Sincerely yours,

G. Courbet

1. Now quai Perdonnet. The house was built by the painter Pierre-Vincent Nicollier and is still standing today. Two windows on the second floor are surmounted by Courbet's medallions (cf. La Tour-de-Peilz 1982, 95).

2. Leloup had visited Courbet in June 1876 (cf. La Tour-de-Peilz 1982, 53).

3. Courbet appears to have exhibited regularly in London galleries, including the London branch of Durand-Ruel's.* Compare letters 75-7 and 77-9.

4. The letter to deputies and senators (letter 76-8), which had been printed by the firm of Antoine Vérésoff.

To Louis Ruchonnet, La Tour-de-Peilz, July 1 [1876] 76-19

Tour-de-Peilz, July 1
Sunday

Dear M. Ruchonnet:

Taking you up on your promise, I would like you to reserve three meters of wall space for me at the Lausanne exhibition,[1] illuminated from right to left on whatever panel you can get, if possible. I am sending three serious things that have never been exhibited:[2]

1. A portrait head: the *Beautiful Irishwoman* [F. 537].
2. The portrait of a *Disabled Veteran of the First Empire* [F. 807], a sketch for my painting the *Pauper* [F. 660?].
3. A sculpted medallion: the *Seagull of the Lake of Geneva at Vevey: A Poem* [Fs. 8].

I have had frames made for the purpose. I would like these three things to be exhibited together, the medallion placed like a painting below the paintings on the line.

This is asking a great deal, yet I believe that it has its purpose. Nothing is for sale except casts of the *Seagull*.[3]

The three pieces are curious specimens, do what you can. Have the titles of these objects put in the catalogue, for they will arrive before July 5. They are one meter wide each. If anything comes up, drop me a note or a telegram.

Sincerely yours,

G. Courbet

1. Every two years the Société suisse des beaux-arts organized an exhibition of contemporary art that traveled through the country, the so-called Turnus. Courbet participated in the Turnus of 1874 and 1876, showing his work in the Musée Arlaud in Lausanne. Courbet apparently hoped that Louis Ruchonnet would use his influence to reserve a prominent space for him in the show.

2. This is not true for the first painting, the *Beautiful Irishwoman*, which had been exhibited several times before (cf. Fernier 1977–78, 2:12).

3. Only one plaster cast of the *Seagull* or *Mouette* is known outside the two medallions found above the windows of the former Nicollier residence in Vevey. Compare letter 76-18, n.

1. The cast in question is in the **Musée Jenisch** in Vevey. A bronze cast of the medallion was made in 1982 (cf. La Tour-de-Peilz 1982, 53; Fernier 1977–78, 2:318).

<u>76-20</u> *To Louis Ruchonnet, La Tour-de-Peilz, July 13, 1876*

La Tour-de-Peilz, July 13, '76

My dear M. Ruchonnet:

My friend Hugues is bringing you this note because he has a mineral he wants to show you, whom I know to be an eminent geologist.

Well, I went to see that exhibition at the Musée Arlaud.[1] Always the same nonsense: local amateurs highlighted at the expense of genuine art, which could do honor to an exhibition of the country in which it is held, in the eyes of people who understand art and its importance, as well as the importance of the country that they represent (which in this exhibition does everything it can to attain that goal).

I had already seen this exhibition in Fribourg and I am sure of what I am saying here: I did not find, among all the good paintings, a single work of genuine art. They were placed in the very top row of the hall. They wronged the artists and the public. They make themselves ridiculous and destroy and discourage everyone.

Among all of them I will cite only four pieces: three still lifes of the same size, wonderfully painted; a landscape by Furet in the stairwell,[2] not to mention the Bocions,[3] etc., etc., preferable to the paintings of young ladies and amateurs that were hung before the traveling exhibition arrived in Switzerland.

As for myself, I once more regret sending anything. I had thought, as with all exhibitions, to show some exceptional pieces that would have had some success as they have had in this canton since I have been here. It was necessary that, once and for all, in Lausanne as everywhere else, the technique of those paintings be seen, even in Lausanne. And because they talk about palette-knife painting, I would have liked to show the result that that method can produce.[4] Confronted with such ill will or such ignorance one must give up. I hope that in Bern I'll have more luck, that is to say, less hostility.

I needed the line; they placed on it a painting that I don't belittle but that could have been put somewhere else, which would have allowed the medallion of the *Seagull* [Fs. 8] to show. I was very keen on that because of the influx of foreigners who'd come for the federal shooting contest.

I don't know whether with your influence you can obtain something without showing them this letter, which is written for you.

Sincerely yours. I am going to the shooting contest[5] on Sunday.

G. Courbet

Please return the crate of the *Helvetia*.[6] The inhabitants of Interlaken have asked for one.[7]

1. The 1876 Turnus in the Musée Arlaud at Lausanne. Compare letter 76-19, n. 1.
2. François ("Francis") Furet (b. 1842), landscape painter, student of Barthélemy Menn.
3. François-Louis Bocion (1828–90), landscape painter who worked in the region surrounding the Lake of Geneva.
4. If that were indeed the case, one wonders why Courbet did not submit a landscape painting in which the palette-knife technique would have been more clearly visible.
5. The so-called *Tir fédéral* at Lausanne (cf. La Tour-de-Peilz 1982, 92–93).
6. Courbet had presented Ruchonnet with a plaster cast of his bust of *Helvetia*. Compare letter 76-15, n. 1.
7. No cast of *Helvetia* or *Liberty* is known in Interlaken today, and there is no record that one was actually shipped there.

To Etienne Baudry, La Tour-de-Peilz, August 9, 1876 76-21

La Tour-de-Peilz, August 9, '76

My dear Baudry:

I was absent and received your letter yesterday.[1] I don't know whether my letter will arrive in time to still find you at Rochemont.

You tell me that you have all the best intentions to come and see us here at La Tour. Everyone is looking forward to seeing you. We'll do a little painting and you will break up the monotony of our exiles' life.[2]

You are going to Paris. Won't you be able to find out whether M. Dufaure* wants to leave me in this ridiculous position indefinitely?[3] My father and my sister Juliette are dying with grief.

I have redone, as I told you already, the painting that you sent me.[4] I have outlined the painting on another similar canvas, and I am waiting for you to come and complete it, for the canvas you sent me cannot be completed, it is too cheap and thin, and one cannot paint over it anymore.

You tell me that you want to send more brandy.[5] Do send a little more for it causes an immense pleasure in this country. I am saving it as much as I can, but there is some instability in that liquor that makes it difficult to keep it as long as you want.

Think of what to take with you. I have no head for it. Bring Castagnary* along if you can.

Kind regards to your lady and our friends.

Sincerely yours,

G. *Courbet*

1. Probably Baudry's letter of August 3, 1876 (Paris, Bibliothèque nationale, Cabinet des estampes, Yb3.1739 [4°], b. 2), in which he announces his visit to La Tour-de-Peilz.

2. Baudry was to travel to La Tour-de-Peilz in September, but arrived just when Courbet had left for La Chaux-de-Fonds. He never saw Courbet as he had to leave before the artist returned.

3. Courbet was still hoping for a solution to his problems through third-party negotiations with the government. He had fastened much hope on Baudry, who was a compatriot of Jules Dufaure's son Gabriel.

4. Perhaps the *Spanish Woman* (F. 170). In a letter from La Tour-de-Peilz to La Chaux-de-Fonds of September 12, 1876 (Paris, Bibliothèque nationale, Cabinet des estampes, Yb3.1739 [4°], b. 2), Baudry writes to Courbet that he is trying to copy his *Spanish Woman* and expresses his regret that Courbet is not there to help him.

5. Baudry had twice sent Courbet brandy: a barrel of sixty-two liters in July 1875 and another one, the same size, in December 1875 (see letters in Paris, Bibliothèque nationale, Cabinet des estampes, Yb3.1739 [4°], b. 2).

76-22 *To Jules Castagnary, La Tour-de-Peilz, August 28, 1876*

Tour-de-Peilz, August 28, '76

My dear friend:

I am still on tenterhooks here, so worried that I cannot work. My father, who is getting very old, writes me all the time and wants me to take advantange of the fact that the deputies are no longer in session to leave here. It's killing me! I end up believing that it is my attorney[1] who, conspiring with Lachaud,* is keeping me in captivity. With all the people we know, is it not possible to find out for certain, either from the minister of the interior or from the police prefect, for certain and with a written affidavit from me that I could show to the border police in order to spend a vacation in the Franche-Comté? You told me and so did E. Baudry* that M. Dufaure's son[2] could have done that. If not him, there are others. I wrote my attorney—who, I believe, is a coward and a thief—on the subject and he has done nothing.

I see France's foremost subjects pass through here. For example, the other day when I went to Louèche, I saw Badinguet,[3] and in Martigny M. Thiers* came to see my statue of the *Republic*.[4] In La Tour-de-Peilz, fortunately for me, he denied himself a call on me.

I am still awaiting Baudry as if he were the Messiah, but I don't see anything coming.[5]

Next Monday or Tuesday I am going to Vallorbe, on the Jougne border, to see my father. That poor old man is dying of sorrow and grief. He is coming on account of our affairs in Ornans. What I inherited from my mother was sequestered. My sister Juliette* bought everything, in order to extirpate the Reverdys.* Nonetheless, it is impossible, they simply insist on staying. They have a shop full of my paintings in Ornans, which they are selling at retail. If I have them seized, they will hand everything over to the government. I am in a singular dilemma, everything is going away, everything is vanishing.

I just found out that the *Vinedresser of La Tour* [F. 963] was exhibited at a dealer's in rue Laffitte.[6]

As usual, send me the money that you have in care of M. Bavon, postmaster at La Tour-de-Peilz, Vaud. I am very grateful for the trouble you are taking on my account.

There is a gentleman here who comes to visit me and who saw Bernheim* in rue Lafayette sell some large-size paintings at the auction house. He withdrew them. They are more of those forgeries, these were snow scenes. That man has some nerve and he cannot even be arrested.

Yours sincerely, I embrace you. Kind regards to all our friends who still remember me.

G. Courbet

I wrote you that I had received the latest money last month. I sell from time to time but not much. I believe I won a prize in Philadelphia.[7]

Banishment, as a method, is unfair, for it falls on the families much more than the individuals. It would perhaps be more fair to leave them with their families and make them wear either red caps or chains around their necks. People would mistrust them.

1. Charles Duval.*

2. Gabriel Dufaure (1846–1914), one of the sons of Prime Minister Jules Dufaure,* was an acquaintance of Baudry, who had approached him several times on Courbet's behalf. See letters 75-13 and 75-14.

3. Badinguet was the nickname of Napoléon III, who had died in London in 1873. It is unclear to whom Courbet refers here, unless it was Napoléon III's son, Eugène-Louis-Jean-Joseph (1856–79), who, though living in England, traveled frequently on the Continent.

4. Courbet had donated a cast of *Helvetia* or *Liberty* to the town of Martigny in the Valais. The statue was inaugurated on December 31, 1876, at midnight and officially installed in May 1877. Unlike the bust in La Tour-de-Peilz, which surmounts a sockle with the inscription *Liberté*, the Martigny bust is inscribed *Helvétia*, even though it has a medallion with a star, not the federal cross. Interestingly, Courbet refers to it here as the *Republic*, a clear indication that his work was consciously intended to fit in the long-standing French tradition of Republican imagery (see Agulhon 1979). On Thiers's visit to Switzerland, see Riat (1906, 358).

5. Baudry was to travel to La Tour-de-Peilz in September but missed Courbet, who had gone to La Chaux-de-Fonds.

6. The *Vinedresser of La Tour*, also called *Vinedresser of Montreux*, had been painted in 1874. It was returned to Courbet in September 1876 by Etienne Baudry, who felt it would be more easily sold in Switzerland than in Paris, where, as he wrote Courbet (September 12, 1876), "Swiss costumes are not in vogue" (letter in Bibliothèque nationale, Cabinet des estampes, Yb3.1739 [4°], b. 2; see also La Tour-de-Peilz 1982, 44).

7. Courbet is not known to have received a prize at the Philadelphia Centennial Exhibition.

<u>76-23</u> *To the comte d'Ideville, La Tour-de-Peilz, August 29, 1876*[1]

Monsieur:

In an article that is very gratifying to me and very well written,[2] and that contains some very acute observations indeed, there occurs an exceedingly serious error, namely the passage concerning the dismantling of the Vendôme Column. Contrary to the idea that you voice, I was the only man in the Commune who tried to protect it and to prevent its being torn down, and that in order to fulfill the function that had been entrusted to me as president of the arts in Paris, or in other words, as conservator.

At the first meeting, which was held at the Ecole de médecine, where the artists of Paris came together and where they entrusted me with that function, which was, incidentally, ratified by the September 4 government, I was charged with chairing the assembly, which proposed unanimously, minus one voice (eight hundred people were present), to tear down the Grand Army Column.[3] Consequently, I had to speak last in order to explain that my role as conservator of the arts in no way allowed the destruction of any monument in Paris, that, furthermore, it would be easy in that case to use any aesthetic consideration whatever to tear down everything there is. I had to propose an amendment that called for transporting the Column to the Invalides and its careful dismantling. That proposal was accepted by acclamation. I was charged with writing a petition to the Government of National Defense, which did not reply at all. Another, similar proposal, but one that called for the brutal destruction of the monument, a proposal signed by Messrs. Jules Ferry,* [?][4] and others, had preceded mine. They wanted me to sign the latter, but I refused, declaring that I was charged by the artists to write another one. I also spoke of placing a great book at the foot of the Column, in which citizens could put their names, as had been done at the place de la Concorde in front of the statue of the City of Strasbourg. The motion did not carry.

By carrying out my function during the Commune, I saved, at risk to myself, the articles and objets d'art belonging to M. Thiers,* who at that moment was shelling the city of Paris. M. Barthélemy-Saint-Hilaire had made a request to that effect.[5] Since these events took place, I have ceaselessly protested, through my attorney, my counsel M. Lachaud,* and all people who care at all about the truth, that false accusation, which you yourself, innocently, I would like to believe, have repeated. Three trials have already been held on the affair, one of which is still pending. The issue is what part of the reconstruction costs I will have to pay, or in other words, what part of the responsibility will fall to me, if the government, with its machinations, persists in throwing the entire indictment on me. The only decree against the Column

was the one voted by the Commune eleven days before the elections that made me a member of the Commune.[6]

When it became necessary to carry out the project, I was already part of the minority, and, though divorced from that Chamber, I went when the decision was announced, in my role as conservator of the fine arts. I expressed my ideas on the subject but I had to abide by the resolution passed by the majority. As a last resort, I requested that at least the bas-reliefs depicting the wars of the [First] Republic and the Consulate be preserved. They would not hear of it. My duty done, it only remained for me to withdraw. And that was my role in the affair.

It is up to you, Monsieur, to do your duty and rectify an allegation that destroys all the attempts that have been made to reestablish the truth for history. This can be done only by publishing the facts as they are and as I am giving them to you. You will not only have rendered homage to the truth but you will have contributed to the reestablishment of my reputation.

Here is some information about my friend Trapadoux.[7] He was a very scholarly man with a distinguished mind and well-versed in philosophical studies. He introduced himself to me, and to Champfleury* and Baudelaire,* with a book that he had written on the life of St. John-of-God.[8] He came from Lyon, where he was born. Associating with us, he changed principles and became a Realist (though you said that that way of being was unconscious in my case) and a Romantic, on account of his past and other associations. He believed that asceticism is an intoxication and is useful for one's understanding. He wrote several very remarkable articles of art criticism on painting, sculpture, and music. He also wrote about literature. He especially studied painting, even traveling for that purpose to Belgium. He wrote newspaper columns and came back to Paris, where he died in poverty eight or nine years ago. His was an original, even eccentric nature, that indulged in extraordinary exercises, believing that he could thereby increase both his physical and his intellectual powers. All in all, an honest, dedicated man. He was known to the entire Paris art world and figured in Murger's *La Bohème:*[9] a man in the spirit of Gérard de Nerval, Privat d'Anglemont, Poterel, and others.[10]

I trust in your sincerity, Monsieur, and am,

Your devoted servant

Gustave Courbet

1. Courbet's letter is not known in the original but only in several printed versions. The comte d'Ideville apparently distributed it to various papers, as Courbet asked him to in the letter, and it appeared with some minor variations in the *Gazette anecdotique* of September 1876 (no. 18) as well as in the *Figaro* and the *Soleil*. Ideville himself reproduced the letter in two books published in 1878 (see Ideville 1878b, 178–81; and Ideville 1878a, 84ff.). The text here reproduced is derived from Ideville 1878b.

2. The comte d'Ideville's article is reprinted in Ideville 1878b, 167–177.

3. Another name for the Vendôme Column, which had been erected on the instigation of Napoléon to celebrate the victories of his army.

4. According to Ideville (1878b, 179), a word erased here may have been the name of Dr. Robinet.

5. See also letter 73-50.

6. In fact, the decree was voted four days before Courbet's election to the Commune. It is possible that in the original text Courbet wrote "4," which was misread as "11."

7. The comte d'Ideville had asked Courbet for information about Trapadoux for an article later reprinted in Ideville (1878b, 203–19).

8. Marc Trapadoux, *Histoire de Saint-Jean de Dieu* (Paris, 1844).

9. Trapadoux was one of the models for the philosopher Colline in Henri Murger's *Scènes de la vie de bohème*.

10. On the bohemian world of Gérard de Nerval (1808–55), Alexandre Privat d'Anglemont (1815–59), and the little-known Poterel, see Labracherie (1967, chap. 4).

76-24 *To his father, La Tour-de-Peilz, September 2, 1876*

> Tour-de-Peilz, September 2, '76

Dear Father:

You have not answered me, which leads me to believe that you are not yet able to come to Vallorbe. If you wrote me at La Tour-de-Peilz, come anyway, for Budry* will read your letter and send a telegram to La Chaux-de-Fonds, where I am obliged to go tomorrow, Sunday, Sept. 3, for a party where I am especially expected, as well as for a business matter.

If you have not yet written to La Tour, write to La Chaux-de-Fonds, to M. Leloup,* to set a date for Vallorbe (I will be leaving from La Chaux-de-Fonds, or La Tour-de-Peilz, it is the same thing) for Tuesday or Wednesday, Thursday, whatever you like. If you have written to La Tour, they will send me a telegram. Do come!

I embrace you,

> *G. Courbet*

In any case, Juliette,* please write to La Chaux-de-Fonds anyway. I'll be there.

76-25 *To his father, La Chaux-de-Fonds, September 4, 1876*

> Chaux-de-Fonds, September 4, '76

Dear Father:

I am here at La Chaux-de-Fonds awaiting your decision. Write me care of M. Leloup* at the *National*, the newspaper. If you'd rather come to La Chaux-de-Fonds, this would be the shortest way for you. You could take the

stagecoach from Pontarlier to Morteau, which at noon reaches Villers-le-Lac, where we'll come to pick you up on whatever day you say. If you give up on the idea of Vallorbe and the train, come to La Chaux-de-Fonds. You have never seen this part of the world. It would be better for both of us. You could see some friends at Morteau: the Chopards,* the Veyels, the Jacots. Bring Joliclerc* with you. In any case, I await your letter at La Chaux-de-Fonds. If you want to meet me in Vallorbe, I'll go there.

I embrace you and Juliette.*

<div style="text-align:right">*G. Courbet*</div>

Juliette tells me to stay put. If she has returned from Besançon, tell her to write me.

To Paul Pia, La Tour-de-Peilz, November 8, 1876 [1] <u>76-26</u>

<div style="text-align:right">Tour-de-Peilz, Nov. 8, '76</div>

My dear Pia:

When I quoted you that price, I had figured in the 15 percent I owe you on the sale,[2] that is ninety [francs]. Let's make it a thousand for the two paintings,[3] without your frames.

Write me later if you make a sale.

Sincerely yours,

<div style="text-align:right">*G. Courbet*</div>

I cannot go any lower and remember to send me the money.

1. In one corner, in Pia's handwriting: "Answered Dec. 10." Also: "Jules Simon, Minister."

2. Pia generally appears to have asked Courbet for a 15 percent commission (cf. La Tour-de-Peilz 1982, 48).

3. The paintings in question cannot be identified.

To Jules Castagnary, La Tour-de-Peilz, December 5, 1876 <u>76-27</u>

<div style="text-align:right">La Tour-de-Peilz, December 5, '76</div>

My dear Castagnary:

I don't know anymore where to inquire! In three and a half years I have written more than five volumes [of letters]. And I have never been able to find out, either from my attorney or from the lawyer,[1] under what terms I had been exiled and to what form of arrest I would be subject if I could not pay.

Nor have I been able to find out what was in the minds of M. Dufaure,* M. de Marcère,[2] and the police prefect. My attorney gives me no guidance and takes no steps. The same is true of M. Lachaud, [who does] even less. As *587*

a result, I, who know nothing about these things, must serve as my attorney's attorney. He wrote me a month ago that he would like to take a little trip to Geneva, if I recommended it for his vacation, and that we could talk about something or other. I did not think that would do me any good. The idea, I think, is to ruin me altogether. I just wrote him six or eight days ago telling him that here I had no idea what was going on, that, if I were in Paris, I would go and see the appropriate people.

I saw our friend Jourdes,* whose visit gave me great pleasure, except that he did not stay long enough. He had promised to write me immediately on his arrival in Paris, and after seeing the police prefect or M. de Marcère to ask them for a hearing. He has done nothing at all. I gave him a story for the newspaper *Soleil*.[3] I don't know whether he answered M. d'Ideville,* a scoundrel like Laurier.*[4]

With this sword of Damocles over my head for so long, it is impossible to fight the delirium tremens, the debilitation, the stultification, and ultimately the *charmante*, which leads to madness.[5]

It is impossible to work! And on top of that my family is profoundly distressed. Even though they took valuables, paintings for more than I have to pay, not to mention their destruction of ateliers and materials, if they insist on making me pay that iniquitous claim, I should at least and at any price—this is my last-resort claim—keep my atelier in Ornans. It was mortgaged before any prosecutions and in accordance with the law. I could never construct another, it is too expensive and too difficult. If they proceed against the mortgage, I think I will give up painting.

I wrote that absurd and dishonest lawyer (for one does not take on the cases of Republicans when one is Napoléonist[6]) to consult you and Jourdes, that you were well aware of what was going on in Paris, and that whatever you did would be the right thing. One cannot fight the government. If I had done nothing from the start, I would have been much better off. Now there are proceedings I don't even dare to think about. Give a thought to my atelier in Ornans. Kind regards to Jourdes and to our friends. Sincerely yours,

G. Courbet

Go and see that lawyer. I don't know where Baudry* is, he hasn't written me.

I acknowledge receipt of what you sent me. You must admit that Durand-Ruel* is hopeless. The Monets and the Chavannes have done better.[7]

1. Charles Duval* and Charles Lachaud,* respectively.
2. Emile-Louis-Gustave Marcère* had been Minister of the Interior in the fourth Dufaure cabinet, which had fallen two days earlier, on December 3.
3. Probably letter 76-23.
4. The comte d'Ideville appears to have been well acquainted with Clément Laurier, to

whom he devotes an entire chapter in his *Vieilles maisons, jeunes souvenirs* (Ideville 1878b, 185–202).

5. Courbet had become a heavy user of absinthe (*la charmante*), which, owing to one of its main ingredients, wormwood (Artemisia absinthium), does indeed cause delirium tremens and permanent mental deterioration.

6. On Lachaud's Bonapartist leanings see the article on him in Larousse XIX.

7. Reference to the paintings of Claude Monet* and Pierre Puvis de Chavannes (1824–98), which apparently sold better than Courbet's own.

To Charles Duval or Charles Lachaud, La Tour-de-Peilz, December 7, 1876

76-28

La Tour-de-Peilz, Dec. 7, 1876

Monsieur:

After thinking long and hard about the situation into which events have landed me, I am determined, in order to find a definitive and practical solution, to propose an arrangement that I consider honorable for all parties. I say "honorable" in the sense that it will offer sincere satisfaction to the courts, to the government, and to the public, to the greatest extent that my present and future means allow.

Everything I owned has been seized by the government (and destroyed by the war) in the last three and a half years, and I have not been able to produce, deprived as I was of my means of operation and excluded from the artistic centers where I have showed my work, that is, from Paris, from its exhibitions, as well as from those in foreign countries, which have been closed to me.

The arrangement would amount to determining amicably, in a final judgment by which I would abide, the proportional part of the indemnity that would fall to me and to stipulating that it be payable in annual installments. Indeed, if the amount of the personal liability that were to fall to me were required in a single payment, it would be entirely impossible for me, for the reasons stated above, ever to pay off my debts, and therefore it would be the same as sentencing me to exile or imprisonment for life, and that without making any kind of financial reparation to the government, whereas if we set the payment of my part of the indemnity (which I hope would be moderate) at annual installments no greater than what I can earn, I would be able to pay off my debt, and in so doing I would be giving full and complete satisfaction to the judgment.

Monsieur, with my regards,

Gustave Courbet

76-29 *To Jules Castagnary, La Tour-de-Peilz, December 7, 1876*

Tour-de-Peilz, 7 December '76

Dear friend:

You will have no complaints about me! Though I am not a jurist, I have ended up writing an instrument that, I believe, neither an attorney nor a notary could have written.[1]

I have hit on an irrefutable solution: it is a settlement like any settlement, which should have been made over a year ago already, if I had been dealing with a lawyer and an attorney who were dedicated.[2]

I do not know now whether among you I could find an envoy to go and see either M. de Marcère,* or the president of the tribunal, or else M. Léon Say,* who is an economist.

It is impossible that, with the help of this document,[3] I not be at the Café Frontin within three weeks at the latest.

If you do not have the time, there is Jourdes,* there is Spuller,* [both] diplomatic, etc., and Carjat.*

I will also send you the statement of my losses and seizures as well as what I lost serving the government during the war.

Try to see the liquidator, Durand-Ruel,* for he'll soon owe me three thousand francs. Tell him that I am painting his *Chillon*.[4]

Best regards to you and our friends.

G. Courbet

If this time I don't succeed, I give up. The document I am sending you is a masterpiece.

1. Probably a reference to letter 76-28.
2. Courbet has by now become totally disillusioned with Charles Lachaud* and Charles Duval* and blames them for his situation.
3. Compare letter 76-28.
4. Perhaps F. 933, one of Courbet's numerous versions of the *Château de Chillon*.

76-30 *To Emile Rigolot [La Tour-de-Peilz, mid-December? 1876]*

[No salutation][1]

I would like M. Rigolot to pay me back the thirty francs that I lent him last year to pay a month's rent. If M. Rigolot is willing to pay me back the money I'll make a gift of it to M. Guérin, who needs it for his trip. If M. Rigolot is willing to sell me his sewing machine, I'll give him another thirty francs, in accordance with the valuation that was done.

Gustave Courbet

1. This letter is unusual in that it is written in the third person, as if it were a legal document. Its contractual nature is confirmed by a note on the back, written by Rigolot:

Though the [sewing] machine is worth sixty francs, I sell it to Monsieur Courbet for thirty francs. Let him give thirty francs to M. Guérin and we are even.

Em. Rigolot

P.S. I did not know that my wife had not returned that money before her departure.

To Juliette Courbet and his father, La Tour-de-Peilz, December 24, 1876

76-31

La Tour-de-Peilz, December 24, 1876

Dear Juliette and dear Father:

I am writing you a few lines to wish you a happy New Year, happier, if possible, than last year. I received your letters, which moved me very much, but I did not know how to answer.

I am still negotiating with the government. I have an inept attorney, a Napoléonist handpicked by my sister,[1] I say no more. As long as he has any of my money, the trials will not end.

When you are in trouble, no one dares have anything more to do with you. All the men in France I know, all my friends, no one is making a move, and everyone is trembling like a leaf. All those people are begging for the republic. My friend Jules Simon,* who is prime minister, is the one who will do the least for me.[2] Someone should wring his neck. I write all day to this one and that one,[3] it is futile. Jourdes* and Castagnary,* editors at the *Siècle*, tell me that I can come back to France but not to Paris. How reassuring! With people like that, once in prison I'll never get out again. It is not the likes of de Vauchier[4] that would get me out, as he is the cause of my situation (unless it is the Proudhons[5]), nor men like Gaudy,[6] who has [],[7] nor even Viette,[8] who wants to get ahead. I have proposed a settlement to the government, that is, to pay a certain amount per year.[9] We'll see.

My dear Juliette, I am perfectly comfortable at the moment, better than I have ever been in my life. I have engaged M. and Mme Morel* to live with me; they have taken charge of my entire house, housekeeping, fire, etc. I am wonderfully well. Only one thing is missing: I cannot see you whenever I want. I was very much delighted to see Father at La Chaux-de-Fonds with Joliclerc.* What also pleased me greatly was Valet: he had the good idea to come see me. That moved me very much.

For a long time now I have wanted to give you a sewing machine and the opportunity has presented itself. A mechanic had it.[10] I bought it from him, a bit dearly. It doesn't matter, I did it to do him a favor. I also noticed that Father liked peppermills. I bought him one as well. I am sending you these two items by mail to Volinde's in Ornans for Victor the messenger. You should get them Tuesday, I think. The peppercorns in it are very good and one

cannot do without this at the table. As for the threader, go see Mesdemoiselles Grosjean in Ornans, they will teach you. You have to buy a little screwdriver to fasten the needle. Don't put it too low or too high: too high it won't sew, too low it will break. You put clarified oil in the little holes. It has plenty of play and works well. There are some needles. You change and tighten them with the screwdriver.

Lastly, keep warm! I am wonderfully well. I embrace both of you. How I love you!

G. Courbet

1. Charles Duval* apparently was hired originally by Zoé Reverdy.*

2. In December 1876, after a failed attempt by Jules Dufaure,* Jules Simon was given the awesome task of forming a viable cabinet at the very height of a major power struggle between Republicans and Monarchists. Courbet had worked closely with Simon under the September 4 government, but after the Commune Simon had distanced himself from the artist.

3. Courbet seems to have fastened his hopes in particular on some Republican deputies from the Franche-Comté, elected in 1876.

4. Probably some local political figure in the Doubs Department.

5. Reference to Hippolyte Proudhon (1807–86), mayor of Ornans between 1871 and 1882, whom Courbet often saw as one of his main detractors, as he had given the order for the removal of his *Boy Catching Bullheads* (Fs. 1) from the fountain in Ornans.

6. Félix Gaudy,* who had been reelected as deputy from the Doubs Department in 1876, in fact did what he could to help Courbet. Several letters from Gaudy to Castagnary are found in Paris, Bibliothèque nationale, Cabinet des estampes, Yb3.1739 (4°), b. 2.

7. Illegible word

8. François Viette, another Republican deputy from the Franche-Comté. See letter 76-6, n. 10.

9. See letter 76-28.

10. See letter 76-30.

77-1 *To Charles Duval, La Tour-de-Peilz, January 8, 1877*

January 8, '77—Tour-de-Peilz

Monsieur Duval:

You have several times asked me for an estimate of the monetary value of the Vendôme Column. Monsieur, if you want to gather information on that piece, please have some research done in the archives. As far as I can recall I seem to remember that its initial cost was 174,000 francs. It was an industrialist who undertook it, on a contract basis. He had commissioned the sculpture from a sculptor friend of his.[1] It is an entirely commercial piece. With the materials that were still there after it was torn down by the Commune and in spite of the Commune (which is common knowledge), I could have had it put back up myself for the sum of 140,000 francs. The stable litter that was spread beneath where it was to fall kept it from being damaged. There was very little breakage in the stone drums that supported the exterior bronze.

The bronze that was broken in spots was easy to repair. As for matters that I know and you don't know, the bronze casting for the Column was done in plaster molds, *à ciel-ouvert* (an art term). The molds for all the spiral panels that surrounded the Column were in the cellars of the Louvre, and, as conservator and president of the arts, I was the one who did not want to surrender them to the Commune, in spite of the order I was given by the Comité du salut public, because I intended to take it to the Invalides.

In a word, at the present time, I am responsible for [reconstructing] the torn-down object as it was, not for [the payment of] 330,000 francs. If it pleases the opportunists to manifest an ardent sycophancy toward the reactionary faction, that is not my business, but one thing is certain: and that is that I myself could have put it back up exactly as it was, using the fallen pieces, for the sum of 140,000 francs. Please take into consideration what I am saying to you here. I am a painter and a sculptor. I have demonstrated that I have some notion of architecture since several houses of my design have been published in albums,[2] and I have had four houses built myself besides.[3] If now—because of a political scheme, sycophancy, and other means—what was initially made of stone and iron is reconstructed in marble and bronze, that is not my problem, it's the problem of the busybodies. I acknowledge only 140,000 francs for this business and, as a sculptor, without presumption, I find myself more strongly opposed than ever to that Column.

It is M. Jules Simon* who requested that the Column be brought down,[4] and, later, put back up. That is politics!

[no signature]

1. The Vendôme Column was begun on August 25, 1806 and completed on August 5, 1810. It was built by two architects, Jacques Gondoin (1737–1818) and Jean-Baptiste Lepère (1761–1844) and the bronze reliefs were cast by Jean-Baptiste Launay (1768–1827).

2. Nothing is known about Courbet's activity as an architect.

3. Though Courbet had adapted several houses for his own use, only one was completely built by him, namely, his studio on the route de Besançon in Ornans.

4. Compare letter 70-32, n. 2.

To Jules Castagnary, La Tour-de-Peilz, January 8, 1877 77-2

La Tour-de-Peilz, Jan. 8, '77

My dear Castagnary:

Vialay[1] and J. Simon* are rabid graduates of the Ecole normale, aristocrats of liberal thought to a certain degree. Vialay is J. Simon's headmaster, instructor, professor. We are very close friends. Deeply sorrowful and morose to the core, Vialay will do anything for me, though he is inhibited by his shyness. His worth comes to the fore in spite of himself.

You have an excellent idea.[2] I thought of it at the same time you did, that

is, since the Simon government.[3] We must bring to an end this illusory, in-iquitous, and ridiculous lawsuit, which other countries find ridiculous. I am less close to Simon, even though, like Vialay, he came and gave evidence before the war council.[4] You know better than anyone that I cannot pay 333,000 francs. It will already be difficult enough paying the attorney and the lawyer. At the moment I am totally ruined and am not selling any paintings.

I will also send you an idea deriving from the fact that the decisions of the war councils cannot be reversed because the deputies who demanded that I be prosecuted did not want a law when M. Dufaure* proposed one.[5] It is impossible to discover by what right the government is attacking me. It is arbitrary and contrary to the principles that they acclaimed in the Chamber favoring legislation of the war councils.[6]

It is about time, I believe, that I should put all this out of my head. All these insanities, these endless worries, these documents about jurisdiction, of which I understand absolutely nothing and against which I cannot defend myself anyway, must come to an end because it is not natural to torment a man like this for three or four years. One would have to have a head of cast steel to bear up against it, especially since, in addition to all this, it brings in its wake unbearable domestic disasters: the destruction and death of an entire family and the triumph of the enemies who plunged me into this situation and who are enjoying—at the republic's expense—their scandalous revenge against me.

[The action] that is being brought against me today is arbitrary. M. Du-faure asked the deputies who are attacking me through their spokesman, M. Bidard,[7] whether they wanted a law. They declined on the grounds that that was outside their jurisdiction, and, on reflection, they left it to the govern-ment, confident as they were that it would do its duty toward me—which is nothing but an arbitrary prosecution, I repeat. M. J. Simon knows better than I how it happened[8] and about the petitions that he has received on this score, such as Jules Ferry's,* among others, which anticipated my own, and which I did not wish to sign, so that it is becoming obvious that I have been prose-cuted and convicted without any proof at all and that one cannot pass sentence on the basis of circumstantial evidence, that is contrary to any spirit of legality and justice.

I thank you very much for the excellent idea you just gave me, and you know, my dear fellow, that I have never doubted the fine feelings you have had for me all this time. You will be the only man I know who will have helped me in this matter. We must get a safe-conduct from J. Simon that will allow me to visit my family so that I can see how they are doing, hearten my old father, and reassure my sister, who is devoted to him. That way I would find the peace of mind that I so badly need in order to go back to work. It is

time that I be allowed the means of action to do my art and produce some more works worthy of the exhibition that will be taking place in Paris.

My dear friend, accept my best wishes for the New Year for you and your family. Kind regards to all,

Sincerely yours,

Gustave Courbet

1. Little is known about F. Vialay (in Courbet's non-autograph dictated letter the name is spelled "Vialey"), who apparently was a friend of Courbet as well as a classmate of Jules Simon. His name first crops up in 1871, when he appears as a defense witness in Courbet's trial (see Riat 1906, 318–19, where he is referred to as "Vialet"). After Jules Simon had become minister president in December 1876, Castagnary or Courbet seems to have approached Vialay to ask him to intervene with Simon on Courbet's behalf. In a letter of January 6, 1877 (Paris, Bibliothèque nationale, Cabinet des estampes, Yb3.1739 [4°], b. 2), Vialay apologizes for not having been able to see Simon, over whom he has less influence than Courbet and Castagnary think. Vialay's letter is written on stationery of the Association philotechnique, a society that was founded on March 29, 1848, for the purpose of free adult education.

2. It seems that, in the light of Vialay's hesitation, Castagnary had recommended that Courbet seek other avenues to approach Jules Simon or even write him directly. Apparently, Courbet turned to his old friend Félix Gaudy, who was a deputy. Unlike Vialay, Gaudy actually went to see Simon, but the latter referred him to the minister of finance, Léon Say. See Gaudy's letter to Castagnary in Paris, Bibliothèque nationale, Cabinet des estampes, Yb3.1739 [4°], b. 2, as well as Riat (1906, 370).

3. Simon's cabinet had been formed on December 13, 1876.

4. Both Jules Simon and F. Vialay had been defense witnesses during Courbet's 1871 trial (cf. Riat 1906, 318–19).

5. Reference to the deliberations in the Chamber in the spring of 1873 with regard to the reerection of the Vendôme Column. Jules Dufaure had rejected the proposed amendment that Courbet pay for the reconstruction expenses as unlawful.

6. On the continued sanctioning of the war councils by the Chamber, see Joughin (1955, 1:75–78).

7. Orléanist deputy Théophile Bidard (1806–77).

8. Courbet seems to refer here to the destruction of the Vendôme Column.

To his father, La Tour-de-Peilz, January 8, 1877[1] 77-3

January 8, Tour-de-Peilz, '77

Dear Father:

You amaze me by always saying the same thing. That is distressing, for one would think you don't understand what I write. Tell me, yes or no, whether I should cross the border and subsequently spend five years in prison. I am doing here whatever I can to reach a solution. Yesterday I wrote another eight pages to Castagnary,[2] who is going to see Jules Simon,* the prime minister, in order to obtain a safe-conduct. The police are arresting people who resemble me all along the border, especially at Pontarlier. When

I went to La Chaux-de-Fonds, my friends, for fun, wanted me to cross the Doubs. I had nothing to fear. At the least policeman, I would have started swimming, but the others would not have been able to return to France. What happened? The next day the French police arrived on the spot, asked questions, and entered Switzerland to interrogate the Swiss police, whom they warned that I was not to try that again because they had a warrant [for my arrest].

If you will pay 330,000 francs for me, I can come back immediately. I just wrote my attorney four pages last night.[3] In order to please the reactionaries, they want to sentence me to the maximum amount, but lessen it later on. But we must let them do what they will. If I act as heedlessly as you advise me, I'll spoil everything, I'll lose everything. I must absolutely stay put, in spite of your legislation. You may imagine that it is not what I want. I want to come back to Ornans or Flagey as much as you do, but we must be patient. They have mounted an enormous enterprise against me in order to agree with the current policy. They are about to confiscate my present and future assets and even my inheritance, do you understand? And you could never do anything against them. Yet, it amounts to far more than my property in Ornans. We should have sold some fields, some meadows that give us nothing but trouble, and just have bought some simple bonds, so that I could inherit something from you, and also to benefit my sister Juliette,* with whom I want to live the rest of my life.

In short, as soon as I have news I will write you. I have sent you for New Years's Day a box that contains a sewing machine worth eighty francs and a peppermill for you worth six francs. I have sent it by mail addressed to Mme Volinde, who will give it to Victor, the messenger from Flagey.[4] I have sent it from Mme Morel* to Juliette Courbet. I sent this box three days before New Years's Day.

I just now received your letter and you don't tell me anything. I have just come from the post office. She doesn't know anything. Go find out from Volinde immediately and let Juliette write me as soon as she can. Mesdemoiselles Bouvet[5] have written me a charming letter. Thank them very much. I embrace both of you.

<div align="right">*G. Courbet*</div>

Dear Juliette, I wrote you at the same time I sent you this sewing machine. You have not answered me at all. Even if the box has not arrived, the letter must have arrived. I am worried, it has perhaps been held at the border.

Kind regards to everyone.

1. The letter bears the seal of Fumey, attorney at Besançon.
2. The only known letter that Courbet wrote to Castagnary around this time is letter 77-2. Though some mention is made of a safe-conduct in that letter, it is only four pages long and is dated on the same day and not a day earlier than Courbet's letter to his father.

3. Perhaps letter 77-1, though it is dated January 8 as well.

4. See also letter 76-31.

5. Perhaps Béatrice Bouvet, the daughter of Courbet's patron Alfred Bouvet, and her sister(s). Courbet had painted Béatrice as a child in 1864 (F. 425).

To Jules Castagnary, La Tour-de-Peilz, January 14, 1877 **77-4**

La Tour, 14 Jan., 1877

My dear Castagnary:

I want to thank you from the bottom of my heart for all you do for me and for your good guidance in this business.

As I had suspected, it is the prefect of Besançon, undoubtedly pushed by the Proudhons of Ornans.[1] Consequently, you see that all these disasters arise from a personal vindictiveness, by means of secret denunciation, as happens so frequently in the times in which we live. Try to emphasize the means to M. Jules Simon,* who must know that such things go on.[2]

I am also sending you, for him, a precious newspaper, the *Démocratie franc-comtoise*, a newspaper that you will be able to read and give to him.[3] Ask M. Jules Simon to please excuse me for not having been able to visit him in Normandy, where he so wanted to entertain me. I was in prison, [it was] impossible to express my thanks to him. If I did not go see him once I was free, it was from fear that it would be disagreeable to him.

I am counting on your approach to him to pull me out of this trying position in which I find myself. I am having this letter delivered to you by a friend, M. Denneval, formerly a justice of the peace during the Commune, and who was convicted like myself.[4]

Duval,* my idiot attorney, sent me, two days ago, for the first time, the *Gazette des tribunaux*[5] to let me know the court's rulings in my regard. Before that I knew nothing about anything.

My dear and good friend, allow me to give you a warm handshake,

Gustave Courbet

1. On Courbet's conviction that Baron de Cardon de Sandrans,* prefect of the Doubs Department between 1871 and 1873, and the family of Hippolyte Proudhon, mayor of Ornans since 1871, had caused all his troubles, see also letter 77-10.

2. Courbet still hoped that Castagnary could convince Simon to intervene on his behalf. See also letter 77-2, n. 2.

3. See letter 77-5, n. 1.

4. Toussaint-Sylvain Denneval (b. 1836) was a Parisian businessman. During the Commune, he had been appointed justice of the peace in the Louvre District. Arrested on May 28, he had been sentenced in July to four months in prison.

5. The official court gazette, which contained reports about current legal cases in Paris.

77-5 *To Charles Beauquier, La Tour-de-Peilz, January 15, 1877*

La Tour-de-Peilz, January 15, 1877

My dear Beauquier:

Please send me by mail ninety-nine copies of the *Démocratie franc-com-toise*, no. 102, July 30, 1873 (Courbet column).[1] They will be most useful to me at this time.

I thank you very much, my dear friend, for the efforts you have made to further my cause. I have only just now heard, from my idiot attorney in Paris, Ch[arl]es Duval,* that I have been persecuted on the instigation of the prefect of the Doubs, who, pushed by that notorious judge, the Proudhons of Or-nans,[2] personally engaged de Vauchier,[3] who set up Bidard from Nantes.[4] Said Bidard formed a coalition of twenty deputies to demand my arrest and the reconstruction of the Column,[5] urged by those you have so aptly identified. Dufaure,* surprised by that attack, which was as unforeseen as it was illegal, asked them if they wanted a special law on my account, so fantastic was the whole thing!![6]

That started them thinking, and as they found themselves to be unquali-fied, they returned to the government the right to act toward me as it thought proper, confident in the reaction that was then taking place.

You see, my dear friend, how one may take advantage of social movements in order to wreak one's personal vengeances. This letter is confidential for the moment.

This explains to me the shameful behavior of the wife of the ex-mayor of Besançon, Mme Proudhon, who, showing me her fist in the middle of Or-nans, said to me, "You! You won't stay here for long, don't worry!"

And now, my dear Beauquier, I wish you a happy New Year, along with your lady and the whole charming editorial staff of the *Démocratie franc-comtoise*, especially Ordinaire* père and fils. And please remember me to Mélanie.

Gustave Courbet

If you can, please send me the newspapers immediately. Address them to M. Budry,* Café du Centre, Tour-de-Peilz, my usual address.

1. The issue in question had contained Courbet's letter to the prefect of the Doubs (see letter 73-36).

2. Hippolyte Proudhon, the mayor of Ornans, had formerly been a justice of the peace.

3. According to letter 77-10, de Vauchier or de Vaulchier was a deputy from Besançon.

4. In the text of this nonautograph dictated letter, the name is spelled "Pinard," but the reference is no doubt to Théophile Bidard, who is also mentioned in other letters, in which his name is sometimes spelled "Bidar" (see letters 77-2 and 77-10). Courbet, recalling the events of the early months of 1873, erroneously associates Bidard with the city of Nantes. Bidard actually came from the nearby city of Rennes, where he had occupied a teaching chair in law

at the university until his early retirement in 1867. He became a deputy in 1871 and belonged to the Orléanist right wing.

5. Reference to the deliberations on the reerection of the Vendôme Column held in the Chamber in the early months of 1873. Compare letter 73-1.

6. Jules Dufaure* had questioned the legality of the proposed amendment to make Courbet financially responsible for the reerection of the Column.

To Charles Duval (?) [La Tour-de-Peilz, February 11 or 12, 1877?] (draft) 77-6

Monsieur:

All things considered, it is dishonest for me to accept any agreements or settlements with the government.[1] If that were possible, I cannot understand why we should have been in court for four years.

You admit as a triumph the entirety of the sum asked—323,000 francs—which means that that sword of Damocles will hang over my head all my life.

After four years in exile I no longer know what the mood is in France, but formerly, and as I have practiced it all my life, it was difficult to speculate in art. Art emerges spontaneously and is inspired, without taking money into account. How, at a time in society when art no longer sells, do you expect a man to commit himself regularly to sell ten thousand [francs'] worth for the government and ten thousand to live on each year, in spite of the times and his exhaustion? It is insane and immoral. The painters of the past never knew the prices of the works they produced.

If, for whatever reasons, even the loss of the rest of my family, even to practice my art, even for my freedom, I were to accept such an arrangement, I would, for the first time in my life, be a dishonest man, for I would be certain beforehand that I could never fulfill those commitments, and if I did fulfill them, it would be to the detriment of my dignity, of my moral independence, as I would always have to be asking for grace periods from people I find contemptible, or else organizing annual auctions in France or abroad (which would be humiliating for my country) to support the extolling of its national vainglories.

If I allow a settlement or an agreement, I declare myself guilty and at fault, whereas I have hitherto pleaded innocent in the Column's fall. I would be illogical, ridiculous, and discredited, and, by the fact of accepting that mendacious persecution, an opportunist whose purpose is to satisfy the Napoleonist party and certain mercenary informers from my part of the world.

At this point—not to collude in that lie, but to appease the hybrid government that hounds me with its bourgeois schemes—let them keep what they have seized from me, except my atelier in Ornans, which is useful to me for the practice of my art and which I have mortgaged in order to be able to

live abroad. That is what I have left of the little that I have earned by my painting in the course of my life. I hope everyone will be satisfied.

In witness whereof I request a cancellation of the warrants and the annoyances that prevent me from working for art and for everyone. I believe I have lost enough by now.

[no signature]

1. On February 10, Charles Duval had written a letter to Courbet (Paris, Bibliothèque nationale, Cabinet des estampes, Yb3.1739 [4°], b. 2) suggesting that he agree to a settlement with the government requiring him to pay an indemnity of 323,000 francs, to be redeemed in yearly installments of ten thousand francs. Courbet's first reaction was to reject Duval's proposal, and he drafted this letter, which apparently he never sent. He subsequently wrote another letter (see letter 77-8), in which he agreed to the settlement, on the condition that he could return to France and resume his former life style.

77-7 *To Jules Castagnary, La Tour-de-Peilz, February 12, 1877*

La Tour-de-Peilz, February 12, 1877

My dear Castagnary:

I just received a letter from my attorney,[1] and I am not satisfied with the outcome, in terms of the amount I have to pay. It was said that they had to determine the part they wanted me to pay of the cost of reconstructing the Column. Now that part has become all of it. It would have been better to have told me that the first day, and the thousands and thousands of francs that they are taking from me in legal fees would have been saved.

However, I will refrain from any comments until you have exhausted all your connections and have informed me of the results of your meetings with Jules Simon.* I send you herewith a copy of M. Duval's* letter. At least you'll know what you have to do.

If you think it appropriate, go and see Denneval,[2] 2 rue de Ronceau, and send him to see Duval.

I am waiting for a line from you, so that I'll know how to answer this letter. Hoping to come soon and shake your hand, I shake it in my heart. Sincerely yours,

G. Courbet

Things should be arranged at least so that we can lodge an appeal. Art cannot be banked on in the way they think.

I saw G. Mathieu* in Geneva, he is in Lyons.

1. See letter 77-6, n. 1.
2. See letter 77-4, n. 4.

To Charles Duval, La Tour-de-Peilz, February 12, 1877 77-8

Monsieur:

In answer to your letter of the 10th inst.,[1] I hasten to thank you for your efforts towards an arrangement between the state and myself, and to authorize you to finalize the settlement according to the terms in your letter.

Thus, Monsieur, I will promise to pay the sum of ten thousand francs per year, and, by virtue of that promise, I will return to my duties in full and will take up my same situation as before the trial.

I hardly need insist on the latter point, for it is obvious that it would be impossible for me to fulfill my promises to the state were I to be deprived of the material and moral means of action indispensable if an artist is to produce.

With kindest regards,

<div style="text-align:right">Gustave Courbet</div>

La Tour-de-Peilz, February 12, 1877
[Address] Monsieur Chs. Duval
 Inferior court attorney
 Paris

1. Compare letter 77-6, n. 1.

To James A. McNeill Whistler, La Tour-de-Peilz, February 14, 1877 77-9

<div style="text-align:right">Tour-de-Peilz, Canton Vaud
February 14, 1877</div>

My dear Whistler:

It is quite a while since we last saw each other. It is a pity, for our ideas have changed. Where is the time, my friend, when we were happy and with no other cares but those of art. Do you remember Trouville and Jo who clowned around to amuse us?[1] In the evenings she used to sing Irish songs so beautifully, she had a feeling and talent for art. I also remember our stealthy move from the Casino to the Hôtel de la Mer, where we went bathing on a frozen beach, and the salad bowls full of shrimp with fresh butter, not to mention the cutlet at lunch, which allowed us to paint the sky, the sea, and the fish all the way to the horizon. And our payment consisted of dreams and sky.

I still have the *Portrait of Jo* [F. 537], which I will never sell.[2] Everyone admires it. The painting of the *Misses Potter* [F. 437] has been bought by Durand-Ruel* and must have gone to London.[3] It is very surprising that M. Potter did not buy it; it is strange, try to find it. I was never paid for it. Durand-Ruel has stopped his payments especially where I am concerned. He

behaved like everyone else. Everything has been stolen from me, and my life has been destroyed.

What years of misfortunes, what torments, what suffering, what cruelties, how many prisons! How many times have I escaped death and the clutches of those cannibals. They have dragged me through the streets with my wrists in chains, they have locked me up in dungeons without air, etc., etc. It is impossible to tell it all.

Let's turn to something else: I am here in a charming countryside—the most beautiful in all the world—by Lake Geneva, which is surrounded by gigantic mountains. You would like the sky, for on one side is the lake and its horizon. It is better than Trouville, because of the landscape.

I will be sentenced one of these days to pay for the Vendôme Column: 333,000 francs, ten thousand francs per year for thirty years, I say no more. So I have to squeeze ten thousand francs a year from painting. At the moment I would like you to lend me a hand. Your friend M. Bergeron[4] did not want me to send a painting of a *Calf* [F. 880] and [a still life of] *Apples*,[5] which are at this moment at M. Deschamps's,[6] I believe. He was positive that I could sell them in London without sending them to Philadelphia, and in a letter that I have here he has engaged to do it. Go and see about it, if you please, for the price of eight thousand francs has been offered to the Genevese merchant Pia,* who represents M. Bergeron. Also go and see M. Gillman, 14 Ashley Place, S.W., and Edmond Levrand,[7] likewise a friend of M. Bergeron, at 93 Great Titchfield Street/Oxford Street. I have entrusted M. B. Reitlinger of Vienna, Austria, with four paintings for the Philadelphia Exhibition, which I believe have been lost.[8] Not only that, they are asking me for four hundred dollars, and I had paid the costs already. With regard to that, see Messrs. Grunebaum, Ballin, & Co., Angel Court, Throgmorton Street. Ask them about Reitlinger.

Well, my friend, that is quite a bit of work for you.

Yours sincerely, please answer me.

<div align="right">

G. Courbet

</div>

1. Courbet became friendly with Whistler in Trouville during the fall of 1865 (cf. letter 65-16). At that time he met Whistler's mistress, Joanna Hiffernan, who had modeled for Whistler's famous *Symphony in White, no. 1: The White Girl* (Washington, D.C., National Gallery of Art), exhibited at the Salon des refusés in 1863.

2. Courbet made four versions of the *Portrait of Jo* or the *Beautiful Irishwoman* (F. 537, F. 538, F. 539, and NIF-A). The version currently in the Nationalmuseum in Stockholm (F. 537) is generally considered the original, which Courbet kept for himself. On the four portraits, see especially Brooklyn (1988, 162–166). According to Courbet's physician, Dr. Collin, Courbet refused to sell the painting to Rochefort* for five thousand francs (cf. Courthion 1948–50, 2:255–56).

3. Following Fernier (1977–78, 1:238), the painting was bought by Durand-Ruel, then sold at auction to Etienne Baudry* (November 20, 1877).

4. Charles Bergeron was a brother-in-law of Seymour Haden, who in turn was a brother-in-law of Whistler. From several letters that Bergeron addressed to Courbet (Paris, Bibliothèque nationale, Cabinet des estampes, Yb3.1739 [4o], b. 2), it appears that Bergeron was in the shipping business and did some art dealing on the side. In a letter to Courbet of April 27, 1876, Bergeron had advised Courbet not to send the *Calf* and some other works deposited in London to the 1876 Philadelphia Centennial Exhibition as he felt they would be more easily sold in London.

5. Probably one of the still lifes of apples that Courbet had painted in 1871–72, while in Ste Pélagie prison and at the nursing home of Dr. Duval.

6. Charles William Deschamps (1848–1908) was the manager of Durand-Ruel's London gallery in New Bond St. (cf. MacDonald and Newton 1986, 204, n. 11).

7. Robert Gillman and Edmond Levrand were both dealers in London. For Courbet's connections with Levrand, see letter 75-7.

8. B. Reitlinger was a part-time dealer, apparently originating from Vienna, who lived at 4 Münsterhof in Zürich. Reitlinger appears to have suggested that Courbet send some paintings to the Philadelphia Centennial Exhibition, promising him the help of his brother, who was an art dealer in New York. As in Vienna, Courbet, an exiled Communard, could not participate in the official French art exhibit at Philadelphia, but he could take part in a special loan exhibition of works belonging to American dealers and collectors organized by the London-born engraver John Sartain. Courbet was, in fact, represented at the Centennial Exhibition with four paintings, three of which were listed in the catalog (nos. 807–810) as belonging to A. H. Reitlinger. The works in question, two views of Chillon Castle, a *Huntsman* (F. 911?), and a *Bather* (F. 627?), were in the loan section of the American exhibition of paintings and were all for sale (cf. MacDonald and Newton 1986, 204, nn. 16, 17; and Brooklyn 1988, 69). See also several letters by B. Reitlinger and others in Paris, Bibliothèque nationale, Cabinet des estampes, Yb3.1739 (4o), b. 2. Courbet spent much time and energy to retrieve these four paintings and got involved in an argument over shipping cost. In August, he asked his friend Cluseret (who had lived in America and had numerous American connections) for assistance (see also letter 77-18). Eventually, the New York law firm of C. Goepp was asked to handle the affair.

To Jules Castagnary, La Tour-de-Peilz, March 1, 1877 77-10

La Tour-de-Peilz, March 1, 1877

My dear Castagnary:

It is a pity that mythological religion has become obsolete, for otherwise we could still today practice the talion punishment, [one of those] religious practices that is essentially lacking in republics.

It was M. Cardon de Sandrans* (if I remember his name correctly), then prefect of Besançon, who, according to the court's ruling, was behind my prosecution, on the instigation quite certainly of the Proudhons of Besançon and Ornans, who of all our enemies are those whom we have had to endure to this day.[1] Those same Proudhons, in the person of the judge,[2] had already been responsible for imprisoning their relative, the great philosopher Pierre-Joseph Proudhon.*

It was after that denunciation that the famous Bidard, professor at the

Nantes law school and a student of my cousin Oudot,* and M. de Vaulchier, an aristocratic deputy from Besançon, incited against me a score of deputies of the Chamber, who demanded my arrest and the reerection of the Column.³

In this naive country in which we live, they tell us that there are reshufflings of the prefects in France and that everyone welcomes the timeliness of this. They have eliminated a few imperialist prefects from that splendid institution. Don't you think that in the present instance it would be timely to fire M. Cardon de Sandrans, the ex-prefect of Besançon, who now holds office in some unknown department. It would be a nice bit of mythology not badly applied, and, I assure you, it would fill many people with pleasure, including all his old friends of the Franche-Comté who were under his jurisdiction. As for the Proudhons, they are cryptogams, parasites who go their hidden ways. That nice M. Gaudy had found a position for their son Fotos [?] as subprefect at Pontarlier, which aroused the people's indignation, and with a petition they got rid of Fotos, who was not a success. Finally, to be done with this brood, they were also responsible for destroying the *Fisherboy* [Fs. 1] of the Ornans fountain.⁴

I send you herewith a copy of M. Duval's* letter, which contains ideas of an insanity and a lunacy that are rarely encountered. Let us do the accounts for the first year:

fine	10,000 francs
interest	16,150
court costs	40,000
my expenses	10,000 (living expenses and supplies)
Total	76,150 francs

According to the settlement that he is proposing to me, and with my paying only ten thousand francs a year, the amount that is claimed from me will add up to about a million in thirty years.

What worries me at this point is whether the money will be returned to me as a means of action. You know better than anyone, my dear friend, that once all the fees have been paid, I will surely be left with nothing. With what could I still produce [paintings]?

The *Chillon* is ready, it will be sent to you immediately, as you clearly told me. Make sure that you give it to M. Heilbronner only for hard cash.⁵ You had said two thousand francs first and then three thousand. I confess that I would be glad if that could be done, for in Switzerland it is impossible to earn anything with art. I have no news at all from Etienne Baudry.* I would like to know what he has decided with regard to the two paintings that he bought from me, the *Young Ladies from the Village* and the study.⁶ Since it is impossible to evade that deceitful conviction that makes me a target for the Napoléonists, I necessarily have to abide by the best arrangements that you

and the attorney Duval can make. See about having the money returned to me or having me receive the interest.

<div align="center">

G. Courbet

</div>

1. Courbet had voiced the same complaint in several earlier letters. See especially letters 77-2 and 77-5.

2. Probably a reference to Hippolyte Proudhon, who, before becoming mayor of Ornans in 1871, had been an assistant justice of the peace (cf. Ornans 1981, 57).

3. Compare letter 77-5, nn. 3, 4.

4. Courbet also blamed the Proudhons for the removal, after his arrest, of the *Boy Catching Bullheads* (Fs. 1) from the Iles-Basses fountain.

5. Castagnary, who himself had received a painting of *Chillon Castle* (F. 990) as a present from Courbet, apparently had secured a commission for another painting of the same subject from a M. Heilbrunner. A letter from Heilbrunner to Castagnary, dated May 26, 1877, may be found in Paris, Bibliothèque nationale, Cabinet des estampes, Yb3.1739 (4o), b. 2. It is not known which of the many paintings of *Chillon Castle* was Heilbrunner's.

6. It seems that Courbet errs here. Baudry did not buy the *Young Ladies from the Village* (F. 127) (which was still claimed by its legitimate owner, the widow of the duc de Morny; cf. Riat 1906, 368), but rather the *Young Ladies of the Banks of the Seine* (F. 203) and one of the preliminary studies for that painting (F. 205).

To B. Mauritz, La Tour-de-Peilz, April 24, 1877 77-11

<div align="right">

La Tour-de-Peilz, April 24, '77

</div>

Monsieur B. Mauritz
Paris
Monsieur:

At one time you spoke to M. Pétrequin-Dard[1] about the *Calf* [F. 880], which is in London at M. Deschamps's,[2] for which you offered 3,000 francs. I cannot bring myself to sell it for less than 4,000. Nevertheless, at M. Pétrequin-Dard's request, I could agree to a special rebate of 500 francs as a personal favor, and let you have it for 3,500 francs, if you were to engage yourself to pay that amount to me promptly, for I need it urgently to pay the costs of my exhibition in Philadelphia.[3]

Looking forward to your reply, I am, sir,

Sincerely yours,

<div align="center">

[*no signature*]

</div>

Bon-Port
Tour-de-Peilz
Canton of Vaud
Switzerland

1. Courbet had been in contact with the painter-dealer Gustave Pétrequin-Dard* in Lausanne at least since 1873 (cf. letter 73-44).

2. See letter 77-9, n. 6.

3. Courbet had sent four paintings to the Centennial Exhibition in Philadelphia and still needed to pay for shipping and handling expenses. See letter 77-9, n. 8.

<u>77-12</u> *To M. Rouberol, La Tour-de-Peilz, May 6, 1877*

La Tour-de-Peilz, May 6, 1877

My dear M. Rouberol:

I did receive your first letter, albeit a little late, but before I could answer you I absolutely had to wait for the outcome of that unspeakable trial, that was based on local denunciations to the prefect of Besançon, M. de Sandrans.[1] The case was heard last Friday. Only now, therefore, can I give you a positive and affirmative answer. I am delighted to entrust that house to a sincere Republican.[2] You may occupy it as of today and, as I am free to return to France, I'll come see you in a week and we will come to an agreement, when you'll have seen what I need in order to work.

As for the garden, my sister[3] writes me that it is real virgin forest. I don't mind, for I do not much like our present civilization. Leave it as it is until I arrive. It is too late to prune the fruit trees anyway. As for the hedge, you could put up fences like the railroad's. Now is the time to do it, as they are barking the oaks. Ask my father for some oak slips for the purpose. I'll pay for them.

Concerning the arrangement of the interior of the house, we'll plan the layout together. You must put a fanlight above the large carriage entrance to replace the window that lets light into the hall. The latter must serve as the dining room. As for the rooms upstairs, we'll make them into an apartment. The large window has been finished for a long time. It is at Amédée the carpenter's shop, next door to Chabot's.* He was paid for it a long time ago.

I don't know what to do about the watchman Simon's lodgings. It is possible that he might sue us if we used them before the end of the quarter. If he has returned the keys, use them.

Be so kind as to tell my father and my sister Juliette that my trial is over. We did everything we could. I have my freedom.

Please do not visit M. and Mme Reverdy.* As for myself, I want never to see them again.

Kind regards to Mme Rouberol. With fraternal best wishes,

Gustave Courbet

[Address] Monsieur Rouberol
Railroad engineer
Ornans, Doubs
France

[Postmark] La Tour-de-Peilz, May 6, 1877

1. On Friday, May 4, the definitive verdict in Courbet's trial was pronounced. Courbet was required to pay an indemnity of 323,001.68 francs, but he was allowed to pay off his debt in yearly installments of 10,000 francs. Cf. Riat 1906, 370. Courbet still blamed his enemies in Ornans, such as the Proudhon family, and the former prefect of the Doubs, Baron de Cardon de Sandrans,* for his verdict.

2. Rouberol, a railroad engineer, apparently had asked him whether he could use part of Courbet's studio on the route de Besançon. See also letter 77-19.

3. Juliette Courbet.*

To Jules Castagnary, La Tour-de-Peilz, May 14, 1877 77-13

La Tour-de-Peilz, May 14, 1877

My dear friend:

I have borrowed the pen of my friend Leloup,* who came from La Chaux-de-Fonds to say hello, so as to answer you right away.

1. I don't need to tell you how much I thank you for all the concern you have shown for me in this disagreeable matter.

2. You advise me to do whatever I can to be represented at the next Exhibition[1] with new paintings that are worthy of me. You are right, but these past years of persecution and of preoccupation beyond my nature and my faculties have profoundly disheartened me. I'll try, however, and will do my best.

So I beg you to sign me up yourself or else to ask one of my painter friends to do so, before the end of the extension period.

I still have to put my affairs in order here, and I also have to spend some time in Ornans, where my father awaits me with great impatience. I am not sure when all that will be finished. I'll go to Paris as soon as I can.

3. I also ask you to be so kind as to go to my attorney[2] to get a few clarifications, for all that legal language is Hebrew to me. I cannot understand whether my atelier in Ornans is included in the seizures, whether it has been returned to me or not. I would also like to know whether I can take my paintings there from Switzerland without risk.

I must also [?] know precisely what is in my brother-in-law Reverdy's* keeping, so that I can take measures against him as soon as I arrive in Ornans as energetically as possible, and to make him cough up everything he stole from us, both from me and from my father.

To that end, M. Quest,[3] my sequestrator, should tell me definitively what has been seized from me, and give me a list of all the objects, so that I can take action not only against Reverdy but also act in all other matters. There is another gentleman who has never bothered to write me a single line, just like my lawyer, M. Lachaud.*

As for the money you have received from Durand-Ruel,* invest it as you

think best, in government annuities or something, and get Durand-Ruel's agent, who promised 3,000 francs, to pay up. Make him give it to you if he has not already done so. That should be easy, now that the verdict has been pronounced and he can no longer use my interdiction as an excuse.

At this point I send you all my thanks and my best regards.

(And, as for me, my dear friend, do I need to remember myself to you? Please say hello to Keller and to all our friends.

J. Leloup)

We are going to Martigny, Valais, for the inauguration of the statue of *Liberty* [Fs. 6] that I have given them.[4]

I also have to finish two or three things that I have started.

Sincerely yours, dear friend,

G. Courbet

Best regards to our friends Baudry,* Carjat,* etc., etc., if there are others.

1. Probably a reference to the 1878 Universal Exhibition in Paris.
2. Charles Duval.*
3. On July 12, 1873, M. Quest, at 90 boulevard Beaumarchais, had been appointed sequestrator in Courbet's case (cf. Riat 1906, 348–49).
4. The bust of *Liberty* or *Helvetia* had been donated to the town of Martigny in 1876 and had been officially inaugurated on December 31, 1876. The festivities in May marked the erection of the statue in the Grande Place at Martigny (cf. La Tour-de-Peilz 1982, 89).

77-14 *To his father and Juliette Courbet, La Tour-de-Peilz, May 17, 1877*

Tour-de-Peilz, May 17, 1877

Dear Father, dear Sister:

That disgraceful trial is finally over. I have to pay ten thousand francs a year, thanks to M. Cardon de Sandrans,* the prefect of Besançon, who was advised by the P[roudhon] family. I don't think that it will be for long but I must pay the first installments.[1] I am going to exhibit at the Universal Exhibition as if nothing had happened.[2]

In order to get myself organized so that I can come see you, I have quite a few matters to take care of first. I have started some snow landscapes that I must finish right away.[3] They will go out in a few days. I have to go to the Valais on Sunday for the inauguration of the statue of *Liberty* [Fs. 6], like the one in La Tour.[4] Then I must go to Geneva to get a passport at the consulate, and my paintings, so that I can finish them for the big exhibition.

Believe me, I am as impatient as you to come see you, but I cannot until I have put my affairs in order here. I have an entirely furnished house here. Everything is in such confusion that I don't know which way to turn, I cannot concentrate, I lose my bearings.

Father writes me that he is going to have the Reverdys* evicted. That is dangerous too. They will take away everything we own. Their suitcases must be searched. They must be treated like servants, with authority, for now they have no business with my things.

Castagnary* and Duval* are pressing me to go to Paris to settle things. It is impossible for me at the moment. I will go from Ornans, after I spend a few days with you. All that is making my head swim, for I am incapable of any activity now. Anyway, I'll write you the day I arrive in Pontarlier. Be patient, please.

I embrace you with all my heart. Kind regards to all the bigwigs and to the friends who take an interest in me.

G. Courbet

1. Compare letter 77-12, n. 1. Courbet's fine of 323,001.68 francs was to be paid in installments of ten thousand francs over a period of thirty-two years. The artist hoped that at some point all Communards would be granted general amnesty so that he would not be required to continue paying for more than a few years.
2. Compare letter 77-13, n. 1.
3. The landscapes cannot be identified with any certainty.
4. Compare letter 77-13, n. 4.

To Auguste Baud-Bovy, La Tour-de-Peilz, May 29, 1877 77-15

La Tour-de-Peilz, May 29, '77

My dear Baud:

I have just come from Martigny, where I witnessed the installation of the statue of the *Republic* [Fs. 6] that I had donated for the Grande Place.[1]

I found your letter and owe you one in return. I am extremely embarrassed about how to answer you and would never recommend anyone to an art dealer, any more than I would recommend an art dealer to anyone. They are all scoundrels and swindlers, save for some very rare exceptions. As for Détrimont,* I have never been satisfied with him, and the dealings I had with him were irregular. You go to that man at your own risk. Make him pay immediately or have him make out three-month promissory notes.

Furet[2] will perhaps see a change of administration in Paris.[3] You know that my lawsuit is over, and though I am free to go there, I prefer to stay in Switzerland till further notice. It would give me the greatest pleasure whenever you and Rochefort* wanted to come see us at La Tour. We heard by chance that Noémi was married.

Kind regards to you and to your lady and M. Darier,[4] Mme Furet, and your entire family.

Gustave Courbet 609

1. Compare letter 77-13, n. 4. Note that Courbet refers here to the *Republic*, whereas in earlier letters he called the bust *Liberty*. When installed in Martigny, the bust was entitled *Helvetia*.

2. The painter François or Francis Furet (b. 1842).

3. No doubt a reference to the May 16 crisis, which had led to the fall of Jules Simon's* cabinet. See also letter 77-16.

4. Though the original (dictated) text reads "Darié," this is no doubt a reference to the painter Albert Darier (b. 1843).

77-16 *To Jules Castagnary [La Tour-de-Peilz, June 1877]*

My dear Castagnary:

The strangest rumors are going around here about the latest coup d'état.[1] People think that Velos IV is on the throne.[2] Others claim it is the direct descendant of Louis XVI.[3] Is it true that there is serious talk of a marriage between Mlle MacMahon* and the Petit Oreillard? If the republic survives all that, we'll be lucky indeed. As for me, I don't dare return to Paris at the moment. We must wait and see. I remember December 2.

In the announcement that I am sending you there are paintings that are not yet finished, such as the *Goats*. As for the women's portraits, there are some at your place, and others at Durand-Ruel's.* I have the *Irish Woman* [F. 537], Durand-Ruel has the *Dutch Woman*, you have the *Russian Woman* and *Caroline*. If this announcement is not enough, write me right away.

With a cordial handshake,

G. Courbet

1. On May 16, 1877, Marshal MacMahon dismissed the Republican cabinet that had been formed by Jules Simon* and summoned the duc de Broglie to form a right-wing ministry, in spite of the overwhelming electoral victory of the Republicans in 1876. A month later, on June 16, the new ministry of the duc de Broglie was voted out with 363 against 158 votes. Immediately, rumors of a coup d'état spread throughout France and the wildest suggestions were made as to the coup's author (cf. Wolf 1963, 367–370).

2. Perhaps a nickname of the Prince Impérial?

3. This would have meant, a descendant of Louis XVI's son Louis XVII (1785–95?), whose death at age ten was doubted throughout the nineteenth century, and, by some, to this day.

77-17 *To Juliette Courbet, La Tour-de-Peilz, July 1, 1877*

Tour-de-Peilz, July 1, '77

Juliette, my dear sister:

Do come, please, with M. Rouberol.* I'll meet you wherever you like, either at my place in La Tour-de-Peilz, or nearer to Pontarlier, in Yverdun or Vallorbe, it is up to you. However, if you have time, La Tour would be better.

You could see my household with M. and Mme Morel.* We have lived together through these bad times.

I am like you. My brain is so weary that answering a letter becomes an enormous effort. I have more than one hundred important business letters that I have not answered.

It is impossible for me to come back at the moment.[1] They are arresting everyone at the borders, traveling salesmen and even the Swiss themselves. If I returned, as everyone is telling me to, I would be apprehended as a precautionary measure. It is the priests, who are staging a coup d'état to rule the world by stupidity. No matter, in spite of their plots and the peasants' foolishness, I believe, as everyone does who is intelligent, free, and from the cities, that we'll have the republic in three months.[2] Do what you can to imbue the people of our region with that reasonable spirit. They are the villains who have destroyed my entire existence. I don't understand your weakness. After the Ornans house was bought, an inventory should immediately have been made of the objects that the house contained so that nothing could be abstracted. There is still time, using M. Panier[3] and the justice of the peace,[4] it is their duty.

As for M. Simon,[5] as he has abandoned his place, and as he no longer fulfils his obligations, since he no longer lives there, the contract becomes invalidated. Some time ago, I wrote Ordinaire* that I had never understood that, under the terms of the rental, the vineyard belonged to him entirely for one year, only when there was no harvest, but half under normal circumstances. It is impossible to understand it differently.

They are stopping everyone here at the border. M. R[ouberol], the engineer, must not say that he is coming to see me. I am expecting you this Sunday, July 7. Write me.

I embrace you with all my heart, you and Father.

G. Courbet

Everyone is writing me not to move for the moment.

1. After the dissolution of the Chamber in June 1877, the political situation was extremely unstable, and Courbet felt it was unwise to return to France.

2. Courbet was too optimistic. MacMahon was not to resign as president of France until January 13, 1879, when the Republican victory in the senatorial elections made his position untenable.

3. Marginal note: "You could have asked him for a safe-conduct for me."

4. Marginal note: "It is a pity that the prefect of Besançon resigned." Probably a reference to the Republican Paul Cambon (1843–1924), who had resigned as prefect of the Doubs department after barely one year in office.

5. Caretaker of Courbet's studio on the route de Besançon. Compare letter 77-12.

77-18 *To General Cluseret, La Tour-de-Peilz, August 21, 1877*

La Tour-de-Peilz, August 21, '77

My dear Cluseret:

Be so kind as to make a copy for me of the charming letter you wrote to New York[1] and send it to me as soon as possible, for I have here with me a man who was on the committee of the Philadelphia exhibition.[2] This gentleman is offering to help me. He knows not only Colonel Forney[3] but also the general who was the director of that exhibition.[4]

With friendly regards.

Gustave Courbet

I was unable to come see you before I left Geneva because I had hurt my leg, which is still healing.

[Address] General Cluseret

Geneva

Carouge

[Postmark] La Tour-de-Peilz, July 21, 1877

1. In 1876, Courbet had exhibited four paintings at the Philadelphia Centennial Exhibition (see letter 77-9, n. 8), under the aegis of the New York-based dealer A. H. Reitlinger. The exhibition had closed on November 10, 1876, but by the summer of 1877 Courbet's paintings had not yet been returned. Early in August 1877, he asked Cluseret, who knew English and had many contacts in America, to assist him in retrieving his paintings. Cluseret wrote a long letter to a connection in New York on August 13, 1877 (copy in Bibliothèque nationale, Cabinet des estampes, Yb3.1739 [4°], b. 2).

2. It is not clear to whom Courbet is referring here.

3. John Wien Forney (1817–81) had been a special commissioner for the Philadelphia Centennial Exhibition charged with stimulating interest in the exhibition in Europe (see Maass 1973, 36).

4. The general director of the Centennial Exhibition was Alfred T. Goshorn (1833–1902), who was generally referred to as the "General" (see Maass 1973, 134).

77-19 *To his father and to Juliette Courbet, [La Tour-de-Peilz,]*
August 23, 1877

Friday, August 23, '77

Dear Father, dear Sister:

M. Rouberol* wrote me a very kind letter, which he sent me along with the plan for my atelier. I am delighted with his goodwill and his affection, but it is impossible for me to negotiate with him right now. I have to be on the spot to see how, in this cohabitation, I can maintain the freedom I and my painting require. Let's let the elections pass,[1] and after the gunshots, if there are any, I will return immediately. The elections look very promising.[2] If this time around they do not succeed, there is no hope.

M. Rouberol tells me that Sunday they are going to Flagey. That will be

very pleasant for you, as you are not exactly spoiled by too many diversions. Tell M. R[ouberol] to go on with the dining room downstairs, to leave the small staircase with one fanlight, to make another one above the carriage entrance. When I am there, they can put in the staircase for the first floor. For the balcony, we need an iron balustrade like the one off Champfleury's* room, finished with a wooden handrail.

I went to the rifle meeting of the canton of Geneva, where I spent some ten days, at the request of the representatives of the Geneva government.[3] I donated a small painting as a prize,[4] as in Besançon. But I had an accident in a hallway in my hotel. I slammed into a half-open door. I hit my head but my knee hurts a lot and for the past five days my leg has been extremely swollen. It must be rubbed all day. It is getting better.

I am not working very much. The heat is excessive.

I don't know whether Simon[5] intends to harvest the whole vineyard this year. That was absolutely not what I had in mind. It is quite understandable, and it is finesse on his part. But that lease should have been terminated a very long time ago, for he has met none of the terms we stated. He was to live there, he was to take care of the trees and trim the hedge. He was to keep watch, and the house was vacant, with him in Chantrans.

Give the carriage to M. Rouberol to put in the atelier. He will use it. I don't know whether M. Reverdy* is still saying that I send scurrilous pamphlets about MacMahon.* He wants to keep me from coming back.

I embrace you with all my heart. Compliments to M. Rouberol's family.

<div style="text-align:center;">*G. Courbet*</div>

M. and Mme Morel* send you their best regards and look forward to seeing you, as I do.

1. The elections for the Chamber of Deputies, which were to be held on October 14.

2. The elections were indeed to be a victory for the Republicans, who won 326 out of 543 seats. Courbet could not foresee that MacMahon, rather than appoint a Republican ministry, would, on November 23, call in General de Rochebouet to form a ministry "of national concentration." This ministry lasted for three weeks. Then MacMahon did an about-face and reappointed Jules Dufaure.*

3. Courbet, during his period of exile, visited several rifle and gymnastics meetings (cf. La Tour-de-Peilz 1982, 92 and passim).

4. The painting cannot be identified.

5. Compare letter 77-12.

To Juliette Courbet, La Tour-de-Peilz, September 15, 1877 (incomplete) 77-20

<div style="text-align:center;">Tour-de-Peilz, September 15, 1877</div>

. . . M. Rouberol* has just written me that they are going to auction off the objects seized by M. Quest,[1] through the offices of M. Caron, receiver at Ornans. I don't know what is included among those seized objects. . . .

The two-wheeled tilbury that I invented is not for sale. It is a work of

industrial art that is not finished and that is destined for an exhibition. . . .²
If the tilbury is auctioned off anyway, buy it back in your name, and tell M.
Rouberol to equip it for you.

Fumey* must absolutely and as soon as possible be told to have seals
affixed to those objects in our house that they have no business with. They
belong to Father and me. So write Fumey, it is Father's duty, unless he wants
to let those people steal thirty or forty thousand francs, perhaps even fifty
thousand from me. And afterward, how would he expect me to live and pay
for the Column? . . .

I am all healed.

I embrace you both, you and Father.

G. Courbet

1. The sequestrator who had seized Courbet's possessions.
2. Perhaps Courbet intended to show his invention at the 1878 Universal Exhibition in
Paris.

<u>77-21</u> *To his father, La Tour-de-Peilz, September [?] 22, 1877*

La Tour-de-Peilz, Sept. [?] 22, '77
Since you told me that Father is going to Ornans tomorrow, I am address-
ing this letter to him in care of Mme Volinde for her to give Father.

Dear Father:

I am very angry about all the troubles that M. Reverdy's* unspeakable
actions are causing you. The people who affixed seals to the objects that are
left in our house did a futile job. The court has nothing to do with it and for
the moment has no right of seizure over what belongs to us. Its only jurisdic-
tion is over the objects seized before the court's last verdict. Its rights can only
resume if I do not pay the five thousand francs on January 1, 1878. The seals
affixed to the objects in our house are not superfluous, but where they will be
extremely useful is on the objects stolen by M. Reverdy, which are stored in
crates, either at M. Laflie's, or in the house adjoining Cusenier's* [?]. That's
where my paintings are, that were brought from Paris on a cart to avoid
customs and that is also where various objects must be that were taken from
our house when they occupied it by main force, throwing you out with im-
punity. Those paintings are worth a considerable amount and that is the
important point. M. Fumey* or M. Henriot* must absolutely find the courage
to do this. The Reverdys owe rent on our house from the day they violently
threw Father out of the house, for M. Reverdy has no other rights in our
family (as a member of his household) than to receive whatever he might
inherit.

I count on Fumey to carry out what I am asking here, and without fear.

I cannot know what the Ornans receiver has in the way of objects seized from me, but in any case I would like Fumey to oppose the sale of the tilbury, which is a work of industrial art in progress. It is a tool. It would be like taking a painting that was only just begun. One way or another I would want to profit by the invention. I would like to know from the receiver what the objects are that were seized before the verdict. I have learned that M. Reverdy was secretly selling my paintings, and some have been shown to me. I repeat, the Reverdys have very valuable things of mine and cannot, unchecked, empty a whole house over the course of three years. M. Reverdy is a robber by main force. I am counting on all of you.

I embrace you and Juliette,*

<div align="center">

G. Courbet

</div>

Kind regards to all our friends. I'll come after the elections. Greetings to Mme Volinde and her family, to whom I am addressing this letter.

To Jules Castagnary, La Chaux-de-Fonds, November 17, 1877 77-22

<div align="right">

Chaux-de-Fonds, Nov. 17, '77

</div>

[No salutation]

I am borrowing our friend Leloup's* pen to thank you for the affection that you have shown me all this time.

Now, as we have to talk business, let's get to it. I was unable to get the official report or list of what was seized from my Paris atelier. What will happen is that the auction will be held and I will be the only one to have no idea what will be sold.[1]

My attorney,[2] who, as you know, is an impossible man, from whom one cannot get a single positive or clear answer, wrote the attorney in Besançon.[3] He wrote, I say, and gave me details that explain nothing. It appears that I owe 11,750 francs in court costs. It is not specified whether the fees for the lawyers and attorneys of both parties are included in that amount.

There are some things in my atelier that will be sold and that Reverdy* left there on purpose. They will go dirt cheap. For example, the *Portrait of Dupont* [F. 654], a *Self-Portrait* [F. ?], Old-Master paintings by Lesueur, Van Dyck, Mignard, etc., etc. There are also two drawings of mine that I could never do again, the *Painter* [Fd. 17 or Fd. 18] and the *Women in the Wheatfield* [Fd. 40].

I never heard of our friend Etienne Baudry* again, he who would be the perfect person right now to pull various things out of the auction, as well as to buy the *Horse* [F. 341], seized at Durand-Ruel's* (if it went no higher than a thousand francs).

As for the *Proudhon Family* [F. 443], my intention has always been to present it to the city of Besançon, so I cannot buy it back.[4]

I almost forgot to tell you that it appears from the letter of my Besançon attorney that 18,521 francs have already been raised from the sale of objects seized from me (please consult with Duval* to confirm the accuracy of that figure). You would think that that attorney wants to ruin me completely. In fact, Duval lately wrote me, "I have sold six hundred francs' worth of your stocks, to keep you current with my fees. As far as my account goes, I am satisfied."

I don't know what happened with the lawsuits against Laroche and Gilly.[5] Duval had some secrets to tell me, once I got to Paris. I don't know what secrets. He was talking lately about a petition that my Besançon attorney and Lachaud* could address to the government. I believe that the petition would concern remission of the costs, as has always been done for those who, like me, fought against the establishment.

As for the present, five months ago I contracted an illness[6] that has robbed me of all my energy and that has kept me from working to meet the first installment of five thousand francs on January 1. It is true that my paintings would not sell well because they aren't selling at all, either in Paris or abroad, owing to the government's machinations. You can see from the results of the sale of my pictures that selling paintings isn't an option.

The gentlemen painters of the jury opposed your idea.[7] Instead of choosing pictures of mine, such as the *Hunt in the Snow* [F. 612] and others, as you thought they would, they took the opportunity to show the *Wave* [F. 747] and the *Cliffs at Etretat* [F. ?], which they know perfectly well do not belong to me.[8] I do not know how to respond to those gentlemen.

To make things worse, I sent four pictures to the Philadelphia exhibition that were stolen from the administration by a certain Reitlinger from Vienna, a business agent in New York.[9] That is twenty thousand francs' worth and they are demanding forty-five hundred francs to return them to me.

And now we come to the great calamity, the dropsy. I have consulted every possible doctor,[10] and in their opinion it requires the usual medical routine, which I want none of, for I have seen all my friends die with those treatments.[11] They told you that I had found an exceptional treatment here, which makes me feel very good and which will save me from death without any need for a tap.[12]

I thank Dr. Collin* and you very much for your concern, and our friend Pata* as well, and I hope to pull out of this in spite of the unfavorable season. All my friends from the Franche-Comté have come to see me, including Dr. Blondon* from Besançon, who offered his services, as has M. Collin. As far down as the lower abdomen everything is cleared out, except for the legs, whereas the pope is swelling up through the legs and then upwards all the way to the throat, fortunately.[13]

Sincerely yours, my dear Castagnary.

If this terrible illness gets worse later on, I'll write you immediately. I have asked Leloup to write this, I have no energy.

Best wishes to our friends. Sincerely yours. I embrace you and thank you again.

G. Courbet

1. A public auction of paintings and other objects from Courbet's studio in the rue Hautefeuille that had been sequestered to cover the expenses of the reconstruction of the Vendôme Column was scheduled for November 26, in the Hôtel Drouot. It would produce approximately thirteen thousand francs.

2. Charles Duval.*

3. M. Fumey.*

4. Like the *Horse*, the *Portrait of Pierre-Joseph Proudhon* had been seized at Durand-Ruel's. Both paintings were sold at the November 26 auction.

5. Two lawsuits in which Courbet was involved. The Gilly affair is mentioned in several earlier letters.

6. Probably as a result of excessive drinking, Courbet had contracted edema, or dropsy.

7. Probably the jury of the 1878 International Exhibition in Paris.

8. The *Wave* belonged to Etienne-François Haro. The *Cliffs at Etretat* cannot be identified with certainty, but it was probably owned by a dealer as well.

9. Compare letter 77-9, n. 8.

10. On the various doctors and quacks Courbet had seen since August, see Lindsay (1973, 328–332).

11. On Courbet's fear of tapping, see also Lindsay (1973, 331).

12. As he wrote this letter, Courbet was staying in La Chaux-de-Fonds in a private hospital run by Dr. Guerrieri, whose treatment seems to have consisted mostly of purges and steambaths (cf. Riat 1906, 374; and Lindsay 1973, 330; see also letter 77-24).

13. Throughout the fall of 1877, the newspapers reported almost daily on the final illness of Pope Pius IX, whose legs were swollen with sores. The pope was to die five weeks after Courbet, on February 7, 1878.

To Jules Castagnary, La Chaux-de-Fonds, November 23, 1877[1] 77-23

La Chaux-de-Fonds, 23 Nov. 1877

My dear Castagnary:

I did receive your two letters and thank you sincerely for their contents. Your last one certainly gives me very good advice about my illness.[2] Unfortunately it is impossible for me to follow it at the moment. Because of the excessively cold weather we are having I cannot travel. I am well taken care of in La Chaux-de-Fonds,[3] though I know how effective the care I could get in Paris at the Maison Dubois would be.

Let us speak a little about my business affairs. Dr. Blondon,* who keeps me very well informed about my trial, imparted some details that he got from M. Duval,* the attorney. I will quote you one of the most important passages:

"Given these explanations, it follows that the Domain [Administration]

has already realized on the objects seized the sum of 18,521 francs. The legal fees amount to 11,750 francs. Thus, there remain 6,800 francs, now in the hands of the state but belonging to you. What does the Domain [Administration] intend to do with that sum of 6,800 francs? As the fees are currently paid, you do not have to pay out the first installment of the damages until January 1, 1878. Whether they intend to keep that sum as a guarantee or as an advance payment, that is what we have to find out. In the second place, why do they intend to auction off the paintings Durand-Ruel* has of yours? That auction does not seem necessary or needed, as the verdict puts it. Whatever you owe the state right now is paid up. Therefore, far from selling, the Domain [Administration] should reimburse you the sum of 6,800 francs. You don't have to pay anything until January 1, 1878. Till then you must be free to dispose of what belongs to you. It is on those two points that I have had Fumey* ask Duval for further explanation. I am awaiting his reply."

It will be clear to you from all this that the state has no right to have my paintings auctioned[4] since it is currently in debt to me. However that may be, if there is no way to prevent the auction, please be so kind as to be present when it takes place and push the two paintings of which I spoke to you up to the sum of one thousand francs for the *Horse in the Woods* [F. 341] and three hundred francs for the *Portrait of Pierre Dupont* [F. 654].[5] M. Leloup,* back from Neuchâtel, where he attended a meeting of the grand assembly, sends you his friendly greetings.

> *Signed by the scrivener for*
> *MM. Courbet and Leloup*
> *C. Rochette, scrivener*

M. Courbet is in bed at the moment. If it were not for that he would be even more tired.

1. Letterhead: "Hôtel de la Fleur-de-Lys, P. Perret, Chaux-de-Fonds, Suisse."
2. Castagnary had advised Courbet to travel to Paris to be treated at the Dubois nursing home (cf. Lindsay 1973, 330–31).
3. Judging by the letterhead, Courbet was no longer staying at the clinic of Dr. Guerrieri (cf. letter 77-22, n. 12) but in a hotel in La Chaux-de-Fonds.
4. Reference to the auction scheduled for November 26 at the Hôtel Drouot. See letter 77-22, n. 1.
5. As it turned out, the *Horse* was sold for 2,600 francs, the *Portrait of Pierre Dupont* for 395 francs (see Riat 1906, 376).

77-24 *To Jules Castagnary, La Tour-de-Peilz, December 12, 1877*

La Tour-de-Peilz, Dec. 12, 1877

My dear Castagnary:

For two months now my attorney and my lawyer[1] have been making a mystery of a request that they intend to address to the Domain Administration

with regard to paying the five thousand francs that I must pay the state this January 1.

I wonder what I am supposed to do to come up with such a large sum when all year long it has been impossible to sell paintings and when, moreover, I have been afflicted for the past five months with a very serious illness that has prevented me from doing any work since.

Now there is a contract by the terms of which I have to pay five thousand francs every six months, and the state violates that contract by holding an auction of objects belonging to me, the proceeds of which exceed the first installment to be paid.[2]

In spite of that they would like me to pay another five thousand francs, I who cannot sell anything and, worse, who cannot produce anything? Really, that would be too much.

It's my attorney from Besançon, M. Fumey,* who informed me of what is going on, and I would very much appreciate it if you could go and see M. Duval* to talk with him about this business and to make him understand how impossible it is for me to pay those five thousand francs and how unjust it would be to want me to pay them in the crisis we are going through and in my present state of health.

Tell M. Duval that unfortunately I am not an imaginary invalid—I am quite obviously dropsical. Having heard praise of the methods of an Italian doctor established in La Chaux-de-Fonds who treats people with my illness with vapor,[3] I went to see him and after a treatment of seven weeks I came back here, if not cured, at least relieved. The seven weeks that I passed at that doctor's cost me a lot of money; moreover, since my return I have been forced to submit myself to the care of two specialists who did the tap procedure on me.[4] All this is ruinous, and I assure you that my budget is encumbered, very encumbered. It would therefore be impossible for me to give a penny to the state at this time.

I hope that you'll be so kind as to present all these reasons—more than sufficient in my opinion and in the opinion of any being endowed with common sense—so that I will be left in peace until the general state of affairs and of my health have become quite different from the way they are now.

I was very upset to see a hundred frames that cost me seven or eight thousand francs sold for the miserable sum of one thousand francs. Please ask the auctioneer for the name of the buyer of those frames and ask him whether he would be willing to sell them to me for a five-hundred-franc profit, which he would not perhaps realize right now, whereas they would be useful to me (as I have all the paintings that go with them) in case I were to organize an exhibition either in London or in Paris.

And now, my dear Castagnary, I take my leave of you,[5] expressing the wish, both for myself and on behalf of a few friends who are exiled like me,

that our unhappy country will soon emerge from the terrible crisis it is going through. One would blush to be a Frenchman if one did not have the burning conviction that law and justice will have the last word! The Swiss are furious with the patience of the French. Let the French at least prove to the Swiss that if they are patient they will be so to the end, but only to the end of the MacMahonate.[6]

Yours,

G. Courbet

1. Charles Duval* and Charles Lachaud,* respectively.

2. Even though the bids at the November 26 auction (cf. letter 77-22, n. 1) were very low, the total proceeds far exceeded five thousand francs. For the prices of some individual works, see Riat (1906, 376).

3. The clinic of Dr. Guerrieri (cf. Lindsay 1973, 330). A receipt from the Guerrieri clinic is found in Paris, Bibliothèque nationale, Cabinet des estampes, Yb3.1739 (4°), b. 2.

4. The first tap procedure was performed by Dr. Blondon* and Dr. Farvagnie, a physician who practiced in Vevey (see Riat 1906, 377).

5. It is difficult to ascertain the precise meaning attached to this phrase. In retrospect, we know that this was Courbet's last letter to Castagnary, and we therefore tend to read it as a final farewell statement. However, other passages of the letter are quite anticipative, and the phrase may well have been less final than it is often made out to be (cf. Courthion 1948–50, 2:178).

6. The presidency of Marshal MacMahon* was to end thirteen and a half months later with his resignation on January 30, 1879.

77-25 *To M. Fumey, La Tour-de-Peilz, December 18, 1877*

La Tour-de-Peilz, December 18, '77

My dear Fumey:

In my present condition, as Blondon* will tell you, it is impossible for me to see to any business interests whatever. That is why I am sending you a letter that I received lately from my Paris attorney, Duval,* who wants to settle accounts for everything he has done for me up to now, maintaining those suits against the government and other creditors who owed me money. Accordingly, he has proposed to send me his head clerk with all the documents concerning these various suits, and at the same time give me an accounting. I have no idea what accounting he wants to give me because, as you have been able to see for yourself, he is a man who confuses things to such an extent that it is impossible to tell where one is with him. He is so fervently pro-government, holding, as he does, Napoléonist views, that I believe that he and Lachaud* were delighted to waste all the money of mine they had in order to appear in a favorable light in the case.

As you can imagine, if he sends me his head clerk, I can only say yes to each of his explanations. It takes a competent man like you to be able to

respond. For example, two or three months ago he wrote me, "I have just sold six hundred francs' worth of your stock on my account. I am satisfied. I have no further claims." As I know absolutely nothing of the business I have in his keeping, I don't know how he was able to sell those six hundred francs. His persistent silence has kept me entirely in the dark.

Now, I have only one thing left, and that is all his correspondence. I would therefore like to propose to you that you see that he gives you this accounting. If you will, I could send you an authorization modeled after one you would send me, which would make you my attorney. I could send one to M. Duval as well, to confirm the one that I will give you.

I have to pay five thousand francs by January 1, otherwise I lose all the benefits of those five years of legal proceedings. I believe that under the present circumstances it would be very easy to delay the first payment, if you were to address yourself to the director of the Domain [Administration] or even to M. de Marcère.[1] I have already written Castagnary* along these lines (33 rue Notre-Dame-de-Lorette).[2]

I am sending you herewith enclosed M. Duval's letter. Answer me by return mail because we have no time to lose. The Domain Office wanted to give me, before the end of the month, everything they had sold in my name to erase my debt. They have just sold my tools, my means of work, and that in order to carry those sums forward to thirty-three years from now, whereas I, in my present situation, could not answer for myself for a year.

Give my best to Madame Marie, and to all our friends, and tell Blondon that I am still exactly in the same condition in which he left me, that is, with a girth of 140 [centimeters].[3] Only my face is a little better.

Sincerely yours. I am very ill!

G. Courbet

I remember that formerly, when a private citizen sued the government, it was very rarely that he paid the legal fees and the registration. He only had to pay his own, whereas M. Duval, in his otherworldliness, has never informed me about his outlay. Tell me whether I should send you his file, or rather all his letters.

When you write me, please tell me whether Blondon thinks it is necessary for me to write him to come perform the second tap. I believe it is nearly time.[4]

1. Republican deputy Emile Marcère* had just regained his post of minister of the interior on December 13. Courbet had turned to him several times before.

2. Cf. letter 77-24.

3. Courbet's body had swollen to gigantic proportions owing to the edema from which he was suffering.

4. On December 20, Dr. Farvagnie from Vevey was to perform a second tap procedure.

77-26 *To Paul Collin, La Tour-de-Peilz, December 18, 1877 (incomplete)*

. . . In spite of the vapor treatment at La Chaux-de-Fonds,[1] I have had, after my return to La Tour-de-Peilz, to undergo the doctors' tapping treatment in spite of my aversion to that type of treatment. Dr. Blondon* from Besançon was there, and old père Farvagnie from Vevey, whom you know. The tap was done about two weeks ago and now it must be done all over again.[2] As I have regained all my obesity, that is, 145 centimeters, I don't know whether Dr. Collin is still as disposed to come see me. Up to now I have been afraid to bother him, but now that the most interesting phase of this illness has arrived, I will accept the services that he so graciously offered me some time ago. . . .

This obesity is following an absolutely regular course. I have no pain in any part of my body. My heart is slightly enlarged, my pulse is at eighty, and my liver is just as it should be. I don't have headaches and the only tiredness I feel is due to my weight. The first tap, which was only two-thirds completed, produced twenty liters of water. The steam baths of La Chaux-de-Fonds and the purges produced eighteen liters from the anus. My legs are not very swollen. This is my current condition. . . .

1. At the clinic of Dr. Guerrieri. Compare letter 77-22, n. 12.
2. See letter 77-25, n. 4.

77-27 *To Juliette Courbet and his father [La Tour-de-Peilz, December 23, 1877]*[1]

Dear Sister, dear Father:

Don't worry at all, stay calm, and keep warm, if that is possible in Flagey.

I am going to pay the five thousand francs to the government, which doesn't want to come to an understanding about it. I charged Fumey* and Blondon* with the negotiations, and Castagnary* too. I no longer have the head for all that nonsense. I have had enough in the past five years.

I embrace you both with all my heart.

G. Courbet

1. This letter, Courbet's last, was written eight days before his death on December 31, 1877. According to Courthion (1948–50, 2:179), who based himself on Riat (1906, 378), it was written entirely by the artist himself. In fact, neither text nor signature are autograph, and the letter was most certainly dictated to a friend, like most of Courbet's letters from 1877.

UNDATED LETTERS

To Mlle Octavie [Paris, 1850–65][1] *(incomplete)* ND-1

. . . M. Courbet has been so indiscreet as to make his way into the apartment of Mlle Octavie, who no longer comes to see him. . . . [The painter ends by] . . . greeting the young lady as graciously as he is able. . . .

1. This letter and ND-2 probably date from the 1850s or early 1860s, when Courbet appears to have been involved in a number of casual love affairs with *grisettes* or *comédiennes*. See also letters 54-4 and 62-3.

To Odette [Paris, 1850–65][1] *(incomplete)* ND-2

[Odette has procured him a little dog] . . . As soon as you left, the little dog went mad . . . he forced open the door . . . he must have been at your house before you got there. . . .

[He'll send for the dog the next day with a carriage and a muzzle. He also thanks his correspondent for the curtains and the furniture she plans to get for him. He himself has just bought forty chairs and two candelabra at 1 rue Jacob.]

1. See letter ND-1, n. 1.

To Jules Luquet [Paris, 1860–70][1] ND-3

My dear Luquet:
Please give the portrait drawing of my sister playing the guitar to M. Robbe to make a reproduction of it.[2]
Sincerely yours,

Gustave Courbet

He'll bring it back to you right away.

1. This letter no doubt belongs to the group of letters Courbet sent to Luquet in the first half of the 1860s. It is not possible, however, to date it more precisely.
2. Perhaps the etcher Louis-Marie-Dominique-Romain Robbe (1806–87). No reproduction of *Zélie Courbet Playing the Guitar* (Fd. 25) is known today.

To Claude Monet [Paris? n.d.] (paraphrase) ND-4

[He informs Monet that he is sending him seventy-five francs, which is all he can spare until he changes a thousand-franc note.][1]
[Signed] Gustave Courbet

1. This note must date somewhere between 1865, when Courbet, in the course of his lengthy stay in Normandy, probably met Monet for the first time, and 1870, when Monet left France to escape the Franco-Prussian War. However, it is impossible to date it any more precisely as Monet seems to have asked Courbet for money numerous times. In a letter of June 19 [1866?] (now in Paris, Fondation Custodia), e.g., Monet complains that his parents don't want to give him any money, not even enough to buy a stamp for a letter, and he asks Courbet to lend him whatever he can spare; in another letter (Paris, private collection), dating from the spring of 1870, Monet refers to several past occasions in which Courbet has lent him money and asks him once more to place his wallet at his disposal. Many years later, reminiscing about Courbet, Monet remembered his encouragement, his kindness, and his willingness to lend him money in difficult times (cf. Graber 1943, 169).

ND-5 *To Emile Joute [n.p., n.d.]*[1] *(incomplete)*

[Courbet is supposed to paint the portrait of his friend Emile Joute, but instead he sends him a self-portrait (F. 542?), with the following comment] . . . You are not beautiful with your head of lard! Look here, I better give you my [own] head. . . .

1. Léger (1948, 53), who published this fragment, placed it chronologically in the mid-1850s. In my opinion, however, the letter must have been written considerably later, perhaps in the late 1860s or early 1870s, when Courbet seems to have been in close contact with Joute.

ND-6 *To G. Villain [1870s?]*

My dear friend, G. Villain:

I always remember you with the greatest pleasure. I always admire your joyous character, your fine sincerity, your devoted friendship. While being tormented undeservedly, I remember you with happiness.

Gustave Courbet

Your old friend, forever yours.

Chronology

1819	June 10	Birth of Jean-Désiré-Gustave Courbet.
1821		Birth of Clarisse Courbet.
1824		Birth of Jeanne-Thérèse-Zoé Courbet.
1828		Birth of Hélodie-Zélie Courbet.
1831		Birth of Bernardine-Juliette Courbet.
		Gustave is enrolled in the Petit séminaire at Ornans.
1834		Death of Clarisse Courbet.
1837	October	Courbet enters the Collège royal de Besançon as a resident student. He studies philosophy with Charles-Magloire Bénard, mathematics with Pierre-François Delly, and drawing with Charles-Antoine Flajoulot.
1838		Quits the Collège royal de Besançon and enrolls in the Académie de Besançon.
1839	Spring	Produces four lithographs to serve as illustrations for Max Buchon's *Essais poétiques* (Besançon, 1839).
	Late autumn	Moves to Paris to become an artist. Studies in the atelier of Baron Charles de Steuben.
1840		Paints a portrait of Clémentine, the daughter of his second cousin Eliza Jovinet, and perhaps also the portraits of the three younger children of his second cousin Julien-François Oudot.
	Late autumn	Visits his family in Ornans.
1841	January	Moves to 4 rue St. Germain-des-Prés, together with Adolphe Marlet and Urbain Cuenot.
	February	Submits portraits of Marlet and Cuenot to the Salon of that year. Both works are refused.
	Summer	Goes on a one-week trip to Normandy together with Urbain Cuenot.
	Late autumn	Visits his family in Ornans.
1842	January	Moves to 28 rue de Buci.
	February	Submits a hunting scene and an interior to the Salon. Both works are refused.
		Acquires a black cocker spaniel.
	Summer–autumn	Visits his family in Ornans.
	December	Returns to Paris and moves to 89 rue de la Harpe.
1843	February	Submits two paintings to the Salon, the *Portrait of Paul Ansout* (F. 57) and the small *Self-Portrait with Black Dog* (F. 26).
	Late summer, autumn	Visits his family in Ornans.
1844	Winter	Paints his first important painting, *Lot and His Daughters* (F. 13).
	February	Submits *Lot and His Daughters* to the Salon, together with his second *Self-Portrait with Black Dog*

(F. 27) and an unidentified landscape. Only the *Self-Portrait with Black Dog* is accepted.

Paints portraits of a Belgian baron and his father and of a gentleman from Dieppe. None of these works can be identified with certainty.

	Late summer and autumn	Visits his family in Ornans.
1845	February	Submits five paintings to the Salon. Only the *Guitarrero* (F. 52) is accepted.
	Summer	Begins a large painting (8 by 6 feet) that he plans to submit to the 1846 Salon. Is visited by the Dutch dealer H. J. van Wisselingh.
	Autumn	Visits his family in Ornans.
1846	February	Submits eight paintings to the Salon. The large canvas he had started the previous summer is not included. Only one work, a self-portrait (probably F. 93), is admitted.
	August	Visits Belgium, where he stays with the Papeians family in Ghent, and Holland. Visits the museums in Amsterdam and The Hague. Travels back along the Rhine to Ornans.
	Autumn	Visits his family in Ornans.
1847	February	Submits three paintings to the Salon, including a *Portrait of Urbain Cuenot* (F. 85), of which he is very proud. All three paintings are refused.
	August 16	Death of Thérèse-Josèphe Saulnier, Courbet's maternal grandmother.
	September	Trip to Belgium, where he visits Brussels, Malines, Antwerp, Termonde, Ghent, Bruges, Ostend, Louvain, and Liège. Returns along the Rhine to Ornans.
	Autumn	Stays with his family in Ornans.
1848	February	Revolution forces the collapse of the July Monarchy. Courbet designs frontispiece for *Le Salut public*, published by Charles Baudelaire and Charles Toubin. He is gradually introduced into the Parisian bohemia. To the unjuried Salon of this year Courbet submits ten paintings, including the large *Classical Walpurgis Night*, a work later destroyed.
	June	Notorious "June Days." Courbet claims not to have taken part in the fighting.
	August 14	Death of Jean-Antoine Oudot, Courbet's maternal grandfather.
1848–49	Winter	Moves to 32 rue Hautefeuille. Meets Francis Wey.
1849	May	Submits nine paintings and two drawings to the Salon, which this year opens on June 15. Six paintings and one drawing are accepted. Courbet is awarded a medal, and his *After Dinner in Ornans* (F. 92) is bought by the state, to be deposited in

the Lille Museum. Henceforth, he is "hors concours," i.e., he no longer has to submit his work to the jury.

Late August–
early
September Visits Francis Wey in Louveciennes.

October Returns to Ornans to visit his family.

November Paints the *Stonebreakers* (F. 101). Begins the *Burial at Ornans* (F. 91).

1850 May–June Because the opening of the Salon has been delayed until December, Courbet decides to exhibit the works intended for the Salon (including the *Stonebreakers* and the *Burial*) in Besançon and Dijon.

August Returns to Paris. Paints the *Portrait of Jean Journet* (F. 105).

December 30 Official opening of the Salon, to which Courbet has sent nine paintings, including the *Burial at Ornans* (F. 91), the *Stonebreakers* (F. 101), the *Peasants of Flagey Returning from the Fair* (F. 107), the *Portrait of Jean Journet* (F. 105), the *Portrait of Berlioz* (F. 113), the *Portrait of Francis Wey* (F. 103), the *Self-Portrait*, so-called *Man with a Pipe* (F. 39), and two Franche-Comté landscapes.

1851 Winter–
early spring Though much discussed in the Parisian newspapers, Courbet does not receive a medal on May 3, when the Salon awards are distributed. The *Man with a Pipe* appears on a list of paintings to be acquired by the state, but owing to budget restrictions the sale does not materialize.

September 2 Courbet leaves Paris for Brussels, where the *Stonebreakers* (F. 101) and the *Cellist* (F. 74) are exhibited at the annual Exposition générale des beaux-arts, the Belgian equivalent of the Paris Salon. Travels via Munich to Ornans.

1852 January or
February Returns from Ornans to Paris.

March Sends three paintings to the Salon. One of them, the *Young Ladies of the Village* (F. 127), is bought by the comte de Morny before the opening of the Salon on April 1.

June Begins painting of the *Wrestlers* (F. 144).
 Exhibits some of his works in Frankfurt.

Late summer–
early
autumn Begins the *Bathers* (F. 140).
 Is interviewed by Théophile Silvestre for a projected series of artists' biographies.

	October 18	Leaves for Ornans to visit his family.
1853	January	Returns to Paris.
	May	Sends three paintings to the Salon, including the *Wrestlers* (F. 144), the *Bathers* (F. 140), and the *Spinner* (F. 133).
	June	Paints the portrait of Alfred Bruyas (F. 141), who buys two of his paintings, the *Bathers* and the *Spinner*.
	September or October	Luncheon with the comte de Nieuwerkerke.
	October or November	Travels to Bern, to visit Max Buchon, and to Fribourg.
	December	Begins the *Grainsifters* (F. 166) and the *Gypsy Woman and Her Children*, a work that was never completed.
1854	Winter	Completes the *Grainsifters* and reworks the *Return from the Fair* (F. 107).
	Late May–late September	Visits Alfred Bruyas in Montpellier. Paints the *Meeting* (F. 149), two portraits of Bruyas, and several seascapes.
	Late September–October	Travels via Marseille and Lyon to Switzerland, where he visits Max Buchon in Bern.
	Late fall	Back in Ornans.
		Begins the *Atelier* (F. 165).
1855	Winter	Suffers from a bout of jaundice. Continues work on the *Atelier*.
	March	Submits fourteen paintings to the Universal Exhibition of 1855.
	April	The *Atelier* and the *Burial* are not admitted to the Universal Exhibition, and Courbet decides to organize a private show of his work.
	May 15	Opening of the Universal Exhibition, where Courbet is represented with eleven paintings.
	June 28	Opening of Courbet's private exhibition on the avenue Montaigne.
	December	Takes down his private exhibition.
1856	January–August	Remains in Paris and lobbies for the amnesty of Max Buchon. Paints the *Young Ladies on the Bank of the Seine, Summer* (F. 203).
		Publication of Théophile Silvestre's *Histoire des artistes vivants*.
	September–October	Spends five weeks in Le Blanc, where he attends the wedding of Clément Laurier, then one week in Lyon. Returns to Ornans via Chalon.

	November– December	Paints the *Quarry* (F. 188).
1857	January/ February	Returns to Paris. Paints the *Portrait of Louis Guey-mard* (F. 213).
	May/June	Visits Alfred Bruyas in Montpellier.
	June 15– August 15	Six of his paintings are exhibited at the Salon.
	July–August	Back in Paris.
	Late August or September	Leaves for Brussels, where some of his paintings, including the *Quarry* and the *Grainsifters*, are exhibited at the Salon.
1858		Appears to have stayed in Brussels until August. Paints several portraits.
	August	Leaves Brussels for Frankfurt.
	Autumn	Remains in Frankfurt, where he goes hunting and paints several portraits and landscapes.
1859	February	Leaves Frankfurt for Ornans. On his request, his family has bought some land on the route de Besançon, where he wants to construct a large studio.
	May	Returns to Paris.
	Summer	Short trips from Paris to, among other places, Le Havre, where an exhibition of his works is held.
	October 1	*Grande fête du Réalisme* in Courbet's studio.
	November	Returns to Ornans.
	December	Paints in Vuillafans in the house of his friend Félix Gaudy.
1860	January	Continues working in Vuillafans.
	February	Returns to Ornans to supervise the construction of his studio on the route de Besançon. Except for some short trips, he appears to have stayed in Ornans for the remainder of the year.
	May 1	An exhibition of his work opens in Montpellier.
	May 19	First major article on Courbet by Jules Castagnary in the *Opinion nationale*.
	June 21	Article by Champfleury on "Wagner et Courbet" appears in the *Courrier de Paris*.
	June 24	Opening of the Universal Exhibition at Besançon. In the fine arts section, Courbet is represented with fourteen paintings.
	Autumn	Sends five paintings to the Brussels Salon.
	November	Receives a medal at the Besançon exhibition. Daubigny visits him in Ornans.
1861	January	Publication of Champfleury's *Grandes figures d'hier et d'aujourd'hui*, which contains a chapter on Courbet.
	January–April	Paints two large hunting pictures in his new studio

629

		on the route de Besançon, the *Battle of the Stags* (F. 279) and the *Stag in the Water* (F. 277).
	May 1	Opening of the Salon, where Courbet is represented with four hunting scenes and a landscape.
	May 14	Arrives in Paris.
	June 3	A "Realist banquet" is held in Courbet's honor at the Barrière Clichy.
	August 19–21	Presents a paper at a congress on the arts in Antwerp, organized by the *Cercle artistique, littéraire et scientifique*. Also shows his *Battle of the Stags* at the exhibition held simultaneously with the congress.
	Early September	Returns to Paris, after a few days in Ostend, Bruges, and Brussels.
	Autumn	Member of the selection committee for the French art exhibit at the 1862 International Exhibition in London.
		Love affair with Léontine Renaude.
	December 9	Opens a teaching studio at 83 rue Notre-Dame-des-Champs.
1862	February or March	Models the *Boy Catching Bullheads* (Fs. 1) in the studio at the rue Notre-Dame-des-Champs.
	Late March	Closing of the teaching studio.
	March 17	Opening of the exhibition of the Société des beaux-arts de Bordeaux, where Courbet is represented with two paintings.
	April–May	Shows two works at an exhibition organized by the Société des beaux-arts in Besançon.
	May 1	Opening of the International Exhibition in London, where Courbet has sent his *Battle of the Stags* and the *Boy Catching Bullheads*.
	May	Shows the *Portrait of Jean Journet* (F. 105) at an exhibition organized by the Union artistique de Toulouse.
	Late May	Brief trip to London?
	May 31– October	Stays with Etienne Baudry in the château de Rochemont near Saintes.
	October– December	Stays in Port-Berteau, where he paints the *Return from the Conference* (F. 338).
1863	January–May	Stays with the Borreau family in Saintes, where he is the main exhibitor in a group show of local artists held in the town hall (January 15–February 11).
	March	Several of his works are shown in the gallery of Louis Martinet at 26 boulevard des Italiens.
	May 1	Opening of the Salon, where Courbet is represented

		with two paintings and the *Boy Catching Bullheads*.
	Summer	Falling out with Champfleury. Increased friendship with Pierre-Joseph Proudhon, who, prompted by Courbet's *Return from the Conference*, begins to write his *Du principe de l'art et de sa destination sociale* (published posthumously in 1865).
	August	Spends ten days in Fouras, a small bathing resort on the Atlantic.
	Mid-September	Leaves Paris for Ornans.
	Winter	Begins large painting of the *Source of Hippocrene*, which is accidentally destroyed before completion.
1864	January	Begins *Venus and Psyche* (F. 370), which he intends to submit to the Salon.
	April	*Venus and Psyche* is refused access to the Salon for reasons of impropriety.
	Summer	Paints numerous landscapes.
		Exhibits *Venus and Psyche* in Brussels.
	November–December	Stays with Max Buchon in Salins.
1865	January	Castagnary visits Courbet in the Franche-Comté.
	January 19	Death of Pierre-Joseph Proudhon. Courbet immediately starts working on his portrait.
	Spring	Shows two landscapes and the plaster medallion of Mme Buchon (Fs. 3) at the exhibition of the Société des beaux-arts in Besançon. Becomes infatuated with the still-life painter Céline N. from Lons-le-Saunier.
	May 1	Opening of the Salon, where Courbet is represented with the *Portrait of Pierre-Joseph Proudhon in 1853* (F. 443) and the *Puits noir* (F. 462).
	Late May	Leaves Ornans for Paris.
	September–late November	Stays in Trouville, where he paints portraits of fashionable resort guests and seascapes. Spends time with James Abbott McNeill Whistler and the latter's mistress, Joanna Hiffernan.
	Winter	Stays in Paris to prepare himself for the next Salon. Begins the *Woman with a Parrot* (F. 526).
1866	January	Makes a drawing of *Proudhon on His Deathbed* for Jules Vallès's magazine *La Rue*. The issue in which it is to appear is seized by the censor.
	Early spring	Exhibition in the gallery of Jules Luquet.
	May 1	Opening of the Salon, where Courbet shows the *Woman with a Parrot* and the *Covert of the Roedeer* (F. 552).
	Summer	Angry exchange of letters with the comte de Nieuwerkerke regarding the *Woman with a Parrot*.

	Mid-September– mid-October	Stays with the comte de Choiseul in Deauville.
	November	Involved in a lawsuit with the stockbroker Lepel-Cointet on account of *Venus and Psyche*.
1867	January 9	Returns to Ornans at the news that his friend Urbain Cuenot is dying. Cuenot passes away on the eleventh.
	February	Plans his second private exhibition in Paris to coincide with the International Exhibition of 1867.
	March	Paints *Mort of the Stag* (F. 612).
	April	Stays with Édouard Ordinaire in Maizières, where he paints the *Siesta at Haymaking Time* (F. 643).
	April 1	Opening of the International Exhibition, where Courbet shows four works.
	May	Returns to Paris, where his private exhibit opens on May 30.
	July 26	The court decides in Courbet's favor in the case against Lepel-Cointet.
	August 24– September 2	Goes on a one-week vacation to St. Aubin, where he stays with M. Fourquet. His sisters Zélie and Juliette, who have come to Paris, supervise his exhibition pavilion.
	November	Closing of the exhibition.
1868	January	Zoé Courbet announces her plans to marry Eugène Reverdy.
	Spring	Writes a political pamphlet, *Opinions et propos d'un citoyen d'Ornans*, which remains unpublished.
	May 1	Opening of the Salon, where Courbet shows two paintings.
	May	Publication of Etienne Baudry's *Le Camp des bourgeois*, for which Courbet has made the illustrations.
	Summer	Involved in a lawsuit with M. Andler regarding an overdue account.
	August 11	Marriage of Zoé Courbet and Eugène Reverdy.
	September 3– November 15	Participates in the Ghent Salon with twelve paintings, including the *Return from the Conference* (F. 338) and the *Death of Jeannot* (F. 609). Courbet has prepared two illustrated brochures, *Les Curés en goguette* and *La Mort de Jeannot*, to accompany his exhibit.
	September 11	Travels to Le Havre to attend the opening of the exhibition of the local Société des beaux-arts, in which he is represented with eight paintings.
	Mid-September	Leaves for Ornans.
	November	Visits Edouard Ordinaire in Maizières.
1869	May 1	Opening of the Salon to which Courbet has sent two

paintings previously shown at his 1867 private exhibition, *Siesta at Haymaking Time* (F. 643) and *Mort of the Stag* (F. 612).

Mid-May	Returns to Paris from Ornans.
July	Sends off four paintings to the Brussels Salon and four to the Internationale Kunstausstellung in Munich.
August– September	Spends several weeks in Etretat. While there, he hears that he has been named Knight of the Order of Merit of St. Michael by the king of Bavaria and that he has received a medal at the Brussels Salon.
September 31	Leaves for Munich, where he stays for several weeks.
Mid-November	Returns to Ornans via Interlaken, where he visits a friend.
December	Stays in Salins with Max Buchon, who is very ill.
December 13	Death of Max Buchon.

1870

January– February	Raises money for a monument to Max Buchon, to be sculpted by Max Claudet.
February	The committee of Jules de La Rochenoire nominates Courbet as a candidate for the jury of the 1870 Salon. Though not elected, he will be listed as a runner-up in the 1870 Salon catalog.
Late March	Returns to Paris.
April	Exhibits two Etretat seascapes at the Salon.
Spring	*The Woman with a Parrot* is sold to Jules Bordet. Courbet briefly considers marrying Bordet's sister, Mme Villebichot.
May	Leaves for Dijon to attend the opening of an exhibition organized by Jules Bordet for the benefit of the women of Le Creusot.
June	Courbet is awarded a knightship in the Legion of Honor but refuses in an open letter that appears in *Le Siècle* of June 23.
July 19	Official declaration of the Franco-Prussian War.
September 2	Fall of Sedan.
September 4	Proclamation of the Third Republic.
September 6	Courbet is elected president of a self-appointed artists' committee to safeguard works of art in Paris.
September 19	Beginning of the siege of Paris by the Prussians.
September 24	The Government of National Defense appoints an Archives Committee, of which Courbet is made a member.
October 29	Reads his *Open Letters to the German Army* at the Atheneum.
December 1	Resigns from the Archives Committee.

1871

January	When several shells fall near his studio in the rue

		Hautefeuille, Courbet decides to take up lodgings with Adèle Girard in the passage du Saumon.
	January 28	Capitulation of Paris.
	March 18	Beginning of the Commune.
	March 28	First Commune elections.
	April 16	Courbet is elected to the Commune in the supplementary elections.
	May 1	Courbet votes against the establishment of the Committee of Public Safety.
	May 16	Demolition of the Vendôme Column.
	May 28	End of the Commune. Courbet leaves the passage du Saumon and goes into hiding in the house of a friend, A. Lecomte, at 12 rue St. Gilles.
	May 30	Following a decision of the Ornans Municipal Council on May 28, Courbet's *Boy Catching Bullheads* is removed from the Iles-Basses fountain in Ornans.
	June 3	Death of Courbet's mother.
	June 7	Courbet is arrested and detained in police headquarters.
	June 11	Transferred to the Conciergerie.
	July 4	Transferred to the prison of Mazas.
	July 21	Transferred to the Versailles Orangerie in view of his trial.
	Mid-August	Because of ill health, transferred to the Military Hospital in Versailles.
	September 2	Convicted to six months in prison and a fine of five hundred francs.
	September 6	Transferred to the Versailles Orangerie.
	September 22	Transferred to St. Pélagie, Paris.
	December 30	Suffering from an intestinal stricture and severe hemorrhoids, Courbet is transferred to the nursing home of Dr. Duval in Neuilly, where, as prisoner on parole, he stays for the remainder of his prison term.
1872	Late January	Courbet is operated by Dr. Nélaton.
	March 2	Courbet's prison term is over, but he remains in the nursing home of Dr. Duval through April.
	May 20	Leaves Paris for Ornans, where he arrives on May 26, after stops in Besançon and Maizières.
	July	Spends much time in Maizières, where he stays with the family of Edouard Ordinaire.
	August	Courbet produces a large number of landscape paintings and some fish still lifes. He receives assistance from several younger painters, including Jean-Jean Cornu, Alexandre Rapin, and Chérubino Pata.
		Visits La Glacière in the Forêt de Joux and meets Mlle Léontine, whom he wants to marry.

	September	Travels to Pontarlier and Morteau to visit friends. A large dinner is organized in his honor by Alexis Chopard, a well-to-do brewer at Morteau.
	October	Jilted by Mlle Léontine.
	November–December	Produces a series of paintings for M. Pasteur.
1873	January	The matter of the Vendôme Column is discussed in the Chamber of Deputies.
		The official committee charged with the French art exhibit at the Vienna International Exhibition refuses Courbet's participation.
	February	Courbet is busy trying to arrange private exhibitions in London and Vienna.
	Late February	Sells a large number of works to the art dealer Paul Durand-Ruel.
	May	Arrival in Ornans of Mathilde Montaigne Carly de Svazzena, who had seduced Courbet during the Commune and is now blackmailing him with the threat of publishing a series of explicit love letters.
	May 24	Marshal MacMahon replaces Adolphe Thiers as president of the republic.
	May 30	A bill for the reconstruction of the Vendôme Column is adopted by the National Assembly. The bill charges the government to begin work only after a civil tribunal has determined the extent of Courbet's financial responsibility for the Column's reconstruction.
	June 19	Pending the decision of the civil tribunal, Pierre Magne, minister of finance, orders the sequestration of all Courbet's property in France.
	July 23	Courbet goes into exile in Switzerland.
	October	Having spent some time in Fleurier, Neuchâtel, Geneva, and Lausanne, Courbet settles down in La Tour-de-Peilz, where he stays at the boarding house of M. Dulon.
		Eugène and Zoé Reverdy come to Ornans with the intention of moving in with Courbet's father and sisters.
1874	May	Participates in the so-called Turnus exhibition in Lausanne.
	June 19	The case of Courbet's responsibility for the reerection of the Vendôme Column is heard before the Civil Tribunal of the Seine. Victor Lefranc, attorney of the Domain Administration, is the prosecutor, Charles Lachaud the defense attorney.
	June 26	Courbet is condemned to pay the full cost of the rebuilding of the Column. Lachaud lodges an appeal.

	September	Visit of Henri Rochefort. Courbet paints his portrait (F. 962).
	November	Visit of the duchess Colonna ("Marcello") and her friend Olga de Tallenay.
1875	January	Sculpts the *Helvetian Republic* or *Liberty*.
	May 22	Death of Zélie Courbet.
	July	Moves to Bon-Port, a house overlooking the harbor of La Tour-de-Peilz.
	August 1	Inauguration in La Tour-de-Peilz of Courbet's bust of *Liberty*.
	August 6	The Appeal Court of the Seine confirms the verdict of June 26, 1874.
1876	January 30– March 5	General elections. The Republicans gain control of the Chamber of Deputies.
	March	Courbet has a letter printed for distribution among the newly elected Republican senators and deputies, in the hope of having his sentence revoked or general amnesty declared. The letter is not generally distributed.
	July	Participates in the Turnus exhibition in Lausanne.
	December 13	A new cabinet is formed by Jules Simon.
	December 31	Inauguration of Courbet's *Liberty* in Martigny.
1877	May 4	By the definitive verdict of the First Chamber of the Civil Tribunal of the Seine, Courbet is condemned to pay 323,091.68 francs for the reerection of the Vendôme Column, in yearly installments of ten thousand francs.
	May 16	Seize Mai crisis. Fall of Jules Simon's cabinet.
	November	Courbet's health deteriorates rapidly.
	November 26	First auction, at the Hôtel Drouot, of paintings, furniture, and objets d'art seized from Courbet's studio at the rue Hautefeuille.
	December 31	Courbet dies at Bon-Port at 6:30 A.M.

Correspondents and Persons Frequently Mentioned

Correspondents in CAPITALS

Andler. Immigrants from Bavaria or the German-speaking part of Switzerland, Andler and his wife were the owners of the Brasserie Andler or Andler Keller located near Courbet's studio in the rue Hautefeuille. Their beerhouse, modeled after German *Bierkeller* with hams and sausages hanging from the ceiling and vats of sauerkraut standing against the wall, was a popular hangout for the Parisian bohemia in the 1840s and 1850s. Courbet frequented the Andler Keller from about 1848 until 1863, when he left a large unpaid bill. The argument over that bill led to a court case, which was not settled until April 16, 1869.

Ansout, Paul (1820–94). One of Courbet's earliest friends in Paris, Paul Ansout was the son of a cloth merchant in Dieppe. As a law student in Paris in the early 1840s, Ansout may have been responsible for securing some early portrait commissions for Courbet. His own portrait by Courbet (F. 57), painted ca. 1842–43, is now in the Château-Musée of Dieppe.

Arthaud, *Jules*-Gabriel (1820–88). Besançon painter who had been a fellow student of Courbet in the atelier of Charles-Antoine Flajoulot. He taught at the Ecole des beaux-arts of Besançon.

Auguin, *Louis*-Augustin (1824–1904). Born in Rochefort-sur-mer, Auguin was a student of his father, who was a local drawing teacher. In 1842, he went to Paris, where he studied with Jules Coignet and Camille Corot. After having actively participated in the 1848 Revolution, Auguin, disappointed by the coup d'état of Louis-Napoléon, returned to Rochefort in 1852. He married in 1855 and eventually settled down in Port-Berteau. It is here that Courbet, who had been introduced to Auguin by Etienne Baudry, visited him in 1862.

BACHELIN, Auguste (1830–90). Swiss painter, who studied with Charles Gleyre and Thomas Couture in Paris. He accompanied Garibaldi to Italy as a volunteer war correspondent. On his return, he settled in Neuchâtel, where he painted historical and military scenes and occasional genre scenes. Many of his works are found in the museum of Neuchâtel. It is not known where and how Courbet met him.

BACHELIN, Rose (1843–1918). Sister of Auguste Bachelin (q.v.) and wife of Théophile Schüler, painter and illustrator of the work of Victor Hugo, Jules Verne, and Erckmann-Chatrian.

BALLOY (or VILLOY?), Mme. Unknown correspondent. Perhaps a woman Courbet had met in Montpellier.

Barbedienne, Ferdinand (1810–92). Entrepreneur who was especially interested in the industrial arts. Originally in the wallpaper business, Barbedienne later joined with Achille Colas to start a foundry specializing in the production of small-scale reproductions of famous classical as well as modern sculptures. Barbedienne's gallery became world famous, both for the quality and for the quantity of bronzes it produced. Ferdinand Barbedienne may have been related to a gilder and art dealer by the same name whose shop was located at 76 rue Taitbout. Courbet seems to have had relations with both these men.

Bardenet. Art dealer whose gallery was located at 14 rue Taitbout.

Barthélemy-Saint-Hilaire, Jules (1805–95). Philosopher who was especially known for his translation of the works of Aristotle. A Republican, he entered politics in 1869 and, after September 4, 1870, became a staunch supporter of Adolphe Thiers. His connection with Courbet centers around the letter he wrote him during the Commune, asking the artist to use his influence to protect Thiers's art collection from destruction.

BARTHET, Armand (1820–74). Poet and playwright from Besançon, with strong Fourierist leanings. In 1846, he left for Paris, where two years later, at the occasion of the 1848 Revolution, he composed a national hymn, *La Républicaine*. His first play, *Le Moineau de Lesbie*, was performed with much success in 1849; some of his later plays were less well received. In 1864, he returned to the Franche-Comté, married, and settled in the village of Cendrey, where he began to raise rabbits. The debacle of that enterprise, coupled with his failure to secure a post as district judge and his anxiety over the Franco-Prussian War, drove him to insanity. He committed suicide in 1874. His two-volume novel *Une Passion fatale* appeared posthumously in 1876.

Bastide. Last name of Courbet's maternal uncle, the husband of his mother's only sister. When Courbet writes about "Bastide" in his letters, he generally refers to a male cousin, who must have been of approximately the same age.

Bataille, Charles (1831–68). Writer and journalist. After having worked for several small papers, he became an editor at the *Figaro* in 1854. He wrote novels, essays, and some plays, including *L'Usurier de village*, which was performed at the Odéon. He died in an insane asylum at the age of thirty-seven.

BAUD-BOVY, Auguste (1848–99). Swiss painter (student of Barthélémy Menn), who was much influenced by the art of Courbet. He was on the faculty of the Ecole des beaux-arts at Geneva since 1869 and spent a good deal of time with Courbet during the latter's exile in Switzerland.

Baudelaire, Charles (1821–67). Possibly the best-known French poet and art critic of the nineteenth century, famous for his *Les Fleurs du mal*. In his own time, Baudelaire's reputation was closely linked to his translations of the short stories of Edgar Allan Poe and to his Salon criticism and other essays on art. Courbet appears to have met Baudelaire sometime during the second half of the 1840s. In 1848, he designed a frontispiece for the second and last issue of *Le Salut public*, jointly edited by Baudelaire, Champfleury (q.v.), and Charles Toubin. Courbet was closest to Baudelaire in the late 1840s, when he painted his portrait. Their friendship seems to have cooled after the mid-1850s.

BAUDRY, Etienne (b. 1830). Landowner living in the château de Rochemont, near Saintes. Introduced by Castagnary, Courbet stayed with him from May to September 1862. An eccentric dilettante, Baudry authored *Le Camp des bourgois*, which was illustrated by Courbet in 1868. Baudry remained a friend to the end of Courbet's life and came to the rescue during his years of exile, when he helped Courbet retrieve his paintings from various dealers.

Beau, Claude-*Antoine* ("père") (b. 1792). Courbet's first art teacher in Ornans, Beau had studied at the Ecole des beaux-arts of Besançon and later in Paris with Jean-Baptiste Regnault. He made his debut at the Salon of 1834 with a *Portrait of His Daughter at the Piano*, but does not seem to have exhibited afterwards.

BEAUQUIER, Charles (1833–1919). Politician, writer, and journalist. A native of Besançon, he was the founder of the weekly paper *Le Doubs* and later editor-in-chief of the newspaper *Le Républican de l'est*. As town councillor, and later deputy of Besançon, he was strongly anticlerical, with socialist, even radical lean-

ings. His writings deal with folk music, folklore, and dialect in the Franche-Comté, as well as other varied subjects.

Belfort, Mlle. A friend of Courbet's maternal grandparents. Once an Ursuline nun at Ornans, she later became the housekeeper of Abbé Riduet in Besançon. She seems to have been a parents' representative to Courbet while he was at the Besançon Collège.

BERNARD, Pierre (?). Perhaps Pierre Bernard, who served in the police force during the Commune.

Bernheim, Alexandre. Art dealer in Paris. His father, Joseph, had an art supplies store in Besançon. Courbet, who is thought to have been friendly with Alexandre, may have convinced him to move to Paris. By the early 1870s, Alexandre Bernheim seems to have had an art gallery at 8 rue Lafitte. His sons Josse and Gaston were to continue the gallery as "Bernheim jeune."

BIGOT, Léon (1826–72). Lawyer. A staunch Republican, Bigot practiced law in Versailles and Paris. After the Commune, he defended numerous Communards, most notably Gustave Maroteau, in whose defense he published *Dossier d'un condamné à mort* (1871), prefaced by Victor Hugo. He died from a stroke while defending his one hundred twenty-sixth Commune case.

Binet, Thérèse-Adélaïde-*Virginie* (c. 1808–65). Courbet's mistress in the 1840s. She bore him a son by the name of Désiré-Alfred-Emile Binet (1847–72). After their separation, sometime during the winter of 1851–52, she seems to have moved to Dieppe where she died in 1865.

Bingham, *Robert* Jefferson (d. 1871). British photographer working in Paris. He came to Paris in the early 1850s after having published *Photogenic Manipulation* in 1848. In 1855, he opened a studio at 58 rue de Larochefoucauld, together with W. Thompson. He seems to have specialized in the photographic reproduction of artworks. In 1858, he published an album with photographs of the oeuvre of Paul Delaroche (*L'oeuvre de Paul Delaroche reproduit en photographie*). He also made photographs of works by Ary Scheffer, Ernest Meissonier, Courbet, and other artists.

Blavet, Paul. A friend of Courbet during his early days in Paris. Blavet was the son of a stockbroker in Marseille. Courbet painted his portrait around 1845 (F. 63).

BLONDON, Charles (1825–1906). Physician and philanthropist ("le médecin des prolétariens"). A friend and sometime physician of Courbet, Blondon was particularly close to the artist after 1872, when Courbet frequently called on him with financial as well as medical problems. After Courbet's death, he is presumed to have had an amorous relationship with the artist's sister Juliette, which eventually turned sour.

Bon, Jean-Baptiste-*Alphonse* (d. 1851). Boyhood friend and distant relative of Courbet in Ornans. His parents, Jean-François Bon (b. 1791) and Antoinette-*Félicité* Colard-Taland (1792–1866), so-called père and mère Bon, lived next to the Iles-Basses house of Courbet's grandparents (later the artist's studio). Mère Bon supposedly takes a place among the female mourners in Courbet's *Bural at Ornans*.

BONVIN, François (1817–87). Realist painter of genre scenes, still lifes, and portraits. He befriended Courbet shortly after the latter's arrival in Paris and is supposed to have encouraged him to study the art of the past, especially Dutch seventeenth-century paintings, in the Louvre. Their friendship cooled after Bonvin's second marriage in 1860, but in the early 1870s the two artists again seem to have been in contact.

Bordet, Jules. Collector in Besançon who bought Courbet's *Woman with a Parrot* 639

(F. 526) as well as several seascapes. Courbet had a fleeting affair with Bordet's sister, the widowed Mme Villebichot, in 1870.

BORREAU, Laure, née Herbault (b. 1826). With her husband, Jules (b. 1822), she operated a store of fabrics and linens ("A la fiancée") in Saintes. Courbet stayed with the Borreau family from January until April 1863, during which time Laure and her daughter Gabrielle (actually Louise-Laure-Zoïde, b. 1848) served him as models several times. Courbet later had some contact with Jules Lucien (b. 1852), the son of Laure and Jules Borreau.

BOSSET. A friend of Courbet who lived in Arbois. He seems to have operated a business selling fine furniture and antiques.

BOUDIN, Eugène (1824–98). Norman painter, an important precursor of Impressionism. He was the mentor and unofficial teacher of Claude Monet. Courbet frequently met him during his visits to the Norman coast.

Boulet, Joseph and Paul. Friends of Courbet in Ornans.

Bouvet, Alfred (1820-after 1892). Owner of a transport company in Salins. Courbet seems to have known him well. In 1864, he painted portraits of his wife and of his little girl, Béatrice, who later married Pierre Puiseux. Bouvet also bought an important landscape from Courbet, the *Gour de Conche* (F. 614). Bouvet seems to have been acquainted with Courbet's friends Max Buchon and Max Claudet. In 1877, he wrote a pamphlet entitled *Réponse à MM. Max Claudet . . . et Arthur Ligier.* He apparently was still alive in 1892, as in that year he wrote another pamphlet, *Le Tramway de Salins à Levier.*

Brame, Hector. Art dealer in Paris. A militant Republican, Hector Brame left the provinces for Paris in 1848. He became an actor and stage designer at the Comédie française, where he performed under the pseudonym of deLille. He is known to have played roles in plays by Afred de Musset. His love for art made him turn to art dealing. By the late 1860s, he had a gallery at 47 rue Taitbout.

BRIGOT, *Ernest*-Paul (b. 1836). Painter of landscapes and hunting scenes trained in the atelier of Charles Gleyre. In 1861, Brigot registered as a student in Courbet's short-lived atelier at the rue Notre-Dame-des-Champs. In the course of the 1860s, he exhibited several times at the Salon, showing portraits, landscapes, and hunting scenes.

BRUYAS, Alfred (1821–77). Art collector in Montpellier. He was the son of Jaques Bruyas, a partner in the Tissié-Sarus banking establishment in Montpellier. Independently wealthy, Alfred was able to pursue his interests in the arts by collecting works by such contemporary masters as Alexandre Cabanel, Eugène Delacroix, Auguste Glaize, and Octave Tassaert as well as Courbet. The latter met Bruyas in 1853 and twice visited him in Montpellier, in 1854 and in 1857. Bruyas bought and commissioned some of Courbet's most important paintings, including the *Bathers* (F. 140), the *Sleeping Spinner* (F. 133), and the *Meeting* (F. 149). Their friendship cooled somewhat after Champfleury's article *L'Histoire de M. T.*, a persiflage of Bruyas, which appeared in the summer of 1857. Nonetheless, they continued to be in touch throughout the 1860s and 1870s. In 1868, Bruyas donated the better part of his collection, including Courbet's paintings, to the Musée Fabre in Montpellier.

BUCHON, Joseph-Maximin, called *Max* (1818–69). A schoolmate of Courbet (at the Petit séminaire in Ornans) who later became an important author of regional novels and poetry. A confirmed Republican, he lived for several years in exile in Switzerland, where he made a living translating German and Swiss literature (Friedrich Hebbel, Berthold Auerbach, and Jeremias Gotthelf) into French. He

returned to France in 1856 and settled in Salins, where in 1862 he married a much younger woman, *Félicie*-Hélèna Dizien. Buchon's writings include *Essais poétiques* (1838), an early work illustrated by Courbet; *Le Val d'Hery* (1848); *Le Fils de l'ex-maire* (1857); *En province* (1858); *Poésies franc-comtoises* (1862); *Noëls et chants populaires de la Franche-Comté* (1863); and articles and poems in *Le Peuple*, the *Revue des deux mondes*, and Buchon's own paper, the *Démocrate salinois* (1848–49). Courbet painted a portrait of Buchon (F. 163) and sculpted a relief portrait of his wife (Fs. 3).

Budry, Jules. Owner of the Café du Centre in La Tour-de-Peilz. Budry appears to have been a retired butcher.

BURTY, Philippe (1830–90). Important art critic who contributed to the *Gazette des beaux-arts* and the *Chronique des arts et de la curiosité*. Courbet briefly served with him on the Archives Committee, instituted by Jules Simon under the September 4 government. Both Burty and Courbet resigned when it appeared that the committee was largely pro forma.

Cadart, Alphonse. See LUQUET, Jules.

CARDON DE SANDRANS, Baron de. prefect of the Doubs Department between 1871 and 1873.

CAIRON, see NORIAC.

CARJAT, Etienne (1828–1906). Caricaturist and photographer. His early interest in caricature took him to Baden-Baden, where for four years he drew caricatures of the tourists. Later, he moved to Paris and founded the *Diogène* and the *Boulevard*, newspapers that were famous for their caricature portraits. In 1860, he opened a photography studio, which became an instantaneous success. By 1866, he had already made a thousand portrait photographs and received medals in London (1861), Paris (1863, 1864), and Berlin (1865). Since 1862, when he made his first photograph of Courbet, he was friendly with the painter, who shared his strong anti-imperialist and anticlerical views. In the mid-1870s, Carjat abandoned photography. For the next thirty years, he eked out a meager living writing articles and poetry.

CASTAGNARY, Jules-Antoine (1830–88). Lawyer, politician, and art critic. He befriended Courbet in 1860 and became his lifelong supporter. During the 1860s, Castagnary was one of the most influential art critics. His Salon reviews of these years were published in two volumes in 1892. During the Third Republic, he embarked on a political career that culminated in an appointment, in 1887, as director of the Fine Arts Administration. When he died the following year, he received a seminational funeral and was buried in the Cimetière Montmartre. His *Salons* and other writings on art provide much insight into mid-nineteenth-century art history.

Céline N. Painter of still lifes in Lons-le-Saunier with whom Courbet was briefly infatuated in 1865.

Chabot. A carpenter in Ornans.

CHAMPFLEURY, pseudonym of Jules-Antoine-Félix Husson (1821–89). Realist author and critic. His early novel *Chien-Callou* (1847), based on the life of the etcher Rodolphe Bresdin, was followed by numerous Realist novels, plays, and pantomimes. His later writings are mostly of an art historical nature and deal with the history of faïence and caricature. Champfleury's writings were instrumental in reviving the interest in the Lenain brothers. He also wrote perceptively about early Realist art, notably the work of Courbet. Courbet included his full-length portrait in the *Atelier* (F. 165) and contributed frontispieces and illustrations to

several of Champfleury's books, including *Les Amis de la nature* (1859) and *Chansons populaires des provinces de France* (1860). The two men had a major falling out in 1863 and never seem to have spoken to each other again.

CHAUDEY, Ange-*Gustave* (1817–71). Republican lawyer and journalist. Born in Vesoul, Chaudey studied law in Paris. An active participant in the Revolution of 1848, Chaudey was later exiled to Switzerland. Upon his return to France in 1853, he contributed to the *Courrier du dimanche* and *Le Siècle* as an opposition journalist. He was a close friend and follower of Pierre-Joseph Proudhon and served on the committee that published the philosopher's posthumous works. On September 4, 1870, he became mayor of Paris's ninth arrondissement. Arrested and imprisoned during the Commune, he was executed without due process on May 23, 1871, just when the Versaillese army entered Paris.

Chenavard, *Paul*-Marc-Louis (1807–95). Painter. A student of Louis Hersent, Jean-Dominique Ingres, and Eugène Delacroix, Chenavard was a utopian artist more interested in the philosophical aspects of art than in the craft of painting. In 1848, he undertook the ambitious project of decorating the secularized Panthéon with a series of grisaille paintings summing up the history of mankind (the so-called *Palingénésie universelle*). After the coup d'état of 1851, this project was canceled as the Panthéon was returned to the church. In spite of their different outlooks on art, Courbet and Chenavard appear to have been friendly from the late 1840s until the early 1870s. Courbet painted Chenavard's portrait in 1869 (F. 658).

CHENNEVIERES-POINTEL, Marquis Charles-*Philippe* de (1820–99). Art historian and administrator. Though trained as a lawyer, Chennevières's real interest lay in the field of literature and the arts. After writing a number of short novels in the 1840s, he published, from the 1850s onward, several important art historical works, mostly on French art. At the same time, he was active in the field of art administration. As general inspector of art exhibitions during the Second Empire, he was responsible for the organization of the annual Salons and other government-sponsored art exhibitions. During the early Third Republic, he served as director of the Fine Arts Administration (1873–78).

Choiseul, Comte de. The precise identity of this member of the Choiseul family is not known. Perhaps he was one of the ten children of Charles-Laure-Hughes-Théobald, comte de Choiseul, duc de Praslin, and Altarice Sébastiani. The latter's murder in 1847 and the suicide of her accused husband six days later caused a great scandal in France. The comte de Choiseul had a villa in Deauville where Courbet stayed for a few weeks in September 1866.

CHOPARD, Alexis. Brewer at Morteau and director of the local musical society. In 1872, Courbet presented Chopard with the *Boy Catching Bullheads* (Fs. 1), removed from the fountain in Ornans, in recognition of his support after the Commune.

Chopard, Paul. Watchmaker in Besançon. Probably a brother of Alexis Chopard (q.v.).

CLAUDET, Max (1840–93). Sculptor who studied at the Ecoles des beaux-arts of Besançon and Paris. He worked for most of his life in his native town of Salins in the Franche-Comté. During the later part of his career he turned increasingly to ceramics, which brought him some fame. Claudet made a commemorative monument for Max Buchon after his death in 1869 as well as a portrait bust of Jules Marcou. He wrote one of the earliest biographies of Courbet under the title *Souvenirs: Gustave Courbet* (1878).

CLUSERET, *Gustave*-Paul (1823–1900). Army officer (later general), whose adventurous existence took him to the Crimea, Italy (with Garibaldi), and America, where he fought in the Civil War. A radical, he took part in the Commune and went into exile in Belgium and Switzerland, where he began to paint. In 1877–78, he fought in the Ottoman army against Russia. After his return to France, he embarked on a political career, siding with the extreme left. Courbet painted his portrait, but the work cannot be identified with certainty.

COLLIN, *Paul*-Louis (b. 1834). Medical doctor and painter. As an artist, Collin appears to have studied with Courbet and Bazile Quesnel. His paintings, mostly landscapes and still lifes, were exhibited at the Salon between 1877 and 1880. As a physician, Collin assisted Courbet during the last weeks of his life.

COLONNA, Adèle. See MARCELLO.

Considérant, Prosper-*Victor* (1808–93). Journalist and politician. A native of Salins, Considérant, in his youth, became an enthusiastic follower of Fourier. An important Fourierist propagandist, he founded such journals as *La Réforme industrielle* and *La Phalange* and published a three-volume treatise entitled *Destinée sociale de l'humanité* (1834–44). After a brief political career during the Second Republic, Considérant fled France in 1851 and went to America, where he repeatedly though ever unsuccessfully tried to establish a phalansterian community. He returned to France in 1869 and devoted himself to study and writing until his death in 1893.

CONSTANT. Newspaper editor during the Commune.

CONWAY, *Moncure* Daniel (1832–1907). American preacher, writer, and journalist. As part of his multifarious activities, Conway served as American war correspondent for the *New World* during part of the Franco-Prussian War. He visited the exiled Courbet in Switzerland to buy a landscape painting for his friend Judge George Hoadly from Ohio. This visit is described in Conway's two-volume *Autobiography* (1904).

Cornu, *Jean-Jean* (1819–76). Landscape painter. Though not a native Franc-comtois, Cornu on occasion painted in the Franche-Comté. In the early 1870s he collaborated with Courbet.

CORNUEL. Friend of Courbet in the Franche-Comté. In 1872, he acted as go-between for Courbet in his short-lived love affair with one Mlle Léontine.

Corot, Jean-Baptiste (1796–1875). Painter. Born in Paris, Corot studied with Achille-Etna Michallon and Victor Bertin. In 1825, he traveled to Rome, where he stayed for three years. He exhibited at the Salon from 1827 on and received the Legion of Honor cross in 1846. One of the first nineteenth-century artists to work in the Fontainebleau Forest, he became something of a doyen of the Barbizon school. Yet Corot was critical of the work of Théodore Rousseau and Jean-François Millet. He admired Courbet, with whom he worked side by side on several occasions, in Marly, Louveciennes, and Saintes.

Cotel. Transporter of paintings.

COURBET family. Included Courbet's father, Eléonor-*Régis*-Jean-Joseph-Stanislas (1798–1882), a well-to-do landowner with progressive, even pioneering views on agriculture; his mother, Suzanne-*Sylvie*, née Oudot (1794–1871), who likewise came from a landowning family in the Franche-Comté; and his sisters Jeanne-Thérèse-*Zoé* (1824–1905), Jeanne-*Zélie*-Mélodie (1828–75), and Bernardine-*Juliette* (1831–1915). A fourth sister, Clarisse (1821–34) died in early childhood. Of the three sisters, only Zoé married (see Reverdy, Eugène).

Courbet, Joseph. Probably a second cousin of Courbet. He is frequently mentioned in Courbet's letters of the mid-1840s.

CUENOT, Bourbon-Jean-*Urbain* (1820–67). A son of the district judge at Ornans, he was a schoolmate of Courbet. A staunch Republican, he opposed the coup d'état of Napoléon III in 1851 and was imprisoned for some time. A man of independent means, Urbain lived the life of a dilettante. He was fond of music and founded a choral society in Ornans. He also traveled a great deal, at times in the company of Courbet. Courbet painted Cuenot's portrait in 1847 (F. 85).

CUENOT, François-Xavier-*Théodore* (d. 1847). Brother of Urbain Cuenot (q.v.). Courbet's portrait of Théodore Cuenot (F. 83) must have been painted shortly before the sitter's early death in 1847.

Cusenier, Jules. Distiller at Ornans. Courbet is believed to have portrayed him in the huntsman wielding the whip in his *Mort of the Stag* (F. 612)

DAGUET, Alexandre (1816–94). Professor of Swiss history at the Academy (now university) of Neuchâtel and author of the well-known *Histoire de la Confédération suisse*. Daguet belonged to Courbet's circle of friends in Neuchâtel.

Dard, or Pétrequin-Dard, Gustave (b. 1838). French-born landscape painter who lived for most of his life in Lausanne. He studied with C. Bonnefond and with Courbet. He seems to have been a part-time dealer and is known to have aided Courbet in the sale of his paintings.

Darimon, Alfred (1819–1902). Journalist and politician. A follower of Proudhon, Darimon acted for some time as his secretary. He entered politics in the mid-1850s, and as deputy of Paris he was one of the five members of the opposition party. In the 1870s, he contributed several articles to the *Figaro* and published a number of books on contemporary history.

Daubigny, *Charles*-François (1817–78). A student of his father, who was a landscape painter, Daubigny, still a teenager, worked as a restorer in the Louvre under François Granet. His landscapes were exhibited at the Salon beginning in 1837, but he did not get much recognition until 1853, when two of his works were bought by the state. While in the 1840s and 1850s Daubigny was in close contact with members of the Barbizon school, in the next two decades he often sought the company of the younger Impressionist painters, whose interests he protected at the Salon. His late works often have an Impressionist touch. Daubigny seems to have been closest to Courbet in the 1860s. In 1865, he spent time with him at Trouville, and in 1868 he exhibited together with Courbet, Edouard Manet, and Monet (q.v.) in Le Havre.

DAVID, Maxime (1798–1870). Lawyer and miniature painter. He painted miniature portraits of many well-known nineteenth-century personnages, including Louis-Philippe and several members of his family, and Prince Napoléon. After David's death, his family donated many of his works to the museum of Laon. Sometime in the early 1850s, David started an album of artists' autographs, which he dedicated to his daughter, Marie-Maxime David, on her birthday on December 25, 1854.

Delacroix, Ferdinand-Victor-*Eugène* (1798–1863). Painter and lithographer. He studied painting with Pierre-Narcisse Guérin and made his debut at the Salon with the *Bark of Dante* (Paris, Louvre). In the course of the 1820s, he exhibited a number of important works, culminating in his famous *Liberty on the Barricades* (Paris, Louvre), inspired by the Revolution of 1830. A trip to North Africa in 1832 greatly influenced his work, as far as both his use of color and his subject

matter were concerned. In the course of the July Monarchy and the early Second Empire, he received a number of important decorative commissions, in the Palais Bourbon, the Louvre, the Hôtel de ville, and the church of St. Sulpice. A large retrospective exhibition of his work at the 1855 International Exhibition in Paris formed the climax of his career.

Delly, Pierre-François (1804–41). Courbet's mathematics teacher at the Collège de Besançon and a cofounder of the Société de l'émulation du Doubs.

Demesmay, Camille (1815–90). Sculptor and painter. A native of Besançon, Demesmay exhibited at the Paris Salon between 1838 and 1882. He participated in the sculptural decoration of the Louvre, the Hôtel de ville, and several French churches. He made numerous busts, including one of Pierre-Joseph Proudhon (Bibliothèque de Besançon), and monuments. Like Courbet, he seems to have returned regularly to the Franche-Comté. Between 1872 and 1881, he served as director of the Besançon drawing school.

DESAVARY, *Charles*-Paul (1837–85). Painter and lithographer at Arras. He studied with Constant Dutilleux, who later became his father-in-law, and with Thomas Couture. Desavary played an active part in the cultural life of Arras and served for some time as president of the Société artésienne des amis des arts.

Desnoyers, Fernand (1828–69). Writer. Born and raised in Paris, Desnoyers in his youth formed part of Murger's bohemia. His publications are varied and range from pantomimes (such as the *Le Bras noir*, for which Courbet designed a frontispiece) to almanachs, art criticism, and poetry.

Détrimont. Parisian art dealer. In the early 1860s, he had a gallery in the rue Lafitte. He still seems to have been in business in 1877, as Courbet mentions him in his letter to Auguste Baud-Bovy of May 29, 1877.

Diaz de la Peña, *Narcisse*-Virgile (1807–76). Landscape painter of the Barbizon school. His landscapes stand apart from those of other Barbizon artists by their common staffage of mythological figures. Though his works were exhibited at the Salon beginning in the early 1830s, Diaz did not get much recognition until 1844, when he received his first medal. Henceforth, Diaz's work became increasingly popular and fetched high prices, enabling the artist to support less fortunate friends like Jean-François Millet and Théodore Rousseau.

DORIAN, *Pierre*-Frédéric (1814–75). Industrialist and politician. Born in Montbéliard, Dorian became interested in Saint-Simonianism in his youth. As iron master and later factory owner, he showed great concern for his workers, for whom he built houses and schools. He entered politics in 1863 as an opposition candidate and was elected deputy of the Loire Department. In 1870, he became a member of the Government of National Defense, acting as minister of public works. He played a particularly important role in the armament of Paris. In 1871, he was reelected deputy of the Loire Department. Courbet seems to have known Dorian well, and after his death in 1873 he was asked to make a commemorative bust. The project did not materialize.

Dufaure, *Jules*-Armand-Stanislas (1798–1882). Lawyer and politician. Dufaure entered politics as early as 1834, when he was elected deputy from the Saintonge Department. He remained actively involved in politics throughout the July Monarchy, the Second Republic, and the Second Empire, when he joined the opposition. After September 4, 1870, he became minister of justice in the Thiers government. He was asked five times to form a cabinet, twice under Thiers and three times under MacMahon. He served as minister of justice on and off until

1879, when MacMahon was replaced as president by Jules Grévy.

Dufaure's son, Gabriel (1846–1914) seems to have been friendly with Etienne Baudry, who approached him on Courbet's behalf in 1876 and 1877.

DULON, F. Retired preacher who ran a modest pension in La Tour-de-Peilz, where Courbet stayed when he first came to town in 1873.

DUPIN, Madame. Nothing is known about this correspondent of Courbet, to whom he seems to have given a still life in 1871.

DUPONT, Pierre Antoine (1821–79). Poet and chansonnier, especially known for his popular songs, for which he wrote the text as well as composing the music.

Dupré, Jules (1811–89). Landscape painter of the Barbizon school. He exhibited at the Salon from 1831 to 1849, when he received a Legion of Honor cross. During the Second Empire he no longer showed his work at the Salon. He worked in various places in France but always returned to L'Isle-Adam, his permanent home since around 1850.

DURAND-RUEL, Paul (1828–1922). Art dealer. His father Jean-Marie-Fortuné had turned an art supply store into a gallery. Paul Durand-Ruel took over this gallery and expanded it considerably. During the Franco-Prussian War, he took his entire stock to England, where he organized a series of highly successful exhibitions. He returned to France after the Commune and opened a gallery at 7 rue Lafitte. His tendency toward speculation often brought him into great financial difficulties until, in 1884, he began to do business in the United States. Durand-Ruel's employee Alphonse Legrand bought a large number of paintings from Courbet in 1872 and 1873.

Duranty, Louis-*Edmond*-Emile (1833–80). Writer, art critic, and puppet show director. A member of the early Realist circle, Duranty in 1856 published the short-lived magazine *Le Réalisme*. He wrote several novels, including *Les Malheurs d'Henriette Gérard* (1861) and *Les Combats de Françoise Duquesnoy* (1873), and contributed art criticism to several papers. His *La Nouvelle Peinture* (1876) is one of the first surveys of the Realist and early Impressionist movements. In the late 1850s and early 1860s, he directed a puppet show in the Tuileries Gardens.

Dusommerard, Edmond (1817–85). Painter and art administrator. A son of Simon-Nicolas-Alexandre Dusommerard, the founder of the Musée Cluny, young Edmond studied painting and printmaking. It is as art administrator, however, that he made the greatest contribution, serving on the art exhibit committee for the 1867 International Exhibition in Paris as well as on the committees for the International Exhibitions in London and Vienna (1871 and 1873, respectively).

DUVAL, Charles. Courbet's attorney in Paris. In the 1870s his office was located at 189 rue St. Honoré.

Duval, Dr. Vincent (1796–1876). Surgeon. A famous orthopaedic surgeon, Vincent ("père") Duval operated a clinic in Neuilly, together with his son Victor-Eugène.

Erlanger, Emil (1832–1911). Banker. A son of Raphael Erlanger (1806–78), founder of the German banking establishment Von Erlanger & Söhne, Emil represented his father's firm in Paris. Courbet painted a portrait of his wife in Frankfurt.

EYNARD, Gabriel. Neighbor of Courbet at La Tour-de-Peilz. He was a member of a well-known Genevese family, which had its origin in the Dauphinée.

FAJON, Pierre-Auguste (b. 1820). Writer. Little is known about this apparently eccentric figure except that he wrote some short plays, which were performed in Montpellier in the late 1850s (*Les Chevaliers du bois roulant*, 1858, and *Un Proverbe à faire*, 1859). Courbet seems to have met him during one of his visits to Montpellier. He painted his portrait in 1862 (F. 296).

FAVON, Georges (1843–1902). Journalist and politician. A member of the progressive milieu of Geneva, Georges Favon was the founder, in 1875, of the radical paper the *Petit genevois* (later the *Genevois*), in which on October 9, 1875, he wrote an article in defense of Courbet. Favon later became an important politician.

Favre, *Jules*-Gabriel-Claude (1809–80). Lawyer and politician. Born in Lyon, he studied law in Paris. He participated in the revolutions of 1830 and 1848 and became a member of the provisional government during the Second Republic. After the coup d'état of 1851, he returned to the practice of law, but in 1858 he reentered politics, becoming part of the opposition party, Les Cinq. In 1870, he became vice-president and minister of the interior in the Government of National Defense. He retained the latter function under Thiers and negotiated the unpopular peace with Bismarck. He opposed the MacMahon government until his death in 1880.

FIZELIERE, Albert de la (1819–78). Art and literary critic who published an important book on the poet Baudelaire.

Flajoulot, Charles-Antoine (1774–1840). Artist and teacher. A self-proclaimed student of David, Flajoulot taught at the Ecole de dessin of Besançon, where he started a collection of plaster casts. His own art collection was bequeathed to the museum of Besançon. Flajoulot was Courbet's second teacher, succeeding Antoine Beau.

Fould, *Achille*-Marcus (1800–1867). Financial expert and politician. He entered politics in 1842, and as a member of the National Assembly he supported the politics of Guizot. In 1848, he published two influential brochures on the contemporary financial situation. The next year he became minister of finance, a post he held on and off until 1852. During the Second Empire, he was involved in the organization of the 1855 International Exhibition as well as in the administrative reorganization of the Opéra and the completion of the new Louvre. In the early 1860s, he returned to the Ministry of Finance and reorganized the state's fiscal system.

FRANÇAIS, François-Louis (1814–97). Landscape painter. A student of Camille Corot and Jean Gigoux, Français had a successful career as a landscape painter. He received numerous Salon medals and two Legion of Honor crosses. In 1890, he became a member of the Institut.

Fresquet, *Raymond*-Ronnat-Frédéric de (1820–71). Legal scholar. A member of an old Bordeaux family, ennobled in 1692, Raymond de Fresquet studied law in Paris, and, some time after obtaining a doctorate in 1844, he became a professor at the University of Aix-en-Province. In the spring of 1844, Fresquet married Clotilde Oudot, the daughter of Courbet's second cousin Julien-François (who may well have been one of Fresquet's law professors). Courbet painted portraits of Fresquet and his father in 1846. Their present whereabouts are not known.

FROND, Victor. Fireman, photographer, and publisher. Little is known about this friend of Courbet in the 1850s and 1860s. Initially employed as an officer of a Paris fire brigade (portrayed by Courbet in his *Firemen Going to a Fire* [F. 118]), he took an active role in the 1848 Revolution. After the coup d'état of 1851, he was exiled to Africa, but he managed to escape and went to England, where his presence is recorded in 1853. He probably returned to France after the general amnesty of 1859, and he seems to have worked for some time for the photographer Reutlinger (q.v.). During the 1860s, he started a serial publication entitled *Panthéon des illustrations françaises au XIXe siècle*, which, published in book form in 1869, comprised seventeen folio volumes. His last known publication is

the *Actes et histoire de concile oeconomique de Rome*, which came out between 1870 and 1873.

FUMEY. Courbet's attorney in Besançon.

GAILLARD, Louis-Dieudonné (1824–88). Officer, later general in the French army. Served in Algeria, the Near East (Sebastopol), and the Franco-Prussian War. In 1871, he was in charge of detained Communards. Courbet wrote him several letters from prison at that time.

Gambetta, *Léon*-Michel (1838–82). Lawyer and politician. Born in France, though of Italian descent, Gambetta studied law in Paris. During the Second Empire, he joined the Republican opposition. Minister of the interior in the Government of National Defense, he escaped the besieged city of Paris in a balloon in order to mobilize the provinces against Prussia. Elected deputy in 1871, Gambetta, in the course of the 1870s, became one of the most vocal Republican politicians.

GATINEAU, *Louis*-André-Ferdinand (1828–83). Lawyer and politician. Born in Beaufrançois, Gatineau started to practice law in Paris in 1828. After the Commune, he defended many Communards. In 1876, he was elected deputy and associated himself with the Union républicaine. Twice reelected, he gradually moved to the radical left.

GAUCHEZ, Léon. Art dealer and critic. Little is known about Gauchez, who was editor of the magazine *L'Art* and operated as an art dealer in Brussels.

Gaudin, Phoedora (1816–73). Lawyer and politician. An attorney in Saintes, Gaudin was an active member of the local Republican circle. Founder of an opposition paper under the July Monarchy, he was elected in 1848 as a member of the Constituent Assembly. During the Second Empire, Gaudin moved away from politics and became interested in the arts as well as in mysticism and occultism. He bought several paintings from Courbet, including two flower still lifes.

GAUDY, François-Antoine-*Félix* (1832–95). Landowner and politician. Gaudy started his political career as major of Vuillafans and department councillor of the Doubs, respectively. Founder and director of the *Républicain de l'est*, he was elected deputy from the Doubs Department in 1872 and reelected in 1876, 1877, and 1881. He became a senator in 1885. Courbet stayed at his house for several months in the winter of 1859–60 and often went hunting with him. He is supposed to have portrayed Gaudy on horseback in *Mort of the Stag* (F.612).

GAUTIER, Amand (1825–94). Painter and lithographer. Born in Lille, Gautier studied with Léon Cogniet. An early Realist artist, he exhibited at the Salon from 1853 onward and specialized in scenes from the life of the Sisters of Charity. He was a close friend of Courbet in the late 1850s and 1860s and frequently performed services for him in Paris when Courbet was sojourning elsewhere. Gautier made a number of lithographs, including two prints after paintings by Courbet. (N.B.: All starred references are to Amand Gautier).

GAUTIER, Pierre-Jules-*Théophile* (1811–72). Romantic poet, novelist, and art critic. Equally attracted to art and poetry, Gautier first studied painting, but his acquaintance with poets such as Victor Hugo, Gérard de Nerval, and others gradually steered him in the direction of literature. He contributed to numerous papers, including *La Presse*, the *Moniteur universelle*, the *Revue des deux mondes*, *L'Artiste*, and the *Revue de Paris*, of which he was the director from 1851 to 1858. His voluminous oeuvre includes poetry, novels, short stories, literary criticism, and travel accounts. Proponent of the Romantic theory of "art for art's sake," Gautier was critical of the Realist movement.

648 GIGOUX, *Jean*-François (1806–94). Painter, engraver, and lithographer. Born in Be-

sançon, he studied at that town's Ecole de dessin with Flajoulot and later at the Ecole des beaux-arts in Paris. He made his debut at the 1831 Salon and regularly exhibited until the end of his life. Today he is most appreciated for his portraits and landscape lithographs. In the course of his life, Gigoux brought together an enormous art collection, which he eventually donated to the town of Besançon. The Musée Jean Gigoux was inaugurated in 1884. One year later, Gigoux published his *Causeries sur les artistes de mon temps*.

GILL, André (1840–1885). Illustrator and cartoonist. A natural child of the comte de Guines and a seamstress, he was raised by his paternal grandfather. Though trained as an architect, his natural tendency toward caricature led him to illustration. He contributed to numerous (mostly antigovernment) papers, including the *Journal amusant*, *Le Hanneton*, *La Lune*, *La Rue*, *L'Eclipse*, and *La Lune rousse*. His mounting debts drove him to insanity. He died in the insane asylum of Charenton.

Gindre, Paul. Mentioned several times in his letters of 1873, Gindre appears to have been a physician in Pontarlier. He was probably a friend of the Joliclercs (q.v.).

Girard, Adèle. Courbet's landlady at 14 passage du Saumon. The artist lived with her temporarily, between January and May 21, 1871. She seems to have had an amorous relationship with Courbet's friend Emile Joute (q.v.) and perhaps with Courbet as well. In 1873, Girard sued him for unpaid debts. On April 4, 1873, he was ordered by the court to pay her 1,211 francs.

Girardin, Emile de (1806–81). Journalist. Born illegitimately and raised in institutions, Girardin published his first autobiographical novel at age twenty-one. From 1828 onward, he launched several specialized journals, and their success encouraged him to found *La Presse* in 1836. He remained the editor-in-chief of that paper until 1866, when he founded *La Liberté*. During the Third Republic, he bought the *Petit journal* and *La France*.

Goldschmidt. Banker in Frankfurt with whom Courbet seems to have been in contact during his sojourn in that city in 1858. He may have been introduced to Goldschmidt by Emil Erlanger (q.v.).

GRANGER, J. Painter. Born in Valence, Granger seems to have lived most of his life in Lyon. Between 1868 and 1878, he exhibited watercolors and pastels at the Lyon Salon. He published the *Album de la Drôme et de l'Ardèche*.

GREVY, Jules (1807–91). Lawyer and politician. A native of the Franche-Comté, Jules Grévy studied law in Paris. In 1868, he joined the Republican opposition. Elected deputy from the Jura Department in 1871, Grévy became president of the Chamber that same year. He resigned as president in 1873 but was reelected in 1876. He served as president of the Republic from 1879 to 1887.

GUEYMARD, Louis (1822–80). Opera singer, who in 1848 made his Paris debut in the title role of Meyerbeer's *Robert le diable*. Courbet, who was on friendly terms with him in the late 1850s, painted his portrait in that role in 1857 (F. 213).

HAEGHEN, *Ferdinand*-François-Ernst, van der (1830–1913). Librarian. He was head librarian of the university library at Ghent and secretary of the Société royale pour l'encouragement des beaux-arts (Royal society for the encouragement of the fine arts).

HARO, Etienne-François (1827–97). Artist, art dealer, and collector. He studied painting with Jean-Dominique Ingres and Eugène Delacroix and in the 1860s and 1870s exhibited several portraits at the Salon. However, his interests gravitated toward art dealing and collecting, and over the years he built up an impor-

tant collection of contemporary and Old Master paintings, which was auctioned off in two parts in 1892 and 1997. Several major works by Courbet went through his hands, including the *Atelier* (F. 165).

Henriot. Notary at Ornans.

Hesse, Nicholas-*Auguste* (1795–1869). Painter. A student of his brother Henri-Joseph and of Antoine-Jean Gros, Hesse first exhibited at the Salon in 1824. A successful artist, particularly during the July Monarchy, Hesse trained numerous young artists, including Courbet's friend Adolphe Marlet. Courbet often visited Hesse's studio and asked for his advice. For some years he even exhibited at the Salon as Hesse's student.

HETZEL, Pierre-Jules (1814–86). Parisian publisher and author, with strong Republican leanings. His role in the Revolution of 1848 and the Second Republic forced him into exile in Belgium between 1851 and 1859. While during the 1850s he promoted Realist literature, after 1859 he specialized in educational and children's literature (Jules Verne). His numerous short stories were published in *Le Siècle*, the *Journal des débats*, *Le Temps*, and other papers. He often used the pseudonym P. F. Stahl.

Hiffernan, Joanna. The Irish Joanna or Jo Hiffernan became the model of James McNeill Whistler in 1860, when he painted *Wapping* (New York, private collection). She soon became Whistler's mistress and remained so until the end of 1866. With Jo, Whistler traveled to France in the fall of 1865 and spent some time with Courbet in Trouville. At that time Courbet must have painted Jo's portrait (F. 537), of which he later made several copies.

HOLLANDER. Dealer in Brussels, with whom Courbet seems to have tried to do business in the 1870s.

HUGO, Victor (1802–85). Leading French author whose preface to his drama *Cromwell* became the manifesto of the Romantic movement in France. A staunch Republican, he became a deputy during the short-lived Second Republic but went into voluntary exile after the coup d'état of 1851. On the Anglo-Norman islands, Jersey and Guernesey, he wrote several satirical and moralizing works, including *Les Châtiments* and *La Légende des siècles*. He returned to France in 1870 and played an important role in the political life of the Third Republic.

IDEVILLE, *Henry*-Amédée Lelorgne, Comte d' (1830–87). Diplomat and author. He served as diplomat in various European countries and wrote novels, memoirs, and a biography of Courbet, entitled *Gustave Courbet, notes et documents sur sa vie et son oeuvre* (1878).

ILMOETON. The identification of this correspondent is the more problematic as the reading of his name is not certain. He appears to have been working in the field of photography and/or the printing business.

Ingres, Jean-Auguste-*Dominique* (1780–1867). Painter. Born in Montauban, Ingres studied with Jacques-Louis David. After obtaining the Prix de Rome, he lived in Rome and Florence from 1806 to 1824. There he produced a number of important works that earned him a Legion of Honor cross at the Salon of 1824. Henceforth, Ingres was seen as the leading classicist artist in France. He was showered with honors, and the prices of his works increased rapidly. From 1834 to 1841, he was director of the Ecole de Rome. In 1855, a large retrospective exhibition of his work was shown at the International Exhibition in Paris, side by side with a retrospective of the work of Delacroix (q.v.). This juxtaposition of Classicism and Romanticism summed up the artistic situation of the past twenty-five years,

at the moment when it was being replaced by the new Realist movement, represented by Courbet's private exhibition in Paris in the same year.

ISABEY, *Léon*-Marie-Gabriel-Félix (1821–95). Architect. Born in Besançon, he was a nephew of the painter and lithographer Jean-Baptiste Isabey. After studying architecture under the progressive architect Henri Labrouste, he designed workers' flats, day nurseries, and military baths. In 1855, he drew up the plan for Courbet's Pavillon du Réalisme. He also seems to have played a role in the construction and demolition of the 1867 pavilion, for Courbet sued him in 1873 for the removal of the materials of that pavilion, which were used as barricades during the Franco-Prussian War.

Isachers, Van. Belgian (?) dealer who seems to have operated in Frankfurt. Courbet dealt with him in the 1850s.

Jeanron, Philippe-Auguste (1809–77). Painter and art administrator. Ten years older than Courbet, Jeanron was important as an early, even a proto-Realist. Beginning with the *Little Patriots* (Caen, Musée des beaux-arts) of 1831, he exhibited a number of important Realist genre paintings in the course of the July Monarchy. In 1848, he was appointed director of the national museums, a post he held until 1850. He returned to painting in the 1850s but became director of the Musée des beaux-arts at Marseille in 1863.

JOLICLERC, Lydie, née Chenoz (1840–97). Born in Pontarlier, Lydie Chenoz married the painter Charles Joliclerc in 1863. She was a good friend of Courbet, particularly during the artist's later years, when she often acted as a go-between in his amorous affairs. Courbet painted her portrait (F. 429), which is generally dated 1863–64.

JOUTE, *Emile*-Frédéric. Director of the Parisian depot of the Ironworks of the Franche-Comté. Courbet was especially close to him during the early 1870s. He donated a cannon to the forty-fifth battalion of the National Guard, which Joute commanded, and later, on Joute's recommendation, moved to Adèle Girard's (q.v.) boardinghouse in the passage du Saumon.

Jovinet family. A cousin of Courbet's mother, Eliza Oudot, married a M. Jovinet. They lived in Paris and seem to have had at least two children. Courbet painted a portrait of their oldest child, Clémentine, in 1840. Its present whereabouts is unknown.

JULIETTE. See Courbet family.

Khalil Bey. Ottoman ambassador in Paris in the 1860s. He was notorious for his luxurious life-style and his cultivation of beautiful women. His collection of paintings, which included some of Courbet's most explicit paintings of nudes, was auctioned off in 1868, when Khalil Bey was called back to Constantinople.

LACHAUD, *Charles*-Alexandre (1818–82). Lawyer. He studied law in Paris, and, after some years of legal practice in the provinces, he came back there in 1842. A brillant defense lawyer, Lachaud was involved in several famous trials during the Second Empire, including the bigamy trial of Mlle Pavie. He became Courbet's defense lawyer after the Commune.

LACROIX, Jean-Baptiste-Marie-*Albert* (b. 1834). Born in Brussels, Lacroix, though trained as a lawyer, was less interested in law than in literature. During the 1850s, he was in touch with many of the French exiles in Brussels, including Edgar Quinet, who incited him to publish the *Oeuvres de Marnix de Sainte Aldegonde*. Lacroix later associated with the publisher Verboeckhoven and their joint company, the Librarie internationale, soon had branches in Paris, Livorno,

651

and Leipzig. Lacroix and Verboeckhoven published two satirical brochures illustrated by Courbet, *Les Curés en goguette* and *La Mort de Jeannot* (1868).

Laurier, Clément (1831–78). Lawyer and politician. A native of Le Blanc, in the Indre Department, Laurier studied law in Paris, where he remained to practice law. In the course of the Second Empire, he was involved in several famous cases, among them the murder of Victor Noir by Pierre Bonaparte, in which he represented the Noir family. A militant Republican with socialist leanings, Laurier entered politics in 1870 and occupied a post in the Ministry of the Interior under Gambetta. He remained active in government until the end of his life. Interested in the arts, Laurier often invited artists to his country house in Le Blanc. Courbet visited him there in 1851 (or 1852?), together with Pierre Dupont, and again in 1856 at the occasion of his marriage. He painted Laurier's portrait in 1855 (F. 171).

Laveur, "père." Owner of a restaurant in the rue des Poitevins.

Leboeuf, Louis-Joseph (d. 1867). A native of Lons-le-Saunier, Leboeuf first exhibited at the Salon of 1857. A full-length statuette of Courbet was seen at the 1861 Salon.

LEGRAND, Alphonse. Employee of Paul Durand-Ruel (q.v.).

Leloup. Journalist. Editor of *Le National suisse*, a radical paper published in La Chaux-de-Fonds, and deputy to the council of the canton Neuchâtel, Leloup was a close friend of Courbet in the last years of his life. He sometimes helped the artist with his correspondence.

LEMOINE. One of Courbet's framers in Paris.

LEONTINE. See RENAUDE, Léontine.

Lepel-Cointet. Stockbroker in Paris. Courbet sued him in 1866 for refusing to abide by his offer to buy *Venus and Psyche* (F. 370). On July 1867, the court decided in Courbet's favor.

L'EPINE, Ernest (1826–65). Secretary of the comte de Morny until the latter's death in 1865. Author who under the pseudonym of E. Manual published some plays in collaboration with Alphonse Daudet as well as novels and short stories.

LEVRAND, Edmond. Art dealer, whose gallery, in the later 1870s, was at 93 Titchfield Street in London.

Liégeon. Shipping company, operating between Paris and the Doubs Department.

LUQUET, Jules (b. 1824). Art dealer in the rue Bergère, who later became associated with the better-known dealer and print publisher Alfred Cadart in the rue Richelieu. A native of the Franche-Comté, Luquet seems to have known Courbet at least since the early 1860s. He actively promoted Courbet's art throughout the 1860s.

LYDIE. See JOLICLERC, Lydie.

MALASSIS. See POULET-MALASSIS.

MARCELLO, pseudonym of Adèle Colonna, Duchesse de Castiglione, née d'Affry (1836–79). Sculptor. She spent her youth in Italy, where she studied drawing with Joseph Fricero and sculpture with the Swiss sculptor Max Imhoff. After her brief marriage to Duke Carlo Colonna, she went to Paris, where she exhibited at the Salon from 1863 onward. Among her works are busts of Franz Liszt, Adolphe Thiers, Empress Eugénie, and Empress Elisabeth of Austria. Courbet painted her portrait (F. 659) at an unspecified date.

Marcère, Emile de (1828–1918). Politician. After serving in various civil service jobs during the Second Empire, he was elected deputy in 1871 and occupied a seat in the left center. Reelected in 1876, he became minister of the interior, a post he

retained with some interruptions until 1879. He remained active in politics as deputy and as senator until well into the twentieth century.

MARCHAND, Claude-François (1814–73). Pharmacist. He studied pharmacy in Montpellier and received a diploma in 1839. After the 1851 coup d'état, he took refuge in Switzerland and settled as a veterinarian in Locle. A naturalized Swiss citizen since 1859, Marchand moved in left-wing circles and had numerous contacts with the radical Republican faction in France. He spread positive propaganda for the Commune in Switzerland and facilitated the resettlement of Communard refugees.

Marcou, Jules (1824–98). Geologist. Born in Salins, Marcou studied geology with Louis Agassiz. His first independent geological research focused on the mountains near his native Salins. Later he explored other regions of France as well as Canada and the United States, where he worked with Agassiz at Harvard. In 1855, he became professor of geology in Zürich, but he regularly returned to his native region. Marcou was close to Max Buchon, who wrote his biography. Courbet seems to have known him well. In 1864, Marcou commissioned a painting from him (*The Roche-Pourrie*, F. 409), and around the same time he gave him a collection of American Indian weapons, which were hanging in Courbet's studio in Ornans.

Maréchal, "père." Shoeing smith. Little is known about this person other than that Courbet painted his portrait (F. 131). It was shown at the 1867 private exhibition as *The Hunter Maréchal, Amancey (Doubs). 1853*.

MARLET, Adolphe (1815–88). Artist, writer, and lawyer. A boyhood friend of Courbet, he started his career as an artist (student of Adolphe Hesse) but later studied law. He became town councillor of Ornans, then served in the prefecture of Dijon. He wrote numerous articles on local Franche-Comté history.

Marlet, *Alphonse*-Bruno-Jean-Philibert. Brother of Adolphe and Tony Marlet (q.v.).

Marlet, *Antoine*-François or "Tony" (1818–58). Landowner. A childhood friend of Courbet, like his brother Adolphe, Tony lived from the income he received from his landholdings at Trépot.

Martinet, Achille-*Louis* (1806–77). Engraver and art dealer. After a successful career as an engraver, Louis Martinet decided to create a permanent exhibition space for modern paintings in Paris. He opened his gallery in 1858, and, after some initial successes, he founded, in 1861, the *Courrier artistique* and, in 1862, the Société nationale des beaux-arts, which changed the organizational structure of his gallery from an ordinary dealership into a cooperative venture. Courbet exhibited in Martinet's gallery in 1862 and 1863.

MASSON, Bénédict (1819–73). Painter. A student of Paul Delacroche and Paul Chenavard, Masson specialized in history scenes.

Mathieu, Hughes-Antoine-*Gustave*. A forgotten member of the Realist circle, Mathieu was the publisher of the *Almanach de Jean-Raisin, joyeux et vinicole* (1854–). He also wrote two books, *La Légende du grand étang* (1855) and *Triomphe du vin* (1861).

Mathilde, see Montaigne Carly de Svazzena.

MAURITZ, B. Dealer or collector. Nothing is known about this individual, who appears to have been a dealer or a collector of Courbet's work.

MAZAROZ, Jean-*Paul* (1823–after 1880). Industrial sculptor and furniture maker. Born in Lons-le-Saulnier, he studied at the Ecoles des beaux-arts of Dijon and Paris. Together with his partner Ribalier, he had a large furniture workshop in

Paris, which catered to the finest clientele, including Napoléon III, the Russian tzar, and the khedive of Egypt. A Republican and utopian socialist, Mazaroz wrote numerous books and pamphlets on social questions: the fate of workers, syndicalization, universal suffrage, etc. Mazaroz, who must have known Courbet at least since the late 1850s, owned a large collection of works by Courbet.

Mestreau, Frédéric (b. 1825). Politician. A businessman and rich landowner from Saintes, Mestreau was the leader of the Republican opposition in the Saintonge during the Second Empire. He became prefect of the Charente-Inférieure Department at the outset of the Third Republic and later served as deputy and senator. Courbet became friendly with Mestreau during his stay in the Saintonge in 1862–63.

MONET, *Claude*-Oscar (1840–1926). Painter. The leading Impressionist painter, Claude Monet was probably introduced to Courbet by Eugène Boudin (q.v.). The two artists must have met freqently in Monet's native region of Normandie. Courbet is known to have lent money to Monet on several occasions.

MONSELET, Charles (1825–88). Poet, journalist, and author of novels, and anecdotal and gastronomical works. A student of eighteenth-century literature, his own work is often in the light-hearted spirit of that epoch. Monselet's friendship with Courbet no doubt had its origins in the Brasserie Andler. He took part in the Realist celebration that took place in Courbet's studio on October 1, 1859.

Montaigne Carly de Svazzena, Mathilde. Imposter. In 1872–73, she elicited a number of explicit love letters from Courbet and later blackmailed him with the threat of publishing them. As Courbet did not respond, she even came to Ornans, but with the help of Dr. Blondon and Cherubino Pata Courbet managed to get the better of her. Mme Montaigne spent several days in a prison in Besançon and subsequently disappeared.

MONTET. Neighbor and landlord of Courbet in La Tour-de-Peilz.

Morel, *Alfred*-Alexandre. Courbet's housekeeper at Bon-Port. An employee at the Marseille stock exchange, Morel took an active part in the proclamation of the Third Republic on September 4, 1870, and also participated in the 1871 Marseille insurrection (March 23–April 4). He was condemned to imprisonment but made his way to Switzerland, where he and his wife became Courbet's housekeepers at Bon-Port. Morel often helped Courbet with his correspondence.

MORNY, Charles-Auguste, Comte (later Duc) de (1811–65). Illegitimate son of Hortense de Beauharnais and as such a half-brother of Napoléon III. He took part in the coup d'état of 1851 and served as the president of the legislature from 1854 until his death in 1865. He was a liberal Bonapartist and great patron of all the arts. His collection of paintings included Courbet's *Young Ladies from the Village* (F. 127), now in the Metropolitan Museum of Art in New York. Courbet borrowed the painting from Morny's widow for his private exhibition of 1867 and never returned it. The work was sequestered after the Commune but eventually returned to Mme de Morny.

Murger, Henri or Henry (1822–61). Author. In spite of his short life, Murger was a prolific author whose reputation rests today on his *Scènes de la vie de bohème*, first published in Paris in 1852. He wrote numerous other novels, a volume of poetry (*Les Nuits d'hiver*, 1861), and several plays.

Nadar, pseudonym of Félix Tournachon (1820–1910). After pursuing medical studies, Félix Tournachon, under the pseudonym of Nadar, dabbled in journalism, painting, literature, and theater. In 1852, he opened a successful photographic studio with his brother Adrien Tournachon (q.v.). He became fascinated with

ballooning and organized tours in his balloon, *Le Géant*. Ruined after the Franco-Prussian War, he revived his photographic studio and became one of the best-known photographers in Europe.

Nélaton, Auguste (1807–73). Surgeon. One of the best-known surgeons during the Second Empire, Nélaton originated a new operation for stones and devised a probe, used in military surgery, to find bullets.

Nicolle. Industrialist. Nicolle had a factory in the rue Amelot in Paris. Courbet painted his portrait in 1862 (F. 298).

NIEUWERKERKE, *Alfred*-Emilien, Comte de (1811–92). Trained as a sculptor, Nieuwerkerke was appointed general director of museums in 1849. Thanks to his intimate relations with Napoléon's cousin Mathilde, he was appointed superintendent of the Fine Arts Administration, a post he held until the fall of the Second Empire in 1870.

NORIAC, pseudonym of Claude-Antoine-Jules Cairon (1827–82). Author and journalist who contributed to various papers, notably the *Figaro*, the *Revue des beaux-arts*, and the *Soleil*, of which he was the director for some time. He also wrote several novels and plays. His work is spirited and at times sentimental, but not without an undertone of skepticism.

ORDINAIRE, Edouard (1812–87). Medical doctor and politician. Born in Besançon, Ordinaire studied medicine in Strasbourg. He settled in the small town of Maizières, where he became mayor. A follower of Charles Fourier, Ordinaire organized a Fourierist club in Besançon and wrote Fourierist pamphlets. In 1867, a dispute about departmental elections caused him to write a satirical pamphlet, *Une Election dans le grand-duché de Gérolstein*, which created a stir. Two years later, he was elected deputy. In 1870, he became prefect of the Doubs Department, a post that he held for barely five months. Ordinaire was controlled to a large extent by his capable and aggressive wife, Zoé (1826–1918), who founded several newspapers. Their son, Marcel Ordinaire (1848–96), was a painter who studied with Courbet and collaborated with him during his period of exile in Switzerland.

Oudet, Gustave (1816–97). Lawyer, journalist, and politician. Born in the Franche-Comté, Oudet was trained as a lawyer. In 1850, he founded the short-lived *Démocrat franc-comtois*, a local Besançon paper. He served as mayor of Besançon and was a senator of the Doubs Department during the early Third Republic.

Oudot, Abbé. Headmaster and/or rhetoric teacher at the Petit séminaire at Ornans.

Oudot, François-Julien (1804–64). Legal scholar. He was one of the three children of Jean-Antoine Oudot's (q.v.) brother, together with Natalie Vertel (q.v.) and Eliza Jovinet (q.v.). After brilliant studies in Paris, he obtained a faculty chair at Paris University in 1829, when he was only twenty-five years old. He was an excellent teacher with innovative ideas and wrote a number of works on legal education and legal philosophy. He had four children: Clotilde, who married Raymond-Ronnat-Frédéric de Fresquet (q.v.), Jules, Frédéric, and Marie.

OUDOT, Jean-Antoine (1768–1884). Courbet's maternal grandfather. Born in Ornans, Jean-Antoine Oudot was a well-to-do landowner and vintner. He married Thérèse-Josèphe Saulnier, who died in 1847. The couple seems to have had two daughters. One, Suzanne *Sylvie* Oudot, was Courbet's mother. The other, whose first name is not known, married a man by the name of Bastide.

Panier. Owner of an art supply store. A native of the Franche-Comté, Panier had an art supply store at 75 rue Vieille-du-Temple. During his first years in Paris, all the money that Courbet received from his family, passed through Panier's hands.

PAPEIANS DE MORCHOVEN, Adèle, née Damiens (1807–59). Born in Saint-Valérie in France, she married, in 1833, Baron Ludovicus Papeians de Morchoven (1801–63), a Belgian officer in the second regiment of mounted rifles. The couple lived in Ghent, where Courbet visited them in 1846 and perhaps on later occasions as well. It is not known how Courbet became acquainted with the Papeians family, but it is possible that he received an introduction from one of his friends in Dieppe, which is located near Saint-Valérie, the birthplace of Mme Papeians.

PASTEUR, Edouard. Collector. Little is known about Edouard Pasteur, who bought and commissioned several paintings by Courbet in 1872–73. He lived in Paris at 34 rue de Province.

Petit, Georges. Owner of a well-known art gallery in Paris in the later part of the nineteenth and early part of the twentieth century.

PIA, Paul (1831–97). Engineer and art dealer. Engineer and supervisor of the railroad section Paris-Orléans, Pia was appointed general supervisor of railroads during the Commune. Exiled to Switzerland, he lived first in Lausanne, then in Geneva, where he opened an art supplies store and gallery, which featured a permanent display of Courbet's work.

Pillod (or Pillot) family. Owners of the Hôtel de la Poste in Pontarlier.

Poiterlin, Mme. The landlady of Max Buchon during the poet's time of exile in Berne. Courbet seems to have been quite fond of her, as in every letter to Buchon he makes a reference to her.

PORET, Gustave. Nothing is known about this collector of Courbet's work.

POTHEY, Charles. Wood engraver who made reproductions of some of Courbet's works.

Pouchon, Charles (1814–82). Vintner and painter. Born in Mouthier, near Ornans, Pouchon was a fellow student of Courbet at the Petit séminaire in Ornans, where both studied painting with père Beau. Courbet admired his "naive" talent.

POULET-MALASSIS, Paul-Emmanuel-*Auguste* (1825–78). Publisher and bookstore owner. He came from Alençon, where his father was a printer and editor of a local newspaper. Together with his brother-in-law Eugène de Broise he started a publishing company in Paris at 4 rue de Buci. In the fall of 1860, he moved to the passage Mirès, where he combined his publishing company with a bookstore, decorated by several Realist artists. He promoted the work of Charles Baudelaire, Champfleury, Charles Leconte de Lisle, and other major mid-nineteenth-century authors. Bankrupted in 1862, Poulet-Malassis took refuge in Brussels to escape his creditors. He returned to Paris in 1870 and died there eight years later. A friend of Courbet, he bought the latter's *Portrait of Baudelaire* in 1859. He also seems to have owned one or more other works by Courbet.

Pradelles, Hippolyte (b. 1824). Painter of landscapes and military subjects. Born in Strasbourg, he studied with Gabriel Guérin and Gustave Brion. In 1854, he enlisted to fight in the Crimean War and joined a regiment that was stationed in Saintes. While in Turkey, he contracted scurvy and was sent back to Saintes, where he seems to have remained for the rest of his life. In 1862–63, he became friendly with Courbet, with whom he exhibited in Saintes in 1863.

Promayet, Paul-Joseph-*Alphonse* (1823–72). Musician. The son of an Ornans organist and music teacher, Alphonse Promayet studied the violin. He taught music in Paris and later in St. Petersburg, where he was the music teacher of a branch of the Romanov family. He returned to France later in life and died in Montpellier.

Proudhon, Hippolyte (1807–86). Lawyer and mayor of Ornans. Born in Ornans,

Hippolyte Proudhon studied law. Thanks to his marriage to Françoise-Caroline Cuenot, the sister of Urbain Cuenot (q.v.), he was independently wealthy. He was mayor of Ornans from 1871 to 1882. Courbet, who portrayed him in his *Burial at Ornans,* later hated him for having ordered the removal of the *Boy Catching Bullheads* from the Ornans fountain. (N.B.: All starred references are to Pierre-Joseph Proudhon).

PROUDHON, Pierre-Joseph (1809–65). Social thinker. A native of Besançon, Proudhon was a major nineteenth-century philosopher who was famous for his socio-economic theories. His first epoch-making study, *Qu'est-ce que la propriété* (1840), was followed by numerous other more voluminous studies, including *De la justice dans la révolution et dans l'église (1858)*, which was seized by the censor and led to his self-imposed exile in Belgium. When he died, three years after his return to France in 1862, he left several incomplete works, including *Du principe de l'art et de sa destination sociale*, in which major works of Courbet were discussed at length. Courbet painted his posthumous portrait in 1865 (now in Paris, Museé du petit palais).

RADOUX, G. Calotypist and collodion photographer who had a studio at 73 Montagne de la Cour in Brussels. Among his extant works is the album *La Colonne du congrès* (Brussels, Bibliothèque royale), published by the "Imprimerie photographique G. Radoux" (c. 1859).

Ranc, Arthur (1831–1908). Journalist, politician, member of the Commune. Born in Poitiers, he studied law in Paris. In 1853, he was involved in the so-called Hippodrome Plot and was sent to Ste Pélagie, and later to Lambessa, for having belonged to a secret society. He escaped and went to Switzerland, where he directed a boarding school. He returned to France in 1859 and contributed to several radical papers, such as *La Rue* and *La Cloche*. Though a leader of the Commune, he was not immediately prosecuted, but his election to the Chamber of Deputies in 1873 elicited the wrath of his enemies, forcing him to flee to Belgium. He was sentenced to death in absentia but returned to France after the amnesty of 1879 and served first as deputy, then as senator.

Reinach, perhaps Jacques, Baron de (1840–92). Born in Frankfurt, he was a financier well known in Republican circles during the early Third Republic. He was later accused of bribery of officials and died, probably by his own hand, on the eve of his trial.

RENAUDE, Léontine. Actress. She was Courbet's mistress in the early 1860s, until she left him for the photographer Adrien Tournachon (q.v.). She may have been an actress in the Théâtre des variétés.

Reutlinger, Charles (1816-after 1880). Photographer and founder of the well-known Reutlinger studio. Born in Karlsruhe, Reutlinger opened a photographic studio in Paris around 1850. First located at 33 boulevard St. Martin, it was later moved to 21 boulevard Montmartre in 1853 and subsequently to 112 rue de Richelieu. Reutlinger specialized in portraits, particularly of actors and musicians. In 1880, his studio was taken over by his brother, Emile-Auguste (1825–1907), who expanded the studio's activities in the area of nude photography. Courbet knew the Reutlingers probably through Victor Frond (q.v.), who worked for them.

REVERDY, Jean-Baptiste-*Eugène*-César (1822–87). Painter and art expert. A student of Martin Drolling, Reverdy exhibited at the Salons of 1844, 1847, and 1848. After that he seems to have largely given up painting to become the artistic adviser of the marquis de Saint-Denys. It is possible that his acquaintance with Zoé Courbet was due to the fact that she obtained a domestic position in the same

family. However this may be, in 1858 and 1860, respectively, Zoé had two children with him, Eugène-Jean-Charles and Edmond-Jean-Eugène. They married in 1868 and legally recognized their two sons in 1869. The Reverdys were Courbet's main support during the time of his imprisonment after the Commune, but in the following years their relationship turned sour, especially after their move to Ornans in 1873.

RICHARD, Maurice (1832–86). Lawyer and politician. Trained as a lawyer, the Parisian-born Richard entered politics in 1863. A liberal Republican, he was much influenced by the ideas of Émile Ollivier, in whose cabinet he served briefly in 1870 as minister of science and cultural affairs. It was he who was responsible for selecting Courbet as a recipient of a Legion of Honor cross, which the artist chose to refuse.

RIGAULT, *Raoul*-Georges-Adolphe (1846–1871). Member of the Commune. A student in Paris during the Second Empire, Rigault was a militant radical. He welcomed the Third Republic and the Commune, to which he was elected on March 26. During the Commune, he was responsible for the police force. A member of the Committee of Public Safety, he ordered the shooting of Gustave Chaudey (q.v.) on May 23, but the very next day he himself was shot by the soldiers of the Versaillese army.

RIGOLOT, Emile (b. 1839). Engraver. A commercial engraver, Rigolot took part in the Commune. Sentenced by default, he took refuge in Vevey, where for some time he worked for the geographer Elisée Reclus, engraving the maps for the latter's *Géographie universelle*.

Rith, Dr. Arthur (?) (d. 1873). Little is known about this medical doctor in the Doubs Department other than that he appears to have been a staunch Republican.

Robinet, Dr. *Jean*-François-Eugène (1825–1899). Medical doctor, author, and member of the Commune for some days. A popular obstetrician in the sixth arrondissement of Paris, Robinet, during the siege of Paris, became that arrondissement's mayor as well as a member or the armament committee. In the latter capacity he proposed the demolition of the Vendôme Column. On March 26, he was elected to the Commune, but he resigned four days later, claiming ill health. He was a member of the Ligue d'union républicaine des droits de Paris, and for the meetings of this organization he seems to have rented space from Courbet in the latter's apartment at the rue du Vieux-Colombier. After the Commune, he was not prosecuted, and he attempted in vain to enter politics. In later years, he was employed by the Bibliothèque de la ville de Paris.

Rochefort-Luçay, Victor-*Henri*, Marquis de (1830–1913). Journalist and politician. Founder and director of the radical newspaper *La Lanterne*, Rochefort was an outspoken critic of the regime of Napoléon III. After September 4, he became a member of the Government of National Defense for some weeks, then was elected to the National Assembly in February 1871, but he resigned shortly after. Though not a member of the Commune, he was exiled to New Caledonia as a sympathizer. He escaped in 1874 and took refuge in Geneva, where he reissued *La Lanterne*. It was at that time that Courbet painted his portrait. He returned to France in 1880 and wrote for *L'Intransigeant*. Closely associated with General Georges Boulanger, he followed the latter to Brussels in 1889. He returned to Paris in 1895 and wrote for *La Patrie*.

ROCHENOIRE, Emile-Charles-Julien, called *Jules* de La (1825–99). Landscape and cattle painter. A student of Léon Cogniet, Charles Gleyre, and Constant Troyon,

La Rochenoire made his debut as a history painter but, before long, began to specialize in Norman landscapes and cattle scenes, the most important of which he exhibited at the Salon between 1857 and 1888. He authored several art manuals, including *La Peinture apprise seule avec sept couleurs*, and wrote a two-volume review of the 1855 Salon, *Exposition universelle des beaux-arts: Le Salon de 1855 apprécié à sa juste valeur*. In 1869–70, La Rochenoire was active in the artists' movement to reform the Salon.

ROGEARD, *Auguste*-Louis (1820–96). Classical scholar and journalist. Born in Chartres, Rogeard studied classical literature in Paris. He entered politics in 1852 and was a member of the militant opposition. In 1865, he published his famous *Propos de Labiénus*, in which he criticized despotism in all its forms. He was sentenced to five years in prison but had fled abroad previously. He applauded the Third Republic and the Commune, but, though elected (together with Courbet) to the Commune in the supplementary elections of March 26, he resigned owing to the low voter turnout. He lived in exile until 1879, when he returned to Paris.

ROUBEROL. Railroad engineer at Ornans, who rented part of Courbet's studio on the route de Besançon.

RUCHONNET, Louis (1834–93). Swiss lawyer and politician. He started his political career as head of the Department of Public Instruction, Worship, and Cultural Affairs in the canton Vaud. In May 1874, he became a member of the Federal Council, and between 1883 and 1890 he served as president of the Swiss Confederation. Courbet wrote to Ruchonnet several times regarding his participation in exhibitions in Vaud. He also presented him with a cast of the bust of *Helvetia* (Fs. 6).

Sabatier, François, called Sabatier-Ungher. Art critic and translator (1821–91). A friend of Bruyas (q.v.), Sabatier had a country estate at La Tour-de-Farges, near Montpellier. He was a rich dilettant who was much interested in socialist ideas, notably the theories of Charles Fourier and Pierre-Joseph Proudhon (q.v.). He wrote a Salon review in 1851 and did several translations of important German works, including Friedrich Schiller's *Wilhelm Tell*.

Sainte-Beuve, Charles-Augustin (1804–69). Born in Boulogne, he studied medicine in Paris but gave it up for writing. He became the literary critic for the *Globe* and later also wrote for other papers, such as the *Constitutionnel* and the *Moniteur*. He wrote novels, poetry, and literary criticism and is known especially for his collected newspaper articles, the *Causeries de lundi* or "Monday Chats" (15 vols., 1849–61) and *Nouveaux lundis* (13 vols., 1861–66).

Say, Léon (1826–96). Economist and politician. An important economist of the liberal, antisocialist school, Say served as minister of finance on and off from 1872 to 1882. He was elected senator in 1876 and presided over the Senate for two years (1880–82).

Schanne, Alexandre (1823–87). Writer, musician, and industrialist. Gifted in music, writing, and art, the young Schanne formed part of the Parisian bohemia of the 1840s. As "Schaunard," he was immortalized in Henri Murger's *Scènes de la vie de bohème* (1851). He later took over his father's toy factory, but toward the end of his life he published *Les Souvenirs de Schaunard* (1886), in which he recalled his bohemian youth.

SENSIER, Alfred (1815–77). Art critic who supported the Barbizon school. He wrote important biographies of Jean-François Millet and Théodore Rousseau.

Silvestre, Théophile (1823–76). Art critic and administrator. Born in Fossat in the

South of France, Silvestre actively supported the Second Republic in his native region, but, after leaving for Paris to become an art critic, he gradually became a supporter of the imperial regime. In 1857, he was charged by the government to make a study of European museums and art institutions, then was appointed general inspector of fine arts. His *Histoire des artistes vivants,* which includes an essay on Courbet, was published as a book in 1856.

SIMON, Jules (1814–96). A graduate of the Ecole normale supérieure and a doctor of philosophy, Jules Simon entered politics in 1870, when he became minister of public instruction, worship, and fine arts in the Government of National Defense. He retained this portfolio until the fall of Thiers in 1873. Under the presidency of MacMahon, in December 1876, he was asked to form a new cabinet. It lasted only six months, ending with the crisis of May 16, 1877. A senator until his death in 1896, Simon gradually saw his political influence wane.

Spuller, Eugène (1835—96). Lawyer, journalist, and politician. He studied law in Dijon but was more attracted to the world of journalism. Between 1863 and 1869, he contributed to the *Nain jaune,* the *Revue politique,* the *Journal de Paris,* and other papers. He entered politics in 1860, aligning himself with Gambetta (q.v.). Together with the latter he founded the *République française,* of which he became the editor-in-chief. He was elected deputy of the Seine Department in 1876 and remained active in politics until the end of his life.

Steuben, Baron *Charles*-Auguste-Guillaume-Henri-François-Louis de (1788–1856). History painter who was trained in Russia and Paris. He exhibited at the Salon between 1812 and 1843 and received a first-class medal in 1819. He collaborated on the creation of Louis-Philippe's history museum at Versailles and for his services received a Legion of Honor cross.

STEVENS, *Arthur*-Philippe-Louis-Léopold-Victor-Ghislain (1825–90). Art critic and dealer, brother of the painters Alfred and Joseph Stevens. Born in Brussels, he came to Paris at age eighteen to join his brother Alfred. His frequent contact with artists led to his involvement in art dealing. He played an important role as intermediary between artists and well-known collectors such as the duc de Morny and especially Prince Gorchakov, with whom he was very friendly. He also wrote art criticism under the pseudonym "Graham." Later in his life he returned to Brussels, where he became the artistic adviser of several Belgian collectors. Courbet painted his portrait in 1861 (F. 290).

TATTET, Alfred (1809–1856). The son of a Parisian stockbroker, Alfred Tattet belonged to the *jeunesse dorée* of the July Monarchy. A lover of the arts, he moved in literary circles that included Roger de Beauvoir, Emile de Girardin (q.v.), and Charles Sainte-Beuve (q.v.), in addition to his close friend Alfred de Musset. After several years of travel with various women, Tattet settled down in a country house on the edge of the Fontainebleau Forest. He died prematurely, just before his forty-seventh birthday.

Thiers, Adolphe (1797–1877). Politician. One of the most important French statesmen of the nineteenth century, Thiers managed to play an active role in politics from the July Monarchy through the early years of the Third Republic. His hour of glory came in February 1871, when he was elected president with executive power. This enabled him to realize his ideal of a republic with a strong centralized government. His triumph was brief, however, as in May 1873 he was forced to resign. Courbet's involvement with Thiers centered mainly around the fate of the latter's art collection during the Commune. It was Courbet who convinced

the Committee of Public Safety to remove the collection before demolishing Thiers's house in May 1871.

THORÉ, Théophile (1807–69). Journalist, art critic, and art historian. During the July Monarchy, he contributed to several left-wing papers, writing both political articles as well as art criticism. Thoré was an important supporter of the Barbizon school and of early Realism. An active participant in the 1848 Revolution, he was condemned to death for his participation in the uprising of May 15, 1849. Living in exile in Brussels, he wrote a number of important works on Dutch and Flemish art under the pseudonym of W. Bürger. After his return to Paris in 1858, he abandoned politics and devoted himself to the study of art.

Tissié, Louis. Close friend of Alfred Bruyas (q.v.).

Tourangin, Denis-*Victor* (1788–1880). Politician. He was prefect of the Doubs Department between 1831 and 1848 and later served as senator.

Tournachon, Adrien (1825–1903). The brother of Nadar (q.v.) and a photographer as well.

Trapadoux, Marc. A native of Lyon, Trapadoux came to Paris and became part of the Romantic bohemia in the 1840s. Together with Jean Wallon he is generally thought to have been the model of the fictitious philosopher Colline in Henri Murger's *Scènes de la vie de bohème*. In 1844, he published a biography of St. John of God, entitled *Histoire de Saint-Jean-de-Dieu*. According to Courbet (letter 76–23), he also wrote some articles on art. He seems to have died in Paris in the late 1860s. Courbet painted Trapadoux's portrait, seated in his studio in the rue Hautefeuille, in the winter of 1848–49.

Trochu, Louis-Jules (1815–96). General. He owes his reputation to his role in the siege of Paris. In August 1870, he was appointed military governor of Paris. Less than a month later, he became president of the Government of National Defense. He was much criticized in his time for his meek and passive conduct of the defense of Paris.

TROUBAT, Jules (1836–1914). Secretary of Sainte-Beuve (q.v.). On the latter's death in 1869, he edited his posthumous works and eventually became a librarian at the Bibliothèque nationale. A close friend of Champfleury, he was introduced by the latter to Courbet and other members of the Realist circle, about whom he wrote in his memoirs, *Plume et pinceau* (1878) and *Une Amitié à la d'Arthez* (1900).

ULBACH, Louis (1822–89). Journalist. From the mid-1840s, he contributed to several literary and, after 1848, political papers. In 1853, he became the director of the *Revue de Paris*. After its suppression, he was for some time a regular contributor to *Le Temps*, then an editor at the *Figaro*. In 1868, under the pseudonym of Ferragus, he began to publish the radical paper *La Cloche*. Suspended in September 1870, it was reissued in 1871, when Ulbach mounted an attack against the Commune. In spite of that, he was condemned to imprisonment and a fine as a Commune sympathizer.

URBAIN. See Cuenot, Urbain.

Usquin. An acquaintance of Courbet in the 1860s, Usquin seems to have lived in Méry-sur-Oise. Courbet painted his portrait in 1861 (F. 292).

VALLÈS, Jules (1832–85). French journalist and novelist, defender of democratic and revolutionary ideas. After having contributed to numerous newspapers, he started a weekly, *La Rue* (1867, banned in 1868), and a daily, *Le Peuple* (1869). During the Commune, Vallès founded his most famous daily, *Le Cri du peuple*

(1871), but he was forced to flee Paris some months later when the Commune was defeated. Condemned to death in absentia in 1872, he took refuge in London and Brussels, all the while contributing to French papers under fictitious names. After his return to Paris in 1883, he revived the *Cri du peuple*, which became the leading socialist newspaper of France. His books include a three-volume autobiographical novel, *Jacques Vingtras*. Courbet painted his portrait in the early 1860s (F. 294).

Vauthrin. Industrialist in the Franche-Comté. He bought several landscapes by Courbet.

VERMERSCH, Eugène (1845–78). Journalist and writer. Editor-in-chief of *Le Hanneton* since 1866, he wrote for his paper a series of biographical sketches of contemporaries, which later appeared separately as *Les Hommes du jour*. During the Commune, he contributed to Vallès's *Cri du peuple*. Condemned to death in absentia in 1871, Vermersch went into exile in England, where he started the *Vermersch Journal*. He published several books, including a *History of the Commune* (1872).

Vermorel, *Auguste*-Jean-Marie (1841–71). Journalist and historian. He served as editor of various papers, including the *Courrier français* (1866–68) and the *Ami du peuple* (1871). He wrote several books dealing with prostitution during the Second Empire, including *Ces Dames* and *Les Amours vulgaires*. He also published the writings of several important participants in the 1789 Revolution.

Vernier, Emile-Louis (1829–87). Painter and printmaker, especially active as a lithographer. Born in Lons-le-Saulnier, Vernier studied in Paris, where he learned lithographic techniques from Alexandre Collette. A specialist in artistic reproduction, he made lithographs after the works of most mid-nineteenth-century artists, including some ten prints after paintings by Courbet.

Vertel, Natalie, née Oudot. First cousin of Courbet's mother, Sylvie, and sister of Julien-François Oudot (q.v.). After a brief love affair with the critic Sainte-Beuve (q.v.), Natalie married a sea captain by the name of Vertel. She had two daughters, one of whom (Clotilde) passed away as a teenager. Her husband died on his return from America in the winter of 1844–45.

VERWEE, *Alfred*-Jacques (1838–95). Belgian painter of landscapes and animals. He studied with his father and with Eugène Verboeckhoven and F. K. Deweirdt. After traveling to Italy and Holland, he founded a painters' colony in Knocke. From 1857 onward, he regularly exhibited at the Brussels Salon. He often traveled to Paris, where he knew several artists, including Narcisse Diaz, Théodore Rousseau, Edouard Manet, and Courbet. In 1868, he founded the Société libre des beaux-arts, of which Courbet was made honorary member.

VILLAIN. Nothing is known about the identity of this correspondent.

Villemessant, Jean-*Hippolyte*-Auguste (1812–79). Journalist. Born in Rouen, he came to Paris at age twenty. He published numerous more or less ephemeral papers but is best known as the editor-in-chief of the *Figaro*, which he directed from 1854 to 1879.

VIVET. Lawyer. He acted as Courbet's attorney in the 1860s.

WEY, Francis (1812–82). Author. Born in the Franche-Comté, Francis Wey attended the Ecole des Chartes. He wrote several novels, travelogues, critical and historical works, and plays. An early supporter of photography, he regularly contributed to *La Lumière*. He was a close friend of Courbet, who stayed in his house in Louveciennes for prolonged periods of time, particularly during the 1850s. Courbet painted his portrait around 1850 (F. 103).

WEYER. Dealer in Strassburg.

WHISTLER, *James* Abbott McNeill (1834–1905). Painter and etcher. Born in Lowell, Massachusetts, Whistler went to France in 1855 to study art . He became part of the Realist circle and was particularly close to Henri Fantin-Latour and Alphonse Legros. After a trip to South America in 1866, he settled in England, where he remained for the rest of his life. Though probably acquainted with Courbet since 1858, Whistler seems to have been in closest contact with the artist in 1866, when he and his mistress Joanna Hiffernan (q.v.) spent some time in Trouville, where Courbet painted Jo's portrait (F. 537).

Wisselingh, H. J. (or J. H.?). Dutch art dealer. In 1838, Van Wisseling took over a shop of artists' materials in Amsterdam and started to buy and sell paintings. For that purpose, he frequently traveled to Paris, in order to visit the Salon and fellow dealers. He seems to have become interested in Courbet's work in the mid 1840s. Courbet painted his portrait in 1846 (F. 68). Van Wisselingh's gallery was later to become one of the most important modern art galleries in the Netherlands.

ZELIE. See COURBET family.

ZOE. See COURBET family.

Works Mentioned in the Letters and Notes

The F-numbers refer to Courbet's oeuvre catalog by Robert Fernier (Fernier 1977–78). As Fernier uses different sets of numbers for drawings/prints and sculptures, the designation Fd and Fs is used for works in those respective media. Works not listed in Fernier's catalogue (NIF) are listed at the end. All dimensions are in centimeters, height before width. The abbreviation "l.l." stands for "lower left," "l.r." for "lower right," "c.l." for "center left," "c.r." for "center right."

PAINTINGS

F. 13
Lot and His Daughters
Canvas, 89 x 116
Signed, l.l.: G. Courbet
Private collection, Japan
[Comment: Painted in 1844 and not in 1840 as Fernier states. Submitted to the Salon of 1844 but refused.]

F. 20
The Desperate Man
Canvas, 45 x 54
Signed and dated, l.l.: 41, G. Courbet
Private collection, Luxeuil, France
[Comment: According to Paris (1977, 81), signature and date are apocryphal. The painting was probably done a few years later. Dr. Collin referred to it as painted in 1845 (cf. Courthion 1949–50, 2:255).]

F. 26
Self-Portrait
Canvas, 27.5 x 22
Signed, l.l.: G.C.
Musée de Pontarlier, France

F. 27
Self-Portrait or *Courbet with Black Dog*
Canvas, 46 x 56
Signed and dated, l.l.: Gustave Courbet, 1842
Salon of 1844
Musée du petit palais, Paris

F. 29
Woman's Head, [with a Wreath of] Wild Flowers
Canvas, 34 x 28
Signed, l.r.: G. Courbet (?)
Current whereabouts unknown

F. 38
Portrait of a Belgian Baron, Cavalry Officer
Canvas, 194 x 111
Not signed
Musée Jenisch, Vevey
[Comment: This painting cannot be identified with the portrait of a Belgian baron mentioned in letter 44–3. If, in effect, the painter Jean-Jacques Henner saw Courbet paint it in the rue Hautefeuille, it must be dated after 1848. See letter 44–3, n. 2.]

F. 39
Self-Portrait or *Man with a Pipe*
Canvas, 45 x 37
Signed, l.l.: G. Courbet
Salon of 1850
Musée Fabre, Montpellier, France

F. 40
Self-Portrait or *Man with a Pipe* (Replica of F. 39)
Canvas, 45 x 38
Signed, l.r.: G. Courbet
Private collection
[Comment: On panel instead of canvas?]

F. 41
Self-Portrait or *Man with a Pipe* (Replica of
F. 39)
Canvas, 46 x 38
Signed, l.l.: G. Courbet
Private collection

F. 42
Portrait of Juliette Courbet
Canvas, 78 x 62
Signed and dated, c.l.: Gustave Courbet,
1844
Musée du petit palais, Paris
[Comment: Submitted to the Salon of 1845
as the *Portrait de Mlle la B. de M.*, but not
accepted by the jury.]

F. 43
Checkers Players
Canvas, 25 x 34
Signed and dated, l.l.: Gustave Courbet,
1844
Private collection, Caracas, Venezuela

F. 46
Lovers in the Country (*The Waltz?*)
Canvas, 78 x 60
Signed and dated, l.r.: G.C., 1844
Musée des beaux-arts, Lyon, France

F. 48
The Prisoner of the Dey of Algiers
Canvas, 81 x 65
Signed and dated, l.l.: Gustave Courbet,
1844
[Comment: Perhaps identical with the
painting *Un Prisonnier (A Prisoner)*, sub-
mitted to the Salon of 1846.]

F. 51
The Wounded Man
Canvas, 81 x 97
Signed, l.l.: G. Courbet
Musée du Louvre, Paris

F. 52
Guitarrero
Canvas, 55 x 41
Signed and dated, l.r.: 1844, Gustave
Courbet
Salon of 1845
Private collection, New York

F. 53
The Hammock or *Dream of a Young Girl*
Canvas, 71 x 97
Signed and dated, l.l.: 1844, G. Courbet
Collection Oskar Reinhart, Winterthur,
Switzerland

F. 55
Sleeping Woman or *Bacchante*
Canvas, 65 x 81
Private collection

F. 56
Study of a Sleeping Woman
Canvas, 64.5 x 80.5
Signed and dated, l.l.: G. Courbet, 1845
Ottani Memorial Museum of Art, Nishino-
miya, Japan

F. 57
Portrait of Paul Ansout
Canvas, 81 x 65
Signed, l.l.: Gustave C.
Château-Musée, Dieppe, France

F. 58
The Sculptor or *The Poet*
Canvas, 55 x 41.5
Signed and dated, l.l.: G. Courbet, 1845
Private collection

F. 59
Nude Woman Sleeping Near a Brook
Canvas, 82 x 64
Signed and dated, l.l.: 45, G. Courbet
Detroit Institute of Arts

F. 63
Portrait of Paul Blavet
Canvas, 81 x 65
Signed, l.r.: G.C.
Private collection, Paris

F. 68
Portrait of H. J. van Wisselingh
Panel, 57 x 46
Signed and dated, l.l.: Gustave Courbet,
1846
Kimbell Art Museum, Fort Worth, Texas

F. 71
Portrait of a Man
Canvas, 69 x 56
Signed, l.r.: G. Courbet
Collection E. G. Bührle, Zürich
[Comment: Perhaps identical with the *Por-trait of a Man as a Hunter*, mentioned in
letter 58–2.]

F. 73
Self-Portrait
Canvas, 50 x 40
Signed, l.l.: G. Courbet
Musée des beaux-arts, Besançon

F. 74
The Cellist or the *Contrabass Player*
Canvas, 117 x 90
Signed, l.r.: G.C.
Salon of 1848
National Museum, Stockholm
[Comment: Perhaps identical with *Souvenir
de Consuelo (Memory of Consuelo)*, submitted
to the Salon of 1847 but refused.]

F. 76
Portrait of Urbain Cuenot
Canvas, 55.5 x 46.5
Signed, l.l.: G.C.
Musée Gustave Courbet, Ornans

F. 80
L'Essart-Cendrin
Canvas, 33 x 41
Signed and dated, l.l.: G. Courbet, 1847
Collection Jean Demandre, Filain, France

F. 83
Portrait of Théodore Cuenot
Canvas, 78 x 61
Signed, l.l.: G.C.
Musée Gustave Courbet, Ornans

F. 85
Portrait of Urbain Cuenot
Canvas, 95 x 75
Signed, l.l.: G. Courbet
Salon of 1848
Pennsylvania Academy of the Fine Arts,
Philadelphia

F. 91
A Burial at Ornans
Canvas, 313 x 664
Signed, l.l.: G. Courbet
Salon of 1850–51
Musée d'Orsay, Paris

F. 92
After Dinner in Ornans or *Evening at
Ornans*
Canvas, 195 x 257
Not signed
Salon of 1849
Palais des beaux-arts, Lille

F. 93
The Man with the Leather Belt
Canvas, 100 x 82
Signed, l.l.: Gustave Courbet
Musée d'Orsay, Paris
[Comment: Probably identical with the por-trait that was exhibited at the Salon of 1846
as the *Portrait of M. XXX*. According to let-ter 74–14, it was painted in 1842.]

F. 94
The Man with the Leather Belt, copy
Cardboard, 44 x 36
Signed, l.l.: G. Courbet
National Gallery, London

F. 96
Portrait of Marc Trapadoux Looking at an Al-bum of Prints
Canvas, 80 x 65
Signed, l.r.: G. Courbet
Salon of 1849
Current whereabouts unknown

F. 101
The Stonebreakers
Canvas, 165 x 257
Signed, l.l.: G. Courbet
Salon of 1850–51
Presumably destroyed during World War II

F. 103
Portrait of Francis Wey
Canvas, 61 x 50
Signed, l.r.: G. Courbet
Salon of 1850–51
Current whereabouts unknown

F. 105
Portrait of Jean Journet or *Jean Journet Set-
ting Out for the Conquest of Universal
Harmony*
Canvas, 100 x 80
Signed, l.l.: G. Courbet
Salon of 1850–51
Current whereabouts unknown

F. 107
*The Peasants of Flagey Returning from the
Fair*
Canvas, 205 x 275
Signed, l.r.: G.C.
Salon of 1850–51
Musée des beaux-arts, Besançon

F. 108
Stag by a Stream
Canvas, 73 x 92
Signed, l.r.: G. Courbet
Private collection, Paris

F. 110
The Castle of Scey-en-Varais in the Evening or
*The Banks of the Loue on the Road to
Maizières*
Canvas, 49.6 x 75
Signed, l.l.: G. Courbet
Salon of 1850–51
Current whereabouts unknown

F. 113
Portrait of Hector Berlioz
Canvas, 61 x 48
Signed and dated, l.l.: 1850, G. Courbet
Salon of 1850–51
Paris, Musée d'Orsay

F. 115
Portrait of Charles Baudelaire
Canvas, 53 x 61
Signed, l.l.: G. Courbet
Musée Fabre, Montpellier, France

F. 118
Firemen Going to a Fire
Canvas, 388 x 580
Not signed
Musée du petit palais, Paris

F. 120
Portrait of Tony Marlet
Canvas, 46 x 38
Signed, l.l.: G. Courbet
Current whereabouts unknown

F. 121
Portrait of Adolphe Marlet
Canvas, 56 x 46.5
Signed, l.l.: G.C.
National Gallery of Ireland, Dublin

F. 125
Señora Adela Guerrero, Spanish Dancer
Canvas, 158 x 158
Signed and dated, l.l.: G. Courbet,
Bruxelles 1851
Inscribed, l.r.: La Signora Adela Guerrero
Musées royaux des beaux-arts, Brussels

F. 126
The Young Ladies from the Village (Sketch)
Canvas, 54 x 65
Signed and dated, l.l.: G. Courbet, 1851
City Art Galleries, Leeds, Great Britain

F. 127
The Young Ladies from the Village
Canvas, 195 x 261
Signed, l.l.: G. Courbet
Salon of 1852
Metropolitan Museum of Art, New York

F. 128
Portrait of Alphonse Promayet
Canvas, 107 x 70
Signed, l.r.: G. Courbet
Salon of 1857 as *Portrait de M.A.P.*
Metropolitan Museum of Art, New York

F. 131
The Hunter Maréchal
Canvas, dimensions unknown
Signed, l.l.: G.C.
Current whereabouts unknown

F. 133
The Sleeping Spinner
Canvas, 91 x 115
Signed and dated, l.l.: G. Courbet, 1853
Salon of 1853
Musée Fabre, Montpellier

F. 137
Sleeping Woman
Canvas, 46 x 38
Signed?
Current whereabouts unknown

F. 138
Portrait of Zélie Courbet
Canvas, 56.5 x 46.5
Not signed
Museu de arte, São Paulo, Brazil

F. 139
Sleeping Woman
Canvas, 55 x 47
Signed, l.l.: G. Courbet
Private collection, Paris

F. 140
The Bathers
Canvas, 227 x 193
Signed and dated, l.r.: G. Courbet, 1853
Salon of 1853
Musée Fabre, Montpellier

F. 141
Portrait of Alfred Bruyas
Canvas, 91 x 72
Signed and dated, l.l.: 1853, Gustave
Courbet
Musée Fabre, Montpellier

F. 142
Portrait of Alfred Bruyas
Canvas, 46 x 38
Signed, l.r.: G. Courbet; dated, l.l.: 54
Musée Fabre, Montpellier

F. 143
Portrait of Alfred Bruyas
Canvas, 45 x 37
Signed, l.l.: G. Courbet; dated, l.r.: 54
Musée Fabre, Montpellier

F. 144
The Wrestlers
Canvas, 252 x 198.9
Signed and dated, l.l.: Gustave Courbet,
1853
Salon of 1853
Szépmüvészeti Múzeum, Budapest

F. 149
The Meeting, or *Bonjour, Monsieur Courbet*
Canvas, 129 x 149
Signed and dated, l.l.: 54, G. Courbet
Universal Exhibition of 1855
Musée Fabre, Montpellier

F. 151
Souvenir of Les Cabanes
Canvas, 95 x 136
Signed, l.l.: G. Courbet
Philadelphia Museum of Art, John G. Johnson Collection

F. 156
The Roche de dix heures or *Landscape with Rocks*
Canvas, 85 x 160
Signed, l.r.: G. Courbet
Paris, Musée d'Orsay
[Comment: According to Paris (1977, 140), the painting in the Musée d'Orsay cannot be identified with the *Roche de dix heures* shown at the Universal Exhibition of 1855.]

F. 157
The Hippodrome or *The Bullfight*
Canvas, 59 x 48
Signed, l.l.: G. Courbet
Private collection, Paris

F. 159
Hanging Roedeer
Canvas, 187 x 128
Signed and dated, l.r.: Gustave Courbet, 55
H. W. Mesdag Museum, The Hague

F. 160
Self-Portrait with Striped Collar (copy)
Canvas, 54 x 45.5
Signed?
Current whereabouts unknown

F. 161
Self-Portrait with Striped Collar
Canvas, 46 x 37
Signed and dated, l.l.: 54, G. Courbet
Universal Exhibition of 1855
Musée Fabre, Montpellier

F. 163
Portrait of Max Buchon
Canvas, 58 x 46
Signed, l.l.: G. Courbet
Musée national des beaux-arts, Algiers

F. 164
Portrait of André Grangier
Canvas, 81 x 65.5
Signed, l.l.: G. Courbet
Musée des beaux-arts, Marseille

F. 165
The Painter's Atelier: Real Allegory Determining a Phase of Seven Years of My Artistic Life
Canvas, 359 x 598
Signed and dated, l.l.: 55, G. Courbet
Private Exhibition of 1855
Musée d'Orsay, Paris

F. 166
The Grainsifters
Canvas, 131 x 167
Signed and dated, l.l.: 55, G. Courbet
Universal Exhibition of 1855
Musée des beaux-arts, Nantes

F. 167
Mère Grégoire
Canvas, 130 x 97
Signed, l.l.: G.C.
Art Institute of Chicago

F. 170
Portrait of a Spanish Lady
Canvas, 81 x 65
Signed and dated, l.r.: G. Courbet, 55
Universal Exhibition of 1855
Philadelphia Museum of Art, John G. Johnson Collection

F. 171
Portrait of Clément Laurier
Canvas, 100 x 81
Signed, dated, and inscribed, l.l.: Gustave Courbet, 1855, A mon ami Laurier
Art Center, Milwaukee, Wisconsin

F. 172
Portrait of Champfleury
Canvas, 46 x 38
Signed, l.r.: G. Courbet; dated, l.l.: 55
Private Exhibition of 1855
Musée d'Orsay, Paris

F. 173
Le Château d'Ornans
Canvas, 80 x 115
Signed and dated, l.r.: 55, G. Courbet
Universal Exhibition of 1855
Minneapolis Institute of Art, Minnesota

F. 174
The Stream of the Puits noir, Valley of the Loue (Doubs)
Canvas, 104 x 138
Signed and dated, l.l.: G. Courbet, 55
Universal Exhibition of 1855
National Gallery of Art, Washington, D.C.

F. 188
The Quarry or *Mort of the Stag*
Canvas, 210 x 180
Signed, l.r.: G. Courbet
Salon of 1857
Museum of Fine Arts, Boston

F. 191
Landscape Scene Near Le Blanc
Canvas, 59 x 72.5
Signed and dated, l.l.: G. Courbet, 56
National Gallery of Art, Washington, D.C.

F. 200
Portrait of Mme Charles Maquet
Canvas, 100 x 83
Signed, l.r.: G. Courbet; dated, l.l.: 56
Staatsgalerie, Stuttgart, Germany

F. 203
The Young Ladies on the Banks of the Seine, Summer or *Seine Bathers*
Canvas, 174 x 206
Signed, l.l.: G. Courbet
Salon of 1857
Musée du petit palais, Paris

F. 205
Study for *Young Ladies on the Banks of the Seine*
Canvas, 66 x 81
Private collection, United States

F. 210
Peasant Woman with Kerchief
Canvas, 60 x 73
Signed, l.r.: G. Courbet
Private collection, United States
[Comment: Possibly identical with the *Portrait of Mme Erlanger, née Lafitte, in Gypsy Costume*?]

F. 211
Woman with a Garland
Canvas, 125 x 133
Traces of signature, l.r.
Private collection, Paris

F. 213
Portrait of M. Gueymard, Opera Singer, in His Role of Robert-le-Diable
Canvas, 148.6 x 106.7
Signed, l.l.: G. Courbet
Salon of 1857
Metropolitan Museum of Art, New York

F. 215
Hind at Bay in the Snow (Jura)
Canvas, 92.5 x 147
Signed, l.r.: G. Courbet
Salon of 1857
Private collection, New York

F. 220
Ponds at Palavas
Canvas, 38 x 46
Signed, l.l.: G. Courbet
Musée Fabre, Montpellier

F. 223
Portrait of Madame Mathilde Cuoq
Canvas, 175 x 110
Signed, l.r.: G. Courbet
Metropolitan Museum of Art, New York

F. 224
Portrait of Mlle Jacquet
Canvas, 81 x 65
Signed and dated
National Gallery of Art, Washington, D.C.

F. 228
Sleeping Nude
Canvas, 50 x 64
Signed and dated, l.l.: 57, G. Courbet
Private collection, London

F. 231
Hunting Picnic
Canvas, 207 x 325
Signed, l.r.: G. Courbet
Wallraf-Richartz Museum, Cologne

F. 232
Portrait of Mme de Brayer
Canvas, 91.4 x 72.7
Signed and dated, l.r.: Gustave Courbet, 58
Metropolitan Museum of Art, New York

F. 235
The Woman of Frankfurt
Canvas, 103 x 138.5
Signed, l.l.: G. Courbet
Wallraf-Richartz Museum, Cologne
[Comment: Perhaps a member of the St.
Georges family (cf. Hamburg 1978, 259).]

F. 236
View of Frankfurt-am-Main
Canvas, 53.5 x 78
Signed, l.l.: Gustave Courbet
Städelsches Kunstinstitut, Frankfurt-
am-Main

F. 243
Stag and Doe in the Woods or *Deer's Love*
Canvas, 81 x 100
Signed and dated, l.r.: G. Courbet, 59
Tate Gallery, London

F. 244
The German Hunter or *Dying Stag*
Canvas, 119 x 177
Signed and dated, l.l.: 59, Gustave Courbet
Musée de Lons-le-Saunier, France

F. 251
Dressing up the Bride (or *Dressing up the
Dead Woman*)
Canvas, 188 x 252
Not signed
Smith College Museum of Art, Northamp-
ton, Massachusetts

F. 253
Seascape or *The Cliffs of Honfleur*
Canvas, 37 x 45
Signed, l.l.: G. Courbet
Current whereabouts unknown

F. 262
Oraguay Rock or *Landscape with Boat*
Canvas, 152 x 195
Signed and dated, l.l.: Gustave Courbet, 60
Folkwangmuseum, Essen, Germany
[Comment: According to the most recent
catalog of the Folkwangmuseum, the paint-
ing in question cannot be identified with
the *Oraguay Rock*, mentioned in Courbet's
letters and exhibited at the Salon of 1861.]

F. 263
The Fox in the Snow
Canvas, 85 x 127
Signed, l.l.: Gustave Courbet
Salon of 1861
Dallas Museum of Art, Texas

F. 266
Forest, Wintertime or *Covert of the Roedeer*
Canvas, 69 x 107
Signed, l.l.: G. Courbet
Cincinnati Art Museum, Ohio
[Comment: Perhaps identical with the
painting shown in Brussels as *Paysage
d'hiver (Winter Landscape)*.]

F. 268
The Villagewomen with Goat
Canvas, 81 x 65
Signed, l.l.: Gustave Courbet

F. 269
Woman with a Mirror
Canvas, 64.5 x 54
Not signed
Kunstmuseum, Basel, Switzerland

F. 277
The Stag at Bay or *Stag at the Stream* or *Stag
Taking to the Water*
Canvas, 220 x 275
Signed and dated, l.r.: Gustave Courbet, 61
Salon of 1861
Musée des beaux-arts, Marseille

F. 279
The Battle of the Stags, Three Stags, Spring
Rut, or *Large Stags*
Canvas, 356 x 507
Signed and dated, l.l.: 61, Gustave Courbet
Salon of 1861
Musée d'Orsay, Paris

F. 282
Landscape with Lock
Canvas, 65 x 81
Signed, l.l.: G. Courbet
Private collection, Paris

F. 283
The Huntsman
Canvas, 195 x 230
Signed and dated, l.l.: 61, Gustave Courbet
Salon of 1861
Neue Pinakothek, Munich

F. 285
Woman with White Stockings
Canvas, 65 x 81
Signed, l.l.: G. Courbet
Barnes Foundation, Merion, Pennsylvania

F. 286
Portrait of Woman Holding a Parrot (Mlle
Chansons?)
Panel, 61 x 44
Signed and dated, l.l.: 61, Gustave Courbet
Current whereabouts unknown

F. 287
Reading Woman in the Forest
Canvas, 60 x 73
Signed, l.r.: G. Courbet
National Gallery of Art, Washington, D.C.

F. 288
The Spanish Woman
Canvas, 90 x 65
Not signed
Current whereabouts unknown

F. 290
Portrait of Alfred Stevens
Canvas, 65 x 57.5
Signed, l.r.: G.C.
Musées royaux des beaux-arts, Brussels

F. 292
Portrait of M. Usquin
Canvas, 53.7 x 42.9
Signed and dated, l.l.: 61, Gustave Courbet
Museum of Art, Carnegie Institute,
Pittsburgh

F. 294
Portrait of Jules Vallès
Canvas, 26.5 x 21.5
Signed, l.l.: G. Courbet
Musée Carnavalet, Paris

F. 296
Portrait of Pierre-Auguste Fajon
Canvas, 45 x 37
Signed, dated, and inscribed, l.l.: A mon
ami Fajon, 62, Gustave Courbet
Musée Fabre, Montpellier

F. 298
Portrait of M. Nicolle
Canvas, 61 x 46
Signed and dated, l.l: G. Courbet, 62
Private collection, France

F. 334
Reverie or *Portrait of Gabrielle Borreau*
Canvas, 63.5 x 77
Signed and dated, l.l.: G. Courbet, 62
Private collection, Paris

F. 335
Sleeping Nude
Canvas, 75 x 95
Signed and dated, l.r.: Gustave Courbet,
1862
Current whereabouts unknown

F. 338
Return from the Conference or *The Priests*
Canvas, 229 x 330
Signed and dated, l.l.: 63, Gustave Courbet
Destroyed

F. 341
Horse and Bulldog in the Woods or *The Fox Hunt*
Canvas, 110 x 136
Signed and dated, l.l.: 63, Gustave Courbet
Salon of 1863
Städtische Kunsthalle, Mannheim, Germany

F. 345
Forest at Port-Berteau
Canvas, 68 x 52.7
Signed, l.l.: G. Courbet
Fitzwilliam Museum, Cambridge, Great Britain

F. 351
Seascape
Canvas (?), 55 x 65
Signed and dated, l.l.: 63, G. Courbet
Muzeum Narodowe, Warsaw

F. 355
Portrait of the Sculptor Louis-Joseph Leboeuf
Canvas, 65.5 x 51
Signed and dated, l.l.: 1863, Gustave Courbet
Collection E. G. Bührle, Zürich

F. 358
Portrait of Laure Borreau, or *Portrait of Mme L . . .* , or *Woman with Black Hat*
Canvas, 81 x 62
Signed and dated, l.r.: 63, Gustave Courbet
Salon of 1863
Cleveland Museum of Art, Ohio

F. 361
Magnolias
Canvas, 72 x 107
Signed and dated, l.l.: 63, Gustave Courbet
Kunsthalle, Bremen, Germany

F. 366
Two Baskets with Flowers
Canvas, 75 x 100
Signed and dated, l.l.: 63, Gustave Courbet

F. 370
Venus and Psyche, Venus in Jealous Pursuit of Psyche, or *Study of Women*
Canvas, 145 x 195.5
Signed and dated, l.l.: 64, Gustave Courbet
Current whereabouts unknown (destroyed?)

F. 373
Sleeping Woman with Red Hair
Canvas, 57 x 70
Signed, l.l.: G. Courbet
Private collection

F. 379
The Plaisir-Fontaine Brook in the Valley of the Puits noir
Canvas, 81 x 100
Signed and dated, l.r.: Gustave Courbet, 1864
Private collection

F. 387
Source of the Loue River
Canvas, 100 x 142
Signed, l.l.: G. Courbet
Metropolitan Museum of Art, New York

F. 402
Source of the Lison River
Canvas, 91 x 73
Signed and dated, l.l.: G. Courbet, 1864
Current whereabouts unknown

F. 403
Source of the Lison River
54 x 45
Signed and dated, l.l.: G. Courbet, 1864
Current whereabouts unknown

F. 409
The Roche-Pourrie
Canvas, 60 x 73
Signed and dated, l.l.: 1864, Gustave Courbet
Musée Gustave Courbet, Ornans (on loan from the Town of Salins)

F. 410
Landscape with the Chauveroche
Canvas, 81 x 100
Signed and dated, l.r.: Gustave Courbet,
1864
Private collection, Besançon

F. 416
Gour de Conche
Canvas, 72.5 x 59.5
Signed and dated, l.l.: Gustave Courbet,
1864
Musée des beaux-arts, Besançon

F. 420
The Siratu Cascade or *Rocks at Mouthier*
Canvas, 95 x 130
Signed, l.l.: G. Courbet
Current whereabouts, unknown

F. 422
The Doubs Falls
Canvas, 54 x 45
Signed and dated, l.r.: 64, G.C.

F. 425
Portrait of Beatrice Bouvet as a Child
Canvas, 92 x 73
Signed and dated, l.l.: Gustave Courbet,
Salins, 1864
National Museum of Wales, Cardiff, Great
Britain

F. 427
Portrait of Mme Bouvet
Canvas, 92 x 73
Signed and dated, l.l.: G. Courbet, 1864
Current whereabouts unknown

F. 429
Portrait of Mme Lydie Joliclerc
Canvas, 44.5 x 37
Signed, l.l.: G.C.; dated, apocryphally, l.l.:
46
Rijksmuseum Kröller-Müller, Otterlo,
Netherlands

F. 431
Woman with Cat
Canvas, 70 x 55
Signed, l.l.: G. Courbet
Worcester Art Museum, Massachusetts

F. 432
Bathing Woman
Canvas, 64 x 54
Signed, l.r.: G. Courbet
Current whereabouts unknown

F. 435
Girl with Seagulls
Canvas, 81 x 65
Signed, l.l.: G. Courbet
Private collection, New York

F. 437
Three English Girls at the Window
Canvas, 92 x 73
Signed, l.r.: G. Courbet
Ny Carlsberg Glyptotek, Copenhagen

F. 438
The Seeress or *The Somnambulist*
Canvas, 47 x 39
Signed and dated, l.l.: 65, G. Courbet
Universal Exhibition of 1867
Musée des beaux-arts, Besançon

F. 439
Portrait of the Countess Karoly
Canvas, 81 x 65
Signed, dated, and inscribed, l.r.: Dauville
[*sic*], 65, G. Courbet
Private collection, Japan

F. 442
Portrait of Mlle Aubé de la Holde
Canvas, 92 x 73
Not signed
Glasgow Art Gallery and Museum, Great
Britain

F. 443
Portrait of Pierre-Joseph Proudhon in 1853
Canvas, 147 x 198
Signed and dated, l.l.: Gustave Courbet,
1865
Salon of 1865
Musée du petit palais, Paris

F. 444
*Portrait of Mme Euphrasie Proudhon, née
Piégard*
Canvas, 73 x 59
Not signed
Musée d'Orsay, Paris

F. 449
Woman with Podoscaph
Canvas, 173.5 x 210
Not signed
Ishizuka Foundation, Tokyo

F. 451
The Paper Mill at Ornans
Canvas, 60 x 73
Signed, l.r.: G. Courbet
Musée Gustave Courbet, Ornans

F. 454
The Water Mill
Canvas, 73 x 59
Signed and dated, l.r.: G. Courbet, 65
Private collection, United Sates

F. 462
The Puits noir
Canvas, 94 x 135
Signed and dated, l.r.: G. Courbet
Salon of 1865
Musée d'Orsay, Paris

F. 466
Brook of the Puits noir
Canvas, 120 x 160
Signed, l.r.: G. Courbet
Current whereabouts unknown

F. 512
Beach at Trouville during Low Tide
Canvas, 46 x 61
Signed and dated, l.r.: 65, G. Courbet
Private collection

F. 526
Woman with a Parrot
Canvas, 129.5 x 195.6
Signed and dated, l.l.: 66, Gustave Courbet
Salon of 1866
Metropolitan Museum of Art, New York

F. 528
Study for Woman with a Parrot
Canvas, 60 x 73
Signed, l.l.: G.C.
Nasjonalgalleriet, Oslo

F. 532
Sleep, The Sleeping Women, or *Sloth and
Luxury*
Canvas, 135 x 200
Signed and dated, l.r.: G. Courbet, 66
Musée du petit palais, Paris

F. 535
Bather
Canvas, 130 x 98
Signed and dated, l.l.: 66, G. Courbet
Metropolitan Museum of Art, New York

F. 536
Sleeping Woman
Canvas, 50 x 65.5
Signed and dated, l.l.: 66, G. Courbet
H.W. Mesdag Museum, The Hague

F. 537
Portrait of Jo or the *Beautiful Irishwoman*
Canvas, 54 x 65
Signed and dated, l.l.: 66, Gustave Courbet
Nationalmuseum, Stockholm

F. 538
Portrait of Jo or the *Beautiful Irishwoman*
Canvas, 55.9 x 66
Signed and dated, l.l.: 66, Gustave Courbet
Metropolitan Museum of Art, New York

F. 539
Portrait of Jo or the *Beautiful Irishwoman*
Canvas, 52.7 x 63.5
Signed, l.l.: G. Courbet
The Nelson-Atkins Museum of Art,
Kansas City, Missouri

F. 540
Portrait of M. Nodler, Senior
Canvas, 93 x 73
Signed and dated, l.l.: 66, G. Courbet
Smith College Museum of Art, Northamp-
ton, Massachusetts

F. 541
Portrait of M. Nodler, Junior
Canvas, 91.4 x 72.3
Signed and dated, l.l.: 66, G. Courbet
Museum of Fine Arts, Springfield,
Massachusetts

F. 542
Self-Portrait
Panel, 44 x 34
Signed, l.l.: G.C.
Young Memorial Museum,
San Francisco

F. 545
The Greyhounds of the Comte de Choiseul
Canvas, 89 x 116.2
Signed and dated, l.l.: 66, G. Courbet
Saint Louis Art Museum, Missouri

F. 546
The Wounded Man, copy
Canvas, 79 x 99.5
Signed, l.l.: G. Courbet
Kunsthistorisches Museum, Vienna

F. 547
The Breton Shepherdess or the *Breton Spinner*
Canvas, 129 x 199
Signed, l.l.: G. Courbet
Current whereabouts unknown

F. 550
Poverty in the Village, Poverty in the Snow, or
*Poor Woman with Child and Goat, Begging
from Door to Door*
Canvas, 86 x 126
Signed and dated, l.l.: 66, G. Courbet
Private collection

F. 552
Covert of the Roedeer
Canvas, 174 x 209
Signed and dated, l.l.: 66, Gustave Courbet
Salon of 1866
Musée d'Orsay, Paris

F. 583
Solitude
Canvas, 94 x 135
Signed and dated, l.r.: Gustave Courbet, 66
Musée Fabre, Montpellier

F. 593
Etretat Seascape with White Cliffs
Canvas, 54 x 64
Signed, l.l.: G. Courbet
Current whereabouts unknown

F. 597
The Black Rocks
Canvas, 46 x 61
Signed, l.l.: G. Courbet
Private collection, United States

F. 598
The Dunes at Deauville
Canvas, dimensions unknown
Signed, l.l.: G. Courbet
Current whereabouts unknown

F. 599
Fishing Boats on the Beach at Deauville
Canvas, 46 x 60
Signed and dated, l.l.: G. Courbet, 66
Private collection, Lausanne, Switzerland

F. 609
The Death of Jeannot
Canvas, 100 x 140
Signed, l.l.: G. Courbet
Current whereabouts unknown

677

F. 612
Mort of the Stag or *Death of the Hunted Stag*
Canvas, 355 x 505
Signed, l.l.: G.C.
Salon of 1869
Musée des beaux-arts, Besançon

F. 613
Poachers in the Snow
Canvas, 102 x 122
Signed and dated, l.l.: Gustave Courbet, 67
Galleria nazionale d'arte moderna, Rome

F. 620
Hunting Dogs with Dead Hare
Canvas, 92.7 x 148.6
Signed, l.r.: G. Courbet
Metropolitan Museum of Art, New York

F. 623
Roedeer on the Alert
Canvas, 111 x 85
Signed and dated, l.l.: G
Musée d'Orsay, Paris

F. 625
Portrait of a Young Woman
Canvas, 80 x 64
Signed and dated, l.l.: Gustave Courbet, 67
National Museum of Western Art, Tokyo

F. 626
Lady with a Jewelry Box
Canvas, 81 x 64
Signed and dated, l.r.: Gustave Courbet, 67
Musée des beaux-arts, Caen, France

F. 627
The Spring or *Woman at the Spring*
Canvas, 128 x 97
Signed and dated, l.r.: 68, Courbet,
Gustave
Musée d'Orsay, Paris

F. 628
Woman in the Waves
Canvas, 65.4 x 54
Signed and dated, l.l.: 68, G. Courbet
Metropolitan Museum of Art, New York

F. 629
Reclining Woman in Boat
Canvas, 46 x 55
Signed and dated, l.l.: 68, G. Courbet
Philadelphia Museum of Art, Louis E. Stern
Collection

F. 630
Three Bathers
Canvas, 126 x 96
Signed, l.l.: G. Courbet
Musée du petit palais, Paris

F. 631
Nude Woman with Dog
Canvas, 65 x 81
Signed and dated, l.l.: 68, G. Courbet
Musée d'Orsay, Paris

F. 637
Forest Pool with Roedeer
Canvas, 157 x 115
Signed, l.r.: G. Courbet
Museum of Fine Arts, Boston

F. 643
Siesta at Haymaking Time
Canvas, 212 x 273
Signed and dated, l.r.: G. Courbet, 68
Salon of 1869
Musée du petit palais, Paris

F. 644
Roedeer by the River
Canvas, 97 x 130
Signed and dated, l.r.: G. Courbet, 68
Kimbell Art Museum, Fort Worth, Texas

F. 646
Landscape with Roedeer
Canvas, 130.8 x 97.8
Signed and dated, l.l.: 68, Gustave Courbet
Minneapolis Institute of Arts, Minnesota

F. 654
Portrait of Pierre Dupont
Canvas, 52 x 40
Signed and dated, l.l.: 68, G. Courbet
Staatliche Kunsthalle, Karlsruhe, Germany

F. 658
Portrait of Chenavard
Canvas, 54 x 46
Signed and dated, l.l.: 69, G. Courbet
Musée des beaux-arts, Lyon

F. 659
Portrait of Marcello (Adèle Castiglione, née d'Affry)
Canvas, 60 x 49
Signed and inscribed, l.r.: Portrait de Marcello, Gustave Courbet
Musée Saint-Denys, Reims

F. 660
Alms of a Beggar at Ornans
Canvas, 210 x 175
Signed and dated, l.l.: 68, Gustave Courbet
Salon of 1868
Glasgow Art Gallery and Museum, Great Britain

F. 662
Portrait of Mme Sophie Loiseau
Canvas, 72 x 58
Signed, l.r.: G. Courbet
Private collection

F. 663
The Gypsy
Canvas, 50 x 61
Signed and dated, l.r.: 69, G. Courbet
National Museum of Western Art, Tokyo

F. 667
The Lady of Munich
Canvas, 160 x 352 (?)
Not signed
Current whereabouts unknown

F. 668
Copy after Self-Portrait by Rembrandt
Canvas, 87 x 73
Signed and dated, l.l.: 69, G. Courbet
Musée des beaux-arts, Besançon
[Comment: Copy after a self-portrait by Rembrandt in the Alte Pinakothek, which today is no longer considered an authentic work.]

F. 670
Copy after Malle Babbe by Frans Hals
Canvas, 85 x 71
Signed and dated, l.l.: 69, G. Courbet
Kunsthalle, Hamburg, Germany

F. 671
Landscape at Interlaken or *Swiss Landscape*
Canvas, 60 x 72
Signed and dated, l.l.: 69, G. Courbet
Private collection, Italy

F. 673
View of the Starnberg Lake in Bavaria, Germany
Cardboard, 34 x 45.5
Signed and dated, l.l.: 69, G. Courbet
Current whereabouts unknown

F. 745
Cliff at Etretat
Canvas, 133 x 162
Signed and dated, l.l.: 70, Gustave Courbet
Salon of 1870
Musée d'Orsay, Paris

F. 747
Stormy Sea
Canvas, 117 x 160
Signed and dated, l.l.: 70, Gustave Courbet
Salon of 1870
Musée d'Orsay, Paris

F. 759
Portrait of Jules Bordet
Canvas, 60 x 50
Signed, l.l.: G. Courbet; inscribed, l.r.: A mon ami J. Bordet
Private collection, United States

F. 772
Still-life with Apples
Canvas, 46 x 55
Signed, l.l.: G. Courbet
Current whereabouts unknown

F. 773
Still-life with Apples and Pomegranates
Canvas, 46 x 55
Signed, l.l.: G. Courbet
Current whereabouts unknown

F. 782
Flowering Branch of an Apple Tree
Canvas, 33 x 41
Signed, l.l.: 71, G. Courbet
Inscribed, l.r.: Ste-Pélagie
Musée d'Orsay, Paris

F. 786
The Trout
Canvas, 55 x 89
Signed, dated and inscribed, l.l.: 71, G.
Courbet, In Vinculis Faciebat
Kunsthaus, Zurich
[Comment: Probably wrongly dated. In fact
painted in 1872.]

F. 792
Still-life with Pomegranates
Panel, 26.7 x 35
Signed and dated, l.l.: 71, G. Courbet
Glasgow Art Gallery and Museum, Great
Britain

F. 807
The Drunkard of Ornans
Canvas, 71 x 60
Signed and inscribed, l.l.: Esquisse, G.
Courbet
Private collection, Italy

F. 823
The Blue Spring
Canvas, 81 x 100
Signed and dated, l.r.: 72, G. Courbet
Nationalmuseum, Stockholm

F. 828
The Washhouse or *View of the Ruins of the
Château at Scey-en-Varais*
Canvas, 66.5 x 82
Signed, l.r.: G. Courbet
Private collection, United Sates

F. 869
Mushrooms
Canvas, 61 x 65
Signed and dated, l.l.: 72, G. Courbet;
inscribed, l.r.: A M. Ordinaire
Private collection, Paris

F. 880
White Calf or *Swiss Calf*
Canvas, 89 x 116
Signed and dated, l.r.: G. Courbet, 73
Private collection, United States

F. 881
English Horse or *The Horse of M. Duval*
Canvas, 32 x 40.5
No signature
Current whereabouts unknown

F. 882
Horse in the Stable
Canvas, 60 x 73
Signed and dated, l.l.: 73, G. Courbet
National Museum of Western Art, Tokyo

F. 883
The Trout
Canvas, 65 x 99
Signed and dated, l.r.: G. Courbet, 73
Private collection, Paris

F. 885
Three Trout from the Loue River
Canvas, 116 x 87
Signed and dated, l.l.: 73, G. Courbet
Kunstmuseum, Bern, Switzerland

F. 955
The Dent du Midi
Canvas, 151 x 210
No signature
Cleveland Museum of Art

F. 963
The Vinedresser of La Tour or *The Vine-
dresser of Montreux*
Canvas, 100 x 81
Signed, l.l.: G. Courbet
Musée cantonal des beaux-arts, Lausanne,
Switzerland

F. 990
The Château de Chillon
Canvas, 54 x 65
Signed and dated, l.l.: 75, G. Courbet
Private collection, Paris

F. 1019
Study of a Dog
Canvas, 38 x 46
Signed, l.l.: G. Courbet

DRAWINGS AND PRINTS

Fd. 1
Sketchbook, 14 x 22
Cabinet des dessins, Louvre, Paris

Fd. 2
Sketchbook, 10 x 14
Cabinet des dessins, Louvre, Paris

Fd. 9
Four lithographs for Max Buchon's *Essais Poétiques* (Besançon, 1839)

Fd. 10
Pont Nahin at Ornans
Lithograph, 18 x 24
Not signed

Fd. 17
Self-Portrait at Easel
Drawing, charcoal on cream paper, 55.4 x 33.5
Not signed
Fogg Art Museum, Cambridge, Massachusetts

Fd. 18
Self-Portrait at Easel
Drawing, charcoal on off-white paper, 23.3 x 44.7 (sight)
Not signed
Private collection, Paris

Fd. 25
The Guitarist or *Zélie Courbet Playing the Guitar*
Charcoal on off-white paper, 45 x 29
Signed, l.l.: G.C.
Fogg Art Museum, Cambridge, Massachusetts

Fd. 34
The Death of Cousin Moisy
Lithograph, measurements unknown
Signed, top: Gustave Courbet

Fd. 39
Portrait of François Sabatier
Drawing, black chalk on off-white paper, 34 x 26 (oval)
Signed, c.l.: G.C.
Musée Fabre, Montpellier

Fd. 40
Women Sleeping in the Wheatfield
Drawing, conte crayon on off-white paper, 46 x 56
Signed and dated, l.r.: G. Courbet, 1855
Musée des beaux-arts, Lyon

SCULPTURES

Fs. 1
Boy Catching Bullheads
Plaster, (height) 120
Signed and inscribed on the pedestal: Gustave Courbet, Essai
Musée Gustave Courbet, Ornans

Fs. 3
Portrait of Mme Buchon
Plaster relief, 43 x 39
Signed, dated, and inscribed: G. Courbet, 1864, Mme B.
Musée Gustave Courbet, Ornans

Fs. 4
Portrait of Alfred Bouvet
Plaster medallion, (diameter) 40
Signed and dated, l.r.: 1864, G. Courbet
Private collection

Fs. 5
Portrait Head of the Marquise de Tallenay
Plaster, 35 x 23
Musée d'Orsay, Paris

Fs. 6
Helvetia or *Liberty*
Plaster, (height) 100
Musée des beaux-arts, Besançon, and Musée Jenisch, Vevey, Switzerland

WORKS NOT IN FERNIER

NIF. 1
Portrait of Jo or *The Beautiful Irishwoman*
Canvas, 54 x 64
Signed, l.l.: G. Courbet
Collection Rolf and Margit Weinberg, Zurich

NIF. 2
The Little Swineherdess
Canvas, 151 x 131
Signed, l.l.: G. Courbet
Collection E. G. Bührle, Zurich

NIF. 3
Landscape
Canvas, 72 x 59
Musée d'art et d'histoire, Fribourg

NIF. 4
Sunset, Vevey
Canvas, 64 x 80
Signed and dated, l.r.: G. Courbet, 74
Cincinnati Art Museum, Ohio

NIF. 5
Woman Combing Her Hair
Canvas, dimensions unknown
Private collection, England

Chronological Inventory of Letters

The following list provides essential information about each letter. In columns 1 ("No") and 2 ("Corr"), the number of the letter and the name of the correspondent are given.

The third column ("Doc") provides information about the nature of the document in question (length of letter, autograph or not, signed or not, handwritten copy, printed transcript, etc.).

Columns 4 ("Coll") and 5 ("Inv") list the whereabouts of each letter and its classification. A dash (—) in column 5 means that the collection in question does not consistently use classification or inventory numbers. Two dots (. .) in the same column indicate that when this book went to press no inventory number had yet been assigned.

The last column ("Publ") indicates if and where the letter was published *for the first time*. A dash in that column means that, as far as I have been able to ascertain, the letter is unpublished. In some instances, letters or parts thereof may have been made public through dealers and auction catalogs. The full names of the dealer and auction houses in question are provided at the end of the list of references.

Question marks in any column signify that the information is not available. A list of abbreviations is provided below.

ABBREVIATIONS

#	Text based on hand- or typewritten copy
##	Text based on published version
b	box
c	copy
cat	catalog
cdv	auction catalog
cf	facsimile copy
coll	collection
cp	partial copy
d	draft
e	excerpt/paraphrase
f	fragment
i	incomplete
inv	inventory
L	letter
LA	autograph letter
LAS	autograph signed letter
ms	manuscript
no	number
p	page
PAM	pamphlet
pc	private collection
r	recto
t	translation
tp	partial translation
v	verso

ADDB	Archives départementales du Doubs, Besançon
ADRP	Archives Durand-Ruel, Paris
AMLTDP	Archives municipales, La Tour-de-Peilz
AMNP	Archives des musées nationaux, Paris (Louvre)
ANP	Archives nationales, Paris
APPP	Archives de la préfecture de police, Paris
BAAJDP	Bibliothèque d'art et d'archéologie, Fondation Jacques Doucet, Paris
BCMNP	Bibliothèque centrale des musées nationaux, Paris(Louvre)
BCULFR	Bibliothèque cantonale et universitaire, Lausanne, Fonds Ruchonnet
BHVP	Bibliothèque historique, la ville de Paris
BLCUNY	Butler Library, Columbia University, New York
BMB	Bibliothèque municipale, Besançon
BMBSC	Bibliothèque municipale, Bagnols-sur-Cèze
BMG	Bibliothèque municipale, Grenoble
BML	Bibliothèque municipale, Laon
BNP	Bibliothèque nationale, Paris (Cabinet des estampes)
BNPMS	Bibliothèque nationale, Paris (Département des manuscrits)
BPUG	Bibliothèque publique et universitaire, Genève
BPUGBB	Bibliothèque publique et universitaire, Genève, Archives Baud-Bovy
BRB	Bibliothèque royale, Brussels
BRUG	Bibliotheek Rijksuniversiteit, Ghent
BSLP	Bibliothèque Spoulberch-Louvenjol, Paris
CDLP	Cabinet des dessins, Louvre, Paris
FCINP	Fondation Custodia, Institut néerlandais, Paris
GCSM	Getty Center for the History of Art and the Humanities, Santa Monica
GUL	Glasgow University Library
HRCUTA	Humanities Research Center, University of Texas, Austin
LL	Library Leningrad
MBAN	Musée des beaux-arts, Nantes
MCP	Musée Carnavalet, Paris
MGCO	Musée départemental de la maison natale de Gustave Courbet, Ornans
MMANY	Metropolitan Museum of Art, New York
NSMP	Norton Simon Museum, Pasadena
pcAC	private coll., André Charigny
pcAM	private coll., Arno Müller, Homburg
pcAS	private coll., Archives Sanguin
pcATB	private coll., Archives Thierry Bodin
pcBG	private coll., Bernard Gantner
pcCC	private coll., Christophe Czwiklitzer
pcDFR	private coll., D.-F. Ruchon, Geneva
pcJJF	private coll., Jean-Jacques Fernier
pcKH	private coll., Klaus Herding
pcLN	private coll., Linda Nochlin
pcMS	private coll., Mme Mélia-Sevrain, Eysines
pcP	private coll., Mme Perron, France
pcPC	private coll., Petra Chu
pcPF	private coll., Pierre Favarger, Switzerland
pcRS	private coll., Rudolf Springer, Berlin
pcUSA	private coll., United States

pcWH private coll., Werner Hofmann
PMLNY Pierpont Morgan Library, New York
SUBF Stadt- und Universitätsbibliothek, Frankfurt
SUSF Stanford University, San Francisco
UBBGH Universitätsbibliothek, Basel, coll. Geigy-Hagenbach
UMCP University of Maryland, College Park, Maryland
WCNY Wildenstein & Co., New York

No	Corr	Doc	Coll	Inv	Publ
37–1	family	LAS, 3p	pcKH	—	Riat 1906, 6 (e)
37–2	family	LAS, 3p	UMCP	ARCV-79-4	Riat 1906, 7 (e)
37–3	family	LAS, 1p	UMCP	ARCV-79-4	Riat 1906, 7–8 (e)
37–4	family	LAS, 1p	UMCP	ARCV-79-4	Riat 1906, 8 (e)
37–5	family	LAS, 3p	MGCO	ms P9	BAGC 70 (1983), 42–43
37–6	family	LAS, 2p	UMCP	ARCV-79-4	Riat 1906, 8 (e)
37–7	family	LAS, 2p	UMCP	ARCV-79-4	—
38–1	family	LAS, 1p	UMCP	ARCV-79-4	Riat 1906, 8 (e)
38–2	family	LAS, 3p	MGCO	ms P10	BAGC 65 (1981), 15–17
38–3	family	LAS, 3p	UMCP	ARCV-79-4	Riat 1906, 8 (e)
38–4	family	LAS, 2p	FCINP	1978-A88	Chu 1988, 46
38–5	grandfather	LAS, 2p	UMCP	ARCV-79-4	—
39–1	family	LAS, 2p	FCINP	1991-A. .	Riat 1906, 9 (e)
39–2	family	LAS, 1p	UMCP	ARCV-79-4	Riat 1906, 10 (e)
39–3	family	LA, 2p	UMCP	ARCV-79-4	—
39–4	family	LAS, 1p	BAAJDP	carton 10, peintres	—
39–5	family	LAS, 2p	BAAJDP	carton 10, peintres	Paris 1977, 22 (e)
40–1	father	LAS, 4p	UMCP	ARCV-79-4	—
40–2	father	LAS, 3p	pcKH	—	Beuter 1988
40–3	father	LAS, 3p	BAAJDP	carton 10, peintres	Paris 1977, 22 (e)
41–1	family	LAS, 5p	UMCP	ARCV-79-4	—
41–2	family	LAS?#	BNP(cp)	Yb3.1739 (4o), b 3	Courthion 1948–50, 2:70–71
41–3	family	LAS, 1p	UMCP	ARCV-79-4	—
42–1	family	LAS?#	BNP (cp)	Yb3.1739 (4o), b 3	Riat 1906, 24 (e)
42–2	family	LAS, 2p##	?	?	Riat 1906, 24, 26 (e) Saffroy cat 103, 9652
42–3	family	LAS, 3p	UMCP	ARCV-79-4	Riat 1906, 34 (e)
42–4	family	LAS, 3p	UMCP	ARCV-79-4	Riat 1906, 24 (e)
42–5	family	LAS, 3p	UMCP	ARCV-79-4	Riat 1906, 24–25 (e)
44–1	family	LAS, 4p	FCINP	1991-A. .	Riat 1906, 26, 28–29 (e)
44–2	family	LAS, 3p	FCINP	1991.A. .	Riat 1906, 33 (e)
44–3	grandparents	LAS, 4p	UMCP	ARCV-79-4	Riat 1906, 33–34 (e)
44–4	family	LAS, 3p	UMCP	ARCV-79-4	Riat 1906, 34–35 (e)
45–1	father	LAS, 3p	UMCP	ARCV-79-4	Riat 1906, 24, 28 (e)
45–2	family	LAS, 4p	UMCP	ARCV-79-4	Riat 1906, 35–36 (e)

No	Corr	Doc	Coll	Inv	Publ
45–3	family	LAS, 4p	UMCP	ARCV-79-4	Riat 1906, 36, 38 (e)
45–4	family	LAS, 3p	UMCP	ARCV-79-4	Riat 1906, 39–40 (e)
45–5	family	LAS, 3p	UMCP	ARCV-79-4	Riat 1906, 40 (e)
45–6	father	LAS, 3p	UMCP	ARCV-79-4	Riat 1906, 40 (e)
45–7	father	LAS, 1p	BAAJDP	carton 10, peintres	—
46–1	family	LAS, 3p	UMCP	ARCV-79-4	Riat 1906, 42 (e)
46–2	family	LAS, 1p	UMCP	ARCV-79-4	Riat 1906, 42 (e)
46–3	T. Gautier	L, 2p	BSLP	ms 595 (C.493)	—
46–4	family	LAS, 3p	UMCP	ARCV-79-4	
46–5	family	LAS, 2p	FCINP	1991-A. .	Riat 1906, 42–43 (e)
46–6	family	LAS, 3p	UMCP	ARCV-79-4	
46–7	family	LAS?, 3p	BNP	Yb3.1739 (4o), b 1	Courthion 1948–50, 2:73 (e)
46–8	family	LAS, 3p	UMCP	ARCV-79-4	Riat 1906, 46–47 (e)
46–9	family	LAS, 2p	FCINP	1971-A203	Chu 1988, 47
46–10	Papeians	LAS, 3p	UMCP	ARCV-79-4	—
47–1	family	LAS, 4p	UMCP	ARCV-79-4	Riat 1906, 44 (e)
47–2	family	LAS, 3p	FCINP	1991-A. .	Riat 1906, 44–45 (e)
47–3	family	LAS, 3p	FCINP	1991-A. .	—
47–4	family	LAS, 3p	UMCP	ARCV-79-4	—
47–5	father	LAS, 2p	BAAJDP	carton 10, peintres	—
47–6	family	LAS, 3p	UMCP	ARCV-79-4	Riat 1906, 47 (e)
48–1	family	LAS, 3p	BNP	Yb3.1739 (4o), b 1	Paris 1977, 26 (e)
48–2	family	LA, 4p##	MGCO	—	BAGC 60 (1978), 15–16
48–3	family	LAS, 4p##	MGCO	—	BAGC 63 (1980), 16–18
48–4	family	LAS, 2p	pcBG	—	Riat 1906, 50
49–1	Bonvin	LAS, 1p	FCINP	1972-A.761	Chu 1988, 55
49–2	Lottery	L, 1p	?	?	Crépet 1947, 111–12 BAGC 74 (1985), 46 (cf)
49–3	father	LA, 4p(f)	UMCP	ARCV-79-4	
49–4	father	LAS, 3p##	?	?	Charavay cat no 34937 (e)
49–5	Wey	LAS?#	BNP (c)	Yb3.1739 (8o)	—
49–6	family	LAS, 2p	BNP	Yb3.1739 (4o), b 1	—
49–7	Wey	LAS?#	BNP (c)	Yb3.1739 (8o)	—
49–8	Wey	LAS?#	BNP (c)	Yb3.1739 (8o)	Courthion 1948–50, 2:75–76 (e)
49–9	Wey	LAS, 4p	MGCO	ms W1	—
50–1	Champfleury	LAS, 4p	CDLP	Autogr. b 8, 32	Courbet 1931, 385–89
50–2	Wey	LAS?#	BNP (c)	Yb3.1739 (8o)	—
50–3	Buchon	LAS, 4p	MGCO	ms B18	Fernier 1987, no 1
50–4	Wey	LAS?#	BNP (c)	Yb3.1739 (8o)	Courthion 1948–50, 2:78 (e)
50–5	family	LAS?##	?	?	Riat 1906, 83–84 (e)
50–6	mother	LAS, 2p	UMCP	ARCV-79-4	—

No	Corr	Doc	Coll	Inv	Publ
51–1	*La Presse*	LAS, 3p(d)	BCMNP	ms 310, 200	*La Presse*, 20 V 51
51–2	family	LAS, 2p	pcBG	—	Riat 1906, 93 (e)
51–3	*Le Messager*	LAS, 3p	CDLP	Autogr. b 8, 83	BAGC 52 (1974), 12
52–1	Wey	LAS?#	BNP (c)	Yb3.1739 (8o)	—
52–2	Champfleury	LAS?##	?	?	Riat 1906, 94–95(e)
52–3	family	LAS, 5p	FCINP	1991-A. .	—
52–4	family	LAS, 2p	UMCP	ARCV-79-4	—
53–1	Marlet	LAS, 3p	CDLP	Autogr. b 8, 98	Riat 1906, 115–16 (e)
53–2	Morny	LAS, 2p	MGCO	ms M2	BAGC 62 (1979), 1
53–3	family	LAS, 3p	SUSF	—	Riat 1906, 101–2 (e)
53–4	Champfleury	LAS, 3p	CDLP	Autogr. b 8	—
53–5	Bruyas	LAS?#	BAAJDP(c)	carton 10, peintres	Bruyas 1854, 47–48
53–6	Bruyas	LAS, 6p	BAAJDP	ms 216	Courbet 1913, 485–90
53–7	Wey	LAS?#	BNP (c)	Yb3.1739 (8o)	—
54–1	Bruyas	LAS, 4p	BAAJDP	ms 216	Courbet 1913, 482–84
54–2	Bruyas	LAS, 4p	BAAJDP	ms 216	Courbet 1913, 468–71
54–3	Z. Courbet	LAS, 4p##	MGCO	—	Ornans 1980, 22
54–4	Buchon	LAS, 4p	MMANY	Avery album, 74	BAGC 4 (1948), 22
54–5	Mme Balloy?	LAS, 1p	BAAJDP	ms 216	Borel 1922, 49
54–6	Nieuwerkerke	LAS, 1p	ANP	F21, 521B	—
54–7	Bruyas	LAS, 4p	BAAJDP	ms 216	Courbet 1913, 472–76
54–8	Champfleury	LAS, 4p	BCMNP	89083, ms 290, 6–7	Paris 1977, 246–47
55–1	Français	LAS, 4p	BAAJDP	carton 10, peintres	Paris 1977, 31 (e)
55–2	Champfleury	LAS?#	BAAJDP(c)	ms 168⁹	—
55–3	Bruyas	LAS, 4p	BAAJDP	ms 216	Courbet 1913, 476–78
55–4	Bruyas	LAS, 4p	BAAJDP	ms 216	Courbet 1913, 478–79
55–5	Bruyas	LAS, 4p	BAAJDP	ms 216	Courbet 1913, 479–81
55–6	family	LAS, 4p	pcBG	—	Riat 1906, 131 (e)
55–7	Bruyas	LAS?##	?	?	Bruyas 1856, 147–48
55–8	mother	LAS, 4p##	?	?	Drouot cat, 4 V 79, no 49 (e)
55–9	Tattet	LAS, 1p	?	?	Léger 1948, 21
55–10	Gigoux	LAS, 1p	pcBG	—	—
55–11	Bruyas	LAS, 3p	BAAJDP	ms 216	Courbet 1913, 484–85
56–1	friend	LAS?##	?	?	Léger 1948, 61(e)
56–2	L'Epine	LAS, 1p	CDLP	Autogr. b 8, 32	—
56–3	Buchon	LAS, 3p	MGCO	ms B19	Fernier 1987, no 3
56–4	Buchon	LAS, 2p	MGCO	ms B20	Fernier 1987, no 2
56–5	Buchon	LAS, 4p	MGCO	ms B21	Fernier 1987, no 4
56–6	family	LAS?#	BNP (c)	Yb3.1739 (4o), b 1	—
57–1	father	LAS, 3p	BAAJDP	carton 10, peintres	
57–2	A. Gautier	LAS, 3p	MGCO	ms G3,4	BAGC 23 (1959), 8–9
57–3	Bruyas	LAS, 4p	BAAJDP	ms 216	Courbet 1913, 471–72
57–4	Fajon	LAS, 4p	BAAJDP	ms 216	Courbet 1913, 490–92

No	Corr	Doc	Coll	Inv	Publ
58–1	father	LAS, 4p	pcPC	—	—
58–2	A. Gautier	LAS, 2p	MGCO	ms G2	BAGC 31 (1964), 13
58–3	family	LAS, 4p	FCINP	1978-A.2596	Chu 1988, 48
59–1	Radoux	LAS, 4p	CDLP	Autogr. b 8, 84	—
59–2	J. Courbet	LAS, 4p	FCINP	1986-A.2	Chu 1988, 49–50
59–3	Poulet-M.	LAS?#	BNPMS(c)	NAF 15816, 27	—
59–4	family	LAS, 4p	FCINP	1991-A. .	—
59–5	Gueymard	LAS, 1p	MGCO	ms G5	BAGC 31 (1964), 13–14
59–6	Poulet-M.	LAS, 2p	BNPMS	NAF 15816,27v,28r	—
59–7	Champfleury	LAS, 4p	BRB	ms 2927 II, 142	—
59–8	Gaudy	LAS?##	?	?	BAGC 6 (1949), 13
59–9	Buchon	LAS, 3p	MGCO	ms B23	Fernier 1987, no 8
60–1	Buchon	LAS, 3p	MGCO	ms B24	Fernier 1987, no 7
60–2	A. Gautier	LAS, 4p	FCINP	1991-A. .	Léger 1948, 75–76 (e)
60–3	Lunteschütz	LAS, 3p	SUBF	—	—
60–4	Poulet-M.	LAS, 2p	BNPMS	NAF 15816,28r/v	—
60–5	A. Gautier	LAS, 1p	FCINP	I.6872	Léger 1948, 74–75
60–6	Champfleury	LAS, 4p	CDLP	Autogr. b 8	Courbet 1931, 383
60–7	A. Gautier	LAS, 3p	GCSM	860093	Léger 1948, 76
60–8	A. Gautier	LAS, 2p	MGCO	ms G6	BAGC 26 (1960), 10–12
60–9	A. Gautier	LAS, 4p	FCINP	1977.A 1748	Chu 1988, 51–52
60–10	Champfleury	LAS, 4p	CDLP	Autogr. b 8	—
60–11	Hetzel	LAS, 1p	BNPMS	NAF 16941, 580–81	BAGC 15 (1954), 20
61–1	A. Gautier	LAS, 2p##	MGCO	—	BAGC 52 (1974), 11–12
61–2	Buchon	LAS, 3p	MGCO	ms B22	Fernier 1987, no 5
61–3	Poulet-M.	LAS, 2p	BNPMS	NAF 15816,28v,29r	—
61–4	Poulet-M.	LAS, 2p	BNPMS	NAF 15816,29v,30r	—
61–5	Pothey	LAS, 3p	CDLP	Autogr. b 8, 32	—
61–6	Wey	LAS?#	BNP (c)	Yb3.1739 (8o)	Courthion 1948–50, 2:89–94 (e)
61–7	Bruyas	LAS?#	BAAJDP(c)	carton 10, peintres	—
61–8	Nieuwerkerke	LAS, 1p	AMNP	P.30 Courbet	—
61–9	Nieuwerkerke	LAS, 2p	BRB	II 2086, 17	—
61–10	family	LAS, 4p	MGCO	—	BAGC 20 (1957), 20
61–11	family	LAS, ?p##	MGCO	—	BAGC 23 (1959), 11–12 (e)
61–12	Baron Taylor?	LAS, 1p	FCINP	1988-A. .	—
61–13	unknown	LAS, 2p#	MBAN	—	—
61–14	father	LAS, 4p	PMLNY	MA 2645	—
61–15	Buchon	LAS, 3p	MGCO	ms B25	Fernier 1987, no 9
61–16	Paris artists	LS, 6p	MGCO	ms A3	*Courr. du dim.*, 29 XII 61, 4

No	Corr	Doc	Coll	Inv	Publ
62–1	father	LAS, 4p	FCINP	1985-A.280	Chu 1988, 52–53
62–2	father	LAS, 2p	BAAJDP	carton 10, peintres	Bonniot 1973, 351
62–3	Léontine R.	LA, ?p(d)##	pcMS	—	Bonniot 1973, 77–78 (e)
62–4	Troubat	LAS, 4p	CDLP	Autogr. b 8, 85	Toussaint 1980, 94
62–5	Léontine R.	LA, ?p(d)##	pcMS	—	Bonniot 1973, 79–80 (e)
62–6	Castagnary	LAS, 2p	BNP	Yb3.1739 (4o), b 1	Bonniot 1973, 115–16
62–7	Isabey	LAS?#	BNP (cp)	Yb3.1739 (4o), b 5	Bonniot 1973, 179–80 (e)
62–8	Castagnary	LAS, 1p	BNP	Yb3.1739 (4o), b 1	Bonniot 1973, 122–23
62–9	Isabey	LAS?#	BNP (cp)	Yb3.1739 (4o), b 5	Bonniot 1973, 181–82 (e)
62–10	Baudry	LAS, 1p##	pcMS	—	Bonniot 1973, 152
62–11	Isabey	LAS?#	BNP (cp)	Yb3.1739 (4o), b 5	Bonniot 1973, 181 (e)
62–12	Baudry	LAS, 1p##	pcMS	—	Bonniot 1973, 187
62–13	Isabey	LAS?#	BNP (cp)	Yb3.1739 (4o), b 5	Bonniot 1973, 180 (e)
62–14	Baudry	LAS, 2p##	pcMS	—	Bonniot 1973, 154
63–1	Baudry	LAS, 1p##	pcMS	—	Bonniot 1973, 186
63–2	family	LAS, 3p	UMCP	ARCV-79-4	Bonniot 1973, 167 (e)
63–3	Luquet	LAS?#	BNP (cp)	Yb3.1739 (4o), b 1	Riat 1906, 204 (e)
63–4	Isabey	LAS?#	BNP (cp)	Yb3.1739 (4o), b 5	Bonniot 1973, 268–69 (e)
63–5	Carjat	LAS?##	?	?	Riat 1906, 199
63–6	Nadar	LS, 2p#	BNPMS (c)	NAF 24266, 350–51	Bonniot 1973, 278
63–7	Isabey	LAS?#	BNP (cp)	Yb3.1739 (4o), b 5	Bonniot 1973, 269 (e)
63–8	Isabey	LAS?#	BNP (cp)	Yb3.1739 (4o), b 5	Bonniot 1973, 270 (e)
63–9	Fizelière	LAS?#	BNP (cp)	Yb3.1739 (4o), b 3	*Le Rappel*, 18 II 1887, 2
63–10	Isabey	LAS?#	BNP (cp)	Yb3.1739 (4o), b 5	Bonniot 1973, 270–71 (e)
63–11	Proudhon	LS, 1p	MGCO	ms P15	BAGC 21 (1958), 5
63–12	*Figaro*	LAS?##	?	?	*Figaro*, 27 V 1863, 1
63–13	Champfleury	LAS, 4p	BRB	ms II 2086, 16	—
63–14	Proudhon	LAS, 1p	MGCO	ms P16	BAGC 21 (1958), 6
63–15	Frond	LAS, 1p	MGCO	ms F2	—
63–16	father	LAS, 4p	MGCO	ms P17	Riat 1906, 207–08 (e)
63–17	Proudhon	LAS, 8p	MGCO	—	BAGC 57 (1977), 13–16
63–18	Buchon	LAS, 4p	MGCO	ms B26	Fernier 1987, no 6
63–19	father	LAS, 3p	MGCO	ms P18	—
63–20	Isabey	LAS?#	BNP (cp)	Yb3.1739 (4o), b 5	—
64–1	Barthet	LAS, 2p	UBBGH	no 2048	—

No	Corr	Doc	Coll	Inv	Publ
64–2	Castagnary	LAS, 4p	BNP	Yb3.1739 (4o), b 1	Riat 1906, 215–16 (e)
64–3	Luquet	LAS?#	BNP (cp)	Yb3.1739 (4o), b 1	Riat 1906, 216 (e)
64–4	Haro	LAS, 4p	BAAJDP	ms 237, 83	—
64–5	Haro	LAS, 2p	BAAJDP	ms 237, 84	—
64–6	Luquet	LAS, 1p	BAAJDP	. .	*L'Amateur* 292 (1878), 10–11
64–7	Fajon	LAS?##	?	?	Paris 1977, 39 (e)
64–8	Haro	LA, 3p	BAAJDP	ms 237, 85	—
64–9	Mazaroz	LAS, 3p	pcMS	—	—
64–10	Bosset	LAS, 1p	pcP? MGCO (cf)	—	—
64–11	Luquet	LAS?#	BNP (cp)	Yb3.1739 (4o), b 1	Riat 1906, 217 (e)
64–12	Verwee	LAS, 4p	pcRS	—	*Belgique cont.* (VI 1904), 308–9
64–13	Verwee	LAS##	?	?	*Belgique cont.* (VI 1904), 309–10
64–14	Verwee	LAS, 1p	FCINP	1990-A. .	*Belgique cont.* (VI 1904), 310
64–15	Bosset	LAS?##	?	?	Léger 1948, 97 (e)
64–16	Hugo	LAS, 1p	BNPMS	NAF 24801, 354	Bonniot 1972, 241–42
64–17	family	LAS, 3p	BNP	Yb3.1739 (4o), b 1	Riat 1906, 219 (3)
64–18	Hugo	LAS?##	?	?	Léger 1921, 357–58
64–19	Proudhon	LAS, 3p	MGCO	ms P19	BAGC 21 (1958), 6–7
64–20	Castagnary	LAS?#	BNP(c)	Yb3.1739 (4o), b 1	—
64–21	Castagnary	LAS, 2p	BNP	Yb3.1739 (4o), b 1	Brooklyn 1988, 58 (e)
64–22	Hugo	LAS, 3p	?	?	Léger 1921, 360–61
65–1	Buchon	LAS, 2p	MGCO	ms B10	Fernier 1987, no 10
65–2	Castagnary	LAS?#	BNP(c)	Yb3.1739 (4o), b 5	—
65–3	Castagnary	LAS, 4p	BNP	Yb3.1739 (4o), b 1	Courthion 1948–50, 2:102–105
65–4	Chaudey	LAS?##	?	?	Droz 1910, 255–57
65–5	Luquet	LAS?#	BNP (cp)	Yb3.1739 (4o), b 1	Riat 1906, 220–21 (e)
65–6	Luquet	LAS?##	?	?	*La Petite Revue*, 12 V 1866 (e)
65–7	Carjat	LAS?##	?	?	BAGC 2 (1947), 6 (e)
65–8	Verwee	LAS##	?	?	*Belgique cont.* (VI 1904), 310–11
65–9	Castagnary	LAS?#	BNP(c)	Yb3.1739 (4o), b 5	—
65–10	L. Joliclerc	LAS?##	?	?	Bauzon 1886, 238–39
65–11	Luquet	LAS?#	BNP (cp)	Yb3.1739 (4o), b 1	Riat 1906, 222–23 (e)
65–12	L. Joliclerc	LAS?##	?	?	Bauzon 1886, 239
65–13	family	LAS, 4p	BNP	Yb3.1739 (4o), b 1	Riat 1906, 227 (e)
65–14	Sensier	LAS?##	?	?	Riat 1906, 228 (e)
65–15	Cuenot##	LAS, ?p	MGCO	—	BAGC 23 (1959), 9–10

No	Corr	Doc	Coll	Inv	Publ
65–16	family	LAS, 2p	FCINP	1991-A. .	Riat 1906, 228 (e)
65–17	Frond	LAS, 1p	GCSM	860896	Abbaye cat 279, no 42 (e)
66–1	Luquet	LAS?#	BNP (cp)	Yb3.1739 (4o), b 1	—
66–2	family	LAS, 4p	FCINP	1991-A. .	Riat 1906, 231–32 (e)
66–3	Bruyas	LAS, 4p	BAAJDP	ms 216	Courbet 1913, 492–494
66–4	Vallès	LAS?#	BNP (c)	Yb3.1739 (4o), b 5	Courthion 1948–50, 2:105–06
66–5	Bruyas	LAS, 3p	BAAJDP	ms 216	Courbet 1913, 494–96
66–6	Stevens	LAS, 2p##	?	?	Charavay cat 784(1985),40815(e)
66–7	Cuenot	LAS, 5p	UMCP	ARCV-79-4	Riat 1906, 236–37 (e)
66–8	Chennevières	LAS?##	?	?	Chennevières 1979, 43–44
66–9	Chennevières	LAS?##	?	?	Chennevières 1979, 44
66–10	Chennevières	LAS?##	?	?	Chennevières 1979, 44–45
66–11	David	LAS, 1p	BML	coll M. David	—
66–12	Luquet	LAS?#	BNP (cp)	Yb3.1739 (4o), b 1	—
66–13	Chaudey	LAS, 1p	BNP	Yb3.1739 (4o), b 1	—
66–14	Nieuwerkerke	LAS, 2p	AMNP	P.30 Courbet	Mazauric 1968, 28
66–15	Nieuwerkerke	LAS, 4p	AMNP	P.30 Courbet	Mazauric 1968, 28–29
66–16	Chennevières	LAS, 2p	BAAJDP	carton 10, peintres	Chennevières 1979, 45
66–17	Chennevières	LAS, 3p	BAAJDP	carton 10, peintres	Chennevières 1979, 46
66–18	Nieuwerkerke	LS, 20p	AMNP	P.30 Courbet	Mazauric 1968, 31–36
66–19	family	LAS?#	BNP(c)	Yb3.1739 (4o), b ?	Courthion 1948–50, 2:106 & Riat 1906, 241
66–20	Nieuwerkerke	LS, 8p	AMNP	P.30 Courbet	—
66–21	*Monde illustré*	LAS, 5p	CDLP	Autogr. b 8	*Monde illustré*, 11 VIII 1866
66–22	Castagnary	LAS, 2p	BNP	Yb3.1739 (4o), b 1	—
66–23					
66–24	J. Courbet	LAS, 4p	BNP	Yb3.1739 (4o), b 1	Riat 1906, 242 (e)
66–25	Boudin	LAS?##	?	?	Riat 1906, 244
66–26	Luquet	LAS?#	BNP (cp)	Yb3.1739 (4o), b 1	Riat 1906, 244 (e)
66–27	Weyer	LAS, 2p	pcATB(cf)	—	Bodin cat 21 (1984), no 180
66–28	Chaudey	LAS, 1p	BNP	Yb3.1739 (4o), b 1	—
67–1	Chaudey	LAS?#	ADDB(c)	E familles 2911	—
67–2	Bardenet	LAS?#	BAAJDP(c)	ms 168[9]	Paris 1977, 42 (e)
67–3	dealer	LAS, 2p	FCINP	1991.A	BAGC 9 (1951), 15
67–4	Bruyas	LAS, 3p	BAAJDP	ms 216	Courbet 1913, 496–97
67–5	Chaudey	LAS, 2p	pcUSA	—	Stargard cat 642(1988), no 582

No	Corr	Doc	Coll	Inv	Publ
67–6	Chaudey	LAS, 4p	BNP	Yb3.1739 (4o), b 1	—
67–7	Chaudey	LAS, 5p	BNP	Yb3.1739 (4o), b 1	—
67–8	*Le Hanneton*	LAS, 1p	?	?	*Le Hanneton*, 13 VI 1867 (cf)
67–9	Castagnary	LAS, 4p	BNP	Yb3.1739 (4o), b 1	Mack 1951, 217 (tp)
67–10	Lemoine	LAS, 3p	BNP	Yb3.1739 (4o), b 1	—
67–11	Bruyas	LAS, 4p	BAAJDP	ms 216	Courbet 1913, 497–99
67–12	Bruyas?	LAS?#	BAAJDP(c)	carton 10, peintres	—
67–13	Z. or J. Courbet	LAS, 1p	BAAJDP	carton 10, peintres	—
67–14	Noriac	LS, 1p	BAAJDP	carton 10, peintres	—
67–15	editor	LAS, 1p##	?	?	Saffroy cat 71, no 6870
67–16	Thoré	LAS, 1p##	?	?	BAGC 52 (1974), 13
67–17	Bruyas	LAS, 4p	BAAJDP	ms 216	Courbet 1913, 499–500
67–18	Castagnary	LAS, 1p	BNP	Yb3.1739 (4o), b 1	—
67–19	father	LAS, ?p##	MGCO	—	BAGC 23 (1959), 8
67–20	Gill	LAS, 1p	?	?	*La Lune*, 9 VI 1867 (cf)
67–21	Masson	LAS, 1p	CDLP	Autogr. b 8, 35	—
67–22	Chaudey	LAS, 1p	BNP	Yb3.1739 (4o), b 1	—
67–23	Castagnary	LAS, 2p	BNP	Yb3.1739 (4o), b 1	—
67–24	Castagnary	LAS, 2p	BNP	Yb3.1739 (4o), b 1	—
67–25	sisters	LAS, 4p	UMCP	ARCV-79-4	—
67–26	sisters	LAS, 3p	FCINP		—
67–27	family	LAS, 2p	BAAJDP	carton 10, peintres	—
67–28	Luquet	LAS, 1p	?	?	?
68–1	family	LAS, 4p	UMCP	ARCV-79-4	Riat 1906, 259 (e)
68–2	Dupont	LA?#	BNP (cp)	Yb3.1739 (4o), b 4	Courthion 1948–50, 2:144–45 (e)
68–3	Buchon	LA, 2p	MGCO	ms B28	Fernier 1987, no 15
68–4	family	LAS, 2p	UMCP	ARCV-79-4	—
68–5	Bruyas	LAS, 3p	BAAJDP	ms 216	Courbet 1913, 500–502
68–6	Ordinaire	LA, 3p(d, f)	BNP	Yb3.1739 (4o), b 2	—
68–7	Ordinaire	LA, 2p(d, f)	BNP	Yb3.1739 (4o), b 2	—
68–8	Buchon	LAS, 2p	MGCO	ms B29	Fernier 1987, no 12
68–9	Buchon	LS, 4p	MGCO	ms B30	Fernier 1987, no 13
68–10	Buchon	LS, 4p	MGCO	ms B31	Fernier 1987, no 11
68–11	Buchon	LAS, 4p	MGCO	ms B32	Fernier 1987, no 14
68–12	Castagnary	LAS, 1p	BNP	Yb3.1739 (4o), b 1	—
68–13	Castagnary	LAS, 3p	BNP	Yb3.1739 (4o), b 1	Courthion 1948–50, 2:108–09

No	Corr	Doc	Coll	Inv	Publ
68–14	Baudry	LAS, 2p	BNPMS	N.a.fr. 24019, 74	—
68–15	Vivet	LAS, 1p	BCMNP	ms 310, 202	—
68–16	Chaudey	LAS, 6p	BNP	Yb3.1739 (4o), b 1	Mack 1951, 62–63 (tp)
68–17	Castagnary	LAS, 1p	BNP	Yb3.1739 (4o), b 1	—
68–18	Lacroix	LAS?##	pcJJF	—	BAGC 39 (1968), 7–8
68–19	Bruyas	LAS, 3p	BAAJDP	ms 216	Courbet 1913, 502–03
68–20	Haeghen	LAS, 4p	BRUG	ms 2505, 00404	Hoozee 1986, 86–87
68–21	Castagnary	LAS, 2p	BNP	Yb3.1739 (4o), b 1	Forges 1976, 408–10
68–22	Haeghen	LAS, 4p	BRUG	ms 2505, 00405	Hoozee 1986, 86–87
68–23	Castagnary	LA, 4p(f)	BNP	Yb3.1739 (4o), b 1	Courthion 1948–50, 2:110–13
68–24	Castagnary	LAS, 1p	BNP	Yb3.1739 (4o), b 1	—
68–25	Vermersch	LAS, 1p	CDLP	Autogr. b 8, 35	—
69–1	Castagnary	LAS, 1p	BNP	Yb3.1739 (4o), b 1	—
69–2	family	LAS, 1p	FCINP	1991-A. .	Riat 1906, 265 (p)
69–3	Vivet	LAS, 2p	BAAJDP	carton 10, peintres	—
69–4	Castagnary	LAS, 2p	BNP	Yb3.1739 (4o), b 2	—
69–5	Desavary	LAS, 3p	MGCO	ms D2	BAGC 31 (1964), 15
69–6	Gauchez	LAS, 3p	CDLP	Autogr. b 8, 85	—
69–7	family	LAS, 4p	FCINP	1991-A. .	Riat 1906, 270 (e)
69–8	Castagnary	LAS, 4p	BNP	Yb3.1739 (4o), b 2	Riat 1906, 270 (e)
69–9	Castagnary	LAS, 1p	BNP	Yb3.1739 (4o), b 2	—
69–10	Castagnary	LAS, 4p	BNP	Yb3.1739 (4o), b 2	Courthion 1948–50, 2:113–16
69–11	family	LAS, 3p	BAAJDP	carton 10, peintres	Paris 1977, 45 (e)
69–12	Gaudy	LAS, 2p	FCINP	I.6576	BAGC 6 (1949), 13–14
69–13	family	LAS, 2p	UMCP	ARCV-79-4	—
69–14	Castagnary	LAS, 7p	BNP	Yb3.1739 (4o), b 2	Courthion 1948–50, 2:116–20
70–1	Ilmoëton(?)	LAS, 2p	NSMP	—	—
70–2	Gauchez	LAS, 1p	BAAJDP	carton 10, peintres	—
70–3	Claudet	LAS?##	?	?	Léger 1920, 121–22
70–4	Gauchez	LAS, 3p	BAAJDP	carton 10, peintres	Léger 1929, 149 (e)
70–5	Castagnary	LAS, 4p	BNP	Yb3.1739 (4o), b 2	—
70–6	Gauchez	LAS, 2p	BAAJDP	carton 10, peintres	—
70–7	Gauchez	LAS, 2p	BAAJDP	carton 10, peintres	—
70–8	Gauchez	LAS, 1p	BAAJDP	carton 10, peintres	—
70–9	Rochenoire	LAS?##	?	?	Léger 1929, 151 (e)
70–10	Rochenoire	LAS, 6p	BNP	Yb3.1739 (4o), b 2	—
70–11	J. Courbet	LAS?#	BNP (cp)	Yb3.1739 (4o), b 1	—
70–12	Castagnary	LAS, 1p	BNP	Yb3.1739 (4o), b 2	—
70–13	J. Courbet	LAS, 2p	UMCP	ARCV-79-4	Riat 1906, 276–77 (e)
70–14	Castagnary	LAS, 1p	BNP	Yb3.1739 (4o), b 2	—
70–15	Richard	LAS, 1p##	?	?	BAGC 74 (1985), 47

No	Corr	Doc	Coll	Inv	Publ
70–16	Castagnary?	LAS, 1p	?	?	BAGC 74 (1985), 48 (cf)
70–17	Poret	LAS, 1p	MGCO	ms P20	?
70–18	Castagnary	LAS, 2p	BNP	Yb3.1739 (4o), b 2	—
70–19	Richard	LAS?##	?	?	*Le Siècle*, 21 VI 1870
70–20	family	LAS?##	?	?	Riat 1906, 279 (e)
70–21	family	LAS?#	BNP (cp)	Yb3.1739 (4o), b 7	Riat 1906, 280 (e)
70–22	judge	LAS, 1p	pcAM	—	Stargardt cat 618, 632
70–23	family	LAS, 4p	UMCP	ARCV-79-4	Riat 1906, 282 (e)
70–24	family	LAS?#	BNP (c)	Yb3.1739 (4o), b 7	Lindsay 1973, 248 (e,t)
70–25	family	LAS, 2p	MGCO	ms P21	Léger 1920, 123
70–26	Simon	LS, 3p	ANP	87AP9, 12	—
70–27	government	LS	BNP	Yb3.1739 (4o), b 7	Riat 1906, 286–87 (e)
70–28	Simon	LS, 1p	ANP	87AP9, 12	—
70–29	Ulbach	LAS, 1p	MGCO	ms S4	—
70–30	Simon	LS, 2p	ANP	87AP2	—
70–31	Simon	LS, 3p	ANP	87AP9, 12	—
70–32	government	LAS?##	?	?	*Le Réveil*, 5 X 1870, 2
70–33	Simon	LS, 3p	CDLP	Autogr. b 8, 82	—
70–34	German army	Pam, 15p	APPP	Ba 1020	Pamphlet, Oct. 1870
70–35	Burty	LAS, 1p	BAAJDP	carton 10, peintres	
70–36	Simon	LAS?##	?	?	*Le Rappel*, 1 XII 1870, 2
71–1	Dorian	LAS, 1p	BHVP	ms 3045, 162	—
71–2	Carjat	LS, 3p	APPP	Ba 1020	
71–3	Paris citizens	LAS, 1p	?	?	*L'Autographe* VIII 1871 (cf)
71–4	father	LAS, 4p	UMCP	ARCV-79-4	Riat 1906, 292–93 (e)
71–5	colleagues	LAS?##	?	?	*Le Rappel*, 18 III 1870
71–6	Bernard	LAS, 1p	MGCO	ms B6	—
71–7	Constant	LAS, 1p##	?	?	Abbaye cat 280, no 100
71–8	Paris artists	LAS?##	?	?	*Cri du peuple*, 6 IV 1871
71–9	Paris artists	LAS?##	?	?	*Le Rappel*, 7 IV 1871
71–10	Rigault	LS, 1p	BVP	ms 1131, 226	—
71–11	Rigault	LS, 1p	BVP	ms 1131, 227	—
71–12	*Le Rappel*	LAS?##	?	?	*Le Rappel*, 16 IV 71
71–13	Rogeard	LAS, 2p	MCP	—	—
71–14	Paris citizens	LAS?##	?	?	*Cri du peuple*, 29 IV 1871
71–15	family	LAS, 6p	BNP	Yb3.1739 (4o), b 1	Riat 1906, 301–2 (e)
71–16	*London Times*	LAS?##	?	?	*London Times*, 27 VI 1871 (t)
71–17	Castagnary	LAS, 1p	BNP	Yb3.1739 (4o), b 2	Courthion 1948–50, 2:141

No	Corr	Doc	Coll	Inv	Publ
71–18	family	LAS?#	BNP (c)	Yb3.1739 (4o), b 7	Riat 1906, 311 (e)
71–19	Dorian	LAS, 4p	BHVP	ms 1122, 125–26	—
71–20	Grévy	LA, 4p (d)	BVP	ms 1131, 234–35	—
71–21	Joute	LAS, 2p	BMB	ms 2234, 1–5	BAGC 24 (1959), 3,10 (e)
71–22	Daguet	LAS?##	pcPF?	—	BAGC 4 (1948), 23
71–23	E. Reverdy	LAS?#	BNP (cp)	Yb3.1739 (4o), b 7	Riat 1906, 311
71–24	Bachelin, A.	LAS?##	pcPF?	—	BAGC 4 (1948), 23
71–25	Bachelin, R.	LAS?##	pcPF?	—	BAGC 4 (1948), 23–24
71–26	sisters	LAS, 2p	pcBG	—	Riat 1906, 313 (e)
71–27	Joute	LAS, 4p	FCINP	I.6873	Chu 1988, 53–54
71–28	Bigot	LAS	WCNY	—	*L'Autographe*, 9 IX 1871 (cf)
71–29	J. Courbet	LAS, 4p	BNP	Yb3.1739 (4o), b 1	Riat 1906, 314–15 (e)
71–30	Gatineau	LAS, 4p	pcJJF	—	—
71–31	Lachaud	LAS, 2p	pcAS	—	—
71–32	family	LAS, 3p	FCINP	1991-A. .	Riat 1906, 323–24 (e)
71–33	Gaillard?	LAS?##	LL?	?	BAGC 45 (1971), 34
71–34	Gaillard?	LAS, 1p##	?	?	Charavay cat 787, no 41259 (e)
71–35	Castagnary	LAS, 2p	BNP	Yb3.1739 (4o), b 2	—
71–36	police	LAS, 1p	APPP	Ba 1020	—
71–37	Ste Pélagie	LAS, 1p	MGCO	ms S5	BAGC 31 (1964), 12
71–38	J. Courbet	LAS, 4p	BNP	Yb3.1739 (4o), b 1	Riat 1906, 324 (e)
71–39	L. Joliclerc	LAS?##	?	?	Bauzon 1886, 240
71–40	Castagnary	LAS, 3p	BNP	Yb3.1739 (4o), b 2	Courthion 1948–50, 2:141–42
71–41	unknown	LAS, 1p	APPP	Ba 1020	—
71–42	Lachaud	LAS, 2p	pcAS	—	—
71–43	Dupin	LAS, 1p	FCINP	1991-A. .	—
71–44	Dupin	LAS?##	?	?	Riat 1906, 327 (e)
72–1	Boudin	LAS, 2p	ADRP	—	Cario 1928, 27
72–2	family	LAS, 6p	FCINP	1991-A. .	Riat 1906, 328–29 (e)
72–3	Colonna	LAS?##	?	?	Bessis 1968, 24
72–4	J. Courbet	LAS, 6p	UMCP	ARCV-79-4	Riat 1906, 332–33 (e)
72–5	Joute	LAS, 4p	BMB	ms 2234, 1–5	—
72–6	Gaillard	LAS, 1p##	?	?	Drouot cat, 18 XII 85, no 97 (e)
72–7	Castagnary	LAS, 1p	BNP	Yb3.1739 (4o), b 2	—
72–8	Marchand	LAS, 2p	HRCUTA	—	—
72–9	sisters	LAS, 4p	pcBG	—	Riat 1906, 338 (e)
72–10	family	LAS?#	BNP(c)	Yb3.1739 (4o), b 1	—
72–11	Beauquier	LAS, 4p	BVP	ms 1131, 236–39	*Républ. de l'est*, 9 VI 72
72–12	sisters	LAS, 2p	UMCP	ARCV-79-4	—
72–13	sisters	LAS, 4p	pcAC	—	Léger 1920, 123–24
72–14	E. Reverdy	LAS?#	BNP (p)	Yb3.1739 (4o), b 7	—

No	Corr	Doc	Coll	Inv	Publ
72–15	Castagnary	LAS, 4p	BNP	Yb3.1739 (4o), b 2	—
72–16	sisters	LAS, 3p	UMCP	ARCV-79-4	—
72–17	sisters	LAS, 2p	UMCP	ARCV-79-4	—
72–18	Cornuel	LAS?#	BNP (c)	Yb3.1739 (4o), b 7	BAGC 16 (1954), 19–20
72–19	Cornuel	LAS, 3p	CDLP	Autogr. b 8, 85	Courthion 1948–50, 2:150–51
72–20	unknown	LAS, 1p	BMBSC	Coll. Léon Allègre	—
72–21	Pasteur	LAS, 1p	MGCO	ms P23	—
72–22	Pasteur	LAS?##	?	?	Léger 1948, 146 (e)
72–23	Pasteur	LAS, 2p	MGCO	ms P24	—
72–24	Pasteur	LAS, 4p	MGCO	ms P25	—
73–1	Castagnary	LAS, 4p	BNP	Yb3.1739 (4o), b 2	Courthion 1948–50, 2:151–52
73–2	Z. Reverdy	LAS?##	?	?	Riat 1906, 340 (e)
73–3	L. Joliclerc	LAS?##	?	?	Courbet 1901, 198–99
73–4	Poret	LAS, 1p	MGCO	ms P30	—
73–5	Castagnary	LAS, 4p	BNP	Yb3.1739 (4o), b 2	—
73–6	Castagnary	LS, 2p	BNP	Yb3.1739 (4o), b 2	—
73–7	Castagnary	LAS, 10p	BNP	Yb3.1739 (4o), b 1	—
73–8	Legrand	LAS, 3p	BNP	Yb3.1739 (4o), b 2	—
73–9	Vienna A.U.	LA, 2p(d,t)	BNP	Yb3.1739 (4o), b 2	—
73–10	family	LAS, 3p	UMCP	ARCV-79-4	—
73–11	Castagnary	LAS, 4p	BNP	Yb3.1739 (4o), b 2	—
73–12	Legrand?	LAS, 1p	BCMNP	ms 310, doc. 203	—
73–13	Conway	LAS, 4p	BLCUNY	Conway ms	Conway 1904, 1:251 (t)
73–14	Legrand	LAS, 4p	CDLP	Autogr. b 8, 33	—
73–15	Legrand	LAS, 2p	CDLP	Autogr. b 8, 34	—
73–16	Pasteur	LAS, 2p	?	?	Wartmann 1936, 55 (cf)
73–17	sisters	LAS, 2p	FCINP	1991-A. .	—
73–18	Castagnary	LAS, 2p	BNP	Yb3.1739 (4o), b 2	—
73–19	Legrand	LAS, 4p	CDLP	Autogr. b 8, 35	—
73–20	Pata	LAS, 2p	BAAJDP	ms 237, 86	—
73–21	L. Joliclerc	LAS?##	?	?	Courbet 1901, 199–200
73–22	Bruyas	LAS?#	BAAJDP(c)	carton 10, peintres	Courbet 1913, 503–04
73–23	Castagnary	LAS, 4p	BNP	Yb3.1739 (4o), b 2	Courthion 1948–50, 2:153–54
73–24	Pref. Doubs	LAS?#	BNP (c)	Yb3.1739 (4o), b 2	*Figaro*, 14 IV 73
73–25	Castagnary	LAS, 2p	BNP	Yb3.1739 (4o), b 2	—
73–26	Hollander	LAS?#	BNP (c)	Yb3.1739 (4o), b 2	Leipzig Salon 1, 81
73–27	sisters	LAS, 4p	UMCP	ARCV-79-4	Riat 1906, 343–44 (e)
73–28	Baudry	LAS, 2p	pcMS	—	—
73–29	Pata	LAS, 4p	MGCO	—	BAGC 56 (1976), 15

No	Corr	Doc	Coll	Inv	Publ
73–30	Pata	LAS, 3p	MGCO	ms P27	BAGC 56 (1976), 15
73–31	Castagnary	LAS, 4p	BNP	Yb3.1739 (4o), b 2	—
73–32	Z. Reverdy	LAS?#	BNP (c)	Yb3.1739 (4o), b 2	Riat 1906, 348 (e)
73–33	A. Chopard	LAS?##	?	?	Léger 1929, 181 (e)
73–34	Z. Courbet	LAS, 3p	UMCP	ARCV-79-4	—
73–35	Castagnary	LA, 4p	BNP	Yb3.1739 (4o), b 2	—
73–36	Pref. Doubs	L, 2p	MGCO	ms P28	Léger 1929, 183–84
73–37	sisters	LA, 2p	ADRP	—	—
73–38	Lachaud	LS, 2p	pcAS	—	—
73–39	Blondon	LAS, 1p	MGCO	ms B9	—
73–40	L. Joliclerc	LAS?##	?	?	Bauzon 1886, 241–42
73–41	sisters	LAS, 4p	UMCP	ARCV-79-4	Riat 1906, 350 (e)
73–42	Castagnary	LS, 5p	BNP	Yb3.1739 (4o), b 2	—
73–43	Blondon	LA, 3p	MGCO	ms B8	—
73–44	family	LA, 3p	UMCP	ARCV-79-4	Riat 1906, 351 (e)
73–45	Blondon	LA?#	ADDB(c)	—	—
73–46	Blondon	LA, 1p	MGCO	ms B10	Léger 1920, 124
73–47	Z. Courbet	LAS, 2p	UMCP	ARCV-79-4	Riat 1906, 313 (e)
73–48	father	LAS, 8p	BAAJDP	carton 10, peintres	—
73–49	father	LAS?#	ADDB (c)	E familles 2911	—
73–50	*Gaz de Lausanne*	LS, 4p	MGCO	—	*Gazette de Lausanne,* 27 X 1873
73–51	Castagnary	LAS, 2p	BNP	Yb3.1739 (4o), b 2	—
74–1	Castagnary	LS, 4p	BNP	Yb3.1739 (4o), b 2	—
74–2	Pia	LAS, 3p	BAAJDP	carton 10, peintres	—
74–3	Castagnary	LAS, 4p	BNP	Yb3.1739 (4o), b 2	—
74–4	Pia	LAS, 4p	pcBG	—	—
74–5	Baudry	LAS, 1p	pcMS	—	—
74–6	Duval	LS, 1p	BNP	Yb3.1739 (4o), b 2	La Tour-de-Peilz 1982, 42
74–7	Castagnary	LS, 4p	BNP	Yb3.1739 (4o), b 2	—
74–8	Castagnary	LS, 4p	BNP	Yb3.1739 (4o), b 2	—
74–9	Castagnary	LS, 2p	BNP	Yb3.1739 (4o), b 2	—
74–10	Baudry	LS, 4p	pcMS	—	—
74–11	Pia	LAS, 1p##	?	?	Neuf Muses cat, n.d., no 30 (e)
74–12	*Republ. franç.*	LS, 1p	CDLP	Autogr. b 8, 31	*République française,* ? VI 1874
74–13	Monselet	LS, 2p	BAAJDP	carton 10, peintres	—
74–14	Baudry	LS, 3p	pcMS	—	—
74–15	Castagnary	LS, 2p	BNP	Yb3.1739 (4o), b 2	La Tour-de-Peilz 1982, 43
74–16	Dulon	LAS?##	?	?	BAGC 15 (1955), 13
74–17	Pata	LAS?##	?	?	Léger 1948, 151 (e)
74–18	Granger	LAS, 4p	BMG	N. 1471, réserves	—
74–19	Tallenay	LAS?#	BNP(c)	Yb3.1739 (4o), b 2	Fernier 1965, 14
75–1	J. Courbet	LAS?#	ADDB (cp)	E familles 2911	—

No	Corr	Doc	Coll	Inv	Publ
75–2	Castagnary	LAS, 4p	BNP	Yb3.1739 (4o), b 2	La Tour-de-Peilz 1982, 82 (e)
75–3	Baudry	LAS, 4p	pcMS	—	—
75–4	Castagnary	LAS, 4p	BNP	Yb3.1739 (4o), b 2	—
75–5	Castagnary	LAS, 4p	BNP	Yb3.1739 (4o), b 2	—
75–6	Tour-de-Peilz	LS, 1p	AMLTDP	—	La Tour-de-Peilz 1982, 84 (cf)
75–7	Levrand	LAS, 1p	MGCO	—	Ornans 1988, 47
75–8	sisters	LAS, 4p	pcBG	—	*Le Siècle*, 1 IV 79
75–9	J. Courbet	LAS, 4p	UMCP	ARCV-79-4	*Le Siècle*, 1 IV 79
75–10	Pia	LAS, 2p	MGCO	ms P32	BAGC 65 (1981), 17–19
75–11	Baudry	LS, 4p	pcMS	—	—
75–12	Tour-de-Peilz	LAS, 1p	pcS	—	La Tour-de-Peilz 1982, 41 (cf)
75–13	Baudry	LAS?#	ADDB(c)	—	Léger 1920, 124–27
75–14	Castagnary	LS, 2p	BNP	Yb3.1739 (4o), b 2	—
75–15	Synd. Typogr.	LS, 1p	BPUG	Arch. Synd. Typogr.	La Tour-de-Peilz 1982, 77 (cf)
75–16	Favon	LS, 1p	pcDFR	—	La Tour-de-Peilz 1982, 76
75–17	Baudry	LS, 4p	BNP	Yb3.1739 (4o), b 2	—
76–1	Baudry	LS?#	BNP(c)	Yb3.1739 (4o), b 2	—
76–2	Castagnary	LS, 4p	BNP	Yb3.1739 (4o), b 2	—
76–3	Castagnary	LS, 3p	BNP	Yb3.1739 (4o), b 2	—
76–4	Cluseret	LAS, 2p##	?	?	Drouot cat, 9 IV 68, no 142(e)
76–5	J. Courbet	LAS?##	?	?	*Le Siècle*, 1 IV 79
76–6	J. Courbet	LAS, 8p	pcBG	—	Drouot cat, 10 III 86, no 15 (e)
76–7	Castagnary	LAS, 2p	BNP	Yb3.1739 (4o), b 2	—
76–8	deputies	Pam, 4p	BNP	Yb3.1739 (4o), b 2	Pamphlet, March 1876
76–9	Castagnary	LAS, 2p	BNP	Yb3.1739 (4o), b 2	—
76–10	Castagnary	LAS, 4p	BNP	Yb3.1739 (4o), b 2	—
76–11	Castagnary	LS, 2p	BNP	Yb3.1739 (4o), b 2	—
76–12	Castagnary	LA, 2p	BNP	Yb3.1739 (4o), b 2	—
76–13	Eynard	LAS, 2p	BPUG	?	—
76–14	Montet	LAS, 2p	CDLP	Autogr. b 8, 35	—
76–15	Ruchonnet	LAS, 1p	BCUL	IS 1922, 52.2	Chessex 1975, 53
76–16	Castagnary	LS, 3p	BNP	Yb3.1739 (4o), b 2	—
76–17	father	LAS, 4p	MGCO	—	BAGC 62 (1979), 2
76–18	Pia	LAS, 3p	pcBG	—	—
76–19	Ruchonnet	LAS, 3p	BCUL	IS 1922, 52.2	Chessex 1975, 45
76–20	Ruchonnet	LAS, 4p	BCUL	IS 1922, 52.2	Chessex 1975, 46–47
76–21	Baudry	LAS, 3p	pcMS	—	—
76–22	Castagnary	LAS, 4p	BNP	Yb3.1739 (4o), b 2	—
76–23	Ideville	LAS?##	?	?	*Gazette anecdotique*, IX 1876

No	Corr	Doc	Coll	Inv	Publ
76–24	father	LAS, 2p	pcLN	—	—
76–25	father	LAS, 2p	UMCP	ARCV-79-4	—
76–26	Pia	LAS, 1p	MGCO	?	BAGC 66 (1981), 26–27 (cf)
76–27	Castagnary	LAS, 4p	BNP	Yb3.1739 (4o), b 2	Courthion 1948–50, 170–71 (e)
76–28	Duval or Lachaud	LS, 2p	BNP	Yb3.1739 (4o), b 2	—
76–29	Castagnary	LAS, 2p	BNP	Yb3.1739 (4o), b 2	Courthion 1948–50, 171–72
76–30	Rigolot	LAS, 1p	pcCC	—	Czwiklitzer 1976, n.p. (cf)
76–31	family	LAS, 4p	UMCP	ARCV-79-4	Riat 1906, 368–69 (e)
77–1	Duval	LAS, 4p	FCINP	1991-A. .	—
77–2	Castagnary	LS, 4p	BNP	Yb3.1739 (4o), b 2	—
77–3	father	LAS, 4p	pcBG	—	Riat 1906, 369 (e)
77–4	Castagnary	LS, 2p	BNP	Yb3.1739 (4o), b 2	—
77–5	Beauquier	LS, 3p	BMB	ms 2234, 6–7	BAGC 24 (1959), 9 (e)
77–6	Duval (?)	LA, 4p	FCINP	1991-A. .	—
77–7	Castagnary	LS, 2p	BNP	Yb3.1739 (4o), b 2	—
77–8	Duval	LS, 2p	MGCO	ms D3	—
77–9	Whistler	LAS, 4p	GUL	BPII, C64	Newton 1986, 203
77–10	Castagnary	LS, 3p	BNP	Yb3.1739 (4o), b 2	—
77–11	Mauritz	L, 2p	MGCO	ms M4	Léger 1929, 179, no 1
77–12	Rouberol	LS, 4p	MGCO	ms R9	Léger 1920, 131
77–13	Castagnary	LS, 4p	BNP	Yb3.1739 (4o), b 2	—
77–14	family	LAS?#	BNP (c)	Yb3.1739 (4o), b 7	*Le Siècle*, 1 IV 79 (e)
77–15	Baud-Bovy	LS, 2p	BPUGBB	no 215, 142–43	La Tour-de-Peilz 1982, 37
77–16	Castagnary	LS, 2p	BNP	Yb3.1739 (4o), b 2	—
77–17	J. Courbet	LAS, 4p	UMCP	ARCV-79-4	Riat 1906, 373 (e)
77–18	Cluseret	LS, 1p	MGCO	ms C23	—
77–19	family	LAS, 4p	pcBG	—	—
77–20	J. Courbet	LAS?#	BNP (c)	Yb3.1739 (4o), b 7	*Le Siècle*, 1 IV 79 (e)
77–21	father	LS, 4p	BNP	Yb3.1739 (4o), b 1	—
77–22	Castagnary	LS, 6p	BNP	Yb3.1739 (4o), b 2	Courthion 1948–50, 2:174–78
77–23	Castagnary	L, 2p	BNP	Yb3.1739 (4o), b 2	—
77–24	Castagnary	LS, 5p	BNP	Yb3.1739 (4o), b 2	Courthion 1948–50, 2:178 (e)
77–25	Fumey	LS, 4p	MGCO	ms F6	BAGC 62 (1979), 3–4
77–26	Collin	LS?##	?	?	Lemonnier 1988, 82–83 (e)
77–27	family	L, 1 p	BNP	Yb3.1739 (4o), b 1	Riat 1906, 378

UNDATED LETTERS

ND-1	Octavie	LAS, 1p##	?	?	Abbaye cat 280, 99 (e)
ND-2	Odette	LAS, 2p##	?	?	Argonauts cat 11, no 29 (e)
ND-3	Luquet	LAS?#	BNP (c)	Yb3.1739 (4o), b 1	—
ND-4	Monet	LAS, 1p##	?	?	Sotheby cat 17 IX 88, no 186 (e)
ND-5	Joute	LAS?##	?	?	Léger 1948, 53 (e)
ND-6	Villain	LAS?#	BAAJDP (c)	carton 10, peintres	—

References

Abe 1962
 Abe, Y. "Un *Enterrement à Ornans* et l'habit noir baudelairien." *Etudes de langue et littérature françaises (Bulletin de la Société japonaise de langue et littérature françaises)* 1 (1962): 29–41.

Académie royale des sciences, des lettres et des beaux-arts de Belgique 1866–1982
 Biographie nationale publiée par l'Académie royale des sciences, des lettres et des beaux-arts de Belgique. 42 vols. Brussels, 1866–1982.

Adhémar 1977
 Adhémar, Jean. "Deux notes sur des tableaux de Courbet." *Gazette des beaux-arts*, 6th ser., 90 (1977): 200–4.

Adriance 1987
 Adriance, Thomas J. *The Last Gaiter Button*. New York/Westport, Conn./London, 1987.

Agulhon 1979
 Agulhon, Maurice. *Marianne au combat: L'Imagerie et la symbolique républicaine de 1789 à 1880*. Paris, 1979.

Alexander 1965
 Alexander, Robert L. "Courbet and Assyrian Sculpture." *Art Bulletin* 47 (1965): 447–52.

Aragon 1952
 Aragon, Louis. *L'Exemple de Courbet*. Paris, 1952.

Audin and Vial 1918
 Audin, M., and Vial, E. *Dictionnaire des artistes et ouvriers d'art du Lyonnais*. Paris, 1918.

Auer 1985
 Auer, Michèle, and Auer, Michel. *Photographers Encyclopedia International*. 2 vols. Geneva, 1985.

BAGC
 Bulletin [de la Société] des amis de Gustave Courbet. Paris/Ornans, 1947-.

Baillods 1940
 Baillods, Jules. *Courbet vivant*. Neuchâtel, 1940.

Balteau et al. 1933–
 Balteau, J.; Barroux, M.; Prevost, M.; et al., eds. *Dictionnaire de biographie française*. Paris, 1933–.

Baltimore 1938
 Baltimore, Museum of Art. *An Exhibition of Paintings by Courbet*. 1938.

Baudry 1868
 Baudry, Etienne. *Le Camp des bourgeois*. Paris, 1868. [With illustrations by Courbet.]

Bauzon 1886
 Bauzon, Louis. "Documents inédits sur Courbet." *L'Art* 40 (1886): 237–42.

Beecher and Bienvenu 1972
 Beecher, Jonathan, and Bienvenu, Richard. *The Utopian Vision of Charles Fourier*. Boston, 1972.

Bénédite [1911] 1913
 Bénédite, Léonce. *Courbet*. Paris, [1911]. Translated into English as *Gustave Courbet*. Philadelphia/London, 1913.

References

Bénézit 1966

 Bénézit, E., ed. *Dictionnaire critique et documentaire des peintres, sculpteurs, dessinateurs et graveurs.* 8 vols. Reprint. Paris, 1966.

Beraldi 1885–92

 Beraldi, Henri. *Les Graveurs du XIX*ᵉ *siècle.* 12 vols. Paris, 1885–92.

Berger 1943

 Berger, Klaus. "Courbet in His Century." *Gazette des beaux-arts* 24 (1943): 19–40.

Bergerat 1871

 Bergerat, Emile. *Sauvons Courbet.* Paris, 1871.

Besançon 1952

 Besançon, Musée des beaux-arts. *Exposition Gustave Courbet, 1819–1877.* 1952.

Bessis 1968

 Bessis, Henriette. "Courbet pendant la Commune: Une Lettre inédite du peintre à la duchesse Colonna." *L'Oeil* 157 (January 1968): 24.

Bessis 1981

 Bessis, Henriette. "Courbet en Suisse surveillé par la police française." *Gazette des beaux-arts*, 6th ser., 98 (1981): 115–26.

Beuter, 1988

 Beuter, Christian; Schuster, Peter Klaus; and Warnkel, Martin, eds. *Kunst um 1800 und die Folgen: Werner Hofmann zu Ehren.* Munich, ca. 1988.

Boas 1938

 Boas, George, ed. *Courbet and the Naturalistic Movement.* Baltimore, 1938.

Boime 1971

 Boime, Albert. "The Second Republic's Contest for the Figure of the Republic." *Art Bulletin* 53 (1971): 68–83.

Bonniot 1972

 Bonniot, Roger. "Victor Hugo et Gustave Courbet: Un Projet de portrait abandonné." *Gazette des beaux-arts*, 6th ser., 80 (1972): 241–48.

Bonniot 1973

 Bonniot, Roger. *Gustave Courbet en Saintonge.* Paris, 1973.

Borel 1922

 Borel, Pierre, ed. *Le Roman de Gustave Courbet, d'après une correspondance originale du grand peintre.* Paris, 1922.

Borel 1951

 Borel, Pierre, ed. *Lettres de Gustave Courbet à Alfred Bruyas.* Geneva, 1951.

Boudaille 1969

 Boudaille, Georges. *Gustave Courbet, Painter in Protest.* Greenwich, Conn., 1969.

Boudry 1951

 Boudry, Robert. "Courbet et la Fédération des artistes." *Europe* 29 (April–May 1951): 123–128.

Bourgin and Henriot 1924–45

 Bourgin, Georges, and Henriot, Gabriel. *Procès-verbaux de la Commune de 1871.* 2 vols. Paris, 1924–45.

Bouvier 1913

 Bouvier, Emile. *La Bataille réaliste.* Paris, 1913.

Bowness 1972

 Bowness, Alan. *Courbet's "Atelier du peintre."* Newcastle upon Tyne, 1972. (Reprinted in Chu 1977.)

Bowness 1977
> Bowness, Alan. "Courbet and Baudelaire." *Gazette des beaux-arts*, 6th ser., 90 (1977): 189–99.

Bowness 1978
> Bowness, Alan. "Courbet's Proudhon." *Burlington Magazine* 120 (1978): 123–29.

Briais 1981
> Briais, Bernard. *Grandes Courtisanes du Second Empire*. Paris, 1981.

Brooklyn 1988
> Brooklyn Museum. *Courbet Reconsidered*. 1988. (Also shown in the Minneapolis Institute of Arts. 1989.)

Brun [1905] 1967
> Brun, Carl, ed. *Schweizerisches Künstler-Lexikon*. 1905. Reprint. Neudeln, Liechtenstein, 1967.

Brune 1912
> Brune, Paul. *Dictionnaire des artistes et des ouvriers d'art de la France: Franche-Comté*. Paris, 1912.

Brunesoeur 1866
> Brunesoeur, René. *Muséum contemporain: Gustave Courbet*. Paris, 1866.

Bruno 1872
> Bruno, Jean [Jean Vaucheret]. *Les Misères des gueux*. Brussels, 1872.

Bruyas 1854
> Bruyas, Alfred. *Explication des ouvrages de peinture du cabinet de M. Alfred Bruyas*. Paris, 1854.

Bruyas 1856
> Bruyas, Alfred. *Recueil de lettres*. Montpellier, 1856.

Buchon 1839
> Buchon, Max. *Essais poétiques*. Besançon, 1839.

Buchon 1856
> Buchon, Max. *Recueil de dissertations sur le réalisme*. Neuchâtel, 1856.

Bulletin des amis de Gustave Courbet. See *BAGC*.

Cario 1928
> Cario, Louis. *Eugène Boudin*. Paris, 1928.

Castagnary 1864
> Castagnary, Jules. *Les Libres Propos*. Paris, 1864

Castagnary 1883
> Castagnary, Jules. *Gustave Courbet et la Colonne Vendôme: Plaidoyer pour un ami mort*. Paris, 1883.

Castagnary 1911–12
> Castagnary, Jules. "Fragments d'un livre sur Courbet." *Gazette des beaux-arts*, 4th ser., 5 (1911): 1–20; 6 (1911): 488–97; 7 (1912): 19–30. (Partially translated and reprinted in Chu 1977.)

Chadbourne 1977
> Chadbourne, Richard M. *Charles-Augustin Sainte-Beuve*. Boston, 1977.

Champfleury 1856
> Champfleury [Jules-François-Félix Husson]. *Les Demoiselles Tourangeau*. Paris, 1856.

Champfleury 1857
> Champfleury [Jules-François-Félix Husson]. *Le Réalisme*. Paris, 1857.

References

Champfleury 1859

Champfleury [Jules-François-Félix Husson]. *Les amis de la nature*. Paris, 1859. [With frontispiece by Courbet.]

Champfleury 1860

Champfleury [Jules-François-Félix Husson]. *Chansons populaires des provinces de France*. Paris, 1860. [With illustrations by Courbet.]

Champfleury 1861

Champfleury [Jules-François-Félix Husson]. *Grandes Figures d'hier et d'aujourd'hui*. Paris, 1861.

Champfleury 1872

Champfleury [Jules-François-Félix Husson]. *Souvenirs et portraits de jeunesse*. Paris, 1872.

Champfleury 1913/19

Champfleury [Jules-François-Félix Husson]. "Lettres inédites de Champfleury au poète franc-comtois Max Buchon." *La Revue* 105 (1913): 39–49, 213–30; 133 (1919): 531–45, 701–10.

Chamson 1955

Chamson, André. *Gustave Courbet*. Paris, 1955.

Chennevières [1883–89] 1979

Chennevierès-Pointel, Philippe, marquis de. *Souvenirs d'un directeur des beaux-arts*. Paris, 1883–89. Reprint. Paris, 1979.

Chessex 1975

Chessex, Pierre. "Gustave Courbet et la vie artistique en Suisse Romande (1873–1877)." *Etudes de lettres*, 3d ser., 8 (1975): 37–53.

Chirico 1925

Chirico, Giorgio de. *Gustave Courbet*. Rome, 1925.

Choury 1969

Choury, Maurice. *Bonjour, Monsieur Courbet!* Paris, 1969.

Chu 1977

Chu, Petra ten-Doesschate, ed. *Courbet in Perspective*. Englewood Cliffs, N.J., 1977.

Chu 1980a

Chu, Petra ten-Doesschate. "Courbet's Unpainted Pictures." *Arts Magazine* 55 (September 1980): 134–41.

Chu 1980b

Chu, Petra ten-Doesschate. "Gustave Courbet: Illustrator." *Drawing* 2 (November-December 1980): 78–85.

Chu 1988

Chu, Petra ten-Doesschate. "Lettres de Gustave Courbet appartenant à la Fondation Custodia." *Archives de l'art français*, n.s., 29 (1988): 45–55.

Claretie 1882

Claretie, J. *Courbet*. Paris, 1882.

Clark 1969

Clark, Timothy J. "A Bourgeois Dance of Death." *Burlington Magazine* 111 (1969): 208–12, 286–90.

Clark 1973

Clark, Timothy J. *Image of the People: Gustave Courbet and the Second French Republic, 1848–1851*. Greenwich, Conn., 1973.

Claudet 1878

Claudet, Max. *Souvenirs, Gustave Courbet*. Paris, 1878.

Clouard 1891
 Clouard, Maurice. *L'Oeuvre de Champfleury*. Paris, 1891.

Conway 1904
 Conway, Moncure D. *The Autobiography of Moncure D. Conway*. 2 vols. Boston/New York, 1904.

Courbet 1856
 Courbet, Gustave. *Autographes sur l'exposé du tableau "La Rencontre" (de G. Courbet): Salon 1855*. Paris, 1856.

Courbet 1868a
 Les Curés en goguette. Brussels, 1868. [With illustrations by Courbet.]

Courbet 1868b
 La Mort de Jeannot: Les frais du culte. Brussels, 1868. [With illustrations by Courbet.]

Courbet 1870
 Courbet, Gustave. *Lettres à l'armée allemande et aux artistes allemands, lues à l'Athénée, dans la séance du 29 octobre 1870*. Paris, 1870.

Courbet 1901
 "Deux lettres inédites de Courbet." *La Nouvelle Revue* 10 (May-June 1901): 198–200.

Courbet 1913
 "Lettres inédites à Bruyas, de Courbet et de sa famille." *L'Olivier*, September-October 1913.

Courbet 1931
 "Documents inédits sur Gustave Courbet." *L'Amour de l'art*, 12ᶜ année, 10 (October 1931): 383–91.

Courthion 1931
 Courthion, Pierre. *Courbet*. Paris, 1931.

Courthion 1948–1950
 Courthion, Pierre, ed. *Courbet raconté par lui-même et par ses amis*. 2 vols. Geneva, 1948–50.

Courthion 1985
 Courthion, Pierre. *L'opera completa di Courbet*. Milan, 1985.

Crapo 1990
 Crapo, Paul B. "Courbet, La Rochenoire et les réformes du Salon en 1870." *Bulletin des amis de Gustave Courbet* 84 (1990): n.p.

Crapo 1991
 Crapo, Paul B. "Disjuncture on the Left: Proudhon, Courbet, and the Antwerp Congress of 1861." *Art History* 14 (1991): 67–91.

Crapo 1992
 Crapo, Paul B. "Gustave Courbet and Reform of the Fine Arts under the Government of National Defense: Five Letters of the Artist to Jules Simon." *Gazette des beaux-arts*, forthcoming (1992)

Crépet 1947–53
 Crépet, Jacques and Claude Pichois. *Correspondance générale de Baudelaire*. 6 vols. Paris, 1947–53.

Dantès 1971
 Dantès, Alfred. *La Franche-Comté littéraire, scientifique, artistique*. Geneva, 1971.

Daniel 1991
 Daniel, Malcolm Ries. "The Photographic Railway Albums of Edouard-Denis Baldus." Ph.D. diss., Princeton University, 1991.

References

Darcel 1870

 Darcel, Alfred. "Les Musées, les arts et les artistes pendant le siège de Paris." *Gazette des beaux-arts*, 2d ser., 4 (1871): 285–306, 414–429; 5 (1872): 41–65.

Delacroix 1972

 Delacroix, Eugène. *The Journal of Eugène Delacroix*. Translated by Walter Pach. New York, 1972.

Delestre 1960

 Delestre, G. "Courbet à l'exposition universelle de Besançon en 1860." *Bulletin des amis de Gustave Courbet* 26 (1960): 5–15.

Delvau 1862

 Delvau, Alfred. *Histoire anecdotique des cafés et cabarets de Paris*. Paris, 1862.

Desnoyers 1856

 Desnoyers, Fernand. *Le Bras noir*. Paris, 1856. [With illustration by Courbet.]

Droz 1910

 Droz, Edouard. "Pierre-Joseph Proudhon: Lettres inédites à Gustave Chaudey et à divers Comtois, suivies de quelques fragments inédits de Proudhon et d'une lettre de Gustave Courbet sur la mort de Proudhon." *Bulletin de la Société d'émulation du Doubs*, 8th ser., 5 (1910): 255–57.

Dubief 1960

 Dubief, H. "Défense de Courbet par lui-même." *L'Actualité de l'histoire* 30 (January-March 1960): 27–37.

Dufay 1931

 Dufay, Pierre. *Autour de Baudelaire*. Paris, 1931.

Dumesnil 1945

 Dumesnil, René. *L'Epoque réaliste et naturaliste*. Paris, 1945.

Duranty 1856

 Duranty, Edmond. *Le Réalisme*. Paris, 1856.

Durbé 1969

 Durbé, Dario. *Courbet e il realismo francese*. Milan, 1969.

Duret 1867

 Duret, Théodore. *Les Peintres français en 1867*. Paris, 1867.

Duret 1908

 Duret, Théodore. "Courbet graveur et illustrateur." *Gazette des beaux-arts*, 3d ser., 39 (1908): 421–32.

Duret 1918

 Duret, Théodore. *Courbet*. Paris, 1918.

Echard 1985

 Echard, William E., ed. *Historical Dictionary of the French Second Empire, 1852–1870*. Westport, Conn., 1985.

Edelson 1988

 Edelson, Douglas E. "Patronage and Criticism of Courbet and Manet in Nineteenth-Century America." M.A. thesis, Queens College, City University of New York, 1988.

Edwards 1988

 Edwards, Gary. *International Guide to Nineteenth-Century Photographers and their Works*. Boston, ca. 1988.

Estignard 1896

 Estignard, A. *G. Courbet, sa vie et ses oeuvres*. Besançon, 1896.

Fermigier 1971

 Fermigier, André. *Courbet, étude biographique et critique*. Geneva, 1971.

Fernier 1987
 Fernier, Jean-Jacques. *Gustave Courbet, correspondance*. Ornans, 1987.
Fernier 1951
 Fernier, Robert. "Courbet avait un fils." *Bulletin des amis de Gustave Courbet* 10 (1951): 1–7.
Fernier 1968
 Fernier, Robert. "Courbet éditeur." *Bulletin des amis de Gustave Courbet* 39 (1968): 6–8.
Fernier 1969
 Fernier, Robert. *Gustave Courbet, peintre de l'art vivant*. Paris, 1969. Translated into English as *Gustave Courbet*. New York, 1969.
Fernier 1970
 Fernier, Robert. "Un Ami de Courbet: Charles Pouchon, le peintre-vigneron." *Bulletin des amis de Gustave Courbet* 43 (1970): 8–11.
Fernier 1977–78
 Fernier, Robert. *Courbet*. 2 vols. Paris, 1977–78.
Fohlen 1965
 Fohlen, Claude, ed. *Histoire de Besançon*. 2 vols. Paris, 1965.
Fontainas 1927
 Fontainas, André. *Courbet*. Paris, 1927.
Forges 1976
 Forges, Marie-Thérèse. "Un Nouveau Tableau de Courbet au Musée des beaux-arts de Caen." *Revue du Louvre* 26 (1976): 408–10.
Fosca 1940
 Fosca, François. *Courbet*. Paris, 1940.
Fourquet 1929
 Fourquet, Emile. *Les Hommes célèbres et les personnalités marquantes de Franche-Comté*. Besançon, 1929.
Frey 1940
 Frey, Hugo. *Max Buchon et son oeuvre*. Besançon, 1940.
Fribourg 1980
 Fribourg, Musée d'art et d'histoire. *Marcello (1836–1879)*. 1980.
Fried 1990
 Fried, Michael. *Courbet's Realism*. Chicago, 1990.
Gautier 1940
 [Gautier, Amand]. "Lettres du peintre Amand Gautier à son ami le Dr. P. F. Gachet." Auvers, 1940. Typescript.
Gazier 1906
 Gazier, Georges. *Gustave Courbet, l'homme et l'oeuvre*. Besançon, 1906.
Gläser 1928
 Gläser, Curt. "Courbet und Bruyas." *Kunst und Künstler* 27, no. 3 (1928): 87–92.
Goncourt 1969
 Goncourt, Edmond de. *Paris under Siege, 1870–1871: From the Goncourt Journal*. Edited and translated by George J. Becker. Ithaca, N. Y., 1969.
Graber 1943
 Graber, Hans. *Camille Pisarro, Alfred Sisley, Claude Monet, nach eigenen und fremden Zeugnissen*. Basel, 1943.
Grimmer 1951
 Grimmer, Georges. "Courbet et Chenavard." *Bulletin des amis de Gustave Courbet* 9 (1951): 1–9.

References

Grimmer 1956
 Grimmer, Georges. "Zoé Courbet." *Bulletin des Amis de Gustave Courbet* 17/18 (1956): 1–27.
Gros-Kost 1880
 Gros-Kost, Emile. *Courbet: Souvenirs intimes*. Paris, 1880.
Guichard 1862
 Guichard, M. *Les Doctrines de M. Courbet, maître peintre*. Paris, 1862.
Haddad 1988
 Haddad, Michèle. *Courbet et le milieu littéraire de son temps*. D.E.A. thesis, Université de Paris IV, 1988.
Haedeke 1980
 Haedeke, Marion. *Alfred Bruyas: Kunstgeschichtliche Studie zum Mäzenatentum im 19. Jahrhundert*. European University Studies, ser. 28, vol. 14. Frankfurt, 1980.
Hamburg 1978
 Hamburg, Kunsthalle. *Courbet und Deutschland*. 1978. (Also shown in Frankfurt, Städelsches Kunstinstitut. 1979.)
Herding 1977
 Herding, Klaus. "*Les Lutteurs détestables:* Stil-und Gesellschaftskritik in Courbet's Ringerbild." *Jahrbuch der Hamburger Kunstsammlungen* 22 (1977): 137–74.
Herding 1978
 Herding, Klaus. *Realismus als Widerspruch: die Wirklichkeit in Courbets Malerei*. Frankfurt, 1978.
Hoozee 1986
 Hoozee, R. "Gustave Courbet op het Gentse Salon van 1868." In *De wagenmenner en andere verhalen: Album Discipulorum Prof. Dr. M. De Maeyer*, ed. C. van Damme and P. Van Calster, 82–89. Ghent, 1986.
Howard [1961] 1979
 Howard, Michael. *The Franco-Prussian War*. 1961. Reprint. New York, 1979.
Howarth 1961
 Howarth, T. E. B. *Citizen-King: The Life of Louis-Philippe, King of the French*. London, 1961.
Huyghe et al. 1944
 Huyghe, René; Bazin, Germain; and Adhémar, Hélène. *Courbet: "L'Atelier du peintre, allégorie réelle," 1855*. Tours, 1944.
Ideville 1878a
 Ideville, Henry d'. *Notes et documents sur la vie et l'oeuvre de Courbet*. 1878.
Ideville 1878b
 Ideville, Henry d'. *Vieilles Maisons et jeunes souvenirs*. Paris, 1878.
Jean-Aubry 1968
 Jean-Aubry, G. *E. Boudin*. Neuchâtel, 1968.
Jeanneret 1872
 Jeanneret, Georges. *Paris pendant la Commune révolutionnaire de 71*. Neuchâtel, 1872. Reprint, Paris, 1968.
Joughin 1955
 Joughin, Jean T. *The Paris Commune in French Politics, 1871–1880*. 2 vols. Baltimore, 1955.
Kahn 1927
 Kahn, Gustave. *Courbet*. Paris, 1927.

Kaschnitz 1949
 Kaschnitz, Marie-Louise. *Gustave Courbet*. Baden-Baden, 1949.
Kotalik 1950
 Kotalik, Jiri. *Courbet*. Prague, 1950.
Koumans 1930
 Koumans, M. M. C. *La Hollande et les hollandais au XIX^e siècle vus par les français*.
 Maastricht, 1930.
Kranzberg 1950
 Kranzberg, Melvin. *The Siege of Paris, 1870–71*. Ithaca, N.Y., 1950.
Labracherie 1967
 Labracherie, Pierre. *La Vie quotidienne de la bohème littéraire au XIX^e siècle*. Paris, 1967.
Lagrange 1861
 Lagrange, Léon. "Des sociétés des amis des arts en France." *Gazette des beaux-arts*, 1st
 ser., 9 (1861): 291–301; 10 (1861): 29–47, 102–117, 158–168, 227–242.
Larkin 1939
 Larkin, O. "Courbet and His Contemporaries, 1848–1867." *Science and Society* 3
 (1939): 42–63.
Larousse XIX
 Pierre Larousse, ed., *Grand Dictionnaire universel du XIXxe siècle*. Paris, 1865–76.
La Rue 1878
 La Rue, Jean [Jules Vallès]. "Courbet et enterrement de Courbet." *Le Réveil*, 6/7 Janu-
 ary, 1878.
La Tour-de-Peilz 1950
 La Tour-de-Peilz, Musée Jenisch. *Gustave Courbet*. 1950.
La Tour-de-Peilz 1982
 La Tour-de-Peilz, Château. *Courbet et la Suisse*. 1982.
Lazar 1911
 Lazar, Béla. *Courbet et son influence à l'étranger*. Paris, 1911.
Léger 1910
 Léger, Charles. *Au pays de Gustave Courbet*. Meudon, 1910.
Léger 1920
 Léger, Charles. *Courbet selon les caricatures et les images*. Paris, 1920.
Léger 1921
 Léger, Charles. "Courbet et Victor Hugo, d'après des lettres inédites." *Gazette des beaux-
 arts*, 5th ser., 4 (1921): 353–63.
Léger 1925
 Léger, Charles. *Courbet*. Paris, 1925.
Léger 1929
 Léger, Charles. *Courbet*. Paris, 1929.
Léger 1934
 Léger, Charles. *Courbet*. Paris, 1934.
Léger 1947
 Léger, Charles. "Les Chansons de Courbet." *Arts*, 24 September, 1947, 1ff.
Léger 1948
 Léger, Charles. *Courbet et son temps*. Paris, 1948.
Lemonnier 1878
 Lemonnier, Camille. *G. Courbet et son oeuvre*. Paris, 1878.
Lenôtre 1984
 Lenôtre, G. *Le Château de Rambouillet: Six Siècles d'histoire*. Paris, ca. 1984.

References

Levine 1980
 Levine, Stephen Z. "Gustave Courbet in His Landscape." *Arts* 54 (1980): 67–69.
Lindsay 1973
 Lindsay, Jack. *Gustave Courbet, His Life and Art*. Bath, 1973.
Lyon 1954
 Lyon, Musée des beaux-arts. *Courbet*. 1954.
Lyonnet 1969
 Lyonnet, Henry. *Dictionnaire des comédiens français*. 1902–8. Reprint. Geneva, 1969.
Maass 1973
 Maass, John. *The Glorious Enterprise: The Centennial Exhibition of 1876 and H. J. Schwarzmann, Architect-in-Chief*. New York, 1973.
McCarthy 1975
 McCarthy, James C. "Courbet's Ideological Contradictions and the *Burial at Ornans*." *Art Journal* 35 (1975): 12–16.
MacDonald and Newton 1986
 MacDonald, Margaret, and Newton, Joy. "Letters from the Whistler Collection (University of Glasgow): Correspondence with French Painters." *Gazette des beaux-arts*, 6th ser., 108 (December 1986): 201–214.
Mack 1951
 Mack, Gerstle. *Gustave Courbet*. New York, 1951.
MacOrlan 1951
 MacOrlan, Pierre. *Courbet*. Paris, 1951.
McWilliam 1983
 McWilliam, Neil. "'Un enterrement à Paris': Courbet's Political Contacts in 1845." *Burlington Magazine* 125 (1983): 155–57.
Magelhaes and Roosens
 Magelhaes, Claude, and Roosens, Laurent. *De fotokunst in België. 1839–1940*. Deurne/Antwerp, 1970.
Mainardi 1979
 Mainardi, Patricia. "Gustave Courbet's Second Scandal: *Les Demoiselles de Village*." *Arts Magazine* 53 (January 1979): 95–102.
Mainardi 1987
 Mainardi, Patricia. *Art and Politics of the Second Empire*. London/New Haven, 1987.
Mainzer 1982
 Mainzer, C. R. "Gustave Courbet, Franc-Comtois: The Early History Paintings, 1848–50." Ph.D. diss., Ohio State University, 1982.
Maitron 1964–66
 Maitron, Jean, ed. *Dictionnaire biographique du mouvement ouvrier français, 1789–1864*. 3 vols. Paris, 1964–66.
Maitron and Egrot 1967–71
 Maitron, Jean, and Egrot, M. *Dictionnaire biographique du mouvement ouvrier français, 1864–1871*. 5 vols. Paris, 1967–71.
Malvano 1966
 Malvano, Laura. *Courbet*. Milan/Paris, 1966.
Mason 1967
 Mason, Edward S. *The Paris Commune: An Episode in the History of the Socialist Movement*. New York, 1967.
Mayaud 1979
 Mayaud, Jean-Luc. "Des notables ruraux du XVIIIᵉ au XIXᵉ siècle en Franche-Comté:

La Famille de Gustave Courbet." *Mémoires de la Société d'émulation du Doubs*, n.s., 21 (1979): 15–28.

Mayaud 1986
Mayaud, Jean-Luc. *Les Secondes Républiques du Doubs*. Paris, 1986.

Mazauric 1968
Mazauric, Lucie Chamson. "Comment on perd un tableau." *Revue du Louvre* 18 (1968): 27–36.

Meier-Graefe 1921
Meier-Graefe, Julius. *Courbet*. Munich, 1921.

Michaud 1966–1970
Michaud. *Biographie universelle ancienne et moderne*. 45 vols. New ed. Paris, 1966–70.

Michelin-Jura 1985
Michelin guide de tourisme: Jura-Franche Comté. Paris, 1985.

Mirecourt 1870
Mirecourt, Eugène de. *Les Contemporains: Champfleury, Courbet*. Paris, 1870.

Molhuysen et al. 1911–37
Molhuysen, P. C.; Blok, P. J.; and Kossmann, Fr. K. H., eds. *Nieuw Nederlandsch biografisch woordenboek*. 10 vols. Leiden, 1911–37.

Montpellier 1985
Montpellier, Musée Fabre. *Courbet à Montpellier*. 1985.

Muther 1909
Muther, Richard. *Courbet*. Berlin, 1909.

Naef 1947
Naef, Hans. *Courbet*. Bern, 1947.

New York 1919
New York, Metropolitan Museum of Art. *Loan Exhibition of the Works of Gustave Courbet*. 1919.

Nicolson 1953
Nicolson, Benedict. "Courbet at the Marlborough Gallery." *Burlington Magazine* 95 (1953): 246–49.

Nicolson 1962
Nicolson, Benedict. "Courbet's *L'Aumône d'un mendiant*." *Burlington Magazine* 114 (1962): 73–74.

Nicolson 1973
Nicolson, Benedict. *Courbet: "The Studio of the Painter."* London, 1973.

Nochlin 1965
Nochlin, Linda. "Innovation and Tradition in Courbet's *Burial at Ornans*." In *Essays in Honor of Walter Friedländer*, 119–26. New York, 1965.

Nochlin 1966
Nochlin, Linda. *Realism and Tradition in Art, 1848–1900*. Englewood Cliffs, N.J., 1966.

Nochlin 1967
Nochlin, Linda. "Gustave Courbet's *Meeting*: A Portrait of the Artist as a Wandering Jew." *Art Bulletin* 49 (1967): 209–22.

Nochlin 1971
Nochlin, Linda. "Gustave Courbet's *Toilette de la mariée*." *Art Quarterly* 34 (1971): 30–54.

Nochlin 1976
Nochlin, Linda. *The Development and Nature of Realism in the Work of Gustave Courbet: A Study of the Style and Its Social and Artistic Background*. New York, 1976.

References

Ornans 1962
 Ornans, Hôtel de ville. *Gustave Courbet*. 1962.
Ornans 1981
 Ornans, Musée Gustave Courbet. *Ornans à l'enterrement*. 1981.
Ornans 1988
 Ornans, Musée Gustave Courbet. *Cherubino Pata (1827–1899)*. 1988.
Paris 1855
 Paris, Pavillon du Réalisme. *Exhibition et vente de 40 tableaux et 4 dessins de M. Gustave Courbet*. 1855.
Paris 1867
 Paris. Pavillon du Rond-Point de l'Alma. *Catalogue des oeuvres de Gustave Courbet exposées au Rond-Point de l'Alma*. 1867.
Paris 1882
 Paris, Ecole des beaux-arts. *Exposition des oeuvres de G. Courbet*. 1882.
Paris 1917
 Paris, Galerie Bernheim jeune. *Exposition Courbet*. 1917.
Paris 1929
 Paris, Petit palais. *Gustave Courbet*. 1929.
Paris 1949
 Paris, Galerie Alfred Daber. *Gustave Courbet: Exposition du 130ᵉ anniversaire de sa naissance*. 1949.
Paris 1955
 Paris, Palais des beaux-arts. *G. Courbet*. 1955.
Paris 1966
 Paris, Galerie Claude Aubry. *Courbet dans les collections privées françaises*. 1966.
Paris 1973
 Paris, Musée du Louvre. *Autoportraits de Courbet*. 1973.
Paris 1974
 Paris, Grand palais. *Le Musée du Luxembourg*. 1974.
Paris 1977
 Paris, Grand palais. *Gustave Courbet (1819–1877)*. 1977–78. (Also shown in London, Royal Academy. 1978.)
Philadelphia 1959
 Philadelphia, Museum of Art. *Gustave Courbet, 1819–1877*. 1959.
Pierrard 1968
 Pierrard, Pierre. *Dictionnaire de la IIIᵉ République*. Paris, 1968.
Prinet 1966
 Prinet, Jean, and Dilasser, Antoinette. *Nadar*. Paris, 1966.
Proudhon 1865
 Proudhon, Pierre-Joseph. *Du principe de l'art et de sa destination sociale*. Paris, 1865.
Riat 1906
 Riat, Georges. *Gustave Courbet*. Paris, 1906.
Rome 1969
 Rome, Villa Medici. *Gustave Courbet*. 1969.
Rougerie 1964
 Rougerie, Jacques. *Procès des Communards*. Paris, 1964.
Rubin 1980
 Rubin, James. *Realism and Social Vision in Courbet and Proudhon*. Princeton, N.J., 1980.

Salvisberg 1884
Salvisberg, Paul. *Courbet und der Moderne Impressionnismus in der Französischen Malerei*. Stuttgart, 1884.

Schanne 1886
Schanne, A. *Souvenirs de Schaunard*. Paris, 1886.

Schapiro 1941
Schapiro, Meyer. "Courbet and Popular Imagery: An Essay on Realism and Naïveté." *Journal of the Warburg and Courtauld Institutes* 4 (1941): 164–91.

Scharf 1974
Scharf, Aaron. *Art and Photography*. London, 1974.

Schmidt 1946
Schmidt, Georg. "Eine unbekannte erste Fassung zu Courbets *Retour de la conférence*." *Rapport annuel du Musée des beaux-arts de Bâle*, 37–50. 1946.

Sedgwick 1954
Sedgwick, John Popham, Jr. "Courbet's Evolution." Ph.D. diss., Harvard University, 1954.

Seltzer 1977
Seltzer, Alex. "Gustave Courbet: All the World's a Studio." *Artforum* 16 (Sept. 1977): 44–50.

Serman 1986
Serman, William. *La Commune de Paris*. Paris, 1986.

Sheon 1981
Sheon, Aaron. "Courbet, French Realism and the Discovery of the Unconscious." *Arts* 55 (1981): 114–28.

Silvestre 1856
Silvestre, Théophile. *Histoire des artistes vivants, études d'après nature*. Paris, 1856.

Sterling and Salinger 1966
Sterling, Charles, and Salinger, Margaretta M. *French Paintings: A Catalogue of the Collection of the Metropolitan Museum of Art*. Vol. 2. Greenwich, Conn., 1966.

Sutton 1971
Sutton, Denys. "Editorial: The Queen City of the West." *Apollo* 43 (1971): 236–43.

Tainturier 1860
Tainturier, A. "Exposition de Besançon." *Gazette des beaux-arts* 8 (October 1860): 56–60, 112–116.

Thoré 1847
Thoré, Théophile. *Le Salon de 1847*. Paris, 1847

Thoré 1860
Thoré, Théophile. "Exposition générale des beaux-arts à Bruxelles." *Gazette des beaux-arts* 8 (October 1860): 88–97.

Tourneux 1919
Tourneux, Maurice. *Salons et expositions d'art à Paris (1801–1870): Essai bibliographique*. Paris, 1919.

Toussaint 1979
Toussaint, Hélène. "Le Réalisme de Courbet au service de la satire politique et de la propagande gouvernementale." *Bulletin de la Société de l'histoire de l'art français*, December 1979, 233–44.

Toussaint 1980
Toussaint, Hélène. "Deux peintures de Courbet." *Revue du Louvre* 30 (1980): 91–94.

Traz 1940
Traz, Georges de, ed. *Courbet*. Paris, 1940.

References

Troubat 1878
 Troubat, Jules. *Plume et pinceau*. Paris, 1878.
Troubat 1900
 Troubat, Jules. *Une Amitié à la d'Arthez: Champfleury, Courbet, Max Buchon*. Paris, 1900.
Vapereau 1893
 Vapereau, G. *Dictionnaire universel des contemporains*. Paris, 1893.
Vuilleumier 1978
 Vuilleumier, Marc. "Courbet et Genève." *Musées de Genève* 183 (March 1978): 16–20.
Wagner 1981
 Wagner, Anne M. "Courbet's Landscapes and Their Market." *Art History* 4 (1981): 410–31.
Walter 1973
 Walter, Rodolphe. "Un Dossier délicat: Courbet et la Colonne Vendôme." *Gazette des beaux-arts*, 6th ser., 81 (1973): 173–84.
Wartmann 1936
 Wartmann, W. "Die *Forelle* von Gustave Courbet." *Jahresbericht der Zürcher Kunstgesellschaft*, 1936, 55–58.
Weisberg 1981
 Weisberg, Gabriel P. *The Realist Tradition: French Painting and Drawings, 1830–1900*. Cleveland, 1981.
Weisberg 1982
 Weisberg, Gabriel P., ed. *The European Realist Tradition*. Bloomington, Ind., 1982.
Weisberg 1984
 Weisberg, Yvonne M. L., and Gabriel P. *The Realist Debate: A Bibliography of French Realist Painting, 1830–1885*. New York/London, 1984.
Wey 1861
 Wey, Francis. "Melchior Wyrsch et les peintres bisontins." *Mémoires de la Société d'émulation du Doubs*, 3d ser., 6 (1861): 25–52.
White and White 1965
 White, Harrison C., and White, Cynthia A. *Canvases and Careers: Institutional Change in the French Painting World*. New York, 1965.
Williams 1969
 Williams, Roger L. *The French Revolution of 1870–1871*. New York, 1969.
Winner 1962
 Winner, Matthias. "Gemalte Kunsttheorie: zu Gustave Courbets *Allégorie réelle* und der Tradition." *Jahrbuch der Berliner Museen* 4 (1962): 150–85.
Wolf 1963
 Wolf, John B. *France: 1814–1919*. New York, 1963.
Woodcock 1956
 Woodcock, George. *Pierre-Joseph Proudhon: A Biography*. London, 1956.
Zahar 1950
 Zahar, Marcel. *Gustave Courbet*. Paris, 1950.
Zemisch 1973
 Zemisch, Brigitte, et al. *Foundation Emil G. Bührle Collection*. Zürich, 1973. [All entries on nineteenth- and twentieth-century art by Brigitte Zemisch.]
Zürich 1935
 Zürich, Kunsthaus. *Gustave Courbet*. 1935–36.

In addition to the works listed above, the catalogs of the following dealers and auction houses have been consulted:

Librairie de l'Abbaye, Paris
Les Argonautes, Paris
Librairie Thierry Bodin, Paris
Maison Charavay, Paris
Hôtel Drouot, Paris
Les Neuf Muses, Paris
Henri Saffroy, Paris
Sotheby's, London
J. A. Stargardt, Marburg, Germany

General Index

Note: References to specific works by Courbet are listed in the Index of Courbet's Works, following this index. Recipients of letters are not indexed unless they are the subject of the text; for listings of recipients, see pp. 637–63 and 683–700.

Académie de Besançon, 21, 22, 25, 26
Académie française, 345–46, 347
Administration of Fine Arts. *See* Fine Arts Administration
Age, Courbet on, 184, 324, 330
Alma Bridge Exhibition. *See* Exhibitions: Paris
America, 271, 278, 301, 517, 570
American exhibits. *See* Exhibitions: Boston, Philadelphia
Amsterdam. *See* Exhibitions: Amsterdam
Andler, 338–39
Antwerp. *See* Exhibitions: Antwerp
Arrest. *See* Imprisonment
Art, comments on, 58, 88, 203–4, 224, 230, 232, 346, 348–49, 355, 407–9, 436, 445, 479
 and Germany, 355, 363, 370, 395–400
 and government, 365, 369–71, 410
 and money, 279, 291, 315, 424, 599
 and politics, 77, 83, 98, 99, 104–5, 107, 115–17, 353, 369–71, 378–79, 406–7, 479
 protection of in war, 386–99, 418–19, 422–24, 451, 460–61, 519, 522–23, 553–55
Arthaud, J.-G., 185, 194–95
Artists, comments on, 231–34, 276, 406, 408–9
 French, 408, 410
 German, 406, 409
Artists' Committee to Safeguard the National Museums, 385–88, 399, 401, 405–7, 410–11, 416–17, 420, 423, 427
 president of, 385, 420, 522–23, 553–55
Atelier, Courbet's, 119, 129–31, 161–62, 165, 168, 171, 178, 184–85, 206, 235, 304, 405, 424, 449, 460, 489, 500, 508, 554, 612
 students', 203, 205
Auguin, L.-A., 216

Awards, 198, 202, 345, 351–53, 355, 357, 378–79, 385, 411, 451, 568, 583. *See also* Legion of Honor; Medals

Barthet, A., 186, 198, 235
Baudelaire, C., 92, 113, 132, 150, 236
Baudry, E., 541, 542, 545, 573, 574, 581
Bavaria. *See* Exhibitions: Munich
Beauty, comment on, 204
Belgium, comments on, 73, 244, 276, 344
Bernheim, J., 525, 561, 583
Besançon. *See* Exhibitions: Besançon
Bidard, T., 598, 603
Bigot, L., 433
Binet, T.-A.-V., 106, 133
Bingham, R., 239, 240
Bonvin, F., 225
Brussels. *See* Exhibitions: Brussels
Bruyas, A., 4, 8, 114, 115, 117, 119, 122, 125, 126, 128, 132, 133, 135, 139, 141, 142, 147, 156, 157, 180, 273, 274, 311–12, 314–15, 326–27
 photographs, 120
Buchon, J.-M., 96, 102, 107, 109, 113, 129, 132, 148–49, 150–52, 171, 174, 179, 180, 186, 232–33, 248, 250, 256, 257, 266, 278, 333, 357–63, 426, 493
 death, 358–61, 364
 Essais poétiques, 27
 pamphlet, 330, 331, 332–35

Cannon, "Courbet," 402, 405
Caracci, 554
Carjat, E., 218, 256
Carnival, 93–94
Castagnary, J.-A., 7, 176, 209, 254, 335, 345, 378, 420, 444, 480, 483, 505, 506, 529, 567, 594, 607
Céline N., 263, 269, 272
Censorship, 60
Champfleury. *See* Husson, J.-A.-F.

Chaudey, A.-G., 309, 334, 426

Chavannes. *See* Puvis de Chavannes, P.

Chenavard, P.-M.-L., 115, 117, 355

Chennevières, C.-P. de, 189–90, 197, 280, 285–86, 390

Cholera, 84, 124–25, 127, 129, 134

Circe (attributed to Prud'hon), 524–26, 532

City of Strasbourg, 392, 529, 531, 584. *See also* Vendôme Column

Class, comments on, 230

Classicism, comments on, 336

Commissions, comments on, 106–7, 125, 230

Committee to Safeguard the National Museums. *See* Artists' Committee to Safeguard the National Museums

Commune (of Paris, 1871), 4, 6, 403, 413, 414–15, 416–17, 421, 423, 425, 434, 437, 449, 451, 464, 472, 480, 490, 493, 495, 496, 501, 506, 509–10, 518–20, 529, 568, 584–85, 592–93

Corot, J.-B., 355, 357, 538

Courage, comments on, 115, 122

Courbet, Gustave
comments on himself, 95
music, his own, 85, 86, 113
portaits of, 218, 219, 308
photographs, 218, 219
philosophy, 105, 116–7, 122–23, 174, 194, 223–25, 227, 228–31, 246, 249, 253, 258, 325, 327, 369–71, 491, 599
son, 106, 133
wife, 133
works. *See* Index of Courbet's Works *following* General Index

Courbet, Suzanne-Sylvie (mother)
death, 427, 428–29
estate, 479, 486. *See also* Property seizure

Courbet, Zoé, 48, 55, 153, 161, 165, 316, 322, 326, 437, 441, 449, 454, 459–60, 500, 505, 549, 564. *See also* Reverdy

Critics, comments on, 60, 79, 82, 148, 150, 236, 291, 336

Cross of Honor. *See* Legion of Honor

Cuenot, B.-J.-U., 69, 71, 75, 125, 126, 132, 158, 161, 186, 205, 359
his death, 302, 303

Daubigny, C.-F., 183

Death, comments on, 95, 186

Decentralization, comments on, 229–30

Delacroix, F.-V.-E., 107, 249, 538, 554

Democracy, comments on, 229, 249, 392

Détrimont, 180, 181, 183–84, 186, 187, 191, 192, 194, 217

Dupont, P., 224, 236, 324

Durand-Ruel, 533, 559–62

Dutch masters, comments on, 72

Ecole des beaux-arts, 406, 410

Editors, comments on, 101

Education, comments on, 174, 203–4

Emperor. *See* Napoléon III

English, comments on the, 191

Erlanger, Mme, 161, 165, 177

Exhibitions, 116, 410–11. *See also* Salons
Amsterdam, 180
Antwerp: (1861), 200–202; (1870), 368
Bavaria. *See* Munich
Besançon: (1860, Universal Exhibition), 176, 178–80, 182, 185, 186; (1862), 206; (1865, Société des beaux-arts), 262
Boston (Mass., 1866, Allston Club), 278
Brussels, Exposition générale des beaux-arts: (1864), 244, 250; (1865), 261; (1866), 293, 350, 351, 353; (1869), 349
Dijon. *See* Le Creusot
Frankfurt (1852), 110–11, 113, 162
Ghent (Salon, 1868), 341–44, 351
Lausanne (1876, Turnus exhibition), 574, 579, 580
Le Creusot benefit (Dijon, 1870), 373, 375–77
Le Havre (Société des beaux-arts), 333
London, Durand-Ruel (1874), 524. *See also* Durand-Ruel, *main entry*
London, International Exhibition: (1860), 176; (1862), 202; (1873), 487
Munich (1869), 351–53, 355, 357
Ornans (1850), 97–99
Paris, private: (1855), 99, 120–21, 135, 142, 144–45, 147, 174; (1867, Alma Bridge), 305–6, 311–14, 316, 318, 321, 327, 341
Paris, Martinet Gallery, 217
Paris, Universal Exhibition: (1855), 6, 115, 120, 128, 129, 133–35, 139–41, 143, 145; (1867), 6, 303, 304, 309, 321

Paris Salons. *See* Salons, *main entry*
Philadelphia (1876, Centennial Exhibition), 577, 583, 612, 616
The Hague (1866), 287, 297
Vienna (1873, Austrian Art Union), 471–72, 474–75, 477–81, 483–85, 487–90, 493, 496
Exile, comments on, 493, 499, 500, 501, 503–5, 508, 514, 516, 570, 582, 587, 591, 595–96, 599, 611
Exposition générale des beaux-arts. *See* Exhibitions: Brussels

Fajon, P. A., 157
Fame, comments on, 382
Fine Arts Administration, 107, 115, 286–97, 309, 351, 364, 365, 370, 378–79, 406, 530
Flajoulot, C.-A., 13, 35, 36
Forgeries, 525, 534, 561, 583
Fountain of Hippocrene, 272, 277
Français, F.-L., 103, 105, 109, 115, 117
France, comments on, 553–55, 567–70, 599, 620
Franchard Valley, 146
Franche-Comté, 98, 183, 327–28, 398
Franco-Prussian war, 382, 384–99, 568.
 See also Paris, siege of; War
Frankfurt. *See* Exhibitions: Frankfurt
Freedom, comments on, 231, 246, 262, 327, 365, 369–71
Fresquet, R.-R.-F. de, portraits, 66. *See also* Oudot
Friends of the Constitution, 103
Friendship, comments on, 128, 157, 225, 326–37
Frond, V., 107, 222, 270, 294

Gatti de Gamond, J.-B., 42
Gaudy, F.-A.-F., 173
Gautier, A., 154, 159, 180, 186
Gautier, P.-J.-T., 113, 236, 336
Genius, comments on, 230
Germany, comments on, 405, 409
 army, 395–400
 art, 355, 363, 370, 385, 395–400
 artists, 406
 hunting, 166
 letters to German army and German artists, 395–400

Gérôme, J.-L., 287
Ghent. *See* Exhibitions: Ghent
Gigoux, J.-F., 70
Girard, A., 405, 430–32, 455–57, 523, 525, 533, 542
Girardon, F., 530
Government, comments on, 115–17, 148–49, 165, 197, 198, 217, 223–25, 244, 249, 263, 275, 292, 316, 346, 351, 365, 375, 382, 404–7, 416–17, 434, 435, 443, 448–51, 474–75, 491, 554
Great Lottery, 82
Greatness, comments on, 231, 248–49
Grévy, J., 423

Hague, The. *See* Exhibitions: The Hague
Happiness, comments on, 128–29
Haro, E.-F., 237–39, 240, 241
Havre, Le. *See* Exhibitions: Le Havre
Hesse, N.-A., 45, 53, 54, 69, 101
History, comments on, 203–4, 228
Holland, 66, 68
Hospital, Versailles, 433–34
Hugo, V., 200, 246, 248–49, 253, 568
Hunting, comments on, 93, 119, 120, 126, 129, 135, 164, 166, 188, 192–94, 254, 463
Husson, J.-A.-F. [pseud. Champfleury], 3, 7, 93, 108, 113, 117, 125, 130, 138, 141, 151, 157, 159, 170–71, 173, 174, 179, 180, 187–88, 202, 213, 221, 223–25, 232, 362

Immorality, 222, 240, 244
Imprisonment, 420, 421, 423–33, 436–45, 447–51, 453, 503, 554, 591
Indecency. *See* Immorality
Independence. *See* Freedom
Ingres, J.-A.-D., 236, 243, 551
Irish, 132
Isabey, L.-M.-G.-F., 206, 227, 234–35, 305, 309

Jaundice, 129, 133, 134
Joliclerc, L., 262, 265, 442, 473
Joute, E.-F., 425, 430–32. *See also* Cannon, "Courbet"
Jovinet, 34, 37, 49, 57, 78, 153
Judges, comments on, 62, 70–71, 102, 116, 139, 141, 151. *See also* Juries

Juries, 202, 218, 219, 276, 344, 365. *See also* Judges

Khalil Bey, 306, 307

Lachaud, C.-A., 429, 436, 445–46, 449, 510, 521, 529, 531, 556–57, 564, 582, 584, 588
Lamartine, A., 236
Landscapes, 87, 119, 193–94, 249, 263, 276
Leboeuf, L.-J., 214
Le Creusot. *See* Exhibitions: Le Creusot
Legion of Honor, 6, 296, 378–79, 405. *See also* Awards; Medals
Legrand, A., 422, 480, 483, 494. *See also* Durand-Ruel
Le Havre. *See* Exhibitions: Le Havre
Leonardo da Vinci, 293
Léontine. *See* Renaude, Léontine
Lepel-Cointet, 280, 317, 318
 lawsuit, 302, 303, 305–8
Life, comments on, 105, 324. *See also* Philosophy
Lithography, 26, 27, 175
London. *See* Exhibitions: London
Louis-Philippe, King, 80, 90
Louvre, 60, 63, 391, 394
Love, comments on, 126, 128–29, 212, 214, 215, 231, 262, 265, 490
"Lovers in the Village" (song), 328

Mannequins, 271. *See also* Models
Marlet, A., 49, 74, 75, 118
Marriage, 106
Masson, B., 317
Mathieu, H.-A.-G, 236
Mathilde. *See* Montaigne Carly de Svazzena
Mazaroz, J.-P., 179, 241
Medals, 6, 182, 185, 198, 218, 219, 276, 281, 291–93, 296. *See also* Awards; Legion of Honor
Military, comments on, 35
Models, 75, 93. *See also* Mannequins
Monet, C.-O., 300, 588
Money, comments on, 229–31
Monselet, C., 236
Montaigne Carly de Svazzena, Mathilde, 472, 473, 498, 511, 513
Morny, C.-A. Comte de, 106, 111, 148

Mother, Courbet's:
 death, 427, 428–29
 estate, 479, 486. *See also* Property seizure
Movement, comment on, 193
Munich, 102
Murillo, B. E., 104, 526, 532
Music, Courbet's, 85, 86, 113

Nadar. *See* Tournachon, Félix
Napoléon III (Louis Napoléon), 105, 122, 164, 198, 202, 220, 221, 229, 309, 359, 373, 375, 382, 384, 401, 443, 453
National Assembly, 403, 405, 423
Nélaton, A., 447, 449, 452, 554
Nicolle, 161, 165
Nieuwerkerke, A.-E., Comte de, 115–17, 134, 142, 144, 190, 197, 223, 240, 266, 276, 279, 283–92, 295–99, 306, 364, 365
Nudes, 109, 129, 171

Opinions et propos d'un citoyen d'Ornans. See Pamphlets
Oraguay rock, 194, 197
Ordinaire, E., 91, 258, 322–23, 325, 329–31, 335, 366, 378, 383, 472, 527
 Une Election dans le grand-duché de Gé-rolstein, 322, 323, 325, 329
Ornans, 3, 87, 89, 94, 443. *See also* Exhibitions: Ornans
Oudot, F.-J. family, 30–32, 37, 40, 42, 46, 49, 51, 57, 62, 63, 70, 79, 481
Oudot, Mlle. 46. *See also* Fresquet

Painting, comments on, 127, 204, 276, 291–92, 315
Paintings, large, comments on, 53, 54, 55, 93
Pamphlets, 342
 Les Curés en Goguette ("La Conférence"), 340
 drawings for, 340, 342
 La Mort de Jeannot: Les Frais du culte, 340
 Opinions et propos d'un citoyen d'Ornans, 330, 331, 332–35
 Ordinaire's *Une Election dans le grand-duché de Gérolstein*, 322, 323, 325, 329, 330
 on Vendôme Column, 517, 521, 529

Panier, 36, 40

Paris. *See also* Exhibitions: Paris; Salons
 siege of, 402, 404–5, 408, 424, 523

Pasteur, E., 468–71

Pata, 480, 486, 493, 496, 498, 511, 513

Patronage, comments on, 101

Peisse, J.-L.-H., 88

Philosophy, Courbet's, 105, 116–17, 122–23,
 174, 194, 223–25, 227–31, 246, 249,
 253, 258, 325, 327, 369–71, 491, 599

Photography and photographs, 120, 127,
 130, 137, 143, 144, 222, 226, 239, 240,
 252, 256, 273, 342, 344, 361, 530, 532,
 550
 of Courbet, 218, 219

Pia, P., 526–27

Pierrots, 93

Politics, 79, 103–5
 and art, 99, 100, 104–5, 107, 115–17
 and artists, 77, 83

Portraits by Courbet. *See* Index of Courbet's
 Works *following* General Index

Portraits of Courbet, 218, 219, 308

Portraiture, comments on, 58, 122, 267

Pothey, C., 195

Pouchon, C., 33

Poulet-Malassis, P.-E.-A., 190

Poussin, N., 554

Pradelles, H., 216

Presidency. *See* Artists' Committee to Safe-
 guard the National Museums.

Promayet, P.-J.-A., 159

Property seizure, 471, 475–77, 479–82,
 485–86, 489–91, 495, 499–506,
 508, 516–17, 542, 553–55, 564–71,
 573, 589, 614–15

Proudhon, P.-J., 2, 4, 132, 137, 150, 180,
 200, 222, 226, 227, 232–33, 251, 255,
 260, 261, 266, 273, 325, 409, 413
 death of, 256, 257–58, 259, 274
 family, 597, 598, 603

Prud'hon, P.-P., 530, 532. See also *Circe*

Public, comments on the, 64, 70–71, 76,
 99, 194, 198, 229–31. *See also* Society

Puvis de Chavannes, P., 588

Realism, 103, 107, 130, 131, 150, 151, 156,
 173, 188, 193, 201, 204, 236, 252, 254,
 276, 335, 336, 360, 413, 538, 585

Reality, comment on, 233

Rembrandt, 554

Renaude, Léontine, 207–11, 466–67

Reni, G., 530

Republic, the, 404–5, 461, 464

Republicans, 79, 103, 132

Reverdy, J.-B.-E.-C., and Zoé, 322, 326,
 352, 437, 442, 459–60, 477, 480–81,
 483, 484, 493, 494, 500, 505, 514–18,
 543–44, 547–48, 555, 564–66, 574,
 577–78, 582, 607, 614. *See also* Cour-
 bet, Zoé

Revolution, 79, 81, 83, 104–5, 220, 249,
 257, 275, 329–30, 346, 358, 409, 413,
 414–15, 436, 491

Riat, G., 8

Richard, M., letter to, 378–81

Rochefort, H., 373, 541, 553

Romanticism, 151, 194, 252, 336, 538, 585

Rubens, P.-P., 401, 554

Sainte-Beuve, C.-A. de, 275

Salons
 1840, 31
 1844, 5, 45, 46, 47
 1845, 51, 53
 1846, 54, 60, 61, 62, 63, 64
 1847, 69, 70
 1848, 5, 76, 77
 1849, 3, 85, 92
 1850, 94, 96, 100, 101
 1852, 106
 1853, 109, 111
 1857, 154, 156
 1859, 161, 164, 165, 166
 1861, 182, 183–84, 189, 191, 192, 193–
 94, 198
 1863, 218, 219, 220
 1864, 236, 237–39, 240, 241
 1865, 254, 259, 263
 1866, 268, 276, 279, 282, 286–92, 298
 1870, 352, 354, 365, 368; constitution,
 369–71
 1871, 406
 1873, 472, 474–75
 1875, 541, 545
 1877, 595
 des refusés, 221

Sculptors, comment on, 214

721

Sculpture, comment on, 205

Sea, comment on, 38

Seascapes, 181, 375, 382

Sentimentality, 232–33

Settlement of charges, 589–96, 599–601, 604, 619. *See also* Imprisonment; Property seizure; Trial; Tribunal;

Silvestre, T., 110–11, 113, 122, 130, 151, 223, 225

Simon, J., 385, 422, 423, 529, 531, 540, 591, 593, 594, 597, 611

Socialism, 103–5, 229–30, 325, 329–30, 413

Société des beaux-arts, Besançon (1865), 262

Société des beaux-arts, Le Havre (1868), 333

Society, comments on, 115, 128–29, 133, 223–25, 229–31. *See also* Public

Song, "Lovers in the Village," 328–29

Steen, J., 530

Steuben, Baron C., 29, 32

Strasbourg, City of. See *City of Strasbourg;* Vendôme Column

Students, 101–2, 216

Studio. *See* Atelier

Switzerland, 129, 452, 454, 503, 505, 508–9, 522, 570, 571. *See also* Exile

Teachers, 101–2

Teaching, 203–4

Tentoonstelling van Levende Meesters. *See* Exhibitions: Amsterdam; Exhibitions: The Hague

The Hague. *See* Exhibitions: The Hague

Thiers, A., 404, 415, 416, 419, 464, 475, 518–20, 523, 554, 582

Thoré, T., 71, 321

Tintoretto, 530

Titian, 107

Tourangin, D.-V., 148, 151

Tournachon, Félix [pseud. Nadar], 113, 181, 208–11, 219

Trapadoux, M., 91–92, 585

Trial (1871), 429–34, 436, 437, 475, 584, 594, 597, 598

Tribunal (1874), 474–77, 481, 489, 490, 499, 501, 503–10, 514, 521, 531–33, 535–36, 555, 587–88, 594, 597, 598

appeal, 555–56, 567–70, 572, 573, 584, 587–88, 602, 606, 607, 608

Truth, comment on, 99

Universal Exhibition. *See* Exhibitions: Besançon; Exhibitions: Paris

Velazquez, 554

Vendôme Column, 6, 392–93, 419, 421–24, 434, 437, 439, 441, 471–73, 481, 482, 486, 489, 499, 504, 506, 508–10, 514, 516–20, 529, 531–32, 535–36, 555, 567–70, 584–85, 592–93, 599, 602

Vernier, E.-L., 171, 175

Vertel, N., 29, 39, 49, 51, 57, 59

Verwee, A.-J., 244, 245

Vouet, S., 554

War, 81. *See also* Franco-Prussian war

War Council, 471, 509–10, 519, 554. *See also* Trial; Tribunal

Watteau, J.-A., 530

Wey, F., 2, 3, 89, 104, 118, 192

Whistler, J. A. M., 269, 601–2

Women, comments on, 126, 231

Work, comments on, 184, 230–31

Wouwermans, 554

Zoé Courbet Reverdy. *See* Courbet, Zoé; Reverdy.

Index of Courbet's Works

Note: All works are paintings unless otherwise noted.

After Dinner in Ornans, or *Evening at Ornans,* 3, 5, 88, 100, 102, 141, 143, 145
Amor and Psyche, 182, 185, 187
Apples. See *Still-life with Apples*

Bacchante. See *Sleeping Woman*
Banks of the Loue. See *Castle of Scey-en-Varais*
Bathers, 111, 116, 117, 122, 129, 131, 139, 141, 142, 144, 145, 147, 175, 176, 273, 312, 315
Bathing Sarah, 525
Bathing Woman, 525
Battle of the Stags, Three Stags, or *Spring Rut,* 184, 185, 189, 191–94, 197, 202, 217, 284, 291, 308, 481, 483
Beach at Trouville during Low Tide, 343
Beautiful Irishwoman. See *Portrait of Jo*
Black Rocks, 369
Blue Spring, 473, 490
Bonjour, Monsieur Courbet. See *Meeting*
Boy Catching Bullheads (sculpture), 119, 205–7, 210, 219, 421, 450, 461, 604
Breton Shepherdess, or *Breton Spinner,* 311, 487, 488, 551, 559
Breton Spinner. See *Breton Shepherdess*
Bullfight. See *Hippodrome*
Burial at Ornans, 5, 89, 91, 93, 96, 107, 116, 128, 129, 131, 133, 134, 136, 137, 139, 141, 161, 179, 190, 192–93, 245, 276, 304, 309, 310, 481, 483, 487

Castle of Scey-en-Varais, or *Banks of the Loue,* 87
Cellist, or *Contrabass Player,* 103, 541, 551
Château de Chillon, 523
Checkers Players, 51
Cliff at Etretat, 352, 354, 377
Contrabass Player. See *Cellist*
Copy after Malle Babbe by Frans Hals, 356, 364, 484, 485
Copy after Portrait of a Young Man after Velazquez, 356

Copy after Self-Portrait by Rembrandt, 356, 364, 484, 485
Courbet with Black Dog, 45, 46, 47
Covert of the Roedeer, 272, 275, 279, 280, 284, 307, 308, 309, 364
Covert of the Roedeer. See *Forest*

Death of Jeannot, 341, 342, 344, 487
Death of the Hunted Stag. See *Mort of the Stag*
Desperate Man, 53
Doubs Falls, 247
Dream of a Young Girl. See *Hammock*
Drunkard of Ornans, 579
Dying Stag. See *German Hunter*

English Horse, or *Horse of M. Duval,* 483
Essart-Cendrin, L', 112
Etretat Seascape with White Cliffs, 364, 616
Evening at Ornans. See *After Dinner in Ornans*

Forest, Wintertime, or *Covert of the Roedeer,* 175; fountain for, 227, 234–35
Forest at Port-Berteau, 264
Fox Hunt. See *Horse and Bulldog in the Woods*
Fox in the Snow, 197

German Hunter, or *Dying Stag,* 237
Girl with Seagulls, 350
Gour de Conche, 247
Grainsifters, 121, 128, 133, 135, 138, 200, 309
Guitarrero, 51, 53, 56
Gypsy, 503

Hammock, or *Dream of a Young Girl,* 51
Hanging Roedeer, 197
Helvetia, Liberty, or *Republic* (sculpture), 546, 562, 576, 582, 608, 609
Hind at Bay in the Snow, 154
Hippodrome, or *Bullfight,* 160

Horse and Bulldog in the Woods, or Fox Hunt, 218, 219, 615, 618
Horse in the Stable, 483, 487
Horse of M. Duval. See English Horse
Hunting Dogs with Dead Hare, 304, 309, 525, 551
Huntsman, 191, 193–94

Jean Journet Setting Out for the Conquest of Universal Harmony. See Portrait of Jean Journet

L'Essart-Cendrin, 112
Lady of Munich, 356, 364
Lady with a Jewelry Box, 344
Landscape at Interlaken, or Swiss Landscape, 364, 373
Landscape with Boat. See Oraguay Rock
Landscape with Lock, 368
Le Château d'Ornans, 128, 137
Liberty. See Helvetia
Lot and His Daughters, 5, 44
Lovers in the Country, 60, 450

Magnolias, 217, 220
Man with a Pipe (F.39), 107, 127, 128, 129, 133, 136, 137, 144, 147, 156, 273, 341, 488; (F.40), 449, 477, 487, 488; (F.41), 122, 449, 477
Man with the Leather Belt, 60, 62, 122, 536
copy, 483, 487
Meeting, or Bonjour, Monsieur Courbet, 128, 129, 136, 137, 139, 141, 144, 156, 273
Mère Grégoire, 311, 462, 464, 497, 525
Mort of the Stag, or Death of the Hunted Stag, 254, 304, 305, 306, 308, 374, 464, 481, 483, 616
Mort of the Stag. See Quarry
Mushrooms, 462

Nude Woman Sleeping Near a Brook, 525
Nude Woman with Dog, 209, 210, 523, 552

Oraguay Rock, or Landscape with Boat, 197, 353

Painter's Atelier, 5, 128, 129, 138, 139, 141, 161, 232–36, 487
Peasant Woman with Kerchief, 163, 165, 470

Peasants of Flagey Returning from the Fair, 119, 121, 129, 131, 141, 143, 145, 243, 311
Poachers in the Snow, 320, 551
Poet. See Sculptor
Ponds at Palavas, 156
Poor Woman with Child and Goat. See Poverty in the Village
Portrait of Alfred Bruyas (F.141), 312 ; (F.142), 156, 312
Portrait of Alphonse Promayet, 481, 551
Portrait of Mlle Aubé de la Holde, 267, 268, 474
Portrait of Beatrice Bouvet as a Child, 247
Portrait of a Belgian Baron, 47
Portrait of Mme Buchon (sculpture), 254
Portrait of Champfleury, 128, 138, 139
Portrait of Clément Laurier, 146
Portrait of the Countess Karoly, 267, 268
Portrait of Gabrielle Borreau. See Rêverie
Portrait of M. Gueymard, 153
Portrait of H. J. van Wisselingh, 68
Portrait of Jean Journet, or Jean Journet Setting Out for the Conquest of Universal Harmony, 100
Portrait of Jo, or Beautiful Irishwoman, 579, 601, 610
Portrait of Jules Bordet, 486
Portrait of Juliette Courbet, 51
Portrait of Mme L. See Portrait of Laure Borreau
Portrait of Laure Borreau, or Portrait of Mme L., 218, 219
Portrait of Mme Lydie Joliclerc, 247
Portrait of a Man, 525
Portrait of Marcello (Adèle Castiglione), 333, 342, 487, 579
Portrait of M. Nodler, Junior, 267
Portrait of Mme Mathilde Cuoq, 105
Portrait of Max Buchon, 180, 304
Portrait of Pierre Dupont, 615, 618
Portrait of Pierre-Joseph Proudhon in 1853, 260–64, 278, 318, 342, 551, 615
Portrait of Rochefort, 541
Portrait of a Spanish Lady, 450, 477, 481, 483, 487
Portrait of Urbain Cuenot, 51, 69, 71, 477, 481, 483, 487
Portrait of Woman Holding a Parrot, 551

Portrait of a Young Woman, 487
Portrait of Zélie Courbet, 449
Poverty in the Snow. See *Poverty in the Village*
Poverty in the Village, Poverty in the Snow, or *Poor Woman with Child and Goat,* 308, 318, 320, 337
Priests. See *Return from the Conference*
Prisoner of the Dey of Algiers, 60
Puits noir, 263, 282, 283, 304, 309

Quarry, or *Mort of the Stag,* 154, 243, 279

Reclining Woman, 170, 185
Reclining Woman in Boat, 367, 368
Republic. See *Helvetia*
Return from the Conference, or *Priests,* 215, 216, 218, 220–22, 226, 227, 233, 245, 252, 271, 273, 309, 318, 341, 342, 344, 487
Rêverie, or *Portrait of Gabrielle Borreau,* 217
Rocks at Mouthier. See *Siratu Cascade*
Roedeer by the River, 343, 344, 364, 367, 368
Roedeer on the Alert, 337

Sculptor, or *Poet,* 56
Seagull on the Lake of Geneva at Vevey (medallion), 578–80
Seascape, 264
Seascape with Waterspout, 487
Seeress, or *Somnambulist,* 304, 309, 484, 487
Seine Bathers. See *Young Ladies on the Banks of the Seine*
Self-Portrait: (F.26), 540–41; (F.542), 484, 487, 624
Self-Portrait, or *Courbet with Black Dog,* 45, 46, 47
Self-Portrait, or *Man with a Pipe:* (F.39), 107, 127, 128, 129, 133, 136, 137, 144, 147, 156, 273, 341, 488; (F.40), 449, 477, 487, 488; (F.41), 122, 449, 477
Self-Portrait at Easel, drawing, 615
Self-Portrait with Striped Collar: (F.160), 450, 477, 487; (F.161), 137, 139, 147, 273, 309, 312, 315, 341, 488
Señora Adela Guerrero, Spanish Dancer, 551
Siesta at Haymaking Time, 308, 551
Siratu Cascade, or *Rocks at Mouthier,* 243, 487

Sleep, Sleeping Woman, or *Sloth and Luxury,* 293
Sleeping Nude, 367, 368, 373
Sleeping Spinner, 111, 130, 133, 139, 147, 148, 312, 315
Sleeping Woman. See *Sleep*
Sleeping Woman (F.137), 450
Sleeping Woman, or *Bacchante* (F.55), 525
Sleeping Woman with Red Hair, 525
Sloth and Luxury. See *Sleep*
Solitude, 275
Somnambulist. See *Seeress*
Source of the Lisou: (F.402), 247; (F.403), 247
Source of the Loue River, 243, 551
Spring, or *Woman at the Spring,* 368, 475, 481, 487
Spring Rut. See *Battle of the Stags*
Stag and Doe in the Woods, 552
Stag at Bay, or *Stag at the Stream* (F.277), 176, 180, 185, 187, 189, 191, 193–94, 202, 259, 309
Stag at the Stream. See *Stag at Bay*
Stag by a Stream (F.108), 187
Still-life with Apples, 602
Still-life with Pomegranates, 447
Stonebreakers, 2, 5, 88, 89, 92–93, 100, 102, 121, 128, 133, 137, 168, 179, 180, 181, 318, 353
Stormy Sea, 352, 354, 377, 616
Stream of the Puits noir, 128, 137
Study of a Dog, 209, 210
Study of a Sleeping Woman, 525
Study of Women. See *Venus and Psyche*
Summer. See *Young Ladies on the Banks of the Seine*
Swiss Calf. See *White Calf*
Swiss Landscape. See *Landscape at Interlaken*

Three Bathers, 497
Three English Girls at the Window, 487, 601
Three Stags. See *Battle of the Stags*
Three Trout from the Loue River, 462, 524
Trout: (F. 786), 462, 485, 486; (F.883), 462
Two Baskets with Flowers, 551
Two Poachers with Dog Following the Trail of a Hare, 237

Venus and Psyche, Venus in Jealous Pursuit of Psyche, or *Study of Women,* 238–41, 244, 245, 250, 252, 303, 307, 374

Venus in Jealous Pursuit of Psyche. See *Venus and Psyche*

View of the Mediterranean, 171

View of the Ruins of the Château at Scey-en-Varais. See *Washhouse*

View of the Starnberg Lake in Bavaria, 487

Villagewoman with Goat, 487

Vinedresser of La Tour or *Vinedresser of Montreux,* 583

Vinedresser of Montreux. See *Vinedresser of La Tour*

Walpurgisnacht, 5, 56, 59

Washhouse, or *View of the Ruins of the Château at Scey-en-Varais,* 485

White Calf, or *Swiss Calf,* 524, 602, 605

Wintertime. See *Forest*

Woman, 525

Woman at the Spring. See *Spring*

Woman in the Waves, 481, 488, 560

Woman of Frankfurt, 497

Woman with a Garland, 450

Woman with a Mirror, 175, 176, 184, 185, 187

Woman with a Parrot, 275, 277, 279, 282–98, 303, 373, 374, 487, 530

Woman with Cat, 238, 488

Woman with Podoscaph, 267, 268

Woman with White Stockings, 485

Woman's Head, Wild Flowers, 60

Women Sleeping in the Wheatfield, 615

Wounded Man: (F.51), 122, 300; (F.546), 266, 497

Wrestlers, 109, 111, 141, 243, 271, 311, 525

Young Ladies from the Village, 104, 106, 107, 111, 119, 128, 133, 135, 148, 309, 574, 604

Young Ladies on the Banks of the Seine (study), 604

Young Ladies on the Banks of the Seine, Summer, or *Seine Bathers,* 604